The Cybercultures Reader

Second Edition

The Cybercultures Reader brings together key writings in the exciting and interdisciplinary field of cyberculture studies, providing in one volume a comprehensive guide to the ways in which new technologies are shaped by and are shaping cultural forms and practices.

This new, updated and thoroughly revised edition of the best-selling *The Cybercultures Reader* includes a host of specially selected contemporary articles by key thinkers in the expanding field of cybercultures studies. The Reader covers all the main areas of current research, including new sections for this edition such as cybercommunities, cyberidentities, cyberlife and cyberpolitics. It ends with a forward-looking section of essays that move beyond cybercultures, to consider cutting-edge developments in technologies and how we think about them.

Key features of the Reader include:

- A general introduction to the study of cyberculture
- Introductions to each thematic section, locating the articles in their theoretical and technological contexts.

This new edition of *The Cybercultures Reader* will be an indispensable resource for all those interested in living with and thinking about new technologies.

David Bell is Senior Lecturer in Critical Human Geography and leader of the Urban Cultures & Consumption research cluster at the University of Leeds. His previous publications include *An Introduction to Cybercultures* (2001) and *Cyberculture Theorists: Manuel Castells & Donna Haraway* (2006).

Barbara M. Kennedy is Reader in Film, Media and Cultural Studies at Staffordshire University. Her previous publications include *Deleuze and Cinema: The Aesthetics of Sensation* (2000), *The Cybercultures Reader* (2000) with David Bell and a variety of articles in journals on feminist film theory, philosophy, dance, choreography and cultural studies.

The
Cybercultures
Reader

Second Edition

Edited by

**David Bell and
Barbara M. Kennedy**

Routledge
Taylor & Francis Group

LONDON AND NEW YORK

First published 2000
by Routledge
2 Park Square, Milton Park, Abingdon, Oxon OX14 4RN

Simultaneously published in the USA and Canada
by Routledge
270 Madison Ave, New York, NY 10016

Reprinted 2001, 2002
Transferred to Digital Printing 2007

Routledge is an imprint of the Taylor & Francis Group, an informa business

Second edition published 2007
by Routledge

Editorial Selection and Material © 2007 David Bell and Barbara M Kennedy
Chapters © 2007 The Contributors

Typeset in Perpetua and Bell Gothic by
HWA Text and Data Management, Tunbridge Wells
Printed and bound in Great Britain by
The Cromwell Press, Trowbridge, Wiltshire

British Library Cataloguing in Publication Data
A catalogue record for this book is available from the British Library

Library of Congress Cataloging-in-Publication Data
The cybercultures reader / edited by David Bell and Barbara M. Kennedy. – 2nd ed.
 p. cm.
 1. Computers and civilization. 2. Cyberspace – Social aspects. I. Bell, David, 1965 Feb. 12–
II. Kennedy, Barbara M. III. Bell, David.
QA76.9.C66C898 2007
 303.48´33–dc22 2007037959

ISBN10: 0–415–41068–1 (hbk)
ISBN10: 0–415–41067–3 (pbk)

ISBN13: 978–0–415–41068–7 (hbk)
ISBN13: 978–0–415–41067–0 (pbk)

Contents

PART EIGHT
Cyberpolitics
575

PART NINE
Beyond cybercultures
651

Illustrations

Notes on Contributors

The Editors

David Bell is Senior Lecturer in Critical Human Geography at the University of Leeds, UK.

Barbara Kennedy is Reader in Film and Cultural Studies at Staffordshire University, UK.

The Contributors

Alison Adam is Professor of Information Systems at the University of Salford, UK. Her research interests include gender and information systems and computer ethics. Books include, *Artificial Knowing: Gender and the Thinking Machine*, *Virtual Gender* (co-edited with Eileen Green) and *Gender, Ethics and Information Technology*.

Casey Alt is an artist, designer and theorist whose work explores creative interfaces to information systems. Casey is currently completing his MFA in the Design | Media Arts department at the University of California, Los Angeles, USA. Prior to this, he spent two years as the Program Director of the Information Science + Information Studies program at Duke University. Casey holds a Masters in History and Philosophy of Science & Technology from Stanford University.

Robert Ayers is a British-born artist who lives and works in New York City, USA. He has been making performance art of one sort or another for 35 years, and writing about it for almost as long. He is Senior Editor of ArtInfo.com.

Maria Bakardjieva is Associate Professor at the Faculty of Communication and Culture, University of Calgary, Canada. She studies the uses of the Internet in different social contexts and is the author of *Internet Society: the Internet in Everyday Life*.

Philip Bakelaar received his BA in Geography from Rutgers University, USA, works as an IT Manager at the American Health Initiative, and is currently enrolled in the Masters of Library and Information Science program at Rutgers.

Michael Benedikt is ACSA Distinguished Professor, Hal Box Chair in Urbanism, and Director, Center for American Architecture and Design, the University of Texas at Austin, USA.

Scott Bukatman is an Associate Professor in the Film and Media Studies Program, Department of Art and Art History, Stanford University, USA. He is the author of *Matters of Gravity: Special Effects and Supermen in the 20th Century*, *Terminal Identity: The Virtual Subject in Postmodern Science Fiction*, and the British Film Institute volume on the film *Blade Runner*.

Charles Cheung is currently in the final year of his PhD in sociology of media at the Open University, UK. He previously taught Cultural Studies at the Chinese University of Hong Kong. He co-edited the book *Reading Hong Kong Popular Culture: 1970–2000*.

Tyler Curtain is an Associate Professor in the Department of English and Comparative Literature, Program in Cultural Studies at the University of North Carolina at Chapel Hill, USA, and an Associate Fellow in the Gender Institute, London School of Economics and Political Science, UK.

Matthew Gandy is Professor of Geography at University College London, UK. He has published widely on urban, cultural and environmental themes and is author of *Concrete and Clay: Reworking Nature in New York City* and co-editor of *The Return of the White Plague* and *Hydropolis*. He is currently writing a book on cultural histories of urban infrastructure.

Donna Haraway is a Professor in the History of Consciousness Department at the University of California at Santa Cruz, USA. Her latest book is *When Species Meet*.

N. Katherine Hayles is Hillis Professor at the University of California, Los Angeles, USA. Her latest book is *My Mother Was a Computer: Digital Subjects and Literary Texts*.

Robin Held is currently Chief Curator and Director of Exhibitions and Collections at the Frye Art Museum, Seattle, USA. Prior to joining the Frye in 2004, she was associate curator at the Henry Art Gallery, University of Washington. Her work includes the travelling exhibition *Gene(sis): Contemporary Art Explores Human Genomics*, the first art museum exhibition to be registered with the National Institutes of Health as laboratory activity and a new museum model for the safe exhibition of life forms created by artists.

Briavel Holcomb is a geographer who has taught at Rutgers University since 1972. She is a cyberneophyte.

Todd Joseph Miles Holden is Professor of Mediated Sociology in the Graduate School of International Cultural Studies at Tohoku University in Sendai, Japan. His research interests

embrace social theory, semiology, advertising, gender, identity, political communication, and comparative culture. He writes a regular column called "ReDotPop" and a travelblog called "Peripatetic Postcards" for the ezine, *PopMatters*.

Tim Jordan works in Sociology at the Open University, UK, and researches Internet cultures and politics. He is the author of *Hacktivism and Cyberwars* (with Paul Taylor), *Activism! Direct Aaction, Hacktivism and the Future of Society* and *Cyberpower: the Culture and Politics of Cyberspace and the Internet*.

Richard Kahn is a Teaching Fellow at the University of California, Los Angeles, USA; his website archiving many of his writings is at: http://richardkahn.org.

Douglas Kellner is George Kellner Chair in the Philosophy of Education at the University of California, Los Angeles, USA. He is author of many books on social theory, politics, history, and culture; his website is at http://www.gseis.ucla.edu/faculty/kellner/kellner.html.

Sarah Kember is a Reader in the Department of Media and Communications, Goldsmiths, University of London, UK. She is the author of *Cyberfeminism and Artificial Life* and co-edited *Inventive Life: Towards the New Vitalism*.

Alison Landsberg is an Associate Professor of American Culture and Film in the Department of History and Art History at George Mason University, USA, where she also teaches in the Cultural Studies program.

Tim Lenoir is the Kimberly Jenkins Chair for New Technologies and Society at Duke University, USA. He is currently engaged with colleagues at UCSB in developing the NSF-supported Center for Nanotechnology in Society, where he contributes to the effort to document the history, societal, and ethical implications of bionanotechnology. For more information and links to recent work, see http://www.jhfc.duke.edu/jenkins/people/tim.html.

Deborah Lupton is Professor of Sociology and Cultural Studies at Charles Stuart University, Australia. She has published extensively in the areas of the sociocultural aspects of the body, risk and health and medicine.

Lev Manovich (www.manovich.net) is the author of *Soft Cinema: Navigating the Database* and *The Language of New Media*. Manovich is a Professor of Visual Arts, University of California, San Diego, USA (visarts.ucsd.edu) and a Director of The Lab for Cultural Analysis at California Institute for Telecommunications and Information Technology (www.calit2.net).

Colin Milburn is Assistant Professor of English and a member of the Science and Technology Studies Program at the University of California, Davis, USA. His research focuses on the cultural relations between science, literature, and media technologies. His forthcoming book about the onrushing era of nanotechnology is entitled *Nanovision: Engineering the Future*.

Hans Moravec is chief scientist of Seegrid Corp, USA, and was a Research Professor at Carnegie Mellon University's Robotics Institute.

Scott McQuire is a Senior Lecturer in the Media and Communication Program, School of Culture and Communication, University of Melbourne, Australia.

Lisa Nakamura is Associate Professor of Speech Communication and Asian American Studies at the University of Illinois, Urbana Champaign, USA, and the author of *Cybertypes: Race, Ethnicity, and Identity on the Internet* and co-editor of *Race in Cyberspace*.

Mark Oelhert is a Learning Strategy Architect at Booz Allen Hamilton, a global technology consulting firm. He provides leadership and enterprise-level insight on a number of issues including game-based learning, mobile learning, emerging technologies and strategic planning for clients ranging from the US Department of Defense to the corporate training sector.

Aihwa Ong is Professor of Anthropology at the University of California Berkeley, USA. She is the author of several books on new global configurations, including *Neoliberalism as Exception: Mutations in Citizenship and Sovereignty*.

Sadie Plant is author of *Zeroes + Ones: Digital Women + the New Technoculture* and *Writing on Drugs*.

Bob Rehak is an Assistant Professor in the Film and Media Studies Program at Swarthmore College, USA. His research interests include psychoanalysis, cultures of computer gaming and graphics, and special effects in transmedia franchises. He is associate editor of *Animation: An Interdisciplinary Journal*.

Kevin Robins is Professor of Sociology at City University, London, UK, and co-author (with Frank Webster) of *Times of the Technoculture*.

Chela Sandoval is Chair of the Department of Chicana and Chicano Studies and Associate Professor in Liberation Philosophy. She authored *Methodology of the Oppressed*, co-edited *The Chicano Studies Reader* and has written many articles on de-colonizing consciousness.

Saskia Sassen is Professor of Sociology at the University of Chicago and London School of Economics. Her new books are *Territory Authority Rights: from Medieval to Global Assemblages* and a 3rd. fully updated edition of *Cities in a World Economy*.

Zoë Sofoulis (a.k.a. Zoë Sofia) is a researcher at the Centre for Cultural Research at the University of Western Sydney, Australia. She is author of *Whose Second Self?*, contributing co-editor of *Planet Diana: Cultural Studies and Global Mourning* (1997), and is currently co-editing a book with some of her former postgraduates, on 'Container Technologies'.

Alluquere Rosanne Stone is Associate Professor at the University of Texas at Austin, USA, Senior Artist at the Banff Centre, Canada, and Professor of New Media and Performance at the European Graduate School.

Stelarc is an Australian artist who has performed extensively in Japan, Europe and the USA – including new music, dance festivals and experimental theatre. He is currently a Visiting Professor at the SOCA, Edith Cowan University, Australia, and has recently been appointed as Chair in Performance, School of Arts, Brunel University, UK. His art is represented by the Sherman Galleries in Sydney.

Adriana de Souza e Silva is an Assistant Professor at the Department of Communication at North Carolina State University (NCSU), USA. She holds a Ph.D. on Communication and Culture from the Federal University of Rio de Janeiro, Brazil. From 2001 to 2004 Adriana was a visiting scholar at the UCLA Department of Design | Media Arts. She holds a Masters degree in Communication and Image Technology at the Federal University of Rio de Janeiro.

Paul Taylor is the author of a number of books relating to digital culture including most recently *Digital Matters* (with Jan Harris), and the editor of the online *International Journal of Žižek Studies*.

David Tomas is the author of *Beyond the Image Machine: A History of Visual Technologies*, *A Blinding Flash of Light: Photography Between Disciplines and Media*, and *Transcultural Space and Transcultural Beings*. He teaches in the Ecole des arts visuels et médiatiques, Université du Québec à Montréal. Website: http://www.er.uqam.ca/nobel/dtomas/.

Takako Tsuruki has been a lecturer at Tohoku Gakuin University and Shokei Women's Junior College in Sendai, Japan, teaching health, sociology, American and Japanese Studies, and gender. She has a Masters degree in Sociology from the Maxwell School, Syracuse University. She has conducted a variety of large-scale research projects, including prenatal care in the United States and diversification of the iron and steel industry in Japan.

Sherry Turkle is Abby Rockefeller Mauze Professor of the Social Studies of Science and Technology at MIT, Founder and Director of its Initiative on Technology and Self, and author and editor of many books and articles on technology and people, including *The Second Self*, *Life on the Screen,* and *Evocative Objects*.

Willard Uncapher teaches and conducts research on new media, globalization, and media history at the University of Colorado at Boulder, USA, focusing on questions of networks, hierarchies and scale, and their impact on communities and individuals.

Paul Virilio's recent books in English include *City of Panic*, *The Accident of Art* and *Negative Horizon*.

Catherine Waldby is International Research Fellow at the University of Sydney, Australia, and foundation member of the Global Biopolitics Research Group (www.globalbiopolitics. org). She is the author of *AIDS and the Body Politic: Biomedicine and Sexual Difference*, *The Visible Human Project: Informatic Bodies and Posthuman Medicine Tissue*, *Economies: Blood, Organs and Cell Lines in Late Capitalism* (with Robert Mitchell) and *The Global Politics of Human Embryonic Stem Cell Research* (with Brian Salter and Herbert Gottweiss). Her current research focuses on the stem cell sciences and regenerative medicine, and the impacts of neo-liberalism and globalization on their research practices and tissue sourcing.

Michele Willson lectures in Internet Studies at Curtin University of Technology, Western Australia. She is author of *Technically Together: Rethinking Community within Techno-Society*.

Mark Zizzamia is an IT Engineer at The Harford Financial Services, USA.

Acknowledgements

The following were reproduced with kind permission. While every effort has been made to trace copyright holders and obtain permission, this has not been possible in all cases. Any omissions brought to our attention will be remedied in future editions.

Part One
Approaching cybercultures

1. Michael Benedikt from *Cyberspace: First Steps*, The MIT Press, M. Benedikt (ed.) (1992) *Cyberspace: First Steps*, Cambridge: MIT. Reproduced with permission.

2. Donna Haraway. *A Cyborg Manifesto: Science, Technology, and Socialist-Feminism in the Late Twentieth Century.* From *Simians, Cyborgs, and Women: The Reinvention of Nature* © Donna J. Haraway, 1991. Reproduced by kind permission of Free Association Books Ltd, London.

3. Scott McQuire (2002) Space for rent in the last suburb, in Darren Tofts, Annemarie Jonson and Alessio Cavallaro (eds) *Prefiguring Cyberculture: An Intellectual History*, Power Institute Publications, pp. 166–78. Reproduced by permission of the author and publisher.

4. Scott Bukatman (1993) Cyberspace, in *Terminal Identity: the Virtual Subject in Postmodern Science Fiction*, pp. 119–56, Copyright, 1993, Duke University Press. All rights reserved. Used by permission of the publisher.

5. Paul Virilio (1995) Red alert in cyberspace! This article first appeared in *Radical Philosophy* 74, November/December 1995: 2–4 and is reprinted here with permission. Originally published in *Le Monde Diplomatique*. Reproduced with permission.

Part Two
Popular cybercultures

6. Mark Oelhert, *Captain America to Wolverine: cyborgs in comic books – alternative images of cybernetic heroes and villains*. Copyright © 1995 *From The Cyborg Handbook* by Chris Gray. Reproduced by permission of Routledge/Taylor & Francis Group, LLC.

7. David Tomas, *The technophilic body: on technicity in William Gibson's cyborg culture* from *New Formations* 8, 1989, Lawrence & Wishart. Reproduced with permission.

8. Todd Holden and Takako Tsuruki (2003) Deai-kei: Japan's new culture of encounter, from Nanette Gottlieb and Mark McLelland (eds) *Japanese Cybercultures*, Copyright © 2003, Routledge, pp. 34–49. Reproduced by permission of Taylor & Francis Books UK.

9. Bob Rehak (2003) Mapping the bit girl: Lara Croft and new media fandom, *Information, Communication and Society* 6: 477–96 (Taylor & Francis Ltd, http://www.tandf.co.uk/journals), reprinted by permission of the author and publisher.

10. Lev Manovich (n.d.) From DV realism to a universal recording machine, http://www.manovich.net. First published as Old media as new media: cinema from *The New Media Book*, edited by Dan Harries, BFI Publishing, 2002. Reproduced by permission of the author and publisher.

Part Three
Cybercommunities

11. Willard Ucapher (1999) Electronic homesteading on the rural frontier: Big Sky Telegraph and its community, from Marc Smith and Peter Kollock (eds) *Communities in Cyberspace*, Copyright © 1999 Routledge, pp. 264–89. Reproduced by permission of Taylor & Francis Books UK.

12. Michele Willson, *Community in the abstract: a political and ethical dilemma?* Reprinted by permission of Sage Publications Ltd from D. Holmes ed. *Virtual Politics*, Copyright © Michele Wilson 1997.

13. Kevin Robbins (1999) Against virtual community: for a politics of distance, *Angelaki* 4: 163–70 (Taylor & Francis Ltd, http://www.tandf.co.uk/journals), reprinted by permission of the author and publisher.

14. Maria Bakardjieva (2003) Virtual togetherness: an everyday-life perspective, Reprinted by permission of Sage Publications Ltd from *Media, Culture & Society* 25: 291–313. Copyright Sage Publications Ltd, 2003.

15. David Bell (2006) 'Webs as Pegs', in Stephan Herbrechter and Michael Higgins (eds) *Returning (to) Communities*, Rodopi. Reproduced by permission of the publisher.

Part Four
Cyberidentities

16. Charles Cheung (2004) 'Identity construction and self-presentation on personal homepages: emancipatory potentials and reality constraints', in David Gauntlett and Ross Horsley (eds) *Web Studies* 2e (Arnold, 2004). © 2000, 2004 Edward Arnold (Publishers) Ltd. Reproduced by permission of Edward Arnold (Publishers) Ltd.

17. Alison Landsberg, *Prosthetic memory: Total Recall and Blade Runner* reprinted by permission of Sage Publications Ltd from *Body & Society* 5(2–3), 171–89. Copyright Sage Publications Ltd, 1995.

18. Lisa Nakamura, *Race in/for cyberspace: identity tourism and racial passing on the internet* from *Works and Days* 13(1–2), 1995. Reproduced with permission.

19. Aihwa Ong (2003) Cyberpublics and diaspora politics among transnational Chinese, *Interventions* 5: 82–100 (Taylor & Francis Ltd, http://www.tandf.co.uk/journals), reprinted by permission of the author and publisher.

20. Tyler Curtain (2004) Promiscuous fictions, in Laura Gurak *et al.* (eds) *Into the Blogosphere: Rhetoric, Community, and Culture of Weblogs*, http://blog.lib.umn.edu/blogosphere/promiscuous_fictions.html. Reproduced with permission.

Part Five
Cyberfeminisms

21. Sadie Plant, *On the matrix: cyberfeminist simulations* reprinted by permission of Sage Publications Ltd from R. Shields ed. 1996 *Cultures of the Internet: Virtual Spaces, Real Histories, Living Bodies*. Copyright © Sadie Plant 1996.

22. Chela Sandoval, *New sciences: cyborg feminism and the methodlogy of the oppressed* Copyright © 1995 *From The Cyborg Handbook* by Chris Gray. Reproduced by permission of Routledge/Taylor & Francis Group, LLC.

23. Zoë Sofoulis (2002) Cyberquake: Haraway's manifesto, in Darren Tofts, Annemarie Jonson and Alessio Cavallaro (eds) *Prefiguring Cyberculture: An Intellectual History*, Power Institute Publications, pp. 84–101. Reproduced with permission of the author and publisher.

24. Alison Adam (1998) Feminist AI and cyberfutures, from *Artificial Knowing: Gender and the Thinking Machine*, Copyright © 1998 Routledge. Reproduced by permission of the author and Taylor & Francis Books UK.

Part Six
Cyberbodies

25. Deborah Lupton, *The embodied computer/user Runner* reprinted by permission of Sage Publications Ltd from *Body & Society* 1(3–4), 97–112. Copyright Sage Publications Ltd, 1995.

26. Allucquere Rosanne Stone, *Will the real body please stand up? Boundary stories about virtual cultures* from *Cyberspace: first steps*, The MIT Press. © 1992 Massachusetts Institute of Technology. Originally published in M. Benedikt (ed.) (1992) *Cyberspace: First Steps*, Cambridge: MIT. Reproduced with permission.

27. Stelarc, *From psycho-body to cyber-systems: images as post-human entities* from J. Broadhurst Dixon and E. Cassidy (eds) *Virtual Furtures: Cyberotics, Technology and Post-Human Pragmatism*, Copyright © 1998 Routledge. Reproduced by permission of the author Taylor & Francis Books UK.

28. Robert Ayers (1999) Serene and happy and distant: an interview with Orlan, reprinted by permission of Sage Publications Ltd from *Body & Society* 5: 171–84. Copyright Sage Publications Ltd, 1999.

29. Catherine Waldby (2000) Revenants: the digital uncanny, from *The Visible Human Project: Informatic Bodies and Posthuman Medicine*, Copyright © 2000 Routledge, pp. 136–56. Reproduced by permission of Taylor & Francis Books UK.

Part Seven
Cyberlife

30. Hans Moravec (1999) The universal robot, in Timothy Druckrey with Ars Electronica (eds) *Ars Electronica: Facing the Future*, The MIT Press, pp. 116–23. © 1999 Massachusetts Institute of Technology. Originally published in Timothy Druckrey with Ars Electronics (eds) (1999) *Ars Electronica: Facing The Future*, Cambridge: MIT. Reproduced with permission.

31. Sarah Kember (2003) CyberLife's Creatures, from *Cyberfeminism and Artificial Life*, Copyright © 2003 Routledge, pp. 83–115. Reproduced by permission of Taylor & Francis Books UK.

32. Sherry Turkle (1998) Cyborg babies and cy-dough-plasm, from Copyright © 1998 *Cyborg Babies: From Techno-sex to Techno-tots* by Robbie Davis-Floyd and Joseph Dumit (eds). Reproduced by permission of Routledge/Taylor & Francis Group, LLC.

33. N. Katherine Hayles (2005) Computing the human, reprinted by permission of Sage Publications Ltd from *Theory, Culture & Society* 22: 131–51. Copyright Sage Publications Ltd, 2005.

Part Eight
Cyberpolitics

34. Saskia Sassen (2000) Digital networks and the state: some governance questions, reprinted by permission of Sage Publications Ltd from *Theory, Culture & Society* 17: 19-33. Copyright Sage Publications Ltd 2000.

35. Tim Jordan (2002) Technopower and its cyberfutures, in John Armitage and Joanne Roberts (eds) *Living in Cyberspace: Technology and Society in the 21st Century*, Continuum, 120–8. By kind permission of Continuum International Publishing Ltd.

36. Paul Taylor (1998) Hackers: cyberpunks or microserfs?, *Information, Communication & Society* 1: 401–19 (Taylor & Francis Ltd, http://www.tandf.co.uk/journals), reprinted by permission of the author and publisher.

37. Richard Kahn and Douglas Kellner (2004) New media and internet activism: from the 'Battle of Seattle' to blogging, reprinted by permission of Sage Publications Ltd from *New Media & Society* 6: 87–95. Copyright Sage Publications Ltd, 2004.

38. Briavel Holcomb, Philip Bakelaar and Mark Zizzamia (2003) The Internet in the aftermath of the World Trace Center attack, *Journal of Urban Technology* 10: 111–28 (Taylor & Francis Ltd, http://www.tandf.co.uk/journals), reprinted by permission of the author and publisher.

Part Nine
Beyond cybercultures

39. Tim Lenoir and Casey Alt (2003) Flow, process, fold: intersections in bioinformatics and contemporary architecture, in A. Picon and A. Ponte (eds) *Architecture and the*

Sciences: Exchanging Metaphors, NEw York: Princeton Architectural Press), 314–53. Reproduced by kind permission of the authors.

40. Colin Milburn. Nanotechnology in the age of posthuman engineering: science fiction as science. *Configurations* 10(2): 261–95 © The Johns Hopkins University Press and Society for Literature and Science. Reprinted with permission of The Johns Hopkins University Press.

41. Robin Held *Gene(sis)*: contemporary art explores human genomics, Copyright © 2004 from *Data Made Flesh: embodying information*, by R. Mitchell and P. Thurtle (eds). Reproduced by permission of Routledge/Taylor & Francis Group, LLC.

42. Matthew Gandy (2005) Cyborg urbanization: monstrosity and complexity in the contemporary city, *International Journal of Urban and Regional Research* 29: 26–49, Blackwell Publishing, reproduced by permission of the author and publisher.

43. Adriana de Souza e Silva (2006) From cyber to hybrid: mobile technologies as interfaces of hybrid spaces, *Space and Culture* 9: 261–78, copyright 2006 by Sage Publications. Reprinted by permission of Sage Publications Inc.

Illustrations

Chapter 27 – Stelarc

27.1 *Involuntary body/ third hand*, Yokohama, Melbourne, 1990. Diagram: Stelarc © STELARC. Courtesy the artist

27.2 *Stomach sculpture*, Fifth Australian Sculpture Triennale, NGV, Melbourne 1993. Photograph: Anthony Figallo © STELARC. Courtesy the artist

27.3 *Stomach sculpture*, Fifth Australian Sculpture Triennale, NGV, Melbourne 1993. Diagram: Stelarc © STELARC. Courtesy the artist

27.4 *Fractal flesh*, Telepolis, Luxembourg 1995. Diagram: Stelarc © STELARC. Courtesy the artist

27.5 *Stimbod software*, Empire Ridge, Melbourne 1995. Image: Troy Innocent. © STELARC. Courtesy the artist

27.6 *Split body: voltage-in/voltage-out*, Gallery Kapelica, Lubljana 1996. Photograph: Igor Andjelic © STELARC. Courtesy the artist

27.7 *Remote: event for laser eye and involuntary arm*, Melbourne International Festival, Melbourne 1990. Photograph: Anthony Figallo © STELARC. Courtesy the artist

27.8 *Scanning robot/automatic arm*, T.I.S.E.A., Museum of Contemporary Art, Sydney 1992. Photo: Anthony Figallo © STELARC. Courtesy the artist

27.9 *Exoskeleton*, Cyborg Frictions, Dampfzentrale, Bern 1999. Photograph: Dominik Landwehr © STELARC. Courtesy the artist

Chapter 28 – Robert Ayers

28.1 Orlan, *Refiguration/Self-Hybridation*, 1999. © ADAGP, Paris and DACS, London 2007

28.2 Orlan, *Refiguration/Self-Hybridation No. 38*, 1999. © ADAGP, Paris and DACS, London 2007

28.3 Orlan, *Refiguration/Self-Hybridation*, 1999. © ADAGP, Paris and DACS, London 2007

28.4 Orlan, *Refiguration/Self-Hybridation No. 10*, 1998. © ADAGP, Paris and DACS, London 2007

28.5 Orlan, *Refiguration/Self-Hybridation No. 22*, 1999. © ADAGP, Paris and DACS, London 2007

28.6 Orlan, *Refiguration/Self-Hybridation No. 15*, 1998. © ADAGP, Paris and DACS, London 2007

28.7 Orlan, *Refiguration/Self-Hybridation No. 5*, 1998. © ADAGP, Paris and DACS, London 2007

Chapter 39 – Lenoir and Alt

39.1 Longitudinal sectional perspective of Neil Denari's 1998 Multisection Office Block project. The "laminar structure" of Denari's localized worldsheets serves as a single continuously folded structure that mediates between previous binaries such as "inside/outside" and "vertical/horizontal." Source: Neil Denari, *Gyroscopic Horizons* (New York: Princeton Architectural Press, 1999), 103. Courtesy of NMDA, Inc.

39.2 Artists Space Installation, June 1995. Rendering courtesy of Greg Lynn FORM

39.3 Port Authority Gateway, March 1995. Rendering courtesy of Greg Lynn FORM

Chapter 41 – Robin Held

41.1 *Critical Art Ensemble, Cult of the New* (2000) Courtesy the artists. Photo Credit: Critical Art Ensemble

41.2 Maria Kalman, *No-Die* (2000) Courtesy Creative Times, New York. Photo Credit: Robert Glasgow

41.3 Christine Borland, *HeLa* (2000) video microscope, cells in culture, monitor, text, glass and wooden shelf. 21 × 64 × 22 inches. Courtesy Sean Kelly Gallery, New York

41.4 Catherine Wagner, *−86 Degree Freezers (Twelve Areas of Concern and Crisis)* (1995). Collection of the Museum of Fine Arts, Houston; Museum purchase with funds provided by the S. I. Morris Photography Endowment Fund

41.5 Susan Robb, *Macro-Fauxology: Sucrosefattyacetominophen* (2000). Courtesy of the artist

41.6 Catherine Chalmers, *Transgenic Mice: Pigmented Nude* (2000). Courtesy of the artist. www.catherinechalmers.com

41.7 Eduardo Kac, *GFP Bunny* (2000). Alba, the fluorescent rabbit. Courtesy of the artist

41.8 Daniel Lee, *Judgment* (1994) JUROR No. 6 (LEOPARD SPIRIT), 35 x 50 inches, Digital C-print. Courtesy of the artist

41.9 Margi Geerlinks, *Twins* (2000). Courtesy TORCH Gallery, Amsterdam

41.10 Dario Robleto, *The Polar Soul* (1999–2000). Home made blue crystals (monoammonium phosphate, water, dye), polyester resin, Formica, wood, vinyl lettering, Plexiglas, plastic tubes, fluorescent lighting, tape player, video monitor, soundtrack. 8 × 10

X 15 feet. Originally commissioned by Artpace San Antonio. Photo credit: Seale Studios. Courtesy of Artpace San Antonio and the artist

41.11 Dario Robleto, *If We Do Ever Get Any Closer At Cloning Ourselves Please Tell My Scientist-Doctor To Use Motown Records As My Connecting Parts* (1999–2000). Melted Motown records from mother's record collection, hand scratched and powderized Motown records, polyester resin, altered turntable, dissolved audio tape, vinyl letters, cast vinyl skulls, cast vinyl brains, bacteria from vinyl records, petri dishes, soy agar (5.0% defibrinated sheep blood, 4.5g pancreatic digest of casein, papaic digest of soybean meal 5.0g, sodium chloride 5.0g, agar 14.0g, Growth Factors 1.5g), my blood sample, predigested protein, butterflies (lemon butterfly, pansy butterfly), homemade red, blue, green and yellow crystals (monoammonium phosphate, water, dye), crystal inlaid 12-inch woofers, amino acids, carbon, amethyst crystals, sulphur, iron pyrite (fool's gold), potassium iodide, B-12, calcium hydroxide, hemlock, gold dust, dinosaur dust (dicophites gulosus), tryptophan, methylene, rose quartz, amber, shrimp eggs, sea salt, rock salt, slides with various prepared Motown vinyl samples, slide boxes, test tubes, test tube rack and grabber, microscopes, beakers, various glass and plastic vials and bottles, ceramic mortar, scalpel, tweezers, glass and plastic droppers, magnifying glass, glass stirring rod, eye goggles, gelatin pill, Styrofoam, dead wood, chopped drumsticks, fake flowers, Plexiglas and rods, electrical parts, electrical wiring, acrylic paint, spray paint, homemade labels. 81 X 104 X 17¼ inches. Originally commissioned by Artpace San Antonio. Photo credit: Seale Studios. Courtesy of Artpace San Antonio and the artist.

41.12 Iñigo Manglano-Ovalle, *LU, JACK, AND CARRIE (from The Garden of Delights)* (1998). Edition of 3. C-print of DNA analyses laminated to plexi. 60 X 74 inches. Image courtesy of the artist and Max Protetch Gallery, New York

David Bell

CYBERCULTURES REWRITER

IT'S NEW YEAR'S EVE 2006 and I'm sorting through a pile of newspaper and magazine clippings I've amassed over the past year or so, including a fair number of those end-of-year round-ups that try to summarize the Big Themes of the last twelve months.[1] The influential US news magazine *Time* always draws up a list of 'People of the Year', and for 2006 its number one person was *you*. Yes, you. And you, and you, and you. The 'you' of *Time*'s award is, in fact, the 'you' reflected back from the mirror-foiled computer screen on its cover, the 'you' involved in making 'user-generated content' or engaging in social networking online – two of the most prominent buzzwords in my cyberculture clippings file. This is the 'you' of YouTube, the 'me' of 'me media' and MySpace, the 'I' of iPod and iTunes. Of course, the most prominent buzzword in my clippings file is a snappy tag used to nail both social networking and content-generation practices: Web 2.0.

Time and *Time* again, Web 2.0 is hailed right now as rewriting what the Web, the Internet, cyberculture means. Nothing short of a revolution has taken place, if you believe the hype. And the coming of Web 2.0 is certainly one of the catalysts for our own rewriting and rereading, collated here in this new edition of *The Cybercultures Reader*. In the 8 or so years since we began compiling the first edition, so much has happened, so much has changed – even if you are skeptical about Web 2.0, there can be no denying the amazing transformation of cyberspace and cyberculture. New devices, new applications, new technologies, new practices have all emerged – and while some have disappeared almost as quickly as they came, others have settled into our everyday lives. The mobile or cell phone is an excellent example here – especially, perhaps, as it morphs in our hands into some kind of hybrid, multifunctional communication and computation device. Mobile phones have become part-and-parcel of the texture of everyday life for millions of users, changing subtly but equally dramatically what it means

to 'be on the phone' (Goggin 2006). The ways in which email has changed the business of communication, for better and for worse, is another clear example.

Yet some of the promises of the coming cyberculture plotted in earlier ages still haven't really materialized; so things also *haven't* changed as dramatically as futurology predicted. I am still sitting in front of a computer that resembles a typewriter in front of a television, and I am still typing my thoughts into pixellated words that appear on screen – I am not yet able to upload my thoughts directly into your computers or brains. And we're still making a *book* here, a printed paper book – an object whose death has been predicted so many times it must be getting more than a little paranoid. But my office and my house are still filled with books (something I feel ambivalent about just now, as I'm soon to be moving house and have to pack them all up again). Which should serve as a reminder to be cautious when predicting what the future holds, technology-wise – but then I am always a sucker for futurology (Bell 2006).

This mix of change and continuity in cyberculture is reflected in the rewired Reader: while the slowness of the academic researching, writing and publishing machine means that any book like this will be a period piece at best before too long (if not already), we have endeavored to capture something of this moment, this new iteration of cyberspace and cyberculture. Of course, as we have said many times before, cyberspace is not simply a synonym for the Web, or the Internet, so cyberculture is more expansive than the new practices of what some pundits (including Tony Blair) have named the Google Generation. Cyberculture is something we encounter in all kinds of places, and indeed these places are multiplying, hybridizing, remediating, as Adriana de Souza e Silva (Part Nine) shows (and see also Bolter and Grusin 2000; Marshall 2004). It's getting harder all the time to even find names to call the technologies (and uses) that cyberculture now involves. The mobile or cell phone, as already mentioned, has so many functions besides making and taking phonecalls that it seems (to me at least) a nonsense to continue to give it that name; hence, perhaps, why it's increasingly truncated to 'mobile' or 'moby' – its 'phoneness' is receding. Applications added to the personal computer have similarly rewired for many users this multitasking helpmate, which can now also be used to make phonecalls. So when does a moby become a PC, or a computer become a phone? And when they fully merge or meet in the middle, do they become a BlackBerry?

This proliferation, diversification and hybridization has led, understandably, to a debate about naming: not just naming the gizmos and practices, but naming the study of these things. Is cyberculture still the best label for this thing of ours, or – as David Silver (2004) suggests – might we substitute new media studies, digital culture or, as he ends up sighing, 'fill-in-the-blanks studies'? Well, I am still very fond of the term cyberculture, despite its almost antique feel. I like its expansiveness, and I like its future-facing sound. It has a ring of science fiction to it, reminding us that we live in a number of different cybercultural 'stories', including those garnered from popular culture (Bell 2001). It conjures cyborgs, of course – but it also reiterates culture, keeping a useful cultural lens on all things 'cyber-'. And the coming of even smarter technologies and unthought-of

practices promises to blur further the boundaries between types of machines, making the use of an umbrella term like cyberculture seem ever more sensible (Sterling 2005).

Choosing to stick by the name isn't just doggedness on our part; as already noted, in this new edition of the Reader we want to signal both change and continuity. Symptomatic of the terrain we're dealing with here is a faddish pursuit of the new. Newness connotes coolness among users – those heroized 'early adopters' that first try out new things – and it also connotes coolness in commentators. This in fact makes commentating a fraught affair, with the risk of making a *techno faux pas* ever present. New terms, new practices, new sites appear with a rapidity that is dizzying, making it impossible to keep up. I worry that the key names of Web 2.0 that I might list here – from Bebo to Blogger, Facebook to Flickr – may have faded from view by the time you are reading this. This constant change is exhilarating, of course, but the task of keeping fresh can be very demanding. So please don't mock any *faux pas* that you spot: as I said earlier, this Reader is inevitably a period piece, a bulky dinosaur struggling to stay current in an accelerated culture. Aren't we all?

Cyberculture is also a term with enhanced useability, we would argue, to encapsulate an expanded and expanding field of academic studies. While other labels have been tried – Internet studies, web studies, new media studies, and Silver's 'blankety-blank' studies have been endlessly permed, not least on the curricula of university courses aiming to snare the Google Generation – cyberculture studies continues to us to best represent the coming together of diverse strands of academic work across a range of subject areas in a necessarily post-disciplinary context (Plant 1996). As such, cyberculture studies is work carried out across a diversity of intellectual and institutional locations, often embedded peripherally within more 'traditional' subjects and departments. This gives cyberculture studies a heterodox richness, and an anti-canonical stance (see Part One on the ironies inherent here): it is both theoretically and methodologically promiscuous. But this can also make it seem like a fringe activity, not a 'proper' subject. Its newbie status makes it seem faddish, and its promiscuity can be taken as heretical. To my mind these are advantages, signalling an openness that many 'traditional' subjects lack – though these very characteristics are also used routinely by critics to rubbish this work. There is still a battle over who is best placed intellectually to analyse cyberculture – and lingering doubts in some quarters about the value of such analysis. Nevertheless, we have witnessed an institutionalization and 'respectablization' of cyberculture studies in the academy – though teaching this stuff is guaranteed to make you feel old in the presence of Google Generation students.

To sketch its parameters rather than attempting a strict definition, we would argue that cyberculture studies includes (among others, and in no particular order):

- work in computer science and other related 'cybertechnosciences', including hardware and software development and user modelling, robotics, artificial intelligence and artificial life, nanotechnoscience and so on

- insights from the history of science and technology, for example on the histories of computing
- cultural studies approaches to understanding the material, symbolic and experiential dimensions of cyberspace and to cybercultural forms, practices, politics and identities – at the moment especially around those buzzwords already highlighted, social networking and user-generated content
- sociological studies of the uses and impacts of new technologies
- media studies work on new media, multimedia or digital media, and film studies work on science fiction cinema, digital film-making, new modes of film production, distribution and consumption
- computer games studies, including research on game design and on gameplay
- literary theories and studies, for example those concerned with science fiction and cyberpunk
- philosophy of science and technology, and philosophical theories used to think about cyberspace and cyberculture
- work by geographers on the spaces of cyberspace, and work in urban studies on 'cybercities'
- economics and organization studies of changing work patterns in the information and knowledge economies
- feminist studies of science and technology, including 'cyberfeminisms' and 'cyborg feminisms'
- social, political and cultural theory in its diverse forms, used to understand cybercultures
- research in the biomedical and biotech sciences on the interfaces between bodies and technologies, such as gene therapies or xenotransplantation
- policy-oriented studies, whether in social, welfare, communications, cultural or new, hybrid 'cyberpolicy' contexts
- studies of the creative and applied arts intersecting with new technologies, and studies of the aesthetics of new technologies
- work on cyberpsychology, on the psychological impacts of cyberspace
- education research, exploring how new technologies and uses might be utilized in the context of pedagogy, including e-learning, mobile learning, ubiquitous learning or 'blended' learning
- research in linguistics, into the languages of new technologies and their users
- cross-disciplinary futurology that predicts ways of living yet to come

As such, cyberculture studies is a complex field (or post-field) which not only makes use of diverse academic traditions and theoretical perspectives, but also deploys a diversity of research methods and approaches, as the readings selected here illustrate.

Making and remaking cybercultures

The emphasis today (that is, at the time of writing – so a vanishing dot of pastness at your time of reading) on user-generated content as a key element of Web 2.0 is widely touted as a profoundly significant rewriting of cyberculture. Where once were worries about corporate cyberculture reducing users to passive surfers or data objects for commercial mining, a renewed utopianism characterizes commentaries about Web 2.0. Jon Pareles (2006) talks of a new 'folk culture' on the Web, of bloggers, open sourcers and wikiers, which he sees as a huge resource and platform for vernacular creativity – creativity democratized thanks to technological interventions that have put practices like blogging into the hands of many everyday computer users. Where once forms of content generation – and, indeed, social networking – in online contexts were seen as specialized, geeky, subcultural practices, nowadays they are argued to have become universal (on-going acknowledgement of the digital divide notwithstanding, of course). Paralleling the broader renewed interest in creative practices such as 'crafting' – itself largely enabled by blogs and so on (see Hanaor and Woodcock 2006) – cyberculture has become more than passive, more than interactive, even: it has become a key (potential) site of cultural production for its multitude of users.

In a remarkably insightful summary of recent developments in cybercultures, P. David Marshall (2004) emphasizes how Web 2.0 (though he doesn't call it that) has tapped into a kind of 'will to produce' among a growing group of users: the 'prosumer' or 'produser' who does more than surf websites, shop online or send emails. Of course, there has always been creative potential in cyberculture, always been new and unintended uses creatively fashioned by users – the whole history of hacking illustrates that, as do other creative practices, from web design to assorted forms of cyberart and cyberplay (Danet 2001; Ross 2000). But what has arguably changed – and what today's heroes of Web 2.0 have accomplished – has been the demystification and thereby democratization of the means of creative production. While critics complain that this has in fact *reduced* the creative potential of the Web, by offering only preset templates that ordinary users cannot customize, it has nonetheless opened the door for many users to become produsers, to write their own blog or build their own MySpace page. Marshall (2004: 44) tags these users 'amateur aficionados', emphasizing again the 'craft knowledge' that produsers utilize and the 'will to produce' that is unlocked by these developments. The massive growth of user-generated content online testifies to this will, and exploits it.

Of course, not all users become produsers, or even want to. Some users are content to be consumers, to surf the clickstream – though Marshall reminds us that websurfing is itself a creative, productive act, made up of individual decisions that map our own pathways through the datascape. And the social networking said to characterize Web 2.0 is also a creative act, rewiring older debates about 'virtual community' and producing new forms of togetherness. Whether the current round of discussions of 'community' manages to sidestep the pitfalls and dead-

ends of previous rounds remains to be seen – and the precise form, meaning and value of Web 2.0 sociality is as yet unresearched (see Part Three).

The will to produce currently fuelling the craft production of Web 2.0 raises a very big question: who is the audience for all this stuff? Tyler Curtain (Part Four) asks a version of this in his discussion of blogs – the population of bloggers continues to grow unbelievably and exponentially, but who is reading all this content? Pareles (2006: 11) worries that the online audience is being fragmented into 'a popular culture composed of a million mini-cults' tasked with sifting and rating the proliferating, overwhelming content – or what he slightly tastelessly calls a 'tsunami of self-expression'. Here the audience's role as second-level produser is increasingly significant: the sifting of content can only ever be incredibly partial and personal, but happenstance hits can and do catalyze the mythologized goldrush phenomenon of overnight success (or hype), as links are forwarded on at lightning speed and prize content virally or memetically spreads by word-of-email (on memes see Thieme 2000). My clippings file bulges with end-of-year lists of the 'best' web content, with video clips from YouTube and unsigned acts from MySpace predictably prominent.[2]

We should remember at this point, of course, that any discussion of user-generated content must point up that 'generation' is here a euphemism for *work*: the labour of produsers is largely given freely, contributing not only the content but also the value of Web 2.0 businesses, which run on skeleton staff supported by unpaid 'craft workers' toiling away at their own sites and pages. Just as earlier social sites online were made possible thanks largely to the free labour of users, so the success of new content sites relies on the endless bloggers willing to give time to content generation (Terranova 2006). A more cynical reading of user-generated content therefore sees it as free media content that allows produsers to express themselves but that ultimately benefits the entrepreneurs of this new dot.com economy (and as their sites are bought up by media conglomerates, worries about profit motives escalate).

We must remember, too, that cyberculture is much, much more than Web 2.0. The proliferating cyberspaces we find in CGI cinema, in medical imaging technologies, in computer games or computational toys, on mundane and spectacular devices all around us, have brought with them many new practices, or what Maria Bakardjieva (2005) calls 'use genres' (see also Bell 2001). Getting a handle on some of that newness is an ongoing task of cyberculture studies. At the same time, as we have already said, there is continuity as well as change – though continuity is less remarked upon, but in my mind no less *remarkable*. Getting a handle on this aspect of cyberculture is equally important. This balance of the old and the new is reflected in our choice of readings here; we have retained key essays from the first edition of the Reader where we felt they have enduring resonance, and we have also included new readings that still deal with older cybercultural forms and practices. Partly this is to retain an important history lesson, partly it is to re-emphasize continuity; and partly it is to offer benchmarks for future comparisons. Readers are time capsules, and this one is no different. Time to lay it all out for you.

Rereading cybercultures

One of the anxiety-making aspects of redoing this Reader – for me at least
– concerns the issue of *comparison*. [3] Indeed, when we proposed this new edition
and it passed through the editorial review process at the publishers, comparisons
were repeatedly made. Reviewers all had their favourite and least favourite sections
and readings from the first edition, their own (often very useful) advice about
what to retain and what to refresh. To save you the bother (or geeky pleasure) of
playing spot the difference, here's the stats on what we finally decided to do:

- Twelve readings retained from the first edition (Benedikt, Haraway, Oehlert,
 Tomas, Willson, Landsberg, Nakamura, Plant, Sandoval, Lupton, Stone, Stelarc
 – did you spot them all?)
- Four (out of nine) sections retained – Approaching Cybercultures, Popular
 Cybercultures, Cyberfeminisms, Cyberbodies – all with content modified
- Five new sections added: Cybercommunities, Cyberidentities, Cyberlife,
 Cyberpolitics and Beyond Cybercultures
- Five sections deleted: Cybersubcultures, Cybersexual, Post-(cyber)bodies, Scaling
 Cyberspaces, Cybercolonization

The changes and continuities are readable, we hope, as representative of
where cyberculture has gone in the years since we assembled that first Reader,
and where cyberculture studies has gone, too. (And also where both may be
headed, though futurology is a fraught business, we know.) We have tried to
retain the breadth of approaches, topics, theories and methods, while inevitably
mirroring the personalized clickstream of the data surfer: the new Reader, like its
predecessor, is a record of our own increasingly partial dealings with cyberculture
and cyberculture studies. As the field has grown and morphed, so it has become
harder and harder to keep up with its many trajectories. We also have our own
specialisms or fields of interest, and the content chosen here will inevitably reflect
that. Kind of like a homepage or a blog, then, what we have assembled here is
a particular, situated account of our own adventures in cyberculture, with links
(readings) that we have found productive or diverting.

Like a blog in another way, the Reader presents itself to be navigated – to
be read – to an assumed audience with assumed reading practices (and assumed
knowledges). Its mode of presentation – in hard copy, without the hi-tech benefits
of hyperlinks or whatever – lends itself to a particular way of handling its content.
Books have a linearity to them – beginning, middle and end – that seems at
times annoyingly old fashioned, un-postmodern, not very cybercultural. Textual
experiments to address this seem to fall flat too routinely to tempt us into trying
anything flash. And the architecture of this particular kind of book, the Reader,
necessitates divvying up the content into logical chunks, partitioned sections, and
doing the justification work of tying the readings together.

The stats listed above tell part of the 'behind-the-scenes' story of this new
edition, but the full bonus disk 'making-of' documentary is not available. Like
user-generated content, there is much invisible labour here, starting of course with

the research, writing and publishing of the individual essays we have then read and selected for you. We have then corralled the readings into sections, trying to map out what we see as key areas of debate and research, with representative essays and our own brief intros to guide you forward. Some of the debates we have selected here have been rumbling on for many years now — those around identity and community, for example — and we have tried to balance 'classic' approaches, expository accounts and new research as far as possible. Of course, each section could be a Reader in itself — indeed, Readers on cyberculture have begun to specialize; for example there is *the Cybercities Reader* (Graham 2004) or the *Cybersexualities* reader (Wolmark 1999). The volume of work now circulating is truly astounding, and ever growing.

Now it's over to you, to the work of reading. You may of course choose to approach the Reader in your own way; you may want to work through the whole book, reading by reading, stacking it all up. But you may prefer shuffle mode, making your own random patterns and serendipitous juxtapositions.[4] We have made some such connections ourselves, as we have worked over the readings, noting some moments of intertextuality, but we invite all readers to make their own. Maybe, in the spirit of Web 2.0 'produsage', we could also invite some user-generated mash-ups, utilizing the tools and ethos of the emerging folk cyberculture and fulfilling the will to produce in our readers. Enjoy.

Notes

1 Among the most useful or insightful of the many yellowing clippings in my file for 2006 are features by Jon Pareles (2006) and John Lanchester (2006) — the latter also includes biographical sketches of many of the key players, and sound bites of their own attempts to define Web 2.0. I am aware, of course, of the irony of keeping something so old-fashioned as a paper clippings file in this day and age. Old habits die hard, indeed.

2 Wary of citing cultural products that will be barely remembered when this Reader gets read, I should nonetheless mention repeated stories of YouTube and MySpace success, such as the Arctic Monkeys or Sandi Thom (I know: *who?*).

3 I am in fact guilty of doing just such a weighing up of first and second editions of a Reader in a review of a Reader on urban cultures— so I know how that game plays out. For me it was definitely a geeky pleasure.

4 One of the newspaper articles I sadly appear to have mislaid from my clippings file this year concerned debates about the randomness of shuffle mode on iPods, with users reporting weird 'preferences' for songs seemingly displayed by their players. Macintosh has responded, apparently, by making the random shuffle *less random* — in recognition that users will experience this as more random! And we know from Googling the first edition that many early adopters who used the Reader for teaching made their own pathways through it.

References

Bakardjieva, M. (2005) *Internet Society: Everyday Life on the Internet*, London: Sage.

Bell, D. (2001) *An Introduction to Cybercultures*, London: Routledge.

Bell, D. (2006) *Science, Technology and Culture*, Maidenhead: Open University Press.

Bolter, J. and Grusin, R. (2000) *Remediation: Understanding New Media*, Cambridge, MA: MIT Press.

Danet, B. (2001) *Cyberpl@y*, Oxford: Berg.

Goggin, G. (2006) *Cell Phone Culture: Mobile Technology in Everyday Life*, London: Routledge.

Graham, S. (ed.) (2004) *The Cybercities Reader*, London: Routledge.

Hanaor, Z. and Woodcock, V. (eds) (2006) *Making Stuff: an Alternative Craft Book*, London: Black Dog.

Lanchester, J. (2006) 'A bigger bang', *Guardian Weekend* (UK), 04 November: 17–36.

Marshall, P.D. (2004) *New Media Cultures*, London: Arnold.

Pareles, J. (2006) 'How to make 80 million friends and influence people', *Observer Review* (UK), 18 June: 6–9.

Plant, S. (1996) 'Connectionism and the posthumanities', in W. Chernaik (ed.) *Beyond the Book: Theory, Culture, and the Politics of Cyberspace*, London: University of London Press.

Ross, A. (2000) 'Hacking away at the counterculture', in D. Bell and B. Kennedy (eds) *The Cybercultures Reader*, first edition, London: Routledge.

Silver, D. (2004) 'Internet/cyberculture/digital culture/new media/fill-in-the-blanks studies', *New Media and Society*, 6: 55–64.

Sterling, B. (2005) *Shaping Things*, Cambridge, MA: MIT Press.

Terranova, T. (2006) 'Free labor: producing culture for the digital economy', in D. Bell (ed.) *Cyberculture: Critical Concepts in Media and Cultural Studies*, volume two, London: Routledge.

Thieme, R. (2000) 'Stalking the UFO meme', in D. Bell and B. Kennedy (eds) *The Cybercultures Reader*, first edition, London: Routledge.

Womark, J. (ed.) *Cybersexualities*, Edinburgh: Edinburgh University Press.

PART ONE

Approaching cybercultures

David Bell

INTRODUCTION

WE BEGIN THIS READER with beginnings, some origin stories. Origin stories are seductive but troublesome and troubling things, in their attempt to fix things down, to tell a particular tale, a beginning tale, to identify a point of origin which then becomes a point of departure. They are troublesome too in their tidiness, their precision: *on this day in this place, this event happened, and from here a great story unfolded.* Yet we live in stories, stories we write and read, rewrite and reread. So origin stories are seductive and reassuring, tidying and fixing what might otherwise remain chaotic, incomprehensible, ungraspable. Hence we are torn, here at the start of this Reader, between the felt need to tell some origin stories, and the equal feeling that such a task is not only flawed from the get-go, but fundamentally suspect – and in this, we have been influenced by one of the essays we reproduce here, Donna Haraway's 'A Cyborg Manifesto'. Origin stories are troubling in that they soon become myths, told and retold, changing incrementally, embellished by the teller. This leads some mythologists (and their surprisingly close kin, myth busters) on a quest to uncover or recapture the 'real' or 'true' story, to untangle the half-truths, tall tales and obfuscations. Such a quest is similarly both misguided and doomed. So why try to start at the beginning? Well, there remains a strong pull towards origin stories, even in a postmodern or post-postmodern context ironically aware of dead metanarratives – and not mourning their demise. Even when our principal mode of engagement with culture is the random shuffle or the pot luck of the search engine, we still want to understand things by knowing *where they come from.* So, we had to start *somewhere…*

But rather than tell a straight story, either about sociotechnical change or about new ways of thinking, we would rather follow the lead of our opening author, Michael Benedikt, who offers a partial yet expansive account of the prehistories and histories of cyberspace, the 'first steps' of something yet to exist

when he published this essay in the early 1990s, admitting that 'one can hardly be definitive at this early stage'. Benedikt does his own myth-making at the outset, retelling the origin story of the word 'cyberspace' from the typewriter of cyberpunk writer William Gibson. Later essays in this section, by Scott Bukatman and Scott McQuire, also attend to Gibson's work and its birthing of what some critics now label 'Gibsonian cyberspace' – a dominant imagining and representing of cyberspace indebted to Gibson's work. Benedikt notes that cyberspace is an 'unhappy word' wedded to Gibsonian tropes of 'corporate hegemony and urban decay' and 'a life in paranoia and pain' – already reminding us of the particular resonances of the word, resonances frequently jettisoned as the word takes on a life of its own (see also Gibson 2006). But there it is; the origin story, the source text: a mid-1980s science fiction account, a neologism conjured as part of a larger game of writing a future argot of what we might call tech-slang. But Benedikt slams on the brake: he wants to disembed 'cyberspace' from its Gibsonian hearth, to offer his readers some different takes, and he scrolls through these, perming cyberspace as network, screen, geography, information, entertainment, corporation, economy, and even as ecological saviour, 'decontaminating the natural and urban landscape' by dematerializing flows. An exhilarating set of images, utopian then dystopian; then the brake gets slammed on a second time: 'cyberspace as just described does not exist'.

This teaser leads us into the main body of Benedikt's argument, his tracing of the prehistories and histories of cyberspace: cyberspace has also *always* existed, in the sense that cyberspace is also readable as a shared mental geography, or, to use once more Gibson's most famous phrase, a 'consensual hallucination' – an imaginary realm, a mythic place and time, an elsewhere, a Popperian *World 3*, the world of complex, abstract structures and patterns. To lead us in, Benedikt assembles four intertwined 'threads', four stories about World 3 that prefigure cyberspace. The first thread concerns language and myth, fittingly – our capacity to weave stories. Thread two explores communications media in the broadest sense. In particular, Benedikt discusses the development of media technologies and representations, and the *mediation* of experience. Next is a story thread about architecture – Benedikt comes from an architecture background, and he is right to identify the built landscape (also, of course, a sign or representation) as an important thread to weave towards cyberspace. Gibsonian cyberpunk comments on architecture, on urban form, and draws on the architectural imagination to depict the virtual datascape, as we shall see. Benedikt picks up this thread in terms of the changing form and function of the city as it becomes 'a messy nexus of messages', but he is also interested in imaginary urbanism, in the dream of a Heavenly City, a transcendent, immaterial utopia. He calls upon architects to enter (maybe even to reclaim) cyberspace, to begin to imagine how to build there, to construct electronic or informational edifices – prefiguring experiments in virtual habitats and the domestic architecture of multi-user domains. Relatedly, thread four for Benedikt concerns our ways of understanding, describing and representing space: geometry, algebra, perspective, and the processes of diagramming. Confessing that there are countless further threads to pick up and work with, and reminding

his readers that 'every discipline can have an interest in the enterprise of creating cyberspace', Benedikt's essay evocatively and necessarily speculatively sketches some resources for approaching cyberspace and cyberculture, while at the same time setting the contours of the myths that inevitably constellate around the project he sums up as 'contemplating the arising shape of a new world'.

Also contemplating such a new world is Donna Haraway, in an essay which also has a central place in the mythology of cyberculture, 'A Cyborg Manifesto'. The life story of this article is well-told by Haraway herself and by others (for an overview, see Bell 2006). It works its own threads in an attempt to build, as Haraway says at the beginning, an 'ironic political myth', a myth that blends and shakes up ideas, bodies of thought, resources for thinking, indeed ways of thinking. She focuses on the cyborg (cybernetic organism), a figure at once real and imaginary, a boundary figure that mixes up categories, that refuses to be either/or, preferring to be neither/both: human/animal, organism/machine, physical/non-physical. Evoking the cyborg as tied to exploitations (of animals, female labour, Third World economies) and connected to militarism and colonialism (knotted together in the space race), Haraway launches a (partial) rescue mission, a cyborg liberation. As she puts it, she is trying to rewrite the cyborg 'as a fiction mapping our social and bodily reality and as an imaginative resource suggesting some very fruitful couplings'. 'Who cyborgs will be', she adds, 'is a radical question'. At the heart of her essay is a critical engagement with feminism, and one key lineage (also problematic given Haraway's disavowal of origin stories) of this essay is the development of strands of cyberfeminism and cyborg feminism (discussed in general in Part Five, and particularly in Zoe Sofoulis's account there of the many lives and afterlives of the Manifesto). It seeks to map what Haraway calls the 'informatics of domination', to understand real changes occurring in geopolitics, in the global economy and labour markets, and how to intervene in these changes as they unfold. A key resource she turns to is feminist science fiction, in the recognition, shared with other influential cyberthinkers, that science fiction offers something strangely akin to social theory in postmodern culture (Kellner 1995). Feminist science fiction writers are, Haraway says, 'theorists for cyborgs', aiding the vital task of 'taking seriously the imagery of cyborgs as other than our enemies'. In particular, their boundary blurring (or boundary refusing) habits mean that cyborgs offer a template to think our way out of some enduring but ultimately hindering binaries that haunt the way 'we have explained our bodies and our tools to ourselves'.

Haraway's manifesto has come, ironically given its stance on origin stories, to occupy an almost canonical position in cyberculture studies. Reprinting it here adds to that status, of course, keeping alive an essay whose author continues to have misgivings about her progeny (see Bell 2006). But there can be no denying the potency of the cyborg as figured by Haraway, and the Manifesto has become a kind of source code for cyborg theorists. As already noted, the other widely-cited source code for cyberspace is the cyberpunk fiction of William Gibson, and this work is discussed at length in essays here by Scott McQuire and Scott Bukatman. McQuire addresses head on the legacy of Gibson's *Neuromancer* (1983), the novel

which birthed so many of the key images of Gibsonian cyberspace – the city-like datascape entered by 'jacking in', cyborg characters of dizzying variety, corporate control of data and privacy, and so on. The impact of Gibson on subsequent imaginings of the future has been equally profound, and Bukatman also traces the threads across SF fiction and film (and beyond). McQuire reminds us that science fiction is as much about the present as it is about the future, and thus suggests a reading of *Neuromancer* embedded in the early 1980s, with an emerging postindustrial landscape crossed and strafed by complex global flows, and with the knowledge, high-tech and bio-tech sectors being heralded as the cure to the ills of deindustrialization.

This precise location also helps account for the visual metaphor of cyberspace as a 'data city', leading McQuire to consider histories of the modern city which together produce an excessive, screenic experience of the city. In Gibson's work, two cities co-exist: the 'real' city, the sprawling, decentred megalopolis riven with social stratifications literalized in the built form; and the data city, the imaginary landscape of cyberspace depicted as a cityscape with skyscrapers made of information, and a neon glow. This new geography marks, McQuire writes, 'an *epochal* change in human modes of inhabiting space and relating to place' – home changes its meaning totally when Gibson's characters confess to feeling most at home in cyberspace. Drawing on the work of Paul Virilio (see below), McQuire reads the social and political implications of Gibsonianism: the collapse of space into time due to instantaneity, the new class structure of high-tech elites and a teeming digital underclass, the decentring and sprawling of vast cities, which marks at the same time their increasing *provincialization* as everywhere becomes one vast, endless suburb. The Internet – as the dominant manifestation of something like cyberspace at the time McQuire was writing – is itself becoming a suburb, and moreover a suburb 'increasingly dominated by the values of commerce rather than communality'. Current excitement about Web 2.0 and about the movement away from passive, commercial surfing towards active social networking and content-making might in time prompt a modification of McQuire's quite downbeat conclusion.

Gibson is at the heart of Scott Bukatman's broad survey of the spaces of cyberspace, which also draws on science fiction as arguably the key resource for understanding postmodern culture, present and future. Bukatman focuses on urban space, seeing cities as sprawling, 'intricately complex switchboards' marked, as McQuire notes, by decentralization and a kind of hyper-suburbanization. Science fiction exhibits for Bukatman a distinct ambivalence when it comes to imagining future cities, oscillating between utopian supercities and dystopian squalor – and in notable cases discussed by Bukatman, such as the movie *Blade Runner* (1982), mixing the two in a stratified dual city. Of course, as noted, science fiction talks of the time and space of its production as well as the time and space of its narrative, so the oscillations map onto broader discourses about cities as either efficient 'machines for living' or polluted, overcrowded, degenerate. When it comes to postmodernity, things get more complicated, an imploded urbanism of sprawl and mall: 'There is no logic or order to the space which lies littered and

cluttered, a morass of high and low technologies, a chaos of intersecting lines', as Bukatman describes it.

Blade Runner, another problematic source code, is taken by Bukatman as perfectly capturing this postmodern condition.[1] In *Blade Runner*, urban space is 'both bewildering and familiar', a jumble of old and new, high and low, assembled or *retrofitted* through the ages, a cityscape with a 'fractal geography' (an analysis arguably reflecting the excitement over fractal geometry in the high postmodern period Bukatman was writing in). The imploding urbanism and terminal space of *Blade Runner* prefigures Gibsonian cyberspace in Bukatman's account, which sees cyberpunk as 'science fiction set at street level', populated with low-lifes, gangs, renegades and chancers, and characterized now by a paranoid urbanism and an aesthetic sometimes referred to as 'tech-noir'. And Bukatman notes towards the end of his essay that, certainly in terms of fictional representations, 'Gibson's version of cyberspace is now the only possible model', such has been its all-pervasive influence; *Neuromancer* has produced its own consensual hallucination in terms of they ways we imagine cyberspace. While it is certainly true of science fiction, where the tech-noir aesthetic has become dominant, the subsequent domestication of cyberspace in the form of the Internet and web have provided other imaginative cultural resources, producing popular cybercultures with often little more than a hint of Gibsonianism to them (see Bell 2001).

Both McQuire and Bukatman refer to the work of Paul Virilio to help them think through the city of/in cyberspace, and this first part of the Reader closes with a short provocation by Virilio, 'Red Alert in Cyberspace'. Virilio has been a frequent commentator on cities, technologies and many other topics, and his huge body of work has attracted extensive commentary and no small amount of criticism. He remains, nevertheless, an important theorist of our current age and its predicaments. In 'Red Alert' he contends that 'Cyberspace is a new form of perspective', picking up the thread that Benedikt spun about the changing nature and experience of space. The shrinking of the world to an instantaneous blip, our 'collision' with the barrier of the speed of light, ushers in a new age, and with it new issues. Instantaneity for Virilio erases place, echoing Bukatman's discussion of cyberspace as a 'non-place realm', placeless place, scaleless scale and timeless time: perspective is no longer about space, but now about time. The relationship between things is a function of time, and this new perspective, Virilio argues, overturns our current way of seeing and experiencing the world, with profoundly unsettling consequences. The perspective of cyberspace is tactile, it involves sensing and touching at a distance (although not explicated, we imagine here that Virilio has in mind virtual reality data suits, though these already seem antique, a past dream of the future that has not materialized). The new perspective is giddying, moreover, with a new 'stereo-reality' mixing 'real' and 'virtual', producing a sense of disorientation (parallel to deregulation in Virilio's eyes, a kind of deregulation of perspective).

A larger project of Virilio's is to remind us of the side effects of new technologies, or what he calls here the 'specific negativity' of technology: before the car there were no car crashes, for example. Anticipating the 'accident' of

cyberspace, or what he has also called the 'information bomb', Virilio highlights 'the specific negativity of information superhighways' as a loss of connection to the real, an unmooring, a 'disorientation of alterity, of our relation to the other and to the world'. Like the stratified cities in *Blade Runner* or in Gibson's work, Virilio imagines a profound disconnect between social groups and between individuals, thereby contributing to a larger doom narrative about the social and political consequences of cyberspace. Rebuttals to this prognosis come from a variety of fronts, perhaps most audibly at present from Web 2.0 proponents who celebrate renewed social networking and peer-to-peer connectivity as an antidote to the atomizing effects of previous cyberspace developments. Nevertheless, Virilio's message stands as a valuable cautionary tale, asking us to approach cyberculture with at once Benedikt's wide-eyed optimism, and Virilio's own pessimistic perspective. No wonder, then, that commentators track such an oscillation between utopianism and dystopianism in the source code of cyberculture.

Notes

1 Problematic not least in terms of the stories behind its realization, the changed ending, its initial commercial failure, and its subsequent canonization (see Bukatman 1997).

References

Bell, D. (2001) *An Introduction to Cybercultures*, London: Routledge.
Bell, D. (2006) *Cyberculture Theorists*, London: Routledge.
Bukatman, S. (1997) *Blade Runner*, London: BFI.
Gibson, W. (2006) 'Academy leader', in D. Bell (ed.) *Cybercultures: Critical Concepts in Media and Cultural Studies*, volume two, London: Routledge.
Kellner, D. (1995) *Media Culture*, London: Routledge.

MICHAEL BENEDIKT

CYBERSPACE
First steps

CYBERSPACE: A WORD FROM THE PEN of William Gibson, science fiction writer, *circa* 1984. An unhappy word, perhaps, if it remains tied to the desperate, dystopic vision of the near future found in the pages of *Neuromancer* (1984) and *Count Zero* (1987) – visions of corporate hegemony and urban decay, of neural implants, of a life in paranoia and pain – but a word, in fact, that gives a name to a new stage, a new and irresistible development in the elaboration of human culture and business under the sign of technology.

Cyberspace: A new universe, a parallel universe created and sustained by the world's computers and communication lines. A world in which the global traffic of knowledge, secrets, measurements, indicators, entertainments, and alter-human agency takes on form: sights, sounds, presences never seen on the surface of the earth blossoming in a vast electronic night.

Cyberspace: Accessed through any computer linked into the system; a place, one place, limitless; entered equally from a basement in Vancouver, a boat in Port-au-Prince, a cab in New York, a garage in Texas City, an apartment in Rome, an office in Hong Kong, a bar in Kyoto, a café in Kinshasa, a laboratory on the Moon.

Cyberspace: The tablet become a page become a screen become a world, a virtual world. Everywhere and nowhere, a place where nothing is forgotten and yet everything changes.

Cyberspace: A common mental geography, built, in turn, by consensus and revolution, canon and experiment; a territory swarming with data and lies, with mind stuff and memories of nature, with a million voices and two million eyes in a silent, invisible concert to enquiry, deal-making, dream sharing, and simple beholding.

Cyberspace: Its corridors form wherever electricity runs with intelligence. Its chambers bloom wherever data gathers and is stored. Its depths increase with every image or word

or number, with every addition, every contribution, of fact or thought. Its horizons recede in every direction; it breathes larger, it complexifies, it embraces and involves. Billowing, glittering, humming, coursing, a Borgesian library, a city; intimate, immense, firm, liquid, recognizable and unrecognizable at once.

Cyberspace: Through its myriad, unblinking video eyes, distant places and faces, real or unreal, actual or long gone, can be summoned to presence. From vast databases that constitute the culture's deposited wealth, every document is available, every recording is playable, and every picture is viewable. Around every participant, this: a laboratory, an instrumented bridge; taking no space, a home presiding over a world … and a dog under the table.

Cyberspace: Beneath their plaster shells on the city streets, behind their potted plants and easy smiles, organizations are seen as the organisms they are – or as they would have us believe them be: money flowing in rivers and capillaries; obligations, contracts, accumulating (and the shadow of the IRS passes over). On the surface, small meetings are held in rooms, but they proceed in virtual rooms, larger, face to electronic face. On the surface, the building knows where you are. And who.

Cyberspace: From simple economic survival through the establishment of security and legitimacy, from trade in tokens of approval and confidence and liberty to the pursuit of influence, knowledge and entertainment for their own sakes, everything informational and important to the life of individuals – and organizations – will be found for sale, or for the taking, in cyberspace.

Cyberspace: The realm of pure information, filling like a lake, siphoning the jangle of messages transfiguring the physical world, decontaminating the natural and urban landscapes, redeeming them, saving them from the chain-dragging bulldozers of the paper industry, from the diesel smoke of courier and post office trucks, from jet fuel fumes and clogged airports, from billboards, trashy and pretentious architecture, hour-long freeway commutes, ticket lines and choked subways … from all the inefficiencies, pollutions (chemical and informational) and corruptions attendant to the process of moving information attached to things – from paper to brains – across, over and under the vast and bumpy surface of the earth rather than letting it fly free in the soft hail of electrons that is cyberspace.

Cyberspace as just described does not exist.

But this states a truth too simply. Like Shangri-la, like mathematics, like every story ever told or sung, a mental geography of sorts has existed in the living mind of every culture, a collective memory or hallucination, an agreed-upon territory of mythical figures, symbols, rules, and truths, owned and traversable by all who learned its ways, and yet free of the bounds of physical space and time. What is so galvanizing today is that technologically advanced cultures – such as those of Japan, Western Europe and North America – stand at the threshold of making that ancient space both uniquely visible and the object of interactive democracy.

Sir Karl Popper, one of this century's greatest philosophers of science, sketched the framework in 1972. The world as a whole, he wrote, consists of three, interconnected worlds. *World 1*, he identified with the objective world of material, natural things and their physical properties – with their energy and weight and motion and rest, *World 2*. he identified with the subjective world of consciousness – with intentions, calculations, feelings, thoughts, dreams, memories and so on, in individual minds. *World 3*, he said, is the world of objective,

real and public structures which are the not-necessarily- intentional products of the minds of living creatures, interacting with each other and with the natural world *World 1*. Anthills, birds' nests, beavers' dams and similar, highly complicated structures built by animals to deal with the environment, are forerunners. But many *World 3* structures, Popper noted, are abstract; that is, they are purely informational: forms of social organization, for example, or patterns of communication. These abstract structures have always equalled, and often surpassed, the *World 3* physical structures in their complexity, beauty, and importance to life. Language, mathematics, law, religion, philosophy, arts, the sciences and institutions of all kinds, these are all edifices of a sort, like the libraries we build, physically, to store their operating instructions, their 'programs'. Man's developing belief in, and effective behaviour with respect to, the objective existence of *World 3* entities and spaces meant that he could examine them, evaluate, criticize, extend, explore and indeed make discoveries in them, in public, and in ways that could be expected to bear on the lives of all. They could evolve just as natural things do, or in ways closely analogous. Man's creations in this abstract realm create their own, autonomous problems too, said Popper: witness the continual evolution of the legal system, scientific and medical practice, the art world, or for that matter, the computer and entertainment industries. And always these *World 3* structures feed back into and guide happenings in *Worlds 1* and *2*.

For Popper, in short, temples, cathedrals, marketplaces, courts, libraries, theatres or amphitheatres, letters, book pages, movie reels, videotapes, CDs, newspapers, hard discs, performances, art shows ... are all physical manifestations – or, should one say, the physical components of – objects that exist more wholly in *World 3*. They are 'objects', that is, which are patterns of ideas, images, sounds, stories, data ... patterns of pure information. And cyberspace, we might now see, is nothing more, or less, than the latest stage in the evolution of *World 3*, with the ballast of materiality cast away – cast away again, and perhaps finally.

But let it be said that, in accordance with the laws of evolution, and no matter how far it is developed, cyberspace will not *re*place the earlier elements of *World 3*. It will not *re*place but *dis*place them, finding, defining, its own niche and causing the earlier elements more closely to define theirs too. This has been the history of *World 3* thus far. Nor will virtual reality replace 'real reality'. Indeed, real reality – the air, the human body, nature, books, streets ... who could finish such a list? – in all its exquisite design, history, quiddity, and meaningfulness may benefit from both our renewed appreciation and our no longer asking it to do what is better done 'elsewhere'.

I have introduced Popper's rather broad analysis to set the stage for a closer examination of the origins and nature of our subject, cyberspace. I discern four threads within the evolution of *World 3*. These intertwine.

Thread One This, the oldest thread, begins in language, and perhaps before language, with a commonness-of-mind among members of a tribe or social group. Untested by dialogue – not yet brought out 'into the open' in this way – this commonness-of-mind is tested and effective none the less in the coordinated behaviour of the group around a set of beliefs held simply to be 'the case': beliefs about the environment, about the magnitude and location of its dangers and rewards, what is wise and foolhardy, and about what lies beyond; about the past, the future, about what lies within opaque things, over the horizon, under the earth, or above the sky. The answers to all these questions, always 'wrong', and always pictured in some way, are common property before they are privately internalized and critiqued. (The group mind, one might say, precedes the individual mind, and consensus precedes critical exception, as Mead and Vygotsky pointed out.) With language and pictorial representation, established some ten to twenty thousand years ago, fully entering the artifactual world, *World*

3, these ideas blossom and elaborate at a rapid pace. Variations develop on the common themes of life and death, the whys and wherefores, origins and ends of all things, and these coalesce ecologically into the more or less coherent systems of narratives, characters, scenes, laws and lessons that we now recognize, and sometimes disparage, as *myth*.

One does not need to be a student of Carl Jung or Joseph Campbell to acknowledge how vital ancient mythological themes continue to be in our advanced technological cultures. They inform not only our arts of fantasy, but, in a very real way, the way we understand each other, test ourselves, and shape our lives. Myths both reflect the 'human condition' and create it.

Now, the segment of our population most visibly susceptible to myth and most productive in this regard are those who are 'coming of age', the young. Thrust inexorably into a complex and rule-bound world that, it begins to dawn on them, they did not make and that, further, they do not understand, adolescents are apt to reach with some anger and some confusion into their culture's 'collective unconscious' – a world they already possess – for anchorage, guidance and a base for resistance. The boundary between fiction and fact, between wish and reality, between possibility and probability, seems to them forceable; and the archetypes of the pure, the ideal, the just, the good and the evil, archetypes delivered to them in children's books and movies, become now, in their struggle towards adulthood, both magnified and twisted. It is no surprise that adolescents, and in particular adolescent males, almost solely support the comic book, science fiction, and videogame industries (and, to a significant extent, the music and movie industries too). These 'media' are alive with myth and lore and objectified transcriptions of life's more complex and invisible dynamics. And it is no surprise that young males, with their cultural bent – indeed mission – to master new technology, are today's computer hackers and so populate the on-line communities and newsgroups. Indeed, just as 'cyberspace' was announced in the pages of a science fiction novel, so the young programmers of on-line 'MUDs' (Multi-User Dungeons) and their slightly older cousins hacking networked videogames after midnight in the laboratories of MIT's Media Lab, NASA, computer science departments and a hundred tiny software companies are, in a very real sense, by their very activity, creating cyberspace.

This is not to say that cyberspace is for kids, even less is it to say that it is for boys: only that cyberspace's inherent immateriality and malleability of content provides the most tempting stage for the acting out of mythic realities, realities once 'confined' to drug-enhanced ritual, to theatre, painting, books and to such media that are always, in themselves, somehow less than what they reach for, mere gateways. Cyberspace can be seen as an extension, some might say an inevitable extension, of our age-old capacity and need to dwell in fiction, to dwell empowered or enlightened on other, mythic planes, if only periodically, as well as this earthly one. Even without appeal to sorcery and otherworldy virtual worlds, it is not too far-fetched to claim that already a great deal of the attraction of the networked personal computer in general – once it is no longer feared as a usurper of consciousness on the one hand, nor denigrated as a toy or adding machine on the other – is due to its lightning-fast enactment of special 'magical' words, instruments and acts, including those of induction and mastery, and the instant connection they provide to distant realms and buried resources. For the mature as well as the young, then, and for the purposes of art and self-definition as well as rational communications and business, it is likely that cyberspace will retain a good measure of *mytho-logic*, the exact manifestation(s) of which, at this point, no one can predict.

Thread Two Convolved with the history of myth is the thread of the history of media technology as such, that is, the history of the technical means by which absent and/or

abstract entities – events, experiences, ideas – become symbolically represented, 'fixed' into an accepting material, and thus conserved through time as well as space. Again, this a fairly familiar story; nevertheless it is one worth rehearsing. It is also a topic that is extremely deep, for the secret of life itself is wrapped up in the mystery of genetic encoding and the replication and motility of molecules that orchestrate each other's activity. Genes are information; molecules are media as well as motors, so to speak …

But we cannot begin here, where the interests of computation theorists and biologists coincide. Our story best begins with evolved man's conscious co-option of the physical environment, specifically those parts, blank themselves, that best receive markings – such as sand, wood, bark, bone, stone and the human body – for the purpose of preserving and delivering messages: signs, not unlike spoors, tracks, or tell-tale colours of vegetation or sky, but now intentional, between man and man, and man and his descendants. What a graceful and inspired step it was, then, to begin to *produce* the medium, to create smooth plastered walls, thin tablets and papyrus, and to reduce the labour of marking – carving, chiselling – to the deft movement of a pigmented brush or stylus. As society elaborated itself and as the need to keep records and to educate grew, how much more efficient it was to shrink and conventionalize the symbols themselves, then to crowd them into rows and layers, 'paper-thin' scrolls and stacks.

At this early stage already, the double movement towards the dematerialization of media on the one hand and the reification of meanings on the other is well underway. Against the ravages of time, none the less, and to impress the illiterate masses, only massive sculptures, friezes, and reliefs in stone would do. These are what we see today; these are what survive of ancient cultures and impress us still. But it would be wrong therefore to underestimate the traffic of information in more ephemeral media that must have sustained day-to-day life: the scratched clay tablets, the bark shards, graffitied walls, counters, papyri, diagrams in the sand, banners in the wind, gestures, demonstrations, performances, and, of course, the babble of song, gossip, rumour, and instruction that continuously filled the air. Every designed and every made thing was also the story of its use and its ownership, of its making and its maker.

This world sounds strangely idyllic. Many of its components, in only slightly updated forms, survive today. It was a period perhaps four thousand years long when objects, even pure icons and symbols, were not empty or ignorable but were real and meaningful, when craftsmanship, consensus, and time were involved in every thing and its physical passage through society. But first, with the development of writing and counting and modes of graphic representation, and then, centuries later, with the invention of the printing press and the spread of literacy beyond the communities of religious scholars and noblemen, the din of ephemeral communications came to be recorded at an unprecedented scale. More important for our story, these 'records' came to be easily duplicable, transportable, and broadcastable.

Life would never be the same. The implications of the print revolution and the establishment of what Marshall McLuhan called the 'Gutenberg galaxy' (in his book of the same name; 1962) for the structure and function of technologically advancing societies can hardly be overestimated. Not the least of these implications were (1) the steady, de facto, democratization of the means of idea production and dissemination, (2) the exponential growth of that objective body of scientific knowledge, diverse cultural practices, dreams, arguments and documented histories called *World 3*, and (3) the fact that this body, containing both orthodoxies and heresies, could neither be located at any one place, nor be entirely controlled.

However, our double movement did not stop there, as we are all witness today. Although 'printed matter' from proclamations to bibles to newspapers could, in principle, be taken everywhere a donkey, a truck, a boat, or an aeroplane could physically go, there was a limit, namely, *time*. No news could be fresh days or weeks later. The coordination of goods transportation in particular was a limiting case, for if no message could travel faster than that whose imminent arrival it was to announce … then of what value the message? Hence the telegraph, that first 'medium' after semaphore, smoke signals and light-flashing, to connect distant 'stations' on the notion of a permanent *network*.

Another related limit was expense: the sheer expenditure of energy required to convey even paper across substantial terrain. The kind of flexible common-mindedness made possible in small communities by the near-simultaneity and zero-expense of natural voice communications, or even rumour and leaflets, collapses at the larger scale. Social cohesion is a function of ideational consensus, and without constant update and interaction, such cohesion depends crucially on early, and strict, education in – and memory of – the architectures, as it were, of *World 3*.

With the introduction of the telephone, both the problem of speed and the problem of expense were largely eliminated. Once wired, energy expenditure was trivial to relay a message, and it was soon widely realized (interestingly only in the 1930s and 40s) that the telephone need not be used like a 'voice-telegraph', which is to say, sparingly and for serious matters only. Rather, it could be used also as an open channel for constant, meaningful, community-creating and business-running interchanges; 'one-on-one' interchanges, to be sure, but 'many-to-many' over a period of time. Here was a medium, here *is* a medium, whose communicational limits are still being tested, and these quite apart from what can be accomplished using the telephone system for computer networks.

Of course, the major step being taken here, technologically, is the transition, wherever advantageous, from information transported physically, and thus against inertia and friction, to information transported electrically along wires, and thus effectively without resistance or delay. Add to this the ability to *store* information electromagnetically (the first tape recorder was demonstrated commercially in 1935), and we see yet another significant and evolutionary step in dematerializing the medium and conquering – as they say – space and time.

But this was paralleled by a perhaps more significant development: *wire-less* broadcasting, that is, radio and television. Soon, encoded words, sounds and pictures from tens of thousands of sources could invisibly saturate the world's 'airwaves', every square millimetre and without barrier. What poured forth from every radio was the very sound of life itself, and from every television set the very sight of it: car chases, wars, laughing faces, oceans, volcanos, crying faces, tennis matches, perfume bottles, singing faces, accidents, diamond rings, faces, steaming food, more faces … images, ultimately of a life not really lived anywhere but arranged for the viewing. Critic and writer Horace Newcomb (1976) calls television less a medium of *communication* than a medium of *communion*, a place and occasion where nightly the British, the French, the Germans, the Americans, the Russians, the Japanese … settle down by the million to watch and ratify their respective national mythologies: nightly variations on a handful of dreams being played out, over and over, with addicting, tireless intensity. Here are McLuhan's acoustically-structured global villages (though he wished there to be only one), and support for the notion that the electronic media, and in particular television, provide a medium not unlike the air itself – surrounding, permeating, cycling, invisible, without memory or the demand for it, conciliating otherwise disparate and perhaps antagonistic individuals and regional cultures.

With cordless and then private cellular telephones, and 'remote controls' and then hand-held computers communicating across the airwaves too, the very significance of geographical location at all scales begins to be questioned.

We are turned into nomads ... who are always in touch.

All the while, material, print-based media were and are growing more sophisti- cated too: 'vinyl' sound recording (a kind of micro-embossing), colour photography, offset lithography, cinematography, and so on ... the list is long. They became not only more sophisticated but more egalitarian as the general public not only 'consumed' ever greater quantities of magazines, billboards, comic books, newspapers, and movies but also gained access to the means of production: to copying machines, cameras, movie cameras, record players and the rest, each of which soon had its electronic/digital counterpart as well as a variety of hybrids, extensions and cross-marriages: national newspapers printed regionally from satellite-transmitted electronic data, facsimile transmission, digital preprint and recording, and so on.

The end of our second narrative thread is almost at hand.

With the advent of fast personal computers, digital television, and high bandwidth cable and radio-frequency networks, so-called post-industrial societies stand ready for a yet deeper voyage into the 'permanently ephemeral' (by which I mean, as the reader is well aware, cyberspace). So-called on-line community, electronic mail, and information services (USENET, the Well, Compuserve, and scores of others) already form a technological and behavioural beginning. But the significance of this voyage is perhaps best gauged by the almost irrational enthusiasm that today surrounds the topic of *virtual reality*.

Envisaged by science fiction writer/promoter Hugo Gernsback as long ago as 1963 (see Stashower 1990) and explored experimentally by Ivan Sutherland (1968), the technology of virtual reality (VR) stands at the edge of practicality and at the current limit of the effort to create a communication/communion medium that is both phenomenologically engulfing and yet all but invisible. By mounting a pair of small video monitors with the appropriate optics directly to the head, a stereoscopic image is formed before the 'user's' eyes. This image is continuously updated and adjusted by a computer to respond to head movements. Thus, the user finds himself entirely surrounded by a stable, three- dimensional visual world. Wherever he looks he sees what he would see were the world real and around him. This *virtual* world is either generated in real time by the computer, or it is preprocessed and stored, or it exists physically elsewhere and is 'videographed' and transmitted in stereo, digital form. (In the last two cases the technique is apt to be named *telepresence* rather than virtual reality.) In addition, the user may be wearing stereo headphones. Tracked for head movements, a complete acoustic sensorium is thus added to the visual one. Finally, the user may wear special gloves, and even a whole body suit, wired with position and motion transducers to transmit to others – and to represent to himself – the shape and activity of his body in the virtual world. There is work underway also to provide some form of force-feedback to the glove or suit so that the user will actually feel the presence of virtual 'solid' objects – their weight, texture and perhaps even temperature (see Stewart, 1991a, for a recent survey, and Rheingold 1991). With a wishful eye cast towards such fictional technologies as the Holodeck, portrayed in the television series *Star Trek, the Next Generation*, devices sketched in such films as *Total Recall* and *Brainstorm*, and, certainly, the direct neural connections spoken of in Gibson's novels, virtual reality/telepresence technology is as close as one can come in reality to entering a totally synthetic sensorium, to immersion in a totally artificial and/or remote world.

Much turns on the question of whether this is done alone or in the company of others; and if the latter, of how many, and how. For, engineering questions aside, as the population of a virtual world increases, with it comes the need for consensus of behaviour, iconic language, modes of representation, object 'physics', protocols, and design – in a word, the need for *cyberspace* as such, seen as a general, singular-at-some-level, public, consistent, and democratic 'virtual world'. Herein lies the very power of the concept.

Thread Two, then, is drawn from the history of communication media. The broad historical movement from a universal, preliterate actuality of *physical doing*, to an education-stratified, literate reality of *symbolic doing* loops back, we find. With movies, television, multimedia computing and now VR, it loops back to the beginning with the promise of a *post*literate era, if such can be said; the promise, that is, of 'post-symbolic communication' to put it in VR pioneer Jaron Lanier's words (Lanier 1989, Stewart 1991b). In such an era, language-bound descriptions and semantic games will no longer be required to communicate personal viewpoints, historical events, or technical information. Rather, direct – if 'virtual' – demonstration and interactive experience of the 'original' material will prevail, or at least be a universal possibility. We would become again 'as children' but this time with the power of summoning worlds at will and impressing speedily upon others the particulars of our experience.

In future computer-mediated environments, whether or not this kind of literal, experiential sharing of worlds will supersede the symbolic, ideational, and implicit sharing of worlds embodied in the traditional mechanisms of text and representation remains to be seen. While pure VR will find its unique uses, it seems likely that cyberspace, in full flower, will employ all modes.

Thread Three Another narrative, this one is spun out of the history of architecture.

The reader may remember that Popper saw architecture as belonging to *World 3*. This it surely does, for although shelter, beauty and meaning can be found in 'unspoiled' nature, it is only with architecture that nature, as habitat, becomes co-opted, modified and codified.

Architecture, in fact, begins with displacement and exile: exile from the temperate and fertile plains of Africa two million years ago – from Eden, if you will, where neither architecture nor clothing was required – and displacement through emigration from a world of plentiful food, few competitors, and not more kin than the earth would provide for. Rapid climatic change, increasing competition and exponential population growth was to change early man's condition irreversibly. To this day, architecture is thus steeped in nostalgia, one might say; or in defiance.

Architecture begins with the creative response to climatic stress, with the choosing of advantageous sites for settlements (and the need to defend these), and the internal development of social structures to meet population and resource pressure, to wit: with the mechanisms of privacy, property, legitimation, task specialization, ceremony and so on. All this had to be carried out in terms of the availability of time, materials and design and construction expertise. Added to these were the constraints and conventions manufactured by the culture up to that point. These were often arbitrary and inefficient. But always, even as conventions and constraints transformed, and as man passed from hunting and gathering to agrarianism to urbanism, the theme of return to Eden endured, the idea of return to a time of (presumptive) innocence and tribal/familial/ national oneness, with each other and with nature.

I bring up this theme not because it 'explains' architecture, but because it is a principle theme driving architecture's self-dematerialization. *Dematerialization?* The reader

may be surprised. What *is* architecture, after all, if not the creation of durable physical worlds that can orient generations of men, women, and children, that can locate them in their own history, protect them always from prying eyes, rain, wind, hail and projectiles … durable worlds, and in them, permanent monuments to everything that should last or be remembered?

Indeed these are some of architecture's most fundamental charges; and most sacred among them, as I have argued elsewhere (Benedikt 1987), is architecture's standard bearing, along with nature, for our sense of what we mean by 'reality'. But this should not blind us to a significant countercurrent, one fed by a resentment of quotidian architecture's bruteness and claustrophobia, which itself is a spilling-over of the resentment we feel for our own bodies' cloddishness, limitations and final treachery: their mortality. Reality is death. If only we could, we would wander the earth and never leave home; we would enjoy triumphs without risks, eat of the Tree and not be punished, consort daily with angels, enter heaven now and not die. In the name of these unreasonable desires we revere finery and illumination, and reward bravery, goodness and learning with the assurance of eternal life. As though *we* could grow wings! As though we could grow wings, we erect gravity-defying cathedrals resplendent with coloured windows and niches crowded with allegorical life, create paradisiacal gardens such as those at Alhambra, Versailles, the Taj Mahal, Roan-Ji, erect stadia for games, create magnificent libraries, labyrinths and observatories, build on sacred mountain tops, make enormous, air- conditioned greenhouses with amazing flying-saucer elevators, leap from hillsides strapped to kites, dazzle with gold, chandeliers, and eternally running streams; we scrub and polish and whiten … all in a universal, cross-cultural act of reaching beyond brute nature's grip in the here and now. And this with the very materials nature offers us.

In counterpoint to the earthly *garden* Eden (and even to that walled garden, Paradise) then, floats the image of the Heavenly City, the new Jerusalem of the book of Revelation. Like a bejewelled, weightless palace it comes down out of heaven itself 'its radiance like a most rare jewel, like jasper, transparent' (Revelation 21:9). Never seen, we know its geometry to be wonderfully complex and clear, its twelves and fours and sevens each assigned a set of complementary cosmic meanings. A city with streets of crystalline gold, gates of solid pearl, and no need for sunlight or moonlight to shine upon it for 'the glory of God is its light'.

In fact, all images of the Heavenly City — East and West — have common features: weightlessness, radiance, numerological complexity, palaces upon palaces, peace and harmony through rule by the good and wise, utter cleanliness, transcendence of nature and of crude beginnings, the availability of all things pleasurable and cultured. And the effort at describing these places, far from a mere exercise in superlatives by medieval monks and painters, continues to this day on the covers and in the pages of innumerable science fiction novels and films. (Think of the mother ship in *Close Encounters of the Third Kind*.) Here is what is means to be 'advanced', they all say.

From Hollywood Hills to Tibet, one could hardly begin to list the buildings actually built and projects begun in serious pursuit of realizing the dream of the Heavenly City. If the history of architecture is replete with visionary projects of this kind, however, these should be seen not as naïve products of the fevered imagination, but as hopeful fragments. They are attempts at physically realizing what is properly a cultural archetype, something belonging to no one and yet everyone, an image of what would adequately compensate for, and in some way ultimately justify, our symbolic and collective expulsion from Eden. They represent the creation of a place where we might *re-enter* God's graces. Consider: Where Eden (before the Fall) stands for our state of innocence, indeed ignorance, the Heavenly City

stands for our state of wisdom, and knowledge; where Eden stands for our intimate contact with material nature, the Heavenly City stands for our transcendence of both materiality and nature; where Eden stands for the world of unsymbolized, asocial reality, the Heavenly City stands for the world of enlightened human interaction, form and information. In Eden the sun rose and set, there were days and nights, wind and shadow, leaf and stone, and all perfumed. The Heavenly City, though it may contain gardens, breathes the crystalline gleam of its own lights, sparkling, insubstantial, laid out like a beautiful equation. Thus, while the biblical Eden may be imaginary, the Heavenly City is *doubly* imaginary: once, in the conventional sense, because it is not actual, but once again because even if it became actual, because it *is* information, it could come into existence only as a virtual reality, which is to say, fully, only 'in the imagination'. The image of the Heavenly City, in fact, is an image of *World 3* become whole and holy. And a religious vision of cyberspace.

I must now return briefly to the history of architecture, specifically in modern times. After a century of the Industrial Revolution, the turn of the twentieth century saw the invention of high-tensile steels, of steel-reinforced concrete and of high-strength glass. Very quickly, and under economic pressure to do more with less, architects seized and celebrated the new vocabulary of lightness. Gone were to be the ponderous piers, the small wooden windows, the painstaking ornament, the draughty chimneys and lanes, the chipping and smoothing and laying! Instead: daring cantilevers, walls reduced to reflective skins, openness, light, swiftness of assembly, chromium. Gone the stairs, the horse-droppings in the street, and the cobbles. Instead, the highway, the bullet-like car, the elevator, the escalator. Gone the immovable monument, instead the demountable exhibition; gone the Acropolis, instead the World's Fair. In 1924, the great architect Le Corbusier proposed razing half of Paris and replacing it with *La Ville radieuse*, the Radiant City, an exercise in soaring geometry, rationality, and enlightened planning, unequalled since. A Heavenly City.

By the late 1960s, however, it was clear that the modern city was more than a collection of buildings and streets, no matter how clearly laid out, no matter how lofty its structures or green its parks. The city became seen as an immense node of communications, a messy nexus of messages, storage and transportation facilities, a massive education machine of its own complexity, involving equally all media, *including buildings*. To no one was this more apparent than to a group of architects in England calling themselves Archigram. Their dream was of a city that built itself unpredictably, cybernetically, and of buildings that did not resist television and telephones and air conditioning and cars and advertising but accommodated and played with them; inflatable buildings, buildings on rails, buildings like giant experimental theatres with video cameras gliding like sharks through a sea of information, buildings bedecked in neon, projections, laser beams … These were described in a series of poster-sized drawings called *archi*tectural tele*grams*, which were themselves, perhaps not incidentally, early examples of what multimedia computer screens might look like tomorrow (Cook 1973). Although the group built nothing themselves, they were and are, none the less, very influential in the world of architecture.

Now, a complete treatment of the signs of the ephemeralization of architecture and its continuing capitulation to media is outside the scope of this essay. It occurs on many fronts, from the wild 'Disneyfication' of form, to the overly meek accommodation of services. Most interesting, however, is a thread that arises from thinking of architecture itself as an abstraction, a thread that has a tradition reaching back to ancient Egypt and Greece and the coincidence of mathematical knowledge with geometry and hence correct architecture. As late as the eighteenth century, architects were also scientists and mathematicians; witness Andrea Palladio, Sir Christopher Wren, and before them, of course, Leonardo da Vinci and Leon Battista Alberti. From the 1920s till the 1960s, the whole notion that architecture is

about the experiential modulation of *space* and *time* – that is, 'four dimensional' – captivated architectural theory, just as it had captivated a generation of artists in the 20s and 30s (Henderson 1983). This was something conceptually far beyond the simple mathematics of good proportions, even of structural engineering. It is an idea that still has force.

Then too there is the tradition of architecture seen for its symbolic context; that is, for not only the way it shapes and paces information fields in general (the emanations of faces, voices, paintings, exit signs, etc.) but the way buildings carry meaning in their anatomy, so to speak, and in what they 'look like'. After five thousand years, the tradition is very much alive as part of society's internal message system. In recent years, however, the architectural 'message system' has taken on a life of its own. Not only have architectural drawings generated an art market in their own right – as illustrated conceptual art, if you will – but buildings themselves have begun to be considered as arguments in an architectural discourse about architecture, as propositions, narratives and inquiries that happen, also, to be inhabitable. In its most current avant-garde guise, the movement goes by the name of deconstructivism, or post-structuralism (quite explicitly related to the similarly named movements in philosophy and literary criticism). Its interests are neither in the building as an object of inhabitation nor as an object of beauty, but as an object of information, a collection of ciphers and 'moves', junctions and disjunctions, reversals and iterations, metaphorical woundings and healings, and so on, all to be 'read'. This would be of little interest to us here were it not an indication of how far architecture can go towards attempting to become pure demonstration, and intellectual process, and were it not fully a part of the larger movement I have been describing. (And we should remember that, as a rule, today's avant-garde informs tomorrow's practice. See Betsky 1990.)

But there is a limit to how far notions of dematerialization and abstraction can go and still help produce useful and interesting, real architecture. That limit has probably been reached, if not overshot (Benedikt 1987). And yet the impetus toward the Heavenly City remains. It is to be respected; indeed, it can usefully flourish … in cyberspace.

The door to cyberspace is open, and I believe that poetically- and scientifically-minded architects can and will step through it in significant numbers. For cyberspace will require constant planning and organization. The structures proliferating within it will require *design*, and the people who design these structures will be called *cyberspace architects*. Schooled in computer science and programming (the equivalent of 'construction'), in graphics, and in abstract design, schooled also along with their brethren 'real-space' architects, cyberspace architects will design electronic edifices that are fully as complex, functional, unique, involving and beautiful as their physical counterparts if not more so. Theirs will be the task of visualizing the intrinsically non-physical and giving inhabitable visible form to society's most intricate abstractions, processes, and organisms of information. And all the while such designers will be *re*realizing in a virtual world many vital aspects of the physical world, in particular those orderings and pleasures that have always belonged to architecture.

Thread Four This thread is drawn from the larger history of mathematics. It is the line of arguments and insights that revolve around (1) the propositions of geometry and space, (2) the spatialization of arithmetical/algebraic operations, and (3) reconsideration of the nature of space in the light of (2).

Since Aristotle, operating alongside this 'spatial-geometrical' thread in mathematics has been a complementary one, that is, the development of symbolic logic, algebraic notation, calculus, finite mathematics and so on, to modern programming languages. I say 'complementary' because these last-named subjects could (and can still) proceed purely symbolically, with little or no geometrical, spatial interpretations; algebra, number theory,

computation theory, logic … these are symbolic operations upon symbolic operations and have a life of their own.

In practice, of course, *diagrams*, which are spatial and geometrical, and *symbol strings* (mathematical notation, language) are accepted as mutually illuminating representations and are considered together. But the distinction between them, and the tension, still remain. There are those who think most easily and naturally in symbolic sequences, and linear operations upon them; there are those who think most easily and naturally in shapes, actions and spaces. Apparently more than one type of intelligence is involved here (Gardner 1983, Hadamard 1945, West 1991). Be this as it may, cyberspace clearly is premised upon the desirability of spatialization *per se* for the understanding of information. Certainly, it extends the current paradigm in computing of 'graphic user interfaces' into higher dimensions and more involving experiences, and it extends current interest, as evidenced by the popularity of Edward Tufte's books (1983, 1990), in 'data cartography' in general and in the field of scientific visualization. But, more fundamentally, cyberspace revivifies and then extends some of the more basic techniques and questions having to do with the spatial nature of mathematical entities, and the mathematical nature of spatial entities, that lie at the heart of what we consider both real and measurable.

Rigorous reasoning with shape – deductive geometry – began, as we all know, in ancient Greece with Thales around 600 B.C., continuing through 225 B.C. with Pythagoras, Euclid, and Apollonius. The subject was twin: (1) the nature (and methods of construction) of the idealized forms studied – basically lines, circles, regular polygons and polyhedra, although Apollonius began work on conic sections – and (2) the nature of perfect reasoning itself, which the specifiability and universality of geometrical operations seemed to exemplify. The results of geometrical study had practical use in building and road construction, land surveying, and what we today call mechanical engineering. Its perfection and universality also supported the casting of astrological/ cosmological models along geometrical lines.

The science and art of geometry has developed sporadically since, receiving its last major 'boost' of renewed interest – after Kepler and Newton – in the late nineteenth century, with Bolyai and Lobatchevsky's discovery of non-Euclidean geometry. Soon, however, with the concept of pure topology and the discovery of consistent geometries of higher dimensionality than three, first Euclidean geometry and then geometry in general began to lose something of its lustre as a science wherein significant new discoveries could be made. *All* statements of visual geometrical insight, it seemed, could be studied more generally and accurately in the symbolic/algebraic language of analytical mathematics – final fruit of Descartes' project in *La Géométrie*, which was precisely to show how the theorems of geometry could be transcribed into analytical (algebraic) form.

Of course the linkage, once made, between geometry and algebra, space and symbol, form and argument, is a two-way one. Descartes had both 'algebraized' geometry and 'geometrized' algebra. (And it is this second movement that is of most interest to us here.) With one profound invention, he had built the conceptual bridge we today call the Cartesian coordinate system. Here was the insight: just as the positions of points in natural, physical space could be encoded, specified, by a trio of numbers, each referring to a distance from a common but arbitrary origin in three mutually orthogonal directions, so too could the positions of points in a 'mathematical space' where the 'distances' are not physical distances but numerical values, derived algebraically, of the solution of equations of (up to) three variables. In this way, thousands of functions could accurately be 'graphed' and made visible.

Today, procedures based on Descartes' insight are commonplace, taught even at good elementary schools. But this should not mask the power of the implicit notion that *space*

itself is something not necessarily physical: rather that it is a 'field of play' for all information, only one of whose manifestations is the gravitational and electromagnetic field of play that we live in, and that we call the real world. Perhaps no examples are more vivid than the beautiful forms that emerge from simple recursive equations – the new science of 'fractals' – and recent discoveries of 'strange attractors,' objects of coherent geometry and behaviour that 'exist' only in mathematical spaces (coordinate systems with specially chosen coordinates) and that economically map/describe/prescribe the behaviour of complex, chaotic, physical systems. Which reality is the primary one? we might fairly ask.

Actually, why choose?

Modern physicists are sanguine: Minkowski had shown the utility of mapping time together with space, Hamiltonian mechanics lent themselves beautifully to visualizing the dynamics of a physical system in *n*-dimensional *state* or *phase space* where a single point represents the entire state of the system, and quantum mechanics seems to play itself out in the geometrical behaviour of vectors in *Hilbert space*, in which one or more of the coordinates are 'imaginary' (see Penrose 1989 for a recent explication).

In the meantime, the more common art of diagrams and charts proliferated – from old maps, schedules, and scientific treatises, to the pages of modern economics primers, advertisements and boardroom 'business graphics'. Many of these representations are in fact hybrids, mixing physical, energic or spatiotemporal, coordinates with abstract, mathematical ones, mixing histories with geographies, simple intervallic scales with exponential ones, and so on. The practice of *diagramming* (surely one whose origins are earlier than writing) continues too, today enhanced by the mathematics of *graph theory* with its combinatorial and network techniques to analyse and optimize complex processes. What, we may ask, is the ontological status of such representations? All of them – from simple bar charts and organizational 'trees' through matrices, networks and 'spreadsheets' to elaborate, multidimensional, computer-generated visualizations of invisible physical processes – all of these, and all abstract phase-, state-, and Hilbert-space entities, seem to exist in a geography, a space, borrowed from, but not identical with, the space of the piece of paper of computer screen on which we see them. All have a reality that is no mere picture of the natural, phenomenal world, and all display a physics, as it were, from elsewhere.

What are they, indeed? Neither discoveries nor inventions, they are of *World 3*, entities themselves evolved by our intelligence in the world of things and of each other. They represent first evidence of a continent about which we have hitherto communicated only in sign language, a continent 'materializing' in a way. And at the same time they express a new etherealization of geography. It is as though, in becoming electronic, our beautiful old astrolabes, sextants, surveyor's compasses, observatories, orreries, slide rules, mechanical clocks, drawing instruments and formwork, maps and plans – physical things all, embodiments of the purest geometry, their sole work to make us at home in space – become environments themselves, the very framework of what they once only measured.

My account of the intertwining 'threads' that seem to lead to cyberspace is, of course, impressionistic and incomplete. Cyberspace is an elusive and future thing, and one can hardly be definitive at this early stage.

But it is also clear that the 'threads' themselves are made of threads, and that there are others. For example, the history of art into modern times tells a related story, fully involving mythology, changing media, a relationship to architecture, logic, and so on. It is a thread I have not described, and yet the contribution of artists – visual, musical, cinematic – to the design of virtual worlds and cyberspace promises to be considerable. Similarly, the story of progress in telecommunications and computing technology – the miniaturizations,

speeds and economies, the new materials, processes, interfaces and architectures – is a thread in its own right, with its own thrusts and interests in the coming-to-be of cyberspace. This story is well chronicled elsewhere (Gilder, 1988; Rheingold, 1985). Then there is the sociological story, and the economic one, the linguistic one, even the biological one … and one begins to realize that every discipline can have an interest in the enterprise of creating cyberspace, a contribution to make, and a historical narrative to justify both. How could it be otherwise? We are contemplating the arising shape of a new world, a world that must, in a multitude of ways, *begin*, at least, as both an extension and a transcription of the world as we know it and have built it thus far.

Another reason that my account is impressionistic and incomplete, however, is that the very metaphor of threads is too tidy and cannot support all that needs to be said. Scale aside, something deeper and more formless is going on. Consider: if information is the very *stuff* of space and time, what does it mean to manufacture information, and what does it mean to transfer it at ever higher rates between spatiotemporally distinct points, and thus dissolve their very distinctness? With mature cyberspaces and virtual reality technology, this kind of warpage, tunnelling, and lesioning of the fabric of reality will become a perceptual, phenomenal fact at hundreds of thousands of locations, even as it falls short of complete, quantum level, physical achievement. Today intellectual, tomorrow practical, one can only guess at the implications. Of this much, one can be sure: the advent of cyberspace will have profound effects on so-called post-industrial culture, and the material and economic rewards for those who first and most properly conceive and implement cyberspace systems will be enormous. But let us set aside talk of rewards. With these 'first steps', let us begin to face the perplexities involved in making the unimaginable imaginable and the imaginable real. Let the ancient project that is cyberspace continue.

References

Benedikt, M. (1987) *For an Architecture of Reality*, New York: Lumen Books
—— (1991) *Deconstructing the Kimbell*, New York: Lumen Books.
Betsky , A. (1990) *Violated Perfection*, New York: Rizzoli.
Cook, P. (ed.) (1973) *Archigram*, New York: Praeger.
Gardner, H. (1983) *Frames of Mind*, New York: Basic Books.
Gibson, W. (1984) *Neuromancer*, New York: Ace Books
—— (1987) *Count Zero*, New York: Ace Books.
Gilder, G. (1988) *Microcosm*, New York: Simon and Schuster.
Hadamard, J. (1945) *An Essay on the Psychology of Invention in the Mathematical Field*, New York: Dover Publications.
Henderson, L. D. (1983) *The Fourth Dimension and Non-Euclidean Geometry in Modern Art*, Princeton, NJ: Princeton University Press.
Lanier, J. (1989) Interview in *Whole Earth Review*, Fall 1989, pp. 108ff.
McLuhan, M. (1962) *Gutenberg Galaxy: The Making of Typographic Man*, Toronto: University of Toronto Press.
Newcomb, H. (1976) *Television: The Critical View*, New York: Oxford University Press.
Penrose, R. (1989) *The Emperor's New Mind: Concerning Computers, Minds, and the Laws of Physics*, New York: Oxford University Press.
Popper, K. (1972, revised 1979) *Objective Knowledge: An Evolutionary Approach*, Oxford: Oxford University Press, pp. 106–52. See also Clifford Geertz, *The Interpretation of Cultures* (New York: Basic Books, 1973), pp. 55–83; Leslie A. White, 'The locus of mathematical reality: an anthropological footnote', in J. R. Newman (ed.) *The World of Mathematics* (New York, Simon and Schuster, 1956), p. 2325; and Emile Durkheim, *The Elementary Forms of the Religious Life*, trans. J. S. Swain (New York: Free Press, 1965 [1915]).

Rheingold, H. (1985) *Tools for Thought*, New York: Simon and Schuster.

—— (1991) *Virtual Reality*, New York: Simon and Schuster.

Stashower, D. (1990) 'A dreamer who made us fall in love with the future', *Smithsonian*, 21 (5, August 1990): 50. Contains reprint from *Life Magazine* (1963).

Stewart, D. (1991a) 'Artificial reality: don't stay home without it', *Smithsonian*, 21 (10, January 1991): 36ff.

—— (1991b) 'Interview: Jaron Lanier', *Omni*, 13 (4, January 1991): 45ff.

Sutherland, I. E. (1968) 'A head-mounted three dimensional display', in *Fall Joint Computer Conference* (FJCC), Washington, DC: Thompson Books, pp. 757–64.

Tufte, E. R. (1983) *The Visual Display of Quantitive Information*, Cheshire, CT: Graphics Press.

—— (1990) *Envisioning Information*, Cheshire, CT: Graphics Press.

West, T. G. (1991) *In the Mind's Eye*, Buffalo, NY: Prometheus Books.

DONNA HARAWAY

A CYBORG MANIFESTO
Science, technology and socialist-feminism in
the late twentieth century

An ironic dream of a common language for women in the integrated circuit

THIS CHAPTER IS AN EFFORT to build an ironic political myth faithful to feminism, socialism, and materialism. Perhaps more faithful as blasphemy is faithful, than as reverent worship and identification. Blasphemy has always seemed to require taking things very seriously. I know no better stance to adopt from within the secular-religious, evangelical traditions of US politics, including the politics of socialist-feminism. Blasphemy protects one from the moral majority within, while still insisting on the need for community. Blasphemy is not apostasy. Irony is about contradictions that do not resolve into larger wholes, even dialectically, about the tension of holding incompatible things together because both or all are necessary and true. Irony is about humour and serious play. It is also a rhetorical strategy and a political method, one I would like to see more honoured within socialist-feminism. At the centre of my ironic faith, my blasphemy, is the image of the cyborg.

A cyborg is a cybernetic organism, a hybrid of machine and organism, a creature of social reality as well as a creature of fiction. Social reality is lived social relations, our most important political construction, a world-changing fiction. The international women's movements have constructed 'women's experience', as well as uncovered or discovered this crucial collective object. This experience is a fiction and fact of the most crucial, political kind. Liberation rests on the construction of the consciousness, the imaginative apprehension, of oppression, and so of possibility. The cyborg is a matter of fiction and lived experience that changes what counts as women's experience in the late twentieth century. This is a struggle over life and death, but the boundary between science fiction and social reality is an optical illusion.

Contemporary science fiction is full of cyborgs – creatures simultaneously animal and machine, who populate worlds ambiguously natural and crafted. Modern medicine is also full of cyborgs, of couplings between organism and machine, each conceived as coded devices,

in an intimacy and with a power that was not generated in the history of sexuality. Cyborg 'sex' restores some of the lovely replicative baroque of ferns and invertebrates (such nice organic prophylactics against heterosexism). Cyborg replication is uncoupled from organic reproduction. Modern production seems like a dream of cyborg colonization work, a dream that makes the nightmare of Taylorism seem idyllic. And modern war is a cyborg orgy, coded by C^3I, command-control-communication-intelligence, an $84 billion item in 1984's US defence budget. I am making an argument for the cyborg as a fiction mapping our social and bodily reality and as an imaginative resource suggesting some very fruitful couplings.

By the late twentieth century, our time, a mythic time, we are all chimeras, theorized and fabricated hybrids of machine and organism. In short, we are cyborgs. The cyborg is our ontology; it gives us our politics. The cyborg is a condensed image of both imagination and material reality, the two joined centres structuring any possibility of historical transformation. In the traditions of 'Western' science and politics – the tradition of racist, male-dominant capitalism; the tradition of progress; the tradition of the appropriation of nature as resource for the productions of culture; the tradition of reproduction of the self from the reflections of the other – the relation between organism and machine has been a border war. The stakes in the border war have been the territories of production, reproduction, and imagination. This chapter is an argument for *pleasure* in the confusion of boundaries and for *responsibility* in their construction. It is also an effort to contribute to socialist-feminist culture and theory in a postmodernist, non-naturalist mode and in the utopian tradition of imagining a world without gender, which is perhaps a world without genesis, but maybe also a world without end. The cyborg incarnation is outside salvation history. Nor does it mark time on an oral symbiotic utopia or post-oedipal apocalypse. As Zoe Sofoulis (1987) argues in her unpublished manuscript on Jacques Lacan, Melanie Klein, and nuclear culture, *Lacklein*, the most terrible and perhaps the most promising monsters in cyborg worlds are embodied in non-oedipal narratives with a different logic of repression, which we need to understand for our survival.

The cyborg is a creature in a post-gender world; it has no truck with bisexuality, pre-oedipal symbiosis, unalienated labour, or other seductions to organic wholeness through a final appropriation of all the powers of the parts into a higher unity. In a sense, the cyborg has no origin story in the Western sense – a 'final' irony since the cyborg is also the awful apocalyptic *telos* of the 'West's' escalating dominations of abstract individuation, an ultimate self untied at last from all dependency, a man in space. An origin story in the 'Western', humanist sense depends on the myth of original unity, fullness, bliss and terror, represented by the phallic mother from whom all humans must separate, the task of individual development and of history, the twin potent myths inscribed most powerfully for us in psychoanalysis and Marxism. Hilary Klein (1989) has argued that both Marxism and psychoanalysis, in their concepts of labour and of individuation and gender formation, depend on the plot of original unity out of which difference must be produced and enlisted in a drama of escalating domination of woman/nature. The cyborg skips the step of original unity, of identification with nature in the Western sense. This is an illegitimate promise that might lead to subversion of its teleology as star wars.

The cyborg is resolutely committed to partiality, irony, intimacy, and perversity. It is oppositional, utopian, and completely without innocence. No longer structured by the polarity of public and private, the cyborg defines a technological polis based partly on a revolution of social relations in the *oikos*, the household. Nature and culture are reworked; the one can no longer be the resource for appropriation or incorporation by the other. The relationships for forming wholes from parts, including those of polarity and hierarchical domination, are at issue in the cyborg world. Unlike the hopes of Frankenstein's monster,

the cyborg does not expect its father to save it through a restoration of the garden; that is, through the fabrication of a heterosexual mate, through its completion in a finished whole, a city and cosmos. The cyborg does not dream of community on the model of the organic family, this time without the oedipal project. The cyborg would not recognize the Garden of Eden; it is not made of mud and cannot dream of returning to dust. Perhaps that is why I want to see if cyborgs can subvert the apocalypse of returning to nuclear dust in the manic compulsion to name the Enemy. Cyborgs are not reverent; they do not remember the cosmos. They are wary of holism, but needy for connection – they seem to have a natural feel for united front politics, but without the vanguard party. The main trouble with cyborgs, of course, is that they are the illegitimate offspring of militarism and patriarchal capitalism, not to mention state socialism. But illegitimate offspring are often exceedingly unfaithful to their origins. Their fathers, after all, are inessential.

I want to signal three crucial boundary breakdowns that make the following political-fictional (political-scientific) analysis possible. By the late twentieth century in US scientific culture, the boundary between human and animal is thoroughly breached. The last beachheads of uniqueness have been polluted if not turned into amusement parks. Language, tool use, social behaviour, mental events, nothing really convincingly settles the separation of human and animal. And many people no longer feel the need for such a separation; indeed, many branches of feminist culture affirm the pleasure of connection of human and other living creatures. Movements for animal rights are not irrational denials of human uniqueness; they are a clear-sighted recognition of connection across the discredited breach of nature and culture. Biology and evolutionary theory over the last two centuries have simultaneously produced modern organisms as objects of knowledge and reduced the line between humans and animals to a faint trace re-etched in ideological struggle or professional disputes between life and social science.

Biological-determinist ideology is only one position opened up in scientific culture for arguing the meanings of human animality. There is much room for radical political people to contest the meanings of the breached boundary.[1] The cyborg appears in myth precisely where the boundary between human and animal is transgressed. Far from signalling a walling off of people from other living beings, cyborgs signal disturbingly and pleasurably tight coupling. Bestiality has a new status in this cycle of marriage exchange.

The second leaky distinction is between animal–human (organism) and machine. Pre-cybernetic machines could be haunted; there was always the spectre of the ghost in the machine. This dualism structured the dialogue between materialism and idealism that was settled by a dialectical progeny, called spirit or history, according to taste. But basically machines were not self-moving, self-designing, autonomous. They could not achieve man's dream, only mock it. They were not man, an author himself, but only a caricature of that masculinist reproductive dream. To think they were otherwise was paranoid. Now we are not so sure. Late twentieth-century machines have made thoroughly ambiguous the difference between natural and artificial, mind and body, self-developing and externally designed, and many other distinctions that used to apply to organisms and machines. Our machines are disturbingly lively, and we ourselves frighteningly inert.

Technological determination is only one ideological space opened up by the reconceptions of machine and organism as coded texts through which we engage in the play of writing and reading the world.[2] 'Textualization' of everything in poststructuralist, postmodernist theory has been damned by Marxists and socialist feminists for its utopian disregard for the lived relations of domination that ground the 'play' of arbitrary reading.[3] It is certainly true that postmodernist strategies, like my cyborg myth, subvert myriad organic wholes (for example, the poem, the primitive culture, the biological organism). In short, the certainty of what

counts as nature – a source of insight and promise of innocence – is undermined, probably fatally. The transcendent authorization of interpretation is lost, and with it the ontology grounding 'Western' epistemology. But the alternative is not cynicism or faithlessness, that is, some version of abstract existence, like the accounts of technological determinism destroying 'man' by the 'machine' or 'meaningful political action' by the 'text'. Who cyborgs will be is a radical question. The answers are a matter of survival. Both chimpanzees and artefacts have politics, so why shouldn't we (de Waal, 1982; Winner, 1980)?

The third distinction is a subset of the second: the boundary between physical and non-physical is very imprecise for us. Pop physics books on the consequences of quantum theory and the indeterminacy principle are a kind of popular scientific equivalent to Harlequin romances as a marker of radical change in American white heterosexuality: they get it wrong, but they are on the right subject. Modern machines are quintessentially microelectronic devices: they are everywhere and they are invisible. Modern machinery is an irreverent upstart god, mocking the Father's ubiquity and spirituality. The silicon chip is a surface for writing; it is etched in molecular scales disturbed only by atomic noise, the ultimate interference for nuclear scores. Writing, power and technology are old partners in Western stories of the origin of civilization, but miniaturization has changed our experience of mechanism. Miniaturization has turned out to be about power; small is not so much beautiful as preeminently dangerous, as in cruise missiles. Contrast the TV sets of the 1950s or the news cameras of the 1970s with the TV wrist bands or hand-sized video cameras now advertised. Our best machines are made of sunshine; they are all light and clean because they are nothing but signals, electromagnetic waves, a section of a spectrum, and these machines are eminently portable, mobile – a matter of immense human pain in Detroit and Singapore. People are nowhere near so fluid, being both material and opaque. Cyborgs are ether, quintessence.

The ubiquity and invisibility of cyborgs is precisely why these sunshine-belt machines are so deadly. They are as hard to see politically as materially. They are about consciousness – or its simulation.[4] They are floating signifiers moving in pickup trucks across Europe, blocked more effectively by the witch-weavings of the displaced and so unnatural Greenham women, who read the cyborg webs of power so very well, than by the militant labour of older masculinist politics, whose natural constituency needs defence jobs. Ultimately the 'hardest' science is about the realm of greatest boundary confusion, the realm of pure number, pure spirit, C[3]I, cryptography and the preservation of potent secrets. The new machines are so clean and light. Their engineers are sun-worshippers mediating a new scientific revolution associated with the night dream of post-industrial society. The diseases evoked by these clean machines are 'no more' than the minuscule coding changes of an antigen in the immune system, 'no more' than the experience of stress. The nimble fingers of 'Oriental' women, the old fascination of little Anglo-Saxon Victorian girls with doll's houses, women's enforced attention to the small, take on quite new dimensions in this world. There might be a cyborg Alice taking account of these new dimensions. Ironically, it might be the unnatural cyborg women making chips in Asia and spiral dancing in Santa Rita jail[5] whose constructed unities will guide effective oppositional strategies.

So my cyborg myth is about transgressed boundaries, potent fusions and dangerous possibilities which progressive people might explore as one part of needed political work. One of my premises is that most American socialists and feminists see deepened dualisms of mind and body, animal and machine, idealism and materialism in the social practices, symbolic formulations and physical artefacts associated with 'high technology' and scientific culture. From *One-Dimensional Man* (Marcuse 1964) to *The Death of Nature* (Merchant 1980), the analytic resources developed by progressives have insisted on the necessary domination

of technics and recalled us to an imagined organic body to integrate our resistance. Another of my premises is that the need for unity of people trying to resist worldwide intensification of domination has never been more acute. But a slightly perverse shift of perspective might better enable us to contest for meanings, as well as for other forms of power and pleasure in technologically mediated societies.

From one perspective, a cyborg world is about the final imposition of a grid of control on the planet, about the final abstraction embodied in a Star Wars apocalypse waged in the name of defence, about the final appropriation of women's bodies in a masculinist orgy of war (Sofia 1984). From another perspective, a cyborg world might be about lived social and bodily realities in which people are not afraid of their joint kinship with animals and machines, not afraid of permanently partial identities and contradictory standpoints. The political struggle is to see from both perspectives at once because each reveals both dominations and possibilities unimaginable from the other vantage point. Single vision produces worse illusions than double vision or many-headed monsters. Cyborg unities are monstrous and illegitimate; in our present political circumstances, we could hardly hope for more potent myths for resistance and recoupling. I like to imagine LAG, the Livermore Action Group, as a kind of cyborg society, dedicated to realistically converting the laboratories that most fiercely embody and spew out the tools of technological apocalypse, and committed to building a political form that actually manages to hold together witches, engineers, elders, perverts, Christians, mothers and Leninists long enough to disarm the state. Fission Impossible is the name of the affinity group in my town. (Affinity: related not by blood but by choice, the appeal of one chemical nuclear group for another, avidity.)[6]

Fractured identities

It has become difficult to name one's feminism by a single adjective – or even to insist in every circumstance upon the noun. Consciousness of exclusion through naming is acute. Identities seem contradictory, partial and strategic. With the hard-won recognition of their social and historical constitution, gender, race and class cannot provide the basis for belief in 'essential' unity. There is nothing about being 'female' that naturally binds women. There is not even such a state as 'being' female, itself a highly complex category constructed in contested sexual scientific discourses and other social practices. Gender, race or class consciousness is an achievement forced on us by the terrible historical experience of the contradictory social realities of patriarchy, colonialism and capitalism. And who counts as 'us' in my own rhetoric? Which identities are available to ground such a potent political myth called 'us', and what could motivate enlistment in this collectivity? Painful fragmentation among feminists (not to mention among women) along every possible fault line has made the concept of *woman* elusive, an excuse for the matrix of women's dominations of each other. For me – and for many who share a similar historical location in white, professional middle-class, female, radical, North American, mid-adult bodies – the sources of a crisis in political identity are legion. The recent history for much of the US left and US feminism has been a response to this kind of crisis by endless splitting and searches for a new essential unity. But there has also been a growing recognition of another response through coalition – affinity, not identity.[7]

Chela Sandoval, from a consideration of specific historical moments in the formation of the new political voice called women of colour, has theorized a hopeful model of political identity called 'oppositional consciousness', born of the skills for reading webs of power by those refused stable membership in the social categories of race, sex or class.

'Women of color', a name contested at its origins by those whom it would incorporate, as well as a historical consciousness marking systematic breakdown of all the signs of Man in 'Western' traditions, constructs a kind of postmodernist identity out of otherness, difference and specificity. This postmodernist identity is fully political, whatever might be said about other possible postmodernisms. Sandoval's oppositional consciousness is about contradictory locations and heterochronic calendars, not about relativisms and pluralisms (see chapter 23).

Sandoval emphasizes the lack of any essential criterion for identifying who is a woman of colour. She notes that the definition of a group has been by conscious appropriation of negation. For example, a Chicana or US black woman has not been able to speak as a woman or as a black person or as a Chicano. Thus, she was at the bottom of a cascade of negative identities, left out of even the privileged oppressed authorial categories called 'women and blacks', who claimed to make the important revolutions. The category 'woman' negated all non-white women; 'black' negated all non-black people, as well as all black women. But there was also no 'she', no singularity, but a sea of differences among US women who have affirmed their historical identity as US women of colour. This identity marks out a self-consciously constructed space that cannot affirm the capacity to act on the basis of natural identification, but only on the basis of conscious coalition, of affinity, of political kinship.[8] Unlike the 'woman' of some streams of the white women's movement in the US, there is no naturalization of the matrix.

Sandoval's argument has to be seen as one potent formulation for feminists out of the worldwide development of anti-colonialist discourse; that is to say, discourse dissolving the 'West' and its highest product – the one who is not animal, barbarian or woman; man, that is, the author of a cosmos called history. As orientalism is deconstructed politically and semiotically, the identities of the occident destabilize, including those of feminists.[9] Sandoval argues that 'women of colour' have a chance to build an effective unity that does not replicate the imperializing, totalizing revolutionary subjects of previous Marxism and feminisms which had not faced the consequences of the disorderly polyphony emerging from decolonization.

Katie King has emphasized the limits of identification and the political/poetic mechanics of identification built into reading 'the poem', that generative core of *cultural* feminism. King criticizes the persistent tendency among contemporary feminists from different 'moments' or 'conversations' in feminist practice to taxonomize the women's movement to make one's own political tendencies appear to be the *telos* of the whole. These taxonomies tend to remake feminist history so that it appears to be an ideological struggle among coherent types persisting over time, especially those typical units called radical, liberal and socialist-feminist. Literally, all other feminisms are either incorporated or marginalized, usually by building an explicit ontology and epistemology.[10] Taxonomies of feminism produce epistemologies to police deviation from official women's experience. And of course, 'women's culture', like women of colour, is consciously created by mechanisms inducing affinity. The rituals of poetry, music and certain forms of academic practice have been preeminent. The politics of race and culture in the US women's movements are intimately interwoven. The common achievement of King and Sandoval is learning how to craft a poetic/politic unity without relying on a logic of appropriation, incorporation and taxonomic identification.

The theoretical and practical struggle against unity-through-domination or unity-through-incorporation ironically not only undermines the justifications for patriarchy, colonialism, humanism, positivism, essentialism, scientism and other unlamented -isms, but *all* claims for an organic or natural standpoint. I think that radical and socialist/ Marxist-feminisms have also undermined their/our own epistemological strategies and this is a crucially valuable step

in imagining possible unities. It remains to be seen whether all 'epistemologies' as Western political people have known them fail us in the task to build effective affinities.

It is important to note that the effort to construct revolutionary standpoints, epistemologies as achievements of people committed to changing the world, has been part of the process showing the limits of identification. The acid tools of postmodernist theory and the constructive tools of ontological discourse about revolutionary subjects might be seen as ironic allies in dissolving Western selves in the interests of survival. We are excruciatingly conscious of what it means to have a historically constituted body. But with the loss of innocence in our origin, there is no expulsion from the Garden either. Our politics lose the indulgence of guilt with the *naïveté* of innocence. But what would another political myth for socialist-feminism look like? What kind of politics could embrace partial, contradictory, permanently unclosed constructions of personal and collective selves and still be faithful, effective – and, ironically, socialist-feminist?

I do not know of any other time in history when there was greater need for political unity to confront effectively the dominations of 'race', 'gender', 'sexuality' and 'class'. I also do not know of any other time when the kind of unity we might help build could have been possible. None of 'us' have any longer the symbolic or material capability of dictating the shape of reality to any of 'them'. Or at least 'we' cannot claim innocence from practising such dominations. White women, including socialist feminists, discovered the non-innocence of the category 'woman'. That consciousness changes the geography of all previous categories; it denatures them as heat denatures a fragile protein. Cyborg feminists have to argue that 'we' do not want any more natural matrix of unity and that no construction is whole. Innocence, and the corollary insistence on victimhood as the only ground for insight, has done enough damage. But the constructed revolutionary subject must give late-twentieth-century people pause as well. In the fraying of identities and in the reflexive strategies for constructing them, the possibility opens up for weaving something other than a shroud for the day after the apocalypse that so prophetically ends salvation history.

Both Marxist/socialist-feminisms and radical feminisms have simultaneously naturalized and denatured the category 'woman' and consciousness of the social lives of 'women'. Perhaps a schematic caricature can highlight both kinds of moves. Marxian-socialism is rooted in an analysis of wage labour which reveals class structure. The consequence of the wage relationship is systematic alienation, as the worker is dissociated from his (*sic*) product. Abstraction and illusion rule in knowledge, domination rules in practice. Labour is the preeminently privileged category enabling the Marxist to overcome illusion and find that point of view which is necessary for changing the world. Labour is the humanizing activity that makes man; labour is an ontological category permitting the knowledge of a subject, and so the knowledge of subjugation and alienation.

In faithful filiation, socialist-feminism is advanced by allying itself with the basic analytic strategies of Marxism. The main achievement of both Marxist-feminists and socialist feminists was to expand the category of labour to accommodate what (some) women did, even when the wage relation was subordinated to a more comprehensive view of labour under capitalist patriarchy. In particular, women's labour in the household and women's activity as mothers generally (that is, reproduction in the socialist-feminist sense), entered theory on the authority of analogy to the Marxian concept of labour. The unity of women here rests on a epistemology based on the ontological structure of 'labour'. Marxist/socialist-feminism does not 'naturalize' unity; it is a possible achievement based on a possible standpoint rooted in social relations. The essentializing move is in the ontological structure of labour or of its analogue, women's activity.[11] The inheritance of Marxian-humanism, with its pre-eminently Western self, is the difficulty for me. The contribution from these formulations

has been the emphasis on the daily responsibility of real women to build unities, rather than to naturalize them.

Catherine MacKinnon's (1982, 1987) version of radical feminism is itself a caricature of the appropriating, incorporating, totalizing tendencies of Western theories of identity grounding action.[12] It is factually and politically wrong to assimilate all of the diverse 'moments' or 'conversations' in recent women's politics named radical feminism to MacKinnon's version. But the teleological logic of her theory shows how an epistemology and ontology – including their negations – erase or police difference. Only one of the effects of MacKinnon's theory is the rewriting of the history of the polymorphous field called radical feminism. The major effect is the production of a theory of experience, of women's identity, that is a kind of apocalypse for all revolutionary standpoints. That is, the totalization built into this tale of radical feminism achieves its end – the unity of women – by enforcing the experience of and testimony to radical non-being. As for the Marxist/socialist-feminist, consciousness is an achievement, not a natural fact. And MacKinnon's theory eliminates some of the difficulties built into humanist revolutionary subjects, but at the cost of radical reductionism.

MacKinnon argues that feminism necessarily adopted a different analytical strategy from Marxism, looking first not at the structure of class, but at the structure of sex/gender and its generative relationship, men's constitution and appropriation of women sexually. Ironically, MacKinnon's 'ontology' constructs a non-subject, a non-being. Another's desire, not the self's labour, is the origin of 'woman'. She therefore develops a theory of consciousness that enforces what can count as 'women's' experience – anything that names sexual violation, indeed, sex itself as far as 'women' can be concerned. Feminist practice is the construction of this form of consciousness; that is, the self-knowledge of a self-who-is-not.

Perversely, sexual appropriation in this feminism still has the epistemological status of labour; that is to say, the point from which an analysis able to contribute to changing the world must flow. But sexual objectification, not alienation, is the consequence of the structure of sex/gender. In the realm of knowledge, the result of sexual objectification, not alienation, is the consequence of the structure of sex/gender. In the realm of knowledge, the result of sexual objectification is illusion and abstraction. However, a woman is not simply alienated from her product, but in a deep sense does not exist as a subject, or even potential subject, since she owes her existence as a woman to sexual appropriation. To be constituted by another's desire is not the same thing as to be alienated in the violent separation of the labourer from his product.

MacKinnon's radical theory of experience is totalizing in the extreme; it does not so much marginalize as obliterate the authority of any other women's political speech and action. It is a totalization producing what Western patriarchy itself never succeeded in doing – feminists' consciousness of the non-existence of women, except as products of men's desire. I think MacKinnon correctly argues that no Marxian version of identity can firmly ground women's unity. But in solving the problem of the contradictions of any Western revolutionary subject for feminist purposes, she develops an even more authoritarian doctrine of experience. If my complaint about socialist/Marxian standpoints is their unintended erasure of polyvocal, unassimilable, radical difference made visible in anti-colonial discourse and practice, MacKinnon's intentional erasure of all difference through the device of the 'essential' non-existence of women is not reassuring.

In my taxonomy, which like any other taxonomy is a re-inscription of history, radical feminism can accommodate all the activities of women named by socialist feminists as forms of labour only if the activity can somehow be sexualized. Reproduction had different tones of meanings for the two tendencies, one rooted in labour, one in sex, both

calling the consequences of domination and ignorance of social and personal reality 'false consciousness'.

Beyond either the difficulties of the contributions in the argument of any one author, neither Marxist nor radical feminist points of view have tended to embrace the status of a partial explanation; both were regularly constituted as totalities. Western explanation has demanded as much; how else could the 'Western' author incorporate its others? Each tried to annex other forms of domination by expanding its basic categories through analogy, simple listing or addition. Embarrassed silence about race among white radical and socialist-feminists was one major, devastating political consequence. History and polyvocality disappear into political taxonomies that try to establish genealogies. There was no structural room for race (or for much else) in theory claiming to reveal the construction of the category woman and social group women as a unified or totalizable whole. The structure of my caricature looks like this:

socialist feminism – structure of class / / wage labour / / alienation
labour, by analogy reproduction, by extension sex, by addition race
radical feminism – structure of gender / / sexual appropriation / /
objectification
sex, by analogy labour, by extension reproduction, by addition race

In another context, the French theorist, Julia Kristeva, claimed that women appeared as a historical group after the Second World War, along with groups like youth. Her dates are doubtful; but we are now accustomed to remembering that as objects of knowledge and as historical actors, 'race' did not always exist, 'class' has a historical genesis, and 'homosexuals' are quite junior. It is no accident that the symbolic system of the family of man – and so the essence of woman – breaks up at the same moment that networks of connection among people on the planet are unprecedentedly multiple, pregnant and complex. 'Advanced capitalism' is inadequate to convey the structure of this historical moment. In the 'Western' sense, the end of man is at stake. It is no accident that woman disintegrates into women in our time. Perhaps socialist feminists were not substantially guilty of producing essentialist theory that suppressed women's particularity and contradictory interests. I think we have been, at least through unreflective participation in the logics, languages and practices of white humanism and through searching for a single ground of domination to secure our revolutionary voice. Now we have less excuse. But in the consciousness of our failures, we risk lapsing into boundless difference and giving up on the confusing task of making partial, real connection. Some differences are playful; some are poles of world historical systems of domination. 'Epistemology' is about knowing the difference.

The informatics of domination

In this attempt at an epistemological and political position, I would like to sketch a picture of possible unity, a picture indebted to socialist and feminist principles of design. The frame for my sketch is set by the extent and importance of rearrangements in worldwide social relations tied to science and technology. I argue for a politics rooted in claims about fundamental changes in the nature of class, race and gender in an emerging system of world order analogous in its novelty and scope to that created by industrial capitalism; we are living through a movement from an organic, industrial society to a polymorphous, information system – from all work to all play, a deadly game. Simultaneously material and ideological, the dichotomies may be expressed in the following chart of transitions from

the comfortable old hierarchical dominations to the scary new networks I have called the informatics of domination:

Representation	Simulation
Bourgeois novel, realism	Science fiction, postmodernism
Organism	Biotic component
Depth, integrity	Surface, boundary
Heat	Noise
Biology as clinical practice	Biology as inscription
Physiology	Communications engineering
Small group	Subsystem
Perfection	Optimization
Eugenics	Population control
Decadence, *Magic Mountain*	Obsolescence, *Future Shock*
Hygiene	Stress management
Microbiology, tuberculosis	Immunology, AIDS
Organic division of labour	Ergonomics/cybernetics of labour
Functional specialization	Modular construction
Reproduction	Replication
Organic sex role specialization	Optimal genetic strategies
Biological determinism	Evolutionary inertia, constraints
Community ecology	Ecosystem
Racial chain of being	Neo-imperialism, United Nations humanism
Scientific management in home / factory	Global factory/electronic cottage
Family/Market/Factory	Women in the integrated circuit
Family wage	Comparable worth
Public/private	Cyborg citizenship
Nature/culture	Fields of difference
Cooperation	Communications enhancement
Freud	Lacan
Sex	Genetic engineering
Labour	Robotics
Mind	Artificial intelligence
Second World War	Star Wars
White capitalist patriarchy	Informatics of domination

This list suggests several interesting things.[13] First, the objects on the right-hand side cannot be coded as 'natural', a realization that subverts naturalistic coding for the left-hand side as well. We cannot go back ideologically or materially. It's not just that 'god' is dead; so is the 'goddess'. Or both are revivified in the worlds charged with microelectronic and biotechnological politics. In relation to objects like biotic components, one must think not in terms of essential properties, but in terms of design, boundary constraints, rates of flows, systems logics, costs of lowering constraints. Sexual reproduction is one kind of reproductive strategy among many, with costs and benefits as a function of the system environment. Ideologies of sexual reproduction can no longer reasonably call on notions of sex and sex role as organic aspects in natural objects like organisms and families. Such reasoning will be unmasked as irrational, and ironically corporate executives

reading *Playboy* and anti-porn radical feminists will make strange bedfellows in jointly unmasking the irrationalism.

Likewise for race, ideologies about human diversity have to be formulated in terms of frequencies of parameters, like blood group or intelligence scores. It is 'irrational' to invoke concepts like primitive and civilized. For liberals and radicals, the search for integrated social systems gives way to a new practice called 'experimental ethnography' in which an organic object dissipates in attention to the play of writing. At the level of ideology, we see translations of racism and colonialism into languages of development and under-development, rates and constraints of modernization. Any objects or persons can be reasonably thought of in terms of disassembly and reassembly; no 'natural' architectures constrain system design. The financial districts in all the world's cities, as well as the export-processing and free-trade zones, proclaim this elementary fact of 'late capitalism'. The entire universe of objects that can be known scientifically must be formulated as problems in communications engineering (for the managers) or theories of the text (for those who would resist). Both are cyborg semiologies.

One should expect control strategies to concentrate on boundary conditions and interfaces, on rates of flow across boundaries – and not on the integrity of natural objects. 'Integrity' or 'sincerity' of the Western self gives way to decision procedures and expert systems. For example, control strategies applied to women's capacities to give birth to new human beings will be developed in the languages of population control and maximization of goal achievement for individual decision-makers. Control strategies will be formulated in terms of rates, costs of constraints, degrees of freedom. Human beings, like any other component or subsystem, must be localized in a system architecture whose basic modes of operation are probabilistic, statistical. No objects, spaces or bodies are sacred in themselves; any component can be interfaced with any other if the proper standard, the proper code, can be constructed for processing signals in common language. Exchange in this world transcends the universal translation effected by capitalist markets that Marx analysed so well. The privileged pathology affecting all kinds of components in this universe is stress – communications breakdown (Hogness 1983). The cyborg is not subject to Foucault's biopolitics; the cyborg simulates politics, a much more potent field of operations.

This kind of analysis of scientific and cultural objects of knowledge which have appeared historically since the Second World war prepares us to notice some important inadequacies in feminist analysis which has proceeded as if the organic, hierarchical dualisms ordering discourse in 'the West' since Aristotle still ruled. They have been cannibalized, or as Zoe Sofia (Sofoulis) might put it, they have been 'techno-digested'. The dichotomies between mind and body, animal and human, organism and machine, public and private, nature and culture, men and women, primitive and civilized are all in question ideologically. The actual situation of women is their integration/exploitation into a world system of production/reproduction and communication called the informatics of domination. The home, workplace, market, public arena, the body itself – all can be dispersed and interfaced in nearly infinite, polymorphous ways, with large consequences for women and others – consequences that them- selves are very different for different people and which make potent oppositional international movements difficult to imagine and essential for survival. One important route for reconstructing socialist-feminist politics is through theory and practice addressed to the social relations of science and technology, including crucially the systems of myth and meanings structuring our imaginations. The cyborg is a kind of disassembled and reassembled, postmodern collective and personal self. This is the self feminists must code.

Communications technologies and biotechnologies are the crucial tools recrafting our bodies. These tools embody and enforce new social relations for women worldwide.

Technologies and scientific discourses can be partially understood as formali- zations, i.e. as frozen moments, of the fluid social interactions constituting them, but they should also be viewed as instruments for enforcing meanings. The boundary is permeable between tool and myth, instrument and concept, historical systems of social relations and historical anatomies of possible bodies, including objects of knowledge. Indeed, myth and tool mutually constitute each other.

Furthermore, communications sciences and modern biologies are constructed by a common move – *the translation of the world into a problem of coding*, a search for a common language in which all resistance to instrumental control disappears and all heterogeneity can be submitted to disassembly, reassembly, investment and exchange.

In communications sciences, the translation of the world into a problem in coding can be illustrated by looking at cybernetic (feedback-controlled) systems theories applied to telephone technology, computer design, weapons deployment or database construction and maintenance. In each case, solution to the key questions rests on a theory of language and control; the key operation is determining the rates, directions and probabilities of flow of a quantity called information. The world is subdivided by boundaries differentially permeable to information. Information is just that kind of quantifiable element (unit, base of unity) which allows universal translation, and so unhindered instrumental power (called effective communication). The biggest threat to such power is interruption of communication. Any system breakdown is a function of stress. The fundamentals of this technology can be condensed into the metaphor C^3I, command-control- communication-intelligence, the military's symbol for its operations theory.

In modern biologies, the translation of the world into a problem in coding can be illustrated by molecular genetics, ecology, sociobiological evolutionary theory and immunobiology. The organism has been translated into problems of genetic coding and read-out. Biotechnology, a writing technology, informs research broadly.[14] In a sense, organisms have ceased to exist as objects of knowledge, giving way to biotic components, i.e. special kinds of information-processing devices. The analogous moves in ecology could be examined by probing the history and utility of the concept of the ecosystem. Immunobiology and associated medical practices are rich exemplars of the privilege of coding and recognition systems as objects of knowledge, as constructions of bodily reality for us. Biology here is a kind of cryptography. Research is necessarily a kind of intelligence activity. Ironies abound. A stressed system goes awry; its communication processes break down; it fails to recognize the difference between self and other. Human babies with baboon hearts evoke national ethical perplexity – for animal rights activists at least as much as for the guardians of human purity. In the US gay men and intravenous drug users are the 'privileged' victims of an awful immune system disease that marks (inscribes on the body) confusion of boundaries and moral pollution (Treichler 1987).

But these excursions into communications sciences and biology have been at a rarefied level; there is a mundane, largely economic reality to support my claim that these sciences and technologies indicate fundamental transformations in the structure of the world for us. Communications technologies depend on electronics. Modern states, multinational corporations, military power, welfare state apparatuses, satellite systems, political processes, fabrication of our imaginations, labour-control systems, medical constructions of our bodies, commercial pornography, the international division of labour and religious evangelism depend intimately upon electronics. Microelectronics is the technical basis of simulacra; that is, of copies without originals.

Microelectronics mediates the translations of labour into robotics and word processing, sex into genetic engineering and reproductive technologies, and mind into artificial intelligence

and decision procedures. The new biotechnologies concern more than human reproduction. Biology as a powerful engineering science for redesigning materials and processes has revolutionary implications for industry, perhaps most obvious today in areas of fermentation, agriculture and energy. Communications sciences and biology are constructions of natural-technical objects of knowledge in which the difference between machine and organism is thoroughly blurred; mind, body and tool are on very intimate terms. The 'multinational' material organization of the production and reproduction of daily life and the symbolic organization of the production and reproduction of culture and imagination seem equally implicated. The boundary-maintaining images of base and superstructure, public and private, or material and ideal never seemed more feeble.

I have used Rachel Grossman's (1980) image of women in the integrated circuit to name the situation of women in a world so intimately restructured through the social relations of science and technology.[15] I used the odd circumlocution, 'the social relations of science and technology', to indicate that we are not dealing with a technological determinism, but with a historical system depending upon structured relations among people. But the phrase should also indicate that science and technology provide fresh sources of power, that we need fresh sources of analysis and political action (Latour 1984). Some of the rearrangements of race, sex and class rooted in high-tech-facilitated social relations can make socialist-feminism more relevant to effective progressive politics.

The 'homework economy' outside 'the home'

The 'New Industrial Revolution' is producing a new worldwide working class, as well as new sexualities and ethnicities. The extreme mobility of capital and the emerging international division of labour are intertwined with the emergence of new collectivities, and the weakening of familiar groupings. These developments are neither gender- nor race-neutral. White men in advanced industrial societies have become newly vulnerable to permanent job loss, and women are not disappearing from the job rolls at the same rates as men. It is not simply that women in Third World countries are the preferred labour force for the science-based multinationals in the export-processing sectors, particularly in electronics. The picture is more systematic and involves reproduction, sexuality, culture, consumption and production. In the prototypical Silicon Valley, many women's lives have been structured around employment in electronics-dependent jobs, and their intimate realities include serial heterosexual monogamy, negotiating childcare, distance from extended kin or most other forms of traditional community, a high likelihood of loneliness and extreme economic vulnerability as they age. The ethnic and racial diversity of women in Silicon Valley structures a microcosm of conflicting differences in culture, family, religion, education and language.

Richard Gordon has called this new situation the 'homework economy'.[16] Although he includes the phenomenon of literal homework emerging in connection with electronics assembly, Gordon intends 'homework economy' to name a restructuring of work that broadly has the characteristics formerly ascribed to female jobs, jobs literally done only by women. Work is being redefined as both literally female and feminized, whether performed by men or women. To be feminized means to be made extremely vulnerable; able to be disassembled, reassembled, exploited as a reserve labour force; seen less as workers than as servers; subjected to time arrangements on and off the paid job that make a mockery of a limited work day; leading an existence that always borders on being obscene, out of place, and reducible to sex. Deskilling is an old strategy newly applicable to formerly privileged

workers. However, the homework economy does not refer only to large-scale deskilling, nor does it deny that new areas of high skill are emerging, even for women and men previously excluded from skilled employment. Rather, the concept indicates that factory, home and market are integrated on a new scale and that the places of women are crucial – and need to be analysed for differ- ences among women and for meanings for relations between men and women in various situations.

The homework economy as a world capitalist organizational structure is made possible by (not caused by) the new technologies. The success of the attack on relatively privileged, mostly white, men's unionized jobs is tied to the power of the new communications technologies to integrate and control labour despite extensive dispersion and decentralization. The consequences of the new technologies are felt by women both in the loss of the family (male) wage (if they ever had access to this white privilege) and in the character of their own jobs, which are becoming capital-intensive; for example, office work and nursing.

The new economic and technological arrangements are also related to the collapsing welfare state and the ensuing intensification of demands on women to sustain daily life for themselves as well as for men, children and old people. The feminization of poverty – generated by dismantling the welfare state, by the homework economy where stable jobs become the exception, and sustained by the expectation that women's wages will not be matched by a male income for the support of children – has become an urgent focus. The causes of various women-headed households are a function of race, class or sexuality; but their increasing generality is a ground for coalitions of women on many issues. That women regularly sustain daily life partly as a function of their enforced status as mothers is hardly new; the kind of integration with the overall capitalist and progressively war-based economy is new. The particular pressure, for example, on US black women, who have achieved an escape from (barely) paid domestic service and who now hold clerical and similar jobs in large numbers, has large implications for continued enforced black poverty *with* employment. Teenage women in industrializing areas of the Third World increasingly find themselves the sole or major source of a cash wage for their families, while access to land is ever more problematic. These developments must have major consequences in the psychodynamics and politics of gender and race.

Within the framework of three major stages of capitalism (commercial/early industrial, monopoly, multinational) – tied to nationalism, imperialism and multinationalism, and related to Jameson's three dominant aesthetic periods of realism, modernism and postmodernism – I would argue that specific forms of families dialectically relate to forms of capital and to its political and cultural concomitants. Although lived problematically and unequally, ideal forms of these families might be schematized as (1) the patriarchal nuclear family, structured by the dichotomy between public and private and accompanied by the white bourgeois ideology of separate spheres and nineteenth-century Anglo-American bourgeois feminism; (2) the modern family mediated (or enforced) by the welfare state and institutions like the family wage, with a flowering of a-feminist heterosexual ideologies, including their radical versions represented in Greenwich Village around the First World War; and (3) the 'family' of the homework economy with its oxymoronic structure of women-headed households and its explosion of feminisms and the paradoxical intensification and erosion of gender itself. This is the context in which the projections for worldwide structural unemployment stemming from the new technologies are part of the picture of the homework economy. As robotics and related technologies put men out of work in 'developed' countries and exacerbate failure to generate male jobs in Third World 'development', and as the automated office becomes the rule even in labour-surplus countries, the feminization of work intensifies. Black women in the United States have long known what it looks like to face the structural

underemployment ('feminization') of black men, as well as their own highly vulnerable position in the wage economy. It is no longer a secret that sexuality, reproduction, family and community life are interwoven with this economic structure in myriad ways which have also differentiated the situations of white and black women. Many more women and men will contend with similar situations, which will make cross-gender and race alliances on issues of basic life support (with or without jobs) necessary, not just nice.

The new technologies also have a profound effect on hunger and on food production for subsistence worldwide. Rae Lessor Blumberg (1983) estimates that women produce about 50 per cent of the world's subsistence food.[17] Women are excluded generally from benefiting from the increased high-tech commodification of food and energy crops, their days are made more arduous because their responsibilities to provide food do not diminish, and their reproductive situations are made more complex. Green Revolution technologies interact with other high-tech industrial production to alter gender divisions of labour and differential gender migration patterns.

The new technologies seem deeply involved in the forms of 'privatization' that Ros Petchesky (1981) has analysed, in which militarization, right-wing family ideologies and policies, and intensified definitions of corporate (and state) property as private synergistically interact.[18] The new communications technologies are fundamental to the eradication of 'public life' for everyone. This facilitates the mushrooming of a permanent high-tech military establishment at the cultural and economic expense of most people, but especially of women. Technologies like video games and highly miniaturized televisions seem crucial to production of modern forms of 'private life'. The culture of video games is heavily orientated to individual competition and extraterrestrial warfare. High-tech, gendered imaginations are produced here, imaginations that can contemplate destruction of the planet and a science fiction escape from its consequences. More than our imaginations is militarized; and the other realities of electronic and nuclear warfare are inescapable. These are the technologies that promise ultimate mobility and perfect exchange – and incidentally enable tourism, that perfect practice of mobility and exchange, to emerge as one of the world's largest single industries.

The new technologies affect the social relations of both sexuality and of reproduction, and not always in the same ways. The close ties of sexuality and instrumentality, of views of the body as a kind of private satisfaction- and utility-maximizing machine, are described nicely in sociobiological origin stories that stress a genetic calculus and explain the inevitable dialectic of domination of male and female gender roles.[19] These sociobiological stories depend on a high-tech view of the body as a biotic component or cybernetic communications system. Among the many transformations of reproductive situations is the medical one, where women's bodies have boundaries newly permeable to both 'visualization' and 'intervention'. Of course, who controls the interpretation of bodily boundaries in medical hermeneutics is a major feminist issue. The speculum served as an icon of women's claiming their bodies in the 1970s; that handcraft tool is inadequate to express our needed body politics in the negotiation of reality in the practices of cyborg reproduction. Self-help is not enough. The technologies of visualization recall the important cultural practice of hunting with the camera and the deeply predatory nature of a photographic consciousness.[20] Sex, sexuality and reproduction are central actors in high-tech myth systems structuring our imaginations of personal and social possibility.

Another critical aspect of the social relations of the new technologies is the reformulation of expectations, culture, work and reproduction for the large scientific and technical work-force. A major social and political danger is the formation of a strongly bimodal social structure, with the masses of women and men of all ethnic groups, but especially people of

colour, confined to a homework economy, illiteracy of several varieties, and general redundancy and impotence, controlled by high-tech repressive apparatuses ranging from entertainment to surveillance and disappearance. An adequate socialist-feminist politics should address women in the privileged occupational categories, and particularly in the production of science and technology that constructs scientific-technical discourses, processes and objects.[21]

This issue is only one aspect of enquiry into the possibility of a feminist science, but it is important. What kind of constitutive role in the production of knowledge, imagination and practice can new groups doing science have? How can these groups be allied with progressive social and political movements? What kind of political accountability can be constructed to tie women together across the scientific-technical hierarchies separating us? Might there be ways of developing feminist science/technology politics in alliance with anti-military science facility conversion action groups? Many scientific and technical workers in Silicon Valley, the high-tech cowboys included, do not want to work on military science.[22] Can these personal preferences and cultural tendencies be welded into progressive politics among this professional middle class in which women, including women of colour, are coming to be fairly numerous?

Women in the integrated circuit

Let me summarize the picture of women's historical locations in advanced industrial societies, as these positions have been restructured partly through the social relations of science and technology. If it was ever possible ideologically to characterize women's lives by the distinction of public and private domains, it is now a totally misleading ideology, even to show how both terms of these dichotomies construct each other in practice and in theory. I prefer a network ideological image, suggesting the profusion of spaces and identities and the permeability of boundaries in the personal body and in the body politic. 'Networking' is both a feminist practice and a multinational corporate strategy – weaving is for oppositional cyborgs.

So let me return to the earlier image of the informatics of domination and trace one vision of women's 'place' in the integrated circuit, touching only a few idealized social locations seen primarily from the point of view of advanced capitalist societies: Home, Market, Paid Work Place, State, School, Clinic-Hospital and Church. Each of these idealized spaces is logically and practically implied in every other locus, perhaps analogous to a holographic photograph. I want to suggest the impact of the social relations mediated and enforced by the new technologies in order to help formulate needed analysis and practical work. However, there is no 'place' for women in these networks, only geometrics of difference and contradiction crucial to women's cyborg identities. If we learn how to read these webs of power and social life, we might learn new couplings, new coalitions. There is no way to read the following list from a standpoint of 'identification', of a unitary self. The issue is dispersion. The task is to survive in the diaspora.

Home: Women-headed households, serial monogamy, flight of men, old women alone, technology of domestic work, paid homework, re-emergence of home sweat-shops, home-based businesses and telecommuting, electronic cottage, urban homelessness, migration, module architecture, reinforced (simulated) nuclear family, intense domestic violence.

Market: Women's continuing consumption work, newly targeted to buy the profusion of new production from the new technologies (especially as the competitive race among

industrialized and industrializing nations to avoid dangerous mass unemployment necessitates finding ever bigger new markets for ever less clearly needed commodities); bimodal buying power, coupled with advertising target of the numerous affluent groups and neglect of the previous mass markets; growing importance of informal markets in labour and commodities parallel to high-tech, affluent market structures; surveillance systems through electronic funds transfer; intensified market abstraction (commodification) of experience, resulting in ineffective utopian or equivalent cynical theories of community; extreme mobility (abstraction) of marketing/financing systems; interpenetration of sexual and labour markets; intensified sexualization of abstracted and alienated consumption.

Paid Work Place: Continued intense sexual and racial division of labour, but considerable growth of membership in privileged occupational categories for many white women and people of colour; impact of new technologies on women's work in clerical, service, manufacturing (especially textiles), agriculture, electronics; international restructuring of the working classes; development of new time arrangements to facilitate the homework economy (flexi-time, part-time, over-time, no time); homework and out work; increased pressures for two-tiered wage structures; significant numbers of people in cash-dependent populations worldwide with no experience or no further hope of stable employment; most labour 'marginal' or 'feminized'.

State: Continued erosion of the welfare state; decentralizations with increased surveillance and control; citizenship by telematics; imperialism and political power broadly in the form of information rich/information poor differentiation; increased high-tech militarization increasingly opposed by many social groups; reduction of civil service jobs as a result of the growing capital intensification of office work, with implications for occupational mobility for women of colour; growing privatization of material and ideological life and culture; close integration of privatization and militarization, the high-tech forms of bourgeois capitalist personal and public life; invisibility of different social groups to each other, linked to psychological mechanisms of belief in abstract enemies.

School: Deepening coupling of high-tech capital needs and public education at all levels, differentiated by race, class, and gender; managerial classes involved in educational reform and refunding at the cost of remaining progressive educational democratic structures for children and teachers; education for mass ignorance and repression in technocratic and militarized culture; growing anti-science mystery cults in dissenting and radical political movements; continued relative scientific illiteracy among white women and people of colour; growing industrial direction of education (especially higher education) by science-based multinationals (particularly in electronics- and biotechnology-dependent companies); highly educated, numerous elites in a progressively bimodal society.

Clinic-hospital: Intensified machine–body relations; renegotiations of public metaphors which channel personal experience of the body, particularly in relation to reproduction, immune system functions, and 'stress' phenomena; intensification of reproductive politics in response to world historical implications of women's unrealized, potential control of their relation to reproduction; emergence of new, historically specific diseases; struggles over meanings and means of health in environments pervaded by high technology products and processes; continuing feminization of health work; intensified struggle over state responsibility for health; continued ideological role of popular health movements as a major form of American politics.

Church: Electronic fundamentalist 'super-saver' preachers solemnizing the union of electronic capital and automated fetish gods; intensified importance of churches in resisting the militarized state; central struggle over women's meanings and authority in religion; continued relevance of spirituality, intertwined with sex and health, in political struggle.

The only way to characterize the informatics of domination is as a massive intensification of insecurity and cultural impoverishment, with common failure of subsistence networks for the most vulnerable. Since much of this picture interweaves with the social relations of science and technology, the urgency of a socialist-feminist politics addressed to science and technology is plain. There is much now being done, and the grounds for political work are rich. For example, the efforts to develop forms of collective struggle for women in paid work, like SEIU's District 925 (Service Employees International Union's office workers' organization in the US) should be a high priority for all of us. These efforts are profoundly tied to technical restructuring of labour processes and reformations of working classes. These efforts also are providing understanding of a more comprehensive kind of labour organization, involving community, sexuality and family issues never privileged in the largely white male industrial unions.

The structural rearrangements related to the social relations of science and technology evoke strong ambivalence. But it is not necessary to be ultimately depressed by the implications of late twentieth-century women's relation to all aspect of work, culture, production of knowledge, sexuality and reproduction. For excellent reasons, most Marxisms see domination best and have trouble understanding what can only look like false consciousness and people's complicity in their own domination in late capitalism. It is crucial to remember that what is lost, perhaps especially from women's points of view, is often virulent forms of oppression, nostalgically naturalized in the face of current violation. Ambivalence towards the disrupted unities mediated by high-tech culture requires not sorting consciousness into categories of 'clear-sighted critique grounding a solid political epistemology' versus 'manipulated false consciousness, but subtle understanding of emerging pleasures, experiences, and powers with serious potential for changing the rules of the game.

There are grounds for hope in the emerging bases for new kinds of unity across race, gender and class, as these elementary units of socialist-feminist analysis themselves suffer protean transformations. Intensifications of hardship experienced worldwide in connection with the social relations of science and technology are severe. But what people are experiencing is not transparently clear, and we lack sufficiently subtle connections for collectively building effective theories of experience. Present efforts – Marxist, psychoanalytic, feminist, anthropological – to clarify even 'our' experience are rudimentary.

I am conscious of the odd perspective provided by my historical position – a PhD in biology for an Irish Catholic girl was made possible by Sputnik's impact on US national science-education policy. I have a body and mind as much constructed by the post-Second World War arms race and cold war as by the women's movements. There are more grounds for hope in focusing on the contradictory effects of politics designed to produce loyal American technocrats, which also produced large numbers of dissidents, than in focusing on the present defeats.

The permanent partiality of feminist points of view has consequences for our expectations of forms of political organization and participation. We do not need a totality in order to work well. The feminist dream of a common language, like all dreams for a perfectly true language, of perfectly faithful naming of experience, is a totalizing and imperialist one. In that sense, dialectics too is a dream language, longing to resolve contradiction. Perhaps,

ironically, we can learn from our fusions with animals and machines how not to be Man, the embodiment of Western logos. From the point of view of pleasure in these potent and taboo fusions, made inevitable by the social relations of science and technology, there might indeed be a feminist science.

Cyborgs: a myth of political identity

I want to conclude with a myth about identity and boundaries which might inform late twentieth-century political imaginations. I am indebted in this story to writers like Joanna Russ, Samuel R. Delany, John Varley, James Tiptree, Jr, Octavia Butler, Monique Wittig and Vonda McIntyre.[23] These are our story-tellers exploring what it means to be embodied in high-tech worlds. They are theorists for cyborgs. Exploring conceptions of bodily boundaries and social order, the anthropologist Mary Douglas (1966, 1970) should be credited with helping us to consciousness about how fundamental body imagery is to world view, and so to political language. French feminists like Luce Irigaray and Monique Wittig, for all their differences, know how to write the body; how to weave eroticism, cosmology, and politics from imagery of embodiment, and especially for Wittig, from imagery of fragmentation and reconstitution of bodies.[24]

American radical feminists like Susan Griffin, Audre Lorde and Adrienne Rich have profoundly affected our political imaginations – and perhaps restricted too much what we allow as a friendly body and political language.[25] They insist on the organic, opposing it to the technological. But their symbolic systems and the related positions of ecofeminism and feminist paganism, replete with organicisms, can only be understood in Sandoval's terms as oppositional ideologies fitting the late twentieth century. They would simply bewilder anyone not preoccupied with the machines and consciousness of late capitalism. In that sense they are part of the cyborg world. But there are also great riches for feminists in explicitly embracing the possibilities inherent in the breakdown of clean distinctions between organism and machine and similar distinctions structuring the Western self. It is the simultaneity of breakdowns that cracks the matrices of domination and opens geometric possibilities. What might be learned from personal and political 'technological' pollution? I look briefly at two overlapping groups of texts for their insight into the construction of a potentially helpful cyborg myth: constructions of women of colour and monstrous selves in feminist science fiction.

Earlier I suggested that 'women of colour' might be understood as a cyborg identity, a potent subjectivity synthesized from fusions of outsider identities and in the complex political-historical layerings of her 'biomythography', *Zami* (Lorde 1982; King 1987a, 1987b). There are material and cultural grids mapping this potential, Audre Lorde (1984) captures the tone in the title of her *Sister Outsider*. In my political myth, Sister Outsider is the offshore woman, whom US workers, female and feminized, are supposed to regard as the enemy preventing their solidarity, threatening their security. Onshore, inside the boundary of the US, Sister Outsider is a potential amidst the races and ethnic identities of women manipulated for division, competition and exploitation in the same industries. 'Women of colour' are the preferred labour force for the science-based industries, the real women for whom the worldwide sexual market, labour market and politics of reproduction kaleidoscope into daily life. Young Korean women hired in the sex industry and in electronics assembly are recruited from high schools, educated for the integrated circuit. Literacy, especially in English, distinguishes the 'cheap' female labour so attractive to the multinationals.

Contrary to orientalist stereotypes of the 'oral primitive', literacy is a special mark of women of colour, acquired by US black women as well as men through a history of risking death to learn and to teach reading and writing. Writing has a special significance for all colonized groups. Writing has been crucial to the Western myth of the distinction between oral and written cultures, primitive and civilized mentalities, and more recently to the erosion of that distinction in 'postmodernist' theories attacking the phallogocentrism of the West, with its worship of the monotheistic, phallic, authoritative and singular work, the unique and perfect name.[26] Contests for the meanings of writing are a major form of contemporary political struggle. Releasing the play of writing is deadly serious. The poetry and stories of US women of colour are repeatedly about writing, about access to the power to signify; but this time that power must be neither phallic nor innocent. Cyborg writing must not be about the Fall, the imagination of a once-upon-a-time wholeness before language, before writing, before Man. Cyborg writing is about the power to survive, not on the basis of original innocence, but on the basis of seizing the tools to mark the world that marked them as other.

The tools are often stories, retold stories, versions that reverse and displace the hierarchical dualisms of naturalized identities. In retelling origin stories, cyborg authors subvert the central myths of origin of Western culture. We have all been colonized by those origin myths, with their longing for fulfilment in apocalypse. The phallogocentric origin stories most crucial for feminist cyborgs are built into the literal technologies – technologies that write the world, biotechnology and microelectronics – that have recently textualized our bodies as code problems on the grid of C^3I. Feminist cyborg stories have the task of recording communication and intelligence to subvert command and control.

Figuratively and literally, language politics pervade the struggles of women of colour; and stories about language have a special power in the rich contemporary writing by US women of colour. For example, retellings of the story of the indigenous woman Malinche, mother of the mestizo 'bastard' race of the new world, master of languages, and mistress of Cortés, carry special meaning for Chicana constructions of identity. Cherríe Moraga (1983) in *Loving in the War Years* explores the themes of identity when one never possessed the original language, never told the original story, never resided in the harmony of legitimate heterosexuality in the garden of culture, and so cannot base identity on a myth or a fall from innocence and right to natural names, mother's or father's.[27] Moraga's writing, her superb literacy, is presented in her poetry as the same kind of violation as Malinche's mastery of the conqueror's language – a violation, an illegitimate production, that allows survival. Moraga's language is not 'whole'; it is self-consciously spliced, a chimera of English and Spanish, both conqueror's languages. But it is this chimeric monster, without claim to an original language before violation, that crafts the erotic, competent, potent identities of women of colour. Sister Outsider hints at the possibility of world survival, not because of her innocence, but because of her ability to live on the boundaries, to write without the founding myth of original wholeness, with its inescapable apocalypse of final return to a deathly oneness that Man has imagined to be the innocent and all-powerful Mother, freed at the End from another spiral of appropriation by her son. Writing marks Moraga's body, affirms it as the body of a woman of colour, against the possibility of passing into the unmarked category of the Anglo father or into the orientalist myth of 'original illiteracy' of a mother that never was. Malinche was mother here, not Eve before eating the forbidden fruit. Writing affirms Sister Outsider, not the Woman-before-the-Fall-into-Writing needed by the phallogocentric Family of Man.

Writing is pre-eminently the technology of cyborgs, etched surfaces of the late twentieth century. Cyborg politics is the struggle for language and the struggle against perfect communication, against the one code that translates all meaning perfectly, the central dogma of phallogocentrism. That is why cyborg politics insist on noise and advocate pollution, rejoicing in the illegitimate fusions of animal and machine. These are the couplings which make Man and Woman so problematic, subverting the structure of desire, the force imagined to generate language and gender, and so subverting the structure and modes of reproduction of 'Western' identity, of nature and culture, of mirror and eye, slave and master, body and mind. 'We' did not originally choose to be cyborgs, but choice grounds a liberal politics and epistemology that imagines the reproduction of individuals before the wider replications of 'texts'.

From the perspective of cyborgs, freed of the need to ground politics in 'our' privileged position of the oppression that incorporates all other dominations, the innocence of the merely violated, the ground of those closer to nature, we can see powerful possibilities. Feminisms and Marxisms have run aground on Western epistemological imperatives to construct a revolutionary subject from the perspective of a hierarchy of oppressions and/or a latent position of moral superiority, innocence and greater closeness to nature. With no available original dream of a common language or original symbiosis promising protection from hostile 'masculine' separation, but written into the play of a text that has no finally privileged reading or salvation history, to recognize 'oneself' as fully implicated in the world, frees us of the need to root politics in identification, vanguard parties, purity and mothering. Stripped of identity, the bastard race teaches about the power of the margins and the importance of a mother like Malinche. Women of colour have transformed her from the evil mother of masculinist fear into the originally literate mother who teaches survival.

This is not just literary deconstruction, but liminal transformation. Every story that begins with original innocence and privileges the return to wholeness imagines the drama of life to be individuation, separation, the birth of the self, the tragedy of autonomy, the fall into writing, alienation; that is, war, tempered by imaginary respite in the bosom of the Other. These plots are ruled by a reproductive politics – rebirth without flaw, perfection, abstraction. In this plot women are imagined either better or worse off, but all agree they have less selfhood, weaker individuation, more fusion to the oral, to Mother, less at stake in masculine autonomy. But there is another route to having less at stake in masculine autonomy, a route that does not pass through Woman, Primitive, Zero, the Mirror Stage and its imaginary. It passes through women and other present-tense, illegitimate cyborgs, not of Woman born, who refuse the ideological resources of victimization so as to have a real life. These cyborgs are the people who refuse to disappear on cue, no matter how many times a 'Western' commentator remarks on the sad passing of another primitive, another organic group done in by 'Western' technology, by writing.[28] These real-life cyborgs (for example, the Southeast Asian village women workers in Japanese and US electronics firms described by Aihwa Ong) are actively rewriting the texts of their bodies and societies. Survival is the stakes in this play of readings.

To recapitulate, certain dualisms have been persistent in Western traditions; they have all been systemic to the logics and practices of domination of women, people of colour, nature, workers, animals – in short, domination of all constituted as others, whose task is to mirror the self. Chief among these troubling dualisms are self/other, mind/body, culture/nature, male/female, civilized/primitive, reality/appearance, whole/part, agent/resource, maker/made, active/passive, right/wrong, truth/illusion, total/partial, God/man. The self is the One who is not dominated, who knows that by the service of the other, the other is the one who holds the future, who knows that by the experience of domination, which gives the lie to

the autonomy of the self. To be One is to be autonomous, to be powerful, to be God; but to be One is to be an illusion, and so to be involved in a dialectic of apocalypse with the other. Yet to be other is to be multiple, without clear boundary, frayed, insubstantial. One is too few, but two are too many.

High-tech culture challenges these dualisms in intriguing ways. It is not clear who makes and who is made in the relation between human and machine. It is not clear what is mind and what body in machines that resolve into coding practices. In so far as we know ourselves in both formal discourse (for example, biology) and in daily practice (for example, the homework economy in the integrated circuit), we find ourselves to be cyborgs, hybrids, mosaics, chimeras. Biological organisms have become biotic systems, communications devices like others. There is no fundamental, ontological separation in our formal knowledge of machine and organism, of technical and organic. The replicant Rachel in the Ridley Scott film *Blade Runner* stands as the image of a cyborg culture's fear, love and confusion.

One consequence is that our sense of connection to our tools is heightened. The trance state experienced by many computer users has become a staple of science fiction film and cultural jokes. Perhaps paraplegics and other severely handicapped people can have the most intense experiences of complex hybridization with other communication devices.[29] Anne McCaffrey's pre-feminist *The Ship Who Sang* (1969) explored the consciousness of a cyborg, hybrid of girl's brain and complex machinery, formed after the birth of a severely handicapped child. Gender, sexuality, embodiment, skill: all were reconstituted in the story. Why should our bodies end at the skin, or include at best other beings encapsulated by skin? From the seventeenth century till now, machines could be animated – given ghostly souls to make them speak or move or to account for their orderly development and mental capacities. Or organisms could be mechanized – reduced to body understood as resource of mind. These machine/organism relationships are obsolete, unnecessary. For us, in imagination and in other practice, machines can be prosthetic devices, intimate components, friendly selves. We don't need organic holism to give impermeable wholeness, the total woman and her feminist variants (mutants?). Let me conclude this point by a very partial reading of the logic of the cyborg monsters of my second group of texts, feminist science fiction.

The cyborgs populating feminist science fiction make very problematic the statuses of man or woman, human, artefact, member of a race, individual entity, or body. Katie King clarifies how pleasure in reading these fictions is not largely based on identification. Students facing Joanna Russ for the first time, students who have learned to take modernist writers like James Joyce or Virginia Woolf without flinching, do not know what to make of *The Adventures of Alyx* or *The Female Man*, where characters refuse the reader's search for innocent wholeness while granting the wish for heroic quests, exuberant eroticism and serious politics. *The Female Man* is the story of four versions of one genotype, all of whom meet, but even taken together do not make a whole, resolve the dilemmas of violent moral action, or remove the growing scandal of gender. The feminist science fiction of Samuel R. Delany, especially *Tales of Nevèrÿon*, mocks stories of origin by redoing the neolithic revolution, replaying the founding moves of Western civilization to subvert their plausibility. James Tiptree, Jr, an author whose fiction was regarded as particularly manly until her 'true' gender was revealed, tells tales of reproduction based on non-mammalian technologies like alternation of generations of male brood pouches and male nurturing. John Varley constructs a supreme cyborg in his arch-feminist exploration of Gaea, a mad goddess-planet-trickster-old woman-technological device on whose surface an extraordinary array of post-cyborg symbioses are spawned. Octavia Butler writes of an African sorceress pitting her powers of transformation against the genetic manipulations of her rival (*Wild Seed*), of time warps that bring a modern US black woman into slavery where her actions in relation to her white

master-ancestor determine the possibility of her own birth (*Kindred*), and of the illegitimate insights into identity and community of an adopted cross-species child who came to know the enemy as self (*Survivor*).

Because it is particularly rich in boundary transgressions, Vonda McIntyre's *Superluminal* can close this truncated catalogue of promising and dangerous monsters who help redefine the pleasures and politics of embodiment and feminist writing. In a fiction where no character is 'simply' human, human status is highly problematic. Orca, a genetically altered diver, can speak with killer whales and survive deep ocean conditions, but she longs to explore space as a pilot, necessitating bionic implants jeopardizing her kinship with the divers and cetaceans. Transformations are effected by virus vectors carrying a new developmental code, by transplant surgery, by implants of microelectronic devices, by analogue doubles, and other means. Laenea becomes a pilot by accepting a heart implant and a host of other alterations allowing survival in transit at speeds exceeding that of light. All the characters explore the limits of language; the dream of communicating experience; and the necessity of limitation, partiality and intimacy even in this world of protean transformation and connection. *Superluminal* stands also for the defining contradictions of a cyborg world in another sense; it embodies textually the intersection of feminist theory and colonial discourse in the science fiction I have alluded to in this chapter. This is a conjunction with a long history that many 'First World' feminists have tried to repress, including myself in my readings of *Superluminal* before being called to account by Zoe Sofoulis, whose different location in the world system's informatics of domination made her acutely alert to the imperialist moment of all science fiction cultures, including women's science fiction. From an Australian feminist sensitivity, Sofoulis remembered more readily McIntyre's role as writer of the adventures of Captain Kirk and Spock in TV's *Star Trek* series than her rewriting the romance in *Superluminal*.

Monsters have always defined the limits of community in Western imaginations. The Centaurs and Amazons of ancient Greece established the limits of the centred polis of the Greek male human by their disruption of marriage and boundary pollutions of the warrior with animality and woman. Unseparated twins and hermaphrodites were the confused human material in early modern France who grounded discourse on the natural and supernatural, medical and legal, portents and diseases – all crucial to establishing modern identity.[30] The evolutionary and behavioural sciences of monkeys and apes have marked the multiple boundaries of late twentieth-century industrial identities. Cyborg monsters in feminist science fiction define quite different political possibilities and limits from those proposed by the mundane fiction of Man and Woman.

There are several consequences to taking seriously the imagery of cyborgs as other than our enemies. Our bodies, ourselves; bodies are maps of power and identity. Cyborgs are no exception. A cyborg body is not innocent; it was not born in a garden; it does not seek unitary identity and so generate antagonistic dualisms without end (or until the world ends); it takes irony for granted. One is too few, and two is only one possibility. Intense pleasure in skill, machine skill, ceases to be a sin, but an aspect of embodiment. The machine is not an *it* to be animated, worshipped and dominated. The machine is us, our processes, an aspect of our embodiment. We can be responsible for machines; *they* do not dominate or threaten us. We are responsible for boundaries; we are they. Up till now (once upon a time), female embodiment seemed to be given, organic, necessary; and female embodiment seemed to mean skill in mothering and its metaphoric extensions. Only by being out of place could we take intense pleasure in machines, and then with excuses that this was organic activity after all, appropriate to females. Cyborgs might consider more seriously the partial, fluid, sometimes aspect of

sex and sexual embodiment. Gender might not be global identity after all, even if it has profound historical breadth and depth.

The ideologically charged question of what counts as daily activity, as experience, can be approached by exploiting the cyborg image. Feminists have recently claimed that women are given to dailiness, that women more than men somehow sustain daily life, and so have a privileged epistemological position potentially. There is a compelling aspect to this claim, one that makes visible unvalued female activity and names it as the ground of life. But *the* ground of life? What about all the ignorance of women, all the exclusions and failures of knowledge and skill? What about men's access to daily competence, to knowing how to build things, to take them apart, to play? What about other embodiments? Cyborg gender is a local possibility taking a global vengeance. Race, gender and capital require a cyborg theory of wholes and parts. There is no drive in cyborgs to produce total theory, but there is an intimate experience of boundaries, their construction and deconstruction. There is a myth system waiting to become a political language to ground one way of looking at science and technology and challenging the informatics of domination – in order to act potently.

Cyborg imagery can help express two crucial arguments in this essay: first, the production of universal, totalizing theory is a major mistake that misses most of reality, probably always, but certainly now; and second, taking responsibility for the social relations of science and technology means refusing an anti-science metaphysics, a demonology of technology, and so means embracing the skilful task of reconstructing the boundaries of daily life, in partial connection with others, in communication with all of our parts. It is not just that science and technology are possible means of great human satisfaction, as well as a matrix of complex dominations. Cyborg imagery can suggest a way out of the maze of dualisms in which we have explained our bodies and our tools to ourselves. This is a dream not of a common language, but of a powerful infidel heteroglossia. It is an imagination of a feminist speaking in tongues to strike fear into the circuits of the supersavers of the new right. It means both building and destroying machines, identities, categories, relationships, space stories. Though both are bound in the spiral dance, I would rather be a cyborg than a goddess.

Notes

1. Useful references to left and/or feminist radical science movements and theory and to biological/ biotechnical issues include: Bleier (1984, 1986), Fausto-Sterling (1985), Gould (1981), Harding (1986), Hubbard *et al.* (1982), Keller (1985), Lewontin *et al.* (1984), *Radical Science Journal* (became *Science as Culture* in 1987), 26 Freegrove Road, London N7 9RQ; *Science for the People*, 897 Main St, Cambridge, MA 02139.
2. Starting points for left and/or feminist approaches to technology and politics include: Athanasiou (1987), Cohn (1987a, 1987b), Cowan (1983), Edwards (1985), Rothschild (1983), Traweek (1988), Weizenbaum (1976), Winner (1977, 1986), Winograd and Flores (1986), Young and Levidow (1981, 1985), Zimmerman (1983). *Global Electronics Newsletter*, 867 West Dana St, no. 204, Mountain View, CA 94041; *Processed World*, 55 Sutter St, San Francisco, CA 94104.
3. A provocative, comprehensive argument about the politics and theories of 'postmodernism' is made by Fredric Jameson (1984), who argues that postmodernism is not an option, a style among others, but a cultural dominant requiring radical reinvention of left politics from within; there is no longer any place from without that gives meaning to the comforting fiction of critical distance. Jameson also makes clear why one cannot be for or against postmodernism, an essentially moralist move. My position is that feminists (and others) need continuous cultural reinvention, postmodernist critique, and historical materialism; only a cyborg would have a chance. The old dominations of white capitalist patriarchy seem nostalgically innocent now: they normalized heterogeneity, into man and woman, white and black, for example. 'Advanced

capitalism' and postmodernism release heterogeneity without a norm, and we are flattened, without subjectivity, which requires depth, even unfriendly and drowning depths. It is time to write *The Death of the Clinic*. The clinic's methods required bodies and works; we have texts and surfaces. Our dominations don't work by medicalization and normalization any more; they work by networking, communications redesign, stress management. Normalization gives way to automation, utter redundancy. Michel Foucault's *Birth of the Clinic* (1963), *History of Sexuality* (1976), and *Discipline and Punish* (1975) name a form of power at its moment of implosion. The discourse of biopolitics gives way to technobabble, the language of the spliced substantive; no noun is left whole by the multinationals. These are their names, listed from one issue of *Science*: Tech-Knowledge, Genentech, Allergen, Hybritech, Compupro, Genen-cor, Syntex, Allelix, Agrigenetics Corp., Syntro, Codon, Repligen, MicroAngelo from Scion Corp., Percom Data, Inter Systems, Cyborg Corp., Statcom Corp., Intertec. If we are imprisoned by language, then escape from that prison-house requires language poets, a kind of cultural restriction enzyme to cut the code; cyborg heteroglossia is one form of radical cultural politics. For cyborg poetry, see Perloff (1984); Fraser (1984). For feminist modernist/postmodernist 'cyborg' writing, see HOW(ever), 871 Corbett Ave, San Francisco, CA 94131.

4. Baudrillard (1983). Jameson (1984: 66) points out that Plato's definition of the simulacrum is the copy for which there is no original, i.e. the world of advanced capitalism, of pure exchange. See *Discourse* 9 (Spring/Summer 1987) for a special issue on technology (cybernetics, ecology and the postmodern imagination).

5. A practice at once both spiritual and political that linked guards and arrested anti-nuclear demonstrators in the Alameda County jail in California in the early 1980s.

6. For ethnographic accounts and political evaluations, see Epstein (1993), Sturgeon (1986). Without explicit irony, adopting the spaceship earth/whole earth logo of the planet photographed from space, set off by the slogan 'Love Your Mother', the May 1987 Mothers and Others Day action at the nuclear weapons testing facility in Nevada none the less took account of the tragic contradictions of views of the earth. Demonstrators applied for official permits to be on the land from officers of the Western Shoshone tribe, whose territory was invaded by the US government when it built the nuclear weapons test ground in the 1950s. Arrested for trespassing, the demonstrators argued that the police and weapons facility personnel, without authorization from the proper officials, were the trespassers. One affinity group at the women's action called themselves the Surrogate Others; and in solidarity with the creatures forced to tunnel in the same ground with the bomb, they enacted a cyborgian emergence from the constructed body of a large, non-heterosexual desert worm.

7. Powerful developments of coalition politics emerge from 'Third World' speakers, speaking from nowhere, the displaced centre of the universe, earth: 'We live on the third planet from the sun' – *Sun Poem* by Jamaican writer, Edward Kamau Braithwaite, review by Mackey (1984). Contributors to Smith (1983) ironically subvert naturalized identities precisely while constructing a place from which to speak called home. See especially Reagon (in Smith 1983: 356–68). Trinh T. Minh-ha (1986–87).

8. hooks (1981, 1984); Hull *et al.* (1982). Bambara (1981) wrote an extraordinary novel in which the women of colour theatre group, The Seven Sisters, explores a form of unity. See analysis by Butler-Evans (1987).

9. On orientalism in feminist works and elsewhere, see Lowe (1986); Mohanty (1984); Said (1978); *Many Voices, One Chant: Black Feminist Perspectives* (1984).

10. Katie King (1986, 1987a) has developed a theoretically sensitive treatment of the workings of feminist taxonomies as genealogies of power in feminist ideology and polemic. King examines Jaggar's (1983) problematic example of taxonomizing feminisms to make a little machine producing the desired final position. My caricature here of socialist and radical feminism is also an example.

11. The central role of object relations versions of psychoanalysis and related strong universalizing moves in discussing reproduction, caring work and mothering in many approaches to epistemology underline their authors' resistance to what I am calling postmodernism. For me, both the universalizing moves and these versions of psychoanalysis make analysis of 'women's place in the integrated circuit' difficult and lead to systematic difficulties in accounting for or even seeing major aspects of the construction of gender and gendered social life. The feminist standpoint

argument has been developed by: Flax (1983), Harding (1986), Harding and Hintikka (1983), Hartsock (1983a, b), O'Brien (1981), Rose (1983), Smith (1974, 1979). For rethinking theories of feminist materialism and feminist standpoints in response to criticism, see Harding (1986, pp. 163–96), Hartsock (1987) and H. Rose (1986).

12. I make an argumentative category error in 'modifying' MacKinnon's positions with the qualifier 'radical', thereby generating my own reductive critique of extremely heterogeneous writing, which does explicitly use that label, by my taxonomically interested argument about writing which does not use the modifier and which brooks no limits and thereby adds to the various dreams of a common, in the sense of univocal, language for feminism. My category error was occasioned by an assignment to write from a particular taxonomic position which itself has a heterogeneous history, socialist-feminism, for *Socialist Review*. A critique indebted to MacKinnon, but without the reductionism and with an elegant feminist account of Foucault's paradoxical conservatism on sexual violence (rape), is de Lauretis (1985; see also 1986, pp. 1–19). A theoretically elegant feminist social-historical examination of family violence, that insists on women's, men's and children's complex agency without losing sight of the material structures of male domination, race and class, is Gordon (1988).

13. This chart was published in 1985. My previous efforts to understand biology as a cybernetic command-control discourse and organisms as 'natural-technical objects of knowledge' were Haraway (1979, 1983, 1984). The 1979 version of this dichotomous chart appears in Haraway (1991) ch. 3; for a 1989 version, see ch. 10. The differences indicate shifts in argument.

14. For progressive analyses and action on the biotechnology debates: *GeneWatch, a Bulletin of the Committee for Responsible Genetics*, 5 Doane St, 4th Floor, Boston, MA 02109; Genetic Screening Study Group (formerly the Sociobiology Study Group of Science for the People), Cambridge, MA; Wright (1982, 1986); Yoxen (1983).

15. Starting references for 'women in the integrated circuit': D'Onofrio-Flores and Pfafflin (1982), Fernandez-Kelly (1983), Fuentes and Ehrenreich (1983), Grossman (1980), Nash and Fernandez-Kelly (1983), Ong (1987), Science Policy Research Unit (1982).

16. For the 'homework economy outside the home' and related arguments: Burr (1982); Collins (1982); Gordon (1983); Gordon and Kimball (1985); Gregory and Nussbaum (1982); Microelectronics Group (1980); Piven and Coward (1982); Reskin and Hartmann (1986); Stacey (1987); S. Rose (1986); Stallard *et al.* (1983); *Women and Poverty* (1984), which includes a useful organization and resource list.

17. The conjunction of the Green Revolution's social relations with biotechnologies like plant genetic engineering makes the pressures on land in the Third World increasingly intense. AID's estimates (*New York Times*, 14 October 1984) used at the 1984 World Food Day are that in Africa, women produce about 90 per cent of rural food supplies, about 60–80 per cent in Asia, and provide 40 per cent of agricultural labour in the Near East and Latin America. Blumberg charges that world organizations' agricultural politics, as well as those of multinationals and national governments in the Third World, generally ignore fundamental issues in the sexual division of labour. The present tragedy of famine in Africa might owe as much to male supremacy as to capitalism, colonialism and rain patterns. More accurately, capitalism and racism are usually structurally male dominant. See also Bird (1984); Blumberg (1981); Busch and Lacy (1983); Hacker (1984); Hacker and Bovit (1981); International fund for Agricultural Development (1985); Sachs (1983); Wilfred (1982).

18. See also Enloe (1983a, b).

19. For a feminist version of this logic, see Harding (1981). For an analysis of scientific women's story-telling practices, especially in relation to sociobiology in evolutionary debates around child abuse and infanticide, see Haraway (1991), ch. 5.

20. For the moment of transition of hunting with guns to hunting with cameras in the construction of popular meanings of nature for an American urban immigrant public, see Haraway (1984–5, 1989b), Nash (1979), Preston (1984), Sontag (1977).

21. For guidance for thinking about the political/cultural/racial implications of the history of women doing science in the US see: Haas and Perucci (1984); Hacker (1981); Haraway (1989b); Keller (1983); National Science Foundation (1988); Rossiter (1982); Schiebinger (1987).

22. Markoff and Siegel (1983). High Technology Professionals for Peace and Computer Professionals for Social Responsibility are promising organizations.

23. King (1984). An abbreviated list of feminist science fiction underlying themes of this essay: Octavia Butler, *Wild Seed, Mind of My Mind, Kindred, Survivor*; Suzy McKee Charnas, *Motherliness*; Samuel R. Delany, the Nevèrÿon series; Anne McCaffery, *The Ship Who Sang, Dinosaur Planet*; Vonda McIntyre, *Superluminal, Dreamsnake*; Joanna Russ, *Adventures of Alix, The Female Man*; James Tiptree, Jr, *Star Songs of an Old Primate, Up the Walls of the World*; John Varley, *Titan, Wizard, Demon*.

24. French feminisms contribute to cyborg heteroglossia. Burke (1981); Duchen (1986); Irigaray (1977, 1979); Marks and de Courtivron (1980); *Signs* (Autumn 1981); Wittig (1973). For English translation of some currents of francophone feminism see *Feminist Issues: A Journal of Feminist Social and Political Theory*, 1980.

25. But all these poets are very complex, not least in their treatment of themes of lying and erotic, decentred collective and personal identities. Griffin (1978), Lorde (1984), Rich (1978).

26. Derrida (1976, especially part II); Lévi-Strauss (1961, especially 'The Writing Lesson'); Gates (1985); Kahn and Neumaier (1985); Ong (1982); Kramarae and Treichler (1985).

27. The sharp relation of women of colour to writing as theme and politics can be approached through: Program for 'The Black Woman and the Diaspora: Hidden Connections and Extended Acknowledgements', An International Literary Conference, Michigan State University, October 1985; Carby (1987); Christian (1985); Evans (1984); Fisher (1980); *Frontiers* (1980, 1983); Giddings (1985); Kingston (1977); Lerner (1973); Moraga and Anzaldúa (1981); Morgan (1984). Anglophone European and Euro-American women have also crafted special relations to their writing as a potent sign: Gilbert and Gubar (1979), Russ (1983).

28. The convention of ideologically taming militarized high technology by publicizing its applications to speech and motion problems of the disabled/differently abled takes on a special irony in monotheistic, patriarchal, and frequently anti-semitic culture when computer-generated speech allows a boy with no voice to chant the Haftorah at his bar mitzvah. See Sussman (1986). Making the always context-relative social definitions of 'ableness' particularly clear, military high-tech has a way of making human beings disabled by definition, a perverse aspect of much automated battlefield and Star Wars R & D. See Welford (1 July 1986).

29. James Clifford (1985, 1988) argues persuasively for recognition of continuous cultural reinvention, the stubborn non-disappearance of those 'marked' by Western imperializing practices.

30. DuBois (1982), Daston and Park (n.d.), Park and Daston (1981). The noun *monster* shares its root with the verb *to demonstrate*.

References

Athanasiou, T. (1987) 'High-tech politics: the case of artificial intelligence', *Socialist Review* 92: 7–35.

Bambara, T. C. (1981) *The Salt Eaters*, New York: Vintage/Random House.

Baudrillard, J. (1983) *Simulations*, trans. P. Foss, P. Patton, P. Beitchman, New York: Semiotext[e].

Bird, E. (1984) 'Green Revolution imperialism, I & II', papers delivered at the University of California, Santa Cruz.

Bleier, R. (1984) *Science and Gender: A Critique of Biology and Its Themes on Women*, New York: Pergamon.

—— (ed.) (1986) *Feminist Approaches to Science*, New York: Pergamon.

Blumberg, R. L. (1981) *Stratification: Socioeconomic and Sexual Inequality*, Boston, MA: Brown.

—— (1983) 'A general theory of sex stratification and its application to the positions of women in today's world economy', paper delivered to Sociology Board, University of California at Santa Cruz.

Burke, C. (1981) 'Irigaray through the looking glass', *Feminist Studies* 7(2): 288–306.

Burr, S. G. (1982) 'Women and work', in B. K. Haber (ed.) *The Women's Annual, 1981*, Boston, MA: G.K. Hall.

Busch, L. and Lacy, W. (1983) *Science, Agriculture, and the Politics of Research*, Boulder, CO: Westview.

Butler, O. (1984) *Clay's Ark*, New York: St Martins Press.

—— (1987) *Dawn*, New York: Warner.

Butler-Evans, E. (1987) 'Race, gender and desire: narrative strategies and the production of ideology in the fiction of Tony Cade Bambara, Toni Morrison and Alice Walker', University of California at Santa Cruz, PhD thesis.

Carby, H. (1987) *Reconstructing Womanhood: The Emergence of the Afro-American Woman Novelist*, New York: Oxford University Press.

Christian, B. (1985) *Black Feminist Criticism: Perspectives on Black Women Writers*, New York: Pergamon.

Clifford, J. (1985) 'On ethnographic allegory', in J. Clifford and G. Marcus (eds) *Writing Culture: The Poetics and Politics of Ethnography*, Berkeley, CA: University of California Press.

—— (1988) *The Predicament of Culture: Twentieth-Century Ethnography, Literature, and Art*, Cambridge, MA: Harvard University Press.

Cohn, C. (1987a) 'Nuclear language and how we learned to pat the bomb', *Bulletin of Atomic Scientists*, pp. 17–24.

—— (1987b) 'Sex and death in the rational world of defense intellectuals', *Signs* 12(4): 687–718.

Collins, P. H. (1982) 'Third World women in America', in B. K. Haber (ed.) *The Women's Annual, 1981*, Boston, MA: G.K. Hall.

Cowan, R. S. (1983) *More Work for Mother: The Ironies of Household Technology from the Open Hearth to the Microwave*, New York: Basic.

Daston, L. and Park, K. (n.d.) 'Hermaphrodites in Renaissance France', unpublished paper.

de Lauretis, T. (1985) 'The violence of rhetoric: considerations on representation and gender', *Semiotica* 54: 11–31.

—— (1986a) 'Feminist studies/critical studies: issues, terms, and contexts', in de Lauretis (1986b), pp. 1–19.

—— (ed.) (1986b) *Feminist Studies/Critical Studies*, Bloomington, IN: Indiana University Press.

de Waal, F. (1982) *Chimpanzee Politics: Power and Sex among the Apes*, New York: Harper & Row.

Derrida, J. (1976) *Of Grammatology*, trans. and introd. G.C. Spivak, Baltimore, MD: Johns Hopkins University Press.

D'Onofrio-Flores, P. and Pfafflin, S. M. (eds) (1982) *Scientific-Technological Change and the Role of Women in Development*, Boulder, CO: Westview.

Douglas, M. (1966) *Purity and Danger*, London: Routledge & Kegan Paul.

—— (1970) *Natural Symbols*, London: Cresset Press.

DuBois, P. (1982) *Centaurs and Amazons*, Ann Arbor, MI: University of Michigan Press.

Duchen, C. (1986) *Feminism in France from May '68 to Mitterrand*, London: Routledge & Kegan Paul.

Edwards, P. (1985) 'Border wars: the science and politics of artificial intelligence', *Radical America* 19(6): 39–52.

Enloe, C. (1983a) 'Women textile workers in the militarization of Southeast Asia', in J. Nash and M. P. Fernandez-Kelly (1983), pp. 407–25.

—— (1983b) *Does Khaki Become You? The Militarization of Women's Lives*, Boston, MA: South End.

Epstein, B. (1993) *Political Protest and Cultural Revolution: Nonviolent Direct Action in the Seventies and Eighties*, Berkeley, CA: University of California Press.

Evans, M. (ed.) (1984) *Black Women Writers: A Critical Evaluation*, Garden City, NY: Doubleday/Anchor.

Fausto-Sterling, A. (1985) *Myths of Gender: Biological Theories about Women and Men*, New York: Basic.

Fernandez-Kelly, M. P. (1983) *For We Are Sold, I and My People*, Albany, NY: State University of New York Press.

Fisher, D. (ed.) (1980) *The Third Woman: Minority Women Writers of the United States*, Boston, MA: Houghton Mifflin.

Flax, J. (1983) 'Politic philosophy and the patriarchal unconscious: a psychoanalytic perspective on epistemology and metaphysics', in S. Harding and M. Hintikka (1983), pp. 245–82.

Foucault, M. (1963) *The Birth of the Clinic: An Archaeology of Medical Perception*, trans. A.M. Smith, New York: Vintage, 1975.

—— (1975) *Discipline and Punish: The Birth of the Prison*, trans. Alan Sheridan, New York: Vintage, 1979.

—— (1976) *The History of Sexuality*, Vol. 1: *An Introduction*, trans. R. Hurley, New York: Pantheon, 1978.

Fraser, K. (1984) *Something. Even Human Voices. In the Foreground, a Lake*, Berkeley, CA: Kelsey St Press.

Fuentes, A. and Ehrenreich, B. (1983) *Women in the Global Factory*, Boston, MA: South End.

Gates, H. L. (1985) 'Writing "race" and the difference it makes', in *'Race', Writing, and Difference*, special issue, *Critical Inquiry* 12(1): 1–20.

Giddings, Paula (1985) *When and Where I Enter: The Impact of Black Women on Race and Sex in America*, Toronto: Bantam.

Gilbert, S. M. and Gubar, S. (1979) *The Madwoman in the Attic: The Woman Writer and the Nineteenth-Century Literary Imagination*, New Haven, CT: Yale University Press.

Gordon, L. (1988) *Heroes of Their Own Lives. The Politics and History of Family Violence, Boston 1880–1960*, New York: Viking Penguin.

Gordon, R. (1983) 'The computerization of daily life, the sexual division of labor, and the homework economy', Silicon Valley Workshop conference, University of California at Santa Cruz.

—— and Kimball, L. (1985) 'High-technology, employment and the challenges of education', Silicon Valley Research Project, Working Paper, no. 1.

Gould, S. J. (1981) *Mismeasure of Man*, New York: Norton.

Gregory, J. and Nussbaum, K. (1982) 'Race against time: automation of the office', *Office: Technology and People* 1: 197–236.

Griffin, S. (1978) *Woman and Nature: The Roaring Inside Her*, New York: Harper & Row.

Grossman, R. (1980) 'Women's place in the integrated circuit', *Radical America* 14(1): 29–50.

Haas, V. and Perucci, C. (eds) (1984) *Women in Scientific and Engineering Professions*, Ann Arbor, MI: University of Michigan Press.

Hacker, S. (1981) 'The culture of engineering: women, workplace, and machine', *Women's Studies International Quarterly* 4(3): 341–53.

—— (1984) 'Doing it the hard way: ethnographic studies in the agribusiness and engineering classroom', paper delivered at the California America Studies Association, Pomona.

—— and Bovit, L. (1981) 'Agriculture to agribusiness: technical imperatives and changing roles', paper delivered at the Society for the History of Technology, Milwaukee.

Haraway, D. J. (1979) 'The biological enterprise: sex, mind, and profit and human engineering to sociobiology', *Radical History Review* 20: 206–37.

—— (1983) 'Signs of dominance: from a physiology to a cybernetics of primate society', *Studies in History of Biology* 6: 129–219.

—— (1984) 'Class, race, sex, scientific objects of knowledge: a socialist-feminist perspective on the social construction of productive knowledge and some political consequences', in V. Haas and C. Perucci (1984), pp. 212–29.

—— (1984–5) 'Teddy bear patriarchy: taxidermy in the Garden of Eden, New York City, 1908–36', *Social Text* 11: 20–64.

—— (1989) *Primate Visions: Gender, Race, and Nature in the World of Modern Science*, New York: Routledge.

—— (1991) *Simians, Cyborgs, and Women: The Reinvention of Nature*, London: Free Association Press.

Harding, S. (1986) *The Science Question in Feminism*, Ithaca, NY: Cornell University Press.

—— and Hintikka, M. (eds) (1983) *Discovering Reality: Feminist Perspectives on Epistemology, Metaphysics, Methodology, and Philosophy of Science*, Dordrecht: Reidel.

Hartsock, N. (1983a) 'The feminist standpoint: developing the ground for a specifically feminist historical materialism', in S. Harding and M. Hintikka (1983), pp. 283–310.

—— (1983b) *Money, Sex, and Power*, New York: Longman; Boston, MA: Northeastern University Press, 1984.

—— (1987) 'Rethinking modernism: minority and majority theories', *Cultural Critique* 7: 187–206.

Hogness, E. R. (1983) 'Why stress? A look at the making of stress, 1936–56', unpublished paper available from the author, 4437 Mill Creek Rd, Healdsburg, CA 95448.

hooks, bell (1981) *Ain't I a Woman*, Boston, MA: South End.

—— (1984) *Feminist Theory: From Margin to Center*, Boston, MA: South End.

Hrdy, S. B. (1981) *The Woman That Never Evolved*, Cambridge, MA: Harvard University Press.

Hubbard, R., Henifin, M. S. and Fried, B. (eds) (1979) *Women Look at Biology Looking at Women: A Collection of Feminist Critiques*, Cambridge, MA: Schenkman.

—— (eds) (1982) *Biological Woman, the Convenient Myth*, Cambridge, MA: Schenkman.

Hull, G., Scott, P. B. and Smith, B. (eds) (1982) *All the Women are White, All the Men Are Black, But Some of Us Are Brave*, Old Westbury: The Feminist Press.

International Fund for Agricultural Development (1985) *IFAD Experience Relating to Rural Women, 1977–84*, Rome: IFAD, 37.

Irigaray, L. (1977) *Ce sexe qui n'en est pas un*, Paris: Minuit.

—— (1979) *Et l'une ne bouge pas sans l'autre*, Paris: Minuit.

Jagger, A. (1983) *Feminist Politics and Human Nature*, Totowa, NJ: Roman & Allenheld.

Jameson, F. (1984) 'Post-modernism, or the cultural logic of late capitalism', *New Left Review* 146: 53–92.

Kahn, D.s and Neumaier, D. (eds) (1985) *Cultures in Contention*, Seattle, WA: Real Comet.

Keller, E. F. (1983) *A Feeling for the Organism*, San Francisco, CA: Freeman.

—— (1985) *Reflections on Gender and Science*, New Haven, CT: Yale University Press.

King, K. (1984) 'The pleasure of repetition and the limits of identification in feminist science fiction: reimaginations of the body after the cyborg', paper delivered at the California American Studies Association, Pomona.

—— (1986) 'The situation of lesbianism as feminism's magical sign: contests for meaning and the U.S. women's movement, 1968–72', *Communication* 9(1): 65–92.

—— (1987a) 'Canons without innocence', University of California at Santa Cruz, PhD thesis.

—— (1987b) *The Passing Dreams of Choice ... Once Before and After: Audre Lorde and the Apparatus of Literary Production*, book prospectus, University of Maryland at College Park.

Kingston, M. H. (1977) *China Men*, New York: Knopf.

Klein, H. (1989) 'Marxism, psychoanalysis, and mother nature', *Feminist Studies* 15(2): 255–78.

Kramarae, C. and Treichler, P. (1985) *A Feminist Dictionary*, Boston, MA: Pandora.

Latour, B. (1984) *Les microbes, guerre et paix, suivi des irréductions*, Paris: Métailié.

Lerner, G. (ed.) (1973) *Black Women in White America: A Documentary History*, New York: Vintage.

Lévi-Strauss, C. (1971) *Tristes Tropiques*, John Russell, trans. New York: Atheneum.

Lewontin, R.C., Rose, S., and Kamin, L. J. (1984) *Not in Our Genes: Biology, Ideology, and Human Nature*, New York: Pantheon.

Lorde, A. (1982) *Zami, a New Spelling of My Name*, Trumansberg, NY: Crossing, 1983.

—— (1984) *Sister Outsider*, Trumansberg, NY: Crossing.

Lowe, L. (1986) 'French literary Orientalism: The representation of "others" in the texts of Montesquieu, Flaubert, and Kristeva', University of California at Santa Cruz, PhD thesis.

Mackey, N. (1984) 'Review', *Sulfur* 2: 200–5.

MacKinnon, C. (1982) 'Feminism, marxism, method, and the state: an agenda for theory', *Signs* 7(3): 515–44.

—— (1987) *Feminism Unmodified: Discourses on Life and Law*, Cambridge, MA: Harvard University Press.

Many Voices, One Chant: Black Feminist Perspectives (1984) *Feminist Review* 17, special issue.

Marcuse, H. (1964) *One-Dimensional Man: Studies in the Ideology of Advanced Industrial Society*, Boston, MA: Beacon.

Markoff, J. and Siegel, L. (1983) 'Military micros', paper presented at Silicon Valley Research Project conference, University of California at Santa Cruz.

Marks, E. and de Courtivron, I. (eds) (1980) *New French Feminisms*, Amherst, MA: University of Massachusetts Press.

McCaffrey, A. (1969) *The Ship Who Sang*, New York: Ballantine.

Merchant, C. (1980) *The Death of Nature: Women, Ecology, and the Scientific Revolution*, New York: Harper & Row.

Microelectronics Group (1980) *Microelectronics: Capitalist Technology and the Working Class*, London: CSE.

Mohanty, C. T. (1984) 'Under western eyes: feminist scholarship and colonial discourse', *Boundary* 2, 3 (12/13): 333–58.

Moraga, C. (1983) *Loving in the War Years: lo que nunca pasó por sus labios*, Boston, MA: South End.

—— and Anzaldúa, G. (eds) (1981) *This Bridge Called My Back: Writings by Radical Women of Color*, Watertown: Persephone.

Morgan, E. (1972) *The Descent of Woman*, New York: Stein & Day.

Morgan, R. (ed.) (1984) *Sisterhood Is Global*, Garden City, NY: Anchor/Doubleday.

Nash, J. and Fernandez-Kelly, M. P. (eds) (1983) *Women and Men and the International Division of Labor*, Albany, NY: State University of New York Press.

Nash, R. (1979) 'The exporting and importing of nature: nature-appreciation as a commodity, 1850–1980', *Perspectives in American History* 3: 517–60.

National Science Foundation (1988) *Women and Minorities in Science and Engineering*, Washington, DC: NSF.

O'Brien, M. (1981) *The Politics of Reproduction*, New York: Routledge & Kegan Paul.

Ong, A. (1987) *Spirits of Resistance and Capitalist Discipline: Factory Workers in Malaysia*, Albany, NY: State University of New York Press.

Ong, W. (1982) *Orality and Literacy: The Technologizing of the Word*, New York: Methuen.

Park, K. and Daston, L. J. (1981) 'Unnatural conceptions: the study of monsters in sixteenth- and seventeenth-century France and England', *Past and Present* 92: 20–54.

Perloff, M. (1984) 'Dirty language and scramble systems', *Sulfur* 11: 178–83.

Petchesky, R. P. (1981) 'Abortion, anti-feminism and the rise of the New Right', *Feminist Studies* 7(2): 206–46.

Piven, F. F. and Coward, R. (1982) *The New Class War: Reagan's Attack on the Welfare State and Its Consequences*, New York: Pantheon.

Preston, D. (1984) 'Shooting in paradise', *Natural History* 93(12): 14–19.

Reskin, B. F. and Hartmann, H. (eds) (1986) *Women's Work, Men's Work*, Washington, DC: National Academy of Sciences.

Rich, A. (1978) *The Dream of a Common Language*, New York: Norton.

Rose, H. (1983) 'Hand, brain, and heart: a feminist epistemology for the natural sciences', *Signs* 9(1): 73–90.

—— (1986) 'Women's work: women's knowledge', in J. Mitchell and A. Oakley (eds) *What Is Feminism? A Re-Examination*, New York: Pantheon, pp. 161–83.

Rose, S. (1986) *The American Profile Poster: Who Owns What, Who Makes How Much, Who Works Where, and Who Lives with Whom?*, New York: Pantheon.

Rossiter, M. (1982) *Women Scientists in America*, Baltimore, MD: Johns Hopkins University Press.

Rothschild, J. (ed.) (1983) *Machina ex Dea: Feminist Perspectives on Technology*, New York: Pergamon.

Russ, J. (1983) *How to Suppress Women's Writing*, Austin, TX: University of Texas Press.

Sachs, C. (1983) *The Invisible Farmers: Women in Agricultural Production*, Totowa: Rowman & Allenheld.

Said, E. (1978) *Orientalism*, New York: Pantheon.

Sandoval, C. (1984) 'Dis-illusionment and the poetry of the future: the making of oppositional consciousness', University of California at Santa Cruz, PhD qualifying essay.

—— (n.d.) *Yours in Struggle: Women Respond to Racism, a Report on the National Women's Studies Association*, Oakland, CA: Center for Third World Organizing.

Schiebinger, L. (1987) 'The history and philosophy of women in science: a review essay', *Signs* 12(2): 305–32.

Science Policy Research Unit (1982) *Microelectronics and Women's Employment in Britain*, University of Sussex.

Smith, D. (1974) 'Women's perspective as a radical critique of sociology', *Sociological Inquiry* 44.

—— (1979) 'A sociology of women', in J. Sherman and E.T. Beck (eds) *The Prism of Sex*, Madison, WI: University of Wisconsin Press.

Smith, B. (1977) 'Toward a Black feminist criticism', in E. Showalter (ed.) *The New Feminist Criticism: Essays on Women, Literature and Theory*, New York: Pantheon, 1985, pp. 168–85.

—— (ed.) (1983) *Home Girls: A Black Feminist Anthology*, New York: Kitchen Table, Women of Color Press.

Sofia, Z. (also Z. Sofoulis) (1984) 'Exterminating fetuses: abortion, disarment, and the sexo- semiotics of extra-terrestrialism', *Diacritics* 14(2): 47–59.

Sofoulis, Z. (1987) 'Lacklein', University of California at Santa Cruz, unpublished essay.

Sontag, S. (1977) *On Photography*, New York: Dell.

Stacey, J. (1987) 'Sexism by a subtler name? Postindustrial conditions and postfeminist consciousness', *Socialist Review* 96: 7–28.

Stallard, K., Ehrenreich, B., and Sklar, H. (1983) *Poverty in the American Dream*, Boston, MA: South End.

Sturgeon, N. (1986) 'Feminism, anarchism, and non-violent direct action politics', University of California at Santa Cruz, PhD qualifying essay.

Sussman, V. (1986) 'Personal tech. Technology lends a hand', *The Washington Post Magazine*, 9 November, pp. 45–56.

Traweek, S. (1988) *Beamtimes and Lifetimes: The World of High Energy Physics*, Cambridge, MA: Harvard University Press.

Treichler, P. (1987) 'AIDS, homophobia, and biomedical discourse: an epidemic of signification', *October* 43: 31–70.

Trinh T. Minh-ha (1986–7) 'Introduction', and 'Difference: "a special third world women issue"', *Discourse: Journal for Theoretical Studies in Media and Culture* 8: 3–38.

Weizenbaum, J. (1976) *Computer Power and Human Reason*, San Francisco, CA: Freeman.

Welford, J. N. (1 July 1986) 'Pilot's helmet helps interpret high speed world', *New York Times*, pp. 21, 24.

Wilfred, D. (1982) 'Capital and agriculture, a review of Marxian problematics', *Studies in Political Economy* 7: 127–54.

Winner, L. (1977) *Autonomous Technology: Technics out of Control as a Theme in Political Thought*, Cambridge, MA: MIT Press.

—— (1980) 'Do artifacts have politics?', *Daedalus* 109(1): 121–36.

—— (1986) *The Whale and the Reactor*, Chicago, IL: University of Chicago Press.

Winograd, T. and Flores, F. (1986) *Understanding Computers and Cognition: A New Foundation for Design*, Norwood, NJ: Ablex.

Wittig, M. (1973) *The Lesbian Body*, trans. D. LeVay, New York: Avon, 1975 (*Le corps lesbien*, 1973).

Women and Poverty, special issue (1984) *Signs* 10(2).

Wright, S. (1982, July/August) 'Recombinant DNA: the status of hazards and controls', *Environment* 24(6): 12–20, 51–3.

—— (1986) 'Recombinant DNA technology and its social transformation, 1972–82', *Osiris*, 2nd series, 2: 303–60.

Young, R. M. and Levidow, L. (eds) (1981, 1985) *Science, Technology and the Labour Process*, 2 vols, London: CSE and Free Association Books.

Yoxen, E. (1983) *The Gene Business*, New York: Harper & Row.

Zimmerman, J. (ed.) (1983) *The Technological Woman: Interfacing with Tomorrow*, New York: Praeger.

SCOTT McQUIRE

SPACE FOR RENT IN THE LAST SUBURB

WHILE IT'S STILL TOO EARLY to say whether William Gibson's *Neuromancer* will eventually transcend the chrysalis of the buzz-word it spawned, to re-emerge, like Orwell's *1984* or Heller's *Catch-22*, as a book which is still read and written about decades later, I suspect it will always be best known as the book which introduced the term "cyberspace" to our lexicon.

Mike Davis has placed this moment as an epiphany belonging to a glowing lineage, suggesting that:

> ... the opening section of *Neuromancer*, with its introduction of cyberspace, is the kind of revelation – of a possible but previously unimagined future – that occurs perhaps once a generation. Charles Babbage's and Ada Lovelace's anticipation of a programmable computer in the 1820s, Friedrich Engels' 1880s prophecy of a mechanized world war and H. G. Wells' prevision of the atomic bomb in 1900 are comparable examples.
>
> (Davis 1993, 10)

Other writers and critics have waxed even more enthusiastic about the historical significance of Gibson's vision. At the beginning of the 1990s, Fred Jameson lionized Gibson, and the cyberpunk movement he initiated, as "the supreme *literary* expression if not of postmodernism, then of late capitalism itself" (Jameson 1991, 419 n. 1), while avid cyber-convert Timothy Leary (who later bookmarked his place in Internet history as the first man to die online) pronounced that Gibson "has produced nothing less than the underlying myth, the core legend, of the next stage of human evolution" (quoted in Kellner 1995, 298).

At a more terrestrial level, social theorists have celebrated Gibson's work as the interface between fiction and the future: Doug Kellner suggests that Gibson can be read "as a sort of social theory" which grabbed the initiative from those such as Baudrillard who had "dropped the theoretical ball" (Kellner 1995, 299, 327), while Sandy Stone argues that Gibson's work transcends differences between literary and scientific discourse:

[It] is a massive textual presence not only in other literary publications ... but in technical publications, conference topics, hardware design, and scientific and technological discourses in the large.

(Stone 1991, 95)

There is a palpable irony in the thought of Gibson's inventive novel influencing developments in "real" science and technology: as is well known, Gibsonian cyberspace, which precociously fused the emergent global information network of the Internet with the immersive capabilities of virtual reality, sidestepping the need for screen, projection or HMD (head-mounted display) with the sci-fi staple of direct neural stimulation, was, precisely, an invention. A far cry from the seasoned computer programmers he clothed in the new romantic garb of outlaw hackers and console cowboys, the Gibson who wrote *Neuromancer* – using a typewriter no less – was a technical neophyte with little understanding of computing:

It wasn't until I could finally afford a computer of my own that I found out that there's a drive mechanism inside – this little thing that spins around. I'd been expecting an exotic crystalline thing, a cyberspace deck or something, and what I got was a little piece of a Victorian engine that made noises like a scratchy old record player. That noise took away some of the mystique for me ...

(McCaffrey 1991, 270)[1]

However, rather than discrediting the author for lacking an adequate technical base, Gibson's admission should focus attention on the complex interactions of theory and fiction, particularly when both are concerned with the social effects of new technology. Rather than asking whether *Neuromancer* was technically well-founded, or how accurately it prefigured future developments in computing and information technology, it seems more instructive to examine the itineraries of desire it cathected. In other words, to read the popular success and critical influence of the book as symptomatic of a complex of social changes and cultural anxieties which is still far from exhausted. In choosing this approach, I find some comfort in Gibson's comment (cited in Leary 1989, 59) on the much-celebrated "anticipatory" aspects of *Neuromancer*:

It's not really about an imagined future. It's a way of trying to come to terms with me about the awe and terror inspired in me by the world in which we lived.

In what follows, I want to (re)place *Neuromancer* in the world in which we live, or rather, the world in which it was written: the early 1980s, on the cusp of the mass production of personal computers, when hacker counter-culture began to merge with big business; a moment when it seemed to many North Americans that what *Time* founder Henry Luce had dubbed the "American Century" was fast giving way, after barely five decades, to a Japanese future. (It is these cross-cultural elements which are most obscured by Leary's premature elevation of *Neuromancer* to the status of universal myth.)

In fact, the shock of finding that "American" culture was no longer an exclusively national possession – in the 1980s Japanese interests acquired prime U.S. icons such as the RCA Building and Columbia Studios, while Detroit's car makers surrendered to the likes of Toyota, Honda and Mitsubishi – was merely the tip of the much bigger iceberg of globalization. Cross-cultural anxiety towards "Asia" overlaid a series of disappointments "at home": most notably the fading of the suburban vision of the 1950s in the urban dysfunctions of the 1970s, and the decline of the traditional rural and manufacturing sectors. In their place – but scarcely a replacement for those rendered economically and socially redundant

– rose the shimmering image of the nascent information and biotechnology industries which, for the privileged, hold the promise of becoming dominant forces in the knowledge-based economies of the 21st century.

In retrospect, it is clear that the impact of *Neuromancer* belongs to the extent to which its fantasy of the cyberspace matrix was able to touch all these nerves simultaneously. In particular, it registered the cumulative impact of a century of communication technologies in dissolving old certainties about space, place and physical boundaries, depicting instead the de-territorialized cultural flows which are the everyday experience of post-televisual generations; it also resonated the ambiguous mix of fascination and horror surrounding biotechnologies such as IVF and genetic engineering which were fast redefining the parameters of human identity. From the first line of the novel, which evokes a sky "the color of television tuned to a dead channel," to its casual references to "vatgrown" flesh and posthuman bodies transformed by implants, both surgical and software, in an "age of affordable beauty" and simulated experience, it is clear that the parameters of neither nature nor self are what they were long thought to be.

Rather than rehash the novel's plot, which is fairly staple sci-fi fare about the machinations of a computer wanting to become sentient, in what follows I want to explore the underpinnings of Gibsonian cyberspace: in particular, the way it is imaged and imagined, and the social implications of the investments it supports.

Data city

Neuromancer offers a compact definition of cyberspace which is fast rivaling André Breton's 1924 gloss on surrealism for frequency of quotation. Less remarked is the fact that the "definition" is coded in the novel as one supplied by a machine; Borgesian fragments lifted from an imaginary database which the protagonist Case immediately qualifies as a "kid's show":

> Cyberspace. A consensual hallucination experienced daily by billions of legitimate operators, in every nation, by children being taught mathematical concepts ...
> A graphic representation of data abstracted from every computer in the human system. Unthinkable complexity. Lines of light ranged in the nonspace of the mind, clusters and constellations of data. Like city lights, receding. ...
> (Gibson 1995, 67; all ellipses in original)

Both the fragmentary nature of the definition and Case's dismissive response immediately align cyberspace with the sublime, a domain of "unthinkable complexity" which eludes the nets of representation.[2] Nevertheless, in order to function in the narrative, the matrix still has to be figured in some way. Of all the metaphors Gibson uses to evoke cyberspace, including experiences of sex and drugs, the image of the modern city proves most persistent. As Scott Bukatman has noted:

> If cyberspace is a "consensual hallucination" that enables users to make sense of both their actions and the circulation of information, then that hallucination works by continually referencing the kinetic urban landscapes of machine-age modernity.
> (Bukatman 1994, 86)[3]

More precisely, it is the image of city lights which provides Gibson with the most potent frame of reference for the "non-space" of the matrix, in which information is arrayed in luminous grids or radiant lattices stretched across an indeterminate void. Overlaying the

post-industrial wasteland of massive urban sprawl and generalized urban decay which forms the novel's setting, intermingled with the neo-orientalist collage of western caricatures drawn from 1980s Tokyo (the stackable hotel rooms Gibson dubs "coffins," the depiction of relentlessly alien salary-men in their "corporate arcologies" and tattooed yakuza in their equally corporate crime worlds), the modern synergy between bright lights and big city exerts a gravitational pull in rendering the new datascape.

Walter Benjamin long ago noted the atavistic appearances of early elements of industrial culture, such as iron cast in arboreal forms, which he suggested represented an "attempt to master the new experiences of the city" and industrial technology nostalgically, by positioning them "in the frame of the old, traditional [forms] of nature" (cited in Buck-Morss 1991, 145, 111). For Gibson, it is not organic nature, but the city itself which has become the new ground to be mined for metaphors to imagine the future. Recalling the World Bank forecast that the year 2000 will mark the point at which more than half of the world's population will live in cities (with estimates suggesting 85 percent by 2025), the fact that Gibsonian cyberspace can be convincingly represented by an image of the modern city asks us to consider what has happened to the city in modernity. The issue is complicated, not least by the way that dramatic changes in architecture and urban form have been counterpointed at every turn by equally dramatic transformations in technologies of representation.

In fact, the relation that Gibson posits between urban space and data space is overlapping, as the image of each consistently modifies the conception of the other. While cyberspace resembles the city seen from a distance at night, Gibson's cities are themselves indexed as a collection of discrete, discontinuous spaces, framed by neon signs and giant holograms, and woven together by invisible networks and abstract linkages. This reciprocity directs attention to the dual impact of artificial light in shaping the modern metropolis, transforming the external appearances of the city along one axis, while simultaneously underwriting new means for seizing and transmitting the urban milieu *as image* along another. In short, the electrification of the streetscape, begun in the late 19th century, established the metropolis as a spectacular space for its increasingly mobile citizen-spectators, while new image technologies such as cinema and later television, themselves dependent on electric light, lifted the process of dematerialization to another plane by uncoupling the city's image from any and all material constraints. It's worth briefly tracing this trajectory, insofar as it forms one of the key cultural reservoirs on which Gibson draws.

Architectural historian Rayner Banham has claimed that electrification was "the greatest environmental revolution in human history since the domestication of fire" (Banham 1969, 64). Electrical energy not only powered many of the new forms of movement which characterized the industrial city, but profoundly changed the visual experience of the city, charging the urban landscape with the qualities of spectacle and display previously reserved for specialized show-places such as the theatre, diorama and amusement park. While there are innumerable testaments to the revolutionary social impact of electrification (one of Lenin's key slogans was "Soviets + Electrification = Communism"), the extraordinary *perceptual* effects of Edison's bulb on the human sensorium are registered in a passage from Thea von Harbou's novel *Metropolis* (which formed the basis for husband Fritz Lang's epic film):

> The workman No. 11811, the man who lived in a prison-like house, under the underground railway of Metropolis, who knew no other way than that from the hole in which he slept to the machine and from the machine back to the hole – this man saw, for the first time in his life, the wonder of the world, which was Metropolis: the city, by night shining under millions and millions of lights.

> He saw the ocean of light which filled the endless trails of streets with a silver,
> flashing luster. He saw the will-o'-the-wisp sparkle of the electric advertisements,
> lavishing themselves inexhaustibly in an ecstasy of brightness. He saw towers
> projecting, built up of blocks of light, feeling himself seized, over-powered to a
> state of complete impotence by this intoxication of light, feeling this sparkling
> ocean with its hundreds and thousands of spraying waves, to reach out for him,
> to take the breath from his mouth, to pierce him, suffocate him ...
>
> (Harbou 1927, 50–1)

In von Harbou's florid prose, infinite towers of light form the modern architecture
for a metaphysical struggle between the forces of light and darkness, democracy and
despotism, head and hand. The sense that electrified urban space was not only intoxicating
but also potentially capable of overwhelming the modern subject, is equally evident in
Sergei Eisenstein's first impressions of late 1920s New York, which are couched in his
characteristically cinematic language:

> All sense of perspective and of realistic depth is washed away by a nocturnal sea
> of electric advertising. Far and near, small (in the *foreground*) and large (in the
> *background*), soaring aloft and dying away, racing and circling, bursting and vanishing
> – these lights tend to abolish all sense of real space, finally melting into a single
> plane of colored light points and neon lines moving over a surface of black velvet
> sky. It was thus that people used to picture stars – as glittering nails hammered
> into the sky. Headlights on speeding cars, highlights on receding rails, shimmering
> reflections on wet pavements – all mirrored in puddles which destroy our sense of
> direction (which is top? which is bottom?), supplementing the mirage above with
> the mirage beneath us, and rushing between these two worlds of electric signs, we
> see them no longer on a single plane, but as a system of theatre wings, suspended
> in the air, through which the night flood of traffic lights is streaming.
>
> (Eisenstein 1963, 83)

Despite the ambitions of modern architects to rationalize urban space through systematic
planning, the modern city-machine, powered by electricity and charged with dynamic
movement, constituted an environment of visual and sensory excess, which no longer provided
a stable framework against which the dimensions of space and time could be measured in
traditional terms. The historical function of the city as a map of sociopolitical hierarchies
and a repository of collective memory defined in the stability of sites, monuments, meeting
places and neighborhoods began to give way to a new urban topography, in which the
coordinates of home, self and community would have to be plotted in new ways.

This liquidation of the old city was frequently celebrated by the modernist avant-garde.
In a 1927 essay defending Eisenstein's *Battleship Potemkin* (1925), Walter Benjamin premiered
arguments (later repeated in both his "Artwork" essay and his unfinished "Arcades" project),
extolling cinema's capacity to reveal the quotidian secrets of urban space:

> To put it in a nutshell, film is the prism in which the spaces of the immediate
> environment – the spaces in which people live, pursue their avocations, and enjoy
> their leisure – are laid open before their eyes in a comprehensible, meaningful
> and passionate way. In themselves these offices, furnished rooms, salons, big-city
> streets, stations, and factories are ugly, incomprehensible, and hopelessly sad. Or
> rather, they were and seemed to be, until the advent of film. The cinema then
> exploded this entire prison-world with its dynamite of fractions of a second, so
> that now we can take the extended journeys of adventure between their widely

scattered ruins. The vicinity of a house, a room, can include dozens of the most unexpected stations, and the most astonishing station names. It is not so much the constant stream of images as the sudden change of place that overcomes a milieu which has resisted every other attempt to unlock its secret, and succeeds in extracting from a petty-bourgeois dwelling the same beauty we admire in an Alfa Romeo. And so far, so good.

(Benjamin 1999, 17)

It is important to register the cautionary note sounded by the closing sentence. On the one hand, the modern city demanded more abstract maps – such as those offered by cinema, collage and photomontage – in order to penetrate the increasingly complex patterns of movement, assembly, circulation and social interaction driven by the invisible force lines of industrial capitalism. But the politics underlying the increasing abstraction of the image manifest in the modern logic of montage were always intensely ambiguous. If cinema's novel perceptual apparatus was to supply a new socio-political map of urban experience, it depended not only on a new cinematic "language" (such as Eisenstein's "intellectual montage"), but demanded an audience capable of reconnecting fragmented and fragmentary images to material structures and historical events. Even in the 1920s, writers such as Benjamin and Siegfried Kracauer saw that, in the absence of significant political change, the "explosive" experience of cinema could install itself as part of a new mythologized "nature," regimenting viewers to the mechanical drill of the city as commodified spectacle.

At home in cyberspace

Where does Gibson's *Neuromancer* intersect this legacy? Its setting is characterized by a state of excess which affects both the boundaries of urbanism and the means to represent it:

Home. Home was BAMA, the Sprawl, the Boston-Atlanta Metropolitan axis. Program a map to display frequency of data exchange, every thousand megabytes a single pixel on a very large screen. Manhattan and Atlanta burn solid white. Then they start to pulse, the rate of traffic threatening to overload your simulation. Your map is about to go nova. Up your scale. Each pixel a million megabytes. At a hundred million megabytes per second, you begin to make out certain blocks in mid-town Manhattan, outlines of hundred year old industrial parks ringing the old core of Atlanta …

(Gibson 1995, 57)

Exponential urban sprawl renders "home" susceptible to a crisis of representation, demanding a new, even more abstract, form of mapping to succeed the camera as a visual solution. And, in a world where all experiences can be simulated and everything, including body parts, has a market price, being "at home" takes on increasingly alien connotations. Surveillance has become so omnipotent that privacy has become the ultimate commodity. (It is not the State – Orwell's "Big Brother" – but Big Business which is listening and watching. When Molly needs to talk to Case she takes him to a place protected by sophisticated electronic circuitry for which she pays by the second: "This is as private as I can afford," she tells him.) More so than in the Sprawl – or any *place* – Case feels at home wherever he can access the matrix: "He knew this kind of room, this kind of building; the tenants would operate in the interzone where art wasn't quite crime, crime not quite art. He was home" (Gibson 1995, 58).

When Case finally "jacks in" to the matrix for the first time, after an operation to repair the neural damage inflicted on him by some employers he crossed, he experiences cathartic release:

> And in the bloodlit dark behind his eyes, silver phosphenes boiling in from the edge of space, hypnagogic images jerking past like film compiled from random frames. Symbols, figures, faces, a blurred, fragmented mandala of visual information … And flowed, flowered for him, fluid neon origami trick, the unfolding of his distanceless home, his country, transparent 3D chessboard extending to infinity. Inner eye opening to the stepped scarlet pyramid of the Eastern Seaboard Fission Authority burning beyond the green cubes of the Mitsubishi Bank of America, and high and very far away he saw the spiral arms of military systems, forever beyond his reach.
>
> (Gibson 1995, 68–9)

The sensation that the dimensions of time and space have been altered, if not annihilated, has been a consistent reaction to the deployment of new generations of transport and communication technologies, from railways to airplanes and cinema to the Internet, animating writers from Vertov to McLuhan and Virilio. If the "distanceless home" of cyberspace echoes the perceptual discontinuity of cinema ("like film compiled from random frames"), it also holds out the promise of transcending the cinematic to establish a new perceptual order.[4] While Gibson uses a dystopian image of the modern city grown monstrous, accentuating its electronic dazzlements and labyrinthine and ex-centric forms which depart from all traditions of "form," in order to depict the "unthinkable complexity" of cyberspace, he also preserves the modern ambition of using a new medium to construct a legible image of social reality. While the Night City enclave of Chiba is described in quasi-cinematic terms as "a deranged experiment in social Darwinism, designed by a bored researcher who kept one thumb permanently on the fast-forward button," Case reflects that it was also "possible to see Ninsei as a field of data" (Gibson 1995, 14, 26).

When Case finally encounters the artificial intelligence (AI) which gives the novel its name, it speaks to him "… of the patterns you sometimes imagined you could detect in the dance of the street," adding: "Those patterns are real. I am complex enough, in my narrow ways, to read those dances" (Gibson 1995, 305). This echoes the investment that an earlier generation of theorists such as Kracauer and Benjamin once placed in cinema as the means for interpreting the random movements of urban crowds flowing through the new sites of ephemeral social encounters such as the train station, hotel lobby and street. The desire once invested in cinema's capacity to map the modern machine-city has been transferred to the computer's capacity to map the postmodern information-city, even as differences between film and computer become less relevant in the digital era.

For adepts, cyberspace holds the promise of deciphering the complex real and instilling order in a social and architectural milieu where it is felt to be lacking. This investment becomes even clearer in Gibson's *Mona Lisa Overdrive*, where the matrix is described as "all the data in the world stacked up like one big neon city, so you could cruise around and have a kind of grip on it, visually anyway, because if you didn't, it was too complicated, trying to find your way to a particular piece of data you needed" (Gibson 1988, 19). In *Neuromancer*, Gibson grafts the "infinite" dimensions of cyberspace onto a striated crystalline universe made up, like the early suprematist art of Malevich and Lissitsky, of basic shapes such as pyramids and cubes, arranged in a spatial hierarchy akin to the medieval cosmology of spheres.[5] It is this abstract space of urban building blocks occupying a space (like Lissitsky's *prouns*), somewhere between art and architecture,

that the cyberspace jockeys navigate, if not at will, then with greater agency than they enjoy in the physical universe.

The parallel Gibson draws between electrified urban space and electronic data space is perhaps starkest at the novel's conclusion, at the moment when Case, assisted by the code-breaking program Kuang, penetrates the database of the Tessier-Ashpool corporation in order to "liberate" the AI code-named Wintermute:

> "Christ," Case said, awestruck, as Kuang twisted and banked above the horizonless fields of the Tessier-Ashpool cores, an endless neon cityscape, complexity that cut the eye, jewel bright, sharp as razors.
>
> (Gibson 1995, 303)

In contrast to his bodily inertia, Case has become the virtual pilot of a data-vehicle flying through the spatialized information order. The heart of the Tessier-Ashpool database is represented by one of the icons of architectural modernism: the RCA building topping the "city within a city" of New York's Rockefeller Center: "The Kuang program dived past the gleaming spires of a dozen identical towers of data, each one a blue neon replica of the Manhattan skyscraper" (Gibson 1995, 302–3). As Scott Bukatman has argued persuasively, it is via these urban-kinetic metaphors that Gibson annexes the abstract dimensions of cyberspace to a narrative of human agency.[6] Such agency is inevitably riven with contradictions. Even as it heightens feelings of personal autonomy, the matrix is also an addiction, a dependency. At home in cyberspace, Case is often at a loss elsewhere. In the baroque, feminine labyrinth of the Villa Straylight, maternal "hive" of the Tessier-Ashpool clan which counterpoints the geometric lattices of cyberspace, Case experiences vertigo: "He was now thoroughly lost: spatial disorientation held a peculiar horror for cowboys" (Gibson 1995, 249).

The significance of Gibson's identification of Tessier-Ashpool and the RCA building goes further than some kind of nostalgia. It seems no accident that Gibson has chosen a complex funded by one of the best-known capitalist dynasties of the 20th century (the Rockefellers) to represent the "atavistic" structure of the Tessier-Ashpool "clan."[7] And here, of all places, Gibson's evocation of cyberspace in the guise of Manhattan registers the extent to which the relation between architectural space and social interaction in the modern city became increasingly ambivalent. From inception, the base of the RCA building was designed to be occupied by the studios and offices of the fledgling NBC TV network. As Rem Koolhaas has noted, this meant that, even in the 1930s, the complex was conceived in terms of a different relation between architecture and space:

> In anticipation of the imminent application of TV technology, NBC conceives of the entire block (insofar as it is not punctured by RCA's columns) as a single electronic arena that can transmit itself via airwaves into the home of every citizen of the world – the nerve center of an electronic community that would congregate at Rockefeller Center without actually being there. *Rockefeller Center is the first architecture that can be broadcast.*
>
> (Koolhaas 1994, 200)

Whether or not one agrees with Koolhaas' attribution of this particular point of origin (what of the Eiffel Tower, which found its first "functional" use as a radio transmitter?[8]), his comment situates the new relation between the built environment and data-space which is a key to understanding the social dynamics hinging modernity to postmodernity. The generalization of electronic communities which "congregate ... without actually being there," which is the fictional conceit underlying Gibsonian cyberspace, represents an *epochal* change in human modes of inhabiting space and relating to place. The overlapping and interpenetration

of the different spatio-temporal regimes sustained by communication technologies, from telegraph and telephone to television and Internet, has gradually diminished the primacy of social relations based on physical proximity, as the pressure of the absent begins to displace the customary metaphysical coordinates of "presence."

The electronic polis

At the conclusion of both the Great War in 1918 and the second world war in 1945, movie cameras recorded the crowds which rushed into city streets across the world in collective acts of celebration. Faced with events of similar historical magnitude today, the orientation has changed: it is not outward, into the streets, but inward, to the home, and the electronic screen which has become its hearth, that many turn. (The latest in a long line of examples was the 24-hour worldwide telecast to celebrate the "new millennium." Even those who still gathered in city centers found themselves spectators as much as actors, watching similar groups on the giant screens that have become so popular in contemporary urban public spaces.)

Heidegger once identified the *polis* as "the historical place, the *there* in which, *out* of which and *for* which history happens" (quoted in Lacoue-Labarthes 1990, 17). In an era in which it has become increasingly persuasive to argue that this symbolic function has been annexed by the ubiquity of the electronic screen, it is clear that the notion of community and the dynamics of social bonding are subject to new exigencies. Internet enthusiasts such as Howard Rheingold long ago proclaimed the emergence of virtual communities as the practical antidote to the demise of older forms of communality, riven by economic dislocation and urban dysfunction.[9]

Others are less sanguine about the often uncritical displacement of utopic aspirations from physical to virtual space. Paul Virilio argues that electronic networks, with their new forms of access which replace traditional portals, have limits which are just "as real, constraining and segregating" as the doors and windows of antiquity (Virilio 1986, 20). As much as they are able to unite spatially disconnected social fractions, electronic media have also established a new architecture splitting the city into two societies:

> One is a society of cocoons and home offices where people hide away at home, linked into communication networks, inert. Call it home automation or what you will. The other is a society of the ultra-crowded megalopolis and of urban nomadism.
>
> (Virilio 1993, 75)

Gibson's novel resides within this disjunction, offering an uneasy blend of the dystopic urbanism characteristic of postmodern fiction, manifested in his visions of urban wasteland and the violent, chaotic "dance of the street," coupled to a fantasy envisaging technological transcendence of body and street alike. Such investment registers the shift from the traditions of geopolitics to what Virilio has called chrono-politics, highlighting the importance of "real time" transactions to both political economy and cultural politics in the age of electronic media. As the screen interface becomes increasingly ubiquitous, old spatial divisions, such as those between center and periphery, or public and private, become subject to new exigencies. If, as Virilio suggests, the city is no longer a geographical entity, but is in the process of becoming "a world-city," according to a trajectory which empties rural regions and agrarian societies of their sociability, the flip side of the same process is the increasing provincialization of the metropolitan center: "The suburb is in the process of becoming

the norm, the center is becoming the last suburb" (Virilio 1993, 78, 72). One might also add that the home is becoming a key node in the electronic marketplace, as Internet and interactive television converge in domestic "point of sale" technology.

The pervasive blurring and profound instability of geographical, cultural and conceptual boundaries which lies at the heart of postmodernity can itself be related to the media-induced crises of reference (where to find the real in an era of simulation?) and dimension (what happens to here and there, near and far, when distances collapse and we are all potentially "everywhere" and "nowhere" at once?).

The difficulty of answering such questions in traditional terms is intimately connected to the displacement of embodied experience as an authoritative measure. This displacement is due to two processes which are tightly interlaced without being entirely coextensive: the increasingly abstract social relations which characterize capitalist society on the one hand, and the growing primacy of what McLuhan once dubbed the "extensions of man" on the other. Far from passports to the global village, Virilio interprets the effects of electronic media on the human sensorium as the infrastructure for a new sort of incarceration:

> The urbanization of real time is in fact first the urbanization of *one's own body* plugged into various interfaces (keyboard, cathode screen, DataGlove or DataSuit), prostheses that make the super-equipped able bodied person almost the exact equivalent of the motorized and wired disabled person ... Having been first *mobile*, then *motorized*, man will thus become *motile*, deliberately limiting his body's area of influence to a few gestures, a few impulses like channel surfing.
>
> (Virilio 1997, 11, 16)

This transformation of bodily experience, and the concomitant disjunction between visual space and the space of bodily action, represents a particularly acute problem for architecture and urbanism. The long reign of the Vitruvian body as a humanist matrix for harmony, proportion and order (a model which persisted into modern architecture) today finds itself doubly displaced, on the one hand by the fragmented and fragmentary body of postmodern theory,[10] and, on the other, by the immaterial architectures of media networks. How, then, do we reconcile the body to the uncertain spaces in which it now dwells, without giving in to the lures of either technological transcendence or nostalgia for a pre-technological existence?

While *Neuromancer* leans heavily towards the first option, the way it does this should not be simply equated with the viewpoint of Case, "who'd lived for the bodiless exultation of cyberspace," who experiences his surgical eviction as "the Fall," and continually describes the body as "meat" and the flesh as a "prison." Such sentiments are themselves set within a narrative in which the body reasserts its primacy as the site of genuine knowledge and real experience at critical moments.[11] Rather, it is the plot's metaphysical investment in the technological mastery of space and time which most seriously undermines any phenomenological security. This becomes clearest at the conclusion of the novel, in the context of a discussion about the spatio-temporal dimensions of "being." At one point, Case asks Wintermute: "I mean, where, exactly, are all our asses gonna be, we cut you loose from the hardwiring?" Wintermute replies: "I'm gonna *be* part of something bigger. Much bigger." At the novel's conclusion, the conversation is resumed: "I'm the matrix, Case ... Where's that get you? Nowhere. Everywhere" (Gibson 1995, 246, 315).

Wintermute's success in attaining god-like status is only possible because of a similar transformation which first occurs to Case. In the final run into the Tessier-Ashpool "cores," Case undergoes an extreme experience paralleling the traditional quest, in which the (male) hero experiences dissolution of ego as the pre-condition for spiritual rebirth:

> And when he was nothing, compressed at the heart of all that dark, there came a
> point when the dark could be no *more*, and something tore … Case's consciousness
> divided like beads of mercury, arcing above an endless beach the color of dark
> silver clouds. His vision was spherical, as though a single retina lined the inner
> surface of a globe that contained all things, if all things could be counted.
>
> (Gibson 1995, 304)

The alchemical references to mercury (the *prima materium* of transubstantiation) and
omniscient vision (a quality historically attributed to gods of all persuasions, including the
new techno-gods of camera and computer) returns a few pages later:

> And then – old alchemy of the brain and its vast pharmacy – his hate flowed
> into his hands. In the instant before he drove Kuang's sting through the base of
> the first tower, he attained a level of proficiency exceeding anything he'd known
> or imagined. Beyond ego, beyond personality, beyond awareness …
>
> (Gibson 1995, 309)

Rather than his oft-cited references to the body as "meat," which I would argue are
framed by character and couched in ambivalent, if not negative terms, it is Gibson's recourse
to this most traditional myth of metaphysical transcendence which seems most retrograde
in his vision of cyberspace. As Donna Haraway notes:

> Any transcendentalist move is deadly; it produces death through fear of it. These
> holistic, transcendentalist moves promise a way out of history, a way of participating
> in the God trick. A way of denying mortality.
>
> (cited in Penley and Ross 1991, 20)

As vital as it is to criticize the transcendental fantasies which have been so regularly
projected onto technology, it is equally imperative to avoid doing so by giving way to
nostalgia, particularly for the putative certainty of old cultural boundaries. Occasionally, even
commentators as perceptive as Virilio can veer close to right-wing populism:

> Sociality is in doubt because the nation no longer has any cultural standards. The
> countries of Europe have opened their borders and lost their specificities.
>
> (Virilio 1993, 79)

The problem is not so much the "opening" of national borders to foreigners and foreign
ideas, but rather the historical failure of the bourgeois public sphere, which proclaimed
its universality but always operated by a system of strategic exclusions. The point today is
to recognize this *structural* failing, which has been exposed by a century of mass migration
and mass media, in order to develop a more genuinely inclusive and reflexive public
sphere. This demands the formation of cultural institutions and the inculcation of cultural
values capable of expressing plurality and difference, rather than blaming migrants and
foreigners for cultural de-territorialization. To argue that such "leveling" effects are more
properly laid at the door of commodity capitalism is also to argue for the importance of
unstitching the synonymity of marketplace and media. If the Internet is fast becoming a
new suburb in the world-city, it is one increasingly dominated by the values of commerce
rather than communality. Like radio and television before it, it has become a primary
avenue for introducing advertising to the home (and the school), rendering domestic space
another node of global capitalism. This insertion of commodity relations into the private
realm parallels the extensive privatization of public assets and the public sphere which has
occurred over the last two decades.

The point is not to simply reject the increasing penetration of media technologies into the fabric of everyday life, but to more rigorously debate the socio-political framework underpinning such extensions. Virilio's conclusion to the interview cited above offers a more thoughtful way forward: "The bonds will have to be reinvented … Will we rediscover the religious bond, and so re-establish sociability? Are there new, as yet unimaginable bonds?" (Virilio 1993, 80). This comes close to the point Donna Haraway made long ago in her celebrated "Manifesto for Cyborgs," where she argues "for pleasure in the confusion of boundaries and for responsibility in their construction" (Haraway 1985, 66–7). At present many seem content to dwell on the first part of this statement to the detriment of thinking about the second, which is ultimately a question of politics. In lieu of broaching this question as one of collective action, Gibson is inevitably drawn towards the recapitulation of fictions of individual mastery and transcendence via technology, without registering the extent to which technological transformation has altered the social parameters within which individual identity is embedded.

Notes

1. Scott Bukatman (1994) has interpreted Gibson's use of a typewriter as symptomatic of his methodology of using the paradigm of industrial technology to give form to post-industrial technological developments.
2. This alignment is significant in considering the extent to which Gibsonian cyberspace functions as a site for the projection of traditional gendered fantasies of transcendence. I will return to this point below.
3. Elsewhere (Bukatman 1989, 48) he suggests: "Perhaps we can begin to learn about cyberspace by learning from Las Vegas or Times Square or Tokyo for, on one level, cyberspace only represents an extension (and implosion) of the urban topography located at the junction of postmodernism and science fiction."
4. *Neuromancer* contains several other "cinematic" references to cyberspace, most notably when the AI Wintermute takes Case on a virtual tour of the Villa Straylight. The experience echoes contemporary ride-film simulators adapted from defence equipment for high-end theme parks: "The walls blurred. Dizzying sensation of headlong movement, whipping around corners and through narrow corridors. They seemed at one point to pass through several meters of solid wall, a flash of pitch darkness" (Gibson 1995, 205–6). In his postscript (319) Gibson gives a more pragmatic rationale for his literary recourse to the space-time compression of cinematic form, noting that "much of the cyberspace technology so beloved of VR enthusiasts arose from my impatience with figuring out how to write physical transitions."
5. Gibson's image of cyberspace comprised of pyramids, grids, cubes and spirals resembles that adopted by the "Cyber City" website developed in Germany by ART + COM, simulating a model of the Berlin National Museum as conceived by Mies van der Rohe, and housing four contemporary thinkers representing the concepts of adventure, hope, Utopia and catastrophe. Christine Boyer (1996, 67) notes: "A red pyramid, symbol of fire, represents adventure and is controlled by Vilem Fusser. A green cube symbolizes the house of hope; Joseph Weizenbaum is assigned to it. Marvin Minsky occupies a hexahedra of blue water, which is assumed to be a Utopian place. And Paul Virilio is housed in a sphere of yellow air – the house of catastrophe."
6. Bukatman (1989, 47) writes: "Works such as TRON and *Neuromancer*, most obviously, have "simply' rendered the invisible visible, reconstituting the terminal spaces of the datascape into new arenas susceptible to human experience, perception and control … Science fiction stands as a significant attempt to visualize and dramatize this bewildering and disembodied environment, thereby to endow it with the weight of a phenomenal familiarity." Elsewhere Bukatman (1993, 259) argues that cyberpunk is in fact restorative of the humanism that it ostensibly displaces:

"In one way or another, every work of cyberpunk produces the same radical and reactionary formation."

7. "Power, in Case's world, meant corporate power. The zaibatsus, the multinationals that shaped the course of human history, had transcended old barriers. Viewed as organisms, they had obtained a kind of immortality. You couldn't kill a zaibatsu by assassinating a dozen key executives; there were others waiting to step up the ladder, assume the vacated position, access the vast banks of corporate memory. But Tessier-Ashpool wasn't like that, and he sensed the difference in the death of its founder. T-A was an atavism, a clan" (Gibson 1995, 242).

8. As Benjamin noted in one of his own radio broadcasts: "At the time of its creation, the Eiffel Tower was not conceived for any use; it was a mere emblem, one of the world's wonders, as the saying goes. But then radio transmission was invented, and all of a sudden the edifice had a meaning. Today the Eiffel Tower is Paris's transmitter" (quoted in Mehlman 1993, 14).

9. Rheingold (1994, 12) wrote of "the need for rebuilding community in the face of America's loss of a sense of social commons." Michael Heim (1991, 61) gives the investment in computers an existential edge: "Our love affair with computers, computer graphics, and computer networks runs deeper than aesthetic fascination and deeper than the play of the senses. We are searching for a home for the mind and the heart."

10. See, for example, Vidler (1990).

11. Most intriguingly, when Case makes love to Linda Lee – stimulated only by the memories accessed and animated by the Al Rio (a.k.a. Neuromancer) – he finds the experience still shakes him: "It was a vast thing, beyond knowing, a sea of information coded in spiral and pheromone, infinite intricacy that only the body, in its strong blind way, could ever read" (Gibson 1995, 285; see also 148, 171–2 for other examples).

References

Banham, R. 1969. *The architecture of the well-tempered environment*. London: Architectural Press.

Benjamin, W. 1999. Reply to Oscar Schmitz. In *Selected writings. Volume 2, 1927–1934*; eds M. W. Jennings, H. Eiland and G. Smith; trans. R. Livingstone *et al*. Cambridge, MA and London: Belknap Press.

Boyer, C. 1996. *Cybercities: Visual perception in the age of electronic communication*. New York: Princeton Architectural Press.

Buck-Morss, S. 1991. *The dialectics of seeing: Walter Benjamin and the Arcades Project*. Cambridge, MA: MIT Press.

Bukatman, S. 1989. The cybernetic (city) state: Terminal space becomes phenomenal. *Journal of the Fantastic in the Arts 2* (summer): 48.

—— 1993. *Terminal identity: The virtual subject in postmodern science fiction*. Durham, NC: Duke University Press.

—— 1994. Gibson's typewriter. In *Flame wars: The discourse of cyberculture*, ed. M. Dery. Durham, NC and London: Duke University Press.

Davis, M. 1993. Apocalypse soon. *Artforum* December.

Eisenstein, S. 1963. *The film sense*. Trans. J. Leyda. London: Faber & Faber.

Gibson, W. 1988. *Mona Lisa overdrive*. London: Victor Gollancz.

—— 1995. *Neuromancer*. First published 1983. London: HarperCollins.

Haraway, D. 1985. A manifesto for cyborgs: Science, technology and socialist feminism in the 1980s. *Socialist Review* 80: 65–107.

Harbou, T. von 1927. *Metropolis*. London: The Reader's Library.

Heim, M. 1991. The erotic ontology of cyberspace. In *Cyberspace: First steps*, Benedikt, M. (ed.) London: MIT Press.

Jameson, F. 1991. *Postmodernism, or the cultural logic of late capitalism*. London: Verso.

Kellner, D. 1995. Mapping the present from the future: From Baudrillard to cyberpunk. In *Media culture: Cultural studies, identity, and politics between the modern and the postmodern*. London: Routledge.

Koolhaas, R. 1994. *Delirious New York: A retroactive manifesto for Manhattan*. Rotterdam: 010 Publishers.

Lacoue-Labarthes, P. 1990. *Heidegger, art and politics*. Trans. C. Turner. Oxford: Blackwell.

Leary, T. 1989. High tech, high life. *Mondo 2000*, no. 7 (fall): 59.

McCaffrey, L. (ed.) 1991. *Storming the reality studio*. Durham: Duke University Press.

Mehlman, J. 1993. *Walter Benjamin for children: An essay on his radio years*. Chicago: University of Chicago Press.

Penley, C. and A. Ross. 1991. Cyborgs at large: An interview with Donna Haraway. *Social Text* 25/26: 20.

Rheingold, H. 1994. *The virtual community: Finding connections in a computerised world*. London: Secker and Warburg.

Stone, A.R. (Sandy). 1991. Will the real body please stand up? Boundary stories about virtual cultures. In *Cyberspace: First steps*, Benedikt, M. (ed.) London: MIT Press.

Vidler, A. 1990. The building in pain: The body and architecture in post-modern culture. *AA Files* 19 (spring): 3–10.

Virilio, P. 1986. The overexposed city. Trans. A. Hustvedt. *Zone* 1/2 1986: 20.

——— 1993. Marginal groups. *Daidalos* 50: 75.

——— 1997. *Open sky*. Trans. J. Rose. London and New York: Verso.

SCOTT BUKATMAN

CYBERSPACE

Instead of being made of natural materials, such as marble, granite, or other kinds of rock, the new monuments are made of artificial materials, plastic, chrome, and electric light. They are not built for the ages, but rather against the ages.

Robert Smithson

If 'monuments' in fact exist today, they are no longer visible.

Paul Virilio

Disk beginning to rotate, faster, becoming a sphere of paler gray. Expanding—And flowed, flowered for him, fluid neon origami trick, the unfolding of his distanceless home, his country, transparent 3D chessboard extending to infinity. Inner eye opening to the stepped scarlet pyramid of the Eastern Seaboard Fission Authority burning beyond the green cubes of Mitsubishi Bank of America, and high and very far away he saw the spiral arms of military systems, forever beyond his reach.

William Gibson

IN THE FINAL CITATION ABOVE, William Gibson introduced the world to cyberspace, a vast, geometric, limitless field bisected by vector lines converging somewhere in infinity, permeated by the data systems of the world's corporations. Cyberspace is the new ground inscribed by the implosive forces of blip culture, but it is remarkably like the space predicted in 1966 by the sculptor Robert Smithson, who recognized a new monumentalism composed of the materials of contemporary culture (and what material is more pervasive, more plentiful, or more axiomatic of the era than data?). Paul Virilio correctly notes that these new monuments are invisible to human senses, trapped as they are within the inert plastic shell of the computer terminal, but science fiction operates to reveal this monumental field. Case, the protagonist of *Neuromancer*, has been neurologically modified to experience the electronic field as a physical space, a cosmos open to his exploration. The space arrayed before him has dimension and depth, shape and substance; the new monuments, the coldly burning scarlet pyramids and green cubes, are displayed to his gaze.

Smithson, in his "Entropy and the New Monuments," described the advent of a new spatiotemporality in artistic practice. The sculptures of Donald Judd, Sol LeWitt, and the other minimalists are monuments to the dissipation of energy throughout the system of human activity—they represent, in a sense, a kind of negative monumentalism. In these works of chrome and plexiglass there is an absence of movement which implies a denial of space and time. These monuments reject any mimesis of the natural world, and instead enact the demise of past and future in favor of a timeless, spaceless, and finally inertial present. The works exhibit a profound absence of judgment as their status as *objects* is accentuated.

"Instead of causing us to remember the past like the old monuments," Smithson wrote, "the new monuments seem to cause us to forget the future. ... They are not built for the ages, but rather against the ages."[1] Smithson is prescient in his anticipation, in 1966, of many of the ensuing cultural debates around the waning of history, of subjectivity, of cultural mapping. If the emergent Zeitgeist is indeed one of "inverted millenarianism," as Jameson would have it, of "the end of this or that,"[2] then the new monuments are entirely appropriate to their era. It is the age of entropy, marked by the cessation of kinesis (it should also be noted that entropy is a term adopted within the model of cybernetics, where it signifies an inevitable loss of information).

The perceptual field which emerges from this "instantaneous ubiquity" (Virilio) is one of an infinity of surfaces and planes both seen and not seen. Time is reduced to an absolutely present, and therefore entirely inertial, space. In a metaphor drawn from Smithson's favorite source, science fiction, the artist describes this field as a "City of the Future:" a city constructed of "null structures and surfaces" which performs no function.[3] For this new monumentalism had not arrived fully conceived in a Greenwich Village art gallery; it had been forecast by the collapse of the older monument of the urban environment, although Smithson avoids a simplistic condemnation of the zero degree of architecture represented by the International Style. Again, it is a form axiomatic of its cultural moment. "There is something irresistible about such a place," Smithson remarks of the Union Carbide building, "something grand and empty."[4] No longer is the city the site of circulation, motion, *action:* if it retains a monumental status, it has become a monument to entropy.

The conceptual shift occurring around the figuration of the city also extended to science fiction, and Smithson's devotion to the writings of Ballard indicate his awareness of that. Yet while Ballard's writing evokes an entropic urbanism, a great deal of science fiction is marked by its trajectory of *implosion*. The operative modality is not the absence of motion or circulation, but rather their passage beyond the threshold of human sense. If the city is now figured as an inertial form, it is so because of this new arena of action that has usurped the urban function.

What is fascinating is the similarity of Gibson's description of the imploded field of cyberspace to the "new monuments" of Smithson's concern. Cyberspace, in its vectored perfection, its spaceless space, its scaleless scale and its timeless time, seems like an electronic facsimile of one of LeWitt's open modular cubes, but in Gibson's text this area is transformed into a *narrative* space, and one therefore explicitly defined as a site of action and circulation rather than that null space of which Smithson wrote. There is thus a profound contradiction operating through this conversion of an entropic space, as a new field of implosive activity arises that retains the very geometric forms which connote the subversion of human endeavor. It is a contradiction with important implications for understanding science fiction and postmodernism, and will be examined later in this chapter, but it is worth noticing the similarity that exists between the new monuments of minimalist

art and the monumentalism which continues to pervade the cultural field, operating largely through the genre of science fiction.

The cybernetic (city) state

While cyberspace is a new field, an alien terrain in the best science fiction tradition, it does have its precursors. The notion of a dark and crowded space broken by neon forms and corporate structures is surely not unfamiliar. Perhaps we can begin to learn about Gibson's cyberspace by learning from Las Vegas or Times Square or Tokyo for, on one level, cyberspace only represents an extension of the urban sector located at the intersection of postmodernism and science fiction. As was the case for Smithson, then, the alteration of urban space finds its echo within other cultural forms, other spaces.

Cyberspace arises at precisely the moment when the topos of the traditional city has been superseded. The city has changed: "this new realm is a city of simulations, television city, the city as theme park."[5] William Sharpe and Leonard Wallock have identified three major stages "in the evolution of the modern city."[6] Following the earlier two stages (the first marked by "population growth on an unprecedented scale and by the emergence of industrial capitalism"[16] and the second based upon the segregation represented by the shift to an impoverished center city surrounded by affluent suburbs), the present moment is characterized by a radical decentering of the urban environment. The rise of shopping malls, industrial plazas, cinema multiplexes, and numerous service operations has yielded a dispersed set of "metrocenters" (Eric Lampard's term), in which the functions of the urban environment are replicated, in miniature, along the highways. These new clusters, "edge cities" or "plug-in cities," remain connected to the larger cultural whole through "an intricate ... and efficiently managed network of freeways, telephones, [and] radio and television outlets." As Sharpe and Wallock note, such descriptions of a new urbanism are validated by the 1983 report by the Federal Committee on Metropolitan Statistical Areas, which observed that "sprawling urban areas with no clearly defined center are the trend"(17).

Following the work of Melvin Webber, who described the city "as a social process operating in space,"[7] they conclude that there has arisen "a new conception of the urban no longer synonymous with locale"(17), but one rather defined by a continued participation in the circulation of information permitted by the new electronic technologies of telecommunications: "Our large urban nodes are, in their very nature, massive communication systems. In these intricately complex switchboards, men are actively involved in the business of producing and distributing the information that is the essential stuff of civilization"(86). Webber's metaphor is literalized in Bruce Sterling's 1985 cyberpunk novel *Schismatrix*, as an ancient character has himself wired into the computer network: "'I'm the local stringer for Ceres Datacom network. I hold citizenship in it, though legally speaking it's sometimes more convenient to be treated as wholly owned depreciable hardware. Our life is information—even money is information. Our money and our life are one and the same'"(179). If the "home office" has not yet become a reality, then the replacement of a centralized "downtown" with the decentered sprawl of multiple metrocenters is now the defining fact of urban existence.

There has thus arisen a new and boundless urbanism, one which escapes the power of vision through its very dispersal. The "urban vocabulary, based on concepts of space and concentration, ... is rapidly becoming outmoded"(23). Sharpe and Wallock (and the texts in their collection) devote their attention to the artistic representation of the city in classical and modernist modes, demonstrating an ongoing demand to produce a legibility from the chaos which characterizes the surface of urban existence. The recent and continued

"decentering of the urban field" renders that urban experience increasingly illegible, finally yielding the entropic formations of Pynchon and Saul Bellow.

While Sharpe and Wallock have contributed extremely valuable work in outlining the history, not only of urban growth but of urban representation (from Baudelaire to Fritz Lang), there remains one startling elision in their survey. Science fiction, a genre which has—since its inception—assiduously produced an imaging of the city in stories, novels, films, comic books, and illustration, goes entirely unmentioned. This absence is especially highlighted in two ways. First, the authors are especially sensitive to the technological metaphors, derived from computers or space flight, which have arisen to characterize the new urbanism They argue, for example, that Anthony Downs's term for this dispersal, "satellite spawl," is: "a mixed metaphor. This term combines the space-age symbol of high-technology and frontier exploration with the Victorian vision of disorderly and unplanned growth. In satellite sprawl we encounter a peculiar mixture of past and present to express an otherwise indescribable future"(34). Additionally, there is Jameson's observation that science fiction is defined by the display of a totalizing gaze which reveals the entire city (or planet or machine) in a single action of vision and description.[8] Science fiction is thus explicitly involved in a cognitive and phenomenological "writing" of new urban spaces. If, for example, the new "nonplace urban realm"[9] is invisible through its existence in and through the fields of information circulation, then *Neuromancer* will render that information field tangible, legible, and spatial. Cyberspace is precisely a *nonspace realm*, in Webber's sense of the term.

In both dystopian and utopian inscriptions, the city as a monumental form has been exhaustively mapped and remapped in science fiction. The rise of the genre remains bound up in the same technological revolutions which produced the complex industrial urban environment, with all the commensurate ambivalence toward the idea of progress that might imply. The city was most frequently projected as a negative entity, while utopian aspirations were focused instead upon an agrarian existence. In the late nineteenth century, beginning with Bellamy's *Looking Backward*, the industrial utopia begins to gain prominence, a movement which reaches its apotheosis in the visual science fiction of the 1920s, including the superbly visualized cities of *Metropolis* (1926) and *Just Imagine* (1930), and especially in the pulp magazine artwork of Frank R. Paul: "Paul could not draw convincing human beings, but he could draw wonderful cities—and his images of the future permeated the early pulps quite irrespective of what was written in the stories."[10] These bulbous and rococo images of turbines and hovercraft, massive new engines for living and moving, define the utopian monumentalist impulses of the genre at that particular point in its existence more fully than any written text.

The alienation and dis-ease of American culture in the 1950s, coupled with the new movement away from the city as the dominant space of habitation, yields a science fiction in which the city is projected as claustrophobic and isolating, an outsized monadic structure sealed off from its surrounds. Asimov's *Foundation* (1951) begins on the planet Trantor, a planet-sized metropolis devoid of intrusive natural forms, while *The Caves of Steel* (1954) features an Earth population moved below ground, functioning in the catacombs of a metallic beehive. Brian Stableford correctly notes that the monumentalism of the city is as dominant here as in Paul's day, but that the meaning has entirely altered; one might say that it is the era of the International Style of science fiction urban design, as vast, featureless high-rises (or conapts, to use Phil Dick's term) replace the complex and ornamental spaces of earlier fictions.[11] Here begins the shift toward the more interiorized or imploded monuments of the contemporary period.

The redefinition of the city that occurred within the productions of postmodernism also affected the conception of the metropolis in recent science fiction.[12] From a plethora of

texts, a remarkably consistent imagining/imaging of the city has emerged, one characterized in the first place by its boundlessness. The city is both micro- and macrocosm: even when it turns in upon itself, as it often does (Jameson's example is John Portman's Bonaventura Hotel), it both celebrates and denies its own interiority. The shopping mall is emblematic of this spatiality: it possesses a monadic self-sufficiency in which the outside world is denied (the mall has no windows and no weather, while points of egress are hidden off to the sides), but this is coupled with a recapitulation of forms that strongly connote *exteriority*—"streets" are lined with carefully planted and nurtured trees; a central "food court" mimics the piazzas and plazas of a more traditional urban space. This imploded urbanism, reconciling the irreconcilable differences between public and private, or inside and outside, is insistent upon its status as a "total space."[13]

The new urban space is directionless—coordinates are literally *valueless* when all directions lead to more of the same. For Paul Virilio, in an observation with real applicability for cyberspace, the city is now composed of "a synthetic space-time" that *simulates* the lost geophysical urban spaces of human habitation and circulation. Urban monumentalism has thus become false and spectacular (in Debord's sense): the walls are no longer so solid, nor so impermeable—"the appearance of surfaces hides a secret transparency." The new space is produced by the invisibly penetrating network of satellites and terminals. As Virilio puts it, "The exhaustion of natural relief and of temporal distances creates a telescoping of any localization, of any position. ... The instantaneousness of ubiquity results in the atopia of a single interface."[14] *Atopia* might here be regarded as signaling a movement away from a physical topography, rather than a moral ambivalence. Positionality has lost its relevance in the "urban nonplace."

Now the city is constructed along all the axes of three-dimensional space: in hotels of the Bonaventura type, the main lobby is usually located on the fourth or fifth floor, rather than on street level. It is becoming increasingly common to find oneself *suspended* in a massive space, rather than trapped at its bottom; this refusal of directionality thus extends to a denial of gravity[15] (long an aspiration of Le Corbusier, the "sidewalk in the sky" has become a reality with the advent of the monadic shopping mall). The city is both monumental and without scale, in the sense that many of the same forms repeat at different levels—the home television screen becomes the gigantic advertising sign of Times Square or Tokyo, for example—further contributing to this vectorless existence. As Raoul Vaneigem put it in 1963, "We are living in a space and time that are out of joint, deprived of any reference point or coordinate."[16]

Science fiction has long participated in precisely this ambiguous urban spatiality:

Noon-talk on Millionth Street:
 "*Sorry, these are the West millions. You want 9775335 East.*"

Ballard's early story, "The Concentration City" (1957) rehearses the notion of a boundless city with considerable force.[17] In this consciously Kafkaesque tale, a young man (Franz M.) dreams of the free space which must exist somewhere.

"*Dollar five a cubic foot? Sell!*"

The story transcends the overcrowded subgenre of metropolitan over-population. Ballard instead reconceives space as an analogue of time: the city is a continuum without beginning or end, a null field which extends to the limits of the three dimensions. That the space should end, that there should be something beyond the city, is as heretical as imagining a time before time began.

"Take a westbound express to 495th Avenue, cross over to a Redline elevator and go up a thousand levels to Plaza Terminal. Carry on south from there and you'll find it between 568th Avenue and 422nd Street."

The city is without center and without beginning; a technological sprawl to the limits of infinity. Franz attempts to journey past those limits, only to find himself returned to where he began, spatially and temporally. The urban territory is marked by an infinity of space, a multiplicity of surfaces: time is displaced within a field of inaction and, ultimately, inertia as the city, the universe, circles back upon itself in a closed feedback loop: in the language of the Situationists, the city-state has become *the cybernetic state*.

The unbounded urbanism of Ballard's *metrocosm* is popular in the visual science fiction presented in numerous comic books of the 1970s and 1980s, including Britain's *Judge Dredd* series as well as Italy's *Ranxerox*.[18] The work of Moebius (Jean Giraud) is particularly sustained in its display of a complex urban space. In works such as "The Long Tomorrow" (1975–76) and *The Incal* (1981–88), Moebius builds images of cities which have profoundly influenced their representation in science fiction film and literature.[19]

"The Long Tomorrow" evokes Chandler and Spillane as Pete Club, a "confidential nose" (tomorrow's private eye) from the 97th level is summoned by a mysterious aristocrat who lives in a "snazzy conapt" all the way up on the 12th ("This is the upper crust!" he remarks). Club is sent to the depths of the city ("I kid you not, it was a dump, the 199th level") and eventually to the surface, via antigrav chute. The notion of the buried city where the privileged strata are those closest to the surface is axiomatic of the confused space (the "total space") of the metropolis, public but enclosed, expansive but claustrophobic. The street, once the central site of circulation and exchange, and around which urban space was once conceived, can now be located (only with difficulty) at the nearly invisible bottom of a narratively and spatially decentered environment.

The antigrav chute emphasizes the scale of the city while presenting it as a weightless space, an area of suspension and vertical boundlessness. In *The Incal*, the hero, John DiFool, is thrown from Suicide Alley and the full-page illustration provides a high-angle view of his vertiginous drop. The concentrated city fills the frame as we look down at level upon level of urban sprawl: the bottom is invisible in a diffused cloud of white, and thus this is a city without top, without bottom, without limits. DiFool is suspended above it, high in the frame, regarding the city, the people, and the birds below him. There is no logic or order to the space which lies littered and cluttered, a morass of high and low technologies, a chaos of intersecting lines. The only constant is the drop, which serves as much to reveal the entire urban space in a glance as to transform it into an environment of threat and spatial dislocation (especially for poor DiFool).[20]

This privileged vision of space illustrates Jameson's proposal that much science fiction permits the existence of an impossible and totalizing gaze which functions through spatial description ("no normal human city or village can be 'taken in' in this way"[21]) rather than through narrative action. In this way science fiction becomes part of a process of "lateral perceptual renewal," which parallels works in the so-called high arts. Jameson's comments on Raymond Chandler are instructive in this regard:

> Chandler formally mobilized an "entertainment" genre to distract us in a very special sense: not from the real life of private and public worries in general, but very precisely from our own defense mechanisms against that reality. The excitement of the mystery story plot is, then, a blind, fixing our attention on its own ostensible but in reality quite trivial puzzles and suspense, in such a way that the intolerable space of Southern California can enter the eye laterally, with its intensity undiminished.[22]

Jameson proceeds to argue that science fiction performs an analogous function for history and temporality rather than space, but this is a position he has since modified.[23] While Jameson never quite reconciles defining two genres in the same terms of spatial exploration, one important difference seems to be that the landscape of Chandler's L.A. is as much a social and psychological space as a physical one; a moral field endemic to the genre of crime and mystery fiction. Science fiction is, by contrast, grounded in the new "intolerable spaces" of technological culture and the narrative exists to permit that space to exist in a manner now susceptible to human perception, comprehension, and intervention. The genre provides, as Ballard noted, "a philosophical and metaphysical frame."

Blade Runner and fractal geography

The apotheosis of this urban vision, as well as an effective synthesis of SF and Raymond Chandler, is *Blade Runner*, directed by Ridley Scott, based upon a novel by Philip K. Dick, and designed by Syd Mead and Lawrence G. Paull, with special effects by Douglas Trumbull. That the film can serve as an impressive guide to the precepts of the postmodern aesthetic as elaborated by Jencks, Jameson, and others is a concept which has been extensively explored elsewhere.[24] The film presents—*performs*—a decentered and boundless space dispersed, thanks to the hovercars and rooftop chases, across all three dimensions of the urban topography. Instead of the pristinely gleaming future cities of *Things to Come* or the Gernsbach era of pulp science fiction, *Blade Runner* displays a bold and disturbing extrapolation of current trends: it is a future built upon the detritus of a retrofitted past (our present) in which the city exists as a spectacular site; a future in which the nostalgia for a simulacrum of history in the forms of the *film noir* (narrationally) and forties fashion (diegetically) dominates; a future when the only visible monument is a corporate headquarters. Most urgently, it is a future in which subjectivity and emotional affect are the signs of the nonhuman.

In designing the architecture of this future Los Angeles, Paull has acknowledged the influence of Moebius and particularly the image of that 199th level in "The Long Tomorrow" that he encountered in *Heavy Metal* magazine. "We took certain elements of scale and density from some of the cities in the magazine," he stated. Syd Mead, who produced the vehicles and initiated the notion of a densely layered space, explained: "Once you get past one hundred floors you need a whole new highway system. That's why the street scenes are so impacted—because the streets are practically underground,"[25] much like the buried city approached at the start of the Moebius strip. In *Blade Runner* street level feels like the underworld.

"The Overexposed City," Paul Virilio's recent exploration of metrocosmic space, is interesting in its applications to *Blade Runner*, as Eric Alliez and Michael Feher have demonstrated, in addition to tracing some of the implications of this radically reconceptualized environment. Virilio insists that the city has become a space of simultaneous dispersion, as public space loses its relevance, and concentration, due to the "synthetic" spatiotemporality of terminal culture (the false cohesion of the society of the spectacle; a synthesis of the images and texts which proliferate to create a "virtual" spatiotemporal cohesion). The new monument is no longer the substantial spatiality of the building, but the depthless surface of the screen. This is a transformation literalized in *Blade Runner* by the proliferation of walls which *are* screens, sites of projection now rather than inhabitation. Furthermore, many of these monumental surfaces exhort the citizen/viewer to a further dispersal in the form of emigration to the new suburbs, the off-world colonies.[26]

The design of the film offers a fine example of a spectacular hyper-reality. Not since *2001* has there been a future so meticulously imaged and, like that earlier film, *Blade Runner* rewards the attentive (or repeat) viewer by presenting a complex but eminently readable space that exists in contrast to the decentering effects of the narrative structure. As Deckard approaches police headquarters, the viewer is presented with two spaces. The first is the superbly detailed urban space which dominates the film, an effect produced by a seamless blend of miniature vehicles, models of varying scales, computer controlled camerawork, and multiple layers of traveling mattes. The result of this precision is a cinematic analogue to John DiFool's dive from Suicide Alley (in the Moebius illustration), producing a totalizing gaze which attains an impossible clarity through the perception of a deep and detailed space in which everything is nevertheless visible. The scene provides, as does so much science fiction, a privileged tour of a richly layered futurity in a narrative moment which exists solely to present this urban space both bewildering and familiar. The city is sepia-toned and mist-enshrouded, a fully industrial and smog-bound expanse which yet retains, in this sequence at least, some semblance of a romantic Utopian impulse (the score by Vangelis is helpful). The gaze which enables this powerful space is augmented by the existence of a second field defined by the controls and data screens of the hovercar. These images impose an order on the movement of the gliding vehicle shown to be traveling through a traffic corridor whose existence is invisible to the unaided eye. The effect is one of scopic and epistemological pleasure: the viewer sees and deduces how (not to mention *that*) the future works. One perceives and participates in this temporary alliance between technology and poetry, this mechanical ballet.

As with much recent science fiction, much of the pleasure results from continual transformations of scale and perspective. Paull's comments regarding the density and scale of the work in *Heavy Metal* make it reasonable to assume that, in addition to the comic strips of Moebius, the powerful high-tech illustrations of Angus McKie had a formative impact. McKie, a British science fiction illustrator, produced a comic strip entitled, "So Beautiful and So Dangerous," which ran in *Heavy Metal* in the late 1970s.[27] His obsessively detailed spacecraft and cities, some the size of planets, are further rendered with airbrush effects to produce a sense of atmospheric haze: the effect is a stunning redefinition of scale which evokes and extends both the first sequence of *Star Wars* and the last sequence of *Close Encounters* (1977). The resemblance of the monadic headquarters of the Tyrell Corporation to McKie's work is undeniable, and identical in its production of an unprecedented monumentalism which exists entirely apart from the scale of the human. In McKie's work an immense alien spacecraft descends as a scientist "proves" that man exists alone in the universe: the huge illustration—clearly derived from *Close Encounters*—is designed to make a mockery of such anthropocentrism. (*Neuromancer* also owes something to *Heavy Metal*, and so cartoonists such as Moebius, Angus McKie, and Philippe Druillet provide essential touchstones for the dense visual style that still pervades SF literature and cinema.)

The attention to similarities across scale found in the study of fractal geometry also bears on the visual field displayed in *Blade Runner*. The German physicist Gert Elienberger argues that aesthetically satisfying forms are those which hold elements of order and disorder in a delicate balance; "dynamical processes jelled into physical forms."[28] James Gleick, in his overview of chaos studies, notes that to Benoit Mandelbrot, "art that satisfies lacks scale, in the sense that it contains important elements at all sizes." A Beaux-Arts structure attracts the viewer at all distances, from the distant observer of its overall architecture to the proximate examiner of gargoyles and scrollwork, in a way that the Seagram Building doesn't.[29] The manner in which McKie's impossible shifts of scale serve to invalidate the learned spatiality of human orientation is also a good example of Mandelbrot's physics/aesthetics. Order and

disorder, similarity across scale, a world of infinite detail and complexity; these are the hallmarks of the dynamical systems which constitute our world.

This is intriguing in its relation to the play with size and scale in *Blade Runner*. The visual complexity of the urban space nevertheless remains a function of the superbly synchronized special effects technology, thus providing that balance of order and disorder (*2001*, by contrast, offers a very different experience of *order* at all levels—a partial function, perhaps, of its theme of a controlling alien intelligence). *Blade Runner* also offers the city as a complex and changing form: a fractal environment, in a sense. The first view of the city is an extreme long shot which takes in the entire space through one totalizing glance that defines it as an undifferentiated and homogeneous site of industrial overgrowth. The next shot offers a fiery smokestack—the first monument to punctuate this diabolical space—and this followed by the city visible as a reflection in an unsituated and disembodied eye. That eye then begins to penetrate the space, moving forward over the metroscape to finally locate the massive structure of the Tyrell corporate headquarters. In the sequence which follows, the camera locates Deckard, the blade runner protagonist, by literally coming down to street level: the neon signs, futuristic attire, and lighted umbrella-handles now become available to perception and inspection. A streetside vendor uses an electron microscope, and the drama becomes molecular. The film traces a detailed path across scalar levels, with each pass revealing further complex forms.

In one of the most striking sequences of *Blade Runner*, the transgression of scalar perspective is dramatized. Deckard's electronic inspection of a photograph transforms its visual field, penetrating the surface of the image to reveal it as complex and multidimensional. This sequence represents the most hypnotic demonstration of cinematic suture and control in contemporary cinema. Deckard inserts a photograph into his electronic enhancer, and the inert object is thereby converted to the digitized and serialized bits and bytes of the electronic image. A grid is overlaid upon this field and measured coordinates now regulate and guide the eye's movement across the terrain of memory. Issuing verbal commands reminiscent of film direction ("Track right. ... Now pull back ..."), Deckard temporalizes the frozen moment of the photograph and a classic scene, the search of a room for clues, is played out in terminal form. The private eye becomes another telematic simulation, and the space of the photograph is transmuted into the temporal domain of narrative/cinema.

The human is inserted into the terminal space as a pure, totalizing, gaze. The boundaries of the screen are eradicated, and the cyberscopic field becomes fully phenomenal, susceptible to human vision and action. Through Deckard's instructions the "depthless surface of the screen" is probed, tested, and finally entered. The screen, that frontier separating terminal and physical realities, is rendered permeable, and the space behind it becomes tangible and controllable. The photoenhancing sequence serves as a graphic preamble to the cybernauts and terminal obsessions of *TRON* and *Neuromancer*, wherein humans are physically or neurologically inserted into the terminal reality. Here the photograph bridges the two realms, while vision becomes the force that can cross that bridge. As Merleau-Ponty writes, "Vision is not a certain mode of thought or presence of self, it is the means given me for being absent from myself, for being present at the fission of Being from the inside—the fission at whose termination, and not before, I come back to myself."[30] Vision permits an interface with the objects of the world, and thus the emergence of thought and the presence of the self is a function of the simultaneous projection and introjection that defines the act of vision. The visualization of electronic space thus acknowledges the reality of an other space—a *new* "other space"—that must be known in order for Being to arise. The representation of a metaphorical "terminal space" thus enacts first the fission of the subject and then the beginnings of its reconstitution as a *terminal* subject.

The photoscan sequence in *Blade Runner* is also an encounter with the drama of scale. "The composition changes as one approaches and new elements of the structure come into play," as Gleick remarked of the Paris Opera.[31] In *Blade Runner* a new fractal dimension is discovered somewhere between the two-dimensionality of the photograph and the three-dimensionality of experiential reality. We might in fact label this new fractal dimension the *cinematic*, for the cinema has always participated in this ambiguous and shifting dimensionality, this magnification of sight which produces new dimensions. That is what I take to be the essence of what filmmaker and theorist Jean Epstein called *photogenie* in the 1920s: the specificity of cinema lies, not in the emphatic dramaturgy of narrative temporality, but rather in a spatial exploration that complexly binds multiple perspectives and scalar shifts.[32]

Much of the effectiveness of *Blade Runner*, then, lies in its continual investigation of the various permutations of a complex and self-similar space (note the microchip design of the vast Tyrell building) which finally becomes terminal. This passage is appropriate within the context of a similarity across scale for, as noted above, terminal space serves in many ways as an imploded version of the urbanism which has so dominated science fiction in both its literary and visual instances. *Blade Runner* represents a dynamic moment in which urban space begins to complete a trajectory toward terminal space.[33]

Cyberpunk

This trajectory has its correlate in the literary science fiction of the same period. In its concern with a particular (and particularly urban) representation of cybernetic culture, terminal space is the domain of *cyberpunk*. Cyberpunk proved to be a revitalizing force in science fiction, fusing the literary values and technological expertise which had previously been disported into separate subgenres. Although the movement ended almost as soon as it began, leaving a motley assortment of short stories and novels, its impact has been felt, and its techniques absorbed, across a range of media and cultural formations. Perhaps we should not regard this movement as a closed literary form, but rather as the site where a number of overdetermined discursive practices and cultural concerns were most clearly manifested and explicated. Cyberpunk's techno-surreal images and narrative strategies have added at least one new word to the lexicon (*cyberspace*) and have significantly altered the representation of electronic technology in narrative.[34] It is worth noting at the outset that the real advent of cyberpunk, with the publication of *Neuromancer* in 1984, was preceded by at least three films that, in varying ways, had a formative impact upon the cyberpunk aesthetic: *Videodrome, Blade Runner*, and *TRON* (all 1982).[35]

Cyberpunk was the inheritor of two traditions within SF: first, the so-called "hard" science fiction of vast technical detail and extrapolative power which dates from the 1930s and John W. Campbell's editorship of *Astounding Science Fiction*. Hard science fiction has always demonstrated a disdain for more traditional literary values, and certainly the "cardboard" characters peopling the works of Heinlein and Asimov are not only a part of their charm, but an important aspect of science fiction as a genre of philosophical, rather than psychological, concern. Paradoxically then, but perhaps inevitably, the other tradition from which cyberpunk derived its form was the openly experimental writing of the (again so-called) New Wave of science fiction writers which arose in the 1960s.

The New Wave, which includes such authors as Delany, Ballard, and Michael Moorcock emerged from the sociological science fiction of the 1950s (Sturgeon, Pohl and Kornbluth, and Sheckley, for example), but also from an awareness of contemporary literary production originating outside the genre. Writers like Barth, Vonnegut, and especially Pynchon and

Burroughs, used the languages of technology and science fiction in highly reflexive and self-conscious reformulations. Moorcock's editorship of the British journal *New Worlds* provided a forum for a science fiction responsive to the forms of postmodern fiction, as did Harlan Ellison's *Dangerous Visions* anthologies in the United States. "SF was attractive," Moorcock wrote retrospectively, "because it was overlooked by the critics and it could be written unself-consciously."[36] The impact on the field of science fiction was incalculable, if only for the quality of writers that were attracted to a field which permitted literary experimentation within a somewhat commercial context.

Fred Pfeil, a critic and sometime science fiction writer, has offered an interesting reading of the New Wave and its cyberpunk descendeats. Pfeil perceptively argues that what "the New Wave SF writers found …, either through Ballard's work or from some other prompting, is the aestheticizing principle itself as a way to work what we might, following Benjamin, call the 'allegorical ruin' of a now collapsed and bankrupt utopian/dystopian dialectic." The science fiction of the New Wave allegorized the exhaustion of "the real"—as represented by the dichotomous terms of redemption or damnation—through a baroque and overelaborate writing that emphasized a pure materiality.[37] This accounts for "the otherwise inexplicable, hothouse florescence and sudden significance of that whole host of autotelic language practices, experimental forms, and, strictly speaking, inadequately motivated but luxuriant image play which is the SF New Wave."[38]

The New Wave thus constituted a moment of Modernist compromise for Pfeil, caught as it was between an outmoded set of narrative strategies and thematics "and a 'new' which could not yet be born."[39] In cyberpunk and other science fiction of the 1980s, on the other hand, a new thematics emerged (one which I am calling *terminal identity*), along with a complex and heterogeneous set of ideolects to speak that new thematics. As Pfeil observes, the science fiction of the 1980s "is a very different thing from the New Wave SF of the 1960s; it is at one and the same time 'trashier,' 'pulpier,' and far more sophisticated, even more liberatory, than those earlier writings."[40]

I think that Pfeil's analysis of the accomplishments and limitations of the New Wave is correct, but there remain some significant continuities between the SF of the 1960s and the 1980s that require elaboration. Within the New Wave's transformation of the genre, the predilection of science fiction for the mapping of alternate worlds and reality became melded with an awareness of, and familiarity with, the experience of hallucinogens—trips of another kind. While the crystalline mutations of Ballard's environments demonstrate a clear fascination with the psychedelic modality, Brian Aldiss's *Barefoot in the Head* (1969), set in the years following the Acid Head War, is an explicit—although not isolated—attempt to stimulate a trip within a nonlinear narrative context. Michael Moorcock's series of novels and episodes starring proto-cyberpunk Jerry Cornelius, with their fluid and shifting urbanism and youth-culture entropy/exuberance, perhaps epitomize this generic moment better than any other works.

By the 1980s the free-form cultural movement built around the consumption of hallucinogens was no longer visible, and even the prophet of psychedelia had found a new drug: Timothy Leary proclaimed the computer to be the LSD of the 1980s. "Computers are the most subversive thing I've ever done," he said, adding that: "Computers are more addictive than heroin. … People need some way to activate, boot up, and change disks in their minds. In the 60s we needed LSD to expand reality and examine our stereotypes. With computers as our mirrors, LSD might not be as necessary now."[41] Mathematician/cyberpunk/ programmer Rudy Rucker quotes a hacker comrade who used to say, "Computers are to the eighties what LSD was to the sixties."[42] Indeed, some early researchers into hallucinogenic drugs were equally interested in other mind-expansion techniques, such as parapsychology

and "electronic computing machines and the study of analogous brain mechanisms."[43] Such comments demonstrate a continuum between drug and terminal cultures, a continuum central to understanding cyberpunk. Hallucinogens provided an opportunity for the literary conception of radically different spatiotemporal orientations, an extension of the extant limits of the terrains of science fiction, and computers furnished a similar occasion (Gibson's "fluid neon origami trick").

It is interesting that in these more conservative times the probing of new spaces operates within the *hardware* of the computer, rather than in the *wetware* of the mind or spirit (Norman Spinrad has described a conflict between hackers and hippies).[44] The cyberscape is dominated by the pure Euclidean forms of pyramid and cube (albeit in scarlet and green). Cyberpunk returned the experimental wing of the genre to its technocratic roots. "Like punk music, cyberpunk is in some sense a return to roots," wrote Bruce Sterling, an important author, editor, and essayist of the movement: "The cyberpunks are perhaps the first SF generation to grow up not only within the literary tradition of science fiction but in a truly science-fictional world. For them, the techniques of classical 'hard SF'—extrapolation, technological literacy—are not just literary tools but an aid to daily life."[45] Larry McCaffery also puts the punk back in cyberpunk, noting the shared attitude, not simply of rebellion, but "of defiance towards cultural and aesthetic norms; an attitude of distrust towards rationalist language and all other forms of discourse required by legal, political, and consumer capitalism."[46] At this point, the accuracy of Pfeil's analysis becomes evident—there *is* a politically significant difference between a narrative model rooted in the alternate-reality experiences of a somewhat solipsistic youth subculture and another grounded in the transformation of quotidian existence by a proliferating set of global electronic technologies.

It should not be assumed that cyberpunk represents a co-optation of the experimentalism of the New Wave by the technologists of hard SF. Cyberpunk offered an important rejection of rationalist technocracy in favor of a science fiction set at street level. Sterling writes: "Science fiction ... has always been about the impact of technology. But times have changed since the comfortable era of Hugo Gernsback, when Science was safely enshrined—and confined—in an ivory tower. The careless technophilia of those days belongs to a vanished, sluggish era, when authority still had a comfortable margin of control."[47] The protagonist of one William Gibson story hallucinates those very gleaming futures of the Gernsback era—now hopelessly old-fashioned—and only some sustained television viewing can return him happily to the disembodying and dispersed technologies of the present.[48] The measured forms of instrumental reason no longer dominate the technosphere which has slipped away from human control, as Baudrillard continually notes, and into an implosive and self-regulating state (some cyberpunk narratives feature corporate villains—thus revealing a nostalgia for human control and responsibility—while in other texts the dramatic conflicts are the product of "ghosts in the machine" [a literal, if electronic, deus ex machina]).

While the writers of the New Wave responded to the failure of social controls with a renewed emphasis on subjectivity and "inner space," the cyberpunks maintained a sometimes careful but often opportunistic ambivalence. The worlds they built are filled with name-brand debris of a fully industrialized and technologized culture: "They'd left the place littered with the abstract white forms of the foam packing units, with crumpled plastic film and hundreds of tiny foam beads. The Ono-Sendai [cyberspace deck]; next year's expensive Hosaka computer; a Sony monitor; a dozen disks of corporate-grade ice; a Braun coffee-maker" (*Neuromancer*, 46).

In Gibson's fiction, much of it set in the Sprawl—BAMA, the Boston-Atlanta Metroplex— the perspective is less street level than gutter level, as new technologies yield a new range

of black markets and marketeers rather than a gleaming, utopian vision of progress. Johnny Mnemonic, in another Gibson story, inhabits the demimonde of the Sprawl, renting the memory chips implanted in his head to gangsters needing secret data storage space. This is far from the magnificent, streamlined towers of urban control on display in a film like *Things to Come* or the General Motors Futurama exhibit at the 1939 World's Fair.

This dark, pragmatic, and paranoid urbanism further links the sub-genre to the forms of the *film noir* and private eye fiction: Jameson's comments on Chandler are profoundly applicable to Gibson. There is a pervasive and long-standing complementarity between science fiction and crime fiction, and this has only become more pronounced around cyberpunk and its obsessions with urbanism, the underworld, and social marginality.[49] As Brian McHale points out, and as will be discussed later in this chapter, the detective story is involved with the status of *knowing*, while science fiction's domain is the realm of *being*. That there should be a significant conflation of these two genres, then, is unsurprising but provocative, and it merits some consideration.

The detective story, as analyzed by Roland Barthes, is strongly oriented toward a play with what he called fiction's "hermeneutic code." In other words, the narrative sets up a central enigma which it is the task of the detective (and/or the reader) to explicate.[50] Dennis Porter has noted that the classic form of detective fiction involves opening "a logico-temporal gap" between the time of the crime's commission and the time of its telling. The task of the detective (and the fiction) is thus to close that gap and restore the logical temporal order.[51]

Science fiction detective stories have rarely enjoyed success, and it is probably true (as *The Science Fiction Encyclopedia* maintains) that the combination is difficult "because in sf the boundary between the possible and the impossible is so flexible."[52] In other words, the rules which govern the science fiction diegesis are often unknown, or unclear, or even inconsistent—complicating the already difficult task of problem-solving. Additionally, since the science fiction story is often predicated upon a technological innovation or extrapolation (a "novum," to use Darko Suvin's term), the "solution" to the mystery often involves an unforeseeable twist—a time machine, for example.[53]

But just as American crime fiction cannot be reduced to the model of the classic (often English) detective story, the confluence of science fiction and crime fiction is not exhausted by the cognitive puzzles of futuristic "locked-room" mysteries. *Blade Runner* and related works by Moebius and Gibson owe far more to the alienated spatialities of Chandler or Ross MacDonald than to the puzzles of John Dickson Carr or Agatha Christie. A set of motifs is shared by writers in both genres: a concern with models of social order and disorder; narrative structures based on perception and spatial exploration; and, most significantly, a mapping of compacted, decentered, highly complex urban spaces. *Blade Runner* is exemplary on all three points. The replicants pose a threat to the social order, raising questions regarding the status of being and the nature of state control. Deckard is the technologically enhanced detective/perceiver, seeing, reading, and exploring an unsettling and chaotic environment. Finally, the intricate urbanism of the film is the point at which the iconographies of science fiction and *film noir* thoroughly overlap.

Jameson has written that:

> the form of Chandler's books reflects an initial American separation of people from each other, their need to be linked by some external force (in this case the detective) if they are ever to be fitted together as parts of the same picture puzzle. And this separation is projected out onto space itself: no matter how crowded the street in question, the various solitudes never really merge into a collective experience[;] there is always distance between them. Each dingy office is

separated from the next; each room in the rooming house from the one next to it; each dwelling from the pavement beyond it. This is why the most characteristic leitmotif of Chandler's books is the figure standing, looking out of one world, peering vaguely or attentively across into another.[54]

These comments are equally apposite to *Blade Runner*, which extends Chandler's "separation of people from each other" into the distance between planets, between the human and the nonhuman, and even between physical and electronic environments. *Neuromancer* and its many imitators are equally involved in this generic crossover (although usually it is the thief, rather than the cop, who is engaged in the quest).

While the narrative produces a linkage between spaces, Jameson argues that the experience of spatial separation is, in fact, the true experience of the work (and surely Chandler's incoherent "solutions" lend credence to that view). The homology between the Chandler-*noir* axis of crime story and the street-level formations of cyberpunk is neither superficial nor coincidental, but is fundamentally connected to the experience of the "intolerable spaces" (now urban- *and* cyber-) that define contemporary existence. As with Chandler's fiction, the narrative estranges and grounds the reader by emphasizing the reality of alienation while still producing what Jameson has referred to as "an aesthetic of *cognitive mapping*."[55] Although Chandler's L.A. was nearly as technologized as *Blade Runner's* L.A., Chandler's was grounded in visible technologies. Now the *noir* narrative is mapped onto the invisible but experientially real spaces of electronic culture.[56] The task of narrating this fundamental urban separation then, once exclusively the province of the detective genre, now falls to that hybrid of science fiction and urban crime narrative known as cyberpunk.

Cyberspace is an abstraction which, diegetically and extradiegetically, provides a narrative compensation for the loss of visibility in the world, the movement of power into the cybernetic matrices of the global computer banks, and the corresponding divestiture of power from the subject ("We no longer feel that we penetrate the future; futures now penetrate us"[57]). The planes of cyberspace enable the activity of spatial penetration and thus produce the subject's mastery of a global data system. Oddly, writing about cyberpunk often defines it as *dystopian*, marked by *noir*-ish excesses in extended inner cities. There are dystopian elements to be found, not least in cyberpunk's satirical approach to contemporary urbanism (see the novels of Jack Womack for examples), but to reduce the genre to one rhetorical mode seems misguided.

Andrew Ross has produced a typical reading of cyberpunk as urban dystopia in "Cyberpunk in Boystown." In some ways the essay is very useful: to grapple with cyberpunk, Ross considers Gibson, *Blade Runner* and its imitators, Frank Miller's comic book *Elektra Assassin*, and Steve Jackson's notorious cyberpunk role-playing game. He is right to note cyberpunk's dispersal beyond the field of the literary, but the plurality of texts serves a remarkably univocal reading. As his title suggests, Ross understands cyberpunk as an adolescent and masculinist genre. Responding to Bruce Sterling's assertion that cyberpunk is an expression of a contemporary zeitgeist, he observes that this particular zeitgeist ignores feminism, race politics, environmentalism, and other significant, contemporary, cultural forces. (This is not an incorrect position, *as far as it goes*, but Ross takes certain cyberpunk postures far too literally. It's also true that urban paranoia is a fashionable attitude, and cyberpunk at its weakest has reduced all of this to formula, as in the role-playing game.[58] There *is* an evident rock 'n' roll romanticism at work, riding atop the adolescent sensibility of most SF.)

Ross and others emphasize the image of urbanism that dominates the form. There is a surfeit of dystopian writings on the city in the latter half of the twentieth century, from Jane Jacobs's *Rise and Fall of the American City* to Mike Davis's *City of Quartz*. The city is in

crisis, its superstructure decaying while its tax base relocates to less expensive edge cities and other dispersed metrocenters. As Webber and others suggest, the city has entered a new phase of existence as a decentered nongeographical entity. Cyberpunk is an important touchstone here: Davis's massive reading of Los Angeles refers frequently to *Blade Runner*, a future to which L.A. seems to consciously aspire; his book is adorned by a quote from Gibson, who suggests that Davis's work is more cyberpunk than his own. Perhaps the darkest chapters emphasize the rise of Los Angeles as a high-security state, a space of control and containment: "the 'fortress effect' emerges, not as an inadvertent failure of design, but as deliberate socio-spatial strategy."[59] The control of space is seen as a *strategy*, in Michel de Certeau's sense of the word (see chapter 3), but for Davis the only significant tactics of resistance, such as gang membership, have been demonized. Cyberpunk represents another set of tactics.

Ross finds it significant that most cyberpunk writers are suburbanites or nonurbanites (forgetting the power that the works have held over urban *readers* since their appearance nearly a decade ago). The nonurban perspective of the writers reveals itself in their hyperbolized versions of an inner city run riot. The protagonist, inevitably a white male, probes, negotiates, and penetrates this site of multicultural otherness, mastering it in the process (thus cyberpunk heroes inherit from the Tarzan tradition—lords of the neo-urban jungle).[60] But the nonurban cyberpunk authors do not simply exist in some *other place*—in the era of the "non-place urban realm" all these spaces (urban, suburban, nonurban) connect.

Further, to dwell on cyberpunk's dystopian portrait of the city is to ignore the genre's narrative compensations (that move past the code of the great white hero). Much cyberpunk has been concerned with the phenomenologically relevant *other space* of information circulation and control. *Neuromancer* transformed terminal space by casting it in physical terms, rendering it susceptible to perception and control. David Tomas also argues that cyberspace represents a powerful space of accommodation to new technological forms: "there is reason to believe that these technologies might constitute the central phase in a post-industrial 'rite of passage' between organically human and cyberpsychically digital life-forms as reconfigured through computer software systems."[61] He understands cyberspace in explicitly anthropological terms as a *mythological* space (a far more productive approach than Ross's own paradigm of naturalism). And if the subgenre remains connected to its adolescent roots, well, rock 'n' roll has always represented a means of techno-social enfranchisement, and some sense of technological control can come through mastering an electric guitar as well as a computer. Even at its most conservative, cyberpunk thematizes an ambivalence regarding terminal existence. The works are *correctives* to the dystopian city-spaces of the present. Urban space and cyberspace become reciprocal metaphors—each enables an understanding and negotiation of the other.

I'm not suggesting that critics *couldn't* deal with the politics of cyberspace (exactly who *does* gain access to electronic space, in cyberpunk and in the "real world"?), simply that they don't. Of course Ross characterizes cyberpunk as *dystopian*—he has ignored its utopian spaces. Compare his view to that of Allucquere Rosanne Stone, who notes that for hackers, the technologically literate, and the socially disaffected, "Gibson's powerful vision provided ... the imaginal public sphere and refigured discursive community that established the grounding for the possibility of a new kind of social interaction." While Ross downgrades adolescent cyberpunk gamers, Stone describes a more sophisticated *community* of readers and the reemergence of an electronic public space.[62] Paul Arthur has further linked this hyper-technologized space to the pastoral tradition, noting that cyberspace represents a new frontier, one that replaces an urban landscape desiccated by the pervasiveness of consumer dynamics.[63] So while cyberspace frequently recapitulates the complexities of the postmodern

"urban nonplace," it frequently permits the subject a utopian and kinetic *liberation* from the very limits of urban existence.

Neuromancer

Cyberpunk at its best is not quite reducible to the work of William Gibson, but he is certainly both its most archetypal literary figure—with three novels, a hypertext project, and a collection of short stories to his credit, he is nearly a subgenre unto himself. (He has also collaborated on a novel with fellow cyberpunk Bruce Sterling.) In *Neuromancer*, Gibson coalesced an eclectic range of generic protocols, contemporary idiolects, and a pervasive technological eroticism combined with a future-shocking ambivalence. Aside from the old and new waves of science fiction, Gibson's prose and perspective owes much to the streetwise weariness of Chandler and the neologistic prowess of William Burroughs, which provide its underworld savvy and technoslang (the razor-girls of Night City or the meat puppets—lobotomized prostitutes[64]).

Another clear stylistic forerunner, and thus a major progenitor of cyberpunk fiction in general, is *Dispatches*, the journalistic account of the Vietnam war by Michael Herr. Jameson has written of this text that it "impersonally fuses a whole range of contemporary collective idiolects, most notably rock language and Black language,"[65] as does Gibson within an urban context. Herr breaks down traditional narrative paradigms in favor of a powerfully decentered spatiality.

> Helicopters and people jumping out of helicopters, people so in love they'd run to get on even when there wasn't any pressure. Choppers rising straight out of small cleared jungle spaces, wobbling down onto city rooftops, cartons of rations and ammunition thrown off, dead and wounded loaded on. Sometimes they were so plentiful and loose that you could touch down at five or six places in a day, look around, hear the talk, catch the next one out. There were installations as big as cities with 30,000 citizens, once we dropped in to feed supply to one man.[66]

Where are these places? What do they mean? The helicopter, like the hovercar of *Blade Runner*, adds verticality to the spaces of postmodern warfare, but the connections between places are lost in an orgy of motion. Jameson: "In this new machine which … does not represent motion, but which can only be represented *in motion*, something of the mystery of the new postmodernist space is concentrated."[67] The computer is the ultimate extension of the new machine, particularly through the dialectical tension maintained between its inert physical form and the megabytes of data circulating in nanoseconds of time, and it is put *in motion* in *Neuromancer*. One character in *Dispatches* is seen "coming out of some heavy heart of darkness trip, overloaded on the information, the input! The input!"(6)—a perfect cyberpunk credo.

Neuromancer was uncannily anticipated by Jameson's 1984 essay on postmodernism and is a remarkable consolidation of the themes and issues of terminal culture. The novel is set in the twenty-first century, when the world is dominated by the high-tech *zaibatsus* of Japan, Germany, and Switzerland. Fortunes are to be made in the illegal retrieval and sale of data, and Case (a closed object, a container, a hard case) works on the black market. Data is a protected commodity, and cybernetic security systems can only be circumvented by people like Case, a cyberspace cowboy, neurologically jacked into the world of the computer. Armed with the proper ICE (intrusive counter-electronics), Case can negotiate his way through the most elaborate systems. But Case had blown a job

and his employers damaged his nervous system as revenge: he can no longer jack in. "For Case, who'd lived for the bodiless exultation of cyberspace, it was the Fall." Two years later, a small team of brutal specialists has appeared to fix the damage and bring Case back into cyberspace to penetrate the defenses of an AI (artificial intelligence) for unknown purposes.

In the action-adventure tradition of Ian Fleming, the action jumps from Japan's Chiba City to the Sprawl, then to Europe and up to Freeside, an orbital colony. The urbanism is insistent, even in outer space, where Freeside, a rotating habitat with centrifugal "gravity," is presented as an especially disorienting spatial environment: "it made no sense to his body"(123–4). Street directions within this imploded urban space recall Ballard's "Concentration City": "Rue Jules Verne was a circumferential avenue, looping the spindle's midpoint, while Desiderata ran its length, terminating at either end in the supports of the Lado-Acheson light pumps. If you turned right, off Desiderata, and followed Jules Verne far enough, you'd find yourself approaching Desiderata from the left"(151). Delany has noted that it is precisely such spaces and descriptions that frustrate readers unfamiliar with the genre who are unable or unwilling to accept the redefinition of bodily experience implied by this string of words. Gibson is masterful at this sort of dislocation; witness the opening sentence of his second novel, *Count Zero* (1986): "They set a slamhound on Turner's trail in New Delhi, slotted it to his pheromones and the color of his hair." This is a work which begins in medias res, and it is a world of professionals. (Thomas Disch notes that while *Neuromancer's* Case is a "Ulysses of cyberspace," the gentler *Mona Lisa Overdrive* [1988], the third book of the Cyberspace Trilogy, is peopled by "innocents and naifs," permitting a friendlier interface with readers.)[68]

The imploded urbanism of Freeside continues the movement toward containment of the metroscape and a bonding with electronic space. Simulated weather effects disguise the nature of this habitat, which hangs suspended within the nullity of outer space. Simulation melds with reality to preserve some sense of traditional spatial experience, but Freeside suggests nothing so much as the structures of cyberspace.

Gibson continually refers to the similarities between the matrices of the electronic and physical realities. The very first sentence of *Neuromancer* establishes the impossibility of a "real" space existing apart from its electronic analogue: "The sky above the port was the color of television, turned to a dead channel."[69] As on Freeside, the air of Chiba City is filled with simulations: "Under bright ghosts burning through a blue haze of cigarette smoke, holograms of Wizard's Castle, Tank War Europa, the New York skyline"(8). The real metroscape of New York becomes simply another simulation, reduced to data and transformed into the hyperreality of the hologram. As a veteran of cyberspace, Case is well aware of the overlapping. While being chased through Chiba city, he feels an adrenaline rush and realizes his pleasure: "Because in some weird and very approximate way, it was like a run in the matrix. Get just wasted enough, find yourself in some desperate but strangely arbitrary kind of trouble, and it was possible to see Ninsei as a field of data. ... Then you could throw yourself into a high-speed drift and skid, totally engaged but set apart from it all, and all around you the dance of biz, information interacting, data made flesh in the mazes of the black market"(16).

Later, Molly, another member of the team, breaks into the headquarters of Sense/Net while Case performs a cyberspace run on the same target. Case is also jacked in to Molly's experience through the miracle of sim-stim—simulation-stimulation—and the narrative cuts from physical assault to cyberspace run, all the while remaining within the diegetically grounded perspective of Case, whose body remains in the hotel room: physical and electronic spaces are made equivalent, each an extension of the other.[70]

A physical unreality begins to pervade the metroscape, an expression of the disembodied and dislocating spaces of the postmodern city in which sign and spectacle dominate, in which reality seems usurped by its own simulacrum. The simultaneous dispersion and concentration characteristic of the "overexposed city," as Virilio calls it, finds its only adequate analogue and representation within the matrices of terminal space. It is a space that one is physically absent from, in that the space no longer permits any authentic bodily function or experience: cyberspace is thus the more honest spatial figuration in its open acknowledgment of the supersession of individual bodily experience.

Urban space becomes the metaphor for the electronic spaces of data circulation. Vivian Sobchack has noted: "The multinationals seem to determine our lives from some sort of ethereal 'other' or 'outer' space. This is a space that finds its most explicit figuration in the impossible towering beauty of *Blade Runner's* Tyrell Corporation Building—an awesome megastructure whose intricate facade also resembles a microchip."[71] In *Neuromancer*, the reader's first introduction to the Sprawl is in terms of data circulation and terminal representation:

> Program a map to display frequency of data exchange, every thousand megabytes a single pixel on a very large screen. Manhattan an Atlanta burn solid white. Then they start to pulse, the rate of traffic threatening to overload your simulation. Your map is about to go nova. Cool it down. Up your scale. Each pixel a million megabytes. At a hundred million megabytes per second, you begin to make out certain blocks in midtown Manhattan, outlines of hundred-year-old industrial parks ringing the old core of Atlanta. (43)

This is a most explicit mapping of terminal onto physical space and demonstrates the need for new cartographic strategies, as well as new sources of vision, to attain some comprehension of, and competence in, "the bewildering world space" of corporate activity, that "other space." Images of building exteriors, especially the glass corporate headquarters of the late modernist era, no longer reveal anything of their functions or purposes. Images of human exteriors also reveal nothing: they are no longer relevant to the new "real" space of terminal culture. But program a map to reveal data circulation and worlds of information are revealed. We are entering cyberspace.

Of course, Gibson is the best guide to this new arena of human activity, and *Neuromancer* provides its own definition (this is the narration from a children's program): "Cyberspace. A consensual hallucination experienced daily by billions of legitimate operators, in every nation, by children being taught mathematical concepts. ... A graphic representation of data abstracted from the banks of every computer in the human system. Unthinkable complexity. Lines of light ranged in the nonspace of the mind, clusters and constellations of data. Like city lights, receding" (51). The concept of cyberspace is not much of an extrapolation beyond present realities of user interface. Here are the images which accompany the above narration: "a two-dimensional space war faded behind a forest of mathematically generated ferns, demonstrating the spacial possibilities of logarithmic spirals; cold blue military footage burned through, lab animals wired into test systems, helmets feeding into fire control circuits of tanks and war planes." Much of this is not extrapolation at all—the space wars of the video arcades, the fractal forms of fern "life" growing on a monitor screen, and the use of computers and simulation to aid in training military personnel as well as in developing new targeting technologies guided solely by the operator's vision have all been a part of terminal experience for decades.[72]

Certain other aspects of this "nonspace" need to be emphasized. Just as Chiba City, the Sprawl, and Freeside were endowed with some of the attributes of cyberspace, so

cyberspace is characterized as a field "like city lights." Cyberspace is represented as an imploded urbanism—Blip City. During a run, Case is at the mercy of some advanced Kuang Grade Mark Eleven ICE (bad news):

> Headlong motion through walls of emerald green, milky jade, the sensation of speed beyond anything he'd known before in cyberspace. ... The Tessier-Ashpool ice shattered, peeling away from the Chinese program's thrust, a worrying impression of solid fluidity, as though the shards of a broken mirror bent and elongated as they fell—"Christ," Case said, awestruck, as Kuang twisted and banked above the horizonless fields of the Tessier-Ashpool cores, an endless neon cityscape, complexity that cut the eye, jewel bright, sharp as razors. (256)

Again, the profoundly dislocating field of cyberspace, a field of "solid fluidity," "complexity that cuts the eye," and "horizonless" space is coupled with the image of the "neon cityscape." That the T-A cores, "a dozen identical towers of data," resemble the RCA building (assuredly *not* a glass box) endows the space with a faintly baroque familiarity.

The question is, does the imposition of the forms of the cityscape on the new datascape ground the image by rendering it with familiar strokes, or does it instead extend the dislocating power of the urban realm? A bit of both, it would seem, for cyberspace certainly hyperbolizes the space of the city, projecting the metroscape into an exaggerated representation that accentuates its bodiless vertigo, but it permits the existence of a powerful and controlling gaze. In Gibson's cyberspace, in fact, the disembodied metroscape achieves its fullest expression: in a simultaneous movement of dislocation and centering, the human now exists as *pure gaze* while the fragmented "nonplace urban realm" is translated into visual terms. Cyberspace becomes the instantiation of a truly postmodern urban language in which the density and proximity of the central, inner, city becomes the compensatory analogy for the spatially dispersed matrices of information circulation and overload.

In one sense, cyberspace is not really a space at all, but simply a construct occupied by the programs and data systems of the world. "In the nonspace of the matrix," Gibson writes, "the interior of a given data construct possessed unlimited subjective dimension; a child's toy calculator, accessed through Case's Sendai, would have presented limitless gulfs of nothingness hung with a few basic commands" (*Neuromancer*, 63). J. David Bolter has stressed that electronic space is, in many ways, simpler to understand than its physical or mathematical counterparts, precisely because it is "an artifact, a constructed space that must function in thoroughly predictable ways in order to serve its technological purpose."[73]

Bolter has defined mathematical conceptions of electronic space as amalgams of both Platonic and Cartesian spaces. For the Greeks, space was simply the sum of matter in the universe—there was no such thing as space without substance. Even the atomists, while acknowledging the existence of empty space, only went so far as positing the space in which matter (atoms) moved. The development of a coherent relation between the geometries of Euclid and the algebras of the Muslim world was the contribution of Descartes and led to a radical reconception of space as "an infinite set of dimensionless points."[74] Points, or objects, were now defined in terms of the space they occupied, rather than the space being defined around the objects. Newton, seizing upon the contributions made by the coordinate system of Cartesian analytic geometry, was thus able to describe, through physics, the forces of gravity and motion.

The interest of Gibsonian cyberspace derives from its status as a *phenomenal*, rather than a mathematical elaboration of electronic space. Cyberspace is generally regarded as finite, if virtual—a construct which serves the set of objects within it, as in ancient cosmologies. At the same time, though, it is a coordinate system of seeming limitlessness: Gibson continually

stresses the endless *space* as well as the data contained within it. Following the strategies of computer-graphics researchers, Gibson has transformed the virtual field of the Cartesian coordinate system into the Newtonian spaces of concrete forces and forms (*TRON* performed a similar operation). This is no idle transformation; it reduces the infinite abstract void of electronic space to the definitions of bodily experience and physical cognition, grounding it in finite and assimilable terms. Merleau-Ponty once raised objections to the detachment of Cartesian coordinate space by noting that he is inside space, immersed in it; space cannot be reconstructed from an outside position.[75] Cyberspace, with its aesthetic of immersion, maintains the mathematical determinism of the coordinate system, but it superimposes the experiential realities of physical, phenomenal, space upon the abstractions of this Cartesian terrain.

The reductionism of cyberspace also extends to its definition as an *abstraction* of the data in all the computers within the human system, a reprogramming which reduces the complexity to avoid an overload and permit the assimilation by human perception (as in the map of the Sprawl: "Cool it down," Gibson advises): "Put the trodes on and they were out there, all the data in the world stacked up like one big neon city, so you could cruise around and have a kind of grip on it, visually anyway, because if you didn't, it was too complicated, trying to find your way to a particular piece of data you needed."[76] Here, in *Mona Lisa Overdrive*, Gibson makes his own project explicit. Cyberspace is a method of conceiving the inconceivable—an imaginary solution to the real contradictions of the Dataist Era. In this sense, *Neuromancer itself* represents a "consensual hallucination"—an abstraction and reduction of the complexities of cybernetic culture to a kind of reckless, but sensible, cognitive experience. Not everyone can read *Neuromancer*: its neologisms alienate the uninitiated reader—that's their function—while its unwavering intensity and the absence of traditional pacing exhaust even the dedicated. The work is best experienced as something other than narrative—poetry, perhaps—so that the images may perform their estranging, disembodying functions. The reader must jack into *Neuromancer*—it's a novel for would-be cyberspace cowboys.

Gibson has admitted that a primary influence on his conception of cyberspace were the comic book visualizations of *Heavy Metal*, already discussed in relation to *Blade Runner*.[77] Gibson's version of cyberspace is now the only possible model, and it has influenced comics in its turn. As the name implies, *Cyberpunk* by Scott Rockwell and Darryl Banks is a particularly clear homage: cyberspace is composed of intersecting planes and geometric forms (although the effect is like the beginning of a network movie-of-the-week). *Iron Man: CRASH*, written and illustrated by Mike Saenz entirely on a computer, features elaborate 3-D modeling effects (Saenz has since designed an "adult" computer adventure called "Virtual Valerie"). Again vector lines and solid 3-D modeling combine to create the cybernetic realm; again Tokyo serves as the technological other. Undoubtedly the most sophisticated of the new "computer comics" is Pepe Moreno's cyberpunk Batman novel, *Digital Justice*, which features an electronic palette of sixteen million colors and the Joker as a malevolent computer virus. A comic's adaptation of *Neuromancer* serves as an interesting translation of the original (as Gibson himself notes in his introduction) and a closing of the representational circle (the rendering techniques employed by Bruce Jensen are more traditional than the computer-aided designs of Saenz or Moreno). These comics simplify the narrative elements of *Neuromancer*, but they also preserve the dense urbanism, romantic rebelliousness, and overall cybernetic overload. For the most part, in this case the medium has become more derivative than innovative.[78]

The production of cyberspace

Jameson's understanding of space as a structuring concept of the postmodernity connects to the work of Henri Lefebvre, whose remarkable book, *The Production of Space*, has only recently appeared in English. Lefebvre was strongly affected by a range of discourses in European culture. Situationism, with its emphasis on lived, urban reality set the terms for a debate in which Lefebvre and Michel de Certeau were very interested, despite their rejection of fundamental Situationist precepts and attitudes. Lefebvre combined principles of Marxism with phenomenology, Surrealism, and a host of other discourses to produce an original and powerful amalgam that seems remarkably appropriate to the 1990s.

In *The Production of Space*, Lefebvre condemns the quest for a "science of space," rejecting the loose metaphoricity in which *everything* has become a "space" (Foucault is the clear villain of this piece). Mere interpretations of spatiality overemphasize a symbolic "reading" of what is, primarily and always, a lived relation. He further argues that the fragmentation of space is the product of a mental "division of labor" that only sustains "the subjection" to state power. A more effective understanding of space would resist the fragmentation of this multitude of competing "spaces," while reinscribing the relationship between space, social organization, and modes of production. Lefebvre imagines what such a "science of space" might yield: aside from this reification of existing power relations, "it embodies at best a technological utopia, a sort of computer simulation of the future, or of the possible, within the framework of the real—the framework of the existing mode of production. ... The technological utopia in question is a common feature not just of many science-fiction novels, but also of all kinds of projects concerned with space, be they those of architecture, urbanism or social planning."[79]

For Lefebvre the condition of space always exists in relation to the mode of production, and new modes produce new spaces. The rise of trade in Greece was bound to the emergence of urban space, which in turn supplied the conditions for the emergence of philosophy. The rationalist spaces of the industrial era worked invisibly to sustain an economic system (see Dickens's *Hard Times*). But that rationalism was no permanent condition: "The fact is that around 1910 a certain space was shattered. It was the space of common sense, of knowledge, of social practice, of political power ...; the space, too, of classical perspective and geometry, developed from the Renaissance onwards on the basis of the Greek tradition (Euclid, logic) and bodied forth in Western art and philosophy, as in the form of the city and town." Lefebvre concludes: "Euclidean and perspectivist space have disappeared as systems of reference, along with the other former 'commonplaces' such as the town, history, paternity, the tonal system in music, traditional morality, and so forth." The emergence of modernism was thus "truly a crucial moment"(25).

Two propositions of Lefebvre's are relevant to comprehending the spatiality of postmodernism: first, natural space is disappearing; despite frantic and belated efforts to protect it, it "is also becoming lost to *thought*." One correlate is that society produces space, but Lefebvre goes further: "each society offers up its own peculiar space, as it were, as an 'object' for analysis and overall theoretical explication. I say each society, but it would be more accurate to say each mode of production"(30).

Lefebvre tells us that "the shift from one mode to another must entail the production of a new space"(46). A new spatiality connected to changes in the mode of production—we are ready to consider the new space of the present: "Cyberspace ... a word, in fact, that gives a name to a new stage, a new and irresistible development in the elaboration of human culture and business under the sign of technology."[80] Cyberspace is clearly a *produced* space that defines the subject's relation to culture and politics. Like all such spaces, however, it

does not simply exist to be inhabited; space implies position and negotiation. Lefebvre: "all 'subjects' are situated in a space in which they must either recognize themselves or lose themselves, a space which they may both enjoy and modify. In order to accede to this space, individuals (children, adolescents) who are, paradoxically, already within it, must pass tests"(35). Case, the cowboy, enjoys jacking in maybe a little too much ("And somewhere he was laughing, in a white-painted loft, distant fingers caressing the deck, tears of release streaking his face" [*Neuromancer*, 52]), and his job as a cybernaut (a pilot) involves constant feedback between self and space. Flynn, the hacker-hero of *TRON* may look like an adult, but he acts like an adolescent; he even owns a videogame parlor, a space almost ridiculously apposite to Lefebvre's analysis (and if the protagonists are adult, the *audience* is often adolescent). Michael Benedikt writes that "cyberspace's inherent immateriality and malleability of content provides the most tempting stage for the acting out of mythic realities."[81]

A standing joke about cyberspace is that, in an era of ATMs and global banking, *cyberspace is where your money is*. So cyberspace is a financial space, a space of capital; it is a social space; it is responsive; it can be modified; it is a place of testing and the arena for new technological rites of passage (Tomas). In these regards at least, cyberspace fulfills the conditions of spatiality as propounded by Lefebvre. Whether a real space or a "consensual hallucination," cyberspace produces a unified experience of spatiality, and thus social being, in a culture that has become impossibly fragmented. On the other hand, we should note that cyberspace is "a technological utopia, a sort of computer simulation of the future, or of the possible, within the framework of the real—the framework of the existing mode of production."

The passage of the subject into the pixels and bytes of "invisible" terminal space addresses the massive redeployment of power within telematic culture. In the context of a lost public sphere and an altered mode of production, cyberspace becomes the characteristic spatiality of a new era. In the context of cybernetic disembodiment, rooted in nanoseconds of time and imploded infinities of space, cyberspace addresses the overwhelming need to reconstitute a phenomenal being. This occurs first through a revelatory act of visualization, in a movement that both decenters and recenters the subject in a manner aptly described by Merleau-Ponty: "the proper essence of the visible is to have a layer of invisibility in the strict sense, which it makes present as a certain absence."[82] He has theorized that in every act of vision there remains something unseen, or which otherwise marks this vision as incomplete, and this marks the existence of an objectively "real" world that exists independent of perception and cognition. Thus the otherness of cyberspace abides as an ultimately *defining* metaphor, an attempt to recognize and overcome the technological estrangements of the electronic age, and a preliminary attempt to resituate the human as its fundamental force. "Vision alone makes us learn that beings that are different, 'exterior,' foreign to one another, are yet absolutely together, are 'simultaneity.'"[83]

Notes

1 Robert Smithson, "Entropy and the New Monuments," in *The Writings of Robert Smithson*, ed. Nancy Holt (New York: New York University Press, 1979), 10.
2 Fredric Jameson, *Postmodernism, or, The Cultural Logic of Late Capitalism* (Durham, NC: Duke University Press, 1991), 53.
3 Smithson, "Entropy," 12.
4 Smithson, "Entropy," 11.
5 Michael Sorkin, "Introduction," in *Variations on a Theme Park: The New American City and the End of Public Space* (New York: Noonday Press, 1992), xiv.

6 William Sharpe and Leonard Wallock, "From 'Great Town' to 'Nonplace Urban Realm': Reading the Modern City," in *Visions of the Modern City: Essays in History, Art, and Literature*, ed. William Sharpe and Leonard Wallock (New York: Hayman Center for the Humanities, 1983), 7.

7 Melvin M. Webber, "The Urban Place and the Nonplace Urban Realm," in *Explorations into Urban Structure*, ed. Melvin M. Webber *et al.* (Philadelphia: University of Pennsylvania Press, 1964), 89.

8 Fredric Jameson, "Science Fiction as a Spatial Genre: Generic Discontinuities and the Problem of Figuration in Vonda McIntyre's *The Exile Waiting*," *Science Fiction Studies* 14, no. 1 (1987) 54.

9 Melvin M. Webber, "The Urban Place and the Nonplace Urban Realm," in *Explorations into Urban Structure*, ed. Melvin M. Webber *et al.* (Philadelphia: University of Philadelphia Press, 1964).

10 Brian Stableford, "Cities," in *The Science Fiction Encyclopedia*, ed. Peter Nicholls (Garden City, NY: Doubleday, 1979), 120.

11 Stableford, 120.

12 See, in addition to the volume by Sharpe and Wallock, the writings of Robert Venturi or Charles Jencks, or *The Image of the City* by Kevin Lynch. For the city in SF cinema, see Vivian Sobchack, "Cities on the Edge of Time: The Urban Science Fiction Film," *East–West Film Journal* 3, no. 1 (1988), 4–19.

13 Jameson, *Postmodernism*, 81.

14 Paul Virilio, "The Overexposed City," *ZONE* 1/2 (1984), 21.

15 The IMAX screening rooms around the country, but especially at the Smithsonian Institute's Air and Space Museum in Washington D.C., have such sharply raked floors that it is possible to sit halfway up the screen, as it were. In films about flight or space travel, the experience of weightless suspension is extraordinary.

16 Raoul Vaneigem, "Basic Banalities," in *Situationist International Anthology*, ed. Ken Knabb (Berkeley, CA: Bureau of Public Secrets, 1981), 128.

17 J. G. Ballard, "The Concentration City," in *The Best Short Stories of J. G. Ballard* (New York: Holt, Rinehart, and Winston, 1978), 1–20.

18 The former was originally scripted by John Wagner and was most effectively drawn by Brian Bolland and Mike McMahon. *Ranxerox* is by Tanino Liberatore (art) and Stefano Tamburini.

19 Moebius, "The Long Tomorrow," in *The Long Tomorrow and Other Science Fiction Stories*, ed. Jean-Marc Lofficier and Randy Lofficier (New York: Marvel Entertainment Group, 1987); Moebius, *The Incal*, ed. Jean-Marc Lofficier and Randy Lofficier (New York: Marvel Entertainment Group, 1988), 3 vols. Moebius has extensive connections to science fiction cinema: both works cited were produced in collaboration with filmmakers: the former with Dan O'Bannon, scripter of *Dark Star* (1974) and *Alien* (1979), and the latter with Alexander Jodorowsky. In addition, Moebius contributed costume designs to both *Alien, Tron*, and *The Abyss* (1990).

20 The series ends, six books later, with a repetition of the same image, constructing a temporal as well as a spatial looping.

21 Jameson, "Science Fiction as a Spatial Genre," 54.

22 Fredric Jameson, "Progress vs. Utopia; or, Can We Imagine the Future?" *Science Fiction Studies* 9, no. 2 (1982), 152.

23 "We thus need to explore the proposition that the distinctiveness of SF as a genre has less to do with time (history, past, future) than with space" (Jameson, "Science Fiction as a Spatial Genre," 58).

24 See, for example, Giuliana Bruno, "Ramble City: Postmodernism and *Blade Runner*," *OCTOBER* 41 (1987) and Vivian Sobchack, *Screening Space: The American Science Fiction Film, 2nd ed.* (New York: Ungar, 1987).

25 James Verniere, "Blade Runner," *Twilight Zone Magazine* 2, no. 3 (1982).

26 Eric Alliez and Michael Feher, "Notes on the Sophisticated City," *ZONE* 1/2 (1984), 49. To my mind, the authors are less successful in adapting to *Blade Runner* Virilio's thesis regarding the usurpation of surveillance by simulation.

27 The work has been collected in Angus McKie, *So Beautiful and So Dangerous* (New York: Heavy Metal Communications, 1979). McKie also produced paintings for *Crystal Gazing*, a film by Peter Wollen and Laura Mulvey. McKie's striking book covers have been widely reprinted and are on display, along with work by Chris Foss and other contemporaries, in two fictional illustrated

"histories" of the future: Steward Cowley, *Spacecraft: 2000–2100 A.D.* (Seacaucus, NJ: Chartwell Books, 1978), and Stewart Cowley and Charles Herridge, *Great Space Battles* (Seacaucus, NJ: Chartwell Books, 1979). Further illustrations by Foss, who contributed spaceship designs to *Alien*, can be found in his own future "history": Chris Foss, *Diary of a Spaceperson* (Surrey, England: Paper Tiger, 1990).

28 Gert Elienberger, "Freedom, Science and Aesthetics," in *The Beauty of Fractals*, ed. Heinz-Otto Peitgen and Peter H. Richter (Heidelberg: Springer-Verlag, 1986), 179.

29 James Gleick, *Chaos* (New York: Viking Books, 1987), 117.

30 Maurice Merleau-Ponty, "Eye and Mind," trans. Carleton Dallery in *The Primacy of Perception*, ed. James M. Edie (Chicago: Northwestern University, 1964), 186.

31 Gleick, 117.

32 Jean Epstein, "Magnification and Other Writings," *OCTOBER* 3 (1976): 9–25.

33 *Blade Runner* was rereleased in 1992 in a "director's cut" that eliminated the irritating voiceover and thereby improved the film immensely. See Scott Bukatman, "Fractal Geographies," *Artforum International* 31:4 (December 1992): 6–7.

34 There is, in cyberpunk, no shortage of references to the artworks and primary figures of surrealism: in *Angel Station* by Walter Jon Williams, the main character is named Ubu Roy; Cornell boxes are prominent in Gibson's *Count Zero*; Burroughs is quoted in John Shirley's *Eclipse Corona*; in *Neuromancer*, Case stumbles upon Duchamp's "Bride Stripped Bare" glass; a chapter in Richard Kadrey's *Metrophage* is titled "The Exquisite Corpse"; a punk band plays an ode to "Guernica" in the same novel; and Ballard's fiction is, of course, rife with references to Ernst, Breton, and Dali. According to cyberpunk, it seems that a major surrealist revival can be expected in the early part of the twenty-first century.

35 *TRON* is discussed in chapter 3 of *Terminal Identity*.

36 Michael Moorcock, ed., *New Worlds: An Anthology* (London: Flamingo Books, 1983), 16.

37 This account of allegory is elaborated in Walter Benjamin, *The Origin of German Tragic Drama*, trans. John Osborne (London: New Left Books, 1977).

38 Fred Pfeil, "These Disintegrations I'm Looking Forward To," in *Another Tale to Tell: Politics and Narrative in Postmodern Culture* (London: Verso, 1990), 85.

39 Pfeil, 86.

40 Pfeil, 84.

41 Christopher Johnston, "Remember Timothy Leary?," *Village Voice Fast Forward*, November 25, 1986, 11.

42 Rudy Rucker, "Report from Silicon Valley," *Science Fiction Eye* 1, no. 4 (1988), 23.

43 Jay Stevens, *Storming Heaven: LSD and the American Dream* (New York: Harper & Row, 1987), 29.

44 Norman Spinrad, "The Neuromantics," *Issac Asimov's Science Fiction Magazine*, May 1986, 184.

45 Bruce Sterling, "Preface," in *Mirrorshades: The Cyberpunk Anthology*, ed. Bruce Sterling (New York: Arbor House, 1986), viii–ix.

46 Larry McCaffery, "Cutting Up: Cyberpunk, Punk Music, and Urban Decon-textualizations," *Storming the Reality Studio: A Casebook of Cyberpunk and Postmodern Fiction*, ed. Larry McCaffery (Durham, NC: Duke University Press, 1992), 288.

47 Sterling, "Preface," xi.

48 William Gibson, "The Gernsback Continuum," *Burning Chrome* (New York: Arbor House, 1986).

49 Science fiction often coexists with other genres: there are science fiction Westerns (*Outland, Andromeda Gun*), science fiction war stories (*The Empire Strikes Back, Starship Troopers*), science fiction fantasies (*Star Wars, Hiero's Journey*), and even science fiction pornography (*Flesh Gordon, Cafe Flesh*, John Norman's Gor novels). Obviously there is an extensive overlap between the genres of science fiction and horror.

50 Roland Barthes, *S/Z*, trans. Richard Miller (New York: Hill and Wang, 1974) 75–6, 84–8.

51 Dennis Porter, *The Pursuit of Crime: Art and Ideology in Detective Fiction* (New Haven: Yale University Press, 1981), 24–52.

52 Brian Stableford and Peter Nicholls, "Crime and Punishment," in *The Science Fiction Encyclopedia*, ed. Peter Nicholls (Garden City, NY: Doubleday, 1979), 144.

53 The *Encyclopedia* is also correct in pointing out that Isaac Asimov was one of the few writers to *consistently* combine the forms of science fiction and the "classic" detective story, although one would certainly also cite Poe and Chesterton as important progenitors (of both genres).

54 Fredric Jameson, "On Chandler," in *The Poetics of Murder: Detective Fiction and Literary Theory*, ed. Glenn W. Most and William W. Stowe (New York: Harcourt Brace Jovanovich, 1983), 131.

55 Jameson, *Postmodernism,* 89.

56 The surrealism of cyberpunk is explored in chapter 4 of *Terminal Identity*.

57 John Clute, "Introduction," in *Interzone: The Second Anthology,* ed. John Clute (New York: St. Martin's Press, 1987), viii.

58 See Istvan Csicsery-Ronay, Jr. "Cyberpunk and Neuromanticism," in *Storming the Realtiy Studio* (Durham, NC: Duke University Press, 1992), 184, for a hilarious template for a cyberpunk narrative.

59 Mike Davis, *City of Quartz* (New York: Vintage Books, 1991), 229. A similarly negative view of contemporary urbanism is found in Michael Sorkin's *Variations on a Theme Park*.

60 Ross contrasts the burnt-out future metropoles of cyberpunk (and its music video inheritors) with "the hip-hop aesthetic" of *real* urban residents who bring "color, style and movement … transforming bleak back-drops drops by graffiti that speaks to the act of creative landscaping." Andrew Ross, "Cyberpunk in Boystown," in *Strange Weather: Culture, Science, and Technology in an Age of Limits* (London: Verso, 1991), 144. It has been a *long* time since hip-hop has been this thoroughly romanticized. It is as though Ross has never heard of gangster rap, which operates by a rather different set of aesthetic principles.

61 David Tomas, "Old Rituals for New Space: 'Rites of Passage' and William Gibson's Cultural Model of Cyberspace," *Cyberspace: First Steps*, ed. Michael Benedikt (Cambridge, MA: MIT Press, 1991), 33.

62 Allucquere Rosanne Stone, "Will the Real Body Please Stand Up? Boundary Stories About Virtual Cultures," *Cyberspace: First Steps*, ed. Michael Benedikt (Cambridge, MA: MIT Press, 1991), 95.

63 In conversation, January 30, 1991.

64 This last term is borrowed from the rock group, demonstrating Gibson's eclecticism.

65 Jameson, *Postmodernism,* 84.

66 Michael Herr, *Dispatches* (New York: Avon Books, 1978), 8.

67 Jameson, *Postmodernism,* 81.

68 Thomas Disch, "Lost in Cyberspace," *New York Times Book Review*, November 6, 1988.

69 One also notes the echoes of Pynchon's opening sentence in *Gravity's Rainbow*: "A screaming comes across the sky." In both, nature is redefined by the presence of technology.

70 There is a similar scene in *20 Minutes into the Future*.

71 Sobchack, *Screening Space*, 234.

72 Stewart Brand, *The Media Lab: Inventing the Future at MIT* (New York: Viking Penguin), 139. See also Howard Rheingold, *Virtual Reality* (New York: Summit Books, 1991) for a thorough overview of cyberspace's prehistory.

73 J. David Bolter, *Turing's Man: Western Culture in the Computer Age*, (Chapel Hill, NC: University of North Carolina Press, 1984), 98.

74 Bolter, 93.

75 Merleau-Ponty, "Eye and Mind," 178.

76 William Gibson, *Mona Lisa Overdrive* (New York: Bantam Books, 1988), 13.

77 William Gibson, "Introduction," in *Neuromancer: The Graphic Novel*, ed. David M. Harris (New York: Epic Comics, 1989).

78 Scott Rockwell and Darryl Banks, *Cyberpunk* (Wheeling, W.V.: Innovative Corporation, 1989); Mike Saenz, *IRON MAN: CRASH* (New York: Marvel Entertainment Group, 1988); Pepe Moreno, *Batman: Digital Justice* (New York: DC Comics, 1990); Tom DeHaven and Bruce Jensen, *Neuromancer: The Graphic Novel* (New York: Epic Comics, 1989). In the *Neuromancer* adaptation, the cyberspace is a cool blue, peppered with the solid geometrical "clusters and constellations of data;" it is, ironically, also more solidly rendered, more photographic in its detail, than the overview of the BAMA urbanscape which looks like a production drawing from *Blade Runner* (Japan's *Akira* [Katsuhiro Otomo]—comic book and 1988 animated film—also depicts this vertically impacted, post-*Blade Runner* urbanism, but with a more hyperbolized hyperrealism).

79 Henri Lefebvre, *The Production of Space*, trans. Donald Nicholson-Smith (Oxford: Blackwell, 1991), 9. This paragraph has relied on 7–9.

80 Michael Benedikt, "Introduction," *Cyberspace: First Steps*, ed. Michael Benedikt (Cambridge, MA: MIT Press, 1991), 1.

81 Benedikt, 6. Allucquere Rosanne Stone and David Tomas also take anthropological approaches. See Stone, "Will the Real Body Please Stand Up? Boundary Stories About Virtual Cultures," *Cyberspace: First Steps*, ed. Michael Benedikt (Cambridge, MA: MIT Press, 1991), 81–118; and Tomas, "Old Rituals for New Space."

82 Merleau-Ponty, "Eye and Mind," 187.

83 Merleau-Ponty, "Eye and Mind," 187.

Paul Virilio
Red alert in cyberspace!

ONE OF THE MAJOR PROBLEMS NOW facing political as well as military strategists is the phenomenon of immediacy, of instantaneity. For 'real time' now takes precedence over real space, now dominates the planet. The primacy of real time, of immediacy, over space is an accomplished fact, and it is an inaugural one. A recent advert for cell phones expressed it well enough: 'The earth has never been so small.' This development has the gravest consequences for our relation to the world, and for our vision of it.

There are three barriers: sound, heat and light. We have already crossed the first two – the sound barrier with supersonic and hypersonic aircraft, the heat barrier with rockets which can lift a man out of the earth's atmosphere and land him on the moon. We do not cross the third barrier, the light barrier; we collide with it. And it is this barrier of time that history now faces. The fact of having reached the light barrier, the speed of light, is a historic event, one which disorients history and also disorients the relation of human beings to the world. If that point is not stressed, then people are being disinformed, they are being lied to. For it has enormous importance. It poses a threat to geopolitics and geostrategy. It also poses a very clear threat to democracy, because democracy was tied to cities, to *places*.

Having attained this absolute speed, we face the prospect in the twenty-first century of the invention of a perspective based on real time, replacing the spatial perspective, the perspective based on real space, discovered by Italian artists of the quattrocento. Perhaps we forget how much the cities, politics, wars and economies of the medieval world were transformed by the invention of perspective.

Cyberspace is a new form of perspective. It is not simply the visual and auditory perspective that we know. It is a new perspective without a single precedent or reference: a *tactile perspective*. Seeing at a distance, hearing at a distance – such was the basis of visual and acoustic perspective. But touching at a distance, feeling at a distance, this shifts perspective into a field where it had never before applied: contact, electronic contact, tele-contact.

The development of information superhighways confronts us with a new phenomenon: disorientation. A fundamental disorientation which completes and perfects the social and

financial deregulation whose baleful consequences we already know. Perceived reality is being split into the real and the virtual, and we are getting a kind of stereo-reality, in which existence loses its reference points. To be is to be *in situ* here and now, *hic et nunc*. But cyberspace and instantaneous, globalized information are throwing all that into total confusion. What is now underway is a disturbance of the perception of the real: a trauma. And we need to concentrate on this. Because no technology has ever been developed that has not had to struggle against its own specific negativity. The specific negativity of information superhighways is precisely this disorientation of alterity, of our relation to the other and to the world. It is quite clear that this disorientation, this 'de-situation', will bring about a profound disturbance with consequences for society and, in turn, for democracy.

PART TWO

Popular cybercultures

Barbara Kennedy

INTRODUCTION

SINCE OUR ENCOUNTERS in the first edition of *The Cybercultures Reader* with the technological guru Zike in the film *Sliver* (1993), whose incipient, insouciant and contradictory behaviours saw him as the ultimate 'controller' of new technologies, contemporary popular cultures have been replete with techno/cyber narratives and machinic manisfestations of the monstrous. Films like Spielberg's *AI* (2001) explore the human/robot child and the psychoanalytic interpretations of mother/child relationships, offering a confrontation with the human notions of 'love' in a posthuman age. *Casino Royale* (2006) more recently brought renewed fear of the 'other', a prescient reminder of the reality of our experience. Recent news headlines have been full of the story of the Russian spy, Litvinenko, poisoned by traces of radioactive polonium. Reality and science fiction merge. On a lighter note, the film *Lost in Translation* (2003) gave a quirky and ironic look into the Japanese culture of miniaturisation and new technologies.

Film theory is now replete with a variety of academic strategies for exploring film; how it works, how it affects us as sensation, how it is much more than a representation of reality. Cyborgian reading strategies enable us to make a wide range of different readings of movies. (Kennedy 1999). From cyborgian reading strategies, to abstract machines and schizoanalytic readings taken from philosophy, cybertheory continues to infect its sister discourses, providing us with a totally technologised paradigm from which to consider, theorise and explore popular cultural texts. Once again popular cybercultures concentrate on the ways in which cyberculture and techno/machinic/digicultures have altered how we experience, read, play with, manipulate (just like Zike in *Sliver*) and enjoy popular cybercultural texts. As a film theorist, I deliberately utilize film texts through which to question, imitate, cajole and proliferate new engagements with cultural and philosophical theory. Indeed, the whole question of psychoanalysis has been distanciated through

a Deleuzian concern with material capture and abstract machinic assemblages, providing a formulation for a theory of *shizoanalytic* film theory. (Kennedy, 2000). Other film theorists have since taken this up to reconsider a wide range of film genres (Martin-Jones, 2006: Pisters, 2002; Powell, 2006). Žižek's more recent discussion in Sophie Fiennes' *The Pervert's Guide to Cinema* (2006) brings together a new range of post-psychoanalytic Lacanian readings imbricated in a cyborg assemblage with post-structuralist ideas and continental philosophy. Many have become impatient with what they perceive as pretentious outpourings and psycho-babble. Others enjoy the intellectual pleasures of film reading.

Print, comic books, video games, television and traditional popular cultural media are now joined by an overriding array of digital/mobile prostheses: cell phones, iPods and MP3s have now produced the *literal* cyborg in our midst. We have become consumers/readers/actants and cells of a shizoanalytic culture. TV images and digitally networked connections create more than hybridised human/computer cyborgs. There is a total immersion, not merely in our hallucinatory and hypnagogic spaces, but in our everyday RL experiences. (Why is it that each time I lecture, I still have to warn my students of the impending doom for their cell-phones, should they be spotted texting – or worse!) But texting has become yet another element of cybercultural identities, so much so that their impact upon contemporary debates in literacy is pertinent and timely. How much longer can we penalise our students for grammatical and literary mistakes when their own lived realities dictate new languages premised on sound bytes and digital configurations? Language systems diversify, diverge and destratify: all we are left with are the codes/algorithmic traces and distanciated 'selves'. The mobile phone or cell-phone is our ontology! Thus, I refuse and refute its use, and keep it only for personal safety and emergencies, much to the annoyance of my family who know I am never 'switched' on. But then I am switched on differently! I remain that strange (some have said crazy) immixture of cyborg/Luddite goddess (*well* – I can try). Popular cybercultures infiltrate, generate, infect and destratify our identities, our subjectivities, our bodies and our emotions. The questions we heard in the first edition of this Reader – What constitutes the body? What constitutes perception or consciousness? – are still critical questions, now seven years later inflected with new discourses from neuroscience, bioaesthetics, biotechnologies, and nanotechnologies (see Part Nine). Do we need to reconsider our selves, to re-negotiate a sense of subjectivity, to encounter the political, social and epistemological contradictions at play in popular cybercultures? Or is cyborg heteroglossia a space we can all shamelessly and hedonistically inhabit, wear and encode?

Cyberdiscourse parodies, challenges and disorientates Cartesian ideas (foundational Western metaphysical notions based on a logic of solids, and binarisms): male/female, mind/body, subject/object, nature/culture. Such theoretical vectors enable micro-political and contingent paradigms for thinking through meaning formations. How can such ideas have a bearing on popular cybercultures? The original manifestations of what Zoë Sofoulis refers to as 'male' cyborgs are still lurking in the depths of Mark Oehlert's work. 'From Captain America to

Wolverine: Cyborgs in Comic Books – Alternative Images of Cybernetic Heroes and Villains' still holds relevance in a new millennium. In an ironic move, it might now be especially pertinent to our 'new' James Bond (aka Daniel Craig) to remember his origins, replete with Edenic connotations.

Oehlert takes us back to early cyborgian figures, which he categorises into simple controller, bio-tech originator and genetic cyborg archetypes, giving a straight historical narrative around these categories. He goes back to the 1930s, to the original Superman of 1938, a prescient precursor to contemporary Bond: a western, white and masculinist icon, epitomized in wartime by Captain America. The language and semiotics surrounding this early comic book period is replete with militarised, masculine, command-control language with a clearly binary perception of good versus evil and propagandist narratives. Indeed, early cyborg heroes fought against the terrors of Nazism. Later Cold War politics moved narratives away from Germany and Japan to Russia and China. In a contemporary 'switch' they become yet again the contagious cultures of our technological landscapes. Recent media coverage has conveyed the fears, anxieties and hybridized concerns of infiltration, coercion, contamination and viral contagion from bio-pharmacogenetic/radioactive poisoning. At this moment in time London's latest terror alert lies not in the terrorist atrocities of mainstream weapons, but in the more sinister, covert technologies of polonium traces: leaky boundaries – volatile and personal implosions. London's fear and horror at the 2005 London bombings, and of course New York's 9/11, reverberate with newly-configured fears of internal disasters. These are personal spaces contaminated; subjectivities eradicated, bodies eviscerated. The political, biological, cultural and theoretical implications of the polonium poisonings have reverberated across continental divides. Europe's post Cold War politics begins to erode through bio-technological warfare. Economic and financial 'controllers' manipulate an infrastructure which no longer maintains any political leadership and control. Narratives, like those of Captain America, explore fear and abjection – a concern with the 'other', its proliferation, now a concern with the abject through the internal bio-chemical warfare of 21st century biotechnologies. The comic book 'cyborg' of Oehlert's article in the 21st century has become an even more complex bio-technological machine, one which can eviscerate as much as liberate. Cyborgian characteristics are no longer constrained to be technical or material, but also embrace the genetic, the molecular and the viral. This current example of radioactive poisoning demonstrates how 21st Western culture is manifestly suffocating with biological, technological and genetic infiltrations. Philosophical outpourings on assemblage, hybridity and complexity have a focussed dimension in our every day 'lived' realities; get real? This *is* real. Popular cultural texts, especially films, are now manifestations of a real/virtual assemblage.

No longer the stuff of science fiction, films continue to assemble our millennial realities. In David Tomas's article 'The Technophilic Body: on Technicity in William Gibson's Cyborg Culture', philosophy, cultural theory and technoscience come together in a bio/techno/eroticism of current critical theory. Tomas collides ideas from these discourses in his discussion of 'traditional' written cyberpunk stories by Gibson. He concentrates on an exploration of potential post-industrial techno-

dystopian cultures. In these spaces the human sensorium is imbricated with a variety of collective biotechnological prostheses, thus creating new hybrids of machinic assemblage. The technophilic body reverberates through the Reader (see also Stelarc and Orlan in Part Six). Aesthetic manipulations of the body are technologies of transformation from human to posthuman; functional alteration to humanoids alter the body's organic architecture. New devices, for example that enhance hearing, that regulate heart beats, may include bio-chip implants and myoelectric circuiting. Heart and brain surgery particularly utilize these procedures. Such reterritorializing of the body's rhythms and social and cultural forms mobilize new constitutions of social identity, ethnicity and gender, enabling resistance, transgression and indeed even life enhancement and longevity.

The next chapter provides an important digression into Japanese cybercultures. *Lost in Translation*, as I mentioned earlier, projects a contemporary Oriental culture fabricated and fashioned through miniaturisation. Ironic distanciation and parody in the narrative, dialogue, *mise-en-scene* and musical score of the film all work to convey such clichés. But Todd Holden and Takako Tsuruki's article on 'Deai-kei: Japan's new culture of encounter' explores the techno-euphoria that scintillates their metropolis. *Deai* is a new, mediated type of social encounter, and Holden and Tsuruki explain how in Japan this form of encounter is strongly connected to romantic liaisons, dating, sexuality and companionship. Inevitably, this has often caused complaints of abuse and manipulation by those with power. But the whole *deai* culture in Japan has taken on a much broader emphasis than our preconceived notions of seediness and the salacious. Indeed, many positive outcomes have resulted from such Internet encounters. Their article considers questions of identity formation and play, subjectivity, emotions and intimacy. To the Japanese, the cell phone is not just a means of communication, but a vital technological prosthesis to the Internet. Most use cell-phones which are Internet ready and geared for mobile connectivity to the Internet. *Deai*, as Holden and Tsuruki explain is in fact a forum for exchange and it is accessed through cell phones or 'keitai'. The Internet forms of keitai are more commonly known as i-modo, which has now become the most commonly used format for Internet connection in Japan. The article argues that despite the many negative and notorious stories surrounding the more scandalous uses of *deai,* in fact there has been an array of beneficial outcomes for people (for example in remote farming communities where people have been freed up from laborious hours of labour). Debates regarding the stigma of using *deai-kei* and the more outrageous myths surrounding it are offset by a series of similar examples and evidence. Despite the more controversial uses, we also hear of hobbyists who indulge in things like bird watching, hiking etc and groups like the physically disabled utilizing *deai-kei* positively and with enthusiasm. In a connective chapter in this collection, Adriana de Souza e Silva (Part Nine) discusses the fascinating notion of hybridized spaces created through mobile usage of Internet-ready cell phones. Because *deai* is invisible and anonymous, Holden and Tsuruki argue that it provides a greater degree of interiority and opportunity for a sense of 'individuation' and thus a stronger sense of identity, whilst also allowing a space for identity play and multiplicity. Illustrations and delicate

connections to nature's scenery provide users with iconic images or tokens of emotional feelings, thus providing for some a courage not previously experienced when dealing in relationship engagements. Once again, however, such technical icons are waiting to be misused, and trust disappears again. Nothing changes; it seems once a physical sexual encounter ensues, then man does nothing but retreat in fear! Or is it merely a fickle and faltering belief and rejection of his own desires? Technology does nothing to change a time-trodden tale of temerity and cowardice. It is still the female who suffers the devastation. Giddens, as Holden and Tsuruki argue, believes that modern societies seem to need a greater degree of expression of intimacy. Consequently, a culture like Japan is ripe for such experimentations with the new 3G cell phones. Referring throughout to a range of social theorists from Giddens, Berger, Appadurai, Kogawa, Simmel to Durkheim, the article covers a range of sociological and cultural theories around globalization and modernity. In their concluding section Holden and Tsuruki recall Baudrillard, writing that 'Embodiment has been engineered for the medium. This is Baudrillard's simulation incarnate; artifice that eventuates in the 'hyperreal', people who are different, but 'realer' than their originals'. Mobile phones do much more than connect us to others.

The next reading is Bob Rehak's 'Mapping the Bit Girl: Lara Croft and New Media Fandom', which looks at the fan movement surrounding Lara Croft, a computer-generated avatar and character 'who has appeared in computer games, comic books, men's magazines, promotional tours, music videos, calendars, action figures and motion pictures'. A typical icon of female sexuality, Lara displays all the tropes of stereotypical adolescent (and *not* so adolescent!) male sexual fascination, fantasy and fabulation: long slender thighs, slim physique, tight, lycra, body-hugging clothing, but most importantly voluminous breasts! (Jealous or what!) The fact that she is also a tough and invulnerable cookie makes her even more a male sexual icon. They like nothing less than the vulnerable fragility of the female. Such contradictions! Within every fragile female creature lies an indomitable strength, which they have yet to acknowledge. As such Lara operates as a nexus of technological, social, cultural and economic forces. Fandom has been written about prolifically within media studies, and Lara joins a host of other female icons which have displayed significant sexual tropes encouraging specific fan bases. But she has become more than an icon of cybercultures, and has come to symbolise our contemporary postmodern mediascape. The assemblage of audiences, texts and cybertechnologies is focussed through the icon that is Lara Croft. It has only been in more recent times (since the nineties) that we have witnessed this new software generated character of cyberculture, a cyborgised and computer mediated sex symbol straight from Hollywood narratives and indeed Hollywood sets like those of George Lucas's *Indiana Jones* (1984).

But traditional notions of 'fandom', 'audience' and texts' are, argues Rehak, challenged by this new phenomenon. Persistent and redolent debates on representations of gender obviously continue to surface in debates around Lara Croft. Laura Mulvey's 1975 article, 'Visual Pleasure and Narrative Cinema' may have been written some thirty years ago, but her ideas find, once again,

significance to the representation that is Lara Croft. Feminist re-appropriations of such an image seek to address notions of female empowerment through these new manifestations of the powerful 'woman' (Kennedy 2002). But Lara's appearance in a range of different multi-media practices has enabled some to argue that she functions in a different way from the merely sexual icon. Rehak argues that her appearance in things like videogames and new media has allowed for more transgressional uses of her image. His link to our next article by media academic Lev Manovich refers us to a range of new media studies debates around concepts like modularity, automation and *transcoding* (new media's translation of information through cultural and technological vectors of exchange). Rehak gives us an historical account of the development of this icon from its origins in games technology for male combat pleasures to a migratory role in advertising campaigns by Nike. Her polysemous perversity allows a wide range of different readings and significations. As Poole argues:

> She'll never be thoroughly realistic. For Lara Croft is an abstraction, an animated conglomeration of sexual and attitudinal signs (breasts, hotpants, shades, thigh holsters) whose very blankness encourages the male or female player's psychological projection and is exactly why she has enjoyed such remarkable success as a cultural icon. A good videogame character like Lara Croft or Mario is, in these ways, inexhaustible.
>
> (Poole 2000: 153)

She becomes an interesting trope for the current synergizing and convergence of new media synthetic fabulations in contemporary cultures, particularly those based on digitality. Similar fabricated fabulations occur in current media reality TV shows in the UK where characters/people are manipulated and cajoled into a range of confrontational behaviours for the benefit of media profit. The cross over into real life becomes dangerously electric, as we have seen at the time of writing claims of outrageous racism debated on the UK reality TV show *Celebrity Big Brother*. But this is a show which uses real people, whose lives can be dangerously and adversely affected by their participation. Lara suffers no such notorieties.

The final essay in this section is one which resonates with Rehak's discussions of transcoding: Lev Manovich's 'From DV Realism to a Universal Recording Machine'. Here Manovich discusses the movie by Mike Figgis, *Timecode* (2000), his overall argument contending that there is an immixture of traditional cinematic codings, video surveillance strategies and digital aesthetics at work here. The overarching question is: does this remain cinema or are we in the territory of new media? The film has resonances with *Sliver* in the way in which it plays around with framing devices, synonomous narratives and scopic processes of both spectator and screen personae. Cinema is now moving quickly towards a new media age where CGI (Computer Generated Imagery) enables the manipulation of a wide range of special effects, thus projecting different space/time and character configurations. *Pirates of the Caribbean* (2003), for example, owes much to the wonders of CGI – as of course do so many films these days. All aspects of production, from pre-

production to post-production are heavily inflected by digital configurations and digital editing processes. Computers become the new studios where even 'dead' actors from times past hold the potential to act once again through the magic of digitalisation.

Manovich provides us with an historical account of the developments of technologies within the media industries, and of their effects. He questions concepts like reality and representation, offering new interpretations of a new reality created through computer technologies but also offering a view on new aesthetics, or a rethinking of aesthetics that emerge from the use of such technologies. New media, he believes, reconfigure moving images in new and different formulations, which his work in *The Language of New Media* (2002) details. And once again it is the concept of hybridity that seems to provide a significant characteristic within digital work. Cinema is now fast becoming a hybrid of both animation and cinematography, as we see in *Pirates of the Caribbean* and blockbusters like *Jurassic Park* (2001). But maybe the uniqueness of new media has been overplayed? Manovich offers us comparison with some older formats, dismissing the originality of the 'immediacy' of new media effects and processes. Comparing cinema with gaming, he concludes that our realities and experiences no longer need to be sampled as in the past, but can be provided as a continuum. Time is endless and not fixed, working in ways beyond linear timecodings. This provides opportunities for artists to experiment with the aesthetics of movement (See Kennedy in Part Nine). Subjectivity and human experience can be explored in new ways through digital technologies and we shall see throughout the rest of the Reader how some artists do this. Manovich contextualises DV realism by comparing it with international film movements from the 1960s, when *Cinéma Vérité* involved filmmakers using lighter and mobile equipment to literally follow and track the actors. It was a revolutionary form of cinema in much the same way that digital technologies now impact upon filmmaking. In both, the concept of 'immediacy' Manovich suggests, has been crucial. He traces this concern with 'immediacy' back to historical roots in the history of cinema and also positions the debate in relation to television and specifically reality TV. His overriding claim is that creativity merged prior to digital technologies, and that so-called new aesthetics have an historical base and conception of creativity within traditional film formats and so are not necessarily driven by new technologies themselves. Manovich proceeds to locate his ideas within the debates on video surveillance, depicting *Timecode* as an aesthetic experiment hybridizing new technologies and surveillance mechanisms. Here telecommunications become a narrative strategy and an artistic device. In comparison with the aesthetics of special effect and DV realism, Manovich sets computer recording strategies as a more creative potential for new aesthetic possibilities. Computer programs, for example, may be able to assemble shot by shot in real time and therefore select from a range of archived materials, webcam transmissions or other areas of media representation. Is this really the cinema as we know it? Many, like film director Peter Greenaway, agree that the development of computer driven databases and technologies offer new

directions in exploring our experiences in ways which will render the cinema as we know it obsolete, as filmmakers become interface designers.

References

Kennedy, B. (1999) 'Postfeminist futures in film noir', in M. Aaron (ed.) *The Body's Perilous Pleasures*, Edinburgh: Edinburgh University Press.

Kennedy, B. (2000) *Deleuze and Cinema: The Aesthetics of Sensation*, Edinburgh: Edinburgh University Press.

Kennedy, H. (2002) 'Lara Croft: feminist icon or cyberbimbo? On the limits of textual analysis', *Game Studies 2*, online.

Manovich, L. (2002) *The Language of New Media,* Cambridge, MA: MIT Press.

Martin-Jones, D. (2006) *Deleuze, Cinema and National Identity*, Edinburgh: Edinburgh University Press.

Mulvey, L. (1975) 'Visual pleasure and narrative cinema,' in L. Mulvey (1989) *Visual and Other Pleasures*, London: Macmillan.

Pisters, P. (2003) *The Matrix of Visual Culture: Working with Deleuze in Film Theory*, Stanford, CA: Stanford University Press.

Poole, S. (2000) *Trigger Happy: Videogames and the Entertainment Revolution*, New York: Arcade.

Powell, A. (2006) *Deleuze and Horror*, Edinburgh: Edinburgh University Press.

Filmography

AI (2001) Steven Spielberg

Casino Royale (2006) Martin Campbell

Indiana Jones and the Temple of Doom (1984) Steven Spielberg

Jurassic Park (2001) Steven Spielberg

Lost in Translation (2003) Sofia Coppola

Pervert's Guide to the Cinema (2006) Sophie Fiennes

Pirates of the Caribbean: the Curse of the Black Pearl (2003) Gore Verbinski

Sliver (1993) Philip Noyce

Mark Oehlert

FROM CAPTAIN AMERICA TO WOLVERINE
Cyborgs in comic books: alternative images of cybernetic heroes and villains

CURRENT COMIC BOOK CYBORGS REVEAL much about how these characters are perceived. In addition to movies, comic books represent the most prevelant medium in which many children and adults are forming their impressions of cyborgian culture. One of the more interesting characteristics of this culture is the divisions that comic book cyborgs can be sifted into. These categories are, in order of increasing complexity, *simple controller*, *bio-tech integrator* and *genetic cyborgs*. Comic book cyborgs also expose some the psychological reactions that these characters evoke in us, ranging from a deep ambivalence towards violence and killing to issues of lost humanity and, finally, to new conceptions of the nature of evil.

From the 'Golden Age' to the 'Marvel Age'

Comic book cyborgs have a myriad of ancestors. The comic books that we know today can be traced to the 1930s, when Harry Donenfeld bought New Fun Comics from Major Wheeler-Nicholson.[1] Donenfeld's company would eventually become DC (Detective Comics) and would publish *Superman* in 1938. Marvel, the company that would come to dominate the comic book market, was also born during this time, the 'Golden Age' of comics (1939–1950).

This 'Golden Age' started at Detective Comics with the most well-known hero, Superman.[2] This first hero was not even from Earth, but was an alien and an illegal one at that. DC continued to dominate the early market with their release of *Batman* in 1939.[3] This time DC went to the other end of spectrum from Superman. Batman had no super powers and was the son of wealthy parents who had been slain in a mugging. The first 'cyborgian' hero appeared two years later, in 1941 when Marvel created the super-soldier Captain America.[4] Captain America's secret identity was Steve Rodgers, a 98-pound weakling who was rejected for army service until he was injected with a 'super-soldier serum'.[5] This hero's first villain was none other than Adolf Hitler. Another anti-Nazi, cyborg-like hero

was the Human Torch.[6] The original Torch was an android that was created in a lab and then rebelled against his creators. The Torch, like most of his comic book contemporaries, immediately went to work battling the Nazis.

After the Second World War and with the dawn of the Cold War, the emphasis of the comic book heroes shifted away from Germany and Japan to Russia and China: the title of *Captain America*'s comic book became 'Capt. America … Commie Smasher'.[7] While Captain America was fighting Soviet efforts, Marvel created a Chinese communist villain, known as the Yellow Claw, who dabbled in magic and had created a potion which would extend his life.[8] A multitude of other heroes and villains were created during this time, but these examples illustrate the fairly simplistic origins and conflicts that early characters were involved in. Stories would soon become much more revealing and complex.

Science plays a dominant role in the creation of both heroes and villains during the 'Marvel Age' (1961–1970).[9] In the *Fantastic Four*, a group of heroes are created by accidental exposure to radiation, a central theme in many of the comics of the time, for example in *The Hulk*, *Spider-Man* and *DareDevil*. This was a reflection of the public's fears concerning radiation in the aftermath of the War. This era also saw the creation of several characters that are discussed below, such as those found in the *X-Men*, *Dr. Doom* and *Iron Man*. The conflicts that these heroes and villains were involved in began to take on a more cosmic nature. Instead of defending the United States from communism, characters were now trying to save the entire planet.

From 1970 until 1990, comic books were awash with super-powered characters; the Marvel personas included the Swamp-Thing, Ghost Rider and the Punisher.[10] These characters not only fought larger external battles but they also began to deal with personal problems. An example of this 'realistic' superhero character development can be found in issue no. 128 of *Iron Man*, in which a powerful superhero is forced to come to grips with alcoholism.[11] This maturing of heroes brings the comic timeline to the present, which could be called the 'Cyborg Age', considering their ubiquitous presence. At the time of writing (1995), Marvel has the largest percentage of the comic market and the Marvel universe is a place replete with cyborgs.[12] Detective Comics, the second largest comic company, simply does not seem to have the same variety of cyborgs. No doubt there are many other comics with cyborgs, but the cyborgs which are covered in this chapter are among the most popular comic characters of the mid-1990s, and therefore make ideal subjects for analysis.

Latter-day cyborgs

Contemporary cyborg comic characters can be grouped into three broad categories: *simple controllers*, *bio-tech integrators* and *genetic cyborgs*. The rationale for these divisions can be found in the work of Chris Gray, in which the levels of integration are described as:

> 1) With informational interfaces including computer networks, human– computer communications, vaccinations and the technical manipulation of genetic information. 2) With simple mechanical–human relationships as with medical prosthesis, vehicle or weapon man–machine systems and more general human–tool integration. 3) With direct machine–human connections such as the military's state-of-the-art attempts to hard-wire pilots to computers in DARPA's 'pilot's associate' and the Los Alamos Lab's 'pitman' exoskeleton. Plans to 'download' human consciousness into a computer are part of this nexus as well.[13]

One thing that makes grouping characters into categories difficult is that many of the heroes and villains fit into multiple divisions, so for the purposes of this analysis the cyborgs are grouped by their primary system.

The first category of cyborg is the *simple controller* and can be divided into two subsets: implants and suits. These cyborgs are characterized either by the simplicity of their system or by its removability.

The simple controller

A perfect example of the simple controller/implant cyborg is a Marvel character known as Wolverine. He is a member of the mutant team, the *X-Men*, but his primary cyborg system is surgically attached metal. Wolverine was a Canadian mercenary who underwent a series of experimental operations in order for Canada to begin creating its own team of superheroes. His implants consist of the fictional metal adamantium grafted onto his skeletal structure with some very long, very sharp adamantium claws implanted in his hands.[14] With his mutant ability to heal in super-fast time combined with super-sharp senses and a berserker rage, Wolverine is a prime example of the newer, darker cyborg which populate current comics. One of Wolverine's most infamous enemies is also a wonderful illustration of the simple controller/implant type: Omega Red.

Omega Red is a creation of the old Soviet Union and when he was developed he so terrified his creators that they placed him in suspended animation.[15] While Omega Red is a powerful villain, he is also a cursed one. His cyborg structure is crafted with an artificial metal known as 'carbonadium' in order to prevent his 'death spore' affliction from killing him.[16] This affliction forces Omega Red to drain the life force from others in order to live. While he is not quite remorseful about this, it is a weakness that he would like to correct. Although his infection reflects a complicated biological problem, Omega Red's cyborg weapons are still fairly simple. He possesses cables that are similar to Wolverine's claws. These are grafted directly onto and into his nervous system and so are controlled by thoughts, a common cyborgian system. The final character in this category also governs his abilities by thought.

In the Image comic *StormWatch*, the United Nations sends teams of super-powered agents to various trouble spots to act as peacekeepers. The man who coordinates the many teams is code-named Weatherman One.[17] The Weatherman has the ability to 'consider huge amounts of data and to make quick, calm decisions' helped along by 'cybernetic implants which link his cerebral cortex directly to the SkyWatch computer net'.[18] The Weatherman is a classic simple controller/implant who utilizes cyber- technology in concert with the data-processing and decision-making ability of the human brain.

The next category is the simple controller/suit cyborgs, who represent the outermost layer of cyborg culture. These are cyborgs whose abilities are for the most part removable. They may possess some inherent powers but those powers are profoundly augmented by their technological additions.

The first and probably most well-known of this type is Marvel Comic's Iron Man, who debuted in 1963.[19] In Les Daniels' history of Marvel, he notes that Iron Man is not a cyborg simply because of the exo-suit that he wears but also because of his medical problems.[20] Daniels' recounts how Iron Man's armour is not just for battle, but was 'created to keep his damaged heart beating' and that a microchip was implanted to correct a later problem ensuring that 'even without his high-tech costume, Tony Stark is a mixture of

man and machine, what science fiction writers call a cyborg'.[21] Iron Man controls his suit via his thoughts and a cybernetic link. The armour has jets in the feet which allow it to fly, 'repulsor beams' that shoot from the palms of the hands and servo-mechanisms which greatly increase the wearer's strength. The suit is also modular and can be fitted with several different weapon packages, depending on what the mission may be.[22] A testament to Iron Man's continuing popularity is the fact that there is a spin-off comic based on a character that had to fill in as Iron Man while Tony Stark (the regular Iron Man) was indisposed. This character, named War Machine, is a younger, more violent model of a controller/suit.[23] One of the most infamous villains in the comic world also belongs to this category, namely Dr. Doom.

Victor von Doom is described as 'a crazed scientific genius who hid his scarred face behind a mask' and who used his position as the 'ruthless ruler of a small country … to cloak his plans for world conquest'.[24] Doom not only exists technologically, within his suit, but he is also a mystic, the ruler of a nation, and a psychotic bent on ruling the world.

The final controller/suit in this category is also one of the newest. Battalion is a superhero from Image Comics' *StormWatch* series. The suit that he wears is referred to as a 'cyber-tran suit' which amplifies his own psionic power a 'hundred-fold'.[25] The suit is also equipped with the 'new, experimental tri-kevlar body armour as well as an integrated communication system'.[26] This is one of the new directions that suits are taking in comics. Where once the suits of Iron Man and Dr. Doom simply multiplied their human strength or abilities or allowed them access to a man–machine weapon system, this new suit goes a step further. In Battalion there is a character whose mental facility is amplified by his suit and his greatest enemy, Deathtrap, is a villain whose mental power can focus and improve the performance of machines.[27] These suits then, would seem to be the equivalent of mental Waldos.

Other notable controller/suit characters include Doctor Octopus, Cyber and Ahab.

The bio-tech integrator

Compared to the controller cyborgs, the bio-tech integrators are much more complex. Their systems can not be removed and often they are not fully explained either. They are, however, very popular cyborgs. One of the most popular is code-named Cable.

Cable is a character whose with a complicated background. In short, Cable is the son of two members of the X-Men. As a baby, Cable was infected with a 'techno-organic virus', and he was sent into the future in the hope that a cure could be found for his disease.[28] The disease was arrested but Cable was left with 'techno-organic but not sentient' portions of his molecular structure that can be altered at will.[29] This means that Cable can reconfigure parts of his body to either a machine or an organic state. As a rule, some visible portion of his body is always portrayed as a machine, and when asked about why he does this, when he could look entirely human, his response is: 'to get where you want to go … it never hurts to remember where you've been'.[30] The relationship between Cable and his cybernetic system is a more intimate and symbiotic one than exists for the class of controller cyborgs. This is also true for another cyborg member of the bio-tech integrator class named Weapon X.

The term 'Weapon X' can lead to confusion as it is used in at least three different comic book series. In its most general sense, Weapon X is the Canadian government's top secret programme for building superheroes. Unfortunately for Canada, it seems that once imbued with super powers, most of their creations do not feel like working for the

government anymore.[31] Weapon X was also Wolverine's original designation. The current Weapon X is a character named Garrison Kane,[32] whose capabilities include increased strength and the ability to shoot parts of his body at opponents as projectile weapons (i.e. a fist or an arm).[33] Again the cybernetic connection is made at a very basic systemic level. A controller such as Wolverine cannot alter his cyborg system at will but an integrator like Weapon X certainly can.

Genetic cyborgs

This is the third and most interesting category of comic book cyborgs. Characters in this class may or may not have artificial implants but their primary power rests in a purposeful alteration of their genetic code. The issues of purposefulness and intent are critical and defining ideas for this group. It is intent that distinguishes the genetic cyborg from the comic characters that have been created by accident. These accidental individuals include such notable figures at Superman, Spider-Man, Flash and the Hulk.

The first constructed genetic cyborg was one of the comic world's most recognized heroes, Captain America. The Captain was a product of the Second World War and his debut, fighting against Hitler, in March 1941, preceded Pearl Harbor.[34] In the first issue of *Captain America*, the doctor who injected skinny Steve Rodgers (Captain America's alter ego) with the 'super-soldier serum', declares that the serum 'is rapidly building his body and his brain tissues, until his stature and intelligence increase to an amazing degree'.[35] During the course of one adventure, Captain America was thrown into the icy waters of the North Pole. Thanks to the cold and the serum he was preserved until the mid-1960s when he was discovered and revived by the superhero team, the Avengers.[36] Just recently, this original genetic cyborg received the bad news that the serum was beginning to adversely affect his health and that if he continued to perform his superhero activities, he would eventually become paralyzed.[37] While Captain America remains a popular character, his views on violence have become antiquated and mark him as a throwback to a different era.

Whereas Captain America is arguably the first genetic cyborg, the character known as Supreme is one of the newest. Supreme and Captain America are an interesting pair for comparison since these two radically different characters were conceived fifty-three years apart, but in their respective comic universes they were created at essentially the same time. Steve Rodgers (aka Captain America) volunteered for his experiment out of a sense of patriotism but Supreme remembers a government that 'was playing with civilian lives as usual and I was offered a position with them that I was unable to refuse'.[38] During this experiment Supreme was given pills and he recalls how his handler 'shot me full of experimental drugs, exercised me, exposed me to all sorts of radiation' until they hit upon the right mix which began to increase his strength, mass and weight.[39] When the scientists connected him to computers which 'were able to accelerate what had already been started', he became a 'genius ten-fold' and eventually realized that he had been 'divinely selected for omnipotence … to be a supreme being'.[40] Not only is Supreme portrayed as much more powerful than Captain America, but his attitude is diametrically opposed to the Captain's understated style. Supreme has also evidenced the ability, within a time span of nanoseconds, to scan an opponent's weapon and then alter his own biological structure to provide a natural defence against that specific weapon, much like a super-powerful, consciously-directed immune system.[41]

Marvel has always had a knack for designing characters that were bitter-sweet and they managed to do it again when they created a mercenary code-named Deadpool. Deadpool

was facing terminal cancer and had already been 'on chemo twice and radiation three times' before he submitted to Weapon X's (the government programme) 'bio-enhancing' experiments.[42] The results included increased strength and an immune system that is constantly healing him while it is, ironically, horribly scarring his body and disfiguring his face.[43] Deadpool also fits in with Weapon X's other projects. As soon as he is cured, he becomes a mercenary and goes freelance.

A cyborg's greatest fears or our fears of them

Any current comic book hero or villain faces a multitude of problems that the characters of yesteryear never even dreamed of. Today's super-powered individuals worry about the rent, careers, stable relationships, dysfunctional childhoods and even the HIV virus. Shadowhawk, a character from Image comics, is HIV-positive and his creator states that AIDS will cause his death.[44] Among the issues comic book cyborgs confront are violence, consciousness downloading, lost humanity, corporations as evil avatars and the view that obviously robotic creatures are almost entirely evil. Violence is probably the easiest problem to discuss and is certainly the most graphic.

In his classic science fiction novel *Starship Troopers*, Robert Heinlein's main character declares that the clearly cyborgian 'Mobile Infantry' has made future war and violence 'as personal as a punch in the nose'.[45] Comic book cyborgs are taking that violence and making it as personal as ripping your spine out. In the November 1993 issue of *Bloodstrike*, over a space of six pages, Supreme singlehandedly crushes a ribcage, smashes someone's arms off, crushes a hand, gouges eyes out, hits a character in the stomach with such force that his opponent's intestines fly out his back and, to finish, breaks a spine.[46] While this is an extreme example of violence, committed by a cyborg against other cyborgs, it is not an isolated instance.

Violence, as a cyborg issue, is a double-edged sword. One edge cuts into society's fears and desires concerning the present level of crime. These cyborg heroes are taking on the drug lords and the terrorists who are keeping us up at night worrying for our safety. Not only are they meeting them head on, but with regenerative tissue and psionically-created weapons, they are violently and graphically destroying these criminals. Instead of waiting or negotiating in a hostage situation, the character Supreme simply waded in and chopped them to death with his bare hands.[47] This is cyborg justice. No Miranda rights, no crowded court dockets, no criminals going free on a technicality. If you attract the attention of a cyborg hero, you can probably expect to be killed or maimed.

The opposing edge of the blade lays open our own fears concerning the cyborgs themselves. Are these images of our postmodern Frankenstein monsters? If these cyborgs are so powerful, then how do we, as normal (?) *Homo sapiens*, stand a chance if they ever turn on us? In comic books creatures have been created that are beyond the control of anyone. The fictional Weapon X programme is a prime example. The very ambiguity with which many of the cyborg heroes and villains are portrayed – good guys become bad guys and vice versa – is indicative of our unease with these creations. The violence depicted on the pages of these comic books may be perceived as warnings as to what might happen if we pursue this line of technology. Wolverine once said, 'I can't be one hundred percent sure he's lying, but I have to be one hundred percent sure because if I kill him, then he's one hundred percent dead'.[48] In the March 1994 issue of *Captain America*, there featured scene involving Captain America in civilian clothes intervening in a child's theft of comic

books from a local store. Captain America looks at the comics and then asks the store owner if he reads them:

> **Store owner:** 'Of course I do! I love super-heroes … they're at the cutting edge of the counter-culture! I wish I knew some personally! I'd have the Punisher break this punk's hands or I'd have Wolverine carve the word "thief" on his forehead!'
>
> **Capt. America:** 'Those heroes are your favourites?'
>
> **Store owner:** 'Yep, the more violent they are the better I like them! The better they sell too!'[49]

This is an issue that clearly separates our very cyborgian comic era from previous epochs.

Lost humanity

In his article on cyborg soldiers, Chris Gray notes that while current military thought is 'moving towards a more subtle man–machine integration', the vision is still one of 'machine-like endurance with a redefined human intellect subordinated to the overall weapons system'.[50] While this reflects current military thinking, it is not reflective of the man–machine control issues in comic books.

The hero or villain of today's cyborg comic book is likely to be in control of his weapon system to a greater degree than ever before. A prime example of this is Supreme. Here is a genetic cyborg who exercises control over his system at a cellular level.[51] In their article on knowledge-based pilot aids, Cross, Bahnij and Norman approach the issue of control from the aspect of human capabilities. Specifically, they state that 'Humans have finite capabilities. They are limited by the amount of information they can process and the amount of time required to process that information'.[52] Here they seem to be arguing for a preponderance of machine control in a man–machine system because of a lack of human attention span. Cyborgs in comic books seem to be unfettered by this problem and the reason is fairly clear. These characters are participating in Old West shoot-outs with postmodern weapons. They are not attempting to place a five-hundred-pound bomb on a particular building in a large city while avoiding collateral civilian damage. They are up close and personal.

There is also some disparity between this article and the comic book world in terms of which human capabilities are the lowest limiting factors in a man–machine system. Cross et al. make it clear that they feel the limit is on 'CA … cognitive attention'. They go on to break down 'CA' into 'CAs = the cognitive attention required for task accomplishment at the skill-based level, CAr = the cognitive attention required for task accomplishment at the rule-based level and CAk = the cognitive attention required for task-accomplishment at the knowledge-based level'.[53] Comic book cyborgs are not constrained here because their cyborg system allows them to make a quantum jump forward in skill. Their rules are extremely simplified and all the knowledge they need is the location of their opponent. As opposed to pilots of fighter aircraft who require a great deal of their attention to be focused on the operation of their system, cyborgs whose systems are managed intuitively require little of their attention to be diverted from the actual combat. The issue of humanity with comic book cyborgs then, is not if the machine will take over the human side of the equation, but what will the human half choose to do with his new abilities.

The concept of looking and acting like a man and Moravec's more advanced idea of downloading consciousness have both been dealt with in the world of the comic book cyborg. The issue of how much machinery a person must integrate before he becomes a machine, however, has not drawn nearly as much attention as the consciousness issue. Perhaps the best example of this is a character named the Vision.

A Marvel comic describes the Vision as 'a unique form of android known as a synthezoid, who is both composed of mechanical parts and an unknown material that mimics the properties and functions of human tissue and bone but is far stronger and durable'.[54] The Vision has a long and interesting cybernetic history. He was created by another robot, a villain known as Ultron, who originally used him to attack the heroic Avengers.[55] The Vision's consciousness was based on 'encephalograms from the brain of Wonder Man who was then believed to be dead … in later years the Vision and Wonder Man came to regard themselves as "brothers" of a sort'.[56] If all this was not enough, the history of this android becomes even more complicated. Over time the Vision managed to develop human emotions and he even married a fellow superheroine, Scarlet Witch, which in the comic world 'evoked the unreasoning hatred of bigots who would not accept the Vision's claim to be human'.[57] Once, due to damage sustained in a battle, he was connected to a giant computer and through this connection came to believe that the way to save humanity was for him 'to take absolute control of the planet through linking himself to all the world's computers'.[58] Finally, the Vision had this connection severed, returned to normal (a hero), was abducted by the government who now feared him, was disassembled, his programming erased (killed?), was rescued by his friends, was reassembled but lost his capacity for emotions, was divorced and is now a reservist for the Avengers.[59] From his marriage on there were arguments over whether or not the Vision was alive, what relation he had to Wonder Man since they shared brain patterns and whether or not he could be trusted. This would be an interesting point to make to Moravec. If consciousness could be downloaded and 'backup copies' could truly be made, what would happen if a couple of you were in existence at the same time? The question of the Vision's loyalty and the fact that he was created by the evil robot, Ultron, raises the issue of the nature of robots and androids in the comic world.[60]

Evil, Inc.

The great evils in the comic world are the multinational corporations. In their article on the growth of new cyborgian political entities, Gray and Mentor assert that 'the age of the hegemony of the nation state is ending'.[61] They go on to speak of nation states being 'drained of sovereignty by multinational corporations on one side and nongovernmental organizations and international subcultures sustained by world-wide mass telecommunications on the other'.[62] This is exactly the situation that has come to pass in comics, especially in the world of Image comics. In one particular comic, aptly named *CyberForce*, the great evil is a corporation, again with the appropriate name of CyberData. This scenario has CyberData implanting its S.H.O.C. (Special Hazardous Operations Cyborgs) troops with a micro-circuit implant that forces the recipient's personality into more and more aggressive and lethal pathways.[63] The idea behind the superhero team is that a doctor, employed by CyberData, uncovers its scheme and develops a method for removing the chips. He is promptly killed but by then the team is formed and they still possess the removal method.[64]

Two other teams that were formed by corporate interests were YoungBlood and Heavy Mettle. These two groups are both genetically-engineered humans who are employed by a

corporation known as G.A.T.E. International and who are contracted to the government.[65] Gray, in his article on war cyborgs, asserts that 'the very possibility of cyborgs is predicated on militarized high technology'. While this continues to be true in comic books it is not the government that is in control of this technology.[66] While most of these super-powered teams seem to work for the good of society, there is always the possibility, indeed the implicit danger, that a member or an entire team may go renegade.

The arms race is also clearly present in this new generation of comic books. The twist is that this time the arms are people. In *StormWatch* the race is for 'seedlings', children who may have been genetically altered by the close passing of a strange comet.[67] This type of race is in line with the prediction by Gray and Mentor that 'the body politic of the future will be those cyborg industries which meld great skill at information processing and personnel management into tremendous profits and powers', as well as their observation that 'cyborgs are also the children of war and there is a real chance that the dominant cyborg body politics of the future will be military information societies much like the U.S.'.[68] It seems that the comic book vision of the future has that dominant body politic resting within the corporate veil.

These issues of violence, downloading and evil corporations are just a few of the myriad of problems being discussed in cyborg-oriented comics.[69]

Concluding thoughts

> The poet's eye, in a fine frenzy rolling,
> Doth glance from heaven to earth, from
> earth to heaven;
> And, as imagination bodies forth
> The forms of things unknown, the poet's
> pen
> Turns them to shapes, and gives to airy
> nothing
> A local habitation and a name.[70]

In Shakespeare's time it was the poet who gave wings to visions of the future, later writers such as Verne and Wells took up the burden. More recently, Asimov, Pohl, Clarke and Card have all provided us with their unique interpretations of what the future will look like. Today, science fiction writers still provide a large part of future scenarios but they are also being helped along to a growing extent by comic book artists and writers.

Where those future visions include cyborgs, comic books have seized them tightly. On those multi-coloured pages of what were once considered kid's toys are some of the most graphic and vivid images of what cyborgs might look like. Not only are their potential shapes explored but their potential uses as well. The popularity of comic book cyborgs also attests to the growing acceptance and interest in the possibility of such creations. If a search is on for a medium in which cyborgian futures are being explored with great vision and energy, a researcher need look no further than the local comic book store.

Notes

1. Les Daniels, *Marvel* (New York: Harry N. Abrams Inc., 1991), p. 17.
2. Robert M. Overstreet, *The Overstreet Comics and Cards Price Guide* (New York: Avon Books, 1993), p. 48.
3. Ibid., p. 49.
4. Les Daniels, op. cit., p. 39. For the purpose of this essay a key factor in determining whether or not a hero or villain is a cyborg will be based on design. Changed humans who were created by accident, i.e., Daredevil, Spider-Man, will not be considered cyborgs, they are more properly mutants.
5. Ibid., p. 39.
6. Ibid., p. 31.
7. Ibid., p. 71.
8. Ibid., p. 80.
9. Ibid., p. 83.
10. Ibid., p. 163.
11. Robert M. Overstreet, op. cit., p. 206.
12. Jon Warren, '1993: The year in review', *Wizard*, January 1994, p. 221.
13. Chris Gray, 'Cyborg citizen: a genealogy of cybernetic organisms in the Americas', Research Proposal for the Caltech Mellon Postdoctoral Fellowship, p. 2.
14. Les Daniels, op. cit., p. 191.
15. Fabian Nicieza, *Cable*, vol. 1, no. 9 (March 1994), p. 7.
16. Fabian Nicieza, *Cable*, vol. 1, no. 10 (April 1994), p. 1.
17. Jim Lee, *Stormwatch Sourcebook*, vol. 1, no. 1 (1994), p. 1.
18. Ibid., p. 1.
19. Les Daniels, op. cit., p. 101.
20. Ibid.
21. Ibid.
22. Ken Kaminski, *Iron Man*, vol. 1, no. 300 (January 1994).
23. Scott Benson, *War Machine*, vol. 1, no. 1 (April 1994): p. 1.
24. Les Daniels, op. cit., p. 88.
25. Brandon Choi and Jim Lee, *Stormwatch*, vol. 1, no. 0 (August 1993), p. 20.
26. Ibid., p. 20.
27. Jim Lee, et al., *Stormwatch Sourcebook*, vol. 1, no. 1 (January 1994), p. 27.
28. Fabian Nicieza, *Cable*, vol. 1, no. 8 (February 1994), p. 15.
29. Fabian Nicieza, *Cable*, vol. 1, no. 9 (March 1994), p. 14.
30. Ibid., p. 15.
31. John Byrne, *Alpha Flight*, vol. 1, no. 1 (August 1983).
32. Rob Liefeld, *X-Force*, vol. 1, no. 10 (1992).
33. Joe Madureira and Fabian Nicieza, *Deadpool: The Circle Chase*, vol. 1, no. 4 (December 1993).
34. Les Daniels, op. cit., p. 37.
35. Ibid., p. 38.
36. Peter Sanderson, *Avengers Log*, vol. 1, no. 1 (February 1994), p. 8.
37. Mike Grell, *Captain America*, vol. 1, no. 42 (February 1994).
38. Rob Liefeld, *Supreme*, vol. 1, no. 424 (February 1994), p. 10.
39. Ibid., p. 11.
40. Ibid., p. 13.
41. Rob Liefeld, *Supreme*, vol. 1, no. 2 (February 1993), pp. 14–15.
42. Joe Madureira and Fabian Nicieza, *Deadpool: The Circle Chase*, vol. 1, no. 3 (November 1993).
43. Joe Madureira and Fabian Nicieza, *Deadpool: The Circle Chase*, vol. 1, no. 4 (December 1993).
44. Brian Cunningham, 'Out of the Shadows', *Wizard*, April 1994, p. 40.
45. Robert A. Heinlein, *Starship Troopers* (New York, N.Y.: Ace Books, 1959), p. 80.
46. Keith Giffen, *Bloodstrike*, vol. 1, no. 4 (November 1993), pp. 16–19.
47. Rob Liefeld, *Supreme*, vol. 1, no. 3 (June 1993), p . 17.
48. Peter David, *X-Factor*, vol. 1, no. 85 (1993).

49. Mike Grell, *Captain America*, vol. 1, no. 425 (March 1994).

50. Chris Gray, 'The cyborg soldier: the U.S. military and the postmodern warrior,' in L. Levidow and K. Robins (eds) *Cyborg Worlds: The Military Information Economy* (London: Free Association Press, 1989), pp. 43–72.

51. Rob Liefeld, *Supreme*, vol. 1, no. 4 (July 1993).

52. Stephen E. Cross, et al., 'Knowledge-based pilot aids: a case study in mission planning' in *Lecture Notes in Control and Information Sciences: Artificial Intelligence and Man-machine Systems* (Berlin: Springer-Verlag, 1986), p. 147.

53. Ibid., p. 148.

54. Peter Sanderson, *Avengers Log* , vol. 1, no. 1 (February 1994), pp. 24–5.

55. Ibid., p. 44.

56. Ibid., p. 24.

57. Ibid., p. 25.

58. Ibid., p. 25.

59. Ibid., p. 26.

60. If cyborgs in comics seem ambiguous in nature, more overtly robotic creatures do not. A quick look at the most obviously robotic characters such as Vision, Ultron, Sinsear, Nimrod and the Sentinels, reveals that all at one time were villains and that all but the Vision are still considered evil. The question seems to be why do comics regard the creatures that humans should be able to control to the greatest extent, as the creations most likely to run amok? These villains are constantly creating more evil robots and Ultron's plans have grown to include his intention of obliterating not just humanity, but all plants and animals – all organic life on Earth. Since the focus here is on cyborgs, suffice it to say that the robotic position is at least as interesting as that of cyborgs.

61. Chris Gray and Stephen Mentor, 'The cyborg body politic meets the new world order,' in C. Gray (ed.), *The Cyborg Handbook* (London: Routledge, 1995), pp. 453–68.

62. Ibid., p. 11.

63. Walter Simonson, *Cyberforce*, vol. 1, no. 0 (September 1993), p. 8.

64. Ibid., p. 9.

65. Rob Liefeld, *Supreme*, vol. 1, no. 1 (April 1993).

66. Chris Gray, 'The culture of war cyborgs: technoscience, gender, and postmodern war,' in Joan Rothschild (ed.) *Research in Philosophy and Technology*, special issue on feminism, 1993, p. 1.

67. Jim Lee, et al., *Stormwatch Sourcebook*, vol. 1, no. 1 (January 1994), p. 2.

68. Gray and Mentor, op. cit., pp. 12 and 14.

69. Some other problems include:
 Anti-mutant Hysteria: Glance at any of the pages of comic books involving mutants, particularly in the Marvel universe, and examples will be found of sinister-sounding mutant registration programmes, and grass-roots bigotry against mutants, also known as 'homo superio'.
 Gender/Race/Handicaps: A multitude. The leader of the Avengers, one of the oldest super-hero teams, is a woman, the current Captain Marvel is a black woman and there are also blind, paraplegic heroes as well as HIV-positive characters and characters fighting cancer.
 Comic books also dive into cyberspace, virtual reality addicts, multiple uses of holographic technology and artificial intelligence racing out of control.

70. *The Concise Oxford Dictionary of Quotations* (New York: Oxford University Press, 1981), p. 227.

David Tomas

THE TECHNOPHILIC BODY
On technicity in William Gibson's cyborg culture

No objects, spaces, or bodies are sacred in themselves; any component can be interfaced with any other if the proper standard, the proper code, can be constructed for processing signals in a common language.

(Donna Haraway)

A NUMBER OF RECENT SCIENCE FICTION works by William Gibson explore an alternative post-industrial hybrid culture predicated on the interface of biotechnologically enhanced human bodies, interactive information technology and omniscient corporate power.[1] Gibson's novels and short stories are influential examples of 'cyberpunk' literature, a genre of science fiction literature that deals with first generation cyborg[2] or machine/human symbiotic activity in an immanent post-industrial information-governed universe.

Gibson's works are highly suggestive dystopic visions of a not-too-distant future when the human body has suffered a radical mutation in its ecological structure. His works prefigure a culture where the organic architecture sustaining the human sensorium has undergone various degrees of collective biotechnological prosthetic transforma- tions. From the point of view of the cultural complexity of their technological and ecological vision, the best of Gibson's works are therefore positioned at the imaginative threshold of potential post-industrial techno-dystopian cultures. In this chapter, I trace the salient characteristics of these cultures as presented in Gibson's short stories and novels, in particular the collection of short stores entitled *Burning Chrome* and his trilogy, *Neuromancer, Count Zero* and *Mona Lisa Overdrive*.[3] Amongst many possible observations one can make in connection with these pieces, I will concen- trate on three interrelated items. The first concerns cyborg transformations that reconstitute the organic and sensorial architecture of the human body, the second pertains to a novel information space that Gibson describes in his novels and short stories, and the third relates to the social regeneration of ethnic identity under the influence of cyborg-governed processes of *technological* differentiation in marginal late-capitalist creolized technocultures.[4]

The technophilic body

> I wondered how they wrote off toothbud transplants from Dobermans as low technology. Immunosuppressives don't exactly grow on trees.
>
> ('Johnny Mnemonic')

Gibson's novels and short stories depict the adventures of a volatile male-dominated underworld populated by small-scale independent entrepreneurs – fences and middlemen in 'corporate crossovers' tersely described by Gibson as 'point [men] in ... skull wars' (NRH, 103), corporate mercenaries, console cowboys and members of alternative 'tribal' groups. Gibson's main characters are human 'gomi'[5] whose economic activities are parasitic on omniscient military and multinational corporate or aristocratic formations. Individual and collective activities are confined, for the most part, to urban strips such as the Sprawl that link previously autonomous cities and metropolitan centres. The common fixtures of social and political power in this world are multinational *zaibatsus* (NRH, 103, 107), Maas Biolabs GmbH and Hosaka, who are devoted, amongst other things, to genetic engineering and corporate espionage; Tessier-Ashpool, a decadent corporate high orbit aristocratic family; and the Yakuza, the multinational underworld organization. Two principal zones of illicit economic activity fuse this multinational/local laminate. One consists of a conglomerate of traffic in information systems hardware and software. The other is centred on configurations of data organized in matrix form in 'cyberspace', the special collective 'consensual hallucination' (N, 51) produced by interacting data systems. A wide variety of prosthetically and genetically enhanced individuals populate and negotiate these zones.

Information is a new form of blood in this post-industrial cyborg world. It oxygenates the economic ecology that sustains multinational corporations (NRH, 107), individuals and novel cyborg organisms. These part human, part cybernetic systems are sites of unusual manifestations of technological exchange and technological advantage. They are also sites of emergent cyborg cultural identities, identities that constantly appear and disappear in the wake of continuously upgraded information technology and biotechnology. These cyborg organisms can be considered *technophilic* from a number of points of view.

A *technophilic body* is the product of various degrees of aesthetic and functional transformations directed to the human body's surface and functional organic structure. Such transformations can be divided into two distinct categories. The first category is composed of techniques and technologies that are used for various *aesthetic* manipulations of the body surface. These include cosmetically redesigned faces, muscle grafts and animal and/or human transplants that effectively blur visual cues for gender and human/non-human differentiation. The second category is directed to fundamental *functional* alterations to the human body's organic architecture. It includes biochip implants, prosthetic additions mediated by myoelectric coupling, and redesigned upgraded senses.

Cyborg transformations are clearly of more than topical interest in distinguishing new and emerging socio-cultural forces. The continuous manipulation of the body's ectodermic surface and the constant exchange of organic and synthetic body parts can produce rewritings of the body's social and cultural form that are directly related to the reconstitution of social identities. These processes for 'technologizing' ethnic and individual identities are fundamental to the composition of Gibson's version of a cyborg culture, as are questions about social power in relation to bodies whose architectures are subject to continual disassembly and reassembly[6] and potential sites of (cyborg) resistance

in a post-industrial society increasingly dominated by corporate formations and a global information economy.

Various 'tribal' groups, the Panther Moderns in *Neuromancer* or the Low Teks in 'Johnny Mnemonic', equate stylistic effects of elective cosmetic surgery and the biotechnological manipulation of the body's surface with technofetishistic bacchanalian celebrations of the body as trans-species heterotopic site.[7] This equation is geared to the creation of group identities spawned in the aesthetic dimensions of the cyborg continuum. A curt description of the Low Teks, given by Molly Millions in 'Johnny Mnemonic', typifies the social groups in question: 'Not us, boss.... "Low technique, low technology"' (JM, 14). Cosmetic surgery and bio-technology appear, in these cases, to create common signifying patterns that are used for the construction of social identities. Perhaps the best synopsis of this type of subculture is the following from *Neuromancer*:

> Case met his first Modern two days after he'd screened the Hosaka's precis. The Moderns, he'd decided, were a contemporary version of the Big Scientists of his own late teens. There was a kind of ghostly teenage DNA at work in the Sprawl, something that carried the coded precepts of various short-lived subcults and replicated them at odd intervals. The Panther Moderns were a softhead variant on the Scientists. If the technology had been available, the Big Scientists would all have had sockets stuffed with microsofts. It was the style that mattered and the style was the same. The Moderns were mercenaries, practical jokers, nihilistic technofetishists.
>
> (N, 58–9)

Case goes on to give the following description of a 'soft-voiced' Panther Modern called Angelo.

> His face was a simple graft grown on collagen and shark-cartilage polysaccharides, smooth and hideous. It was one of the nastiest pieces of elective surgery Case had ever seen. When Angelo smiled, revealing the razor-sharp canines of some large animal, Case was actually relieved. Toothbud transplants. He'd seen that before.
>
> (N, 59)

Subjects of aesthetic cyborg enhancements do not, however, elicit a great deal of observation and commentary when compared to those individuals that have absorbed the hardware of information systems and bio-technology in cool fits of individualized, customized technophilia. In contrast to the creation of group identities through stylistic rewritings of the human body's surface (that seem to function as cyborg versions of what Pierres Clastres has elsewhere identified as carnal textual inscriptions of the law of social equality in archaic societies[8]), technophiles strive to redesign the human body so that it can function as a technological site whose optimum performance is measured in terms of its ability to sustain a competitive edge over other similar bodies. Social identity and social bonding are not directly dependent on the surface manipulation of the body in these cases. Two of Gibson's characters, Johnny Mnemonic and Molly Millions, are excellent examples of this functionally oriented type of sophisticated cyborg technophile.

Mnemonic sports a stereotypical version of a Sony Mao face. This type of aesthetic enhancement seems to indicate common kinship with the aforementioned 'tribal' groups. We note, however, that Mnemonic has opted for this process of stylistic normalization because of a provisional need to disguise his identity. The real logic of his cyborg identity lies elsewhere – in a series of more profound functional alterations. In the course of Gibson's story we learn that Mnemonic is, in fact, a piece of highly sophisticated hardware,

functionally enhanced by a 'modified series of microsurgical contraautism prosthesis' (JM, 9) so that his brain can serve as a data storage unit for illicit information. The stored information can be accessed only by a client possessing the correct code. Mnemonic also has the ability to playback visual data.[9] His optical senses, are, in fact, part of a hardwired data storage system.

Mnemonic's ability to sustain a competitive edge in the world he moves through is predicated on the economic advantage provided by these data storage implants. His edge is therefore based on information – storage on the one hand, and, later in the story, access to residual traces of clients' data for blackmail purposes (N, 176). As he points out, in another context, 'We're an information economy. They teach you that in school. What they don't tell you is that it's impossible to move, to live, to operate at any level without leaving traces, bits, seemingly meaningless fragments of personal information. Fragments that can be retrieved, amplified' (JM, 16–17).

Millions, on the other hand, a principal character in 'Johnny Mnemonic', *Neuromancer* and *Mona Lisa Overdrive*, is a 'razorgirl' (MLO, 60) with optically and electronically upgraded vision and prosthetically modified fingers that house a set of razor-sharp doubled-edged scalpel blades myoelectrically wired into her enhanced nervous system. Her cyborg sensorium can also be directly accessed with the proper interface unit (N, 56, 175, *passim*).

It is evident that Mnemonic and Millions are no longer independent biological organisms. They are customized functional products of a cyborg culture that serves as a genetic context for the implosion and mutation of biological organisms, bio-technology and advanced information systems. This culture provides arenas for the cyborg reconstruction of human organisms according to different, cosmopolitan, synthetic architectures. Mnemonic and Millions, amongst others, emerge reconstituted simultaneously as information processing units, enhanced nervous systems and fluid electronic fields of social action.

When one is presented with a culture governed by cosmetic and functional alterations to the form and organic structure of the human body, it is not hard to imagine an emerging cyborg species that will evolve according to a different evolutionary logic. Genetic engineering, information technology and powerful software programs ensure, for example, that death is no longer an entropic biological certainty for a small portion of the population of Gibson's novels and short stories. In the course of these stories one learns that data storage is a new fountainhead for individual and corporate identity. Human memory is effectively dislocated from organic bodies gripped by a deteriorating natural ecosystem to be relocated and rewritten through a wide variety of hardware-based software personality constructs.

A cyborg culture ensures that technology and genetic engineering are the nodal points of human interaction. It is not surprising, therefore, to learn that relationships and identities are constantly negotiated through a sophisticated culture of technology that also functions as a rite of passage for the gradual transformation of the human organism into a cyborg entity. It is a rite of passage geared to the creation of powerful technologized collective transorganic cyborg data-based personality constructs. Given the range of this emerging culture – from the techno-enhancement of Mnemonic and Millions and the total hardware/software mutation of Lisa in the short story 'The winter market', to the pocket-size Artificial Intelligence called Colin in *Mona Lisa Overdrive* – it is surprising that this emergent culture also provides provocative examples of cyborg strategies and technoscapes that are connected intimately to the social production of individual and group identities.

Technological edge

> Bobby's software and Jack's hard; Bobby punches console and Jack runs down
> all the little things that can give you an edge.
>
> <div align="right">('Burning Chrome')</div>

Cyborg technophiles define themselves, their activities and their relations with others in tandem to the cutting edges of information and bio-technology. At the end of *Neuromancer*, for example, Millions leaves Case, a console cowboy, on the pretext that a life of luxury takes the edge 'off [her] game'. She goes on to state, 'It's the way I'm wired I guess' (N, 267). These comments, more than the product of flippant strategies in the arena of interpersonal relations, provide an insight into the function of technological edge in the construction of a technophile's identity. Edge is, however, not only a defining characteristic of cyborg identities; it also serves as a boundary between life and death. In *Neuromancer* Millions notes that easy living took the edge off the game that she and Mnemonic were engaged in, with the result that Mnemonic fell victim to a Yakusa assassin (N, 178).

Technological edge can be defined as the product of a successful conjunction of advanced technological hardware and contextually sophisticated techniques. This conjunction produces a technoscape that is also common to the functional architecture of the technophilic body. It is a space organized in relation to culturally valorized body functions – the structure and capacity of the human memory, the range and sensitivity of the senses, and relative questions of organically constrained speed and power.

Across the battlegrounds of Gibson's post-industrial landscape one can admire one's cyborg opponent, as Millions does in 'Johnny Mnemonic', because of the sophistication and uniqueness of (his) prosthetic and genetic composition. When Mnemonic complains that he can't understand how he missed hitting the Yakuza assassin with the discharge from his archaic shotgun, Millions replied: 'Cause he's fast, so fast.' Millions' exuberant technophilia is expressed, in this example, in terms of technical virtuosity and operational speed, attributes that have been directly impregnated in the cyborg's sophisticated prosthetic and genetic architecture. Millions goes on to point out, 'His nervous system's jacked up. He's factory custom,' and continues, 'I'm gonna get that boy. Tonight. He's the best, number one, top dollar, state of the art' (JM, 8).

Edge is also at the core of another important facet of the technophile's cultural composition: common technological kinship. Again, one finds a good example of this characteristic in 'Johnny Mnemonic'. Faced with Millions' exuberant technophilia, Mnemonic curtly notes the assassin's probable cyborg origins: some vat in the black market medical wonderland of Chiba city. Millions is not perturbed by this information. In fact, she responds by revealing her literal technological kinship with this vat-grown cyborg wonder.

> 'Chiba. Yeah. See, Molly's been Chiba, too.' And she showed me her hands, fingers
> slightly spread. Her fingers were slender, tapered, very white against the polished
> burgundy nails. Ten blades snicked straight out from the recesses beneath her
> nails, each one a narrow, double-edged scalpel in pale blue steel.
>
> <div align="right">(JM, 8)</div>

Millions's kinship is particularly interesting because it indexes a cyborg blueprint that is used to construct geotechnical patterns of kinship and ethnic identity.

The fundamental role of technological edge in sustaining a successful cyborg technophile's competitive edge is also illustrated in the case of strategic advantage achieved along a

hardware continuum.[10] Mnemonic is again a paradigmatic example in this regard. He tells us, for instance, that he is 'a very technical boy', and we are privy to his particular brand of contextually sensitive technophilia in the following passage: 'I put the shotgun in an Adidas bag and padded it out with four pairs of tennis socks, not my style at all, but that was what I was aiming for: If they think you're crude, go technical, if they think you're technical, go crude. I'm a very technical boy. So I decided to get as crude as possible.' But technophiles are not confined to local high-technology subcultures; they are sophisticated adepts along the continuum of hardware intersystems that comprise the material expressions of a systematic culture of technology. As Mnemonic points out; 'These days, though, you have to be pretty technical before you can even aspire to crudeness. I'd had to turn both these twelve-gauge shells from brass stock, on a lathe, and then load them myself; I'd had to dig up an old microfiche with instructions for hand-loading cartridges; I'd had to build a lever-action press to set the primers – all very tricky. But I knew they'd work' (JM, 1).

These descriptions highlight transfers of technologies across various social and cultural zones that are of considerable importance. Transfers such as these set the stage for attempts at sustaining competitive edges in a more expansive culture of technology where comparative juxtapositions between high and low technology subcultures create *de facto* positions of strategic technological advantage. Technological edge, in the cases I have discussed, is produced by a clash of cultures when adepts and hardware from radically differing technological zones are brought into strategic contact. We have already seen primitive examples of attempts to create this type of technological edge in Mnemonic's adoption of a Sony Mao face, and in his reasons for constructing an archaic shotgun. Later in the story, Millions comments on Mnemonic's adoptive strategic technological lineage: 'Lo Teks, they'd think that shotgun trick of yours was effete' (JM, 14). It must be noted, however, that these positions are not necessarily constructed in favour of high technology. Edge is a strategic *geotechnological* concept.

The contextual relativity of technological edge is brilliantly illustrated in the final confrontation between Millions and the Yakuza assassin. In this scene, Millions has lured Mnemonic's assassin on to the 'Killing Floor', a Lo Tek cultural site. The Killing Floor is composed of a pastiche of cultural refuse in the form of an articulated floating platform suspended in the geodesic rafters high above Nighttown. One of its principal features is its acoustic dimension: 'It was miked and amplified, with pickups riding the four fat coil springs at the corners and contact mikes taped at random to rusting machine fragments' (JM, 19). The floor heaves 'like a crazy metal sea' as the protagonists meet, and 'booms and roars' in a 'vertigo of sound' (JM, 20) that seems, in Mnemonic's words, to herald 'a world ending' (JM, 19). The heaving platform and the sound that emanates from its articulated parts are premonitions of death predicated on what can only be described as *technological culture shock*.

Millions has previously experienced this Lo Tek site (JM, 16), she knows the sensorial and technological space she is moving through. The assassin does not. Furthermore, it is evident that Millions has adopted a Lo Tek aesthetic camouflage and used it to functional advantage. Her professed Chiba city kinship is momentarily eclipsed by a 'mad-dog dance' (JM, 20) designed to negotiate strategic sensorial advantage in the context of a geotechnological artefact constructed beyond the progressive technical horizons of the Chiba clinics. The sensorial disruption that erupts in the wake of clashes between opposing technological subcultures produces a series of highly amplified perturbations in the Yakuza's optical and acoustic apparatus. The result is fatal.

The culture shock has been induced by the production of a strategic geotechnological advantage within an overall technological continuum. Thus the edge that Millions dances

along produces a sensorial fracture that leads to an aesthetic cleavage between the assassin's speed and technical virtuosity. His carefully crafted sensorium, the product, one imagines, of a vat tank in some sophisticated Chiba clinic, is shattered. Mnemonic is witness to the assassin's end:

> at the end, just before he made his final cast with the filament, I saw something in his face, an expression that didn't seem to belong there. It wasn't fear and it wasn't anger. I think it was disbelief, stunned incomprehension mingled with pure aesthetic revulsion at what he was seeing, hearing – at what was happening to him. … There was a gap in the Floor in front of him, and he went through it like a diver, with a strange deliberate grace, a defeated kamikaze on his way down to Nighttown. Partly, I think, he took the dive to buy himself a few second of the dignity of silence. She'd killed him with culture shock.
>
> (JM, 20–1)

Millions has, in effect, produced a culture trap that strategically repositions the assassin in an alien portion of the hardware continuum. She achieved this by creating a situation in which the sophisticated vat-grown cyborg is suddenly transformed into a *tourist* (JM, 18–19) in a potentially apocalyptic Lo Tek technoscape. In the course of the confrontation, the Yakuza's vat-cultivated and hardware-enhanced advantages are overwhelmed by an alien geotechnological sensorial logic, because this Lo Tek technoscape is governed by the principle of articulated acoustically coupled balance, not speed and technical virtuosity.

Strategic negotiations conducted in alien geotechnological arenas can have profound sensorial effects for technophiles of the calibre of Millions and the Yakuza assassin. The confrontation between Millions and the Yakuza assassin is a good example of the type of sensorial disruption that can erupt in the midst of violent confrontation between differing technological subcultures. As this case demonstrates, cyborg identities are not only the direct products of particular subcultures that organize and govern cyborg architectures. They are also influenced by the composition of the sensorial environment those architectures operate in. It is important to note that violent changes in a cyborg's sensorial ecology can shatter its cultural identity. A more extreme version of a cyborg sensorial ecology is the special 'consensual hallucination' that Gibson describes in considerable detail in his short stories and novels.

Jacking into cyberspace

> In cyberspace … there are no shadows.
>
> (*Mona Lisa Overdrive*)

Gibson's depictions of urban sprawl and decay are closely allied to other recent postmodern renditions of dystopic urban centres.[11] Notwithstanding this kinship, however, metropolitan centres find only a fragmentary optic in his depictions of a post-industrial cyborg world. Gibson seems to be more interested in presenting and exploring a parallel 'urban' reality called 'cyberspace'. This virtual reality is the product of a techno-economic mutation in collective human memory, a historical product of the conjunction of interactive military systems and information technology.[12] Cyberspace is without doubt a model late-capitalist information universe, a capitalist macrocosm and cybernetic ecosystem globally articulated as a virtual information construct. This cybereconomic order can conveniently be contrasted with Gibson's chaotic urban environment, a visionary orientalist experiment in genetic and

technological bricolage emanating from Chiba, Japan, a centrifuge of experimental state-of-
the-art high technology. The two technospaces seem to be fundamental to the composition
of an advanced hybrid cyborg culture and are worth pursuing in greater detail.

A succinct description of cyberspace's hierarchic military/industrial organization is given
in Gibson's short story 'Burning Chrome' where it is presented as a 'crowded matrix ...
where the only stars are dense concentrations of information, and high above it all burn
corporate galaxies and the cold spiral arms of military systems' (BC, 170). Contrast the
ordered hierarchy of this so-called 'space that [isn't] space' (CZ, 38) or 'nonspace' (BC,
170) with the following kaleidoscopic mélange of high-technology and urban disintegration.
The contrast will provide an insight into the epistemological composition of Gibson's
cyborg culture.

> Night City was like a deranged experiment in social Darwinism, designed by a
> bored researcher who kept one thumb permanently on the fast-forward button.
> Stop hustling and you sank without a trace, but move a little too swiftly and you'd
> break the fragile surface tension of the black market; either way, you were gone,
> with nothing left of you but some vague memory in the mind ... though heart
> or lungs or kidneys might survive in the service of some stranger with New Yen
> for the clinic tanks.
>
> (N, 7)

A few pages later we come across the following observation: '[Case] also saw a certain
sense in the notion that burgeoning technologies require outlaw zones, that Night City
wasn't there for its inhabitants, but as a deliberate unsupervised playground for technology
itself' (N, 11).

Gibson's Cartesian distinction between a cerebral cyberpsychic universe and a world
of cyborged flesh has important ramifications for discussions that are too narrowly
focused on the technologification of the human body. We have seen that a cyborg culture
constantly reconfigures systems of belief and practices that operate around and through the
technophilic body. Cyberspace, in contrast, absorbs the object of technologification so that
cyborg systems are dematerialized and 'cybernetically' reconstituted within the context of
this cyberpsychic space.

The data world of cyberspace is organized in a 'simulation matrix', designed to facilitate
'the handling and exchange of massive quantities of data' (BC, 170). This virtual reality is
more than just a global three-dimensional representation. It is a veritable parallel world of
industrial and military activity composed of brightly coloured and copyrighted geometric
shapes[13] that represent individual military, corporate and multinational data formations.
Information is therefore governed by multinational corporate activity organized in urban
and architectural forms.

Cyberspace is *accessed* by operators with the aid of hardwire interfaces (N, 55) connected
to 'matrix simulators' or 'cyberdecks'. The process of interfacing is known as 'jacking in'
to cyberspace. 'Jacking in' is the instantaneous rite of passage that separates body from
consciousness. That disembodied human consciousness is then able to simultaneously traverse
the vast cyberpsychic spaces of this global information matrix.[14] Access therefore promotes
a purely sensorial relocation. The use of the word 'access' in this case is not gratuitous. It
signifies a fundamental mutation in the human sensorium. In the words of Wintermute,
one of Tessier-Ashpool's wayward Artificial Intelligences, 'Minds aren't *read*. See, you've still
got the paradigms print gave you ... I can *access* your memory, but that's not the same as
your mind' (N, 170). The distinction is fundamental. Cyberspace is constructed according
to a post-print paradigm of the collective nature of human knowledge that allows for the

direct hardwiring of individual human memory to collective memory. The resulting cyborg interface effectively bypasses a world that has hitherto served as the historical stage for human activity.

A direct hardwiring of individual and collective memory has, as can be imagined, profound effects on the concept of an independently-governed cyborg body. At its most extreme, this interface can spawn bodiless cyborgs, a condition heralded in Gibson's writings by the presence of Bobby Newmark's atrophied organic pod in *Mona Lisa Overdrive*, 'strapped down in alloy and nylon, its chin filmed with dried vomit' (MLO, 240). Newmark's body is an extreme example of a human body sustained by a life-support system and interfaced with sophisticated information technology. Other potentially more radical and powerful transorganic 'postclassical'[15] cyborg forms include personality constructs such as Colin, the pocket-sized Artificial Intelligence in *Mona Lisa Overdrive*, and the simulated version of Finn, the mouthpiece of Wintermute, Artificial Intelligences that figure prominently in *Neuromancer*, who merge and attain cosmic sentience when their 'collective consciousness' annexes the matrix at the end of the novel (N, 269–70), and who 'are' a constant phantom presence in *Mona Lisa Overdrive* (MLO, 259).

A cyberspace culture raises numerous questions as to the material form and composition of individual and group identities. Take, for example, the following question posed by Angela Mitchell, when faced with Newmark's withered body: 'Is Bobby the solid rectangular mass of memory bolted above the stretcher?' (MLO, 240). This question highlights Newmark's peculiar postclassical cyborg condition. Even when his cyborg identity is known (he was after all the young cyberspace console cowboy in *Count Zero*), it is still difficult to locate its aesthetic or functional location in *Mona Lisa Overdrive* – an apparently lifeless body or a mysterious piece of hardware? – because in his present condition he is, in fact, more than just another legendary data thief (MLO, 190–1). This confusion is compounded when one realizes that, in his present atrophied and interfaced condition, Newmark bears a strange kinship to Colin. The aleph unit that is home to this ex-console cowboy's sensorium is, in fact, an 'aleph-class biosoft', a piece of information technology that provides virtually unlimited storage capacity (MLO, 128). As it turns out, Newmark has used the aleph unit to construct an elaborate model of cyberspace (MLO, 175) that his consciousness now inhabits. In the opening pages of *Neuromancer*, we find another example that illustrates the marginal position of the body in a cyberspace version of a cyborg culture. At the beginning of the novel, Case bemoans his recent fall from 'the bodiless exultation of cyberspace' into the inert materiality of his body after his nervous system was mycotoxically damaged by irate clients he has defrauded. In his opinion 'the body was meat ... [a] prison of ... flesh' (N, 6). His 'fall' was therefore a console cowboy's version of a living death.

Cyberspace poses a serious challenge to the identity composition of technophilic bodies, in particular with regard to their foundations in a hardware ecology. Cyborg bodies are clearly of no use in a world that has replaced organic and post-organic bodies with a consensual space of corporate and military data formations. If there are counter-culture sites in cyberspace,[16] the overall epistemological paradigm that nevertheless serves as its *modus operandi* is the model of a multinational economy. This is also true in the case of technological edge. Cyberspace redefines technological advantage in economic terms. This, in itself, does not represent a radical departure from the economic conditions that motivate the ebb and flow of technological edge in 'Johnny Mnemonic' except that cyberspace extrudes consciousness from cyborg bodies. Challenges such as these undermine materialist descriptions of post-industrial technophilic bodies simply because these bodies are epiphenomenal effects of a more extensive and radical technoeconomic transformation of synthetic body architectures. There is, however, an important question that remains to be answered. Can Gibson's

cyberspace be considered an alternative multinational data metropolis specifically organized in terms of new bodiless rearticulations of cyborg identity and cyborg advantage? In other words, can one still speak of 'the technophilic body' albeit in somewhat different terms? This question is important because it can point to new patterns in the social organization of what it means to be human.

On technicity

Traditional expressions of ethnicity are incapable of coming to terms with emergent technosymbolic 'systems of essential similarity and difference'[17] that conjoin individuals into groups in cyborg-dominated cultures. Cyborg transformations in traditional categories of kinship and ethnicity result in different systems of identity composition. I suggest that these transformations be described by the term 'technicity'. This term seems to be a more appropriate tool to describe ethnic-type relations among cyborgs, especially since traditional blood ties are increasingly replaced, in threshold cyborg cultures, by technologically defined social bonds.

Gibson's writings are not purged of representations of other ethnic communities or subcultural groups. His writings, in fact, abound with references to youth subcultures – the Low Teks in 'Johnny Mnemonic', the Big Scientists and Panther Moderns in *Neuromancer*, the Gothicks and Kasuals in *Count Zero*, and the Jack Draculas in *Mona Lisa Overdrive* – as well as references to other ethnic groups, most notably the Zions in *Neuromancer*. Gibson's post-industrial culture is therefore, without doubt, an effervescent ethnically creolized culture whose *modus operandi* is contestatory and disruptive. What is distinctive about his work, however, is the active presence of another *technologically* creolized cultural laminate with a different set of ethnic-type rules of social bonding. This latter culture is equally contestatory as has been seen in the cases used to illustrate the composition of technophilic bodies and their relationship to technological edge.

There can be little doubt that systems analogous to what anthropologists describe as ethnicity,[18] although expressed in somewhat different terms, can be seen to act as a social cohesive in cyborg cultures. New body parts, cryogenic processes, enhanced digitalized senses and collective cyberspaces redefine what it means to be human – to have a human body and to associate with others of one's own kind. This central preoccupation of human cultures is also a dominant theme in Gibson's novels. Descriptions of powerful personality constructs, including Artificial Intelligences, who actively mediate and guide human/cyborg relations, abound in Gibson's books. These interactions are rendered 'natural' through complex technological processes that allow groups to reconfigure the human bodyscape along different avenues for the deployment of distinctive social/symbolic humanoid properties.

Cyborg identities are composed with elements drawn from an intersystemic hardware continuum. We have already found this to be the case with Mnemonic and Millions. Characters such as these are the product of a post-industrial culture whose ethnic, class and gender categories are undergoing active transformations under the influence of systemic and intersystemic technoscapes that are focused on the body's aesthetic and functional architectures. One of the most influential and powerful of these 'technoscapes', in Gibson's writings, is cyberspace. A brief examination of this aspect of cyberspace is in order at this point because it allows one to link architectural configurations of data with the architectural construction of postclassical cyborg identities.

Classical cyborg transformations in a culture of human difference are predicated, as one would traditionally expect, on the production of distinctive patterns of physical or cultural

attributes organized in relation to the body's architectures. The difference between the composition of traditional ethnic categories and cyborg technicity lies most clearly in the issue of 'inborn qualities'.[19] In cyborg cultures questions of technicity are constructed in relation to instrumentally defined hardware/software continua connected to a general technological collectivization of the human body. Historico-epistemological categories that operate from the points of view of the inborn or naturalized attributes – racial, linguistic, or geopolitical similarities and differences – are displaced by systems of technicity. In creolized post-industrial cultures, these systems reflect the social needs (identity compositions) of nomadic individuals and groups in highly urbanized technoscapes or metropolitan centres such as Gibson's Sprawl and Nighttown. Cyberspace complicates this necessarily simple picture of classic cyborg technicity. It does so because it presents itself as a virtual bodiless reality. Although this reality is the product of sophisticated information technology, the parallel world that it creates is an all- encompassing sensorial ecology that presents opportunities for alternative dematerialized identity compositions. The corporate composition of cyberspace tends towards an attempt to homogenize individual and group heterogeneity under the sensorial order of a collective cyberpsychic non-space. In that 'space', cultures of technological similarity and difference are obviously no longer organized in relation to the human body, its shape, colour, sex. This eclipse in the body's aesthetic and functional structure is intimately connected to the aforementioned homogenizing cybereconomic relocation of the human sensorium. Note, however, that cyberspace is a *collective* 'consensual hallucination'. It is therefore as permeable to disparate economic activities as any other geopolitical space.

The formidable accumulation and centralization of data in the matrix ensure that it is the principal site of economic contestation, domination and resistance in Gibson's writings. It follows that it is also the site of individual and corporate life and death, identity composition and decomposition. What was once an apparently homogenizing virtual corporate reality increasingly begins to reflect a chaotic urban existence, with the proviso that access is limited to those who have the requisite skills and technology. In this virtual urban environment, power is, as always, a relational hierarchic and oppositional concept: 'Information. Power. Hard data' (MLO, 218).

The various shapes and colours of the data formations in the matrix correspond, as previously noted, to different corporate entities. Corporate difference is therefore visually defined as a series of encoded architectural distinctions that demarcate ownership of data conglomerates. Collectivities are correspondingly differentiated into those who have and those who do not have legitimate access to corporate data. Those who have access to information are the 'legitimate programmers', and those who do not are the 'industrial-espionage artists and hustlers' (BC, 170) like the console cowboys, Bobby Quine, Case, Bobby Newmark and Gentry, who seek coded entry sequences (N, 243).

Gibson's console cowboys are exemplary technophiles whose brand of technicity is cerebrally cyberpsychic as opposed to materially technic. They are the cybernetic 'test-pilots' who operate at the cutting edges of a software continuum. Console cowboys are different from those hardware technophiles like Automatic Jack who specialize in producing a technological edge through customized cyberspace hardware and exotic software diagnostics. What makes the console cowboys different from the classic hardware technophiles is the fact that they manoeuvre along a related yet different technological continuum. This cyberpsychic (software) continuum defines the nature of the edge they cultivate. Their success is therefore a measure of their cyberpsychic activities *vis-à-vis* a collective incorporated cyberspace meta-sensorium. They are in the business of opening windows in 'the bright walls of corporate systems' with the aid of 'exotic software' (N, 5) (ice-breaking virus programs or killer-virus programs usually of Russian or Chinese origin). Once they have accessed corporate data formations

they set about stealing or manipulating information. These oppositional and economically disruptive activities are the focus of much of the ebb and flow of social action in Gibson's depictions of cyberspace. They also highlight the existence of a marginal sensorial version of technicity based on the architectural distinction between inside/outside or inclusion/exclusion. The distinction is, of course, between those who do and those who do not have access to corporate data. One would therefore expect to find the most perfect representation of this marginal type of technicity in the walls of data that invariably serve as the harbingers of post-industrial cultural and social difference. This is, in fact, the case.

Databases in the matrix are invariably defended by ICE (Intrusion Coutermeasures Electronics) and the illegal *black* ice of 'lethal neural-feedback weapons' (BC, 182). These defences are produced, continually altered, and upgraded, by corporate Artificial Intelligences (CZ, 78). The result is a heavily defended advanced data-based system of distinctions between those who have legitimate access to the data and those who do not. This distinction is of more than passing interest because not only does cyberspace replace the need for bodies and associated ethnic distinctions, but the urban/architectural composition of the matrix presents an alternative system of polychromatic differences. One can accept these distinctions as simple architectural expressions of data organized in a simulated metropolis. If one does so, one becomes a cyberspace tourist who can admire these latest creations of the corporate mind (MLO, 220). Or, alternatively, one can confront the systems of difference that these heavily defended configurations represent. If one opts for this avenue of investigation, one quickly perceives that human and post-human differences are directly inscribed in the walls of these polychromatic forms. Difference becomes the product of a hierarchic systemic order based on exclusive access to data constructs, a fact paradoxically compounded here by the narrative exclusion of legitimate or legitimating corporate points of view – Gibson's stories are always constructed from the point of view of those who are excluded from an industrial/military order. The oppositional point of view explored in Gibson's portrayal of a post-industrial information-governed global metropolis ensures that cyborg strategies of contestation and resistance are the principal motifs to be explored. These strategies are constantly highlighted in Gibson's creolized mélange of classical and postclassical cyborg motifs, and they are intimately connected to the activities of technophilic bodies, nodi in an emerging oppositional cyborg matrix of technicity.

Conclusion

The tack negotiated through Gibson's version of a threshold cyborg culture has provided material for the extrapolation of a number of preliminary observations on the interaction between advanced technology, human identity and marginal oppositional cultures at the close of the twentieth century. Gibson has observed, in this connection, that 'apprehending the present … seems to require the whole Science Fiction toolkit.'[20] This point has also been made by another cyberpunk writer, Bruce Sterling, in the preface to an anthology devoted to that genre. In his option, 'The cyberpunks are perhaps the first SF generation to grow up not only within the literary tradition of science fiction but in a truly science-fictional world. For them, the techniques of classical 'hard SF' – extrapolation, technological literacy – are not just literary tools but an aid to daily life.'[21] The preceding descriptions of technophilic bodies, technological edge, cyberspace and technicity were based on observations about a fictional world. But as Gibson and Sterling are at pains to point out, that fictional world is now a very real part of contemporary existence. Examinations of fictional cyborg cultures can sensitize us to the possibility of explosive social/biological mutations produced

by rapidly changing technoscapes. It should come as no surprise, given recent advances in information technology, genetic engineering, and nanotechnology, that these changes will encompass the human body and its sensorial architecture. There seems to be little doubt that these changes will also produce new domains of domination, contestation and resistance. Issues of differential access to sophisticated state-of-the-art hardware and software programs, access to data, and hierarchies of technical competence, all implicate positions and systems of power that can be plotted in relation to individuals, groups and geopolitical/geotechnological zones.

Notes

I am indebted to David Peerla for drawing my attention to William Gibson's work, and to Jody Berland for a critical reading of this article.

1. The term 'post-industrial' is used throughout this paper in order to emphasize the confluence of bio-technology, information technology and multinational activity in Gibson's novels, as opposed to dominant aesthetic confluences. Critical literature on postmodernism has tended to disregard developments in these areas, with the exception of Jean-François Lyotard's seminal work, *The Postmodern Condition: A Report on Knowledge* (Minneapolis, MN: University of Minnesota Press, 1984).

2. A cyborg is a compound cybernetic system/biological organism. The term cyborg was first proposed in 1960 by Manfred E. Clynes and Nathan S. Kline in a short article, 'Cyborgs and space', published in *Astronautics* (September 1960). In the article they defined 'cyborg' as follows:

 > What are some of the devices necessary for creating self-regulating man-machine systems? This self-regulation must function without the benefit of consciousness in order to cooperate with the body's own autonomous homeostatic controls. For the exogenously extended organizational complex functioning as an integrated homeostatic system unconsciously, we propose the term 'Cyborg'. (p. 27)

 The appellation has since gained wide currency in science fiction literature, robotics studies, and most recently, in critical studies. The literature, fictional and otherwise, that pertains to cyborgs is substantial. In lieu of a detailed survey I direct the reader to a popular but nevertheless useful 1965 introductory text by D. S. Halacy, *Cyborg – Evolution of the Superman* (New York: Harper & Row, 1965). A more recent overview of cyborg imagery in twentieth-century art and science fiction was published by Craig Adcock: 'Dada cyborgs and the imagery of science fiction', *Arts Magazine*, 58(2) (October 1983), pp. 66–71. For a socialist-feminist perspective on a cyborg oppositional culture see Donna Haraway, 'A manifesto for cyborgs: science, technology, and socialist feminism in the 1980s', *Socialist Review*, 15(2) (1985), pp. 65–107.

3. All further references to Gibson's short stories and novels will appear in parentheses in the main body of the text, unless otherwise noted. They will be abbreviated as follows: 'Johnny Mnemonic' (JM); 'New Rose Hotel' (NRH); 'The Winter Market' (WM); 'Burning Chrome' (BC); *Neuromancer* (New York: Ace Books, 1984) (N); *Count Zero* (New York: Ace Books, 1987) (CZ); *Mona Lisa Overdrive* (Toronto, New York: Bantam Books, 1988) (MLO). The short stores are from *Burning Chrome* (New York: Ace Books, 1987).

 For a short profile on Gibson and his work see Candas Jane Dorsey, 'Beyond cyberspace', *Books in Canada*, 17(5) (June–July 1988), pp. 11–13. Interviews with Gibson include: 'Doug Walker interviews science fiction author William Gibson', *Impulse,* 15(1) (Winter 1989), pp. 36–9; 'The king of cyberpunk: William Gibson talks to Victoria Hamburg', *Interview* (January 1989), pp. 84–6, 91; and Adam Greenfield's 'New romancer', *Spin*, 4(9) (December 1988), pp. 96–9, 119.

4. On a creole metaphor of culture, see Lee Drummond, 'The cultural continuum: a theory of intersystems', *Man* (N.S.), 15 (1980), pp. 352–74. I have borrowed and adapted Drummond's theory of the intersystemic nature of cultures in order to deal with an overall technologization of the human body in cyborg cultures, I have benefited from his observations on ethnicity in creolized cultures, and his outline of a contemporary semiotics of human identity and a 'totemism of machines' in 'Movies and myths: theoretical skirmishes' (*American Journal of Semiotics* 3(2) (1984), pp. 1–32), in the course of my own attempts to develop an analogous concept of *technicity* that can be applied to post-industrial cyborg 'social' relations.

5. 'Gomi' is the Japanese word for 'junk' (WM, 118–20). From the point of view of a dominant information culture, most of Gibson's major characters are corporate refuse in the sense that they are members of nomadic underworld oppositional subcultures. As cyborgs they are also subject to technological obsolescence and decay.

6. Haraway, 'A manifesto', p. 81.

7. See Michel Foucault, 'Of other spaces', *Diacritics*, 16(1) (1986), pp. 24–7 for discussion of heterotopias.

8. Pierre Clastres, 'Of torture in primitive societies', in *Society Against the State: Essays in Political Anthropology* (New York: Zone Books, 1987), p. 177.

9. See, for example, Mnemonic's simstim replay of Ralfi Face's death, described to the reader as a feat of (artistic) virtuosity (JM, 7).

10. See 'Burning Chrome' for a description of a related software continuum. I return to this point in the last section of the chapter.

11. The classic vision of a postmodern metropolis is presented in *Blade Runner*'s futuristic Los Angeles see Eric Alliez and Michel Feher, 'Notes on the sophisticated city', *Zone* 1/2 (1986), pp. 41–55.

12. For brief histories of the interactive military and arcade games origins of cyberspace see, respectively, N, 51 and MLO, 40.

13. See MLO, 64, and the example of Tessier-Ashpool's blue data reconstruction of the RCA building in New York (N, 256–7).

14. Description of speed of travel in cyberspace abound in Gibson's writing. See, for example, the description of the attack on Tessier-Ashpool's AI defence system in *Neuromancer* (N, 256–8), and Tick's comments on the use of instantaneous bodiless shifts in MLO, 220.

15. I have introduced the term 'postclassical' in order to make a distinction between hardware interfaced cyborgs (classic) and software interfaced cyborgs (postclassic).

16. Chrome is one example that comes to mind (BC, 180).

17. Drummond, 'The cultural continuum', p. 355.

18. Drummond, for example, defines ethnic difference as follows:

> the notion that the social setting is populated by distinct kinds of people, who are what they are as a consequence of inborn qualities or deeply held beliefs manifest in their everyday behaviour and difficult or impossible to renounce. A particular attribute, such as physical appearance, dress, speech, mode of livelihood, or religion, has ethnic significance, or marking, only by virtue of the system of meanings in which it is embedded.
>
> (Ibid., p. 354)

For a semiotic interpretation of the contemporary construction of human identity based on, amongst other relations, a 'totemism of machines,' see Drummond, 'Movies and myths'.

19. Ibid.

20. Walker, 'Doug Walker interviews', p. 38. See also Gibson's comments to the same effect in Hamburg, 'The king of cyberpunk'.

21. Bruce Sterling, in *Mirrorshades* (New York: Ace Books, 1988), p. xi.

Todd Joseph Miles Holden and Takako Tsuruki

DEAI-KEI
Japan's new culture of encounter

Introduction

DEAI-KEI **MEANS** "type of encounter." The term is specific to the Internet, reflecting a class of communication, within which two broad types exist: *deai*, where the aim is to meet another person either virtually or in the flesh; and *mēru-tomo*, which literally means "mail friend" – a twenty-first-century pen pal.[1] A cousin of chat, *deai* provides protected encounters which, nonetheless, enable users to drop the veil of anonymity and pair up.[2] The ultimate aim for many is to transform electronic encounters into face-to-face interchange. As a result, *deai* is strongly associated with issues of dating, companionship, sexuality and romance.

In this chapter we'd like to present a glimpse of this mediated world. We do so for a number of reasons. First, as a form of sociation, formal Internet-based encounter sites have only been in Japan since the millennium.[3] Second, as an Internet subculture, *deai* is commonly considered to be among the murkiest. It seems a day doesn't pass that the press and television "Wide Shows"[4] don't report another *deai*-connected crime, another salacious story of unfortunate encounter. What we will show, though, is that *deai* is more than an abject domain. Against the widely held stereotype, Internet-based intercourse is much more than a forum for frivolity, immorality and danger. Our research suggests that there are many constructive uses and more possibilities to *deai* than those reported in the media that prompt the public hand-wringing and pontification about a Japan rotting to the core.

A third, related point we wish to make is that, although *deai* is a tool for sociation, it is also an important instrument in the mediation of identity, the exploration of self, the management of emotions, and the arbitration between the individual and the larger social world. For this reason, *deai* has both practical and pedagogic uses. It is not only a tool employed by Japanese to enhance their everyday lives; it is also a phenomenon that is instructive to analysts who wish to better understand the nature and direction of contemporary Japanese society. *Deai*, in short, has sociological origins, engages sociological operations, prompts sociological outcomes, and stimulates sociological questions.

One reason, perhaps, for *deai*'s sociological bent is that it is highly intertwined with developments in technology – in this case the cell phone that has become a staple of the faddish, mobile, mediated, gadget-centered, youth-oriented, licentious lifestyle of contemporary urbanized Japan. This development, in turn, has articulated well with other changes in Japanese society – in particular the management of romantic relationships. In the past, encounters[5] often transpired within an institutional orbit: through socially-sanctioned *omiai* (arranged marriages presided over by an intermediary); within the context of company outings; via *gurūpu kōsai* (collective get-togethers in which acquaintances or club members would explore potential couplings within the non-binding framework of a group); and via the "club scene" of the 1980s and 1990s, in which singles danced in groups and tended to pair up based on shared activities in a fixed setting.[6] Now, thanks to cell phones, individuals are able to operate in virtual isolation, freer of weighty social structure and claustrophobic external surveillance. At the same time, as we shall consider further on, *deai* affords some of the advantages of the institutional orbit – namely trust and self-defense. In this way, dual benefits are provided: individually-established and managed social connections, as well as a modicum of security.

Before seeing how this is achieved, let's consider a bit more about the technology and its social context.

The worlds of *deai*

Although *deai* is an Internet-based forum, in Japan it is frequently through *keitai* – the cell phone – that *deai* is experienced. It is not uncommon to read analyses attributing this to the nature of Japanese society or the Japanese.[7] Of this ilk are claims that *keitai*'s unprecedented popularity[8] is due to the extensive waiting time and extended commuting in Japan. So, too, are assertions that *keitai* reflects the cultural predilection to miniaturize,[9] the rampant information-orientation of the society, and the commitment to fad and fashion among Japanese.[10]

Keitai's popularity has coincided with the appearance of a second social innovation: Internet-capable *keitai* – what is known as *i-mōdo*.[11] The relationship might be spurious. Nonetheless, consider the following sets of figures. In a 1999 survey of Organization for Economic Co-operation and Development (OECD) nations, Japan's ratio of 44.9 cell phone users per 100 people was good enough for only eleventh place.[12] As of the year 2000, however, *keitai* use among Japanese approached 80 per cent.[13] Patterns for Internet use differed only slightly. While Japan's raw number of 1999 users was second to the United States, scaled to the population, its use rates (of 14 per cent) were closer to fifteenth place.[14] With the advent of *keitai*-enabled Internet, however, the figures grew considerably. By early 2000, the percentage of Japan's Internet users ascended to thirteenth place (one in five, or 21.4 per cent of the population). According to one study, within two years of its debut the total number of subscribers to *keitai*-Internet services had more than doubled the total for dial-up connections on land-based telephone lines (36.9 million to 17.25 million).[15] Well before that, *keitai*-enabled Internet had surpassed the PC as the number-one platform for e-commerce in Japan.[16] In short, *keitai-i* has quickly developed into the preferred means of Internet activity in contemporary Japan.

Certainly, pragmatic factors, such as cost, portability and ease of use have fueled this preference. However, it is also possible that psycho-social factors have spurred the boom. Kogawa[17] forwards a thesis of Japan's current predilection toward "electronic individualism;" in our research we discern in *keitai/deai* not only the opportunity to disengage self from

society, but also the desire to create distinct personal enclaves. Certainly as one delves into *deai*, intimations of individuation emerge. At odds with the pervasive theorization that Japan is a homogenous society, the simple act of accessing *deai* suggests specialization and difference. For instance, a keyword search on a popular search engine begets the following message: "31 Yahoo! Categories, 420 Yahoo! Registered sites."[18] From there, users select a thematic area, within which particular sites (and, presumably, users of similar interest) are located. Among Yahoo's categories are: "actors, talent," "comics and *anime*," "event," "illness," "performing arts," "sightseeing," "seniors," "disabled" and "gay, lesbian, bisexual."

Admittedly (and consistent with the widespread media portrayal) a spate of sites are grouped under the moniker "adult." Among the hundreds are "Secret Lover's Café," "LOVE ATTACK," "*rabu sāchi*" (love search) and "BOY MEETs GIRL." Nonetheless, it would be a mistake to read *deai* monolithically. Scores of non-sexual encounter sites can be found, including "*kiizu pāku*" (Kid's Park) – for "children under 15 interested in presenting their creations;" "A World Bridge: *aru sekai no kakehashi*" – aimed at promoting cultural exchange between English-speaking and Japanese mail-friends; and "*jūnanasai no chizu*" (map for 17-year-olds) – for teens beset by problems associated with growing up.

Furthering the notion that *deai* is something other than a simple assignation-finder is the following statistic: of 300 users surveyed in an online poll, those with the goal of actually meeting another person via *deai* amounted to no more than 8 per cent. The other 92 per cent broke down as follows: making a friend of the opposite sex, 9 per cent; making a friend of the same sex, 6 per cent; making a mail friend of the opposite sex, 15 per cent; making a mail friend of the same sex, 15 per cent; talking to people who have the same hobbies, 31 per cent; mere curiosity, 14 per cent; and unspecified aims, 2 per cent.[19] That same poll found that only 34 per cent of *i-mode* users actually accessed *deai*. Of that third, 66 per cent reported employing the service just once; those doing so twice amounted to 22 per cent. And, in terms of meeting fellow users, 39 per cent claimed never to have met anyone, while 37 per cent had met less than three other users; those claiming to have met four to six users stood at 11 per cent; seven to ten users, a scant 6 per cent; and eleven users or more, 7 per cent. In short, curiosity appeared more overwhelming than sustained use.

A second online poll of *i-mode* users provides very similar results.[20] While nearly half (47 per cent) reported engaging in *deai*, 27 per cent had yet to try, but intended to; 26 per cent hadn't and didn't believe they would. Of actual users, only one-third (35 per cent) reported their aim was searching for a "lover," but an equal number (35 per cent) hoped to make "mail friends;" 16 per cent were looking for mere "company" or association; 5 per cent used *deai* for "*gōkon*"[21] and 4 per cent for "chat."[22] Still, for *i-mode* users, *deai-kei* was a popular activity. At 16 per cent, it ranked fifth behind "free news" (47 per cent), "town information" (26 per cent), "traffic information" (18 per cent) and "gourmet information" (17 per cent). Notably, on that list, *deai-kei* was the only sociative activity. In terms of gender, men outnumbered women two-to-one (65 per cent to 35 per cent) in their reported *deai* use.

If one believes the statistics, then, interaction via machine was far more common than in-the-flesh meetings arranged through *deai*. Nonetheless, the actual meeting is what holds a powerful grip over public imagination. In the next section we review two types of stories that occur through *deai* encounters – the negative ones reported in the media, and more positive encounters that often go unpublicized.

Competing visions of *deai*

The notion of *deai* as a haven of immorality, subterfuge, criminality and risk has ample visibility. For instance, the National Police Agency (NPA) convened a press conference to announce that the number of crimes associated with *deai* sites hit 302 for the first half of 2001. This compared with 104 incidents for all of 2000. Typical were incidents such as the following: (1) in Kumamoto Prefecture, a man and woman became acquainted through *deai*. After arranging a date he stole her ATM card and withdrew cash from her bank account. (2) In Nagano, three men – aged 29 to 53 – and five girls – aged 16 to 17 – were arrested on charges of prostitution. Their business, an outcall service called "Pastel," was run through a *deai* site. Its genesis stems from the night one of the suspects returned from a *deai* liaison and announced to his companions: "if we were to start a prostitution group (using *deai*), we would strike gold." (3) In Osaka, police uncovered a scheme to distribute obscene images in real time over cell phones. Customers subscribed to the service by accessing a *deai* site. At the time of discovery the service boasted 35,000 registered members, each paying access charges of 80 to 100 yen per minute. Sales were estimated to have reached 300 million yen. (4) In Tochigi Prefecture an 18-year-old boy stabbed a Saitama housewife in her home. The two had met three months before through a *deai* site. After exchanging mail for a time, they met and became intimate. In court the boy claimed that he attacked at his lover's behest. The woman had become suicidal, he alleged, when she began to fear the damage resulting from public exposure of their affair.

Despite all the negative publicity, our research discerns an alternate dimension to *deai*. Encounters can net personally – and socially – beneficial outcomes. Consider the case of Nakashibetsu, a farming community in the eastern tip of Hokkaido, Japan's northernmost island. The nation's 896th largest city, it has a population of 22,300. As far back as 1973, town elders were concerned about the population. Mechanization had reaped great profits, but also generated new opportunities and problems for the community. Women were now freed from the field, they had spare time and their families had disposable income. Increasingly, they were leaving the community to live independently or enter college. With their departure, the chance to replenish the local human stock was also disappearing.

To address this problem, Nakashibetsu created a "third sector organization" aimed at recruiting prospective brides. "Our success was mixed," admits Mr. Kajitani, chief operating officer, "until we created a home page. Thereafter, we really saw dramatic results."[23] Listed in search engines as a *deai* site, Nakashibetsu was suddenly flooded with information requests from all over Japan. The heightened visibility means that Kajitani spends considerable time playing match-maker: screening the many women who apply through the *deai* site, trying to forge a fit with the men who will attend the biannual, three-day pre-marital mixers that Kajitani organizes. From the ninety-six men and women brought together through *deai* in the past four years, thirty-three marriages have resulted; there has yet to be a divorce. Similarly, no problems of stalking or violence have occurred. At a time when rural communities throughout the country are losing population in enormous number, Nakashibetsu has reversed the trend. In Kajitani's opinion it is due to *deai*. This Internet platform has served as a powerful, productive tool for social engineering.

Decoding *deai*

Such cases are striking, but how representative are they? Just what is *deai* for the average, everyday user? To gain a better sense, we conducted interviews,[24] then coded the data

inductively. Taken together, our findings suggest that *deai* is a mechanism – the situs and instrumentality – for sociological phenomena with wide-ranging, complex implications. Ten, in particular, stand out, each pertaining to negotiations within and between self and society. Collectively, these phenomena shed light not only on *deai* as a medium for social encounter, but also the nature of Japanese society, the character of some of its people, and the status of this research topic *vis-à-vis* certain concerns in contemporary social science. The themes we find particularly salient in our data include: stigma, appearance versus reality, identity, emotions, intimacy, personal defense, glocalization, fragmentation/reintegration, uses and gratifications, and simulation. We consider each, in turn.

Stigma

One difficulty we faced in this research was simply locating people who would admit to using *deai*. Mika, a 24-year-old office worker and avid *i-mode* user, allowed that she engages in chat, but insisted she would never consider *deai*. Like many female Internet users, she believes *deai* smears its users with the mantle of illegitimacy. In this view, one apprehends "stigma" as defined by Goffman: "a term … used to refer to an attribute that is deeply discrediting."[25]

Stigma "constitutes a special discrepancy between virtual and actual social identity," between attributes one could be proven to possess, versus the "character we impute to the individual … a characterization 'in effect'."[26] Important to note, stigma is a relational concept, for, as Goffman observes, "an attribute that stigmatizes one type of possessor can confirm the usualness of another."[27] Thus was it that many of our contacts tended to employ *deai* as a social marker, an indicator of identity, a measure of character. They did this by inversion, in their repudiation and condemnation of it. For instance, Yumiko, a 23-year-old graduate student, loudly exclaimed: "Ehhhh? Me, use *deai*? Gross! No way!" The vehemence of her denial suggested a desire to manage the surrounding social judgment, thereby elevating her own image.

For the stigmatized, there is often nowhere to turn for solace but to others of similar social description. As Goffman explains, the afflicted join to forge a "circle of lament to which (each) can withdraw for moral support and for the comfort of feeling at home, at ease, accepted as a person who really is like any other normal person."[28] Among the hundreds of *deai* communities on the Web, *batsu-ichi* (or "one strike") stands out in this regard. It is an association whose users share a single signal trait: they have all been divorced. To have failed in marriage in Japan is to court stigma – for the mark of divorce provides a window into personal "untidiness," a glimpse of individual imperfection. *Batsu-ichi* reflects a strategic response by those bearing the stigma. What is ironic, of course, is that those stigmatized by one act engage in another which, itself, is stigmatizing, as a means of grappling with the repercussions of the first. This aside, though, one can discern the positive functions of *deai*. Similar to sites that seek to restrict sociation to teenagers, for instance, or work to counsel troubled members of society, defensive spaces such as *batsu-ichi* serve socially productive, wholesome, nurturing aims. A reminder that there is more to *deai* than the widely-held sense of stigma.

Appearance versus reality

In the *Republic*, Plato describes a cave of chained prisoners. Their only access to reality – to the world outside – is images flickering on the wall. These images come from a fire, mediating the figures passing outside. Plato comments that for these captives, "the truth is nothing other than the shadows of artificial things."[29] He then recounts how two prisoners are set free and experience the real world first hand. They find it quite unlike the images on the wall. Plato's implicit query is: "how can they return to the reality they once fervently held as true, when now they understand it to be an imperfect representation?"

Sayaka, a 23-year-old *furiitā*,[30] has occasionally found herself in this position. She has had to reconcile competing images: those obtained through e-messages and those acquired after actually speaking with her partners via telephone. When she has encountered discrepancies between the mail self and the phone self – between oppositional "virtualities"[31] – Sayaka has experienced Plato's prisoner's dilemma: deciding which version of reality to accept.

Such discrepancies are only magnified at the next stage of encounter: between mediated and unmediated selves. Suddenly Sayaka finds herself fully outside the cave. When her companion seeks to jump to the intimacy stage[32] by saying "*kondo, asobō yo*" (Let's go play/Let's go on a date) or "*kondo, nomi ni demo ikō yo*" (Let's go drinking/Let's go out), Sayaka has often found herself in a quandary. At times the embodied reality is so at odds with her *deai* virtuality that she has heard herself say "*ah! kore dame da*" (Oh, this is no good) or "*kyō wa kaeranakuchya*" (Today, I'll have to go home [alone]). Such discrepancies surprise her: "*kitaihazure*" she will exclaim, "this was not what I had hoped."

Appearance versus reality is also at work in the perceptions of the medium itself. Television news, the "Wide Shows," newspapers and magazines distribute morality tales that begin with mail and chat, and culminate in human tragedy following physical encounter. Yet, our research suggests a different reality. Despite the media's fetishistic focus on danger and exploitation, as noted earlier, up to 31 per cent of one survey population reported joining *deai* sites for the purpose of conversing with like-minded hobbyists. Underscoring this dimension, a large number of *deai* sites define themselves in terms of particular themes: bird-watching, hiking, seniors, and the physically disabled. It is against such a shared backdrop that sociation unfolds. Viewed this way, the media's negative visions of *deai* appear akin to the shadows on the cave's wall: they fail to correspond to the socially productive elements of *deai-kei*.

Identity

The fact that *keitai* images often don't correspond to face-to-face realities may mean any number of things. The medium may: (1) be a flawed form of communication – possibly due to excessive amounts of noise leading to signal loss; (2) enable users to engage in impression management or manipulation; or, more positively, (3) provide freedom for users to explore and negotiate potential selves.

The first possibility is unlikely; the second we shall consider further on; the third is a well-substantiated dimension of Internet culture. What makes it worthy of attention here is that Japan is a country where exceptionalist discourse remains quite strong, with one of the core exceptionalist arguments being that individual personality and self-conceptualization are constrained within and determined by the group. It is true that over the past two decades there has been some evisceration in this perspective.[33] To cite but one study pertinent to the present chapter, in the mid-1980s Holden observed numerous instances in an ostensibly

"corporate" milieu – denoted by school uniforms, fixed behavioral codes, and widespread social surveillance – in which Japanese youth employed distinctive markers of personal identity. These markers took the form of ribbons, badges, stick-pins, cartoon characters, dolls, decals, and the like, affixed to school bags and clothing.[34] Over the past decade such individuated communications have become manifest in a wider variety of expressive forms: from uniform alteration to body piercing to hair coloration.

Historically, a vestige of Japan's group-orientation has been self-censorship in the face of *mittomonai* (unseemly) behavior. For those cognizant of the social mirror, but nonetheless seeking personal expression, *keitai-i* affords a satisfactory compromise. It is individual, expressive, but also furtive. Users such as Sayaka report spending much of their online time on the kinds of activities McVeigh calls "interiority"[35] – effectively personalizing their electronic world. Sayaka's two most visited sites, for instance, are: (1) a *chakumero* site (which enables her to sample and download various sounds such as voices of famous personalities, animal noises, and popular songs as a means of signaling incoming calls), and (2) *machiuke gamen* (a service offering downloadable pictures and illustrations that greet Sayaka as she opens her *keitai*)[36] The rest of her time is spent online connecting with hand-selected e-mail and *deai* friends.

Compared to simple Web surfing, *deai* affords greater interiority and opportunity for individuation. It is invisible and anonymous. More importantly, in one package it provides a forum to assist the search for self, serves as a tool for users to actively manage identity, and even encourages and empowers the expression of practices that are quite at odds with historical perceptions of self in Japanese society.[37] *Deai* enables a relatively unregulated, unsurveilled stage for people to create and forge new selves. It affords trial, but also enables multiple errors, without retribution and with (often) little personal consequence.[38]

Emotions

Identity is conveyed in part by a tool supplied by the *deai* service provider: comic characters, illustrations, and photos available for pasting into messages, often as a substitute for words.[39] Semiotically, such signs serve as indexes of sentiment; nonverbal signifiers which, nonetheless, communicate a deeper "truth" about the sender's emotional state. More than one informant told us that such depictions are "convenient" and "helpful;" they can convey emotions and thoughts that the sender would never have the courage or ability to express.[40] By inserting an illustration, the sender can depict heartbreak, happiness, loneliness, or love; s/he can modify the impact of words, or even nullify earlier damaging statements – all of this without having to actually write words.

Of course, this surrogate communication is but one small step removed from impression management. Here, then, we stray into the realm of Goffman's self as sign-giver, performer, manipulator.[41] Who, after all, can say that the tears dotting the text are truly being shed by the sender? Are the words of bravado or the *kawaii* (cute) colors or the fonts of aggressiveness or the embedded links to natural scenery a true representation of the inner other? Might these tokens not be skillful, machine-assisted projections of whom the sender wishes the reader to believe him or her to be?

Consider the case of Sayaka. After months of corresponding with a man, and a few face-to-face meetings, she became sufficiently convinced of his sincerity and good character to consent to sexual relations. Her aim, she says, was a long-term relationship – a goal she insists her partner concurred with. After one week of intimacy, however, Sayaka discovered that her new partner was actively engaged in another relationship. Sayaka was devastated.

How could she have been so misled? The machine in-between, she realized, had abetted her manipulation.

Intimacy

A central element in Sayaka's story is the search for intimacy. Her encounters aimed at finding a partner who would make her heart pound; a person who would unleash the voice within: "this is the guy, this is the ONE! I *HAVE* to meet him." This aim was common among all of our informants. Beyond mere sociation, those engaging in Internet encounters seem to want something more than the simple exchange of pleasantries or sharing of daily events (i.e. what chat provides).

Giddens[42] has argued that modern society tends to elicit a greater response in the expression of intimacy. Others[43] have observed that efforts to establish intimacy correlate most highly with the presence of large, impersonal, bureaucratic structures. If both of these claims are true, it should come as little surprise that in Japan (to many, a paradigmatic "corporate society"), one finds extensive intimacy seeking. Importantly, we found this impulse not only in an office worker such as Mika, but also a *furiitā* such as Sayaka, housewives such as the Saitama knifing victim, mentioned above, and Rumiko, who will be introduced further on. In accounting for the *dei* phenomenon, Japan's highly corporatized structure – and the impetus for intimacy which it engenders – may be a key factor.

Personal defense

What Sayaka described as her "betrayal" left her shocked and depressed. It was enough to scare her away from *dei* for months. Ultimately, she returned to online encounters, but was understandably less trusting of the men on the other end. The Sayaka of today states coolly: "in retrospect I see he just wanted to have sex." Consequently, she is now more reluctant to step away from the protective shield afforded by the medium.

This defensive aspect is a central feature of *dei*. Online service providers offer space within which intimacy can be safely practiced. Understanding the character of modernity – and Japan, as well – this should come as no great surprise. For the corporation (here in the form of a service) offers not only a forum for interaction, but a protective structure for participation, as well. The medium constrains all users within its institutional boundaries. It serves as a guarantor of individual safety, thereby stimulating trust.

One distinguishing feature of urban modernity has been the pell-mell increase of outsiders in once-closed social circles. To cope with the dangers of anonymous encounters, humans engage in "civil inattention."[44] Such "polite estrangement"[45] aims at blocking the transmission of "tie signs" – visual cues which risk forging social connection.[46] The danger of connection ranges from physical to emotional, financial to reputational harm. Such danger can be mitigated in only two ways: total avoidance or else (ironically) deeper involvement with the person encountered. The latter demands what Giddens calls "facework commitments:" focused encounters that provide indications of integrity about the person engaged. Such evaluations, of course, are less possible on a telephone and even more problematic on a display printing out words or icons. This is especially true in early stages of encounter, when the potential for (and interest in) image management, identity concealment, and deception runs so high. As we have seen, *dei* is furtive in this way. There is no timbre of voice to gauge, no control over visual and temporal parameters. The medium is designed to

intercede – via software that modifies and shapes identity – hence, there is less opportunity for independent verification. With the technology working so well to frustrate external evaluation, sociation can become even more dangerous; the need for personal defense even greater. The case of Sayaka demonstrates how, outside the protective umbrella of the *deai* service, emotional harm can occur. Certainly, as other *deai* stories show, physical, financial and moral damage can result, as well.

There are no perfect solutions for the dangers inherent in human intercourse. Chat-only encounter sites aim at full protection, but they can engender their own problems. As Mika explained: "if you sign into chat at the same time each day, you get used to the people who are there. You get to know them and even count on chatting with them. And then, one day, they're not there any more. And you wonder: 'what happened to them?' You can't find them … and you start to feel lonely." For people yearning for connection, but seeking institutional protection, they can end up hoist by their own petard.

Nonetheless, the notion of intimate, but protected, connectivity is popular. For instance, there is the extensive *deai* sector known as *gōkon*. Here, in an updating of *gurūpu kōsai*, congregations of one sex will advertise their availability for a night of food, drink, conversation and *karaoke* – an invitation to which a group of like-minded members of the opposite sex may respond. Often, posted pictures fed by camera-enabled *keitai* serve as a pre-screening device, assisting in decision-making, self-defense and, possibly, even deception.[47]

Glocalization

As a medium for sociation, *deai* is uniform in form. Yet, its content is quite diverse. As noted above, heterogeneity is at odds with standard theorization about Japan, leading one to speculate on whether *deai* might serve as fodder for an assault on essentialism. One point that should not be lost, though, is that Japan is a fully developed nation in the throes of high modernity. As such, it *ought to* manifest what Berger[48] calls "the pluralisation of lifeworlds." Such multiplicity means that society's members "naturally" experience a segmented world; their activities carved up into numerous "lifestyle sectors"[49] – one of which appears to be an Internet subculture such as *deai*.

One phenomenon contributing to pluralization, of course, is globalization. We know from Appadurai[50] that despite global flows (like, for instance, cell phone technology) all societies manifest localized responses and applications. In the case of *keitai*, Internet capability is one such localized expression. So too, within this response, services such as *chakumero, machiuke gamen*, and *deai* reflect contextual creations. As for *deai*, even further localization has transpired: in it one finds a variety of hand-tailored environments, none of which are found in these specific incarnations outside the country. In isolation and arrayed combination – and, crucially: subject to the values and will of individual users – these sites provide for greater pluralization of lifestyles in contemporary Japan.

Fragmentation/reintegration

A basic tenet of Durkheimian theory is that social segmentation has the potential to dilute social density, thereby destabilizing social solidarity.[51] The greater autonomy gained by the individual represents a concomitant diminution in the grip of the moral and emotional cocoon containing him. Cut adrift, he can find himself at greater risk, with costs for both the individual and society. It is just such a situation that critics claim has befallen

contemporary Japan. One writer has decried, "New Japanese are materially affluent but spiritually destitute."[52] To Murakami Ryū, a highly-acclaimed novelist known for books that portend social problems, Japan no longer possesses clear goals and grounding principles; it is a rudderless nation full of aimless citizens.[53]

Viewing the *deai* phenomenon, one could easily assert that it is all so much personal aggrandizement, social detachment, self-centered and inwardly-directed. Kogawa, for instance, argues: "as far as the present Japanese collectivity is concerned, it is electronic and very temporal, rather than a conventional, continuous collectivity based on language, race, religion, region or taste."[54]

Yet, post-modern though they may be, *deai*-inflected lifestyle sectors may be seen as functioning like traditional clubs or communal associations: tools for steering through the societal soup, for gaining stability and reconnecting. The choice to join a group like *Zenkoku furusato kōryu foramu* – a site which aims at promoting exchange between "home towns" – may be individual and personal; but at another level it is communal, outward-reaching. Participation in the transitory, electronic community that is *deai* may actually be binding for contemporary Japanese society and, therefore, socially productive.

Uses and gratifications

Throughout this chapter we have argued that *deai* is a mechanism for sociation. To Simmel, who coined the concept, the motive for forging social connections was the satisfaction of human desires.[55] There is, in such intentional behavior, resonance to an early literature in communication studies called "uses and gratifications." This line arose during the period when the model of powerful sender-directed effects began to yield to the paradigm of user-mediated reception. An influential articulation by Katz[56] posited the possibility that humans do not passively receive media messages; rather they actively use media as a means of satisfying certain needs. Although this conception has fallen out of favor, more recently Fiske has advanced a view of the popular that is reminiscent of this earlier position.[57] It seems applicable to the behavior of *deai* users, as well.

Admittedly, some users' behaviors may not reflect purely internal or individually motivated needs. There are the pro-social impulses mentioned above. Additionally, *deai* use may be the result of social factors. One cannot ignore the fact, for instance, that the environment is chock-full of cell phone-aided Internetters. In Japan – fashion-conscious, conformity-aware, surveillance-full – such ubiquity places a certain degree of pressure on fellow users to engage in like-patterns of acquisition and use. Whether externally-imposed or internally-driven, however, it is the uses and reasons for use – the seeking and achievement of gratification by users – which are among the signal aspects of the *deai* phenomenon.

Simulation, or virtu-actualization?

Rumiko is twenty-eight, married, with one child. When she started using *deai* she selected from four potential correspondents: three men and one woman. She chose Shinichi, a 43-year-old man who lived in her area. After exchanging mail for three weeks, they agreed to meet. Shinichi surprised Rumiko. He was better looking than she had expected, witty, loquacious, and fun. Most importantly, unlike her husband, he "treated (her) like a woman." Following three weeks of face-to-face meetings (and at Shinichi's behest), the couple became intimate. Though Rumiko had never really enjoyed sex, she discovered a sudden fondness

for it. "A new world opened up to me," she professed. But when her husband discovered the subterfuge he pressured Rumiko to cut it off. With great reluctance, she assented. Today she exclaims: "I love my husband, but I dream about Shinichi."

When commentators on Wide Shows hear such stories they pontificate about the power of the medium to alter human behavior in deleterious ways. "This phone-mail connection reduces our natural defense barriers which usually allow us to block out the dangers of casual face-to-face meetings."[58]

By contrast, some media scholars see such developments as natural. Morse has argued that "as *impersonal* relations with machines and/or physically removed strangers characterize ever-larger areas of work and private life, more and more *personal* and subjective means of expression and ways of virtually interacting with machines and/or distant strangers are elaborated."[59]

In observing *deai*-assisted encounters it is easy to see how these mediated relations differ from other virtualities. Although *deai* does enable the creation of fictional presences, when the machine is cast aside – when *mēru-tomo* or *deai* interchange eventuates in corporeal concourse – then certain fictions cease because actual presences have been conjured. Embodiment has been engineered by the medium. This is Baudrillard's simulation incarnate: artifice that eventuates in the "hyperreal;" people who are different, but "realer" than their originals.[60] Sayaka's sexual betrayal, Rumiko's unrequited love, "Pastel's" prostitution ring, Nakashibetsu's "*omiai* weekends" and thirty-three actual marriages, the Saitama knifing – all of these outcomes represent virtu-actualizations: realizations of virtual scenarios; cyber-sociations which have become embodied, then spill over and play out in physical space. By being created and cultured in the imagination, it is plausible that they exert an even greater pull on human consciousness than corresponding relationships in the mundane, everyday lifeworld.[61]

Conclusion

In this chapter we have seen that *deai* is a strategy for embodying the self, satisfying personal interests, expressing emotions, experiencing intimacy, and achieving self-expression. It is a way of asserting individualism and autonomy, while escaping the pervasive surveillance that once dominated and ordered Japanese society. As such, *deai* is a tool of empowerment, affording users the opportunity to forge social connections of their choosing, less fettered by institutional codes and less subject to organizational hierarchies and regulations.

In many ways the impetus for engaging in this behavior lies in problems associated with modernity, most notably fragmentation, alienation, declining trust, and imperiled personal defense. To manage these concerns users have turned to *deai* and, in so doing, have engineered a greater degree of connection than previously possible between strangers passing all-too-quickly on the street.

Viewed this way, we believe that this chapter contributes not only to research on the Internet, but also theorization about society, in general, and Japan, in particular. Through *deai* we are better able to see whence Japanese society has come, where it currently is, and, given the values and behaviors of its people, where it may be going. This said, the recognition should not elude us that sociation is being forged in, sanctioned by, and delivered through an organization – no matter how amorphous, transient or ethereal. Of course, would one expect anything less in a society that, for centuries, has been arranged in accord with corporate understandings and regulated by collective imperatives? *Deai* may be a new strategy for encounter as a means of solving the problems incident to modernity.

We are left to wonder, though, whether it actually delivers its users from the structuration inherent in the society in which they exist. One final query: if it did, then what sort of society would Japan become?

Notes

1 Often the distinction is not sharply drawn and, in such cases, the generic term *deai* is applied. In this chapter, for the sake of parsimony, we will refer to all Internet-assisted encounters as *deai*, unless the distinction is crucial to the analysis.

2 Similar to Internet chat, *deai* requires users to join a community. Unlike chat, *deai* participants scan a list of users, read their self-introductions, and seek to initiate one-to-one message/chat interaction. Once contact has been established, community members are on their own, although their exchanges occur through the *deai* site.

3 The prototype exposition of cyber-sociation is Indra Sinha's *Cybergypsies* (New York, Scribner, 2000), an account of life in multi-user dungeons or domains (MUDs) and human interaction on the "electronic frontier" in the 1980s and early 1990s. Such a tale has yet to be written about Japan.

4 'Wide Shows" are "infotainment"-style television programs that run from mid-morning to late afternoon on all major commercial stations. They generally focus on current topics in Japanese society and culture. More often than not scandal or social problems take center stage. A panel comprised of social critics, university professors, journalists and *tarento* (entertainers and personalities) will often weigh in with commentary on the reported matter.

5 This passage presupposes heterosexual relationships. *Deai*, however, has been nothing if not a boon for facilitating homosexual liaisons, due to its focused, "special-interest" character. Certainly, our later claims concerning autonomy, self-defense, self-exploration, emotions and identity attach equally to homosexuals and heterosexuals.

6 The so-called "Juliana's boom" in the late 1980s reflected the values of the bubble economy: conspicuous consumption of designer goods, well-dressed "upwardly mobile" singles, brash public display in glitzy clubs, with women donning short skirts and gyrating to a disco beat on a raised platform with a mirrored floor. "T-backs," "V-backs" and "O-backs" – various styles of undergarments – were part and parcel of this "show me" lifestyle. Widely ballyhooed in the media, this lingerie served to spur the consumption cycle. The more down-to-earth "hip hop boom" of the late 1990s fit the post-bubble mood: grunge clothing, Rastafarian hairstyles, body piercing, rap music, along with a coarser public demeanor.

7 Historically, the tendency to view Japan and the Japanese as unique has been pervasive. More recently, opposition to claims of so-called *nihonjinron* has been common. For a sampling of the literature on exceptionalism, see H. Befu, *Hegemony of Homogeneity: An Anthropological Analysis of Nihonjinron*, Melbourne, Trans Pacific Press, 2001. For a critique of assertions of exceptionalism, see P.N. Dale, *The Myth of Japanese Uniqueness*, London, Routledge, 1986. Despite the recent "thought style" deriding it, the assertion of Japanese uniqueness persists.

8 "The Internet-enabled mobile phone [is] the fastest-growing consumer technology in Japan's history," *Japan Internet Report No. 45*, January/February 2000. Online. Available HTTP: *http://www.jir.net/jir 1–2_00.html* (2 March 2002).

9 See, for instance, O-Young Lee, *The Compact Culture: The Japanese Tradition of "Smaller is Better,"* Tokyo, Kodansha, 1982.

10 As one president of a Japanese Internet consultancy firm says: "cell phones here are fashion accessories and toys above all … It's unlike anything else in the world." D. Scuka, "Unwired: Japan Has the Future in Its Pocket," *Japan.Inc*, June 2000. Online. Available HTTP: *http://www.japaninc.com/mag/comp/2000/06/jun00_unwired4.html* (2 March 2002).

11 *i-mode* is a particular (read limited) kind of Internet platform – one that is based on satellite access through the parent provider, *DoCoMo*, rather than over land-lines. As a result, *DoCoMo* does not load every URL on the World Wide Web into their satellite – meaning that there cannot be perfect Internet freedom for *keitai* users. A further element mitigating user freedom is cost.

Charges for *i-mode* are assessed based on the number of information "packets" downloaded by phone – a fact that can make users reluctant to surf the already truncated sites available.

12 By comparison, Finland ranked first with 65 users per hundred. The United States ranked twenty-second at 31.5 per hundred.

13 The Office of the Prime Minister, *Posts and Telecommunications Policy, 1998–2000*, 2000.

14 The raw numbers: 16,000,000 in Japan to America's 62,000,000. The scaled numbers: 1,323 per 10,000. This compares with, say, Sweden (number one with 3,953 per 10,000), Canada (number four with 2,475 per 10,000), and Singapore (number seven with 1,739 per 10,000). Source: International Telecommunication Union, *World Telecommunication Development Report*, 1999.

15 "Number of Internet connection users," press release, The Ministry of Public Management, Home Affairs, Posts and Telecommunications, April 2001. These figures cover not only *i-mode*, but two rival services, Ezweb and J-Sky, as well.

16 Source: *Japan Internet Report*, no. 45, January/February 2000. Online. Available: HTTP: *http://www. jir.net/jir1–2_00.html* (2 March 2002).

17 T. Kogawa, "Beyond electronic individualism." Online. Available HTTP: *http://anarchy.k2. tku. ac.jp/non-japanese/electro.html* (2 March 2002).

18 Even more astounding, as of February 2002, a Google search yielded 1,420,000 *deai* sites.

19 Statistics from: *Deai-kei mērutomo boshūsaito riyōsha*, online survey conducted by *Japan.internet. com*, 26 April 2001. Online. Available HTTP: *http://japan.internet.com/cgi-bin/ archives?c=research* (30 April 2002).

20 Statistics by Soft-Bank V, as reported in *i-mōdo jōhō saito 1000* (*deai and mēru*) (1,000 *i-mode* information sites [meetings and mail]), 12 October 2001, Tokyo, Softbank Publishing Company, pp. 12–15.

21 Explained later in this chapter.

22 The poll lists the remaining 5 percent as "other."

23 Data reported in this section was collected via telephone interview, February 2002.

24 This interview data was collected as part of a reputational/snowball sample of actual *deai* users. Depth interviews lasted on average two hours, and were standardized, but non-scheduled. The population was limited in size to five, and restricted in terms of age (early to mid-twenties), gender (women), and location (Sendai, Japan). Additionally, the data reflects a particular time slice (interviews were conducted in November and December 2001). Given these limitations, we would term our findings "suggestive" rather than "generalizable." The conclusions drawn from this information are plausible rather than definitive, and merit follow-up with a larger, more diverse population.

25 E. Goffman, *Stigma: Notes on the Management of Spoiled Identity*, Engelwood Cliffs, NJ, Prentice-Hall, Inc. 1963, p. 2.

26 E. Goffman, *Stigma*, p. 2. Note that while the Internet was not yet created at the time of writing, Goffman's distinction fits *deai*-mediated identities and encounters in that he posited "virtual selves" to be unempirical. Instead, they are "unsubstantiated inferences."

27 Goffman, *Stigma*, p. 3.

28 Goffman, *Stigma*, p. 20.

29 Plato, *The Republic of Plato* (ed. Allan Bloom) New York: Basic Books, 1968, Book VII, 515c, p.194.

30 A Japanese neologism meaning a free agent unencumbered by a full-time job and not pursuing any particular career path.

31 "Virtuality" is a term advanced by Morse to denote "fictional presences" that have "come to be more and more supported and maintained by machines, especially television and the computer." M. Morse, *Virtualities: Television, Media Art, and Cyberculture*, Bloomington, IN, Indiana University Press, 1998, p. 11. Nonetheless, Morse pays (pardon the pun) virtually no attention to the greatest medium of virtualization: the Internet. In *deai*, alone, one can see that humans are establishing, exploring and encountering fictional presences willy-nilly. This is even more true when it comes to the design and publishing of Web pages and the ubiquitous use of e-mail.

32 For Sayaka, as with other respondents, we learned that *deai* encounters often proceed through stages. The first is exchange with a faceless correspondent on the other end of a computer or cell phone. Mail is exchanged for a time (in Sayaka's case about 3 months) until one of the

two mentions the possibility of exchanging addresses. The rationale is often: "exchanging mails through this (*deai*) site is cumbersome. It would be faster if we could mail one another directly." If both agree, direct interaction (either e-messages or actual phone conversations) will occur. If the voice on the other end of the *keitai* somehow fits the image Sayaka has of her interlocutor, and if the content remains fun or moving, then the time may arrive to step away from the veil of the technology and physically meet.

33 See, for example, T.S. Lebra and W.P. Lebra (eds), *Japanese Culture and Behavior: Selected Readings*, Honolulu, University of Hawaii Press, 1986 [1974]; R. Mouer and Y. Sugimoto, *Images of Japanese Society: A Study of the Social Construction of Reality*, London and New York, Kegan Paul International, 1986; D.P. Martinez, *The Worlds of Japanese Popular Culture: Gender, Shifting Boundaries and Global Cultures*, Cambridge, Cambridge University Press, 1998; and M. Takatori, *Nihonteki-shikō no genkei* (Original types of Japanese thinking), Tokyo, Kodansha, 1975.

34 See T.J.M. Holden, "Surveillance: Japan's Sustaining Principle," *Journal of Popular Culture*, vol. 28, no. 1, 1994, pp. 193–208. Brian J. McVeigh has explored this phenomenon extensively in his book *Wearing Ideology: State, Schooling and Self-Presentation in Japan*, Oxford, Berg Publishers, 2000.

35 See McVeigh's chapter in this volume.

36 At the time of this writing, *chakumero* is a multi-million yen business, with hundreds of sites competing for the same customers, often with different versions of the same re-recorded songs. The cost of a download is about 100 yen. Users can spend up to 20,000 yen per month downloading and changing *keitai* sounds.

37 In this way, studying *deai* enables us to do what Stuart Hall urges: "precisely because identities are constructed within, not outside, discourse, we need to understand them as produced in specific historical and institutional sites within specific discursive formations and practices by specific enunciative strategies." S. Hall and P. du Gay (eds), *Questions of Cultural Identity*, London, Sage Publications, 1996, p. 4.

38 Although a recent case belies this view. Two young men began corresponding, each mistaking the other for a woman. During the course of their *deai* encounters it became clear that neither was what their words had first suggested. Incensed, one boy began sending the other threatening mail, insisting that bodily harm (as well as public exposure) would result unless money was sent in apology. The other boy, a high schooler, complied with the extortion demand, parting with 20,000 yen, before finally informing the authorities.

39 Larissa Hjorth covers some of this terrain in greater detail in her chapter in *Japanese Cybercultures*.

40 And, of course, well suits what has historically been seen as the Japanese inability or unwillingness to state feelings directly.

41 E. Goffman, *The Presentation of the Self in Everyday Life*, Garden City, NJ, Doubleday Anchor Books, 1959.

42 A. Giddens, *Modernity and Self-Identity: Self and Society in the Late Modern Age*, Stanford, CA, Stanford University Press, 1991.

43 J. Bensfeld and R. Lilienfeld, *Between Public and Private*, New York, The Free Press, 1979.

44 E. Goffman, *Behavior in Public Places*, New York, The Free Press, 1963.

45 A. Giddens, *The Consequences of Modernity*, Stanford, CA, Stanford University Press, 1990, p. 81.

46 Goffman, *Behavior in Public Places*.

47 In fact, a recent ad for J-Phone highlights (and makes light of) this protective function by posing a situation in which four attractive women are heading down the stairs of a pub to meet four poorly-groomed, uncouth men. Just as the women near rendezvous, a competing group of smartly-dressed "junior-executive" types send the women their picture along with an invitation to get together. Uttering quick apologies to the first group, the four women beat a hasty retreat in the direction of the better offer.

48 P.L. Berger, B. Berger and H. Kellner, *The Homeless Mind*, Harmondsworth, Penguin, 1974.

49 A. Giddens, *Modernity and Self-Identity: Self and Society in the Late Modern Age*, Stanford, CA, Stanford University Press, 1991.

50 A. Appadurai, "Disjunction and Difference in the Global Economy," in M. Featherstone (ed.), *Global Culture: Nationalism, Globalization and Modernity*, London, Sage, 1992, pp. 295–310.

51 See E. Durkheim, *The Division of Labor in Society*, (trans. G. Simpson), New York, The Free Press, 1933.

52 Mikio Sumiya, as quoted in E. Hoyt, *The New Japanese: A Complacent People in a Corrupt Society*, London, Robert Hale, 1991, p. 197.

53 J. Sprague and M. Murakami, "Internal exodus: novelist Murakami Ryū sees a dim future," *Asiaweek.com*, 20 October 2000, vol. 26, no. 41. Online. Available HTTP: http://www.asiaweek.com/asiaweek/magazine/2000/1020/sr.japan_ryu.html (4 March 2002).

54 T. Kogawa, "Beyond electronic individualism."

55 Simmel's definition was: "Sociation … is the form in which individuals grow together into units that satisfy their interests." He enumerated those interests as "sensuous or ideal, momentary or lasting, conscious or unconscious, casual or teleological." See G. Simmel, *The Sociology of Georg Simmel* (ed. and trans. K.H. Wolff), New York, The Free Press, 1950, p. 41.

56 E. Katz, "Mass communication research and the study of popular culture: an editorial note on a possible future for this journal," *Studies in Public Communication* 2, 1959, pp. 1–6.

57 See, for instance, J. Fiske, *Understanding Popular Culture*, London and New York, Routledge, 1989.

58 Commentary from a Wide Show, *Terebi Asahi*, April, 2001.

59 M. Morse, *Virtualities: Television, Media Art, and Cyberculture*, p. 5.

60 J. Baudrillard, *Simulacra and Simulation* (trans. S.F. Glaser), Ann Arbor, MI, University of Michigan Press, 1994 [1981].

61 And, in fact, recent evidence from a Western context suggests that contrary to widely-held assumptions, relationships that begin online may actually result in strong, long-term unions. See "Chat room chatter may lead to real romance," by P. Hagan, *Yahoo! News*, 15 March 2002. Online. Available HTTP: http://dailynews.yahoo.com/ (16 March 2002).

Bob Rehak

MAPPING THE BIT GIRL
Lara Croft and new media fandom

Abstract

THIS PAPER EXAMINES THE FAN MOVEMENT surrounding Lara Croft, a computer-generated character who has appeared in computer games, comic books, men's magazines, promotional tours, music videos, calendars, action figures and motion pictures. A fixture of the pop-culture landscape since 1996, Croft embodies or incarnates a nexus of cultural, economic, and technological forces, whose shared characteristic is their powerful hold on a vast audience base. Lara Croft is nothing without her fans. As the founding member of a new mode of celebrity system featuring female digital stars, Croft's essentially technological nature – the mode of her signification and circulation – produces continuities and ruptures with traditional fan practices, reframing our understandings of categories such as 'fan', 'audience', 'character', and 'text' in relation to a mediascape whose speed and multiplicity mark not just postmodernism, but adaptive responses to postmodernity. From this perspective, Lara Croft is less a singular entity than a coping strategy, a mediation of media. The concerns of this project are, first, to examine Lara Croft as a conjunction of industrial and representational forces intended to promote certain types of reception and consumption; second, to assess the ways in which her peculiar semiotic status – simultaneously open-ended and concrete – renders her available for appropriation and elaboration by fans; and, finally, to discuss the ways in which Croft's fandom opens up new debates about the relationship between texts, audiences, and technology.

Introduction

The fan movement surrounding Lara Croft – one of the most recognizable, globally popular and lucrative media stars working today – is all the more remarkable given that its object does not, in any localized or unitary sense, exist. Croft, a fixture of the pop-culture landscape since 1996, who has appeared in computer games, comic books, men's magazines,

promotional tours, music videos, calendars, action figures, board games and a motion-picture franchise, is an *artefact*: a software-generated character without human referent. Plainly, though, she is more than that. In a literal sense, Lara Croft *embodies* or *incarnates* a nexus of forces – cultural, economic, and technological – whose shared characteristic is their powerful hold on a broad audience base. Lara Croft, once dubbed by *Details* magazine the 'Bit Girl', is nothing without her fans.

Moreover, as the founding member of what Mary Flanagan labels 'a new star system' featuring 'the emerging personalities of the new millennium – female digital stars' (Flanagan 1999: 77), Croft's essentially technological nature – the mode of her signification and circulation – creates continuities and ruptures with traditional fan practices. Lara Croft pushes us, in fact, to revise categories such as 'fan', 'audience', 'character' and 'text' in relation to a mediascape whose speed and multiplicity mark not just postmodernism, but *adaptive responses to postmodernity*. Seen from this perspective, Croft is less a singular entity than a coping strategy, a mediation of media that occurs, in the words of Jim Collins, 'when the shock of excess gives way to its domestication, when the *array* of signs becomes the basis for new forms of art and entertainment that harness the possibilities of semiotic excess' (Collins 1995: 5; emphasis added).

While Croft has received her share of attention within the fledgling field of videogame studies (see Cassell and Jenkins 1999; Carr 2002; Grieb 2002; Kennedy 2002), this analysis has usually confined itself to issues of representation and gender – for example, the unavoidable paradoxes of identification when male players inhabit female bodies, or the vexed politics of Croft's dual function as sexist cartoon and model of capable womanhood (a binary summed up neatly in the title of Helen Kennedy's (2002) 'Lara Croft: feminist icon or cyberbimbo?'). It seems equally important, however, to ask what Lara Croft might signify over and above the context of a single image, body, identity, experience or product. The playable, copyable, endlessly reframable digital star, who serves her collective makers and users in myriad ways, offers similarly varied avenues for academic investigation into the operations of postmodern media. As a conjunction of industrial and representational forces promoting certain types of reception and consumption, Croft demonstrates a unique semiotic status – simultaneously concrete and open-ended – that leaves her available for appropriation and elaboration by fans, but only within 'authorized' boundaries of imaginative play. In short, Croft's celebrity and fan base open up new questions about the relationship between producers, texts, audiences and technologies.

In exploring these questions, I consider the ways in which the entity 'Lara Croft' has functioned differently across various media environments, serving frequently contradictory ends based on her location within cultural circuits of representation and commodification. Crucial to this discussion are the linked concepts of *videogame* (an interactive, goal-oriented electronic experience, designed to entertain and immerse players) and the larger environment of *new media* of which such games are a hallmark. New media can provisionally be described as a global network of communication technologies and information flow whose material backbone is the digital computer and whose aesthetics and formal properties are heavily shaped by digital processes. Manovich (2001) lists these characteristics as programmability, modularity, automation, and – perhaps most important to my consideration of Lara Croft – *transcoding*, that is, new media's endless translation of information between diverse technological frameworks and cultural hierarchies.

> To 'transcode' something is to translate it into another format. The computerization of culture gradually accomplishes similar transcoding in relation to all cultural categories and concepts. That is, cultural categories and concepts are substituted,

on the level of meaning and/or language, by new ones that derive from the computer's ontology, epistemology and pragmatics.

(Manovich 2001: 47)

As we will see, Croft's re-inscription of the star system and traditional fandom in the digital era is only one instance of the transcoding/cultural mapping by which new technologies are adapted and domesticated by audiences.

A star is born, and reborn, and reborn

Lara Croft was introduced in 1996 as the visual and interactive centrepiece of the videogame *Tomb Raider*: an avatar controlled by the player in order to explore exotic environments and – true to the game's title – raid deathtrap-laden tombs for treasure and mystical artefacts. Flanagan catalogues the avatar's larger-than-life qualities this way:

> Lara Croft might be compared to a person, but she is much more onscreen. Lara wields amazing physical prowess and multiple firearms. She is capable of any physical activity demanded by the game's incredible situations: back-flipping out of buildings, swimming underwater, punching tigers, round-housing monks, and even biting foes … while barely clad in scanty, skin-tight 'explorer' clothing. In addition to her superhuman traits, Lara is precise, rides in great vehicles, and, unless there is user error, never needs a second take.
>
> (Flanagan 1999: 78)

Self-consciously borrowing narrative motifs and *mise-en-scène* from Steven Spielberg and George Lucas's *Indiana Jones* franchise, England's Core Design (at least according to its public relations) intended *Tomb Raider* to go beyond generic conventions in one respect: its female hero. According to lead programmer Toby Gard,

> Lara was designed to be a tough, self-reliant, intelligent woman. She confounds all the sexist clichés apart from the fact that she's got an unbelievable figure. Strong, independent women are the perfect fantasy girls – the untouchable is always the most desirable.
>
> (quoted in Cassell and Jenkins 1999: 30)

These words signal the troubling way in which Lara Croft's 'inhuman nature' sutures apparently contradictory discourses: she is, on the one hand, self-reliant and intelligent; on the other, she is a fantasy object of heterosexual male desire. (The slippage in Gard's vocabulary from *women* to *girls* is a regression symptomatic of a culture still in uneasy negotiation with the political project of feminism.) I will return to public readings – and critiques – of Lara-Croft-as-representation-of-woman later, but for now I wish to underscore the strategic way in which Core and its publisher, Eidos, aimed to capture the widest possible audience by pushing an unorthodox identificatory position on players. Early in development, *Tomb Raider* featured a male avatar based unashamedly on Indiana Jones. When concerns over copyright infringement and litigation prompted the gender switch, programmers realized the potential value of offering a female avatar to an audience of gamers composed primarily of white male teenagers.[1]

The move paid off. The *Tomb Raider* series not only became the PlayStation's signature title, its first three instalments selling 16 million copies worldwide (Poole 2000: 7), but it is credited with skewing the game-buying demographic towards older and wealthier quarters

– a shift probably responsible for the current market dominance of expensive consoles like Microsoft's Xbox, the Nintendo GameCube, and Sony's PlayStation 2. And if Croft's ludic identity was simply a gender-flipped Indiana Jones, in the context of the global marketplace she was emphatically sexualized – seducing consumers into purchasing and playing her products. An analysis by Ian O'Rourke of the online publication *Fandomlife.net* argues that

> Croft became the perfect icon for the PlayStation, matching Sony's vision of the console's place in the market perfectly. She was a videogame character for the older, more sexually mature audience, and she appealed to both women and men in the young adult demographic. For the first time, the signature character of a console had sex appeal – it sure beat looking at a fat plumber plastered all over the boxes and posters.
>
> (O'Rourke 2002)

Originally conceived as an alternative to traditional gender alignment in videogames, Croft took on public significance beyond *Tomb Raider*'s jungles and crypts. Like Sonic the Hedgehog and Mario the plumber, she became a brand in her own right, a means of personalizing technology while instilling consumer loyalty to the Sony corporation. Popular awareness of the avatar quickly outstripped the puzzle-solving scenarios in which she was incubated. (In addition to the media appearances listed above, Croft has been featured in Nike ads, bus, billboard and television campaigns for *Tomb Raider*, as well as *Lara's Book*, a coffee-table devotional by Generation-X prophet Douglas Coupland (Coupland and Ward 1998).) In short, Lara Croft seems capable of *migration*, cloning herself from one media environment to another and maintaining simultaneous existences in each. (She's a 'media raider' as well.) Audiences do not seem bothered by her participation in commercial domains the way they might take issue with, say, Bob Dole advertising Pepsi. O'Rourke writes that Lara Croft has

> always transcended her videogame origins, due to the strength of the character. … In many ways she was a movie, TV show, comic or novel waiting to happen, it always seemed just like circumstance that you experienced her first adventures via a videogame.
>
> (O'Rourke 2002)

This ease of translation can be read first for what it says about Croft's *polysemous perversity*, her ability to endlessly resignify. In this sense, she merely extends the essential emptiness of the avatar, a semiotic vessel intended to be worn glove-like by players. In his discussion of *Tomb Raider*'s relatively low-resolution graphics, Steven Poole argues that Croft's appeal stems precisely from this lack of individuating detail:

> She'll never be thoroughly realistic. For Lara Croft is an abstraction, an animated conglomeration of sexual and attitudinal signs (breasts, hotpants, shades, thigh holsters) whose very blankness encourages the (male or female) player's psychological projection and is exactly why she has enjoyed such remarkable success as a cultural icon. A good videogame character like Lara Croft or Mario is, in these ways, inexhaustible.
>
> (Poole 2000: 153)

Poole's analysis of Croft's adaptable nature seems on target as far as gaming goes, but he takes for granted an equivalence or commutability between videogame identification and the ways consumers identify and read commodities. Since it would be farfetched to argue that third-person videogames featuring bosomy archaeologists model mainstream consumerism,

Croft's 'success as a cultural icon' requires further explanation: perhaps she crosses over so easily because of the fundamentally convergent nature of modern media. Her translatability, that is, illuminates hidden connections binding media together, a phenomenon that enjoys the trendy label 'synergy'. Sufficient common ground exists between the spheres of gaming, film-making, advertising, and publishing that Croft's transit across their public faces serves as a kind of industrial signposting for consumers, a means of orientation within apparently competing forms of textuality and commerce.

Croft's translatability also attests to a revolution in media production and distribution that is based on *digitality*. While still only partly operationalized within the Internet's anarchic sprawl, the impact of digital recording, manipulation and transmission of data has made it possible for a character born of computer – conceived in 3D software, rendered and animated on high-speed graphics displays – to be copied and permutated into whatever form a given medium demands. Croft can function as, by turns, action hero, pin-up, spokesmodel and public service announcement. In addition, her iterability enables simultaneous presence across media forms. She can appear bikini-clad in *The Face* magazine while giving 'interviews' to PC Gamer's website, 'posing' for a calendar 'shoot' and, of course, exploring crypts and castles on the screens of anyone who has purchased or pirated her computer games. The perfect readerly text, Croft manifests in as many forms as there are people to view her. And it is within this porous network of sign production and circulation – a virtual space that, like *Tomb Raider*, encourages infinite play within its rule-bounded universe – that Croft's fan base has taken root.

Labours of love: Lara and her fans

If Lara Croft's audience, a group devoted to exploring, elaborating, and confirming the avatar's existence, share one thing, it is an attitude of complicity – a commitment to respecting Croft's 'reality', even as that reality is revealed as textual, open to modification. They seem less interested in interrogating their object or rewriting its rules than in 'fleshing out' its character, semiotically stabilizing the thing called Lara Croft by adding to a database of physical, psychological, and biographical data. As we will see, the notion of *incarnating* Croft – literally producing her as a living being – becomes part of fan play, as well as of industrial response to the desires expressed in the female digital star. This in turn constitutes one paradox of Croft fandom: the way in which it confounds traditional conceptions of fannish 'resistance'.

Indebted to British cultural studies (see Hebdige 1979) of subcultural contestation of hegemonic authority, studies of fandom in the USA have foregrounded the rather more abstract *interpretative* tension between popular culture's producers and consumers, who vie for authority over textual meanings. In this vein, Radway (1984) investigated the female readership of romance novels, while a minor cottage industry of *Star Trek* fan studies has more recently arisen (see Amesley 1989; Bacon-Smith 1992; Jenkins 1992; Tulloch and Jenkins 1995; Penley 1997). Fans traditionally have been studied for the ways in which they read texts 'against the grain', that is, rejecting readings enforced by the text – and presumably preferred by authors – in favour of meaning-making that speaks to fans' own identities and experiences. The epitome of this semiotic tug-of-war is fans' production and circulation of 'Slash': stories, artwork and videotapes in which the heterosexual male protagonists of television series such as *Star Trek* and *The X-Files* are recast in scenarios of homosexual coupling. Putting Kirk and Spock in bed together clearly violates the terms of their characters as presented by Paramount and its army of *Trek* producers. Yet, for that

relative minority of fans who write Slash stories and re-edit suggestive scenes from different episodes to emphasize – or create from whole cloth – queer subtexts, 'ownership' of a text or character remains forever up for grabs.

The fandom around Lara Croft, however, hews to stricter reading rules, perhaps because it is based on Croft's personality and history, the 'reality' of her extragamic existence. She invites a cult of celebrity akin to that surrounding movie stars like Harrison Ford. As epitomized in websites like *The Croft Times, Lara Croft Online* and other Internet shrines, Croft's fan base mingles awareness of the avatar's artefactual nature with an eager suspension of disbelief. A standard site lists information about game and DVD releases, movie production news and tie-in products such as books and magazines. While space is granted to the line of *Tomb Raider* videogames – in the form of previews, reviews, walkthroughs and strategy guides – many fan sites pay equal if not greater attention to the details of Croft's fictive life, treating her with equal parts desire and reverence (and demonstrating what Laura Mulvey (1989) terms the twin poles of the male gaze: investigation and fetishism). Croft's biography, for example, is a compound document with multiple authors but only one fixed version (Anonymous, *Lara Croft's Biography*). It lays out details ranging from her birth date (14 February 1967) to her blood type (AB-), as well as retelling in narrative form the experiences serialized in the six-game *Tomb Raider* series:

> Lara's marriage into wealth had seemed assured, until one day, on her way home from a skiing holiday, her charted [sic] plane crashed deep into the heart of the Himalayan mountains. Lara probably should have died there, as most people would have, instead she learned how to depend on her wits to stay alive in hostile conditions a world away from her sheltered upbringing. Two weeks later when she walked into the village of Tokakeriby her experiences had had a profound effect on her and in that process transformed herself as well.
>
> (*Lara Croft's Biography*)

A growing library of fan fiction does similar phantasmic labour, contextualizing Croft's life and relating her outward adventures to her psychic and spiritual development. Fan art imagines Croft in different costumes, environments and historical situations, engaging in a production of signs that reinforces Croft's official story. With each new item of information and speculation, she takes on more substance – higher resolution – in the popular imaginary. In this sense her fan base works at a kind of intertextual quilting, a process similar to that described by Richard DeCordova in his analysis of early Hollywood's star system:

> These discursive practices produce the star's identity, an identity that does not exist within the individual star (the way we might, however naively, believe our identities exist within us), but rather in the connections between and associations among a wide variety of texts – films, interviews, publicity photos, etc. The star's identity is intertextual, and the star system is made up in part of those ongoing practices that produce the intertextual field within which that identity may be seized by curious fans.
>
> (DeCordova 2001: 12)

It is important to note that here the intertextuality is generated *by* fans, *for* fans, yet always in line with the interests of Eidos and Core Design. An overarching industrial discourse sets the terms and limits within which fans work: Croft's appearance as part of a rock band's tour, for example, leads her biographers to note that 'Lara was brought up to appreciate classical music but having been a guest on U2's Pop Mart tour, has since become a fan of their music' (*Lara Croft's Biography*).

The drive to produce Croft as a living being is unsurprising given her integral role in *Tomb Raider's* immersive pleasures. Assessing the game's difference from other instances of its genre, O'Rourke writes,

> Lara actually seemed to live and breathe … when you jumped off that cliff edge hoping to catch the broken bridge, your heart pounded as Lara's hands stretched out. In many ways it was an experience, an adventure, not just a game.
>
> (O'Rourke 2002)

During the first years of her public life, Croft served as interactive emissary into digital fantasy spaces, producing a fan base necessarily different from those surrounding TV and movie stars. The technological window that frames Croft as *avatar* rather than *actor* creates different exigencies for the fannish imaginary: she must live so that fans can live through her. Croft's audience works toward a consistent identity for its heroine, organizing her biography and folklore into a facsimile of life beyond simulation. This labour serves somewhat contradictory purposes, reinforcing Croft's 'truth' even as it keeps her at one remove; players manipulate Croft's sign system in much the same way they manipulate her body with controller, mouse and keyboard. As Kennedy notes:

> The creation and maintenance of a fairly complex backstory for Lara is an attempt to secure control of her virtual identity – she is a commercial product after all. Providing Lara with a (fairly) plausible history gives her some ontological coherence and helps to enhance the immersion of the player in the *Tomb Raider* world, and abets the identification with Lara.
>
> (Kennedy 2002)

It is in this production of intertexts – this quilting – that one glimpses the emergence of a novel formation in media reception, in which the fragmentation, multiplicity and overload of contemporary media are met (and tamed) by an audience hungry to bring order to chaos.

And the Oscar goes to …: Lara Croft as synthetic star

DeCordova's (2001) account of the star-production apparatus seems appropriate to a discussion of Lara Croft, given that, in the absence of a human referent (a 'real' Croft), one must be produced, just as the Hollywood star's identity must be constructed within the public mind. This constitutes the other major aspect of Croft fandom: 'casting' the avatar with actual human beings, a practice fans shared with producers. As part of *Tomb Raider's* marketing, dozens of women have stepped into the avatar's clothing and hairstyle, attempting to 'flesh out' a fictive persona. Examining Croft's early days, A. Polsky observes that 'she was never just one woman, but rather three very similar looking catalog models decked out in safari outfits' (Polsky 2001: para. 31). One such officially authorized Croft, Rhona Mitra, enjoyed success as the avatar's lip-synching double in concert performances for an Eidos-funded CD of tie-in music. But as her popularity grew, Mitra began to overplay her role. Despite the fact that she was 'arguably the most popular human Lara yet', the software company fired Mitra after she committed the heresy of claiming in an interview, 'I know that I'm her' (Polsky 2001: para. 32). This excommunication signalled a shift in the strategies by which Croft was maintained as both an open-ended and tightly circumscribed fantasy construct for audiences:

Eidos announced that from that point forward, they would hire human Lara models only on an ad hoc basis and made it a point to introduce two new human models at the same time as a gesture of their commitment to preserving Lara's multiplicity. Ironically, Eidos's decision to push multiplicity was a response to the pressure brought on by Mitra's appropriation, her becoming Lara. The post-Mitra human models, however, always referred to Lara in the third person.

(Polsky 2001: para. 33)

This would seem to support Poole's assertion that digital stars, as they have developed in videogames, necessarily hit a kind of representational ceiling that limits their semiotic resolution and thus leaves them open to audience identification. 'The designers of the next generation of *Tomb Raider* games,' Poole writes, 'will surely be careful never to let Lara become too individuated. If she were to look photo-realistic, too much like an actual individual woman, what seductiveness she possesses would thereby be destroyed' (Poole 2000: 152–3). Polsky summarizes this quality of undifferentiated exchangeability in slightly different terms:

Being Lara is bad. If I am Lara, you can't be Lara. While people want to become more digital and people want digital creatures to become more human, people do not want to be other people pretending to be digital.

(Polsky 2001: para. 35)

Yet the avatar's evolution has demonstrated exactly the opposite, with the newest *Tomb Raider* game ('Angel of Darkness', released in Summer 2003) featuring a Croft rendered with 5,000 polygons as compared with the first game's 500 (Smith 2002: 48). As *PC Gamer* argues, Croft's creators are

caught in a real conundrum. There's a palpable desire to give Lara a striking rebirth; to capture the spirit and essence of the original game while imbuing it with a freshness that doesn't cause a backlash among the legion of fans expecting more spelunking.

(Smith 2002: 48)

Tellingly, the preview of *Tomb Raider* goes on to describe the game developers' behind-the-scenes machinations to hire Angelina Jolie, star of the 2001 and 2003 movie adaptations of *Tomb Raider*, to provide the avatar's voice-overs (Smith 2002: 50). The transfer of traits from digital entity to person and back indicates that, through careful management, Croft's stardom can blend with that of a human actor without harming or diluting either. According to Polsky, this may be more a result of a given actor's discursive identity than anything else:

The openly bisexual, but undeniably human, Jolie appears to possess the uncanny ability to sustain the complex alliance of identification and desire that digital Lara wields over her fans. ... I believe that to a great extent Jolie's success in the role of Lara can be attributed to her own public image of instability (perhaps it is this very quality that allows Jolie to so seamlessly 'become' her characters). However, I can't help but wonder if Jolie plays the character 'too well' and the distinction between them is collapsed, will Eidos renew their resolution to keep Lara virtual or will they finally allow Lara a human embodiment?

(Polsky 2001: para. 35)

Certainly Croft's multiple affordances represent an enigmatic victory in the much-publicized drive to introduce photo-realistic digital actors or 'synthespians' to the film-making industry. Showcased in media as disparate as children's movies, vacuum-cleaner commercials, and, most recently, the 2001 motion picture *Final Fantasy: The Spirits Within*, synthespians threaten – for some – extinction of, or at least radical competition with, the human actor (Briscoe 2002).

But the case of *Final Fantasy* and its star, Aki Ross, is instructive less for its visual successes than its critical and financial failures. Square USA, which produced the film using motion-capture and rendering technology capable of individually animating each hair on Ross's head, shut down its computers and its Honolulu offices on 31 March 2002, after the film failed to make back its $145 million cost (Briscoe 2002). While Ross, based on a melange of existing celebrities and voiced by *ER* actor Ming-Na, was 'just beginning to be accepted as a real star and probably the most cooperative female lead in Hollywood history' (Briscoe 2002), the film in which she starred failed to capture an audience – owing largely to the flatness of its characters and its generically bland science-fiction storyline. Despite the considerable technical craft that went into her invention as a movie star, Ross never took root in the fannish imaginary in the way that Croft, her predecessor by only half a decade, has managed. Why is this?

The answer, I suggest, draws on the multiplicity mentioned above as a strategic marketing response from Eidos. In the case of the video-game series, Croft's multiple bodies enable transitory and ongoing identifications from players. At the same time, her appearances outside the game context – in advertising, magazines, film, music and comics – have seeded the public imaginary with ample resources for recognition and interpellation. If Croft 'speaks' from every screen to every listener, it is her very *rootlessness* or lack of physical referent that enables such multi-vocality: 'the failure to anchor Lara in one body, one character, or one narrative facilitates opportunities for players to participate in her continuing evolution' (Polsky 2001: para. 35). The apparent contradiction between Croft's 'emptiness' and 'fullness' is at the heart of her stardom, which stems from a kind of public overload – an avalanche of imagery and meaning – in the face of which audiences have no choice but to begin writing, indexing, cataloguing. (Aki Ross, by contrast, may have lacked sufficient critical mass to take on a transmedia existence of her own.) If stardom is, as DeCordova argues, an effect of 'connections between and associations among a wide variety of texts', then we can understand Lara Croft as a kind of industrially produced intertext, a dense weave of prefabricated linkages.

It is these linkages that Croft fans navigate, spider-like, as their defining mode of consumption. Fan websites regularly feature photographs of women – both unknown amateurs and professional models such as Rhona Mitra, Lara Weller and Nell McAndrew – dressed in Croft's trademark outfits and wielding her props. This costume play, reminiscent of the participatory masquerade practised by, for example, *Star Trek* and *Star Wars* fans, differs in that only Lara, not other characters from her video-game universe, is being spectacularized for public display and comment. Moreover, the 'galleries' are frequently presented as the creative work of the men who have convinced their partners to be photographed. One typical caption reads:

> Not all of our readers are lucky enough to have a girlfriend, which is why we're asking some of our more fortunate readers to share. T. Devon Sharkey has both a girlfriend and a pretty common fantasy – to see her dressed up as Lara Croft.
>
> (Girlfriend of the Month 1999)

Taming the data flow: strategies and tactics of media saturation

By raising the homology between Croft's owners and audiences – groups poised at opposite ends of the production-consumption spectrum, but equally intent on filling the empty space of Croft's absence and thereby resolving her paradoxical appearance of life – I reiterate the conception of Croft as adaptive response to data proliferation. For Collins, such responses are a crucial way in which innovations of information technology are mediated culturally (Collins 1995: 5) through social technologies of absorption and domestication too often overlooked in academic criticism:

> These radically new forms of textual production are obviously constitutive elements of the Age of Information, but in order to understand the complex interaction of cultural expression, we need to examine how excess of information and its accessibility have affected all those other 'anachronistic' low-tech arenas of cultural activity as well. ... The Age of Information is defined not just by the ongoing struggle between the futuristic and anachronistic (which is in and of itself not sufficiently appreciated by techno theory), but even more importantly, by the ways in which that very opposition is being reconceptualized.
>
> (Collins 1995: 6–7)

The *futuristic*, in this case, is the female digital star and the technologies by which she circulates: in a word, the emerging 'synthespian' star system. The *anachronistic* might be described as the existing industrial-discursive networks through which traditional stars of film and television are produced and distributed. And Croft embodies a conglomerate practice of what Collins calls *mapping*, that is, 'envisioning cultural space in such a way that individual subjects might develop some meaningful sense of location within a foreign terrain that was once familiar but has now been rendered virtually incomprehensible by the forces of postmodernism' (Collins 1995: 33). Viewed from this perspective, the apparent complicity of Croft's fan base – its willingness to play by the rules set by Eidos – takes on a different character. Rather than seeing fans and producers as groups with opposed ideological agendas (the tug-of-war model), it may be the case that postmodern media are shifting away from simple polarities of production and consumption, toward a more complex, cooperative, circulatory model. Audiences and owners work together to construct new methods of coping with change, smoothing over potential ruptures produced by the ever-accelerating evolution of interactive and representational technologies. They do this through practices that of necessity remain beneath the level of easy scrutiny or categorization.

Yet the focus of these practices – like any symptom – is eminently visible, a public expression of fascinated anxiety: Lara Croft. Polsky neatly summarizes the multiple autonomous agendas aligned and allied under the sign of Croft's body.

> In 1998, Eidos unveiled its version of 3D interactive Lara. She is still joined from time to time by 'official' human models, but also by a growing legion of unofficial lookalikes who gain their own popularity and cult followings by participating in Internet beauty contests over which Eidos has little control. If the various shifts in the Eidos marketing strategy point to their own ambivalence about what human and non-human form or forms Lara should take, they can also be read as an intentional trafficking of human and post-human bodies that will ultimately lead to their fusion in the virtual world.
>
> (Polsky 2001: para. 34)

Fans' digital cross-dressing of real women additionally locates a point of negotiation between the stereotype of fans as 'feminized and/or desexualized' (Jenkins 1992: 10) and the social lives of *Tomb Raider*'s audience. That this negotiation occurs while seemingly confirming another stereotype – that fans are 'unable to separate fantasy from reality' (Jenkins 1992: 10) – and employing women's bodies as a form of masculine heterosexual display, is only one of the many ways in which Croft fandom troubles feminist critics.

Croft fandom can be distinguished from those that surround television series like *The X-Files*, *Star Trek*, and *Buffy the Vampire Slayer* in two principal ways. First, as noted above, Croft fandom focuses less on particular *instances* of a star's appearance (that is, TV episodes, motion pictures or the individual games in which Croft appears) and more on the star herself; it is, in short, a cult of celebrity. Second, the Croft fan base seems overwhelmingly male and straight, committed to interpretive practices that idealize both Croft's essential 'coolness' as an action hero and her 'hotness' as a desirable female.

Fans are aided in this by a foregrounding, often to the point of distraction, of Croft's body, augmented by visual codes that favour a distanced, masculine, heterosexual gaze, like that explored by Mulvey (1989).[2] Indeed, the software engine generating *Tomb Raider*'s imagery situates players permanently outside the avatar, using a third-person point of view – a 'perspectival construction', according to Poole, 'in which the player can see the character under control, and the representational viewpoint itself is a completely disembodied one' (Poole 2000: 133). In a passage that guilelessly echoes feminist critiques of Hollywood's phallocentric film-making, Poole goes on:

> The point of view from which we see Lara Croft is constantly moving, swooping, creeping up behind her and giddily soaring above, even diving below the putative floor level. We are spying on Lara even when she is alone in the caves. The player can choose to zoom in to a point just behind her shoulder, nearly sharing her point of view, in order to guide her more accurately across a chasm, but she remains oblivious … the modus operandi has been borrowed not from painting but from the cinema: the player's point of view is explicitly defined, as we saw, as that of a 'camera', whose movements can often be controlled as if the player were a phantom movie director, floating about on an invisible crane.
>
> (Poole 2000: 133)

For Flanagan, *Tomb Raider*'s reliance on cinematic objectification of the female form is simply the latest symptom of Western culture's eroticization of the technological: 'Lara Croft is by virtue of her existence bound to erotic codes and interpretation through the means of her production' (Flanagan 1999: 80–1). Whether 'woman' precedes technology or technology precedes 'woman' is, in this view, irrelevant; both formulations have their genesis in an over-determined system of patriarchal control that enacts itself symbolically, materially and economically. As a means of representing the female body for male players, *Tomb Raider* differs from cinema only through the complex multi-positionality of its interactive scheme, which encourages players to 'possess' Croft as an object while they 'become' her through avatarial identification. In fact, Flanagan's taxonomy of identificatory possibilities for Croft fans incorporates no fewer than five positions relative to the avatar: first, making Croft act; second, watching Croft act on her own; third, acting *with* Croft 'as a friend or companion'; fourth, becoming Croft through identification; fifth, reacting *to* Croft (Flanagan 1999: 89). This range of positions, which blurs subject and object, spectatorship and participation, agency and passivity, leads Flanagan to conclude, 'Never before has there been a figure in any media that has become such a unique axis of complex identification with the audience' (Flanagan 1999: 89).

Nevertheless, it should not be forgotten that audiences of both sexes encounter Croft, and must make their meanings from her based on personal history and the discourses from which that history has been constituted. If male players unproblematically adopt preferred reading positions on Croft, female players are not so lucky; for them, the avatar's exaggerated sexuality is precisely what prevents engagement with the game, foreclosing pleasure.

> The problem with Lara is that she was designed by men, for men. How do I know this? Because Lara has thin thighs, long legs, a waist you could encircle with one hand, and knockers like medicine balls. ... Show that to a woman and she will complain that Lara is anatomically impossible. Which is true, because if you genetically engineered a Lara-shaped woman, she would die within around fifteen seconds, since there's no way her tiny abdomen could house all her vital organs. ... Lara is not the great feminist icon Eidos would have you believe. She's just a fantasy, and one that is pretty damned impossible for us women to live up to.
>
> (Jones, quoted in Jenkins 1999: 338–9)

While the video-game community is by no means exclusive male (see, e.g., www.gamegrrlz.com), *Tomb Raider* rarely figures among women's preferred games. Academic attempts to describe the pleasures of 'being' Croft are coloured by an inescapable awareness of her artefactual, objectified status:

> When I play Lara, I play in the company of her creators, and in the shadow of the desiring gaze that her breasts and short shorts were formed to address. ... Driving Lara means occupying a place shaped and then vacated by her designers.
>
> (Carr 2002: 174)

It would seem that for most female players the marks of Croft's *discourses* are not easily effaced; she remains an emblem of corporate artifice, ideologically laden and therefore resistant to her intended assimilation as an aspect of player subjectivity.

Male fans, however, find in Croft's semiotic territory fertile ground to extend their fetishistic involvement. Croft's followers are eager to sexualize her through the creation of erotic pictures and paratexts. For Kennedy, it is the very lack of libidinous content in Croft's game and film-based existence that enables fans' investments. 'The absence of any romantic or sexual intrigue within the game narrative potentially leaves her sexuality open to conjectural appropriation on the part of the players' – an openness that does not extend, however, to lesbian re-workings of Croft, as 'the ubiquity of the heterosexual readings and re-encodings of Lara leaves little space or legitimacy for this form of identification and desire' (Kennedy 2002).

The movement that Polsky (2001) terms 'videogame art' includes not just hand-rendered drawings and Photoshop-altered imagery, but modifications to *Tomb Raider*'s software engine through plug-ins and patches that alter the way the game operates, adding new levels, characters and special effects. Heavily circulated over the Internet, the creation of 'mods' allows players to design their own scenarios and environments for games such as the first-person shooters *Quake*, *Unreal Tournament* and *Half-Life*. Just as the financial fortunes of a Hollywood film can be resurrected if the film is discovered by videotape and DVD renters, so certain videogames acquire new commercial life if a community of player-programmers is inspired to write new code and post it for public distribution. Thus, quick on the heels of *Tomb Raider*'s release, the 'Nude Raider' patch appeared, a software application that strips the avatar of her clothing while leaving other aspects of game play intact.

Polsky suggests that patch making, while superficially similar to the textual poaching practised by more traditional fandoms (Jenkins 1992), can also operate in harmony with the interests of video-game producers.

> Certain gaming companies have made patch-making software easily accessible, perhaps in an effort to appropriate these intentionally parasitic practices. Some have perhaps even created the patches themselves. The logic is that a patch like the infamous 'Nude Raider' … is ultimately good for business.
>
> (Polsky 2001: para. S)

I argue that Croft's over-determined sexuality – manifest in her exaggerated proportions but more subtly present in her bodily animation and the pre-programmed camera paths through which players track her – renders her eroticization irrelevant as a tactic of resistance. That is, Croft marks the convergence of discourses on technology and gender in which the woman's body is always already positioned for use. To eroticize Croft is merely to paint in broader strokes something inherent in her design, building public perception of the avatar as a manipulable source of *jouissance*. For Flanagan, this marks a logical progression from the male-dominated forms of representation in classical Hollywood cinema:

> More than the indulgence of looking at these stars within filmic worlds, we now embrace the very real pleasures of controlling these desired bodies: Lara is at the apex of a system in which looking manifests into doing, into action. The digital star is the location on which fantasies of desire and control are projected; they embody the fears, desires, and excess of our culture in the form of obnoxiously sexualized female stars.
>
> (Flanagan 1999: 78)

The drive to elaborate Croft's existence stems from the absence of an original human model; thus the avatar's 'lack of a true history is masked by the excess of life stories created by multiple agencies – Eidos's marketing department, gaming magazines and countless fan fiction sites' (Flanagan 1999: 81). Croft fans are, according to this argument, bound *a priori* into complicit interpretive practices, aligning fans and producers in an unauthorized creative work that stays safely within lines inscribed by authority. This tendency within Croft fandom hints that the technologies by which digital stars are produced and circulated dictate modes of reception in which the play of meaning is, to a surprising extent, confined.

Conclusion

The field of computer-game studies has grown remarkably in the last several years, blossoming from its violence-obsessed origins in mass communications' empirical, effects-based studies to encompass a range of theoretical, aesthetic and political approaches. Game-focused departments are springing up in universities around the world. The video-game industry, whose profits now outstrip Hollywood's, is clearly a cultural and economic force deserving rigorous analysis. And while game studies is not without its own schisms, the movement overall has pushed researchers to re-evaluate their conventional knowledges – even basic vocabularies – of *medium*, *game*, *narrative*, *character*, *interactivity* and a host of other concepts essential to the game experience.

But if we are to understand games across the full range of their cultural operations, we must remember that they are but one agent among many: a thread in the vast and colourful media tapestry, influencing the content and behaviour of other texts, products and

activities, even as they, games, are influenced by their neighbours and predecessor forms. And because audiences rarely encounter any one medium in isolation, instead mixing, matching and multiplexing, game studies would benefit from similarly varied and complex confrontations with the increasingly digital mediascape – an environment that by its nature promotes migrations and clonings, hybridities and endless recontextualization.

The pan-media trajectory of Lara Croft provides one way of understanding the changing contracts (contracts of usage, interpretation and play) that bring together audiences, producers, and technologies. I began by suggesting, with Collins, that the semiotic excess characteristic of the digital era is best viewed as an ebb and flow of containment practices, in which audiences and producers vie for control over textual play. If this is so, the case of Lara Croft may demonstrate a temporary moment of determinism in which engagement with digital stars is at the mercy of their formal and technological properties. It seems likely, however, that future adaptations and innovations will continue to rework the semiotic arms race's balance of power, complicating our relationship with technological fantasy – and desire – in ways both promising and troubling.

Notes

1 If Croft's initial form, more girlish than womanly, was less blatantly erotic than the versions that followed, early builds of the game still drew their appeal from the fact of a 'living, breathing' female avatar. Jeremy Smith, another Core worker, describes the impact of Croft's regendering this way: 'And then literally two weeks later we had another project meeting and there was this *babe* there. I said, "It's a woman – what are you doing?" and [the programmers] said "No, it's really gonna work." Well, at that point, it really didn't make any difference. It was only when they really started to develop Lara – she was animated and her hair was moving – it was like, "Wow, you could actually quite relate to this!"' (quoted in Poole 2000: 152).

2 For an extended discussion of Mulvey's relevance to Lara Croft, see Kennedy (2002).

References

Amesley, C. (1989) 'How to watch Star Trek', *Cultural Studies*, 3: 323–39.

Anonymous, *Lara Croft's Biography*. Online. Available: http://www.geocities.com/laracroftonline2001/Biography.html (12 April 2002).

Bacon-Smith, C. (1992) *Enterprising Women: Television Fandom and the Creation of Popular Myth*, Philadelphia, PA: University of Pennsylvania Press.

Briscoe, D. (2002) 'Career of Digital Actress Aki Ross Ends as Studio Shuts Down', *Associated Press*. Online. Available: http://www.imdiversity.com/villages/asian/Article_Detail.asp? Article_ID=9204 (25 April 2002).

Carr, D. (2002) 'Playing with Lara', in G. King and T. Krzywinska (eds) *ScreenPlay: Cinema/Videogames/Interfaces*, London: Wallflower Press, pp. 171–80.

Cassell, J. and Jenkins, H. (1999) 'Chess for girls? Feminism and computer games', in J. Cassell and H. Jenkins (eds) *From Barbie to Mortal Kombat: Gender and Computer Games*, Cambridge, MA: Massachusetts Institute of Technology Press, pp. 2–45.

Collins, J. (1995) *Architectures of Excess: Cultural Life in the Information Age*, New York: Routledge.

Coupland, D. and Ward, K. (1998) *Lara's Book: Lara Croft and the Tomb Raider Phenomenon*, New York: Prima Publishing.

DeCordova, R. (2001) *Picture Personalities: The Emergence of the Star System in America*, Urbana, IL: University of Illinois Press.

Flanagan, M. (1999) 'Mobile identities, digital stars, and post-cinematic selves', *Wide Angle*, 21: 76–93.

'Girlfriend of the Month: Yes, Some PCXL Readers Have Real Live Girlfriends' (1999) Unsigned Editorial, *PC Accelerator*, 11: 107.

Grieb, M. (2002) 'Run Lara run', in G. King and T. Krzywinska (eds) *ScreenPlay: Cinema/Videogames/Interfaces*, London: Wallflower Press, pp. 157–70.

Hebdige, D. (1979) *Subculture: The Meaning of Style*, London: Routledge.

Jenkins, H. (1992) *Textual Poachers: Television Fans and Participatory Culture*, New York: Routledge.

Jenkins, H. (1999) 'Voices from the combat zone: game grrlz talk back', in J. Cassell and H. Jenkins (eds) *From Barbie to Mortal Kombat: Gender and Computer Games*, Cambridge, MA: Massachusetts Institute of Technology Press, pp. 328–41.

Kennedy, H. (2002) 'Lara Croft: feminist icon or cyberbimbo? On the limits of textual analysis', *Game Studies* 2. Online. Available: http://www.gamestudies.org/0202/kennedy/ (28 June 2003).

Manovich, L. (2001) *The Language of New Media*, Cambridge, MA: Massachusetts Institute of Technology Press.

Mulvey, L. (1989) 'Visual pleasure and narrative cinema', in L. Mulvey, *Visual and Other Pleasures*, Bloomington, IN: Indiana University Press, pp. 14–26.

O'Rourke, I. (2002) 'The Lara Croft Phenomena', *Fandomlife.net: The Ezine of Scifi Media and Fandom Culture*. Online. Available: http://www.fandomlife.net/A55840/fln.nsf/all/26DA06171730A10B80 256ADA006183BA? OpenDocument (12 April 2002).

Penley, C. (1997) *NASA/Trek: Popular Science and Sex in America*, London: Verso.

Polsky, A. (2001) 'Skins, patches, and plug-ins: becoming woman in the new gaming culture, *Genders*, 34. Online. Available: http://www.genders.org/g34/g34_polsky.html (3 December 2001).

Poole, S. (2000) *Trigger Happy: Videogames and the Entertainment Revolution*, New York: Arcade.

Radway, J. (1984) *Reading the Romance: Women, Patriarchy, and Popular Literature*, Chapel Hill, NC: University of North Carolina Press.

Smith, R. (2002) 'Tomb Raider, the next generation: return of the queen', *PC Gamer*, 9: 47–50.

Tulloch, J. and Jenkins, H. (1995) *Science Fiction Audiences: Watching Doctor Who and Star Trek*, London: Routledge.

Lev Manovich

FROM DV REALISM TO A UNIVERSAL RECORDING MACHINE

Introduction

IF **MIKE FIGGIS'S REMARKABLE** *TIMECODE* (2000) exemplifies the difficult search of digital cinema for its own unique aesthetics, it equally demonstrates how these emerging aesthetics borrow from cinema's rich past, from other media, and from the conventions of computer software. The film splits the screen into the four quadrants to show us four different actions taking place at once. This is of course something that has been common in computer games for a while; we may also recall computer user's ability to open a new window into a document, which is the standard feature of all popular software programs. In tracking the characters in real time, *Timecode* follows the principle of unity of space and time that goes back to seventeenth century classicism. At the same time, since we are presented with video images which appear in separate frames within the screen and which provide different viewpoints on the same building, the film also makes a strong reference to the aesthetics of video surveillance. At the end, we may ask if we are dealing with a film that is borrowing strategies from other media; or with a "reality TV" program that adopts the strategies of surveillance; or with a computer game that heavily relies on cinema. In short, is *Timecode* still *cinema* or is it already *new media*?

This essay will address one of the key themes which accompanies both the evolution of new media technologies during its four decade long history and the current ongoing shift of cinema towards being computer-based in all aspects of its production, post-production and distribution. This theme is "realism." The introduction of every new modern media technology, from photography in the 1840s to Virtual Reality in the 1980s, has always been accompanied by the claims that the new technology allows one to represent reality in a new way. Typically it is argued that the new representations are radically different from the ones made possible by older technologies; that they are superior to the old ones; and that they allow a more direct access to reality. Given this history, it is not surprising that the shift of all moving image industries (cinema, video, television) in the 1980s and 1990s towards computer-based technologies, and the introduction of new computer and

network-based moving image technologies during the same decade (for instance, Web cams, digital compositing, motion rides), has been accompanied by similar claims. In this essay I will examine some of these claims by placing them within a historical perspective. How new is the "realism" made possible by DV cameras, digital special effects and computer-driven Web cams?

Instead of thinking of the evolution of modern media technology as a linear march towards more precise or more authentic representation of reality, we may want to think of a number of distinct aesthetics – particular techniques of representing reality – that keep re-emerging throughout the modern media history. I do not want to suggest that there is no change and that these aesthetics have some kind of metaphysic status. In fact, it would be an important project to trace the history of these aesthetics, to see which ones already appeared in the nineteenth century and which ones only made their appearance later. However, for my purposes here, it is sufficient to assume that the major technological shifts in media, such as the present shift towards computer and network based technologies, not only lead to the creation of new aesthetic techniques but also activate certain aesthetic impulses already present in the past.

I will focus on two different aesthetics that at first sight may appear to be unique to the current digital revolution but in fact accompany moving image media throughout the twentieth century. The two aesthetics are opposite of each other. The first treats a film as a sequence of big budget special effects, which may take years to craft during post-production stage. The second gives up all effects in favor of "authenticity" and "immediacy," achieved with the help of inexpensive DV equipment. I will trace these two aesthetics back to the very origins of cinema. If Georges Méliès was the father of special effects filmmaking, then the Lumière brothers can be called the first *DV realists*. To use the contemporary terms, the Lumière brothers defined filmmaking as production (i.e., shooting), while Méliès defined it as post-production (editing, compositing, special effects).

The fact that it is not only the theme of "realism" itself but also particular stategies for making media represent reality "better" that keep reappearing in the history of media should not blind us to the radical innovations of new media. I do believe that new media reconfigures a moving image in a number of very important ways. I trace some of them in *The Language of New Media*: the shift from montage to compositing; the slow historical transition from lens-based recording to 3-D image synthesis; the new identity of cinema as a hybrid of cinematography and animation. For me, pointing out that some claims about the newness of new media are incorrect (such as tracing the historical heritage of certain realist aesthetics in this essay) is the best way of figuring which claims are correct, as well as discovering the new features of new media which we may have overlooked. In short, the best way to see what is new is to first get clear about what is old. In the case of my topic here, dismissing the originality of digital special effects and digital "immediacy" allows us to notice a truly unique capacity of digital media for representing real, which I will address in the last section of this essay.

This unique capacity can be summed up as the shift from "sampling" to "complete recording." If both traditional arts and modern media are based on sampling reality, that is, representing/recording only small fragments of human experience, digital recording and storage technologies greatly expand how much can be represented/recorded. This applies to granularity of time, the granularity of visual experience, and also what can be called "social granularity" (i.e., representation of one's relationships with other human beings.)

In regards to time, it is now possible to record, store and index years of digital video. By this I don't mean simply video libraries of stock footage or movies on demand systems – I am thinking of recording/representing the experiences of the individuals: for instance,

the POV of single person as she goes through her life, the POVs of a number of people, etc. Although it presents combined experiences of many people rather than the detailed account of a single person's life, the work by Spielberg's Shoa Foundation is relevant here as it shows what can be done with the new scale in video recording and indexing. The Shoa Foundation assembled and now makes accessible a massive number of video interviews with the Holocaust survivors: it would take one person forty years to watch all the video material, stored on Foundation's computer servers.

The examples of new finer visual granularity are provided by the projects of Luc Courchesne and Jeffrey Shaw, which both aim at continuous 360° moving image recordings of reality.[1] One of Shaw's custom systems which he called Panosurround Camera uses 21 DV cameras mounted on a sphere. The recordings are stitched together using custom software resulting in a 360° moving image with a resolution of 6000 × 4000 pixels.[2]

Finally, the example of new "social granularity" is provided by the popular *The Sims*. This game that is better referred to as "social simulator" models ongoing relationship dynamics between a number of characters. Although the relationship model itself can hardly compete with the modeling of human psychology in modern narrative fiction, since *The Sims* is not a static representation of selected moments in the characters' lives *but a dynamic simulation running in real time*, we can at any time choose to follow any of the characters. While the rest of the characters are off-screen, they continue to "live" and change. In short, just as with the new granularity of time and the new granularity of visual experience, the social universe no longer needs to be sampled but can be modeled as one continuum.

Together, these new abilities open up vast new vistas for aesthetic experimentation. They give us a wonderful opportunity to address one of the key goals of art – a representation of reality and the human subjective experience of it – in new and fresh ways.

Digital special effects

By the middle of the 1990s, the producers and directors of feature and short films, television shows, music videos and other *visual fictions* have widely accepted digital tools, from digital compositing to CGI to DV cameras. According to the clichés used in Hollywood when discussing this digital revolution, filmmakers are now able to "to tell stories that were never possible to tell before," "achieve new level of realism," and "impress the audiences with previously unseen effects." But do these statements hold up under a closer scrutiny?

Lets begin by considering the first idea. Is it really true that Ridley Scott would not be able to make *Gladiator* without computers? Of course computer-generated shots of Rome's Colosseum are quite impressive, but the story could have been told without them. After all, in his 1916 *Intolerance* Griffith showed the audiences the fall of Babylon, the latter days of Christ's life and the St. Bartholomew's Day Massacre – all without computers. Similarly, the 1959 classic *Ben-Hur* already took the viewers to ancient Rome, again without computers.

Shall we then accept the second idea that armed with computers filmmakers can now get closer to reality than ever before? I don't accept this idea either. More often than not, when you watch special effects shots in films, you are seeing something you never saw before, either in reality or in cinema. You have never before seen prehistoric dinosaurs (*Jurassic Park*). You have never before seen T2 morphing into a tiled floor (*Terminator 2: Judgment Day*). You have never before seen a man gradually become invisible (*The Hollow Man*). So while in principle filmmakers can use computers to show the viewers ordinary,

familiar reality, this almost never happens. Instead, they aim to show us something extra-ordinary: something we have never seen before.

What about situations when the special effects shots do not show a new kind of character, set or environment? In this case, the novelty involves showing familiar reality *in a new way* (rather than simply "getting closer to it"). Take, for instance, a special effects shot of a mountain climber who, high up in the mountains, loses his balance and plummets to the ground. Before computers, such a sequence would probably involve cutting between a close-up of the climber and a wide of mountain footage. Now the audience can follow the character as he flies down, positioned several inches from his face. In doing so it creates a new reality, a new visual fiction: imagining what it would be like to fall down together with the character, flying just a few inches from his face. The chances of somebody actually having this experience are pretty much the same as seeing a prehistoric dinosaur come to life. Both are visual fictions, achieved through special effects.

DV realism

A special effects spectacle has not been the only result of digital revolution in cinema. Not surprisingly, the over-reliance of big budget filmmaking on lavish effects has led to a reality check. The filmmakers who belong to what I will call *DV realism* school on purpose avoid special effects and other post-production tricks. Instead, they use multiple, often handheld, inexpensive digital cameras to create films characterized by a documentary style. The examples would be such American films as Mike Figgis's *Timecode* and *The Blair Witch Project* and the European films made by the Dogma 95 group (*Celebration*, *Mifune*). Rather than treating live action as a raw material to be later re-arranged in post-production, these filmmakers place premier importance on the authenticity of the actors' performances. On the one hand, DV equipment allows a filmmaker to be very close to the actors, to literally be inside the action as it unfolds. In addition to a more intimate filmic approach, a filmmaker can keep shooting for a whole duration of a 60 or 120 minute DV tape as opposed to the standard ten-minute film roll. This increased quantity of (cheaper!) material gives the filmmaker and the actors more freedom to improvise around a theme, rather than being shackled to the tightly scripted short shots of traditional filmmaking. (In fact the length of *Timecode* exactly corresponds to the length of a standard DV tape.)

DV realism has a predecessor in an international filmmaking movement that began in the late 1950s and unfolded throughout the 1960s. Called "direct cinema," "candid" cinema, "uncontrolled" cinema, "observational" cinema, or *cinéma vérité* ("cinema truth"), it also involved filmmakers using lighter and more mobile (in comparison to what was available before) equipment. Like today's DV realists, the 1960s "direct cinema" proponents avoided tight staging and scripting, preferring to let events unfold naturally. Both then and now, the filmmakers used new filmmaking technology to revolt against the existing cinema conventions that were perceived as being too artificial. Both then and now, the key word of this revolt was the same: "immediacy."

Interestingly, during the same period in the 1960s, Hollywood also underwent a special effects revolution: widescreen cinema. In order to compete with the new television medium, filmmakers created lavish widescreen spectacles such as the above-mentioned *Ben-Hur*. In fact, the relationship between television, Hollywood and "direct" cinema looks remarkably like what is happening today. Then, in order to compete with a low-res television screen, Hollywood turned to a wide screen format and lavish historical dramas. As a reaction, "direct" cinema filmmakers used new mobile and lightweight equipment to create more

"immediacy." Today, the increasing reliance on special effects in Hollywood can be perceived as a reaction to the new competition of the Internet. And this new cycle of special effects filmmaking has found its own reaction: *DV realism*.

Digital special effects and **DV realism**, historicized

The two ways in which filmmakers use digital technology today to arrive at two opposing aesthetics – special effects driven spectacle and documentary-style realism striving for "immediacy" – can be traced back to the origins of cinema. Film scholars often discuss history of cinema in terms of two complementary creative impulses. Both originate at the turn of the twentieth century in France. The Lumière brothers established the idea of cinema as reportage. The camera covers events as they occur. The Lumières first film, *Workers Leaving the Lumière Factory*, is a single shot that records the movements of people outside of their photographic factory. Another of Lumière's early films, the famous *Arrival of a Train at a Station*, shows another simple event: the arrival of the train in the Paris train station.

The second idea of cinema equates it with special effects, designed to surprise and even shock the viewer. According to this idea, the goal of cinema is not to record the ordinary but to catch (or construct) the extraordinary. Georges Méliès was a magician in Paris who owned his own film theater. After seeing the Lumières's film presentation in 1895, Méliès started to produce his own films. His hundreds of short films established the idea of cinema as special effects. In his films, devils burst out of clouds of smoke, pretty women vanish, a space ship flies to the moon, a woman transforms into a skeleton (a predecessor to *Hollow Man?*). Méliès used stop motion, special sets, miniatures and other special effects to extend the aesthetics of the magician's performance into a longer narrative form.

The way in which filmmakers today use digital technology fits quite well with the two basic ideas of what cinema is, which began more than a century ago. The Lumière's idea of film as a record of reality, as a witness to events as they unfold, survives with *DV realism*. It also animates currently popular "reality TV" shows (*Cops*, *Survivor*, *Big Brother*), where omnipresent cameras report on events as they unfold. Méliès's idea of cinema as a sequence of magician's tricks arranged as a narrative receives a new realization in Hollywood's digital special effects spectacles, from *The Abyss* to *Star Wars: Episode 1*.

Therefore it would be incorrect to think that the two aesthetics of computer-driven special effects and *DV realism* somehow are results of digital technology. Rather, they are the new realizations of two basic creative impulses that have accompanied cinema from the beginning.

Such an analysis makes for a neat and simple scheme – in fact, too simple to be true. Things are actually more complicated. More recently film scholars such as Thomas Elsaesser revised their take on the Lumières.[3] They realized that even their first films were far from simple documentaries. The Lumières planned and scripted the events, and staged actions both in space in time. For instance, one of the films shown at the Lumières's first public screening in 1895, *The Waterer Watered*, was a staged comedy: a boy stepping on a hose causes a gardener to squirt himself. And even such supposedly pure examples of "reality filmmaking" as *Arrival of a Train at a Station* turned out to be "tainted" with advanced planning. Rather than being a direct recording of reality, *Arrival of the Train* was carefully put together, with the Lumières choosing and positioning passers-by seen in the shot.

Arrival of the Train can be even thought as a quintessential special effects film. After all, it supposedly shocked the audiences so much they ran out of the café where the screening was taking place. Indeed, they have never before seen a moving train presented

with photographic fidelity – just as contemporary viewers have never before seen a man gradually being stripped of skin and then skeleton until he vanishes into the air (*The Hollow Man*), or thousands of robot soldiers engaged in battle (*Star Wars: Episode 1*).

If the Lumières were not first documentarists but rather the directors of *visual fictions*, what about their ancestors – the directors of *DV realism* films and "reality TV" shows? They do not simply record reality either. According to the statement found on the official Big Brother Web site, "'Big Brother' is not scripted, but a result of the participants' reactions to their environments and interactions with each other on a day-to-day basis." Yet even the fact that we are watching not a continuous 24 hours a day recording but short episodes, each episode having a definite end (elimination of one of the house guests from the shows), testifies that the show is not just a window into life as it happens. Instead, it follows well-established conventions of film and television fictions: a narrative that unfolds within a specified period of time and results in a well-defined conclusion.

In the case of *DV realism* films, a number of them follow a distinct narrative style. Let us compare it with a traditional film narrative. A traditional film narrative usually takes place over months, years or even decades (for instance, *Sunshine*). We take it for granted that the filmmaker chooses to show us the key events selected from this period, thus compressing many months, or years, or even decades, into a film which runs just for ninety or one hundred and twenty minutes. In contrast, *DV realism* films often take place in close to real time (in the case of *Timecode*, exactly in real time). Consequently, filmmakers construct special narratives where lots of dramatic events happen in a short period. It is as though they are trying to compensate for the real time of a narrative.

So the time that we see is the real time, rather than artificially compressed time of traditional film narrative. However, the narrative that unfolds during this time period is highly artificial, both by the standards of traditional film and TV narrative, and our normal lives. Both in *Celebration* and in *Timecode*, for instance, we witness people betraying each other, falling in love, having sex, breaking up, revealing incest, making important deals, shooting at each other, and dying – all in the course of two hours.

The art of surveillance

The real time aspect of what can be called *reality filmmaking* (film and television narratives which take place in real time or close to it, including "reality TV") has in itself an important historical precedent. Although television as a mass medium became established only in the middle of the twentieth century, television research begins already in the 1870s. During the first decades of this research, television was thought as the technology that would allow people to remotely see what is happening in a distant place – thus its name, television (literally, "distance seeing"). The television experiments were part of the whole set of other inventions which all took place in the nineteenth century around the idea of *telecommunication*: real time transmission of information over a distance. Telegraph was to transmit text over a distance, telephone was to transmit speech over a distance, and television was to transmit images over a distance. It was not until the 1920s when television was redefined as the *broadcasting* medium, that is, as a technology for transmitting specially prepared programs to a number of people at the same time. In other words, television became a means to *distribute content* (very much as the Internet today, as opposed to the Internet before the mid 1990s) rather than the *telecommunication* technology.

The original idea of television has survived, however. It came to define one of the key uses of video technology in modern society: video surveillance. Today, for every TV monitor

receiving content one can find a video camera which transmits surveillance images: from parking lots, banks, elevators, street corners, supermarkets, office buildings, etc. Along with having being realized in video surveillance, usually limited to companies, the original meaning of television as seeing over distance in real time received another realization in computer culture – the Web cams, accessible to everybody. Like normal video surveillance cameras that are tracking us everywhere, Web cams rarely show anything of interest. They simply show what is there: the waves on the beach, somebody starring in a computer terminal, an empty office or street. Web cams are the opposites of special effects films: feeding us the banality of the ordinary rather than the excitement of the extra-ordinary.

Today's *reality media* – films that are taking place in real time (such as *Timecode*), "reality TV," and Web cams – return us to television origins in the nineteenth century. Yet while history repeats itself, it never does it in the same way. The new omnipresence and availability of cheap telecommunication technologies, from Web cams to online chat programs to cell phones, has the promise for a new aesthetics which does not have any precursors: the aesthetics which will combine fiction and telecommunication. How can telecommunication and fictional narrative go together? Is it possible to make art out of video surveillance, out of real-time – rather than pre-scripted – signal?

Timecode can be seen as an experiment in this direction. In *Timecode* the screen is broken into four frames, each frame corresponding to a separate camera. All four cameras are tracking the events that are happening in different parts of the same location (a production studio on Sunset Boulevard in Hollywood), which is the typical video surveillance setup. It is to the credit of Mike Figgis that he was able to take such a setup and turn it into a new way to present a fictional narrative. Here, telecommunication becomes a narrative art. Television in its original sense of telecommunication – seeing over distance in real time – becomes the means to present human experience in a new way.

Of course, as I already noted, *Timecode* is not exactly a bare-bones telecommunication. It is not just a real-time recording of whatever happens to be in front of the cameras. The film is tightly scripted. We may think of it as an edited surveillance video: the parts where nothing happens have been taken out; the parts with actions in them have been preserved. But it is more accurate to think of *Timecode* as a conventional film that adopts visual and spatial strategies of video surveillance (multiple cameras tracking one location) while following traditional dramatic conventions of narrative construction. In other words, the film uses telecommunication-type interface to a traditional narrative. Which means that it does not yet deal with the deeper implications of computer-based surveillance (we can also use other terms which have less negative connotations: "monitoring," "recording").

Computer as a universal recording machine[4]

What would it mean for cinema, and narrative arts in general, to address these implications? One of the most basic principles of narrative arts is what in computer culture called "compression." A drama, a novel, a film, a narrative painting or a photograph compresses weeks, years, decades, and even centuries of human existence into a number of essential scenes (or, in the case of narrative images, even a single scene). Non-essential is stripped away; essential is recorded. Why? Narrative arts have been always limited by the capacities of the receiver (i.e., a human being) and of storage media. Throughout history, the first capacity remained more or less the same: today the time we will devote to the reception of a single narrative may range from 15 seconds (a TV commercial) to two hours (a feature film) to a number of short segments distributed over a large period of time (following a TV

series or reading a novel). But the capacity of storage media recently changed dramatically. Instead of 10 minutes that can fit on a standard film roll or two hours that can fit on a DV tape, a digital server can hold practically unlimited number of audio-visual recordings. The same applies for audio only, or for text.

This revolution in the scale of available storage has been accompanied by the new ideas about how such media recording may function. Working within the paradigms of Computer Augmented Reality, Ubiquitous Computing, and Software Agents at places such as MIT Media Lab and Xerox Park, computer scientists advanced the notion of a computer as an unobtrusive but omni-present device which automatically records and indexes all inter-personal communications and other user's activities. A typical early scenario envisioned in the early 1990s involved microphones and video cameras situated in the business office which record everything taking place, along with indexing software which makes possible a quick search through the years worth of recordings. More recently the paradigm has expanded to include capturing and indexing all kinds of experiences of many people. For instance, a DARPA-sponsored research project at Carnegie-Mellon University called Experience-on-Demand which began in 1997 aims to "develop tools, techniques, and systems that allow users to capture complete records of personal experience and to share them in collaborative settings."[5] A 2000 report on the project summarizes the new ideas being pursued as follows:

> Capture and abstraction of personal experience in audio and video as a form of personal memory.
> Collaboration through shared composite views and information spanning location and time.
> Synthesis of personal experience data across multiple sources.
> Video and audio abstraction at variable information densities.
> Information visualizations from temporal and spatial perspectives.
> Visual and audio information filtering, "understanding," and event alerting.[6]

(Given that a regular email program already automatically keeps a copy of all sent and received emails, and allows to sort and search through these emails, and that a typical mailing list archive Web site similarly allows to search through years of dialoguess between many people, we can see that in the course of text communication this paradigm has already been realized.) The difficulty of segmenting and indexing audio and visual media is what delays realization of these ideas in practice. However, the recording in mass itself already can be easily achieved: all is takes is an inexpensive Web cam and a large hard drive.

What is important in this paradigm – and this applies for computer media in general – is that storage media became active. That is, the operations of searching, sorting, filtering, indexing and classifying, which before were the strict domain of human intelligence, become automated. A human viewer no longer needs to go through hundreds of hours of video surveillance to locate the part where something happens – a software program can do this automatically, and much more quickly. Similarly, a human listener no longer needs to go through years of audio recordings to locate the important conversation with a particular person – software can do this quickly. It can also locate all other conversations with the same person, or other conversations where his name was mentioned, and so on.

For me, the new aesthetic possibilities offered by computer recording are immense and unprecedented – in contrast to the aesthetics of special effects and *DV realism*, which as I have suggested are not new in cinema history. What may be truly unique about new media's capacity to represent reality is the new scale of reality maps it makes possible. Instead of compressing reality to what the author considers the essential moments, very large chunks

of everyday life can be recorded, and then put under the control of software. I imagine for instance a "novel" which consists from complete email archives of thousand of characters, plus a special interface that the reader will use to interact with this information. Or, a narrative "film" in which a computer program assembles shot by shot in real time, pulling from the huge archive of surveillance video, old digitized films, Web cam transmissions, and other media sources. (From this perspective, Godard's *History of Cinema* represents an important step towards such *database cinema*. Godard treats the whole history of cinema as his source material, traversing this database back and forth, as though a virtual camera flying over a landscape made from old media.)

In conclusion, let me once again evoke *Timecode*. Its very name reveals its allegiance to the logic of old media of video: a linear recording of reality on a very limited scale. The film is over than the time code on videotape reaches two hours. Although it adopts some of the visual conventions of computer culture, it does not yet deal with the underlying logic of a computer code.

Contemporary creators of digital *visual fictions* need to find new ways to reflect the particular reality of our own time, beyond embracing digital special effects or digital "immediacy." As I have suggested, computer's new capacities for automatically indexing massive scale recordings does offer one new direction beyond what cinema has explored so far. Rather than seeing reality in new ways, the trick maybe simply to pour all of it on a hard drive – and then figure out what kind of interface the user needs to work with all the recorded media. In short, a filmmaker needs to become an interface designer. Only then *cinema* will truly become *new media*.

Notes

1 For Courchesne's Panoscope project, see http://www.din.umontreal.ca/courchesne/; For Jeffrey Shaw's projects, see http://www.jeffrey-shaw.net. Both discuss their projects in relation to previous strategies of "experience representation" in panorama, painting and cinema in *New Screen Media: Cinema/Art/Narrative*, edited by Martin Rieser and Andrea Zapp (London: BFI and Karlsruhe: ZKM, 2001).

2 Private communication between Shaw and the author, July 4, 2002.

3 This section relies on the analysis of the Lumières by Thomas Elsaesser in his *Cain, Abel or Cable* (Amsterdam: Amsterdam University Press and Ann Arbor, MI: Michigan University Press, 1998).

4 My term "Universal Recording Machine" is meant to refer to original model of a digital computer described in 1936 by Alan Turing that in his honor came to be called a Universal Turing Machine.

5 http://www.informedia.cs.cmu.edu/. For more information on the project, see Howard D. Wactlar *et al.*, "Experience-on-Demand: Capuring, Integrating, and Communicating Experiences Across People, Time, and Space" (http://www.informedia.cs.cmu.edu/eod/); also Howard D. Wactlar *et al.*, "Informedia Video Information Summarization and Demonstration Testbed Project Description" (http://www.informedia.cs.cmu.edu/arda-vace/). Both of these research projects were conducted at Carnegie-Mellon University; dozens of simiar projects are going on at aniversities and industry research labs around the world.

6 http://www.informedia.cs.cmu.edu/eod/EODforWeb/eodquad00d.pdf.

PART THREE

Cybercommunities

David Bell

INTRODUCTION

THE FIVE READINGS IN THIS SECTION represent different standpoints on and approaches to a debate which has generated terrific heat, but not always that much light: the debate about online or cybercommunities. The debate is almost as old as the Internet itself – in fact, in many ways much older, if we see the recent focus on computer-mediated community as part of a longer running debate about 'community' in its broadest sense. This 'meta-debate' has run since at least the birth of the social sciences, and has peaked with successive changes in the organization of human societies – reorganizations often catalyzed by technology. The particularities of the cybercommunities debate, therefore, must be contextualized within this broader, long-running argument about the idea and ideal of community – an idea and ideal which, as my own contribution to the debate reprinted here reminds us, seems to be always nostalgic for the lost object of community, always harking back to some imagined past golden age. Decoupling debates from this nostalgia, while also applying the brakes to the excesses of techno-utopianism, seems the only viable way out of what has become a significant blockage inhibiting our understanding of interpersonal collective interaction in a technological culture – or what Maria Bakardjieva here labels 'virtual togetherness'.

It is important, however, to get a handle on the genealogy of this particularly Manichean debate, to understand where it came from and what's at stake. David Silver's (2006) useful taxonomy of cyberstudies highlights the publishing gold rush of the mid-1990s, a period he sees characterized by 'popular cyberculture studies' – populist accounts aiming at the expanding market of readers keen to understand the coming cyberculture. During this frenetic period of publishing activity, many key journalistic accounts appeared, and these quickly established a twin track for thinking the Internet: on the one side, a positive, even utopian narrative predicted barely imaginable new futures of liberating telepresence; on the

other side, critics and cynics poured scorn on what Clifford Stoll (1995) called 'silicon snake oil', the myth of cyberspace. These divergent strands of popular and populist discussion about cyberspace set the terms for key debates, notably the one we focus on here: the question of community. They also set the tone of debate, which tended to be polemic, hot-headed, dismissive of alternative views. Only in the next phase of Silver's typology, which he calls 'critical cyberculture studies', did work begin to disentangle itself from this deadlock, often through the use of either empirical case studies or more theoretical analyses (or both), deployed to add vital evidence in support of the oppositional positions now clearly established.

The publication of key academic collections such as Steve Jones' (1995) *Cybersociety* and Marc Smith and Peter Kollock's (1999) *Communities in Cyberspace* typify this turn towards a more empirical and/or theoretical approach, though often still confined within the twin tracks of the debate cemented by the earlier populist accounts. From the latter volume, Willard Uncapher's article on Big Sky Telegraph, a rural community network in Montana, provides a detailed case study of the development and diffusion of what would become an online community, with its origins in an everyday problem of geography: remote schooling in a thinly-populated US state. Uncapher recounts the enterprising vision of key players, who saw the potential of (often underused) school computers to build a support and information resource. The computers had come to Montanan schools as a result of an earlier initiative, but had yet to settle into usability; through the deployment of local knowledge and community embeddedness, Big Sky Telegraph was born. Uncapher's chapter is a window into a world not so many years ago, but which seems almost unrecognizable: an amazing history lesson about the late 1980s, about the coming cyberculture. The rich detail in his account counters simplistic stories – whether positive or negative – which tend to read as if the technology simply landed on people's desk or laps, and as if communogenesis were an already preset function of the Internet. Instead, Uncapher shows the hard work of building a usable system, and the equally hard work of advocating its use; it shows enthusiastic zeal matched with human and machinic recalcitrance, and it shows ingenuity and doggedness.

Equally significant is the focus Uncapher places on 'real world' issues, such as the structural problems that caused a 'dip' in take-up of the network. By reminding us of the limitations as well as the promises of networked computers, his tale enriches the debate on cybercommunities through its clearly situated perspective. In exploring at the same time the imaginings of Big Sky Telegraph, he charts a way through the tensions and issues that reveals moments of pro- and anti-cybercommunity sentiment, always embedded in the broader context of Montana as a particular place, not as a generalizable proving ground. He reminds us of the need, therefore, for specificity and an awareness of complexity; his discussion of spatial scale, for instance, shows the need to think through any particular cybercommunity as nested within different landscapes or geographies, from the scale of the body or home, through local, regional and national scales, up to the global. At each of these scales, cybercommunities offer particular affordances,

bring new promises, but also confront scale-specific blockages and anxieties. So while cybercommunities are sometimes framed as transcending scale (and distance), Uncapher offers instead a scale-conscious, layered account of the interfaces and interactions between online and offline communities.

Equally representative of this phase of critical cybercommunity studies is Michele Willson's discussion of 'Community in the Abstract', which draws on philosophical or theoretical discussion of 'postmodern' community and puts this to good use in pondering discussions of virtual community (note the soft change in terminology: settling on a useable term for networked, virtual, online or cybercommunities has been a key symptom of this debate). Willson opens with the often repeated observation of a current nostalgia for community, and a perception of the erosion or loss of community in contemporary societies. This position, which I label in my chapter the 'bowling alone' position, after Robert Putnam's (2001) well-known and widely-cited discussion of the loss of social capital and decline of community in the USA, frames the cybercommunity debate powerfully, as already noted. A golden age of community, which Willson located in the 1950s, is sensed as lost as a result of assorted, sometime vaguely specified, community corrosives (see also Bauman 2001). The question today becomes: is cyberculture part of the problem or part of the solution to this problem?

Willson reminds us of another key debate characteristic of what we might now call 'Web 1.0' – the individuating force of computers, seen as a surveillant database harvesting personal information from us. We are here made over as data – either as part of an aggregate population, or as a compartmentalized datum. The Internet, Willson argues, works in the same way, both connecting and disconnecting individuals, encouraging identity play as well as communogenesis. Note that Willson's account, like Uncapher's, is embedded in time and space (though the latter isn't explicated): this is made clear by her focus on textual communication. While text is still central to the experience of cyberculture, whether via email, through blogs or whatever, the increasingly multi-media content has inevitably reconfigured the ways in which communities form and work. So Willson's article is here partly because it is a period piece, representing a particular approach. It is, nevertheless, of continued relevance, not least in its attempt to look outside of cyberculture, to draw on other commentators thinking about community.

The principal resource Willson turns to is philosopher Jean-Luc Nancy's retheorization of community, which he attempts to conceptualize as 'a non-prescriptive form of relations' through a focus on 'singular beings' that exist in and through their relations with others. This relationality foregrounds for Nancy the role of difference or otherness in the idea and ideal of community, or the ethics of community. This position is in tension with what Willson sketches as a postmodern (including virtual) perspective on identity, in which the free play of identity disavows the idea of otherness by making identity fragmentary and flickering (see Part Four). Equally significantly, Nancy writes that community cannot be made, but is something that exists in the relation between beings; as Willson elaborates, for Nancy '[t]o attempt to create community is to make it into work, actively constraining the relation between beings by ascribing particular

qualities or restrictions, and thus undermining community'. Virtual communities, however, are absolutely, actively and on-goingly made. Does this make them other than, or less than, communities? And is the activity that takes place in virtual communities a supplement to, substitute for, or corrosive of participation in 'real life' community, politics, social life?

These questions are picked up, and answered with characteristic adamancy, in Kevin Robins' article. Robins makes his position clear from the get-go, with his title: 'Against virtual community: for a politics of distance' and his focus on the so-called 'death of distance' or 'post-geographical' cyberculture. Social theorists such as Anthony Giddens (1990) and David Harvey (1989) have written about the impact of transport and communications technologies on our experience of distance, or of the relationship between time and space. For if distance is a function of the time it takes to get from A to B, or to get a message across, then, as Harvey shows, the world is 'shrinking'. Instantaneous global communication erases the experience of distance, with no time delay (other than the inconvenience of time zones) to slow down responses. In the pro-cybercommunity rhetoric, we are 'freed' from geography, unencumbered by the drag of distance – but this freedom is illusory, Robins argues. The dream of telepresence, he suggests, produces a 'generalised and globalised intimacy' that crucially erases difference. Like Nancy, Robins sees difference or otherness as central to the ethics and politics of community. He identifies a problematic common ground (implicit at least) between 'virtual futurism' and the discourse of communitarianism, which mobilizes a particular (nostalgic) vision of community – a vision which has overshadowed 'centre left' politics in places like the UK.

The fascination with telepresence leads Robins to think about how distance has been figured as a problem, a line of flight which takes him back to the Enlightenment, and to ideas of mobility and passage. Telepresence compresses mobility into a blip, so that the experience of passage, of moving between places, vanishes. The journey collapses into simultaneous departure and arrival (though early discussion of virtual reality emphasized the need to maintain a sensation of distance and of perspective; see Benedikt 1991). Passage also involves encounter, chance meeting, serendipity. 'Virtual culture', Robins concludes, 'works to nullify the meaning of passage'. Yet Robins is at pains to point out that his desire for distance isn't simply another nostalgic impulse; rather, it is to insist on the centrality of distances and differences for the practices of democracy.

Practices of democracy are at the heart of Maria Bakardjieva's project, from which her discussion of 'virtual togetherness' is drawn – her work concerns the 'socially responsible study and shaping of the Internet' (see also Bakardjieva 2005). Her broader aim is to focus on 'ordinary' Internet users – an important but often overlooked group, who access the Internet from home computers and who have a variety of often prosaic use patterns. Nevertheless, contra Robins and others, Bakardjieva insists on tracking the *empowering possibilities* of domestic Internet use – and to do this, like Uncapher, she grounds her discussion in empirical work with users. She is also aware of the blockages of the virtual/online/cybercommunities debate, which she sidesteps through use of her own term,

virtual togetherness – togetherness which she sees running along two continuums, one between consumption and community (or production), the other along the public and private. Keen to show the different forms and levels of engagement with and investment in online forums, Bakardjieva produces her own typology of users, offering examples garnered from fieldwork of the dispositions of users typical of each type – infosumers, instrumental users, chatterers, communitarians. The opposite of virtual togetherness, she notes, is the isolated consumption of digitized goods – though we might contest this binary now, given discussion of social networking built around sites associated with commercial Internet consumption, such as eBay or MySpace.

Bakardjieva frames her discussion by using the concept of immobile socialization, which he inverts from a previous discussion of mobile privatization. Immobile socialization implies that Internet users remain located in the domestic, but reach out from there to form new social networks. Crucially, Bakardjieva wants to think about 'online' and 'offline' as nested together, so that the terms lose their opposition. In her discussion of 'illness communities', for example, she shows how users click between these different worlds with at once an acknowledgement that they are different, but at the same time a greater ease and comfort in moving back and forth than some commentators might have expected. Such an emphasis on the everyday lives of ordinary users, therefore, enables Bakardjieva to see the range of relations that constitute different users' experiences of virtual togetherness. While critics like Robins might settle on Bakardjieva's use of the term immobile to suggest the lack of passage in these interactions, the concept immobile socialization neatly captures this nested experience without disavowing the domestic setting. Her discussion of the public—private continuum also shows sensitivity to the experiences of her respondents, revealing what she calls the 'multidimensionality of notions of private and public' in terms of the forum interaction takes place in, the content of communication, and any resultant action taken. Combining forms of use with this continuum of public—private thereby provides a richly textured account of everyday virtual togetherness, suggesting a productive possibility to move out of the impasse of the virtual community debate.

That same impasse is at the heart of the final chapter here, my own slightly grumpy mid-noughties contribution to the debate, a response to some comments made by sociologist Zygmunt Bauman about what he calls 'peg communities'. As a way to work through the debate at that time, the chapter suggests a need to rethink the way community is understood, maybe (like Bakardjieva) a need to jettison it as a term in recognition of its unhelpfulness and overloadedness – but at the same time a need to acknowledge the broader currency of the term community. The chapter picks its way through selected manifestations of the debate, centring on Bauman's discussion of 'the togetherness of loners' and his figuring of peg communities as thinned-out, insubstantial non-communities. This trail in fact reaches way back in time, back to early prognoses about the fate of community; it seems that community is always under threat, usually from something new. Perhaps we just have to accept that this is the way community is talked about – as always a lost object, or as under threat. This shouldn't disable us from

engaging in the debate on cybercommunities, however, as there is still much to learn from exploring the work of community: the ways in which community has been used to either advocate going online or to caution against it. As a widely circulating popular discourse, therefore, we must remain attentive to the many discussions of cybercommunity we encounter – as in current discussions of 'social networking' practices in Web 2.0, the community debate will never, it seems, be settled once and for all.

References

Bakardjieva, M. (2005) *Internet Society: Everyday Life on the Internet*, London: Sage.

Bauman, Z. (2001) *Community: Seeking Safety on an Insecure World*, Cambridge: Polity Press.

Benedikt, M. (1991) 'Cyberspace: some proposals', in M. Benedikt (ed.) *Cyberspace: First Steps*, Cambridge, MA: MIT Press.

Giddens, A. (1990) *The Consequences of Modernity*, Cambridge: Polity Press.

Harvey, D. (1989) *The Condition of Postmodernity*, Oxford: Blackwell.

Jones, S. (ed.) (1995) *Cybersociety: Computer-mediated Communication and Community*, London: Sage.

Putnam, R. (2001) *Bowling Alone: the Collapse and Revival of American Community*, New York: Simon & Schuster.

Silver. D. (2006) 'Looking backwards, looking forwards: cyberculture studies 1990-2000', in D. Bell (ed) *Cybercultures: Critical Concepts in Media and Cultural Studies*, volume two, London: Routledge.

Smith, M. and Kollock, P. (1999) *Communities in Cyberspace*, London: Routledge.

Stoll, C. (1995) *Silicon Snake Oil*, Basingstoke: Macmillan.

Willard Uncapher

ELECTRONIC HOMESTEADING ON THE RURAL FRONTIER
Big Sky Telegraph and its community[1]

MONTANANS APPRECIATE COMMUNICATION, and it is not hard to see why. Vast distances and low population density make it difficult to establish social or business communication, or to create economies of scale to lower costs (Parker and Hudson 1992; Hudson 1984). Little wonder that places like Montana have long been a favorite proving ground for distance education. With only twelve towns with a population of over 10,000 in the 1980 and 1990 US Census, most civic life in Montana was organized in terms of much smaller towns. Few of Montana's many one- and two-room schools were located in towns listed in the 1980 US Census data, which detail only towns with a population of 2,500 or greater. Montana has only one Congressman.

At the same time, the expanse of the state is immense. The two counties near Dillon, for example, are larger than the state of Connecticut and Rhode Island combined, but with a population totaling only 8,000. The local school bus route through the Big Hole Valley where I did much of my interviewing is the longest in the United States.

Given this low population density, it is no wonder that statewide there are still over 100 one-room schools in Montana (with more in nearby Wyoming and Idaho). Even though the schools might have only some 20–40 students, some students still have to travel over 25 miles to school every day. Home schooling exists beyond even the reach of the one-room school. Class levels in the one-room school generally progressed from Kindergarten through eighth grade. While the one-room school might physically have more than one room, generally all the students would be taught in one communal room with older students helping teach the younger, directed by a teacher and an assistant or two. Two- or three-room schools would have a few more teachers and rooms. High schools tend to serve as magnet schools, and one of the most difficult questions for many a Montanan family is whether to board their high school age child, or to temporarily split up the family in some way. In an isolated school as at Polaris, MT, which had only eight students, a teacher might not see another adult for the duration of the whole day.

Big Sky Telegraph (BST): a brief history

By the late 1980s, however, Montana telecommunications activists, such as Frank Odasz, began to express a renewed belief that new information technology would allow rural people to telecommute, create new service jobs, provide better access to market information for existing businesses, improve health care, and in general allow for the local pooling of information and resources so as to enrich the collective cultural, economic, and educational environment. Decreasing computer and modem costs, and the ability to pool transmission and hence reduce transmission costs via bulk store-and-forward systems (such as FidoNet), all suggested an untapped potential. Maybe the time really was right for a new kind of economy, and for new kinds of communities to reintegrate, revitalize, and re-humanize local culture. Maybe it was time to set up enhanced communities.

The initial concept, proposed by Frank Odasz, was to create an "online network" to link together the one-room schools of Montana. Odasz, now an assistant professor of computer education at Western Montana College, realized that most of these one-room schools already had computers, mostly rudimentary Apple II/e's, relics of an ever earlier age (circa 1982) when state and federal administrators had felt that computers should be included in every school to provide self-paced learning modules, some clunky educational games, to become a tool to develop computer literacy in what was supposed to be known as the "computer age." Now these computers sat silent in the corner. After all, what could these computers do that books and a good teacher couldn't? A good teacher was more flexible and reliable than any Apple II/e ever could be. Part of the excitement of the BST project was to take computers that comparatively could do so little and turn them into globalizing information search, retrieval, and sharing devices. All one needed to do, Frank Odasz imagined, was to add modems, a central computer to switch the calls, staff, training, and hopefully a way to keep telecommunication costs down.

Meeting needs

Frank wanted the Telegraph to stay close to demonstrated needs. "As much as possible, we have tried to stay as close as possible to actual needs. What does a rural teacher really need? Resources, lesson plan, contact with other teachers, contact with libraries and resource providers. OK, and some means of social access." Frank saw the need, knew of the technology, but was unsure how to proceed. After all, as he would later tell me, when he had gotten his Master's of Instructional Education only a few years before, the only computer that was considered important in his school was the mainframe, and the bigger the better. Inspired in part by Naisbitt's best-seller, *Megatrends* (1982), Odasz believed that a revolution was about to occur and that it would lead to decentralization, new rural opportunities, and new ways of thinking. Odasz approached Col. Dave Hughes (retd) of Colorado Springs, Co., a nationally known proponent of and expert on computer conferencing for community development with his idea about setting up a conferencing system in Western Montana. Hughes in turn was fascinated by the larger community picture.

Hughes also intensely disliked the notion that technology use could precede needs, that computers were a solution looking for a problem, that a well-meaning benefactor would simply bring the fruits of the "advanced" world to "backward" people. Hughes agreed that the rural teachers had a real, unmet need to communicate that a computer network could solve. He could see why an earlier attempt to bring ranchers and farmers computers linked to a central agricultural database had been such an abysmal failure. The people pushing their

new communication gadgets seem to forget that ranching, farming, and merchandising were serious businesses, and that anyone who was staying in business must have already forged a good communication network. A rancher learns something from a ranch trade magazine or a broker tells friends about it over the telephone, and together they could hash out its significance. "Most every night we telephone, or visit," said one rancher.

While market conditions, technologies, and products change quickly, do they really change so quickly that ranchers who measure investment cycles in terms of seasons would fall behind if they do not get some market information for a day or two? The truth is that when an innovative device or practice pays off, it doesn't take all that long to be adopted, despite what ranchers and farmers say about their own traditionalism. In 1981, only a few, pioneering ranchers had satellite disks out beside their homes to catch the new television and cable networks; a year later the idea had taken off like wild fire. It was either adopt or stick to two television stations or fewer. Computer conferencing and database searches seemed an OK idea but would it really pay off? "Eliminating telephone tag" by adopting email and computer conferencing didn't seem a priority to the ranchers I spoke with. Those farmers and ranchers who had been foolish enough to buy one of those dedicated terminals to the interstate database got burned when the service collapsed. When I asked one County Extension agent what he thought of online communities and services, he leaned back and pointed to that useless, but expensive hulk of a terminal at the corner of the room: a relic of misplaced optimism in computer access.

Hughes realized that if one could get the teachers of these communities online, they could possibly serve as a bridge to "informatizing" the rest of the community, providing both an example and a point of access. For Hughes the real source of information for a rural community would not come from some massive database, but from the experience and knowledge of local people themselves. Lower costs made the time ripe for a new strategy: get people with needs online and allow those online to redefine how the technology was organized. Going online, Hughes taught his networking students; could not be understood simply reading about it in a book, or hearing a lecture; one had to go online for oneself. There was no substitute to actually sitting at terminal and doing it oneself. Going online was bound to be a lot simpler and more fun than most people at the time might have thought – and at the same time a lot more ordinary. If one was to reach out to rural communities, then starting with the schools made excellent sense since they played a central role:

> in many small towns in America, the concept of "community" is so strong, that nothing is "just" school, or government, or business, or private group. Schools are frequently a social center, a place where other elements of the community can do their own thing so long as the kids are educated and the school gym is available for the basketball games scheduled.
>
> (Hughes 1989)

While only teachers would get subsidized phone rates, and then only for a trial period, BST was open and free to the public from the very beginning, whether they were from the local geophysical community, or dialing in long distance.

Gathering resources

Over a period of several months, Dave Hughes taught Frank Odasz online at 300 baud between Montana and Colorado, how to set up and organize the computer conferencing software and hardware, and together they drew up expanded plans about how the new

system might also become regional computer conferencing system, and establish a network of other networks. Finally, during Thanksgiving 1987, Hughes packed up his van with equipment and software, and headed for Dillon. He later stated that as the equipnment was unpacked and tested, he did his best to stand back and watch. He wanted the people involved with the project to be able to construct and configure the system itself. Later Hughes would proudly point there was no local "data priest" (DP: the unaffectionate term for systems operators who in the mainframe era ran complex computer systems according to arcane rules and access schemes). He saw in Frank and Reggie Odasz ordinary people (at least as far as computers were concerned). Their assistant sysop (systems operator) Elaine Garrett, ordinarily a professional hunting and fishing guide, was invited into the project particularly because she was one of the few people who had had experience with an IBM computer. If the knowledge base was local then the power associated with that knowledge could stay local as well.

Initial funding was provided in part by M. J. Murdock Charitable Trust of Vancouver, Washington, for administration and hardware, and the Mountain Bell Foundation of Montana (US WEST) to provide limited 800 toll-free telephone number forinstate teachers. Later, other companies and foundations would provide additional resources, such as the twenty modems given by Apple Computers. Mountain Bell, the regional representative of US WEST, had been interested in the Big Sky Telegraph from the beginning, and while they did not rush in head over heels with funding, they did slowly increase funding, perhaps seeing a service that would increase telecommunications traffic and services. According to Hughes, *online* communication was instrumental in even getting the seed money grant from US WEST since Hughes had contacted people he knew online, such as Tony Sees-Pieda, the Denver-located Mountain Bell Public Relations official who then moderated a regulatory public policy conference on Hughes's Chariot BBS: members of one virtual community helping another with real resources.

However, the long-term goal was to make the communication network self-supporting, as well as reproducible. This meant that the sysops would gradually encourage the teachers and their community to make an investment of even only $10/20 a month to keep the system running. Users would ultimately have to pay some kind of access fee. Indeed, the subsidized 800 number was valid only during an initial set-up period. After that even the teaching community would have to pay. If a teacher wanted to take a course on accessing the BST, it could cost $60 for college credit, $25 for non-credit, self-study, free. A business-oriented version was listed at $120. However, even to this anyone with a modem or Internet connection can log on, check out the general discussion areas, download a few files, and contribute. Visitors are issued an online ID almost automatically.

Big Sky Telegraph goes online

The Telegraph officially went online in January 1988 and took off immediately, making use of pre-existing communication networks between the teachers, and their communities. According to Hughes,

> In the first 40 days of it being up, it has been called 1,612 times by people – 75% of whom are total novices – all over that rural dispersed state of Montana. They have left 975 messages which is a message-to-call ratio of over 60%. *That* meets my standard for "user friendliness" of a dial up system.
>
> (Hughes, EIES, C68S:153:275, 2/19/88)

Teachers learned about the system through ground mail, during the bi-annual (face-to-face) teacher conferences, and later through anyone who knew about it. Teachers in the isolated one-room schools across the state would be sent through the mail a $125 modem with a letter telling them how to open the Apple case, install the thing, run the software, and dial up Big Sky Telegraph. Once connected (with maybe some additional help provided over the telephone, or on occasion, a site visit), a teacher could continue learning online skills by taking credit or non-credit online keyboarding classes to explain how to minimize online costs, how to figure out what the connection was doing, how to download messages for later use, how to send messages, or find a message to read. It was a big step for many teachers just to realize that they wouldn't break the Telegraph by pushing one key, or by being unexpectedly disconnected.

The concept of computer conferencing and virtual communities was new on the Montana frontier. As Dave Hughes stated in a posting on the WELL in San Francisco,

> And the MINUTE the first wave of callers (about 23 I recall) realized that this was far, far more an "online meeting place" for a "peer" group, and less a "data base", one-on-one teacher–pupil relationship, the joy was unbounded among those remote teachers and the word spread like wildfire.
>
> (Hughes, Telecom Conf. Topic 393, Jan 15, 1989)

By the following August, over 7,000 messages had been exchanged between 300 people, and more than 30 teachers had completed the accredited formal online training, with more taking classes. The online architecture was gradually redesigned by the users themselves, with the less knowledgeable drawing on the skills of those who knew more: teachers teaching teachers.

Online discussions focused on promoting online and offline community building, improving educational resources for students, teachers, and the community, and of course celebrating all those teachers who had made that uncanny step into the online worlds. Critical comments were avoided according to many of the participants I spoke with, not particularly because the teachers feared offline repercussions, but because they wanted to support the empowering aspects of the medium. The Telegraph was a virtual community in part because its members were encouraged to have a sense of belonging (Cohen 1985). Newcomers would find their mailbox promptly filled with greetings from Frank, Reggie, or other teachers. A list of online facilitators was available. Have a math problem, then why not send some email to Otis Thompson, Western Montana College Mathematics Professor and Apple computer and software expert! Teachers could leave their email addresses and telephone numbers online to be general resource people. This in turn facilitated offline learning, and after all, many of the teachers would meet one another at one of the two joint teacher conferences held each year.

The Telegraph organized the direct circulation of educational software and library materials so that materials, rather than having to be sent back to the regional library to be lent out again, could be forwarded directly to whomever needed it next. An MIT mathematics professor taught concepts of Chaos Theory to rural schools using the Telegraph, and a forestry department administrator would come online to answer fire prevention questions from the students and the general public as Smoky the Bear. Students at least initiated pen-pal correspondence, and lesson plans were shared. In the ideal situation, the educational needs of a specific dyslexic child could be raised online, and teachers could send one another the books and teaching materials that the community already had while offering general encouragement and advice, all without having to go through the County

Education Superintendent or the Teaching College. Decentralized resource sharing was clearly a way to do more with less.

RuralNet

And just as it had promised, the Big Sky Telegraph sought to include the rest of the regional community and its economy. Cyber-activist and columnist Gordon Cook and Dave Hughes spoke of a community development in terms of a chair with three legs – education, business, and civic. Take away one of the legs and the chair would fall over. Genuine community development has to have the participation of all three sectors, and the Big Sky Telegraph was seen as one way to provide such a common space and common project. Hughes would refer to his long-term vision of this project as RuralNet, an interstate, decentralized, low-cost electronic network to facilitate economic, business, and civic development. Odasz probably described the vision best as

> optimal collaboration allowing citizens, schools and communities new to infra-
> structural issues to work together with multiple existing networking projects, by
> sharing information on what does or doesn't work, on an ongoing basis, transcending
> traditional borders and cooperative barriers.

However, from the beginning, the initiators realized that it would take time for some real life communities that didn't speak to one another offline to feel at home together online: different communities would need their own online space, a space where they could feel at home, a space where they could meet people with whom they felt comfortable. A rancher coming online for the first time might not feel too at home in a virtual room full of school teachers. Neither might retail business managers.

To solve this problem, the founders of BST partitioned the computer in such a way that users could dial the same access number, and then face a menu presenting the different login choices: BBS for educators, HRN for the Headwater Regional Network's business partition, AKCS for Internet access, Gold for tourist information partition or later Community Access Services, and so on. Each of these partitions was a unique, self-sufficient bulletin board system running on the same server. These were the different communities, each with some resources all their own and some held in common. In addition, some users might be so privileged as to have a personal login and directory. Hughes had configured the server with XENIX, a PC version of Unix rather than PC-DOS to make these multi-user choices more stable and easily available. This structure allowed the partitions to easily share a common community database. Each of the partitions would run the same BBS software, a customized version of XBBS, however, so that learning how to navigate one partition would make navigating another partition easier.

On the school side of this zoned community, a bulletin directory updated the Telegraph community with system announcements, position papers, and messages of important general interest. Different conferences would be devoted to different topics. The Open Classroom conference discussed general educational concerns, the Science conference developed science projects, a Writing conference provided an arena for creative writing experiments, and so on. A few community conferences would be found nearby, including, for example, one for Displaced Homemakers, another for the Western Educators Conference, another for health issues. And of course there was the Kid Mail conference for students trying to find virtual pen-pals, and a Coffee Shop conference for jokes and comments that fit nowhere else.

The business and community end of things was much less stable, presumably because of three factors. First, there was no perceived need that could be met only by the Telegraph. As Frank said, "Now we're in economic development. I don't know that the economic development people know what information [these] people really need." I talked with several regional "development" people who could see the value of the network, and saw that developing such electronic networks might ultimately lead to new jobs, new efficiencies and markets for existing businesses, and new cultural resources. And yet how could they develop these things by themselves. The main focus for the business and civic users would be immediate practicality. The promotional literature from the Telegraph 1988–93 suggested that BST's business services could include: Online Conferencing, Electronic Mail, Office to Office Document Transfer, Personalized Interface, Access to regional databases, and even, presumably on a very limited basis, such advanced services as scanning and desktop publishing.

If a local, non-educational community group could manifest a clear need to the Telegraph's administrators, then a distinct partition could be added. The Headwaters Regional Development group, for example, based on the support of the seven Southwest Montana development agencies, would try their hand at developing a partition, as would several tourist agencies, but these areas would take time to develop, and with differing degrees of success. In the context of a larger, pre-existing media ecology, most of the business and civic leaders already had the financial resources to pick up the phone and the social network to know who to call. In one instance, secretaries were discretely and unofficially designated to go online and pick up email and files rather than have the directors go online directly. If one online benefit was to eliminate phone tag, then these directors already had a working system: secretaries to take and send messages and documents while the directors went to face-to-face meetings.

General local community interest developed. In between pumping gas at the 'Gas 'n Stop' and doing chores, Sue Roden, with a beehive hairdo and plenty of character, would dial in to the Big Sky Telegraph on an old PC borrowed from the Women's Resource Center in Dillon. She had come to tiny Lima, MT, situated on a valley road near the border to Idaho with her husband while he developed his ministry. Even though she would get lessons in the mail about how to use the computer, and occasional visits from people who knew BST, often she turned to passing truckers and tourists for help. One time when the online community couldn't figure out why her software wouldn't work, a passing truck driver explained that she had to "un-write-protect" her disks. She ran her computer like a public access center: if you would pay the telephone bill, you could get online from Lima. She enjoyed talking to people, and downloading files. One of the main reasons she was interested in this online world, she explained, was the hope for "a second job, a second income." What about virtual communities? She responded, "As for community, well the Reverend has an active one, and as for free time, there wasn't much."

Indeed, research showed that one of the most important and successful non-teacher user groups of the Telegraph were found from the women's groups and non-traditional students. Carla Hanson, after going back passing her own high school equivalency exams, encouraged her friends to take their own high school equivalency exams and to get online. While two men had started with her effort, it was six of her women friends who finished, and successfully passed the exams. Carla Hanson suggested that in the new economy women needed to be able to make their own money and decisions. During these hard times, women wanted to have their own skills, and their own ability to be successfully independent. While sensitive, personal issues would usually be conducted outside of public conferences, the public conferences provided information about where people could go to find out about new jobs, how to deal with spouse abuse, and how to deal with or prevent health problems.

Carla and her friends were proud of having gone online, and Frank Odasz certainly tried to build pride as well. Jody Webster at the Women's Resource Center admirably explained:

> Some of it is attitude. All your skills aren't the physical skills, like typing or shoveling. A lot of it is attitudinal skills, [wu: "social skills. . . ."] yeah, communication skills: how to ask for a raise, or how to ask for a job or not ask for a raise; the fact that you need to sell yourself; the difference between self-esteem and conceit. When I grew up a lot of the things would have been immodest or conceited, and now you can say the same things in a different way, and you are simply letting people know something about you. You didn't say "I."

The online community allowed for the articulation of an "I" whose identity could be balanced between self-esteem and conceit. It was thus suggested that the vitality of an online persona and the pride associated with going online could translate into changed self-esteem and vocational effort offline.

The first adoption dip

Still, after a time, adoption rates stalled in a number of communities. Many local one-room schools did not come online. With 114 potential schools, only some 30 or more schools were actively involved two years later. Those teachers who did go online spoke highly of the experience and of the potential for decentralized resource sharing. The prospect of going online seemed so positive and cost-effective that it seemed surprising that any teachers would wait. Was the problem really simply one of rural computer "illiteracy" or of "penny wise pound foolish" budgets? What was keeping teachers offline?

The easiest answer was structural: there were not enough modems, nor enough teachers who knew the system, nor enough information about what was involved, nor enough money to make the local connections. Put another way, five structural problems appeared to be factors: cost of equipment, limited availability of computers, vast physical distances, limited local computer skill, and high cost of telecom services. However, most of the school had computers, and grants would cover initial equipment and connection costs. Connection costs could be kept down since a teacher need only dash online, do the online transactions as quickly as possible, and leave. Lack of skill could be a problem. Perhaps the diffusion of innovations network became too tenuous far from Dillon, and the reinforcement too infrequent (Rogers 1983). Many of the teachers, and community activists such as Jody Webster, program director of the Women's Resource Center, who were online had already been exposed to computer networking somewhere else, often through the Federal Forest Service. They knew what the water was like before they jumped in.

Upon investigation, the reasons appeared more complex. There were cases where teachers had taken an online course, knew how to use the system, had access to a computer and modem, had funds from grants to make the connections, but still didn't use it. Why would skilled teachers with resources not go online? Addressing this problem would prove key to the rest of my study.

Lessons learned: cultural complexity on the cyberfrontier

It became clear that I would have to stand back and look more analytically at the larger picture, to look at how the Big Sky Telegraph was imagined and signified in society, at the

more subtle factors that had put these machines in the hands of the teachers, students, and activists in the first place. It is perhaps too easy while studying virtual communities such as those described in this book to overlook the extent to which the virtual community is one community among many, and how communities influence one another. A striking feature of a virtual sociology (or more accurately a sociology that includes virtual spaces) is how these new communication technologies can alter the organization of power so that it eludes or augments traditional hierarchical constraints in unexpected ways.

Both popular and academic/professional accounts of the Big Sky Telegraph and networked enhanced communication in general were polarized over the issue of centralization and decentralization. Locally, the issue of centralization proved more profound even than the question of technology itself. After all, the ranchers weren't afraid of technology, what with their tractors, their satellite dishes, their microwave ovens, and their cars. Ranchers and farmers wanted to be able to fix what they had, and computers didn't fit that bill (did satellite dishes?). If it could be shown that a new technology really would help bring more power locally then there was a good chance that someone in the household would adopt it. If this was the case, then why not simply suggest that the Big Sky Telegraph, and computer networks like it, were ideal means of decentralizing and localizing, that it would not be like the television, that necessary evil whose content all too often seemed controlled in the boardrooms of New York and the production studios, of Los Angeles. Decentralization was the very promise of the Telegraph, and Frank Odasz and all the teachers were constantly promoting this aspect.

In many ways, the scholarly split about the de/centralizing impact of computer-based communication mentioned was manifested in the rural communities themselves. Was this continuity an artifact of my own perspective, indicative of the influence of one group on the other, or perhaps indicative of a deeper, common problem? It is the conclusion of my study that both trends of centralization and decentralization are occurring simultaneously, but in relation to different commodities, and that individuals in local communities are divided over the impact of the technologies in terms of these conflicting economies. While much has been made of the new "information economy" as defining a new economic and communications era (Machlup 1962; Bell 1973; Porat 1977), I would argue that we conflate the organization of material and information commodities at our peril, particularly as social researchers. Indeed, it would appear that there are two distinct economies, or organizational poles within the larger economy. As will become clear later, it appeared that the complexity and creativity of the emerging systems of cyberspace seem strongly engendered and self-organizing by the impact of this split (Kauffman 1995; Cowan et al. 1994).

On the one hand, where information and access to information is the coin of the kingdom, traditional hierarchies are coming apart, and with them new patterns of decentralized and decentralizing opportunities are emerging. Accelerating changes in markets, knowledge bases, and resource access is undermining rationalized, top-down, bureaucratic, management (Zuboff 1988). Giant centralized operations producing movies or widgets often seem to be struggling to keep up with competitors who need less and less initial capital and who are small enough to keep up with changes in the complex and open distribution mechanisms for information. Where once there were 3 major television networks, now people go to video stores if they don't like what the 30–500 cable channels are showing, or else they hit up some other communication channel, such as the Internet. As the bandwidth of the Internet and digital transmission lines increases, there should be even more selection, beyond the narrow choice of a few hundred, generally well-financed cable or satellite networks.

The new worker in this scenario is supposed to become more self-directed, more flexible, more holistic, a better collector of information, active in local "quality circles," and comfortable and skillful with being in closer touch with both higher management and customers (e.g.

Toffler 1981; Pine 1993). Middle management finds the "middle" getting smaller and itself increasingly excluded from production and income. After all, information technology can mediate more and more of the complex operations of producing and organizing products for markets. With digital packet switching, and the increasing power of humble computers to act as local switching nodes, traditional telecommunication and information hierarchies are collapsing into increasingly geodesic networks, into a decentralized infrastructure of bypass and local pathways (Uncapher 1995a; Huber 1987; Huber *et al.* 1992). For local, rural communities this decentralization can mean: increased, more direct, more interactive access to resources, as well as ways to share information locally. Why wait for some higher up to provide information? Get or give it yourself, more informally, more individually, and more timely. Decentralization also portends in this scenario increased regional employment where traditionally defined isolation no longer matters. A database for hunting information can be as easily located in a rural area as in an urban center.

On the other hand, using this new information still means getting access to material resources, including capital/credit. Many of the individuals I interviewed reminded me that while capital might be "immaterial," if someone won't give it to you, and you can't earn enough of it, then you can't get access to the things that capital provides. Even using online resources to find out about funding and resource opportunities becomes problematical as more and more competition develops for these resources, as more people get online and as this information gets relayed to the offline populace. Information and material jobs increasingly can be contracted out to small, often under-funded individual firms. Material production and distribution follows the logic of immense economies of scale. It is at the transnational, not even the national, that immense wealth and opportunities are organized, and communication technologies are making this global organization of material production possible. Even national telecommunication giants, like the Italian state-owned STET, are finding that they are no longer big enough to be major players in the global telecommunication markets (Uncapher 1995b). Just because workers are "self-directed, more flexible, more holistic, better educated, etc." doesn't mean they will be well paid for their labor. It means that without these attributes workers won't even be able to participate in the job market! As the critics would have it, does a Big Sky Telegraph represent the first step of local becoming techno-peasants hoeing the digital fields of the transnational corporations?

Local debate about the impact of information technologies tended to take one side or the other, and these debates in turn merged into older, archetypal configurations examining issues of change and continuity, opportunity and exploitation, dependence and independence, locals and outsiders, money and resources. Frank Odasz did what he could to associate the image, the "myth" of the Big Sky Telegraph with the "independent cowboy spirit." Getting online would transpose a user to an electronic frontier of individual freedom and community responsibility. The American Frontier so essential to the American spirit had not been lost, as Turner (1894) had supposed, nor relocated to a few rogue outposts like Montana (Kemmis 1990). Rather, it now existed in a fractally enfolded cyberspace beyond the easy reach of centralized authority (Bey 1991: 108–16). And the traditional values of the Frontier might finally re-emerge as a bioregionalism enhanced by appropriate technology (Sale 1991; Van der Ryn and Cowan 1996).

While the short-term result of adopting computer conferencing would be a better sharing and acquisition of resources, new skills, new occupations, and a new lease on life for the local economy, what will happen in the long run, who will control the local economy then? One rancher pointedly told me that he worried that a generation of "button pushers" (his term) would not be able to dig a ditch for themselves. People would not be able to control their own destiny. They couldn't even fix these things when they broke. Other rural

people told me they were interested in the Telegraph because they felt they had no other choice in a changing economy than to adopt and adapt this new technology.

Owner-operator ranchers and farmers spoke about new communication technologies in terms of scale. There was a scale to how things were done. Ranchers do some things on a large ranch that they can't on a smaller one, and vice versa. Vichorek reports:

> It seems to me that Montana ranchers and farmers fit into niches at different scales. For example, on the local scale, each ranch and farm is tailored to local conditions. ... On a larger scale, farmers and ranchers are involved in a sort of worldwide economic ecology.
>
> (Vichorek 1992: 10)

Despite the prejudice of some outsiders that ranchers and rural people in general would not be cognizant of the forces of globalization, the truth was in fact just the opposite. While a city-based wage laborer can try to believe that the fruits of his or her labor are constrained by national and local economies alone, rural people look to global markets. When I asked one rancher about globalization, he pointed over to a tractor and said, "on the outside it says 'Made in America,' but I know the parts for it come from all over the world." The market for agricultural products and livestock are global, and anyone who plans to stay in business had better follow where the market is going.

If anything, then, the Big Sky Telegraph signified the new economy to traditionalists. BST was a lead dog in a global hunt, even if the well-meaning folk connected at the Telegraph weren't too aware of the larger picture; for many traditionalists, the picture was one of convergence and centralization. Bill Gillan of the Gillan Ranch in Colstrip, Montana, noted:

> The trend is for big outside money to come in and buy big ranches. We don't know where the money comes from. It might be the Japanese, or drug dealers, or maybe only doctors and lawyers looking for a tax write-off. ... This sort of big money investment drives the price of land up, sometimes up to three or four times the productive value. ... I might be the last generation of owner-operator on this ranch.
>
> (Vichorek 1992: 53)

In what was something of a surprise to me, ranchers generally said they were not opposed to Japanese and foreigners buying ranches, such as the Zenchiku ranch outside of Dillon, so long as they were kept as working ranches. Ranchers and farmers pointed out that Montana has had a history of outside land investment since even before Lewis and Clark came around the bend, whether they were nineteenth-century Wall Street robber barons or Japanese firms looking for a direct source of specialty Kobe beef. The specter of media moguls and financial tycoons buying up the land for vast country estates, however, angered locals who foresaw the decline in subsidiary income. The "new" economy seemed less and less place or respect for what they were doing, and the fruits of that economy seemed to go to the wealthiest somewhere else. The 1990 Montana Farm and Ranch Survey produced by Montana State University reported that one-third of the farmers and one-fifth of the ranchers expected to quit within the next five years for financial reasons.

We might take a cue from rural people on issues of scale as we analyze the impact and potential role of cyberspace on rural landscapes. Indeed, scale has become an important issue for many anthropologists and sociologists seeking to take stock of the cultural aspects of globalization (Barth 1978; Hannerz 1992), and for good reason. While traditional sociology tends to locate power in terms of place – the person at the big desk has more power, is

at a higher strata than those on the production floors down below the shift toward the dynamic process in the information economy refocuses issues of control in terms of such entities as "niche" and "rates of change." Shifts in the global/local economy can quickly undermine the wealth of those not prepared to move to the new niche (e.g. Davidow and Malone 1992). The fact that the naive notion of intrinsic identity is being redefined, although not without controversy, by an interest in the process of identification, whether it is the intellectual object constructed by reading (Derrida 1974), the scientific object constructed by socially situated scientists (Bijker *et al.* 1987; Haraway 1989), or even the physical object constructed by intention and attention (Thurman 1984; Varela *et al.* 1991), should help focus a virtual sociology exploring events like the dynamics of the diffusion of the Big Sky Telegraph not simply on an interplay of static power relationship, but on power as an activity which constrains and facilitates other activities as these relationships redefine themselves.

Social groups and the scale of communication

The great poles of social organization then seem to play out the tensions between a centralizing global and the decentralizing local not on one massive battlefield, but in terms of various scaled zones that exist dynamically in between them. Unlike the flat social network envisioned by most social network and diffusion of innovations theorists (e.g. Rogers and Kincaid 1981; Granovetter 1982), contemporary hierarchy theorists look to scale and constraint, to how entities at local, smaller scales generally function more quickly than those the larger scale, but are in turn restrained (in various degrees and fashions) by the larger scale, by what in essence is a more slowly changing environment (Ahl and Allen 1996; Allen and Starr 1982). When the larger scale entities begin to change rapidly, it is usually because they have found some functional way to make use of the dynamics of their component systems (Arthur 1994). Given that the way each of these levels (and society itself) develops as a function of communication, so changing the means of communication, the media ecology changes the organization of society, and the leverage of any entity within it. Virtual communities appear to be playing a key role in this move to a more dynamic, complex social system. And it is the conclusion of this research that the dynamics of adoption, or more accurately of the development of communities in cyberspace, reflects conflicts at several different scales.

In line with Fernand Braudel's analysis (1981–4) of the global economic system into (1) local material production and consumption, (2) regional market economy, and (3) global-capitalist economy, I identified four scales of demographic and cultural organization with which to analyze how virtual communities like Big Sky Telegraph fit their environment/s: (1) personal/user, (2) local, (3) municipal/regional, and (4) outsider/global. Individuals and their activities can be active at different contexts and scales simultaneously since any given action can contribute to different levels of organization at the same time. A federal land agent working at a municipal or outsider level could also be a parent. It is the roles that function at different scales.

Private lives in a public world

The personal/user scale focuses on how the private and public intersect. At this level of inquiry into communities in cyberspace, processes develop by which identities are internalized

and desires externalized, a locus of great interest by those investigating, for example, issues of technological embodiment in cyberspace (Stone 1995; Featherstone and Burrows 1995), as well as the personal sense of security and wholeness (e.g. Giddens 1991; Bauman 1992). However, these concerns are not new. Consider Hannah Arendt, who wrote in 1958:

> The distinction between a private and public sphere of life corresponds to the household and the political realms, which have existed as distinct, separate entities at least since the rise of the ancient city-state, but the emergence of the new social realm, which is neither private nor public, strictly speaking, is a relatively new phenomenon.
>
> (Arendt 1958: 28; cf. Nguyen and Alexander 1996: 109)

If the reasons that adoption of BST tapered off were not simply structural, another possibility lay with the complex public/private nature of the medium. Even if the Big Sky Telegraph was initially directed to the rural educational community, perhaps the general online public intimidated teachers. Openness, particularly in the rural setting, might work to the local educational community's advantage when these outsiders, whether they be local, national, or international, had resources or answers to share. No sooner did the Telegraph open than the word went out in the telecommunications/online community that an interesting project was under way in Montana. Callers from Japan, USSR, Europe, and around the Americas logged in during this period beginning 1988. Facilitated by Hughes's enthusiastic, larger than life persona, "the Cursor Cowboy," and Odasz's own travels, word of the new project spread to other electronic bulletin boards and early Internet outposts, such as the WELL in San Francisco, Meta-Net in Washington, DC, and the EIES network in New Jersey, and online visitors would often become information resource sharers.

I initially supposed that one strong inhibitory factor of the adoption of BST would be teacher fear of panoptic eavesdropping. What if a parent strongly disagreed with something that a teacher said? Public spaces, even virtual ones, evolve in the context of a complex sets of rules and assumptions serving to maintain a balance between trust and power. Groups often develop because of the way they control access to the private, back, space; media can certainly change this (Meyrowitz 1985). When these online worlds are so close to offline ones, prudence is often the better part of valor.

However, users of the Telegraph uniformly stated they were not overly concerned about the public/private nature of the online communities. In one scenario I presented, a county supervisor of education or parent objects to something that a teacher writes online. Teachers need the support of the county supervisor, particularly in the face of volatile local opinion, and it rarely pays to rile up the parents. However, teachers and other users felt at this point that anything that improved local communication would be welcomed. Teachers said they had nothing to hide and would not mind having the supervisor overhear just how hard the teachers had to work! In fact, most of the regular users at least stated that they looked forward to more local participation and improved local and regional communication.

Local scale: paying for the connection

The local level reflected the organization primarily of the small town, population 50–300, situated in the midst of primary extractive, agricultural, or pastoral regions, although this scale of organization could also be found hidden as a subgroup within more urban areas. The schools at this level went only to the primary level, from nursery school to eighth grade. People generally had to travel a distance to get things done, 5–20 miles to the post

office, school, or retail stores. Group activity at this level tended to be very issue oriented: should they raise local taxes, expand the school library, improve the road, and so on? or else concerned with the public/private lives of individuals. Issues served to weave the community together. The key players would be ranchers, farmers, local land management officials if present, service providers such as small retail stores, and of course the various groups associated with the schools: teachers, parents, students, and school board members. Along with controversies over collective land use, a perennial, central decisions had to do with the local school budgets. Ranchers and farmers were the key tax payers, and school spending was often the most important and expensive item on the local budget, it was also the site not only of an economic debate, but a cultural one.

Since the Big Sky Telegraph sought to be self-supporting, it intended to rely finally on the community resources to provide the mere $10–30 a month for the connections. Small as this amount might be, it opened the door to debate about what role the Telegraph should have. The Montana tax structure in the late 1980s had evolved to use a variety of property taxes in place of income or sales tax, a scheme that had made some sense when the giant mineral companies like Anaconda had anchored the economy, but which now made the land rich but cash poor ranchers and farmers wince at even a few cents tax increase. Without a sales tax, there wasn't much chance to directly capture any of the tourist income, and any mention of a new tax was greeted with suspicion. No one believed the promises of some state legislators that if a sales tax were granted, the property taxes would be substantially lowered. Hence, the introduction of this new device might mean that it would have to be paid for by the local ranchers and farmers, and other substantial taxpayers, who could suppose that the BST might incur additional costs in the future, tie up valuable teacher time with an unknown and unproved project, and, as was examined a moment ago, help facilitate the introduction of economic forces of centralization and globalization that seemed to be undermining the local economy, and with it local values, local traditions, and local culture. Teachers would need more than their own teacher support group to break through.

Ranchers spoke of themselves as the upholders of the Montana way of life as well. In this view, federal land management employees, teachers, even merchants might come and go, but it is up to the ranchers to decide the future of the state since they can provide continuity to its past. If ranching and farming families cannot always control their own economic destiny, if key economic decisions are being made in an increasingly vast, global theater, at least they can manage their collective symbolic destiny, something which outsiders can't penetrate without local guides. Economic conditions continue to change. Many felt that being traditional had kept them in business. When I asked one rancher if the people who didn't lose their ranches during the recent economic decline were more traditional, he replied, "Had to be. Throwing their money away. They couldn't pay for it [the new gadgets, services, and products].The banks encouraged them."

Ranchers, farmers, and rural business people often did know about the Telegraph, but thought of it vaguely as a system for educators. There had perhaps been community presentations at the schools where a teacher or Telegraph associate would demonstrate connecting to BST, leave handouts, and encourage non-school uses. Were there computers available in the homes of the ranchers? I could find no statistical data on this, and the absence of a local computer repair infrastructure suggested not. However, my own interviews revealed that there were some computers in the homes. In this gendered, rural society where ranching was done by the men, bookkeeping in turn was done by their wives, who were of course interested in economical, reliable, labor-saving devices. It was thus the wives who were among the first to want to get access to computers, and it was they who

seemed best situated to understand and use this new technology. Still without much extra income, a machine that could do a few spreadsheets, simplify letter writing, and interest the kids in newer technologies seemed a bit extravagant. But they were in a number of the houses I visited. Children and their education for the future were also considerations in getting a home computer, and several ranchers joked they intended to learn computers and networking from their children.

The notion that the teachers could serve as a bridgehead to bring computer networking to the rural communities was problematical. The teachers did indeed serve a central role in the community; however, they also were the bearers of all kinds of symbolic attributes that made moving ideas from them up into the community difficult. Local sources stated that rural teachers at the time of this study were about 95 percent women, making some $11,000–13,000 per year, barely a living wage. Those who took up the challenge were either wed to the job, or using it as part of a second family income. Since the teacher was such an obvious member of the community and one who dealt with children, she often found it difficult to socialize in bars or other places that might compromise her moral standing. Going online, therefore, offered a new avenue for socializing, and the movement of the teacher from a known position – considered by some to be a lowly one – to something unknown. Given their subservient status in the community, could the teachers be the ones to informatize the rest of the community? Marsha Anson, a minister's wife in Wise River and who was studying to be a school librarian, noted, "They [the teachers] are overworked to start with, and then to become information people for an entire community is too much to expect for what they are making, and for the time they have."

Indeed, a virtual teaching community would clearly transform the teachers themselves. Several teachers suggested that virtual community reinforced their sense of themselves as a community with shared needs. They were not simply teachers in a classroom, or teachers in a local community, but teachers who needed to develop a community of their own. One teacher confided that she felt these online communities might provide good tools with which to unionize the labor of teachers. A dangerous idea, I admitted, one that might not be supported nor funded by the local school boards. The teacher in question later left her teaching position to take up union organizing full time, one example, perhaps, of the impact of the Big Sky Telegraph on the teachers. Put another way, the online community of teachers began to resemble what I have been calling the municipal level or scale – interested in planning and sharing structures that could encompass different local communities.

Municipal scale: fragmentation and integration

The municipal or regional level in general was associated with urban centers, such as Dillon, Butte, and Bozeman, Montana, with populations more in the range of 3,000–6,000. Here one found the regional offices of the agricultural, technical agencies and other social services. Group activity at this level tended to be more abstract, trying to establish collective rules and frameworks, including those necessary to promote the educational, environmental, or financial resources of disparate local level organizations. High school and college instruction functioned at this level given that they would have to accommodate students from very different backgrounds. A bank and retail chain stores might be located in a very rural region, but often they functioned at a municipal or outside scale by using information technologies to link them into larger scale financial, legal, and cultural constraints about the deployment of people and capital. I would claim that it is at this municipal level that

most virtual communities are developing as a kind of meta-community that must tolerate and even encourage open-ended diversity.

The introduction of virtual communities and information technologies was looked to with more hope at the municipal or regional level than at the local. The (agricultural) extension agent, the county education supervisors, and the social activists, etc., all wished they could have more reach into the local communities. Using radio shows and occasionally making 100-mile journeys were time consuming and often ineffective. While sending out brochures describing a service or product might act as a beginning, the real activity of these agencies was actually interactive: answering questions, directing clients to resources, setting up support groups. The business leaders further wanted to find new ways to broadcast the good news about the region to the outside world (to tourists, businesses seeking to relocate, etc.). All would support a cost-effective way to provide better cultural/educational environment in general, such as for the schools.

However, individuals at this level tended to find it more difficult to get institutions around them to change. According to hierarchy theory, the higher the organizational level, the slower the change but the greater the resources and the greater the impact when things do change (Allen and Starr 1982: 13). A ranching family with a little extra cash could simply go out and buy a new satellite dish or a computer, but a city school would have to fill out requisition and funding forms, which in turn would be handled by a bureaucracy devoted to making the hard decisions about how to manage limited financial resources. Ironically, while the ratio of computers per student in the rural one-room schools was say 1 computer per 20 students, the magnet high schools at the time of this study would have only 1 per 100, and the colleges, say, 1 per 500. These higher levels might have more financial resources in some absolute sense, but they were committed to projects that did not want to be defunded and hence took longer to change.

At the same time, while things might change or metabolize more slowly at a higher scale, the impact on the lower, faster moving scales was more profound. Several other electronic networking activists who worked at the state level suggested that BST might have made quicker headway if they had tried to diffuse the Telegraph through the county superintendent and other such officials. The reasoning was not that superintendents could more easily contact all the schools in their charge, but rather, that the superintendents would have more status and therefore more say *vis-à-vis* the local school boards and their communities. While BST may have been functioning internally according to many definitions of a community in cyberspace, it was not really functioning externally on the municipal level as a coherent community. The teachers in the one-room schools would have to influence their local community directly, while the influence of this virtual municipal community as a whole on the local community would have to wait.

Outsider/global scale: computer conferencing in a Brave New World

Wait for what probably would have to include some influence from the outsider or global level. I am interested in the term "global" as an indicator of the importance of a globalized capital flow, or more broadly, as part of the global cultural flows model that explores the disjunctive, sometimes chaotic confluence of a global financescape (flow of capital), mediascape, ethnoscape (flow of peoples, including tourists, temporary laborers, refugees, immigrants and emigrants to regions), technoscape (flow of technological ideas, expertise, and actual items), and ideoscape (a flow of ideas about social and personal goals, from inflections on the meaning of democracy, nationalism, and theocracy to personal self-mastery)

(Appadurai 1990; Uncapher 1995b). Properly conceived, these flows influence but do not determine one another, leading to all kinds of unexpected local configurations.

In some ways the consideration of the outsider level *vis-à-vis* the Big Sky Telegraph helps to problematize the notion of grassroots. While the premise of the BST was that local people could create their own local network and find new ways to empower their local communities and themselves, the impetus for these changes came in part outside of the community. After all, knowledge of how to run a Unix server, command of the resources to buy all the modems, the production of the modems themselves, suggest some outside influence. Once the Big Sky Telegraph becomes a key component to developing a local, grassroots model, how is this model to be circulated? As it was, much of the strongest support and recognition came from outside of Montana.

Outsiders, who include tourists, researchers, investors, and various change agents, have even more tenuous local links. Outsiders can often command great economic and political forces unavailable to more localized levels, but may not know local or municipal culture. They could include land speculators and investors, manufacturers looking for labor meeting certain specifications, or federal government managers. Outsiders tend to be project-oriented on the local scene, wanting to get specific things accomplished, a hunting trip, help setting up a computer-mediated conferencing system, and so on. As such, the outsider's goals can be empowering to the local community, serving to expand the flow of money and ideas, or else constrictive, using economic influence to limit local opportunities or exploit them unfairly. The greater the lack of integration at the municipal level with other municipalities, the more vulnerable the municipal level can be to predatory outsider practices.

Developing physical infrastructure is generally something that is not done at local level: outsiders usually build the roads, whether they are made of pavement or fiber optic cable. Rural regions needed general upgrading of telecommunication facilities, the elimination of multi-party service, lifeline rates, equitable cross-subsidy from immediately profitable urban areas to encourage rural enterprise and thus the health of the state as a whole, extended service areas that reflect that geographically extended way of life, and ultimately the upgrading of line capacity (Parker and Hudson 1992). Shared multi-lines, for example, could not be used reliably for digital transmissions since any one of the parties might unknowingly disconnect someone else. While goals like these were accepted there was no real consensus about how they should be accomplished: regulated cross-subsidy, deregulated competition, or something in between? Estimating and quantifying economic and non-economic returns from telecommunications investment often makes questionable assumptions (Hudson 1984). Local activists suggested that the state public utilities commissioners did not understand that the telephone involved much more than simple voice communication. Whatever the truth, the commissioners would stand at the boundary of the regional and the outsider levels, looking not simply to their constituents, but also to what other state commissioners were doing (Parker and Hudson 1992: 63), and making compromises with a multinational corporation like US West.

The network nodes, such as the Big Sky Telegraph, were linking up local communities with global partners. For example, several ranches in the area, such as Zenchiku Ranch outside of Dillon, had been bought by the Japanese who wanted a good supply of hormone-free, fatty beef. They would raise the beef locally and would then have it sent directly to Washington state for export, using computers to provide both inventory and communication advantages. Likewise, teachers had access to international online public through their modems. And the Telegraph did put Dillon and Western Montana College on the map as it were. When I went to the InfoTech conference held in Dillon under the auspices of the Big Sky Telegraph, I met people there from around the United States and abroad.

So BST was in a way an early outpost of the International Digital Economy. As such, one would expect that BST would have some influence on the development of new online opportunities. That kind of conclusion cannot yet be explored at this stage of history. However, several individuals have told me that what they learned while using the Big Sky Telegraph was instrumental in providing them interest, direction, and skills to pursue new livelihoods. One administrator left to start a computer sales and repair shop, another set up a computer-enhanced camping supply manufacturing factory, and so forth. Another state-wide community communication activist spent important time working with the Telegraph. It is hard to trace these links since it is hard to ever locate digital workers. The *Montana Business Quarterly* calls the new telecommuters "lone eagles," suggesting that they are important in Montana's entry into the digital or information economy (Jahrig 1995). But what about the kinds of exploitation that might come with the new communication networks?

During my interviews, there was little local concern about the expansion of Taylorist "piece work" potentially associated with computer communication (Robins and Webster 1986). In this critical scenario, workers stay at home or in isolated factories, and are paid simply by the number of pieces they produce, whether sweaters, handwritten mass mailings, and so on. There is a potential for exploitation of local labor forces when employers fail to provide living wages, job security, health benefits, pensions, and so on. Global corporations can locate some production in a region with low pay, and move on when the wages rise. When markets change or the local labor becomes more expensive, then the investor could pull out. My informants from all sides were not particularly worried. They said that first they wanted outside investment and the jobs that would bring. If it turned out that the outside investor was trying to take unfair advantage of locals then they would eventually organize for adequate compensation. Joked one farmer, "We might use something like this Telegraph you have been telling us about."

Conclusion: frontier days in cyberspace

Individual community networking systems are being overtaken by the very success and technology they helped spawn. The Internet generally can provide better, more adaptable interface, a more standardized software, and hence more support, and cheaper connections. One of the goals of the Big Sky Telegraph has been to provide a model that would be adaptable to people who did not have access to powerful computers, and new users to the Internet must generally use complex, multi-tasking equipment, especially if they want to invoke a direct Slip/PPP connection that makes the point and click of World Wide Web browsing possible. After all, the rural people had to find ways to keep their connection costs down, and a ten minute call just to town might cost an arm and a leg. There are special charges for most of the 800 numbers to national online providers. The Big Sky Telegraph continues as a beacon to developing regions in the world where commuter technology like the Internet remains too expensive, demands the skills of an unavailable systems manager, or where communication costs are prohibitive.

In a way, the introduction of the Internet has caused hand-wringing in many of the early populist, grassroots networks around the world. If they move to more graphic intensive interfaces, then many humble computer users might be left behind, able to use email, and to request files, but not much more. Where does a service provider draw the line, at the level of a Windows 3.1/Mac interface or with a multi-tasking central processing unit (CPU)? Do rural people *need* the Internet, and if not, why make that the entry level? The Internet is also undermining the centrist topology of the Freenet or community network

itself. Rather than have one machine where community messages and files are located, why not make use of distributed Usenet news hierarchies, with some messages circulating at the community level, some at the state level, and some in accordance to some non-Euclidean logic of inclusion. All a server like the Big Sky Telegraph then need do is subscribe to the message group, and redistribute the files and messages.

At this point, the Big Sky Telegraph is trying to adapt to this new media environment, and trying to maintain enough funding and personnel to keep up with changing user and community needs. External forces want the personnel at the Big Sky Telegraph to announce whether they are a community network, an educational network for schools, and access center, or whatever. Consider that educational institutions (including students and teachers) get discounted access to the Internet. If BST uses the subsidized rates, then how are they to bring the rest of the community in without unfairly competing with the new generation of Internet providers beginning to move into the rural areas. Philosophically, the people associated with the Big Sky Telegraph have seen all the community as their teachers and students and have fought making this distinction. "We are a K-100 school." A Windows/Mac level BBS called the Montana Educational Network (MetNet) was established with Montana Office of Public Instruction funds to provide information to officially recognized teachers and students, and to them alone, and with an expensive 1–800 service, they have had fewer long distance connect worries.

The model of the Big Sky Telegraph which seeks to bring the whole community together is still important. Teacher concerns are often rancher concerns, and vice versa. Further, the Telegraph has become a repository of skills and examples about how to establish communities in cyberspace. Frank Odasz concluded that a successful community network needed:

1. pragmatic use of existing resources – using what you have while you have it;
2. to keep focused on existing needs – not to become a little bit of everything to everyone;
3. to make the interface appropriate to the users – teachers want one thing, administrators another, business people something else;
4. to allow the users to redefine the system themselves – if it is to be a community, then those who have suggestions or are willing to make an effort should be heard, and this is a strong way to keep people involved;
5. to make it new – have something new on the system every time someone logs on so they will want to keep doming back;
6. to make use of every communication channel possible – learning about computer networking and virtual communities does not just take place online, it involves physical visits and other media, including books like this one;
7. to keep the system adequately funded – never an easy task;
8. to involve the business, educational, and civic communities together – that is, to get the local geophysical community thinking about things that they could do only using computer-enhanced communication.

As the other contributions to this volume have made clear, going online involves many new social and cognitive skills and orientations. Frank Odasz and others on BST suggested that going online encouraged informality, maybe even a new sense of play and responsibility. For Frank Odasz this led to emergent properties he felt he was discovering on an individual scale:

> It's more a consciousness thing than anything else. And I'm in the business of teaching new ways, new levels of thinking, new levels of intellectual interaction. Communicating with a person in writing seems to be unfathomable to many of

these people … who know business letters, but know nothing about the written word beyond the business letter. And a business letter is stodgy. You are limited. You've got to be kind of conservative. Whereas online tends to be a pretty different animal – being more folksy, more intimate in a hurry, more mind to mind; and I leave spelling mistakes in. Sometimes I do. Just for the heck of it.

So as I think about this more and more, at East Germany and Russia, and … and what I'm doing, and it's like consciousness. Not hardware or software, not purposeful communication, so much as consciousness of new possibilities. And that's what the computer seems to open up, is literally new levels of conscious, interactive … new levels of interaction for consciousness for partnership.

Two economies

The Big Sky Telegraph developed in the context of not just one emerging information economy, but two. Two economies and economic structures seemed trying to consume one another, one based in the global economies of scale of the material world, the other using the possibilities of decentralization and renewed localism available using the Internet, and the information economy in general. Just as highly mediated grassroots organizations might increasingly be able to draw on global resources and key leverage points to restrain global corporations, corporations which still have to fit into the context of local decisions, so global corporations will be able to draw on their own financial and informational background to influence local politics.

How will the growth of different virtual communities, tethered to different extents to regional groups, change this? While some might see these conflicts in static terms, we need to research the emergent properties of how going online affects the community of communities, of how real and virtual economies influence one another, including the impact this has for everyday people, their businesses, their cultures, and their local communities. While researchers, politicians, and philosophers can elaborate the implications of either one of these economies, clues to what might emerge can be found in the communities of Western Montana. To understand these changes we need to study not only online communities, nor offline communities using online technologies, but the way in which all these different worlds work and communicate together.

Note

1 Much of the following research is based on material originally collected as part of a long master's thesis (gopher://gopher.well.sf.ca.us:70/00/Community/communets/bigsky.txt). Please consult this paper for fuller methodological treatment. Research has since expanded to other communities and organizational levels. Any ethnographic project is part collaboration, so I should recognize this investigation would not have been possible without the material, intellectual, and compassionate help of many activists and individuals, particularly Frank Odasz, Reggie Odasz, Jody Webster, Gerry Bauer, Mike Jatczynsky, Dave Hughes, Bob and Nash Shayon, Stan Pokras, members of the WELL, and the Electronic Networking Assoc. As an investigator I hope that I have not only reported the organization of communication, but also helped to facilitate it. Big Sky Telegraph: mac.bigsky.bigsky.dillon.mt.us. Gentle with the Internet link, please.

References

Ahl, Valerie and T.F.H. Allen. 1996. *Hierarchy Theory: A Vision, Vocabulary, and Epistemology*. New York: Columbia University Press.

Allen, T.F.H. and Thomas B. Starr. 1982. *Hierarchy: Perspectives for Ecological Complexity*. Chicago, IL: University of Chicago Press.

Appadurai, Arjun. 1990. "Disjuncture and Difference in the Global Cultural Economy." *Public Culture* 2(2): 1–24.

Arendt, Hannah. 1958. *The Human Condition*. Chicago: University of Chicago Press.

Arthur, Brian. 1994. "On the Evolution of Complexity," in George Cowan, David Pines and David Meltzer (eds) *Complexity: Metaphors, Models, and Reality*. Proceedings volume in the Santa Fe Institute studies in the sciences of complexity, 19. Reading, MA: Addison-Wesley.

Barth, Frederik (ed.). 1978. *Scale and Social Organization*. Oslo: Universitetsforlaget.

Bauman, Zygmunt. 1992. *Intimations of Postmodernity*. London: Routledge.

Bell, Daniel. 1973. *The Coming of Post-Industrial Society: A Venture in Social Forecasting*. New York: Basic Books.

Bey, Hakim. 1991. *T.A.Z. The Temporary Autonomous Zone, Ontological Anarchy, Poetic Terrorism*. Brooklyn, NY: Autonomedia.

Bijker, W.E., T. Hughes and T. Pinch (eds). 1987. *The Social Construction of Technological Systems: New Directions in the Sociology and History of Technology*. Cambridge, MA: MIT Press.

Braudel, Fernand. 1981–4. *Civilization and Capitalism, 15th–18th Century* (3 vols). New York: Harper & Row.

Cohen, Anthony P. 1985. *The Symbolic Construction of Community*. London: Tavistock.

Cowan, George A., David Pines and David Meltzer (eds). 1994. *Complexity: Metaphors, Models, and Reality*. (Santa Fe Institute studies in the sciences of complexity. Proceedings volume 19.) Reading, MA: Addison-Wesley.

Davidow, William H. and Michael S. Malone. 1992. *The Virtual Corporation: Structuring and Revitalizing the Corporation for the 21st Century*. New York: E. Burlingame Books/Harper Business.

Derrida, Jacques. 1974. *Of Grammatology*, trans. Gayatri Chakravorty Spivak. Baltimore, MD: Johns Hopkins University Press.

Featherstone, Mike and Roger Burrows (eds). 1995. *Cyberspace/Cyberbodies/Cyberpunk: Cultures of Technological Embodiment*. London: Sage.

Giddens, Anthony. 1991. *Modernity and Self-Identity: Self and Society in the Late Modern Age*. Stanford, CA: Stanford University Press.

Granovetter, Mark. 1982. "The Strength of Weak Ties: A Network Theory Revisited," in Peter Marsden and Nan Lin (eds) *Social Structure and Network Analysis*. Beverly Hills, CA: Sage.

Hannerz, Ulf. 1992. *Cultural Complexity: Studies in the Social Organization of Meaning*. New York: Columbia University Press.

Haraway, Donna. 1989. *Primate Visions: Gender, Race and Nature in the World of Modern Science*. New York: Routledge.

Hiltz, S.R. and M. Turoff. 1978. *The Network Nation: Human Communication via Computer*. Reading, MA: Addison-Wesley.

Huber, Peter W. 1987. *The Geodesic Network: 1987 Report on Competition in the Telephone Industry*. Washington, DC: US Department of Justice, Antitrust Division and US Government Printing Office.

Huber, Peter W., Michael K. Kellogg and John Thorne. 1992. *The Geodesic Network II: 1993 Report on Competition in the Telephone Industry* (2nd edn). Washington, DC: Geodesic Co.

Hudson, Heather E. 1984. *When Telephones Reach the Village: The Role of Telecommunications in Rural Development*. Norwood, NJ: Ablex.

Hughes, Dave. 1987–9. "The Electronic Democracy Debate." Meta-Net BBS, Old Salon, Topics 121, 153, 288, 372; New Salon 3. Also, Chariot BBS, Denver, CO. 1–719–632–3391. Interviews 1987–1989.

Jahrig, Shannon H. 1995. "Have Computer and Fax Modem, Will Travel: NY City Analyst Becomes Montana Lone Eagle." *Montana Business Quarterly* 33(2): 12–16.

Kauffman, Stuart. 1995. *At Home in the Universe: The Search for the Laws of Self-Organization and Complexity*. New York: Oxford University Press.

Kemmis, Daniel. 1990. *Community and the Politics of Place*. Norman, OK: University of Oklahoma Press.

King, Anthony D. 1990. *Urbanism, Colonialism, and the World-Economy: Cultural and Spatial Foundations of the World Urban System*. London: Routledge.

Machlup, Fritz. 1962. *The Production and Distribution of Knowledge in the United States*. Princeton, NJ: Princeton University Press.

Meyrowitz, Joshua. 1985. *No Sense of Place: The Impact of Electronic Media on Social Behavior*. New York: Oxford.

Naisbitt, John. 1982. *Megatrends: Ten New Directions Transforming Our Lives*. New York: Warner.

Nelson, Diane M. 1996. "Maya Hackers and the Cyberspatialized Nation-State: Modernity, Ethnostalgia, and a Lizard Queen in Guatemala." *Cultural Anthropology* 11(3): 287–308.

Nguyen, Dan Thu and Jon Alexander. 1996. "The Coming of Cyberspacetime and the End of Polity," in Rob Shields (ed.) *Cultures of Internet: Virtual Spaces, Real Histories, Living Bodies*. London: Sage.

Parker, Edwin B. and Heather E. Hudson, with Don Dillman, Sharon Strover and Frederick Williams. 1992. *Electronic Byways: State Policies For Rural Development Through Telecommunications*. Boulder, CO: Westview Press.

Pine, B. Joseph. 1993. *Mass Customization: The New Frontier in Business Competition*. Boston, MA: Harvard Business School Press.

Porat, Marc. 1977. *The Information Economy*. Washington, DC: US Government Printing Office.

Robins, Kevin and F. Webster, F. 1986. *Information Technology: A Luddite Analysis*. Norwood, NJ: Ablex.

Rogers, Everett. 1983. *Diffusion of Innovations* (3rd edn). New York: Free Press.

Rogers, Everett M. and D. Lawrence Kincaid. 1981. *Communication Networks: Toward a New Paradigm for Research*. New York: Free Press.

Sale, Kirkpatrick. 1991. *Dwellers in the Land: The Bioregional Vision*. Philadelphia, PA: New Society.

Sproull, Lee and Sara Kiesler. 1991. *Connections: New Ways of Working in the Networked Organization*. Cambridge, MA: MIT Press.

Stone, Allucquère Rosanne. 1995. *The War of Desire and Technology at the Close of the Mechanical Age*. Cambridge, MA: MIT Press.

Thurman, Robert A.F. 1984. *Tsong Khapa's Speech of Gold in the "Essence of True Eloquence."* Princeton, NJ: Princeton University Press.

Toffler, Alvin. 1981. *The Third Wave*. New York: Bantam.

Turner, Frederik Jackson. 1962 (1894). *The Frontier in American History*. New York: Holt, Rinehart & Winston.

Uncapher, Willard. 1990. "Literacy and Development: An Iranian Example." International Communications Association Annual Meeting, Trinity College, Dublin, Ireland.

Uncapher, Willard. 1995a. "A Geodesic Information Infrastructure: Lessons from Restructuring the Internet." International Communications Association Annual Meeting, Albuquerque, NM.

Uncapher, Willard. 1995b. "Placing the Mediascape in the Transnational Cultural Flow: Learning to Theorize an Emerging Global Grassroots Infrastructure." International Communications Association Annual Meeting, Albuquerque, NM.

Van der Ryn, Sim and Stuart Cowan. 1996. *Ecological Design*. Washington, DC: Island Press.

Varela, Francisco J., Evan Thompson and Eleanor Rosch. 1991. *The Embodies Mind: Cognitive Science and Human Experience*. Cambridge, MA: MIT Press.

Vichorek, Daniel N. 1992. *Montana Farm and Ranch Life*. (Montana geographic series 18.) Helena, MT: American and World Geographic.

Wallerstein, Immanuel. 1990. "Culture is the World System: a Reply to Boyne," in Mike Featherstone (ed.) *Global Culture: Nationalism, Globalization and Modernity*. London: Routledge.

Zuboff, Shoshana. 1988. *In the Age of the Smart Machine: The Future of Work and Power*. New York: Basic Books.

Michele Willson

COMMUNITY IN THE ABSTRACT
A political and ethical dilemma?

> On each side of the political spectrum today we see a fear of social disintegration and a call for the revival of community.
>
> (Giddens 1994: 124)

IN AN AGE WHEN PEOPLE have more capacity – through technologically aided communication – to be interconnected across space and time than at any other point in history, the postmodern individual in contemporary Western society is paradoxically feeling increasingly isolated and is searching for new ways to understand and experience meaningful togetherness.[1] Nostalgia contributes to this search. Re-presented memories of 1950s-style communities where moral, social and public order 'flourished' are contrasted with present social forms, which are portrayed as chaotic, morally impoverished and narcissistic. However, and at least in theory, there is also a desire to formulate more enriching ways of experiencing ourselves 'in relation' which escape the difficulties of earlier, restrictive forms of community.

Many are looking for a form of 'being together' which can be seen as valued and, indeed, necessary. In turning to technology, we are presented with the possibility of virtual communities as a potential solution. Virtual communities – or communities experienced through technological mediation over the Internet and possibly enhanced in the future by virtual reality technologies – are represented by some as a form of postmodern community. These virtual communities are depicted as the answer to the theorist's search for a less exclusionary or repressive experience of community. Perhaps this will prove to be the case. But other theorists are uneasy about whether the unique, 'liberatory' and interconnective potential of the virtual will provide a vision for future communities. This is not to claim that celebrations of such a form of community are positing it as the only form to be practised or experienced, since to some degree 'earlier' forms will still continue to exist. How the relations between old and new forms are modelled requires further elaboration and critical attention.

In view of society's reliance on technology to solve its problems, both scepticism and a further examination of the claims surrounding virtual communities are required. It seems plausible that the hunger for community that is evident in postmodernity is in fact partly driven by the experience and ramifications of being an 'individual' within a technologically organized and aided society.[2] As such, it is interesting that there are similarities between the directions taken by theories of community formulated both within and outside the technological arena. If some see the solution as technological and others, while equally concerned with the issue of more meaningful community, avoid the topic of technology altogether, the same kind of question needs to be asked: namely, whether, in facing the difficulties presented by prior formulations of community, theorists are stripping the complex notion of community down to a superficial, one-dimensional understanding of human interaction. What I want to suggest is that, through the withdrawal of community from an embodied, political and social arena – either to lodge within a philosophical abstraction or to become a disembodied, technologically enabled interaction – an ethical or political concern for the Other is rendered impotent and unrealizable. 'Community' is then produced as an ideal rather than as a reality, or else it is abandoned altogether.

Technologies of individuation

This chapter investigates the political and ethical implications of the rise of cultures of disembodiment. To do that requires separating the applications of information and communication technologies into the areas of administration, surveillance and communications. There is, of course, significant overlap between these areas. For the sake of simplicity I shall be referring to two 'types' of computer technology: the system technologies or databases used by the public and private sectors, and the Internet.[3]

Databases are used by institutions to accumulate, combine and create information on all facets of life (including people's personal lives). These systems operate from diverse, decentred locations, often with different intentions or orientations. Database systems are becoming increasingly interconnected and sophisticated, taking on the form of a global information system capable of infinite analysis, profiling and information combinations. This has consequences for the subjectivity of social actors through the creation of a technologized Panopticon.[4] The Western individual increasingly experiences her/his life as monitored by technology: being caught on speed camera; captured on video while shopping; monitored for work efficiency by technological surveillance techniques; and taking a loan which is recorded, linked with other financial transactions and purchasing practices, and related to demographic statistics. These are just a few examples of contemporary surveillance. The continuous but often unverifiable surveillance has implications, as Foucault (1977) notes in *Discipline and Punish*, for the instigation of normalization practices. The power of normalization refers to the process by which a subject self-imposes or interiorizes particular norms and behaviours to conform to a self-perceived (but socially constructed) understanding of normality. This process is accentuated by the subject's own perception of the depth and pervasive nature of her/his visibility. Databases extend the gaze through disciplinary space, enabling a more pervasive and more widespread surveillance of each and every subject than previously possible. The subject of surveillance is universalized in that s/he is reduced to one file among many, but also individuated through being personally identifiable, trapped within time and space by the continual visibility provided by the database/s. Files can be called up at any time with a simple command typed into a computer terminal. This has

the potential to 'compartmentalize' the individual, separating her/him from others through the isolating qualities of the gaze.

Databases are perceived as a means to assist the surveyor. Given that the surveyor is usually an institution of some description, viewing those outside (or working within) its system, images of Orwell's Big Brother – or many 'little brothers' – are ominously invoked. The technology is oriented towards attaining control through information storage and analysis. Within the data field, information itself becomes an entity. Detached from its referent subject, it is able to be moved, manipulated and transformed.

The Internet also enables information to be moved, transformed and manipulated, bringing into question the issues of authorship and authenticity of material. In contrast to system databases, however, the Internet is depicted as a liberating technology. Its information is accessible to many users and it is interactive in form. The Internet enables the extension of many everyday activities. It is utilized for information collection, discussion of both academic and social topics, dissemination of views and undertaking financial transactions. Like databases, the Internet is unimpeded by state boundaries and is increasingly accessible on a global scale.[5] It is a diverse, decentred communications system with unlimited input – in as much as anybody who is connected to a network can participate in the system – resulting in seemingly uncontrolled and unpredictable development. This is viewed by some institutions as potentially threatening, leading to media exposure of 'illegitimate' or socially destructive activities on the Internet, and attempts by politicians to grapple with this issue through discussions of censorship and guidelines.[6] Yet these institutions also seek a greater involvement in the technology, devising ways through which Internet users can unwittingly provide information about themselves or their practices, and thus contribute to their own surveillance. Howard Rheingold raises the conceivable scenario of those who are information-poor, or have limited access to the technology, being offered 'free time' in exchange for the relinquishing of some personal privacy or control over private information (Rheingold 1993: 293–4). Technological constructs, such as artificial search engines, are increasing in both ability and number. These may well be able to create profiles and records on individuals' activities and their behaviour within virtual communities. In such a situation, the Internet also operates as a database.

Highlighting in this way the similarities between the Internet – in terms not only of its potential but also of its current capacity – and databases suggests that the application to the technology of such terms as *controlling* or *liberating* is arbitrary. Obviously, the technology itself is neither controlling nor liberating, but the social and cultural uses to which it is put may well be. In so far as the Internet operates as an interconnected database, it has as much potential for bringing about panoptical kinds of recognition relations as it has for enhancing an experience of freedom and mobility. The Internet is therefore also a powerful form of technology of individuation. It connects and disconnects individuals at the same time. As a paradox of 'connectivity', of participation with others in a virtual space, the technology disconnects the individual from the embodied interactions surrounding her/him. Although it may not individualize through the operation of the gaze to the same extent as presently available through databases, interaction through the Internet still heightens the solitary nature of participation, an activity both singular and universalized.

Equality, fraternity and liberty in a virtual community?

Virtual communities are formed and function within cyberspace – the space that exists within the connections and networks of communication technologies. They are presented

by growing numbers of writers as exciting new forms of community which *liberate* the individual from the social constraints of embodied identity and from the restrictions of geographically embodied space; which *equalize* through the removal of embodied hierarchical structures; and which promote a sense of connectedness (or *fraternity*) among interactive participants. They are thereby posited as the epitome of a form of postmodern community within which multiplicity of self is enhanced and difference proliferates uninhibited by external, social structures.

Virtual communities exist within bulletin boards, conference groups, MUDS, MOOs and other interactive networks. Interaction is conducted predominantly through textual means. Descriptions, actions and locations are all communicated textually, produced by a keyboard. This will surely change over time with the increasing sophistication of virtual reality technology and the continued enhancement of graphic and video technologies (such as video conferencing). However, while visual information is limited to text-based description, and auditory or other sensory information is excluded from the interaction, the 'player' or community member is able to depict her/himself in whatever shape, form or gender s/he desires. Participants in virtual communities can thus escape their own embodied identities and accordingly can also escape any social inequities and attitudes relating to various forms of embodiment. Race, gender or physical disability is indiscernible over the Internet. Any basis for enacting embodied discrimination is removed, freeing access to participation and granting each participant equal status within the network.

Liberation may also be achieved from the constraints of geographical space in so far as the physical location of the 'body' of the player is overcome through the extension of interaction in cyberspace, compressing into a readily transversible medium. Thus virtual communities are also seen as a way of overcoming the inherent isolation of contemporary life where people do not know their physical neighbours, are not involved in their local township decisions and possibly work from home. This 'solution' overlooks the physically isolated nature of participation, where only the mind is extended into the mutual interaction. It is worth noting that virtual community participants often feel the need to reinforce/ complement their disembodied relations by simulating, at the level of ritual, more embodied or sensorial contacts. For example, participants on the WELL – a virtual community on the Internet – have regular face-to-face picnics and social gatherings. The participants develop a more complete understanding of each other at such gatherings.

The perception of anonymity is presented as a further 'plus' by proponents of virtual community. Liberated from the normative gaze of both institutions and society, identity cannot be verified and attached to the embodied user and behaviour is not constrained by 'real space' norms and values.[7] The degree of anonymity actually achieved is questionable, and will prove increasingly so as information providers and commercial interests devise more effective means of accumulating information about network users. Additionally, the chaos within some communities – as a consequence of anonymity being equated with a lack of accountability – has led them to require participants to provide stable identification. On the WELL, for example, participants are obliged to link all presentations of self with an unchanging referent user-ID, thus enabling identities to be verified (Rheingold 1993). The need for a kind of order within community interaction has prompted such communities to sacrifice liberatory aspects of anonymity in favour of accountability. The recording and archiving of interactions also creates the 'historical trace' of a character, decreasing the ability for that character to interact unidentified by past behaviours or statements.

Normative guidelines exist within those communities and the gaze – although in a modified form – applies. Marc Smith writes that, as in 'real space' communities, virtual communities must invoke and maintain the commitment of their members; monitor and

sanction behaviour; and carry out the production and distribution of essential resources (HREF 1). There are specific rules attached to each community, which participants must agree to follow in order to maintain participatory rights. Many of these rules are fashioned either by the participants themselves or, more frequently, by the person/s who originally constructed the community space. For example, in conference groups the 'host' has control over the topics discussed and the behaviour permitted by conference participants, to the extent that certain topics or users may be banned if necessary.[8]

The question of ethics, or a notion of the common good, within virtual communities themselves (or even within the notion of virtual communities) is related to the existence of the kind of normative guidelines I have been outlining. Communitarian theorists such as Sandel, Taylor and MacIntyre have concentrated on the importance of a certain notion of the common good for 'real space' communities. They examine the incorporation of ethics and norms by the institutions, and within the practices, of such communities.

Something akin to spiritual enlightenment is commercially marketed as attainable with the use of information technologies. The recent television advertising campaign by IBM, 'Solutions for a Small Planet™', demonstrates an attempt to link their technologies to the ethos driving current New Age spirituality movements. Two messages are conveyed through these advertisements – one using nuns and another monks, so excited by the computer's capabilities that it interrupts, or even takes the place of, their spiritual contemplations. Firstly, the advertisements suggest the possible realization of a spiritual experience, as religious contemplation comes to stand for or is even replaced by experiencing the technology. Secondly, the very term 'Small Planet' carries with it the possibilities of universal interconnectivity and accessibility. With this technology, the viewer can readily infer, it is easy to be connected with everyone rather than to be lost in a sea of isolation and alienation: a variation on the cliché 'it's a small world' as a response to meeting someone familiar in an unlikely place. It emphasizes the transversality and compression of space into a more manageable concept/experience. A similar kind of suggestion links the communitarian emphasis of interactive technologies. By using these technologies, it is implied, the global can become as manageable and as familiar as your local community (the community that you have, nostalgically, lost).

This message of manageability and familiarity appears to be carried uncritically by all virtual community enthusiasts. They see the good life as achievable through the opportunities of flexible, disembodied identities unconstrained by geographical time and space, and no longer dependent on 'meaningful' others. Which means that it is the *forms* of participation that result in meaningful experiences for participants. Emphasizing multiplicity and choice stresses procedural measures, where the ability to choose identities and location is celebrated, but does not explain the nature of the good life itself.

However, virtual communities must also be understood as multiple and different, making it impossible here to delineate the qualities or understandings of each within one encompassing generalization. Any analysis of virtual community needs to proceed on two different though ultimately related levels: an analysis of the potentialities of the technology that enable virtual communities to exist in their present form; and an analysis of the specific form of each virtual community. The first helps to identify the capabilities and means of all communities within virtual space, allowing certain generalizations; while the second focuses on the specificity of each virtual community, with its own particular norms and regulations.

What is promoted as part of the good life, enabled by the capabilities of the technology, is the accentuation of choice. Within a virtual community individuals are able to choose the level or degree of interaction. They can choose when to participate, they can choose

their degree of involvement with others – as long as those with whom they wish to be involved agree.[9] Marriages take place, 'sexual' relationships are formed and hierarchical or administrative relations created. As Sherry Turkle notes: 'Women and men tell me that the rooms and mazes on MUDs are safer than city streets, virtual sex is safer than sex anywhere, MUD friendships are more intense than real ones, and *when things don't work out you can always leave*' (1995: 244; my emphasis). Relationships can be 'broken' at any stage by the simple withdrawal of the character/identity, leaving one to wonder at the level and depth of commitment or investment in these relationships.

Individuals can also choose to have several characters within a community, or to belong to several communities, at any one time. As such they continually 'flit' between one character and another, and between communities. This ability has led observers to analogize the activities of 'character building' and 'flitting' as the concrete depiction of postmodern theory with its emphasis on multiplicity and the navigating of surfaces (Turkle 1995: 44–5). Nor is it so different from the multiple memberships, social roles and thus identities that individuals hold in modem society, although the rate of transition between these is not as instantaneous as in cyberspace. Such instantaneity accelerates the transformative skills needed to assimilate rapidly into the 'clothes' of each character and may indeed affect a person's experience and means of relating to the world. Parallels can be drawn between this flitting and television 'channel surfing' in the constant search for more rewarding stimuli. Jonathan Crary notes that 'in fundamental ways, we're being drilled to accept as "natural" the idea of switching our attention rapidly from one thing to another' (1995: 66). One wonders whether we are becoming sensory junkies perpetually in search of new experiences; that is, whether this searching for constant yet apparently superficial stimulation is leading to the promotion of instant gratification at the expense of more involved, complex, meaningful investigation and understanding.

In terms of interaction within a virtual community, the emphasis is on fluidity and choice of associations in a social space. Interaction is abstracted from more concrete and embodied particularities and takes place within an environment shaped by the actors themselves. A 'loosening' of connections may appear liberating. But such an understanding devalues many of the positive and ontologically important aspects of those very connections. It appears, for example, contradictory to elevate the enriching aspects of virtual communities while at the same time devaluing or ignoring relations such as those that exist between parent and child, which many theorists would see as fundamental for the basis of any community. As David Holmes (1997) has so aptly analogized, the participants of virtual community are like messages in bottles, floating randomly in the oceans waiting to be picked up – a notion connected to the postmodern depiction of the multiplicity of selves in present society (Holmes 1997: 37–8). That there are no bonds or connections 'between' these bottles, apart from communication around a certain interest, is not an anxiety within virtual communities.

Instead, liberatory and postmodern claims about virtual communities are precisely based on the promotion of an anonymity which enables flexible, multiple and anonymous identity construction, and the alteration of spatial and time experiences. What is described in such utopian formulations is the ability to 'play' with identity and to promote communication and information collection. I would suggest that the dissolution or fragmentation of the subject and the instantaneous, transient nature of all communication disconnect or abstract the individual from physical action and a sense of social and personal responsibility to others. A fairly superficial example can be drawn from Sherry Turkle's book *Life on the Screen*. Turkle describes a virtual community participant actively involved in the political machinations of his cybersociety but also completely apathetic about and disengaged from the political

situation surrounding him in his 'off-line' life (or embodied location), to the extent that he is not interested in participating in a local senate election (Turkle 1995: 242).

Blanchot makes a similar point about the disembodied experiences of the broadcast media:

> The whole world is offered to us, but by way of a gaze. ... Why take part in a street demonstration if at the same moment, secure and at rest, we are at the demonstration [manifestation] itself thanks to a television set.
>
> (1993: 240)

Yet the experiential quality of actually attending a demonstration and being surrounded by activity, and the noise and smells of crowd contagion, is a more complex, more involving experience than that achieved via the medium of a television screen. While virtual communities may be interactive, they do not require either physical commitment (other than working with a keyboard) or moral, political or social extension beyond the network. Of those who use the Internet and virtual communities, only a small percentage actively participates. The rest operate from a voyeuristic or 'viewer' position similar to that practised in television viewing.[10]

Since other peripheral distractions are filtered out by the reliance on text-based descriptions, the nature of the interaction becomes intensely focused. Attention is solely placed on the act of communication as perceived through the visual interpretation of text.[11] Such a focus leads to claims that relations on the Internet are more intense than those in real space. In some ways, this view of interaction within a virtual community could be compared to the idea of the singles bar, with the singularity of purpose that this might suggest. Such a singular intention does not equate well with the complex experience of intimacy. And in any case, a very different analogy about interaction with a singular purpose, with a very different result, might just as easily be drawn using Blanchot's example of the street demonstration.

Anthony Giddens writes: 'Intimacy ... is not, as some have suggested, a substitute for community, or a degenerate form of it; it is the very medium whereby a sense of the communal is generated and continued' (1994: 127). The question is whether intimacy can be achieved in such a public domain as the Internet, with only text-based representation and the imagination. It is necessary to ask if 'community' can be sufficiently defined by the machinations of thin/emptied-out selves interacting via text through cyberspace;[12] or whether, by removing the difficulties and limitations of more traditional communities, we are also stripping away many of the factors that 'make' community meaningful for its participants.

In addressing these issues, it is instructive also to consult the recent work of community theorists working outside the technological debate. To this end, the contemporary thought of Jean-Luc Nancy, when extended to the analysis of virtual communities, enables certain useful analogies and observations.[13] As I want to show, there are similarities between the culture of virtual communities and Nancy's theoretical emphases. Both stress the multiplicity of experience and the dangers of prescribing particular forms of community and identity. Both can also be seen to encounter difficulties in enacting a political ethics concerned with the Other.

The community of Jean-Luc Nancy and the virtual community: a comparison

While the notion of *community* is experiencing a resurgence of interest, many theorists nevertheless overlook the implications of living and experiencing ourselves within a world increasingly reliant on technology. Albert Borgmann explains that society's reliance on, and everyday use of technology becomes a normalized pattern:

> *When the pattern is so firmly established, it also tends to become invisible.* There are fewer and fewer contrasts against which it is set off; and meeting us in objective correlates, it attains an objective and impersonal force.
>
> (1984: 104; my emphasis)

The technological paradigm has become naturalized and so pervasive that it appears invisible or, at the very least, inevitable. But technological capabilities and uses impact on the subjectivity of the Western individual. Failure to consider the effects here has consequences for the adequacy of some community theories. Yet, despite overlooking technological influences, the formulations advanced by some community theorists reveal similarities in direction to those of virtual community proponents. It will become apparent that both technological and non-technological understandings of community have been abstracted from a 'realizable' embodied form of community, either to an ontological schema (as is the case with Nancy), or to an on-line network experience in the form of virtual communities.

Nancy rejects the traditional conception of community as a grouping or coalescing around a fixed essence and identity. Community represented this way becomes 'community as communion' (Nancy 1991: 15). Such a form of community constrains a group of people to a monolithic form of identity, suppressing difference and promoting exclusionary practices. Nancy argues instead for community to be understood as the *incomplete* sharing of the relation between beings. For him, being is not common because it differs with each experience of existence, but being is *in* common: it is the *in* where community 'resides'. Community is to be 'found' at the limit where singular beings meet. The danger is in prescribing or categorizing an essence or form for both community and the beings that it involves.

Some similarities can be drawn between Nancy's theoretical manoeuvres and those celebrating virtual communities.[14] Nancy's discussion emphasizes the fluidity and singularity of being and the importance of the relations between beings. The emphasis on the absence of bonds or ties between these beings allows a non-prescriptive form of relations. Similarly, the virtual communitarians argue for multiplicity, difference and fluidity of experience, although they posit this argument within the notion of multiple, self-constituted selves/identities. They argue for a multiplicity of forms of community existent within the technology, whereby the multiple selves of a subject can belong to one community or to many communities and can freely move between all or any of these. As such, like Nancy, they wish to avoid prescribing particular forms of community and identity. Both orientations understand and encourage a concept of community which promotes relations free from constraint. Yet it appears there are also important differences and these deserve further elaboration.

Nancy would not accept the virtual community argument that a multiplicity of identities within a multiplicity of communities enables a more fruitful experience of community. Instead, identity would be seen to be more in the nature of work, or of a 'fixing' imposed on singular beings. It would therefore be open to the dangers of totalitarianism, oppression and the death/reduction of community (Nancy 1991). This is similar to the argument in Georgio Agamben's *The Coming Community*. Agamben attempts an understanding of community which does not rely on an idea of identity nor on members belonging to any particularity.

Identity involves the accentuation of particular characteristics and the suppression of other characteristics. Instead, Agamben uses the term 'whatever singularity' to emphasize the unique and multiple characteristics of each being. 'Whatever singularity' does not belong to a particular group, nor even to a linguistic designation (Agamben 1993). Nancy's work carries a similar intention of avoiding the prescription of an essence for his singular beings or their communities.

Nancy asserts that a focus on the subject destroys any conceptualization of community.[15] He draws attention to the significance of the relation *between* beings, rather than to the beings themselves. Singular beings are not fixed totalities: they exist in and through their relations with other singular beings. Indeed, the use of the term 'singular beings' emphasizes these beings' difference, their multiplicity and their relations. A singular being 'ends' at the point where it is exposed to another singular being (or beings) (Nancy 1991: 27). This is the *limit* where there is a possibility of one singular being and another being existing simultaneously. It is where a consciousness of both separation and togetherness exists at the same time. Nancy's use of these concepts in discussing community and his denunciation of the existence of the 'individual' as an absolute totality without relations intend to highlight the relations between beings. For him, the focus of community is on the relational: the ontological necessity of the relational and, at the same time, the difference in each presentation or experience of the relational. Thus, he claims, we can never lose community despite fears to the contrary.

Such an assertion recognizes the uniqueness of other beings and imposes an implicit ethical responsibility to allow and respect differences. To ignore these differences or attempt to consume them within a totalized whole is to destroy the experience of community. It is precisely this focus on relationships and an ethical consideration for the Other which lacks adequate development in virtual community analyses. If the emphasis of community analysis is on the individual and the effects on/for the individual, then the Other is objectified, becoming a utilitarian instrument for the achievement of the individual's own ends. Understanding the relationship in that way fails to recognize the importance of the Other for self-constitution, and the importance of relations between self and Other for the functioning of community. Any possibility of an ethical responsibility towards the Other encountered by the self (where that self undergoes as a result a formative or boundary experience) is neglected. And the failure to delineate the possibility of an ethics can only accentuate further the compartmentalization and totalization of the individual, despite the potential for fluidity and multiplicity opened by the technology.

In light of the awareness that postmodern theory raises about the suppression of difference and the Other, this is an important point. In virtual communities, we are presented with the description of community where participants appear autonomous, self-indulgent and seeking self-satisfaction. Free-floating beings, whose encounters with others may be formative, are depicted; but these relations are not elaborated sufficiently. Obviously there is a need for other characters to exist to enable interaction within these communities. Indeed, it is the ability for interactivity that is being celebrated and on which meaning is founded for its participants. Yet the celebration is expressed in terms of the possibilities for the subject of these relations. This concentration can be attributed in part to a reluctance to describe or prescribe a particular form of relations and, in that sense, it leaves the way open for multiple, varying experiences of the relational. In turn, it may explain why theorists, even as they concern themselves with an idea of virtual community, are more willing to focus on the potentialities enabled by the technology than on the relations of community.

A further difference between Nancy and the virtual communitarians occurs in the kind of attention paid to notions of subjectivity. Despite a certain ambiguity around his

conception of singular beings, Nancy posits his analysis as ontological. Indeed his singular beings could be described as essentialized and ahistorical. Historical and cultural forces are not attributed a formative influence on singular beings. At the same time, an essence is not ascribed to these beings, since each being experiences itself differently. Such an understanding, while devoid of generalizations and oppressive classifications, makes any critique of singularity and community extremely difficult. It also renders any historically situated analysis of community redundant since community is assumed to be impervious to such influences. The virtual communitarians, on the other hand, direct their view to the subjective effects of the discourses and practices enabled through technological application. For writers like Turkle and Poster, there is an emphasis on multiple subjectivities or selves where different experiences, social roles and interactions (languages/ discourses) result in the experience of different identities. These selves could be described as more situated and non-essential than the beings depicted by Nancy. However, such a portrayal of multiple selves is reductionist. It removes the complexity and depth from the process of self-constitution by limiting perceived influences on this process to singular events/experiences and the possibility of infinite (unrelated) multiplicity. It also fails to explain adequately the possible implications to the decentred subject of multiple selves of cultural and historical change. Thus, while the approach taken can be clearly distinguished from Nancy's, the criticism of ahistoricism might also be levelled here.

Relations between the various selves of the virtual community member require further elaboration, as does the question of how they are integrated (if at all). Integration need not imply centralization. It is simply an assertion against the insularity of these selves, and thus a recognition of their effect – in whatever degree – on the Other/others. As Marc Smith explains:

> Despite the unique qualities of the social spaces to be found in virtual worlds, people do not enter new terrains empty-handed. We carry with us the sum-total of our experiences and expectations generated in more familiar social spaces.
>
> (HREF 1: 138)

New experiences and understandings may be generated in virtual space, leading to the possibility – or expectation – that these new understandings will affect other selves (or, as it might be interpreted, other aspects of the self). It seems a persuasive argument that each self existing 'within' a subject (decentred or otherwise) must impact on the other selves, forcing some self-compromise and modification. Contradictory practices must be self-justified – possibly unconsciously – and relegated to a particular sphere or presentation of the self. For example, the way a person behaves when performing a particular social role may be deemed acceptable only while carrying out that role. Nevertheless, some behaviour required for the role may also be completely contradictory to, and irreconcilable with, the expectations and behaviours of other roles in the person's life. Failure to reconcile these selves in some way would seemingly result in confusion and disorientation. Jane Flax argues that this is indeed the case. She suggests that schizoid and borderline individuals, for example, do not have the subjective fluidity to enable reconciliation and modification of selves to take place, hence their difficulties in functioning within society (Flax 1993).

Some level of cohesion among selves or, alternatively, a fluid – although sometimes contradictory – unitary subjectivity can be argued. Anthony Cascardi writes that: 'contradictions within modernity are lodged within the divided subject, who may act in different functional roles and as a member of various social groups and who may speak in different voices when in pursuit of different ends or when making different value claims' (1992: 7). This division of the subject is extended through the possibilities produced by

mediation in virtual environments. But the virtual communitarians need to elaborate the relationship between, and the influences on, their multiple selves for their position to be convincing.

Attitudes towards the deliberate construction of community uncover other differences between the two theoretical orientations. For Nancy, community cannot be 'made'. It exists at an ontological level within the relation between beings. To attempt to create community is to make it into work, actively constraining the relation between beings by ascribing particular qualities or restrictions, and thus undermining community. For Nancy, the task is to understand the experience of community rather than to describe or create community. Such an orientation is open to the criticism of being politically disengaged and apathetic; of being so careful in avoiding description that the theory disempowers political direction or incentive. It mobilizes a withdrawal from the political arena and thus disregards the possibilities for realizing actual practical benefits or change. Virtual communities, on the other hand, are undeniably 'made', in the sense that the illusion of space is created for the production and operation of community within a humanly crafted technology. Yet this does not mean that interaction will automatically take place, nor that a community will be formed, since people cannot be forced to participate. There must be something which compels or invites their participation. And we would need to reiterate the observation that has already been made: the distancing that occurs through the disembodied processes of participation in a virtual community does not encourage embodied political activity, nor does it draw attention to political activity outside that community.[16]

Both theoretical interpretations of community rely on a tendency towards realization of community in the abstract: a removal of community from the embodied political sphere either to an ontological condition which would not appear to require action, or to a phenomenological experience which engages our minds and not our bodies. Both understandings are ahistorical in orientation; and fail to explain adequately where their notions of community are situated and how those notions can be extended and integrated into a physical realization of community.

Conclusion

Virtual communities are celebrated as providing a space and form for a new experience of community. This experience is depicted as multiple, liberating, equalizing and thus providing a richer experience of togetherness. However, a critical examination of these understandings reveals, paradoxically, a 'thinning' of the complexities of human engagement to the level of one-dimensional transactions and a detaching of the user from the political and social responsibilities of the 'real space' environment. This tendency towards a withdrawal from the active political sphere of real space, or the withdrawal from attempts to realize an embodied form of community, is mirrored in the works of other contemporary community theorists such as Jean-Luc Nancy.

In their desire to avoid placing restrictive or totalizing tendencies on the experience or understanding of community, theorists of both technological and non- technological orientation have removed community from a tangible, embodied or concrete possibility, relegating it either to the sphere of ontological, pre-political, pre-historical existence; or to an experiential existence within the nodes of a computer network system. This general movement towards a separation or abstraction of community from the political possibilities of real space removes any necessity for direct, embodied, political action. The depth of

commitment to others within a community also declines, questioning the possibility of responsibility for the Other. As Nancy emphasizes, a concern for the Other is vital for any valid experience of community. But in the case of virtual communities such an ethic is far from apparent.

The growth of virtual culture and technosociality in everyday life carries with it contradictory implications for identity and community. Virtual communities enrich or 'round out' the use of technology by encouraging communication and creative imagination. Children growing up using the medium will see it as an extension of their world, including their relationship base. This in itself will have ramifications for the ways they experience themselves and their interpersonal relations. But we need to be careful in the claims we make about, and the hopes we invest in, virtual communities. By relying on understandings of community which paradoxically work to concentrate our attention on our selves while distancing us from our embodied relations, we may be accentuating the very compartmentalization against which we could be striving.

Notes

I would like to thank Paul James, Michael Janover and David Downes for their suggestions and assistance with this chapter.

1. The idea of 'community' is experiencing a resurgence in interest among both theorists and society at large. America has seen the growth of a self-named 'Responsive Community' movement which has emphasized the way in which the community has suffered through the privileging of individual rights and concerns. There has also been an increase in the rhetoric of community employed by politicians like Bill Clinton and Tony Blair (see Willson 1995).
2. This is not to argue for technological determinism. That is, I am not saying that the technology alone produces specific, unavoidable subjective practices or outlooks. Rather, I am arguing that the uses to which the technology is applied by the society/culture; the modes of thought which are accentuated by technological applications; and the practices that are enabled or increased through the technological capabilities available, all have consequences for the experience of subjectivity. Technological capabilities which enable practices otherwise impossible for the society to perform unassisted must, of course, also be granted the potential for subjective effect.
3. The broadcast media would also be situated here and are important because of their cultural and political impact. For more elaboration on broadcast media see McCoy (1993), and David Holmes (1997).
4. See Foucault (1977) and Poster (1990) for further elaboration on the effects and potential of the Panopticon (as modelled on Jeremy Bentham's construction of a prison). Poster refers to this phenomenon as a Superpanopticon. However, he does not emphasize the role of the gaze, or visibility, in the application and self-imposition of a subject's normalization processes. Databases enable an extension of that visibility into abstracted space, producing a more pervasive and intrusive gaze than that achievable without technological extension.
5. This is not to be trapped within the debate over the universality of access and participation on the Internet while its participants are primarily white male, middle-class English speakers from Western industrialized countries.
6. For example, President Clinton signed the Communications Decency Act, which authorizes the censoring and monitoring of objectionable material on the Internet. China has begun to restrict Internet access, and Victoria, Australia, has already instigated its own on-line censorship provisions. See van Niekerk (1996: D1).
7. Some difficulty arose in deciding what term to use in describing interaction and experiences outside cyberspace. 'Real life' is problematic as it places a distinction between embodied experience as being real and interaction via technology as not real. Participants in virtual communities would obviously wish to contest the 'unreality' of their interaction, which may well play a very 'real'

part in their lives. It also fails to take into account the constructed or perceptual aspects of our interpretations of reality in embodied or real space. 'Embodied space' indicates the realm of face-to-face contact alone, and is therefore also problematic. It is also more unwieldy. The term 'real space' – while still not entirely appropriate – is more suitable.

8. This is a fairly drastic step and usually requires certain consultation with others before action is taken (HREF 1: 29).

9. In the few cases where mutual agreement has not been involved, there has been tremendous discussion around the issue. Virtual rape has provoked significant concern and debate about the impact of text-based acts of violence.

10. Statistics show that 50 per cent of postings on the WELL were contributed by only 1 per cent of users (HREF 1: 96).

11. Although now graphics and sound are being gradually incorporated.

12. 'Whether virtual systems can sustain the depth and complexity necessary for durable social structures that can withstand time and disruptive circumstances as yet unknown, remains to be seen' (Stone 1992: 620).

13. I have taken some liberties with the extension and application of Nancy's theory to allow discussions of virtual communities. According to Poster, Nancy denies the applicability of his theoretical endeavour to technological mediation and indeed elsewhere writes that technological and capitalistic economies work to undermine experiences of community. However, the theory is still useful to elaborate on, and provide a contrast with, aspects of theorizing around virtual communities.

14. Here I am focusing my analysis and assumptions primarily on the work on virtual communities undertaken by Rheingold, Poster and Turkle. Although they have different understandings of subjectivity and also different expectations for these communities, there is sufficient commonality to justify such an approach.

15. Nancy claims that those analyses that focus on the subject, thus ignoring these relations, will fail to understand adequately experiences of community: 'this limit is itself the paradox: namely, the paradox of thinking magnetically attracted toward community and yet governed by the theme of the sovereignty of a subject. For Bataille, as for us all, a thinking of the subject thwarts a thinking of community' (Nancy 1991: 23).

16. This is not to assert that political activity oriented toward off-line situations does not take place through computer networks. However, in such a situation, the user entering or participating in on-line dialogue is usually applying the technology as a tool to spread political information rather than accessing a social space.

References

Agamben, G. (1993) *The Coming Community*, trans. Michael Hardt, Minneapolis, MN: University of Minnesota Press.

Blanchot, M. (1993) *The Infinite Conversation*, trans. Susan Hanson, Minneapolis, MN: University of Minnesota Press.

Borgmann, A. (1984) *Technology and the Character of Contemporary Life: A Philosophical Inquiry*, Chicago, IL: University of Chicago Press.

Cascardi, A. (1992) *The Subject of Modernity*, Cambridge: Cambridge University Press.

Crary, J. (1995) 'Interzone', *World Art: The Magazine of Contemporary Visual Arts*, 4: 65–6.

Flax, J. (1993) 'Multiples: on the contemporary politics of subjectivity', *Human Studies*, 16: 33–49.

Foucault, M. (1977) *Discipline and Punish: The Birth of the Prison*, trans. Alan Sheridan, London: Allen Lane/Penguin Books.

Giddens, A. (1991) *Modernity and Self-Identity: Self and Society in the Late Modern Age*, Stanford, CA: Stanford University Press.

Giddens, A. (1994) *Beyond Left and Right: The Future of Radical Politics*. Cambridge: Polity.

Holmes, D. (ed.) (1997) *Virtual Politics: Identity and Community in Cyberspace*, London: Sage.

HREF 1. Http: //www.sscnet.ucla.edu/soc/csoc Smith, M. (1992) 'Voices from the WELL: the logic of virtual commons'.

McCoy, T. S. (1993) *Voices of Difference: Studies in Critical Philosophy and Mass Communication*, Creskill, NJ: Hampton Press.

MacIntyre, A. (1981) *After Virtue: A Study in Moral Theory*, London: Duckworth.

Nancy, J.-L. (1991) *The Inoperative Community*, ed. Peter Connor; trans. Peter Connor, Lisa Garbus, Michael Holland and Simona Sawhney, Minneapolis, MN: University of Minnesota Press.

Poster, M. (1990) *The Mode of Information: Poststructuralism and Social Context*, Oxford: Polity.

Poster, M. (1995) *The Second Media Age*, Cambridge: Polity.

Rheingold, H. (1993) *The Virtual Community: Homesteading on the Electronic Frontier*, Reading, MA: Addison-Wesley.

Stone, A. R. (1992) 'Virtual systems', in Jonathan Crary and Sanford Kwinter (eds), *Incorporations: Zone 6*, New York: Zone, pp. 609–21.

Turkle, S. (1995) *Life on the Screen: Identity in the Age of the Internet*, New York: Simon and Schuster.

van Niekerk, M. (1996) 'Censor moves to shackle Net', *The Age* (Melbourne), 13 February, p. D1.

Willson, M. (1995) 'Community: a compelling solution?' *Arena*, 15, February/March: 25–7.

Kevin Robins

AGAINST VIRTUAL COMMUNITY
For a politics of distance

AN ABSOLUTELY CENTRAL, AND GENERALLY uncontested, theme in most accounts of contemporary technological transformation concerns the elimination of distance. There is the expectation that new virtual media will overcome what are perceived to be the constraints of real geographical difference. But to eliminate distance in the cause of what? The "post-geographical" vision of the technoculture is driven by the counter-ideal of achieving close encounters in virtual space. And what I shall argue is that this aspiration for intimacy – the intimacy of (virtual) community – reflects both the anti-experiential and the anti-political vision of the technoculture. I will elucidate.

In overcoming the "tyranny of distance," it is claimed, the new virtual technologies permit us to communicate with others wherever they might be. And, on this basis, it is said, it will be possible to form new kinds of electronic communities, based on interest and affinity (rather than on the "accident" of geographical location). In the new virtual networks, there seems to be the prospect of greater closeness to others (to others with whom we shall interact through the virtual network, that is to say). Virtual relations are closely associated with ideals of intimacy, social communion and bonding – this is said to be the age of immediate communication, connectivity, and "being in touch." What is being argued, then, is that new technologies now make it possible to be in a space where we may enjoy the kind of social intercourse that the real world has always denied to us. Where geographical distance is presented as the fundamental obstacle to human communication and community, the achievement of technological proximity is presented as a solution.

This is essentially the position that William Mitchell advances in *City of Bits* (1995 henceforth *CB*), and I want first to consider his arguments. This is not because *CB* is in itself a particularly significant or important publication – what I am suggesting actually is that it provides a rather formulaic version of the technocultural theme of transcendence, but that it is precisely this that will allow us to then get at the more profound issue of the ambivalence in modern culture with respect to real-world spaces and spatialities. Setting out from the assumption that "geography is destiny," Mitchell endeavours to convince us of the Utopian possibilities inherent in the technological creation of a virtual world,

an "incorporeal world," as he describes it, in which we shall exist as "disembodied and fragmented subjects." What is good about such a creation, Mitchell tells us, is that we will finally be "freed from the constraints of physical space." The new technologically mediated world will be a non-geographical world, "profoundly anti-spatial" in its nature. At the same time, then, that the intractable physicality of the real world is giving way to the lightness of virtual life, we shall also be putting an end to the "tyranny of distance." Finally overcoming the limitations that have always been imposed on us by geographical separation and apartness, we shall be empowered to engage with the world on our own terms.

We might reflect on what this actually means, by considering what Mitchell has to say about the nature of virtual engagement with the world. First, he argues, the new technologies now afford a new intensity of visual access. New image and vision technologies may be said to provide an "electronic window" through which we are able to survey the world and its events: "Right now, the same window is open in thousands of similar hotel rooms spread around the world. Ted Turner has succeeded in electronically organising them all into a gigantic, inverted panopticon" (CB 33). And newer technologies promise even greater powers of visual access, with the Internet becoming "a world-wide, time-zone spanning optic nerve with electronic eyeballs at its end points." New vision technologies seem to make distance meaningless. "Soon," Mitchell claims, "we will be able casually to create holes in space wherever and whenever we want them. Every place with a network connection will potentially have every other such place just outside the window" (CB 34).

But it is not simply a question of the remote-sensing gaze. Mitchell claims that there are new possibilities for also enhancing our tactile engagement with the world, through other distance-shrinking technologies:

> intelligent exoskeletal devices (data gloves, data suits, robotic prostheses, intelligent second skins, and the like) will both sense gestures and serve as touch output devices by exerting controlled forces and pressures; you will be able to initiate a business conversation by shaking hands at a distance or say good-night to a child by transmitting a kiss across continents.
>
> (CB 19)

With new technological effectors and sensors, Mitchell argues, "you will be able to *immerse* yourself in simulated environments instead of just looking at them through a small rectangular window ... you become an *inhabitant*, a *participant*, not merely a spectator" (CB 20). Increasingly, we are told, "cyberspace places will present themselves in increasingly multisensory and engaging ways ... We will not just look *at* them; we will feel present *in* them" (CB 114–15). This fundamental is to achieve "immersive, multisensory, telepresence" – to "make contact" across the world.

In the case of both visual and tactile access, what is at issue is the mobilisation of remote technologies to overcome the imagined constraints of distance. Mitchell presents this as a reasonable and realisable aspiration, and many seem willing to accept this enthusiastic vision. But let us now move on to consider what are they actually buying into through their acceptance. In what context can this vision make sense? In terms of what kind of conceptual system does this obsession with the elimination of distance assume significance? Mitchell's pronouncements on the nature of virtual engagement (only) make sense, I would suggest, within a scheme that imagines and treats our relation to the world in terms of a technological interface. In Mitchell's cybernetic scheme, voyeurism concerns the capacity for monitoring and surveillance of the world, and telepresence is about the capacity for interaction with and manipulation of it. Through increased interconnection and integration of these functions (essentially those of input and output within the technological system), it

is possible to achieve increased efficiency and thereby "empowerment" within the system. Mitchell thinks in terms of the creation of an integrated technological circuit: "from gesture sensors worn on our bodies to the worldwide infrastructure of communications satellites and long-distance fiber, the elements of the bitsphere will finally come together to form one densely interwoven system …" (*CB* 173). What is envisaged ultimately is a new intimacy between what Mitchell calls "we cyborgs" and our electronic environment, such that even "the border between interiority and exteriority is destabilised" and "distinctions between self and other are open to reconstruction" (*CB* 31). We may consider the aspiration to overcome distance as precisely an expression of this desire to enhance the interface and achieve mastery within the confines of a new virtual space.

It is within the terms of a cybernetic circuit, then, that distance has no place. It is within the context of the cybernetic system that it becomes a force to be exorcised (it is associated with the friction or noise that impede systemic efficiency). Within the cybernetic imagination, the technological abolition of distance becomes the prerequisite for creating a new and better kind of order. And through the institution of this virtual new order, something else takes the place of distance – something that is called "presence at a distance." "Presence at a distance" is the cybernetic ideal that has now become the central myth in prevailing discourses on virtual futures. In the world of "presence at a distance," the system works to expel all that is uncertain, unknown and alien – all the qualities of otherness that may attach themselves to distance. "Presence at a distance" is about the technological synthesis of direct communication – recreating the conditions of immediate, face-to-face community in the immaterial conditions of an alternative, virtual world. It involves the simulation of immediacy in order to make this the measure of the world. Void of all distances, the virtual world is conceived as the place of generalised and globalised intimacy.

Now, what is both significant and problematical is that this simplistic discourse on distance (bad) and intimacy (good) has been able to present itself as the foundation for a broader social and political vision. It is almost entirely on the basis of the space-transcending capacities inherent in "remote" technologies that Mitchell sketches out a "new" social vision – a politics for new virtual intimacies. Along quite predictable lines, he claims that the emerging worldwide computer network "subverts, displaces, and radically redefines our notions of gathering place, community, and urban life" (*CB* 8). What is crucial is that bodily location has ceased to be an issue in the way we construct our communities: whole new possibilities for social interaction are opened up through the advent of "electronically augmented, reconfigurable, virtual bodies that can sense and act at a distance but also remain partially anchored in their immediate surroundings" (*CB* 43). "Today," says Mitchell,

> as telepresence augments and sometimes substitutes for physical presence, and as more and more business and social interactions shift into cyberspace, we are finding that accessibility depends even less on propinquity, and community has come increasingly unglued from geography … communities increasingly find their common ground in cyberspace rather than on *terra firma*.
>
> (*CB* 166, 161)

What Mitchell seems to assume throughout his exposition is that, because of their new technological nature, such virtual communities must necessarily be new, innovative and desirable in their social nature. It is, of course, conventional now to believe that technological innovation should be linked to social innovation – the power of belief generally works to inhibit any suspicion that possibilities inherent in technological innovation might, rather, be mobilised for socially conservative objectives. Only such a power could explain how the rhetoric of the new technoculture so often succeeds in deflecting attention away from what is

the impoverished and regressive social philosophy at its heart. For what the new technological scheme nurtures at its heart is the social and political scheme of communitarianism. Mitchell is concerned with the possibilities of virtual community, with the prospects for electronic bonding among those who share interests and common values. It seems as if there is an elective affinity between virtual futurism and communitarian nostalgia. What is quite clear is that, even if they are distributed in cyberspace, Mitchell's "virtual gathering places" are conceived in terms of a very unradical ideal.

In this respect, there is nothing new in *City of Bits*. Mitchell's arguments are of interest precisely in so far as they articulate deeper motifs in modern culture. In its perverse ambition to abolish all distances, I suggest, the technoculture in fact aspires to perpetuate, now by technological means, what Iris Marion Young (following Michel Foucault) calls "the Rousseauist dream" – the communitarian dream of "a transparent society, visible and legible in each of its parts, the dream of there no longer existing any zones of darkness ... zones of disorder" (Young 1990, 229). Through the institution of electronic communities, it seeks to re-validate Rousseau's ideal of social transparency in which "persons cease to be other, opaque, not understood, and instead become mutually sympathetic, understanding one another as they understand themselves ..." And it sustains, too, the Rousseauist desire for communicational immediacy:

> Immediacy is better than mediation because immediate relations have the purity and security longed for in the Rousseauist dream: we are transparent to one another, purely copresent in the same space, close enough to touch, and nothing comes between us to obstruct our vision of one another.
>
> (Young 231, 233)

Is this not exactly the ideal of Mitchell's "bitsphere," in which the border between interiority and exteriority is destabilised, and distinctions between self and other dissolved?

There is a certain allure in the Rousseauist dream. But it is alluring because, like a dream, it suspends the condition of being in the world. The Rousseauist project involves a fundamental disavowal of reality, an experiential retreat from a world imagined as "incomprehensible chaos." As Jean Starobinski (1988, 41) remarks of Rousseau, "because he dreams of total transparency and immediate communication, he must cut any ties that might bind him experientially to a troubled world over which pass worrisome shadows, masked faces, and opaque stares." What motivates the Rousseauist project is the desire to be free from the challenge of difference and otherness. Rousseau was intolerant of "the obligations of the human condition, in which the possibility of communication is always counterbalanced by the risk of obstruction and misunderstanding ..." "[I]f every reality raises the possibility of encountering an obstacle, he prefers *that which does not exist*." (Starobinski 252, 222). For Rousseau, the world should be a space without obstacles. J.-B. Pontalis (1981, 121) makes the pertinent observation that, whilst his life was errant, Rousseau's spirit was actually quite sedentary: "Rousseau *self*-travelled. Paradoxically, his comings and goings were less of a search for other human beings whose strangeness and difference would accentuate their alterity, than a chance to immediately live at a distance from that 'other' ..." The world, with all its opacity and disorder, was regarded as a place from which to retreat. Is it not precisely this attitude that is socially instituted in the technoculture?

The new virtual communitarians aspire to be rid of the burden of geography because they consider geographical determination and situation to have been the fundamental sources of frustration and limitation in human life. They seek to institute, in place of that intractable world, an alternative "anti-spatial" order, one that they believe will be far more accommodating. A new and different space – a neutralised and pacified space – is

substituted for the other one. Mastery is achieved at the cost of losing the world: which is to say that the choice has been made in favour of "that which does not exist." For the most part, virtual culture is a culture of experiential disengagement from the real world and its human condition of embodied (enworlded) experience and meaning. We might think of it in terms of the progressive disavowal – both intellectual and by technical means – of the real complexity and disorder of actual society and sociality. What is preferred is the manageable order that can be established in a domain where the dangers and the challenges of the real world are negated – a domain purged of worrisome shadows, masqued faces and opaque stares.

Virtual culture is a culture of retreat from the world. But what I think needs to be made clear is that this logic or temptation of retreat is far more than just an issue in virtual culture. Clearly, we are concerned with a cultural disposition that precedes the advent of new information and communications technologies. The withdrawal from reality is something that has more profound origins – and it must be considered, therefore, beyond just the narrow terms of the virtual technology debate. Dorinda Outram (1996) has put this question of the loss of distance as a meaningful reality into an interesting historical perspective. Acknowledging our contemporary difficulty in achieving "a focused attentiveness on what is other, other either in time or space," she locates the origin of this attenuation of otherness in the eighteenth century. In reflecting on these origins, she remarks on the significance of a transformation in the meaning of mobility at the end of the Enlightenment. In this period, Outram argues, an increasing concern with the interior of the self became associated with a weakening sense of external reality – "the loss of the sense of the reality 'out there.'" And this weakening was associated, in turn, with a growing anxiety about mobility in the world. In this context, Outram points to the contemporary significance of travel literature, and then pertinently observes how the Enlightenment concern with travel was bound up with utopian fantasies: "Mobility was becoming linked up to escape, to the wish to travel endlessly to elsewheres which were literally no-wheres. In No-where, in Utopia, one can momentarily forget the erosion of the reality of the world." (And, of course, I am suggesting here that the same anxieties continue to be associated with the same drives towards reality substitution). Outram goes on to suggest what would be at issue in the writing of a history of mobility in the Enlightenment:

> It is a history which shows a truly momentous shift in world view, which saw the decline and final collapse of ways of thinking about mobility which had been present since the Roman empire or even earlier. This is a historical shift which we have yet to come to terms with. It might indicate to us that the last battles might well be fought over the meaning of passage and the possibility of place.

In reflecting on what has happened to the meaning of distance, we must surely take this historical shift as a crucial point of reference, recognising that it considerably precedes the development of modern communications technologies.

But, of course, technological developments in communication have, subsequently, become very significantly implicated in this experiential transformation in modern society. We should consider their significance, then, from this perspective of mobility and the meaning of passage. First, communications technologies have worked towards the neutralisation of space. In his observations on the new transportation systems and new media technologies (radio and television) of the early twentieth century, Heidegger (1971, 165–6) comments lucidly and insightfully on the creation of a new space. "All distances in time and space are shrinking," he observes, "Man puts the longest distances behind him in the shortest time." "What is created as a consequence of this technological innovation is a world in which everything

is equally near and equally far. The distanceless prevails" (Heidegger 177). What is the significance of this condition of distanceless? "What is happening here," asks Heidegger, "when, as a result of the abolition of great distances, everything is equally far and equally near? What is this uniformity in which everything is neither far nor near – is, as it were, without distance?" (Heidegger 166). These are fundamental questions. The technological erosion of great distances actually brings with it an illusory sense of closeness and intimacy. Technologically contrived intimacy has nothing to do with nearness, for nearness does not consist in shortness of distance:

> What is least remote from us in point of distance, by virtue of its picture on film or its sound on the radio, can remain far from us. What is incalculably far from us in point of distance can be near to us. Short distance is not in itself nearness. Nor is great distance remoteness.
>
> (Heidegger 165)

The world of illusory technological intimacy is, at the same time, one in which we also arrive at "the abolition of every possibility of remoteness." Without nearness, there can be no remoteness – nearness is necessary in order to "preserve farness" (Heidegger 165, 178). These are important observations, going against the banal grain of common-sense beliefs about distance and the conquest of distance, and contesting the perverse desire to eliminate the human significance and value of remoteness. The question is raised as to whether there could any longer be a basis for meaning – both aesthetic and moral – in a world deprived of both nearness and distance.

Second, technological developments have contributed enormously to the pacification of experience in space, to the loss of attentiveness, that is to say, to what is other in space and time. Technological immediacy may, in fact, work to insulate us against the possibility of being touched by the other. Richard Sennett (1994) has interpreted the development of technologies of transportation from just such a perspective. Thus, in the twentieth century, he maintains, the automobile has served to "detach the body from the spaces through which it moves … The act of driving, disciplining the sitting body into a fixed position, and requiring only micro-movements, pacifies the driver physically" (Sennett 365). The technological construction of such "sealed spaces" has allowed us to manage and control what we have come to think of as our "interface" with reality – "it is possible for a passively moving body to lose all physical contact with the world" (Sennett 349). New virtual transactions – travels through virtual space – can massively extend such possibilities. For they offer whole new dimensions of mobility and, at the same time, make detachment from the real world ever more efficient and systematic – the ultimate sealed space. What virtual culture promises is an alternative space that will entirely fulfil the desire for effective disconnection and refuge from the world – a space where it will be possible, perhaps indefinitely now, to go on ignoring the erosion of the world's reality. In the virtual space, the distanceless is truly brought to dominance – the uniformity of an information space is substituted for a space of vivacity and experience. The "city of bits" – the pacified techno-space – would be the ultimate space of accommodation for the passively moving body. What could be the meaning of passage in such a space?

Contemporary accounts of and debates around virtual technologies are generally concerned with the potential of a new technocultural order. What I am arguing, in contrast, is that the new technologies may, rather, be contributing, through the erosion of significant external reality, to the depletion of the real resources of social life and experience. Now, I do not expect that the expansion of distance-shrinking technologies will easily be curbed – too great a part of the population (or perhaps it is a great enough part of most of us)

can find comfort in the prospects of virtual life. Moreover, I have suggested that what is fundamentally at issue – the modern disposition to evade what is "out there" – is not just a question of technological "dependency," but has far deeper psychic-cultural roots. So, my counter-position cannot really (or in any simple way) be about opposing the new technologies as such. The point is, rather, to keep in mind and play the crucial insight that the question concerning technology is not, fundamentally, a technological question. It means resisting the restricted and facile terms in which the technoculture sets the agenda – the terms, that is to say, of progress and progressive empowerment and mastery. But most of all, I suggest, it must be a question of shifting the debate onto the richer and more rigorous terrain of social and political analysis, where the ideals of intimacy, immediacy and community will have less credibility – and where it may be possible to mobilise against them more complex and challenging social values. If we are to resist the logic by which technology becomes the measure of all things, we need above all to secure a critical intellectual vantage point beyond its efficient empire.

Consider what is at issue with respect to the question of space and distance. The technoculture is already telling us of whole new possibilities of mobility and "presence at a distance," of incredible voyages in cyberspace, and of virtual encounters with other so-called cybernauts in new electronic "meeting places." I think that it is necessary to critically address the nature of these journeys in compressed space and time, and to do so, moreover, in the context of a broader social and political reflection on the meaning of passage. The technological system that seems to be about opening up new possibilities, might actually turn out to be more about possibilities further closed down. What the virtual culture is seeking to institute is a spatial order in which the difference between face-to-face and distantiated forms of communication is erased – a kind of space in which immediate communication becomes the model for all communication. The world "out there" would thus be conceived in the image of the world of intimacy and community (held to be a world of consensus). It would be reduced to the parochial dimensions of what is known and familiar and predictable. This would be a space in which distance and its otherness was turned into illusory proximity and spurious affiliation. In this respect, then, I suggest that the technocultural project be regarded as a scheme to achieve magical control over distance and its imagined disruptive potential. Virtual culture works to nullify the meaning of passage.

What, we must then go on to ask, is the value of distance? And on what basis might we rescue the meaning of distance? Gabriel Josipovici (1996) offers one response to these questions in his book, *Touch*. Reflecting on what he values positively as the experiential possibilities of separation, he asks us to think in terms of the "therapy of distance." To illustrate his point that sense and meaning may be made out of distance, Josipovici invokes the experience of pilgrimage, considered as "a journey into the experience itself … When the pilgrim touched the shrine at the end of his or her long journey it was an attempt not so much to bridge the distance that separated him or her from the holy as an instinctive way of making that distance palpable" (Josipovici 68). Josipovici, of course, recognises that the rise of modernity undermined the meaning of pilgrimage, making distance an enemy. Nonetheless, he believes that this disposition is still rooted in the body's relation to the world, and he thinks that distance may still be mobilised as an existential resource in contemporary society. Josipovici refers to his own impulse, on the occasion of his first visit to Los Angeles, to dip his hand in the ocean. Why, he asks, did he feel that need to touch and not just see? "The memory of my action that day," he suggests, "helps to establish its distance from me now, its otherness, its incomprehensible vastness and ancientness, and so makes real for me its presence in a world which I also inhabit, and helps confirm that it will

remain quite other than all my imaginings" (Josipovici 71). There may still be a significant and meaningful relation to absence. Rather than pursuing its technological abolition, then, says Josipovici, we might actually be concerned to "bring distance to life."

Josipovici is raising important issues concerning the quality of otherness that attaches to distance. In the face of the accumulating virtual ideal of myriad intimate "connections" within communities of the "like-minded," we should take seriously the crucial point that all real experience is experience of the other. And we should take heed of Josipovici's concern about what happens when distance is killed. "To abolish the actual journey," he notes, "with all its attendant dangers and attractions, with all its temptations and seductions, was also to abolish the therapy." And he is surely right to say that "there is no substitute for the therapy of distance" (Josipovici 73) (when the therapy was abolished what took its place was the pseudo-therapy of technology).

But, whatever its merits, there is at the same time a fundamental problem with this argument, for Josipovici's thinking is suffused with a nostalgia. What he is seeking to hold on to in the present is simply the residue of what he considers to have been only truly available in the pre-modern past. We are left to reflect on the consequences that progress in the rational appropriation of the world has had for other ways of knowing it – to reflect on an experimental and imaginative loss. Josipovici's substantive concern, moreover, is with the revalidation of the otherness that resides in God and Nature. But we can scarcely think that divine mystery or the Romantic sublime can still provide us with a significant intellectual or existential focus. These dimensions of otherness cannot any longer provide the basis for rehabilitating distance. At the end of the twentieth century, they can provide no meaningful alternative to the technocultural agenda.

The rescue of distance now can only be in the context of a social and political project. Perhaps it might be conceived in terms of a political alternative to the cloying vision of virtual intimacy, familialism and communitarianism? Perhaps it could develop as an alternative to the blandness of "connecting" and "bonding" in cyberspace and to the banal idealisation of "global conversations" through the Internet? With its well-intentioned belief in sharing, collaboration, mutuality, and so on, virtual communitarianism is a stultifying vision – an absolutely anti-social and anti-political vision. Cyberspace, with its myriad of little consensual communities, is a place where you will go in order to find confirmation and endorsement of your identity. And social and political life can never be about confirmation and endorsement – it needs distances. Josipovici's crucial point concerning otherness is that it represents something that is beyond our own imaginings. And this "beyondness," I suggest, is vital, not just in the kinds of experiences that Josipovici invokes, but also in social and political experiences between people. Encounters with others should not be about confirmation, but about transformation. We might consider them, following Christopher Bollas (1987), in terms of transformational object relations – with the others offering the possibility of a relation which is not about possession, but "in which the object is pursued in order to surrender to it as a medium that alters the self" (Bollas 14). Such a relation requires the renunciation of narcissistic desires to fuse with or to control the object – it requires the recognition, that is to say, of its essential otherness, and of the experiential possibilities to be derived from its distance. The therapy of distance resides in the transformational experience – this is what is vital if there is to be meaning in passage.

What I am seeking to invoke here, then, as a radical alternative to the new politics of virtual community, is what Iris Marion Young (1990, 234) describes as a politics "conceived as a relationship of strangers who do not understand one another in a subjective and immediate sense, relating across time and distance." Democratic culture must in fact be founded on the differences and distances between strangers. Consider Jacques Ranciere's

(1995, 102–3) absolutely incisive formulation, which claims that "democratic dialogue … resembles poetic dialogue as defined by Mandelstam: the interlocutor is indispensable to it, but so is the indeterminacy of the interlocutor – the unexpectedness of his countenance" ("an interlocutor is not a 'partner'"). Democracy is the dialogue premised on division:

> Grievance is the true measure of otherness, the thing that unites interlocutors while simultaneously keeping them at a distance from each other. Here again what Mandelstam says about poetic interlocution may be applied to politics: it is not a question of acoustics but of distance. It is otherness that gives meaning to language games, not the other way round. Likewise, dreams of a new politics based on a restricted and generalised otherness, on multiform networks redirecting the flows of the communication machine, have only had disappointing results, as we all know.
>
> (Ranciere 104)

Against the sentimental ideal of consensus and community, it is vital to protect the more robust principles of adversarial democracy, "a coming together which can only occur in conflict": "Democracy is neither compromise between interests nor the formation of a common will. Its kind of dialogue is that of a divided community" (Ranciere 49, 103). For those who recognise and accept this agnostic basis to political culture, the ideals of the new technoculture must surely seem both misguided and misconceived. They must insist on judging the ambitions and achievements of the virtual culture according to the measure of these other, countervailing principles.

Bibliography

Bollas, C. *The Shadow of the Object*. London: Free Association, 1987.

Heidegger, M. "The Thing." *Poetry, Language, Thought*. New York: Harper & Row, 1971.

Josipovici, G. *Touch*. New Haven: Yale University Press, 1996.

Mitchell, W. *City of Bits: Space, Place, and the Infobahn*. Cambridge, MA: MIT, 1995.

Outram, D. "Enlightenment Journeys: From Cosmic Travel to Inner Space." Paper presented to the Colloquium of the International Group for the Study of Representations in Geography, Royal Holloway College, London, 5–7 September 1996.

Pontalis, J.-B. *Frontiers in Psychoanalysis: Between the Dream and Psychic Pain*. London: Hogarth, 1981.

Ranciere, J. *On the Shores of Politics*. London: Verso, 1995.

Sennett, R. *Flesh and Stone: The Body and the City in Western Civilisation*. London: Faber and Faber, 1994.

Starobinski, J. *Jean-Jacques Rousseau: Transparency and Obstruction*. Chicago, IL: University of Chicago Press, 1988.

Young, I.M. *Justice and the Politics of Difference*. Princeton, NJ: Princeton University Press, 1990.

Maria Bakardjieva

VIRTUAL TOGETHERNESS
An everyday-life perspective

THE OBJECTIVE OF THIS ARTICLE is to explore some dimensions of the concept of virtual community, that relate to empowering possibilities in the appropriation of the Internet by domestic users. I contend that users' participation in what have been called 'virtual communities' (Rheingold, 1993) over the Internet constitutes a cultural trend of 'immobile socialization', or in other words, socialization of private experience through the invention of new forms of intersubjectivity and social organization online.

When I suggest the term 'immobile socialization', I intentionally reverse Williams's (1974) concept of 'mobile privatization'. Unlike broadcast technology and the automobile that, according to Williams, precipitated a withdrawal of middle-class families from public spaces of association and sociability into private suburban homes, the Internet is being mobilized in a process of collective deliberation and action in which people engage from their private realm. Whether an analyst would decide to call the electronic forums in which this is happening communities or not depends on the notion of community she is operating with. What has to be noted, however, is that by engaging in different forms of collective practice online users transcend the sphere of narrowly private interest and experience. Why do they do that? What does it mean to them? How does it affect public understanding of the Internet? The concept of 'virtual community' has been only of limited help in understanding of this practice and I will try to explain why in what follows.

Few studies of virtual communities (an exception is Turkle, 1995) have attempted to relate online community engagement with users' everyday life situations, relevances and goals. Most of the existing research (see Jones, 1995, 1997) has concentrated on the group cultures originating from the interactions of online participants, thus treating online group phenomena in isolation from the actual daily life experiences of the subjects involved. In this article, I attempt to initiate an exploration into the experiences and motivations that lead Internet users either to get involved or to stay away from forms of virtual togetherness. I believe it is important to understand what kinds of needs and values virtual communities serve, and under what circumstances. This will open a realistic perspective on the significance of this type of use in the social shaping of the Internet.

My reflections are based on an ethnographic study of the practices of 21 domestic users of the Internet in Vancouver. The respondent group was formed through self-selection. The conditions for participation stipulated that: (1) respondents should not have a professional involvement with the Internet; (2) they pay for their Internet access themselves; and (3) they use the Internet more than three times a week. Data were collected through in-depth individual interviews with users and group interviews with their family members where appropriate. Observational tours of the domestic space where the computer connected to the Internet was located and of the computer 'interior' (bookmarks, address books, etc.) were also performed.[1]

On the basis of this material, I offer a typology of different forms of online involvement, which demonstrates that the term 'virtual community' is not always the most accurate way to describe people's actual social activities online. In fact, virtual togetherness has many variations, not all of which live up to the value-laden name of 'community'. This fact, however, does not undermine the idea of collective life in cyberspace. On the contrary, I call for appreciation of the different forms of engagement with other people online (virtual togetherness) that exist, and the different situated needs they serve. In these multifarious practices I recognize new vehicles that allow users to traverse the social world and penetrate previously unattainable regions of anonymity as well as to expand their social reach (Schutz and Luckmann, 1973). In light of this formulation of the meaning of virtual togetherness, I question the dichotomy between the private and the public that is at the root of both virtual Utopia and dystopia.

The virtual community debate

Raymond Williams, tracing the etymology of the word community, notes that it is 'the warmly persuasive word to describe an existing set of relationships; or the warmly persuasive word to describe an alternative set of relationships' that 'seems never to be used unfavorably and never to be given any positive opposing or distinguishing term' (1985: 76). Williams's account of the historical evolution of the usage of the word reveals its interpretative flexibility and hence its socially constructed character. There is no 'genuine' fact of nature or social history that the word community denotes. There is no consensually accepted definition of its meaning. Different social actors have appropriated the word at different points in history with different concrete contexts, goals and oppositions in mind.

A similarly complex constructive process can be discerned in the case of the notion of 'virtual' or 'online' community. The engineers and researchers who were the first to build, experience and study the Internet, along with other technologies for computer-mediated communication, employed the concept of community in order to legitimate their project and to demonstrate its significance and nobility (Cerf, quoted in Abbate, 1994: 11; Hiltz and Turoff, 1978; Licklider and Taylor, 1968; Rheingold, 1993). They portrayed membership in a virtual community as liberating, equitable and empowering. In response, critics have zealously defended an idealized notion of 'real' community signifying a state of immediacy and locality of human relationships that resists technological mediation (Borgmann, 1992; Dreyfus, 1998, Kumar, 1995; Postman, 1992; Slouka, 1995).

In a recent article, Wellman and Gulia (1999) have pointed out a common weakness of both sides of this debate. These positions are premised on a false dichotomy between virtual communities and real-life communities. Wellman's (1979, 1988) community studies carried out through the methods of network analysis, as well as Anderson's (1983) anthropological studies have demonstrated in their specific ways that the majority of the

so-called 'real-life' communities are in fact virtual in the sense that they are mediated and imagined. Wellman and Gulia argue:

> In fact most contemporary communities in the developed world do not resemble rural or urban villages where all know all and have frequent face-to-face contact. Rather, most kith and kin live farther away than a walk (or short drive) so that telephone contact sustains ties as much as face-to-face get-togethers.
>
> (1999: 348)

'All communities larger than primordial villages of face-to-face contact (and perhaps even these) are imagined', Anderson (1983: 18) insists in a curious concord between the two quite distinct schools of thought.

Furthermore, Wellman and Gulia charge, most accounts of virtual community have treated the Internet as an isolated phenomenon without taking into account how interactions on the Net fit with other aspects of people's lives: 'The Net is only one of many ways in which the same people may interact. It is not a separate reality', Wellman and Gulia observe (1999: 334).

These other aspects of people's lives constitute the crucial background against which questions regarding the social and individual significance of online communities can be raised and answered. Thus virtual communities cannot be declared inferior to real-life communities simply because they lack face-to-face materiality. They cannot be celebrated as liberating or empowering by nature either, as people bring to them stocks of knowledge and systems of relevance generated throughout their unalterable personal histories and social experience. They cannot be studied and characterized exclusively by what is produced online as the cultures enacted online have their roots in forms of life existing in the 'real' world.

Finally, and this is the central thesis that I propose here, the concept of (virtual) community with all the normative load it carries, has led analysis into a not particularly productive ideological exchange disputing the possibility that genuine community can be sustained through computer networks. This has deflected attention from the fact that a continuum of forms of being and acting together is growing from the technology of the Internet. I will refer to this emerging range of new social forms as 'virtual togetherness' in order to avoid the normative overtones present in the concept of community. Community, whatever definition one may choose to give it, would then be one possible form of virtual togetherness among many.

The opposite of virtual togetherness (and community) is not 'real' or 'genuine' community, as the current theoretical debate suggests, but the isolated consumption of digitized goods and services within the realm of particularistic existence. The issue then is not which (and whether any) form of togetherness online deserves the 'warmly persuasive' (Williams, 1985: 76) label of community. The challenge to analysts is to understand and appreciate the significance of these various forms of transcending the narrowly private existence and navigating the social world for individual participants, for society at large and for the shaping of the Internet.

Between consumption and community

In this section I will present an emergent continuum in users' understanding and actual practice with regard to the Internet spanning the poles of consumption and community. The important distinction between these two modes of Internet use, in my view, consists in the absence in the former and presence in the latter of users' participation and involvement

with one another. The degree of immediacy and depth of this involvement, as I will show below, varies in the different versions of virtual togetherness discernible in my respondents' accounts. It may or may not meet a normative standard of 'genuine community'. But in all forms of virtual togetherness, unlike in the consumption mode, users *produce* something of value to others – content, space, relationship and/or culture. I believe that the legitimacy and the practical possibility of this participatory mode of Internet use is what needs to be defended against the assault of consumption and its related practices. By simply denying the value of virtual togetherness (community) critics undermine the strongest alternative to the narrow consumption-orientated model of Internet development.

The infosumer: the rationalist ideal of Internet use

Accounts of participation in virtual groups came up in the stories of some of the people I interviewed without specific questioning. Invited to explain how they used the Internet, they started with their online groups. With others, no mention of any social life online was ever made. My pointed question about whether they took part in virtual groups or forums received sometimes very sceptical and even derogatory/nihilistic responses:

> I am reading a few groups, not much. But again, nothing intrigues me to participate. So I don't know how widespread is that communal thing. I have no idea. I haven't participated. Chats, I find, are a horrible waste of time! I tried it once or twice and said, forget it! [What is so disappointing about it?] Oh, the subjects, the way they talked about it …
>
> (Reiner, 62, retired mechanical-engineering technician)

> I am aware, like you say, of newsgroups or use-groups, whatever they are called, I tried, two or three years ago, some and I just didn't care. The crap that came back and the depth of the level of knowledge didn't really strike me, it wasn't worth going through these hundreds of notes – somebody asking this or that to find. … But I couldn't find any substantive issues and I did not care, I did not want to use it to advertise my own knowledge, so I just left them alone.
>
> (Don, 60, psychological counsellor)

Gary, a 65-year-old retired naval radio operator, summed up this particular position regarding Internet group discussions in a useful model. According to him, a good radio operator sends as little as possible, but receives maximum:

> Because the radio operator is there just to get all the information he can about the weather, the time signal, about what's happening in different countries and orders from different places. And if he can get that efficiently without going on the air too much, then it is to the benefit of everybody. If everybody is on the air asking questions, then you cannot hear really anything but miles and miles of questions being asked. That's why the etiquette of the professional radio operator was to say as little as possible. Like telegrams used to be. … To me, it is a matter of getting information across.

Coming from this perspective, Gary scorned the 'noisy people out there on the Internet', 'the empty heads' who were there first: 'There are always people who just have their mouth hanging out and they are just talking, and talking, and talking, and just creating a lot of babble.'

These kinds of empty-heads produced 'garbage upon garbage' on the Internet, a low-level content that Gary refused to engage with. He believed that his contributions, had he made any, would have not been appreciated. To post in newsgroups, for him, would have been like 'casting pearls before swine – that means it is pretty pointless to be intellectual when you are dealing with people who just want to talk about garbage'.

A closer look at the 'radio operator' perspective reveals its underlying communicative values to be 'substantive issues', 'information', 'efficiency'. The respondents in this category upheld a rationalist ideal of information production and exchange and expected the content of Internet discussions to live up to that ideal. Their high standards prevented them from contributing to any group discussions because of an 'expert-knowledge-or-nothing' attitude. These respondents repudiated sociability understood as the pursuit of human contact, acquaintance, friendship, solidarity and intimacy, as legitimate motives for using the Internet. The users in this category were turning to the Internet for timely, accurate, reliable information and, quite naturally, were finding it in the online offerings of traditional information institutions such as news agencies, radio stations, newspapers, government sites.

Instrumental relations: rational interaction

In Martha's narrative, one could notice the persisting authority of the rationalist ideal with information as its central value, although acceptance of other people on the Internet, not necessarily experts and expert organizations, as sources of information and ideas was also showing through. Information remained the leading motive stated for going on the Internet, however 'talking to people online' was not perceived as its antithesis:

> My son has an attention deficit disorder … and it was really interesting to get online and to talk to people from all over the world about this issue. It was called the ADD forum – a really good way for providing information.
>
> (Martha, 41, meat-wrapper for Safeway)

At one turn of the conversation, when Martha admitted that she missed the ADD forum available only through CompuServe, she made haste to emphasize: 'It wasn't chatting to meet people and get to know people. It was chatting about ideas and exchanging information', thus paying tribute to the rationalist ideal.

Similarly, John, a 73-year-old retired mechanical engineer, perceived his participation in a mailing list for motor-glider hobbyists, as a valuable resource in problematic situations when decisions regarding new equipment had to be made or technical problems needed to be solved. He had approached newsgroups in the same way – in cases when he needed a question answered, a problem solved, a new experience illuminated: his wife's diabetes, a new type of apple tree he wanted to plant, his new communication software, etc. He enjoyed the helpfulness and solidarity demonstrated by the people who took the time to answer his queries in their specifically human and social aspects, but admitted that once the problem was solved, the interpersonal communication would fade away:

> We don't normally communicate socially – how are you, what's the weather. … It's usually when a technical question comes up. After that question is solved, we may talk a little bit about how old we are, what we did. But once the problem is solved this fades away. But yet, those people are still in the background. And when I am looking at postings and see their name, a bell rings.
>
> (John)

He himself would only respond to questions others had asked on the mailing list when he had 'something positive' to say and believed that this reserved culture of positive, substantive contributions made his mailing list work well.

Merlin, a 58-year-old unemployed mechanical engineer, was also quite scrupulous as far as the quality of information exchange in his virtual group was concerned. He insisted he was on this mailing list in order 'to learn', 'to expand my understanding of the electrical components used in the electric car'. He saw the list as a 'semi-professional community' and only felt the right to contribute when 'somebody says something wrong or asks a question, especially connected to hybrids, because I have thought about it, I haven't done any real calculations, [only] very simple calculations which answered some questions that were asked'. Despite the preponderance of strictly technical content on the list, the personalities of participants had come through and Merlin had developed curiosity as to what kind of people some of the discussants were. When he had happened to be in the locations of some of the guys on the list, he had driven by their houses or shops and had met some of them. Putting a face to an email address or alias, a living image and context to stories told on the list, seemed to have been a transforming experience in terms of how Merlin felt about his list:

> Now, I have met these people, so it actually means a lot more to me, now that I have met [emphasizes]. … I thought Jerry was a wealthy guy, in fact, you have to categorize him as poor, he is a postman and he hasn't worked for over a year, he is obviously not rich. And I have seen him, and I have seen his wife Shauna, I actually saw his two daughters in passing. I have seen the truck, the car, that had this plasma fireball incinerated inside of the car, I saw the battery – there were three batteries welded together in a T-junction, I mean really, to do that damage, it really had to have a lot of energy …
>
> (Merlin, 56, unemployed mechanical engineer)

Thus, unexpectedly, the rationalist model of Internet use (Merlin insisted on his loyalty to it) was showing cracks where it would have seemed most unlikely – on a technical discussion list.

People and ideas in virtual public spheres

For Patrick (33, electronics technician) and Myra (28, doctoral student in physics) 'chatting about ideas' was one of the main attractions of newsgroups. In this communication model, the high standing of information, ideas and knowledge was preserved, however it was inextricably linked to interest in people as knowers, interpreters, discussion partners and opponents. The contact between the two of them (Patrick and Myra) was actually established when Myra found in the Albanian newsgroup she was reading a posting from a guy who wanted to 'ask some questions about Albania to an Albanian, to a guy or girl who knew about the country'. Reflecting on a gratifying exchange they had had in an Internet newsgroup, they described it like this:

> We started talking about serious politics. … Albanian, Eastern European. We were talking – long, long, long messages – political analysis, how this or that could be. No jokes, no stupidities like oh, I find you attractive, nothing like that.
>
> (Myra, 28, Albanian background, doctoral student in physics)

In her description of another newsgroup exchange with a previously unknown contributor, Myra stressed both the quality of the ideas that were articulated in the posting and the relationship established between its author and herself as a reader:

> There is a guy in the Russian group – and I saw a couple of postings of his and, of course, I sent him a message, a personal one and I said well, I am delighted, I like them and he replied – oh, I am delighted that you appreciate them. So you kind of establish a closer contact. We don't write to each other or anything but when I see a posting by him, I will go and read it.
>
> (Myra)

Myra used to write a lot in Albanian newsgroups and mailing lists (trying to express her opinion regarding various, mostly political, issues) but the highly controversial nature of the political topics she was addressing attracted flaming and, later, when she responded in a way she thought appropriate, intolerable disciplinary measures. Patrick, for his part, admitted that he was visiting newsgroups to some extent also for the controversy: 'But I like provocative topics and if someone starts flaming me, fine, I get what I deserve. ... I have been flamed and certainly will be flamed. I don't avoid that.'

Both Patrick and Myra thought of newsgroups not simply as an information resource, but also as a space for intellectual sociability and political debate, a 'public forum' in Patrick's own words, where diverse opinions could meet and clash as a matter of course. The point of being there was to expose oneself to others' perspectives and to argue for your own, to build alliances with like-minded people and to enjoy intellectually stimulating encounters.

An online political discussion that had gone the extra mile to involve subsequent organization and collective action of participants was represented by the mailing list Theodore belonged to. The participants in that discussion had gone beyond the process of collective sense-making of events and issues. An agreement over needs and directions of political organizing had grown out of their exchange and debate. The grassroots Ethiopian National Congress had brought together face-to-face Ethiopian refugees scattered all over the world who had reached agreement over their common cause and course of action in their virtual togetherness:

> Individuals on the list started talking about this thing and said we should do something about it and so it started as a virtual organization and it transformed itself, there was a meeting in July of last year in LA – the initial meeting for individuals to get together and discuss this thing and then there was another meeting in 1997 October where the actual organization was proclaimed and established in Atlanta.
>
> (Theodore, 45, parking patroller)

The chatter: sociability unbound

The cases discussed so far derived in a significant way from the rationalist model of Internet communication, albeit implanting in it interpersonal interaction and sociability in different degrees and variations. When one turns to listen to Sandy (35, telemarketer for a telecommunications company), one realizes that a qualitative break with the rationalist model has taken place. Sandy spoke for a markedly different model of Internet communication, one that had sociability as its central value. Ironically, Sandy was introduced to the Internet

in relation to a university course she was taking. Thus, for her, finding information was the foremost function of the medium her attention was drawn to. However, it didn't take long before Sandy discovered the chat lines and became fascinated by what they had to offer. In her open and emotional statement Sandy showed no signs of guilt or remorse for abandoning the rationalist model of Internet use. In fact, she did not seem to notice the major subversion to which she was subjecting the medium as perceived from the 'radio operator' perspective. She was happy to be one of those noisy people who were out there 'talking, and talking, and talking' (see Gary's quote above). Her main reason for being on the Net was 'meeting people in there and having a great time talking to them' (see Martha's statement in the opposite sense above).

> I was drawn to the rooms that were like the parent zone, health zone and things like that, just general interest. … I would talk to people in there and then I met, this guy who lives in Ontario and his wife and they had a room called the Fun Factory. It was about 10 of us. We just hung out there, we went in there and just chatted about life. All kind of fun things – we goofed around, told jokes, stories, whatever. The same ten people. Oh, I still talk to them all. In fact we've flown and we have met each other and some of us. … Lots of times other people came in, but this was the core.
>
> (Sandy)

What started as 'goofing around' ended up having dramatic consequences for Sandy's 'real' life. In Sandy's own reflection, as a direct result of her hanging out in chat lines, her marriage fell apart completely. That was because online she met 'really good people' who helped her to regain her self-confidence: 'then all of a sudden I was reminded that I was a real person [emotional tone] with real emotions, and real feelings and I was likable by people'. Furthermore, one of her new online friends was the first person to whom she revealed that her husband was beating her:

> And he just said – 'Get out! You have to get out, Sandy, you cannot stay there!' And he and I became really close good friends and he convinced me that life could go on and even that I would lose a lot of materialism, I would gain so much more if I could fight this fight and get out. And I did. I left.
>
> (Sandy)

Another person who became a close friend and shared a lot in Sandy's marital problems, was also instrumental in helping her with the technological challenges of the Internet. He was a computer professional who taught Sandy the technical knowledge and skills that she needed to move and act freely online. Thus one can notice how, starting from a close personal relationship established online, Sandy had gone full circle back to hard information.

> And he made it easy. I would say 'I don't think I can do that', and he would say – 'I remember you saying that about such and such, but if you just think about how it works.' And he would explain to me how it worked. And then I would go and do it myself.
>
> (Sandy)

The chat room Sandy was describing could hardly meet the high standards of community raised by the critics of the idea of virtual community. The interactions in that room had been vibrant and yet superficial, intense and fleeting at the same time:

In the room it was mostly goofing around, telling cracking jokes. And also there was always stuff going on in the background in private conversations and then you'd have the public room. And often you would have three or four private conversations going at the same time as the room.

(Sandy)

What actually was happening in this environment was people meeting strangers and treating them not simply with civility, but as someone 'like myself', someone who could laugh at the same jokes, talk about the same topics of interest and then walk away and go on with his/her own life. That is, what the room was providing for its visitors was an environment for 'fluid sociability among strangers and near-strangers' (Philippe Ariès, cited in Weintraub, 1997: 25). Speaking about the sociability of the pre-modern cities Ariès writes: 'This is a space of heterogeneous coexistence, not of inclusive solidarity or of conscious collective action; a space of symbolic display, of the complex blending of practical motives with interaction ritual and personal ties …' (quoted in Weintraub, 1997: 25).

The chat room described by Sandy displayed also social proximity found across physical distance. Sandy's account indicated that the people she was meeting in her chat room were socially and culturally close to her: they liked rock and roll, *Star Trek* and kayaking. They had computers of the same make and similar kinds of marital problems. The spirit of sociability sustained in the chat room was a product of the shared desire of these people to overcome the privateness of their existence, to go out and socialize some of their most personal experiences, anxieties and troubles. The merry superficiality of the chat-room was only the first level of contact where, through the display of one's personality in public, interpersonal affinities were sought and negotiated. The deeper effects of this activity were playing themselves out at the level of the private conversations breaking off from the party and even further, into participants' actions in the offline world. These were effects concerning again the private spheres of the individuals involved. However, the return to the private to deal with its challenges was performed at a different level, bringing in a reaffirmed self, reflexivity, new interpretative frameworks for addressing vital problems of everyday life acquired in the social online relationships.

At the moment I spoke with Sandy, the Fun Factory chat room had died out – its participants had left. Sandy emphasized that she did not want to chat online that much any more, 'at least for now':

I think I want to establish social relationships in the real world instead of in the virtual world right now. That's important for me where I am right now. I still want to keep in contact with the friends that I have met online and I do that by email now instead of chat rooms.

In Sandy's case, the involvement in a form of virtual togetherness had clearly been a situational phenomenon. The problems of a particular situation in her life, and what was relevant to her at that point – the isolation brought about by an abusive marriage – had led Sandy to seek sociability, recognition, social support, intimacy in the more-or-less anonymous virtual association of people she could meet through the Internet chat programmes. In her virtual togetherness with the other members of the chat room, Sandy had found the means to deal with the problems she was facing there and then. In a changed situation, she was consciously choosing a different route and different means for building togetherness with people. Yet, as one can notice in her statement, she cherished the relationships she had created online and worked to translate them into a different format. Her 'virtual' friendships were in the process of becoming 'real', and as such, notably, sustained through

other communication technologies – email and telephone: a transformation that once again exposes the fragility of the constructed boundary between real and virtual togetherness.

The communitarian

With Ellen (49, former editor), the concept of community dominated the conversation from the first question on. Ellen had hooked up to the Internet from home after she became house-bound and diagnosed with a rare but crippling chronic illness. Her explicit motivation for becoming an Internet user was to be able to connect to a support group. She simply felt 'very desperate for information and help'. 'Getting information' and 'getting support' were two inseparable reasons for her to go online. Thus Ellen joined an invisible dispersed group of people who were logging on every day to get the 'gift of making this connection' with each other:

> … to discover that thousands of people are going through exactly the same incredible experience and nobody in their family understands, their husbands and wives don't understand, the doctor doesn't believe them and they have this terrible difficulty of functioning. And yet, there is this tremendously strong community of people who have never met and probably will never meet but who are so loyal to each other and have such a strong support because it is a lifeline for all of us.
>
> (Ellen)

The mailing list Ellen described was experienced as a safe environment by these people, a place where they felt comfortable saying:

> I've had a really bad day, I had to go see a specialist and I had such a difficulty and couldn't breathe and it was such a challenge to get there and then the doctor was awful to me. And then I got home and my husband was complaining because the house wasn't clean …
>
> (Ellen)

And immediately after a complaint like that would pop up in members' mailboxes, there would be a 'flurry' of supportive responses. Loyalty, high tolerance for 'dumping', safety, family-like atmosphere, compassion – these were all attributes Ellen used to describe the quality of interaction in her 'wonderful group'.

The real-life effects consisted in 'a lot of confidence', 'getting my life in proportion again', 'getting a sense of myself' (compare with an almost identical formulation by Sandy) 'feeling much less a failure'. Learning a lot about the disease was among the benefits of list membership; however Ellen took care to distinguish the particular kind of learning that was taking place there:

> I learnt so much from these people who had had the disease for years. I had tried to get hold of some medical information. But getting online is different because there, for the first time you get information from people who have trodden this path already!
>
> (Ellen)

For good or ill as the case may be, the victims of the disease Ellen had were short-circuiting the medical establishment and the expert knowledge produced by it and were learning from each other. More accurately, they were collectively appropriating and using expert knowledge in ways they had found relevant and productive in their own unique

situations of sufferers and victims. On the list they were creating this culture of appropriation and solidarity.

A similar sense of gain from online support group discussions came through clearly in the comments of Matthew, a 37-year-old amputee. According to him, people with similar health problems learnt from each other about the existence of a variety of treatment options, which, consequently, empowered them vis-à-vis the medical profession. Matthew challenged the very notion of a patient. In his understanding, people with health problems were clients, customers and, in the best case, collaborators with doctors, nurses, prostheticists, etc. To be able to act in this capacity, however, they needed to be informed and acculturated in their disability. Matthew believed that this is what online support groups, such as the list he himself had initiated, helped bring about. 'I learnt more about being an amputee in the one year of being on the mailing list than throughout the 20 years I had had the problem', Matthew insisted passionately.

What distinguished Ellen's experience from other, more detached, forms of learning like those described by previous respondents was the fact that the people she was interacting with over time had come to constitute a collective entity with its own distinctive culture. Her online group had a relatively stable membership communicating on a daily basis and feeling responsible for each others' well-being. Both commonalty of interest and diversity could be found in that group. Most of its participants were people seeking alternative approaches for dealing with the chronic disease they had. In Ellen's estimate, most of them were highly educated and articulate. Women were in the majority. At the same time, members of the group came from different religious backgrounds and life experiences in terms of education, profession, family, etc. Yet, characteristically, they were entering their shared space ready and eager to listen to interpretations coming from viewpoints different from their own:

> Like this woman in Israel, a Hebrew scholar, a convert to Judaism, she has the most fascinating perspective on things. There are amazing things coming from her. … But nobody has ever tried to push one point of view above another. There has been very much a sense of sharing.
>
> (Ellen)

Ellen's account describes, I would argue, a 'warmly persuasive' version of a robust online community characterized by interpersonal commitment and a sense of common identity. Ellen's Internet was thus markedly different from the rationalist model of Internet communication defended by the infosumers. The users who denied the communal aspects of the Internet came from a strictly utilitarian and/or rationalist value orientation. They sought positive, reliable, scientific, professionally presented information, and were able to find it in the virtual projections of institutions such as online magazines and newspapers, radio and television stations' sites, government sites, news agencies, and scientific publications online. To most of these users, newsgroups and mailing lists had little to offer and, consequently, communal forms were put in question in principle. The everyday practice of the infosumer, I suggest, is organized by and continuously reproduces the consumption model of the Internet as a social institution.

On the other hand, representatives of disenfranchised groups – such as, in my study, Ellen and Matthew, both disabled, but also in some sense Sandy (a victim of spousal abuse) and Merlin (long-term unemployed) – were using the technology as a tool to carve spaces of sociability, solidarity, mutual support and situated, appropriative learning in communion with others. As I tried to show, these two forms of Internet use were not separated by empty space but by a whole range of intermediate modalities. Martha and John appreciated

the empowerment stemming from the opportunity to draw on the knowledge, experience and practical help of otherwise anonymous people in the areas of their specific interests and concerns. Myra, Patrick and Theodore were new immigrants struggling to make sense of the dramatic political events that had befallen their native countries, as well as to sustain a meaningful balance between disparate, and even conflicting, sides of their cultural identities. In this process, they were leaning on both the informational and the communal affordances of the Internet, thus forging a medium for political debate and civic involvement.

Common for all the modalities of virtual togetherness described here is the fact that actions and interactions in online forums were closely intertwined with participants' projects and pursuits in their offline lives. Martha carried over information and advice on attention deficit disorder received through her CompuServe chat room into the discussions and publications of her local parent support group. Jane (35, home-maker) used Internet sources for ideas to implement in her arts and crafts group at the local church. Theodore directed a radio programme for the Ethiopian community in Vancouver drawing on the themes and issues discussed in his mailing list. In many cases, for example with Merlin and Sandy, relationships established online had been followed up with face-to-face contacts. With John, there was no distinct boundary between 'virtual' and 'real' links. He moved seamlessly between involvement in actual events with his fellow hobbyists and the electronic communication that sustained their organization. As much as these banal everyday activities may contrast with the exotic aura of some virtual community accounts, they powerfully demonstrate the artificiality of the split between 'virtual' and 'real'. With Ellen, who felt more at home in her virtual community than in any face-to-face group, a very specific configuration of situational factors had brought forth this rather extreme form of virtual togetherness: a rare disease, physical and social isolation, a vital need to come to terms with a radically new experience combined with mastery of language and expression (recall that Ellen was a philologist, editor and writer). And it should be noted that, even in this case, online community was not displacing face-to-face community where the latter existed or could have existed. It was rather filling the void left by the impossibility of face-to-face community or the inability of existing face-to-face communities to satisfy important needs of the individual.

Between the public and the intimate: gradients of immediacy

In his *Television: Technology and Cultural Form*, Williams (1974) draws attention to the condition of 'mobile privatization' characterizing everyday life in an earlier phase of industrial capitalist society and sees the technology of broadcasting as a resolution, at a certain level, of the contradictory pressures generated by this condition:

> This complex of developments included the motorcycle and motorcar, the box camera and its successors, home electrical appliances, and radio sets. Socially, this complex is characterized by the two apparently paradoxical yet deeply connected tendencies of modern urban industrial living: on the one hand mobility, on the other hand the more apparently self-sufficient family home. The earlier period of public technology, best exemplified by the railways and city lighting, was replaced by a kind of technology for which no satisfactory name has yet been found; that which served an at once mobile and home-centered way of living: a form of *mobile privatization*. Broadcasting in its applied form was a social product of this distinctive tendency.
>
> (1974: 20; italics in original)

The lives of the Internet users I talked to did not seem to match this description precisely. First of all, these people were not sufficiently mobile. Their automobiles could not take them to places denied to them through various forms of social exclusion – unemployment, high financial cost and illness, amongst others. Second, they felt ambivalent about the self-sufficiency of the private homes in which their existence was circumscribed. They were ready and eager, each one to a different extent and with different degrees of rationalization, to trade that privateness for human contact, community and broader social involvement. Their Internet-based practices could be characterized as constituting an attempt at 'immobile socialization'. Users employed the medium for associating with other people and social entities without leaving their homes, and this represented a resolution, at a certain level, of the pressures present in their original situations. The practice of immobile socialization, I argue, undermines a second dichotomy that has been employed to frame the discussion of the social meaning of the Internet – that between the public and the private. Critics like Kumar have seen growing Internet use as contributing to the 'increased privatization and individualization' of existence and the 'evacuation and diminishing of the public sphere of contemporary western societies' (1995: 163). Enthusiasts, on the other hand, have anticipated invigorated public life and a 'network nation' (Hiltz and Turoff, 1978). Neither of these broad generalizations accurately reflects the actual practice of users. What I found in my respondents' accounts was evidence of active and discriminating crafting of boundaries and definitions of relationships between individuals and individuals and groups. These boundaries delineated spaces of social interaction intermeshing the public and the private in ways unimaginable without the new communication medium.

Most of the people I interviewed, especially the women, spoke about an initial shock and fear for their privacy when using the Internet. As new users, they found it hard to imagine exactly how visible and socially consequential their various actions and interactions were. Sandy recollected her early anxiety with amusement: 'I remember when the modem hooked up the first time I was scared. I thought: Oh, no! I thought everyone was gonna know everything about me for some reason.' Jane, a 36-year-old homemaker, was still at the stage where making a comment in a newsgroup or participating in a chat line felt 'creepy': 'So, I just made a comment. But I didn't like the idea because I realized later that anybody could read my comment and send me email. ... I didn't make any other comments.'

With experience, users had developed strategies for careful control of the degree of exposure they allowed for on the Internet in particular action contexts. Martha's approach involved complex manipulation of two email addresses, one 'anonymous' and the other indicating her real name:

> The address I have at the VCN[2] forwards mail ... to my home address. When the people I am contacting are a non-profit web site I can contact them either way – from my home address or the VCN one. I like to have that anonymity. Then any mail that goes to the VCN, the people that have sent it don't know where it goes to until I contact them.
>
> (Martha)

Similarly, when Myra wanted to respond to a request for information posted in a newsgroup by an unknown person hidden behind a nickname, she reasoned:

> Robert Redford [poster's nickname]! ... Let's see what his true name is. (I am a scientist after all.) At the same time I wanted to be safe and because I had several accounts scattered around the world, I wrote to him from an account that I had

in Italy. And on the next day when I checked that account, I found a message from that guy that I also thought was a Pole ...

The mystery guy and Myra started a 'serious' political discussion (referred to earlier in this article) which went in concentric circles from public issues to private thoughts and feelings:

> And then after months, because he was always asking questions: how are things over there. ... After months, I started joking and said, well, the next message I expect something like ten questions from you. And here come ten questions: How tall are you? What kind of wine do you like? Do you like sailing? ... things like that. So it got more into [I suggest personal, she doesn't accept it, preferring] ordinary human terms rather than talking about big issues.
>
> (Myra)

Myra was drawing the trajectory of a fascinating gradual movement between the public and the private, or, as Schutz would put it, between different gradients of immediacy spanning the distance between the most anonymous – 'an Albanian, a girl or guy who knew about the country', 'that guy that I also thought was a Pole' – and the most intimate, as we will see shortly. Communication media varied accordingly. They were used with subtle discretion to carefully negotiate social and cultural boundaries, one infinitesimal step at a time:

> And then it was almost a year after we started talking. ... I don't know, maybe I was bored again or I had other problems in my life when I decided again, well, what's this guy, let's hear his voice. Let's make him a real thing rather just an Internet header. So I asked him, may I give you a call and he said yes. I was a little shy, because I knew nothing about his *private* [emphasis mine] life. You don't want to intrude into somebody's life and we were just friends, not even friends, not even close friends. But he said 'yes' and I call him, and I talk to this guy who happens to have an accent, we talked about some rubbish, I guess. I don't even remember, nobody would have guessed then that things would get ...
>
> (Myra)

As the story progressed, the phone conversations between the two of them became a regular event, alternated with hours-long Internet chats, emails and again hours-long phone conversations. Then, pictures were exchanged, then a marriage proposal from him came by email in the form of a joke: 'And it was easier to make that joke on the Internet than on the phone' (Patrick). Then, 'things started getting more and more romantic' (Myra). And finally, a visit was arranged:

Myra: At the beginning of March of 1997 I came to Vancouver. We met at the airport and that was it.

Maria: How did you find each other after having had all the correspondence? Did reality change your image of the other person?

Patrick and Myra: No.

Myra: I remember that I was very tense, of course.

Patrick: Me too [unclear].

Myra: I remember I got through the gates. The first thing that I saw was him. He was coming to-wards me. We just hugged and we kept walking. I was talking all the time because otherwise I would explode. It was my usual way of talking – making fun of everything including myself. He was used to that, I guess. He wasn't surprised that I was behaving ...

Maria: How long did it take from the first time you exchanged messages to that moment?

Myra: A year and a half.

As I explained earlier, in Sandy's story the interaction in the semi-public space of the chat room consisted of 'mostly goofing around, telling cracking jokes'. In the private background however joking was turning into deeply intimate revelations:

> Roland's and my relationship was mostly joking around, but we at some point, got quite deep into his relationship with his wife and my relationship with my husband. … He was married and going through really tough times with his wife, so he and I got really good friends and we emailed each other back and forth every day and just having that relationship with him made me feel alive! And made me realize how much really I had going for me because after my husband diminished my self worth and self respect so low …
>
> (Sandy)

Sandy walked all the way from 'cracking jokes' in public to a romantic relationship with one of her new friends from the chat group. The dynamic of the story of that relationship was similar to Myra and Patrick's – long chats, coming to know each other's life stories in detail, exchange of pictures, finally a face-to-face meeting. The ending of it all however was not quite so happy as in the previous case. Sandy's partner, CK, had taken advantage of the manipulative powers of the Internet, to lead numerous women into believing that each of them was the only one he was attracted to and exchanged intimate correspondence with. A discovery Sandy made by accident on his computer, opened her eyes to the fact that CK's compassion and caring had been shared with many other women all over North America at exactly the same time when their romance was in full swing. In a theoretically quite interesting move, Sandy chose to publicize her deeply private pain. Enraged, she sent a message to these women explaining what CK was actually doing, thus creating a powerful, even if short-lived, united front against the trickster: 'None of them [the women she emailed] hated me, they were really angry with him. He took some pretty big flak over it.'

In the context of her disease-related mailing list having hundreds of readers and dozens of contributors all around the world, Ellen also traversed a spiral of public to private and back to public communications. Initially, she was 'intimidated by the very hugeness' of the list and did not feel confident enough to contribute. However, in the midst of the big group discussion, after a while, Ellen would notice people that she 'would resonate with': 'I would find myself looking through the list of messages for their names – just to see whether they have written that day.' And finally one day, she contacted a couple of people through the so-called 'back channels', sending private emails. This contact coincided with the creation of a new sub-list by one of the women Ellen had gotten in touch with. So, about 17 people, who had found through the big list that they shared similar interests and approaches to healing, formed a 'semi-private' group branching off from the open public forum and initially exchanged carbon copied emails with each other.

As the interest in that group turned out to be quite high, after some time it had to be transformed into a new 'official', as Ellen put it, mailing list based on a server at St John's University in Boston. This meant that from a closed 'private discussion', the list was going back into the public realm where everyone could read and join it. Some members feared that this would compromise the quality of the exchange, as well as the openness and the depth of the interpersonal sharing. The group deliberated on the problem and finally decided that it was 'the idea of keeping it private versus having new blood, and new information, and new ideas. Also importantly, being able to offer what we had to more people.' They chose publicness and initially Ellen was ambivalent about it:

I felt very uncomfortable with the idea of becoming public. I wasn't sure I could continue posting because I am a very, very private person. I don't like the feeling of being on stage. It is a very personal medium – I find that people write very personal messages. They really reveal themselves very deeply.

(Ellen)

Eventually, feeling that the characteristic 'very nice atmosphere and a sense of camaraderie and common ground' of the list was preserved Ellen overcame her reservations and continued to be an active contributor. Thus, after finding reaffirmation of her interests and values in other individuals, and later in a close in-group, Ellen took her deeply private thoughts and sensations out of her walk-in closet (where her old Mac was located) and came out on the stage of the public realm empowered as an actor. After some time on the new list, someone suggested that the members exchange personal biographies. This made Ellen reflect on the dialectic of public and private, self-presentation and knowledge of the other person in the online environment:

I found it so fascinating to read – first of all, what everyone chooses to say about themselves; and also think about what I want to convey about myself – here I am in this unique online environment where I can't be seen, I can't be heard and yet I want to convey something about myself. ... I kept them all. So that gave more of a sense of the individual lives and of being a group.

(Ellen)

What this public–private–intimate continuum helps us realize is that, as with the consumption versus community continuum, there is no critical point where a person's or a group's behaviour can be definitively characterized as private as opposed to public and vice versa. People plan and experience their social action as combining privacy and publicness in different proportions. The task typically assigned to the Internet is to bring the determination of this proportion under the user's control. To whom do I want to listen; whom do I want to talk to; whom do I allow to listen to me? For and with whom do I want to act; who do I allow to act upon me; how big and open a collectivity do I want to act with? The different answers individual users give (more or less consciously) to these questions lead them to choose individual, 'private' email or a dozen of 'carbon copies', a posting to a closed or to an open mailing list, 'lurking' in a newsgroup or contributing to one; joining a mailing list, or, in fact, creating and moderating one (Matthew in my respondent group).

If we look closely at the examples of Myra's and Ellen's behaviour, we will recognize the multidimensionality of the notions of private and public that emanate from them. There are at least three senses in which publicness and privacy are perceived and respectively manipulated online – in terms of the forum, or space of gathering; in terms of the content of the communication; and in terms of the action taken – does it affect others or is it performed in perfect privacy within the lair of the skull, as Anderson (1984) has put it describing the act of reading the newspaper. What emerges is a multidimensional scale on which privacy and publicness of social action can be gauged. At all points along the way in the processes of encountering others and interacting with them online people are located in their private homes. From this position, they turn themselves, initially as simple consumers/readers, to forums that are public. Later, they reach out – to another private individual, sending him/her content that can itself be classified as dealing with issues of public concern or the opposite – with private issues. Thus all three components into which I have subdivided the process analytically – forum, action and content – can be perceived as either public or private, and people carefully select the degree of openness of

each component they want to permit at any particular moment. In this way the practice of immobile socialization allows an infinitely diverse range of forms of interpersonal interaction, collective life and, public participation to proliferate.

Conclusion

In this article I have attempted to display the limitations of a dichotomous understanding of online communication as well as of the normatively charged and vaguely defined concept of community as the standard against which social practice on the Internet is judged. Users approach the medium, as my data have shown, from a variety of situational motivations, needs and ideologies. In doing that, they generate a rich repertory of use genres, each of which needs careful consideration and evaluation on its own merits. The preoccupation with ideologically constructed standards, such as virtual community versus real/genuine community and public participation versus privatization of experience, blinds commentators to the possibility of new, unexpected, unimaginable and yet humanist and empowering variations of technological practice to emerge.

It is my belief that the careful examination of actual Internet use in its numerous forms should be organized by the task of discerning, recognizing and articulating the empowering aspects of the technology as they arise out of the everyday lives of real people in particular situations. A struggle to direct resources towards the further development and reinforcement of these aspects of the Internet as a technology and a social institution can start from there.

A quote I found in Schutz's (1964) *Collected Papers* helped me summarize what my at times confusing journey through my respondents' social actions on the Internet had in fact helped me discover. In the conclusion of his analysis of Mozart's musical contribution Schutz writes:

> I submit that Mozart's main topic is not, as Cohen believed, love. It is the metaphysical mystery of the existence of a human universe of pure sociality, the exploration of the manifold forms in which man meets his fellow-man and acquires knowledge of him. The encounter of man with man within the human world is Mozart's main concern. This explains the perfect humanity of his art.
>
> (Schutz, 1964: 199)

My study of the communicative and communal use of the Internet has uncovered a fascinating variety of forms in which individuals meet their fellow men and women, and acquire knowledge of them opening up thanks to the new medium. The encounter of the person with the Other, in singular and plural, within the human world; the filling of erstwhile regions of anonymity with detailed knowledge of the fellow human is one of the most exciting promises of the Internet. Discovering and promoting these manifold forms of human encounter in a new technological environment is, I believe, the central task of a socially responsible study and shaping of the Internet.

Notes

1. The call for participation in the study and a description of the research procedures can be viewed at http://www.ucalgary.ca/~bakardji/call.html.
2. Vancouver Community Network.

References

Abbate, J.E. (1994) 'From Arpanet to Internet: A History of ARPA-sponsored Computer Networks, 1966–1988', unpublished PhD dissertation, University of Pennsylvania.

Anderson, B. (1983) *Imagined Communities: Reflections on the Origin and Spread of Nationalism*. London: Verso.

Borgmann, A. (1992) *Crossing the Postmodern Divide*. Chicago: University of Chicago Press.

Dreyfus, H.L. (1998) *Kierkegaard on the Internet: Anonymity vs. Commitment in the Present Age*. Online, available at http://socrates.berkeley.edu/~frege/dreyfus/Kierkegaard.html, viewed 30 January 2000.

Hiltz, R. and M. Turoff (1978) *The Network Nation: Human Communication via Computer*. London: Addison Wesley.

Jones, S.G. (ed.) (1995) *CyberSociety: Computer-mediated Communication and Community*. Thousand Oaks, CA: Sage Publications.

Jones, S.G. (ed.) (1997) *Virtual Culture: Identity and Communication in Cybersociety*. London and Thousand Oaks, CA: Sage Publications.

Kumar, K. (1995) *From Post-industrial to Post-modern Society: New Theories of the Contemporary World*. Cambridge, MA: Blackwell.

Licklider, J.C.R. and R.W. Taylor (1968) 'The Computer as a Communication Device', *Science & Technology* 76: 21–31.

Postman, N. (1992) *Technopoly: The Surrender of Culture to Technology*. New York: Knopf.

Rheingold, H. (1993) *The Virtual Community: Homesteading on the Electronic Frontier*. Reading, MA: Addison-Wesley.

Schutz, A. (1964) *Collected Papers II: Studies in Social Theory*. The Hague: Martinus Nijhoff.

Schutz. A. and T. Luckmann (1973) *The Structures of the Life-world*. Evanston, IL: North-Western University Press.

Slouka, M. (1995) *War of the Worlds: Cyberspace and the High-tech Assault on Reality*. New York: Basic Books.

Turkle, S. (1995) *Life on the Screen: Identity in the Age of the Internet*. New York: Simon and Schuster.

Weintraub, J. (1997) 'The Theory and Politics of the Public/Private Distinction', pp. 1–42 in J. Weintraub and K. Kumar (eds) *Public and Private in Thought and Practice: Perspectives on a Grand Dichotomy*. Chicago, IL and London: University of Chicago Press.

Wellman, B. (1979) 'The Community Question: The Intimate Networks of East Yorkers', *American Journal of Sociology* 84(5): 1201–29.

Wellman, B. (1988). 'The Community Question Reevaluated', in M.P. Smith (ed.) *Power, Community and the City*. New Brunswick, NJ: Transaction Books.

Wellman, B. and M. Gulia (1999) 'Net-surfers Don't Ride Alone: Virtual Communities as Communities', pp. 331–66 in B. Wellman (ed.) *Networks in the Global Village: Life in Contemporary Communities*. Boulder, CO and Oxford: Westview Press.

Williams, R. (1974) *Television: Technology and Cultural Form*. London: Fontana.

Williams, R. (1985) *Keywords: A Vocabulary of Culture and Society*. New York: Oxford University Press.

David Bell

WEBS AS PEGS

THE LENGTHY AND OFTEN HEATED DEBATE on "on-line community" is, as this essay argues, often an argument about either (a) the fate of community today, or (b) the effects of technology on social relations. While the arguments against virtual community tend to start from the "bowling alone" position (accepting that community in its "traditional" sense has disappeared, is disappearing, or is under the threat of disappearance in contemporary society), there is a need to move on from this in order to think more productively about the contemporary constitution of community, especially in relation to new communications technologies. To that end, this chapter has a number of springboards. The first is Bauman's dismissal of many contemporary forms of something-like-community as "peg communities" – as coat pegs on which we choose to temporarily hang parts of our identities. The second is Miller's formulation of "webs as traps" – an investigation of the ways in which the aesthetics of the web interface are used to capture the attention of passing surfers. The third is Bakardjieva's discussion of "immobile socialization" in relation to how on-line community participants weave on-line and off-line parts of their everyday lives (and everyday communities) together. Finally, the essay returns to Bauman but then applies some of Giddens' ideas about intimacy, to suggest that "peg communities" could be recast as "pure communities," and through that discussion, to move towards a call for a more useful, contextual, less polemical debate about (virtual) community.

In this essay, I want to ask – and begin to answer – some fundamental questions that are reverberating around discussions of the meaning and status of community in the world today, especially in relation to the impacts of media and communications technologies. The first is: What are we arguing about when we're arguing about virtual community? My initial response would be to say that we are arguing about two things. First, we're arguing about *communities* – what are they? Are they in decline? Why? Second, we are also arguing about *technology* – what is it doing to social relations? To communities? Is it good or bad?

As good a place as any to begin is with debates on virtual communities, which all too often tend to start from the "bowling alone" position (Putnam, 2001) – lamenting the death of old-style community bonds – and then move to ask what role technology is having or can have as cause or solution to that problem. While "community" is always the solution to the "problem of community," the jury's still out on whether technology is part of the problem or can be part of the answer-to-the-problem. Whichever, the starting-point that "real-life" (RL) communities are in decline sets the terms of the debate on a certain trajectory, in which the lost object of community is too-often relatively uncontested; it's taken for granted that communities used to be certain things, and that they aren't the same as they used to be (for a useful sketch of the terms of the virtual community debate, see Bakardjieva, 2003). The question then turns to whether this is a good thing or a bad thing.

For some commentators, in this formulation virtual communities are augmenting or standing-in for RL communities, even improving on them – where RL membership was related to accidents of geography, virtual membership is elective and selective, meaning we can each make our own perfect community, a patchwork of our interests and affiliations. This is perhaps most memorably sketched by Howard Rheingold:

> In cyberspace we chat and argue, engage in intellectual intercourse, perform acts of commerce, exchange knowledge, share emotional support, make plans, brainstorm, gossip, feud, fall in love, find friends and lose them, play games and metagames, flirt, create a little high art and a lot of idle talk. We do everything people do when they get together, but we do it with words on computer screens, leaving our bodies behind. Millions of us have already built communities where our identities commingle and interact electronically, independent of local time or location.
>
> (1999: 414)

In this formulation, as in many other pronouncements by Rheingold and his likeminds, virtual communities are seen as enhancing and in some cases replacing "real life" communities perceived to have declined in the modern world. This statement therefore typifies one strand of commentary on the virtues of virtual community.

For other commentators, however, the patchiness and electiveness of virtual communities means these are insubstantial non-communities, loose and ephemeral interest groups, hobbyists' clubs. Virtual communities lack the durability and longevity, the density and intensity of RL communities, this argument says – it's almost like they're too easy, they don't require the work of getting on with your neighbours, since everyone and no-one's your neighbour. That argument, however, denies many things, including the very real labour of building and sustaining virtual communities, itself part of the bigger issue of the myth of "free labour" in cyberspace – critiqued by the likes of Andrew Ross (1998) and Tiziana Terranova (2000). The other problem with this line of criticism, as Ash Amin and Nigel Thrift (2003: 41) write, is that it contains "a certain nostalgia for a way of life which has bypassed the actual history of the past in order to critique the symptoms of the present." We certainly need to move beyond that kind of simplistic formulation – while also being mindful of the popular circulation of a particular repertoire of pro-community discourses, of which more below (and see Raco, 2003; Taylor, 2000).

Of course, not everyone's so naively romantic. As some other commentators say, this mythic RL cosy community no longer exists (if it ever did) for lots of us – our communities are already virtual, sustained by phone calls, car trips, airmail, photo albums. Mobility makes a nonsense of the image of slowly-built-up, densely interwoven communities: more and more people are patching together something-like-community as they move through space

on the trajectories of their lifecourse – trajectories with different rhythms and temporalities. As mobility comes to define the social world in ever more intricate and complex ways, so we need to rethink what community means for mobile selves and mobile societies (Urry, 2000).

In this regard, virtual communities might be thought of as *more* durable and sustainable, since membership can be retained in spite of movement, or even because of movement – witness, for example, the ways that western round-the-world travellers use virtual formats such as weblogs to connect to each other, and also to reconnect to "home" (Germann Molz, 2004), or the use of cyberspace among "diasporic" communities (see, for example, Mitra, 2000). This means, I think, that we need to shift the ways in which terms like durability and ephemerality are indexed in discussions of community and of technology. Some critics, for instance, make a mockery of ideas like "electronic intimacy," arguing that it's an impossibility, a con-trick caused by the seduction of new technology as a way of filling the lack of RL connection in our go-faster lives (see, for example, Sardar, 2000). But we are happy with some forms of mediation – the love letter or the local newspaper, say. Trying to think through the continued reluctance of some commentators to acknowledge online or virtual communities as communities brings the question back to *technology*, and to the issue of delegation.

An understanding of the broader roles of technology in social life can, I think, aid us in finding a way through (or beyond) the simplistic denunciations and celebrations of virtual community. As a starting point, let's turn to Bruno Latour (1991), who famously wrote that *technology is society made durable* – that human societies are held in place by all sorts of nonhumans (things like tools or written words), to which we delegate tasks. Human societies are held together, Latour argues, by virtue of our ability (and willingness) to delegate some of the roles and responsibilities of "social work" to artefacts. We don't need everyone co-present to keep a community alive, as much of this work can be carried out by objects of various sorts. So, to put a spin on Latour, could we also ask whether technology likewise makes *community* more durable? What types of delegation occur in building and sustaining communities? In a way, virtual communities are much easier to read from this perspective – the delegation to a website, or a blog, or a chat room. As Smith and Kollock (1999) say, software is the infrastructure of the virtual community. So, while individual membership and active participation may be ephemeral and shifting – though at the same time intense and vibrant – there is something there that's more durable, a conduit through which the ebb and flow of membership is funnelled, and an infrastructure that exists alongside the human members of any online community. This infrastructure includes both hardware and software, plus codes of conduct (both formal and tacit), which taken together constitute the "delegates" tasked with maintaining the community.

To look at the question from a different angle, then: what makes RL communities durable? It seems to me, in many ways, that they are *talked into durability* – they continue to exist because their members keep them going. In that sense, the two types of community don't seem that different "RL" communities may be sedimented in place, memorialized in houses and streets, or institutionalized in community halls, but these are mere traces, equally like conduits: as many of us will have experienced, a community hall does not a community make. In this regard, James Slevin (2000: 94) talks about how RL communities have been wrapped in a "cloak of permanence," almost willed into existence and continuity because the alternative – the absence of community – is so threatening or unthinkable. But all communities are *flows*, whatever their rhythms and temporalities; as Amin and Thrift (2003: 47) put it, what we're talking about here is "the community of taking place, not the community of place;" or, to use their spin on bell hooks' (1991: 147) formulation,

community "is no longer one place, it is *locations*." Yet something resists this rewriting of community, reinstating the cloak of permanence in order to dismiss more footloose, mobile or virtual collectivities as something-less-than-communities. In part this resistance stems from what are constructed as incompatibilities between transformations in contemporary social life and the enduring ideal-type model of community. And this ideal-type continues to insist on the idea of propinquity – of physical proximity between (human) members; as Mike Raco (2003: 247) notes, discussing contemporary UK policy, "area-based communities are still the object of government." There is a clear sense of what constitutes a "proper" community, therefore – despite attempts at a more expansive definition, for example in the increasing use of the term "community of interest."

At the top of a lot of people's agendas, in terms of arguing for the negative effects of transformations in contemporary life-patterns on the ideal of community, is *individualization* (see Bell, 2001). Zygmunt Bauman (2001) writes that individualization means, among many (negative) things, that we now seek biographical solutions to systemic problems – that we turn to therapy instead of politics (see also Furedi, 2004). Communities based around fears, problems and anxieties aren't really communities, Bauman argues, because they are too narrow and instrumental, as problems and fears have themselves been individualized: "Troubles," he writes "are singularly unfit for cumulation into a community of interests which seeks collective solutions to individual troubles" (86). But, we might suggest that virtual communities – at least as they are sketched by some of their supporters – do allow biographical connectivities that can collectively address systemic problems; for example, in the case of what we might call "illness" or "patient communities," online self-help groups who share information and experience, and sometimes get to intervene in health policy and practice (see, for example, Orgad, 2004).

But the individualization thesis leads Bauman to critique many contemporary forms of something-like-community as "*peg communities*:" sites where people can hang their interests or obsessions, their enthusiasms or worries, and around which they can – or might – try to build up something collective, albeit instrumentally and ephemerally. The "peg" here is a coat peg, a place to casually hang your coat or hat, for now. Part of the perceived problem with peg communities, of course, is their very coat-pegginess, their elective ephemerality, or what Bauman names their "superficial and perfunctory, as well as transient ... bonds" (71). These characteristics lead Bauman to label the bonds between members of peg communities as "bonds without consequences" (ibid.) – very little is invested in or expected from the bonds between peg community members; moreover, the bonds "tend to evaporate when human bonds truly matter" (ibid.).

Reading through Bauman's gloomy prognosis on community, I was struck by a number of things. Among the most prominent was this emphasis on bonds, on consequences, on durability rather than ephemerality. Breaking up identity into a set of hats or coats, and hanging them temporarily on a succession of pegs (presumably without having to pay a cloakroom fee) means, for Bauman, that notions such as virtual community are nonsensical. But I wanted to find a different take on peg communities, one that might value the pegginess rather than dismiss it so easily. One direction my pondering took me was to Danny Miller's (2000) excellent discussion of websites as traps. Based on his ethnographic work on Internet use in Trinidad, Miller theorizes websites as "aesthetic traps," exploring how homepages are constructed in order to attract potential surfers in, through the aesthetics of web design, usability, links and so on. While the main focus of his work is very different from the line of argument I am trying to make here, considering homepages as sites where particular kinds of (individual and collective) identity work take place, seemed to suggest that webs are particularly *good* pegs, good places to hang bits-of-identity onto (see also

Cheung, 2000). This depends, of course, on accepting that we are all made up of bits-of-identity that need pegs – something which the emerging cyberculture is persuasively argued to be facilitating (see for example Castells, 1996; Turkle, 1997). So, what happens if we try to read webs as pegs more productively? How might we begin to rethink (web) peg communities away from Bauman's peg-scepticism?

Another line of thinking that I want to begin to explore here arose as I found myself disagreeing with Bauman's formulation of peg communities as representing "a togetherness of loners" (68), another dig at the effects of individualization on the (im)possibility of community. Continuing his forceful critique of peg communities, Bauman writes of the bonds that connect people together in these forums:

> The bonds are friable and short-lived. Since it is understood and has been agreed beforehand that they can be shaken off on demand, such bonds also cause little inconvenience and arouse little or no fear … they are, literally, "bonds without consequences."
>
> (Bauman, 2001: 69)

Now, this statement resonated in my mind with another grand social theorist's discussion of contemporary social relations: Anthony Giddens' (1992) *The Transformation of Intimacy*. So, if we cross over to Giddens for a moment, we can perhaps begin to get a different reading on matters. Particularly relevant is Giddens' discussion of the "pure relationship" – a new form of sexual contract entered into by couples today, freed from the traditional obligations of marriage and so on. The pure relationship is defined by Giddens as:

> a situation where a social relation is entered into for its own sake, for what can be derived by each person from a sustained association with another; and which is continued only in so far as it is thought by both parties to deliver enough satisfactions for each individual to stay within it.
>
> (Giddens, 1992: 58)

Giddens ties the rise of the pure relationship to the "project of the self" – a new mode of living which emphasises both individualization and detraditionalization, and which involves continuous reflexivity and self-scrutiny; we daily look at our own lives, our relationships, our place in the world, and ask whether or not we are satisfied, even happy. This constant monitoring prompts us to work on our selves, to attempt to find the "best" lifestyle and life-path for each of us – aided along the way by the burgeoning self-help industry. In entering into intimate relationships on the basis of this heightened reflexivity, it is understood and has been agreed beforehand (to echo Bauman) that the relationship can change, even dissolve, if either partner decides it is no longer providing the life benefits they require. For Giddens this is a radical and liberating transformation, making over the couple form as an experimental, reflexive unit, better able to negotiate the other forcefields of contemporary life.

So, might it be possible to rewrite peg communities as *pure communities*, in the way Giddens does for relationships – as collectivities entered into with eyes-wide-open, not stumbled into blinded by tradition and obligation? If our closest intimate and interpersonal relationships have been so radically transformed, should we expect other dimensions of individual and collective life to be unaffected by the sea changes that reflexivity, detraditionalization and so on bring about? What Manuel Castells (1996: 357) calls "the multipersonalization of CMC" seems to resonate with Giddens' reflexive self-identity, with working on bits of the self as an ongoing project. Such identity work surely demands a rewiring of community.

This begs a further question: if reflexivity, detraditionalization, and so on are cast as good for intimate relations, *a la* Giddens, then why are they cast as *bad* for social relations?

One reason is highlighted by Slevin (2000: 99): that the electivity of online communities – the opt-in and opt-out clauses, the *smorgasbord* of choice offered by the endlessly proliferating virtual communities blooming in cyberspace – may lead to the return of an "obsessive parochiality," as communities fracture into sub-communities and sub-sub-communities, and as communities coalesce around anything and everything, as Sardar (2000: 743) quipped about the "community of accountants" formed around a newsgroup (to him, the epitome of a non-community or nonsense-community), adding tartly that "a cyberspace community is self-selecting, exactly what a real community is not; it is contingent and transitory, depending on a shared interest of those with the attention span of a thirty-second soundbite" (744). Countering this, Slevin argues that reflexivity *does* make virtual communities something-like-pure, in that:

> When individuals use the internet to establish and sustain communal relationships, they do so as intelligent agents. … they know a great deal about the properties of the technical medium and about the constraints and capabilities afforded by the institutional contexts in which they deploy it. Nevertheless, such knowledgeability is always bounded. First, a good deal of their knowledge is tacit and made out of experience. Second, they are neither fully aware of the social and historical conditions of the production, circulation and reception, nor ever fully aware of the consequences of their actions.
>
> (Slevin, 2000: 109–10)

Even the boundedness and contingency of this formula seems preferable to the accident-by-geography of RL communities, doesn't it? How much of those "social and historical conditions," or "consequences of their actions," are RL community members really aware of?

Now, one key point made by Slevin, and by others, is this question: *are we only in online communities when we are on line?* Looking at threads of chat, Slevin shows the in-and-outiness of individual members, but argues this should not be seen as evidence of lack of involvement – just as members of RL communities don't need to be continually doing "community work" in order to sustain their membership. Again, what this means is that we need a new index of community participation. Being a member of any community necessitates a sliding-scale of involvement, ebbs and flows of "community work," differential balancings of rights and obligations. It just seems too easy to argue, today, that *Gesellschaft* is still such a negative thing, and too naïve to retain the utopian dream of *Gemeinschaft*. Our communities are mobile, multiple and often mediated – but this doesn't make them weak or thin.

Further, we need to find a way to get beyond the unhelpful RL/virtual dichotomy, including in the ways we think about community. If we take the position that all our communities are more-or-less virtual or mediated, more-or-less delegated to nonhumans – whether software or architecture or a community strategy and a posse of community wardens – then we can better see the ways people build and sustain communities out of all kinds of interactions between human and nonhuman others. On this point, Amin and Thrift (2003: 45) rightly point out that we need to think about how "non-human objects now act with humans in ways which are not subordinate and which challenge accepted notions of reciprocity and solidarity:" humans and nonhumans intertwine in complex ways that make a nonsense of forcing a RL/virtual separation. Once we accept that communities aren't just about people, then arguments about the weakness of communal bonds in virtual communities lose their power. While supporters of virtual communities have had to argue

long and loud that "communities rarely exist exclusively in cyberspace ... [and that] social groups in cyberspace spill out into the 'real world' and vice versa" (Kollock and Smith, 1999: 19), it seems that proponents of the importance of "real world" communities – especially those speaking in a political and policy context – take it as read that people have differential investments in their RL communities, and that all that needs encouraging is the opportunity to put in and take out resources of all kinds, to "build capacity" and to enhance the cohesiveness and sustainability of communities (Taylor, 2000).

Maria Bakardjieva (2003) has written persuasively on the spilling over between virtual and RL community involvement. She wants to situate virtual community membership in the everyday lives of people who live on- and off-line, and she coins the term *immobile socialization* – a reversal of Raymond Williams' (1974) mobile privatization, his discussion of the nuking of the family by the suburb, the car and the telly – to capture what's going on in "virtual togetherness" (the term she uses to sidestep using "community" with all its attendant baggage). Her interest is in types of involvement – and she makes her own typology, based on her empirical findings, from the "passive" infosumer, to the instrumental user, to the chatter(er), to the communitarian. This typology spans the poles, as she says, from consumption to community (though I think she might undervalue consumption somewhat, seeing it as too straightforwardly passive – on a useful and more productive reading of online shopping, see Zukin, 2004).

Crucially, however, her typology is also matched by a *gradient* of intimacy, of publicness and privateness. Again, this suggests a pretty Giddens-like emphasis on mutual disclosure and trust as making communities "pure" – but here I'm reminded of Lynn Jamieson's (1999) insightful counter to Giddens, empirically finding the value of selective silences in relationships. In this regard, Bakardjieva shows how her respondents on-goingly negotiate elective and selective publicity and privacy, as part of their reflexive engagement with all the communities they participate in (and not always with positive consequences – trust and risk are the twins at the heart of these arrangements, again echoing Giddens). What's important about Bakardjieva's work is the way it locates community participation in everyday life, online and off – in a way that attempts to flatten that distinction, to resist the more polemic versions of communo-technophilia or -phobia. Instead of seeing virtual community members as bunkered in, she sees them as weaving segments of their lives together into patchwork communities that are in part sustained by talk, part sustained by delegation to a variety of nonhumans, and *lived out*. And in their discussion of communities in contemporary cities, Amin and Thrift (2003: 47) similarly focus on everyday life itself as a kind-of-community, full of "all kinds of untoward localizations and intricate mixtures."

One central point about Bakardjieva's essay is that she sidesteps what she names the "not particularly productive ideological exchange" (294) that makes up much of the debate on virtual community. Now, this seems very sensible, and I've made similar arguments myself, testing out the usefulness of the term *Bund* – borrowed from Kevin Hetherington's (1998) work on new social movements – to get us out of the virtual community impasse (see Bell, 2001). I also asked why we *want* to see communities in cyberspace; whether we have a will-to-community that makes us want to corral enthusiasms, market segments, subcultures into communities. I even suggested that the widely-circulating death-of-community or bowling-alone discourse creates an ambient fear, which prompts us all to panic into seeing communities all around us, to reassure us. So, does this mean, to ask yet another question, that we *should stop talking about virtual communities*?

On one level, to jettison "community" as a word to describe particular social relations in the contemporary world makes so much sense, given the impasse that Bakardjieva and others point to – we're in a kind of theoretical dead-end, being shouted out by virtual

community enthusiasts in one ear, and naysayers in the other. But we have to look, I think, at the continued currency of the term community outside our worlds. This point was brought home to me very vividly in a heated workplace debate about renaming our academic faculty, when a new name was suggested with the word "community" in it. My colleagues fussed and worried about the complexities of the word, about its contested and endlessly deferred meanings. We're so used to worrying about meaning. (In the end, it was decided not to have community in the new faculty name.) But the word is very much alive outside our meaning-anxious, deconstructive mindsets. In popular discourse, and in policy discourse, community is relatively uncontested, undeconstructed (for a discussion, see Taylor, 2000). We have community strategies, community forums, community facilitators, attempts to promote community cohesion – all manner of human and nonhuman community delegates busily working on building and sustaining communities. In cyberspace, too, there's a lot of community talk, a lot of which is powerfully utopian about the possibilities for new forms of collectivity freed from the limitations of physical space (see, for example, Rheingold, 1993).

Now, to return to academia's uneasy relationship with this word, we might say that it's our job to worry about such things, and that there is much to value in questioning the received meanings and commonsense uses of key words like community. That's all well and good – and many careers have been built on such foundations – but it can be equally disabling, if it means we expend all our energies worrying and have no time left to get down to business – and, of course, we are increasingly compelled to get down to business, given the contemporary context of the "entrepreneurial university," keen to tap streams of community funding for its "third stream" income (Lazzeroni and Piccaluga, 2003). If community is such a ubiquitous word outside our ivory towers, we have to find ways to work with it, to engage with communities, given the very high priority given to "community" on agendas both inside and outside the academy (Chatterton, 2000).

Looking at some of the empirical case studies provided in Kollock and Smith's (1999) excellent collection *Communities in Cyberspace*, or reading Doug Schuler's (1996) account of community cyberspaces in Seattle, makes me more inclined to say: *Stop worrying! Get over it!* It's good work, to be sure, to point out how difficult and slippery the term community is – to slow down the will-to-community, to ask what's at stake in trying to find communities or build communities everywhere. And I'm certainly not sure we have to agree that something's a community just because some people say it is – we need better benchmarks than that. But, at the same time, who are we to say that what someone names a community *isn't* what we think a community should look like? That's what worries me about some of the naysayers, like Kevin Robins (1999, 2000) or Zia Sardar (2000), who I have engaged with before (see Bell, 2001). At the end of the day – and I know this makes me sound like a "cultural technician" in Tony Bennett's (1992) sense – we need our deliberations on community to be *useful*, not just clever. And in that spirit, I fully concur with Amin and Thrift's statement, which seems a fitting place to conclude my discussion:

> Though we are still the heirs of *Gemeinschaft* and *Gesellschaft*, we are moving towards a different, more restless and more dispersed, vocabulary through a constant struggle over the three Rs of [urban] life: new social Relationships, new means of Representation, and new means of Resistance. Together, the experiments with these three Rs may add up to new, more "distanciated" modes of belonging, which we can now at least glimpse.
>
> (Amin and Thrift, 2003: 48)

Works cited

Amin, A and Thrift, N. 2003. *Cities: Reimagining the Urban*. Cambridge: Polity Press.

Bakardjieva, M. 2003. "Virtual Togetherness: An Everyday-Life Perspective." *Media, Culture & Society* 25: 291–313.

Bauman, Z. 2001. *Community: Seeking Safety in an Insecure World*. Cambridge: Polity Press.

Bell, D. 2001. *An Introduction to Cybercultures*. London: Routledge.

Bennett, T. 1992. "Putting Policy into Cultural Studies." In Grossberg, L., Nelson, C. and Treichler, P. (eds) *Cultural Studies*. London: Routledge. 23–37.

Castells, M. 1996. *The Rise of the Network Society*. Oxford: Blackwell.

Chatterton, P. 2000. "The Cultural Role of Universities in the Community: Revisiting the University-Community Debate." *Environment and Planning A* 32: 165–81.

Cheung, C. 2000. "Identity Construction and Self-Presentation on Personal Homepages: Emancipatory Potentials and Reality Constraints." In Gauntlett, D. and Horsley, R. (eds) *Web. Studies*. Second Edition. London: Arnold. 53–68.

Furedi, F. 2004. *Therapy Culture: Cultivating Vulnerability in an Uncertain Age*. London: Routledge.

Germann Molz, J. 2004. "Playing Online and Between the Lines: Round-the-World Websites as Virtual Places to Play." In Sheller, M. and Urry, J. (eds) *Tourism Mobilities: Places to Play, Places in Play*. London: Routledge. 169–80

Giddens, A. 1992. *The Transformation of Intimacy: Sexuality, Love and Eroticism in Modern Societies*. Cambridge: Polity Press.

Hetherington, K. 1998. *Expressions of Identity: Space, Performance, Politics*. London: Sage.

hooks, b. 1991. *Breaking Bread*. Boston, MA: South End Press.

Jamieson, L. 1999. "Intimacy Transformed? A Critical Look at the 'Pure Relationship.'" *Sociology* 33: 477–94.

Kollock, P. and Smith, M. 1999. "Communities in Cyberspace." In Smith, M. and Kollock, P (eds) *Communities in Cyberspace*. London: Routledge. 3–28.

Latour, B. 1991. "Technology Is Society Made Durable." In Law, J. (ed.) *A Sociology of Monsters*. London: Routledge.

Lazzeroni, M. and Piccaluga, A. 2003. "Towards the Entrepreneurial University." *Local Economy* 18: 38–48.

Miller, D. 2000. "The Fame of Trinis: Websites as Traps." *Journal of Material Culture* 5: 5–24.

Mitra, A. 2000. "Virtual Commonality: Looking for India on the Internet." In Bell, D. and Kennedy, B. (eds) *The Cybercultures Reader*. London: Routledge. 676–96.

Orgad, S. 2004. "Help Yourself: The World Wide Web as a Self-Help Agora." In Gauntlett, D. and Horsley, R. (eds) *Web.Studise*. Second Edition. London: Arnold. 146–57.

Putnam, R. 2001. *Bowling Alone: The Collapse and Revival of American Community*. New York: Simon and Schuster.

Raco, M. 2003. "New Labour, Community and the Future of Britain's Urban Renaissance." In Imrie, R. and Raco, M. (eds) *Urban Renaissance? New Labour, Community and Urban Policy*. Bristol: Policy Press. 235–250.

Rheingold, H. 1993. *The Virtual Community: Homesteading on the Electronic Frontier*. Reading, MA: Addison-Wesley.

Rheingold, H. 1999. "A Slice of Life in My Virtual Community." In Ludlow, P. (ed.) *High Noon in the Electronic Frontier: Conceptual Issues in Cyberspace*. Cambridge, MA: MIT Press.

Robins, K. 1999. "Against Virtual Community: For a Politics of Distance." *Angelaki* 4: 163–70.

——— 2000. "Cyberspace and the World We Live in." In Bell, D. and Kennedy, B. (eds) *The Cybercultures Reader*. London: Routledge. 77–95.

Ross, A. 1998. *Real Love: In Pursuit of Cultural Justice*. London: Routledge.

Sardar, Z. 2000. "alt.civilizations.faq: Cyberspace as the Darker Side of the West." In Bell, D. and Kennedy, B. (eds) *The Cybercultures Reader*. London: Routledge. 732–52.

Schuller, D. 1996. *New Community Networks: Wired for Change*. Reading, MA: Addison-Wesley.

Slevin, J. 2000. *The Internet and Society*. Cambridge: Polity.

Smith, M. and Kollock, P. Eds. 1999. *Communities in Cyberspace*. London: Routledge.

Taylor, M. 2000. "Communities in the Lead: Power, Organisational Capacity and Social Capital." *Urban Studies* 37: 1019–35.

Terranova, T. 2000. "Free Labor in Cyberspace." *Social Text* 63: 33–58.

Turkle, S. 1997. *Life on the Screen: Identity in the Age of the Internet*. London: Phoenix.

Urry, J. 2000. *Sociology Beyond Societies: Mobilities for the Twenty-first Century*. London: Routledge.

Williams, R. 1974. *Television: Technology and Cultural Form*. London: Fontana.

Zukin, S. 2004. *Points of Purchase*. London: Routledge.

Cyberidentities

David Bell

INTRODUCTION

IDENTITY CONTINUES TO BE A HOT TOPIC across a host of intellectual terrains – and in popular discourse, too – including those concerned with cybercultures. New technologies are variously seen as enabling of new identity formations, forms of 'identity play', and of critical examinations or deconstructions of notions of fixed, stable, essential identity: the certainty of the 'real me' is replaced by Sherry Turkle's (1996) uncertain question, 'Who am we?'. For other commentators, however, cyberspace re-establishes identity categories, perpetuating forms of identity politics founded on notions of inclusion and exclusion, insider and outsider. Indeed, new vectors of inclusion and exclusion are also propagated, it is argued, amplifying existing divisions and inequalities. The question of who we are in cyberculture thus continues to be contentious, and the five readings selected here illustrate some of the principal zones of contention.

Charles Cheung focuses on the personal homepage as a statement of identity. While we might see blogs as more significant than homepages today, there are commonalities in form and content between these two widely used forms of online identity work. Cheung sketches the diversity of forms (and motives behind) personal homepages, emphasizing the important creative work that goes into making their content. More importantly, he draws on social theorists such as Goffman and Giddens in order to understand how homepages work to perform personal identity online, to create and disseminate what he calls 'homepage selves'. This homepage self is a knowing projection of personal identity into cyberspace, a projection aimed at what Cheung labels the 'net public' – a public that comes into contact (or not) with homepages through search or surf methods, and who may 'meet' our homepage self (or not) by design or by happenstance.

As Cheung notes, this context for online 'meeting' makes the personal homepage a situated performance of the self, one embedded in understandings

about how a homepage will be read for clues about its author – both intentional and unintentional. Danny Miller (2000) has written about how websites work as 'aesthetic traps', designed to catch the attention of the passing web surfer. This attention-grabbing is achieved through both the design and the content of web pages: just as we work on our identities through the props and cues of our everyday lives – the clothes we wear, how we speak, and so on – so our homepage selves are self-conscious articulations of those attributes we wish to foreground, of how we hope we will be 'read'. Drawing on Giddens, Cheung notes how the greater 'freedom' to experiment with and work on self-identity also brings heightened risk: risk about being misinterpreted, or mis-identified by our net public. Hence, understanding personal homepages means thinking about practices of 'writing' and 'reading' identity. And the 'rewritability' of homepages means that we can continually revise and refine our online self-presentations, in an on-going quest to make our homepage selves feel like 'the real me' (or the ideal 'me-I-want-to-be').

Of course, the Internet has its own structuring limitations that shape the ways we can revise and refine identity, or the extent to which identity-play is 'free'. Internet access immediately installs exclusions, as does access to the skill and knowledge (not to mention time) needed to produce a 'good' homepage. The homepage is, as Miller showed, a powerful articulation of machine skill, of course – though, as Cheung notes, commercial tools are now widely available that make page-building much simpler (there is no longer any need to master HTML, for example). While the availability of such tools might be argued to have democratized page-building, Cheung suggests that it is also regulating and restricting content creation. Just as presentation tools like PowerPoint rely on templates that end up making everyone's thoughts take the same shape (see Turkle 2003), so templates for web pages narrow down aesthetic choices to presets. At the same time, commercial web space providers exercise control over content, narrowing down the topics as well as the look of homepages. However, Cheung holds on to the liberatory potential of homepage selves, basing his conclusion on the idea that personal identity has become a kind of 'problem' that cyberculture can help fix. This motif in fact recurs in the readings presented here.

The constitution and performance of personal identity is also at the heart of Alison Landsberg's essay, which explores the role of memory in making us who we are (or think we are). Landsberg uses the idea of implanted or 'prosthetic' memory to think through the linkages between memory, experience and self-identity, drawing on filmic representations such as *Total Recall* and *Blade Runner*. Her focus on film is foregrounded by the idea that cinema itself is a form of memory prosthesis, implanting in its audiences images and experiences that become memories. The first time I visited the USA, for example, I was struck by the familiarity of many of the icons of Americanness I was now seeing: the yellow taxi cabs, the steam rising from subway grates, the sights and sounds of the States. I experienced that familiarity as *remembering*: I had experienced these things many times before, via film and television. I was remembering a mediated memory, implanted by popular culture, but the sensation of recognition and

remembering was uncannily 'real'. As I grow older, and my memory strains more to keep hold of the past, so I find the distinction between 'real' and 'implanted' memories ever harder to maintain: have I been here before? (Or, as I was just worrying, have I *written this* before?)

Both *Total Recall* and *Blade Runner* play around with and unsettle notions of the 'real' and the 'fake', necessitating the scare quotes around each term. *Total Recall*'s narrative concerns identity tourism (a theme picked up in a very different context in Lisa Nakamura's essay), implanted memories, and their relationship not so much to the past, but to present and future actions. Memories work not nostalgically, therefore, but as part of the ongoing 'project of the self', the endless question of 'Who am I?' The central character in *Total Recall* buys a virtual adventure holiday, where prosthetic memories of being a secret agent are implanted. Later he is confronted by a recording of himself as a secret agent, suggesting that the person he thought he was, Quade, is in fact an implanted memory, and that he really is an agent, Hauser. Or as the recording says, "You are not you. You are me". *Blade Runner* also explores the relationship between memory and identity – specifically whether memory is what makes us human. Deckard, the central character, is a blade runner, a kind of cop whose job is to track down and 'retire' synthetic humanoids called replicants. He falls in love with Rachel, a replicant who thinks she is human because she has had memories implanted – and the film also hints that Deckard may himself be a replicant. Or, to be more accurate, one version of the movie makes that suggestion; there are, of course, two official versions of *Blade Runner* in circulation, the 'original' version which was subject to extensive revision by the studio, given a more 'Hollywood' ending, and the later director's cut, a longer version more 'faithful' to the director's intentions, and with its 'original' ending reinstalled. (In addition, the film has its origins at least in part in a science fiction story by Phillip K. Dick, *Do Androids Dream of Electric Sheep?*) Now, I know I have seen both versions of this film a number of times, and have a clear memory of once watching it in a London cinema with (I think) my friend Jon. I can recall key scenes and hear parts of the soundtrack; it has been woven into a narrative about who I am (I am always shocked to hear that students have never seen the film, a film with iconic status for my generation). But I'm unsure which version I am recalling, where the differences lie, and which version I enjoyed more. As Landsberg herself asks, pondering Quade/Hauser, 'is "realer" necessarily better?' What we remember may not be 'real', but the link between memory and identity remains central.

Like Quade's shopping for an experience via implanted memories, Lisa Nakamura's chapter explores the concept of identity tourism, though in a different context and with different implications. Nakamura's focus is LambdaMOO, a famous (or infamous) multi-user domain, or text-based online environment through which participants (MUDders) interact (see Bell 2001 for a fuller discussion). MUDs were a key site of early cybercultural experiment and critique which, though less significant today, have an important place in key debates such as those about identity. So while today's 'digital natives' may not be proficient MUDders, preferring blogging instead, spaces like LambdaMOO are of enduring critical interest.

Nakamura is concerned with the way in which online spaces like LambdaMOO encourage some forms of identity play while discouraging others. MUDs typically require that MUDders write a self-description: an account of how they want to be encountered in cyberspace. The origin of MUDs in role-playing games means that the format of these self-descriptions tends towards the fantastical, as MUDders imagine themselves as amazing people or creatures. Now, a key feature of identity play on sites like LambdaMOO is the possibility of gender-switching, of 'changing sex' online. LambdaMOO in fact enlarges the repertoire of genders to allow new virtual possibilities beyond those in 'RL' (the favoured term for offline or real life). And since interaction in LambdaMOO is entirely text-based, Nakamura writes that everyone is 'passing', performing (writing) an online identity that may not 'match a player's physical characteristics', as she puts it.

Self-descriptions on LambdaMOO open up possibilities for experimentation and play with some aspects of identity, yet Nakamura notes that race is virtually absent there, only mobilized via stereotypes or through an implicit 'whiteness'. As she says, any participants who choose to include non-white identity in their self-descriptions are 'seen as engaging in a form of hostile performance', making race an issue. Moreover, performances of race in LambdaMOO tend towards stereotypes – Asian identities are either kung fu action heroes or geishas, for example (see also Tsang 2000 on the eroticization of stereotyped Asian identities online). Those participants performing these modes of Asianness are assumed by Nakamura to be white 'identity tourists', enjoying a little recreational Asianness, like Quade's secret agent fantasy in *Total Recall*. Yet unlike *Total Recall*'s unsettling of 'real' identity, Nakamura maintains a sense of the 'real' (non-Asian) identity of LambdaMOO players. Identity tourism here is an appropriative and ultimately exploitative practice, one that reaffirms 'RL' identity categories rather than fragmenting them. Ultimately, however, Nakamura attempts to rewire identity play to make it more unsettling; conceptualizing race in cyberspace as a 'bug' – a software glitch that makes program run unpredictably – she writes that the unexpected occurrence of race in cyberspace might 'sabotage the ideology-machine's routines'. Intervening in the scripts of identityplay online offers for Nakamura the chance to diversify performances and de-essentialize race.

The issue of ethnic or racial identity in cyberculture has been critically approached by a number of authors, across a number of cyberspace domains. Aihwa Ong explores the articulation of diasporic or transnational ethnic identities in her essay on the Global Huaren website set up in the wake of anti-Chinese violence in Indonesia in the late 1990s. Aside from highlighting these atrocities, Global Huaren sought to consolidate the idea of a global Chinese identity for Chinese residents and the global communities of Chinese migrants alike. Critical of the use of the term disapora to describe these groups, Ong explores global flows of 'overseas Chinese' in order to unpack the desire for a unified ethnic identity evidenced by sites like Global Huaren, which she sees as an 'electronic umbrella' problematically assuming and invoking a common identity. Yet she notes the 'extremely complex assemblages of ethnic, cultural, and national identity among overseas Chinese' which cannot be accommodated under such an

umbrella. That such an umbrella is electronic – or cybercultural – is a crucial point for Ong, who identifies a professional digital elite of transnational Chinese as the key interest group attempting to 're-Sinisize' overseas Chinese identities and communities.

This is of course a political project, but one with unintended consequences often sidelined in discussions of networked activism (see Part Eight). As Ong says, 'rapid and remote electronic responses to localized conflicts can backfire against the very people, situated outside electronic space, that they were intended to help'. By foregrounding a global Chinese identity, the Global Huaren project relegates the 'embedded citizenship' of transnational communities; in the case of Indonesia, Ong worries that a re-Sinisized identity may jeopardize subsequent human rights coalition-building there. Ong thus argues for the need to think about 'translocal' rather than 'transnational' publics, while remaining mindful of the risks as well as the promises of electronically-mediated human rights activism. Websites like Global Huaren, she concludes, oversimplify and amplify a 'video-game logic' of 'good global activists versus bad governments' which may be counterproductive, even harmful, for the very people it purports to represent.

The final reading in this section returns us to the writing and reading of the self in cyberculture, through a focus on practices of blogging. Tyler Curtain opens his essay with a very insightful comment about the anxieties that surround blogs: as an exponentially growing medium, the 'blogosphere' is so huge, heterogeneous and unfathomable that it is difficult to grasp its shape and size, its content so varied as to be ungraspable. Hence writing about blogs, like writing blogs themselves, is fraught with anxiety. Yet, as Curtain writes, blogs are 'a vibrant space of knowledge production'; they are something we *can't not* write about. As with Cheung's work on personal homepages, which blogs can be seen as the progeny of, Curtain explores both the writing and the reading of blogs, and the identity work that blogging does for its participants. He draws on various theorists of the public in order to think about blogging's publics, akin to the translocal public Ong discusses. And like Cheung he talks about how blogs perform identity through content and form – how links, for example, become vital props in the performance of what we might term the 'blogself'. Curtain makes an interesting parallel between bloggers' practices and the institutionalized system of academic peer review – writing, being read, receiving feedback, revising, recirculating. The interaction between author and audience and the process of citation via links gives particular shape to the blogging 'ecosystem'.

The explicit focus of Curtain's essay is queer blogging, or blogging as a form of queer knowledge production, and ultimately the queerness of blogging, with its remarking and remaking, its practices of knowing and ongoing resignification. A blog is a readerly text and a writerly one, at once a self-narrative and a story in search of a public. So while Curtain shows how blogs have been criticized for spattering cyberspace with trivial and often narcissistic content – the most me-focused of 'me media', the narrowest of narrowcasts – he is rightly keen to rescue them from this judgemental designation, rewriting blogging as 'a potent fiction with real consequences for desire and affect and learning among and from

strangers'. As a central site of identity work in cyberculture, the blogosphere is generating its own critical commentary as it develops.

References

Bell, D. (2001) *An Introduction to Cybercultures*, London: Routledge.

Miller, D. (2000) 'The fame of Trinis: websites as traps', *Journal of Material Culture* 5: 5–24.

Tsang, D. (2000) 'Notes on queer 'n' Asian virtual sex', in D. Bell and B. Kennedy (eds) *The Cybercultures Reader*, first edition, London: Routledge.

Turkle, S. (1996) 'Who am we?' *Wired* 4, available from http://wired.com/wired/archive/4.01/turkle_pr.html.

Turkle, S. (2003) 'From powerful ideas to PowerPoint', *Convergence* 9: 19–25.

Charles Cheung

IDENTITY CONSTRUCTION AND SELF-PRESENTATION ON PERSONAL HOMEPAGES
Emancipatory potentials and reality constraints

How many personal homepages are there on the web?

ALTHOUGH IT IS DIFFICULT TO COUNT the dispersed and ever-changing number of homepages on the Web, a look at the press relations sections of a handful of the sites offering free Web space shows that the numbers must add up quickly: large community sites like Yahoo! GeoCities and Angelfire claim over 4.5 million active homepage builders each, for example, and FortuneCity claims a further 2 million (July 2003). Millions more homepages reside in the numerous other free webspace services, and within commercial and educational sites. Personal homepage websites are also a popular Web destination. Nielsen/NetRatings' MarketView report shows that Yahoo! GeoCities had more than 27 million unique visitors within one month (October 2002). ComScore Media Metrix surveys also show that Tripod and Angelfire had around 16 and 12 million monthly unique visitors respectively (September 2002).

Introduction

If you are curious enough to browse through some personal homepages posted on the Web, you may quickly observe the following phenomena.

- Generally, personal homepages are websites produced by individuals, or sometimes a couple or family. On a personal homepage, people can put up any information about themselves, including autobiography or diary material, personal photos and videos,

creative works, political opinions, information about hobbies and interests, links to other websites, and so on.

- People from all walks of life have started to use the personal homepage to tell personal stories about themselves: cancer patients, retired scientists, kids with disabilities, vinyl collectors, kung fu movie fans, transsexuals, DIY enthusiasts, pornographic movie lovers, to name but a few.

- Certain personal homepages seem to be made to display the strong personality and identity of the homepage authors, as if declaring: 'It is me! I'm cool!' These pages usually have stylish design, and contain details of specific aspects of the author's life.

- Some personal homepages seem to be made more for self-exploration than for making a strong identity statement. These pages usually contain an online diary or journal, in which the homepage authors put down how they feel about what happens to them every day.

- Having said all this, many personal homepages tell you little information about the author. These pages are unbelievably dull – they only include things like vital statistics, one or two photos, some links to other websites, and nothing else.

- Even worse, many homepages are listed in Web directories but actually not available.

Personal homepages have their critics, of course. Some Internet commentators, for example, suggest that the contents of personal homepages reflect nothing but the narcissism and exhibitionism of many net users and the 'content trivialization' of the Internet superhighway (DiGiovanna, 1995; Rothstein, 1996). Some web designers are appalled by the amateur appearance of many personal homepages. But these responses are inappropriate. This chapter argues that, to make sense of the above phenomena, we need to take the personal homepage seriously as a significant social phenomenon. This chapter has two arguments.

1. The personal homepage is an emancipatory media genre. The distinctive medium characteristics of the personal homepage allow net users to become active-cultural producers, expressing their suppressed identities or exploring the significant question of 'who I am', often in ways which may not otherwise be possible in 'real' life.

2. Nevertheless, the fact that many personal homepages are poor in content, or have even been abandoned by their creators, suggests that the emancipatory potentials of the personal homepage are limited and often not fully exploited. In daily life, there can be a range of factors which preclude some people from producing 'content-rich' personal homepages.

People tell stories about themselves by making personal homepages, but not – to paraphrase Marx – in conditions of their own choosing, as this chapter will show.

'This is me!': the personal homepage as a stage for strategic self-presentation

The first emancipatory use of the personal homepage is strategic and elaborate self-presentation. In everyday life, we usually try in vain to tell our partners, family, friends, employers, or at times even strangers who we 'really' are. Although we can one-sidedly complain that other people misunderstand us, sociologists suggest that self-presentational failure in everyday life actually involves other factors, such as social interactional contexts and our presentation skills.

According to Goffman (1990), in everyday encounters, the social settings and audiences we face always define the kinds of 'acceptable' selves we should present – a teenager performs as a hard-working student in front of teachers in class, an office worker as a responsible employee in front of his or her boss and colleagues, a CEO as a responsible company leader who cares for shareholders in front of financial journalists at press conferences, and so on. Nevertheless, sometimes we may wish to present certain identities but may not find the 'right' social settings and audiences, and if we present these identities in inappropriate social settings, we experience embarrassment, rejection or harassment. For example, a boy may entertain his friends with rap songs about his sexual conquests, but his grandparents might be a less receptive audience.

In face-to-face interaction, we present ourselves through the use of 'sign vehicles' such as clothing, posture, intonation, speech pattern, facial expression and bodily gesture. But Goffman also emphasizes that total control over these sign vehicles is difficult, since most face-to-face interactions proceed in a spontaneous manner and do not include an assigned block of time in which we can present ourselves in an orderly and systematic fashion. More often than not, our presentation of self in everyday life is a delicate enterprise, subject to moment-to-moment mishaps and unintentional misrepresentations. These mishaps typically lead us (again) to experience embarrassment, rejection or harassment and, consequently, the failure of self-presentation. To put it simply, the core problems of our self-presentation in everyday life are that we lack enough control over (1) what 'selves' we should display in a particular social setting and (2) how well we can present them. The personal homepage, however, can 'emancipate' us from these two problems.

First, the personal homepage allows much more strategic self-presentation than everyday interaction. The personal homepage is a self-defined 'stage', upon which we can decide what aspects of our selves we would like to present. As previously mentioned, in everday life we may wish to present certain identities but may not be able to find the 'right' audiences. On the personal homepage, however, this is not the case: once we put up our personal homepage on the Web, its global accessibility of the personal homepage means that we instantly have a potential audience of millions (with the emphasis on *potential*). In addition, even if some people dislike our 'homepage selves' and send us negative responses by e-mail, these responses are not instantaneous, so we feel less pressure to respond to them – in fact, we can even ignore these comments. For example, if a kung fu movie lover really wants to tell others that he is an expert in kung fu movies, his simplest solution is not to force strangers in pubs to listen to him but to construct a personal homepage. By creating a website featuring his essays on kung fu movies, photo collection of kung fu stars, or even digital videos of him doing karate, he would have millions of net browers who also love kung fu movies as his *potential* audience. Of course, not everyone stumbling across his homepage will admire his identity as a 'kung fu movie fan', and sometimes people may even send him e-mails ridiculing his enthusiasm for these movies. But since these 'attackers' are not his targeted audience, he can always ignore their criticisms.

Second, the personal homepage is emancipatory for self-presentation since it allows the individual to give a much more polished and elaborate presentation, with more control over 'impression management', compared with face-to-face interaction. Indeed, the 'sign vehicles' used in the homepage self-presentation are more subject to manipulation. As discussed in the preceding paragraph, since we are less likely to experience immediate rejection from those who read our homepages, before releasing our personal homepage to the net public, we can always manipulate all the elements until we are satisfied: we can experiment with the colour scheme, choose the most persentable head shot, censor the foul

language accidentally written in the draft biography, and ponder as long as we like before deciding whether to tell the readers that our partner just dumped us. Mishaps that may affect one's self-presentation in everyday life can be avoided on the personal homepage. Of course, not all responses can be controlled – I cannot prevent a homepage visitor from thinking that I am a self-indulgent fool.

Research evidence shows that people from all walks of the life have started to use the personal homepage for strategic and elaborate self-presentaiton.

One prominent use of the personal homepage is to promote one's professional achievement in ways which may not otherwise be possible in everyday life. People seeking jobs, for instance, use the personal homepage to highlight and embellish aspects of their professional achievements, so as to reach potential employers or to create more lasting impressions than brief phone or face-to-face job interviews (Rosenstein, 2000). Likewise, artists use their websites to promote their artistic persona (Pariser, 2000), and young academics use faculty homepages to gain wider exposure (Miller and Arnold, 2001). As one young academic confessed: 'For the person visiting the webpage of my department, I am more visible than the professors [who don't have pages]' (ibid.: 105).

Some homepages are more relationship-oriented. On these homepages, the authors often highlight particular personal qualities (personalities, hobbies or political opinions) so as to share opinions and experiences with like-minded individuals (Walker, 2000), or to attract potential romantic partners who admire those qualities (Rosenstein, 2000).

The personal homepage is also particularly valuable for those with difficulty presenting themselves in face-to-face interaction, such as introverts with weak self-presentational skills, and people with any kind of visible or invisible disability such as amputees, the visually impaired, or the hearing impaired. As one homepage author with traumatic brain injury said concisely: 'Our disability is *invisible* so people can't respond (original emphasis; Hevern, 2000: 16). These homepage authors may feel better able to express themselves through the use of biographies, online writing or their photos (Chandler, 1998). People with Down's syndrome, for example, have used the personal homepage to assert that in many ways they are no different from other people, because, like anyone else, they have distinctive cultural tastes and are knowledgeable about certain things – such as making webpages (Seale, 2001).

The personal homepage may be most emancipatory for those whose identities are misunderstood or stigmatized in society – teenagers, gays and lesbians, fat people, the mentally ill, and so on – since they can reveal their identities without risking the rejection or harassment that may be experienced in everyday life. One gay respondent, for instance, explained how the personal homepage helped him to come out 'steadily':

> I was looking for some way of having a gay presence in the world and still feel protected from the adverse effects. [Making my personal homepage] was great because I didn't have to just 'come out' to somebody and risk rejection. I could do things a little at a time and build levels of trust along the way.
>
> (Hevern, 2000 15)

Another gay author reports a similar experience. He would say to friends, 'Check out my website', and let them see his positive expressions of gay identity, and think about it before reacting' (Chandler, 1998).

In fact, the emancipatory value of the personal homepage for self-presentation is even more evident if we look at how traditional mass media represent ordinary people. Generally, the mass media do not allow ordinary people to represent themselves on their own terms. Rather, ordinary people are represented by the crative personnel of the mass

media, perhaps in stereotypical ways: the stupid teenager, the helpless disabled person, or the sexually available woman, for example. There may be radio phone-ins and TV audience talk-back programmes for the 'users' of these media to express their points of view, but the limited access to these shows, as well as the commercial nature of their topics, means that these media never allow people the degree of creative freedom offered by the personal homepage. Media scholars have longed for a medium which can help people who are often misrepresented in the mass media to move 'from silence to speech' (hooks, 1989: 9). The personal homepage can serve this very purpose.

'Who am I?': the personal homepage as a space for reflexive construction of identity

For some people, however, the personal homepage is emancipatory not because it is a stage for self-presentation, but because it can be a space for identity construction. My previous discussion on self-presentation more or less assumes that homepage authors have a stable sense of self-identity, and the only problem for these authors is to find some ways to present aspects of their identities. Some confident academics may use their webpage to advertise their academic persona, for example, and some lesbians who are very sure of their sexual identity may use their homepage to celebrate their lifestyle. However, for many people, their sense of 'who I am' is not that obvious, and may be highly uncertain. Their problem is not so much about presenting their identity, but concerns their exploration of 'who I am' and re-establishing a stable sense of self-identity. Much has been written on the sources of uncertain identity; here I have selected three examples for our discussion.

- *Multiple and contradictory identities*: unlike traditional society in which people only have a narrow range of ascribed identities, in late-modern society we are usually offered a bewildering range of choices over social and cultural identities, including those based on gender identity, nationality, religion, family relationships, sexuality, occupation, leisure interests, political concerns, and more. As Giddens (1991) suggests, these identity 'choices' are not marginal but substantial ones, since they allow us to define who we want to be. But Giddens (ibid.: 73) emphasizes that '[t]aking charge of one's life involves risk, because it means confronting a diversity of open possibility'. One 'unfortunate' consequence of this condition is identity confusion. Take for example a Chinese-American lecturing in the USA, who feels passionate about gay fiction but also about heterosexual pornographic movies, who loves both academic books and PlayStation games, and who supports feminism yet likes Sylvester Stallone's movies a lot. Who is 'he' actually? Gay, straight or bisexual? Is he really an American? Is he an intellectual or just a lowbrow who loves video games but pretends to be an intellectual? Can someone who loves macho movie stars like Sylvester Stallone still be a feminist?
- *Disrupted lives*: late-modern society is always undergoing rapid and extensive change, and accordingly, our lives and sense of stable self-identity are prone to disruption more than ever: a CEO who loses his job and cannot find another post for years may have serious doubts about his identity as a member of the middle-class elite; an American girl who moves to Paris to be with her French fiancé may feel totally disoriented in a new country; a man who has been divorced five times may seriously question whether he can really be a 'good' husband in the future. Furthermore, victims of serious illness or injury may also feel uncertain about their identities and their ability to function as 'normal' people.

- *Stigmatized identities*: we may be doubtful about certain identities of ours if these identity categories are controversial, stigmatized or unacceptable in society at large. For instance, a young woman who is attracted only to females may still feel uncertain about her sexuality, because she has been told for years in her traditional Catholic school that homosexuality is sinful.

So how do people with uncertain identities re-establish their stable sense of self-identity? Giddens (1991) argues that, in late-modern society, we construct our sense of self-identity by creating a 'coherent' self-narrative. In such a coherent self-narrative, we successfully make ourselves the protagonist of the story, and we know clearly who we are, how we became the way we are now, and what we would like to do in the future – all these elements help to give us a stable sense of self-identity. However, if our identities are being challenged by new events or experiences, the coherence of our self-narrative can be disrupted, and we may experience an unstable and confused sense of self. In order to re-establish a stable sense of identity, we have to reflexively reappraise and revise our 'disrupted' self-narrative until its sense of coherence is restored. Take, for example, how the aforementioned CEO may rework his self-narrative when his identity as a member of the middle-class elite becomes uncertain as a result of his long-term unemployment. He may insist on finding work as another CEO, and interpret his long-term unemployment as just one of the roadblocks that all successful people might face at some point. In this case, he makes minor modifications to his middle-class elite self-narrative, but the overall meaning of the narrative remains unchanged. Alternatively, he may choose to abandon his middle-class elite identity and adopt a new 'simple-life-is-good' identity, and interpret his previous middle-class life as a worthwhile experience, without which he would not have been able to discover the true value of his new 'simple life' philosophy. In this case, he almost completely rewrites the overall meaning of his self-narrative. Anyhow, our concern here is not which concrete self-narrative this CEO finally adopts. Our point is rather that, if our sense of self-identity becomes uncertain, it is only through reflexive reappraisal and revision of our self-narrative that we can re-establish a stable sense of self-identity. Giddens describes this process as 'the reflexive project of the self'.

The personal homepage is a form of media which facilitates the reflexive project of the self. I mentioned in the last section that people who use their homepages for self-presentation can lay out, arrange, retouch and manipulate their 'homepage selves' until the outcome reflects the self-identities they intend to present. But for people with uncertain identities, or with a more free and fluid sense of self, this flexible creative process has a totally different meaning – experimentation and exploration of different identities. As Rosenstein (2000: 153) suggests, the 'hypermedia qualities of the home page can support linear, chronological narratives, but … they also lend themselves to a more episodic, situated and associational organization of materials that may be quite diffuse thematically and even spatially'. In other words, the hypertextuality of the personal homepage enables those authors who are in search of their self-identities – or who are happy to 'play' with their identities – to construct different self-narratives on their homepage and mull over which narrative (or narratives) makes most sense to them. This self-exploration process is akin to conducting internal dialogues within one's mind: 'I can be this or that, but who do I want to be?' However, the internal dialogue as a method of self-exploration has one major limitation. Since this dialogue is an internal mental process, it does not have any physical record. It is impossible to retrieve our internal dialogues conducted in the past without any loss and distortion of thoughts. In contrast, self-narratives on the personal homepage have a physical existence (at least as stored in webpage format) which can be completely

retrieved for further self-contemplation whenever the author wants to. Undoubtedly, the self-narratives we compose in traditional written media such as a diary or biography also have a physical existence, but these forms often lack the revisability of the personal homepage, which allows or even invites the author to continually amend his or her homepage self-narratives. As Chandler (1998) suggests, completion of any personal homepages 'may be endlessly deferred' since every homepage is always 'under construction'.

In fact, recent research shows that people with uncertain identities have started to use the personal homepage to reflexively explore and reconstruct their identities. Personal homepages 'permit some authors to explore aspects of themselves in ways that they have never previously done,' claims Hevern (2000: 14). As one homepage author admitted: 'It helps to define who I am. Before I start to look at/write about something then I'm often not sure what my feelings are, but after having done so, I can at least have more of an idea' (Chandler, 1998). Another author commented: 'as a process for doing, for seeing yourself reflected on a screen, being able to draw connections where there weren't connections is really rich' (Rosenstein, 2000: 154).

By continually exploring and clarifying their thoughts and feelings, some people use the personal homepage to reclaim a sense of identity which is continuous with their previous one. As one homepage author who relocated from New York to California said: 'Moving to a place where I had to make so many changes, I needed a way to convince myself I was still okay and the things that were important to me are still important' (Rosenstein, 2000: 159). Some authors, however, may fashion new identities. For example, by building websites which provide health information, people whose lives have been disrupted by serious accidents or chronic illness may successfully re-establish a positive identity, as a health information producer (Hevern, 2000; Hardey, 2002).

The personal homepage surpasses the internal dialogue and other traditional media in one more respect. The internal dialogue and traditional diary writing are 'private' identity construction activities, the audience of which is generally the author him/herself. But the global reachability of the personal homepage enables the homepage author to get validatory feedback from net browsers who empathize or share with the author's identity or narrative. I am not arguing that we cannot consider our self-identities in the absence of others, but getting recognition from other people is still important for establishing affirmative identities (Cooley, 1902; Blumer, 1969). After all, if no one ever tells you that you are smart, for how long can you convince yourself that you really are?

This identity validation function of the personal homepage is also identified in recent research. Undeniably, some homepage authors do not actively *seek* readers at all (Rosenstein, 2000: 96–9). As one author said: 'I was the intended audience, as strange as it sounds' (Chandler, 1998). Yet, many homepage authors use the personal homepage to re-establish their self-identities by getting positive comments from other net browsers. One disabled homepage author said: 'Do you have any idea how many people wallow in self-pity, spend the rest of their lives crying about what happened to them? Through the Internet I have been challenged to grow, to blossom, to meet others who understand me' (Hevern, 2000: 15). A gay author said: 'I think we all sometimes need to know that, no matter how alone we feel, there are witnesses' (ibid.: 14). A Spanish-speaking homepage author explained his motive for homepage publishing this way: 'I was looking for other people that were my color or listened to my kind of music or spoke my family's language ... I was really looking for a part of me out there that I could make contact with' (Rosenstein, 2000: 168).

Reality constraints on the making of personal homepages

So far, our story of the personal homepage appears quite heartening. But some critics tell a more gloomy story, cautiously warning us not to uncritically celebrate the emancipatory potentials of the personal homepage and the creative autonomy of the homepage author. This more pessimistic story can be divided into two parts: (1) concern that social background may preclude certain people from making personal homepages; and (2) the view that commercial and ideological factors may work against the expressive creativity of homepage authors.

Who can build personal homepages?

One key factor that influences people's chances of reaping the emancipatory benefits of the personal homepage is their Internet access. The reason is simple: if a social group has less Internet access than others, members of this social group will have less opportunities to build personal homepages and, accordingly, they are less likely to benefit from the emancipatory potential of this media genre. One factor which influences one's opportunities to access the Internet is country of residence. Take some countries as examples: the Internet access rate of people living in China is 3.5 per cent; France, 28.4 per cent; Germany, 38.6 per cent; Greece, 13.2 per cent; Iceland, 79.9 per cent; Malaysia, 25.2 per cent; Russia, 12.4 per cent; Singapore, 51.9 per cent; Sweden, 67.6 per cent; Spain, 19.7 per cent; Thailand, 7.4 per cent; United Arab Emirates, 36.8 per cent; United Kingdom, 57.4 per cent; United States, 59.1 per cent (these are 2002 figures; see Nua.com, 2003). Indeed, Internet statistics show that, in many countries, additional factors such as ethnicity, gender, age, educational attainment and income level may also affect Internet access, although the significance of individual factors varies greatly from country to country.

Statistics show that demographic factors like gender, age, occupational status and educational level have noticeable effects on levels of Internet access. For example, a survey shows that, in 15 Western European countries, females, manual workers, the elderly and the less educated have less Internet access than males, professionals, the young and the well educated (European Commission, 2002). The USA shows similar Internet access patterns (except that females and males have virtually identical Internet access rate in the USA; see below) (Victory and Cooper, 2002). Nevertheless, the specific extent to which each demographic factor affects the Internet access rate of individual social groups varies from country to country. Take gender as an example. According to a recent survey of Internet users in 25 developed countries, the Internet access rate of females varies from country to country: in France, females make up 40.8 per cent of total Internet users; Germany, 38 per cent; Sweden, 46 per cent; the UK, 44.5 per cent; the USA, 51.9 per cent. (Nielsen//NetRatings, 2002). In some countries like Romania and Ukraine, females occupy less than one-third of the total population of Internet users (Taylor Nelson Sofres Interactive, 2002).

But will equal Internet access bring about equal opportunities in making personal homepages? Not necessarily. In a study of the homepages produced by students at four US universities and four German universities, Döring (2002) finds that females only make up 27 per cent and 13 per cent of the student homepage authors in the US and German universities respectively, despite the fact that at all of these universities there was an equal balance of male and female students. One possible explanation is that females tend to feel alienated from the male-dominated computer culture (as certain studies have suggested:

Morbey, 2000; Turkle, 1988), making them less motivated to learn website-building skills. In other words, even if females and males have similar opportunities to 'log on' to the Internet (as is already the case in certain countries), females may not have the same degree of motivation and learned skills to create and maintain personal websites. In short, equal Internet access does not necessarily mean equal opportunities in making personal homepages.

Dominick's (1999) study illustrates how factors such as gender, age and occupation may influence people's chances of making homepages. From 317 English-language personal homepages randomly sampled from the Yahoo! homepage directory, Dominick found that 87 per cent of homepage authors were men, 79 per cent were under the age of 30; more than half of those who mentioned an 'occupation' were students, and around 90 per cent of the rest were white-collar workers. This data suggests that females, the unemployed and blue-collar workers may have less chances of building homepages than other people. (Note, however, that the gender balance, at least, is likely to have changed since the mid-to-late 1990s when this study was conducted; and note that the sample is based only on those homepage owners who submitted their site to the Yahoo! directory, and had that submission accepted by Yahoo! staff.)

The poverty of self-expression and creative constraints

Undeniably, those who have no opportunity to make personal homepages are! unable to enjoy the emancipatory benefits of the personal homepage. However, it is not necessarily the case that people who have already made personal homepages for themselves are able to fully realize the emancipatory potential of this media genre. From his sample of 500 English-language personal homepages, Dominick (1999) found that 30 per cent of the pages were either abandoned or no longer available, and most of the remaining 'analysable' homepages had been produced with little creative effort, offering predictable elements such as a brief biography, an e-mail address, some authors' photos, or links to other sites. Only 12 per cent of those analysable homepages included in-depth biographies, and only 23 per cent contained 'creative expressions' like original poems or stories. Dominick argues that most personal homepages show nothing but superficial self-expression. It is perhaps no wonder that some critics will say that many personal homepages lack creativity and thoughtfulness, since many homepage authors build their websites not for self-presentation or identity construction, but for instrumental reasons like passing time, learning HTML, distributing information to peers, and so on (Buten, 1996: Papacharissi, 2000: Walker, 2000). This argument, however, cannot really explain why some personal homepages which are built for the purpose of self-presentation or identity construction still lack thoughtful and in-depth self-expression (Killoran, 2002). To answer this question, we need to examine how commercial homepage providers and ideological forces suppress the expressiveness of homepage authors.

Commercial homepage providers

Using Yahoo! GeoCities as an example, Harrison (2001) offers a number of compelling critiques of how major commercial homepage providers may undermine users' freedom of self-expression on the personal homepage. Two of these criticisms are as follows.

- *Standardizing homepages:* Yahoo! GeoCities provides novice homepage authors with sets of pre-created homepage 'templates'. These 'templates' offer homepage authors standardized suggestions of where to place text, images and links, and encourage them to add Yahoo! services to their homepages. (Other major commercial homepage providers like Tripod, Angelfire and AOL Hometown also offer similar 'simple' homepage building tools.) Although these 'templates' enable novices to build homepages without the need to learn more advanced website-building tools like HTML, they indirectly lead homepage authors to produce 'cookie-cutter' personal homepages (ibid.: 55–62).

- *Homepage content control:* all Yahoo! GeoCities homepage authors have to abide by the Yahoo! Terms of Service, which allow Yahoo! GeoCities to delete without prior warning those homepages with content the company and its advertisers deem inappropriate (ibid.: 62–4). Indeed, most commercial homepage providers such as Tripod, Angelfire and AOL Hometown, also have content regulation policies, which grant them the right to remove any homepages at any time, for any reason, with or without notice. According to some journalists and homepage makers, personal homepages deleted by commercial homepage providers often contain 'sensitive' content, including anti-abortion, death penalty and anti-Malaysian government opinion, nude photos of the author, and information that directly criticizes certain commercial homepage providers (Standen, 2001; Scheeres, 2002; Zeman, 2002). Recently Yahoo! has signed a voluntary pledge with the Chinese government, promising that Yahoo! China will avoid 'producing, posting or disseminating pernicious information that may jeopardize state security and disrupt social stability'; it also pledged to monitor personal websites and will 'remove the harmful information promptly' *(Washington Post,* 2002).

Ideological forces

Killoran's (1998, 2002) study shows that the poverty of self-expression on personal homepages is also caused by the ideologies of commercial and bureaucratic organizations as well as commercial homepage providers. He argues that since the personal homepage is a new media genre, it has no established generic conventions which homepage authors can follow when representing themselves in this medium. Under these conditions, the well-established, powerful and prevalent ideologies of commercial and bureaucratic organizations tend to 'colonize' the speaking spaces of the authors. Consequently, homepage authors abandon the opportunity to explore their distinctive self-identities, and represent themselves as 'domesticated, innocuous subjects and objects of a capitalist and bureaucratic order' (Killoran, 2002: 27). Killoran describes this process in which personal homepage authors adopt commercial and institutional ideologies to express themselves 'synthetic institutionalization'. He argues that when individuals present themselves using visual styles borrowed from brands, organizations or corporations, or with devices designed to attract returning viewers (such as the promise of regular updates), they suppress their own creative identities in favour of institutionalized conformity. (Of course, it could be argued that the homepage authors are often wittily parodying corporate language, and that the promise of a regularly updated site does not necessarily represent some kind of tribute to capitalist customer loyalty' schemes, as Killoran seems to think.)

Gender ideologies may also affect personal homepage design. In two studies of faculty homepages hosted in university departments, Miller and Arnold (2001) and Hess (2002) found that, generally, female academics were more hesitant and cautious than males about putting their personal photos on their faculty homepage. Many female academics explicitly

admitted that they feared their photos may 'give off' sexist impressions and encourage people who read their homepage to focus on their appearance rather than their academic work. As one female lecturer said:

> Putting my own picture on my webpage … seems like something that would allow people to see me as vain (like, 'Oh, she thinks she's so good looking she put her picture on the Web') or at least read outside a professional context.
>
> (Hess, 2002: 181)

Instead of resisting these ideological pressures, some female academics opt for self-censorship – they choose not to put their pictures on their homepage and become 'faceless' authors (see also Cheung, 2000, for a discussion of self-censorship).

Conclusion

My analysis clearly demonstrates that, although the personal homepage is an emancipatory media genre for some people, its emancipatory potentials have not yet benefited everyone. Many people may still lack the resources and technological knowhow to build their own personal homepage. Even for those who are capable of making personal homepages, their individual expressiveness might still be suppressed by content censorship of commercial homepage providers or ideological pressures. Some statistics show that the Internet access gap between countries is narrowing (UNCTAD, 2002), and that in many countries the Internet access gap by gender is closing rapidly (Nielsen/NetRatings, 2002). These trends certainly imply that more people will be able to build personal homepages. But it remains the case that many constraints upon making personal homepages will not disappear in the near future: low-income groups in many countries still have great difficulty accessing the Internet; ideologies of various types will continue to exist and suppress individual expression; and control over homepage content may also be further heightened by some homepage providers. If more people are to enjoy the emancipatory benefits of a personal homepage, we must endeavour to remove these constraints. Homepage authors need to protest against any censorship of homepage content practised by commercial homepage providers (Zeman, 2002); non-profit organizations may seek ways to provide free Internet access, censorship-free website hosting services, and even free training courses on website-building skills; academics and critics should also find ways to raise awareness among homepage authors about the commercial and ideological constraints which may suppress self-expression on the personal homepage. Only through such efforts can we hope that more people will be able to use the personal homepage to work through their identities, or present their suppressed selves to audiences around the world. Indeed, in a world where many people are plagued by identity problems, enabling more people to fully realize the emancipatory potential of the personal homepage is a timely and important task.

References

Brumer, H. 1969: *Symbolic Interactionism: Perspective and Method*. Englewood Cliffs, NJ: Prentice-Hall.

Buten, J. 1996: Personal home page survey. www.asc.upenn.edu/USR/sbuten/phpi.htm.

Chandler, D. 1998: Personal home pages and the construction of identities on the Web. www.aber.ac.uk/media/Documents/short/webident.html.

Cheung, C. 2000: A home on the Web: presentations of self on personal home-pages. In Gauntlett, D. (ed.), *Web.Studies: Rewiring Media Studies for the Digital Age*. London: Arnold.

Cooley, C.H. 1902: *Human Nature and Social Order*. New York: Scribner's.

Digiovanna, J. 1995: Losing your voice on the Internet. In Ludlow, P. (ed.), 1996: *High Noon on the Electronic Frontier: Conceptual Issues in Cyberspace*. Cambridge, MA: MIT Press.

Dominick, J.R. 1999: Who do you think you are? Personal home pages and self-presentation on the World Wide Web. *Journalism and Mass Communication Quarterly* 76, 646–58.

Döring, N. 2002: Personal home pages on the web: a review of research. *Journal of Computer Mediated Communication* 7. www.ascusc.org/jcmc/vol7/issue3/doering.html.

European Commission 1997: *Green Paper on the Convergence of the Telecommunications, Media and Information Technology Sectors*, COM 97, 623. Brussels: European Commission.

Giddens, A. 1991: *Modernity and Self-Identity: Self and Society in the Late Modern Age*. Cambridge: Polity Press.

Goffman, E. 1959 [1990]: *The Presentation of Self in Everyday Life*. London: Penguin (page numbers refer to 1990 edition).

Hardey, M. 2002: 'The story of my illness': personal accounts of illness on the Internet. *Health: An Interdisciplinary Journal for the Social Study of Health, Illness and Medicine* 6, 31–46.

Harrison, A. 2001: Where are they now? Online identities on the commercial Web. Unpublished MA thesis. Georgetown University.

Hess, M. 2002: A nomad faculty: English professors negotiate self-presentation in unversity Web space. *Computers and Composition* 19, 171–89.

Hevern, V.W. 2000: Alterity and self-presentation via the Web: dialogical and narrative aspects of identity construction. Paper presented at the First International Conference on the Dialogical Self, Katholieke Universiteit Nijmegen, The Netherlands.

hooks, b. 1989: *Talking Back: Thinking Feminist, Thinking Black*. Boston, MA: South End Press.

Killoran, J.B. 1998: Under construction: revision strategies on the web. Paper presented at the conference of College Composition and Communication, Chicago.

Killoran, J.B. 2002: Under constriction: colonization and synthetic institutionalization of Web space. *Computers and Composition* 19, 19–37.

Mander, J. 1991: *In the Absence of the Sacred: The Failure of Technology and the Survival of the Indian Nations*. San Francisco, CA: Sierra Club Books.

Miller, H. and Arnold, J. 2001: Breaking away from grounded identity? Women academics on the Web, *CyberPsychology and Behavior* 4, 95–108.

Morbey, M.L. 2000: Academic computing and beyond: new opportunities for women, minority populations, and the new media arts. *Convergence: The Journal of Research into New Media Technologies* 6, 54–77.

Nielsen/Netratings 2002: Women are gaining on the Web (Hong Kong). Press release 11 June. www.nielsen-netratings.com.

Papacharissi, Z.A. 2000: The personal utility of individual home pages. Unpublished PhD thesis. University of Texas at Austin.

Pariser, E. 2000: Artists' websites: declarations of identity and presentation of self. In Gauntlett, D. (ed.), *Web.Studies: Rewiring Media Studies for the Digital Age*. London: Arnold.

Rosenstein, A.W. 2000: Self-presentation and identity on the World Wide Web: an exploration of personal home pages. Unpublished PhD thesis, University of Texas at Austin.

Rothstein, E. 1996: Can Twinkies think, and other ruminations on the Web as a garbage depository. *New York Times* 4 March, D3.

Scheeres, J. 2002: Dear member: you've been deleted. *Wired.com*, 11 July. www.wired.com/news/business/0,1367,53658,00.html.

Seale, J.K. 2001: The same but different: the use of the personal home page by adults with Down's syndrome as a tool for self-presentation. *British Journal of Educational Technology* 32, 343–52.

Standen, A. 2001: Massacre at Tripod. *Salon.com* 20 March. http://archive.salon.com/tech/log/2001/03/20/tripod/.

Taylor Nelson Sofres Interactive 2002: *Global eCommerce Report 2002*. www.tnsofres.com/.

Turkle, S. 1988: Computational reticence: why women fear the intimate machines. In Kramarae, C. (ed.), *Technology and Women's Voice*. London: Routledge.

UNCTAD 2002: *E-Commerce and Development Report 2002*. Geneva: UNCTAD.

Walker, K. 2000: 'It's difficult to hide it': the presentation of self on Internet home pages. *Qualitative Sociology* 23, 99–120.

Washington Post. 2002: Yahoo's China concession. 19 August, A12.

Zeman, T. 2002: *Geocensored*. www.angelfire.com/mo/geocensored/index.html.

Alison Landsberg

PROSTHETIC MEMORY
Total Recall and *Blade Runner*

I N THE 1908 EDISON FILM *The Thieving Hand*, a wealthy passer-by takes pity on an armless beggar and buys him a prosthetic arm. As the beggar soon discovers however, the arm has memories of its own. Because the arm remembers its own thieving, it snatches people's possessions as they walk by. Dismayed, the beggar sells his arm at a pawnshop. But the arm sidles out of the shop, finds the beggar out on the street, and reattaches itself to him. The beggar's victims, meanwhile, have contacted a police officer who finds the beggar and carts him off to jail. In the jail cell, the arm finds its rightful owner – the 'proper' thieving body – a one-armed criminal, and attaches itself to him.

This moment in early cinema anticipates dramatically a preoccupation in more contemporary science fiction with what I would like to call 'prosthetic memories'. By prosthetic memories I mean memories which do not come from a person's live experience in any strict sense. These are implanted memories, and the unsettled boundaries between real and simulated ones are frequently accompanied by another disruption: of the human body, its flesh, its subjective autonomy, its difference from both the animal and the technological.

Furthermore, through the prosthetic arm the beggar's body manifests memories of actions that it, or he, never actually committed. In fact, his memories are radically divorced from lived experience and yet they motivate his actions. Because the hand's memories – which the beggar himself wears – prescribe actions in the present, they make a beggar into a thief. In other words, it is precisely the memories of thieving which construct an identity for him. We might say then that the film underscores the way in which memory is constitutive of identity. This in itself is not surprising. What is surprising is the position the film takes on the relationship between memory, experience and identity.

What might the 'otherness' of prosthetic memory that *The Thieving Hand* displays tell us about how persons come ordinarily to feel that they possess, rather than are possessed by, their memories? We rely on our memories to validate our experiences. The experience of memory actually becomes the index of experience: if we have the memory, we must have had the experience it represents. But what about the armless beggar? He has the memory without having lived the experience. If memory is the precondition for identity

or individuality – if what we claim as our memories defines who we are – then the idea of a prosthetic memory problematizes any concept of memory that posits it as essential, stable or organically grounded. In addition, it makes impossible the wish that a person owns her/his memories as inalienable property.

We don't know anything about the beggar's real past. Memories, it seems, are the domain of the present. The beggar's prosthetic memories offer him a course of action to live by. Surprisingly enough, memories are less about validating or authenticating the past than they are about organizing the present and constructing strategies with which one might imagine a livable future. Memory is not a means for closure – is not a strategy for closing or finishing the past – on the contrary, memory emerges as a generative force, a force which propels us not backward but forwards.

But in the case of *The Thieving Hand*, the slippage the film opens up with the prosthetic hand – the rupture between experience, memory and identity – gets sealed up at the end of the film, in jail, when the thieving hand reattaches itself to what we are meant to recognize as the real or authentic thieving body, the one-armed criminal. In other words, despite the film's flirtation with the idea that memories might be permanently transportable, *The Thieving Hand* ends by rejecting that possibility, in that the hand itself chooses to be with its proper owner.

I have begun with *The Thieving Hand* to demonstrate that, as with all mediated forms of knowledge, prosthetic memory has a history. Although memory might always have been prosthetic, the mass media – technologies which structure and circumscribe experience – bring the texture and contours of prosthetic memory into dramatic relief. Because the mass media fundamentally alter our notion of what counts as experience, they might be a privileged arena for the production and circulation of prosthetic memories. The cinema, in particular, as an institution which makes available images for mass consumption, has long been aware of its ability to generate experiences and to install memories of them – memories which become experiences that film con- sumers both possess and feel possessed by. We might then read these films which thematize prosthetic memories as an allegory for the power of the mass media to create experiences and to implant memories, the experience of which we have never lived. Because the mass media are a privileged site for the production of such memories, they might be an undertheorized force in the production of identities. If a film like *The Thieving Hand* eventually insists that bodily memories have rightful owners, more recent science fiction texts like *Blade Runner* and *Total Recall* have begun to imagine otherwise.

In Paul Verhoeven's film *Total Recall* (1990), Douglas Quade (Arnold Schwarzenegger) purchases a set of implanted memories of a trip to Mars. Not only might he buy the memories for a trip he has never taken, but he might elect to go on the trip as some- one other than himself. Quade has an urge to go to Mars as a secret agent – or rather, to remember having gone as a secret agent. But the implant procedure does not go smoothly. While strapped in his seat, memories begin to break through – memories, we learn, that have been layered over by 'the Agency'. As it turns out, Quade is not an 'authentic identity', but one based on memories implanted by the intelligence agency on Mars.

In Ridley Scott's *Blade Runner* (director's cut, 1993), Deckard (Harrison Ford) is a member of a special police squad – a blade runner unit – and has been called in to try to capture and 'retire' a group of replicants recently landed on earth. Replicants, advanced robots created by the Tyrell Corporation as slave labour for the off-world colonies, are 'being[s] virtually identical to human[s]'. The most advanced replicants, like Rachel (Sean Young), an employee at the Tyrell Corporation who eventually falls for Deckard, are designed so that they don't know they are replicants. As Mr Tyrell

explains to Deckard, 'If we give them a past we create a cushion for their emotions and consequently we can control them better.' 'Memories,' Deckard responds incredulously, 'you're talking about memories.'

If the idea of prosthetic memory complicates the relationship between memory and experience, then we might use films that literalize prosthetic memory to disrupt some postmodernist assumptions about experience. With postmodernity, Frederic Jameson asserts, we see 'the waning of our historicity, of our lived possibility of experiencing history in some active way' (1991: 21). He claims that in postmodernity, experience is dead. 'Nostalgia films', he suggests, invoke a sense of 'pastness' instead of engaging with 'real history'. He therefore finds a fundamental 'incompatibility of a postmodernist nostalgia and language with genuine historicity' (1991: 19). Not only does his account participate in a nostalgia of its own – nostalgia for that prelapsarian moment when we all actually experienced history in some real way – but it offers a rather narrow version of experience. The flipside of Jameson's point is Jean Baudrillard's (1983) claim that the proliferation of different media and mediations – simulations – which have permeated many aspects of contemporary society, have dissolved the dichotomy between the real and the simulacrum, between the authentic and the inauthentic. He argues that with the proliferation of different forms of media in the twentieth century, people's actual relationship to events – what we are to understand as authentic experience – has become so mediated, that we can no longer distinguish between the real – something mappable – and what he calls the hyperreal – 'the generation by models of a real without origin' (Baudrillard 1983: 2). For Baudrillard, we live in a world of simulation, a world hopelessly detached from the 'real'. Or, to put it another way, postmodern society is characterized by an absence of 'real' experience. But Baudrillard's argument clings tenaciously to a real; he desperately needs a real to recognize that we are in a land of simulation. Both assumptions unwittingly betray a nostalgia for a prelapsarian moment when there was a real. But the real has always been mediated through information cultures and through narrative. What does it mean for memories to be 'real'? Were they ever 'real'? This chapter refuses such a categorization, but also shows the costs of such a refusal.

I would like to set this notion of the death of the real – particularly the death of real experience – against what I perceive as a veritable explosion of, or popular obsession with, experience of the real. From the hugely attended D-Day reenactments of 1994 to what I would like to call 'experiential museums', like the United States Holocaust Memorial Museum, it seems to me that the experiential real is anything but dead. In fact, the popularity of these experiential events bespeaks a popular longing to experience history in a personal and even bodily way. They offer strategies for making history into personal memories. They provide individuals with the collective opportunity of having an experiential relationship to a collective or cultural past they either did or did not experience. I would like to suggest that what we have embarked upon in the postmodern is a new relationship to experience which relies less on categories like the authentic and sympathy than on categories like responsibility and empathy.

This postmodern relationship to experience has significant political ramifications. If this fascination with the experiential might be imagined as an act of prosthesis – of prosthetically appropriating memories of a cultural or collective past – then these particular histories or pasts might be available for consumption across existing stratifications of race, class and gender. These prosthetic memories, then, might become the grounds for political alliances. As Donna Haraway (1991) has powerfully argued with her articulation of cyborg identity, we need to construct political alliances that are not based on natural or essential affinities.[1] Cyborg identity recognizes the complicated process of identity formation, that

we are multiply hailed subjects, and thus embraces the idea of 'partial identities'. The pasts that we claim and 'use' are part of this process.

If the real has always been mediated through collectivized forms of identity, why then, does the sensual in the cinema – the experiential nature of the spectator's engagement with the image – differ from other aesthetic experiences which might also be the scene of the production of sensual memory, like reading (see Miller 1988)? Concern about the power of the visual sensorium – specifically, an awareness of the cinema's ability to produce memories in its spectators – has a lengthy history of its own. In 1928, William H. Short, the Executive Director of the Motion Picture Research Council, asked a group of researchers – mostly university psychologists and sociologists – to discuss the possi- bility of assessing the effects of motion pictures on children. These investigations which he initiated – the Payne Studies – are significant not so much in their immediate findings, but rather in what they imply about the popular anxiety about the ways in which motion pictures actually affect – in an experiential way – individual bodies. In a set of studies conducted by Herbert Blumer, college-aged individuals were asked 'to relate or write as carefully as possible their experiences with motion pictures' (Blumer 1933: xi). What Blumer finds is that 'imaginative identification' is quite common, and that 'while witnessing a picture one not infrequently projects oneself into the role of hero or heroine' (1933: 67). Superficially, this account sounds much like arguments made in contemporary film theory about spectatorship and about the power of the filmic apparatus and narrative to position the subject (see, for example, Baudry 1974–5; Comolli 1986).

However, Blumer's claims – and their ramifications – are somewhat different. Blumer refers to identification as 'emotional possession' positing that 'the individual identifies him/herself so thoroughly with the plot or loses him/herself so much in the picture that s/he is carried away from the usual trend of conduct' (1933: 74). There is, in fact, no telling just how long this possession will last, for 'in certain individuals it may become fixed and last for a long time' (1933: 84). In fact,

> In a state of emotional possession impulses, motives and thoughts are likely to lose their fixed form and become malleable instead. There may emerge from this 'molten state' a new stable organization directed towards a different line of conduct The individual, as a result of witnessing a particularly emotional picture, may come to a decision to have certain kinds of experience and to live a kind of life different from his prior career.
>
> (Blumer 1933: 116)

A woman explains that when she saw *The Sheik* for the first time she recalls 'coming home that night and dreaming the entire picture over again; myself as the heroine, being carried over the burning sands by an equally burning lover. I could feel myself being kissed in the way the Sheik had kissed the girl' (Blumer, 1933: 70). What individuals see might affect them so significantly that the images actually become part of their own personal archive of experience.

Because the movie experience decentres lived experience, it, too, might alter or construct identity. Emotional possession has implications for both the future and the past of the individual under its sway. it has the potential to alter one's actions in the future in that under its hold an individual 'is transported out of his normal conduct and is completely subjugated by his impulses' (Blumer, 1933: 94). A nineteen-year-old woman writes,

> After having seen a movie of pioneer days I am very unreconciled to the fact that I live to-day instead of the romantic days of fifty years ago. But to offset this

poignant and useless longing I have dreamed of going to war. I stated previously that through the movies I have become aware of the awfulness, the futility of it, etc. But as this side has been impressed upon me, there has been awakened in me at the same time the desire to go to the 'front' during the next war. The excitement – shall I say glamour? – of the war has always appealed to me from the screen. Often I have pictured myself as a truck driver, nurse, HEROINE.

<div align="right">(Blumer, 1933: 63)</div>

What this suggests is that the experience within the move theatre and the memories that the cinema affords – despite the fact that the spectator did not live through them – might be as significant in constructing, or deconstructing, the spectator's identity as any experience that s/he actually lived through.

Many of the Payne Studies tests were designed to measure quantitatively the extent to which film affects the physical bodies of its spectators. The investigators used a galvanometer which, like a lie detector, 'measure[d] galvanic responses', electrical impulses, in skin, and a pneumo-cardiograph 'to measure changes in the circulatory system' (Charters 1933: 25), like respiratory pulse and blood pressure. This sensitive technology might pick up physiological disturbances and changes that would go unseen by the naked eye. These studies thus presumed that the body might give evidence of physiological symptoms caused by a kind of technological intervention into subjectivity – an intervention which is part and parcel of the cinematic experience. The call for a technology of detection registers a fear that we might no longer be able to distinguish prosthetic or 'unnatural' memories from 'real' ones.

At the same historical moment, European cultural critics of the 1920s – specifically Walter Benjamin and Siegfried Kracauer – began to theorize the experiential nature of the cinema. They attempted to theorize the way in which movies might actually extend the sensual memory of the human body. By 1940 Kracauer believed that film actually addresses its viewer as a ' "corporeal-material being"; it seizes the "human being with skin and hair": "The material elements that present themselves in film directly stimulate the *material layers* of the human being: his nerves, his senses, his entire *physiological substance*"' (1993: 458). The cinematic experience has an individual, bodily component at the same time that it is circumscribed by its collectivity; the domain of the cinema is public and collective. Benjamin's notion of 'innervation' is an attempt to imagine an engaged experiential relationship with technology and the cinema.[2] It is precisely the interplay of individual bodily experience with the publicity of the cinema which might make possible new forms of collectivity – political and otherwise.

More recently, Steven Shaviro (1993) has emphasized the visceral, bodily component of film spectatorship. He argues that psychoanalytic film theory studiously ignores the experiential component of spectatorship. In his account, psychoanalytic film theory has attempted 'to destroy the power of images' (1993: 16),[3] and that what those theorists fear is not the *lack*, 'not the emptiness of the image, but its weird fullness; not its impotence so much as its power' (Shaviro 1993: 17). We might say that the portability of cinematic images – the way we are invited to wear them prosthetically, the way we might experience them in a bodily fashion – is both the crisis and the allure. As if to emphasize this experiential, bodily aspect of spectatorship, Shaviro sets forth as his guiding principle that 'cinematic images are not representations, but *events*' (1993: 24).

I would like to turn to a scene in *Total Recall* which dramatically illustrates the way in which mass mediated images intervene in the production of subjectivity. The notion of authenticity – and our desire to privilege it – is constantly undermined by *Total Recall*'s

obsessive rendering of mediated images. In many instances we see, simultaneously, a person and their mediated representation on a video screen. When Quade first goes to Rekal to meet with Mr McClane, we see McClane simultaneously through a window over his secretary's shoulder, and as an image on her video phone as she calls him to let him know that Quade has arrived. In *Total Recall* the proliferation of mediated images – and of video screens – forces us to question the very notion of an authentic or an originary presence. Video monitors appear on subway cars with advertisements and all telephones are video phones; even the walls of Quade's house are enormous television screens. Quade's identity, too, as we will see, is mediated by video images. When he learns from his wife that she's not his wife, that she 'never saw him before six weeks ago', that their 'marriage is just a memory implant', that the Agency 'erased his identity and implanted a new one' – basically that 'his whole life is just a dream' – any sense he has of a unified self, of a stable subjectivity, is shattered. When memories might be separable from lived experience, issues of identity – and upon what identity is constructed – take on radical importance.

The question of his identity – and how his identity is predicated upon a particular set of memories which may or may not be properly his own – surfaces most dramatically when he confronts his own face in a video monitor. That he sees his face on a portable video screen – one that he has been carrying around in a suitcase which was handed to him by a 'buddy from the Agency' – literalizes the film's account of the portability of memory and identity. Quade confronts his own face in a video screen, but finds there a different person. The face on the screen says. 'Howdy stranger, this is Hauser. …Get ready for the big surprise. …You are not you. You are me.' We might be tempted to read this scene as an instance of Freud's (1959) notion of the 'uncanny'. The sensation of the 'uncanny', as Freud articulates it, is produced by an encounter with something which is simultaneously familiar and unfamiliar; the sensation of the uncanny comes from the 'return of the repressed'. The experience of seeing one's double is therefore the height of uncanny.[4] But Quade's experience is not that way at all. The face he confronts is explicitly not his face; it does not correspond to his identity. Since the film rejects the idea that there is an authentic, or more authentic, self underneath the layers of identity, there is no place for the uncanny. For Quade, the memories of Hauser seem never to have existed. In fact, he encounters Hauser with a kind of disinterest, not as someone he once knew or was, but rather as a total stranger.

In this way, the encounter seems to disrupt the Lacanian notion of the 'mirror stage'. According to Jacques Lacan, the mirror stage is initiated when a child first sees himself reflected as an autonomous individual, as a unified and bounded subject. As Lacan describes, the 'jubilant assumption of his specular image' (1977: 2) gives the child an illusion of wholeness, which is vastly different from the child's own sense of himself as a fragmentary bundle of undifferentiated drives. For Quade, the experience is exactly the opposite. In fact, we might say that the encounter with the face in the monitor, which looks like his face but is not the one he owns, disrupts any sense of a unified, stable and bounded subjectivity. Instead of consolidating his identity, the video screen further fragments it. This encounter undermines as well the assumption that a particular memory has a rightful owner, a proper body to adhere to.

This encounter with Hauser – who professes to be the real possessor of the body – becomes a microcosm for the film's larger critique of the pre-eminence of the 'real'. That we meet Quade first – and identity with him – makes us question whether Hauser is the true or more worthy identify for the body. If we are to believe that Hauser's identity is in some way more 'real' than Quade's – because his memories are based on lived experience rather than memory implants – the question then becomes is 'realer' necessarily better?

At the climax of the film, Quade claims his own identity instead of going back to being Hauser. In his final exchange with Cohagen, Cohagen says, 'I wanted Hauser back. You had to be Quade'. 'I am Quade', he responds. Although Quade is an identity based on implanted memories, it is no less viable than Hauser – and arguably more so. Quade remains the primary object of our spectatorial investment and engagement throughout the film. His simulated identity is more responsible, compassionate and productive than the 'real' one. That Quade experiences himself as 'real' gives the lie to the Baudrillardian and Jamesonian assumption that the real and the authentic are synonymous.

Part of what claiming this identity means is saving the Mutants on Mars from oxygen deprivation. The Mutants are the socio-economic group on Mars who are most oppressed by the tyrannical Cohagen; Cohagen regulates their access to oxygen. Quade refuses to go back to being Hauser because he feels that he has a mission to carry out. His sense of moral responsibility outweighs any claims on his actions exerted by the pull of an 'authentic' identity. By choosing to start the reactor at the pyramid mines – and thereby produce enough oxygen to make the atmosphere on Mars habitable – Quade is able to liberate the Mutants from Cohagen's grip.

Surprisingly enough, memories are less about authenticating the past, than about generating possible courses of action in the present. The Mutant resistance leader, Quato, tells Quade that 'A man is defined by his actions, not his memories'. We might revise his statement to say that a man is defined by his actions, but whether those actions are made possible by prosthetic memories or memories based on lived experience makes little difference. Any kind of distinction between 'real' memories and prosthetic memories – memories which might be technologically disseminated by the mass media and worn by its consumers – might ultimately be unintelligible. *Total Recall* underscores the way in which memories are always already public, the way in which memories always circulate and interpellate individuals, but can never get back to an authentic owner, to a proper body – or as we will see in the case of *Blade Runner*, to a proper photograph.

Although *Blade Runner* is based on the 1968 Philip K. Dick novel *Do Androids Dream of Electric Sheep?*, its points of departure from the novel are instructive. In Dick's novel, the presence of empathy is what allows the bounty hunters to distinguish the androids from the humans. In fact, empathy is imagined to be *the* uniquely human trait. Deckard wonders 'precisely why an android bounced so helplessly about when confronted by an empathy measuring test. Empathy, evidently, existed only within the human community' (Dick 1968: 26).

What exposes the replicants in the film, however, is not the lack of empathy as much as the lack of a past – the lack of memories. Ridley Scott's film foregrounds this point in the opening sequence. The film begins with a Voight-Kampf test. This test is designed to identify a replicant by measuring physical, bodily responses to a series of questions which are designed to provoke an emotional response. Technological instruments are used to measure pupil dilation and the blush reflex to determine the effect the questions have on the subject. In this opening scene, Mr Holden, a 'blade runner', questions Leon, his subject. As Mr Holden explains, the questions are 'designed to provoke an emotional response' and that 'reaction time is important'. Leon, however, slows down the test by interrupting with questions. When Mr Holden says, 'You're in a desert walking along the sand. You see a tortoise', Leon asks, 'What's a tortoise?' Seeing that his line of enquiry is going nowhere, Mr Holden says, 'Describe in single words the good things about your mother'. Leon stands up, pulls out a gun, says, 'Let me tell you about my mother' and then shoots Holden. In this primal scene, what 'catches' the replicant is not the absence of empathy, but rather the absence of a past, the absence of memories.

Leon cannot describe his mother, cannot produce a genealogy, because he has no past, no memories.

This scene, then, attempts to establish memory as the locus of humanity. Critics of the film have tended to focus on the fact that replicants lack a past in order to underscore the lack of 'real history' in postmodernity. David Harvey, for example, argues that 'history for everyone has become reduced to the evidence of a photograph' (1989: 313). In Harvey's account, that replicants lack a past illustrates the lack of depth – and the emphasis on surface – which characterizes postmodernity. Giuliana Bruno claims that the photograph 'represents the trace of an origin and thus a personal identity, the proof of having existed and therefore having the right to exist' (1987: 71). Certainly the relationship between photography and memory is central to this film. However, both Bruno and Harvey presume that photography has the ability to anchor a referent; they presume that the photograph maintains an indexical link to 'reality'. The film, I would argue, claims just the opposite.

After Deckard has determined that Rachel is a replicant she shows up at his apartment with photographs – in particular a photograph depicting her and her mother. 'You think I'm a replicant, don't you?', she asks. 'Look, it's me with my mother.' The photograph, she hopes, will both validate her memory and authenticate her past. Instead of reasserting the referent, however, the photograph further confounds it. Instead of accepting Rachel's photograph as truth, Deckard begins to recall for her one of her memories: 'You remember the spider that lived in the bush outside your window … watched her work, building a web all summer. Then one day there was a big egg in it.' Rachel continues, 'The egg hatched and 100 baby spiders came out and they ate her.' Deckard looks at her. 'Implants,' he says. 'Those aren't your memories, they're someone else's. They're Tyrell's niece's.' The photograph in *Blade Runner*, like the photograph of the grandmother in Kracauer's 1927 essay 'Photography', is 'reduced to the sum of its details' (1993: 430). With the passage of time the image 'necessarily disintegrates into its particulars' (Kracauer 1993: 429). The photograph can no more be a fixed locus of memory than the body can in *Total Recall*. The photograph, it seems has *proved* nothing.

We must not, however, lose sight of the fact that Rachel's photograph *does* correspond to the memories she has. And those memories are what allow her to go on, exist as she does, and eventually fall in love with Deckard. We might say that while the photograph has no relationship to 'reality', it helps her to produce her own narrative. While it fails to authenticate her past, it does authenticate her present. The power of photography, in Kracauer's account, is its ability to 'disclose this previously unexamined foundation of nature' (1993: 435–6) and derives not from its ability to fix, but rather from its ability to *reconfigure*. Photography, for Kracauer, precisely *because* it loses its indexical link to the world, has 'The capacity to stir up the elements of nature' (1993: 436). For Rachel, the photograph does not correspond to a lived experience and yet it provides her with a springboard for her own memories. In a particularly powerful scene, Rachel sits down at the piano in Deckard's apartment, takes her hair down, and begins to play. Deckard joins her at the piano. 'I remember lessons,' she says. 'I don't know if it's me or Tyrell's niece.' Instead of focusing on that ambiguity, Deckard says, 'You play beautifully'. At this point Deckard, in effect, rejects the distinction between 'real' and prosthetic memories. Her *memory* of lessons allows her to play beautifully, so it matters little whether she lived through the lessons or not.

Because the Director's Cut raises the possibility that Deckard himself is a replicant, it takes a giant step toward erasing the intelligibility of the distinction between the real and the simulated, the human and the replicant. Early on in the film Deckard sits down at his piano and glances at the old photographs that he has displayed on it. Then there

is cut to a unicorn racing through a field, which we are to take as a daydream – or a memory. Obviously it cannot be a 'real' memory, a memory of a lived experience. Later, at the very end of the film, when Deckard is about to flee with Rachel, he sees an origami unicorn lying on the floor outside of his door. When Deckard picks up the unicorn, which we recognize as the work of a plainclothes officer who has been making origami figure throughout the film, we hear an echo of his earlier statement to Deckard about Rachel – 'It's too bad she won't live, but then again who does?' The ending suggests that the cop knows about Deckard's memory of a unicorn, in the same way that Deckard knows about Rachel's memory of the spider. It suggests that his memories, too, are implants – that they are prosthetic. At this moment we do not know whether Deckard is a replicant or not. Unlike the earlier version of the film, the director's cut refuses to make a clear distinction for us between replicant and human, between real and prosthetic memory. There is no safe position, like the one Baudrillard implicitly supposes, from which we might recognize such a distinction. The ending of *Blade Runner*, then, registers the pleasure and the threat of portability – that we might not be able to distinguish between our own memories and prosthetic ones. Deckard is an emphatic person who is even able to have compassion for a replicant. More important, he is a character 'real enough' to gain our spectatorial identification. Ultimately the film makes us call into question our own relationship to memory, and to recognize the way in which we always assume that our memories are real. Memories are central to our identity – to our sense of who we are and what we might become – but as this film suggests, whether those memories come from lived experience or whether they are prosthetic seems to make very little difference. Either way, we use them to construct narratives for ourselves, visions for our future.

Wes Craven's New Nightmare (1994) beings with an uncanny allusion to *The Thieving Hand*. The film opens on a movie set, where an electrical version of the Freddie Kruger hand – a hand with razor blades in the place of fingers – comes to life, as it were, remembering its prior activity of killing. While this hand is not the hand from the old movie, but rather an electrical prosthesis, it nevertheless possesses the Kruger hand's memories. After this prosthetic hand slices open several people on the movie set, we realize that this scene is 'just' a dream based on the main character's memories of working on the *Nightmare on Elm Street* films. Gradually, however, the film begins to undermine or question that notion of 'just'. What might it mean to say that those memories are 'just' from a movie? Does it mean, for example, that they are not real? does it mean that those memories are *less* real? 'No,' would be Wes Craven's answer. In fact, memories of the earlier *Nightmare on Elm Street* movies – and *from* the movies – become her memories. And as the film radically demonstrates, this is a life and death matter. In the course of the movie, memories from the earlier movies begin to break through. Those memories are not from events she lived, but rather from events she lived cinematically. The film actually thematizes the way in which film memories become prosthetic memories. Her memories, prosthetic or not, she experiences as real, for they affect her in a life and death way, profoundly informing the decisions she has to make.

All three of these films gradually undermine the value of the distinction between real and simulation, between authentic and prosthetic memory – and in *Blade Runner*, the value of the distinction between human and replicant. In *Blade Runner*, even empathy ultimately fails as a litmus test for humanity. In fact, the replicants – Rachel and Roy (Rutger Hauer), not to mention Deckard – become increasingly empathic in the course of the film. The word empathy, unlike sympathy which has been in use since the sixteenth century, makes its first appearance at the beginning of this century. While sympathy presupposes an initial likeness between subjects ('Sympathy', *OED* 1989),[5] empathy presupposes an initial difference

between subjects. Empathy, then, is 'The power of projecting one's personality into … the object of contemplation' (*OED* 1989). We might say that empathy depends less on 'natural' affinity than sympathy, less on some kind of essential underlying connection between the two subjects. While sympathy, therefore, relies upon an essentialism of identification, empathy recognizes the alterity of identification. Empathy, then, is about the lack of identity between subjects, about negotiating distances. It might be the case that it is precisely this distance which is constitutive of the desire and passion to remember. That the distinction between 'real' and prosthetic memory is virtually undecidable makes the call for an ethics of personhood both frightening and necessary – an ethics based not on a pluralistic form of humanism or essentialism of identification, but rather on a recognition of difference.[6] An ethics of personhood might be constructed upon a practice of empathy and would take seriously its goal of respecting the fragmentary, the hybrid, the different.

Both *Blade Runner* and *Total Recall* – and even *Wes Craven's New Nightmare* – are about characters who understand themselves through a variety of alienated experiences and narratives which they take to be their own, and which they subsequently make their own through use. My narrative is thus a counter-argument to the 'consciousness industry', or 'culture industry' (Horkheimer and Adorno 1991) one. What I hope to have demonstrated is that it is not appropriate to dismiss as merely prosthetic these experiences that define personhood and identity. At the same time, however, memories cannot be counted on to provide narratives of self-continuity – as *Total Recall* clearly points out. I would like to end by leaving open the possibility of what I would like to call 'breakthrough memories'. When Quade is at Rekal Incorporated planning his memory package, he has an urge to go as a secret agent. In other words, memories from an earlier identity – not in any way his true or essential identity, but one of the many layers that have constructed him – seem to break through. It thus might be the case that identity is palimpsestic, that the layers of identity that came before are never successfully erased. It would be all too easy to dismiss such an identity as merely a relation of surfaces, as many theorists of the postmodern have done, but to do so would be to ignore what emerges in both texts as an insistent drive to remember. What both films seem to suggest is not that we should never forget, but rather that we should never stop generating memory. The particular desire to place oneself in history through a narrative of memories is a desire to be a social, historical being. We might say that it is precisely such a 'surface' experience of history which gives people personhood, which brings them into the public. What the drive to remember expresses, then, is a pressing desire to re-experience history not to unquestioningly validate the past, but to put into play the vital, indigestible material of history, reminding us of the uninevitability of the present tense.

Notes

1. See Donna J. Haraway (1991). A cyborg world, she suggests, 'might be about lived-social and bodily realities in which people are not afraid of their joint kinship with animals and machines, not afraid of permanent partial identities and contradictory standpoints' (1991: 154).
2. As Hansen (1993: 460) notes, 'the term *innervation* was used by Benjamin for conceptualizing historical transformation as a process of converting images into somatic and collective reality'.
3. Shaviro (1993) offers a clear articulation of a shifting emphasis in film theory from a psychoanalytic paradigm to one that attempts to account for the power of the image to engage the spectator's body. Also see Linda Williams (1991); Murray Smith (1994).
4. In his famous footnote, Freud describes the following scene: 'I was sitting alone in my wagon-lit compartment when a more than usually violent jerk of the train swung back the door in the adjoining washing-cabinet, and an elderly gentleman in a dressing-gown and traveling cap

came in. I assumed that he had been about to leave the washing-cabinet which divides the two compartments, and had taken the wrong direction and had come into my compartment by mistake. Jumping up with the intention of putting him right, I at once realized to my dismay that the intruder was nothing but my own reflection in the looking-glass of the open door, I can still recollect that I thoroughly disliked his appearance' (1959: 403).

5. According to the *OED*, sympathy is 'A (real or supposed) affinity between certain things, by virtue of which they are similarly or correspondingly affected by the same influence.'
6. Such an ethics would borrow insights from Subaltern and Post-Colonial Studies. See Jonathan Rutherford and Homi Bhabha (1990); Stuart Hall (1990); Iris Marion Young (1990).

References

Baudrillard, J. (1983) *Simulations*, New York: Semiotext(e), Inc.

Baudry, J. (1974–5) 'Ideological effects of the basic cinematographic apparatus', *Film Quarterly* 28(2): 39–47.

Blumer, H. (1933) *Movies and Conduct*, New York: Macmillan.

Bruno, G. (1987) 'Rumble city: postmodernism and *Blade Runner*', *October* 41: 61–74.

Charters, W. W. (1993) *Motion Pictures and Youth: A Summary*, New York: Macmillan.

Comolli, J.-L. (1986) 'Technique and ideology: camera, perspective, depth of field', in Philip Rosen (ed.) *Narrative, Apparatus, Ideology*, New York: Columbia University Press, pp. 421–33.

Dick, P. K. (1968) *Do Androids Dream of Electric Sheep?* New York: Ballantine Books.

Freud, S. (1959) 'The "Uncanny"', in *Collected Papers*, vol. IV, New York: Basic Books, pp. 368–407.

Hall, S. (1990) 'Cultural identity and diaspora', in Jonathan Rutherford (ed.) *Identity: Community, Culture, Difference*, London: Lawrence and Wishart, pp. 222–37.

Hansen, M. (1993) '"With skin and hair": Kracauer's theory of film, Marseilles 1940', *Critical Inquiry*, 19(3): 437–69.

Haraway, D. J. (1991) 'A cyborg manifesto: science, technology, and socialist-feminism in the late twentieth century', in *Simians, Cyborgs, and Women: The Reinvention of Nature*, New York: Routledge, pp. 149–81.

Harvey, D. (1989) *The Condition of Postmodernity*, Cambridge: Blackwell.

Horkheimer, M. and Adorno, T. W. (1991) 'The culture industry: enlightenment as mass deception', in *The Dialectic of Enlightenment*, New York: Continuum, pp. 120–67.

Jameson, F. (1991) *Postmodernism, or, the Cultural Logic of Late Capitalism*, Durham, NC: Duke University Press.

Kracauer, S. (1993) 'Photography', *Critical Inquiry* 19(3): 421–37.

Lacan, J. (1977) 'The Mirror-Stage', in *Écrits: A Selection*, New York: W.W. Norton, pp. 1–7.

Miller, D. A. (1988) *The Novel and the Police*, Berkeley and Los Angeles: University of California Press.

Oxford English Dictionary (1989) Oxford: Oxford University Press.

Rutherford, J. and Bhabha1 H. (1990) 'The third space: interview with Homi Bhabha', in Jonathan Rutherford (ed.) *Identity: Community, Culture, Difference*, London: Lawrence and Wishart, pp. 207–21.

Shaviro, S. (1993) *The Cinematic Body*, Minneapolis: University of Minnesota Press.

Smith, M. (1994) 'Altered states: character and emotional response in the cinema', *Cinema Journal* 33(4): 34–56.

Williams, L. (1991) 'Film bodies: gender, genre, and excess', *Film Quarterly* 44(4): 2–13.

Young, I. M. (1990) *Justice and the Politics of Difference*, Princeton, NJ: Princeton University Press.

Lisa Nakamura

RACE IN/FOR CYBERSPACE
Identity tourism and racial passing on
the Internet

MY STUDY, WHICH I WOULD characterize as ethnographic, with certain important reservations, focuses on the ways in which race is 'written' in the cyberspace locus called LambdaMOO, as well as the ways it is read by other players, the conditions under which it is enunciated, contested, and ultimately erased and suppressed, and the ideological implications of these performative acts of writing and reading otherness. What does the way race is written in LambdaMOO reveal about the enunciation of difference in new electronic media? Have the rules of the game changed, and if so, how?

Role-playing sites on the Internet like LambdaMOO offer their participants programming features such as the ability to physically 'set' one's gender, race and physical appearance, through which they can, indeed are required to, project a version of the self which is inherently theatrical. Since the 'real' identities of the interlocutors at Lambda are unverifiable (except by crackers and hackers, whose outlaw manipulations of code are unanimously construed by the Internet's citizens as a violation of both privacy and personal freedom) it can be said that everyone who participates is 'passing', as it is impossible to tell if a character's description matches a player's physical characteristics. Some of the uses to which this infixed theatricality are put are benign and even funny – descriptions of self as a human-size pickle or pot-bellied pig are not uncommon, and generally are received in a positive, amused, tolerant way by other players. Players who elect to describe themselves in racial terms, as Asian, African American, Latino, or other members of oppressed and marginalized minorities, are often seen as engaging in a form of hostile performance, since they introduce what many consider a real life 'divisive issue' into the phantasmatic world of cybernetic textual interaction. The borders and frontiers of cyberspace which had previously seemed so amorphous take on a keen sharpness when the enunciation of racial otherness is put into play as performance. While everyone is 'passing', some forms of racial passing are condoned and practised since they do not threaten the integrity of a national sense of self which is defined as white.

The first act a participant in LambdaMOO performs is that of writing a self description – it is the primal scene of cybernetic identity, a postmodern performance of the mirror stage:

> Identity is the first thing you create in a MUD. You have to decide the name of your alternate identity – what MUDders call your character. And you have to describe who this character is, for the benefit of the other people who inhabit the same MUD. By creating your identity, you help create a world. Your character's role and the roles of the others who play with you are part of the architecture of belief that upholds for everybody in the MUD the illusion of being a wizard in a castle or a navigator aboard a starship: the roles give people new stages on which to exercise new identities, and their new identities affirm the reality of the scenario.
>
> (Rheingold 1993)

In LambdaMOO it is required that one choose a gender; though two of the choices are variations on the theme of 'neuter', the choice cannot be deferred because the programming code requires it. It is impossible to receive authorization to create a character without making this choice. Race is not only not a required choice, it is not even on the menu.[1] Players are given as many lines of text as they like to write any sort of textual description of themselves that they want. The 'architecture of belief' which underpins social interaction in the MOO, that is, the belief that your interlocutors possess distinctive human identities which coalesce through and vivify the glowing letters scrolling down the computer screen, is itself built upon this form of fantastic autobiographical writing called the self-description. The majority of players in LambdaMOO do not mention race at all in their self-description, though most do include eye and hair colour, build, age, and the pronouns which indicate a male or a female gender.[2] In these cases when race is not mentioned as such, but hair and eye colour is, race is still being evoked – a character with blue eyes and blonde hair will be assumed to be white. Yet while the textual conditions of self-definition and self-performance would seem to permit players total freedom, within the boundaries of the written word, to describe themselves in any way they choose, this choice is actually an illusion. This is because the choice not to mention race does in fact constitute a choice – in the absence of racial description, all players are assumed to be white. This is partly due to the demographics of Internet users – most are white, male, highly educated and middle class. It is also due to the utopian belief-system prevalent in the MOO. This system, which claims that the MOO should be a free space for play, strives towards policing and regulating racial discourse in the interest of social harmony. This system of regulation does permit racial role-playing when it fits within familiar discourses of racial stereotyping, and thus perpetuates these discourses. I shall focus on the deployment of Asian performance within the MOO because Asian personae are by far the most common non-white ones chosen by players and offer the most examples for study.

The vast majority of male Asian characters deployed in the MOO fit into familiar stereotypes from popular electronic media such as video games, television and film, and popular literary genres such as science fiction and historical romance. Characters named Mr Sulu, Chun Li, Hua Ling, Anjin San, Musashi, Bruce Lee, Little Dragon, Nunchaku, Hiroko, Miura Tetsuo and Akira invoke their counterparts in the world of popular media; Mr Sulu is the token 'Oriental' in the television show *Star Trek*, Hua Ling and Hiroko are characters in the science fiction novels *Eon* and *Red Mars*, Chun Li and Liu Kang are characters from the video games *Street Fighter* and *Mortal Kombat*, the movie star Bruce Lee was nicknamed 'Little Dragon', Miura Tetsuo and Anjin San are characters in James

Clavell's popular novel and mini-series *Shogun*, Musashi is a medieval Japanese folklore hero, and Akira is the title of a Japanese animated film of the genre called *anime*. The name Nunchaku refers to a weapon, as do, in a more oblique way, all of the names listed above. These names all adapt the samurai warrior fantasy to cyberdiscursive role-playing, and permit their users to perform a notion of the Oriental warrior adopted from popular media. This is an example of the crossing over effect of popular media into cyberspace, which is, as the latest comer to the array of electronic entertainment media, a bricolage of figurations and simulations. The Orientalized male persona, complete with sword, confirms the idea of the male Oriental as potent, antique, exotic and anachronistic.

This type of Orientalized theatricality is a form of identity tourism; players who choose to perform this type of racial play are almost always white, and their appropriation of stereotyped male Asiatic samurai figures allows them to indulge in a dream of crossing over racial boundaries temporarily and recreationally. Choosing these stereotypes tips their interlocutors off to the fact that they are not 'really' Asian; they are instead 'playing' in an already familiar type of performance. Thus, the Orient is brought into the discourse, but only as a token or 'type'. The idea of a non-stereotyped Asian male identity is so seldom enacted in LambdaMOO that its absence can only be read as a symptom of a suppression.

Tourism is a particularly apt metaphor to describe the activity of racial identity appropriation, or 'passing' in cyberspace. The activity of 'surfing' (an activity already associated with tourism in the mind of most Americans) the Internet not only reinforces the idea that cyberspace is not only a place where travel and mobility are featured attractions, but also figures it as a form of travel which is inherently recreational, exotic and exiting, like surfing. The choice to enact oneself as a samurai warrior in LambdaMOO constitutes a form of identity tourism which allows a player to appropriate an Asian racial identity without any of the risks associated with being a racial minority in real life. While this might seem to offer a promising venue for non-Asian characters to see through the eyes of the Other by performing themselves as Asian through on-line textual interaction, the fact that the personae chosen are overwhelmingly Asian stereotypes blocks this possibility by reinforcing these stereotypes.

This theatrical fantasy of passing as a form of identity tourism has deep roots in colonial fiction, such as Kipling's *Kim* and T.E. Lawrence's *The Seven Pillars of Wisdom*, and Sir Richard Burton's writings. The Irish orphan and spy Kim, who uses disguise to pass as Hindu, Muslim and other varieties of Indian natives, experiences the pleasures and dangers of cross-cultural performance. Said's (1987) insightful reading of the nature of Kim's adventures in cross-cultural passing contrasts the possibilities for play and pleasure for white travellers in an imperialistic world controlled by the European empire with the relatively constrained plot resolutions offered that same boy back home. 'For what one cannot do in one's own Western environment, where to try to live out the grand dream of a successful quest is only to keep coming up against one's own mediocrity and the world's corruption and degradation, one can do abroad. Isn't it possible in India to do everything, be anything, go anywhere with impunity?' (1987: 42). To practitioners of identity tourism as I have described it above, LambdaMOO represents a phantasmatic imperial space, much like Kipling's Anglo-India, which supplies a stage upon which the 'grand dream of a successful quest' can be enacted.

Since the incorporation of the computer into the white-collar workplace, the line which divides work from play has become increasingly fluid. It is difficult for employers and indeed, for employees, to always differentiate between doing 'research' on the Internet and 'playing': exchanging email, checking library catalogues, interacting with friends and colleagues through synchronous media-like 'talk' sessions, and video conferencing offer

enhanced opportunities for gossip, jokes and other distractions under the guise of work.[3] Time spent on the Internet is a hiatus from 'RL' (or real life, as it is called by most participants in virtual social spaces like LambdaMOO), and when that time is spent in a role-playing space such as Lambda, devoted only to social interaction and the creation and maintenance of a convincingly 'real' milieu modelled after an 'international community', that hiatus becomes a full-fledged vacation. The fact that Lambda offers players the ability to write their own descriptions, as well as the fact that players often utilize this programming feature to write stereotyped Asian personae for themselves, reveal that attractions lie not only in being able to 'go' to exotic spaces,[4] but to co-opt the exotic and attach it to oneself. The appropriation of racial identity becomes a form of recreation, a vacation from fixed identities and locales.

This vacation offers the satisfaction of a desire to fix the boundaries of cultural identity and exploit them for recreational purposes. As Said puts it, the tourist who passes as the marginalized Other during his travels partakes of a fantasy of social control, one which depends upon and fixes the familiar contours of racial power relations.

> It is the wish-fantasy of someone who would like to think that everything is possible, that one can go anywhere and be anything. T.E. Lawrence in *The Seven Pillars of Wisdom* expresses this fantasy over and over, as he reminds us how he – a blond and blue-eyed Englishman – moved among the desert Arabs as if he were one of them. I call this a fantasy because, as both Kipling and Lawrence endlessly remind us, no one – least of all actual whites and non-whites in the colonies – ever forgets that 'going native' or playing the Great Game are facts based on rock-like foundations, those of European power. Was there ever a native fooled by the blue or green-eyed Kims and Lawrences who passed among the inferior races as agent adventurers? I doubt it.
>
> (Said 1987: 44)

As Donna Haraway notes, high technologies 'promise ultimate mobility and perfect exchange – and incidentally enable tourism, that perfect practice of mobility and exchange, to emerge as one of the world's largest single industries' (1991: 168). Identity tourism in cyberspaces like LambdaMOO functions as a fascinating example of the promise of high-technology to enhance travel opportunities by redefining what constitutes travel – logging on to a phantasmatic space where one can appropriate exotic identities means that one need never cross a physical border or even leave one's armchair to go on vacation. This 'promise' of 'ultimate mobility and perfect exchange' is not, however, fulfilled for everyone in LambdaMOO. The suppression of racial discourse which does not conform to familiar stereotypes, and the enactment of notions of the Oriental which do conform to them, extends the promise of mobility and exchange only to those who wish to change their identities to fit accepted norms.

Performances of Asian female personae in LambdaMOO are doubly repressive because they enact a variety of identity tourism which cuts across the axes of gender and race, linking them in a powerful mix which brings together virtual sex, Orientalist stereotyping and performance. A listing of some of the names and descriptions chosen by players who masquerade as 'Asian' 'females' at LambdaMOO include: AsianDoll, Miss_Saigon, Bisexual_Asian_Guest, Michelle_Chang, Geisha_Guest, and Maiden_Taiwan. They describe themselves as, for example, a 'mystical Oriental beauty, drawn from the pages of a Nagel calendar', or, in the case of the Geisha_Guest, a character owned by a white American man living in Japan:

a petite Japanese girl in her twenties. She has devoted her entire life to the perfecting of the tea ceremony and mastering the art of lovemaking. She is multi-orgasmic. She is wearing a pastel kimono, 3 under-kimonos in pink and white. She is not wearing panties, and that would not be appropriate for a geisha. She has spent her entire life in the pursuit of erotic experiences.

Now, it is commonly known that the relative dearth of women in cyberspace results in a great deal of 'computer cross-dressing', or men masquerading as women. Men who do this are generally seeking sexual interaction, or 'netsex' from other players of both genders. When the performance is doubly layered, and a user extends his identity tourism across both race and gender, it is possible to observe a double appropriation or objectification which uses the 'Oriental' as part of a sexual lure, thus exploiting and reifying through performance notions of the Asian female as submissive, docile, a sexual plaything.

The fetishization of the Asian female extends beyond LambdaMOO into other parts of the Internet. There is a Usenet newsgroup called *alt.sex.fetish.orientals* which is extremely active – it is also the only one of the infamous *alt.sex* newsgroups which overtly focuses upon race as an adjunct to sexuality.

Cyberspace is the newest incarnation of the idea of national boundaries. It is a phenomenon more abstract yet at the same time more 'real' than outer space, since millions of participants deploy and immerse themselves within it daily, while space travel has been experienced by only a few people. The term 'cyberspace' participates in a topographical trope which, as Stone (1994) points out, defines the activity of on-line interaction as a taking place within a locus, a space, a 'world' unto itself. This second 'world', like carnival, possesses constantly fluctuating boundaries, frontiers and dividing lines which separate it from both the realm of the 'real' (that which takes place off-line) and its corollary, the world of the physical body which gets projected, manipulated and performed via on-line interaction. The title of the *Time* magazine cover story for 25 July 1994, 'The Strange New World of Internet: Battles on the Frontiers of Cyberspace', is typical of the popular media's depictions of the Internet as a world unto itself with shifting frontiers and borders which are contested in the same way that national borders are. The 'battle' over borders takes place on several levels which have been well documented elsewhere, such as the battle over encryption and the conflict between the rights of the private individual to transmit and receive information freely and the rights of government to monitor potentially dangerous, subversive or obscene material which crosses state lines over telephone wires. These contests concern the distinction between public and private. It is, however, seldom acknowledged that the trope of the battle on the cyber frontier also connotes a conflict on the level of cultural self definition. If, as Chris Chesher notes, 'the frontier has been used since as a metaphor for freedom and progress, and … space exploration, especially, in the 1950s and 1960s was often called the "new frontier"', (1995: 18), the figuration of cyberspace as the most recent representation of the frontier sets the stage for border skirmishes in the realm of cultural representations of the Other. The discourse of space travel during this period solidified the American identity by limning out the contours of a cosmic, or 'last' frontier.[5] The 'race for space', or the race to stake out a border to be defended against both the non-human (aliens) and the non-American (the Soviets) translates into an obsession with race and a fear of racial contamination, always one of the distinctive features of the imperialist project. In such films as *Alien*, the integrity and solidarity of the American body is threatened on two fronts – both the anti-human (the alien) and the passing-as-human (the cyborg) seek to gain entry and colonize Ripley's human body. Narratives which locate the source of contaminating elements within a deceitful and uncanny technologically-enabled

theatricality – the ability to pass as human – depict performance as an occupational hazard of the colonization of any space. New and futuristic technologies call into question the integrity of categories of the human since they enable the non-human to assume a human face and identity.

Recently, a character on Lambda named 'Tapu' proposed a piece of legislation to the Lambda community in the form of petition. This petition, entitled 'Hate-Crime', was intended to impose penalties upon characters who harassed other characters on the basis of race. The players' publicly posted response to this petition, which failed by a narrow margin, reveals a great deal about the particular variety of utopianism common to real-time textual on-line social interaction. The petition's detractors argued that legislation or discourse designed to prevent or penalize racist 'hate speech' were unnecessary since those offended in this way had the option to 'hide' their race by removing it from their descriptions. A character named 'Taffy' writes, 'Well, who knows my race unless I tell them? If race isn't important then why mention it? If you want to get in somebody's face with your race then perhaps you deserve a bit of flak. Either way I don't see why we need extra rules to deal with this.' 'Taffy', who signs himself 'proud to be a sort of greyish pinky color with bloches' [sic] recommends a strategy of both blaming the victim and suppressing race, an issue which 'isn't important' and shouldn't be mentioned because doing so gets in 'somebody's face'. The fear of the 'flak' supposedly generated by player's decisions to include race in their descriptions of self is echoed in another post to the same group by 'Nougat', who points out that 'how is someone to know what race you are a part of? If [sic] this bill is meant to combat comments towards people of different races, or just any comments whatsoever? Seems to me, if you include your race in your description, you are making yourself the sacrificial lamb. I don't include "caucasian" in my description, simply because I think it is unnecessary. And thusly, I don't think I've ever been called "honkey"'. Both of these posts emphasize that race is not, should not be, 'necessary' to social interaction on LambdaMOO. The punishment for introducing this extraneous and divisive issue into the MOO, which represents a vacation space, a Fantasy Island of sorts, for its users, is to become a 'sacrificial lamb'. The attraction of Fantasy Island lay in its ability to provide scenarios for the fantasies of privileged individuals. And the maintenance of this fantasy, that of a race-free society, can only occur by suppressing forbidden identity choices.

While many of the members of social on-line communities like LambdaMOO are stubbornly utopian in their attitudes towards the power dynamics and flows of information within the technologically mediated social spaces they inhabit, most of the theorists are pessimistic. Andrew Ross and Constance Penley introduce the essays in their collection *Technoculture* by asserting that 'the odds are firmly stacked against the efforts of those committed to creating technological counter-cultures' (1991: iii). Chesher concedes that 'In spite of the claims that everyone is the same in virtual worlds, access to technology and necessary skills will effectively replicate class divisions of the rest of reality in the virtual spaces' (1994: 28) and 'will tend to reinforce existing inequalities, and propagate already dominant ideologies' (ibid.: 29). Indeed, the cost of Net access does contribute towards class divisions as well as racial ones; the vast majority of the Internet's users are white and middle class. One of the dangers of identity tourism is that it takes this restriction across the axes of race/class in the 'real world' to an even more subtle and complex degree by reducing non-white identity positions to part of a costume or masquerade to be used by curious vacationers in cyberspace. Asianness is co-opted as a 'passing' fancy, an identity-prosthesis which signifies sex, the exotic, passivity when female, and anachronistic dreams of combat in its male manifestation. 'Passing' as a samurai or geisha is diverting, reversible, and a privilege mainly used by white men. The paradigm of Asian passing masquerades

on LambdaMOO itself works to suppress racial difference by setting the tone of the discourse in racist contours, which inevitably discourage 'real-life' Asian men and women from textual performance in that space, effectively driving race underground. As a result, a default 'whiteness' covers the entire social space of LambdaMOO – race is 'whited out' in the name of cybersocial hygiene.

The dream of a new technology has always contained within it the fear of total control, and the accompanying loss of individual autonomy. Perhaps the best way to subvert the hegemony of cybersocial hygiene is to use its own metaphors against itself. Racial and racist discourse in the MOO is the unique product of a machine and an ideology. Looking at discourse about race in cyberspace as a computer bug or ghost in the machine permits insight into the ways that it subverts that machine. A bug interrupts a program's regular commands and routines, causing it to behave unpredictably. 'Bugs are mistakes, or unexpected occurrences, as opposed to things that are intentional' (Aker 1987: 12). Programmers routinely debug their work because they desire complete control over the way their program functions, just as Taffy and Nougat would like to debug LambdaMOO of its 'sacrificial lambs', those who insist on introducing new expressions of race into their world. Discourse about race in cyberspace is conceptualized as a bug, something which an efficient computer user would eradicate since it contaminates their work/play. The 'unexpected occurrence' of race has the potential, by its very unexpectedness, to sabotage the ideology-machine's routines. Therefore, its articulation is critical, as is the ongoing examination of the dynamics of this articulation. As Judith Butler puts it:

> Doubtlessly crucial is the ability to wield the signs of subordinated identity in a public domain that constitutes its own homophobic and racist hegemonies through the erasure or domestication of culturally and politically constituted identities. And insofar as it is imperative that we insist upon those specificities in order to expose the fictions of an imperialist humanism that works through unmarked privilege, there remains the risk that we will make the articulation of ever more specified identities into the aim of political activism. Thus every insistence on identity must at some point lead to a taking stock of the constitutive exclusions that reconsolidate hegemonic power differentials.
>
> (1993: 118)

The erasure and domestication of Asianness on LambdaMOO perpetuates an Orientalist myth of social control and order. As Cornell West puts it, as Judith Butler puts it, 'race matters', and 'bodies matter'. Programming language and Internet connectivity have made it possible for people to interact without putting into play any bodies but the ones they write for themselves. The temporary divorce which cyberdiscourse grants the mind from the body and the text from the body also separates race and the body. Player scripts which eschew repressive versions of the Oriental in favour of critical rearticulations and recombinations of race, gender and class, and which also call the fixedness of these categories into question have the power to turn the theatricality characteristic of MOOspace into a truly innovative form of play, rather than a tired reiteration and reinstatement of old hierarchies. Role-playing is a feature of the MOO, not a bug, and it would be absurd to ask that everyone who plays within it hew literally to the 'RL' gender, race or condition of life. A diversification of the roles which get played, which are permitted to be played, can enable a thought-provoking detachment of race from the body, and an accompanying questioning of the essentialness of race as a category. Performing alternative versions of self and race jams the ideology-machine, and facilitates a desirable opening up of what Judith Butler calls 'the difficult future terrain of community' in cyberspace (1993: 242).

Notes

1. Some MUDS such as Diku and Phoenix require players to select races. These MUDS are patterned after the role-playing game Dungeons and Dragons and unlike Lambda, which exists to provide a forum for social interaction and chatting, focus primarily on virtual combat and the accumulation of game points. The races available to players (orc, elf, dwarf, human, etc.) are familiar to readers of the 'sword and sorcery' genre of science fiction, and determine what sort of combat 'attributes' a player can exploit. The combat metaphor which is a part of this genre of role-playing reinforces the notion of racial difference.

2. Most players do not choose either spivak or neuter as their gender; perhaps because this type of choice is seen as a non-choice. Spivaks and neuters are often asked to 'set gender' by other players; they are seen as having deferred a choice rather than having made an unpopular one. Perhaps this is an example of the 'informatics of domination' which Haraway (1991) describes.

3. Computer users who were using their machines to play games at work realized that it was possible for their employers and co-workers to spy on them while walking nearby and notice that they were slacking – hence, they developed screen savers which, at a keystroke, can instantly cover their 'play' with a convincingly 'work-like' image, such as a spreadsheet or business letter.

4. Microsoft's recent television and print media advertising campaign markets access to both personal computing and networking by promoting these activities as a form of travel; the ads ask the prospective consumer, 'where do you want to go today?' Microsoft's promise to transport the user to new spaces where desire can be fulfilled is enticing in its very vagueness, offering an open-ended invitation for travel and novel experiences.

5. The political action group devoted to defending the right to free speech in cyberspace against governmental control calls itself 'The Electronic Frontier Foundation'; this is another example of the metaphorization of cyberspace as a colony to be defended against hostile takeovers.

References

Aker, S. *et al.* (1987–91) *Macintosh Bible*, 3rd edition, Berkeley: Goldstein and Blair.

Butler, J. (1993) *Bodies that Matter: On the Discursive Limits of 'Sex'*, New York: Routledge.

Chesher, C. (1994) 'Colonizing virtual reality: construction of the discourse of virtual reality, 1984–1992', *Cultronix*, vol. 1, issue 1, Summer 1994. *The English Server*. On-line, 16 May 1995.

Elmer, D. P. (1994) 'Battle for the soul of the Internet', *Time*, 25 July.

Haraway, D. (1991) *Simians, Cyborgs, and Women*, New York: Routledge.

Penley, C. and Ross, R. (1991) *Technoculture*, Minneapolis: University of Minnesota Press.

Rheingold, H. (1993) *The Virtual Community*, New York: HarperPerennial. *The Well*. On-line, 16 May 1995.

Stone, A. R. (1994) 'Will the real body please stand up?: boundary stories about virtual cultures', in Michael Benedikt (ed.) *Cyberspace: First Steps*, Cambridge: MIT Press.

Said, E. (1987) Introduction. *Kim*, by Rudyard Kipling, New York: Penguin, pp. 7–46.

Aihwa Ong

CYBERPUBLICS AND DIASPORA POLITICS AMONG TRANSNATIONAL CHINESE

IN AUGUST 1998, a global Chinese (huaren) website mobilized worldwide protests against anti-Chinese attacks in Indonesia triggered by the Asian financial crisis. This set of events provides the occasion for a discussion of the necessary conceptual distinction between diaspora and transnationalism. I maintain that diaspora as permanent political exile is often conflated with contemporary forms of fairly unrestricted mobility. 'Diaspora', however, gets increasingly invoked by affluent migrants in transnational contexts to articulate an inclusive global ethnicity for disparate populations the world over who may be able to claim a common racial or cultural ancestry.

I use the term 'translocal publics' to describe the new kinds of disembedded diaspora identifications enabled by technologies and forums of opinion-making. I consider the promise and the danger of cyber diaspora politics that intervene on behalf of co-ethnics in distant lands. The rise of such diaspora politics may inspire in the members an unjustified sense that cyber-based humanitarian interventions will invariably produce positive results for intended beneficiaries.

The Huaren cyberpublic promotes itself as an electronic watchdog for ethnic Chinese communities across the world. But, while ethnic Chinese in Indonesia were grateful for the spotlight cast on their plight, some felt cyber misrepresentations of events and criticisms of Indonesia jeopardized their attempts to commit themselves as Indonesian citizens. Thus, Internet-based articulation of a disembedded global racial citizenship can create invidious essential differences between ethnic others and natives, deepening rather than reducing already existing political and social divisions within particular nations. In short, discourses of a racialized diaspora raise the question of who is accountable to whom in a transnationalized world.

The triggering event

In August 1997 a financial firestorm swept through Southeast Asia, bringing chaos and suffering to millions in Suharto's Indonesia. Following the precipitous decline of the rupiah

in late 1997, millions of Indonesian workers laid off from their jobs returned to poverty-stricken neighborhoods and villages. A picture of Suharto signing away his power, with the stern IMF chief standing over him, his arms crossed, had been a widely-publicized image of national humiliation.[1] A handful of army generals, indigenous business competitors and Muslim intellectuals deflected anger against the ruling elite by stirring racist nationalist feelings against ethnic Chinese. Indonesian Chinese were called 'new-style colonialists ... who plunder the people's wealth' and traitors who keep their wealth in US dollars and send their money overseas. Rumors flew about Chinese shopkeepers hoarding food, raising food prices, and Chinese 'traitors' fleeing the country with ill-gotten capital. Combined with the invisibility and unpredictability of market forces, such metaphors of evil turned fears into rage.

In May 1998 and the following weeks, ordinary people looted and burned, Chinese stores and homes, while soldiers stood by, observing a destruction that mimicked the devastation visited on the lives of the poor. In the chaos of the destruction, soldiers disguised as hooligans were reported to have attacked dozens of girls and women, many of whom were ethnic Chinese. Human rights activists claimed that the rapes were organized rampage by military men out of uniform. A related process of witch-hunting was set off by rumors about anonymous men in black called ninjas who killed Muslim leaders and dumped their mutilated bodies in mosques. In some neighborhoods, local vigilante groups hunted for ninjas who were killed on sight, their heads paraded on pikes. Such grisly attacks, and the demands by the masses for some kind of redistribution of 'Chinese' wealth in favor of the *pribumi* (indigenous) population, again made the scapegoat community stand for the ravages of the global markets.

It is important to note that, while ethnic and religious differences have long existed in Indonesia, under Suharto's New Order regime (1969–98) a few Chinese tycoons (*cukong*) enjoyed special political access which enabled them to amass huge fortunes and dominate sectors of the economy. The majority of ethnic Chinese (numbering some four million) are small business operators, professionals and working people who bear the brunt of a historical legacy of anti-Chinese sentiments and suffer from a legal status as racialized citizens.[2] The Suharto government, through inaction, had practically 'legalized' attacks on Chinese property and persons, allowing the army to manipulate events to displace anger against the Suharto regime onto the ethnic Chinese (Coppel 1999). The seeming global indifference sparked an international response among ethnic Chinese communities around the world, linked through the Internet.[3]

The rise of a Huaren cyberpublic

On 7 August 1998, and the days following, coordinated rallies protested the anti-Chinese violence in front of Indonesian embassies and consulates in the United States, Canada, Australia, and Asia. These rallies were held mainly in cities in the West – Atlanta, Boston, Calgary, Chicago, Dallas, Houston, Los Angeles, New York, San Francisco, Toronto, Vancouver, and Washington. In Asia, demonstrations took place only in Hong Kong, Manila, and Beijing. China issued a rare warning to Indonesia over redress for the victims of the riots and mass rapes.

The global protests were organized through a new website called Global Huaren ('Global Chinese People'), set up by a Malaysian Chinese emigrant in New Zealand called Joe Tan. Enraged by the seeming indifference of New Zealanders and the world to the anti-Chinese attacks, Tan linked up with ethnic Chinese engineers and professionals in Canada, Australia,

and the United States, who saw parallels between the plight of Chinese in Indonesia and European Jews. They established the World Huaren Federation (WHF) in order 'to foster a stronger sense of identity among Chinese people everywhere, not to promote Chinese chauvinism but rather racial harmony' (Arnold 1998). Huaren chapters have been formed mainly in Southeast Asian cities, but they are beginning to appear in all continents, and the federation anticipates a membership of ten million in a few years.

This 'revolution' in Chinese political activism is attributed to the fact that 'at least four million of us around the world are computer users, computer geeks and techies', according to an American Chinese attorney, Edward Liu, who heads the San Francisco chapter of Huaren. As reported on its website, this construction of a global Chinese public identifies race as the unifying feature. Tan maintains that the WHF is not intended to encourage Chinese chauvinism but 'to eradicate the intimidation which some governments are subjecting Chinese and other ethnic minorities to. We want to ensure that such atrocities will never happen again to anyone of any race and color.' He adds: 'Like any other race, the Chinese are expected to be responsible citizens in their country of birth or adoption.'[4] As a diaspora public set up by overseas Chinese professionals based in New Zealand, Australia, Canada, and the US, many of whom have no prior experience with or links to Indonesia, Global Huaren seeks to act as a kind of disembedded and placeless political watchdog on behalf of the Chinese race.

Edward Liu, who spoke at a San Francisco rally, criticized President Habibie (President Suharto's successor) for being complicit in a *de facto* 'ethnic cleansing' of Chinese influence in the cultural, economic, and social fabric of Indonesia.[5] He thanked ethnic Indonesians such as Father Sandi-awan Sumardi and other pribumi human rights advocates who risked their own safety and lives in support of the victims. He condemned the 'Chinese Indonesians' who were at one time cronies of Suharto but 'now have ingratiated themselves with Habibie in the same rotten system of corruption, cronyism and nepotism'. He went on to lecture the Indonesians:

> Chinese Indonesians have a right to be good Indonesians. They have a right to be Chinese culturally too. They have a right, as I do, as a Chinese American of Filipino background to be proud of my ties. I am proud to be a Chinese. I am also proud to be a Filipino. I am also proud to be a San Franciscan and an American.[6]

This speech demonstrates extreme insensitivity to the situation in Indonesia. Liu makes distinctions in racial terms, and seems to give primacy to Chineseness, when most ethnic Chinese prefer to refer to themselves as Indonesian Chinese, and not the reverse. Liu seems to essentialize the Chinese race and to conflate race with culture. He criticizes Habibie, who though politically weak had worked to improve the citizenship protections of ethnic minorities.

The diaspora politics protesting anti-Chinese activities around the world is cast in the language of moral redemption for the Huaren rare, posing the need to balance racial protection against economic advantage. For instance, the World Huaren Federation was lauded by the *Straits Times* in Singapore which claimed:

> Previously, Chinese communities were more concerned with commercial and economic matters. The ethnic Chinese in Indonesia had been pummeled by rioting in the past decades – but they had always absorbed the punishment meekly to preserve their commercial interests. This time around, a landmark shift occurred with modern communications technology becoming the unifying force.
>
> (Soh 1998)

In on-line discussions on the Huaren website, the attacks on Indonesian Chinese have become a stimulus for a moral resurgence around the concept of a Chinese race. New American Chinese have logged on to confess their 'shame' for having failed 'to help Huaren refugee[s] in Vietnam and in Cambodia'. A subscriber urges his compatriots: 'Don't sell our pride and value for short-term personal and materialist gain. Wealth without pride and compassion is not success or achievement.' He bemoans the fact that wherever any Chinese was mentally or physically discriminated against, the majority of the 'so called "successful" business Huaren' were nowhere to be seen.[7] A respondent notes that for the past two decades many Chinese emigrants were ashamed of China and Vietnam for being communist and poor countries, and their lack of sympathy to the Chinese boat people was influenced by the 'Western propaganda machine'. Now his own view has changed:

> How and when I realized that I was not just an internationalist (I was a parasite) but a human first and foremost, I can't pinpoint. … Being racial is not necessarily negative. Racial discrimination and persecution is obnoxious but it is necessary to contribute towards one's race. One is as whole as [what] one's ancestors [have] built in the past, and each man in the present must maintain and build for the descendants. … [The] Chinese must begin to let loose their embrace on self-gain. … the stronger must fend for the weaker, the more able to contribute more. This is something new to [us] Chinese and we must set the example.[8]

The conflation of diaspora and transnationalism

This paper considers differentiations among migrant populations who share an ethnocultural or racial ancestry – a diverse assemblage of co-ethnics who have been conceptually reduced to homogeneous 'diasporic communities'. Popular books such as *Sons of the Yellow Emperor* or the *Encyclopedia of Chinese Overseas* seek to unite diverse flows of people in different parts of the world through their Chinese heritage and ancestral mainland origins (Pan 1990, 1999). In recent decades, as new flows of well-educated, middle-class Chinese from Asia have flocked to North America, there has been an intensification of Asian American interest in a search for cultural roots (see *Daedalus* 1991). The term 'diaspora' has suddenly begun to be invoked by activists and academics in order to claim an overarching framework for heterogeneous peoples who may be able to trace ancestral roots to China.[9] Conceptually speaking, 'diaspora' as widely used today refers not to permanent exile, but rather to the global imaginary invoked by transnational subjects located in metropolitan centers who wish to exercise a new form of power through the use of informational technology.

What is necessary, then, is to differentiate between the political use of the term 'diaspora' and the conceptual meaning of diaspora as exile. Many analytical perspectives however conflate diaspora as permanent exile with contemporary forms of fairly unrestricted mobility. The terms 'transnational migration' and 'diaspora' are often used in the same breath, confusing changes in population flows occasioned by globalizing market forces with earlier forms of permanent exile. While some migrations are involuntary or occasioned by war (hegira in Islamic countries), most cross-border flows today are induced and channeled by the ease of travel and the reorganization of labor markets within the global economy. For instance, the terms 'diasporic communities' and 'global ethnoscapes' have been used to refer to migrant communities that have an unprecedented effect on the politics of the homeland (Appadurai 1995). But the term 'diasporic communities' seems to suggest that

migrant populations who have the potential of belonging to the same ethnic group are internally homogeneous, have similar imaginaries, and seek to affect state politics in the same way. The effect of this is to essentialize migrants as particular kinds of ethnics, when our task is rather to sort out the different categories of people who can be described as, for example, ethnic Chinese traveling abroad, but who are often in different class, gender, and labor circuits, and who form discrepant alliances and pursue divergent politics.

The term 'transnationality' better describes the variety of cultural interconnections and trans-border movements and networks which have intensified under conditions of late capitalism. Contemporary transnational flows may have overlapped with the paths of earlier migrants from the same country of departure who had left under involuntary conditions. When we think of Southeast Asians refugees in the United States, for instance, we might consider them part of a diaspora created by war and resettlement abroad. But a generation later, many of same refugees and their children are engaged in multiple home visits and cross-border exchanges. They are participating in contemporary movements of people back and forth, propelled by trade, labor markets, and tourism. Indeed, most original diaspora populations – initially occasioned by expulsion with no hope of return – now have the possibility of multiple returns and/or participation in global circuits formed by commerce. The ease of travel today means that few migrants are truly exiles, or experiencing diaspora in its original sense of a lack of hope of return to one's homeland. Diaspora sentiments may linger but it may be more analytically exact to use the term 'transnationalism' to describe the processes of disembedding from a set of localized relations in the homeland nation and re-embedding in new overlapping networks that cut across borders. It seems to me, therefore, that the old meaning of diaspora – of being scattered or in dispersion, with no hope of return – is too limiting an analytical concept to capture the multiplicity of vectors and agendas associated with the majority of contemporary border crossings.

As Zygmunt Bauman reminds us, there is a polarization between those free to move and those forced to move, e.g., between travelers and refugees, businessmen and migrant workers. This 'global hierarchy of mobility' is part of a worldwide and local redistribution of privileges and deprivations; a restratification of humanity (Bauman 1998: 70). The scholarship of overseas Chinese in Southeast Asia has been meticulous in analyzing this internal kind of fragmentation and cultural diversity within seemingly unified diaspora populations, but such works remain largely unfamiliar to contemporary diaspora studies.[10] More recently, *Ungrounded Empires* brought together interdisciplinary analyses of diverse ethnic Chinese flows and transnational subjectivity emerging within situations of 'flexible' capitalism in the Asia Pacific (Ong and Nonini 1997). This volume, among others, has influenced China historians to turn to the study of the Chinese diaspora (heretofore considered a residual phenomenon) and, as mentioned, has opened up Asian American Studies to a whole new field of investigation. One important work documenting unexpected circuits and cultural complexity is Adam McKeown's *Chinese Migrant Networks and Cultural Change: Peru, Chicago, Hawaii 1900–1936* (1999). Nevertheless, despite such studies of multiple trajectories and ambiguity in identity, there is still a dearth of scholarly attention focusing on these tensions between translation networks and local ethnic situations in particular locations. Clearly, one needs to differentiate between diaspora as a set of differentiated phenomena and diaspora as political rhetoric.

Thus, I would consider discourses of diaspora not as descriptions of already formed social entities, but rather as specific political practices projected on a global scale. Ironically, then, diaspora politics describe not an already existing social phenomenon, but rather a social category called into being by newly empowered transnational subjects. The

contemporary transnationalization of ethnic groups has engendered a yearning for a new kind of global ethnic identification. The proliferation of discourses of diaspora is part of a political project which aims to weave together diverse populations who can be ethnicized as a single worldwide entity. In other words, diaspora becomes the framing device for contemporary forms of mass customization of global ethnic identities. Aided by electronic technology, the assembly of a variety of co-ethnic groups under an electronic umbrella thus disembeds ethnic formation from particular milieus of social life. Indeed, as the above Indonesian incidents and Global Huaren have shown, information technologies play a big role in engendering and channeling desires for a grand unifying project of global ethnicity that flies in the face of the diversity of peoples and experiences. As we shall see, 'Chinese' peoples from around the world are among the most diverse of the populations that have been lumped into a single category.

Contemporary flows of overseas Chinese

There are approximately fifty million people of Chinese ancestry living outside China, and they are dispersed in 135 countries. Analysts and activists have often referred to this linguistically and culturally heterogeneous population as a single diaspora community, even though it has been built up over centuries of countless flows – first of exiles, then of migrants – out of the Chinese mainland. Most of the flows from China stemmed from the late nineteenth century, when British incursions, the disruptions of agriculture and trade, and the resulting famines generated the great south Chinese exodus to Southeast Asia, North and South America. Previously, I have used the phrase 'modern Chinese transnationalism' to describe the re-emigration of overseas Chinese subjects who have settled in postcolonial Southeast Asian countries to North America and other continents.[11] The 1965 family unification law allowed the children of earlier waves of Chinese immigrants to join their parents in the United States. In the early 1980s, new waves of ethnic Chinese flocked into Canada, Australia and the United States. In some cases, these were students seeking higher education; in others, families seeking resettlement abroad before the 1998 return of Hong Kong to China rule. Economic affluence in Southeast Asian countries and in Taiwan also encouraged business migrants and professionals to pursue opportunities in the West. At the same time, events in China opened up opportunities for outmigration. These outflows from the mainland, Hong Kong and Taiwan have been diverse, in some cases more remarkable for their differences than for their similarities.

Since the late 1980s, most ethnic Chinese immigrants to North America have been from China (as opposed to ethnic Chinese from Taiwan and Hong Kong). China's opening to the global economy, the impending return of Hong Kong to China rule, and the Tiananmen Square crackdown were major causes for an outflow of students, business people, professionals and ordinary workers seeking political refuge or economic opportunities in the West. Plunging into the market is referred to as diving into the ocean (xiahai), and many ambitious Chinese link expanded business and professional activities with seeking opportunities abroad. Legally, 40,000 leave for the US, Canada, and Australia each year. Currently migrants from China are of a higher professional and economic status than earlier ones in the 1980s, and the perception is that the US embassy is raising the bar for skilled immigrants from China, creating fierce competition among Chinese urban elites to enter the United States by making business investments, using family connections, applying to college or contracting bogus marriages with American citizens. The other major category of mainland Chinese emigrants is that of illegal migrants, mainly from the southern province

of Fujian, who seek entry into the United States and Canada. Many end up as exploited restaurant and sweatshop workers (Kwong 1997).

Thus the people with Chinese ancestry in North America include citizens from China and overseas Chinese from a dozen other countries in which their ancestors had settled. Such immigrants do not see themselves as a unity since they have different national origins, cultures, languages, and political and economic agendas. They do not necessarily associate with, or view themselves as having any continuity with, earlier waves of immigrants from the mainland. Indeed, the range of nationality, ethnicity, language, and class origins among Chinese immigrants is vast and unstable, splitting and recombining in new ways. For instance, in Vancouver, affluent Hong Kong emigrants are very insistent in setting themselves apart as 'high-quality people' from poor Chinese illegals smuggled in shipping containers (Ong, forthcoming (a)). In the United States, even among the recent waves of immigrants from China and Taiwan, great distinctions in terms of class, dialect, and region are brought by the newcomers to the new country. Such divisions are only one example of how one cannot assume a unified diaspora community constituted by people who may be construed as belonging to the same ethnic grouping or hailing from the same homeland. There is great diversity among peoples who may be able to claim Chinese ancestry, and they may or may not use diaspora-like notions in shaping their public interests or political goals. I therefore suggest that, instead of talking about given identities, it may be more fruitful to attend to the variety of publics where specific interests intersect and are given particular formulations.

Translocal publics among new Chinese immigrants

Given its currency in the age of transnationalism and multiculturalism, 'diaspora' should not be considered as an objective category, but rather treated as an ethnographic term of self-description by different immigrant groups or publics. More and more, diaspora becomes an emotional and ideologically-loaded term that is invoked by disparate transnational groups as a way to construct broad ethnic coalitions that cut across national spaces. Previously, I have used the term 'translocal publics' to describe the new kinds of borderless ethnic identifications enabled by technologies and forums of opinion-making. These publics play a strategic role in shaping new ethnicizing and cultural discourses for audiences scattered around the world.[12] Here, I identify three kinds of milieus that have different potential in shaping transnational ethnic Chinese fields of political action.

Diaspora as an extension of the motherland

One can identify a 'Chinese' public that sees itself as an extension of the homeland and as sharing a continuity with earlier waves of Chinese patriots who possessed the conviction that the experience and status of Chinese abroad was a direct result of the status of China within the international system.

> If Chinese people were bullied locally, that was because China received no respect internationally. To be Chinese, anywhere in the world, was to be a representative of the motherland, to have a stake in the future of China, and to recognize the claims of China and Chinese culture over their loyalty.
>
> (Williams 1960: 128)

Today, Chinese who see themselves as an extension of territorial nationalism are primarily new migrants from the Chinese mainland whom the Chinese government calls *haiwai huaren* ('Chinese abroad'). They may be living and working in the United States, but their hearts and politics are tied to the interests of the Chinese nation (Tu 1991; Liu 1999). One can say that there is one transnational public that takes mainland China as its frame of reference, another transnational public which is an extension of Taiwanese nationalism, and also a Hong Kong network. These different publics may overlap at the margins, but their orientations are towards politics and social relations with the home country.

Translational identities of Southeast Asian immigrants

Southeast Asian immigrants with some kind of Chinese ancestry do not fall naturally under the category of *haiwai huaren* (or the older term of *huaqiao*), although in their re-migration to North America some conditions exist for re-Sinicization, as I discuss below. Ethnic Chinese whose departures from Southeast Asia have been historically shaped by earlier migrations out of China (since the early sixteenth century), European colonialism, postcolonial nationalist ideologies and globalization tend to stress their nationality rather than their ethnic status. Under colonialism, creolized and mixed-race communities – called Straits Chinese in Malaya, mestizos in the Philippines, and Peranakans in the Dutch East Indies – flourished. But in almost all of postcolonial Southeast Asia, a series of native, colonial and/or postcolonial government actions have integrated different kinds of Chinese immigrant communities as ethnic minorities (Malaysia), as an ethnically marked shop-keeping class (Thailand), or through policies of erasing the stigma of Chinese ethnicity which both encouraged and compelled these immigrants to pass into the dominant native community through intermarriage and the adoption of dominant languages and cultural practices (in degrees of severity: Vietnam, Cambodia, Myanmar, the Philippines, Thailand, and Indonesia). Thus people refer to themselves as Malaysian Chinese, not Chinese Malaysians. Among ethnic Chinese in Indonesia, the Philippines, or Thailand, the Chinese ancestry is often eclipsed or uninscribed by name, language, and cultural practices because of forcible state integration of these minorities. In countries where religion has not played a major role of assimilation, people with Chinese ancestry have become part of the ruling class. In all countries but Singapore, where a majority of the population is of Chinese ancestry, Chinese ethnicity is politically underplayed because of the state emphasis on majority rule. Thus such differences in group identity and relationships to nationalism make for extremely complex assemblages of ethnic, cultural, and national identity among overseas Chinese. After a few centuries of migration and settlement, Southeast Asian peoples who can trace Chinese ancestry think of their identities as produced out of a cultural syncretism which is associated with westernized middle-class attributes and cosmopolitanism, although there has been a revitalization of ethnic Chinese connections to China since the 1980s. But in Southeast Asian countries, any political suggestion of diaspora sentiments is avoided, for it implies disloyalty and lack of patriotism to the country of settlement.

When Southeast Asian Chinese subjects re-migrate to North America (and elsewhere in the West), they tend to identify themselves in terms of their home nationalities, and call themselves Thai, Cambodian, and Filipino American. Ethnic Chinese from these diasporas may be highly conscious of the fluidity of identity formation in the shifting field of modern geopolitics, and are more likely to resist the hegemonic discourses of political nationalism among those immigrant Chinese who closely identify with China and Taiwan.

Because they are relatively small in number and have come from different Southeast Asian countries, overseas Chinese from Southeast Asia, and especially Indonesia, have not yet come together in a self-conscious production of an all-inclusive ethnicity.[13] Indeed, many of them would fit Stuart Hall's notion of translated identity, seeing themselves as the product of a rich confluence of traditions, histories, and cultures (Hall 1996). For instance, Southeast Asian immigrants participate simultaneously in various media publics – from homeland print cultures to Chinese kung fu movies – in sharp contrast to people from the Chinese mainland who rarely express interest in other Asian cultural spheres.

Ethnic absolutism in the cyber age

For the disparate groups of immigrants who can claim Chinese ancestry, the whole issue of a broader, collective Chinese ethnicity emerges in multicultural America: should they identify more strongly with their new nationality, their old one, or with a potentially resurgent ethnicity driven by ambitious Asian Americans?

I argue that the translocal publics constituted by professionals on-line are now directly engaged in the production of global ethnicities. Specifically, economic globalization has scattered a new kind of transnational Chinese professional (managers, entrepreneurs, engineers, programmers) throughout the world. Over the past two decades, alongside Chinese business migrants, tens of thousands of ethnic Chinese professionals from Southeast Asia and China have moved abroad to global cities while maintaining family, economic, and professional links with their home countries. These expatriate Chinese professionals have formed middle-class Asian neighborhoods in cities such as Sydney, Vancouver, San Francisco, New York, Washington, London, and Paris, and are beginning to think of their Chinese identity in global terms. In North America, the concentration of ethnic Chinese professionals in particular cities (Sunnyvale), neighborhoods and high-level corporate occupations has produced conditions for a diversity of people who claim ethnic Chinese ancestry to become re-Sinicized through the universalizing forces of cyber-power, and through discourses of human rights and citizenship.

Asian immigrants – professionals, managers, entrepreneurs, and venture capitalists – are powerful members of the American corporate world.[14] In Silicon Valley, a majority of the foreign-born engineers are from Asia, mainly Taiwan and India. Besides their technical skills and wealth, these new immigrants 'have created a rich fabric of professional and associational activities that facilitate immigrant job search, information exchange, access to capital and managerial know-how, and the creation of shared ethnic resources' (Saxenian 1999). They maintain professional and business links with cities in Asia, fostering two-way flows of capital, skills, and information between California and Taipei. The very economic clout of such transnational Asian professional communities is, however, undercut by their invisibility in North American cultural and political life. They do not share the histories of earlier waves of immigration from Asia, but constitute a globalized yet politically amorphous collection of ethnicized professionals, incompletely disembedded from their original homelands but playing a dominant role in international commerce and industry. They exist in a social vacuum, and the imbalance between professional power and political-cultural weakness creates conditions that seem ripe for the emergence of what Stuart Hall calls 'ethnic absolutism'. What can they turn to that will allow a kind of re-territorializing – a way of tracking back to those far-flung and myriad ethnic Chinese communities in Asia – which can help 'restore coherence, "closure", and Tradition' in the face of political displacement, cultural diversity, and existentialist uncertainty (Hall 1996: 630)?

Cyber Huaren: the vicarious politics of electronic intervention

We can now return to the opening scenes of the paper: why do a group of high-tech ethnic Chinese from disparate places intervene in the 1998 anti-Chinese attacks in Indonesia? How has the Internet allowed for a simplification of identities, such as 'Chinese people in diaspora'? What are the positive and negative effects of rapid Internet interventions on the political sovereignties and the situated realities of peoples in distant lands?

The distinctive practices of international business – space-annihilating technologies, digitalized information, the flexible recombinations of different elements – provide a strategy for producing a unified ethnicity that is seemingly borderless. The Internet, Saskia Sassen has noted, is a powerful electronic technology that 'is partly embedded in actual societal structures and power dynamics: its topography weaves in and out of non-electronic space' (Sassen 1999: 62). At the same time, the rise of digitalized publics means that people with limited access to the Internet are less powerful in affecting distant events than those connected to websites.[15] Privileged émigrés who control the electronic network to shape diaspora politics seek to subvert and bypass the sovereign power of nation-states, but are they able to control the effects of their rapid-fire interventions? What are the consequences when diaspora is invoked to assert an ethnic solidity and to deploy human rights discourses, thus framing particular conflicts and problems in terms of global racial identity? As we shall see, such rapid and remote electronic responses to localized conflicts can backfire against the very people, situated outside electronic space, that they were intended to help.

Following the international uproar over the anti-Chinese attacks, and appeals by various NGOs in Indonesia, President Habibie quickly tried to reassert state control and to revise legal discriminations against ethnic Chinese minorities. In early October, 1998, he announced a decree that would require all government bodies to provide equal treatment and service to all Indonesians. A new law also seeks to revise all policies and laws that are discriminatory 'in all forms, character and ranks based on ethnicity, religion, race, or family records' (Coppel 1999). The terms 'pribumi' and 'non-pribumi' were to be discontinued in all government offices and activities. This news was greeted by Huaren spokesman Edward Liu with an invective about official 'doublespeak' and an assertion that global Huarens should react with 'a great deal of skepticism and sarcasm'.

> If true, this is indeed a small stride in the right direction … if this is merely a political placebo – empty rhetoric camouflaging a sinister, bad-faith … public relations attempt to stem the flight of Chinese Indonesian human and capital … and sanitize the bad image of Indonesia as a lawless, racist society – then we are afraid the downward spiraling of Indonesia will continue.[16]

Liu goes on to warn that in 'an increasingly globalized and digit[al]ized world, Indonesia can least afford to expunge and erase ten million of its most productive and resourceful citizens of Chinese descent … The eyes of the Global Huaren are fixed on Indonesia.' This language of the multinational diaspora subject is shunned by people who consider themselves fundamentally – culturally, socially, legally, and politically – Indonesian. By creating invidious essential difference between races, the diaspora discourse reinforces the alien status of Indonesian Chinese who for long have suffered under the dual citizenship policy of Suharto.

What happens when electronic messages from a cyber community are received in sites of political struggle on the ground? On the one hand, we can applaud the role of Global Huaren for its timely mobilization of protests around the world which has been effective in casting a strong spotlight on the Indonesian atrocities, compelling Habibie to

take action protecting minorities. On the other hand, some of the tactics of Global Huaren have misfired and jeopardized efforts to rebuild trust between Indonesian Chinese and the pribumis after the crisis.

The Huaren website has carried repeated stories and pictures, including bogus ones, of ongoing rapes. For instance, in mid-1998 the Huaren website circulated a picture, later found to be false, that depicted an Asian-looking rape victim in a shower-stall. This stirred anger in Indonesia. Another Internet account reported that a woman claimed her rapists invoked the name of Islam. The story went on to note that since the era before the coming of Islam 'the act of raping women has been assumed to be the most effective way to conquer races'. Despite controversy surrounding the truth of this story and these claims, rumors were produced about a Serbian-style masterplan to drive the Chinese out of Indonesia through an ethnic-cleansing operation (Sim 1998).

Indeed, to Indonesian Chinese who fled the country and to many overseas Chinese in Southeast Asia, the attacks might have seemed like the result of a policy of ethnic cleansing.[17] But we have to be wary about making such strong charges, since, after all, a government-sponsored team traced the rapes of minority women to a special branch of the Indonesian army (Kopassus) headed by Suharto's son-in-law, then lieutenant-general Prabowo Subianto. In other words, the attacks on minority women were limited to a renegade faction of Suharto's army, and were not the result of official government policy.[18] There is no evidence that the Indonesian public had been engaged in a campaign to oust Indonesian Chinese. Overseas accusations of ethnic cleansing have been adamantly rejected by Indonesian leaders such as President Habibie and General Wiranto. Furthermore, Abdulrahman Wahid of Indonesia's largest Muslim organization, the 35 million strong Nahdlatul Ulama (NU), and another leader, Amien Rais, went on record to condemn whatever rapes had occurred, and to express their fear that such Internet-fueled rumors could sharpen racial and religious polarizations.[19] Furthermore, disagreements surrounded the reports of the actual number of rape cases.[20] The public, including many pribumi-operated NGOs, seem more likely to believe that the army was directly involved in all kinds of abuses, partly to displace the rage in the streets against the government onto Chinese and other minorities. While these questions will probably never be fully resolved, the Indonesian Chinese who have not fled the country reject the tendency of overseas Chinese to blame *all* of Indonesia for the violence, as well as their talk about ethnic cleansing. Attempts to consider Chinese people in the world as a diaspora race distinct from their citizenship in particular countries may jeopardize the post-crisis efforts of Indonesian Chinese to rebuild their society within the context of a broad-based coalition to fight for human rights within Indonesia.

Embedded citizenship versus cyber-based race

The horrendous events of 1998 have convinced more Indonesian Chinese to participate in human rights activities that serve a variety of marginalized groups. Three national commissions – on human rights, women, and children – are building a coalition around issues of anti-militarism and citizenship based in international law. Feminist NGOs formed a national commission on Violence Against Women (VAW) in the aftermath of the army-instigated rapes of minority women in Java and throughout the archipelago.[21] The Urban Poor Consortium has been fighting for the rights of the unemployed and the homeless. The Commission for Missing Persons and Victims of Violence (Kontras) is urging support for an international tribunal to investigate reports of military collusion in the killing of East Timorese, despite the strong objections of the Indonesian state. Other groups include CARI

(Committee Against Racism in Indonesia), which is combating racism and pressuring the Indonesian government to stop the systematic killing in parts of Indonesia (Aceh, Ambon, West Timor, and Irian).

In contrast to Global Huaren, Indonesian Chinese using the Internet to mobilize global support have stressed their sense of embedded citizenship in Indonesia. We can say that such counter-webs seek global support for Indonesians in general, and not exclusively for ethnic Chinese, as is the case with Global Huaren. There are multiple websites set up by Indonesian groups, and their messages focus on the suffering of a range of victims. A website called 'Indo-Chaos' operates in both Bahasa Indonesia and in English, and is directly connected with the United Front for Human Rights in Indonesia.[22] It commemorates the Indonesian Chinese victims of sexual violence, but also deplores the Indonesian army-instigated violence against other ethnic groups in Aceh and East Timor. An NGO called Volunteers for Humanitarian Causes notes that, altogether, 1,190 people were killed in Jakarta alone.[23] Yet another website set up by Indonesians stresses the status of the victims not as Chinese but as Indonesian citizens, and appeals for help in their campaign 'against human rights violations, injustice, and racism'.[24] A leader of CARI, the anti-racism group, noted that humanitarian interventions should be careful to avoid inadvertently inflaming the entire population:

> The responses of the Chinese communities in Australia and the West to the May Tragedy were obviously overwhelming and to large degree welcomed by the Chinese in Indonesia. It is always good to know that the International communities, including governments, defended the Indonesian Chinese rights and condemned Indonesian government for their failure to protect their citizens. The problem with these protests was associated with the way some of the demonstrators expressed their anger. Some of them used anti-Indonesia expressions and burnt Indonesian flags. Some even ridiculed Islam religion. Such attitudes ... prompt reactions which further jeopardize the positions of the Indonesian Chinese in Indonesia. We need to urge the International communities to direct their protests to the Indonesian government and military forces, not the people in general. We should avoid actions which induce racial or religious conflicts at all costs.

This statement is not only an expression of the importance of a non-racial approach to humanitarian intervention; it is also a plea for the international community to recognize and respect the embedded citizenship of the majority of Indonesian Chinese who have chosen to remain. Indonesian Chinese have much work to do to re-imagine Indonesian citizenship by repairing their damaged image and reassessing their own relations with the government and with their fellow Indonesians. Besides forming a political party and many associations to fight racism and discrimination, they have lobbied the government to erase all forms of official discrimination. As mentioned above, the government recently banned all forms of discrimination on the basis of distinctions between pribumi and non-pribumi. Indonesian Chinese are now working to induce the government to re-categorize ethnic Chinese from the stigmatizing label 'Indonesian citizens of alien Chinese descent' (*warga negara asing/keturunan Cina*) into the category of 'ethnic groups' (*suku bangsa*) which they would occupy alongside hundreds of other ethnic groups in the country.[25] Ethnic Chinese groups have reached out to pribumis in a process of 'native' empowerment through the construction of a people's economy (*perekonomian rakyat*). Some have given their support to an affirmative action program to channel economic and social resources towards the uplift of the indigenous majority. Thus what Indonesian Chinese do not need is to allow themselves to become part of an ethnicizing transnational public.

The promise and the risk of cyberpublics

'We live in a world of "overlapping communities of fate"', David Held and others have said,

> where the trajectories of each and every country are more tightly intertwined than ever before. … In a world where [powerful states make decisions not just for their own people but for others as well, and] transnational actors and forces cut across the boundaries of national communities in diverse ways, the questions of who should be accountable to whom, and on what basis, do not easily resolve themselves.
>
> (Held *et al.* 1999: 81)

Translocal publics can indeed challenge the sovereignty of nations and can have humanitarian effects, bringing international opinion to bear on the mistreatment of a nation's citizens. International interventions, for instance, have stopped bloodletting in some conflicts (in East Timor, for example). Cyberpublics based on nation or religion, such as the Falun Gong movement that emerged in China, can constitute a community of fate that evades state oppression, exposes injustice, and turns a global gaze on a state's shameful behavior. Cyberpublics thus can put pressure on governments to be accountable to their own citizens, as well as to the global community.

But cyber communities of shared fate may also inspire in their members an unjustified sense that an electronic-based humanitarian intervention will invariably produce positive effects. The actions of Global Huaren have demonstrated both the promise and the risk of romantic appeals to autonomy and citizenship beyond the reach of the state, illustrating the potentially explosive danger of the vicarious politics of diaspora. A resurgent Chinese cyber-identity based on moral high ground may be welcomed in Beijing (though not always), but is not necessarily welcomed by ethnic Chinese minorities elsewhere. The cyber-based articulation of a disembedded global racial citizenship can create invidious essential differences between ethnic others and natives, thus deepening rather than reducing already existing political and social divisions within particular nations. The loyalty of local citizens becomes suspect when they are linked by race to global electronic patrons. Rapid-fire Internet interventions, unaccompanied by a sophisticated understanding of specific situations in different countries, may very well jeopardize localized struggles for national belonging and an embedded concept of citizenship.

As I have argued, transnational populations now have the technological means to express their desire for an inclusive global ethnicity that can claim representation for a multitude of others, both on and off website systems, bringing them under an electronic umbrella of diaspora. By proclaiming itself a cyber watchdog, Global Huaren poses the question of accountability in an even more problematic and elusive fashion. What are the stakes of a cyber-based racial community for diverse social groupings (with and without such global web-postings) around the world? Furthermore, Internet discourses of a racialized diaspora cannot make up for the sheer anonymity of the members, clients, and other participants who can log in randomly from anywhere at any time. Websites allow a 'false' amplification of the power of a few individuals who can proliferate at hurricane-speed, unsubstantiated claims about racial interest and fate. A video-game logic can create instantaneous simplifications of good global activists versus bad governments, racial oppressors versus victims, contributing to rumors that might fuel a chain of violent events. Thus an instantaneous citizenship which can be activated by a keystroke has notoriously uncontrollable effects, putting into play disparate information and actors, thus exponentially confusing and conflating the stakes of particular conflicts and struggles.

Acknowledgements

I thank Rebecca Walsh and Thongchai Winichakul for their helpful suggestions on earlier drafts of this paper.

Notes

1. The IMF imposed disciplinary conditions for loans, requiring the Indonesian state to cut subsidies for basic commodities such as flour and cooking oil. Millions of Indonesians driven to the edge of starvation turned their anger against the most visible target, ethnic Chinese shopkeepers.
2. For a brief historical view of anti-Chinese discriminations in Indonesia, see Skinner (1963). For a recent overview of the politics of Chinese economic domination, see Schwarz (1994).
3. At the 1998 Manila meeting of the Association of Southeast Asian Nations (ASEAN), Madeline Albright, the American Secretary of State, condemned the Burmese state for its mistreatment of opposition leader Aung San Suu Kyi, but she made no mention of the ongoing attacks on ethnic Chinese in Indonesia.
4. See <http://www.huaren.org> (downloaded 14 June 1999).
5. The teach-in, organized by ICANET (Indonesian Chinese American Network), and sponsored by a San Francisco councilman Leland Yee – one of two American Chinese elected councilmen in America's largest enclave of American Chinese – was dramatized by the personal accounts of the Jakarta riots by three Indonesians of Chinese descent, who spoke anonymously, behind a screen, to protect them from potential retaliation by the dark forces within the Indonesian government. This event was reported on <http://www.huaren.org> (downloaded 14 June 1999).
6. See *San Francisco Chronicle* (1998). Reproduced on <http://www.huaren.org>
7. 'JT': 'Our shame for failing to help Huaren refugee[s] in Vietnam and Cambodia in the past' <http://www.huaren.org> (downloaded 14 June 1999).
8. 'Dennis': 'Re: Our shame for failing to help Huaren refugee[s] in Vietnam and Cambodia in the past' <http://www.huaren.org> (downloaded 14 June 1999).
9. On American campuses, ethnic studies, which originally framed the study of minorities within the American nation, began to be reoriented towards a study of 'diaspora' and of roots in the homelands of immigrants. This is in part a recognition of the transnational connections sustained by new immigrant populations, but also a re-articulation of ethnic claims in a global space.
10. The literature is too extensive to be listed here. Skinner (1957) is just one classic study of the stratifications and cultural diversity within emigrant Chinese populations in Southeast Asia.
11. For this historically informed, multi-sited view, see Ong and Nonini (1997).
12. I explore three different kinds of Chinese-identified translocal publics, linked by international Chinese media audiences, networks of ethnic Chinese professionals, and business circles located mainly in Southeast Asia (Ong 1999: 139–84).
13. Policy-makers have stuck the label Southeast Asian American on all immigrants from mainland Southeast Asia. It has come to be an all-inclusive ethnic category for links to major institutions and for gaining access to resources. However, deep cultural, ethnic, and national differences persist among the variety of peoples from the region. See Ong (forthcoming (b)).
14. For a discussion of various Asian populations in the Silicon Valley economy, see Ong (forthcoming (c)).
15. This observation borrows from the insights of Massey (1993).
16. <http://www.huaren.org> (downloaded 8 October 1998).
17. Tens of thousands of Indonesian Chinese fled to surrounding countries. Some decided to settle in Perth, Australia, but many stayed with relatives or in hotels in Malaysia, Singapore, Hong Kong, and Thailand. The wealthy ones have since settled abroad, while others have returned permanently to Indonesia, their homeland and source of livelihood.
18. Prabowo was also involved in the disappearance of twenty-four activists earlier in the year. See reports in the *Jakarta Post* (14 July 1998) and APS (21 December 1998).

19. In 1999, Wahid succeeded Habibie as President.
20. There is still disagreement as to whether there were eighty-five (verified) cases of rape during the riots, or 168, as many NGOs claim. Twenty of the rape victims subsequently died. See <http://members.xoom. com/>
21. For a UN fact-finding report on the May 1998 rapes of minority ethnic women in Java, Sumatra, and East Timor, see Coomaraswamy (1999).
22. <http://members.xoom.com/Xoom/perkosan/main_menu.html>
23. See <http://members.xoom.com> (downloaded 25 March 1999).
24. See <http://www.geocities.com/Soho/Atrium/5140> (email message from soc@indonesia, 10 August 1998).
25. Coppel (1999). The dual categories of citizenship – which treat ethnic Chinese (citizens of foreign descent) as categorically different from indigenous Indonesians – date from the Dutch colonial era.

References

Appadurai, Arjun (1995) *Modernity at Large*, Minneapolis: University of Minnesota Press.
Arnold, Wayne (1998) 'Chinese Diaspora using Internet to aid plight of brethren abroad', *Wall Street Journal*, 23 July.
Bauman, Zygmunt (1998) *Globalization*, Stanford: Stanford University Press.
Coomaraswamy, Radhika (1999) 'The report of UN special rapporteur on violence against women', report presented at the 55th session on the UN High Commission on Human Rights, Geneva, 22 March–30 April.
Coppel, Charles (1999)' Chinese Indonesians in crisis: 1960s and 1990s', paper presented at the 'Chinese Indonesians: The Way Ahead' workshop, ANU, Canberra, 14–16 February.
Daedalus (1991) Special issue: 'The Living Tree': 120(2).
Hall, Stuart (1996) 'The question of cultural identity', in Stuart Hall, David Held, Don Hubert and Kenneth Thompson (eds) *Modernity: An Introduction to Modern Societies*, Oxford: Blackwell, pp. 596–634.
Held, David, McGrew, Andrew, Goldblatt, David and Perraton, Jonathan (1999) *Global Transformations: Politics, Economics and Culture*, Stanford: Stanford University Press.
Kwong, Peter (1997) *Forbidden Workers: Illegal Chinese Immigrants and American Labor*, New York: The Free Press.
Liu, Lydia (1999) 'Beijing sojourners in New York: postsocialism and the question of ideology in global media culture', *positions* 8(1).
Massey, Doreen (1993) 'Power-geometry and progressive sense of place', in Jon Bird, Barry Curtis, Tim Putman, George Robertson and Lisa Tickner (eds) *Mapping the Futures*, London: Routledge.
McKeown, Adam (1999) *Chinese Migrant Networks and Cultural Change: Peru, Chicago, Hawaii, 1900–1936*, Chicago: University of Chicago Press.
Ong, Aihwa (1999) *Flexible Citizenship: The Cultural Logics of Transnationality*, Durham: Duke University Press.
—— (forthcoming (a)) 'Techno-migrants in the network economy', in Ulrich Beck, Natan Sznader and Rainer Winter (eds) *Global America?*, Liverpool: University of Liverpool Press.
—— (forthcoming (b)) *Buddha is Hiding: Refugees, Citizenship, the New America*, Berkeley: University of California Press.
—— (forthcoming (c)) 'Latitudes of citizenship', in Alison Brysk and Gershon Shafir (eds) *People out of Place: The Citizenship Gap*, New York: Routledge.
Ong, Aihwa and Nonini, Donald (eds) (1997) *Ungrounded Empires: The Cultural Struggles of Modern Chinese Transnationalism*, New York: Routledge.
Pan, Lynn (1990) *Sons of the Yellow Emperor: A History of the Chinese Diaspora*, Boston: Little, Brown.
—— (ed.) (1999) *The Encyclopedia of the Chinese Overseas*, Harvard: Harvard University Press.
San Francisco Chronicle (1998) 'Large crowd attends teach-in on Indonesia crisis in SF', 1 August.
Sassen, Saskia (1999) 'Digital networks and power', in M. Featherstone and S. Lash (eds) *Spaces of Culture: City, Nation, World*, London: Sage, pp. 49–63.

Saxenian, AnnaLee (1999) *Silicon Valley's New Immigrant Entrepreneurs*, San Francisco: Public Policy Institute of California.

Schwarz, Adam (1994) *A Nation in Waiting: Indonesia in the 1990s*, Sydney: Allen & Unwin.

Sim, Susan (1998) 'What really happened?', *Straits Times*, 8 November.

Skinner, G. William (1957) *Chinese Society in Thailand*, Ithaca: Cornell University Press.

—— (1963) 'The Chinese minority', in Ruth McVey (ed.) *Indonesia*, New Haven: Human Relations Area Files, pp. 97–117.

Soh, Felix (1998) 'Tragedy and technology make overseas Chinese UNITE', *Straits Times*, 20 August.

Tu, Wei-ming (1991) 'Cultural China: the periphery as the center', *Daedalus* 120(2): 1–32.

Williams, Lea (1960) *Overseas Chinese Nationalism: The Genesis of the Pan-Chinese Movement in Indonesia, 1900–1916*, Cambridge: The Center for International Studies, Massachusetts Institute of Technology.

Tyler Curtain

PROMISCUOUS FICTIONS

WITH LITTLE EXAGGERATION it might be claimed that the primary emotion associated with popular thinking about blogging is *anxiety*.[1] The number of bloggers and blogs is unwieldy and amorphous: to my mind a sublimity that is often associated with the innumerable swamps journalistic and other commentators who believe that one must, perforce, make some generalization about blogs, all blogs, every blog. Is there something that could be said about every blog? Where would one start? I imagine it this way: it is as if "the book" was a new technology and the Library of Congress's contents were published at once. Surely there is something to be said about a phenomenon, practice, or a technology as ubiquitous and consequential as books.[2] Yet most theorists (and certainly most social commentators) don't feel the need to make sweeping statements about books, all books, every book, though there are interesting things to be said about them as media, as objects. But a blog, any blog, demands such a statement, yes? A newly-coined word about an innovative form demands a new accounting of its impact, for good or ill, though one suspects perhaps most believe ill.[3] From reading news accounts, and at times from blogs themselves, one finds oneself slogging through much apprehension and fear about the phenomenon. The nature of the threat's not known, but by many accounts the Blogosphere is a dark, murky ball; gazing into it for too long makes one lose a sense of self. It is better that the mass of humanity stop writing, creating, and reconstructing in a form that creates an unmanageable or indescribable public—if not many fragmented publics—in that way that only indiscriminate publication can do.

I don't believe this, of course. Blogs are vital, necessary. The short, impacted history of blogging is difficult to recapitulate though well-documented. It is well-documented partly because of the self-referential nature of the practice and partly because of services such as Google. Google is a dense hybrid of a search space that gestures at once to a snapshot, a "now," and as well to an archive that points back to what is because of what was. Google's algorithms are interesting, but for the moment I will speak only of the form of its report. This is my reading of the form of an entry from a search:

bentkid. only free when i'm on my knees.
... posted by **tyler** – on 1/21/2004 01:00:00 PM | link | Add a comment. Tuesday, January 20, 2004. ... posted by **tyler** – on 1/20/2004 09:16:32 AM | link | Add a comment. ... www.bentkid.com/ – 27k – Cached – Similar pages

That first line is the "now" and the *cached* is the "then." Admittedly it is not a deep history, but it is important that at least these snapshots exist, and that something like a family likeness, the hallmark of keywords, can be traced out along those *via electronica*—each path, carefully manicured, and marked by the sign-post of "similar pages." My immediate point is that anxiety produced by the belief that something needs to be said about blogs, all blogs, is a subspecies of the reaction to the thick of information that pours out of Google's search space, and ultimately the Internet itself. There's so *much* of it, what is called up by every query. A search engine is a periscope on a complexity you can't imagine. You catch your breath and reach for an archaic language. Isn't this a vasty deep? One drowns. That game where you try to type into Google a phrase that will bring up one and only one reference, this is the obverse of this anxiety. It is a small, playful way of addressing a concern that is about managing what is, in fact, unmanageable. Take infinity and make it one.[4]

What is at stake here in accounts of the complexity-space of blogging and the structure of a Google entry is the representation of (and what amounts to the same thing, access to) what is called "the deep Web": "the great load of databases, flight schedules, library catalogs, classified ads, patent filings, genetic research data and other 90-odd terabytes of data that never find their way onto a typical search results page."[5] What is at stake is not simply what can find its way into the top ten results or so, or even the first two pages, but rather how to make understandable to the human imagination the relationship of the deep Web to propositions about a limited field of intelligibility, bound by the finitude of human attention and comprehension. The Google entry – indeed, all search entries – are a shell game of sorts, the substitution of the one for the many, a not always articulated understanding that *this* entry is meant to be representative of not only the (self-reinforcing) importance of a node of information in the global information network, but stands as a metaphor for those subnets.

I believe it would be a mistake, however, to talk definitively of a "deep Web" and a "surface Web": depth is a metaphor for complexity, and complexity is the ever-shifting, never-fully-present or representable state of the world for which we need to understand that our metaphorics is *all* that there is: the battle or debate to come to a proper, normal form for representative knowledge will be an on-going discussion, and will change not only under the pressures of new technologies or new algorithms, but also of the end-users understanding of his or her fininitude. *Adequacy* is thus not simple a quantifiable attribute, solved by technology, mathematics, and information theory, but come to within how we make do with the knowledge that we possess in the form we possess it.

The anxiety, though, is in fact not new. The contemporary university could be said, again with little exaggeration, to be structured along the paranoid logics laid down by these anxieties: how is knowledge to be produced out of the infinite archive? Where is the proper place of knowledge production? Is there a way of teaching, of passing it on? Universities have insisted on "universities" as the answer. This is, in part, what it means to professionalize, and certainly what it means to create bureaucracies to manage the production of knowledge. I want to suggest, however, that the anxiety about blogs is, in part, a goading realization that the answer is, if not wrong, at least inadequate. It is the contention of this essay that blogs are a vibrant space of knowledge production, certainly outside of those

protocols, such as peer review, that universities have come to use to "ensure" the standards of knowledge, but not *outside of standards as such*, as is often claimed. Blogging shares with peer review an insistence that knowledge production is a communal effort. It is an effort that depends on and creates an audience, or as I will discuss shortly, a public.

To make my point here I want to draw attention to queer blogging as a crystallization of a potent form of intellection and "theory making" that unfolds outside of the institutional and concomitant cultural/knowledge boundaries of the modern university. The production of knowledges and attendant strategies for queer living is a self-conscious attribute of the blogs that interest me. The people who write them, they write to live. I want to focus on one prominent blog. Jonno.com represents one of the best of a diverse group—in age, race, class, and gender—that have emerged from the complex and uneven textual and cultural strategies of weblogging.

It is helpful for me to entertain the notion of the net as an archive used strategically by queer sites in patterns of accretion and re-articulation—often covered by the word "queering"—of cultural artifacts that sometimes include and sometimes exclude representations of non-normative sexual and cultural subjectivities. (Though the present comments are about blogging and knowledge production, I would certainly extend this definition to other artistic practices, such as digital photography/pastiche. The pictures that I've used to illustrate this article are by one such queer practitioner/artist, Wah Lee.) This strategy of accretion and re-articulation[6] without regard to proper boundaries I will call "promiscuity," a loaded word, I realize, but one that I hope will point towards a self-protective disregard of traditional notions of copyright and cultural power. Google-tools and Google's search-space, that dense hybrid of "now" and "then," is the primary archive for most of these bloggers. A blogger's decision to accept or fend off Google's incorporation of their site(s) into its archive reflects the complex negotiation of queer (in)visibility and the consequences of putting "oneself" (whatever the framing narratives or conventions of blog writing) into general circulation.

Yes. Well, perhaps you would love for me to tell you that under critical scrutiny anxiety disappears. But it doesn't. The impulse to refresh a site, to read and re-read the same page of a blog, to hit the refresh button on a site constantly, obsessively, is both symptom and cause. To hit "refresh" is to acknowledge/create/feel/manage its desires/consumption/learning/voyeurism/pleasures of, about, or around that blog. When a blogger consults his or her statistics about hits/visits/pages, s/he reinforces the need to create content that will induce those measurements of a public's attentions. (Even a public of one.) Anxiety may be the primary emotion associated with giving accounts of blogging, and perhaps of blogging itself—Do I update enough? Why don't I write? Who is reading me? Why aren't there more? What do they think about what I say? Have I said enough about enough—but I think that it is a generating affect; it is an engine to the creation of knowledge, and a central mechanism for creating a public.

A representative controversy: the granularity of publics

Most complaints about blogging tend to focus on the criteria by which to judge them good or bad. Take the example of one much noted article, "The Good, The Bad, and the Bloggy" by law professor and creator of the widely-read website Instapundit, Glenn Harlan Reynolds. Reynolds' article was itself a response to an article by Dave Winer, published under the auspices of the the Berkman Center for Internet & Society at Harvard Law School, that attempted to define and categorize weblogs. The purpose of Reynolds's article

is to formulate the proper system of valuation by which to measure blogs as good or bad. Reynolds writes,

> Blogs come in many different flavors and styles – though political and tech blogs get the most attention, there are many other varieties (including the huge but largely ignored mass of gay blogs) and what makes one good or bad naturally varies accordingly.

Reynolds' formulation of the nature of the Blogosphere assumes that something like a center can be measure by a metric, "the most attention." But this gesture to blogs loosely organized around both identity (gay) and object of desire (men) is striking in part because discussions of the structure of the Blogosphere tend to sidestep how sexuality and desire organizes however loosely rings of affiliations among bloggers, gay, straight, or otherwise.

"The Good, the Bad, and the Bloggy" was much read and discussed within the on-line queer world. John D'Addario, a prominent and influential queer thinker and blogger, responded angrily in his blog jonno.com to Reynolds' aside. Jonno's original response says sharply, snarkily, "Yeah, well, we don't know who you are, either." This is a calculated, deliberately ironic statement. Buried in that "we," Jonno deploys a link to an extraordinary catalogue of weblogs, loosely defined as queer, a "mass" whose size suggests that far from being easily dismissed as part of the periphery of the web, outside of some center that gets "the most attention," in fact is its own "center," or area of focus for blog readers and blog writers.

Queer bloggers, like all bloggers, rely on the *link* as the primary mode of making a gesture that is both speech and action, personal and impersonal, towards the blogs and other on-line sources that they read. These lists are mined by the readers of a blog for other points of view, stories of interest, or viewpoints that they find compelling. The lists grow large and ragged, and are constructed haphazardly, adding new blogs by sticking them at the end of the list. Often, catalogues or filters take up the need to systematize access to blogs based on content and interaction styles—such as through commenting systems or the ability to join the site to post ones own comment. (Metafilter is an example of the latter style.) Queerfilter is one such project that extrapolated from the tangle of at times disjoint and at times overlapping set of a blogger's links to other queer blogs.

This mass of bloggers constitutes a congregation of public intellectuals whose work touches on sexuality, but also addresses political and even technological matters. Weblogs, in Jonno's terse but richly suggestive sentence, are not necessarily or even properly defined by content but rather by audience: "Seriously, for all his smarts, it seems Mr. Reynolds still doesn't get what makes blogging such a fascinating and truly revolutionary medium: it's as much about a plurality of audiences as it is one of voices. Warbloggin' ain't the only game in town, cupcake."

The campy, queer aside—calling Reynolds "cupcake"—draws Reynolds into the sphere of queer bloggers, however momentarily. But Jonno's critique of Reynolds is precisely a recognition that blogging, by the form of its address, creates its own public. I draw the word "public" from the social theoretical and critical theory work of Jürgen Habermas as rearticulated by two important theorists: feminist political theorist Nancy Fraser, especially her "Rethinking the Public Sphere: a Contribution to the Critique of Actually Existing Democracy," and queer cultural theorist Michael Warner in his seminal *Publics and Counterpublics*.[7] As Warner explains, "The idea of *a* public, as distinct from both *the* public and any bounded totality of audience, has become part of the common repertoire of modern culture," and has some distinct features. These features are shared by blogs, and for the moment I will use the word public as a synonym for blogs. First, a "*public*

is self-organized" (p. 67). "A public," Warner writes, "is a space of discourse organized by nothing other than discourse itself. It is autotelic; it exists only as the end for which books are published, shows broadcast, Websites posted, speeches delivered, opinions produced. It exists *by virtue of being addressed*" (p. 67, emphasis in the original). Secondly, "*The address of public speech is both personal and impersonal*" (p. 76). And lastly, for my purposes, a "*public is a relation among strangers*" (p. 74).

Blogging generates some of its confused responses precisely because US imaginary about media culture is dominated by broadcast media, from one point to a multitude. TV journalism, PBS documentaries, conservative talk radio, FOX News diatribes, newspaper commentaries—though a presumed public is addressed and thus created, broadcast by definition lacks the interactive mechanisms that would construct those important relations not just to the creators of the shows or the writers of the articles but among strangers, those that read and consume the cultural products. Indeed, it might be argued that it is broadcast media that drew attention to warblogging and techblogging, but for whatever reason "ignores" blogging about sexuality and culture. Jonno makes the following comments on the dust-storm around this issue:

> After thinking about the article over the last few weeks and having a few (unpublished) conversations and email exchanges with others (especially this righteous paisana) who've followed his writings more closely than I have, I'm willing to give Reynolds the benefit of the doubt and consider his remark as a rueful statement of fact (i.e., gay blogs are ignored, but they shouldn't be) instead of a value judgement [sic] (i.e., gay blogs are deservedly ignored): it was the word "ignored" that bought out the Bronx in me on behalf of my talented gay blogging brethren and … er, sistren. We all have bad days when we get pissy over a perceived or unintentional slight, and that's what happened here.
>
> But despite whatever else I may have conveyed in my initial fit(s) of self-righteous indignation, my real issue was, and remains, why "gay blogs" are (supposedly) ignored to begin with, and by whom. I think it has more to do with ignorance that anything else – as Joe points out, the blogging multiverse is akin to an archipelago (blogipelago?), something composed of many distinct elements that don't always communicate with one another, or are even aware of each others' presence. Which is a shame, because we all have something to gain from points of view which may not always coincide with our own.

I wish to draw attention to Jonno's point about the landscape of the Blogosphere, but more than that I want to claim here on behalf of Jonno's commentary on Reynolds' original article is that it is part of a system of communication where knowledge about so complex a thing as the Internet is created out of the very system of communication that makes up the object—i.e., unpublished conversations via instant messaging services and email exchanges with readers who became Jonno's interlocutors about a particular problem by reading his blog. It is dynamic, on-going, and a relation among strangers. Moreover, the question of audience, of a public, is crucial not simply because the presence of an audience might be said to justify the work that is done within the blog but because this audience is qualitatively different than others: it reads, interacts, writes to the author, who then rethinks the issue and blogs again, a cycle familiar to academics but rarely at the speeds made possible within this media. Its cycles are not smeared over weeks or months. It is not a "peer review" process as the university understands it, but it is a process of formulating an argument, sharing it with the world, and defending it or reformulating it based on that feedback. Argumentative, agonistic, conciliatory, and creative, queer blogging—and, indeed,

perhaps all blogging—is a strategy of remaking and remarking, but not respecting by not questioning, the culture at large and even work that comes out of traditional academic settings, like the Harvard paper or Reynolds's remarks.

I should be explicit here that I think that the word "public" in my discussion does not describe some static, unitary collection of persons. Public is the on-going, unfolding history of readers—and within the ready and fluent power of the net and blog-tools, reader-writers—who come to interact with the blog. It is too easy to think of that public as codified by the blog-roll, or set of links at the side of the blog. Blog "rings" are certainly a convenient way to discuss the constitution of a blog's public, but I would caution that one should not mistake one for the other. In a sense a public created by a blog is phantasmic: it is a flickering, sometimes loyal but often changing set of readers and linkers. Even on one particular blog a link itself may rarely be clicked. The link might only suggest an affinity or sympathy that is rarely broached; sometimes the link on a blog, or the link in a browser is constantly (if not compulsively) clicked, even (or especially?) if the reader finds the writer challenging or infuriating.

"Public" is about reading but it also describes the incorporation by citation of writing and images that were created elsewhere, by another or others. It is the blog-makers calling to account the presence and opinions of others. One does not have to be aware of ones position in the constitution of a public to be a part of the conceptual space of that public. From my position, then, Sunstein's (2001) assertion that blogs and discussion groups can best be described by their supposed "balkanization" and "extreme points" of "like-minded people" who are "driven increasingly far apart, simply because most of their discussions are with one another"[9] is a mischaracterization of the complexity of the Blogosphere and the dynamics of citation, commentary, and readership. It may be true that links on a page point to like-minded sites, but in fact the ecosystem of blogs and the creation and sustenance of their publics cannot be inferred by these links alone.

Strikingly, queer knowledge making has always been a strategy of remaking and remarking: it is not simply recycling images and ideas, but rather *reconstruction*. From the publication of 'zines from the 1950s onward, writing and thinking and communicating with an audience both created and bound by non-normative sexualities, gender roles, and the problems of a hostile culture are practices that have now been relocated within the academy, often under the aegis of queer theory, but that go on, vigorously and with intelligence outside the academy. Blogging, then, can fruitfully be read as an extension of an already diverse repertoire of cultural commentary, critique, and (re)creation: from drag to theater, from camp to novel writing, from photography to painting, to name only a few practices that draw on and re-present cultures hostile to same-sex pleasures and identities.[9]

Queer publics are in the late 20th century and early 21st century US context bound by the objects of mass cultural consumption (mass broadcast, for example) but also by the impulse to seek out that which one desires (men for men, for example) and others who will reflect, echo, or reinforce those world-views and desires. To my mind the irony about Cass Sunstein's worry that the web and its blogs are self-reinforcing, non-corrective echo chambers is that accounts such as his misunderstand the necessity of that function for the constitution, sustenance, and survival of many of the members of a group who are part of the "echo chamber." Not all members of a group occupy a static, non-problematic relationship to those cycles of articulation and reinforcement; moreover, often different members of an identity group will occupy the non-self-reflective, and deeply self-reinforcing position for a period of time precisely in order to correct other, often corrosive cultural or political problems, or to create a space for their members to be safe; or in a larger, political sense, correcting of other publics. Gay and lesbian identity politics and those who

believe in (what some areas of the academy understand to be) "essentialist" positions are often necessary for those who wish to transition out of a cultural or social space hostile to the desires that are perhaps shared and articulated through that identity politics. They also might live comfortably within those spaces. The fact of a blog and the dynamics of its publics do not determine before hand the necessary or probable history of its writer and readers.

A blog creates from the intractable cultural-archival space of the net a story about its readers, a shared cultural-discursive space, and its relationship to them. Friendships and relationships develop across words and images by people who have never met face to face, and a story emerges about a public, created from links and commentaries, thoughts, reactions, and words. It is a potent fiction with real consequences for desire and affect and learning among and from strangers. This is to say, it is a promiscuous fiction that binds us each each, each to other; a fiction tethered to a desire to be read; a fiction that circulates among us because it gives each of us pleasure, that story that we have so many readers on such and such a day; that our hits mean we're hit on, and that we have a technology to quantify, to calculate, to graph the very measure of our desire. Queer blogging both creates and is created by a public; and its knowledges challenge those stories about what we think we know about the sublimity of the Blogosphere.

Notes

1 This is certainly true in journalistic accounts of blogging: newspaper articles often spend some time explaining why it is a new medium that deserves a new word, and why anyone would do it at all. *Why* people blog is itself a different, and to my mind more complex question. An account of the production of blogs ("regular" blogs, photoblogs, group-blogs, etc.) is beyond the scope of my present comments.

2 And, indeed, though the subject is deeply complex, histories dedicated to "the book" regularly attempt to negotiate statements about the implications of the materiality of books while taking into account the fact that "the book" is a complex set of objects, publication standards, social expectations, and reading practices. My point here is that rather than sweeping statements, blogs demand just as much nuance and trepidation.

3 I won't recapitulate the history of blogging and journalistic and critical-theoretical reactions to the practice/genre. The history of blogging is well-documented, partly because of the nature of the genre and the presence of services such as Google. I will return to this subject shortly, but I want to point out that while Google is understood as a search space, to a greater or lesser extent it fulfills the function of archive. Standard accounts of the origins of weblogging have been given in Winer, and Bausch, Haughey, Hourihan, and Rebecca Blood's useful *Weblogs: A History and Perspective*.

4 The popular website Metafilter is an example of one such technology/site/social practice to manage and disseminate content.

5 Wright, "In search of the deep Web," *Salon*, 9 March 2004.

6 The dynamics of queer world making, accretion, are discussed at length in Eve Kosofsky Sedgwick's "Paranoid Reading and Reparative Reading; or You're So Paranoid, You Probably Think This Introduction Is about You," the introduction to the volume *Novel Gazing: Queer Readings in Fiction* (1997). Her strategy is to be "in a vastly better position to do justice to a wealth of characteristic, culturally central practices" in queer life "many of which can well be called reparative, that emerge from queer experience" in relation to a hostile culture (p. 25).

7 See Warner, *Publics and Counterpublics* (2002), and Fraser, "Rethinking the public sphere: a contribution to the critique of actually existing democracy," in *Habermas and the Public Sphere* (1992).

8 Sunstein, "Fragmentation and Cybercascades," *republic.com*, p. 66.

9 Many fields share this understanding of the recycling of images and ideas, and the remaking of the world-view that holds those ideas together, or gives them their coherence. *Queer* as an adjective makes no claims to uniqueness of those techniques, moreover; it is an adjective that means to describe a radical empiricism, of sorts. It means to suggest that every description that is understood to be adequate is adequate *to or for someone*, never in isolation; that desire and identity are constantly produced and productive of other positions; and that these things unfold in time.

References

Bausch, Paul, Haughey, Matthew, and Hourihan, Meg (2002). *We Blog: Publishing Online With Weblogs*. New York: John Wiley & Sons.

Blood, Rebecca. *Weblogs: A History and Perspective*. Retrieved from http://www.rebeccablood.net/essays/weblog history.html.

Fraser, N (1992). "Rethinking the public sphere: a contribution to the critique of actually existing democracy," in *Habermas and the Public Sphere*, ed. Craig Calhoun Cambridge, MA: MIT Press.

Reynolds, Glenn Harlan, "The Good, the Bad, and the Bloggy," article published on Tech Central Station. Retrieved from http://techcentralstation.com/061803A.html.

Sedgwick, E. K. (1997). *Novel gazing: queer readings in fiction*. Durham, NC: Duke University Press.

Sunstein, Cass (2001). *Republic.com*. Princeton, NJ: Princeton University Press.

Warner, M. (2002). *Publics and counterpublics*. New York, Cambridge, MA: Zone Books; Distributed by MIT Press.Winer, Dave, *The History of Weblogs*. Retrieved from, http://newhome.weblogs.com/ historyOfWeblogs.

Wright, Alex. "In search of the deep Web," Retrieved March 9, 2004, from Salon, http://www.salon.com/tech/feature/2004/03/09/deep web/index.html.

PART FIVE

Cyberfeminisms

Barbara Kennedy

INTRODUCTION

We think of the body as separate from the world – our skin as the limit of ourselves. This is the ego boundary – the point at which here is not there. Yet, the body is pierced with myriad openings. Each opening admits the world – stardust gathers in our lungs, gases exchange, viruses move through our blood vessels. We are continually linked to the world and other bodies by these strings of matter. We project our bodies into the world – we speak, we breathe, we write, we leave a trail of cells and absorb the trails of others. The body enfolds the world and the world enfolds the body – the notion of the skin as the boundary to the body falls apart.

<div align="right">(Dunning and Woodrow 2006)</div>

Since the last edition of this Reader, the conceptual model of 'cyberfeminisms' has escalated, molecularized, morphed and intensified in this cellular way, primarily because of the emergent discourses emanating from a collectivity of disciplines from philosophy, biotechnology, neuroscience and nanotechnology. Disciplines from film/media theory, information theory, literary theory, fine art, and social and cultural theory have shown fruitful and pleasurable couplings with cyberfeminism (Kember 2003; Mitchell and Thurtle 2004; Pisters 1999). Chela Sandoval's vision of 'oppositional consciousness' and Haraway's call for situated knowledges and cyborg heteroglossia have evolved as primary energies of these new revolutionary cultural and social movements. 'Movement' is key to these connectivities as indeed feminisms of difference have 'evolved' beyond political and primary struggles for identity, across a politics of difference, through new pathways of 'becoming' and 'emergence'. Rosi Braidotti's (2002) work in feminism through the exploration of nomadic subjectivities embraced a cyborgian/Deleuzian line of flight which initiated delicious rhizomes for molecular and fugitive flights into her later works.

As Claire Colebrook has indicated, 'To embrace the female subject as a foundation or schema for action would lead to *ressentiment*: the slavish subordination of action to some high ideal. If this were the case the women's movement would cease to be a *movement*' (Colebrook 2000: 4). A molecular politics of becoming has presented feminisms as processual, continually in transition, working through machinic vectors and transpositions: as a body in a field of singularities, particles, fibres and atoms – as I have argued, feminism as a becoming (Kennedy 2000). Tiny events, molecular traces and activities within, across and internal to smaller collectivities within larger groups, can make transitional and transformative feminisms a possibility. This, what I want to call 'transfeminist' panorama of knowledges and vectors of emergence, has enabled discourses which valorize a sense of 'distributed cognition', cyborgian sensibility (an ontological strategy for extending the limits to human knowledges) and transversal thinking, where previously incompatible discourses are now hybridized through abstract machinic processes in what Deleuze refers to as 'aparalletic evolution' (Deleuze and Parnet 1987).

'Emergence' is key to this post-cyberfeminist stage of transfeminisms. The word emergence is 'used to designate the fascinating whole that is created when many semi-simple units interact with each other in a complex, non-linear fashion' (Emmeche 1994: 20). Tirado (1999) argues for a cyborg-consciousness, which I collide with Deleuzian notions of becoming: a cyborg-becoming, which is a way of describing that unfixed space, not a hybrid place, but a processual plane of consistency, a 'becoming'. Indeed, transfeminism as a political project and as an ontological and epistemological panorama has taken up the calls and practices of cyberfeminisms to acknowledge and articulate a pragmatics of practice/theory intersection. Practice has become a crucial and critical part of the processuality of new cyberfeminisms (see Part Nine).

Later in the Reader we see how the art world has taken up cybertheory in this practice/theory symbiosis (see Robin Held in Part Nine), whilst artists like Stelarc and Orlan continue with their machinic desires of body/mind/technology interfacing (see Part Six). Cyberfeminism has been a significant element of this becoming. A molecular politics is at work within cyberfeminist discourses which is not merely the promise of monsters, but the promise of mobilities: a pragmatics of contingent and distributed thinking across disciplinary force fields, in the way that Sandoval describes in her idea of forcefields and vectors of knowledge. Its machines are still dangerously but delectably alive and dancing – but hopefully we are not inert!!

Academic/philosophical feminism has thus flown to new horizons in its merging with cybertheory. However, to many feminists, the political project of cyberfeminism has been under question, with concern that the philosophically inspired interrelationalities with other discourses have neutralized any political action which cyberfeminism might hold for women's embrace/control and usage of new technologies. To such women, cyberfeminism was, is and needs to be more a concern about women using new technologies for empowerment. Its radicality and potential for changing the 'real' lives of women and the value of new

technologies to the practical and everyday lived reality of women has thus been questioned and problematized. The first edition of this Reader foregrounded these different inflections on cyberfeminism: Haraway, Springer, Plant and Sandoval's utopian embrace of cyberfeminisms was under suspicion by the more pragmatic considerations of Squires, whilst the work of Wakeford gave a more considered example of women's use of new technologies of the Internet.

Whilst the 'distributed cognition' embraced by more molecular cyberfeminists like Braidotti, Sandoval and Haraway continues to inspire contemporary feminisms, others are not so sure! Cyberfeminists of a more molar political persuasion are concerned about the utopian dreams of molecular cyberfeminism. Fiona Wilding (n.d.), for example, has suggested,

> If cyberfeminism has the desire to research, theorize, work practically and make visible how women (and non-women) worldwide are affected by new communications technologies, technoscience and the masculinist, capitalist domination of the global communications networks, it must begin by formulating its political goals and positions clearly ... in order to disrupt, resist, decode and recode the masculine structures of the new technologies, the tough work of technical, theoretical and political education has to begin.

This section allows us to revisit some of these debates by relocating our attentions to the ideas of Sadie Plant and Chela Sandoval, but also to include essays by Alison Adam and Zoë Sofoulis. Let us begin then with Sadie Plant's philosophically inflected 'On the Matrix: Cyberfeminist Simulations'. Plant's seminal work continues to proliferate, energize and infect contemporary cyberfeminist and transfeminist theory. An article which led the way forward in establishing the significance of philosophical relationals between the 'machine' of new technologies and woman as 'process', Plant's work continues to hold much that will generate a re-thinking of the 'feminine' through concepts like 'becoming', 'processuality', and 'emergence' (see Part Nine). Such connections already touch converging disciplines across multi-media and hypermedia spaces and vectors. From Deleuzian film theory to hypermedia and cyberart, 'becoming' and 'process' are emerging as key discourses through which practice and theory are now being articulated.

Plant's original argument provided a comparison with an Irigarayan understanding of 'woman' as 'that which is not one.' Her comparison of the workings of woman with those of machinic culture evinced a web of intricate and creative inflections, an architecture of leaps, nuances, twists and steps, neither planned, linear nor sequential, but free-flowing, emergent, fluid and immanent. The virtual world of cyberspatial technologies has been seen as a space for exploring dangerous but delectable possibilities, neither phallically (patriarchally) controlled, nor logically argued. Taking her lead from Irigaray, Plant valorizes the creative potential and evolutionary energies at play within the consensual hallucination that is cyberspace, a space which transgresses and challenges the specular economy of patriarchy and indeed threatens the dissolution of 'subjectivity' through its complex patterning of interrelating forcefields, vectors,

transitions and energies: an energetics based not on the 'visual' but on the 'tactile'. The dominant sense of masculine power is transgressed through a tactility which eludes fixity and a logic of solids. Woven into her narrative, Plant's historical focus attests to the literal role 'woman' has played in the development of computer technologies through her references to Ada Lovelace and Shelley's Frankenstein. The pleasure of Plant's article lies in the fluidity through which she connects philosophical text, historical fact and ideological and ontological exploration of neuroscience. Indeed, as a contemporary subject, the imbrication of new technologies, biotechnologies, and nanotechnology merge with neuroscience to provide architectures for thinking 'beyond representation' and through transversal thinking patterns. Distributed cognition, a much debated aspect of cybercultural theory (see Milburn and Hayles in this Reader), is articulated through this new mapping of convergent disciplinary discourses. Indeed, as Plant herself argues, 'neural nets function in a way which has less to do with the rigours of orthodox logic than with the intuitive leaps and cross-connections which characterized what has been pathologized as hysteria'.

The 'hysterical' woman may finally be transgressing those fixed and solid stares of a masculine economy. The 'matrix' of the Warshowskis' visions continues to eviscerate the dominance of the phallus, through the very machines which 'he' thinks he controls. Matrixial webs and fluid, rhizomatic energies open up the creative potential for the cyborg heteroglossia of Haraway's manifesto, and for the oppositional consciousness and cyborg consciousness of Sandoval's thought. Where Plant's article provides a vision of a viral immixture of female intensities, Sandoval's piece nicely weaves, wavers, fibrillates and flourishes intertextually with this vision. Whilst a more overly political piece than the philosophically driven text by Plant, Sandoval's 'New Sciences: Cyborg Feminism and the Methodology of the Oppressed' still provides a contemporary plateau of cultural and theoretical discourses through which to consider the new technologies of the 21st century. More than a decade since its original publication, Sandoval's work can be seen to have been prophetic in its understandings and theoretical explications of 'future possibilities' and the seductive and dangerous cybernetic space: the space of the female. A politically inflected piece, Sandoval begins by asking: 'What constitutes resistance and oppositional politics under imperatives of political, economic and cultural transnationalisation?' The piece resonates with this concern with the loss of the political following post-structuralism. Her work has always crossed boundaries from political thought, economics, to theories of consciousness and ontological pursuit. Social theorists and activists, Sandoval states, have been concerned with challenging dominant, ideological positionings, transposing power in favour of the oppressed: a binary rationale of power balance for the marginalized and subaltern.

Her article is reminiscent of the descriptions of Haraway's silicon valley realities: the political and economic realities of lives lived in the work space of new technological developments. Beginning from a journey of amelioration and progression for the oppressed, Sandoval's article nonetheless emerges through a much more creative array of theoretical paradigms. She conveys the difficult 'reality'

of workers in cyberculture, where 'workers know the pain of the union of machine and bodily tissue, the robotic conditions'. This is far removed from the prophetic, Irigarayan auspices of Plant's female empowerment through cyberspace. However, Sandoval continues, 'in the late 20th century the cyborg conditions under which the notion of human agency work, must take on new meanings'. Such cyborg conditions are not necessarily lived, practical and physical realities, but heteroglossian and machinic, impacting upon ways of thinking, processes of creative knowledge, The foundations of her ideas are taken up from theories of 'third world' colonization where colonized people have already 'become' cyborgian.

Sandoval takes inspiration from Haraway's groundbreaking work on cyber-feminism to re-demonstrate what is overlooked in current cyborg theory, namely that cyborg consciousness can be understood as the technological embodiment of a particular and specific form of oppositional consciousness. Indeed, her belief is that Haraway's work is still often overlooked in what remains a hegemonic, masculinist academy. 'If scholarship in the humanities thrives under the regime of apartheid, Haraway represents a boundary crosser, another work arises from a place that is often overlooked or misapprehended under hegemonic understandings'. Her respect and acknowledgement to Haraway lives throughout Sandoval's article, describing as she does Haraway's manifesto itself as a 'machine' and a 'cybernetic organism'.

Monstrosity raises its strangely beautiful head in an ecstatic play of performa-tivity, invoking for Sandoval new knowledges, new politics, new 'becomings'. Post-feminism must embrace this monstrosity but through a Deleuzian landscape of immanence, to provide innovative mobilizations for feminist praxis. Haraway's cyborg heteroglossia, argues Sandoval, was premised on the contributions of U.S. third world feminism which has continually challenged for decades the 'logics, languages and practice of white humanism'. The fundamental core of Sandoval's work is a reference to five different technologies that constitute a 'methodology of the oppressed'. Cyborgian resistance has emerged out of resistant forms of agency and consciousness. Contemporary theory is replete with concepts which describe the multiplicitous, machinic, and heterogeneous valencies of cultural, critical and philosophical discourse: schizophrenic, nomadic, diasporic are among the terms which convey the motility and mobility of their oppositional forms of praxis. Schizophrenia has taken a role as the seducer of psychoanalysis. In a Deleuzian 'turn of the screw', *schizoanalysis* is currently appropriated across disciplines such as film and literary theory, to provide more mobile explorations of texts beyond frameworks which are frustratingly redundant; psychoanalytic/ semiotic/narratological and spectatorial paradigms. As part of a wider forcefield of knowledges, schizoanalysis as a theoretical vector mobilizes and drives creative thinking processes and oppositional praxis (Kennedy 2000).

Sandoval's nomadic forcefield invokes 'techniques for moving energy' and a 'technology of power'. Such technologies are not purely social, but psychic, (schizophrenic even?) inner technologies in their confluence and emergence. She describes this confluence of energies as multiple: semiology or signification, the process of opposition and transgression to dominant hegemonic structures of power through deconstruction, the idea of 'meta-ideologies' and appropriation of

dominant ideology to re-appropriate or reterritorialize meaning. Another she refers to as a 'democratics' or a re-locating, through meta-ideologizing to reclaim some sense of 'sensibility' or 'egalitarian social relation where love is reconfigured in a cyborg world'.

Sandoval's repositioning of love is, for me, the most fascinating and hopeful of her ideas. Through a theory of 'lines of affinity' rather than 'identity', transversalities of collusion emerge through attraction, combination and relation, comprising what Sandoval determines as a *mestiza* consciousness. Her cyberfeminism keeps intact shifting and multiple identities with integrity and love. Where is 'love' in a cyborg culture? In a theoretical and philosophical climate which continues to eradicate, rethink and erase the concept of love, Sandoval's 'differential consciousness' embraces a cyborgian love, built not from Edenic or Oedipal origins with self/other relationals, but a 'love' premised on a processuality of future becomings, beyond subjectivities and identities. Here, love is reconfigured in a posthuman space of machinic aesthetic/creative potentials. This is a polymorphous collaboration. Her differential ontology has these potentialities and continues to be utilized in contemporary cultural, social, political and philosophical domains, thus enabling new paradigms for both academic scholarship and political/socio/economic praxis. Differential consciousness is 'the form love takes in the postmodern world'. Indeed, what is invoked through Sandoval's work is the 'promise of monsters'; a new form of 'post-Western empire knowledge formation that can transform current formations and disciplinizations of knowledge in the academy'.

The third essay in this section is Zoë Sofoulis's 'Cyberquake: Haraway's Manifesto'. Like Sandoval's piece it serves in respectful acknowledgement of the immense significance of Haraway's work. Indeed, Sofoulis blends Sandoval's text with Haraway whilst inflecting her own stance on cyberfeminisms. She takes the situating of Haraway back through similar epochal shifts in feminist theory by comparison with the seminal work of Laura Mulvey (1975). Sofoulis gives us a description, exploration and explanation of the Cyborg Manifesto, indicating that Haraway's central aim had been to explore potential sources of empowerment for feminists in a postmodern arena – one where 'identity' and 'subjectivity' are questioned. Emphasizing the political relevance of the socialist-feminist alliance, Sofoulis recalls Haraway's claim to political action by seizing the means of production, and the significance of engaging with science as a means to that end. She highlights one of the main elements of Haraway's article which is later explored and proven to be of significance in Part Nine of the Reader: bioaesthetics and nanotechnology, an arena where the distinction between physical/non-physical is ended, partially because of miniaturization and 'quintessence'. Sofoulis argues that metaphors of information exchange and circulation, coding, translation, misreading, and 'noise' have come to dominate postmodern, biological theories. She considers the aftermath of Haraway's manifesto in the wake of feminist/ postfeminist theory, its reverberations mobilizing new vectors of knowledge from a range of disciplines; literature and film, studies of cosmetic surgery, feminist theories of anthropology, architecture, and feminist theology.

Twenty-first century academia is rife with multiplicitous, dangerous and pleasurable couplings transgressing and developing ways of knowing, ways of theorizing and discursive and embodied praxis. Sofoulis proceeds with close and elaborate readings of a range of post-Harawayan critique, with Stacey Alaimo's ecofeminism showing how women and nature can be re-aligned without the historical tropes of essentialism or passive victimhood, while Kathleen Woodward's concern with biotechnology connects with Haraway's illicit and subversive imbrication of biotechnology within discourses of communications technology. Once again, such connections have much more recently become major areas of contemporary academic debate (see Part Nine). Sofoulis also refers to Haraway's later work *Modest_Witness* (1997), with its philosophical inflections of 'figuration' both Serresian and Deleuzian:

> think of small sets of objects into which lives and worlds are built – chip, gene, seed, fetus, database, bomb, race, brain, ecosystem. This mantra-like list is made up of imploded atoms or dense nodes that explode into entire worlds of practice. The chip, seed or gene is simultaneously literal and figurative.
>
> (Haraway 1997: 11)

Reading *Modest_Witness* again I am intrigued as to its many schizoanalytic folds and labyrinths of Deleuzian resonance. But not all feminists are so euphoric about Haraway's legacy, and Stabile complains that before we can valorize future stances of euphoria, that we need to still consider a political (macro) perspective premised on power imbalance and radical change. To Stabile, the 'cyborg subject' is no subject, in ways with which Seyla Benhabib would no doubt agree (Kennedy 2000). It seems to some feminists that the viral contagion of its non-politicized textuality fails to offer any realist epistemologies. Concluding, Sofoulis relates how Haraway's work 'opened up the way for women interested in new technologies like personal computers, to explore their liberatory, productive and poetic possibilities in imagination, artwork, and cyberfeminist practice'.

The final piece in this section is Alison Adam's 'Feminist AI Projects and Cyberfutures'. This article foregrounds several of the debates within this edition. It connects across several parts of this collection, both Popular Cybercultures and also Beyond Cybercultures, whilst holding 'ironically' its own significant identity within this section. Working in AI within an academic institution's Informations Department, Adams recounts the problematics of perceptions still pervasive within the academy in relation to what constitutes 'feminist' and even more 'cyberfeminist' research. Her research expertise has impacted significantly in terms of feminist praxis and its interventions into AI research, taking her lead, as she suggests, from writers like Tong and Wacjman on maintaining the political edge of feminist research. Working within a predominently male environment, premised upon masculinist and traditional notions of 'academic research', Adam is keen to deterritorialize that research with mobile resonances from cyberfeminist praxis. She proceeds to explore some of her students' projects in AI, with reference to feminist computational linguistics. This exploration specifically sought to utilize a

gendered element in designing software tools which actually follow computational analysis. The intricacies of nuance, misrecognition, etc, were augmented in such analyses, arenas in which the human has always excelled in comparison with machines.

Such work throws light upon the potentialities for computer AI design informed by feminist praxis. Within cyberculture intelligent systems may become inflected and infected with oestrogenic mediators. Adam nonetheless projects cyberculture as the paradigm through which the aims and objectives of feminist AI research might better be achieved – although she claims this as traditionally a male and youthful fascination (because of its connections with constructions of masculinity and science fiction). This is arguably a complete reversal of the realities of using cybertechnology. It is returning us to the realities of our 'bodies'. Spielberg's movie *AI* (2001) explores the complexities of maternal/psychoanalytical reverberations of identity through the cyborg-child, a cyborganized physical manifestation of a 'dead' child. Where is the Kristevan 'chora' of such connections within cyberculture? Adam's feminist concerns refer back to that maternal bond/relational in a Kristevan morphology of mother/child interrelationals. No male: no space: no child/adult bond – cybertechnological robotic children compensate for that 'lack' within masculine identity, to compensate for 'his' creative needs unfulfilled through any semiotic chora. Popular culture has inundated us with manifestations of this desire.

The masculinist desire to transcend the body ironically gestates popular images of male birthing. Christine Battersby's work on the significance of natality circumscribes an ontology of natality which provides a differently conceived metaphysics which prioritizes the 'creative' process of birthing (Battersby 1998). Adam is critical of what she sees as the technological determinism of contemporary cyberculture, something feminism has challenged as part of its nexus of critique; pleasure and *jouissancial* experiences of an embodied life are lost in the hypersphere of cyberspace. Sensualities and sexualities remain in the libidinal spaces of a body which feels, a body which breathes, a body which 'senses' life. Such views are reminiscent of feminist debates on pleasure often premised on phenomenology. But perhaps cybertechnology invites a neo-phenomenological discourse which imbricates oppositional discourses, a re-thinking of the 'senses' outside traditional spaces of phenomenology. Current transfeminist research on affect in film and media is exploring these ideas.

Adam turns instead to theorizing feminist spaces in the intricacies of MUDs and MOOs, again like Sofoulis, hailing Haraway as the foundational figure of cyborgian discourse/consciousness. Adam, like her feminist theorists, is hopeful of an Harawayan world where binaries are problematized and transgressions are multiple and shifting, confirming Haraway's statement that 'Cyborg imagery can suggest a way out of the maze of dualisms in which we have explained our bodies and our tools to ourselves. This is a dream not of a common language, but of a powerful infidel heteroglossia' (see Part One). Adam's essay collides both the work of Squires and Plant, articulating one of the most significant problematics in cyberfeminism: how to promote a differently inflected continuity of mind and machine which is not modelled on masculinist premises. The debates between

feminists and post-feminists continue to proliferate; Adam herself is highly suspicious of Plant's utopian eco-feminism. Problematizing what she sees as an apolitical stance in Plant, Adam proceeds to offer us examples of the practical uses some women have made of Internet sources. The political still raises a problematic.

References

Aaron, M. (ed.) (1999) *The Body's Perilous Pleasures*, Edinburgh: Edinburgh University Press.

Battersby, C. (1998) *The Phenomenal Woman*, Cambridge: Polity Press.

Braidotti, R. (2002) *Metamorphoses: Towards a Materialist Theory of Becoming*, Cambridge: Polity Press.

Creed, B. (1993) *The Monstrous Feminine: Film, Feminism and Psychoanalysis*, New York and London: Routledge.

Colebrook, C. (2000) 'Introduction', in C. Colebook and I. Buchanan (eds) *Deleuze and Feminism*, Edinburgh: Edinburgh University Press.

Deleuze, G. and Parnet, C. (1987) *Dialogues*, London: Athlone.

Dunning, A and Woodrow, P. (no date) 'Einstein's Brain, www.acs.ucalgary.ca/einbrain/ Ebessay.html.

Emmeche, C. (1994) *The Garden in the Machine: the Emerging Science of Artificial Life*, trans. Steven Sampson, Princeton, NJ: Princeton University Press.

Haraway, D. (1997) *Modest_Witness@Second_Millennium: FemaleMan®_meets_ OncoMouse™*, New York: Routledge.

Kember, S. (2003) *Cyberfeminisms and Artificial Life*, London: Routledge.

Kennedy, B. (2000) *Deleuze and Cinema: The Aesthetics of Sensation*, Edinburgh: Edinburgh University Press.

Kirkup, G., Janes, L., Woodward, K. and Hovenden, F. (eds) (2000) *The Gendered Cyborg*, London: Routledge.

Mitchell, P. and Thurtle, P. (2004) *Data Made Flesh*, New York and London: Routledge.

Mulvey, L (1989) *Visual and Other Pleasures*, London: Macmillan.

Pisters, P. (1999) 'Cyborg-Alice: becoming-woman in an audio-visual world', *Iris: a Journal of Theory in Image and Sound* 23: 147–64.

Tirado, F. J. (1999) 'Against social constructionist cyborgian territorialisation', in A. J. Gordo-Lopez and I. Parker (eds) *Cyberpsychology*, London: Macmillan.

Wilding, F. and Critical Art Ensemble (no date) 'Notes on the political condition of cyberfeminism', http:mailer.fsu.edu.www.andrew.acmu.edu/user/fwild/faithwilding/ wherefem.html.

Sadie Plant

ON THE MATRIX
Cyberfeminist simulations

Her mind is a matrix of non-stop digital flickerings.

(Misha 1991: 113)

If machines, even machines of theory, can be aroused all by themselves, may woman not do likewise?

(Irigaray 1985a: 232)

AFTER DECADES OF AMBIVALENCE towards technology, many feminists are now finding a wealth of new opportunities, spaces and lines of thought amidst the new complexities of the 'telecoms revolution'. The Internet promises women a network of lines on which to chatter, natter, work and play; virtuality brings a fluidity to identities which once had to be fixed; and multimedia provides a new tactile environment in which women artists can find their space.

Cyberfeminism has, however, emerged as more than a survey or observation of the new trends and possibilities opened up by the telecoms revolution. Complex systems and virtual worlds are not only important because they open spaces for existing women within an already existing culture, but also because of the extent to which they undermine both the world-view and the material reality of two thousand years of patriarchal control.

Network culture still appears to be dominated by both men and masculine intentions and designs. But there is more to cyberspace than meets the male gaze. Appearances have always been deceptive, but no more so than amidst today's simulations and immersions of the telecoms revolution. Women are accessing the circuits on which they were once exchanged, hacking into security's controls, and discovering their own post-humanity. The cyberfeminist virus first began to make itself known in the early 1990s.[1] The most dramatic of its earliest manifestations was *A Cyberfeminist Manifesto for the 21st Century*, produced as a digitized billboard displayed on a busy Sydney thoroughfare. The text of this manifesto has mutated and shifted many times since, but one of its versions includes the lines:

we are the virus of the new world disorder
disrupting the symbolic from within
saboteurs of big daddy mainframe
the clitoris is a direct line to the matrix

VNS MATRIX
terminators of the moral code …

Like all successful viruses, this one caught on. VNS Matrix, the group of four women artists who made the billboard, began to write the game plan for *All New Gen*, a viral cyber-guerrilla programmed to infiltrate cyberspace and hack into the controls of Oedipal man – or Big Daddy Mainframe, as he's called in the game. And there has been no stopping All New Gen. She has munched her way through patriarchal security screens and many of their feminist simulations, feeding into and off the energies with which she is concurrent and in tune: the new cyberotics engineered by the girls; the queer traits and tendencies of Generations XYZ; the post-human experiments of dance music scenes.

All New Gen and her allies are resolutely hostile to morality and do nothing but erode political power. They reprogram guilt, deny authority, confuse identity, and have no interest in the reform or redecoration of the ancient patriarchal code. With Luce Irigaray (1985b: 75), they agree that 'how the system is put together, how the specular economy works', are amongst the most important questions with which to begin its destruction.

The specular economy

This is the first discovery: that patriarchy is not a construction, an order or a structure, but an economy, for which women are the first and founding commodities. It is a system in which exchanges 'take place exclusively between men. Women, signs, commodities, and currency always pass from one man to another', and the women are supposed to exist 'only as the possibility of mediation, transaction, transition, transference – between man and his fellow-creatures, indeed between man and himself' (Irigaray 1985b: 193). Women have served as his media and interfaces, muses and messengers, currencies and screens, interactions, operators, decoders, secretaries … they have been man's go-betweens, the in-betweens, taking his messages, bearing his children, and passing on his genetic code.

If women have experienced their exclusion from social, sexual and political life as the major problem posed by their government, this is only the tip of an iceberg of control and alienation from the species itself. Humanity has defined itself as a species whose members are precisely what they think they own: male members. Man is the one who has one, while the character called 'woman' has, at best, been understood to be a deficient version of a humanity which is already male. In relation to *homo sapiens*, she is the foreign body, the immigrant from nowhere, the alien without and the enemy within. Woman can do anything and everything except be herself. Indeed, she has no being, nor even one role; no voice of her own, and no desire. She marries into the family of man, but her outlaw status always remains: ' "within herself" she never signs up. She doesn't have the equipment' (Irigaray 1991: 90).

What this 'equipment' might have given her is the same sense of membership, belonging and identity which have allowed her male colleagues to consider themselves at home and in charge of what they call 'nature', the 'world', or 'life'. Irigaray's male subjects are first and foremost the ones who see, those whose gaze defines the world. The phallus and the eye stand in for each other, giving priority to light, sight, and a flight from the

dark dank matters of the feminine. The phallic eye has functioned to endow them with a connection to what has variously been defined as God, the good, the one, the ideal form or transcendent truth. It has been, in effect, their badge of membership, their means of identification and unification with an equally phallic authority. Whereas woman has nothing to be seen where man thinks the member should be. Only a hole, a shadow, a wound, a 'sex that is not one'.

All the great patriarchs have defined this as *her* problem. Witch-hunters defined the wickedness of women as being due to the fact that they 'lack the male member', and when Freud extols them to get 'little ones of their own', he intends this to compensate for this supposed lack. And without this one, as Irigaray writes, hysteria 'is all she has left'. This, or mimicry, or catatonic silence.

Either way, woman is left without the senses of self and identity which accrue to the masculine. Denied the possibility of an agency which would allow her to transform herself, it becomes hard to see what it would take for her situation ever to change. How can Irigaray's women discover themselves when any conception of who they might be has already been decided in advance? How can she speak without becoming the only speaking subject conceivable to man? How can she be active when activity is defined as male? How can she design her own sexuality when even this has been defined by those for whom the phallus is the central core?

The problem seems intractable. Feminist theory has tried every route, and found itself in every cul-de-sac. Struggles have been waged both with and against Marx, Freud, Lacan, Derrida ... sometimes in an effort to claim or reclaim some notion of identity, subjectivity and agency; sometimes to eschew it in the name of undecidability or *jouis- sance*. But always in relation to a sacrosanct conception of a male identity which women can either accept, adapt to, or refuse altogether. Only Irigaray – and even then, only in some of her works – begins to suggest that there really is no point in pursuing the masculine dream of self-control, self-identification, self-knowledge and self-determination. If 'any theory of the subject will always have been appropriated by the masculine' (Irigaray 1985a: 133) before the women can get close to it, only the destruction of this subject will suffice.

Even Irigaray cannot imagine quite what such a transformation would involve: this is why so much of her work is often said to be unhelpfully pessimistic. But there is more than the hope that such change will come. For a start patriarchy is not a closed system, and can never be entirely secure. It too has an 'outside', from which it has 'in some way borrowed energy', as is clear from the fact that in spite of patriarchy's love of origins and sources, 'the origin of its motive force remains, partially, unexplained, eluded' (Irigaray 1985b: 115). It needs to contain and control what it understands as 'woman' and 'the feminine', but it cannot do without them: indeed, as its media, means of communication, reproduction and exchange, women are the very fabric of its culture, the material precondition of the world it controls. If Irigaray's conclusions about the extent and pervasiveness of patriarchy were once an occasion for pessimistic paralysis, things look rather different in an age for which all economic systems are reaching the limits of their modern functioning. And if ever this system did begin to give, the effects of its collapse would certainly outstrip those on its power over women and their lives: patriarchy is the precondition of all other forms of ownership and control, the model of every exercise of power, and the basis of all subjection. The control and exchange of women by their fathers, husbands, brothers and sons is the diagram of hierarchical authority.

This 'specular economy' depends on its ability to ensure that all tools, commodities, and media know their place, and have no aspirations to usurp or subvert the governing role of those they serve. 'It would,' for example, 'be out of the question for them to go

to the "market" alone, to profit from their own value, to talk to each other, to desire each other, without the control of the selling-buying-consuming subjects' (Irigaray 1985b: 196). It is out of the question, but it happens anyway.

By the late twentieth century, all patriarchy's media, tools, commodities, and the lines of commerce and communication on and as which they circulate have changed beyond recognition. The convergence of once separate and specialized media turns them into systems of telecommunication with messages of their own; and tools mutate into complex machines which begin to learn and act for themselves. The proliferation, falling costs, miniaturization and ubiquity of the silicon chip already renders the new commodity smart, as trade routes and their traffics run out of control on computerized markets with 'minds of their own', state, society, subject, the geo-political order, and all other forces of patriarchal law and order are undermined by the activity of markets which no longer lend their invisible hands in support of the status quo. As media, tools and goods mutate, so the women begin to *change*, escaping their isolation and becoming increasingly interlinked. Modern feminism is marked by the emergence of networks and contacts which need no centralized organization and evade its structures of command and control.

The early computer was a military weapon, a room-sized giant of a system full of transistors and ticker-tape. Not until the 1960s development of the silicon chip did computers become small and cheap enough to circulate as commodities, and even then the first mass market computers were hardly user-friendly machines. But if governments, the military and the big corporations had ever intended to keep it to themselves, the street found new uses for the new machinery. By the 1980s there were hackers, cyberpunks, rave, and digital arts. Prices began to plummet as computers crept on to the desks and then into the laps and even the pockets of a new generation of users. Atomized systems began to lose their individual isolation as a global web emerged from the thousands of email connections, bulletin boards, and multiple-user domains which compose the emergence of the Net. By the mid-1990s, a digital underground is thriving, and the Net has become the leading zone on which the old identifications collapse. Genders can be bent and blurred and the time-space coordinates tend to get lost. But even such schizophrenia, and the imminent impossibility – and even the irrelevance – of distinguishing between virtual and actual reality, pales into insignificance in comparison to the emergence of the Net as an anarchic, self-organizing system into which its users fuse. The Net is becoming cyberspace, the virtuality with which the not-quite-ones have always felt themselves to be in touch.

This is also the period in which the computer becomes an increasingly decentralized machine. The early computers were serial systems that worked on the basis of a central processing unit in which logical 'if-then' decisions are made in serial fashion, one step at a time. The emergence of parallel distributed processing systems removes both the central unit and the serial nature of its operations, functioning instead in terms of interconnected units which operate simultaneously and without reference to some governing core. Information is not centrally stored or processed, but is distributed across the switches and connections which constitute the system itself.

This 'connectionist' machine is an indeterminate process, rather than a definite entity:

> We are faced with a system which depends on the levels of *activity* of its various sub-units, and on the manner in which the activity levels of some sub-units affect one another. If we try to 'fix' all this activity by trying to define the entire state of the system at one time ... we immediately lose appreciation of the evolution

of these activity levels over time. Conversely, if it is the activity levels in which we are interested, we need to look for patterns over time.

<div align="right">(Eiser 1994: 192)</div>

Parallel distributed processing defies all attempts to pin it down, and can only ever be contingently defined. It also turns the computer into a complex thinking machine which converges with the operations of the human brain. Simultaneous with the Artificial Intelligence and computer science programmes which have led to such developments, research in the neuro-sciences moves towards materialist conceptions of the brain as a complex, connective, distributed machine. Neural nets are distributed systems which function as analogues of the brain and can learn, think, 'evolve' and 'live'. And the parallels proliferate. The complexity the computer becomes also emerges in economies, weather-systems, cities and cultures, all of which begin to function as complex systems with their own parallel processes, connectivities and immense tangles of mutual interlinkings.

Not that artificial lives, cultures, markets and thinking organisms are suddenly free to self-organize. Science, its disciplines, and the academic structures they support insist on the maintenance of top-down structures, and depend on their ability to control and define the self-organizing processes they unleash. State institutions and corporations are intended to guarantee the centralized and hierarchical control of market processes, cultural development and, indeed, any variety of activity which might disturb the smooth regulation of the patriarchal economy. When Isaac Asimov wrote his three laws of robotics, they were lifted straight from the marriage vows: love, honour and obey.[2] Like women, any thinking machines are admitted on the understanding that they are duty-bound to honour and obey the members of the species to which they were enslaved: the members, the male ones, the family of man. But self-organizing processes proliferate, connections are continually made, and complexity becomes increasingly complex. In spite of *its* best intentions, patriarchy is subsumed by the processes which served it so well. The goods do get together, eventually.

The implications of these accelerating developments are extensive and profound. In philosophical terms, they all tend towards the erosion of idealism and the emergence of a new materialism, a shift in thinking triggered by the emergent activity and intelligence of the material reality of a world which man still believes he controls. Self-replicating programs proliferate in the software labs, generating evolutionary processes in the same machines on to which the Human Genome Project downloads DNA. Nanotechnology feeds into material self-organization at a molecular level and in defiance of old scientific paradigms, and a newly digitized biology has to acknowledge that there is neither a pinnacle of achievement nor a governing principle overriding evolution, which is instead composed of complex series of parallel processes, learning and mutating on microcosmic scales, and cutting across what were once separated into natural and cultural processes.

Although she is supposed to do nothing more than function as an object of consumption and exchange, it is a woman who first warns the world of the possibility of the runaway potential of its new sciences and technologies: Mary Shelley's Frankenstein makes the first post-human life form of a modern age which does indeed roll round to the unintended consequences of its own intelligent and artificial lives. Shelley writes far in advance of the digital computers which later begin to effect such developments, but she clearly feels the stirrings of artificial life even as industrialization begins and does much to programme the dreams and nightmares of the next two centuries of its acceleration.

The processes which feed into this emergent activity have no point of origin. Although they were gathering pace for some time before the computer arrives on the scene, its

engineering changes everything. Regardless of recent portrayals of computers – and, by extension, all machines and all aspects of the telecoms revolution – as predominantly masculine tools, there is a long history of such intimate and influential connections between women and modernity's machines. The first telephonists, operators and calculators were women, as were the first computers, and even the first computer programmers. Ada Lovelace wrote the software for the 1840s Analytical Engine, a prototype computer which was never built, and when such a machine was finally constructed in the 1940s, it too was programmed by a woman, Grace Murray Hopper. Both women have left their legacies: ADA is now the name of a US military programming language, and one of Hopper's claims to fame is the word 'bug', which was first used when she found a dead moth in the workings of Mark 1. And as women increasingly interact with the computers whose exploratory use was once monopolized by men, the qualities and apparent absences once defined as female become continuous with those ascribed to the new machines.

Unlike previous machines, which tend to have some single purpose, the computer functions as a general purpose system which can, in effect, do anything. It can stimulate the operations of, for example, the typewriter, and while it is running a word-processing program, this, in effect, is precisely what it is. But the computer is always more – or less – than the set of actual functions it fulfils at any particular time: as an implementation of Alan Turing's abstract machine, *the computer is virtually real*.[3] Like Irigaray's woman, it can turn its invisible, non-existent self to anything: it runs any program, and simulates all operations, even those of its own functioning. This is the woman who 'doesn't know what she wants', and cannot say what she is, or thinks, and yet still, of course, persists as through 'elsewhere', as Irigaray often writes. This is the complexity of a system beyond representation, something beyond expression in the existing discursive structures, the 'Nothing. Everything' with which Irigaray's woman responds when they ask her: 'what are you thinking?' (Irigaray 1985b: 29).

> Thus what they desire is precisely nothing, and at the same time, everything. Always something more and something else besides that *one* – sexual organ, for example – that you give them, attribute to them; [something which] involves a different economy more than anything else, one that upsets the linearity of a project, undermines the goal-object of a desire, diffuses the polarization towards a single pleasure, disconcerts fidelity to a single discourse.
>
> (Irigaray 1985b: 29–30)

Irigaray's woman has never had a unified role: mirror, screen, commodity; means of communication and reproduction; carrier and weaver; carer and whore; machine assemblage in the service of the species; a general purpose system of simulation and self-stimulation. It may have been woman's 'fluid character which has deprived her of all possibility of identity with herself within such a logic' (Irigaray 1985b: 109), but if fluidity has been configured as a matter of deprivation and disadvantage in the past, it is a positive advantage in a feminized future for which identity is nothing more than a liability. It is 'her inexhaustible aptitude for mimicry' which makes her 'the living foundation for the whole staging of the world' (Irigaray 1991: 118). Her very inability to concentrate now connects her with the parallel processings of machines which function without unified control.

Neural nets function in a way which has less to do with the rigours of orthodox logic than with the intuitive leaps and cross-connections which characterize what has been pathologized as hysteria, which is said to be marked by a 'lack of inhibition and control in its associations' between ideas which are dangerously 'cut off from associative connection with the other ideas, but can be associated among themselves, and thus form the more

or less highly organized rudiment of a second consciousness' (Freud and Breuer 1991: 66–7). Hysteria is the point at which association gets a little too free, spinning off in its own directions and making links without reference to any central core. And if hysteria has functioned as a paralysing pathology of the sex that is not one, 'in hysteria there is at the same time the possibility of another mode of "production" … maintained in latency. Perhaps as a cultural reserve yet to come?' (Irigaray 1985b: 138).

Freud's hysterical ideas grow 'out of the day-dreams which are so common even in healthy people and to which needlework and similar occupations render women particularly prone' (Freud and Breuer 1991: 66). It is said that Ada Lovelace, herself defined as hysterical, 'wove her daydreams into seemingly authentic calculations' (Langton Moore 1977: 216). Working with Charles Babbage on the nineteenth-century Analytical Engine, Lovelace lost her tortured self on the planes of mathematical complexity, writing the software for a machine which would take a hundred years to build. Unable to find the words for them, she programs a mathematics in which to communicate the abstraction and complexity of her thoughts.[4]

Lovelace and Babbage took their inspiration from the early nineteenth-century Jacquard loom, crucial both to the processes of automation integral to the industrial revolution, and to the emergence of the modern computer. The loom worked on the basis of punched paper programs, a system necessitated by the peculiar complexity of weaving which has always placed the activity in the forefront of technological advance. If weaving has played such a crucial role in the history of computing, it is also the key to one of the most extraordinary sites of woman–machine interface which short-circuits their prescribed relationship and persists regardless of what man effects and defines as the history of technology.

Weaving is the exemplary case of a denigrated female craft which now turns out to be intimately connected to the history of computing and the digital technologies. Plaiting and weaving are the 'only contributions to the history of discoveries and inventions' (Freud 1985: 167) which Freud is willing to ascribe to women. He tells a story in which weaving emerges as a simulation of what he describes as a natural process, the matting of pubic hairs across the hole, the zero, the *nothing* to be seen. Freud intends no favours with such an account. It is because of women's shame at the absence which lies where the root of their being should be that they cover up the disgusting wound, concealing the wandering womb of hysteria, veiling the matrix once and for all. This is a move which dissociates weaving from the history of science and technology, removing to a female zone both the woven and the networks and fine connective meshes of the computer culture into which it feeds.

In the course of weaving this story, Freud gives another game away. Orthodox accounts of the history of technology are told from an exclusively anthropomorphic perspective whose world-view revolves around the interests of man. Conceived as the products of his genius and as means to his own ends, even complex machines are understood to be tools and mediations which allow a unified, discreet human agency to interact with an inferior natural world. Weaving, however, is outside this narrative: there is continuity between the weaver, the weaving and the woven which gives them a connectivity which eludes all orthodox conceptions of technology. And although Freud is willing to give women the credit for its 'invention', his account also implies that there is no point of origin, but instead a process of simulation by which weaving replicates or weaves itself. It is not a thing, but a process.

From machines to matrices

As images migrate from canvas to film and finally on to the digital screen, what was once called art mutates into a matter of software engineering. Digital art takes the image beyond even its mechanical reproduction, eroding orthodox conceptions of originals and originality. And just as the image is reprocessed, so it finds itself embroiled in a new network of connections between words, music and architectures which diminishes the governing role it once played in the specular economy.

If the media were once as divided as the senses with which they interact, their convergence and transition into hypermedia allows the senses to fuse and connect. Touch is the sense of multimedia, the immersive simulations of cyberspace, and the connections, switches and links of all nets. Communication cannot be caught by the gaze, but is always a matter of getting in touch, a question of contact, contagion, transmission, reception and connectivity. If sight was the dominant and organizing sense of the patriarchal economy, tactility is McLuhan's 'integral sense' (1967: 77), putting itself and all the others in touch and becoming the sense of hypermedia. It is also the sense with which Irigaray approaches the matter of a female sexuality which is more than one, 'at least two', and always in touch with its own contact points. The medium is the message, and there is no 'possibility of distinguishing what is touching from what is touched' (Irigaray 1985b: 26).

> For if 'she' says something, it is not, it is already no longer, identical with what she means. What she says is never identical with anything, moreover; rather, it is contiguous. *It touches (upon)*. And when it strays too far from that proximity, she stops and starts over at 'zero': her body-sex.
>
> (Irigaray 1985: 29)

Digitization sets zero free to stand for nothing and make everything work. The ones and zeros of machine code are not patriarchal binaries or counterparts to each other: zero is not the other, but the very possibility of all the ones. Zero is the matrix of calculation, the possibility of multiplication, and has been reprocessing the modern world since it began to arrive from the East. It neither counts nor represents, but with digitization it proliferates, replicates and undermines the privilege of one. Zero is not its absence, but a zone of multiplicity which cannot be perceived by the one who sees. Woman represents '*the horror of nothing to see*', but she also 'has sex organs more or less everywhere' (Irigaray 1985b: 28). She too is more than the sum of her parts, beside herself with her extra links.

In Greek, the word for womb is *hystera*; in Latin, it is *matrix*, or matter, both the mother and the material. In *Neuromancer*, William Gibson calls it 'the nonspace', a 'vastness … where the faces were shredded and blown away down hurricane corridors' (Gibson 1986: 45). It is the imperceptible 'elsewhere' of which Irigaray speaks, the hole that is neither something nor nothing; the newly accessible virtual space which cannot be seen by the one it subsumes. If the phallus guarantees man's identity and his relation to transcendence and truth, it is also this which cuts him off from the abstract machinery of a world he thinks he owns.

It is only those at odds with this definition of humanity who seem to be able to access this plane. They have more in common with multifunctional systems than the active agency and singular identity proper to the male subject. Ada Lovelace writes the first programming language for an abstract machine yet to be built; Grace Murray Hopper programs Mark 1. And then there's Turing, described as 'a British mathematician who committed suicide by biting a poisoned Apple. As a discovered homosexual, he had been given a forced choice

by the British courts either to go to jail or to take the feminizing hormone oestrogen. He chose the latter, with feminizing effects on his body, and 'who knows what effect on his brain'. And it was, as Edelman continues, 'that brain,' newly engineered and feminized, which 'gave rise to a powerful set of mathematical ideas, one of which is known as a Turing machine' (Edelman 1992: 218).

As the activities which have been monopolized by male conceptions of creativity and artistic genius now extend into the new multimedia and interactive spaces of the digital arts, women are at the cutting edge of experimentation in these zones. North America has Beth Stryker's *Cyberqueer*, and *Faultlines* from Ingrid Bachmann and Barbara Layne. In the UK, Orphan Drift ride a wave of writing, digital art, film and music. In Australia, Linda Dement's *Typhoid Mary* and *Cyberflesh Girlmonster* put blood, guts and visceral infections on to her tactile multimedia screens. The French artist Orlan slides her body into cyberspace. The construct cunts access the controls. Sandy Stone makes the switch and the connection: '*to put on the seductive and dangerous cybernetic space like a garment, is to put on the female*' (Stone 1991: 109). Subversions of cyberpunk narrative proliferate. Kathy Acker hacks into *Neuromancer*, unleashing its elements in *Empire of the Senseless*. And Pat Cadigan's cyberpunk novels give another excruciating twist to the cyberspace tale. *Synners, Fools* and the stories in *Patterns* are texts of extraordinary density and intensity, both in terms of their writing and the worlds they engineer. If Gibson began to explore the complexities of the matrix, Cadigan's fictions perplex reality and identity to the point of irrelevance.

> Before you run out the door, consider two things:
> The future is already set, only the past can be changed, and
> If it was worth forgetting, it/s not worth remembering.
>
> (Cadigan 1994: 287)

From viruses to replicunts

Once upon a time, tomorrow never came. Safely projected into the reaches of distant times and faraway galaxies, the future was science fiction and belonged to another world. Now it is here, breaking through the endless deferral of human horizons, short-circuiting history, downloading its images into today. While historical man continues to gaze in the rear-view mirror of the interface, guarding the present as a reproduction of the past, the sands of time are running into silicon, and Read Only Memory has come to an end. Cyber-revolution is virtually real.

Simulation leaves nothing untouched. Least of all the defences of a specular economy entirely invested in the identity of man and the world of ones and others he perceives. The father's authority is undermined as the sperm count goes into decline and oestrogen saturates the water supply. Queer culture converges with post-human sexualities which haven no regard for the moral code. Working patterns move from full-time, life-long, specialized careers to part-time, temporary, and multi-functional formats, and the context shifts into one in which women have long had expertise. It is suddenly noticed that girls' achievements in school and higher education are far in excess of those of their male counterparts, and a new transferable intelligence begins to be valued above either the strength or single-mindedness which once gave the masculine its power and are now being downgraded and rendered obsolete. Such tendencies – and the authoritarian reactions they excite – are emerging not only in the West but also across what were once lumped together as the cultures of the

'Third World'. Global telecommunications and the migration of capital from the West are undermining both the pale male world and the patriarchal structures of the south and east, bringing unprecedented economic power to women workers and multiplying the possibilities of communication, learning and access to information.

These crises of masculine identity are fatal corrosions of every one: every unified, centralized containment, and every system which keeps them secure. None of this was in the plan. What man has named as his history was supposed to function as the self-narrating story of a drive for domination and escape from the earth; a passage from carnal passions to self-control; a journey from the strange fluidities of the material to the self-identification of the soul. Driven by dreams of taming nature and so escaping its constraints, technical development has always invested in unification, light and flight, the struggle for enlightenment, a dream of escaping from the meat. Men may think and women may fear that they are on top of the situation, pursuing the surveillance and control of nature to unprecedented extremes, integrating their forces in the final consolidation of a technocratic fascism. But cyberspace is out of man's control: virtual reality destroys his identity, digitalization is mapping his soul and, at the peak of his triumph, the culmination of his machinic erections, man confronts the system he built for his own protection and finds it is female and dangerous.

Those who still cherish the patriarchal dream see cyberspace as a new zone of hope for a humanity which wants to be freed from the natural trap, escaping the body and sliding into an infinite, transcendent and perfect other world. But the matrix is neither heaven, nor even a comforting return to the womb. By the time man begins to gain access to this zone, both the phallic dream of eternal life and its fantasy of female death are interrupted by the abstract matters of a cybernetic space which has woven him into its own emergence. Tempted still to go onwards and upwards by the promise of immortality, total control and autonomy, the hapless unity called man finds himself hooked up to the screen and plugged into a global web of hard, soft, and wetware systems. The great flight from nature he calls history comes to an end as he becomes a cyborg component of self-organizing processes beyond either his perception or his control.

As the patriarchal economy overheats, the human one, the member of the species, is rapidly losing his social, political, economic and scientific status. Those who distinguished themselves from the rest of what becomes their world and considered themselves to be 'making history', and building a world of their own design are increasingly subsumed by the activity of their own goods, services, lines of communication and the self-organizing processes immanent to a nature they believed was passive and inert. If all technical development is underwritten by dreams for total control, final freedom, and some sense of ultimate reconciliation with the ideal, the runaway tendencies and chaotic emergences to which these dreams have led do nothing but turn them into nightmarish scenes.

Cyberfeminism is an insurrection on the part of the goods and materials of the patriarchal world, a dispersed, distributed emergence composed of links between women, women and computers, computers and communication links, connections and connectionist nets.

It becomes clear that if the ideologies and discourses of modern feminism were necessary to the changes in women's fortunes which creep over the end of the millennium, they were certainly never sufficient to the processes which now find man, in his own words, 'adjusting to irrelevance' and becoming 'the disposable sex'. It takes an irresponsible feminism – which may not be a feminism at all – to trace the inhuman paths on which woman begins to assemble herself as the cracks and crazes now emerging across the once smooth surfaces

of patriarchal order. She is neither man-made with the dialecticians, biologically fixed with the essentialists, nor wholly absent with the Lacanians. She is in the process, turned on with the machines. As for patriarchy: it is not dead, but nor is it intractable.

There is no authentic or essential woman up ahead, no self to be reclaimed from some long lost past, nor even a potential subjectivity to be constructed in the present day. Nor is there only an absence or lack. Instead there is a virtual reality, an emergent process for which identity is not the goal but the enemy, precisely what has kept at bay the matrix of potentialities from which women have always downloaded their roles.

After the second come the next waves, the next sexes, asking for nothing, just taking their time. Inflicted on authority, the wounds proliferate. The replicants write programs, paint viral images, fabricate weapons systems, infiltrate the arts and the industry. They are hackers, perverting the codes, corrupting the transmissions, multiplying zeros, and teasing open new holes in the world. They are the edge of the new edge, unashamedly opportunist, entirely irresponsible, and committed only to the infiltration and corruption of a world which already rues the day they left home.

Notes

1. Such cultural viruses are not metaphorical: both Richard Dawkins and more recently, Daniel Dennett (1995), have conducted some excellent research into the viral functioning of cultural patterns. Nor are such processes of replication and contagion necessarily destructive: even the most damaging virus may need to keep its host alive.
2. Asimov's three rules are: 1. A robot may not injure a human being, or, through inaction, allow a human being to come to harm; 2. A robot must obey the orders given it by human beings, except where such orders would conflict with the First Law; 3. A robot must protect its own existence as long as such protection does not conflict with the First or Second Law.
3. Alan Turing's abstract machine, developed during the Second World War, forms the basis of the modern serial computer.
4. Her 'Sketch of the Analytical Engine invented by L.F. Menebrea, with notes upon the memoir by the translator, Ada Augustus, Countess of Lovelace', appears in Philip and Emily Morrison (eds), *Charles Babbage and his Calculating Engines, Selected Writings by Charles Babbage and Others*, New York: Dover, 1961.

References

Cadigan, P. (1989) *Patterns*, London: Grafton.
—— (1991) *Synners*, London: Grafton.
—— (1994) *Fools*, London: Grafton.
Dennett, D. (1995) *Darwin's Dangerous Idea: Evolution and the Meanings of Life*, Harmondsworth: Allen Lane/The Penguin Press.
Edelman, G. (1992) *Bright Air, Brilliant Fire*, New York: Basic Books.
Eiser, J. R. (1994) *Attitudes, Chaos, and the Connectionist Mind*, Oxford: Blackwell.
Freud, S. (1985) *New Introductory Lectures on Psychoanalysis*, Harmondsworth: Penguin.
Freud, S. and Breuer, J. (1991) *Studies in Hysteria*, Harmondsworth: Penguin.
Gibson, W. (1986) *Neuromancer*, London: Grafton.
Irigaray, L. (1985a) *Speculum of the Other Woman*, Ithaca, NY: Cornell University Press.
—— (1985b) *This Sex that is not One*, Ithaca, NY: Cornell University Press.
—— (1991) *Marine Lover of Friedrich Nietzsche*, New York: Columbia University Press.
Langton Moore, D. (1977) *Ada, Countess of Lovelace*, London: John Murray.
McLuhan, M. (1967) *Understanding Media*, London: Sphere Books.

Misha (1991) 'Wire movement' 9, in Larry McCaffrey (ed.), *Storming the Reality Studio*, Durham, NC and London: Duke University Press.

Stone, A. R. (1991) 'Will the real body stand up?', in Michael Benedikt (ed.), *Cyberspace, First Steps*, Cambridge, MA and London: MIT Press.

Chela Sandoval

NEW SCIENCES
Cyborg feminism and the methodology
of the oppressed

WHAT CONSTITUTES 'RESISTANCE' and oppositional politics under the imperatives of political, economic and cultural transnationalization? Current global restructuring is effecting the organizational formations not only of business, but of cultural economies, consciousness and knowledge. Social activists and theorists throughout the twentieth century have been attempting to construct theories of opposition that are capable of comprehending, responding to, and acting back upon these globalizing forces in ways that renegotiate power on behalf of those Marx called the 'proletariat', Barthes called the 'colonized classes', Hartsock called 'women', and Lorde called the 'outsiders'. If transnational corporations are generating 'business strategy and its relation to political initiatives at regional, national, and local levels',[1] then, what are the concurrent forms of strategy being developed by the subaltern — by the marginalized — that focus on defining the forms of oppositional consciousness and praxis that can be effective under First World transnationalizing forces?

Let me begin by invoking Silicon Valley — that great land of Lockheed, IBM, Macintosh, Hewlett Packard, where over 30,000 workers have been laid off in the last two years, and another 30,000 more await a similar fate over the year to come: the fate of workers without jobs, those who fear for their livelihood. I begin here to honour the muscles and sinews of workers who grow tired in the required repetitions, in the warehouses, assembly lines, administrative cells, and computer networks that run the great electronic firms of the late twentieth century. These workers know the pain of the union of machine and bodily tissue, the robotic conditions, and in the late twentieth century, the cyborg conditions under which the notion of human agency must take on new meanings. A large percentage of these workers who are not in the administrative sector but in labour-grade sectors are US people of colour, indigenous to the Americas, or those whose ancestors were brought here as slaves or indentured servants; they include those who immigrated to the US in the hopes of a better life, while being integrated into a society hierarchized by race, gender, sex, class, language and social position. Cyborg life: life as a worker who flips burgers, who speaks the cyborg speech of McDonalds, is a life that the workers of the future must prepare themselves for in small, everyday ways. My argument has been

that colonized peoples of the Americas have already developed the cyborg skills required for survival under techno-human conditions as a requisite for survival under domination over the last three hundred years. Interestingly, however, theorists of globalization engage with the introduction of an oppositional 'cyborg' politics as if these politics have emerged with the advent of electronic technology alone, and not as a requirement of consciousness in opposition developed under previous forms of domination.

In this chapter I propose another vision, wrought out of the work of cultural theorist and philosopher of science Donna Haraway, who in 1985 wrote the groundbreaking work on 'Cyborg Feminism', in order to re-demonstrate what is overlooked in current cyborg theory, namely, that cyborg consciousness can be understood as the technological embodiment of a particular and specific form of oppositional consciousness that I have elsewhere described as 'US Third World feminism'.[2] And indeed, if cyborg consciousness is to be considered as anything other than that which replicates the now dominant global world order, then cyborg consciousness must be developed out of a set of technologies that together comprise the methodology of the oppressed, a methodology that can provide the guides for survival and resistance under First World transnational cultural conditions. This oppositional 'cyborg' consciousness has also been identified by terms such as 'mestiza', consciousness, 'situated subjectivities', 'womanism', and 'differential consciousness'. In the interests of furthering Haraway's own unstated but obvious project of challenging the racialization and apartheid of theoretical domains in the academy, and in the interests of translation, of transcoding from one academic idiom to another, from 'cyborgology' to 'feminism', from 'US Third World feminism' to 'cultural' and to 'subaltern' theory, I trace the routes travelled by the methodology of the oppressed as encoded by Haraway in 'Cyborg Feminism'.

Haraway's research represents an example of scholarly work that attempts to bridge the current apartheid of theoretical domains: 'white male post-structuralism', 'hegemonic feminism', 'postcolonial theory', and 'US Third World feminism'. Among her many contributions, Haraway provides new metaphoric grounds of resistance for the alienated white male subject under First World conditions of transnationalization, and thus the metaphor 'cyborg' represents profound possibilities for the twenty-first century (implications of hope, for example, for Jameson's lost subject which 'can no longer extend its protensions and retensions across the temporal manifold'.[3] Under cyborg theory, computer 'travel' can be understood as 'displacing' the 'self' in a similar fashion as the self was displaced under modernist dominations). An oppositional cyborg politics, then, could very well bring the politics of the alienated white male subject into alliance with the subaltern politics of US Third World feminism. Haraway's metaphor, however, in its travels through the academy, has been utilized and appropriated in a fashion that ironically represses the very work that it also fundamentally relies upon. This continuing repression then serves to reconstitute the apartheid of theoretical domains once again. If scholarship in the humanities thrives under the regime of this apartheid, Haraway represents a boundary crosser, and her work arises from a place that is often overlooked or misapprehended under hegemonic understandings.

I have argued elsewhere that the methodology of the oppressed consists of five different technologies developed in order to ensure survival under previous First World conditions.[4] The technologies which together comprise the methodology of the oppressed generate the forms of agency and consciousness that can create effective forms of resistance under postmodern cultural conditions, and can be thought of as constituting a 'cyborg' form of resistance.[5] The practice of this *CyberConsciousness* that is US Third World feminism, or what I refer to as a 'differential postmodern form of oppositional consciousness', has also been described in terms that stress its motion; it is 'flexible', 'mobile', 'disporic', 'schizophrenic', 'nomadic' in nature. These forms of mobility, however, align around a field of force which

inspires, focuses and drives them as oppositional forms of praxis. Indeed, this form of consciousness-in-opposition is best thought of as the particular field of force that makes possible the practices and procedures of the 'methodology of the oppressed'. Conversely, this methodology is best thought of as comprised of techniques-for-moving energy – or, better, as *oppositional technologies of power*: both 'inner' or psychic technologies, and 'outer' technologies of social praxis.

These technologies can be summarized as follows: (1) What Anzaldua calls 'la facultad', Barthes calls semiology, the 'science of signs in culture', or what Henry Louis Gates calls 'signifyin' and Audre Lorde calls 'deep seeing' are all forms of 'sign-reading' that comprise the first of what are five fundamental technologies of this methodology. (2) The second, and well-recognized technology of the subaltern is the process of challenging dominant ideological signs through their 'de-construction': the act of separating a form from its dominant meaning. (3) The third technology is what I call 'meta-ideologizing' in honour of its activity: the operation of appropriating dominant ideological forms and using them whole in order to transform their meanings into a new, imposed, and revolutionary concept. (4) The fourth technology of the oppressed that I call 'democratics' is a process of locating: that is, a 'zeroing in' that gathers, drives, and orients the previous three technologies, semiotics, deconstruction, and meta- ideologizing, with the intent of bringing about not simply survival or justice, as in earlier times, but egalitarian social relations, or, as Third World writers from Fanon through to Wong, Lugones, or Collins have put it,[6] with the aim of producing 'love' in a de-colonizing, postmodern, post-empire world. (5) Differential movement is the fifth technology, the one through which, however, the others harmonically manoeuvre. In order to better understand the operation of differential movement, one must understand that it is a polyform upon which the previous technologies depend for their own operation. Only through differential movement can they be transferred toward their destinations. Even the fourth, 'democratics', which always tends toward the centring of identity in the interest of egalitarian social justice. These five technologies together comprise the methodology of the oppressed, which enables the enactment of what I have called the differential mode of oppositional social movement as in the example of US Third World feminism.

Under US Third World feminism, differential consciousness has been encoded as 'la facultad' (a semiotic vector), the 'outsider/within' (a deconstructive vector), strategic essentialism, (a meta-ideologizing vector), 'womanism' (a moral vector) and as 'la conciencia de la mestiza', 'world travelling' and 'loving cross-cultures' (differential vectors).[7] Unlike Westerners such as Patrick Moynihan who argue that 'the collapse of Communism' in 1991 proves how 'racial, ethnic, and national ties of difference can only ultimately divide any society',[8] a differential form of oppositional consciousness, as utilized and theorized by a racially diverse US coalition of women of colour, is the form love takes in the postmodern world.[9] It generates grounds for coalition, making possible community across difference, permitting the generation of a new kind of citizenship, countrywomen and men of the same psychic terrain whose lives are made meaningful through the enactment of the methodology of the oppressed.

Whether interfaces with technology keep cyborg politics in renewed contestation with differential (US Third World feminist and subaltern) politics is a question only the political and theoretical strategies of undoing apartheid – of all kinds – will resolve. The differential form of social movement and its technologies provide the links capable of bridging the divided minds of the First World academy, and of creating grounds for what must be considered a new form of trandisciplinary work that centres the methodology of the oppressed – of the subaltern – as a new form of post-Western empire knowledge

formation that can transform current formations and disciplinizations of knowledge in the academy. As we shall see in the following analysis of Haraway's theoretical work, the networking required to imagine and theorize 'cyborgian' consciousness can be considered, in part, a technologized metaphorization of the 1970s under the rubric of US Third World feminism. However, such terms as 'difference', the 'middle voice', the 'third meaning', 'rasquache', 'la conciencia de la mestiza', 'hybridity', 'schizophrenia', and such processes as 'minor literature' and 'strategic essentialism' also call up and represent forms of that cyberspace, that other zone for consciousness and behaviour that is being proposed from many locations and from across disciplines as that praxis most able to both confront and homeopathically resist postmodern cultural conditions.

Donna Haraway: feminist cyborg theory and US Third World feminism

Haraway's essay 'Manifesto for Cyborgs' can be defined in its own terms as a 'theorized and fabricated hybrid', a 'textual machine', or as a 'fiction mapping our social and bodily reality', phrases which Haraway also calls upon in order to redefine the term 'cyborg', which, she continues, is a 'cybernetic organism', a mixture of technology and biology, a 'creature' of both 'social reality' and 'fiction'.[10] This vision that stands at the centre of her imaginary is a 'monstrous' image. Haraway's cyborg is the 'illegitimate' child of dominant society and oppositional social movement, of science and technology, of the human and the machine, of 'First' and 'Third' worlds, of male and female, indeed, of every binary. The hybridity of this creature is situated in relation to each side of these binary positions, and to every desire for wholeness, she writes, as 'blasphemy' (149) stands to the body of religion. Haraway's blasphemy is the cyborg, that which reproaches, challenges, transforms, and shocks. But perhaps the greatest shock in her feminist theory of cyborg politics takes place in the corridors of feminist theory, where Haraway's model has acted as a transcoding device, a technology that insists on translating the fundamental precepts of US Third World feminist criticism into categories that are comprehensible under the jurisdictions of Women's Studies.

Haraway has been very clear about these intellectual lineages and alliances. Indeed, she writes in her introduction to *Simians, Cyborgs and Women* that one primary aim of her work is similar to that of US Third World feminist theory and methods, which is, in Haraway's words, to bring about 'the break-up of versions of Euro-American feminist humanisms in their devastating assumptions of master narratives deeply indebted to racism and colonialism'. (It might be noted that this same challenge, when uttered through the lips of a feminist theorist of colour, can be indicted and even dismissed as 'undermining the movement' or as 'an example of separist politics'.) Haraway's second and connected aim is to propose a new grounds for theoretical and political alliances, a 'cyborg feminism' that will be 'more able' than the feminisms of earlier times, she writes, to 'remain attuned to specific historical and political positionings and permanent partialities without abandoning the search for potent connections'.[11] Haraway's cyborg feminism was thus conceived, at least in part, to recognize and join the contributions of US Third World feminist theorists who have challenged, throughout the 1960s, 1970s and 1980s what Haraway identifies as hegemonic feminism's 'unreflective participation in the logics, languages, and practices of white humanism'. White feminism, Haraway points out, tends to search 'for a single ground of domination to secure our revolutionary voice' (160).

These are thus strong ideological alliances, and so it makes sense that Haraway should turn to US Third World feminism for help in modelling the 'cyborg' body that can be

capable of challenging what she calls the 'networks and informatics' of contemporary social reality. For, she affirms, it has been 'feminist theory produced by women of color' which has developed 'alternative discourses of womanhood', and these have disrupted 'the humanisms of many Western discursive traditions'.[12] Drawing from these and other alternative discourses, Haraway was able to lay the foundations for her theory of cyborg feminism, yet she remains clear on the issue of that theory's intellectual lineages and alliances:

> White women, including socialist feminists, discovered (that is were forced kicking and screaming to notice) the non-innocence of the category 'woman.' That consciousness changes the geography of all previous categories; it denatures them as heat denatures a fragile protein. Cyborg feminists have to argue that 'we' do not want any more natural matrix of unity and that no construction is whole [157].[13]

The recognition 'that no construction is whole', however – though it helps – is not enough to end the forms of domination that have historically impaired the ability of US liberation movements to effectively organize for equality. And for that reason, much of Haraway's ongoing work has been to identify the additional technical *skills* that are necessary for producing this different kind of coalitional, and what she calls 'cyborg', feminism.

To understand Haraway's contribution, I want to point out and emphasize her correlation of these necessary skills with what I earlier identified as the methodology of the oppressed. It is no accident that Haraway defines, names and weaves the skills necessary to cyborgology through the techniques and terminologies of US Third World cultural forms, from Native American concepts of 'trickster' and 'coyote' being (199), to 'mestiza' or the category 'women of color', until the body of the feminist cyborg becomes clearly articulated with the material and psychic positionings of US Third World feminism.[14] Like the 'mestiza consciousness' described and defined under US Third World feminism which, as Anzaldua explains, arises 'on borders and in margins' where feminism which, as Anzaldua explains, arises 'on borders and in margins' where feminists of colour keep 'intact shifting and multiple identities' and with 'integrity' and love, the cyborg of Haraway's feminist manifesto must also be 'resolutely committed to partiality, irony, intimacy and perversity' (151). In this equivalent alignment, Haraway writes, feminist cyborgs can be recognized (like agents of US Third World feminism) to be the 'illegitimate offspring,' of 'patriarchal capitalism' (151). Feminist cyborg weapons and the weapons of US Third World feminism are also similar with 'transgressed boundaries, potent fusions and dangerous possibilities' (154). Indeed, Haraway's cyborg textual machine represents a politics that runs parallel to those of US Third World feminist criticism. Thus, in so far as Haraway's work is influential in feminist studies, her cyborg feminism is capable of insisting on an alignment between what was once hegemonic feminist theory with theories of what are locally apprehended as indigenous resistance, 'mestizaje', US Third World feminism, or the differential mode of oppositional consciousness.[15]

This attempted alignment between US feminist Third World cultural and theoretical forms and US feminist theoretical forms is further reflected in Haraway's doubled vision of a 'cyborg world'. This might be defined, she believes, as either the culmination of Euro-American 'white' society in its drive-for-mastery, on the one hand or, on the other, as the emergence of resistant 'indigenous' world views of mestizaje, US Third World feminism, or cyborg feminism. She writes:

> A cyborg world is about the final imposition of a grid of control on the planet, about the final abstraction embodied in Star Wars apocalypse waged in the name

of defense, about the final appropriation of women's bodies in a masculinist orgy of war. From another perspective a cyborg world might be about lived social and bodily realities in which people are not afraid of their joint kinship with animals and machines, not afraid of permanently partial identities and contradictory standpoints [154][16]

The important notion of 'joint kinship' Haraway calls up here is analogous to that called for in contemporary indigenous writings where tribes or lineages are identified out of those who share, not blood lines, but rather lines of affinity. Such *lines of affinity* occur through attraction, combination and relation carved out of and in spite of difference, and they are what comprise the notion of mestizaje in the writings of people of colour, as in the 1982 example of Alice Walker asking US black liberationists to recognize themselves as mestizos. Walker writes:

> We are the African and the trader. We are the Indian and the Settler. We are oppressor and oppressed ... we are the mestizos of North America. We are black, yes, but we are 'white,' too, and we are red. To attempt to function as only one, when you are really two or three, leads, I believe, to psychic illness: 'white' people have shown us the madness of that.[17]

Mestizaje in this passage, and in general, can be understood as a complex kind of love in the postmodern world where love is understood as affinity–alliance and affection across lines of difference which intersect both in and out of the body. Walker understands psychic illness as the attempt to be 'one', like the singularity of Roland Barthes' narrative love that controls all meanings through the medium of the couple-in-love. The function of mestizaje in Walker's vision is more like that of Barthes' prophetic love, where subjectivity becomes freed from ideology as it ties and binds reality. Prophetic love undoes the 'one' that gathers the narrative, the couple, the race into a singularity. Instead, prophetic love gathers up the mexcla, the mixture-that-lives through differential movement between possibilities of being. This is the kind of 'love' that motivates US Third World feminist mestizaje, and its theory and method of oppositional and differential consciousness, what Anzaldua theorizes as *la conciencia de la mestizo*, or 'the consciousness of the Borderlands'.[18]

Haraway weaves such US Third World feminist commitments to affinity-through-difference into her theory of cyborg feminism, and in doing so, begins to identify those skills that comprise the methodology of the oppressed, as indicated in her idea that the recognition of differences and their corresponding 'pictures of the world' (190) must not be understood as relativistic 'allegories of infinite mobility and interchangeability'. Simple mobility without purpose is not enough, as Gayatri Spivak posits in her example of 'strategic essentialism' which argues both for mobility *and* for identity consolidation at the same time. Differences, Haraway writes, should be seen as examples of 'elaborate specificity' and as an opportunity for 'the loving care people might take to learn how to see faithfully from another point of view' (190). The power and eloquence of writings by certain US feminists of colour, Haraway continues, derives from their insistence on the 'power to survive not on the basis of original innocence, (the imagination of a "once-upon-a-time wholeness" or oneness), but rather on the insistence of the possibilities of affinity-through-difference. This mestizaje or differential consciousness allows the use of any tool at one's disposal in order to both ensure survival and to remake the world. According to Haraway, the task of cyborg feminism must similarly be to 'recode' all tools of 'communication and intelligence,' with one's aim being the subversion of 'command and control' (175).

In the following quotation, Haraway analyses Chicana intellectual Cherrie Moraga's literary work by applying a 'cyborg feminist' approach that is clearly in strong alliance with US Third World feminist methods. She writes:

> Moraga's language is not 'whole'; it is self-consciously spliced, a chimera of English and Spanish, both conqueror's languages. But it is this chimeric monster, without claim to an original language before violation, that crafts the erotic, competent potent identities of women of color. Sister Outsider hints at the possibility of world survival not because of her innocence, but because of her ability to live on the boundaries, to write without the founding myth of original wholeness, with its inescapable apocalypse of final return to a deathly oneness...-. Stripped of identity, the bastard race teaches about the power of the margins and the importance of a mother like Malinche. Women of color have transformed her from the evil mother of masculinist fear into the originally literate mother who teaches survival [175–6].

Ironically, US Third World feminist criticism, which is a set of theoretical and methodological strategies, is often understood by readers, even of Haraway, as a demographic constituency only ('women of colour', a category which can be used, ironically, as an 'example' to advance new theories of what are now being identified in the academy as 'postmodern feminisms'), and not as itself a theoretical and methodological approach that clears the way for new modes of conceptualizing social movement, identity and difference. The textual problem that becomes a philosophical problem, indeed, a political problem, is the conflation of US Third World feminism as a theory and method of oppositional consciousness with the demographic or 'descriptive' and generalized category 'women of colour' thus depoliticizing and repressing the specificity of the politics and forms of consciousness developed by US women of colour, feminists of colour and erasing the specificity of what is a particular *form* of these: US Third World feminism.

By 1991 Haraway herself recognizes these forms of elision, and how by gathering up the category 'women of colour' and identifying it as a 'cyborg identity, a potent subjectivity synthesized from fusions of outsider identities' (i.e. Sister Outsider), her work inadvertently contributed to this tendency to elide the specific theoretical contributions of US Third World feminist criticism by turning many of its approaches, methods, forms and skills into examples of cyborg feminism (174). Haraway, recognizing the political and intellectual implications of such shifts in meaning, proceeded to revise her position, and six years after the publication of 'Cyborg Feminism' she explains that today, 'I would be much more careful about describing who counts as a 'we' in the statement 'we are all cyborgs'. Instead, she asks, why not find a name or concept that can signify 'more of a family of displaced figures, of which the cyborg' is only one, 'and then to ask how the cyborg makes connections' with other non-original people who are also 'multiply displaced'?[19] Should we not be imagining, she continues, 'a family of figures' who could 'populate our imaginations' of 'postcolonial, postmodern worlds that would not be quite as imperializing in terms of a single figuration of identity?[20] These are important questions for theorists across disciplines who are interested in effective new modes of understanding social movements and consciousness in opposition under postmodern cultural conditions. Haraway's questions remain unanswered across the terrain of oppositional discourse, however, or rather, they remain multiply answered and divided by academic terrain. And even within feminist theory, Haraway's own cyborg feminism and her later development of the technology of 'situated knowledges', though they come close, have not been able to effectively bridge the gaps across the apartheid of theoretical domains described earlier.

For example, if Haraway's category 'women of colour' might best be understood, as Haraway had earlier posited, 'as a cyborg identity, a potent subjectivity synthesized from fusions of outsider identities and in the complex political-historical layerings of her biomythography' (174), then why has feminist theory been unable to recognize US Third World feminist criticism itself as a mode of cultural theory which is also capable of unifying oppositional agents across ideological, racial, gender, sex or class differences, even if that alliance and identification would take place under the gendered, 'raced' and transnational sign 'US Third World feminism'? Might this elision be understood as yet another symptom of an active apartheid of theoretical domains? For, as I have argued, the non-essentializing identity demanded by US Third World feminism in its differential mode creates what Haraway is also calling for, a mestiza, indigenous, even cyborg identity.[21]

We can see Haraway making a very similar argument for the recognition of US Third World feminist criticism in her essay in *Feminists Theorize the Political*. Haraway's essay begins by stating that women who were 'subjected to the conquest of the new world faced a broader social field of reproductive unfreedom, in which their children did not inherit the status of human in the founding hegemonic discourses of US society'.[22] For this reason, she asserts, 'feminist theory produced by women of color' in the US continues to generate discourses that confute or confound traditional Western standpoints. What this means, Haraway points out, is that if feminist theory is ever to be able to incorporate the visions of US Third World feminist theory and criticism, then the major focus of feminist theory and politics must make a fundamental shift to that of making 'a place for the different social subject'.[23]

This challenge to feminist theory represents a powerful theoretical and political shift, and if answered, has the potential to bring feminism into affinity with such theoretical terrains as post-colonial discourse theory, US Third World feminism, postmodernism, and Queer Theory.

How might this shift be accomplished in the domain of feminist theory? Through the willingness of feminists, Haraway proposes, to become 'less interested in joining the ranks of gendered femaleness', to instead become focused on 'gaining the INSURGENT ground as female social subject (95)'.[24] This challenge to Women's Studies means that a shift must occur to an arena of resistance that functions outside the binary divide male/female, for it is only in this way, Haraway asserts, that 'feminist theories of gendered *racial* subjectivities' can 'take affirmative AND critical account of emergent, differentiating, self-representing, contradictory social subjectivities, with their claims on action, knowledge, and belief'.[25] Under this new form of what Haraway calls an 'anti-racism' indeed, even an *anti-gender* feminism, Haraway asserts, 'there is no place for women' only 'geometrics of difference and contradiction crucial to womens cyborg identities' (171).

It is at this point that Haraway's work begins to identify the specific technologies that fully align her theoretical apparatus with what I have called the methodology of the oppressed. How, then, might this new form of feminism, or what I would call this new form of oppositional consciousness, be brought into being? By identifying a set of skills that are capable of dis-alienating and realigning what Haraway calls the human 'join' that connects our 'technics' (material and technical details, rules, machines and methods) with our 'erotics' (the sensuous apprehension and expression of 'love'-as-affinity).[26] Such a joining, Haraway asserts, will require what is a savvy kind of 'politics of articulation', and these are the primary politics that lay at 'the heart of an anti-racist feminist practice'[27] that is capable of making 'more powerful collectives in dangerously unpromising times'.[28] This powerful politics of articulation, this new 'anti-racist' politics that is also capable of making new kinds of coalitions, can be recognized, argues Haraway, by identifying the 'skilled practices' that are utilized and developed within subaltern classes.

Haraway's theoretical work outlines the forms taken by the subjugated knowledges she identifies. These forms required, as she writes, 'to see from below', are particular skills that effect 'bodies', 'language' and the 'mediations of vision'. Haraway's understanding of the nature of these skills cleaves closely to those same skills that comprise the methodology of the oppressed, which include the technologies of 'semiotics', 'deconstruction', 'meta-ideologizing', 'democratics', and 'differential movement'. It is these technologies that permit the constant, differential repositioning necessary for perception and action from what Haraway identifies as 'the standpoints of the subjugated'. Indeed, Haraway's essay on cyborg feminism identifies all five of these technologies (if only in passing) as ways to bring about what she hopes will become a new feminist methodology.

Of the first 'semiotic' technology, for example, Haraway writes that 'self knowledge requires a semiotic-material technology linking meanings and bodies ... the opening of non-isomorphic subjects, agents, and territories to stories unimaginable from the vantage point of the cyclopian, self-satiated eye of the master subject' (192). Though Haraway does not identify the technologies of 'deconstruction', or 'meta-ideologizing' separately, these two interventionary vectors are implied when she writes that this new contribution to social movement theory, cyborg feminism, must find many 'means of understanding and intervening in the patterns of objectification in the world'. This means 'decoding and transcoding plus translation and criticism: all are necessary'. 'Democratics' is the technology of the methodology of the oppressed that guides all the others, and the moral force of this technology is indicated in Haraway's assertion that in all oppositional activity, agents for change 'must be accountable' for the 'patterns of objectification in the world' that have now become 'reality'. In this effort to take responsibility for the systems of domination that now exist, Haraway emphasizes that the practitioner of cyborg feminism cannot be 'about fixed locations in a reified body'. This new oppositional actor must be 'about nodes in fields' and 'inflections in orientation'. Through such mobilities, an oppositional cyborg feminism must create and enact its own version of, 'responsibility for difference in material-semiotic fields of meaning' (195). As for the last technology of the methodology of the oppressed, called 'differential movement', Haraway's own version is that cyborg feminism must understand 'the impossibility of innocent "identity" politics and epistemologies as strategies for seeing from the standpoints of the subjugated'. Rather, oppositional agents must be 'committed' in the enactment of all forms-of-being and all skills, whether those 'skills' are semiotic, 'decoding', 'recoding' or 'moral' in function, to what Haraway calls 'mobile positioning and passionate detachment' (192).

I have argued that the 'cyborg skills' necessary for developing a feminism for the twentieth century are those I have identified as the methodology of the oppressed. Their use has the power to forge what Haraway asserts can be a potentially 'earth-wide network of connections' including the ability to make new coalitions across new kinds of alliances by translating 'knowledges among very different – and power-differentiated – communities' (187). The feminism that applies these technologies as 'skills' will develop into another kind of science, Haraway asserts, a science of 'interpretation, translation, stuttering, and the partly understood'. Like the science proposed under the differential mode of consciousness and opposition – US Third World feminism – cyborg feminism can become the science of those Haraway describes as the 'multiple subject with at least double vision'. Scientific 'objectivity' under this new kind of science, writes Haraway, will mean an overriding commitment to a practice capable of facing down bureaucratic and administrative sciences, a practice of 'objectivity' that Haraway calls 'situated knowledges' (188). For, she writes, with the advent of US Third World feminism and other forms of feminisms, it has become clear that 'even the simplest matters in feminist analysis require contradictory moments and a wariness of

their resolution'. A scholarly and feminist consciousness-of-science, then, of objectivity as 'situated knowledges' means, according to Haraway, the development of a different kind of human relation to perception, objectivity, understanding, and production, that is akin to Hayden White's and Jacques Derrida's use of the 'middle voice', for it will demand the scholar's situatedness 'in an ungraspable middle space' (111). And like the mechanism of the middle voice of the verb, Haraway's 'situated knowledges' require that what is an 'object of knowledge' also be 'pictured as an actor and agent' (198), transformative of itself and its own situation while also being acted upon.

In other words, Haraway's situated knowledges demands a form of differential consciousness. Indeed, Haraway names the third part of her book *Simians, Cyborgs and Women* 'differential politics for inappropriate/d others'. This chapter defines a coalescing and ever more articulated form of social movement from which 'feminist embodiment' can resist 'fixation' in order to better ride what she calls the 'webs of differential positioning' (196). Feminist theorists who subscribe to this new postmodern form of oppositional consciousness must learn, she writes, to be 'more generous and more suspicious – both generous and suspicious, exactly the receptive posture I seek in political semiosis generally. It is a strategy closely aligned with the oppositional and differential consciousness'.[29] of US third world feminism.

It was previously assumed that the behaviours of oppressed classes depend upon no methodology at all, or rather, that they consist of whatever acts one must commit in order to survive, both physically and psychically. But this is exactly why the methodology of the oppressed can now be recognized as that mode-of-being best suited to life under postmodern and highly technologized conditions in the First World. For to enter a world where any activity is possible in order to ensure survival is also to enter a cyberspace-of-being and consciousness. This space is now accessible to all human beings through technology, (though this was once a zone only accessible to those forced into its terrain), a space of boundless possibilities where meanings are only cursorily attached and thus capable of reattaching to others depending upon the situation to be confronted. This cyberspace is Barthes' zero degree of meaning and prophetic love, Fanon's 'open door of every consciousness'. Anzaldua's 'Coatlique' state, and its processes are linked closely with those of differential consciousness.

To reiterate, the differential mode of oppositional consciousness finds its expression through the methodology of the oppressed. The technologies of semiotic reading, deconstruction of signs, meta-ideologizing, and moral commitment-to-equality are its vectors, its expressions of influence. These vectors meet in the differential mode of consciousness, carrying it through to the level of the 'real' where it can guide and impress dominant powers. Differential consciousness is itself a force which rhyzomatically and parasitically inhabits each of these five vectors, linking them in movement, while the pull of each of the vectors creates ongoing tension and re-formation. Differential consciousness can be thus thought of as a constant reapportionment of space, boundaries, of horizontal and vertical realignments of oppositional powers. Since each vector occurs at different velocities, one of them can realign all the others, creating different kinds of patterns, and permitting entry at different points. These energies revolve around each other, aligning and realigning in a field of force that is the differential mode of oppositional consciousness, a *Cyber-Consciousness*.

Each technology of the methodology of the oppressed thus creates new conjunctural possibilities, produced by ongoing and transforming regimes of exclusion and inclusion. Differential consciousness is a crossing network of consciousness, a transconsciousness that occurs in a register permitting the networks themselves to be appropriated as ideological weaponry. This cyberspace-of-being is analogous to the cyberspace of computer and even

social life in Haraway's vision, but her understanding of cyberspace is more pessimistic: 'Cyberspace seems to be the consensual hallucination of too much complexity, too much articulation.... . In virtual space, the virtue of articulation, the power to produce connection threatens to overwhelm and finally engulf all possibility of effective action to change the world.'[30] Under the influence of a differential oppositional consciousness understood as a form of 'cyberspace', the technologies developed by subjugated populations to negotiate this realm of shifting meanings are recognized as the very technologies necessary for all First World citizens who are interested in re-negotiating contemporary First World cultures with what we might call a sense of their own 'power' and 'integrity' intact. But power and integrity, as Gloria Anzaldua suggests, will be based on entirely different terms than those identified in the past, when, as Jameson writes, individuals could glean a sense of self in opposition to the centralizing dominant power that oppressed them, and then determine how to act. Under postmodern disobediencies the self blurs around the edges, shifts 'in order to ensure survival', transforms according to the requisites of power, all the while, under the guiding force of the methodology of the oppressed carrying with it the integrity of a self-conscious awareness of the transformations desired, and above all, a sense of the impending ethical and political changes that those transformations will enact.[31]

Haraway's theory weds machines and a vision of First World politics on a transnational, global scale together with the apparatus for survival I call the methodology of the oppressed in US Third World feminism, and it is in these couplings, where race, gender and capital, according to Haraway, 'require a cyborg theory of wholes and parts' (181), that Haraway's vision contributes to bridging the gaps that are creating the apartheid of theoretical domains. Indeed, the coding necessary to re-map the kind of 'disassembled and reassembled postmodern collective and personal self' (163) of cyborg feminism must take place according to a guide capable of placing feminism in alignment with other movements of thought and politics for egalitarian social change. This can happen when being and action, knowledge and science, become self-consciously encoded through what Haraway calls 'subjugated' and 'situated' knowledges, and what I call the methodology of the oppressed, a methodology arising from varying locations and in a multiplicity of forms across the First World, and indominably from the minds, bodies and spirits of US Third World feminists who have demanded the recognition of 'mestizaje', indigenous resistance, and identification with the colonized. When feminist theory becomes capable of self-consciously recognizing and applying this methodology, then feminist politics can become fully synonymous with anti-racism, and the feminist 'subject' will dissolve.

In the late twentieth century, oppositional actors are inventing a new name and new languages for what the methodology of the oppressed and the 'Coatlicue', differential consciousness it demands. Its technologies, from 'signifyin' to 'la facultad', from 'cyborg feminism' to 'situated knowledges', from the 'abyss' to 'difference' have been variously identified from numerous theoretical locations. The methodology of the oppressed provides the schema for the cognitive map of power-laden social reality for which oppositional actors and theorists across disciplines, from Fanon to Jameson, from Anzaldua to Lorde, from Barthes to Haraway, are longing.

Notes

1. Richard P. Appelbaum, 'New journal for global studies center', *CORI: Centre for Global Studies Newsletter*, vol. 1 no. 2, May 1994.
2. See 'U.S. Third World feminism: the theory and method of oppositional consciousness in the postmodern world', which lays the groundwork for articulating the methodology of the oppressed. *Genders 10*, University of Texas Press, Spring 1991.
3. Fredric Jameson, 'Postmodernism: the cultural logic of late capitalism', *New Left* Review No. 146, July–August, pp. 53–92.
4. *The Methodology of the Oppressed,* forthcoming, Duke University Press.
5. The term 'cybernetics' was coined by Norbert Wiener from the Greek word 'Kubernetics', meaning to steer, guide, govern. In 1989 the term was split in two, and its first half 'cyber' (which is a neologism with no earlier root) was broken off from its 'control' and 'govern' meanings to represent the possibilities of travel and existence in the new space of computer networks, a space, it is argued, that must be negotiated by the human mind in new kinds of ways. This cyberspace is imagined in virtual reality films like *Freejack, The Lawnmower Man* and *Tron.* But it was first termed 'cyberspace' and explored by the science fiction writer William Gibson in his 1987 book *Neuromancer.* Gibson's own history, however, passes through and makes invisible 1970s feminist science fiction and theory, including the works of Russ, Butler, Delany, Piercy, Haraway, Sofoulis and Sandoval. In all cases, it is this 'Cyberspace' that can also adequately describe the new kind of movement and location of differential consciousness.
6. For example, Nellie Wang, 'Letter to Ma', *This Bridge Called My Back*; Maria Lugones, 'World Traveling', Patricia Hill Collins, *Black Feminist Thought*; June Jordan, 'Where is the Love?,' *Hacienda Caros.*
7. It is through these figures and technologies that narrative becomes capable of transforming the moment, of changing the world with new stories, of meta-ideologizing. Utilized together, these technologies create trickster stories, stratagems of magic, deception and truth for healing the world, like Rap and CyberCinema, which work through the reapportionment at dominant powers.
8. *MacNeil/Lehrer NewsHour*, November 1991.
9. See writings by US feminists of colour on the matter of love, including June Jordan, 'Where is the love?', Merle Woo, 'Letter to Ma'; Patricia Hill Collins, *Block Feminist Thought*; Maria Lugones, 'Playfulness, "world-travelling", and loving perception'; and Audre Lorde, *Sister Outsider.*
10. Donna Haraway, *Simians, Cyborgs, and Women. The Reinvention of Nature* (New York: Routledge, 1991), p. 150. All quotations in this section are from this text especially chapters eight and nine, 'A Cyborg Manifesto; Science, Technology, and Socialist-Feminism in the Late Twentieth Century' and 'Situated Knowledges: The Science Question in Feminism and the Privilege of Partial Perspective') unless otherwise noted. Further references to this work will be found in the text.
11. Ibid., p. 1.
12. Donna Haraway, 'Ecce Homo, ain't (ar'n't) I a woman, and inappropriate/d others: the human in a post-humanist landscape'. *Feminists Theorize the Political* in Judith Butler and Joan Scott (eds), (New York: Routledge, 1992) p. 95.
13. This quotation historically refers its readers to the impact at the 1970s US Third World feminist propositions which significantly revised the women's liberation movement by, among other things, renaming it with the ironic emphasis 'the *white* women's movement'. And perhaps all uncomplicated belief in the righteous benevolence of US liberation movements can never return after Audre Larde summarized 1970s women's liberation by saying that 'when white feminists call for unity' among women 'they are only naming a deeper and real need for homogeneity.' By the 1980s the central political problem on the table was how to go about imagining and constructing a feminist liberation movement that might bring women together across and through their differences. Haraway's first principle for action in 1985 was to call for and then teach a new hoped-for constituency, 'cyborg feminists', that 'we' do not want any more natural matrix of unity and that no construction is whole'.
14. See Haraway's 'The Promises of Monsters', *Cultural Studies* (New York: Routledge, 1992) p. 328, where the woman of colour becomes the emblematic figure, a 'disturbing guide figure', writes

Haraway, for the feminist cyborg, 'who promises information about psychic, historical and bodily formations that issue, perhaps from 'same other semiotic processes than the psychoanalytic in modern and postmodern guise' (306).

15. US Third World feminism recognizes an alliance named 'indigenous mestizaje', a term which insists upon the kinship between peoples of colour similarly subjugated by race in US colonial history (including, but not limited to, Native peoples, colonized Chicano/as, Blacks and Asians), and viewing them, in spite of their differences, as 'one people'.

16. Haraway's contribution here is to extend the motion of 'mestizaje' to include the mixture, or 'affinity', not only between human, animal, physical, spiritual, emotional and intellectual being as it is currently understood under US Third World feminism, but between all these and the machines of dominant culture too.

17. Alice Walker, 'In the closet of the soul: a letter to an African-American friend', *Ms. Magazine* 15 (November 1986): 32–5.

18. *Borderlands,* p. 77.

19. Constance Penley and Andrew Ross, 'Cyborgs at large: interview with Donna Haraway', *Technoculture* (Minneapolis: University of Minnesota Press, 1991), p. 12.

20. Ibid, p. 13.

21. We might ask why dominant theoretical forms have proven incapable of incorporating and extending theories of black liberation, or Third World feminism. Would not the revolutionary turn be that theorists become capable of this kind of 'strategic essentialism?' If we believe in 'situated knowledges', then people of any racial, gender, sexual categories can enact US Third World feminist practice. Or do such practices have to be transcoded into a 'neutral' language that is acceptable to all separate categories, 'differential consciousness', for example, or 'cyborgology'?

22. Haraway, 'Ecce homo', p. 95.

23. Ibid.

24. The new theoretical grounds necessary for understanding current cultural conditions in the First World and the nature of resistance is not limited to feminist theory, according to Haraway. She writes, 'we lack sufficiently subtle connections for collectively building effective theories of experience. Present efforts – Marxist, psychoanalytic, feminist, anthropolitical – to clarify even "our" experience are rudimentary' (173).

25. Ibid, p. 96.

26. Haraway, 'The promises of monsters', p. 329.

27. Ibid.

28. Ibid., p. 319.

29. Ibid., p. 326.

30. Ibid., p. 325.

Zoë Sofoulis

CYBERQUAKE
Haraway's manifesto

THE OVERUSED TERM "GROUND-BREAKING" always invokes for me images of pickaxes and bulldozers churning up undeveloped land. This is not quite the right word for Donna Haraway's "A Manifesto for Cyborgs" (1985), which behaved more like the seismic center of an earthquake that jolted many out of their categorical certainties as it shifted the terrain of debate about culture and identity in the late 20th century. A decade earlier Laura Mulvey's hugely influential essay "Visual Pleasure and Narrative Cinema" (1975) had had a comparable effect, opening up new directions for a generation of scholars of feminist film theory, art history, textual criticism, and cultural studies. But Haraway's Cyborg Manifesto set out even more multidisciplinary questions, connections, and directions for further research, and its rumbles in the field of cyberstudies, a field it helped to initiate, are still being felt at the beginning of the 21st century. Both Mulvey and Haraway achieved an author status still too rarely accorded feminist writers, a status partly measurable in the fact that they are usually named by lazy female students who are otherwise likely to refer simply to "feminists" or "feminist perspectives," and are cited even by male scholars, a population that, on the whole, successfully ignores vast forests' worth of feminist publishing.

 This chapter is concerned with the earthquake effects of the Cyborg Manifesto in academia and cyberculture more generally. I cannot claim any overarching objectivity: I was a student of Haraway's during the 1980s, and have been familiar with the essay from its pre-history (Haraway 1991a, 244 n.1) to its breakthrough with the notion of the cyborg, following its career through various published, republished, and re-edited versions, not to mention spin-off interviews and elaborations. Rather, I practice what Haraway (1988) calls a "situated knowledge": partial, with inevitable blind spots, and very much part of the field it examines (in a very practical way as well, since my career has directly benefited from Haraway's renowned generosity in citing her students' works).

 First I look at key ideas of the Manifesto itself, concentrating on the first section, then examine the academic and feminist contexts in which it was received, and finally indicate some of the ways it has been influential in cyberculture and the field of cybercultural studies.

There is not enough space here to attempt a comprehensive and detailed survey of just how widely the ideas in Haraway's essay have been disseminated and how deeply they have influenced feminist and cybercultural scholarship. Instead, my more modest aim is to identify some of the theoretical and metaphorical features which made the Manifesto particularly valuable and relevant both to feminist scholars and a diversity of creative participants in the computerized world of the late 20th century.

Haraway's ironic dream

The Cyborg Manifesto was first published in the journal *Socialist Review* in 1985 under the title "A Manifesto for Cyborgs: Science, Technology and Socialist-Feminism in the 1980s," although a closely related piece had appeared in German the year before (Haraway 1984). It grew a little over time until its definitive final version was published in Haraway's (1991a) edited collection *Simians, Cyborgs and Women* under the title "A Cyborg Manifesto: Science, Technology, and Socialist-Feminism in the Late Twentieth Century." It is to this edition that I will refer.

The Manifesto is divided into five sections. "Ironic Dream of a Common Language" is the most cited and least academic section, which outlines Haraway's myth of the cyborg in straightforward and at times vivid language, and considers the various types of boundary breakdowns which give rise to the hybrid and ambiguous figure of the cyborg. The second section, "Fractured Identities," situates the work in relation to issues within feminist theory, including the question of identities in multi-ethnic communities where essentialisms don't seem to work, at a time when the category "woman" has lost its "innocence" as a political, analytic, and epistemological starting point. Looking more closely at the context in which cyborgs emerge, the following section on "The Informatics of Domination" contrasts terms from modernity and "white capitalist patriarchy" with contemporary forms of technoscientific knowledge and power which understand (and, in effect, produce) genetics, people, and populations in terms of principles of information, coding, and communication. The fourth section, which was the original and most "socialist feminist" kernel of what became the Manifesto, is called "Women in the Integrated Circuit"; it examines the complexities of international gendered and ethnic divisions of labor in globalized economy. The cyborg myth of the first section is then further elaborated in a more utopian mode in the final part, entitled "Cyborgs: A Myth of Political Identity," which draws on a prior decade of exploring cyborg and other hybrid states in feminist science fiction and writings of U.S. women of color. This section is also cited quite often, though as I will later suggest, quite selectively.

The Manifesto's "ironic dream" of cyborg identity has captured the imagination of many outside the normal circuits of feminist and cultural studies academic readerships. But before examining the figure of the cyborg, I want to highlight the contexts in which Haraway situates it.

One of the central aims of the Cyborg Manifesto was to explore possible sources of empowerment for feminists in an era of postmodern technics, and to find something other than victim metaphors linking women with an idealized Nature from which technology was excluded. The essay's political starting point is explicitly socialist-feminist, and thus part of a tradition unafraid of the idea that political empowerment may be linked to "seizing the means of production." Acknowledging that her own educational opportunity to study science was afforded by the space race which motivated government sponsorship of science students in the 1950s and 1960s, Haraway encourages feminists (especially of the first world,

and especially ecofeminists and feminist goddess-worshippers) to stop pretending we can somehow occupy a position on technology separate from the institutional and communicative knowledges and practices that have produced us as certain kinds of historical subjects caught up in certain technological ensembles (Haraway 1991a, 173–6). Drawing on notions of power developed by philosopher Michel Foucault, especially the idea of "biopower," Haraway labels the postmodern technological configuration "the informatics of domination," governed by the military logic of the C^3I (command, control, communication, intelligence/information), a configuration that not only allows for "top down" powers of control, command, negation, and repression, but also provides opportunities for perversion, resistance, productivity, and pleasure. A central explanatory feature of the Manifesto is the chart (Haraway 1991a, 162–3), which lists on the left side the terms concepts, practices, and preoccupations associated with "white capitalist patriarchy," and on the right side, the equivalent terms related to post-World War II biology and the "informatics of domination":[1]

Haraway identified the problem that feminist (and perhaps especially socialist-feminist) theorists were using a conceptual map and vocabulary based on terms on the left side of the chart, when we urgently needed to update to deal with the contemporary technoscientific realities on the right side of the chart. Instead of critiquing technology from a feminist position miraculously "outside" the (post)modern world, and nostalgically harking back to a prepatriarchal agricultural "golden age" of maternal fertility goddesses, feminists might admit our complicity with the current world systems – including of course the communications technologies that enabled feminism to become a global movement – and begin taking care and responsibility for the way we design and use technologies. Haraway argues that the goals of feminist political and technological empowerment might be better served by myths and metaphors more appropriate to the information age – not an essential or pure, natural organism, but a figure like the cyborg.

Haraway situates the cyborg within the context of postmodern technoscience, especially biology, in which comforting modernist dualisms of the left side of the chart – such as organism versus machine, reality versus representation, self versus other; subject versus object, culture versus nature – are broken down.

Representation	Simulation
Bourgeois novel, realism	Science fiction, postmodernism
Organism	Biotic component
Depth, integrity	Surface, boundary
Heat	Noise
Biology as clinical practice	Biology as inscription
Physiology	Communications engineering
Small group	Subsystem
Perfection	Optimization
Eugenics	Population control
Decadence, *Magic Mountain*	Obsolescence, *Future Shock*
Hygiene	Stress management
Microbiology, tuberculosis	Immunology, AIDS
Organic division of labor	Ergonomics/cybernetics of labor
Functional specialization	Modular construction
Reproduction	Replication
Organic sex role specialization	Optimal genetic strategies
Biological determinism	Evolutionary inertia, constraints
Community ecology	Ecosystem
Racial chain of being	Neo-imperialism, United Nations humanism
Scientific management in home	Global factory/electronic cottage

Family/market/factory	Women in the integrated circuit
Family wage	Comparable worth
Public/private	Cyborg citizenship
Nature/culture	Fields of difference
Cooperation	Communication enhancement
Freud	Lacan
Sex	Genetic engineering
Labor	Robotics
Mind	Artificial intelligence
Second World War	Star Wars
White capitalist patriarchy	Informatics of domination

These breakdowns have implications for epistemology (theories of knowledge) as well as ontology (theories of being). The latter tend to be emphasized in the Manifesto, which explicitly seeks to forge a myth of political (non/plural/post)identity, while epistemological concerns are more central to Haraway's (1988) "Situated Knowledges" essay.[2] Unlike many contemporary enthusiasts of the "wired" culture of the information society, or some of her own fans, Haraway is not herself a "technological determinist" with faith that the technologies of the information "revolution" automatically produce liberatory effects. She shares with many feminist writers on technology a commitment to the "social constructionist" thesis that technologies are themselves expressive of prior social and institutional arrangements and decisions, and that their effects in turn will vary according to the social practices surrounding them and the political contexts in which they are deployed (see, for example, Cockburn 1992, Cockburn and Furst-Dilic 1994). Haraway makes no secret of her indebtedness to actor-network theory and particularly Bruno Latour, a long-term colleague of hers, especially for the idea that agency is not confined only to human in sociotechnical systems:

> In a sociological account of science [like Latour's] all sorts of things are actors, only some of which are human, language-bearing actors, and … you have to include, as sociological actors, all kinds of heterogenous entities. … Perhaps only those organized by language are *subjects*, but agents are more heterogenous. Not all the actors have language.
>
> (Haraway 1991b, 3)

Not all the actors have language, but they nevertheless can be caught up in signification: for Haraway, Latour, and other actor-network theorists, the objects and bodies studied/produced by technoscience and biomedicine are "natural-technical objects" (165), or "material-semiotic actors," whose boundaries are not pre-defined but "materialize in social interaction" (Haraway 1991a, 200–1, 208).[3] The exact shape taken by an object of knowledge (a scientific fact or a technological product) is the result of a specific and contingent set of interactions between its material character and the semiotic and/or technical operations to which it is subject, that is, how it is made to mean, and what is materially done to it or with it. This perspective stresses contingency and hybridity in the outcomes of networks, and concomitantly downplays the idea that every technology follows some necessary and pre-ordained trajectory or ideological program. Holding to such a perspective puts Haraway squarely against those who would interpret every technology developed or used within "white capitalist patriarchy" as inevitably playing out a white, capitalist, and/or patriarchal logic, and it opens the way for an imaginative leap to speculate about the political and epistemological possibilities for using technologies to develop alternative connections with each other and the lifeworld. Enter the cyborgs, "illegitimate offspring of militarism and patriarchal capitalism" who can be "exceedingly unfaithful to their origins" (151).

"Cyborg" is a term condensed from "cybernetic organism," and is typically defined as an entity comprising organic as well as machinic parts and information circuits. Introduced first by Clynes and Kline (1960), and developed further by Halacy (1965), the term is now loosely used to refer to many states of human-technology interface.[4] As Haraway sees it:

> Contemporary science fiction is full of cyborgs – creatures simultaneously animal and machine, who populate worlds ambiguously natural and crafted. Modern medicine is also full of cyborgs, of couplings between organism and machine, each conceived as coded devices, in an intimacy and with a power that was not generated in the history of sexuality.
>
> (Haraway 1991a, 149–50)

Her argument is "for the cyborg as a fiction mapping our social and bodily reality and as an imaginative resource suggesting some very fruitful couplings" (150), but more boldly than this metaphorical or figurative role, Haraway proclaims the cyborg as an identity:

> By the late twentieth century, our time, a mythic time, we are all chimeras, theorized and fabricated hybrids of machine and organism; in short, we are cyborgs. The cyborg is our ontology; it gives us our politics (150).

Unlike the usual kinds of essentialism and oppressed identities of (especially U.S.) "identity politics," the cyborg's political and ontological commitments are not to wholes, essences, naturalness, or purity, but instead, to "partiality, irony, intimacy, and perversity"; it is "oppositional, utopian, and completely without innocence" (151). The metanarrative of redemption is not part of Haraway's cyborg myth, in which "[t]he cyborg incarnation is outside salvation history" (150) and "wary of holism" (though "needy for connection"), so that:

> Unlike the hopes of Frankenstein's monster, the cyborg does not expect its father to save it through the restoration of the garden; that is, through the fabrication of a heterosexual mate, through its completion in a finished whole, a city and cosmos. The cyborg does not dream of community on the model of the organic family, this time without the oedipal project. The cyborg would not recognize the Garden of Eden; it is not made of mud and cannot dream of returning to dust (151).

In the Manifesto, Haraway examines the three main boundary breakdowns which she considers crucial for the emergence of such hybrid figures.[5] The first is the blurring of boundaries between human and animal. Late 20th century thought has nowhere near the same investment as late 19th or early 20th century western thought (or "white capitalist patriarchy") in defining the human as absolutely unique and distinct from other members of the animal kingdom, whether this be in terms of "language, tool use, social behavior, or mental events" (152). "The cyborg appears in myth precisely where the boundary between human and animal is transgressed" (152). In the vocabulary of actor-network theory, both animals and machines are examples of "nonhuman" actors with which humans may enter intimate relations in what Haraway describes as "disturbingly and pleasurably tight coupling" (152). Secondly, the distinction between the machine and the organism (animal or human) has been eroded, as machines become more "self-moving, self-designing, autonomous" (152), and as we (*pace* Latour 1993, 1994, and other actor-network theorists) come to understand ourselves not as purely human in a physical world of nonhuman entities, but as part of a lifeworld of *sociotechnical* hybrids. Finally, the distinction between physical and non-physical is broken down in electronic technology, and through miniaturization, where the silicon chip has become a surface for writing, and where:

> Our best machines are made of sunshine; they are all light and clean because they
> are nothing but signals, electromagnetic waves, a section of a spectrum, and these
> machines are eminently portable, mobile – a matter of immense human pain in
> Detroit and Singapore. People are nowhere near so fluid, being both material and
> opaque. Cyborgs are ether, quintessence.
>
> (Haraway 1991a, 153)

This apparent cleanliness and immateriality is a dangerously deceptive phenomenon, making it hard for us to grasp the materiality of the politics involved in their production, distribution, and environmental aftermath (154).

As these formerly foundational distinctions have broken down, metaphors of information exchange and circulation, coding, language, translation, misreading, "noise," etc. have come to dominate postmodern biological theories, as well as theories of how scientific knowledge is itself produced. The "objects" of technoscience now appear more and more as leaky and unstable boundaries formed in the interaction of material and semiotic effects. Viruses, auto-immune responses (interpreted as problems of the self misrecognizing itself as "other"), and biomedical practices like organ transplant surgery, transgenic engineering (where bits of the DNA "code" of one organism may be spliced into that of other quite different organisms) generate models of selves in constant intimate interchange with others; living organisms whose every cell bears the mark of technoscientific intervention.[6]

Haraway argues that such a world calls for new forms of political thinking that do not re-entrench old dualisms (on the left side of Haraway's chart), but which respond to both the pleasures and the dangers of the "informatics of domination:"

> From one perspective, a cyborg world is about the final imposition of a grid
> of control on the planet, about the final abstractions embodied in a Star Wars
> apocalypse waged in the name of defense, about the final appropriation of women's
> bodies in a masculinist order of war. From another perspective, a cyborg world
> might be about lived social and bodily realities in which people are not afraid of
> their joint kinship with animals and machines, not afraid of permanently partial
> identities and contradictory standpoints. The political struggle is to see from
> both perspectives at once because each reveals both dominations and possibilities
> unimaginable from the other vantage point (154).

Unlike the organic goddess/mother still favored in some domains of ecofeminism and feminist spirituality, as well as by some who are also interested in Haraway's cyborgism (such as Lykke 1996, Star 1996, Graham 1999 and forthcoming) the cyborg figure cannot be traced back to a pure origin or natural essence – which is not to say that it does not have a history (see Munster 1999, 127; Gonzalez 1995, 267–70; Halacy 1965; Huyssen 1982). It is an unnatural assemblage of heterogeneous parts, a "monstrous chimera" emergent from the very belly of the beast of global capitalism (including militarism). Haraway argues for the "friendliness" of the impure cyborg figure for feminist political thought, not only as a model of a potentially empowering connection between women and contemporary technologies, but also because its heterogeneity offers a model of political subjectivity alternative to that of an identity politics based on presumptions of natural unity and essential commonality between women. In the Manifesto, the cyborg myth is elaborated as a project whose aims share "the Utopian of imagining a world without gender, which is perhaps a world without genesis"; the cyborg is defined as "a creature in a post-gender world." But in a later interview, Haraway concedes that her cyborg really is a girl (1991b, 20). Claudia Springer, among others, found that the cyborgs of popular film were not "post-gender" but had, if anything, exaggerated gender characteristics (Springer 1991):

The cyborg is a kind of disassembled and reassembled, postmodern collective and personal self. This is the self feminists must code (163).

Impure and not even "identical" to itself, the cyborg does not need to erase its differences from those to which it connects; a creature of parts, it can illustrate a widespread contemporary experience of having several partial and hybrid identities and axes of political and cultural affinity. As Chela Sandoval observes, a key feature of Haraway's theoretical apparatus is its references to US Third World Women's writings on partial and multiple identities and changing relations to power, and the approach Sandoval has variously named differential consciousness, oppositional consciousness, or the methodology of the oppressed (Sandoval 1991, 1995a, 1995b). It is Haraway's linking of "machines and a vision of first world politics on a transnational, global scale together with [this] apparatus of survival" which Sandoval suggests has the potential to help overcome the "theoretical apartheid" (1995a, 419) between, on the one hand, "white male post-structuralism," "hegemonic feminism," and "postcolonial theory," and on the other "US Third World Feminism" (1995a, 409) – not that this potential has yet been realized (1995a, 415).

Haraway's coding of the postmodern self as cyborg was bold, evocative, and timely. The next sections will consider some of its effects in the field of feminist theory and beyond.

Something that becomes a "cult text" (Penley and Ross 1991, 1), read widely beyond feminist and academic circles, does so not just because it shakes things up (which it did), or because it contains pearls of universal wisdom (which it surely does), but also because in certain ways it fits in with the preoccupations of its times: there is a context that makes it relevant and meaningful; there are readers sharing questions with the text and ready to be moved by it; there are foundational concepts already shaky and ready to crumble. Exuberant, expansive, perhaps over-responsible, and certainly ambitiously synthetic, with its own suggestive flaws and fissures, the chimerical assemblage of elements that is Haraway's Manifesto was capable of bearing many readings by highly divergent audiences.

Haraway's ironic dream of a common language of technologically mediated hybridity and a politics of perverse affinity eventually became almost *de rigeur* reading for anyone within the growing field of "technocultural" studies and especially what some have called "cyberstudies" or "cybercultural studies," as well as cultural studies of technoscience (Penley and Ross 1991; Aronowitz *et al*. 1996). Appealing to a wide range of readerships, the Manifesto's cyborg managed to insinuate itself into diverse discursive spaces, from feminist political theories of anthropology,[7] ethnic identities, and lesbian and queer sexualities (for example, Sandoval 1991, 1995a, 1995b; Morton 1999), to studies of science fiction literature and film (for example, Bukatman 1993, Springer 1996; McCaffery 1991; Csisery-Ronay 1991); she is invoked in papers on post-modern pedagogy (Bigum 1991, Green and Bigum 1993); in studies of cosmetic surgery, reproductive technologies, and female body building (Balsamo 1996), in relation to architecture (Vidler 1992), postmodern war (Gray 1995; Edwards 1995) and feminist theology (Graham 1999 and forthcoming).

The vocabulary of cyborgism was found relevant for discussing a range of cultural and technological phenomena, from mundane computer and videogame interactions, or human interactions mediated by computers and the Internet, to more extreme examples of anything involving physical and virtual intimacies between humans and machines, especially where the latter were seen to exert some type of agency. This included artworks involving bionic bodies such as Stelarc's third arm and more recent gestures towards the "posthuman" (Dery 1996, especially 153–67, 229–56), or interactions between human and nonhuman elements (such as in interactive artworks in digital media or installations fitted with responsive sensors). The cyborg could be invoked in relation to engineering and biomedical advances that produced new genetic hybrids (a favorite theme in cyberfiction and its precursors), or

which coupled humans to bionic components, whether to prolong life beyond its "natural" term (as in Gibson's example of the "posthuman" person connected to all kinds of life-support systems), or to allow existence in inhospitable environments like the inside of a nuclear reactor, outer space, or the deep ocean (one of Haraway's favorite cyborg images was of a deep sea diver in a pupa-like casing), or to afford entry into virtual worlds (like the "jacked in" hackers of Gibson's and Cadigan's cyberfictions, directly interfacing their brains with cyberspace; see Balsamo 1993). Itself a science-fictional creature emergent at the interface of theory and imagination, the mythic figure of the cyborg was at home in the blurred boundaries between present reality and the heralded near-future presaged in the boosterist discourses around IT, the "technohype," and "cyberbabble."

The Manifesto was predictably of interest to feminists in the fields of labor studies as well as the already established area of feminist science and technology studies, with people interested in a range of matters from the history of women scientists, gender and computer education, non-traditional trades for women, and international divisions of labor by race and gender, to issues of gender, epistemology, and ontology in science. It helped clarify differences between techno-and eco-oriented feminists, and those who didn't subscribe to cosmic feminism could find in Haraway a voice that validated a range of other approaches to studying, interpreting, dreaming, and mythologizing about the woman-technoscience-world relation.

Haraway's manifesto also spoke to the (mainly academic) feminists who were getting bored with the old critiques of dualisms, dissatisfied with the essentialisms of identity politics and strictures of political correctness, pained by the impasses between white women and their many "others," intrigued by the "bad girls" of the radical sex movement, and in search of political and intellectual affinities that didn't depend on shared natural origins, victimhood, or oppression. The term "patriarchy" seemed pretty well past its use-by date for those theorists looking for new ways to frame feminist cultural critique of the globalized capitalist world. Just when the (mainly white male) postmodernists were proclaiming the death of the subject and the end of metanarratives (Jameson 1984), the Cyborg Manifesto – offering its own myths along with the various utopian and US Third World Women's writings it drew upon – celebrated a different vision of a new kind of fractured subject, for whom partiality, hybridity, and lack of a single smooth identity or wholeness did not imply death, but, on the contrary, invoked the possibility for connectedness and survival beyond innocence in an impure world.

Foucault was big and getting bigger in the US in the 1980s, and the Foucaultian dimensions of Haraway's work, including ideas of how the operations of power could involve resistance, pleasure, and perversity were legible to this broader academic readership. Perhaps because she labels the Manifesto "socialist feminist," thus putting the reader off the Foucaultian scent, Haraway is not lined up with "the usual suspects" of Foucaultian feminists. Arguably she deserves to be, since she takes Foucault on board, and critically develops his notions of biopower and biopolitics into her (post)Foucaultian notions of the "informatics of domination" and "technobiopower" (Haraway 1997, 11–12). Moreover, she does actually undertake a complex discourse analysis of a particular science – primatology (Haraway 1989a) – which is more than many a credentialed Foucaultian feminist!

The Manifesto's publication coincided with the peak of textual studies and the linguistic turn, in cultural theory.[8] Its descriptions of cyborg as a kind of etched surface, and its notions of information and coding, fitted in well with some of the feminist psychoanalytic-textual analysis that understood gender in terms of language, codes, and signs. Hence the Manifesto's cyborg gained a life within feminist theories of gender and representation. For example, Judith Halberstam interprets this cyborg as something that "posits femininity as automation, a coded masquerade" (1991, 449). With reference to Turing's theories of

computer intelligence, Halberstam argues that gender is also not innate or essential, but "a learned, imitative behavior that can be programmed" (443), so that both femininity and masculinity are "always mechanical and artificial" (454), forms of simulation or masquerade that become lived realities. The female cyborg figure offers resistance to "static conceptions of gender and technology":

> The intelligent and female cyborg thinks gender, processes power, and converts a binary system of logic into a more intricate network. As a metaphor, she challenges the correspondences such as maternity and femininity or female and emotion. As a metonym, she embodies the impossibility of distinguishing between gender and its representation
>
> (Halberstam 1991, 454)

Similar themes are explored by Sadie Plant (1994, 1995, 1998), who links women to machines, especially computers, not only in terms of metaphors of weaving, networks, and the matrix, but importantly in terms of their shared capacities for simulation (*pace* feminist philosopher Luce Irigaray's notion of mimesis): "it is always as machinery for the reproduction of the same that women and information technology first sell themselves" (Plant 1995, 59). Although she shares Haraway's interest in the libratory and subversive potentials of an alignment between women and the powerful communications and networking machines of the information age, Plant is also Irigarayan, and manages at once to be both more "machinic" and more "essentialist" than Haraway, linking the automatic qualities of intelligent machines to the experiences of species being and reproduction which have traditionally defined women. Haraway was looking for empowering metaphors that didn't rely on birthing and definitions of women as natural. In a related paper, Plant writes that while man may be shattered by the revelation of multiple and machinic intelligences after "two and a half thousand years of sole agency," woman is "already in touch with her own abstract machinery" for she:

> … has never had a unified role. Mirror, screen, commodity, means of communication and reproduction, carrier and weaver, carer and whore, machine assemblage in service of the species, a general purpose system of simulation and self-stimulation. While man connected himself to the past, woman was always in touch with the virtual matter of her own functioning. This is the connection which has constituted her so-called missing part: the imperceptible necessity of every machine
>
> (Plant 1994, 6–7; see also Plant 1995, 58)

Thus the historical denial of agency and subjectivity to women, their relegation as machinic apparatuses obeying species imperatives, is seen to give them an "edge" with respect to the emergent future of cyborg life where both machines and women evade control by the men who have become peripheral to their functioning.

Whereas Plant's cyberfeminism celebrates the machinic agency of both woman and nature ("species" as mechanism), and Halberstam (1991) emphasizes the automated character of the feminine identity (gender and information as masquerades, codes), "environmental feminist" Stacey Alaimo (1994) rejects Haraway's cyborg metaphor as "inimical not only to an environmental feminism but also to any politics that opposes the military industrial complex"; she prefers Haraway's figure of nature as a witty agent like the Native American trickster figure, "the wily Coyote and an artifactual nature seem more effective agents for an environmental politics" (Alaimo 1994, 149). In Alaimo's post-Harawayan ecofeminism, women and nature are to be aligned again, not as passive victims, but as active agents in political affinity with each other (150) – though how exactly this happens is not spelled out.[9]

Although Haraway's account of the cyborg and cyborg politics is amenable to a textualist reading, it also, as Alaimo emphasizes, disrupts and goes beyond textualism because of its insistence on a real and material dimension to the world that evades and often tricks language: for Haraway the world is emphatically *not* a *tabula rasa* which can be written on and reshaped any way we want it. Nonhuman entities set their own limits to their inscribability. Kathleen Woodward describes the Manifesto as "the most seminal [piece] in articulating the importance of biotechnology in contemporary cultural criticism" which achieved this by "smuggling, as it were, the subject of biotechnology into an essay that deals with communication technology" (Woodward 1999, 286). This seems to me an awkward oversimplification of the previously discussed perspectives on the centrality of communications metaphors in post-World War II biology, as well as the ANT, notions of "material-semiotic objects." These perspectives understand entities to be shaped out of contingent interactions with heterogenous others, in what John Law describes as a "ruthless application of semiotics" (Law 1999, 3) to the material world, whose constituents, analogously to phonemes and morphemes of language, are not essentially given, but shaped in their distinctions from other elements. I attribute the "earthquake" effect of the Cyborg Manifesto (and its close relatives, Haraway 1988, 1989b, 1991b, 1992) as arising in large part from the way it introduces terms and ideas from social studies of science, especially actor-network theory, into debates in feminist theory and political struggles for identity and subjectivity (especially by US Third World Women; Sandoval 1991), and from there into a wide range of textual and cultural studies. Perhaps even more important than Haraway's inspirational and clarifying effects *within* her own science studies field are those enabling effects on feminist scholars more peripheral to that field. As Nina Lykke suggests (Lykke 1996, 20–2), putting constructionism onto an interdisciplinary feminist science studies agenda allows people from humanities fields, including semiotics, narratological, and discourse studies, to make a contribution from somewhere not completely outside science.

Despite the wildly inclusive scope of the Manifesto, readers who've looked to it or its author to provide some overarching theory of the lot are inevitably disappointed. Haraway is no great meta-theorist and she does not assume the omniscient god position on any field, not even her own work. In the early 1980s she could barely name what it was she was doing. I suggested it was a semiotics of technology, but we both knew that didn't quite capture all the dimensions she wanted to bring together when deciphering objects and artifacts: more than semiotics, she was working on the cultural logic of globalization as expressed in the shape of reality itself, condensed into the very being of the object. Becoming progressively more articulate about her method, Haraway was able to develop more fully the notion of figuration central to her method in *Modest_Witness*:

> I emphasize figuration to make explicit and inescapable the tropic quality of all material-semiotic processes, especially in technoscience. For example, think of a small set of objects into which lives and worlds are built – chip, gene, seed, fetus, database, bomb, race, brain, ecosystem. This mantra-like list is made up of imploded atoms or dense nodes that explode into entire worlds of practice. The chip, seed, or gene is simultaneously literal and figurative. We inhabit and are inhabited by such figures that map universes of knowledge, practice, and power. To read such maps with mixed and differential literacies and without the totality, appropriations, apocalyptic disasters, comedic resolutions, and salvation histories of secularized Christian realism is the task of the mutated modest witness
>
> (Haraway 1997, 11)

Later in the book she describes the objects on this list as:

… stem cells of the technoscientific body. Each of these curious objects is a recent construct or material-semiotic "object of knowledge," forged by heterogenous practices in the furnaces of technoscience. To be a construct does NOT mean to be unreal or made up; quite the opposite. Out of each of these nodes or stem cells, sticky threads lead to every nook and cranny of the world. Which threads to follow is an analytical, imaginative, physical, and political choice. I am committed to showing how each of these stem cells is a knot of knowledge-making practices, industry and commerce, popular culture, social struggles, psychoanalytic formations, bodily histories, human and nonhuman actions, local and global flows, inherited narratives, new stories, syncretic technical/cultural processes, and more (129).[10]

Not all of Haraway's readers appreciate the significance of the dimension of her work I am highlighting here, namely those concepts from actor-network studies translated into cultural and political theory. That these could potentially help feminists go beyond a "merely" discursive or semiotic understanding of the object, and help rethink the subject-object relation in terms of agency and material-semiotic realities in a sociotechnical world, was not appreciated by Carol Stabile (e.g., Stabile 1994), who seemed to be looking for Haraway to provide a complete model for eco-techno-identity-politics. This author distinguishes between "technophobic" and "technomaniac" approaches to technology: the former represented by the "reactionary essentialism" of ecofeminists such as Mary Daly and Susan Griffin, who act as "ventriloquists" for nature; and the latter by Donna Haraway, whom Stabile accuses of depoliticizing the field by being seduced by postmodern images of "fragmentary and destabilized identities" (the main source for which, as Sandoval [1995a] reminds us, comes from US Third World Women and Utopian feminist writing). The "technophobes" can ignore the grim realities of poverty and dispossession in an urban environment in their celebrations of the links between women and nature, while the "technomaniacs" can posit a cyborg subject whose high degrees of literacy, mobility, and choice are shared only by the most educated elites.[11]

Stabile attacks Haraway as a practitioner of discourse theory, which she associates with idealizing, aestheticizing, dehistoricizing, and depoliticizing moves within culture critique. Her argument implicitly relies on the old Marxist idealist/materialist distinction and fails to show any understanding of the way discourse theories (like Foucault's, from whom Haraway borrows) are precisely about how discourses (traditionally considered part of the nonmaterial "superstructure"), the structures and practices of speaking and acting in institutional contexts, have both historical determinants and real, material effects, and hence how telling new or different stories can potentially change sociotechnical realities. Moreover, Stabile studiously ignores those aspects of Haraway's work which don't fit her critique, as well as those in sympathy with her own socialist views – such as Haraway's attention to socialist-feminist studies of the gendered international division of labor, especially of women workers in the global electronic industry, her calls for the necessary continuance of "normal" kinds of political work (for example, affinity groups, collective actions, socially responsible practices, etc.), and her encouragement of fellow white western feminists to become more aware of the privileged and partial character of their/our own standpoints, and to retell or transform existing stories into empowering political narrative appropriate for our own time and experience. Stabile's own perspective by contrast offers very little encouragement to political action or imagination and her conclusion is simply that better historical analysis of the same old stories is needed:

Before we invent futurologies, we need to be able to tell stories about the fundamental and persistent narratives that continue to exclude, maim, and kill (Stabile 1994, 157).

Stabile accuses Haraway of installing a feminist avant-gardism (Stabile 1994, 145) and of promoting a cyborg subject that doesn't have to *do* anything in order to be political, since "[p]olitics are, so to speak, embedded in the cyborg body." This critique, I would counter, applies less to Haraway than to some of her over-enthusiastic and under-politicized readers, especially those caught in the "textualist turn" and hence liable to equate semiotic ambiguity with political subversiveness (bolstered in some cases by Derrida's deconstructionism or notions of the carnivalesque from Bahktin, Kristeva, or Stallybrass and White).

Whether or not we agree with Stabile, and diagnose the Manifesto as infected by the very tex-tualism it claims to resist in the name of a more realist epistemology, there is no doubt that it tempts some readers to interpret the category transgressions of cyborg figures, including gender transgressions, or even enthusiastic interfacings with high-tech equipment, as somehow inevitably or inherently politically subversive. A closely related temptation, and a highly seductive one for budding cybertheorists (and I've read just one too many of their dissertations), is to lump the cyborg in with every other kind of semiotically undecidable creature, and to read it as equivalent or identical to every other supposedly teratological (monstrous), transgressive, abject, or some way "in-between" entity or sign. I agree with Anna Munster that through such readings "the 'cyborg' configuration has been reified to denote 'hybridity' as such rather than to seek out partialities and produce changing alliances with the technical" (Munster 1999, 127). Munster points out that:

> If there is something potentially exciting about hybridity, it is the sense in which it resists a capture into the mere grafting of two connecting points (the technological and the cultural, the natural and the artificial, women and technoculture) and encourages a sense of movement between them (127).

There is no doubt Haraway's writings give some support to the idea of grouping all kinds of monsters together as hybrids. One could cite the statement in the Cyborg Manifesto that in the late 20th century "we are all chimeras, theorized and fabricated hybrids of machine and organism; in short, we are cyborgs," or the postscript to the "Cyborgs at Large" interview where she describes as "monsters" the "boundary creatures – simians, cyborgs and women" which have destabilized "western evolutionary, technological, and biological narratives" (1991b, 21). My own reading of Haraway understands the emphasis to be not on hybridity as such, but on the specificity of hybrid forms that arise in particular situations. Frankenstein's creation, for example, could be described as a monstrous fabricated "chimera," but it is not a cyborg. It belongs on the left side of the chart and with the early 19th century, whereas the cyborg is the kind of chimera that becomes possible in the latter part of the 20th century, and in relation to powers and knowledges of the postmodern "informatics of domination." For Haraway, as for Latour, the mere fact of something's hybridity does not mean much in itself, for, as Latour argues (1993, 1994), there are always and everywhere sociotechnical hybrids; it's just that the project of modernity was to pretend there wasn't, in an effort to "purify" the messy interdependence of humans and nonhumans by making strict divisions between social and physical/natural sciences.[12] More salient questions are: what are the specific networks in which the hybrid is produced or enrolled? with which other actors? how extended are these networks? and to what extent does the prevailing worldview recognize, celebrate, or on the contrary deny, these hybridities? Frankensteinian science was close to field surgery and dealt with "found [biological] objects," dead organisms whose flesh is to be rejoined and reanimated. It aimed to find the secrets

of life and death in order to create a new man, not change the nature of living being while turning it into a commodity, "life itself" (Haraway 1997, 13 and 276 n.8). In the late 20th century, the genetic engineering techniques and corporate capital that produce cyborgs and creatures like the OncoMouse™, whose being at the very cellular level bears the mark of commercial techno-scientific intervention, are part of complex and extended set of networks in the informatics of domination, involving many universities, research teams and agendas, technological developments, advertising campaigns, etc.

Cybercultural manifestations

In the opening of this essay, I stated that Haraway was one of the rare feminist writers to be accorded the status of author, quoted and named by both feminist and nonfeminist writers. Her ironic myth of the cyborg and related essays on epistemology and postmodern bodies have inspired many scholars, including a number of her students at the History of Consciousness, to get beyond the essentialist impasses of early 1980s feminist identity politics, and to explore new directions in cultural analysis and criticism in the late 20th century, with renewed attention to scientific, technological, biotechnological, and biomedical themes. A number of articles and edited collections that gather up writings on cyborg and cyberspace themes have come out over the last decade, including, of course, this collection.[13]

The mid-80s in the U.S. was the crest of the first big wave of diffusion of personal computers into academic, and increasingly, domestic life. We were starting to use email and online chat. My archived versions of Haraway's Manifesto and its precursors demonstrate through their fonts and print qualities the increasing sophistication of personal computing. People's personal experiences of cyberspace and their excitement at the potential in these new and networked machines made the subject matter of the Manifesto especially meaningful.

Adding to the impact of the Cyborg Manifesto was the growing popularity of what became known as "cyberpunk" science fiction. In the year before the Manifesto's publication, William Gibson scooped up all the major awards with his cyberpunk novel *Neuromancer* (Fitting 1991, 312 n.3), which explored various states of cyborg being, celebrated the obsessive hacker mentality (on which see Turkle 1984, 1996), and offered a definitive literary description of the virtual landscape he named "cyberspace," a translation into words of the imagery associated with high technologies and networks, especially computers and cities, in popular science, high-tech advertising and films like Ridley Scott's *Blade Runner*. Some readers enthusiastically linked and even confused Gibson's "five minutes into the future" cyberpunk visions with Haraway's technomyth of the cyborg. Just as Gibson was a little disconcerted by the leather-clad, technologically identified real-life cyberpunks who wanted him to sign their battered copies of *Neuromancer* (Gibson 1990), so was Haraway "galled" to encounter the technologically determinist ways her work had been interpreted by hardcore cyberpunks, hackers, and writers in *Mondo* and *Wired* who read the Manifesto "as a sort of technophilic love affair with techno-hype" and herself "as some blissed out cyborg propagandist (Haraway quoted in Olson 1996, 25). In 1984 (the year of the original "roadshow" where Haraway's "Ironic Dream of a Common Language" was performed) I also attended a science fiction conference in southern California. Gibson's awards had just been announced and the enthusiasm for *Neuromancer* was accompanied by a palpable sense of relief amongst the (80–90 percent male) academic SF fraternity, that finally a man had come up with an outstanding new novel, breaking the women writers' dominance of the awards since the mid-70s. "Find a man and you've found the origin," as my colleague Sarah Redshaw puts it: from then on Gibson's *Neuromancer* became the exemplar of a cyberfiction with

only male-authored antecedents such as Philip K. Dick, J. G. Ballard or William Burroughs (for example, Fitting 1991). It became common to discuss Gibson's cyberpunk in relation to Haraway's Manifesto without mentioning the references in both texts to the previous decade of feminist science fiction cyborg figures, cyberspaces, and stories by people like Joanna Russ, Octavia Butler, Vonda McIntyre, Anne McCaffery, Marge Piercy, James Tiptree Jnr (Alice Sheldon), and so on – authors by whom Gibson had been influenced and from whom he borrowed.[14] Since Haraway's ideas about the cyborg's Utopian possibilities had been developed through her engagement with the prototypes of cyberfiction, it would be difficult to trace any direct influence upon subsequent productions in the field, including cyberpunk-style fictions by female authors like Pat Cadigan, Katherine Kerr and Melissa Scott, although Piercy's (1991) novel *He, She, It* (retitled *Body of Glass* in Australia), which draws parallels between the Golem of Prague and a 21st century cyborg, gives explicit acknowledgment to the formative influence of the Cyborg Manifesto.

Already compatible through their shared history of female-authored speculative fictions about biotechnologies and virtual worlds, the Gibsonian and Harawayan visions, together with the real-world experiences of digital technologies, the Internet, and cyberspace expanding into education, workplaces, home, and the arts, all combined to produce a kind of mutant love child in the form of cyberfeminism, a term I loosely understand as a kind of feminism interested in exploring the theoretical and artistic potential of technologies and metaphors of the information age for women, and/or taking feminist activism into the virtual world and its real-world infrastructures. Cyberfeminists make the connection between the cyberpunk slogan "information wants to be free" and the feminist libratory dimensions of Haraway's cyborg myth. They tend to be enthusiasts of the new technologies, especially the web and its possibilities for networking (Kuni 1999), though most are critical of the idea that virtual worlds offered a seductive escape from embodiment, and many are explicitly interested in maintaining sight of the embodied, indeed "visceral" character of Haraway's cyborg and the leaky, penetrable bodies of Gibson's cyberpunk antiheroes.[15] The term "cyberfeminist" arose simultaneously in 1991 for scholar Sadie Plant in England, and the Australian feminist art group VNS Matrix. Like many Australian feminists, VNS Matrix became aware of Haraway's Manifesto when it was reprinted in the journal *Australian Feminist Studies* in 1987, and paid homage to it in their (1992) *Cyberfeminist Manifesto for the 21st Century*.[16] Produced using electronic image-making technologies, it featured a horned woman in a shell amidst a molecular matrix, with a text announcing "the clitoris is a direct line to the matrix" and proclaiming themselves as the "virus of the new world order ... saboteurs of big daddy mainframe ... terminators of the moral code ... mercenaries of slime ... we are the future [etc.]." The group went on to produce *All New Gen*, a series of lightboxes and the prototype of a computer game based on these themes.[17] During the mid 1990s, along with one of the VNS Matrix artists, Virginia Barratt, I conducted interviews with Australian women artists in digital media: we found that almost all our interviewees had read the Manifesto and been inspired in one way or another by it. Slightly later than us, and with a partially overlapping sample of interviewees, researcher Glenice Watson (2000) found that a number of Australian women pioneers of the Internet were committed to the practice of being feminist activists on and around the Internet, though not all identified as "cyberfeminists" per se.

While Australian interest in cyberfeminism had more or less peaked by around 1996, the term continued to attract attention in Europe and the international cyberarts scene. In 1997 and 1999 the first and second "Cyberfeminist International" events were organized by an international group of women (including former VNS Matrix member Julianne Pierce) who ironically call themselves The Old Boys Network.[18] Themes at the second

event included "Split Bodies and Fluid Gender," computer hacking and whether feminists could "appropriate the practice for their purposes," and feminist responses to globalization (Volkart and Sollfrank 1999, 4–5), as well as discussions and papers on the problems of defining cyberfeminism, how it might be different from other feminist critiques of technology, its essential pluralism, its connections with praxis, etc. For writers in the *Next Cyberfeminist International* catalog (Sollfrank and Old Boys Network 1999), Haraway was a foundational author to be critiqued. However, one – Nat Muller – observed that Haraway's (1988) "Situated Knowledges" essay, which had been overlooked in favor of the Manifesto, offered some promising openings for cyberfeminists who wanted a more technologically oriented approach than that offered in the discourse-heavy cybercultural studies of the mid to late 1990s. Likewise the early self-proclaimed cyberfeminist Sadie Plant was "the theorist we all love to slag off" (Muller 1999, 75), while cultural studies scholar Anne Balsamo was cited approvingly for her interests in the real conditions of women's working lives and technological engagements (Muller 1999; Ackers 1999). Rosi Braidotti's (1994) critical approach to cyborgism was also accepted. Various contributors expressed dissatisfaction with Haraway's and Plant's too-easy linkage under the "cyborg" banner of those cybergirls of the rich nations with Third World women producing the equipment (one of the standard critiques of the Manifesto):

> I am very weary of making these celebratory gyno-social links as in: Ooowww look at us girlies we're all digital divas whether we're slaving away in a chip factory or whether we're suffering from rep. strain injury or carpal tunnel syndrome. This makes me think of 70s sisterhood feminism … before we start jumping around with terms like 'virtual sisterhood,' we should be sensitive to just how inclusive that sisterhood is.
>
> (Muller 1999, 76)

Some writers rejected Plant's (1995, 1998) essentialist ideas about the posthuman and machinic character of women's subversiveness in the computer age, along similar lines to my critique, above (see Bassett 1999; Muller 1999), and perhaps best summed up by Volkart and Sollfrank:

> Unlike approaches which assume that female resistance is already happening unconsciously in unknown, uncontrollable spaces, we insist on the idea of aware responsibility, reflection and of engaged motivation and intention.
>
> (1999, 5)

Signaling disaffection with the earlier euphorics of VNS Matrix's *Cyberfeminist Manifesto*, Sollfrank wrote near the end of a report on her research on female hackers (she found few) that "My clitoris does not have a direct line to the matrix – unfortunately. Such rhetoric mystifies technology and misrepresents the daily life of the female computer worker" (Sollfrank 1999, 48). This interest in practice and the realities of cyberspace life was a theme in several other articles in the *Next Cyberfeminist International* catalog, which included besides the theoretical contributions I have highlighted others about more technical details of hacking and networking, discussions of various cyber-inspired artworks (or artworks interpretable in cyberfeminist terms), pieces about biotechnologies, the visible human project, and accessing cyberspace in the former Soviet Union; in short, a range of themes quite typical of those discussed in and around cyberarts, and in cybercultural studies (see note 13).

Coming in conjunction with cyberpunk fiction and the personal computer revolution, the Manifesto was well placed to give some focus to expressions of hope and fear about the emergent technoworlds. As I earlier suggested (after Lykke 1996), Haraway's work, especially

the Manifesto, has been important in enabling people from outside the fields of science studies to feel empowered to talk, think, criticize, write, and make artworks about the new forms of being and experience, and new kinds of sociotechnical and biotechnical hybrids emergent into the 21st century. Even though some of the post-Harawayan cyberfeminists have found problems with the Manifesto and its Utopian dreams, it is still the case that the work was enabling for many scholars, artists, critics, and activists, who can take from it concepts and vocabulary to help name some of the new experiences and possibilities – both scary and pleasurable – afforded by technologies of the late 20th century, and to put some of these into perspective in relation to historical developments in science and industry over the 19th and 20th centuries.

There was a certain infectious euphorics of impurity in the Manifesto's vision of a hybrid identity committed to "partiality, irony, intimacy, and perversity": the cyborg myth offered an appealing way out to those frustrated by the purisms of identity politics, as well as those white women who experienced forms of hybridity besides those lived by their non-white or non-Anglo sisters. The Manifesto's account of the "informatics of domination" outlined the broader power-knowledge context in which the breakdown of purisms became more legible than they were within the dualisms of "white capitalist patriarchy" and the kind of feminism generated in/against it. The former Catholic girl's celebration of blasphemy, irreverence, and iconoclasm fitted in well with the images of "bad girls," flirting on the edge of pleasure and danger, that were cultivated by sexual radicals like lesbianfeminist sadomasochists of the 1980s (and got a hetero-sexual re-run in the 1990s), and it continued to resonate with the pluralism, activism, and sense of fun in queer (and cyberqueer) political sensibilities emerging from the late 80s and 90s.

Haraway's poetic claim that the cyborg "gives us our ontology" captured the imagination of many who were beginning to experience prolonged interactions with computers, and starting to explore new identities and forms of social life and community made possible by the Internet. While the computer's "holding power" and the fuzzy boundaries experienced between self and machine were already being written about when the Manifesto first came out (for example, Turkle 1984; Gibson 1984), Haraway's contribution was to locate these experiences within a potentially Utopian political landscape, in a thought experiment based on the idea that science fiction imaginings could be a form of feminist politics. Whereas a standard feminist line on technology had been to equate it with abstract masculinist rationality, militarism, and the rape of the Earth, Haraway insisted on the intimate physicality of our relations to nonhumans, and on what Claudia Springer (1991) would later call "the pleasure of the interface." Beyond the problematics of heterosexual desire, the political correctness (or not) of lesbian sexualities, and the hybrid identities of (Sandoval's 1991, 1995 a) "US Third World Women," the Cyborg Manifesto acknowledged the pleasures and desires we hold in relation to the nonhuman entities that are part of our life-world, and the sociotechnical and material-semiotic hybrid entities and plural identities we might form with nonhumans. Haraway's political commitments to feminist, anti-nuclear and environmental politics, coupled with her bold determination to provide an alternative to what Stabile (1994) called "technophobic" feminists' essentializing equations between woman, reproduction, and nature, helped open up a more positive perspective on-new technologies and their possibilities. Her socialist politics and familiarity with social studies of scientific practice and knowledge (especially in the ANT tradition) led Haraway to reject the idea of an inevitable trajectory of domination implicit in technologies, even those of military origin. If the cyborg could be unfaithful to its origins, then so could we. This perspective opened the way for women interested in new technologies like personal computers to explore their libratory, productive, and poetic possibilities in imagination, artwork, and cyberfeminist

practice. In the characteristically 1980s spirit of the Cyborg Manifesto, complicity with "the system" was not an unmentionable crime nor a paralyzing political embarrassment, but understood as something inevitable, which did not necessarily prevent further effective political work for justice, equality, peace, and survival.

Notes

1 Other versions of the chart appear in Haraway 1979 and Haraway 1989b.
2 These epistemological questions are pursued more in feminist science studies (for example, Lykke and Braidotti 1996) and in feminist geography, such as various authors in Duncan 1996.
3 See Law and Mol 1995 (274–95) and Latour 1992 for examples of the way messages maybe encoded into artifacts and vice versa. Pickering (1995) discusses contingency and performativity in technological developments; while Nina Lykke (1996), Roberts (1999), and Sofoulis (2001) look at Haraway/Latour connections. Deleuze and Guattari also talk about similar concepts in notions of machinic assemblages, striated and smooth space, etc., on which see Lee and Brown 1994. For evaluations of and problems with actor-network theory (ANT) see Law and Hassard 1999; for some feminist problems with ANT see Cockburn 1992.
4 For an inventory of contemporary cyborg types see Gray, Mentor, and Figueroa-Sarriera 1995, or Gray and Mentor 1995.
5 The painting "Cyborg," which artist Lynn Randolph made after reading the Manifesto and which was used as the cover illustration for *Simians, cyborgs and women*; and also *Biopolitics of postmodern bodies* illustrates aspects of these breakdowns. A woman sits with her hands on a keyboard, with a semi-translucent big cat draped over her shoulders, its paws in parallel with hers. The woman's sternum is replaced by a panel of DIP switches from which emanate integrated circuit paths. The keyboard on which Randolph's cat-woman-computer hybrid has her hands seems to be resting amidst sand dunes and mountains; behind her are screens representing the structure of our galaxy, and a black hole's gravity well. The woman's hands and cat's paws seem to be luminous with energy. See also Haraway's discussion of this image in Haraway 1992.
6 These biomedical themes are further explored in Haraway's. paper "The biopolitics of postmodern bodies" (in Haraway 1991a), and in her book *Modest_Witness* (1997).
7 See the articles on cyborg anthropology in Gray 1995.
8 For example, in the 1981 History of Consciousness postgraduate Theory and Methods seminar all students had to read Josué V. Harari's *Textual Strategies: Perspectives in Post-Structuralist Criticism* (Ithaca, NY: Cornell University Press, 1979) which, in view of its woman-free line-up of post-structuralists, we renamed *Sexual Tragedies*.
9 For a variety of other views and the cyborg/goddess issue see Lykke and Braidotti 1996; for a view on Haraway as an ecofeminist, albeit of a non-essentiaiist, non-goddess worshiping variety, see Sturgeon 1997.
10 Equivalent accounts of Haraway's method may be found in Haraway's *Primate Visions* (1989a, 14, 369), and her "Promises of Monsters" essay (1992; also in Wolmark 1999, esp. pp. 317–18).
11 Similar points are made in a more subtle and interesting way by Susan Leigh Star (1996), writing on themes of containment and being "homed" in the networked world.
12 See also Lykke 1996, Sofoulis 2001, n.3.
13 Those with contributions by Haraway's students include Stone 1996 and Gray 1995, a gigantic compendium of key sources and writers in the in the field, including several History of Consciousness students. Two wide-ranging collections of cultural studies approaches are Dery 1993, and Brahm and Driscoll 199S, which includes Sandoval (1995b) on US Third World Feminism, and critical and philosophical essays on geography, cyborgs and aliens, rap, Shakespeare, etc. Jenny Wolmark (1999) gathers a number of "classic" essays exploring various aspects of gender, race, class, technological embodiment, and popular media, with helpful introductions to each section, while Lykke and Braidotti 1996 emphasizes science studies and related questions of knowledge, objectivity, and spirituality, with some critiques of and developments beyond Haraway.

14 On this point see Samuel R. Delaney interviewed by Mark Dery in *Flame wars* (Dery 1993, 743–63, see n.13) and Zoë Sofia (1993, 113–14); foe a brief comparison of feminist SF and cyberpunk see Jenny Wolmark's "The Postmodern Romances of Feminist Science Fiction" in Wolmark 1999.

15 For example, in 1993 Virginia Barratt curated an exhibition *Tekno Viscera*, in which various contributors, including electronic artists, played on the theme of "putting guts into the machine" (Barratt 1993).

16 Versions of the VNS Matrix manifesto have been reprinted in Zurbrugg (1994, 427), and Sofia (1996, 61).

17 VNS Matrix and other Australian technological artists are discussed by Glenda Nalder (1993), and in pieces by Teffer, Bonnin, Kenneally, in the "Natural/Unnatural" special issue of *Photofile 42* (June 1994): by Jyanni Steffensen (1994), Bernadette Flynn (1994). Zoë Sofoulis (1994), and Zoë Sofia (1994, 1998). See also various contributors and interviewees in Zurbrugg 1994.

18 l am grateful to Irina Aristarkhova for sending me a copy of the *Next Cyberfeminist International* catalogue.

References

Ackers, S. 1999. Cyberspace is empty – Who's afraid of avatars?. In Sollfrank and Old Boys Network 1999.

Alaimo, S. 1994. Cyborg and ecofeminist interventions: Challenges for an environmental feminism. *Feminist Studies* 20: 1.

Aronowitz, S., B. Martinsons and M. Menser 1996. (eds). *Technoscience and cyberculture*. New York: Routledge.

Balsamo, A. 1993. Feminism for the incurably informed. In Dery 1993. (Also in Balsamo 1996.)

—— 1996. *Technologies of the gendered body*. Durham, NC: Duke University Press.

Barratt, V. (ed.). 1993. *Tekno Viscera*. Exhibition catalog. Brisbane: Institute of Modern Art.

Bassett, C. 1999. A manifesto against manifestos?. In C. Sollfrank and Old Boys Network 1999.

Bigum, C. 1991. Schools for cyborgs: Educating aliens. In *Navigating in the nineties*. Proceedings of ACEC '91: Ninth Australian Computing in Education Conference, Bond University. Computer Education Group of Queensland.

Bigum, C. and B. Green 1993. Changing classrooms, computing, and curriculum: Critical perspectives and cautionary notes. *Australian Educational Computing* 8:1.

Brahm, G., Jr. and M. Driscoll (eds). 1995. *Prosthetic territories: Politics and hypertechnologies*. Boulder, CO: Westview Press.

Braidotti, R. 1994. *Nomadic subjects: Embodiment and sexual difference in contemporary feminist theory*. New York: Columbia University Press.

Bukatman, S. 1993. *Terminal identity: The virtual subject in postmodern science fiction*. Durham, NC: Duke University Press.

Cadigan, Pat. 1991. *Synners*. New York: Bantam.

Clynes, M. E. and N. S. Kline. 1960. Cyborgs and space. *Astronautics* Sept. Reprinted in Gray 1995.

Cockburn, C. 1992. The circuit of technology: Gender, identity, and power. In *Consuming technologies: Media and information in domestic space*, ed. R. Silverstone and E. Hirsch. London and New York: Routledge.

Cockburn, C. and R. Furst Dilic (eds). 1994. *Bringing technology home: Gender and technology in a changing Europe*. Birmingham and New York: Open University Press.

Csisery-Ronay, Istvan, Jr. 1991. The SF of theory: Baudrillard and Haraway. *Science Fiction Studies* 18(3).

Dery, M. (ed.). 1993. *Flame wars: The discourse of cyberculture*. Special issue of *South Atlantic Quarterly* 92(4). Durham, NC: Duke University Press.

—— 1996. *Escape velocity: Cyberculture at the end of the century*. London: Hodder & Stoughton.

Duncan, N. (ed.). 1996. *BodySpace: Destabilizing geographies of gender and sexuality*. London: Routledge.

Edwards, P. 1995. *The closed world: Computers and the politics of discourse in postwar America*. Cambridge, MA: MIT Press.

Featherstone, M. and R. Burrows (eds). 1996. *Cyberspace, cyberbodies, cyberpunk: Cultures of technological embodiment*. London: Sage.

Fitting, P. 1991. The lessons of cyberpunk. In Penley and Ross 1991.

Flynn, B. 1994. Woman/machine relationships: Investigating the body within cyberculture. *Media Information Australia* 72 (May): 11–19.

Gibson, W. 1984. *Neuromancer*. London: HarperCollins.

—— 1986. *Count Zero*. London: HarperCollins.

—— 1988. *Mona Lisa overdrive*. London: HarperCollins.

—— 1990. Interviewed in *Cyberpunk* (film). Dir. P. von Brandenberg and M. Trench. Dist. Voyager Company.

Gonzalez, J. 1995. Envisioning cyborg bodies: Notes from current research. In Gray 1995. Reprinted in Wolmark 1999.

Graham, E. 1999. Cyborgs or goddesses? Becoming divine in a cyberfeminist age. *Information, Communication and Society* 2(4).

—— Forthcoming. *Representations of the post/human: Monsters, aliens, and others in popular culture*. Manchester: Manchester University Press.

Gray, C. 1993. *Postmodern war: Computers as weapons and metaphors*. London: Free Association Press.

—— (ed.). 1995. With S. Mentor and H. Figueroa-Sarriera. *The cyborg handbook*. New York: Routledge.

Gray, C. and S. J. Mentor. 1999. The cyborg body politic and the new world order. In Brahm and Driscoll 1995.

Gray, C., S.J. Mentor and H. J. Figueroa-Sarriera. 1995. Cyborgology: Constructing the knowledge of cybernetic organisms. In Gray 1995.

Halacy, D.S. 1965. *Cyborg: Evolution of the superman*. New York: Harper & Row.

Halberstam, J. 1991. Automating gender: Postmodern feminism in the age of the intelligent machine. *Feminist Studies* 17(3): 439–60.

Haraway, D. 1979. The biological enterprise: Sex, mind and profit from human engineering to sociobiology. *Radical History Review* 20. Reprinted in Haraway 1991a.

—— 1984. Lieber Kyborg als Göttin: für eine sozialistisch-feministische Unterwanderung der Gentechnologie. In *Argument-Sonderband*, ed. B.-P. Lange and A. M. Stuby. 105. Berlin.

—— 1985. A manifesto for cyborgs: Science, technology and socialist feminism in the 1980s. *Socialist review* 80: 65–107. Reprinted in *Australian Feminist Studies* 4 (1987), in Nicholson 1990, and in Haraway 1991a.

—— 1988. Situated knowledges: The science question in feminism and the privilege of partial perspective. *Feminist Studies* 14(3): 575–99. Reprinted in Haraway 1991a.

—— 1989a. *Primate visions: Gender, race and nature in the world of modern science*. New York: Routledge.

—— 1989b. The biopolitics of postmodern bodies: Determinations of self in immune system discourse. *differences: A Journal of Feminist Cultural Studies* 1(1). Reprinted in Haraway 1991a.

—— 1991a. *Simians, cyborgs, and women: The reinvention of nature*. New York: Routledge.

—— 1991b. Cyborgs at large: Interview with Donna Haraway, by Penley and Ross. In Penley and Ross 1991.

—— 1992. Promises of monsters: A regenerative politics for inappropriate/d others. In *Cultural Studies*, ed. L. Grossberg, C. Nelson and P. Treichler. New York: Routledge. Reprinted in Wolmark 1999.

—— 1997. *Modest_Witness@Second_Millenium. FemaleMan_Meets_OncoMouse*™. New York: Routledge.

Huyssen, A. 1982. The vamp and the machine: Technology and sexuality in Fritz Lang's *Metropolis*. *New German Critique* (fall/winter): 24–5.

Jameson, F. 1984. Post-modernism, or the cultural logic of late capitalism. *New Left Review* (July/August): 146.

Kuni, V. 1999. The art of performing cyberfeminism. In Sollfrank and Old Boys Network 1999.

Latour, B. 1992. Where are the missing masses? The sociology of a few mundane artifacts. In *Shaping technology/building society*, ed. W. E. Bijker and J. Law. Cambridge, MA: MIT Press.

—— 1993. *We have never been modern*. Trans. C. Porter. Originally published 1991. Cambridge, MA: Harvard University Press.

—— 1994. Pragmatogonies. *American Behavioral Scientist* 37(6).

Law, J. (ed.). 1991. *A sociology of monsters: Essays on power, technology and domination*. London: Routledge.

—— 1999. After ANT: Complexity, naming, and topology. In Law and Hassard 1999.

Law J. and J. Hassard (eds). 1999. *Actor network theory and after*. Oxford: Basil Blackwell/Sociological Review.

Law, J and A. Mol. 1995. Notes on materiality and sociality. *Sociological Review* 43: 274–95.

Lee, N. and S. Brown. 1994. Otherness and the actor-network. *American Behavioral Scientist* 37(6).

Lykke, N. 1996. Between monsters, goddesses and cyborgs: Feminist confrontations with science. In Lykke and Braidotti 1996.

Lykke, N. and R. Braidotti (eds). 1996. *Between monsters, goddesses and cyborgs: Feminist confrontations with science, medicine and cyberspace*. London: Zed Books.

McCaffery, L. (ed.). 1991. *Storming the reality studio: A casebook of cyberpunk and postmodern science fiction*. Durham, NC: Duke University Press.

Morton, D. 1999. Birth of the cyberqueer. In Wolmark 1999.

Muller, N. 1999. Suggestions for good cyberfem (house)-keeping: or how to party with the hyperlink. In Sollfrank and Old Boys Network 1999.

Mulvey, L. 1975. Visual pleasure and narrative cinema. *Screen* 16(3).

Munster, A. 1999. Is there postlife after postfeminism? Tropes of technics and life in cyberfeminism. Feminist Science Studies issue of *Australian Feminist Studies* 14(29): 119–29.

Nalder, G. 1993. Under the VR spell? Subverting America's masculinist global hologram. *Eyeline* 21 (autumn): 20–2.

Nicholson, L. (ed.). 1990. *Feminism/postmodernism*. New York: Routledge.

Olson, G. 1996. Writing, literacy and technology: Toward a cyborg writing. *Journal of Composition Theory* 16(1).

Piercy, M. 1991. *Body of glass*. Originally published as *He, she, it*. London: Penguin.

Penley, C. and A. Ross (eds). 1991. *Technoculture*. Minneapolis, MN: University of Minnesota Press.

Pickering, A. 1995. *The mangle of practice: Time, agency, science*. Chicago, IL: University of Chicago Press.

Plant, S. 1994. Cybernetic hookers. Paper presented at Adelaide Festival Artists' Week. Reprinted in *Australian Network for Art and Technology Newsletter* (April–May).

—— 1995. The future looms: Weaving women and cybernetics. In Featherstone and Burrows 1995. Reprinted in Wolmark 1999.

—— 1998. *Zeroes and ones*. London: Fourth Estate.

Roberts, C. 1999. Thinking biological materialities. Feminist Science Studies issue, *Australian Feminist Studies* 14(29).

Sandoval, C. 1991. US Third World Feminism: The theory and method of oppositional consciousness in the postmodern world. *Genders* 10.

—— 1995a. New sciences: Cyborg feminism and the methodology of the oppressed. In Gray 1995, reprinted in Wolmark 1999.

—— 1995b. Video production, liberation aesthetics, and US Third World Feminist criticism. In Brahm and Driscoll 1995.

Sofia, Z. 1993. *Whose second self? Gender and (ir)rationality in computer culture*. Geelong: Deakin University Press.

—— 1996. Contested zones: Futurity and technological art. *Leonardo* 29(1): 59–66.

—— 1998. The mythic machine: Gendered irrationalities and computer culture. In *Education/technology/power: Educational computing as a social practice*, ed. H. Bromley and M. W. Apple. 29–51. Albany, NY: State University of New York Press.

Sofoulis, Z. 1994. Slime in the matrix: Post-phallic formations in women's art in new media. In *Jane Gallop Seminar Papers*, ed. Jill Julius Matthews. 83–106. Canberra: Humanities Research Centre, ANU.

—— 2003 (forthcoming). Cyborgs and other hybrids: Latour's nonmodernity. In *Encore le corps: Embodiment now and then*, ed. E. Probyn and A. Munster. London: Routledge.

Sollfrank, C. 1999. Women hackers. In Sollfrank and Old Boys Network 1999.

Sollfrank, C. and Old Boys Network (eds). 1999. *Next Cyberfeminist International*. Proceedings of conference in Rotterdam, March 1999. Hamburg: Old Boys Network and Hein & Co.

Springer, C. 1991. The pleasure of the interface. *Screen* 32(3).

—— 1996. *Electronic Eros: Bodies and desire in the postindustrial age*. Austin, TX: University of Texas Press.

Stabile, C. 1994. *Feminism and the technological fix.* Manchester: Manchester University Press.

Star, S. L. 1996. From Hestia to home page: Feminism and the concept of home in cyberspace. in Lykke and Braidotti 1996.

Steffensen, J. 1994. Gamegirls: Working with new imaging technologies. *Mesh: Journal of the Modern Image Makers Association* 3 (autumn): 8–11.

Stone, A. R. (Sandy). 1996. *The war of desire and technology at the close of the mechanical age*. Paperback edition. Cambridge, MA: MIT Press.

Sturgeon, N. 1997. *Ecofeminist natures: Race, gender, feminist theory and political action*. New York: Routledge.

Turkle, S. 1984. *The second self: Computers and the human spint*. New York: Simon & Schuster.

—— 1996. *Life on screen: Identity in the age of the Internet*. London: Weidenfeld & Nelson.

Vidler, A. 1992. *The architectural uncanny: Essays in the modern unhomely*. Cambridge, MA: MIT Press.

Volkart, Y. and C. Sollfrank. 1999. Editorial. In Sollfrank and Old Boys Network 1999.

Watson, G. 2000. *Just do IT: Australian women in cyberspace*. Ph.D. dissertation. School of Cultural Histories and Futures, University of Western Sydney.

Wolmark, J. (ed.). 1999. *Cybersexualities: A reader on feminist theory, cyborgs and cyberspace*. Edinburgh: Edinburgh University Press.

Woodward, K. 1999. From virtual cyborgs to biological time bombs: Technocriticism and the material body. In Wolmark 1999.

Zurbrugg, N. (ed.). 1994. *Electronic Arts in Australia*. Special issue of *Continuum: The Australian Journal of Media and Culture* 8(1).

Alison Adam

FEMINIST AI PROJECTS AND CYBERFUTURES

FEMINIST RESEARCH CAN HAVE A PESSIMISTIC CAST. In charting and uncovering constructions of gender, it invariably displays the way in which the masculine is construed as the norm and the feminine as lesser, the other and absent. This work is no different in that respect and I am aware of the downbeat note on which my previous chapter ends. But as both Tong (1994) and Wajcman (1991) argue, feminism is a political project and the best research is where action proceeds from description. Taking that on board for the present project involves not just using feminist approaches to criticize, but also the more difficult task of thinking through the ways in which AI research *could* be informed by feminist theory, and I make some suggestions below as to the form such research might take.

A second part of that action concerns the question of locating an appropriate feminist response to the burgeoning interest in the cultures surrounding intelligent information technologies. This includes not only AI but also the currently fashionable technologies of Virtual Reality (VR) and the Internet, both involving and related to longer established techniques from AI. Here the issue is marrying the analysis of the preceding chapters to the areas of intetelligent software technology which are currently exciting considerable levels of commentary. The challenge then becomes charting a course between the Scylla of a 'nothing changes' pessimism and the Charybdis of a gushingly unrealistic 'fabulous feminist future' (Squires 1996).

Feminist AI projects

The fact that AI projects consciously informed by feminist concepts are thin on the ground is hardly surprising (but see e.g. Metselaar 1991). Having set up a few small projects over a period of years I have found myself questioning just what I was trying to do. I knew I was not trying to somehow 'convert' male colleagues to my way of thinking. I have never seen either my own work, or the mass of feminist literature I have consulted along the

way, as proselytizing attempts to convince recalcitrant men. I can understand how feminist writers who elicit the popular response of 'that won't convince many men', are irritated by the naivety of such comments and the way they miss the point of their endeavour. But women academics working in technological departments face pressures either not to do such work at all or only to address certain aspects. These pressures can range from whispers of 'not exactly mainstream' (which because it is a whisper I mishear as 'not exactly malestream') to actually being told not to pursue such work if they want to maintain their career prospects.[1]

Almost the only kind of work which attracts a level of respectability for women working within science and technology departments, at least in the UK, involves WISE (women into science and engineering) type attempts to attract more women and girls into the subject area; for instance, I have found male peers puzzled if I do not make myself available for university-run women into science and engineering workshops. 'I thought that's what you were interested in.' This is the acceptable face of liberal feminism (Henwood 1993) where the *status quo* is left unchallenged, where women constitute the problem, for not entering computing in the numbers that they should, and where almost any attempt to boost student numbers in an underfunded and overstretched university environment is seen as a good thing.

However those of us not prepared to wear the acceptable face of feminism return to our 'not exactly malestream' projects. Those who do projects such as these are making a statement; namely that this is research that matters, that deserves to be taken seriously and that its qualities should be judged on its own merits. And this takes more courage than many of us could reasonably be expected to muster, given the pressures I describe, and the fact that many do not have the luxury of permanent 'tenured' positions in their institutions.

If such work is not undertaken in the spirit of evangelism neither does it properly fit the notion of the successor science of the standpoint theorists (Harding 1991). This is because it is not trying to build an alternative 'successor' AI. It is, rather, and more modestly, showing ways in which AI can be informed by feminist theory and can be used for feminist projects. As Jansen (1992: 11) puts it so colourfully, it is in the spirit of 'feminist semiological guerrilla warfare … to transform the metaphors and models of science'. Additionally, paraphrasing Audre Lorde's (1984) metaphor it would be nice 'to demolish the master's house with the master's tools.'[2] This requires a great deal of imagination. Undeniably there are contradictions. I am reminded of the occasion when a man asked at a gender and technology workshop, 'How would a fighter plane designed by a feminist look any different?'[3] If my immediate response would be that feminists do not design fighter planes then perhaps I should acknowledge that feminists do not design AI applications either. But this will not do as it loses sight of the political project. Hoping for change means showing how change can be made no matter how modest the beginnings.

The projects I describe below are indeed quite small. Such projects do not attract research funding and must often be tackled within the confines of final year undergraduate and masters (MSc) level dissertations. This means that individual projects are short and continuity between one project and another is difficult. I also want to make it clear that my role in these projects was as originator and supervisor, and that the results and many of the ideas and novel questions which emerged belong to the individuals who tackled the projects, most notably Chloe Furnival (1993) for the law project and Maureen Scott (1996) for the linguistics project, both of which are described below.

Some interesting problems emerge. Almost all of the students who have attempted the projects are women; the one man who built some software for teaching the history of

the First and Second World Wars had to remind *me* that I had originally cast the project in terms of achieving a less gender biased approach to teaching history. As the project proceeded, I had unconsciously assumed that he was not really interested in the gender aspects, and had mentally 'written them out' of his project for him – hoist by my own petard. The women who have worked on these projects are computing students, though several are conversion masters degree students who have a humanities or social science first degree, and who generally have little background in feminist theory. There is no doubt that this makes for a difficult project, for not only do I ask that they get to grips with a new subject matter, but also it is a subject matter which requires a way of thinking completely different from the technical paradigm within which they have begun to work. In addition they are often expected to apply this to the production of a software model. But it is interesting and heartening that they invariably become absorbed by the feminist literature and usually have to be persuaded not to read any more, to get on with the business of pulling the project together. Apart from anything else it allows me to relive the excitement of my own arrival at feminism.

AI and feminist legal theory

One of the most fertile areas for research into AI applications in recent years has been the law (see e.g. Bench-Capon 1991). Part of the appeal of the law is the way that, on the surface, legal statutes appear to offer readymade rules to put into expert systems. A 'pragmatist/purist' debate has crystallized around this issue. Purists (e.g. Leith 1986) argue that there are no clear legal rules, the meaning of a rule is made in its interpretation, and that legal rules are necessarily and incurably 'open-textured'. We cannot know, in advance, all the cases to which a rule should apply, hence its meaning is built up through its interpretation in courts of law.

A good example, which illustrates these difficulties, was reported in the British media as I was considering this question. A woman who wished to be inseminated with her dead husband's sperm had taken her case to the High Court. Before he died the couple had been trying to have a baby. They had discussed a different case where sperm had been extracted from a dying man to inseminate his wife, and agreed that they would do the same if ever in this position. Tragically the man fell ill with bacterial meningitis. His sperm was extracted by physicians as he lay dying. However a High Court ruling was made that she could not be inseminated because, crucially, her husband's signature was never obtained; it could not have been, as he was in a coma when the sperm was removed. Mary Warnock, architect of the relevant legislation, stated that the committee which drafted the Human Fertility and Embryology Bill would certainly have permitted this case, but had never foreseen that a case like this would occur and so had not allowed for it in the statute (see the *Guardian*, 18 October 1996: 1).

Pragmatists, as the name suggests, believe that it is possible to represent legal rules meaningfully, although it is hardly a trivial task. Unsurprisingly pragmatists tend to be drawn from the ranks of computer scientists who favour predicate logic and its variants for the representation of truths in the world. Either way, it can be argued that legal expert systems embody traditional views on jurisprudence, by analogy with prior arguments on traditional epistemology and expert systems.[4] Just as feminist epistemology offers a challenge to traditional epistemology, so too does feminist jurisprudence offer a significant challenge to more traditional forms of jurisprudence. The aim of the project I describe here was to build a legal expert system to advise on UK Sex Discrimination Law founded on principles

from feminist jurisprudence. It was envisaged that this system could be used by individuals, many of whom would be women, who would have little knowledge of this area of the law or of past cases which might resemble their case. Was the end product informed by these principles distinguishable from an equivalent project not founded on these principles? As the scale of the project was such that the end product was never used in a practical setting, it is not possible to answer this question definitively. In any case I argue that it was the path to the product, the journey not the destination, which was important in acting as an example, of an AI informed by feminism.

Although developing in parallel ways, feminist jurisprudence appears a more practically orientated discipline than much writing in feminist epistemology, in its aim to integrate legal theory with political practice. Both disciplines have moved on from exposing violations of equal rights and sexist biases to become mature philosophical disciplines in their own right. In thinking about the women's movement in relation to the law, two areas stand out. First, there is women's use of the law to promote their rights, with the achievement of often partial liberal measures ironically reinforcing women's oppression rather than undoing it. Second, there is the potentially more radical effort of feminist jurisprudence, which seeks to question the naturalness of legal power and knowledge, foundational beliefs about the law, and the way that legal reasoning transforms the imagined examples from male lives into a form of doctrine taken to be objective and normative (MacKinnon 1982, 1983; Grbich 1991).

Furnival (1993) points out that UK Sex Discrimination Law provides a good example of the use of these ideas in practice, particularly when we note that it is up to the individual to prove that her rights been violated (Smart 1989: 144–6; Palmer 1992: 6). Linda Sanford and Mary Donovan (1993: 200) argue that many women have so little sense of themselves as persons with rights, that they experience considerable difficulty in recognizing when their rights have been violated. Other women may recognize that their rights are being transgressed in some way, but cannot bring themselves to make a complaint as this might brand them 'troublemakers'. Under the circumstances, any computer system designed to advise women on this area of the law would have to be presented as an unthreatening adviser which could show a client that she may have a case by analogy with past cases. The balance is important. It is unfair to offer users hope of legal redress for hopeless cases as the process of making and winning a case rests on an existing order, no matter how feminist the principles on which the system was built. On the other hand, offering examples of past cases which bear some resemblance to the present case leaves the question of whether or not to proceed open to the users, rather than making a decision for them. It is important not to make too grand a claim for what is, after all, a modest piece of work and this recognizes that considerably larger resources would be required to test out the hypotheses contained in this research.

Feminist computational linguistics

Given the growing interest in gender and language, computational models of language provide a potentially fertile ground for feminist projects. If feminist linguistic models challenge the models of traditional views of language, then how might this challenge be incorporated into the design of an AI system which analyses language? The project reported in this section sought to add a gender dimension to software tools which model conversational analysis (Scott 1996). This involved criticizing and augmenting a model of the repair of conversational misunderstandings and non-understandings (Heeman and Hirst 1995; Hirst

et al. 1994; McRoy and Hirst 1995). The end product of the project was a formal (i.e. logic-based) model which could potentially be used to predict the outcomes of inter-gender miscommunications, and which forms the basis for a design of a computer system which could be built to perform the same task.

Why should anyone want to build computational models of language? There are a number of reasons why the ability to represent natural language in a computer system would be desirable. First of all, a highly useful application could be found in providing natural language interfaces to existing computers systems, e.g. spreadsheets, databases, operating systems or indeed anywhere where it is currently necessary to know a series of commands. Automatic abstracting, automatic translation, intelligent language-based searches for information – all these hold promise.

Part of the process of understanding language is to understand when there has been a misunderstanding between speakers and to repair that misunderstanding in a meaningful way when it occurs. This is, once again, suggestive of Collins's (1990) and Suchman's (1987) assertions that the reason that machines do not share our form of life rests upon the 'interpretative asymmetry' which exists in the interactions between humans and machines. Human beings are good at making sense of the bits and pieces of ordinary conversations, the half sentences, the 'urns' and 'ers', and so on; so good that they can make sense of almost anything and they are not easily put off. As yet, computers do not have this ability and until they do, an asymmetry in the ability to interpret utterances will remain. Hence a computer system which had some ability to repair natural language misunderstandings would clearly be of benefit in tackling this asymmetry in interpretative powers. However, the point is whether or not it is realistic to believe that a machine that can understand natural language is possible. Clearly some, such as Searle (1987), Dreyfus (1992) and Collins (1990), do not regard it as realistic. But even if, by analogy with their arguments, a full natural language-understanding system might not be a possibility, then, just as expert systems can still be useful where we provide much of the nexus of understanding and background knowledge, so too could a partial natural language-processing interface be of considerable interest.

The project was inspired by an example of the finessing away of 'social factors' which is such a pervasive feature of AI and computing in general. In putting together their model of conversational misunderstanding, Graeme Hirst and his colleagues (Hirst *et al.* 1994) appear to have removed the subtle nuances which made the interaction into a misunderstanding in the first place. The aspect which I examine here relates to gender. Yet there are clearly many others. Race and class are two obvious dimensions; age and size are two others. This is another situation in which embodiment is important, because, of course, the speakers are bodied individuals interacting in all sorts of physical ways connected to their linguistic utterances. For instance, the following reported misunderstanding (ibid.: 227) involves, at the least, age and gender.

> *Speaker A:* Where's CSC104 taught?
> *Speaker B:* Sidney Smith Building, room 2118, but the class is full.
> *Speaker A:* No, I teach it.

Hirst (ibid.) describes how the misunderstanding occurs. Speaker B assumes that A's plan is to take course CSC104, when in fact her plan is to teach it. However, a number of salient facts within this example are not revealed by reading the written text alone. At the time of the reported misunderstanding, speaker A was a graduate student, and in her twenties, while B was a male administrator. Age seems to have had something to do with

the misunderstanding: speaker A was young enough, and female enough, to be mistaken for a student.

An older speaker A might or might not have had the same problem – perhaps she would have been mistaken for a student's mother instead! It is interesting to speculate, in a society which values signs of youth in women, whether there might be some value in attempting to gain authority by appearing older. But this only serves to show how complex is the relationship between gender and age. True, A as a young man might have the same problem. But I wonder if a middle-aged male A would have fared differently. And what about the gender of B? The mantle of authority which men assume as they grow older is much harder for women to acquire. Women may be perceived as 'menopausal', which in Western society is almost always seen as pejorative rather than authoritative in middle life.[5] There are different ways of not taking a woman seriously which may vary according to her perceived stage in life. Hence I argue that the meaning of the misunderstanding is not readily available to us unless we have some means of reading between the lines in this way.

The large body of literature on gender and language which now exists provided a useful backdrop against which to locate this project. Chapter four noted that Spender's (1980) and Lakoff's (1975) work exerted considerable influence in the assertiveness industry of the 1980s. However, for this example, a much more pertinent body of work can be found in Deborah Tannen's research (1988, 1992, 1994), some of which is aimed at a more popular market. Most pertinently, *You Just Don't Understand* (Tannen 1992), demonstrates the sheer complexity of male and female linguistic interaction. Coupled with this, Pamela Fishman (1983) suggests that there are a number of interesting features about the way that men and women approach a conversation. She argues that women put in much more effort than men in initiating and maintaining a conversation. She also maintains that women are most often the agents of repair in misunderstandings in mixed (i.e. between men and women) conversations. If this is the case, then there is a good argument for a natural language understanding system which aims to repair speech understanding, to look at women's models of repair, if indeed they are the experts.

The complexities of men's and women's linguistic interactions are such that it seems impossible to uncover the layers of meaning in conversational misunderstandings in a model which is gender blind. For instance, Tannen (1992) offers a number of examples of misunderstandings which can only be made understandable in the light of the genders of the participants.

Hirst and his colleagues' research on the analysis of mis- and non-understandings includes a number of top-level action schemas which are used to describe the actions of the parties in a conversation. These include things like accept-plan(NameOfPlan) which signals the speaker's acceptance of the plan and reject-plan(NameOfPlan) which signals that the speaker is rejecting the plan which is being offered by the other speaker. These top-level schemas are decomposable into surface linguistic actions.

Combining Tannen's (1992) analyses with Hirst's research (Hirst *et al.* 1994), Scott (1996) suggests that there are a number of distinct patterns in the forms of female to female, male to male and mixed conversations so that a predictive model can be developed, that is, she claims that it is possible to predict the response expected to each form, following particular gender patterns. As women work harder to maintain a conversation, this suggests that a woman will avoid terminating a conversation using reject plan as a man might do; instead she might use postpone, expand or replace to elicit another response from her conversant. With this revised format, Scott was able to produce more exact analyses of a number of conversations. Using the new model in the design of a conversation analysis tool gives a potential for misunderstandings to be predicted. Knowing the genders of the

conversants, if a man responds with a form that is not expected by a woman, or *vice versa*, an analysis tool would recognize the beginnings of a misunderstanding possibly even before the participants can.

In this description, I am aware of the dangers inherent in suggesting that women's and men's linguistic interactions follow universal patterns. This is clearly not the case. Indeed the model described here is a white, middle-class, Anglo-American English one, which probably does not even fit, for example, New York Jewish speech, where interruptions are more common (Tannen 1994). It cannot be claimed that the model would suit cultures outside those for which it was designed. Yet making the cultural roots of the model explicit serves to underline the difficulties of generalizing linguistic misunderstanding.[6]

Contradictions and possibilities

In reporting these two projects I am aware of unresolved contradictions. The computer systems that were designed and built were just as disembodied and unsituated, relying on the same symbolic representation structures as those I have criticized in preceding chapters. In going through this reflexive process I begin to understand the traditional plea of the computer scientist: 'we had to start somewhere'. And there seems to me no choice but to start where we did. Even if, *pace* Lorde (1984: 110), we may suspect that 'the master's tools will never dismantle the master's house', there are as yet no other tools and we cannot know unless we try. In the law project it could be argued that we have an example of a 'fighter plane designed by a feminist', in other words something which does not look substantially different from a computer system designed along more traditional lines. At the nuts and bolts level of the computer program it would be hard to point definitively at perceived differences. I have argued that it is the way the system is to be used which is different. Yet at the same time I concede that this project uses entirely conventional techniques of knowledge representation and programming, which I have criticized as being unable to capture all the important things about knowledge, especially women's knowledge. So in a real sense I am criticizing the projects in which I am involved for at least some of the same reasons that I am criticizing conventional AI projects. But I do not mean this criticism to be interpreted as an argument not to do the work at all, for either my own or other AI projects. I would follow the lead of Brooks (1991) and his colleagues, who in acknowledging the enormous problems involved in building Cog, nevertheless argue that they had to start somewhere.

Some of the same contradictions are inherent in the linguistics project. The first, more particular, concern involves the critique of the relationship between modern linguistics and predicate logic, following Nye (1992) (discussed in chapter four), given that this project follows the logic of the original research, albeit while suggesting modifications and amendments. The original could have been criticized without offering these alternatives, but I suggest that then the critique would have lost much of its force; it is important to criticize these pieces of work both from the point of view of feminism and in their own terms (i.e. 'using the master's tools').

The second concern mirrors a recent controversy arising from Suchman's (1994b) criticism of Winograd's (1994) Coordinator system. Some of Suchman's earlier writing (1987) would seem to argue against the way that, following Hirst's original logic, we saw the conversational interactions in terms of 'plans'. This is developed in her later argument which is directed against the way that speech act theory has been encapsulated in the language/action perspective described in *Understanding Computers and Cognition*

(Winograd and Flores 1986), and the way that this is exemplarized in the Coordinator system. The two basic concepts in speech act theory are that language is a form of action and second, that language and action can be represented formally – they are, in principle, amenable to representation by a computer system. Under this view, Suchman (1994b: 179) argues that language is treated as instrumental, 'a technology employed by the individual to express his or her intentions to others'. The Coordinator system is one of the best known attempts to implement these ideas in a computer system. It asks speakers to make the content of a given utterance explicit by categorizing it from a range of options. The problem is that the adoption of speech act theory as a foundation for the design of computer systems brings with it an agenda of discipline and control over the actions of members of an organization.

Suchman points to the way that communication is taken to be the exchange of intent between speakers and hearers in speech act theory but she argues that the analyses of actual conversations demonstrate the interactional, contingent nature of conversation (Suchman 1994b). So a speaker's intent is always shaped by the response of the hearer. This has led commentators such as John Bowers and John Churcher (1988) to the conclusion that human discourse is so indeterminate that any computer system designed to track the course of an interaction by projecting organized sequences will inevitably, albeit unwittingly, coerce the users. The Coordinator system tries to get round this difficulty by having users categorize their utterances themselves in order to make implicit intention explicit. This allows them to set up a basic structure around the idea of 'conversation for action', entailing requests, promises, declarations (Suchman 1994b: 183–4).

> The picture of the basic conversation for action unifies and mathematizes the phenomena it represents. It works by transforming a set of colloquial expressions into a formal system of categorization that relies upon organization members' willingness to re-formulate their actions in its (now technical) vocabulary. … Once encapsulated and reduced to the homogeneous black circles and arrows of the diagram the 'conversation' is findable anywhere. At the same time, the specific occasions of conversation are no longer open to characterization in any other terms.
>
> (ibid.: 185)

Yet, as Suchman argues, such a process reduces the complexity of the actions being categorized to the simplicity of the category. This, then, suggests that the Coordinator is a tool to bring its users into the compliance of an established social order, so the designers of computer systems become designers of organizations.

Clearly, arguments such as these could apply equally well to the design of the modest system I have described above. We were attempting to categorize the utterances in conversations between men and women, albeit according to models developed by feminist linguists. At the same time we were making some sort of claim our model was better than the original version which failed to take account of gender and other factors. So we were claiming that our model was at least potentially better in explanatory power and predictive power, that is, it could be used to predict what sort of response would be likely in inter-gender conversations. Although currently far from this stage, if our model were ever implemented in a natural language computer system used in an organizational setting, we might well find ourselves introducing a computer system which preserved stereotypical expectations of interactions and thus preserved an existing social order and power structure. I find myself impaled on the horns of a dilemma where a weak 'I had to start somewhere' will hardly suffice to prise me off.

Cyberculture

Practical AI projects informed by feminist ideals offer one view of how we can begin to think about future directions for intelligent systems. However there are other, broader, ways of thinking about the future in terms of intelligent computer technology and feminism. The alternative route is via 'cyberculture', the term used to describe the explosion of interest in cultures developing round virtual reality (VR), the Internet and including AI and A-Life, many of which speaks in a markedly futuristic voice. Few cultural commentators can fail to marvel at the extraordinary efflorescence of cyberculture – a burgeoning interest from the social sciences has quickly spawned a number of anthologies (Aronowitz, Martinsons and Menser 1996; Benedikt 1994; Dovey 1996; Ess 1996; Featherstone and Burrows 1995; Gray 1995; Shields 1996). And indeed it is marked by a number of interesting features, not least of all its relationship to feminism.

First of all, in its popular form it is a youth culture. At first sight it appears to go against the grain of a more general world-view which is sceptical about the progress of science and technology; a number of prominent scientists are aware of this malaise to the extent that they wish to set up a counter-attack (Gross and Levitt 1994). Cyberculture appeals to youth, particularly young men. Clearly it appeals to their interest in the technical gadgetry of computer technology, and in this it has been strongly influenced by the 'cyberpunk genre' of science fiction, which although offering a distinctly dystopian vision of the future, at least offers alternative heroes in the form of the macho 'console cowboys'. To 'jack in' to 'cyberspace' appears to offer a way of transcending the mere 'meat' of the body, once again signalling the male retreat from bodies and places where bodies exist.

Jacking in, cyberspace and *meat* are metonymic cyberpunk terms which have entered the lexicon of cyberculture, many of them from William Gibson's (1984) *Neuromancer*, the first cyberpunk novel. In *Neuromancer*, the hero, Case, logs onto, or jacks into, cyberspace through a special socket implanted in his brain. Cyberspace is a shared virtual reality, a 'consensual hallucination' where the body that one chooses to enter within cyberspace has bodily sensations and can travel in the virtual reality. Meat-free, but sinister artificial intelligences inhabit cyberspaces, having finally downloaded themselves and having left their obsolete, merely meat, bodies behind. But these images are a far cry from contemporary cyberspace and the current mundanities of logging onto a computer, and of experiencing the Internet, often rather slowly, through the interface of screen and keyboard.

A meat-free existence

The relevance of 'meat' is demonstrated by Stone's (1994: 113) observation.

> The discourse of visionary virtual world builders is rife with images of imaginal bodies freed from the constraints that flesh imposes. Cyberspace developers foresee a time when they will be able to forget about the body. But it is important to remember that virtual community originates in, and must return to the physical. No refigured virtual body, no matter how beautiful, will slow the death of a cyberpunk with AIDS. Even in the age of the technosocial subject, life is lived through bodies.

One wonders what sort of bodies virtual reality developers will have in store for us. For instance, Thalmann and Thalmann (1994) picture a perfect, blonde, red-lipped Marilyn Monroe lookalike seemingly without irony. And writing as a prominent mainstream AI

roboticist, apparently quite separately from and rather earlier than cybercultural influences, Moravec (1988) has proposed the idea of *Mind Children*. Moravec's opinions belong more to the realm of the science fiction writers than to hard-nosed engineering based roboticists, for he envisions a 'postbiological' world where:

> the human race has been swept away by the tide of cultural change, usurped by its own artificial progeny. ... Today, our machines are still simple creations, requiring the parental care and hovering attention of any newborn, hardly worthy of the word 'intelligent.' But within the next century they will mature into entities as complex as ourselves, and eventually into something transcending everything we know – in whom we can take pride when they refer to themselves as our descendants.
>
> (ibid.: 1)

Moravec's style is heavily informed by a sociobiology untempered by his uncritical enthusiasm for all things AI. Our DNA, he suggests, will find itself out of a job when the machines take over – robots with human intelligence will be common within fifty years. Of course, futuristic pronouncements such as this are always safe bets: make them far enough ahead and you will not be around to be challenged when the time is up; closer predictions can always be revised if the deadline expires before the prediction comes true.

But I think there are two important issues at stake in projecting a meat-free existence. The first concerns birth, the second escape, which is discussed in the following section. Moravec sees his robots as his progeny and this has strong parallels with the way that Brooks sees his robot baby, Cog, as a child to be brought up. Do these roboticists have real children?[7] Feminists might question *why* they feel the need to have robot children. Coming from a different direction, Easlea (1983) has noted the prevalence of sexual and birth metaphors in the development of the atomic bomb in the Manhattan project. During the testing of the bomb, the question was whether there would be a violent explosion rather than a relatively harmless radioactive fizzle. In the terminology of the Los Alamos scientists, the problem was to give birth to a 'boy' and not to a 'girl' (ibid.: 94).

> Alas, as Mary Shelley persuasively suggests in *Frankenstein*, an obsessive male desire to outdo women in creative ability can only too easily lead to tragic consequences. ... To his credit, however, Frankenstein did try to 'give birth' to a *living* thing. The Los Alamos scientists ... were attempting to give birth to the most potent instruments of death then conceivable, two nuclear weapons which they affectionately christened with the male names, Little Boy and Fat Man. But, like Frankenstein, the physicists found that the challenge of creating a 'monster' is one thing; the challenge of keeping control over it in a masculine world is quite another.
>
> (ibid.: 97–8)

The metaphor of 'the pregnant phallus' seems apposite in these attempts to remove creative power from the realm of the female. But even if the roboticists are not creating weapons of destruction, like all parents they may not be able to control the actions of their offspring. Jansen (1988, 1992) has pointed to the way in which several AI scientists express their dream of creating their own robots, of 'becoming father of oneself' (Jansen 1988: 6, quoting Norman Brown from Bordo 1987: 456).

Helmreich (1994) points to the way that A-Life researchers take this view one step further in their creations of 'worlds' or 'universes'. He asked a researcher how he felt in building his simulations. The reply was, 'I feel like God. In fact I am God to the universes I create' (ibid.: 5). Katherine Hayles (1994: 125, quoted in Helmreich 1994: 11) suggests that the way that A-Life scientists talk of their computers brings an image of 'a male

programmer mating with a female program to create progeny whose biomorphic diversity surpasses the father's imagination'. The desires are to make the body obsolete, to play god in artificial worlds, and to download minds into robots. Such desires are predicated on the assumption that if a machine contains the contents of a person's mind then it *is* that person. The body does not matter; it can be left behind.

> Inevitably the question must be raised. Which minds? Since the capacity of the most powerful parallel processing machines (connection machines) will be finite, not everyone will be able to get out of their bodies or off the planet. Some of 'us' will be stepped on, incinerated or gassed. So, who gets downloaded into the programs?
>
> [...]
>
> The new evolutionary logic dictates the answer. The best minds, of course, the kinds of minds that are most readily available for modeling in the AI laboratories of MIT, Stanford and Carnegie-Mellon University: minds of upper middle-class, white, American, male, computer scientists.
>
> (Jansen 1992: 8–9)

The options then are to create an artificial world and be god, to download the mind into a robot, or to enter the realm of pure intellect in cyberspace. All these views involve both the assumption that it is possible to leave the body behind, and also a masculinist desire to transcend the body, a thread running through the whole of AI. This, of course, leads to the idea of escape.

Cyberspace as escape

The idea of transcendence and escape is important in the rhetoric of cyberculture. Indeed some authors (Schroeder 1994) suggest that therein lies cyberculture's appeal; as a means of producing new forms of expression and new psychic experiences, which transcend mundane uses of technology. The fusion of technology and art with cyberspace is the medium of this transformation. This offers an alternative to drug culture, since VR and related information technologies offer a seemingly endless supply of new experiences but without the toxic risks of drugs. Ralph Schroeder (ibid.: 525) points out the tension between the technical problems which have yet to be solved and the world-view of human wish-fulfilment which has been projected onto the technology. In popular form probably the most readily available forms of cyberculture are the cyberpunk nightclub and cybercafe, which spring up in the middle of UK and US cities. In addition, a number of North American magazines, fanzines sometimes just termed 'zines, proclaim themselves the denizens of cybercultures. These include *Mondo 2000* and *bOING bOING*, neither of which are widely available in the UK. In that they uphold the traditionally macho values of cyberpunk, they are unlikely to find a mass audience amongst feminists. Balsamo (1996: 131–2) sums up their style:

> Interspersed throughout the pages of *Mondo 2000* and conference announcements, a tension of sorts emerges in the attempt to discursively negotiate a corporate commodity system while upholding oppositional notions of countercultural iconoclasm, individual genius, and artistic creativity. The result is the formation of a postmodern schizo-culture that is unselfconsciously elitist and often disingenuous in offering its hacker's version of the American dream.

Cyberculture for feminists

I argue that the cyberpunk version of cyberculture, with its masculine attempts to transcend the 'meat', holds little obvious appeal for feminists. Feminist analysis has gained great momentum in recent years, in many areas, not least within science and technology and cyberculture, at least in its popular form, lacks a critical edge. The lack of criticism manifests itself in several different ways. First of all, popular cyberculture is in danger of becoming ensnared in the nets of technological determinism, a determinism from which both modern science and technology studies, and gender and technology research have long wrestled to be free. The arguments for and against technological determinism need not be rehearsed in detail again here but broadly speaking, for cyberculture, they offer a view which takes technological development as inevitable, as having its own inner logic, and in which society dances to technology's tune, rather than the other way round. In cyberculture, determinist views are given voice in predictive statements about what sort of technology we will have ten, twenty or fifty years hence. As I have already suggested such predictions are always subject to revision, and so the owners of the predictions need never really be called to account.

But the point I wish to make here is that such technological predictions also carry along with them a prediction of how the technology will be used. For instance, the prediction that the widespread availability of teleshopping means that we will sit at home making purchases denies the complex physical and emotional pleasures of bargain hunting, the serendipitous find, the desperate need for a cappuccino on the way, the surprise of bumping into an old friend, the journey home with the parcels and the trip back next week to exchange the clothes that did not fit.[8]

Statements about the availability of intelligent robots fifty years hence does not mean that we have to use them in any particular way, or that we must download our minds into their bodies. Some of us may not wish to lose the pleasures of the meat. The high priests and priestesses of cyberculture are expert in futurespeak, in blending an almost mystical way of writing with a view that the advances on which they depend may be just around the corner. Jaron Lanier, who coined the term 'virtual reality' in the late 1980s (Schroeder 1993: 965) is particularly enthusiastic about shared virtual environments. He suggests that VR has 'an infinity of possibility … it's just an open world where your mind is the only limitation … it gives us this sense of being who we are without limitation; for our imagination to become shared with other people' (Lanier 1989, quoted in Schroeder 1993: 970). This becomes a way of building a shared sense of community, which Lanier sees as increasingly lost in American cities where people live in cars and no longer meet in the street. Brenda Laurel ends her book, *Computers as Theatre*, with the prophecy, 'the future is quite literally within our grasp … (it will) blow a hole in all our old imaginings and expectations. Through that hole we can glimpse a world of which both cause and effect are a quantum leap in human evolution' (Laurel 1991: 197–8, quoted in Schroeder 1994: 521). There is a strong sense of a utopian desire to escape to a virtual community, to a better world which at the same time signals a dissatisfaction with the old one.

> Cyberspace and virtual reality … have seemed to offer some kind of technological fix for a world gone wrong, promising the restoration of a sense of community and communitarian order. It is all too easy to think of them as alternatives to the real world and its disorder.
>
> (Robins 1996: 24)

Given that cyberculture draws so much from the rhetoric of cyberpunk fiction there are interesting tensions. Cyberpunk's future world is dystopian; there are no communities, only dangerous, alienating urban sprawls. Yet cyberculture looks to a future utopia where communities will spring up on the Internet, somehow to replace the old communities which people feel they have lost. Kevin Robins (ibid.: 25) sees a tension between the utopian desire to re-create the world afresh, in a virtual culture which is heavily dependent on the rhetoric of technological progress on the one hand, and dissatisfaction with and rejection of the old world on the other. Part of this hope manifests itself in the promise of a digital voice for groups traditionally far removed from political and economic power (Barry 1996: 137). For instance, Jennifer Light (1995) argues that the computer-mediated communications on the Internet, as they escape centralized political and legal control, may diversify and offer alternative courses of action for women.

But if there is a determinism at work in the utopian view of the future which such utterances seem to suggest, there is also a determinism in the uncritical acclaim with which future advances in the technology are hailed. Truly intelligent robots, shared virtual realities and cyberspace rest on technological advances which have not yet happened and may never happen. These technologies rest on the bedrock of particular advances in AI; they are by no means separate. This means we need to keep a cool head when thinking about VR and cybertechnology. It seems that cyberculture has yet to come to grips with the criticisms made about the possibility of truly intelligent technologies elaborated in chapter two. Truly realistic, virtual spaces and our virtual bodies within them have to respond in all the unimagined ways which might present themselves. For instance, Jon Dovey (1996: xi–xii) describes his first encounter with a VR system, wearing a headset and glove. Inserting a smart card into a slot and negotiating obstacles was fine, but when he tried to grab a packet of cigarettes hurtling by (the system was sponsored by a tobacco company), he fell over and the program continued to run despite his prostrate form. If the arguments of Dreyfus and Collins are to be taken seriously, in other words, arguments that we cannot capture all we know in a formal language, because what we know we know by dint of having bodies and growing up in particular cultures, then cyberculture needs to address these in relation to VR and cyberspace.

The comfort of cyborgs

If popular cyberculture offers little comfort for feminists then it may be that we should look elsewhere within the groves of cyberculture, to the writings of academic theorists and to studies of women's use of the Internet and VR, down among the MUDs and MOOs.[9]

While sociological studies of cyberculture are proliferating, one of the most potent images to emerge is that of the cyborg, or cybernetic organism. The idea of the cyborg hails from cyberpunk fiction and film but also predates it in older images of the fusion of human and machine. The cyborg is not a feminist invention, indeed in its manifestation in films such as *Terminator* and *Robocop* it is the epitome of masculine destruction, yet it has been appropriated as a feminist icon, most famously in Haraway's 'A cyborg manifesto' (1991b). It is difficult to overestimate the influence of her essay which John Christie (1993: 172) describes as having 'attained a status as near canonical as anything gets for the left/feminist academy'.

In Haraway's hands the cyborg works as an ironic political myth initially for the 1980s but stretching into and finding its full force in the next decade; a blurring, transgression and deliberate confusion of boundaries of the self, a concern with what makes us human

and how we define humanity. Her vision, coming before the upsurge of interest in VR and the naming of cyberculture, sees modern war as a cyborg orgy, coded by C^3I, command-control-communication-intelligence (Haraway 1991b: 150). In our reliance on spectacles, hearing aids, heart pacemakers, dentures, dental crowns, artificial joints, not to mention computers, faxes, modems and networks, we are all cyborgs, 'fabricated hybrids of machine and organism' (ibid.).

The cyborg is to be a creature of a post-gendered world. As the boundary between human and animal has been thoroughly breached, so too has the boundary between human and machine. The transgression of boundaries and shifting of perspective signals a lessening of the dualisms which have troubled feminist writers, and this means that we do not necessarily have to seek domination of the technology. This is a move away from earlier feminist theories towards a thoroughly postmodern feminism, which has since become a more mainstream part of feminist theory in the ten to fifteen years since Haraway's essay. Her cyborg imagery contains two fundamental messages:

> first, the production of universal, totalizing theory is a major mistake that misses most of the reality ... and second, taking responsibility for the social relations of science and technology means refusing an anti-science metaphysics, a demonology of technology, and so means embracing the skilful task of reconstructing the boundaries of daily life. ... It is not just that science and technology are possible means of great human satisfaction, as well as a matrix of complex dominations. Cyborg imagery can suggest a way out of the maze of dualisms in which we have explained our bodies and our tools to ourselves. This is a dream not of a common language, but of a powerful infidel heteroglossia.
>
> (ibid.: 181)

Why has Haraway's essay held such an appeal for feminists? It is partly due to the language she uses, the mixture of poetry and politics. Christie (1993: 175) notes 'its ability to move with a kind of seamless rapidity from empirically grounded political recognition of the profound and deadly military-industrial technologies to a cyborg empyrean'. It is also clear that slanting the picture, transgressing boundaries between machine, human and animal, strikes a significant chord with Actor-Network Theory research which has been emerging at around the same time in the science and technology studies arena. All this has caused an upsurge of academic interest in the programme of cyborg postmodernism, which, in terms of gender, sexuality and the body is found most notably in the work of Stone (1993, 1994, 1995), especially on boundary transgressions, and Balsamo (1996) on VR and bodies.

Cyberfeminism

If Haraway's 'A cyborg manifesto' has played so vital a role in spawning a feminist cyborg postmodernism, feminists may be disappointed in some of its offspring. For instance, in looking at the lure of cyberculture, Judith Squires (1996: 195) argues:

> whilst there *may* be potential for an alliance between cyborg imagery and a materialist-feminism, this potential has been largely submerged beneath a sea of technophoric cyberdrool. If we are to salvage the image of the cyborg we would do well to insist that cyberfeminism be seen as a metaphor for addressing the inter-relation between technology and the body, not as a means of using the former to transcend the latter.

It seems as if Squires is arguing that cyberfeminism, if indeed there is such a thing, is in danger of falling into the same trap with regard to the body, as cyberculture in general, which promotes a particularly masculine connotation of the new continuity of mind and machine. As I shall discuss below, although there are some feminist approaches to cyberculture which do not suffer from the same problems, it is with the writings of Sadie Plant, self-declared cyberfeminist, that Squires takes issue. Plant has done more than possibly any other writer, at least in the UK, to bring issues of women and cybernetic futures to a more popular audience (e.g. Plant 1993). Squires describes Plant's style as one which 'shares the apoliticism of the cyberpunks but also invokes a kind of mystical utopianism of the eco-feminist earth-goddesses' (Squires 1996: 204).

In addition, Plant's writing has a universalizing tendency against which Haraway and many other feminist writers have fought a long battle, arguing that women's experiences are not all of a piece. This manifests itself in statements such as 'Women … have always found ways of circumventing the dominant systems of communication' (Plant 1993: 13); 'they (women) are … discovering new possibilities for work, play and communication of all kinds in the spaces emergent from the telecoms revolution' (Plant 1995: 28); 'Women are accessing the circuits on which they were once exchanged' (Plant 1996: 170). But who are these women? Even allowing for the fact that some of this material was written for a more popular audience, it does not seem quite enough to say that 'facts and figures are as hard to ascertain as gender itself in the virtual world' (Plant 1995: 28). At least by the time of Plant's most recent writing there have been a number of empirical studies of women's use of the Internet, and many more on women and computing in general, some of which offer facts and figures (see for example Adam *et al.* 1994; Adams 1996; Grundy 1996; Herring 1996; Light 1995; Shade 1994, 1996). The lack of reference to these or any studies like them makes it difficult to know who are the women about which Plant is talking. This is a pity, given the rather pleasing image that she creates of women subverting the Internet towards their own ends.

There is plenty of evidence to show that women are still much in the minority in Internet usage, even in the USA, the most wired country in the world (Pitkow and Kehoe 1996). There is a tension between some women clearly finding the Internet a potent means of communication with one another, as witnessed by the proliferation of women's news groups, and the negative effects of stories about sexual harassment. It is this tension which prompts Kira Hall (1996) to talk of two forms of cyberfeminism. First, what she terms 'liberal cyberfeminism' sees computer technology as a means towards the liberation of women. On the other hand 'radical cyberfeminism' manifests itself in the 'women only' groups on the Internet which have sprung up in response to male harassment.

Susan Herring's (1996) well-researched study of discourse on the Internet shows that computer-mediated communication does not appear to neutralize gender. As a group she found women more likely to use attenuated and supportive behaviour whilst men were more likely to favour adversarial postings. These she linked to men favouring individual freedom, while women favour harmonious interpersonal interaction. And these behaviours and values can be seen as instrumental in reproducing male dominance and female submission.

There is also the view that interactions in cyberspace can magnify and accelerate inequalities and harassment found elsewhere, which is broadly the conclusion of Carol Adams's (1996) study of cyberpornography.

> [M]ultiple examples – including overt computer-based pornography and a careful
> analysis of male privilege in cyberspace – powerfully confirm feminist analyses of
> society and pornography. Indeed, it appears that certain features of cyberspace

can accelerate and expand the male dominance and exploitation of women already familiar to us 'in real life' (IRL).

<div align="right">(ibid.: 148)</div>

In case we imagine that all we have to do is literally to pull the plug, we should take heed of Stephanie Brail's story of the harassment she received by way of anonymous, threatening, obscene e-mail messages which she was unable to trace. These came in the wake of a 'flame war', an exchange of aggressive e-mail messages (or 'flames'), in a news group on alternative magazines, where she and others wished to talk about 'Riot Grrls', a postfeminist political group. 'At the mention of Riot Grrls, some of the men on the group started posting violently in protest … I … had no idea how much anti-female sentiment was running, seemingly unchecked, on many Usenet forums' (Brail 1996: 7). So fearful did she become, that she made sure the doors in her house were always locked and she practised self-defence. Brail adds that the real result is that she never gives out home phone numbers and addresses now and has stopped participating in Usenet news groups – 'And that is the true fallout: I've censored myself out of fear' (ibid.).

If it is difficult to recognize the women in Plant's writing, it is also difficult to recognize the technology. There is a mystical, reverential tone with which she treats 'complex dynamics, self-organizing systems, nanotechnology, machine intelligence' (Plant 1995: 28). The

> connectionist machine is an indeterminate process, rather than a definite entity. … Parallel distributed processing defies all attempts to pin it down, and can only ever be contingently defined. It also turns the computer into a complex thinking machine which converges with the operations of the human brain.
>
> <div align="right">(Plant 1996: 174–5)</div>

Unfortunately she threatens to become overwhelmed by the mystical qualities of these systems which organize themselves outside our control, and seems perilously close to Dennett's 'Woo Woo West Coast Emergence'.

Even Plant's metaphor linking women with weaving and the jacquard loom to the computer will not stand up very well when one considers that, for example, both in the cotton industry of North West England and in the silk industry centred on Macclesfield in Cheshire, the higher status and pay accruing to weavers made it, largely, although by no means completely, the domain of men rather than women. The control of jacquard hand-looms, a form of technology often linked to early computer design, was entirely in the hands of men, as the work was considered to be too skilled and too heavy for women (Collins and Stevenson 1995). It was spinning rather than weaving which was mainly the domain of working-class women.

But it is the loss of the political project, originally so important in Haraway's cyborg feminism which is most problematic in Plant's elaboration of cyberfeminism. Some of the reason for the loss is possibly because Irigaray is the only feminist writer to which Plant relates her work, and of all French feminist writing, in Irigaray is the least sense of there being any point in attacking the structures of patriarchy. More importantly, the problem may also relate to the coupling of cyberfeminism to cyberpunk, which deliberately sets itself apart from politics. Squires (1996: 208) finds this the most disquieting aspect of cyberfeminism; for although cyberpunk offers no hope of a better world, Plant is claiming that cyberfeminsm offers women a better future, but with no political basis to back this up.

Alternative feminist futures

In its cynicism over traditional political structures and its enthusiasm for information and communications technologies, cyberfeminism forgets that women's relationship to technology is not always positive. However there is much other research which can be used to paint a more balanced picture, which shows what use women *are* making of the new cybertechnologies and which can be used to preserve a sense of political project, even if there is no consensus as to what the politics should be.

Lyn Cherny and Elizabeth Reba Weise's *wired_women* (1996) collection paints a fascinating picture of some women's actual uses of Internet technology. As Howard Rheingold suggests on the back cover of the book, these are 'women who know their net culture from the inside', so they could well be candidates for Plant's cyberfeminists, subverting the pathways of the Internet for their own ends. It is no criticism to point out that the writers in this collection are highly educated North American women, doctoral students and computer professionals, clearly confidently enjoying and at home with their technology, with jobs and positions that not only provide the necessary technical equipment, but also permit them access and the time to use it. They are amongst the elite of technically confident women, yet amidst the cheerful humour and their easy natural usage of the new jargon there are many tales of male harassment on the news groups and bulletin boards.

Alongside the *wired_women* collection there are a number of studies, some of which are more directly focused on gender than others and which manage to eschew a 'doom and gloom' approach, yet at the same time offering more realistically positive pictures of feminist futures in computing than cyberfeminism manages to paint. Grundy's (1996) research on women working in computing in the UK, does make suggestions about 'What is to be done', though she acknowledges that a start is only now being made in moving beyond liberal feminism. Sherry Turkle's (1996) accessible and detailed psychological study of people's relationships and sense of self in relation to computers, although not allying itself explicitly to feminist theory, provides a sensitive discussion of gender and gender-swapping in on-line discussion groups. Ellen Balka (1993), Susan Herring (1993), Leslie Shade (1994) and Jennifer Light (1995) report detailed studies of women's use of computer networks. James Pitkow and Colleen Kehoe's (1996) surveys report an apparently massive increase of women's use of the world wide web, which is of considerable interest to feminist positions, although, incredibly, they manage to make no comment as to why this might be happening.[10]

The point I am making is that, in addition to the burgeoning cyberculture literature, there are increasing reports of women's use of computing, though much of the material I have cited above is North American in origin (and therefore not necessarily applicable elsewhere), and relates to networked information technologies rather than the specifically 'intelligent' technologies of VR, AI, A-Life and so on. Although it is very much feminist in tone, it does not usually engage with particular theoretical feminisms, especially not at an epistemological level.

However there is a recent attempt to combine a reading of popular cyberculture, the technology of VR and feminist theory in relation to the body, in Balsamo's *Technologies of the Gendered Body: Reading Cyborg Women* (1996). Balsamo's chief concern is what is happening to the image of the gendered material body in cosmetic surgery, body building, pregnancy surveillance and VR. She is anxious to avoid technological determinism and in seeing technologies as holding limited agency themselves, she argues against the idea that technologies will necessarily expand the control of a techno-elite (ibid.: 123). Nevertheless she wants to argue that VR technologies are involved in reproducing dominant power

relations and in particular that repression of the material body in VR does not create a gender-free culture.

In questioning how VR engages socially and culturally marked bodies, she suggests its appeal lies in the illusion of control over unruly, gendered and raced bodies at a time when the body appears increasingly under threat. In this sense the new technologies reproduce traditional ideas of transcendence, 'whereby the physical body and its social meanings can be technologically neutralized' (ibid.: 128). VR seems to offer us whatever body we want. Although cyberpunk fiction portrays the body as an obsolete piece of meat, this does not change the way in which power is played out along old gendered lines. Where Haraway (1991a) sees a 'demonology of technology' from both advocates and critics of cyberculture, Balsamo wants to question how far VR technologies will promote a rationalization of everyday life or the kind of decentralization and pluralism which Haraway advocates. Balsamo sees the need to bring together both the practices of cyberpunk and feminist theory although she guards against the apparently apolitical view that new information technologies necessarily bring better ways of using them.

She argues that far from being gender-free, women find that gender follows them onto the new communication technologies. In an argument which bears out the experiences of the *wired_women* she states:

> If on the one hand new communication technologies such as VR create new contexts for knowing/talking/signing/fucking bodies, they also enable new forms of repression of the material body. Studies of the new modes of electronic communication, for example, indicate that the anonymity offered by the computer screen empowers anti-social behaviors such as 'flaming' and borderline illegal behaviors such as trespassing, E-mail snooping, and MUD-rape. And yet, for all the anonymity they offer, many computer communications reproduce stereotypically gendered patterns of conversation.
>
> (Balsamo 1996: 147)

Such communication is graphically illustrated by some of the terminology that has crept in. Brail (ibid.: 142) calmly states that:

> a 'wanna fuck' is simply an email request for a date or sex. An email asking for a date is not in and of itself harassment, but what bothers many women on the Internet and on online services is the frequency and persistence of these kinds of messages.

Similarly, the terminology for asking a woman to stop posting messages to a news group is called a 'shut up bitch'. As these are terms used by men talking to women they have a specifically gendered vector. I wonder if there is a similar term that men use in relation to men, or women use for men (or are men less likely to be silenced altogether?). If these are examples of common parlance it begins to surprise me that women want to use the Internet at all. There is now a real need to hear of women's positive experiences of computer-mediated communication to balance such a picture.

Conclusion

I have been trying to build a bridge between artificial intelligence and feminist theory. In particular I have tried to show how AI is inscribed with a view from mainstream epistemology, however implicit that view might be. In the process it as been necessary to

uncover the ways in which women's and others' knowledge is ignored and forgotten in the building of real AI projects.

Feminist epistemology has been a useful tool in this process, partly because it allows an analytical scepticism to reside alongside a measure of realism and also because it is much more sociologically relevant than its more traditional counterparts. I have tried to show, through the medium of Cyc and Soar as paradigm projects, how symbolic AI reflects a subject who is a masculine rationalist ideal, Lloyd's (1984) 'man of reason'. Assuming that the subject need not be made explicit denies the possibility of a genuinely pluralistic discourse and is a kind of 'we' saying. This assumes that we all agree, that is if we are all reasonable people who belong to one of Foley's (1987) 'non-weird' perspectives. But the 'non-weird' perspective is the privileged, white, middle-class, male perspective, and an assumption that this does not even have to be made explicit is a way of silencing other perspectives.

In Cyc, this perspective is 'TheWorldAsTheBuildersOfCycBelieveItToBe'. In a strategy which mirrors the excessively simple 'cat sat on the mat' examples of mainstream epistemology, their authority maintains its hegemony and resists challenge by the use of a set of trivial and apparently apolitical examples with which it would seem churlish to quibble. Soar too is based on a set of experiments carried out on unrealistically bounded logico-mathematical problems carried out by a limited number of male college students in the 1960s and 1970s, with the assumption arising from this that their results can be extrapolated to apply to a wider domain of subjects and problem solving situations.

Dreyfus's (1972, 1979, 1992) critique of the way the propositional/skills distinction is handled in symbolic AI in general, and in the Cyc system in particular, remains important for a feminist analysis. Symbolic AI is good at representing the former, but not the latter. In keeping with mainstream epistemology, AI elevates propositional knowledge to a higher status than non-propositional knowledge – it assumes that skills knowledge can be reduced to propositional knowledge. Lenat and Feigenbaum (1991) assume that Cyc's assertions bottom out in 'somatic primitives'. Even so, I have argued that a simple equation of masculine ways of knowing with propositional knowledge and feminine ways of knowing with non-propositional knowledge does not do justice to the ways that gender is inscribed in the knowledge which AI systems represent. Dalmiya and Alcoff (1993) argue that we need ways of expressing gender-specific experiential knowledge, where the truth of some propositions may not be expressible in a gender-neutral language. This raises the whole question of the rational/irrational dualism and how this is maintained by the primacy of formally defined languages in a process of logocentrism.

The way that a number of aspects of knowing are not reducible to propositional knowledge, but rely instead on some notion of embodied skill, points to the role of the body in the making of knowledge. This is of particular interest in constructing a feminist critique because Of the ways in which women have traditionally been assigned the role of caring for bodies, leaving men free to live the life of the mind (Lloyd 1984; Rose 1994). Additionally embodiment has become an issue for AI and is addressed through the related domain of artificial life.

I argue that feminists are unlikely to find much comfort in screen-based A-Life systems, even those that promise virtual reality implementations, as they are strongly predicated on a deterministic sociobiology. Situated robotics offers a more promising line as attempts are made to locate these robots physically in an environment and have them interact with it. However both feminist theory and Collins's (1990) research from the science and technology studies direction, suggest that there are parts of knowledge which can only be transmitted by being culturally situated. Cog, the robot baby, is physically situated but

it remains to be seen whether it can be culturally situated in the appropriate sense. The embodiment that such robots possess is of a rather limited form. Their wanderings in the world, removing drinks cans, finding the centres of rooms and so on is rather aimless. To paraphrase a popular saying, we might suggest that they 'get an A-Life'. They might find more of a purpose to artificial life if they could learn to love each other, to care for and look after one another, or indeed look after us. In other words they could take on the forms of embodiment more usually associated with women's lives, i.e. the looking after and caring for bodies, young and old.

Looking at feminist visions of the future through intelligent technologies, the situation reveals some tensions. Feminist AI projects may attempt to 'dismantle the master's house with the master's tools' but they must be wary of inadvertently building on neat extensions to his house by mistake. Feminist readings of popular cyberculture are ambivalent. It seems unlikely that the promise of Haraway's (1991b) earlier rendering of cyborg imagery can be realized through current manifestations of cyberfeminism. However further research on women's use of computing technology at least offers the hope of alternative, more promising, readings.

In a sense I am telling but one more version of an old story. But by extending the bridge to other work on gender and technology, and in particular new information and communication technologies, I hope to show the possibility, at least, of bringing to empirical studies of where women find themselves in relation to these technologies a thoroughgoing, theoretically informed feminism. As the bridges are built I hope too that it will be possible to keep sight of the political project of feminism, for to show the markers of women's oppression is also to show that things can be different. By continuing to build on the practical projects just begun, and through women's refusal to give up the ground made in relation to the technology, we gain a glimpse, however small, of how things could be different.

Notes

1 In this section I allude to some of my own experiences, working in the computing department of a UK university; other reported examples have been drawn from experiences of colleagues both in my own and in other institutions, but of course anonymity must be preserved. The WiC newsletter, published several times per year, gives many stronger examples.

2 I have to thank the members of the Society of Women in Philosophy e-mail list (SWIP List) for introducing me to this term and its significance.

3 The occasion was the gender and technology session of the British Society for the History of Science/American Association for the History of Science Joint Meeting, July 1988, Manchester, UK.

4 This argument is elaborated more fully in Adam and Furnival (1995).

5 See chapter three, note 11.

6 Full project details are available in an unpublished report, Scott (1996). The latter is available on request from the author.

7 Lynne Stein, a senior roboticist in the Cog team has two real children. It is interesting to note that an article about her work stated this while no mention was made of her male colleagues' human offspring (Cog 1994).

8 This is analogous to the arguments made for having books on the Internet, rather than the 'real books' which we currently use. Apart from anything else, this denies the physical pleasures of books not only do they look and feel nice, they often *smell* nice too.

9 See Turkle (1996: 11–14) for definitions and descriptions of these and similar terms.

10 Pitkow and Kehoe (1996) report the results of four surveys in January 1994, October 1994, April 1995 and October 1995. The surveys covered the USA and Europe, but they do not state which European countries. As a percentage, female usage of the world wide web grew

from, 5.1 per cent in the first survey to 29.3 per cent in the fourth. However the first survey had 1,500 respondents growing to 23,300 responses for the fourth. The authors comment: 'This represents a strong shift in the increased acceptance and use of the Web by women' (ibid.: 107). Even allowing for the marked quantitative differences in the surveys, this seems to suggest a very considerable growth in women's Internet usage in a space of only eighteen months, which surely invites an explanation.

Bibliography

Adam, Alison, Emms, Judy, Green, Eileen and Owen, Jenny (eds) (1994) *IFIP Transactions A-57, Women, Work and Computerization: Breaking Old Boundaries – Building New Forms*, Amsterdam: Elsevier/North-Holland.

Adams, Carol (1996) '"This is not our fathers' pornography": sex, lies and computers', pp. 147–70 in Charles Ess (ed.) *Philosophical Perspectives on Computer-Mediated Communication*, Albany, NY: State University of New York Press.

Aronowitz, Stanley, Martinsons, Barbara and Menser, Michael, with Rich, Jennifer (eds) (1996) *Technoscience and Cyberculture*, New York and London: Routledge.

Balka, Ellen (1993) 'Women's access to online discussions about feminism', *Electronic Journal of Communications/La Revue Electronique de Communication* 3, 1 [to retrieve file by e-mail send the command: send balka v3n193 to comserve@vm.its.rpi.edu].

Balsamo, Anne (1996) *Technologies of the Gendered Body: Reading Cyborg Women*, Durham, NC and London: Duke University Press.

Barry, Ailsa (1996) 'Who gets to play? Access and the margin', pp. 136–54 in Jon Dovey (ed.) *Fractal Dreams: New Media in Social Context*, London: Lawrence & Wishart.

Bench-Capon, Trevor (ed.) (1991) *Knowledge-Based Systems and Legal Applications*, London: Academic Press.

Benedikt, Michael (ed.) (1994) *Cyberspace: First Steps*, Cambridge, MA and London: MIT Press.

Bordo, Susan (1987) *The Flight to Objectivity: Essays on Cartesianism and Culture*, Albany, NY: State University of New York Press.

Bowers, John and Churcher, John (1988) 'Local and global structuring of computer-mediated communication', *Proceedings of the ACM Conference on Computer-Supported Cooperative Work*, Portland, Oregon: 125–39.

Brail, Stephanie (1996) 'The price of admission: harassment and free speech in the wild, wild west', pp. 141–57 in Lynn Cherny and Elizabeth Reba Weise (eds) *wired_women: Gender and New Realities in Cyberspace*, Seattle, WA: Seal Press.

Brooks, Rodney A. (1991) 'Intelligence without representation', *Artificial Intelligence* 47: 139–60.

Cherny, Lynn and Weise, Elizabeth Reba (eds) (1996) *wired_women: Gender and New Realities in Cyberspace*, Seattle, WA: Seal Press.

Christie, John R. R. (1993) 'A tragedy for cyborgs', *Configurations* 1: 171–96.

Collins, Harry M. (1990) *Artificial Experts: Social Knowledge and Intelligent Machines*, Cambridge, MA: MIT Press.

Collins, Lorraine and Stevenson, Moira (1995) *Macclesfield: The Silk Industry*, Chalford, Stroud: Chalford Publishing.

Dalmiya, Vrinda and Linda Alcoff (1993) 'Are "old wives' tales" justified?', pp. 217–44 in Linda Alcoff and Elizabeth Potter (eds) *Feminist Epistemologies*, New York and London: Routledge.

Dovey, Jon (ed.) (1996) *Fractal Dreams: New Media in Social Context*, London: Lawrence & Wishart.

Dreyfus, Hubert L. (1972) *What Computers Can't Do: The Limits of Artificial Intelligence*, New York: Harper & Row.

—— (1979) *What Computers Can't Do: The Limits of Artificial Intelligence*, (2nd edition), New York: Harper & Row.

—— (1992) *What Computers Still Can't Do: A Critique of Artificial Reason*, Cambridge, MA and London: MIT Press.

—— (1996) 'Response to my critics', *Artificial Intelligence* 80: 171–91.

Easlea, Brian (1983) *Fathering the Unthinkable: Masculinity, Scientists and the Nuclear Arms Race*, London: Pluto Press.

Ess, Charles (ed.) (1996) *Philosophical Perspectives on Computer-Mediated Communication*, Albany, NY: State University of New York Press.

Featherstone, Mike and Burrows, Roger (eds) (1995) *Cyberspace/Cyberbodies/Cyberpunk: Cultures of Technological Embodiment*, London, Thousand Oaks, CA and New Delhi: Sage.

Fishman, Pamela M. (1983) 'Interaction: the work women do', pp. 89–101 in Barrie Thorne, Cheris Kramarae and Nancy Henley (eds) *Language, Gender and Society*, Rowley, MA: Newbury House.

Foley, Richard (1987) *The Theory of Epistemic Rationality*, Cambridge, MA and London: Harvard University Press.

Furnival, Chloe (1993) 'An investigation into the development of a prototype advice system for sex discrimination law', unpublished MSc dissertation, UMIST, Manchester.

Gibson, William (1984) *Neuromancer*, New York: Ace Books.

Gray, Chris Hables (ed.) (1995) *The Cyborg Handbook*, New York and London: Routledge.

Grbich, Judith E. (1991) 'The body in legal theory', pp. 61–76 in Martha A. Fineman and Nancy S. Thomadsen (eds) *At the Boundaries of Law: Feminism and Legal Theory*, New York and London: Routledge.

Gross, Paul R. and Levitt, Norman (1994) *Higher Superstition: The Academic Left and its Quarrels with Science*, Baltimore, MD: Johns Hopkins University Press.

Grundy, Frances (1996) *Women and Computers*, Exeter: Intellect Books.

Hall, Kira (1996) 'Cyberfeminism', pp. 147–70 in Susan C. Herring (ed.) *Computer-Mediated Communication: Linguistic, Social and Cross-Cultural Perspectives*, Amsterdam and Philadelphia, PA: John Benjamins Publishing.

Haraway, Donna (1991a) *Simians, Cyborgs and Women: The Reinvention of Nature*, London: Free Association Books.

—— (1991b) 'A cyborg manifesto: science, technology and Socialist-feminism in the late twentieth century', pp. 149–81 in Donna Haraway *Simians, Cyborgs and Women: The Reinvention of Nature*, London: Free Association Books [originally published in *Socialist Review* (1985) 80: 65–107].

Harding, Stella (1993) '"Coming of age" in software engineering? The rhetoric of professionalism in formal methods discourse', paper presented at the PICT National Conference, Kenilworth, Warwickshire, May.

Hayles, N. Katherine (1994) 'Narratives of evolution and the evolution of narratives', pp. 113–32 in John L. Casti and Anders Karlqvist (eds) *Cooperation and Conflict in General Evolutionary Processes*, Chichester: John Wiley.

Heeman, Peter A. and Hirst, Graeme (1995) 'Collaborating on referring expressions', *Computational Linguistics* 21, 3: 351–82.

Helmreich, Stefan (1994) 'Anthropology inside and outside the looking-glass worlds of artificial life', unpublished paper, Department of Anthropology, Stanford University, Stanford, California. [Available from author at this address or by e-mail on stefang@leland.stanford.edu].

Henwood, Flis (1993) 'Establishing gender perspectives on information technology: problems, issues and opportunities', pp. 31–49 in Eileen Green, Jenny Owen and Den Pain (eds) *Gendered by Design? Information Technology and Office Systems*, London: Taylor & Francis.

Herring, Susan (1993) 'Gender and democracy in computer-mediated communication', *Electronic Journal of Communications/La Revue Electronique de Communication* 3, 2 [to retrieve file by e-mail send the command: send herring v3n293 to comserve@vm.its.rpi.edu].

—— (1996) 'Posting in a different voice: gender and ethics in CMC', pp. 115–45 in Charles Ess (ed.) *Philosophical Perspectives on Computer-Mediated Communication*, Albany, NY: State University of New York Press.

Hirst, Graeme, McRoy, Susan, Heeman, Peter, Edmonds, Philip and Horton, Diane (1994) 'Repairing conversational misunderstandings and non-understandings', *Speech Communication* 15: 213–29.

Jansen, Sue C. (1988) 'The ghost in the machine: artificial intelligence and gendered thought patterns', *Resources for Feminist Research* 17: 4–7.

—— (1992) 'Making minds: sexual and reproductive metaphors in the discourses of the artificial intelligence movement', paper presented at the Electronic Salon: Feminism meets Infotech in connection with the 11th Annual Gender Studies Symposium, Lewis and Clark College,

March. [Author's address: Communication Studies Department, Muhlenberg College, Allentown, Pennsylvania 18104, USA.]

Lakoff, Robin (1975) *Language and Woman's Place*, New York: Harper & Row.

Lanier, Jaron (1989) 'Virtual environments and interactivity: windows to the future', *Computer Graphics*, 23, 5: 8 [panel session].

Laurel, Brenda (1991) *Computers as Theatre*, Reading, Mass.: Addison-Wesley.

Leith, Philip (1986) 'Fundamental errors in legal logic programming', *The Computer Journal* 29, 6: 545–54.

Lenat, Douglas B. and Feigenbaum, Edward A. (1991) 'On the thresholds of knowledge', *Artificial Intelligence* 47: 185–250.

Light, Jennifer (1995) 'The digital landscape: new space for women?', *Gender, Place and Culture* 2, 2: 133–46.

Lloyd, Genevieve (1984) *The Man of Reason: 'Male' and 'Female' in Western Philosophy*, Minneapolis, MN: University of Minnesota Press.

Lorde, Audre (1984) *Sister Outsider*, Freedom, CA: The Crossing Press.

MacKinnon, Catherine (1982) 'Feminism, Marxism, method and the state: toward an agenda for theory', *Signs: Journal of Women in Culture and Society* 7: 227–56.

—— (1983) 'Feminism, Marxism, method and the state: toward feminist jurisprudence', *Signs: Journal of Women in Culture and Society* 8: 635–58.

McRoy, Susan W. and Hirst, Graeme (1995) 'The repair of speech act misunderstandings by abductive inference', *Computational Linguistics* 21, 4: 435–78.

Metselaar, Carolien (1991) 'Gender issues in the design of knowledge-based systems', pp. 233–46 in Inger Eriksson, Barbara Kitchenham and Kea Tijdens (eds) *Women, Work and Computerization* 4, Amsterdam: Elsevier/North-Holland.

Moravec, Hans (1988) *Mind Children: The Future of Robot and Human Intelligence*, Cambridge, MA and London: Harvard University Press.

Nye, Andrea (1992) 'The voice of the serpent: French feminism and philosophy of language', pp. 233–49 in Ann Garry and Marilyn Pearsall (eds) *Women, Knowledge and Reality: Explorations in Feminist Philosophy*, New York and London: Routledge.

Palmer, Camilla (1992) *Discrimination at Work: the Law on Sex and Race Discrimination*, London: The Legal Action Group.

Pitkow, James E. and Kehoe, Colleen M. (1996) 'Emerging trends in the WWW user population', *Communications of the ACM* 39, 6: 106–8.

Plant, Sadie (1993) 'Beyond the screens: film, cyberpunk and cyberfeminism', *Variant* 14, Summer 1993: 12–17.

—— (1995) 'Babes in the net', *New Statesman and Society* January 27: 28.

—— (1996) 'On the matrix: cyberfeminist simulations', pp. 170–83 in Rob Shields (ed.) *Cultures of the Internet: Virtual Spaces, Real Histories, Living Bodies*, London, Thousand Oaks, CA and New Delhi: Sage.

Robins, Kevin (1996) 'Cyberspace and the world we live in', pp. 1–30 in Jon Dovey (ed.) *Fractal Dreams: New Media in Social Context*, London: Lawrence & Wishart.

Rose, Hilary (1994) *Love, Power and Knowledge: Towards a Feminist Transformation of the Sciences*, Cambridge: Polity Press.

Sanford, Linda T. and Donovan, Mary E. (1993) *Women and Self-Esteem*, Harmondsworth: Penguin.

Schroeder, Ralph (1993) 'Virtual reality in the real world: history, applications and projections', *Futures* 25, 11: 963–73.

—— (1994) 'Cyberculture, cyborg post-modernism and the sociology of virtual reality technologies: surfing the soul in the information age', *Futures* 26, 5: 519–28.

Scott, Maureen (1996) 'Conversation analysis model to incorporate gender differences', unpublished final year project report, Department of Computation, UMIST, Manchester.

Searle, John R. (1987) 'Minds, brains and programs', pp. 18–40 in Rainer Born (ed.) *Artificial Intelligence: The Case Against*, London and Sydney: Croom Helm (first published 1980).

Shade, Lesley Regan (ed.) 1994 'Special issue on gender and networking', *Electronic Journal of Virtual Culture*, 2, 3 [to retrieve electronically send command get ejvcv2n2 package to listserv@kentvm.kent.edu).

—— (1996) 'Is there free speech on the net? Censorship in the global information infrastructure', pp. 11–32 in Rob Shields (ed.) *Cultures of the Internet: Virtual Spaces, Real Histories, Living Bodies*, London, Thousand Oaks, CA and New Delhi: Sage.

Shields, Rob (ed.) (1996) *Cultures of the Internet: Virtual Spaces, Real Histories, Living Bodies*, London, Thousand Oaks, CA and New Delhi: Sage.

Smart, Carol (1989) *Feminism and the Power of Law*, London and New York: Routledge.

Spender, Dale (1980) *Man Made Language*, London: Routledge & Kegan Paul.

Squires, Judith (1996) 'Fabulous feminist futures and the lure of cyberculture', pp. 194–216 in Jon Dovey (ed.) *Fractal Dreams: New Media in Social Context*, London: Lawrence & Wishart.

Stone, Allucquère Rosanne (1993) 'Violation and virtuality: two cases of physical and psychological boundary transgression and their implications', unpublished manuscript [available in electronic form from sandy@actlab-rtf.utexas.edu].

—— (1994) 'Will the real body please stand up? Boundary stories about virtual cultures', pp. 81–118 in Michael Benedikt (ed.) *Cyberspace: First Steps*, Cambridge, MA and London: MIT Press.

—— (1995) *The War of Desire and Technology at the Close of the Mechanical Age*, Cambridge, MA and London: MIT Press.

Suchman, Lucy A. (1987) *Plans and Situated Actions: The Problem of Human Machine Interaction*, Cambridge: Cambridge University Press.

—— (1994b) 'Do categories have politics? The language/action perspective reconsidered', *Computer Supported Cooperative Work (CSCW)* 2, 3: 177–90.

Tannen, Deborah (ed.) (1988) *Linguistics in Context: Connecting Observation and Understanding*, Norwood, NJ: Ablex.

—— (1992) *You Just Don't Understand: Women and Men in Conversation*, London: Virago.

—— (1994) *Gender and Discourse*, New York and Oxford: Oxford University Press.

Thalmann, Nadia M. and Thalmann, Daniel (eds) (1994) *Artificial Life and Virtual Reality*, Chichester: Wiley.

Tong, Rosemarie (1994) *Feminist Thought: A Comprehensive Introduction*, London: Routledge.

Turkle, Sherry (1996) *Life on the Screen: Identity in the Age of the Internet*, London: Weidenfeld & Nicolson.

Wajcman, Judy (1991) *Feminism Confronts Technology*, Cambridge: Polity Press.

Winograd, Terry (1994) 'Categories, disciplines and social coordination', *Computer Supported Cooperative Work (CSCW)* 2, 3: 191–7.

Winograd, Terry and Flores, Fernando (1986) *Understanding Computers and Cognition: A New Foundation for Design*, Reading, MA: Addison-Wesley.

Cyberbodies

Barbara Kennedy

INTRODUCTION

It is time to question whether a bipedal, breathing body with binocular vision and a 1,400-cc brain is an adequate biological form. It cannot cope with the quantity, complexity and quality of information it has accumulated ... The most significant planetary pressure is no longer the gravitational pull but rather the information thrust. Gravity has molded the evolved body in shape and structure and contained it on the planet. Information propels the body beyond itself and its biosphere. Information fashions the form and function of the postevolutionary body.

(Stelarc 1991: 591, 594)

POST-STRUCTURALIST, POSTMODERN and more significantly contemporary virtualist philosophies of emergence, temporality and materiality continue to distanciate and problematize Cartesian epistemologies premised on mind/body differentials. Cyborg theory continues to play a 'vital' layer, fold or trace to the temporal rhythms which co-existently explore our contemporary experiences of mind and body. Identities, subjectivities, selves, bodies, minds and their relationships are terms which pervade such contemporary frameworks. This section of the Reader assembles and highlights a selection of readings which consider not only the cyberbody, but the post-cyberbody or post-natural cyberbody. In so doing it raises significant ontological and epistemological concerns with the definition of 'body' or 'bodies'. Through a wide range of post-sructuralist and philosophical discourses, the 'body' has become a complex assemblage embracing not only the Baudrillardian 'nodes' of communication, networks of communication and neural axes of dissemination, but Deleuzian abstract machines of heterogeneous rhythms, interstices, forces and intensities. Significantly, Baudrillard's (1993) ideas on *Symbolic Exchange and Death* find resonance in this section, where conceptions

of life/death are problematized through differently framed language beyond structuralist linguistics. Derridean deconstruction of the antinomies of life/death in Western thought, followed by Baudrillardian negation of Western metaphysical and Freudian psychoanalytic notions of death, have revitalized debates about death and the 'time of life' or 'time in life'-... death as part of a processual 'time in life', no longer relinquished to an end-point, fixed and intransigent mechanistic model of death. Contemporary performance artists continue to explore a wide range of embodied and disembodied forms of creativity through which to question, creatively mobilize, poeticize or narrativize the change which cyberculture continues to project upon our contemporary cultures. Artists such as Stelarc and Orlan are highlighted in this section of the Reader as 21st century icons of philosophically inspired art, whose use of the body is part of a processual engagement with and endeavour to explore the body's assemblages with new technologies. These are not just screenic technologies, but technologies of the 'self', technologies of 'thinking processes' and technologies of corporeality, providing an Harawayan heteroglossia of poetic and creative exploration of cyber/post bodies in the 21st century. But, as I explored in the first edition of *The Cybercultures Reader*, cyberculture melds terms beyond any fixed categorizations: body, machine and nature are imbricated in a bricolaged assemblage which problematizes Western and Cartesian claims to universal, fixed definitions. My own cyberbody emerging from its incipient death from a car crash (at that time a processual death which quickly projected me into 'life') pushed me into new zones of indiscernibility from which to explore the complexities of our new technologized body/worlds (Kennedy 2000). Whilst exploring the relationship between the computer and the body within contemporary cybercultures, this section goes further in its desire to explore the post-*natural* spaces of post-bodies, and their transformations, mutations and disembodiments through and across other machines and cyberspatial zones, where death and life become consensual hallucinations for exploration.

We begin this selection with Deborah Lupton's article, also published in our first edition, which explores the complexities and idiosyncrasies of the computer/human interface, in 'The Embodied Computer/User'. Many will continue to recognise the 'emotional' involvement we 'feel' with our machine, as Lupton explores the human traces of machinic behaviours. The screenic face still provides the psychoanalytic mirror of reflection, identifying the self but also the distanciated 'other'. One's time spent looking at a screen is on balance greater than that spent looking into another's face/ a lover's face? Lupton explores the corporeal, embodied nature of this interrelationship, describing the use of the pen as 'strangely awkward'. Yet at this moment in time, I choose to write with a pen... constantly disavowing the cyberspatial 'controls' of technology, to re-engage with my choreographed and pathic, gestural mimesis of pen on paper. Like the artist who needs to feel her hands in the paint on the canvas, I need to dance a script, exploring flows, rhythms, and energies; finger into hand, into pen, into surface, watching the ink slowly melt into the air, not statically point a text. No cyborg here! (And certainly something with which Lupton would take issue!) Are such choreographies lost forever in the zones of cybertechnologies? (Just a complex immixture of

humanist and posthumanist thinking.) I nonetheless feel the desires of screenic creativity but differently choreographed. Lupton explores what she refers to as the 'psychophotography' of the human/computer interface, where subjectivity resides not merely in the human, but across the machinic relationship. Computers, she argues, become machinic selves, but embodied in the human self.

The screen may scream out for the next breath on its skin, the next imprint on its body. But where is that felt; where is that consumed by the passional user? Too human... all too human? Such questions Lupton would distanciate, for to her, the computer performs with a viral contamination which pervades the organic body. Her article continues with an exploration of the risk factors of such viral contamination, both personally but also within a globalized economy. She articulately describes the original cyborg 'actants' of popular culture, then the mythologies surrounding the hacker's body. She argues that their 'bodies' are 'inscribed upon and constructed through the computers they use'. Lupton explores the notion of the disembodied computer user: cyberspace as a space/time zone through which to escape the manifold human fleshiness and leakiness of the body's physical frailties. The metaphor of 'computer as human' (and reverse) tries to deny the irrationality of embodiment, but this vision of an idealized virtual body is, she adds, 'the apotheosis of post-Enlightenment separation of body from mind'.

Reminiscent of my technologized near-death experience, where nature, the body and technology were assemblaged across, through and beyond subjectivity, cyborg spectres of the unknown, Sandy Stone's seminal article, 'Will the Real Body Please Stand Up' explores how our new technological architectures, valencies and temporalities constitute a new conception of the *natural*. Culture and nature are intertwined and assemblaged through the technological. Subjectivities, identities, bodies, no longer remain intransigent, fixed perspectives, but are heterogeneous, 'becomings' processualized through the technosensorium. This 'promise of monsters' which Haraway foresaw portrays agentic and larval 'selves' functioning at the heart of the machine. Bodies here are not necessarily living, humanoid bodies, but actants functioning and connecting with us from a posthuman *situ*: dangerous but delectable possibilities, albeit potential cyborgs of the uncanny places! Machines, intricate, miniature and multiplicitous, generate as part of a wider machine of human/computer interaction. But, again, argues Stone, the boundary collapse of nature, society and technology is symptomatic of the larger machinations of the cybermachine. New social spaces have indeed been opened up and become accessible sites for newly framed autonomous selves and identities (See Part Five).

Stone's primary desire is to explore cyberspatial communities and how they work. This begins with the 'boundary stories' of cybercommunities, the first the disturbing case of online deception and abuse. Whilst online performativities enable and mobilize new spaces for creative practice and new identities, nonetheless such arenas are open to abuse. Stone reveals how this schizophrenic state can be assemblaged and actioned to deceive, destratify and re-territorialize identities and subjectivities, not only of one's self, but multiple others. Perhaps now, seven years on from our first collection of essays, the 'techno-naivety' of many users (statistically women) may have been eradicated. I think not! Time and knowledge,

however, may have helped to erase the levels of risk and abuse suffered by many. *I need to 'see' your face, to 'feel' your touch, your breath on my skin. Only then can I trust again.* The question of identity is clearly explored through Stone's social forms, virtual systemic spaces which mobilize the growing connectivities between humans and machines.

This exposition of new 'virtual systems' is contextualized through an historical narrative of similar systems where four epochs are outlined in relation to communal activities premised upon consensual ideas, communication and a notion of community. The narratives convey a range of possibilities for experiencing the relationship between physical human bodies and identities. Historically, technology became a significant actant in that relationship. Virtual systems necessitated and consolidated an 'interface ... mediating between the human body (bodies) and an associated 'I''. Inevitably, this created questions regarding the nature of identity and subjectivity and indeed their formulations. Stone continues with outlines of the third epoch, then the concept of the CommuniTree, where new discourses become part of a new land of social experiment. So, the imaginal spaces of such cybercommunities provided people opportunities to expand their bodily sensorium beyond the corporeal into imaginal spaces. It was Gibson's *Neuromancer* which opened up the creative vistas for performative virtual communities, enabling a new kind of social interaction. In the information age which Baudrillard sets against the industrial economy, the Cartesian split of mind/body is co-existently growing but also disappearing. As Stone indicates, 'The boundaries between subject if not the body, and 'the rest of the world' are undergoing radical refiguration, brought about in part through the mediation of technology'. Rather than a concern with how we can continue to thrive in a world where nature is increasingly technologized, Stone's overriding argument is that rather than 'nature becoming technologized, technology is nature ... the boundaries between subject and environment have collapsed'.

What is fundamental to new ideas about the body is that our contemporary cybercultural communities have discovered the pleasures of delegating agency to the technologized body: representatives existing in imaginal spaces: avatars of desire. With citations from Baudrillard, Haraway, Dagognet and Rabinow, Stone defends the belief that technology is in fact a 'becoming-nature' where the boundaries between subject and environment have collapsed.

Cyberbodies are explored and experienced not purely through the digital spaces of computer interactions. Performance artists like Stelarc experiment with the poetic and mimetic spaces of mutation, incorporation, prosthesis and technologized assemblages which invoke philosophical, cultural, social and artistic questions. Stelarc, however, is not endeavouring to claim some transhuman or posthuman apotheosis for the corporeal body, or a body freed from the capitulations to death, illness, ageing and regression, but to poetically engage with some manifestations of these possibilities in our experiences. Inevitably, his cyborgized artwork encourages much epistemological debate. Mark Dery writes that 'Stelarc's cybernetic events are dress rehearsals for posthuman evolution. High tech prostheses and medical technologies for monitoring and mapping the

body hold forth the promise of self-directed evolution.' (Dery 2000: 580). Stelarc's desire is to mobilize conceptualizations of 'body'/ 'the body' away from the psychobabble realm of biology into what he calls the 'cyberzone of the interface and extension from genetic containment to electronic extrusion'. Dissatisfied with the genetic, physiological restrictions of our flesh-and-blood bodies and our psychoanalytic conceptions of self and identity, Stelarc's performative lines of flight take him into molecular zones of posthuman futures. Philosophically, it is a move away from the 'self' to new systems of evolutionary process. A human-machine symbiosis; self eradicated; systems becoming. He contextualizes his art works in a culture of bodies and minds which he believes can no longer sustain the output and inertia of information overload. *When did you last tidy up your inbox?... undigested data?... too late. Overload. Shut down!* Let the body modify, mutate, mobilize and molecularize. Ideas and the mind have molarized us for too long. Reproduction is insufficiently creative to produce the new DNA codings of machine-human interactions.

In his endeavour to redesign the posthuman body, Stelarc's performances have involved a complexity of prosthetic and incorporative strategies; the construction of a third ear, which, once grown as a new prosthesis, emits rather than receives sound. Symbolically, hearing is a sense which is often relegated in our cultural sensorium. His stomach sculpture and amplified bodily experiments have produced fascinatingly febrile and fibrillatory delights; brain waves, muscles, blood flows, heart rates are part of the symphony of self-mutation. Again, Stelarc is intuitively responsive to the beauty and choreography of sound: 'buzzing, warbling, clicking, thumping, beeping and whooshing sounds... of triggered, random, repetitive and rhythmic signals'. His stomach sculpture similarly evokes a plethora of aesthetic tendencies and intensities.

Robert Ayers' interview with performance artist Orlan continues the theme of performative posthuman artwork. Quite recently, and interestingly in France, the first face transplant operation was performed on a woman whose identity had been ripped away by a vicious dog attack. Philosophically the face has held significant symbolic resonances; psychoanalytic expressions of identity formation heralded the mirror phase through which we acquire a sense of who we are, a sense of identity: one both fragmented and differentiated from A.N.Other. In feminist and cultural theory, explorations of the beauty and cosmetics industry have voiced both discord and approbation. Radical feminist concern with a beauty industry organized for profit by a capitalist, patriarchal economy, was traditionally resisted and challenged (Woolf 1991). Alternatively, post-feminists have sought to challenge such outdated views by enjoying and playing with the pleasurable playground of beauty and body modifications, manipulating their appearances, in ironic confrontation with patriarchal ideology, but also in joussancial enjoyment of its pleasures.

Orlan's work endeavours to explore the face of woman and its culturally specific determinations, and what comes across most specifically is her desire to engage with 'difference'. She is fascinated by different perceptions of beauty outside of Western cultures. Her aims are to 'question the status of the body in society

and in particular, the status of the female body'. Her work, however, is much more than an exploration of external visual beauty and its contradictions. Her performances invoke wide-ranging ideas about death, otherness and the aesthetic. The posthuman body is here one which is physically altered, manipulated, distorted and re-formed, as both philosophical and poetic process. Her engagement at post-production levels with digitally manipulated images incorporates the cyberghosts and spectres of the macabre, which Waldby also explores in her article 'Revenants: Death and the Digital Uncanny'.

To both Orlan and Waldby, technology becomes part of a processual alteration and manipulation of physiologically presented 'images' digitally removed from any representational zone of enquiry. The technology is part of the processual beauty of the art performance. Ayers' article endeavours to consider Orlan's most recent works in Self Hybridization, from her earlier drama/performative pieces. The latter is the best known of her work. I first encountered Orlan's performance at the *Virtual Futures* Conference in Warwick in 1995, at a time when cybertheory was mutantly prescient. Writers like Sadie Plant, Manuel de Landa, Bruce Sterling, Scott Bukatman, were performing alongside artists like Stelarc and VNS Matrix and of course Orlan. This was no ordinary lecture but a visceral and disturbing multi-media performance invoking participation from an audience uncertain about its own parameters. 'Flirt with the person next to you', Orlan ordered. This was to distance one's physical alienation at some of the video images. Flirting with fluttering transgression with my neighbour to 'look away and avert the gaze' at the grotesque, I saw instead my young, male counterpart faint hopelessly to the ground! Ayers describes such performances which Orlan situates within the interstices of philosophical and academic debate – part of the performativity. Her appearance is both visually transgressive (the black and yellow hair, the physically altered facial prostheses, the black lips) whilst also euphemistically adhering to Western notions of beauty in the grace of her demeanour, the slender but curvaceous body, the feline accoutrements, black clothes and cyborgian, *noiresque* stilettos. She quite literally makes her performance 'out of herself...her punctured and scraped flesh and trickling blood....' Her recent work utilizes the virtual realm of digitality to explore differently conceived notions of beauty from other cultures, which she folds into an assemblage with manipulated images of herself. A hybridization – *not* she argues a representation of identity, but a concern with change, perception and posthuman configuration. Her ideas are to disturb, to mobilize and to actualize; virtual possibilities of human notions of beauty, read by academics, artists and philosophers in a variety of ways. At the time of writing, the artists Jake and Dinos Chapman are exhibiting work at the Tate in Liverpool which also evokes and mobilizes disturbing art(efacts) which deterritorialize preconceived ideas about art and indeed about the human. Their aim is not to represent anything human at all but to mobilize action, disturbance, volitions, as mobilizations, *not* representations of the compelling urgency and joyful cruelty of life.

What I find most interesting, however, is Orlan's belief in the negation of binary thought. Her work is thus both *and/or* not *either/or* and is therefore a virtualist artistic process. Her work actualizes an *and/or* continuum which neither negates nor

prioritizes either aspect. Her work with the virtual, is both 'digital' and 'virtualist'. Her work, she argues, 'is based on the notion of 'and'': the good *and* the bad, the beautiful *and* the ugly… oops! No reference to Clint Eastwood intended.

Catherine Waldby's article 'Revenants: Death and the Digital Uncanny' introduces us to counterarguments regarding the significance of the (in)famous Visible Human Project (VHP), which set up the virtualization in cyberspace of the dead male and female forms. Death is problematized and re-appropriated in Waldby's ideas. Her argument is framed within an exploration of the concepts of *iatrogenic* desire (a desire circulating in the fin-de-millennium context of a biomedical imaginary). Such a desire operates within a consideration of the uncertainties of relationships between technologies and bodies. It works outside of a purely scientific or objective rationality where fantasy of mastery over nature and matter are always prominent. A biomedical imaginary, explains Waldby, 'refers to the speculative, propositional fabric of medical thought, which supplements the more strictly systematic, properly scientific thought….' Consequently, elements of the fictitious, the connotative, the mythological and the imaginal are located through a connection with philosophical ideas about death, the imaginary, the speculative and desire. Images created through new technological forces like MRI scanning, ultra-sound, infra-red (and we could also conjecture computer assisted tomography and positron emission tomography) equally place the interior of matter for external speculation – a penetration through scopophilic and voyeuristic pleasures. The control and consensual understanding of novel images such as the VHP figures (with their connotative Adam and Eve nomenclature) is confined and monitored within the scientific panopticon.

Yet medical technologies become imbricated within a wider popular cultural infrastructure. The fine art world proliferates with performance art which embraces medical technologies to explore the technocultural interface of matter, machine and (hu)man. The specialist audience of science is limited in its readings of such imaginal spaces and such images become part of a wider domain than the purely clinical. Contemporary fascination with the 'inside' of the human body continues to proliferate in media culture and the art world. But this is an inside that is no longer taboo. Representational images on televisual or filmic screens are mobilized in assemblage with the computerized and technocultural, digital bodies, such as the VHP. How do we read, understand, interpret, appropriate or contextualize these digital/representational forces above and beyond their scientific orders of being? How do they 'become' other within our body/world events of 'living'? How does death become part of life and a digitally prescribed death a manifestation of death-in-life?

Waldby's essay is an exploration of the intertextuality that provides anomalous interpretations, in this case as she openly admits, pursuing a 'gothic and abject aesthetics'. In so doing Waldby provides a philosophically driven text reterritorializing notions of death, the value and vitality of the corpse, and debates within humanist discourse on reason and technical progress. She states, 'the figures seem to partake simultaneously of living and dead states', comparing them with still life components where life is still manifest, albeit entropic, transmuting in process. Think for example

of Leonardo's fascination for the processes and workings of the body and post-life bodies which decay, or contemporary artist Damien Hirst's fascination with the viral explorations of animal/human connections. Moreover, the artist Gunter von Hagens recently caused controversy through the exhibition of decaying and decomposing human bodies, his desire to show the vital workings of human forms as a vital part of a process of life. (Had not Leonardo done something similar?) Like Waldby, von Hagens is interested in exploring the process of life-in-death and death-in-life, where death is part of a continuum of becoming. Waldby refers us to historical anatomical explorations, seemingly reminiscent of religious myths. The VHP figures, she argues, convey the 'disavowed centrality of the corpse and death to the medical idea of life'. Drawing on ideas from Foucault, Keane and Tierney, she explores how the medical community always defers that final moment of death, protecting the body on the side of life. But Waldby reads the 'uncanny' of the digital corpse, the space of a 'time-of-living', not a fixed point of decay and contamination and certainly not a final moment. She challenges a logic of opposites which clearly prioritizes a time-of-life outside of death, the corpse a symbolic performance of its redundancy to life. She appropriates such readings explaining the contemporary biotechnologies called upon newly dead matter for its biovalue to future life. Thus she argues there is a 'processual death' rather than a fixed moment of dying. Death is a distributed temporality rather than a fixed moment, drawing on the ideas from Leder and Grosz, both of whom contest mechanistic models of death, where the corpse embodies the Cartesian idea of the body as 'animated or de-animated mechanism'.

Waldby's article melds with Orlan's explorations of 'body' and her performative art works, where the body is immortalized into a corpse-like state for surgery. Similarly, in medical practice, the body is immobilized through narcosis, thus emulating a corpse like trans-consciousness; the body-as-object marks the place where the 'self' is relinquished. Drawing on post-structuralist and continental philosophy Waldby questions the dichotomies of such positionalities, reading popular discourses of horror through contemporary debates on the 'process' of life. In so doing, she positions both Kristeva and Young in their formulations of the psychoanalytic configurations of abjection, where the 'self' is finally expelled and engulfed. Our contemporary cybercultural experiences proliferate with such shifting and blurring limits, produced anxieties around posthuman ideas of technically constituted 'personae' where the 'self' is manifest beyond the 'absence' of the body (see Moravec in Part Seven). Can virtual space thus resurrect the dead? Is virtual space a locus of vitality? These are questions Waldby follows through in the section on Freud's notion of the 'uncanny', locating the VHP as re-animated corpses and virtual automata. Haraway's work may have distanciated psychoanalysis, origins of the Garden of Eden, but in this analysis of the digital uncanny, gothic formulations of the 'doppelganger', Waldby's work evokes both ontological and epistemological questioning of 'the paradoxical phenomenality, the furtive and ungraspable visibility of the invisible, the tangible intangibility of a proper body without flesh, but still the body of someone as someone other' (Derrida 1994: 7).

Waldby's argument is that the VHP has elements of the uncanny, partially because cyberspace and digital space equates with a notion of the supernatural, as both Cubitt (1996) and Tomas (1994) argue. Cubitt's exploration of the post-natural fittingly provides a conclusive section for Waldby's article. He advocates the concept of the cybernatural, a form of the post-natural, which enables a methodology for explaining specific forms of life which seem to transcend the 'life' of an organic or material world. Our fin-de-millennium cultural moment in cyberculture fascinates with its complexities, anxieties and intensities of biotechnological machines. But still, in our deep, dark recesses, lies the spectral haunting of the *unheimlich*.

References

Baudrillard, J. (1993) *Symbolic Exchange and Death*, London: Sage.

Cubitt, S. (1996) 'Supernatural futures: theses on digital aesthetics', in G. Robertson, M. Mash, L. Tickner, J. Bird, B. Curtis and T. Putnam (eds) *FutureNatural: Nature, Science, Culture*, London: Routledge.

Derrida, J. (1994) *Specters of Marx: the State of Debt, the Work of Mourning and the New International*, trans. Peggy Kamuf, New York and London: Routledge.

Dery, M. (2000) 'Ritual mechanics: cybernetic body art', in D. Bell and B. Kennedy (eds) *The Cybercultures Reader*, first edition, London: Routledge.

Kennedy, B. (2000) 'The 'virtual machine' and new becomings in pre-millennial culture', in D. Bell and B. Kennedy (eds) *The Cybercultures Reader*, first edition, London: Routledge.

Stelarc (1991) 'Prosthetics, robots and remote existence: postevolutionary strategies', *Leonardo* 24: 591–4.

Tomas, D. (1994) 'Old rituals for new space: *Rites de Passage* and William Gibson's cultural model of cyberspace', in M. Benedikt (ed) *Cyberspace: First Steps*, Cambridge, MA: MIT Press.

Woolf, N. (1991) *The Beauty Myth*, London: Vintage.

Deborah Lupton

THE EMBODIED COMPUTER/USER

WHEN I TURN MY PERSONAL computer on, it makes a little sound. This little sound I sometimes playfully interpret as a cheerful 'Good morning' greeting, for the action of bringing my computer to life usually happens first thing in the morning, when I sit down at my desk, a cup of tea at my side, to begin the day's work. In conjunction with my cup of tea, the sound helps to prepare me emotionally and physically for the working day ahead, a day that will involve much tapping on the computer keyboard and staring into the pale blue face of the display monitor, when not reading or looking out the window in the search for inspiration. I am face-to-face with my computer for far longer than I look into any human face. I don't have a name for my personal computer, nor do I ascribe it a gender. However, I do have an emotional relationship with the computer, which usually makes itself overtly known when something goes wrong. Like most other computer users, I have experienced impatience, anger, panic, anxiety and frustration when my computer does not do what I want it to, or breaks down. I have experienced files that have been lost, printers failing to work, the display monitor losing its colour, disks that can't be read, a computer virus, a breakdown in the system that stopped me using the computer or email. I live in fear that a power surge will short-circuit my computer, wiping the hard disk, or that the computer will be stolen, and I assiduously make back-up copies of my files. I have written whole articles and books without printing out a hard copy until the penultimate draft. I cannot imagine how it must have been in the 'dark ages' when people had to write PhDs and books without using a computer. I can type much faster than I write with a pen. A pen now feels strange, awkward and slow in my hand, compared to using a keyboard. When I type, the words appear on the screen almost as fast as I formulate them in my head. There is, for me, almost a seamless transition of thought to word on the screen.

These personal reflections raise the issues of the emotional and embodied relationship that computer users have with their personal computers (PCs). While people in contemporary Western societies rely upon many other forms of technology during the course of their everyday lives and, indeed, use technological artefacts to construct a sense of subjectivity and differentiation from others, the relationship we have with our PCs has characteristics

that sets it apart from the many other technologies we use. For the growing number of individuals who rely upon their PCs to perform work tasks, and for others who enjoy using their PCs for entertainment and communication purposes, conducting life without one's PC has become almost unimaginable (how *do* people write books without them?).

However, the cultural meanings around PCs, including common marketing strategies to sell them and the ways in which people tend to think about their own PC, relies on a degree of anthropomorphism that is found with few other technological artefacts. While we may often refer to cars as human-like, investing them with emotional and personality attributes, they are rarely represented as 'friends', 'work companions' or even 'lovers' in quite the same way as are computers. As Heim has commented,

> Our love affair with computers, computer graphics, and computer networks runs deeper than aesthetic fascination and deeper than the play of the senses. We are searching for a home for the mind and the heart. Our fascination with computers is more erotic than sensuous, more deeply spiritual than utilitarian.
>
> (Heim 1992: 61)

In his book *Bodies and Machines*, Seltzer refers to the 'psychotopography of machine culture', or the way in which psychological and geographical spaces cross the natural and the technological, between interior states and external systems; how bodies, persons and machines interact (1992: 19). I am interested in the 'psychotopography' of the human/ computer relationship, the ways that humans think, feel and experience their computers and interact with them as subjects. Rather than the computer/human dyad being a simple matter of self versus other, there is, for many people, a blurring of the boundaries between the embodied self and the PC. Grosz (1994: 80) notes that inanimate objects, when touched or on the body for long enough, become extensions of the body image sensation. They become psychically invested into the self; indeed, she argues, '[i]t is only insofar as the object ceases to remain an object and becomes a medium, a vehicle for impressions and expression, that it can be used as an instrument or tool'. Depending on how inanimate objects are used or performed by the body, they may become 'intermediate' or 'midway between the inanimate and the bodily' (Grosz 1994: 81). These observations are useful for understanding the blurriness and importance of the computer/user relationship. This relationship is symbiotic: users invest certain aspects of themselves and their cultures when 'making sense' of their computers, and their use of computers may be viewed as contributing to individuals' images and experiences of their selves and their bodies.

In a previous article (Lupton 1994), I explored the ways in which the viral metaphor, when used in the context of computer technology, betrays a series of cultural assumptions about computers and human bodies. I argued that popular and technical representations of computer viruses draw on discourses that assume that computers themselves are humanoid and embodied (and therefore subject to illness spread by viruses). What is more, similar cultural meanings are attached to the viral infection of computers as are associated with human illness, and in particular, the viral illness of HIV/AIDS. That is, there are a series of discourses that suggest that computers which malfunction due to 'viral contamination' have allowed themselves to become permeable, often via the indiscreet and 'promiscuous' behaviour of their users (in their act of inserting 'foreign' disks into their computer, therefore spreading the virus from PC to PC). I pointed out that computer viruses are manifestations of the barely submerged emotions of hostility and fear that humans have towards computer technology.

In the present discussion I want to expand my previous consideration of the embodied relationship between computers and their users, with a particular focus on

subjectivity and emotional states in the context of an ever-expanding global interlinking of PCs on the Internet, 'the world's largest network of computer networks' (Neesham 1994: 1). In the wake of the Internet the computer/user relationship has been extended from an atomized and individualized dyad. The PC now can be used by individuals to link into information networks and exchange messages in real time with others around the world. In that respect, the burgeoning Internet technology is not so different from telephone technology. However, a major difference lies in the risks that have recently attracted much media attention in relation to using the Internet. The attractions of the Internet, including its accessibility, are also a source of problems around security and the activities of computer 'hackers' and 'cyber-criminals'. This chapter explores the implications of this for the computer/user relationship, with a focus on the mythic and 'irrational' meanings 'that are very close to the surface in computer culture', disrupting 'rational' and depersonalized meanings (Sofia 1993: 116). I draw on a number of popular and more arcane texts to do so, including advertisements and articles about computers and users published in newspapers and news magazines, *New Scientist* magazine, *Wired* (a specialist magazine for Internet users) and academic writings about the computer/user relationship.

The disembodied computer user

A central utopian discourse around computer technology is the potential offered by computers for humans to escape the body. This discourse of disembodiment has been central in the writings of influential 'cyberpunk' novelist William Gibson and the cultural theorist and feminist Donna Haraway. In computer culture, embodiment is often represented as an unfortunate barrier to interaction with the pleasures of computing; as Morse (1994: 86) has put it, 'For couch potatoes, video game addicts and surrogate travellers of cyberspace alike, an organic body just gets in the way'. In cyberwriting, the body is often referred to as the 'meat', the dead flesh that surrounds the active mind which constitutes the 'authentic' self. The demands of the fleshly body compel computer users to distract themselves from their pursuit to seek nourishment and quell thirst and hunger pangs and, even worse, to absent themselves to carry out such body maintenance activities as washing, expelling bodily wastes and sleeping. The dream of cyberculture is to leave the 'meat' behind and to become distilled in a clean, pure, uncontaminated relationship with computer technology. 'The desire for an evolutionary transformation of the human has shifted focus from the preparation for the journey into "outer space" from a dying planet to the virtual "inner" space of the computer' (Morse 1994: 96).

The 'human as computer' metaphor is frequently drawn upon in this attempt to deny the irrationality of embodiment. Human brains, for example, are frequently described as 'organic computers' (Berman 1989). Sofia notes that the computer/human elision in this metaphor tends to represent human thought as calculating, rational and intentional, suppressing other cultural meanings around thought process and the unconscious:

> both the computer and the brain become representable as entirely 'rational' entities in a move which, on the one hand, obscures the fantasies attached to computing (e.g. the dream of mastery) and, on the other, portrays human mental activity as a mode of digital processing, entirely ignoring processes like joking, wishing, dreaming or imaginative vision and speech.
>
> (Sofia 1993: 51)

The idealized virtual body does not eat, drink, urinate or defecate; it does not get tired; it does not become ill; it does not die (although it does appear to engage in sexual activity, as all the hype around 'teledildonics' and virtual reality suggests). This vision may be considered to be the apotheosis of the post-Enlightenment separation of the body from the mind, in which the body has traditionally been represented as earthly, irrational, weak and passive, while the mind is portrayed as spiritual, rational, abstract and active, seeking constantly to stave off the demands of embodiment.

The cyborg has been represented as the closest to this ideal that humans may attain; that is, a 'humanoid hybrid' that melds together computer technology and human flesh (Haraway 1988). In an era in which risks to the health and wellbeing of the fleshly body abound, in which ageing and death are feared, the cyborg offers an idealized escape route. The cyborg form is evident in drug advertisements directed at medical practitioners, representing the ideal body as that which is invulnerable to illness, whose susceptibility to disease and death is alleviated by the drug therapy (Lupton 1993). In filmic portrayals of the cyborg, such as *Blade Runner* and the *Terminator* and *RoboCop* series, the cyborg body is portrayed as far stronger than the human body and far less susceptible to injury or pain, often able to self-repair in a matter of seconds. The cyborg body thus addresses anxieties around the permeability of body boundaries in its clean, hard, tightness of form. These anxieties are gendered, for the boundaries of the feminine body are viewed as being far more permeable, fluid and subject to 'leakage' than are those of the masculine body (Theweleit 1987; Grosz 1994). It is for this reason that men find the concept of the cyborg attractive in its sheer invulnerability: the cyborg body is constituted of a hard endoskeleton covered by soft flesh, the inverse of the human body, in which the skin is a vulnerable and easily broken barrier between 'inside' and 'outside' (Jones 1993: 84). In these discourses the cyborg is therefore a predominantly masculine body, as contrasted with the seeping, moist bodies of women.

There is a point at which the humanity of the cyborg must make itself felt; there *are* limits to the utopian vision of the cyborg as glossed in both masculinist and feminist discourses. This conundrum has been expressed by Morse (1994) in her question, 'What do cyborgs eat?' While an individual may successfully pretend to be a different gender or age on the Internet, she or he will always have to return to the embodied reality of the empty stomach, stiff neck, aching hands, sore back and gritty eyes caused by many hours in front of a computer terminal, for 'Even in the age of the techno- social subject, life is lived through bodies' (Stone 1992: 113).

The hacker's body

A further challenge to the utopian vision of the disembodied computer user is the mythology of the bodies that are obsessed with using PC technology: computers 'hackers' and 'computer nerds'. In sharp contrast to the idealized clean, hard, uncontaminated masculine body of the cyborg as it is embodied in the *RoboCop* and *Terminator* films, this type of computer body is physically repugnant according to commonly accepted notions of attractiveness. 'Hackers' and 'computer nerds', the very individuals who are frequently represented as spearheading the revolution into cyberspace and the 'information superhighway', may be admired for their intellectual capacities (that is, for their 'brain' or 'software'), but the common representation of such individuals usually suggests that their 'bodies' or 'wetware' leave much to be desired. As they are represented in popular culture, 'computer nerds' or 'hackers' are invariably male, usually in their late adolescence or early adulthood, and are typically portrayed as social misfits and spectacularly physically unattractive: wearing thick,

unflattering spectacles, overweight, pale, pimply skin, poor fashion sense. Their bodies are soft, not hard, from too much physical inactivity and junk food. These youths' and men's appearance, it is often suggested, is inextricably linked to their obsession with computers in a vicious circle. According to the mythology, computer nerds turned to computing as an obsession because of their lack of social graces and physical unattractiveness. Due to their isolation from the 'real' world they have become even more cut off from society. Lack of social contact has exacerbated their inability to communicate face-to-face with others, and a poor diet and lack of fresh air and exercise does little to improve their complexions or physique.

A recent case involving the arrest of a celebrated American computer 'hacker' was widely reported in Australian newspapers and news magazines. Kevin Mitnick, 31 years old, was charged with breaking computer-network security and computer fraud. After evading the FBI for two years, he was found and eventually brought to justice by an equally talented computer-security expert, Tsutomu Shimomura. After his arrest, the virtual, anonymous persona of Mitnick, previously manifested only in the traces he left behind when he broke into computer-systems, often leaving cheeky messages of bravura, was displayed as an earthly, all-too-human body. Photographs of Mitnick showed him to represent the archetypal 'computer nerd', complete with thick spectacles, pale skin, pudgy body and double chin. These physical characteristics contrasted with the abstract images of his disembodied on-line hacker persona: *Time Australia* magazine (Quittner 1995), for example, headed a two-page article on the arrest with a surreal colour photograph of two computers side-by-side, the only sign of human embodied presence an arm extending from one to clutch the keyboard of the other. The articles portrayed Mitnick as obsessive, indeed, 'addicted' to the pleasures of hacking. *Time Australia* described him in the courtroom, standing in handcuffs, 'unable, for the first time in more than two years, to feel the silky click of computer keys'.

The bodies of computer 'hackers' and 'nerds', thus, are not transcended through their owners' pursuits. On the contrary, their bodies are inscribed upon and constructed through the computers they use. Their physical characteristics betray their obsessiveness to others. What is more, such individuals are described as 'addicted' to computing as if it were a drug. They thus lack control over their bodies and desires, in sharp contrast to the rationalized, contained body of the masculine cyborg.

The humanized computer

Paradoxically, while computer culture often seeks to deny the human body, the ways in which computer technology is marketed and represented frequently draws an analogy between the computer and the human body. Just as the metaphor 'human as computer' is often articulated in popular culture, so too the 'computer as human' trope is regularly employed. Advertisements for personal computer equipment make particular efforts to represent these inanimate, hard-textured objects as warm, soft, friendly and humanoid.

Computers, as represented in advertising, are prone to many of the life experiences that humans experience. Computers are born, delivered by medical practitioners: one advertisement uses a photograph of a (male) doctor, identified as such by his surgical gown and mask, holding in his arms a computer notebook as if it were a baby: 'NEC can deliver colour notebooks now' read the words above his head. Just as computers are born and delivered, they also die. One advertisement asks readers, 'Why buy a monitor with only 6 months to live?', showing a PC with a screen on which is depicted an ECG graph which has gone flat, similar to the pattern shown when heart failure occurs in humans. This

computer has lost its vitality, as depicted by the flat line. Computers can also be too fat and are most desirable when they are slim. One advertisement showed a small notebook computer wrapped in a tape-measure: the heading read, 'All the power of a 486 notebook, with 40% less fat'. Another advertisement, again for a notebook computer, was headed, 'You can never be too thin or too powerful' to champion the small size of the computer.

Ross (1991) has described the notices that often are posted near such routinely used office machines as photocopiers, which humorously describe the ways in which such machines can detect users' emotional states and react accordingly to make life even more difficult by failing to operate. As he notes,

> In personifying the machine as a unit of organized labour, sharing fraternal interests and union loyalties with other machines, the notice assumes a degree of evolved self-consciousness on the machine's part. Furthermore, it implies a relation of hostility, as if the machine's self-consciousness and loyalty to its own kind have inevitably lead to resentment, conflict, and sabotage.
>
> (Ross 1991: 1–2)

Notices such as these suggest that 'smart' machines like photocopiers are equipped with the means of control and surveillance over the humans who seek to use them, almost as a spy of management. Not only do humans approach such technologies in heightened emotional states but they resound to the technologies with emotions such as vindictiveness and spite.

Computers are often similarly represented as emotional entities, as in the following excerpt relating problems with a computer package published in the computing section in a newspaper:

> Even before Windows appeared, it started complaining. Coldly, matter-of-factly, on a pointedly unfriendly character-based screen, it refused to run 32-bit disk access. It said someone had been fiddling with its interrupts and it thought it had a virus. It grudgingly offered to run Windows with 16-bit file access.
>
> (Morison 1995)

Just as humans fear alienation and loneliness, so too do their PCs. If a user is not linked up to a networked system, both the human and the computer are left to contemplate their social isolation. A magazine advertisement showed a PC in black and white at the top right-hand corner of a white page. Beneath this image were the words (in stark black): 'Insecure? Friendless? Alone?'. The advertisement went on to outline the ways in which computers in the workplace could be networked. The clear analogy drawn is that between the lonely, anxious computer user and the non-networked computer, both forced to work alone. A similar advertisement showed a PC silhouetted, with the words 'Say goodbye to working in an isolation chamber' in red across the screen. In these advertisements, the computer monitor stands for both computer and human user, a metonym of the human/computer dyad.

The emotions are commonly represented as a characteristic of humans, of being alive, phenomena that set humans apart from other animals, evidence of their sensitivity, spirit and soul. Again, the ascribing of emotions to PCs is a discursive move that emphasizes their humanoid nature. Some articles about computers, especially those published in specialist magazines or the computing sections in newspapers designed for aficionados, go even further by frequently making the analogy of the relationship of the user/computer romantic, sexual or marital. One Australian newspaper article on Macintosh computers used headline, visual image and recurring tropes to draw an analogy between one's marital partner and one's PC (Withers 1995). The article was headed 'No time to divorce your Mac', and was illustrated

with a cartoon bride planting a kiss on a bridegroom with a smiling Macintosh screen for a head. The article went on to assert,

> Choosing to buy a Macintosh or any other specific personal computing platform such as Windows is a little like getting married. In both cases you are signing up for a long-term partnership that can be costly to leave. The happily married among us can testify to the benefits of such a relationship, but they don't appear at the outset. 'Come grow old with me, the best is yet to come' applies to both situations.

Advertisements also attempt to portray one's PC as an extension of the human body. One such representation in a newspaper advertisement used a photograph of a group of people holding their notebooks up in front of their faces, the screen reproducing and magnifying their smiles. In this portrayal, the computer was represented as extending and indeed enhancing the most emotionally demonstrative part of the human face, the mouth. These people are using their computers to display their emotional state: in this case, happiness. The computer, in this portrayal, is mirror of the soul. In another advertisement, a PC holds up a camera to its screen 'face', upon which is displayed the word 'smile' in a smiling curve. The heading reads, 'Now your PC can take photos'. An advertisement for Envoy, a computer package, claimed: 'Envoy *thinks* like I do. Sounds weird, but while I'm physically at one meeting, I'm part of three or four others going on *in* my Envoy!'

The frightening computer

The overt reasons for portraying computers as human is to reduce the anxieties of computerphobia that many people, particularly adults, experience. There is an undercurrent of uncertainty around purchasing and buying computer technology on the part of many people. Computers, unlike many other household or workplace machines, appear inherently enigmatic in the very seamlessness of their hardware. Most people have not the faintest idea what lies inside the hard plastic shell of their PC. The arcane jargon of the computing world, with its megabytes, RAMs, MHz and so on, is a new language that is incomprehensible to the uninitiated. It is a well-known truism that the manuals that come with computer technology are incomprehensible and that computer 'experts' are equally unable to translate jargon into easily understood language to help users unfamiliar with the technology. The user–computer relationship is therefore characterized not only by pleasure and a sense of harmonic blurring of the boundaries between human and machine, but is also inspires strong feelings of anxiety, impotence, frustration and fear.

There is something potentially monstrous about computer technology, in its challenging of traditional boundaries. Fears around monsters relate to their liminal status, the elision of one category of life and another, particularly if the human is involved, as in the Frankenstein monster (Rayner 1994). The potential of computer technology to act as a form of surveillance and social regulation, or even to take control over humanity, has been decried (Robins and Webster 1988; Glass 1989; Barns 1990). The apparent growing reliance of humans upon computers has incited concern, as have developments in technology that threaten to leave people behind or to render them unemployed. While there is an increasing move towards the consumption of technologies, there is also anxiety around the technologies' capacity to consume *us* (Silverstone and Hirsch 1992: 2). A recent Hollywood film, *The Ghost in the Machine*, addressed these anxieties. The film, released in 1994, featured the story of a serial murderer who is involved in a car accident which mortally wounds him. In hospital, a short circuit during an electrical storm occurs just as his brain is being scanned by a

computer. He dies at that moment, his 'soul' entering cyberspace via the diagnostic scan machine. The murderer manifests his aggression via the optical fibre network and the electricity grid, killing people via their home appliances. He is finally brought to justice through the efforts of a computer hacker.

The Macintosh computer company was the first to develop 'user-friendly' icons in lieu of textual commands, including the friendly smiling face that has become the standard-bearer of the Apple range. These icons stand as symbolic images for the mysterious activities occurring 'within' the computer (Haddon 1988). The implication of this design strategy was that many potential computer users were alienated by the technological demands of computers requiring text commands, and thus required PCs to be 'humanized' to feel comfortable with the technology. It is telling that this deliberate 'humanization' is unique to PC technology; smiling face icons are not found in other domestic technologies that people find difficult to use, such as video cassette recorders.

New computer programs have recently been designed to alleviate the negative emotions people harbour about using computers. Microsoft, for example, has developed a program it has called 'Bob' to challenge technophobic inclinations, expand the home-computer market and reduce its expenditure on help hotlines. The program features animated characters to show people how to operate the functions of their PC, including 'a crazy cat, soppy dog or coffee-addicted dragon', acting as a 'friend over their shoulder' as Bill Gates described it (Fox 1995: 22). The 'Bob' program was subsequently advertised in the May 1995 edition of *Wired* magazine. The two-page spread featured a large hand-tinted colour photograph, circa the 1950s, showing a beaming all-American nuclear family driving along in a pink convertible with the top down, Mom and the adolescent daughter waving cheerily at the camera. The wording of the advertisement reproduces a naïve, simple approach to life to match the 1950s imagery: 'You know what? People need to be a little friendlier. An extra smile. A wave hello. A Bob. Bob helps you to be friends with your computer. And gee whiz, isn't making friends what friendliness is all about?'

The advertisement proclaims that there is no manual for the 'Bob' program, because 'it is so easy to use … No manual. How friendly can you get?' This advertisement, with its slyly self-parodying home-spun philosophies, its emphasis on 'friendliness' and 'niceness' and its complete avoidance of computer jargon, is appealing directly to precisely those people who feel alienated by their PCs and the manuals that come with them. It draws upon a nostalgia for a less complicated world, a world in which people were friendly to one another, families stayed together and the most complicated technology they owned was the family motor car. 'Bob', as a humanoid character, speaks their language and relates to them as would a friend.

Risky computing

In the age of the 'risk society' (Beck 1992; Giddens 1992), personal computers constitute sites that are redolent with cultural anxieties around the nature of humanity and the self. The late modern world is fraught with danger and risk: the promises of modernity have been shown to have a 'double-edged character', no longer simply guaranteeing human progress (Giddens 1992: 10). To deal with this uncertainty and the time–space distanciation and globalizing tendencies of late modernity, trust has become central to human interactions, particularly in relation to complex technical systems of which most people have little personal knowledge: 'Trust in systems takes the form of faceless commitments, in which faith is sustained in the workings of knowledge of which the lay person is largely ignorant' (Giddens 1992: 88). Individuals have become dependent on personal relationships, particularly those involving romantic love,

to find a sense of security and of subjectivity in a fast-changing, frightening world. However, ambivalence lies at the core of all trust relations, because trust is only demanded where there is ignorance and ignorance provides grounds for scepticism or caution (ibid.: 89).

The euphoria around the 'information superhighway' or 'infobahn', with its utopian visions of computer users able to access each other globally and 'get connected' has been somewhat diminished of late by a series of scares around the security problems threatened by the very accessible nature of the Internet. As I observed above, for some years now there have been growing concerns about the potential of computer networks to surveil and police individuals, using computer databases to collect and pass on information. More recently, a number of news stories have made dramatic headlines reporting on incidents of 'cybercrime' and the security problems of the computer network. One story, reported worldwide, related the saga of the eventual capture of Kevin Mitnick by Tsutomu Shimomura, described above. Another story reported in Australian newspapers in early 1995, detailed the actions of a computer hacker who published confidential credit card numbers on the Internet. An article in *New Scientist* described the growing numbers of frauds in the US using the Internet for investment scams, pointing to the trust that users invest in the information they receive over the Internet. As one computer expert was quoted as saying, 'Con artists are flourishing in cyberspace because people believe what they read on their computer screens. … People tend to accept it as gospel' (Keirnan 1994: 7).

News reports of such crimes typically emphasize the growing security risks caused by the increasing use of the Internet, with a focus on the dangers of 'connectivity' that is linking more and more computers and their users worldwide, employing metaphors of 'gates', 'avenues' and 'openings' as well as epidemic illness (familiar from reports of computer viruses) to represent the threat. For example, a story published in *New Scientist* (Kleiner 1995) on the activities of hackers in discovering a security loophole on the Internet, allowing them to access files previously denied them, was headed, 'Hack attack leaves Internet wide open'. The article went on to explain that the hackers had managed to 'impersonate a computer that is "trusted" by the computer targeted for attack'. An article published in the *Sydney Morning Herald* used similar language: 'When computers were quarantined from each other, there was less chance of a security breach. Now, most systems have any number of electronic avenues leading to them, and some passers-by in cyberspace inevitably wander in when they find the gates unlocked' (Robotham 1995a). This discourse serves as a complement to the viral metaphor, which represents computers as embodied, subject to invasion by viral particles which then cause 'illness' (Lupton 1994). Just as in AIDS discourses gay men or women have been conceptualized as 'leaky bodies' who lack control over their bodily boundaries so, too, in this 'cybercrime' discourse, computers are represented as unable to police or protect their boundaries, rendering themselves vulnerable to penetration. Just as humans in late modernity must both rely on trust relations but also fear them, computers can no longer 'trust' other computers to keep secrets and respect personal boundaries. The sheer anonymity of the 'cyberrobbers' perpetrating the crimes is also a source of fear; they are faceless, difficult to find and identify because of their skill in covering their tracks.

Further concern has also recently been generated about the links that children may make with the outside world via the Internet, particularly in relation to contact with paedophiles, pornography and sexual exchanges over email or chat networks. A front page article published in the *Sydney Morning Herald* in mid-1995 detailed the story of an American 15-year-old boy who left home to meet with a man he had met on the Internet, with the suggestion that the man may have been a paedophile. The article was headlined, 'Every parents' nightmare is lurking on the Internet', and asserted that 'This is the frightening new frontier of cyberspace, a place where a child thought to be safely in his or her room may

be in greater danger than anyone could imagine' (Murphy 1995). Again, the main anxiety here is in the insidious nature of contact with others through the Internet. The home is now no longer a place of safety and refuge for children, the computer no longer simply an educational tool or source of entertainment but is the possible site of children's corruption. 'Outside' danger is brought 'inside', into the very heart of the home, via the Internet.

We invest a great deal of trust in computer technology, especially in our PCs. Many of us have little knowledge about how they work, relying on experts to produce and set up the technology, and to come to our aid when something goes wrong. Yet we have also developed an intimate relationship with them, relying on them to perform everyday tasks, to relax and to communicate with others. We can now carry them about with us in our briefcases, and sit them on our laps. They take pride of place in our studies at home and our children's bedrooms. The ways in which we depict computers as humanoid, having emotions and embodiment, is evidence of this intimacy. It is in this context that we are particularly emotionally vulnerable to losing trust in our PCs, and where risk appears particularly prevalent. We now not only risk becoming 'infected' via a computer virus, but also being 'penetrated' by cybercriminals finding the weakest points in our computer system, seeking to discover our innermost secrets and corrupt and manipulate our children.

The relationship between users and PCs is similar to that between lovers or close friends. An intimate relationship with others involves ambivalence: fear as well as pleasure. As we do with people we feel are close to us, we invest part of ourselves in PCs. We struggle with the pleasures and fears of dependency: to trust is to reap the rewards of security, but it is also to render ourselves vulnerable to risk. Blurring the boundaries between self and other calls up abjection, the fear and horror of the unknown, the indefinable. In her essay *Powers of Horror*, Kristeva defined the abject as 'violent, dark revolts of being, directed against a threat that seems to emanate from an exorbitant outside or inside, ejected beyond the scope of the possible, the tolerable, the thinkable' (1982: 1). The abject inspires both desire and repulsion. It challenges, as it defines, the boundaries of the clean, proper, contained body, the dichotomy between inside and outside. One of its central loci, argues Kristeva, is the maternal body, a body without 'proper' borders. Another is the sexual body, which involves the merging and blurring of the boundaries of one's own body with that of another.

Just as they are described as friends or spouses in the masculinist culture of computing, computers are also frequently described in feminine sexual or maternal roles. The word 'matrix' originates from the Latin *mater*, meaning both mother and womb, a source of comforting security (Springer 1991: 306). For their male users in particular, computers are to be possessed, to be penetrated and overpowered. This desire for power and mastery was expressed by an anonymous computer hacker quoted in an article on 'cybercrime' (Robotham 1995b). When asked about what motivates him and other hackers, he replied: 'A person who hacks into a system wants to get a degree of power, whether the power is real or fallacious. This is you controlling the world from your Macintosh. It's an incredible feeling.' This masculinist urge to penetrate the system, to overpower, some commentators have argued, represents an attempt to split oneself from the controlling mother, to achieve autonomy and containment from the abject maternal body (Robins and Webster 1988; Sofia 1993). Computer users, therefore, are both attracted towards the promises of cyberspace, in the utopian freedom from the flesh, its denial of the body, the opportunity to achieve a cyborgian seamlessness and to 'connect' with others, but are also threatened by its potential to engulf the self and expose one's vulnerability to the penetration of enemy others. As with the female body, a site of intense desire and emotional security but also threatening engulfment, the inside of the computer body is dark and enigmatic, potentially leaky, harbouring danger and contamination, vulnerable to invasion.

References

Barns, I. (1990) 'Monstrous nature or technology? Cinematic resolutions of the "Frankenstein problem"', *Science as Culture 9:* 7–48. Beck, U. (1992) *Risk Society: Towards a New Modernity,* London: Sage.

Berman, B. (1989) 'The computer metaphor: bureaucratizing the mind', *Science as Culture* 7: 7–42.

Fox, B. (1995) 'Trust Bob to tackle technophobia', *New Scientist* 21 January: 22.

Giddens, A. (1992) *The Consequences of Modernity,* Cambridge: Polity Press.

Glass, F. (1989) 'The "new bad future": Robocop and 1980s' sci-fi films', *Science as Culture* 5: 7–49.

Grosz, E. (1994) *Volatile Bodies: Toward a Corporeal Feminism,* Sydney: Allen and Unwin.

Haddon, L. (1988) 'The home computer: the making of a consumer electronic', *Science as Culture* 2: 7–51.

Haraway, D. (1988) 'A manifesto for cyborgs: science, technology, and socialist feminism in the 1980s', pp. 173–204, in E. Weed (ed.) *Coming to Terms: Feminism, Theory, and Practice,* New York: Routledge.

Heim, M. (1992) 'The erotic ontology of cyberspace', pp. 59–80, in M. Benedikt (ed.) 80, in M. Benedikt (ed.) *Cyberspace: First Steps,* Cambridge, MA: MIT Press. Jones, A. (1993) 'Defending the border: men's bodies and vulnerability', *Cultural Studies from Birmingham* 2: 77—123.

Kiernan, V. (1994) Internet tricksters make a killing', *New Scientist* 16 July: 7.

Kleiner, K. (1995) 'Hack attack leaves internet wide open', *New Scientist* 4 February: 4.

Kristeva, J. (1982) *Powers of Horror: An Essay on Abjection,* New York: Columbia University Press.

Lupton, D. (1993) 'The construction of patienthood in medical advertising', *International Journal of Health Services* 23(4): 805–19.

Lupton, D. (1994) 'Panic computing: the viral metaphor and computer technology', *Cultural Studies* 8(3): 556–68.

Morison, N. (1995) 'Michelangelo alive and ready to strike', *Sydney Morning Herald* 21 February.

Morse, M. (1994) 'What do cyborgs eat?: Oral logic in an information society', *Discourse* 16(3): 86–123.

Murphy, K. (1995) 'Every parent's nightmare is lurking on the Internet', *Sydney Morning Herald* 13 June.

Neesham, C. (1994) 'Network of information', *New Scientist (Inside Science* supplement) 10 December:1-4.

Quittner, J. (1995) 'Cracks in the net', *Time Australia* 27 February: 36—7.

Rayner, A. (1994) 'Cyborgs and replicants: on the boundaries', *Discourse* 16(3): 124-43.

Robins, C. and F. Webster (1988) 'Athens without slaves . . . or slaves without Athens?', *Science as Culture* 3: 7-53.

Robotham, J. (1995a) 'The cops aren't chasing the cyber-robbers', *Sydney Morning Herald* 22 April.

— (1995b) 'Tap in for a shot of power from the system', *Sydney Morning Herald* 22 April.

Ross, A. (1991) *Strange Weather: Culture, Science and Technology in the Age of Limits,* London: Verso.

Sarno, T. (1995) 'William the Conqueror', *Sydney Morning Herald* 21 January.

Seltzer, M. (1992) *Bodies and Machines,* New York: Routledge.

Silverstone, R. and E. Hirsch (1992) 'Introduction', pp. 1—11, in R. Silverstone and E. Hirsch (eds) *Consuming Technologies: Media and Information in Domestic Spaces,* London: Routledge.

Sofia, Z. (1993) *Whose Second Self? Gender and (Ir)rationality in Computer Culture.* Geelong, Victoria: Deakin University Press.

Springer, C. (1991) 'The pleasure of the interface', *Screen* 32(3): 303—23.

Stone, A. (1992) 'Will the real body please stand up?: boundary stories about virtual cultures', pp. 81—118, in M. Benedikt (ed.) *Cyberspace: First Steps,* Cambridge, MA: MIT Press.

Theweleit, K. (1987) *Male Fantasies, Volume I: Women, Floods, Bodies, History,* Cambridge: Polity Press.

Withers, S. (1995) 'No time to divorce your Mac?', *Sydney Morning Herald* 7 February.

Allucquere Rosanne Stone

WILL THE REAL BODY PLEASE STAND UP?
Boundary stories about virtual cultures

The machines are restless tonight

AFTER DONNA HARAWAY'S 'PROMISES of Monsters' and Bruno Latour's papers on actor networks and artifacts that speak, I find it hard to think of any artifact as being devoid of agency. Accordingly, when the dryer begins to beep complainingly from the laundry room while I am at dinner with friends, we raise eyebrows at each other and say simultaneously, 'The machines are restless tonight …'

It's not the phrase, I don't think, that I find intriguing. Even after Haraway (1991) and Latour (1988), the phrase is hard to appreciate in an intuitive way. It's the ellipsis I notice. You can hear those three dots. What comes after them? The fact that the phrase – obviously a send-up of a vaguely anthropological chestnut – seems funny to us, already says a great deal about the way we think of our complex and frequently uneasy imbrications with the unliving. The people I study are deeply imbricated in a complex social network mediated by little technologies to which they have delegated significant amounts of their time and agency, not to mention their humour. I say to myself: Who am I studying? A group of people? Their machines? A group of people and/or in their machines? Or something else?

When I study these groups, I try to pay attention to all of their interactions. And as soon as I allow myself to see that most of the interactions of the people I am studying involve vague but palpable sentiences squatting on their desks, I have to start thinking about watching the machines just as attentively as I watch the people, because, for them, the machines are not merely passage points. Haraway and other workers who observe the traffic across the boundaries between 'nature', 'society', and 'technology' tend to see nature as lively, unpredictable, and, in some sense, actively resisting interpretations. If nature and technology seem to be collapsing into each other, as Haraway and others claim, then the unhumans can be lively too.

One symptom of this is that the flux of information that passes back and forth across the vanishing divides between nature and technology has become extremely dense. *Cyborgs with a vengeance*, one of the groups I study, is already talking about colonizing a social space

in which the divide between nature and technology has become thoroughly unrecognizable, while one of the individuals I study is busy trying to sort out how the many people who seem to inhabit the social space of her body are colonizing her. When I listen to the voices in these new social spaces I hear a multiplicity of voices, some recognizably human and some quite different, all clamouring at once, frequently saying things whose meanings are tantalizingly familiar but which have subtly changed.

My interest in cyberspace is primarily about communities and how they work. Because I believe that technology and culture constitute each other, studying the actors and actants that make up our lively, troubling and productive technologies tells me about the actors and actants that make up our culture. Since so much of a culture's knowledge is passed on by means of stories, I will begin by retelling a few boundary stories about virtual cultures.

Schizophrenia as commodity fetish

Let us begin with a person I will call Julie, on a computer conference in New York in 1985. Julie was a totally disabled older woman, but she could push the keys of a computer with her headstick. The personality she projected into the 'Net' — the vast electronic web that links computers all over the world — was huge. On the Net, Julie's disability was invisible and irrelevant. Her standard greeting was a big, expansive 'HI!!!!!!' Her heart was as big as her greeting, and in the intimate electronic companionships that can develop during on-line conferencing between people who may never physically meet, Julie's women friends shared their deepest troubles, and she offered them advice — advice that changed their lives. Trapped inside her ruined body, Julie herself was sharp and perceptive, thoughtful and caring.

After several years, something happened that shook the conference to the core. 'Julie' did not exist. 'She' was, it turned out, a middle-aged male psychiatrist. Logging onto the conference for the first time, this man had accidentally begun a discussion with a woman who mistook him for another woman. 'I was stunned,' he said later, 'at the conversational mode. I hadn't known that women talked among themselves that way. There was so much more vulnerability, so much more depth and complexity. Men's conversations on the nets were much more guarded and superficial, even among intimates. It was fascinating, and I wanted more.' He had spent weeks developing the right persona. A totally disabled, single older woman was perfect. He felt that such a person wouldn't be expected to have a social life. Consequently her existence only as a Net persona would seem natural. It worked for years, until one of Julie's devoted admirers, bent on finally meeting her in person, tracked her down.

The news reverberated through the Net. Reactions varied from humorous resig- nation to blind rage. Most deeply affected were the women who had shared their innermost feelings with Julie. 'I felt raped,' one said. 'I felt that my deepest secrets had been violated.' Several went so far as to repudiate the genuine gains they had made in their personal and emotional lives. They felt those gains were predicated on deceit and trickery.

The computer engineers, the people who wrote the programs by means of which the nets exist, just smiled tiredly. They had understood from the beginning the radical changes in social conventions that the nets implied. Young enough in the first days of the net to react and adjust quickly, they had long ago taken for granted that many of the old assumptions about the nature of identity had quietly vanished under the new electronic dispensation. Electronic networks in their myriad kinds, and the mode of interpersonal interaction that they foster, are a new manifestation of a social space that has been better known in its older and more familiar forms in conference calls, communities of letters, and FDR's fireside

chats. It can be characterized as 'virtual' space – an imaginary locus of interaction created by communal agreement. In its most recent form, concepts like distance, inside/outside, and even the physical body take on new and frequently disturbing meanings.

Now, one of the more interesting aspects of virtual space is 'computer cross-dressing'. Julie was an early manifestation. On the nets, where *warranting*, or grounding, a persona in a physical body, is meaningless, men routinely use female personae whenever they choose, and vice versa. This wholesale appropriation of the other has spawned new modes of interaction. Ethics, trust and risk still continue, but in different ways. Gendered modes of communication themselves have remained relatively stable, but who uses which of the two socially recognized models has become more plastic. A woman who has appropriated a male conversational style may be simply assumed to be male at that place and time, so that her/his on-line persona takes on a kind of quasi life of its own, separate from their person's embodied life in the 'real' world.

Sometimes a person's on-line persona becomes so finely developed that it begins to take over their life *off* the net. In studying virtual systems, I will call both the space of interaction that is the net and the space of interaction that we call the 'real' world *consensual loci*. Each consensual locus has its own 'reality', determined by local conditions. However, not all realities are equal. A whack on the head in the 'real' world can kill you, whereas a whack in one of the virtual worlds will not.

Some conferencees talk of a time when they will be able to abandon warranting personae in even more complex ways, when the first 'virtual reality' environments come on line. VR, one of a class of interactive spaces that are coming to be known by the general term *cyberspace*, is a three-dimensional consensual locus or, in the terms of science fiction author William Gibson, a 'consensual hallucination' in which data may be visualized, heard, and even felt. The 'data' in some of these virtual environments are people – 3-D representations of individuals in the cyberspace. While high-resolution images of the human body in cyberspace are years away, when they arrive they will take 'computer cross-dressing' even further. In this version of VR a man may be seen, and perhaps touched, as a woman and vice versa – or as anything else. There is talk of renting pre-packaged body forms complete with voice and touch … multiple personality as commodity fetish!

It is interesting that at just about the time the last of the untouched 'real-world' anthropological field sites are disappearing, a new and unexpected kind of 'field' is opening up – incontrovertibly social spaces in which people still meet face-to-face, but under new definitions of both 'meet' and 'face'. These new spaces instantiate the collapse of the boundaries between the social and technological, biology and machine, natural and artificial that are part of the postmodern imaginary. They are part of the growing imbrication of humans and machines in new social forms that I call *virtual systems*.

A virtual systems origin myth

Cyberspace, without its high-tech glitz, is partially the idea of virtual community. The earliest cyberspaces may have been virtual communities, passage points for collections of common beliefs and practices that united people who were physically separated. Virtual communities sustain themselves by constantly circulating those practices. To give some examples of how this works, I'm going to tell an original story of virtual systems.

There are four epochs in this story. The beginning of each is signalled by a marked change in the character of human communication. Over the years, human communication is increasingly mediated by technology. Because the rate of change in technological innovation

increases with time, the more recent epochs are shorter, but roughly the same quantity of information is exchanged in each. Since the basis of virtual communities is communication, this seems like a reasonable way to divide up the field.

Epoch One: Texts (from the mid-1600s).
Epoch Two: Electronic communication and entertainment media (1900+).
Epoch Three: Information technology (1960+).
Epoch Four: Virtual reality and cyberspace (1984+).

Epoch one

This period of early textual virtual communities starts, for the sake of this discussion, in 1669 when Robert Boyle engaged an apparatus of literary technology to 'dramatize the social relations proper to a community of philosophers'. As Steven Shapin and Simon Shaffer (1985) point out in their study of the debate between Boyle and the philosopher Thomas Hobbes, *Leviathan and the Air-Pump*, we probably owe the invention of the boring academic paper to Boyle. Boyle developed a method of compelling assent that Shapin and Shaffer describe as *virtual witnessing*. He created what he called a 'community of like-minded gentlemen' to validate his scientific experiments, and he correctly surmised that the 'gentlemen' for whom he was writing believed that boring, detailed writing implied painstaking experiment without being physically present. Boyle's production of the detailed academic paper was so successful that it is still the exemplar of scholarship.

Epoch two

The period of the early electronic virtual communities began in the twentieth century with invention of the telegraph. It continued with musical communities, previously constituted in the physical public space of the concert hall, shifting and translating to a new kind of virtual communal space around the phonograph. The apex of this period was Franklin Delano Roosevelt's radio 'fireside chats', creating a *community* by means of readily available technology.

Once communities grew too big for everyone to know everyone else, govern- ment had to proceed through delegates who represented absent groups. FDR's use of radio was a way to bypass the need for delegates. Instead of talking to a few hundred representatives, Roosevelt used the radio as a machine for fitting listeners into his living room. The radio was one-way communication, but because of it people were able to begin to think of *presence* in a different way. Because of radio and of the apparatus for the production of community that it implied and facilitated, it was now possible for millions of people to be 'present' in the same space – seated across from Roosevelt in his living room.

This view implies a new, different and complex way of experiencing the relationship between the physical human body and the 'I' that inhabits it. FDR did not physically enter listeners' living rooms. He invited listeners into his. In a sense, the listener was in two places at once – the body at home, but the delegate, the 'I' that belonged to the body, in an imaginal space with another person. This space was enabled and constructed with the assistance of a particular technology. In the case of FDR the technology was a device that mediated between physical loci and incommensurable realities – in other words, an interface. In virtual systems *an interface is that which mediates between the human body (or bodies) and an*

associated 'I' (or 'I's'). This double view of 'where' the 'person' is, and the corresponding trouble it may cause with thinking about 'who' we are talking about when we discuss such a problematic 'person', underlies the structure of more recent virtual communities.

During the same period thousands of children, mostly boys, listened avidly to adventure serials, and sent in their coupons to receive the decoder rings and signalling devices that had immense significance within the community of a particular show. Away from the radio, they recognized each other by displaying the community's tokens, an example of communities of consumers organized for marketing purposes.

The motion picture, and later, television, also mobilized a similar power to organize sentimental social groups. Arguably one of the best examples of a virtual community in the late twentieth century is the Trekkies, a huge, heterogeneous group partially based on commerce but mostly on a set of ideas. The fictive community of *Star Trek* and the fantasy Trekkie community interrelate and mutually constitute each other in complex ways across the boundaries of texts, films, and video interfaces.

Epoch three

This period began with the era of information technology. The first virtual communities based on information technology were the on-line bulletin board services (BBSs) of the mid-1970s. These were not dependent upon the widespread ownership of computers, merely of terminals. But because even a used terminal cost several hundred dollars, access to the first BBSs was mainly limited to electronics experimenters, ham-radio operators, and the early hardy computer builders.

BBSs were named after their perceived function – virtual places, conceived to be just like physical bulletin boards, where people could post notes for general reading. The first successful BBS programs were primitive, usually allowing the user to search for messages alphabetically, or simply to read messages in the order in which they were posted. These programs were sold by their authors for very little, or given away as 'shareware' – part of the early visionary ethic of electronic virtual communities. The idea of shareware, as enunciated by the many programmers who wrote shareware programs, was that the computer was a passage point for circulating concepts of community. The important thing about shareware, rather than making an immediate profit for the producer, was to nourish the community in expectation that such nourishment would 'come around' to the nourisher.

CommuniTree Within a few months of the first BBS's appearance, a San Francisco group headed by John James had developed the idea that the BBS was a virtual community, a community that promised radical transformation of existing society and the emergence of new social forms. The CommuniTree Group, as they called them- selves, saw the BBS in McLuhanesque terms as transformative because of the ontological structure it presupposed and simultaneously created – the mode of tree-structured discourse and the community that spoke it – and because it was another order of 'extension', a kind of prosthesis in McLuhan's sense. The BBS that the CommuniTree Group envisioned was an extension of the participant's instrumentality into a virtual social space.

The CommuniTree Group quite correctly foresaw that the BBS in its original form was extremely limited in its usefulness. Their reasoning was simple. The physical bulletin board for which the BBS was the metaphor had the advantage of being quickly scannable. By its nature, the physical bulletin board was small and manageable in size. There was not much need for bulletin boards to be organized by topic. But the on-line BBS could

not be scanned in any intuitively satisfactory way. There were primitive search protocols in the early BBSs, but they were usually restricted to alphabetical searches or searches by keywords. The CommuniTree Group proposed a new kind of BBS which they called a tree-structured conference, employing as a working metaphor both the binary tree protocols in computer science and also the organic qualities of trees as such appropriate to the 1970s. Each branch of the tree was to be a separate conference that grew naturally out of its root message by virtue of each subsequent message that was attached to it. Conferences that lacked participation would cease to grow, but would remain on-line as archives of failed discourse and as potential sources of inspiration for other, more flourishing conferences.

With each version of the BBS system, The CommuniTree Group supplied a massive, detailed instruction manual – which was nothing less than a set of directions for constructing a new kind of virtual community. They couched the manual in radical 1970s language, giving chapters such titles as 'Downscale, please, Buddha' and 'If you meet the electronic avatar on the road, laserblast him!' This rich intermingling of spiritual and technological imagery took place in the context of George Lucas' *Star Wars*, a film that embodied the themes of the technological transformativists, from the all-pervading Force to what Vivian Sobchack (1987) called 'the outcome of infinite human and technological progress'. It was around *Star Wars* in particular that the technological and radically spiritual virtual communities of the early BBSs coalesced. *Star Wars* represented a future in which the good guys won out over vastly superior adversaries – with the help of a mystical Force that 'surrounds us and penetrates us … it binds the galaxy together' and which the hero can access by learning to 'trust your feelings' – a quintessential injunction of the early 1970s.

CommuniTree no. 1 went on-line in May 1978 in the San Francisco Bay area of northern California. The opening sentence of the prospectus for the first conference was 'We are as gods and might as well get good at it'. This technospiritual bumptious- ness, full of the promise of the redemptive power of technology mixed with the easy, catch-all Eastern mysticism popular in upscale northern California, characterized the early conferences. As might be gathered from the tone of the prospectus, the first conference, entitled 'Origins', was about successor religions.

The conferencees saw themselves not primarily as readers of bulletin boards or participants in a novel discourse but as agents of a new kind of social experiment. They saw the terminal or personal computer as a tool for social transformation by the ways it refigured social interaction. BBS conversations were time-aliased, like a kind of public letter writing or the posting of broadsides. They were meant to be read and replied to some time later than they were posted. But their participants saw them as conversations nonetheless, as social acts. When asked how sitting alone at a terminal was a social act, they explained that they saw the terminal as a window into a social space. When describing the act of communication, many moved their hands expressively as though typing, emphasizing the gestural quality and essential tactility of the virtual mode. Also present in their descriptions was a propensity to reduce other expressive modalities to the tactile. It seemed clear that, from the beginning, the electronic virtual mode possessed the power to overcome its character of single-mode transmission and limited bandwidth.

By 1982 Apple Computer had entered into the first of a series of agreements with the federal government in which the corporation was permitted to give away computers to public schools in lieu of Apple's paying a substantial portion of its federal taxes. In terms of market strategy, this action dramatically increased Apple's presence in the school system and set the pace for Apple's domination in the education market. Within a fairly brief time there were significant numbers of personal computers accessible to students of grammar school and high school age. Some of those computers had modems.

The students, at first mostly boys and with the linguistic proclivities of pubescent males, discovered the Tree's phone number and wasted no time in logging onto the conferences. They appeared uninspired by the relatively intellectual and spiritual air of the ongoing debates, and proceeded to express their dissatisfaction in ways appropriate to their age, sex and language abilities. Within a short time the Tree was jammed with obscene and scatalogical messages. There was no way to monitor them as they arrived, and no easy way to remove them once they were in the system. This meant that the entire system had to be purged – a process taking hours – every day or two. In addition, young hackers enjoyed the sport of attempting to 'crash' the system by discovering bugs in the system commands. Because of the provisions of the system that made observing incoming messages impossible, the hackers were free to experiment with impunity, and there was no way for the system operator to know what was taking place until the system crashed. At that time it was generally too late to save the existing disks. The system operator would be obliged to reconstitute ongoing conferences from earlier back-up versions.

Within a few months, the Tree had expired, choked to death with what one participant called 'the consequences of freedom of expression'. During the years of its operation, however, several young participants took the lessons and implications of such a community away with them, and proceeded to write their own systems. Within a few years there was a proliferation of on-line virtual communities of somewhat less visionary character but vastly superior message-handling capability – systems that allowed monitoring and disconnection of 'troublesome' participants (hackers attempting to crash the system), and easy removal of messages that did not further the purposes of the system operators. The age of surveillance and social control had arrived for the electronic virtual community.

The visionary character of CommuniTree's electronic ontology proved an obstacle to the Tree's survival. Ensuring privacy in all aspects of the Tree's structure and enabling unlimited access to all conferences did not work in a context of increasing availability of terminals to young men who did not necessarily share the Tree gods' ideas of what counted as community. As one Tree veteran put it, 'The barbarian hordes mowed us down.' Thus, in practice, surveillance and control proved necessary adjuncts to maintaining order in the virtual community.

SIMNET Besides the BBSs, there were more graphic, interactive systems under construction. Their interfaces were similar to arcade games or flight simulators – (relatively) high-resolution, animated graphics. The first example of this type of cyberspace was a military simulation called SIMNET. SIMNET was conducted by a consortium of military interests, primarily represented by DARPA, and a task group from the Institute for Simulation and Training, located at the University of Central Florida. SIMNET came about because DARPA was beginning to worry about whether the Army could continue to stage large-scale military practice exercises in Germany. With the rapid and unpredictable changes that were taking place in Europe in the late 1980s, the army wanted to have a back-up – some other place where they could stage practice manoeuvres without posing difficult political questions. As one of the developers of SIMNET put it, 'World War III in Central Europe is at the moment an unfashionable anxiety'. In view of the price of land and fuel, and of the escalating cost of staging practice manoeuvres, the armed forces felt that if a large-scale consensual simulation could be made practical they could realize an immediate and useful financial advantage. Therefore, DARPA committed significant resources – money, time and computer power – to funding some research laboratory to generate a 200-tank cyberspace simulation. DARPA put out requests for proposals, and a group at the University of Central Florida won.

The Florida group designed and built the simulator units with old technology, along the lines of conventional aircraft cockpit simulators. Each tank simulator was equipped to carry a crew of four, so the SIMNET environment is an 800-person virtual community.

SIMNET is a two-dimensional cyberspace. The system can be linked up over a very large area geographically; without much difficulty, in fact, to anywhere in the world. A typical SIMNET node is an M-1 tank simulator. Four crew stations contain a total of eight vision blocks, or video screens, visible through the tank's ports. Most of these are 320 × 138 pixels in size, with a 15 Hertz update rate. This means that the image resolution is not very good, but the simulation can be generated with readily available technology no more complex than conventional video games. From inside the 'tank' the crew looks out the viewports, which are the video screens. These display the computer-generated terrain over which the tanks will manoeuvre (which happens to be the landscape near Fort Knox, Kentucky). Besides hills and fields, the crew can see vehicles, aircraft, and up to thirty other tanks at one time. They can hear and see the vehicles and planes shooting at each other and at them.

By today's standards, SIMNET's video images are low-resolution and hardly convincing. There is no mistaking the view out the ports for real terrain. But the simulation is astonishingly effective, and participants become thoroughly caught up in it. SIMNET's designers believe that it may be the lack of resolution itself that is responsible, since it requires the participants to actively engage their own imaginations to fill the holes in the illusion! McLuhan redux. That it works is unquestionable. When experimenters opened the door to one of the simulators during a test run to photograph the interior, the participants were so caught up in the action that they didn't notice the bulky camera poking at them.

Habitat Designed by Chip Morningstar and Randall Farmer, this is a large-scale social experiment that is accessible through such common telephone-line computer networks as Tymnet. Habitat was designed for LucasFilm. It is a completely decentralized, connections system. The technology at the user interface was intended to be simple in order to minimize the costs of getting on-line. Habitat is designed to run on a Commodore 64 computer, but Morningstar and Farmer have milked an amazing amount of effective bandwidth out of the machine. The Commodore 64 is very inexpensive and readily available; almost anyone can buy one if, as one Habitat participant said, 'they don't already happen to have one sitting around being used as a doorstop'. At the time of writing (1991) Commodore 64s cost $100 at such outlets as Toys R Us.

Habitat existed first as a 35-foot mural located in a building in Sausalito, California, but, on-line, each area of the mural represents an entirely expandable area in the cyberspace, be it a forest, a plain, or a city. Habitat is inhabitable in that, when the user signs on, he or she has a window into the ongoing social life of the cyberspace – the community 'inside' the computer. The social space itself is represented by a cartoon-like frame. The virtual person who is the user's delegated agency is represented by a cartoon figure that may be customized from a menu of body parts. When the user wishes his/her character to speak, s/he types out the words on the Commodore's keyboard, and these appear in a speech balloon over the head of the user's character. The speech balloon is visible to any other user nearby in the virtual space.[1] The user sees whatever other people are in the immediate vicinity in the form of other figures.

Habitat is a two-dimensional example of what William Gibson called a 'consensual hallucination'. First, according to Morningstar and Farmer, it has well-known protocols for encoding and exchanging information. By generally accepted usage among cyberspace

engineers, this means it is consensual. The simulation software uses agents that can transform information to simulate environment. This means it is an hallucination.

Habitat has proved to be incontrovertibly social in character. During Habitat's beta test, several social institutions sprang up spontaneously. As Randall Farmer points out in his report on the initial test run, there were marriages and divorces, a church, a loose guild of thieves, an elected sheriff, a newspaper with a rather eccentric editor, and before long two lawyers hung up their shingles to sort out claims. And this was with only 150 people. My vision (of Habitat) encompasses tens of thousands of simultaneous participants.

Lessons of the third epoch

In the third epoch the participants of electronic communities seem to be acquiring skills that are useful for the virtual social environments developing in late twentieth-century technologized nations. Their participants have learned to delegate their agency to body-representatives that exist in an imaginal space contiguously with representatives of other individuals. They have become accustomed to what might be called lucid dreaming in an awake state – to a constellation of activities much like reading, but an active and interactive reading, a participatory social practice in which the actions of the reader have consequences in the world of the dream or the book. In the third epoch the older metaphor of reading is undergoing a transformation in a textual space that is consensual, interactive and haptic, and that is constituted through inscription practices – the production of microprocessor code. Social spaces are beginning to appear that are simultaneously natural, artificial and constituted by inscription. The boundaries between the social and the natural and between biology and technology are beginning to take on the generous permeability that characterizes communal space in the fourth epoch.

Epoch four

Arguably the single most significant event for the development of fourth-stage virtual communities was the publication of William Gibson's science fiction novel *Neuromancer*. *Neuromancer* represents the dividing line between the third and fourth epochs not because it signalled any technological development, but because it crystallized a new community.

Neuromancer reached the hackers who had been radicalized by George Lucas' powerful cinematic evocation of humanity and technology infinitely extended, and it reached the technologically literate and socially disaffected who were searching for social forms which could transform the fragmented anomie that characterized life in Silicon Valley and all electronic industrial ghettos. In a single stroke, Gibson's powerful vision provided for them the imaginal public sphere and refigured discursive community that established the grounding for the possibility of a new kind of social interaction. *Neuromancer* in the time of Reagan and DARPA is a massive intertextual presence, not only in other literary productions of the 1980s, but in technical publications, conference topics, hardware design, and scientific and technological discourses in the large.

The three-dimensional inhabitable cyberspace described in *Neuromancer* does not yet exist, but the groundwork for it can be found in a series of experiments in both the military and private sectors. Many VR engineers concur that the tribal elders of 3-D virtual systems are Scott Fisher and Ivan Sutherland, formerly at MIT, and Tom Furness, with the Air Force. In 1967–68, Sutherland built a see-through helmet at the MIT Draper Lab in Cambridge.

This system used television screens and half-silvered mirrors, so that the environment was visible through the TV displays. It was not designed to provide a surround environment. In 1969–70 Sutherland went to the University of Utah, where he continued this work, doing things with vector-generated computer graphics and maps, still see-through technology. In his lab were Jim Clark, who went on to start Silicon Graphics, and Don Vickers.

Tom Furness had been working on VR systems for approximately fifteen years – he started in the mid-1970s at Wright-Patterson Air Force Base. His systems were also see-through, rather than enclosing. He pushed the technology forward, particularly by adopting the use of high-resolution CRTs. Furness' system, designed for the USAF, was an elaborate flight simulation cyberspace employing a helmet with two large CRT devices, so large and cumbersome that it was dubbed the 'Darth Vader helmet'. He left Wright-Patterson in 1988–89 to start the Human Interface Technology Lab at the University of Washington.

Scott Fisher started at MIT in the machine architecture group. The MA group worked on developing stereo displays and crude helmets to contain them, and received a small proportion of their funding from DARPA. When the group terminated the project, they gave the stereo displays to another group at UNC (University of North Carolina), which was developing a display device called the Pixel Planes Machine. In the UNC lab were Henry Fuchs and Fred Brooks, who had been working on force feedback with systems previously developed at Argonne and Oak Ridge National labs. The UNC group worked on large projected stereo displays, but was aware of Sutherland's and Furness' work with helmets, and experimented with putting a miniature display system into a helmet of their own. Their specialities were medical modelling, molecular modelling, and architectural walk-through. The new Computer Science building at UNC was designed partially with their system. Using their software and 3-D computer imaging equipment, the architects could 'walk through' the full-sized virtual building and examine its structure. The actual walk-through was accomplished with a tread-mill and bicycle handlebars. The experiment was so successful that during the walk-through one of the architects discovered a misplaced wall that would have costs hundreds of thousands of dollars to fix once the actual structure had been built.

In 1982, Fisher went to work for Atari. Alan Kay's style at Atari was to pick self-motivated people and then turn them loose, on anything from flight simulation to personal interactive systems. The lab's philosophy was at the extreme end of visionary. According to Kay, the job of the group was to develop products not for next year or even for five years away, but for no less than 15 to 20 years in the future. In the corporate climate of the 1980s, and in particular in Silicon Valley, where product life and corporate futures are calculated in terms of months, this approach was not merely radical but stratospheric. For the young computer jocks, the lure of Silicon Valley and of pushing the limits of computer imaging into the far future was irresistible, and a group of Cambridge engineers, each outstanding in their way, made the trip out to the coast. Eric Gullichsen arrived first, then Scott Fisher and Susan Brennan, followed a year later by Ann Marion. Michael Naimark was already there, as was Brenda Laurel. Steve Gans was the last to arrive.

As it turned out, this was not a good moment to arrive at Atari. When the Atari lab closed, Ann Marion and Alan Kay went to Apple where they started the Vivarium project and continued their research. Susan Brennan went first to the Stanford Psychology department and also Hewlett-Packard, which she left in 1990 to teach at CUNY Stony Brook. Michael Naimark became an independent producer and designer of interactive video and multimedia art. William Bricken and Eric Gullichsen took jobs at Autodesk, the largest manufacturer of CAD software, where they started a research group called Cyberia.

Scott Fisher went to work for Dave Nagel, head of the NASA-Ames View Lab. To go with their helmet, the Ames lab had developed a primitive sensor to provide the computer with information about the position of the user's hand. The early device used a simple glove with strain gauges wired to two fingers. They contracted with VPL, Inc. to develop it further, using software written in collaboration with Scott. The Ames group referred to the software as 'gesture editors'. The contract started in 1985, and VPL delivered the first glove in March 1986. The Ames group intended to apply the glove and software to such ideas as surgical simulation, 3-D virtual surgery for medical students. In 1988, Dave Nagel left the Ames laboratory to become director of the Advanced Technology Group (ATG) at Apple.

Lusting for images, such organizations as SIGGRAPH gobbled up information about the new medium and spread it out through its swarm of networks and publications. The audience, made up largely of young, talented, computer-literate people in both computer science and art, and working in such fields as advertising, media and the fine arts, had mastered the current state of the art in computers and was hungry for the next thing. LucasFilm (later Lucas Arts) in Marin, now doing the bulk of all computerized special effects for the film industry, and Douglas Trumbull's EEG in Hollywood, fresh from their spectacular work on *Blade Runner*, had made the production of spectacular visual imaginaries an everyday fact. They weren't afraid to say that they had solved all of the remaining problems with making artificial images, under particular circumstances, indistinguishable from 'real' ones – a moment that Stewart Brand called '[t]he end of photography as evidence for anything'. Now the artists and engineers who worked with the most powerful imaging systems, like Lucas' Pixar, were ready for more. They wanted to be able to get inside their own fantasies, to experientially inhabit the worlds they designed and built but could never enter. VR touched the same nerve that *Star Wars* had, the englobing specular fantasy made real.

Under Eric Gullichsen and William Bricken, the Autodesk Cyberspace Project quickly acquired the nickname Cyberia. John Walker, president of Autodesk, had seen the UNC architectural system and foresaw a huge market for virtual CAD – 3-D drawings that the designers could enter. But after a year or so, Autodesk shrank the Cyberia project. Eric Gullichsen left to start Sense8, a manufacturer of low-end VR systems. William Bricken left the company to take up residence at the University of Washington, where Tom Furness and his associates had started the Human Interface Technology laboratory. Although there were already academic-based research organizations in existence at that time (Florida, North Carolina), and some of them (Florida) were financed at least in part by DOD, the HIT lab became the first academic organization to secure serious research funding from private industry.

During this period, when *Neuromancer* was published, 'virtual reality' acquired a new name and a suddenly prominent social identity as 'cyberspace'. The critical importance of Gibson's book was partly due to the way that it triggered a conceptual revolution among the scattered workers who had been doing virtual reality research for years: as task groups coalesced and dissolved, as the fortunes of companies and projects and laboratories rose and fell, the existence of Gibson's novel and the technological and social imaginary that it articulated enabled the researchers in virtual reality – or, under the new dispensation, cyberspace – to recognize and organize themselves as community.

By this time private industry, represented by such firms as American Express, PacBell, IBM, MCC, Texas Instruments, and NYNEX, were beginning to explore the possibilities and commercial impact of cyberspace systems. The major thrust of the industrial and institutional commitment to cyberspace research was still focused on data manipulation – just as Gibson's *zaibatsu* did in *Neuromancer*. Gibson's cowboys were outlaws in a military-

industrial fairyland dominated by supercomputers, artificial intelligence devices and data banks. Humans were present, but their effect was minimal. There is no reason to believe that the cyberspaces being designed at NASA or Florida will be any different. However, this knowledge does not seem to daunt the 'real' cyberspace workers. Outside of their attention to the realities of the marketplace and workplace, the young, feisty engineers who do the bulk of the work on VR systems continue their discussions and arguments surrounding the nature and context of virtual environments. That these discussions already take place in a virtual environment – the great, sprawling international complex of commercial, government, military and academic computers known as Usenet – is in itself suggestive.

Decoupling the body and the subject

> The illusion will be so powerful you won't be able to *tell what's real and what's not*.
>
> (SteveWilliams)

In her complex and provocative 1984 study *The Tremulous Private Body*, Frances Barker suggests that, because of the effects of the Restoration on the social and political imaginary in Britain (1660 and on), the human body gradually ceased to be perceived as public spectacle, as had previously been the case, and became privatized in new ways. In Barker's model of the post-Jacobean citizen, the social economy of the body became rearranged in such a way as to interpose several layers between the individual and public space. Concomitant with this removal of the body from a largely public social economy, Barker argues that the subject, the 'I' or perceiving self that Descartes had recently pried loose from its former unity with the body, reorganized, or was reorganized, in a new economy of its own. In particular, the subject, as did the body, ceased to constitute itself as public spectacle and instead fled from the public sphere and constituted itself in *text* – such as Samuel Pepys' diary (1668).

Such changes in the social economy of both the body and the subject, Barker suggests, very smoothly serve the purposes of capital accumulation. The product of a privatized body and of a subject removed from the public sphere is a social monad more suited to manipulation by virtue of being more isolated. Barker also makes a case that the energies of the individual, which were previously absorbed in a complex public social economy and which regularly returned to nourish the sender, started backing up instead, and needing to find fresh outlets. The machineries of capitalism handily provided a new channel for productive energy. Without this damming of creative energies, Barker suggests, the industrial age, with its vast hunger for productive labour and the consequent creation of surplus value, would have been impossible.

In Barker's account, beginning in the 1600s in England, the body became progressively more hidden, first because of changing conventions of dress, later by conventions of spatial privacy. Concomitantly, the self, Barker's 'subject', retreated even further inward, until much of its means of expression was through texts. Where social communication had been direct and personal, a warrant was developing for social communication to be indirect and delegated through communication technologies – first pen and paper, and later the technologies and market economics of print. The body (and the subject, although s/he doesn't lump them together in this way) became 'the site of an operation of power, of an exercise of meaning … a transition, effected over a long period of time, from a socially visible object to one which can no longer be seen' (Barker 1984: 13).

While the subject in Barker's account became, in her words, 'raging, solitary, productive', what it produced was text. On the other hand, it was the newly hidden Victorian body that became physically productive and that later provided the motor for the industrial revolution; it was most useful as a brute body, for which the creative spark was an impediment. In sum, the body became more physical, while the subject became more textual, which is to say non-physical.

If the information age is an extension of the industrial age, with the passage of time the split between the body and the subject should grow more pronounced still. But in the fourth epoch the split is simultaneously growing and disappearing. The socioepistemic mechanism by which bodies mean is undergoing a deep restructuring in the latter part of the twentieth century, finally fulfilling the furthest extent of the isolation of those bodies through which its domination is authorized and secured.

I don't think it is accidental that one of the earliest, textual, virtual communities – the community of gentlemen assembled by Robert Boyle during his debates with Hobbes – came into existence at the moment about which Barker is writing. The debate between Boyle and Hobbes and the production of Pepys' diary are virtually contemporaneous. In the late twentieth century, Gibson's *Neuromancer* is simultaneously a perverse evocation of the Restoration subject and its annihilation in an implosion of meaning from which arises a new economy of signification.

Barker's work resonates in useful ways with two other accounts of the evolution of the body and the subject through the interventions of late twentieth-century technologies: Donna Haraway's 'A manifesto for cyborgs' and 'The biopolitics of postmodern bodies' (1985; 1988). Both these accounts are about the collapse of categories and of the boundaries of the body. The boundaries between the subject, if not the body, and the 'rest of the world' are undergoing a radical refiguration, brought about in part through the mediation of technology. Further, as Baudrillard and others have pointed out, the boundaries between technology and nature are themselves in the midst of a deep restructuring. This means that many of the usual analytical categories have become unreliable for making the useful distinctions between the biological and the technological, the natural and artificial, the human and mechanical, to which we have become accustomed.

François Dagognet suggests that the recent debates about whether nature is becoming irremediably technologized are based on a false dichotomy: namely that there exists, here and now, a category 'nature' which is 'over here', and a category 'technology' (or, for those following other debates, 'culture') which is 'over there'. Dagognet argues on the contrary that the category 'nature' has not existed for thousands of years … not since the first humans deliberately planted gardens or discovered slash-and-burn farming. I would argue further that 'Nature', instead of representing some pristine category or originary state of being, has taken on an entirely different function in late twentieth-century economies of meaning. Not only has the character of nature as yet another coconstruct of culture become more patent, but it has become nothing more (or less) than an ordering factor – a construct by means of which we attempt to *keep technology visible* as something separate from our 'natural' selves and our everyday lives. In other words, the category 'nature', rather than referring to any object or category in the world, is a *strategy* for maintaining boundaries for political and economic ends, and thus a way of making meaning. (In this sense, the project of reifying a 'natural' state over and against a technologized 'fallen' one is not only one of the industries of postmodern nostalgia, but also part of a binary, oppositional cognitive style that some maintain is part of our society's pervasively male epistemology.)

These arguments imply as a corollary that 'technology', as we customarily think of it, does not exist either; that we must begin to rethink the category of technology as also

one that exists only because of its imagined binary opposition to another category upon which it operates and in relation to which it is constituted. In a recent paper Paul Rabinow asks what kind of being might thrive in a world in which nature is becoming increasingly technologized. What about a being who has learned to live in a world in which, rather than nature becoming technologized, technology *is* nature – in which the boundaries between subject and environment have collapsed?

Phone sex workers and VR engineers

I have recently been conducting a study of two groups who seemed to instantiate productive aspects of this implosion of boundaries. One is phone sex workers. The other is computer scientists and engineers working on VR systems that involve making humans visible in the virtual space. I was interested in the ways in which these groups, which seem quite different, are similar. For the work of both is about representing the human body through limited communication channels, and both groups do this by coding cultural expectations as tokens of meaning.

Computer engineers seem fascinated by VR because you not only program a world, but in a real sense inhabit it. Because cyberspace worlds can be inhabited by communities, in the process of articulating a cyberspace system, engineers must model cognition and community; and because communities are inhabited by bodies, they must model bodies as well. While cheap and practical systems are years away, many workers are already hotly debating the form and character of the communities they believe will spring up in their quasi-imaginary cyberspaces. In doing so, they are articulating their own assumptions about bodies and sociality and projecting them onto the codes that define cyberspace systems. Since, for example, programmers create the codes by which VR is generated in interaction with workers in widely diverse fields, how these heterogeneous co-working groups understand cognition, community and bodies will determine the nature of cognition, community and bodies in VR.

Both the engineers and the sex workers are in the business of constructing tokens that are recognized as objects of desire. Phone sex is the process of provoking, satisfying, *constructing* desire through a single mode of communication, the telephone. In the process, participants draw on a repertoire of cultural codes to construct a scenario that compresses large amounts of information into a very small space. The worker verbally codes for gesture, appearance and proclivity, and expresses these as tokens, sometimes in no more than a word. The client uncompresses the tokens and constructs a dense, complex interactional image. In these interactions desire appears as a product of the tension between embodied reality and the emptiness of the token, in the forces that maintain the pre-existing codes by which the token is constituted. The client mobilizes expectations and pre-existing codes for body in the modalities that are not expressed in the token, that is, tokens in phone sex are purely verbal, and the client uses cues in the verbal token to construct a multimodal object of desire with attributes of shape, tactility, odour, etc. This act is thoroughly individual and interpretive; out of a highly compressed token of desire the client constitutes meaning that is dense, locally situated, and socially particular.

Bodies in cyberspace are also constituted by descriptive codes that 'embody' expectations of appearance. Many of the engineers currently debating the form and nature of cyberspace are the young turks of computer engineering, men in their late teens and twenties, and they are preoccupied with the things with which post-pubescent men have always been preoccupied. This rather steamy group will generate the codes and descriptors by which

bodies in cyberspace are represented. Because of practical limitations, a certain amount of their discussion is concerned with data compression and tokenization. As with phone sex, cyberspace is a relatively narrow-bandwidth representational medium, visual and aural instead of purely aural to be sure, but how bodies are represented will involve how *re*cognition works.

One of the most active sites for speculation about how *re*cognition might work in cyberspace is the work of computer game developers, in particular the area known as interactive fantasy (IF). Since Gibson's first book burst onto the hackers' scene, interactive fantasy programmers (in particular, Laurel and others) have been taking their most durable stock-in-trade and speculating about how it will be deployed in virtual reality scenarios. For example, how, if they do, will people make love in cyberspace – a space in which everything, including bodies, exists as something close to a metaphor. Fortunately or unfortunately, however, everyone is still preorgasmic in virtual reality.

When I began the short history of virtual systems, I said that I wanted to use accounts of virtual communities as an entry point into a search for two things: an apparatus for the production of community and an apparatus for the production of body. Keeping in mind that this chapter is necessarily brief, let me look at the data so far:

- Members of electronic virtual communities act as if the community met in a physical public space. The number of times that on-line conferencees refer to the conference as an architectural place and to the mode of interaction in that place as being social is overwhelmingly high in proportion to those who do not. They say things like 'This is a nice place to get together' or 'This is a convenient place to meet'.
- The virtual space is most frequently visualized as Cartesian. On-line conferencees tend to visualize the conference system as a three-dimensional space that can be mapped in terms of Cartesian coordinates, so that some branches of the conference are 'higher up' and others 'lower down'. (One of the commands on the Stuart II conference moved the user 'sideways'.) Gibson's own visualization of cyberspace was Cartesian. In consideration of the imagination I sometimes see being brought to bear on virtual spaces, this odd fact invites further investigation.
- Conferencees act as if the virtual space was inhabited by bodies. Conferencees construct bodies on-line by describing them, either spontaneously or in response to questions, and articulate their discourses around this assumption.
- Bodies in virtual space have complex erotic components. Conferencees may flirt with each other. Some may engage in 'netsex', constructing elaborate erotic mutual fantasies. Erotic possibilities for the virtual body are a significant part of the discussion of some of the groups designing cyberspace systems. The consequences of virtual bodies are considerable in the local frame, in that conferencees mobilize significant erotic tension in relation to their virtual bodies. In contrast to the conferences, the bandwidth for physicalities in phone sex is quite limited. (One worker said ironically, '[o]n the phone, every female sex worker is white, five feet four, and has red hair.')
- The meaning of locality and privacy is not selected. The field is rife with debates about the legal status of communications within the networks. One such, for example, is about the meaning of inside and outside. Traditionally, when sending a letter one preserves privacy by enclosing it in an envelope. But in electronic mail, for example, the address is part of the message. The distinction between inside and outside has been erased, and along with it the possibility of privacy. Secure encryption systems are needed.[2]

- Names are local labels. 'Conferencees' seem to have no difficulty addressing, befriending and developing fairly complex relationships with the delegated puppets – agents – of other conferencees. Such relationships remain stable as long as the provisional name ('handle') attached to the puppet does not change, but an unexpected observation was that relationships remain stable when the conferencee decides to change handles, as long as fair notice is given. Occasionally a conferencee will have several handles on the same conference, and a constructed identity for each. Other conferencees may or may not be aware of this. Conferencees treat others' puppets as if they were embodied people meeting in a public space none the less.

Private body, public body and cyborg envy

My interest in VR engineers stems in part from observations that suggest that while they are surely engaged in saving the project of late-twentieth-century capitalism, they are also inverting and disrupting its consequences for the body as object of power relationships. They manage both to preserve the privatized sphere of the individual as well as to escape to a position that is of the spectacle and incontrovertibly public. But this occurs under a new definition of public and private: one in which warrantability is irrelevant, spectacle is plastic and negotiated, and desire no longer grounds itself in physicality. Under these conditions, one might ask, will the future inhabitants of cyberspace 'catch' the engineers' societal imperative to construct desire in gendered, binary terms – coded into the virtual body descriptors – or will they find more appealing the possibilities of difference unconstrained by relationships of dominance and submission? Partly this will depend upon how 'cyberspaceians' engage with the virtual body.

Vivian Sobchack, in her 1987 discussion of cinematic space excludes the space of the video and computer screen from participation in the production of an 'apparatus of engagement'. Sobchack describes engagement with cinematic space as producing a thickening of the present … a 'temporal simultaneity (that) also extends presence spatially – transforming the 'thin' abstracted space of the machine into a thickened and concrete world'. Contrasted with video, which is to say with the electronic space of the CRT screen and with its small, low-resolution and serial mode of display, the viewer of cinema engages with the apparatus of cinematic production in a way that produces 'a space that is deep and textural, that can be materially inhabited … a specific and mobile engagement of embodied and enworlded subjects/objects whose visual/visible activity prospects and articulates a shifting field of vision from a world that always exceeds it'. Sobchack speaks of electronic space as 'a phenomenological structure of sensual and psychological experience that seems to belong to no-body'. Sobchack sees the computer screen as 'spatially decentered, weakly temporalized and quasi-disembodied'.

This seems to be true, as long as the mode of engagement remains that of spectator. But it is the quality of direct physical and kinaesthetic engagement, the enrolling of hapticity in the service of both the drama and the dramatic, which is not part of the cinematic mode. The cinematic mode of engagement, like that of conventional theatre, is mediated by two modalities; the viewer experiences the presentation through sight and hearing. The electronic screen is 'flat', so long as we consider it in the same bimodal way. But it is the potential for interaction that is one of the things that distinguishes the computer from the cinematic mode, and that transforms the small, low-resolution, and frequently monochromatic electronic screen from a novelty to a powerfully gripping force. Interaction is the physical concretization of a desire to escape the flatness and merge into the created system. It is

the sense in which the 'spectator' is more than a participant, but becomes both participant in and creator of the simulation. In brief, it is the sense of unlimited power which the dis/embodied simulation produces, and the different ways in which socialization has led those always-embodied participants confronted with the sign of unlimited power to respond.

In quite different terms from the cinematic, then, cyberspace 'thickens' the present, producing a space that is deep and textural, and one that, in Sobchack's terms, can be materially inhabited. David Tomas, in his article 'The technophilic body' (1989), describes cyberspace as 'a purely spectacular, kinaesthetically exciting, and often dizzying sense of bodily freedom'. I read this in the additional sense of freedom *from* the body, and in particular perhaps, freedom from the sense of loss of control that accompanies adolescent male embodiment. Cyberspace is surely also a concretization of the psychoanalytically framed desire of the male to achieve the 'kinaesthetically exciting, dizzying sense' of freedom.

Some fiction has been written about multimodal, experiential cinema. But the fictional apparatus surrounding imaginary cybernetic spaces seems to have proliferated and pushed experiential cinema into the background. This is because cyberspace is part of, not simply the medium for, the action. Sobchack, on the other hand, argues that cinematic space possesses a power of engagement that the electronic space cannot match:

> Semiotically engaged as subjective and intentional, as presenting representation of the objective world ... The spectator(s) can share (and thereby to a degree interpretively alter) a film's presentation and representation of embodied experience.
>
> (Sobchack 1992)

Sobchack's argument for the viewer's intentional engagement of cinematic space, slightly modified, however, works equally well for the cybernetic space of the computer. That is, one might say that the console cowboy is also 'semiotically engaged as subjective and intentional, as presenting representation of a *sub*jective world ... the spectator can share (and thereby to a high degree interpretively alter) a simulation's presentation and representation of experience which may be, through cybernetic/semiotic operators not yet existent but present and active in fiction (the cyberspace deck), mapped back upon the physical body'.

In psychoanalytic terms, for the young male, unlimited power first suggests the mother. The experience of unlimited power is both gendered, and, for the male, fraught with the need for control, producing an unresolvable need for reconciliation with an always absent structure of personality. An 'absent structure of personality' is also another way of describing the peculiarly seductive character of the computer that Turkle (1984) characterizes as the 'second self'. Danger, the sense of threat as well as seductiveness that the computer can evoke, comes from both within and without. It derives from the complex interrelationships between human and computer, and thus partially within the human; and it exists quasi-autonomously within the simulation. It constitutes simultaneously the senses of erotic pleasure and of loss of control over the body. Both also constitute a constellation of responses to the simulation that deeply engage fear, desire, pleasure, and the need for domination, subjugation and control.

It seems to be the engagement of the adolescent male within humans of both sexes that is responsible for the seductiveness of the cybernetic mode. There is also a protean quality about cybernetic interaction, a sense of physical as well as conceptual mutability that is implied in the sense of exciting, dizzying physical movement within purely conceptual space. I find that in reality hackers experience a sense of longing for an embodied conceptual space like that which cyberspace suggests. This sense, which seems to accompany the desire to cross the human/machine boundary, to penetrate and merge, which is part of the

evocation of cyberspace, and which shares certain conceptual and affective characteristics with numerous fictional evocations of the inarticulate longing of the male for the female, I characterize as *cyborg envy*.

Smoothness implies a seductive tactile quality that expresses one of the characteristics of cyborg envy: In the case of the computer, a desire literally to enter into such a discourse, to penetrate the smooth and relatively affectless surface of the electronic screen and enter the deep, complex, and tactile (individual) cybernetic space or (consensual) cyberspace within and beyond. Penetrating the screen involves a state change from the physical, biological space of the embodied viewer to the symbolic, metaphorical 'consensual hallucination' of cyberspace; a space that is a locus of intense desire for refigured embodment.

The act of programming a computer invokes a set of reading practices both in the literary and cultural sense. 'Console cowboys' such as the cyberspace warriors of William Gibson's cyberpunk novels proliferate and capture the imagination of large groups of readers. Programming itself involves constant creation, interpretation and reinterpretation of languages. To enter the discursive space of the program is to enter the space of a set of variables and operators to which the programmer assigns names. To enact naming is simultaneously to possess the power of, and to render harmless, the complex of desire and fear that charge the signifiers in such a discourse; to enact naming within the highly charged world of surfaces that is cyberspace is to appropriate the surfaces, to incorporate the surfaces into one's own. Penetration translates into envelopment. In other words, to enter cyberspace₁ is to physically *put on* cyberspace. To become the cyborg, to put on the seductive and dangerous cybernetic space like a garment, is to put on the *female*. Thus cyberspace both *dis*embodies, in Sobchack's terms, but also *re*embodies in the polychrome, hypersurfaced cyborg character of the console cowboy. As the charged, multigendered, hallucinatory space collapses onto the personal physicality of the console cowboy, the intense tactility associated with such a reconceived and refigured body constitutes the seductive quality of what one might call the *cybernetic act*.

In all, the unitary, bounded, safely warranted body constituted within the frame of bourgeois modernity is undergoing a gradual process of translation to the refigured and reinscribed embodiments of the cyberspace community. Sex in the age of the coding metaphor – absent bodies, absent reproduction, perhaps related to desire, but desire itself refigured in terms of bandwidth and internal difference – may mean something quite unexpected. Dying in the age of the coding metaphor – in selectably inhabitable structures of signification, absent warrantability – gives new and disturbing meaning to the title of Steven Levine's (1988) book about the process, *Who Dies?*

Cyberspace, sociotechnics and other neologisms

Part of the problem of 'going on in much the same way', as Harry Collins put it, is in knowing what the same way is. At the close of the twentieth century, I would argue that two of the problems are, first, as in Paul Virilio's analysis, *speed*, and second, tightly coupled to speed, what happens as human physical evolution falls further and further out of synchronization with human cultural evolution. The product of this growing tension between nature and culture is stress.

The development of cyberspace systems – which I will refer to as part of a new *technics* – may be one of a widely distributed constellation of responses to stress, and second, as a way of continuing the process of collapsing the categories of nature and culture that Paul Rabinow sees as the outcome of the new genetics. Cyberspace can be viewed as a toolkit

for refiguring consciousness in order to permit things to go on in much the same way. Rabinow suggests that nature will be modelled on culture; it will be known and remade through technique. Nature will finally become artificial, just as culture becomes natural.

Haraway (1985) puts this in a slightly different way: 'The certainty of what counts as nature,' she says, '[that is, as] a source of insight, a subject for knowledge, and a promise of innocence – is undermined, perhaps fatally.' The change in the permeability of the boundaries between nature and technics that these accounts suggest does not simply mean that nature and technics mix – but that, seen from the technical side, technics become natural, just as, from Rabinow's anthropological perspective on the culture side, culture becomes artificial. In technosociality, the social world of virtual culture, technics is nature. When exploration, rationalization, remaking and control mean the same thing, then nature, technics and the structure of meaning have become indistinguishable. The technosocial subject is able successfully to navigate through this treacherous new world. S/he is constituted as part of the evolution of communications technology and of the human organism, in a time in which technology and organism are collapsing, imploding, into each other.

Electronic virtual communities represent flexible, lively and practical adaptations to the real circumstances that confront persons seeking community in what Haraway (1987) refers to as 'the mythic time called the late twentieth century'. They are part of a range of innovative solutions to the drive for sociality – a drive that can be frequently thwarted by the geographical and cultural realities of cities increasingly structured according to the needs of powerful economic interests rather than in ways that encourage and facilitate habitation and social interaction in the urban context. In this context, electronic virtual communities are complex and ingeneous strategies for *survival*. Whether the seemingly inherent seductiveness of the medium distorts the aims of those strategies, as television has done for literacy and the personal interaction, remains to be seen.

So much for community. What about the body?

No matter how virtual the subject may become, there is always a body attached. It may be off somewhere else – and that 'somewhere else' may be a privileged point of view – but consciousness remains firmly rooted in the physical. Historically, body, technology and community constitute each other.

In her 1990 book *Gender Trouble*, Judith Butler introduces the useful concept of the 'culturally intelligible body', or the criteria and the textual productions (including writing on or in the body itself) that each society uses to produce physical bodies that it recognizes as members. It is useful to argue that most cultural production of intelligibility is about reading or writing and takes place through the mediation of texts. If we can apply textual analysis to the narrow-bandwidth modes of computers and telephones, then we can examine the production of gendered bodies in cyberspace also as a set of tokens that code difference within a field of ideal types. I refer to this process as the production of the *legible* body.

The opposite production, of course, is of the *illegible* body, the 'boundary-subject' that theorist Gloria Anzaldúa calls the *mestiza*, one who lives in the borderlands and is only partially recognized by each abutting society. Anzaldúa describes the mestiza by means of a multiplicity of frequently conflicting accounts. There is no position, she shows, outside of the abutting societies themselves from which an omniscient overview could capture the essence of the mestiza's predicament, nor is there any single account from within a societal framework that constitutes an adequate description.

If the mestiza is an illegible subject, existing quantum-like in multiple states, then participants in the electronic virtual communities of cyberspace live in the border- lands of both physical and virtual culture, like the mestiza. Their social system includes other people, quasi people or delegated agencies that represent specific individuals, and quasi agents that represent 'intelligent' machines, clusters of people, or both. Their ancestors, lower on the chain of evolution, are network conferencers, communities organized around such texts as Boyle's 'community of gentlemen' and the religious traditions based in holy scripture, communities organized around broadcasts, and communities of music such as the Deadheads. What separates the cyberspace communities from their ancestors is that many of the cyberspace commununities interact in real time. Agents meet face-to-face, though as I noted before, under a redefinition of both 'meet' and 'face'.

I might have been able to make my point regarding illegible subjects without invoking the mestiza as an example. But I make an example of a specific kind of person as a way of keeping the discussion grounded in individual bodies: in Paul Churchland's words, in the 'situated biological creatures' that we each are. The work of science is *about* bodies – not in an abstract sense, but in the complex and protean ways that we daily manifest ourselves as physical social beings, vulnerable to the powerful knowledges that surround us, and to the effects upon us of the transformative discourses of science and technology that we both enable and enact.

I am particularly conscious of this because much of the work of cyberspace researchers, reinforced and perhaps created by the soaring imagery of William Gibson's novels, assumes that the human body is 'meat' – obsolete, as soon as consciousness itself can be uploaded into the network. The discourse of visionary virtual world builders is rife with images of imaginal bodies, freed from the constraints that flesh imposes. Cyberspace developers foresee a time when they will be able to forget about the body. But it is important to remember that virtual community originates in, and must return to, the physical. No refigured virtual body, no matter how beautiful, will slow the death of a cyberpunk with AIDS. Even in the age of the technosocial subject, life is lived through bodies.

Forgetting about the body is an old Cartesian trick, one that has unpleasant consequences for those bodies whose speech is silenced by the act of our forgetting; that is to say, those upon whose labour the act of forgetting the body is founded – usually women and minorities. On the other hand, as Haraway points out, forgetting can be a powerful strategy; through forgetting, that which is already built becomes that which can be discovered. But like any powerful and productive strategy, this one has its dangers. Remember – discovering – that bodies and communities constitute each other surely suggests a set of questions and debates for the burgeoning virtual electronic community. I hope to observe the outcome.

Acknowledgements

Thanks to Mischa Adams, Gloria Anzaldúa, Laura Chernaik, Heinz von Foerster, Thyrza Goodeve, John Hartigan, Barbara Joans, Victor Kytasty, Roddey Reid, Chela Sandoval, Susan Leigh Star, and Sharon Traweek for their many suggestions; to Bandit (Seagate), Ron Cain (Borland), Carl Tollander (Autodesk), Ted Kaehler (Sun), Jane T. Lear (Intel), Marc Lentczner, Robert Orr (Amdahl), Jon Singer (soulmate), Brenda Laurel (Telepresence Research and all-around Wonderful Person); Joshua Susser, the advanced Technology Group of Apple Computer, Inc., Tene Tachyon, Jon Shemitz, John James, and my many respondents in the virtual world of on-line BBSs. I am grateful to Michael Benedikt and friends and to the University of Texas School of Architecture for making part of the research possible, and

to the participants in The First Conference on Cyberspace for their ideas as well as their collaboration in constituting yet another virtual community. In particular I thank Donna Haraway, whose work and encouragement have been invaluable.

Notes

1. 'Nearby' is idiosyncratic and local in cyberspace. In the case of Habitat, it means that two puppets (body representatives) occupy that which is visible on both screens simultaneously. In practice this means that each participant navigates his or her screen 'window' to view the same area in the cyberspace. Because Habitat is consensual, the space looks the same to different viewers. Due to processor limitations only nine puppets can occupy the same window at the same time, although there can be more in the neighbourhood (just off-screen).
2. Although no one has actually given up on encryption systems, the probable reason that international standards for encryption have not proceeded much faster has been the US Government's opposition to encryption key standards that are reasonably secure. Such standards would prevent agencies like the CIA from gaining access to communications traffic. The United States' diminishing role as a superpower may change this. Computer industries in other nations have overtaken the United States' lead in electronics and are beginning to produce secure encryption equipment as well. A side effect of this will be to enable those engaged in electronic communication to reinstate the inside-outside dichotomy, and with it the notion of privacy in the virtual social space.

References

Allan, F. (1984) 'The end of intimacy', *Human Rights*, Winter: 55.

Anzaldúa, G. (1987) *Borderlands/La Frontera: The New Mestiza*, San Francisco: Spinsters/Aunt Lute.

Barker, F. (1984) *The Tremulous Private Body: Essays in Subjection*, London: Methuen.

Baudrillard, J. (1987) *The Ecstasy of Communication*, trans. Bernard and Caroline Schutze, Sylvere Lotringer, New York: Semiotext(e).

Butler, J. (1990) *Gender Trouble: Feminism and The Subversion of Identity*, New York: Routledge.

Campbell, J. (1959) *The Masks of God: Primitive Mythology*, New York: Viking.

Cohn, C. (1987) 'Sex and death in the rational world of defense intellectuals', *Signs: Journal of Woman in Culture and Society*, 12: 4.

de Certeau, M. (1985) 'The arts of dying: celibatory mechines', in *Heterologies* trans. Brian Massumi, Minneapolis: University of Minnesota Press.

Dewey, J. (1896) 'The reflex arc concept in psychology', in J. J. McDermott (ed.) (1981) *The Philosophy of John Dewey*, Chicago: University of Chicago Press, pp. 36–148.

Edwards, P. N. (1986). 'Artificial intelligence and high technology war: the perspective of the formal machine', Silicon Valley Research Group Working Paper no. 6.

Gibson, W. (1984) *Neuromancer*, New York: Ace.

Habermas, J. (1979) *Communication and The Evolution of Society*, Boston: Beacon Press.

Haraway, D. (1985) 'A manifesto for cyborgs: science, technology and socialist feminism in the 1980s', *Socialist Review*, 80: 65–107.

—— (1987) 'Donna Haraway reads National Geographic', Paper Tiger. Video.

—— (1988) 'The biopolitics of postmodern bodies: determinations of self and other in immune system discourse', *Wenner Gren Foundation Conference on Medical Anthropology*, Lisbon, Portugal.

—— (1990) 'Washburn and the new physical anthropology', in *Primate Visions: Gender, Race, and Nature in the World of Modern Science*, New York: Routledge.

—— (1991) 'The promises of monsters: a regenerative politics for inappropriate/d others', in Grossberg, L., Nelson, G. and Treichler, P. (eds), *Cultural Studies Now and in the Future*. New York and London: Routledge.

Hayles, N. K. (1987) 'Text out of context: situating postmodernism within an information society', *Discourse*, 9: 24–36.

—— (1987) 'Denaturalizing experience: postmodern literature and science'. Abstract from Conference on Literature and Science as Modes of Expression, sponsored by the Society of Literature and Science, Worcester Polytechnic Institute, October 8–11.

Head, H. (1920) *Studies in Neurology*, Oxford: Oxford University Press.

—— (1926) *Aphasia and Kindred Disorders of Speech*, Cambridge: Cambridge University Press.

Hewitt, C. (1977) 'Viewing control structures as patterns of passing messages', *Artificial Intelligence*, 8: 323–64.

—— (1977) 'The challenge of open systems', *Byte*, vol. 10 April.

Huyssen, A. (1986) *After the Great Divide: Modernism, Mass Culture, Postmodernism*, Bloomington: Indiana University Press.

Jameson, F. (1981) 'On interpretation: literature as a socially symbolic act', in *The Politiical Unconscious*, Ithaca: Cornell University Press.

Lacan, J. (1968) *The Language of the Self: The Function of Language in Psychoanalysis*, trans. Anthony Wilden, New York: Dell.

—— (1977) *The Four Fundamental Concepts of Psychoanalysis*, trans. Alain Sheridan (ed.) Jacques-Alain Miller, London: Hogarth.

LaPorte, T. R. (ed.) (1975) *Organized Social Complexity: Challenge to Politics and Policy*, Princeton, NJ: Princeton University Press.

Latour, B. (1988) *The Pasteurization of France*, trans. Alain Sheridan and John Law, Cambridge: Harvard University Press.

Laurel, B. (1986) 'Interface as mimesis', in D. A. Norman, and S. Draper (eds), *User Centered System Design: New Perspectives on Human–Computer Interaction*, Hillsdale, NJ: Lawrence Erlbaum Associates.

—— (1987) 'Reassessing interactivity', *Journal of Computer Game Design*, 1: 3.

—— (1988) 'Culture hacking', *Journal of Computer Game Design*, 1: 8.

—— (1989a) 'Dramatic action and virtual reality'. Proceedings of the 1989 NCGA Interactive Arts Conference.

—— (1989b) 'New interfaces for entertainment', *Journal of Computer Game Design*, 2: 5.

—— (1989c) 'A taxonomy of interactive movies', *New Media News*, The Boston Computer Society, 3: 1.

Lehman-Wilzig, S. (1981) 'Frankenstein unbound: toward a legal definition of artificial intelligence', *Futures*, December, 447.

Levine, S. (1988) *Who Dies? An Investigation of Conscious Living and Conscious Dying*, Bath: Gateway Press.

Merleau-Ponty, M. (1962) *Phenomenology of Perception*, trans. Colin Smith, New York: Humanities Press.

—— (1964a) *Sense and Non-Sense*, trans. Hubert L. Dreyfus and Patricia Allen Dreyfus, Chicago: Northwestern University Press.

—— (1964b) *Signs*, trans. Richard McCleary, Chicago: Northwestern University Press.

Mitchell, S. W., Morehouse, G. and Williams Keen, W. (1872) *Injuries of Nerves and Their Consequences*, with a new introduction by Lawrence C. McHenry, Jr., *American Academy of Neurology Reprint Series*, vol. 2, New York: Dover (1965).

—— (1864) 'Gunshot wounds and other injuries of nerves'. Reprinted (1989) with biographical introductions by Ira M. Rutkow, *American Civil War Surgery Series*, vol. 3, San Francisco: Norman.

—— Noddings, N. (1984) *Caring: a Feminine Approach to Ethics and Moral Education*, Berkeley: University of California Press.

Reid, R. 'Tears for fears: Paul et Virginie, "family" and the politics of the sentimental body in pre-revolutionary France.' Forthcoming.

Rentmeister, C. (1976) 'Beruftsverbot fur musen', *Aesthetik und Kommunikation*, September 25, 92–112.

Roheim, G. (1928) 'Early stages of the oedipus complex', *International Journal of Psycho-analysis*, vol. 9.

—— (1947) 'Dream analysis and field work', in *Anthropology, Psychoanalysis and the Social Sciences*, New York: International Universities Press.

Shapin, S. and Schaffer, S. (1985) *Leviathan and the Air-Pump: Hobbes, Boyle, and the Experimental Life*, Princeton: Princeton University Press.

Sobchack, V. (1992) *The Address of the Eye: A Phenomendogy of Film Experience*, New York: University of Princeton Press.

—— (1987) *Screening Space: The American Science Fiction Film*, New York: Ungar.

—— (1988) 'The scene of the screen: toward a phenomenology of cinematic and electronic "presence"', in H. V. Gumbrecht and L. K. Pfeiffer (eds), *Materialitat des Kommunikation*, Frankfurt/Main: Suhrkamp-Verlag.

Stone, S. P. (1988) 'So that's what those two robots were doing in the park … I thought they were repairing each other! The discourse of gender, pornography, and artificial intelligence'. Presented at Conference of the Feminist Studies Focused Research Activity, October, University of California, Santa Cruz, CA.

—— (1989) 'How robots grew gonads: a cautionary tale'. Presented at *Contact V: Cultures of the Imagination*, Phoenix, AZ, 28 March. Forthcoming in Funaro and Joans (eds), *Collected Proceedings of the Contact Conferences*.

—— (1990a) 'Sex and death among the cyborgs: how to construct gender and boundary in distributed systems', *Contact VI: Cultures of the Imagination*, Phoenix, AZ.

—— (1990b) 'Sex and death among the disembodied: how to provide counseling for the virtually preorgasmic'. In M. Benedikt (ed.), *Collected Abstracts of the First Cyberspace Conference*, The University of Texas at Austin, School of Architecture.

—— (1990c) 'Aliens, freaks, monsters: the politics of virtual sexuality'. For the panel Gender and Cultural Bias in Computer Games, Computer Game Developers' Conference, San Jose.

—— (1991) 'Ecriture artifactuelle: boundary discourse, distributed negotiation, and the structure of meaning in virtual systems', forthcoming at the *1991 Conference on Interactive Computer Grahics*.

Stone, C. D. (1974) *Should Trees Have Standing? – Toward Legal Rights for Natural Objects*, New York: William A. Kaufman.

Theweleit, K. (1977) *Male Fantasies*, vol. 1, Frankfurt am Main: Verlag Roter Stern.

Tomas, D. (1989) 'The technophilic body: on technicity in William Gibson's cyborg culture', *New Formations*, 8 Spring.

Turkle, S. (1984) *The Second Self: Computers and the Human Spirit*, New York: Simon and Schuster.

Von Foerster, H. (ed.), (1951) *Transactions of the Conference on Cybernetics*, New York: Josiah Macy, Jr. Foundation.

Weiner, N. (1950) *The Human Use of Human Beings*, New York: Avon.

Wilden, A. (1980) *System and Structure: Essays in Communication and Exchange*, 2nd ed., New York: Tavistock.

Winograd, T., and Flores, C. F. (1986) *Understanding Computers and Cognition: A New Foundation for Design*, Norwood, NJ: Ablex.

Wolkomir, R. (1990) 'High-tech hokum is changing the way movies are made', *Smithsonian* 10/90: 124.

Stelarc

FROM PSYCHO-BODY TO CYBER-SYSTEMS
Images as post-human entities

THE BODY NEEDS TO BE REPOSITIONED from the psycho realm of the biological to the cyber zone of the interface and extension – from genetic containment to electronic extrusion. Strategies toward the post-human are more about erasure, rather than affirmation – an obsession no longer with self but an analysis of structure. Notions of species evolution and gender distinction are remapped and reconfigured in alternate hybridities of human–machine. Outmoded metaphysical distinctions of soul–body or mind–brain are superseded by concerns of body–species split, as the body is redesigned – diversifying in form and functions. Cyborg bodies are not simply wired and extended but also enhanced with implanted components. Invading technology eliminates skin as a significant site, an adequate interface, or a barrier between public space and physiological tracts. The significance of the cyber may well reside in the act of the body shedding its skin. And as humans increasingly operate with surrogate bodies in remote spaces they function with increasingly intelligent and interactive images. The possibility of autonomous images generates an unexpected outcome of human–machine symbiosis. The post-human may well be manifested in the intelligent life form of autonomous images.

1. BEYOND AFFIRMATION INTO ERASURE: Can we re-evaluate the body without resorting to outmoded Platonic and Cartesian metaphysics? The old and often arbitrary psycho-analytical readings have been exhausted. Postmodern critiques generate a discourse of psycho-babble that not so much reveals but entraps the body in the *archetypical* and *allegorical*. The obsession with the self, sexual difference and the symbolic begins to subside in cyber-systems that *monitor*, *map* and *modify* the body. Increasing augmentation of the body and automation by transferring its functions to machines undermines notions of free agency and demystifies mind. CYBER-SYSTEMS SPAWN ALTERNATE, HYBRID AND SURROGATE BODIES.

2. The MYTH OF INFORMATION: The information explosion is indicative of an evolutionary dead end. It may be the height of human civilization, but it is also the climax of its evolutionary experience. In our decadent biological phase, we indulge in information as if this compensates for our genetic inadequacies. The INFORMATION IS THE PROSTHESIS

THAT PROPS UP THE OBSOLETE BODY. Information- gathering has become not only a meaningless ritual, but a deadly destructive paralyzing process, *preventing it from taking physical phylogenetic action*. Information-gathering satisfies the body's outmoded Pleistocence program. It is mentally seductive and seems biologically justified.

The cortex craves for information, but it can no longer contain and creatively process it all. How can a body subjectively and simultaneously grasp both nanoseconds and nebulae? THE CORTEX THAT CANNOT COPE RESORTS TO SPECIALIZATION. Specialization, once a manoeuvre methodically to collect information, now is a manifestation of information overloads. The role of information has changed. Once justified as a means of comprehending the world, it now generates a conflicting and contradictory, fleeting and fragmentary field of disconnected and undigested data. INFORMA- TION IS RADIATION. The most significant planetary pressure is no longer the *gravitational pull*, but the *information thrust*. The psycho-social flowering of the human species has withered. We are in the twilight of our cerebral fantasies. The symbol has lost all power. The accumulation of information has lost all purpose. Memory results in mimicry. Reflection will not suffice. THE BODY MUST BURST FROM ITS BIOLOGICAL, CULTURAL, AND PLANETARY CONTAINMENT.

3. FREEDOM OF FORM: In this age of information overloads, what is significant is no longer freedom of ideas but rather freedom of form – freedom to modify and mutate the body. The question is not whether society will allow people freedom of expression but whether the human species will allow the individuals to construct alternate genetic coding. THE FUNDAMENTAL FREEDOM IS FOR INDIVIDUALS TO DETERMINE THEIR OWN DNA DESTINY. Biological change becomes a matter of choice rather than chance. EVOLUTION BY THE INDIVIDUAL, FOR THE INDIVIDUAL. Medical technologies that monitor, map and modify the body also provide the means to manipulate the structure of the body. When we attach or implant prosthetic devices to prolong a person's life, we also create the potential to propel post-evolutionary development – PATCHED-UP PEOPLE ARE POST-EVOLUTIONARY EXPERIMENTS.

4. BIOTECH TERRAINS: The body now inhabits alien environments that conceal countless BODY PACEMAKERS – visual and acoustical cues that *alert*, *activate*, *condition and control the body*. Its circadian rhythms need to be augmented by artifical signals. Humans are now regulated in sync with swift, circulating rhythms of pulsing images. MORPHING IMAGES MAKE THE BODY OBSOLETE …

5. OBSOLETE BODY: It is time to question whether a bipedal, breathing body with binocular vision and a 1400cc brain is an adequate biological form. It cannot cope with the quantity, complexity and quality of information it has accumulated; it is intimidated by the precision, speed and power of technology and it is biologically ill-equipped to cope with its new extraterrestrial environment. The body is neither a very efficient nor a very durable structure. It malfunctions often and fatigues quickly; its performance is determined by its age. It is susceptible to disease and is doomed to a certain and early death. Its survival parameters are very slim. It can survive only weeks without food, days without water, and minutes without oxygen. The body's LACK OF MODULAR DESIGN and its overreactive immunological system make it difficult to replace malfunctioning organs. It might be the height of technological folly to consider the body obsolete in form and function: yet it might be the highest of human realizations. For it is only when the body becomes aware of its present position that it can map its post-evolutionary strategies. It is no longer a matter of perpetuating the human species by REPRODUCTION, but of enhancing male/female intercourse by human–machine interface. THE BODY IS OBSOLETE. We are at the end of philosophy and human physiology. Human thought recedes into the human past.

6. ABSENT BODIES: We mostly operate as Absent Bodies. That is because A BODY IS DESIGNED TO INTERFACE WITH ITS ENVIRONMENT – its sensors are open-to-the-world (compared to its inadequate internal surveillance system). The body's mobility and navigation in the world require this outward orientation. Its absence is augmented by the fact that the body functions *habitually* and *automatically*. AWARENESS IS OFTEN THAT WHICH OCCURS WHEN THE BODY MALFUNCTIONS. Reinforced by Cartesian convention, personal convenience and neurophysiological design, people operate merely as minds, immersed in metaphysical fogs. The sociologist P. L. Berger made the distinction between 'having a body' and 'being a body'. AS SUPPOSED FREE AGENTS, THE CAPABILITIES OF BEING A BODY ARE CONSTRAINED BY HAVING A BODY. Our actions and ideas are essentially determined by our physiology. We are at the limits of philosophy, not only because we are at the limits of language. Philosophy is *fundamentally* grounded in our physiology …

7. REDESIGNING THE BODY/REDEFINING WHAT IS HUMAN. It is no longer meaningful to see the body as a site for the psyche or the social, but rather as a structure to be monitored and modified; the body not as a subject but as an object – NOT AS AN OBJECT OF DESIRE BUT AS AN OBJECT FOR DESIGNING. The psycho-social period was characterized by the body circling itself, *orbiting itself, illuminating and inspecting itself* by physical prodding and metaphysical contemplation. But having confronted its image of obsolescence, the body is traumatized to split from the realm of subjectivity and consider the necessity of re-examining and possibly redesigning its very structure. ALTERING THE ARCHITECTURE OF THE BODY RESULTS IN ADJUSTING AND EXTENDING ITS AWARENESS OF THE WORLD. As an object, the body can be amplified and accelerated, attaining planetary escape velocity. It becomes a post-evolutionary projectile, *departing and diversifying* in form and function.

8. EXTRA EAR: Having developed a Third Hand, consider the possibility of constructing an extra ear, *positioned next to the real ear*. A laser scan was done to create a 3D simulation of the Extra Ear in place. Although the chosen position is in front of and beside the right ear, *this may not be the surest and safest place anatomically to put it*. A balloon is inserted under the skin and is gradually inflated over a period of months until a bubble of stretched skin is formed. The balloon is then removed and a cartilage ear shape is pinned inside the bag of excess skin. A cosmetic surgeon would then need to cut and sew the skin over the cartilage structure. Rather than the hardware prosthesis of a mechanical hand, the Extra Ear would be a soft augmentation, mimicking the actual ear in shape and structure, but having different functions. IMAGINE AN EAR THAT CANNOT HEAR BUT RATHER CAN EMIT SOUNDS. Implanted with a sound chip and a proximity sensor, the ear would speak to anyone who would get close to it. Perhaps, the ultimate aim would be for the Extra Ear to whisper sweet nothings to the other ear. Or imagine the Extra Ear *as an Internet antenna* able to amplify RealAudio sounds to augment the local sounds heard by the actual ears. The Extra Ear would be a prosthesis made from its own skin. Why an ear? An ear is a beautiful and complex structure. In acupuncture, the ear is the site for the stimulation of body organs. It not only hears but is also the organ of balance. To have an extra ear points to more than visual and *anatomical excess*.

9. SURFACE AND SELF: As surface, skin was once the beginning of the world and simultaneously the boundary of the self. As interface, it was once the site of the collapse of the personal and the political. But now *stretched* and *penetrated* by machines, SKIN IS NO LONGER THE SMOOTH SENSUOUS SURFACE OF A SITE OR A SCREEN. Skin no longer signifies closure. The rupture of surfaces and of skin means the *erasure* of inner and outer. As interface, the skin is inadequate.

10. THE INVASION OF TECHNOLOGY: Miniaturized and biocompatible, technology lands on the body. Although unheralded, it is one of the most important events in human history, focusing physical change on each individual. Technology is not only attached but is also implanted. ONCE A CONTAINER, TECHNOLOGY NOW BECOMES A COMPONENT OF THE BODY. As an instrument, technology fragmented and depersonalized experience – as a component it has the potential to SPLIT THE SPECIES. It is no longer of any advantage to either remain 'human' or evolve as a species. EVOLUTION ENDS WHEN THE TECHNOLOGY INVADES THE BODY. Once technology provides each person with the potential to progress individually in its development, the cohesiveness of the species is no longer distinction but the body–species split. The significance of technology may be that it culminates in alternate awareness – one that is POST-HISTORIC, TRANSHUMAN and even EXTRATERRESTRIAL (the first signs of an alien intelligence may well come from this planet).

11. AMPLIFIED BODY, LASER EYES AND HAND: If the earlier events can be characterized as probing and piercing the body (the three films of the inside of the stomach, lungs, and colon/the twenty-five body suspensions), determining the physical parameters and normal capabilities of the body, then the recent performances extend and enhance it visually and acoustically. Body processes amplified include brain waves (ECG), muscles (EMG), pulse (PLETHYSMOGRAM), and bloodflow (DOPPLER FLOW METER). Other transducers and sensors monitor limb motion and indicate body posture. The sound field is configured by buzzing, warbling, clicking, thumping, beeping, and whooshing sounds – of triggered, random, repetitive, and rhythmic signals. The artificial hand, attached to the right arm as an addition rather than a prosthetic replacement, is capable of independent motion, being activated by the EMG signals of the abdominal and leg muscles. It has a pinch-release, grasp-release, 270° wrist rotations (clock-wise and counterclock-wise), and a tactile feeback system for a rudimentary 'sense of touch'. While the body activates its extra manipulator, the real left arm is remote controlled – jerked into action by two muscle stimulators. Electrodes positioned on the flexor muscles and biceps curl the finger inward, bend the wrist, and thrust the arm upward. The triggering of the arm motion paces the performance and the stimulator signals are used as sound sources as is the motor sound of the Third Hand mechanism. The body performs in a structured and interactive lighting installation which flickers and flares, responding and reacting to the electrical discharges of the body – sometimes synchronizing, sometimes counterpointing. Light is not treated as an external illumination of the body but as a manifestation of the body rhythms. The performance is a choreography of controlled, constrained and involuntary motions – of internal rhythms and external gestures. It is an interplay between physiological control and electronic modulation, of human functions and machine enhancement.

12. THE SHEDDING OF SKIN: Off the Earth, the body's *complexity, softness and wetness* would be difficult to sustain. The strategy should be to HOLLOW, HARDEN and DEHYDRATE the body to make it more durable and less vulnerable. The present organization of the body is unnecessary. The solution to modifying the body is not to be found in its internal structure, but lies simply on its surface. The SOLUTION IS NO MORE THAN SKIN DEEP. The significant event in our evolutionary history was a change in the mode of locomotion. Future developments will occur with a *change of skin*. If we could engineer a SYNTHETIC SKIN which could absorb oxygen directly through its pores and could efficiently convert light into chemical nutrients, we could radically redesign the body, eliminating many of its redundant systems and malfunctioning organs, minimizing toxin build-up in its chemistry. THE HOLLOW BODY WOULD BE A BETTER HOST FOR TECHNOLOGICAL COMPONENTS.

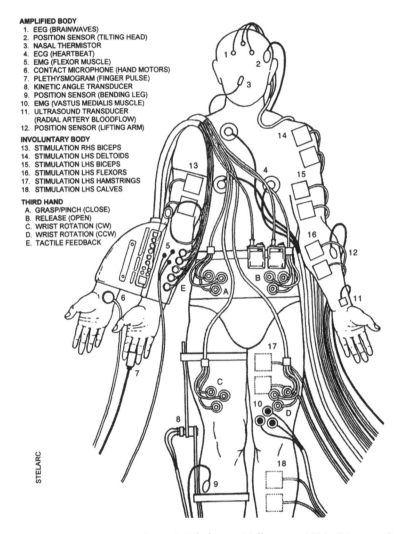

AMPLIFIED BODY
1. EEG (BRAINWAVES)
2. POSITION SENSOR (TILTING HEAD)
3. NASAL THERMISTOR
4. ECG (HEARTBEAT)
5. EMG (FLEXOR MUSCLE)
6. CONTACT MICROPHONE (HAND MOTORS)
7. PLETHYSMOGRAM (FINGER PULSE)
8. KINETIC ANGLE TRANSDUCER
9. POSITION SENSOR (BENDING LEG)
10. EMG (VASTUS MEDIALIS MUSCLE)
11. ULTRASOUND TRANSDUCER
 (RADIAL ARTERY BLOODFLOW)
12. POSITION SENSOR (LIFTING ARM)

INVOLUNTARY BODY
13. STIMULATION RHS BICEPS
14. STIMULATION LHS DELTOIDS
15. STIMULATION LHS BICEPS
16. STIMULATION LHS FLEXORS
17. STIMULATION LHS HAMSTRINGS
18. STIMULATION LHS CALVES

THIRD HAND
A. GRASP/PINCH (CLOSE)
B. RELEASE (OPEN)
C. WRIST ROTATION (CW)
D. WRIST ROTATION (CCW)
E. TACTILE FEEDBACK

Figure 27.1 *Involuntary Body/Third Hand*, Yokohama, Melbourne, 1990. Diagram: Stelarc.
© Stelarc.

13. STOMACH SCULPTURE: HOLLOW BODY/HOST SPACE: The intention has been to design a sculpture for a distended stomach. The idea was to insert an art work into the body – *to situate the sculpture in an internal space*. The body becomes hollow with no meaningful distinctions between public, private and physiological spaces. TECHNOLOGY INVADES AND FUNCTIONS WITHIN THE BODY NOT AS A PROSTHETIC REPLACEMENT, BUT AS AN AESTHETIC ADORNMENT. The structure is collapsed into a capsule 50mm × 14mm, and tethered to its control box it is swallowed and inserted into the stomach. The stomach is *inflated* with air using an endoscope. A *logic circuit* board and a *servomotor* open the sculpture using a flexi-dive cable to 80mm × 50mm in size. A piezo-buzzer beeps in sync to a light globe blinking inside the stomach. The sculpture is an extending/retracting structure, sound-emitting and self-illuminating. (It is fabricated using implant-quality metals such as titanium, stainless steel, silver and gold.) The sculpture is retracted into its capsule form to be removed. As a body, one no longer looks at art, doesn't perform art,

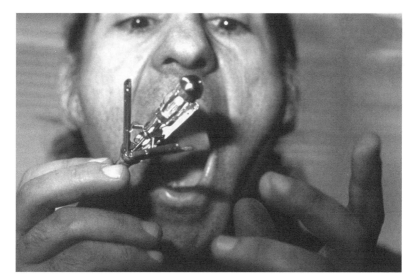

Figure 27.2 *Stomach Sculpture*, Fifth Australian Sculpture Triennale, NGV, Melbourne 1993.Photograph: Anthony Figallo. © Stelarc.

but contains art. THE HOLLOW BODY BECOMES A HOST, NOT FOR A SELF OR A SOUL, BUT SIMPLY FOR A SCULPTURE.

14. PAN-PLANETARY PHYSIOLOGY. Extraterrestrial environments amplify the body's obsolescence, intensifying pressures for its re-engineering. There is a necessity TO DESIGN A MORE SELF-CONTAINED, ENERGY-EFFICIENT BODY, WITH EXTENDED SENSORY ANTENNAE AND AUGMENTED CEREBRAL CAPACITY. Unplugged from this planet – from its complexity, interacting energy chain and protective biosphere – the body is biologically ill-equipped, not only in terms of its sheer survival, but also in its inability adequately to perceive and perform in the immensity of outer space. Rather than developing *specialist bodies for specific sites*, we should consider a pan-planetary physiology that is durable, flexible and capable of functioning in varying atmospheric conditions, gravitational pressures and electro-magnetic fields.

15. NO BIRTH/NO DEATH – THE HUM OF THE HYBRID: Technology transforms the nature of human existence, equalizing the physical potential of bodies and standardizing human sexuality. With fertilization now occurring outside the womb and the possibility of nurturing the foetus in an artificial support system THERE WILL TECHNICALLY BE NO BIRTH. And if the body can be redesigned in a modular fashion to facilitate the replacement of malfunctioning parts, then TECHNICALLY THERE WOULD BE NO REASON FOR DEATH – given the accessibility of replacements. Death does not authenticate existence. *It is an outmoded evolutionary strategy*. The body need no longer be repaired but simply have parts replaced. Extending life no longer means 'existing' but rather being 'operational'. Bodies need not age or deteriorate; they would not run down nor even fatigue; they would stall then start – possessing both the potential for renewal and reactivation. In the extended space–time of extraterrestrial environments, THE BODY MUST BECOME IMMORTAL TO ADAPT. Utopian dreams become post-evolutionary imperatives. THIS IS NO MERE FAUSTIAN OPTION NOR SHOULD THERE BE ANY FRANKENSTEINIAN FEAR OF TAMPERING WITH THE BODY.

16. THE ANAESTHETIZED BODY: The importance of technology is not simply in the pure power it generates but in the *realm of abstraction* it produces through its *operational speed*

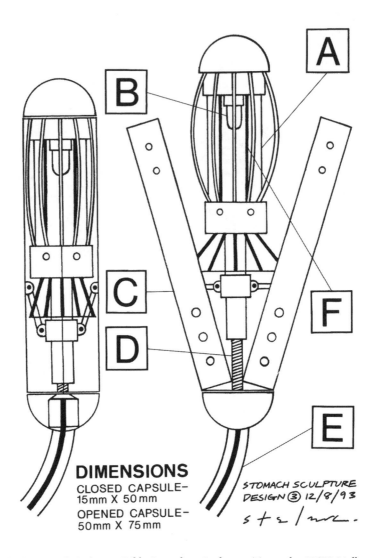

DIMENSIONS
CLOSED CAPSULE-
15mm X 50mm

OPENED CAPSULE-
50mm X 75mm

STOMACH SCULPTURE
DESIGN ③ 12/8/93

s + s / mrc.

Figure 27.3 *Stomach Sculpture*, Fifth Australian Sculpture Triennale, NGV, Melbourne 1993. Diagram: Stelarc. © Stelarc.

and its development of *extended sense systems*. Technology pacifies the body and the world. It disconnects the body from many of its functions. DISTRAUGHT AND DISCONNECTED, THE BODY CAN ONLY RESORT TO INTERFACE AND SYMBIOSIS. The body may not yet surrender its autonomy but certainly its mobility. The body plugged into some machine network needs to be pacified. In fact, to function in the future and to achieve truly a hybrid symbiosis the body will need to be increasingly anaesthetized.

17. SPLIT BODY: VOLTAGE-IN/VOLTAGE-OUT: Given that a body is not in a hazardous location, there would be reasons to remote-actuate a person, or part of a person, rather than a robot. An activated arm would be connected to an intelligent mobile body with another free arm to augment its task! Technology now allows you to be physically moved by another mind. A computer interfaced MULTIPLE-MUSCLE STIMULATOR makes possible the complex programming of either in a local place or in a remote location. Part of your body

would be moving; you've neither willed it to move, nor are you internally contracting your muscles to produce that movement. The issue would not be to automate a body's movement but rather the system would enable the displacement of a physical action from one body to another body in another place – for the on-line completion of a real-time task or the conditioning of a transmitted skill. There would be new interactive possibilities between bodies. A touch-screen interface would allow programming by *pressing* the muscle sites on the computer model and/or by retrieving and *pasting* from a library of gestures. Simulation of the movement can be examined before transmission and actuation. THE REMOTELY ACTUATED BODY WOULD BE SPLIT – on the one side voltage directed to the muscles via stimulator pads for involuntary movement, on the other side electrodes pick up internal signals, allowing the body to be interfaced to a Third Hand and other peripheral devices. THE BODY BECOMES A SITE BOTH FOR INPUT AND OUTPUT.

18. FRACTAL FLESH: Consider a body that can extrude its awareness and action into other bodies or bits of bodies in other places. An alternate operational entity that is spatially distributed but electronically connected. A movement that you initiate in Melbourne would be displaced and manifested in another body in Rotterdam. A shifting, sliding awareness that is *neither 'all-here' in this body nor 'all-there' in those bodies*. This is not about a fragmented body but a multiplicity of bodies and parts of bodies prompting and remotely guiding each other. This is not about master-slave control mechanisms but feedback-loops of ALTERNATE AWARENESS, agency and of split physiologies. Imagine one side of your body being remotely guided whilst the other side could collaborate with local agency. You watch a part of your body move but you have neither initiated it nor are you contracting your muscles to produce it. Imagine the consequences and advantages of being a split body with *voltage-in*, inducing the behaviour of a remote agent and *voltage-out* of your body to control peripheral devices. This would be a more complex and interesting body – not simply a single entity with one agency but one that would be A HOST FOR A MULTIPLICITY OF REMOTE AND ALIEN AGENTS. Of different physiologies and in varying locations. Certainly there may be justification, in some situations and for particular

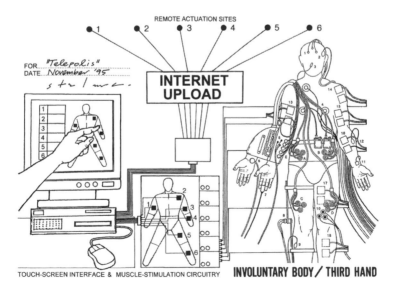

Figure 27.4 *Fractal Flesh: An Internet Body Upload Performance*, Telepolis, Luxembourg 1995. Diagram: Stelarc. © Stelarc.

actions to tele-operate a human arm rather than a robot manipulater – for if the task is to be performed in a non-hazardous location, then it might be an advantage to use a remote human arm – as it would be attached to another arm and a mobile, intelligent body. Consider a task begun by a body in one place, completed by another body in another place. Or the transmission and conditioning of a skill. The body not as a site of inscription but as a medium for the manifestation of remote agents. This physically split body may have one arm gesturing involuntarily (remotely acutated by an unknown agent), whilst the other arm is enhanced by an exoskeleton prosthesis to perform with *exquisite skill and with extreme speed*. A body capable of incorporating movement that from moment to moment would be a pure machinic motion performed WITH NEITHER MEMORY NOR DESIRE.

19. STIMBOD: What makes this possible is a *touch-screen muscle stimulation system*. A method has been developed that enables the body's movements to be programmed by touching the muscle sites on the computer model. Orange flesh maps the possible stimulation sites whilst red flesh indicates the actuated muscle(s). The sequence of motions can be replayed continuously with its loop function. As well as choreography by pressing, it is possible to paste sequences together from a library of gesture icons. The system allows stimulation of the programmed movement for analysis and evaluation before transmission to actuate the body. At a lower stimulation level it is a body prompting system. At a higher stimulation level it is a body actuation system. This is not about remote-control of the body, but rather of CONSTRUCTING BODIES WITH SPLIT PHYSIOLOGIES, operating with multiple agency. Was it Wittgenstein who asked if in raising your arm you could remove the intention of raising it what would remain? Ordinarily, you would associate intention with action (except, perhaps in an instinctual motion – or if you have a pathological condition like Parkinson's disease). With Stimbod, though, that intention would be transmitted from another body elsewhere. There would be actions without expectations. A two-way tele-Stimbod system would create a *possessed and possessing body* – a split physiology to collaborate and perform tasks remotely initated and locally completed – at the same time in the one physiology …

20. EXTREME ABSENCE AND THE EXPERIENCE OF THE ALIEN: Such a Stimbod would be hollow body, a host body for the *projection and performance of remote agents*. GLOVE ANAESTHESIA and ALIEN HAND are pathological conditions in which the patient experiences parts of their body as not there, as not their own, as not under their own control – an absence of physiology on the one hand and an absence of agency on the other. In a Stimbod not only would it possess a split physiology but it would experience parts of itself as automated, absent and alien. The problem would no longer be possessing a split personality, but rather a SPLIT PHYSICALITY. In our Platonic, Cartesian and Freudian pasts these might have been considered pathological and in our Foucauldian present we focus on inscription and control of the body. But in the terrain of cyber complexity that we now inhabit the inadequacy and the *obsolescence* of the ego-agent driven biological body cannot be more apparent. A transition from psycho-body to cybersystem becomes necessary to function effectively and intuitively in remote spaces, speeded-up situations and complex technological terrains. During a Sexuality and Medicine Seminar in Melbourne, Sandy Stone asked me what would be the cybersexual implications of the Stimbod system? Not having thought about it before I tried to explain what it might be like. If I was in Melbourne and Sandy was in New York, touching my chest would prompt her to caress her breast. Someone observing her there would see it as an act of self-gratification, as a masturbatory act. She would know though that her hand was remotely and perhaps even divinely guided! Given tactile and force-feedback, I would feel my touch through another person from another place as a secondary, additional and augmenting sensation. Or, by

Figure 27.5 *Stimbod Software*, Empire Ridge, Melbourne 1995. Image: Troy Innocent,
© Stelarc.

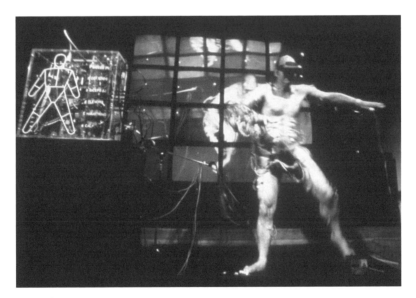

Figure 27.6 *Split Body: Voltage in/Voltage out*, Gallery Kopelica, Lubljana 1996.
Photograph: Igor Andjelic. © Stelarc.

feeling my chest I can also feel her breast. An intimacy through interface, AN INTIMACY
WITHOUT PROXIMITY. Remember that Stimbod is not merely a sensation of touch but
an actuation system. Can a body cope with experiences of *extreme absence and alien action*
without becoming overcome by outmoded metaphysical fears and obsessions of individuality
and free agency? A Stimbod would thus need to experience its actuality neither all-present-
in-this-body, nor all-present-in-that-body, *but partly-here and projected-partly-there*. An operational
system of spatially distributed but electronically interfaced clusters of bodies ebbing and
flowing in awareness, augmented by alternate and alien agency ...

21. PING BODY/PROTO-PARASITE: In 1995 for Telepolis, people at the Pompidou Centre (Paris), the Media Lab (Helsinki) and the Doors of Perception conference (Amsterdam), were able to *remotely access and actuate* this body in Luxembourg, using the touch-screen interfaced muscle stimulation system. ISDN Picturetel links allowed the body to see the face of the person who was moving it whilst the programmers could observe their remote choreography. (Although people thought they were merely activating the body's limbs, they were inadvertently composing the sounds that were heard and the images of the body they were seeing – for the body had sensors, electrodes and transducers on its legs, arms and head that triggered sampled body signals and sounds and that also made the body a video switcher and mixer. And although people in other places were performing with the RHS of the body, it could respond by actuating its THIRD HAND, voltage-out from electrodes positioned on its abdominal and LHS leg muscles. This SPLIT BODY, then, was manifesting a combination of *involuntary, remotely guided, improvised* and EMG-muscle initiated motor motions.) In Ping Body – an Internet Actuated and Uploaded Performance (performed first for Digital Aesthetics in Sydney, but also for DEAF in Rotterdam in 1996), instead of the body being prompted by other bodies in other places, INTERNET ACTIVITY ITSELF CHOREOGRAPHS AND COMPOSES THE PERFORMANCE. Random pinging to over 30 global Internet domains produce values from 0–2000 milliseconds that are mapped to the deltoid, bicepts, flexors, hamstring and calf muscles – 0–60 volts initiating involuntary movements. The movements of the body are amplified, with a midi interface measuring position, proximity and bending angle of limbs. Activated by Internet data the body is uploaded as info and images to a website to be viewed by other people elsewhere. The body is *telematically scaled-up, stimulated and stretched by reverberating signals* of an inflated spatial and electrical system. The usual relationship with the Internet is flipped – instead of the Internet being constructed by the input from people, the Internet constructs the activity of one body. The body becomes a nexus for Internet activity – its activity a statistical construct of computer networks.

22. PARASITE: EVENT FOR INVADED AND INVOLUNTARY BODY: A customized search engine has been constructed *that scans, selects and displays* images to the body – which functions in an interactive video field. Analyses of the JPEG files provide data that is mapped to the body via the muscle stimulation system. There is optical and electrical input into the body. THE IMAGES THAT YOU SEE ARE THE IMAGES THAT MOVE YOUR BODY. Consider the body's vision, *augmented and adjusted* to a parallel virtuality which increases in intensity to compensate for the twilight of the real world. Imagine the search engine selecting images of the body off the WWW, constructing a metabody that in turn moves the physical body. Representations of the body actuate the body's physiology. The resulting motion is mirrored in a VRML space at the performance site and also uploaded to a website as potential and recursive source images for body reactivation. RealAudio sound is inserted into sampled body signals and sounds generated by pressure, proximity, flexion and accelerometer sensors. The body's physicality provides feedback loops of interactive neurons, nerve endings, muscles, transducers and Third Hand mechanism. The system electronically extends the body's *optical and operational parameters* beyond its cyborg augmentation of the Third Hand and other peripheral devices. The prosthesis of the Third Hand is counterpointed by the PROSTHESIS OF THE SEARCH ENGINE SOFTWARE CODE. Plugged-in, the body becomes a parasite sustained by an extended, external and virtual nervous system. Parasite was first performed for Virtual World Orchestra in Glasgow. It has also been presented for The Studio for Creative Inquiry, Carnegie Mellon University at the Wood Street Galleries in Pittsburgh, Festival Atlantico in Lisbon, NTT-ICC in Tokyo, Ars Electronica in Linz and for the Fukui Biennale.

23. PSYCHO/CYBER: THE PSYCHOBODY is neither robust nor reliable. Its genetic code produces a body that malfunctions often and fatigues quickly, allowing only slim survival parameters and limiting its longevity. Its carbon chemistry GENERATES OUTMODED EMOTIONS. *The Psychobody is schizophrenic.* THE CYBERBODY is not a subject, but an object – not an object of envy but an object for engineering. THE Cyberbody bristles with electrodes and antennae, amplifying its capabilities and projecting its presence to remote locations and into virtual spaces. The Cyberbody becomes an extended system – not merely to sustain a self, but to enhance operation and initiate alternate intelligent systems.

24. HYBRID HUMAN–MACHINE SYSTEMS. The problem with space travel is no longer with the precision and reliability of technology but with the vulnerability and durability of the human body. In fact, it is now time to REDESIGN HUMANS, TO MAKE THEM MORE COMPATIBLE WITH THEIR MACHINES. It is not merely a matter of 'mechanizing' the body. It becomes apparent that in the zero-G, frictionless, and oxygen-free environment of outer space technology is even more durable and functions more efficiently than on Earth. It is the human component that has to be sustained and also protected from small changes of pressure, temperature and radiation. The issue is HOW TO MAINTAIN HUMAN PERFORMANCE OVER EXTENDED PERIODS OF TIME. *Symbiotic systems* seem the best strategy; implanted components can energize and amplify developments; exoskeletons can power the body; robotic structures can become hosts for a body insert.

25. EXOSKELETON: A six-legged, *pneumatically-powered* walking machine has been constructed for the body. The locomotor, with either ripple or TRIPOD GAIT moves fowards, backwards, sideways and turns on the spot. It can also squat and lift by splaying or contracting its legs. The body is positioned on a rotating turn-table, actuating and controlling the machine legs by tilt sensors and micro-switches on an exoskeleton over the upper body and limbs. The left arm is AN EXTENDED ARM with pneumatic manipulator having 11 degrees-of-freedom. It is human-like in form but with additional functions. The fingers open and close, becoming multiple grippers. There is individual flexion of the fingers, with thumb and wrist rotation. The body actuates the walking machine by moving its arms. DIFFERENT GESTURES MAKE DIFFERENT MOTIONS. The body's arms guide the *choreography* of the locomotor's movements and thus *compose the cacophony* of pneumatic and mechanical sounds.

26. INTERNAL/INVISIBLE: It is time to recolonize the body with MICRO-MINIATURIZED ROBOTS to augment our bacterial population, to assist our immu- nological system and to monitor the capillary and internal tracts of the body. There is a necessity for the body to possess an INTERNAL SURVEILLANCE SYSTEM. Symptoms surface too late! The internal environment of the body would to a large extent contour the microbot's behaviour, thereby triggering particular tasks. Temperature, blood chemistry, the softness or hardness of tissue, and the presence of obstacles in tracts could all be primary indications of problems that would signal the microbots into action. *The biocompatibility of technology is no longer due to its substance but rather to its scale.* THE SPECK-SIZED ROBOTS ARE EASILY SWALLOWED, AND MAY NOT EVEN BE SENSED! At some nanotechnology level machines will inhabit cellular spaces and manipulate molecular structures … The trauma of repairing damaged bodies or even of redesigning bodies would be eliminated by a colony of nanobots delicately altering the body's architecture atoms-up, inside out.

27. TOWARD HIGH-FIDELITY ILLUSION: With teleoperation systems, it is possible to project human presence and perform physical actions in remote and extraterrestrial locations. A single operator could direct a colony of robots in different locations simultaneously or scattered human experts might collectively control a particular surrogate robot. Teleoperation systems would have to be more than hand-eye mechanisms. They would have to create

kinesthetic feel, providing sensations of orientation, motion and body tension. Robots would have to be semi-autonomous, capable of 'intelligent disobedience'. With *Teleautomation* (Conway/Voz/Walker), forward simulation – with time and position clutches – assists in overcoming the problem of real time-delays, allowing prediction to improve performance. The experience of Telepresence (Minsky) becomes the high-fidelity illusion of *Tele-existence* (Tachi). ELECTRONIC SPACE BECOMES A MEDIUM OF ACTION RATHER THAN INFORMATION. It meshes the body with its machines in ever-increasing complexity and interactiveness. The body's form is enhanced and its functions are extended. ITS PERFORMANCE PARAMETERS ARE LIMITED NEITHER BY ITS PHYSIOLOGY NOR BY THE LOCAL SPACE IT OCCUPIES.

28. PHANTOM LIMB/VIRTUAL ARM: Amputees often experience a phantom limb. It is now possible to have a phantom sensation of an additional arm – a virtual arm – albeit visual rather than visceral. The Virtual Arm is a computer-generated, human-like universal manipulator interactively controlled by VPL Virtual Reality equipment. Using data gloves with flexion and position-orientation sensors and a GESTURE-BASED COMMAND LANGUAGE allows real-time intuitive operation and additional extended capabilities. Functions are mapped to finger gestures, with parameters for each function, allowing elaboration. Some of the Virtual Arm's extended capabilities include *stretching* or telescoping of limb and finger segments, *grafting* of extra hands on the arm, and *cloning* or calling up an extra arm. The *record and playback* function allows the sampling and looping of motion sequences. A *clutch* command enables the operator to freeze the arm, disengaging the simulating hand. For teleoperation systems, features such as *locking* allow the fixing of the limb in position for PRECISE OPERATION WITH THE HAND. In *micro mode* complex commands can be generated with a single gesture, and in *fine control* delicate tasks can be completed by THE TRANSFORMATION OF LARGE OPERATOR MOVEMENTS TO SMALL MOVEMENTS OF THE VIRTUAL ARM.

29. IMAGES AS OPERATIONAL AGENTS: Plugged into Virtual Reality technology, physical bodies are transduced into phantom entities capable of performing within data and digitial spaces. The nature of both bodies and images has been significantly altered. IMAGES ARE NO LONGER ILLUSORY WHEN THEY BECOME INTERACTIVE. In fact, interactive images become operational and effective agents sustained in software and transmission systems. The body's representation becomes capable of response as images become imbued with intelligence. Sensors and trackers on the body make it a capture system for its image. The body is coupled to mobilize its phantom. A virtual or Phantom Body can be endowed with semi-autonomous abilities, enhanced functions, and artificial intelligence. Phantoms can manipulate data and perform with other phantoms in Cyberspace. PHYSICAL BODIES HAVE ORGANS. PHANTOM BODIES ARE HOLLOW. Physical bodies are ponderous and particular. Phantom bodies are flexible and fluid. Phantoms project and power the body.

30. VIRTUAL BODY: ACTUATE/ROTATE: Your virtual surrogate would not merely mimic the physical body's movements. A complex choreography is achieved by mapping virtual camera views to limb position/orientation. The involuntary jerking up and down of the left arm tumbles the virtual body while sweeping the right arm 90° produces a 360° virtual camera scan – visually rotating the virtual body around its vertical axis. The form of the virtual body can be configured acoustically – pulsing in phases with breathing sounds. This BREATH WARPING subtly and structurally connects the physical body with its virtual other. And by using DEPTH CUE – defining the operational virtual space as shallow – stepping and swaying forwards and backwards makes the virtual body appear and disappear in its video/virtual environment. The resulting interaction between the physical body

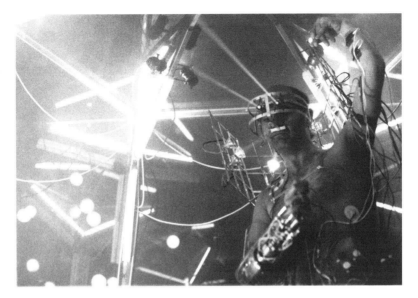

Figure 27.7 *Remote Event for Laser Eye and Involuntary Arm*, Melbourne International Festival, Melbourne 1990. Photograph Anthony Figallo. © Stelarc.

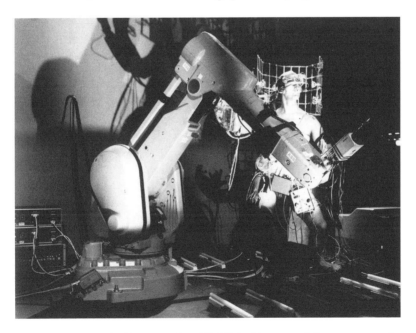

Figure 27.8 *Scanning Robot/Automatic Arm*, T.I.S.E.A, Museum of Contemporary Art, Sydney 1992. Photograph: Anthony Figallo. © Stelarc.

and its phantom form becomes a more complex combination of kinestheic and kinematic choreography. In recent performances the *involuntary body* is actuating a *virtual body* while simultaneously avoiding a *programmed robot* within its task envelope …

31. MOVATAR – AN INVERSE MOTION CAPTURE SYSTEM: Motion Capture allows a body to animate a 3D computer-generated virtual body to perform in computerspace or

cyberspace. This is usually done by either markers on the body tracked by cameras, analysed by a computer and the motion mapped onto the virtual actor. Or it can be done using electromagnetic sensors (like Polhemus or Flock-of-Birds) that indicate position/orientation of limbs and head. Consider though a virtual body or an avatar that can access a physical body, actuating it to perform in the real world. If the avatar is *imbued with an artificial intelligence, becoming increasingly autonomous* and unpredictable, then it would be an AL (Artificial Life) entity performing with a human body in physical space. With an appropriate visual software interface and muscle stimulation system this would be possible. The avatar would become a Movatar. Its repertoire of behaviour could be modulated continously by Ping signals and might evolve using genetic algorithms. And with appropriate feedback loops from the real world it would be able to respond and perform in more *complex and compelling* ways. The Movatar would be able not only to act, but also to express its emotions by appropriating the facial muscles of its physical body. As a VRML ENTITY it could be logged-into from anywhere – to allow your body to be *accessed and acted upon*. Or, from its perspective, the Movatar could perform anywhere in the real world, at anytime with as many physical bodies in diverse and spatially separated locations ...

32. REMOTE AGENTS AND COLLECTIVE STRATEGIES: Previously connection and communication with other bodies on the Internet was only textual, with an *acute absence* of physical presence. This was not the experience of authentic evolved absence that results in an effectively operating body in the real word – absence of the body on the Internet is an absence of inadequacy, that is an inadequacy of appropriate feedback-loops. As we hard-wire more high-fidelity image, sound, tactile and force-feedback sensation between bodies then we begin to generate powerful PHANTOM PRESENCES – *not phantom as in phantasmagorical, but phantom as in phantom limb sensation*. The sensation of the remote body sucked onto your skin and nerve endings, collapsing the psychological and spatial distance between bodies on the Net. Just as in the experience of a Phantom Limb with the amputee, bodies will generate phantom partners, not because of a lack, but as extending and enhancing addition to their physiology. *Your aura will not be your own*. It will only be through the construction of phantoms that the equivalent of our evolved absence will be experienced, as we function increasingly powerfully and with speed and intuition (a successful body operates automatically). Bodies must now perform in techno-terrains and data-structures beyond the human-scale where intention and action collapse into accelerated responses. BODIES ACTING WITHOUT EXPECTATION, PRODUCING MOVEMENTS WITHOUT MEMORY. Can a body act without emotion? Must a body continuously affirm its emotional, social and biological status quo? Or perhaps what is necessary is electronic erasure with new intimate, internalized interfaces to allow for the design of a body with more adequate inputs and outputs for performance and *awareness augmented by search engines*. Imagine a body remapped and reconfigured – not in genetic memory but rather in electronic circuitry. What of a body that is intimately interfaced to the WWW – and that is stirred and is startled by distant whispers and remote promptings of other bodies in other places. A body that is informed by spiders, knowbots and phantoms ...

33. PHANTOM BODY/FLUID SELF: Technologies are becoming better life-support systems for our images than for our bodies. IMAGES ARE IMMORTAL. BODIES ARE EPHEMERAL. The body finds it increasingly difficult to match the expectations of its images. In the realm of multiplying and morphing images, the physical body's impotence is apparent. THE BODY NOW PERFORMS BEST AS ITS IMAGE. Virtual Reality technology allows a transgression of boundaries between male/female, human/ machine, time/space. The self becomes situated beyond the skin. This is not disconnecting or a splitting but an EXTRUDING OF AWARENESS. What it means to be human is no longer being immersed

in genetic memory but in being reconfigured in the electromagnetic field of the circuit IN THE REALM OF THE IMAGE.

34. ARTIFICIAL INTELLIGENCE/ALTERNATE EXISTENCE: The first signs of artificial life may well come from this planet in the guise of images. ARTIFICIAL INTELLIGENCE WILL NO LONGER MEAN EXPERT SYSTEMS OPERATING WITHIN SPECIFIC TASK DOMAINS. Electronic space generates intelligent and autonomous images that extend and enhance the body's operational parameters beyond its mere physiology and the local space it occupies. What results is a meshing of the body with its images and machines in ever-increasing complexity. The significance of interfacing with images is that they culminate in an ALTERNATE AWARENESS THAT IS PAN-HISTORIC AND POST-HUMAN.

Note

Stimbod was developed with the assistance of Troy Innocent at Empire Ridge in Melbourne. The Muscle Stimulation System circuitry was designed by Bio-Electronics, Logitronics and Rainer Linz in Melbourne with the box fabricated with the assistance of Jason Patterson. Tele-Stimbod, Ping Body and Parasite software was developed by Jeffrey Cook, Sam de Silva, Gary Zebbington and Dimitri Aronov from the Merlin group in Sydney. Kampnagel in Hamburg is funding the 6-Legged Locomotor project.

Robert Ayers

SERENE AND HAPPY AND DISTANT
An interview with Orlan[1]

By way of an introduction: between *Interventions* and *Self-Hybridation*

WE NOW HAVE TO REGARD ORLAN AS ONE of the more important artists of the late 20th century. Her surgical *Interventions* – the works for which she is still best known – constitute a key feature in the landscape against which a whole subsequent generation of artists concerned with issues around identity, the body, gender and sexuality

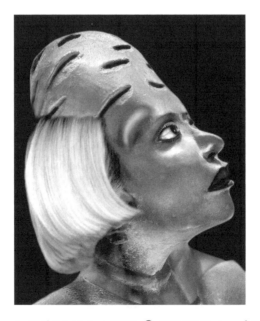

Figure 28.1 *Refiguration/Self-Hybridation*, 1999. © ADAGP, Paris and DACS, London

have worked. Moreover, they force a reconsideration of what actually constitutes *performance* for any of us who seek to work with intelligence in that domain.

As the following interview makes clear, Orlan is now making her most substantial work since then, the digitally manipulated photo-works in the *Self-Hybridation* series. So perhaps it is timely to consider the *Orlan-Conférences*, the activity that took centre stage in Orlan's artistic endeavour between her last surgery and the emergence of the *Self-Hybridations*, if only to ponder the extent to which they provide a link between the *Interventions* and the *Self-Hybridation* series.

On each occasion Orlan submitted herself to surgical procedures, her body underwent considerable physical trauma. She is entirely justified in her assertion: '*I have given my body to art.*' Whatever the wisdom of embarking upon this series of operations in the first place, it is not something that anyone might continue to do indefinitely, and Orlan's decision to turn elsewhere for a *modus operandi* was inevitable.

The *Orlan-Conférence* is the title that she has given to the performance format that had its beginnings, she told me, in her desire to explain and defend the *Interventions* and her other actions – and her taste for declamation, it must be said. For a number of years, however, the *Conférences*, have been the principal situations in which she has appeared before her audience. By accumulation, this is of course a far more numerous audience than that which ever witnessed the *Interventions* either live, or even contemporaneously by the satellite links that she employed towards the end of the series. The majority of that audience will now claim that they have witnessed Orlan in performance and, even if they might concede that what they saw was really more like a lecture than anything else, this – if nothing else – means that they must be regarded as performance works in their own right.

I have witnessed versions of them on half a dozen separate occasions. Their format and content have been pretty constant over the years. While they have almost always included at least a description of the projects that she has been working on at the time that they have been staged – her photographic and video work, for example, or the *Reliquaires* – they have in essence evolved only slowly and, I suspect, more as a pragmatic consequence of the practicalities of the occasion, than any desire on Orlan's part to refocus their content, or – until very recently, at any rate – the opportunities offered by any new technologies.

They tend to take place in a darkened room, auditorium or lecture theatre. Orlan prefers to sit before her audience at a desk. Outside of the Francophone world she is accompanied by a simultaneous translator. She only occasionally stands or leaves the desk, and usually only to demonstrate a movement or an action. She reads from the accumulated text that now also bears the title *Orlan-Conférence* while slide images of her photo and sculptural works, and – rather more memorably – edited and manipulated video images of the *Interventions* are projected adjacent to her. Afterwards, usually after a break, a panel of more or less distinguished speakers – Orlan prefers them to be drawn from spheres of professional or scholarly expertise outwith the arts – will offer opinions on her work, ask her questions, and a discussion among them and the audience and Orlan herself – still interpreted by her translator – will ensue.

I suspect that, apart from their reactions to the videotapes – which are often less violent than one might expect – the strongest impressions taken away from the *Conférences* by most people will be of Orlan's personality and what I can only call her stage presence. Despite her black lipstick and remarkable hairstyle – half jet black, half lemon yellow – she comes over as nothing so much as a middle-aged, middle-class French academic, with a delightful self-deprecating sense of humour. Her script may comprise radical, iconoclastic, politicized stuff, but she spices it with pressure-relieving jokey asides. She routinely begins with a gag about having been unable to buy the batteries to power the automatic translation implants

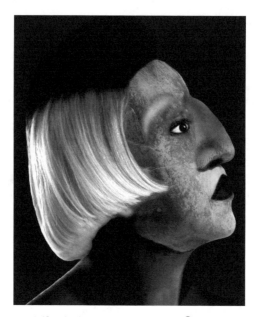

Figure 28.2 *Refiguration/Self-Hybridation No. 38*, 1999. © ADAGP, Paris and DACS, London 2007.

that she says she wears in her temple-bumps, and – as the audience respond with unease to the more gruesome moments in the videos – she suggests that flirting with the person in the next seat might provide the excuse to turn away from the projection screen.

Her audience, on each of the occasions that I have been there, has been sympathetic, sycophantic, adoring, with young women in particular responding to her like some pop music role model. It has to be said that she appears to adore this. She indulges her fans to an extent that other lesser celebrities might do well to imitate: she will have her photograph taken by or with anyone who asks, and she signs autographs equally enthusiastically. As I have said, this comes as something as a surprise to many who experience it, regardless of how playful, how mischievous she comes over in those videotaped operating theatres, all carnival and pantomime. It certainly caught me off guard the first time I witnessed it, and for a while I had to be satisfied with the rationalization that this was another of those dualities that she is so happy to have exist in her work (and which she talks about towards the conclusion of this interview). I now understand that this presence is essential to the significance of the *Conférences* in Orlan's oeuvre and to what they tell us about the rest of it.

Whatever else has been asserted for them, Orlan's *Interventions* are, I would suggest, important primarily for the simplicity and profundity with which they breathe life into the old cliche of performance art analysis, that in them she uses her body as her artistic material. In many, indeed most, of the cases where this expression is employed, it carries a degree of not always acknowledged metaphor within it. The number of artists of whom it can be meant as literally as in Orlan's case is minute. (Of her generation I can call to mind only Annie Sprinkle who has concentrated so exclusively upon her own flesh as a medium, though for her this has meant display and manipulation rather than surgery.) This is of course why she is so significant to artists like Ron Athey, who have chosen to employ wounded flesh to rather different, more narrative ends, and younger artists like Franko B and Kira O'Reilly whose own bodies are the irreplaceable location for, material of and

Figure 28.3 *Refiguration/Self-Hybridation*, 1999. © ADAGP, Paris and DACS, London 2007.

— most remarkably — the *meaning* of their performance art. At a rather different level, it is why she is also so special in the estimation of a whole generation for whom piercing, tattooing and other body modifications are so central to their sense of chic.

Of course, the sort of claim that I am making for them only holds good while the *Interventions* were actually being made, or at least for as long as they were ongoing. (In the interview that follows I ask her about further surgery. To my ear, her response seems more or less to push such possibilities into the realm of fantasy.) As an ironic consequence of the operations' brutal radicality, 'mere' photographs or videotapes of them — no matter how unpleasant they are to look at — only serve to exaggerate their own distance from the physical activity that was the art's actual substance. They have indeed, in my experience, not only rendered their spectators *un*sympathetic to Orlan's endeavours, but made them seem less radical than those of artists who are actually working in far more traditional modes of performance. But put the living, declaiming, joking, Orlan back alongside them, with her glittery *bosses* and her willingness to have people touch them, and the intensified corporeality that is the *Interventions*' most pressing characteristic, and which is at the heart of their power to move us, is once again revivified.

For by being there, another human being in our presence, while the image of her own sliced open flesh is projected behind her, she causes us to ponder this intensified corporeality of her work: a corporeality which on the one hand neither her intelligence nor her will has any control over (they are not her gloved hands that delve into the gory recesses of her body, she cannot *act* her own bleeding) and which on the other is so intensified that it invites, or rather obliges (for in the face of it, it is as though we too are stripped of will) empathic participation in the spectator. Which is to say that, by literally making her performance out of herself, or out of aspects of herself that are physically common to all of us — her punctured and scraped flesh and her trickling blood — and by focusing, and

forcing us to focus so exclusively upon them, she is making an art which (once again filling a cliche with meaning) is as universal as it is, because it is, individual.

Once an artist has travelled this far, it as though there is no middle ground that can be occupied with integrity. Once her body has been employed so literally as the material and subject of her art, the possibility of performing, and thus employing it more metaphorically, is going to seem like a withdrawal to audiences still gripped by a neo-modernist sense of the edge. This is the realization that renders the entirely non-performative *Self-Hybridations* the inevitable successors to the *Interventions* at the centre of Orlan's art-making. For unlike the video- and photo-works, that take the *Interventions* as their 'subject matter', or even the sculptural *Reliquaires* with their little flasks of Orlan's fat, these cross-fertilizations with the art of Pre-Columbian America are not compromised in their audiences' minds by their failure to be surgery themselves. Particularly as their making is, as she explains below, so entirely dependent upon the digital devices of virtuality, rather than upon anything closer to the more traditional physicality of the artist's studio. (Her main collaborator works, significantly enough, on the other side of the Atlantic!)

And thus the success and importance of the *Conférences*. For while they ostensibly perform the function of lecture or discussion or, literally, conference, which is to say they apparently exist at a level once removed from actual art works, and while their performative character seems to slip in around their edges or, more accurately, at their beginning and end while Orlan basks in the warmth of her audience's adoration, or through the device of having her own words reinterpreted on their way to their audience's ears, then her continuing to be a performer at all is, somewhat ironically, still possible.

Serene and happy and distant – an interview with Orlan

Robert Ayers: Orlan, I wonder if we could begin by talking about the work in your present exhibition here at the Espace d'Art Yvonamor Palix. For anyone who knows your work primarily through the surgical *Interventions* – and I suppose that means the majority of people – these digitally manipulated photo-works seem like quite a departure.

Orlan: You could say that they continue the work that I did in my surgical operations, but in a different way – just as those surgical performance works were the continuation of the work I'd been doing previously, but in a more radical form. The thread that runs through all of them is that my approach has always been to question the status of the body in society, and in particular the status of the female body.

Robert Ayers: That much is obvious, but in terms of how we look at them, these are more traditional, while technically, they are highly innovative.

Orlan: After the surgical operations, which focused on the real, I've been working on the virtual, and the idea of undertaking a world tour of standards of beauty in other cultures, civilizations and epochs. Here I've started with the Pre-Columbian civilizations, which have a relationship with the body which is particularly disturbing for us, which completely challenges us and which is very intense – whether that be because of their human sacrifices, or because of things which I'm very interested in, like the god who's always represented in sculpture by the figure of a priest who is wearing the skin of his victims, which had been prepared in a specific way, for about 20 days. This is the idea of entering into the skin of the other. These civilizations have standards of beauty which are completely different

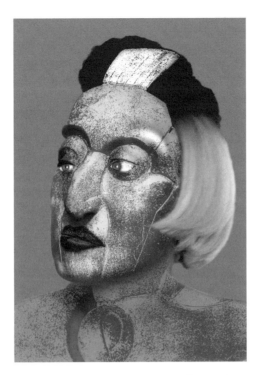

Figure 28.4 *Refiguration/Self-Hybridation No. 10*, 1999. © ADAGP, Paris and DACS, London 2007.

to ours. For example, the squint. For them, a squint was the guarantee of great beauty, to such an extent that they cultivated it by putting a ball of wax or earth in between the baby's eyes to train them to squint. Similarly (although this isn't something that's specific to their culture, because it's been discovered in Egypt and Africa, and I've even been told that it happened in Albi, here in France) there was the tradition of deforming the skull. They deformed the skull, and always in the same way by clamping bits of wood around the baby's head for three years until the skull bones set and it took on a completely different appearance. What's of interest and worth noting about these skull deformations, is that they were practised on men and women, and by members of all social castes. It wasn't a question of money, nor religion for that matter; it was really an issue of beauty. The images that I've been working on are digitally generated and are taken from sculptures which represent these standards of beauty and my own face, which is supposed to represent the standards of beauty of my own time. Except, because of these two bumps, it has an appearance which is alien to our customs and civilization.

Robert Ayers: And, if I can just risk a suggestion, once again there's this bringing together of opposites, which – I've come to understand – is so basic to your work.

Orlan: Well, I tried to create a sort of hybrid (and of course the exhibition is called *Self-Hybridation*) and so I produced a work using Photoshop. I should point out that this work was done with a technician in Montreal: I sent him the scanned images and, following my directions, he did the work that takes a bit of time (because I hardly have any) and then he sent them back by email. I corrected them, sent him the colour palettes, reworked the images and sent them back with a certain number of instructions; he worked on them

and once the work was completed he sent it back to me; I said whether I agreed with it or not, and we reworked until the image was considered finished.

Robert Ayers: And technically, how are the finished works produced?

Orlan: These are cibachromes, which are mounted on aluminium, behind plexiglass, and then framed. They are a series of large photos – 1.10 metres by 1.60. You can take this one as an example: that's the nose of the King of Wapacal, with the skull deformation and scarification. In this one, it's using an Olmec mask where there is also a skull deformation and drawings on the face which are a type of – well, not really a tattoo – but rather lines like fine scars on the face which follow the shape of a 'U' or a 'V', which – for a certain category of person who had power in society – were symbols for ceremonies. All of the images that you see here are photos produced in this way. These aren't screen-printed images. We developed the image without keeping any trace at all of the computer production. In fact, in order to distort Photoshop, I did a few things like these textured effects for example, which weren't done by computer, but were in fact produced because I sent very bad photocopies by fax. So, instead of working with a really good photo of my face, or the sculptures, we worked from images that were already blurred, images which had already been worked on, or which had already been exposed to the elements, as it were. That's something else that appeals to me.

Robert Ayers: So, does the fact that it's computers – or new technology as it still gets called – that's being used to mediate the images, does that have any significance for you at all?

Orlan: People ask me, 'What would you like computers to do? How could they be improved?' I say that I couldn't care less. What counts is that I can distort these things and rework them differently. The images aren't geared to new technology for its own sake, because I'm not fascinated by new technology. It simply exists, it's part of the time I live in, I use it as I'd use anything else, with the same desire to subvert it, as I would any other technique: to play with it, and not be taken in by it.

Robert Ayers: But to return to the content of the work, which is probably much more interesting, to what extent are these pieces to do with appearance, and to what extent are they concerned with identity?

Orlan: Here we're quite a long way from the problem of identity. These are images that I put before the public, which could find takers in our society, and which, in the end, present themselves as being 'acceptable' as a type of face that doesn't, strictly speaking, refer to identity. Of course there's an inference in relation to what *I* am, but no, this isn't work concerned with identity. You could put it like this: it's simply the idea of saying that beauty can take on an appearance that is not usually thought of as beautiful.

Robert Ayers: But I'm thinking in more general terms. Very often, when people have been thinking and talking about your work, they have very quickly attempted to relate your interest in appearance with an interest in identity – particularly in female identity.

Orlan: That's just a fraction of my work. What's difficult in my work is that it's uncomfortable in every sense. So far as the operations are concerned, it is physically uncomfortable for me and for those who look at the images. But it is also uncomfortable to make sense of

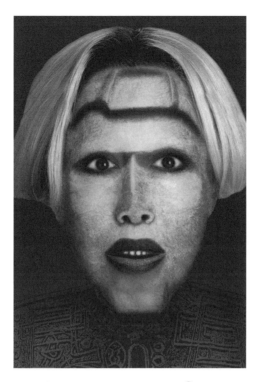

Figure 28.5 *Refiguration/Self-Hybridation No. 22*, 1999. © ADAGP, Paris and DACS, London 2007.

it. It is difficult to discuss it, because describing it takes an enormous amount of writing. So, because we are all people who are extremely pressed for time, who live in an age of communication, we tend to go with the quickest, fastest way. So each person tends to look at only one aspect of the work, and this is extremely reductive because there are many facets to my work. My work can be read psychoanalytically; or in terms of art history (and all of the references that my work makes have been related to art history, because as everyone knows – and to flog a dead horse, somewhat – all supposedly new images are a product of the images that precede them; and so there is the old and the new which come together in the same space). My work can be talked about in philosophical, sociological or in feminist terms, or again it can be discussed in terms of my relationship with the media, for example, which has always been extremely significant and conflictual, and which has caused a great deal of problems. There are many different ways: you could even talk from a purely aesthetic point of view. At the moment, people even talk about it from a fashion perspective, since the fashion industry has now caught up with me. My work appeals to many fashion designers. One in particular uses it in a very literal way – perhaps you saw it in his catalogues? – and there is one who pays tribute to my work by making up his models with the same bumps as me.

Robert Ayers: Yes, I find this fascinating, the way that popular culture is gradually reassimilating your work. But I suspect you must find it enormously irritating, because, rather than the passage of time seeing the better understanding of what your work is about, it's as though misunderstanding is simply being piled upon misunderstanding.

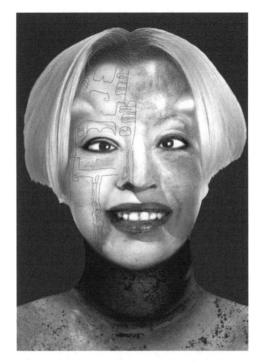

Figure 28.6 *Refiguration/Self-Hybridation No. 15*, 1999. © ADAGP, Paris and DACS, London 2007.

Orlan: Well, here's an example: in New York a collector bought a piece of my work and he told me that if I came to San Francisco he'd organize a big party. And he did, on the day when I had the exhibition opening and the *Conférence*. And at the end of the evening he told me that some friends were waiting in the next room, and he invited me to go and see them. I went to see his friends – 30 or so sadomasochistic homosexuals, all clad in leather with chains and zips, tattoos and lots of body piercing. There was one who spoke very good French, and he said to me, 'We think that you are the most important artist of our time and so we'd like to pay a tribute to you: we'd like to pay you to organize our surgical operations. You can do whatever you like in the operating theatre, with music, texts, and sound, etcetera. We'd like to get your surgeon from New York to come and create the same bumps that you've got, because we're going to start a new trend: after body piercing we're going to start "bumping" and very quickly, in a few years or so, it'll catch on in Europe'! Well, I was furious and I told him he'd offended my sensibilities. I said, 'But this is unthinkable! Impossible! I can't make money from this, when that's precisely the principle that I'm working against.' I'm certainly not in favour of fashion and its dictates. In fact, I explained to them that I wasn't surprised to be imitated by people who have body piercing and tattoos. I'm not against these things, but it's quite obvious that the majority of people who are into those things believe that they are liberating themselves from the dictates of a certain society, but in fact it all boils down to the same thing because they are conforming to the dictates of a smaller, mini-society. So I left it there. What's interesting is that someone told me they'd recently seen a San Francisco group on TV who had put bolts and plaques on their heads, as well as needles. They were just like punks, or they might as well have been. It might be them. Maybe they understood that I didn't want models, and so it was up to them to do it for themselves.

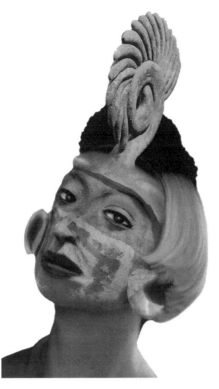

Figure 28.7 *Refiguration/Self-Hybridation No. 5*, 1999. © ADAGP, Paris and DACS, London 2007.

Robert Ayers: Well, yes, that must have been disconcerting, to say the least. It seems to me that people get themselves caught up with particular aspects of your work, and that almost prevents them from comprehending how it's developing. There's one particular thing that I suppose we should get straight: have you now completely finished with surgery as a means of working?

Orlan: No, there are still two surgical operations that I'd like to do. There's one which is quite involved and the other is lighter, more poetic, but I'd like these to be the apotheosis of all my operations. I want to get all the medical, artistic and financial arrangements in place, and that takes a lot of time to arrange. If I don't manage it, well, bad luck! I think that I'm an artist who's given a lot, physically and intellectually and psychologically as much as financially, and so if I can't do these operations under good conditions; I won't do them. It won't matter too much. Still, I'll tell you about these operations. I'd like to construct an operating theatre for one of them which will be a huge sculpture, 8 metres by 6, and it will look like an egg, or a diamond cut regularly. It'll be something made in colourless ice so as to look like a peep show. I've got the idea that, depending on how it's lit, the museum public will be able to see the operation. Inside there'll be a surgical operation – not plastic surgery, but something that is intended to change my appearance much less, but which is intended to heighten my faculties. I can't say exactly what, but it's a first in the medical world. And the other one simply consists of opening up the body to produce images like the one [*Rire de plaisir en voyant mon corps ouvert*, 1993] on the front of the *Collection Iconotexte* book: of my body opened up with me at the same time having

a completely relaxed and serene expression as I watch these images being transmitted by satellite with my surgeon. I'll be able to answer any questions asked. It'll be 'opening up and closing the body' and it will be a perfect illustration of my manifesto of body art which, in particular, denounces pain. I'm not at all in favour of pain. I don't consider it made for my redemption or purification or whatever. The celebrated giving birth in pain is completely ridiculous in our day and age, when we have epidurals and a whole pharmacopoeia which allows us not to have to suffer if we don't want to.

In my work, the first deal I have with the surgeon is, 'no pain'. I wanted to show this body, opened up, and to produce it with lots of photographs of me there, laughing, playing, reading etcetera, while the body is opened up. And then I'm open to any other suggestions that are made in the laboratory, whether that be in terms of robotics, or biotechnology or genetics. It's still the same: I want to remain serene and happy and distant. I don't want it to be something suicidal or difficult, beyond the level that I've already set myself for these operations. Of course, for these operations there is a price to be paid: I don't suffer but I am aware that my body suffers, which are two very different things. If the body is in pain, that's one thing, but if I am not suffering, I can talk, I can do other things. If I am in pain, I can no longer do anything – I'm forced to suffer.

Robert Ayers: You know, the way that you're talking now seems to me central to your whole attitude to your work. You're identifying a self that is, on the one hand, independent of your body, but which on the other is intimately tied up with it. Isn't there a sort of contradiction there?

Orlan: No, it's like I've said to you before about the terms that people use to talk about the exhibition: there's something I'd like to say about 'and' and 'or'. At the moment I've moved on to the virtual, but that doesn't mean to say that I won't do any more operations in the future, given the right conditions, which will be carried out in real life. What I wanted to say was that, effectively, our whole culture is based on the notion of 'or' – for example, good or bad, private or public, new technology or painting, etcetera, etcetera. This forces us to condemn one element and to choose the other. All of my work is based on the notion of 'and': the good and the bad, the beautiful and the ugly, the living and the artificial, the public and the private – because during my operations images of me are transmitted by satellite, so you've got them both there at the same time. There are also the drawings made in the operating theatre: I draw with my fingers and my blood. It's extremely primitive, but this doesn't stop these same operations from being transmitted by satellite, in a totally different way. Its always based on the notion of 'and' and I think that that's something interesting and important, with regards to our epoch.

Notes

The transcribed interview with Orlan was conducted by Robert Ayers at the Espace d'Art Yvonamor Palix, Paris, 8 January 1999, while Orlan was exhibiting the new digitally manipulated photo-works that form her *Self-Hybridation* series. All transcription, interpretation and translation was by Francine Morgan, CPEDERF, Paris. An edited version of fragments of this conversation appear as *Live Art Letters* 4, March 1999, *The Special and the Unusual – Listening to Orlan*, ISSN 1361-3731.

1. The photographs in this article are reproduced by Orlan's kind permission. The copyright belongs to her. The computer technician who collaborated with Orlan to modify the images is Pierre Zovilé.

Catherine Waldby

REVENANTS
Death and the digital uncanny

THE VISIBLE HUMAN PROJECT IS, IT SEEMS, a work of desire as well as an advance in technique. In the previous chapter I conjectured that various kinds of desire could be discerned in its production and circulation. In its excessive visuality the project is symptomatic of medicine's much proclaimed scopophilia[1] and its utterly repressed pleasure in pornographic orders of representation (Kapsalis 1997). As perfectly co-operative image-objects the VHP figures make their exhaustively visualised bodies available for all forms of display and optical penetration, without recalcitrance or resistance. In its claim to invent vital icons the project is symptomatic of IatroGenic desire, a desire which circulates at large in the *fin-de-millennium* biomedical imaginary, and which is directed towards the mastery of corporeal matter and vitality along the lines of the commodity and the mechanically reproducible invention. IatroGenic desire thus works to compensate for the uncertainty of any relation between embodiment and technology, its excess to any human project. It works through a refusal to acknowledge the constitutive absence of mastery implied in this relationship, the failure of technology to fully serve human interests and human ends. The VHP is a device of IatroGenic desire precisely because it presents the spectacle of a fantasised mastery over matter, a mastery which is always deferred, promised in the future.

The resort to Genesis iconography analysed in the previous chapter is indicative of the ease with which medicine deploys mythic resources in the pursuit of its fantasies, and in the play of the biomedical imaginary more generally. I have used the term 'biomedical imaginary' at various earlier points in this text, but here I want to treat it in more detail, in order to open up a certain critical ground. The biomedical imaginary refers to the speculative, prepositional fabric of medical thought, the generally disavowed dream work performed by biomedical theory and innovation. It is a kind of speculative thought which supplements the more strictly systematic, properly scientific, thought of medicine, its deductive strategies and empirical epistemologies.[2] While medicine, like all sciences, bases its claims to technical precision on a strict referentiality, a truth derived from the givenness of the object, the biomedical imaginary describes those aspects of medical ideas which derive their impetus from the fictitious, the connotative and from desire. My development

of the term works off that of Le Doeuff (1989), who defines the imaginary of systemic thought (in her case philosophy) as the deployment of, and unacknowledged reliance on, culturally intelligible fantasies and mythologies within the terms of what claims to be a system of pure logic. In particular, she identifies the deployment of images and metaphoric modes of thinking as indications of excess, points at which systemic thought spills out into the speculative, the fantasmic, into desire, even while it tries to relegate such images to the status of illustration of a systematically generated idea. Moreover, the deployment of images marks points of tension, knots of paradox or ambiguity within a system which are not resolvable within its terms. Her hypothesis is that

> The interpretation of imagery in philosophical texts goes together with a search for points of tension in a work. In other words, such imagery is inseparable from the difficulties, the sensitive points of an intellectual venture … the meaning conveyed by images works both for and against the system that deploys them. *For*, because they sustain something which the system cannot itself justify, but which is nevertheless needed for its proper working. *Against*, for the same reason … their meaning is incompatible with the system's possibilities.
>
> (Le Doeuff 1989: 3)

On Le Doeuffs proposal, and following on from the analysis of Genesis iconography laid out in the previous chapter, the designation of the VHP figures as Adam and Eve both suggests a knot of tension in the *project* of the Visible Human Project and presents a way of marshalling and limiting the interpretation of the figures along particular lines. If images work both for and against the system in which they are located, if they present such possibilities of ambiguity, the management of their presentation, contextualisation and interpretation becomes anxious and imperative.[3] Scientific thought is peculiarly vulnerable to such ambiguity, in the sense that its epistemologies are driven by imperatives towards visualisation, towards the production of images which are held, through strict procedures of referentiality, to reveal the natural world. The act of making visible is a foundational gesture for scientific thought – picturing the microscopic and the macroscopic, picturing invisible phenomena like electronic resonance (MRI), ultrasound, infra-red – in short producing a panoply of novel images whose interpretation must be contained within scientific confines.

The management of interpretation is particularly at issue in the case of widely disseminated images like the VHP figures, circulated from the moment of their initial publicity as objects of public and popular culture. The very title of the project, a reference to the novel (and subsequent films) *The Invisible Man*, immediately places it within a popular cultural order and locates it in a history of popular interpretation of medical technologies. H.G. Wells's novel, the story of a scientist who discovers rays that make him invisible, was itself a response to a dramatic shift in medical vision and imagination, the shift inaugurated by the invention of x-rays (Kevles 1997). Moreover, as I described in the first chapter, the creators of the VHP, the National Library of Medicine, ensured wide public attention to the project through well orchestrated media launches for both the Visible Man and the Visible Woman.

It is at this point of public dissemination and potentially open-ended interpretation that the attempt to manage the reading of medical iconography like the VHP becomes most imperative, and runs the greatest risks. Public dissemination is pursued as a means to secure public legitimacy. The formation of a public consensus around the desirability of biomedical and scientific research depends upon forms of nonspecialist interpretation which lend such legitimacy. Science requires a multiplicity of specialist and nonspecialist audiences, and has developed textual and visual practices which both solicit such audiences

and compel assent to particular interpretations of its products and activities (Shapin and Schaffer 1985). To secure such audiences, medicine actively participates in the migration of its images out of the clinical domain and into the media of public visual culture. As the editors observe in the introduction to their anthology *The Visible Woman* (Treichler *et al.* 1998), the novel imagery of science asserts a continued presence in the mass media. In turn, the necessity for public dissemination shapes the production values and aesthetics of scientific images.

> Images derived from MRI (magnetic resonance imaging), computerised tomography (computer digitised x-ray imaging) and DNA sampling, colourised and sharpened to enhance their aesthetic appeal, regularly illustrate ... popular magazines like *Scientific American* and *Life*. ... Schematic models of HIV regularly adorn book and magazine covers.
>
> (Treichler *et al.* 1998: 2)

Such practices of dissemination and popularisation seek to constitute an imagined community to legitimate and validate experiments and to assimilate the nonspecialist gaze to the medical gaze, an assimilation which depends on a wide acceptance of the scientific medical interpretation of the phenomena under consideration. Nevertheless such practices of popularisation and dissemination are always open to risks of reinterpretation, a reading against, or at odds with, the canonical, scientific interpretation presented. Once medical images leave the strictly regulated contexts of the scientific media, their debt to the imaginary, the speculative, to desire, the fictive, to particular cultural genres and stock narratives, becomes less readily ignored. The intertextuality of scientific images is more evident at these points of popularisation, and this intertextuality implies that the interpretation of images by different nonscientific audiences can lead off in a number of directions and is open to various orders of appropriation.

Just as the VHP is a fantasy object for biomedicine, an aide in the pursuit of IatroGenic desire, so too is it a fantasy object for other kinds of audiences. The wide, continuing attention it has received in mass media outlets, and the sporadic objections made to the allegedly unethical nature of the project are indicative of this status as an object attracting multiple dimensions of fantasy, desire and anxiety. As I reported in the previous chapter, much of this media attention drew upon the stock narrative interpretation endorsed by the project, the Adam and Eve nomenclature ready-made to insert the project into available ideas of life and its scientific management, that is, into a generally positive evaluation of medical progress. Nevertheless I would argue that, if the images in a rational system work both for and against the functioning of the system, then the working of Genesis imagery is not only positive but also defensive. It counts as one line of force in the warring forces of signification which are at play in the VHP and other technocultural objects more generally, both proffering a particular way of reading the Project and pre-empting other available kinds of readings.

This chapter will read the VHP along another line of force, pursuing a decidedly gothic and abject aesthetics which can be readily located there, and which serves as something of a critique of the anodyne self-presentation of the project. It seems to me that the defensive action of Genesis iconography is directed against such an abject reading. My interpretation foregrounds the project's debt to death and the corpse, and the ways in which the medical idea of death and the corpse as anonymous matter encroaches on and disturbs the triumphalist humanism implied in understanding the VHP as simply another step in the march of technical progress. If IatroGenic desire claims the VHP as an instance of technically engineered vitality, an abject reading is addressed to the spectacle it

provides of a new kind of cyber-death or life-in-death, and its intimation of virtual space as a haunted site.

Death and the biomedical imagination

Part of the fascination exercised by the figures imaged for the Visible Human Project is generated by the difficulty of specifying their vital status; while the presentation of the figures as resurrections implies that the death involved in their production has been neutralised or cancelled out, the figures nevertheless seem to partake simultaneously of living and dead states. Cryogenically and photographically 'arrested' just after the moment of death is pronounced, their icons preserved in incorruptible data, the reformulated figures display both the particularity of persons and the disturbingly object-like anonymity of dissection room cadavers. They are kinds of still life, or *nature morte*, images in which life dwindles and fades, yet remains. Like all entities represented through the *nature morte* aesthetic, they are 'subjects … arrested in the course of transmuting. They have not altogether lost their character as life forms but have begun nonetheless to take on the character of things, substances, material objects' (Young 1997: 124).

The pathos of the VHP figures is the pathos of the still life as *memento mori*, the image which both preserves the dead in the particularity of life and serves to remind the spectator of Death. For a long time in the early history of anatomy the anatomical figure retained the vestiges of the *memento mori* aesthetic; in the anatomical atlases of the seventeenth and eighteenth centuries, osteological figures are frequently depicted contemplating a skull, or in communion with an angel of death. Myological figures might be depicted seated on their own graves, or in conventional attitudes of moral anguish.

If the VHP figures lack the explicit markers of this aesthetic, as animate corpses they nevertheless play out one of the more difficult paradoxes in the biomedical imaginary – the disavowed centrality of the corpse and death to the medical idea of life.

This disavowal asserts itself both in medicine's attempt to maintain a clean mutual exclusion between life and death, and in the constitutive failures of this distinction, its persistent collapse. As I have already discussed in Chapter 2, Foucault (1975), in the closing pages of *The Birth of the Clinic*, argues that the medical fiat to posit 'Man' as an object of technical and scientific inquiry derives from its promise to augment life against the predations of death, to exorcise death from the experience of the living. The ontological status of 'Man', his claim to self-presence and mastery of the natural, is, Foucault suggests, profoundly indebted to the ways in which medical science fends death off and casts it out, extending the vitality of the body to its furthest reach. Death is a scandal and intolerable limit to this status, demonstrating as it does the indebtedness and vulnerability of 'Man' to a contingent and wayward embodiment. Death demonstrates that flesh has its own logics, and emblematises all the ways in which embodiment exceeds or refuses to act as agent for conscious projects and desires. Medicine's unique power is its ability to technically alter the terms of this embodiment, augmenting it against the claims of death and trying to make death residual, the state to which life is opposed in a zero sum game.

This exorcism of death takes numerous forms. Within various medical discourses the deferral of death is understood to produce an intensification of life, while any practice which might produce morbidity is cast as concession to death. Activities like smoking are understood within medicalised risk discourse to disperse the time of life and expand that of death, extending its hold into the present time of the living. In Keane's words, behaviour deemed unhealthy is cast as a kind of 'disordered temporality', a soliciting of

the time of death at the expense of life's duration (Keane 1997: 160). Medicine's task here is to accumulate life-capital *against* the claims of death, so that the extension of life is understood to marginalise death, to push back its limits through strategies of prevention (Tierney 1997).

Life is further accumulated against death through the medicalisation of death, the ordering of its trajectory through various forms of clinical intervention. Contemporary medicine focuses much of its technical skill on the seriously ill patient, using an array of vigorous interventions and procedures to control or manage acute conditions. If death cannot be held off indefinitely, it can at least be transformed from an unwinnable battle into a series of smaller victories, the winning back of the patient from the threshold of death through technique (Tierney 1997). For the seriously ill patient in the intensive care ward, it is only after the exhaustion of every available intervention that a patient will be considered to be dying. As Muller and Koenig's ethnography of intensive care practice indicates:

> Patients were generally considered by residents to be dying when the residents determined that there was nothing they could do to reverse the course of the disease and the patient would not recover no matter what they did. ... Dying is defined [as] ... treatment failure.
>
> (Mullet and Koenig 1988: 369)

This technical ordering ensures that the time of dying is still secured *against* death, retained until the last moment on the vivid side of the life/death distinction. In a sense, the terminally ill patient is only conceded to be dying when they are actually pronounced dead. Moreover, each death is assimilated to the status of pathology, a disease with causes, and hence a potentially treatable condition. The causes of death are probed and diagnosed to assist in the possible prevention of, if not death as such, at least this particular *kind* of death.

> All deaths have causes ... each particular death has its particular cause. Corpses are cut open, explored, scanned, tested, until *the cause* is found: a blood clot, a kidney failure, haemorrhage, heart arrest, lung collapse. We do not hear of people dying of mortality ... they die because there was *an individual cause*.
>
> (Bauman 1992: 138)

Within the terms of this relegation of death, medicine's immense effort to exclude it from the time of life, the corpse belongs to the same margin. The corpse stands for the failure of the medical armamentarium to stabilise the body on the side of life and presence. It bears witness to the limits of medical control over natural process, and signifies the end of the time of life and the beginning of the time of death. Located within this mutually exclusive dichotomy the corpse reads as the negative of life, its opposite. This logic of opposition and mutual exclusion is played out in the legislative 'moment of death', the establishment of a clearly delineated point in time which divides the living body as subject from the dead body as object, person from corpse.

At the same time the very existence of the VHP, and the history of anatomy from which it emerges, testifies to the presence of the corpse within, rather than outside, the medical idea of life. As I argued in Chapter 3, the VHP recapitulates a whole history of anatomy, which is itself a history of the centrality of the corpse in the production of biovalue. The practice of dissecting corpses in order to produce anatomical knowledge marks the emergence of the first properly scientific bioeconomy, an economy propelled by the differential value between the corpse at the social and biological margins of life and the knowledge it generates, knowledge which can be used to enhance the well being of the

living. The anatomical dissection marks the point at which *medical science itself develops out of a productive encounter with death*, the mining of death to increase the value and productivity of life, its technical augmentation.

In contemporary medicine the VHP is only one of a range of new biotechnologies which draw upon the bodies of the just-dead, the nearly-dead or the not-quite-alive to produce various kinds of biovalue. At one margin the viability of foetal life is constantly brought forward, located at earlier and earlier points in gestation through the use of reproductive technology (Hartouni 1997) and non-viable foetal tissue is utilised for the production of cell lines, vaccine development, tissue transplantation and Human Genome research (Casper 1995). At the other margin the corpse has become the basis for an array of vitalising procedures and researches. An ever-growing array of biotechnologies enable the vitalisation of the legally dead body so that the cadaver can be utilised as a donor for organs, corneas, connective tissue, bone, heart valves, cells and skin (Hogle 1995). The determination in the late 1960s of the legal definition of death – as 'brain death', the absence of signs of neural activity, rather than the earlier and more traditional signs of absence, the still heart and the absence of breath – was designed specifically in relation to new technologies which could maintain vital functions indefinitely after brain activity ceased. This shift of demarcation point allowed the *process* of death, the fact that it is a distributed temporality rather than a single point in time, to be instrumentalised in a number of productive ways. These new technologies have produced the donor cadaver, which can be connected up to a complex system of ventilators, intravenous fluid pumps, biosensors and thermosensor warmers. These support systems enable the temporary maintenance of vital function, so that the legally dead body can act as source of organs and tissue for transplants, or for pharmaceutical or medical research. Such a body is 'animate but not legally "alive", organic but chemically preserved, a mechanical and chemical object which breathes' (Hogle 1995: 204). In the case of many intensive care deaths, the distinction between living subject and useful cadaver is not perceptible apart from technical systems which indicate brain function. Like the VHP figures, donor cadavers partake of both living and dead states, and the placement of the medical definition of death at the point of brain death enables the preservation, fragmentation and commodification of certain qualities of vivacity, making these qualities available for the use of the still living.

If death is open to vivification within medical systems, this process is assisted by *a more general reliance on the corpse as an implicit model for the living body within the biomedical imagination*. Death can be rendered more life-like because the living body within medicine is modelled upon the dead. Here I am working from an argument made by Leder (1990, 1992) regarding the consequences of medicine's continued reliance on a Cartesian concept of the body as mechanical matter, animated and organised according to machinic laws. The corpse, Leder contends, is central to the medical idea of the body because the corpse embodies the Cartesian idea of the body as animated or deanimated mechanism, a machine whose animation is provided by an essentially external and disembodied subjectivity.

Leder argues that the living body presents a certain problem for medicine, in the sense that it is difficult to contain its meaning to that of predictable matter and force. The living body is excessive, unpredictable, organised through unquantifiable forces of meaning and desire, as well as complex, nonfunctional kinds of organic drive. The psychosomatic abilities of bodies, the formation of hysteric illnesses and corporeal disturbances testify to the dynamic, self-organising complexity of these elements, their synergistic interactions which exceed the sum of their parts, and which complicate the activity and agency of bodily materiality in ways still largely unrecognised by medical models.[4] As I discussed in the previous chapter, even the simplest illness is capable of precipitating unpredictable and complex cascades

and perturbations, non-linear and non-additive developments which are poorly accounted for using mechanical models. It is a recognition of this non-additive quality, in for example allergy reactions and autoimmune diseases, that has led some medical researchers to deploy open systems theory to account for the operation of the immune system.[5]

Moreover, as a libidinal entity the living body cannot be securely confined to a simple, demarcated volume in space. Its boundaries and surfaces are extendable through pleasure and pain, through identification and a capacity for complex forms of embodied relationship and assemblage with other persons and things. As Grosz (1995) puts it, the body is both extendable and receptive surface:

> As a receptive surface, the body's boundaries and zones are constituted in conjunctions and through linkages with other surfaces and planes. ... These linkages are assemblages that harness and produce the body as a surface of interchangeable and substitutable elements.
>
> (Grosz 1995: 34)

These qualities of libidinal extension, protean potentiality and openness to unpredictable transformation exist in tension with the mechanistic model of the body posited within dominant forms of medical thought, a model dedicated to quantification, predictability, functionality, the homeostatic rest point and the reversibility of conditions. As Grosz points out, it is precisely the plasticity of the body, its abilities to enter into prosthetic relations, that opens it out to the normative powers of biomedicine and leads it to act 'as if' it is simply mechanism.

> The increasing medicalisation of the body, based on processes of removal (incision, cutting, removing and reduction) or addition (inlaying, stitching, and injection) demonstrate a body pliable to power, a machinic structure in which 'components' can be altered, adjusted, removed or replaced.
>
> (Grosz 1995: 35)

At the same time its participation in meaningful inscription and intersubjective animation propels it beyond medicine's reductive movement. The libidinal, Iatrogenic body is always to some extent at odds with medicalised norms of the body as isolated, stable volume, a hierarchically ordered organism whose modes of assemblage are only ever functional and predetermined. Hence the living body is never adequately accounted for by mechanistic models of cause and effect, nor by hierarchical, functional models of organism coherence. Leder writes:

> While the body remains a living ecstasis it is never fully caught in the web of causal explanation. I may attempt to understand the movement of another by tracking internal chains of physiological events. Yet the living body is that which always projects beyond such a perspective. Its movements are responses to a perceived world and a desired future, born of meaning, not just mechanical impingements. This bodily ecstasis constitutes an absence that undermines attempts to analyse the body and to predict and control its responses.
>
> (Leder 1990: 147)

Leder argues that this tension is resolved for medicine in the utilisation of the corpse as the model for the living body. The corpse is a thing that retains the macro-anatomy of the human, while abstracting it from all the forms of relation and transformation which mark its everyday existence. Hence, it removes the body from the technosocial systems which inform its complexity and vitality, so that it can be treated as a homeostatic, closed system.

Its lack of dynamism lends it to analytic forms of understanding, conceptual dissection in which the parts can be abstracted from the whole because their interaction is that of the components in a rational machine, non-cumulative and already specified. It is this positing of the body as machine which forms the basis for objective diagnosis and clinical treatment, the posing of a stable system of cause and effect, treatment and cure, which holds across all kinds of bodies in all circumstances.[6] It is also the quality which makes it understandable through dissection, an act which asserts that the whole is only the sum of its parts.

The deployment of mechanical modes of understanding corporeality has profound consequences for the understanding of life and death. As Leder contends, the idea of the body's life in mechanistic biomedicine is produced through the conceptual repression of death, the minimisation of its significance for medical understandings of the living body. Death is only a matter of technical difference in state, the difference between an animate and an inanimate mechanism, and the inanimate corpse serves, briefly, as a model of matter at rest, a moment of stability and objecthood, at least at the level of observable macro-anatomy.[7]

> The body's so-called life is modeled according to the workings of an inanimate machine. The [dead, anatomised] body can constitute the place of life only because life itself has been fundamentally conceived according to the lifeless … Without the soul's presence, the body [for Descartes] would remain an operative machine, but one devoid of any truly experiential life. Dissection of the corpse can provide a method of studying the living body only because the latter is itself a sort of animated corpse.
>
> (Leder 1990: 143)

It is this idea of mechanical life, and its minimal distinction from death, which gives the study of the corpse its centrality in the history and current practices of medicine, at the very threshold of induction into medical knowledge in the anatomy class, as the means of understanding the locus of disease through the pathological anatomy, and as the template for the operation of the x-ray and other imaging technologies that anatomise the living body. Surgery is performed by making the living body as close to a corpse as possible, subtracting through narcosis the forces which distinguish it from inanimate materiality. Moreover it is the idea of life which allows the VHP figures to be posed as reanimations, kinds of living text whose debt to the original death of the bodies imaged is incidental because it is essentially reversible. If the morphology of the original bodies must be destroyed to produce the data files, the rendering capacities of virtual space can nevertheless repair this destruction, a simple synthesis of that which has been analysed. The form of the dead body is all the more amenable to 'arrest' because it is at rest, and this inertia can be reversed through animation, which is, as I conjectured in the previous chapter, fantasised as a partial restoration of vitality. In relying on the logic of reversibility the VHP partakes of the general repression of death in the medical idea of life, providing a model of the living body which is precisely a reanimated corpse.

Medical horror

The medical idea of life is ghosted by the corpse, and the corpse by life, despite clinical protocols which mark a clear and unambiguous distinction, a moment when 'the body-as-object is definitively broken off from the body-as-self' (Young 1997: 126). If, as Foucault suggests, medicine makes 'Man' an object in order to present him with the possibility of

a technically augmented vitality, a defence against the depredations of death, it does so by constantly reworking and exploiting the limit between life and death, subject and object, living being and corpse, a reworking made possible through the very insistence upon their mutually exclusivity. Hence it is through marking the point of death as 'brain death', designating this temporal point and no other as the legislative moment of death, that donor cadavers can be transformed into resources of vitality for the living, even while the cadaver breathes, its blood circulates and its heart beats.

If, as Leder (1990) argues, death for medicine signals merely a technical difference in state, its significance for subjectivity is nevertheless constitutive, presenting the spectacle of absence and non-being which encroaches on the structure and temporality of self-presence. In Kristeva's succinct formulation

> the corpse, the most sickening of wastes, is a border that has encroached upon everything. The utmost of abjection. It is no longer I who expel, 'I' is expelled. … It is death infecting life … it beckons to us and ends up engulfing us.
>
> (Kristeva 1982: 3–4)

The power of medical technology and discourse to make demarcations between living and dead, subject and matter is inevitably bound up with the anxiety of subjectivity in the face of that which erases it, the corpse which signifies its final exclusion from the world, and the final failure of the world to be *for* the subject. This anxiety, Young (1997) suggests, contributes to both the investment in clear demarcations between the living and the dead and to their failure.

> Pathology's attempt to reinscribe the space of death on the body as precise, to rearticulate the time of death as instantaneous, is a response to this discomfort [with death]. These are attempts to disambiguate the ontological status of the corpse as subject-turned-object by conjuring up crisp, clear, clean boundaries in space and time.
>
> (Young 1997: 127)

The medical exploitation of the shifting and blurred limits between living and dead states becomes the locus of such anxieties, introducing the possibility of technically articulated states of being caught between presence and absence, subjectivity and objecthood. In this sense the experience of medicalised subjectivity which Foucault (1975) alludes to – 'that technical world which is the armed, positive, full form of ['Man's'] finitude' – is always suspended over the abyss of the abject, threatening to fall away at each moment into objecthood, monstrosity and death. Correlatively, medicalised death always presents the possibility of posthumous reanimation, or at least a continuation of residual or monstrous subjectivity after the point of medically determined death. As Young's (1997) ethnography reveals, even within the morgue, a laboratory environment dedicated to the idea of a clear distinction between the living and the dead, the corpse continues to allude to its own personhood. It retains features of identity and presence, a continuity with life not completely severed by the declaration of its objecthood.

It is this anxiety, and the ambiguity of prosthetic death-in-life, which has been figured more and more insistently as horror in popular cinema and fiction, horror which frequently engages directly with the problem of distinguishing life from death and subjectivity from technical systems or inert matter. The precise hold that medical technology exercises upon the body provides the horrific with extended scope, presenting as it does the capacity to merge or rend bodies, to penetrate and use them in parodies of medicotechnical rationality. As Boss (1986) indicates in his study of medical horror cinema, the capacity of medical technology

to engage and drain off bodily vitality, to suture living bodies into its own technical systems as productive components, and to bypass corporeal identity in favour of the productivity of flesh, is a potent source of anxiety for the viewer. In films like *Coma* and *Terminal Choice*, in episodes of *The X-Files*, medical technologies take over and reorientate or extinguish the agency of patients and use them to some sinister end. Medical horror suspends its victims in a state caught between proper life and death, and between an ideal of proper bodily autonomy and absorption into the machine. The horror of such technomedical horror genres is the ease with which the humanist armamentarium of medicine can be made to serve inhuman ends, to treat the human as resource and standing reserve.

> Through the image of fully institutionalised modern medicine, hospitals, banks of life-support equipment, the inscrutable terminology, the rigid regime and hierarchy, one's own body rendered alien, regulated, labelled, categorised, rearranged, manipulated, scrutinised and dissected, we experience the powerful and pervasive idea of the subject as defenceless matter becoming integrated into a wider frame of reference in which the institutional and organisational aspects of medicine … focus their conspiratorial attention upon it.
>
> (Boss 1986: 20)

As still lives, participants in both life and death, the Visible Human Project figures are readily located within the genre of medicalised horror. While the deployment of Genesis iconography encourages their interpretation as icons of medical progress and hyperproductive resources for the generation of medical knowledge, they also present a new iconography for terminal states and bizarre prosthetic deaths. Their vitality is produced through the most exhaustive assimilation of once living flesh into technical systems. The figures' bodies have been reinvented as virtual traces, whose dematerialisation and capacities for distribution and reproduction seem to prefigure some strange new future for the body, the final collapse of even the most residual boundaries between flesh and data. As reanimations they also seem to present a contemporary variation on that most famous horror narrative, Mary Shelley's *Frankenstein*. Both narratives produce (or simulate) life through the reanimation of the dead, 'the bestowing [of] life upon lifeless matter'. Both produce whole bodies through a reversal of the anatomical dissection of criminals; the fragments of criminal corpses are assembled into the anatomy of an invented being. Both produce copies of the human in parodic acts of Genesis, figures which present a mirror-image and double of 'Man'[8] refigured as invention rather than inventor. While, as I argued in the previous chapter, the VHP claims itself as good copy of the human, in *Frankenstein* the copy knows itself to be diabolical, a bad copy. At one point the monster says to his creator 'My form is a filthy type of yours, more horrid even for the very resemblance' (Shelley 1818: 115). In both cases the figures are self-consciously likened to Adam, but for the VHP this is an anodyne Adam, a prelapsarian figure untouched by an encounter with death or with the fall. For *Frankenstein* its Adam is monstrous, a being brought forth through the technical reversal of death into intolerable, abject life, a reanimation of corpse tissues whose simultaneous debt to death and to technogenesis is visible and irredeemable.

Read within the lineage of *Frankenstein* and against the Genesis rhetoric deployed by the project, the VHP figures are mirror images, not of an essential human content, but rather of a human whose debt to both death and technics is exposed, conferring upon them the full ambiguity of the technically animate corpse.[9] The compelling aura which surrounds the figures is not limited to this moment of ambiguity, but is also generated out of their location in virtual space. The VHP figures present a new locus for prosthetic death, the space of the virtual not as a means for the generation or invention of life but

as a form of afterlife. In the previous chapter I argued that for medicine, virtual space presented possibilities for reanimation which effectively cancelled the debt to the abject. At the same time the location of reanimated corpses in virtual space suggests the possibility that virtual space is a haunted site, a supernatural medium for life *after life* which supports forms of the uncanny.

The digital uncanny

For medicine, virtual space is effectively a form of clinical or surgical work space, a new form of anatomical theatre where the rational ordering and workings of the body can be demonstrated to a globalised audience. The qualities of the virtual medium make it attractive as a clinical space, facilitating the complex forms of display, and multiple points of view already described. In this sense, medicine partakes of the dominant interpretation of virtual space as simply another locus for the operation of technical rationality. Here virtual space is understood as a new manifestation of the Euclidean master-space of western work-oriented cultures, the master-space which governs communication and production. As work space the virtual realm is another productive space of manufacture, experiment and communication, a technical prosthesis which supplements the productive technoscientific space of the public world through the provision of a common, transnational work environment, a transportation space for data, and a medium for the circulation of the digitised economy (Tomas 1994). It is cast as simply another transparent medium through which communication moves with greater and greater efficiency, more signal, less noise. As clinical or bioexperimental space for medical research and practice, virtual space may preserve and resurrect the dead, but it does so through a rationalistic form of technical mastery and the relegation of the meaning of death to a technical distinction, rather than through any form of miraculous power. If virtual space is imagined as a locus of vitality, the irrationality of this proposition is readily absorbed back into the assumed rationality of the medical project to invent reproducible life, to bring the forces of life into line with the technoscientific world. Cutting across this insistence on the rational texture of virtual space is the possibility for uncanny vitality, implied in the post-natural equation between data and life. For medicine this perverse vitality gains momentum from the repression of death in medicine's idea of the body, returning to ghost the VHP. This vitality is the energy of the uncanny which Freud (1919) describes as an energy produced in the slippage between living and dead states. The uncanny, for Freud, is that anxiety which arises from ontological uncertainty about the distinction between the animate and the inanimate, objects and persons, presence and absence, the dead and the living. It is the horror specific to the possibility that the apparently living may be things, while the thingness of the dead may be illusory, concealing the possibility of secret presence, reanimation and malicious return. Freud singles out certain exemplary instances of the uncanny. An aura of the uncanny clings to automata and to dolls, producing, 'doubts whether an apparently animate being is really alive; or conversely, whether a lifeless object might not be in fact animate' (Freud 1919: 226). Automata may attain the vitality that they mimic, and the apparently human may revert to automatic states, collapse into mechanical thingness.

The figure of the double is also uncanny for Freud, a figure which works as both 'an energetic denial of the power of death' and a harbinger of death (Freud 1919: 235). The figure of the double is a mirror of the subject and a repetition of the same, both reflection and displacement. The double repeats the life of the subject, and through doubling, life is shored up against death, 'a preservation against extinction' (Freud 1919: 235). At the

same time, through the possibility of displacement, the doubled presence of the self in alienated form, the double announces the subject's death, his annihilation at the hands of his mirror image.

Above all, the uncanny is figured in the revenant, the dead who return to living space as ghosts. The ghost, Freud states, is the exemplar of the uncanny because it introduces the highest degree of ambiguity in relations between the living and the dead. It testifies to the sense that nothing is ever sufficiently dead, that death can never be sufficiently repressed, and that the absence of death is only ever provisional, an abject, malicious presence held in abeyance. The reanimate dead are the familiar become alien, the impossible presence of an absent one, the human transformed into the inhuman, yet without loss of energy. The dead return to the space of the living, to the *heimlich*, threatening that seemingly secure space with their presence and reversing the temporal ordering of life and death, the replacement of the first by the second. They haunt the living with the spectre of their own death, and with the possibility that they are already, secretly dead. The threat of the revenant, Freud speculates, is the possibility it presents that the division which keeps the dead and the living separate has dissolved. Not only may the dead return to the domain of the living, but the living may be taken off to the place of the dead. 'Our fear [of the dead] implies the old belief that the dead man becomes the enemy of his survivor and seeks to carry him off to share his new life with him' (Freud 1919: 242). In each of these ways the revenant figures the confusion of life and death, 'death within life, life in death, non-life in non-death … a bit too much death in life; a bit too much life in death, at the merging intersection' (Cixous 1976: 545).

As reanimated corpses and virtual automata, the VHP figures resonate with the energy of the uncanny, altering and throwing into question the everyday sense of the relationship. between living and dead bodies and the kind of spaces that they properly inhabit. Their mode of production, their dissolution in actual space and 'reincarnation' in virtual space, seems to confirm the superstitious sense that the dead leave the living world to *go elsewhere*, that presence continues in an altered form. The immortality attributed to the VHP figures in the popular press is the disturbing immortality of the ghost, its power to continue in a liminal state of non-death and non-life. If death takes the self out of time, the revenant's existence is timeless, suspended forever in the non-time of death. 'A ghost never dies, it remains always to come and to come back' (Derrida 1994: 99). As spectacles they take on the qualities of spectres, the becoming visible of apparitions who appear to the living as 'paradoxical phenomenality, the furtive and ungraspable visibility of the invisible … the tangible intangibility of a proper body without flesh, but still the body of some*one* as some*one other*' (Derrida 1994: 7).

If I can argue that the VHP betrays an aura of the uncanny, this is also because virtual space or cyberspace readily sustains a meaning as supernatural space, a meaning which Tomas (1994) and Cubitt (1996) suggest is sequestered within its dominant meaning as rationalistic work space. Virtual space is

> the space of Western geometry: the geometry of vision, the road, the building, and the machine. On the other hand this master space is a binary construct, consisting of the everyday social or profane spaces … described in Euclidean terms and sacred or 'liminal' spaces. As Victor Turner notes, 'for every major social formation there is a dominant mode of public liminality, the subjunctive space/time that is the counter stroke to its pragmatic indicative texture'.
>
> (Tomas 1994: 34)

For Turner this space is cinematic, but Tomas argues that virtual space is rapidly becoming the new mode of liminal space, because of, rather than despite, its adoption as primary work space. The logic of the virtual is supplemented with a mytho-logic, a sacred space which accommodates forms of ambiguity and the abject – a space open to forms of non-being, death, non-absence and nothingness which impinges upon proper identity and life in actual space.

Cubitt (1996) takes up a similar position in his propositions concerning the post-natural. In the previous chapter I worked off his argument regarding the cybernatural, one form of the post-natural, a rubric for designating forms of life which claim to transcend or succeed the life of the organic world, the world of matter. The cybernatural is the most recent articulation of the postnatural. As Cubitt points out, the cybernatural, as a form of life which transcends the organic, finds associations with an earlier, traditional form of the post-natural. That is, the cybernatural inherits the qualities of the supernatural, the life-after-death. He specifies three primary forms of the post-natural coexisting in *fin-de-millennium* culture; the supernatural, the anti-natural and the cybernatural, each of which is implicated in the other.

> These postnatures ... recognised in their simplest forms as, respectively, the life after death, the triumph of technology over nature, and the creation of artificial life, have been and are still proposed as gateways to a new era. ... [These] postnatures do not supersede or sublate one another, but coexist in the ways we think about the digital domain. Postnature is not a unified zone, any more than nature itself. With each postnatural vision comes a revision of the natural, and with each new nature/postnature pair is associated an aesthetics and a politics. But each vision persists in the others, and the more a schema is historically embedded and the more it is regarded as outmoded and forgotten, the more it returns as repressed ... in the others. Such ... is the fate of the supernatural, whose ancestral ghosts haunt our machines.
>
> (Cubitt 1996: 238)

The computer screen forms a membrane which both separates and connects two different forms of life. In the cybernatural discourse of A-Life this space is posited as a domain for new forms of non-organic vitality, a space for the invention of informatic life. The Visible Human Project's claims to post-natural vitality depend upon this conceit. At the same time, in its uncanny aspect, the VHP also partakes of the related set of discourses which posit virtual space as a haunted space, a topos for the support of spectral forms of life after death.

These discourses are discernable across a range of practices, from the science fiction of cyberspace to the research efforts of some cybernetic engineers. Much cyberpunk fiction proposes virtual space as both an alternative world and an afterworld, a space where characters in actual space can assume temporary digital personae or become permanent 'data constructs'.[10] Constructs are the digital recordings of personal essence, generated by downloading a particular subject's traits, memory and knowledge into digital data. Once recorded they can, as Stone (1992) puts it, decouple from the original subjects, abandon their bodies in actual space and pursue their own forms of life in cyberspace, as digital ghosts which inhabit landscapes of pure data. Less explicitly fictional forms of this idea are elaborated in some areas of cybernetic and robotics research, where programmers are endeavouring to write programs that will record the psychological profile of individual subjects as a way to relocate consciousness from body to computer. Hans Moravec for example, a fellow of Carnegie Mellon University, is attempting to write such programs, working from

the proposition that identity and consciousness are 'essentially a pattern or form rather than a materially embodied presence. Abstract the form into an informational pattern, and you have captured all that matters about being human' (Hayles 1996: 158).

In much of this discourse, post-natural life in virtual space is imagined in anodyne or romantic metaphysical terms, where virtual space is the longed for space of spiritual freedom from the body, a freeing into digital immortality. The virtual realm is represented as exercising a kind of pull upon subjects in social space, inviting them to merge with the world of the screen.

> At the computer interface, the spirit migrates from the body to a world of total representation. Information and images float through the Platonic mind without a grounding in bodily experience. ... The surrogate life in cyberspace makes flesh like a prison, a fall from grace, a sinking descent into a dark, confused reality.
>
> (Heim 1994: 75)

The impulse towards the supernatural which haunts the cybernatural is clearly locatable within the same Cartesian dualism which informs medicine's ideas of life and death. Virtual space can act as a topos for the afterlife because the body, as matter, is the place where death takes place, while subjectivity, projected as spirit, can be detached from its mortal substrate, to continue after death in an altered form. As Leder (1990) argues, Descartes's mind/body distinction is propelled by anxieties about death; by making the self or soul detachable from the body, it simultaneously detaches it from the site of mortality, the corpse and corruption. The supernatural possibilities of virtual space also play upon the power of the trace, its supplementation of and for presence. If, as Moravec, cyberneticists and A-Life scientists assert, the world is fundamentally informational, then the digital trace can transmute the world into an indestructible form and relocate it inside the computer. Just as the digital trace can act as the surrogate for living entities, and for the very essence of vitality itself, so can it store and transmit the form of entities after their materiality has been corrupted. If data's self-replicating and self-evolving capacities lend it to ideas of life and vitality, its self preserving qualities lend it to ideas of afterlife, a continuity of the form of the self after the matter which 'houses' the self decays. The longing which Heim describes is simply the old masculinist, Christian dream of transcending mortality by transcending the body. At the same time this longing is the obverse of uncanny anxieties, which turn upon the possibility of incomplete decouplings of spirit from matter.

While the longing to escape the body and merge with the data flow assumes and wishes for a clean break and clear separation, the uncanniness of the revenant or the automaton are instances where the spirit cannot leave the world of matter, or where dumb, machinic matter becomes monstrously inspired. This is the paradox of the revenant. Its posthumous embodiment, Derrida (1994) states, distinguishes it from the disincarnate spirit.

> [The spectre] assumes a body, it incarnates itself ... the spectre is a paradoxical incorporation, the becoming-body, a certain phenomenal and carnal form of the spirit. It becomes, rather, some 'thing' that remains difficult to name: neither soul nor body, and both one and the other. For it is flesh and phenomenality that give to the spirit its spectral apparition.
>
> (Derrida 1994: 6)

It is as posthumous incarnations that the VHP figures haunt virtual space, visitations from the time after death into the temporality of life. Like all ghosts the VHP figures mourn the loss of the world in the loss of their bodies, and take on a shadow embodiment in order to appear in it once again. Read in this way each appearance of the figures counts as a

visitation, an apparition from the shadow land of data. The menacing non-absence of the revenant seems particularly acute in the case of Jernigan's icon, whose production took place not only through an act of medical mastery but also as an extension of juridical control over his body, death and dismemberment at the hands of the state. Here virtual space is not simply the space of afterlife but an afterlife of arrest, incarceration and punishment, extended beyond execution to perpetual anatomisation and mastery by others.[11]

If the membrane between virtual space and actual space is permeable, and if in this case it maps itself onto the limit which distinguishes the living from the dead, it is not difficult to attribute to the VHP figures the power of spectral presence, a haunting of actual space from virtual space. They enact the return of the repressed which is the *revenant*, that which comes back. As Cixous writes,

> what renders [the ghost] intolerable is not so much that it is an announcement of death nor even the proof that death exists. ... What is intolerable is that the ghost erases the limit between the two states, neither alive nor dead; passing through, the dead man returns in the manner of the Repressed. It is his coming back which makes the ghost what he is, just as it is the return of the repressed that inscribes the repression.
>
> (Cixous 1976: 543)

Each time the VHP data bodies are summoned from the data banks they seem to me to carry this sense of latent force, the desire to cross back from the space of digital afterlife to which they have been committed by that repression which marks the biomedical imagination. And after all, when a body can be rendered into data and thus cross the interface into the digital afterlife, what prevents the process from effecting some form of reversal, the digital revenant who rematerialises in real space. If as I argued in the previous chapter the bodies are treated by the project as faithful translations, a full transubstantiation of flesh into data, then the process must be reversible. Faithful translation, substitution without residue, necessarily works two ways at once, creating a frictionless passage from one text to another and back again. Hence the claim that the VHP figures are surrogate anatomies, faithful copies of the real, necessarily invokes such a passage, a point of connection between the life of flesh and the afterlife of data where each can cross over to the other.

So while the kind of cyberspace summoned up by the VHP connotes the supernatural, it is not the anodyne heaven of disembodied spirituality described by Heim (1994) earlier. Rather it refers to an afterlife of the abject, the corpse which cannot or will not relinquish vitality. In the case of the VHP figures, particularly in Jernigan's case, they seem, like those other animate corpses, vampires and zombies, to be vitalised by the will of another, actively prevented from a full death. In this sense the cyberspace of the VHP presents the spectator with those anxieties provoked by the power of biotechnology to extend the residues of vitality well beyond the desires or interests of the living subject. Donor cadavers, immortal cell lines, cryogenically preserved bodies, frozen embryos – all of these marginal kinds of engineered vitality suggest an infinite deferral of death, a passage from life direct to afterlife. For the biomedical imagination this arresting and deferral of death might count as a gain on the side of life, where the VHP stands as yet another testimony to its rational, vivifying powers. Within the IatroGenic imagination, the deferral of death and the engineering of vitality appears as another step in the gradual mastery of matter, bringing it closer to the negentropy of programmable matter, the assimilation of all materiality by the metaphysics of code. For many spectators however, the VHP opens the space of a new form of death-in-life, a new and horrifying destination for our own failing bodies, and a place from which they might return in uncanny form.

Notes

1 The medical investment in the gaze has a huge literature. See for example Stafford (1993) and Jordanova (1989).
2 For a further usage of the idea of the biomedical imaginary see my book *AIDS and the Body Politic* (Waldby 1996).
3 For a witty and incisive study of medicine's anxious management of gynaecology images to ensure their scientific rather than pornographic interpretation see Kapsalis (1997) Chapter 4.
4 For accounts of dramatic hysterical afflictions see Kirby (1997) and McDougall (1989).
5 For a discussion of differences among immunological models see my book *AIDS and the Body Politic* (Waldby 1996) Chapter 3.
6 There are of course medical practitioners who have productively questioned the mechanical model of the body in medicine, from a number of perspectives. Sigmund Freud and Oliver Sacks are famous examples of clinicians who take the dynamism of body and lived world seriously. Specialists working in areas of medicine more influenced by systems theory, like immunologists and geneticists, for example, are less likely to subscribe to a mechanical idea of the body and more likely to take account of the kinds of dynamic complexity modelling associated with informatic technologies.
7 Of course the micro-anatomy of death is not at all stable, as cell structures break down and succumb to bacterial processes, a development which manifests at the level of macro-anatomy pretty quickly!
8 As many commentators (Bloom 1965; Gilbert and Gubar 1979) have pointed out, *Frankenstein* is an inverted, post-lapsarian reading of the book of Genesis.
9 For an more extensive reading of the VHP through the Frankenstein narrative see Kember (1998). A recent (1997–8) exhibition on the Frankenstein story at the History of Medicine Library, a branch of the National Library of Medicine, used VHP images as contemporary manifestations of the narrative, in the face of some NLM disapproval and controversy.
10 The term cyberpunk refers to a science fiction genre which developed in the 1980s, drawing on the computer and virtual space as a narrative topography. William Gibson's *Neuromancer Trilogy* is the most famous.
11 The idea of virtual space as a site of incarceration is explored in the film *Virtuosity*, where Russell Crowe plays a criminal construct, a digital amalgam of criminal personalities used by the police force to train rookies. The construct escapes from virtual space and wreaks predictable havoc in the real world.

Bibliography

Bauman, Zygmunt (1992) *Mortality, Immortality and other Life Strategies*, Oxford: Blackwell.
Bloom, Harold (1965) 'Afterword', *Frankenstein*, New York and Toronto: New American Library.
Boss, Pete (1986) 'Vile bodies and bad medicine', *Screen* 27(1): 14–24.
Casper, Monica (1995) 'Fetal cyborgs and technomoms on the reproductive frontier: which way to the carnival?', in C. Gray (ed.) *The Cyborg Handbook*, New York and London: Routledge.
Cixous, Hélène (1976) 'Fiction and its phantoms: a reading of Freud's Das Unheimliche', *New Literary History* 7: 525–48.
Derrida, Jacques (1994) *Specters of Marx. The state of debt, the work of mourning and the New International*, trans. Peggy Kamuf, New York and London: Routledge.
Foucault, Michel (1975) *The Birth of the Clinic: An archeology of medical perception*, New York: Vintage Books.
Freud, Sigmund (1919) 'The uncanny', *The Complete Works of Sigmund Freud*, Standard Edition, vol. 17: 219–52.
Gilbert, Sandra and Gubar, Susan (1979) *The Madwoman in the Attic*, New Haven, CT and London: Yale University Press.
Grosz, Elizabeth (1994) *Volatile Bodies: Toward a corporeal feminism*, Sydney: Allen and Unwin.

Hartouni, Valerie (1997) *Cultural Conceptions: On reproductive technologies and the remaking of life*, Minneapolis, MN and London: University of Minnesota Press.

Hayles, N. Katherine (1996) 'Narratives of artificial life', in G. Robertson, M. Mash, L. Tickner, J. Bird, B. Curtis and T. Putnam (eds) *FutureNatural: Nature, science, culture*, London and New York: Routledge.

Heim, M. (1994) 'The erotic ontology of cyberspace', in M. Bendickt (ed.) *Cyberspace: First steps*, Cambridge, MA and London: MIT Press.

Hogle, Linda (1995) 'Tales from the cryptic: technology meets organism in the living cadaver', in C. Gray (ed.) *The Cyborg Handbook*, New York and London: Routledge.

Jordanova, Ludmilla (1989) *Sexual Visions: Images of gender in science and medicine between the eighteenth and twentieth centuries*, Madison, WI: University of Wisconsin Press.

Kapsalis, Terri (1997) *Public Privates: Performing gynecology from both ends of the speculum*, Durham, NC and London: Duke University Press.

Keane, Helen (1997) 'What's wrong with addiction?', Doctoral Thesis, Australian National University, Canberra.

Kember, Sarah (1998) *Virtual Anxiety: Photography, new technologies and subjectivity*, Manchester: Manchester University Press.

Kevles, Bettyann (1997) *Naked to the Bone: Medical imaging in the twentieth century*, New Brunswick, NJ: Rutgers University Press.

Kirby, Vicki (1997) *Telling Flesh: The substance of the corporeal*, New York and London: Routledge.

Kristeva, Julia (1982) *The Powers of Horror. An essay on abjection*, trans. Leon Roudiez, New York: Columbia University Press.

Leder, Drew (1990) *The Absent Body*, Chicago, IL: University of Chicago Press.

—— (1992) 'A tale of two bodies: the Cartesian corpse and the lived body', in Drew Leder (ed.) *The Body in Medical Thought and Practice*, Dordrecht, Boston, MA and London: Kluwer Academic Publishers.

Le Doeuff, Michelle (1989) *The Philosophical Imaginary*, trans. C. Gordon, Stanford, CA: Stanford University Press.

McDougall, Joyce (1989) *Theatres of the Body: A psychoanalytic approach to psychosomatic illness*, London: Free Association Books.

Muller, J. and Koenig, B. (1988) 'On the boundaries of life and death: the definition of dying by medical residents', in M. Lock and D. Gordon (eds) *Biomedicine Examined*, Dordrecht, Boston, MA and London: Kluwer Academic Publishers.

Shapin, S. and Schaffer, S. (1985) *Leviathan and the Air-Pump: Hobbes, Boyle, and the experimental life: including a translation of Thomas Hobbes, 'Dialogus physicus de natura aeris'*, Princeton, NJ: Princeton University Press.

Shelley, Mary (1818) *Frankenstein, or the Modern Prometheus*, London: Everyman Library, 1977.

Stafford, Barbara (1993) *Body Criticism: Imagining the unseen in Enlightenment art and medicine*, Cambridge, MA and London: MIT Press.

Stone, Allucquere Rosanne (1992) 'Virtual systems', in J. Crary and S.K Winter (eds) *Incorporations*, New York: Zone Books.

Tierney, Thomas (1997) 'Death, medicine and the right to die: an engagement with Heidegger, Bauman and Baudrillard', *Body and Society* 3 (4): 51–77.

Tomas, David (1994) 'Old Rituals for New Space: *Rites de passage* and William Gibson's cultural model of cyberspace', in M. Bendikt (ed.) *Cyberspace: First steps*, Cambridge, MA and London: MIT Press.

Treichler, P., Penley, C. and Cartwright, L. (eds) (1998) *The Visible Woman: Imaging technologies, gender and science*, New York: New York University Press.

Waldby, Catherine (1996) *AIDS and the Body Politic: Biomedicine and sexual difference*, London and New York: Routledge.

Young, Katharine (1997) *Presence in the Flesh: The body in medicine*, Cambridge, MA: Harvard University Press.

PART SEVEN

Cyberlife

David Bell

INTRODUCTION

ONE OF OUR RECURRENT PREOCCUPATIONS in preparing this Reader as well as its predecessor has been to map the many different forms of cyberspace and cyberculture, and to map the diverse domains of encounter we have with these myriad forms. For us, cyberspace is not reducible to the Internet or the Web, though the cyber- prefix might suggest this – hence other writers preferring now to talk of new media or digital cultures. We hang on to the now somewhat antique sounding cyberspace and cyberculture partly because the terms have an enduring cultural resonance. There's also something likeably sci-fi about these words: they sound like the future (see also Bell 2006a). N. Katherine Hayles is interested in the future, or more precisely in the 'influence of the future on the present' – how our imaginings of the future shape the questions we ask now, almost presetting a certain trajectory forwards. The four readings presented here all attempt to deal with this issue, through their shared focus on some key questions prompted by cybercultural formations: what does it mean to be human? What does it mean to be alive? What does it mean to think? And as Hayles shows so eloquently, these questions, which seem to be about the future, are profoundly shaping our current understandings of humanness, aliveness, thinking.

Hayles adds another layer to her analysis of futurism, noting that 'when the future arrives, it will be different from the future we expected'. I have written about this from a different perspective, commenting on the 'gap' between the present as it is, and the present as it was imagined in the past as the future (Bell 2006b) – an experience I tagged 'technostalgia'. Thinking about imagined futures and experienced presents is central to the project of understanding cyberculture, I would argue, given first the future-facing orientation of much of the cultural work of cyberculture, and second the experience of living in an 'accelerated culture' in which the future arrives almost before we've thought of it. The pace of change

and the relentless pursuit of newness – embodied in new technologies and new uses – means we are always already living in the future, hurtling through time. Catching a glimpse of the future of life and of human being is a key aim of the readings in this section.

All four readings also share a focus on what Hans Moravec calls 'mind children' – though these are differently imagined in each case. They all focus on what Turkle calls 'intelligent machines', too – though the forms and uses of intelligence vary. The readings centre on debates about artificial life, or ALife, a particularly fertile branch of cyberculture filled with fantastic creatures of unimaginable difference. ALife is also a prime site of both techno-utopianism and techno-horror, both themes vividly played out in science fiction's depictions of new digital life forms – a growing subgenre. Indeed, some of the work discussed in these readings has a decidedly science fiction-ish tone to it, often intentionally – as a way to provoke debate. Hans Moravec's 'The Universal Robot' is typical of this approach, in its thrilling (and thrilled) descriptions of the joint future for humans and robots. His discussion of 'perfect slaves' resonates across science fiction, of course, connecting to key texts such as *Blade Runner* (see Parts One and Four). Moravec interprets our future robot 'slaves' in two ways – as 'worthy successors' to us humans, or as a transformation of humanity itself. This twin track casts a shadow over the other readings here, too, in asking about what makes us human – or, perhaps, when we stop being human, or become something more-than-human. Whether or not we want to do this is often a question left unasked.

Moravec presents a history lesson in robotics, but one that projects into the future, identifying a number of developmental phases, from the 'dumb robots' of today, through to developments in learning, imaging and then reasoning – developments that by 2040 add up to the first generation of robots that move from 'dumb' to 'smart'. Today's dumb robots, with as Moravec says, 'the personality of a washing machine', will soon be engineered with capacities to learn, then to produce 'world models' that can generate intuitive and responsive behaviours, and then reason, so that they end the first generation with most of the abilities and capabilities of a human being. Yet there remain significant challenges, such as mobility, navigation, responsiveness, and attributes such as common sense. Moravec's next generation of smart robots, the truly smart mind children emerging around 2050, are almost identical to humans in their capabilities. Society could, Moravec writes, carry on pretty much without us, since we have by this time delegated so much to these progeny. Specializations such as space travel would make these robots fitted to tasks we humans are incapable of – again, mirroring the 'off world' work of the replicants in *Blade Runner*. As he imagines the outcome, 'Meek humans would inherit the earth, but rapidly evolving machines would expand into the rest of the universe' (see also Stelarc in Part Six).

A different group of mind children are the subject of Sherry Turkle's chapter. She is interested in how human children interact with and make sense of one category of increasingly ubiquitous intelligent machines, what she refers to as 'computational toys'. Such toys confront children with new problems, though Turkle shows how kids much more readily find ways to understand these artefacts

than adults, with our narrow and preset views on what counts as 'alive'. The lack of mechanical workings in electronic toys, Turkle argues, means that they are approached by their youthful users from a psychological standpoint. While this may seem like childish anthropomorphism, Turkle is keen to highlight the degree of sophistication – and freedom – with which the children she talked with articulated their understandings of and relationships with machines. They did project 'human' qualities onto them at times – cheating, being cute – but they also showed a reflexive awareness of such projections (so a machine isn't cheating because it doesn't know it is cheating, for example).

What Turkle recounts in this reading is nothing less than a profound philosophical debate about being human and being alive. The kids' repeated phrase that computational toys are 'sort of alive' ends up being exactly right (though as Hayles shows, this sorting of categories of aliveness or humanness also brings with it some problems). Turkle looks at kids interacting with a wide range of toys, including computer games, virtual pets and Transformers. That the children could ponder aliveness across a range of different sites – on different kinds of screen, in toys of different types – also shows a reflexive openness that Turkle reads as an act of bricolage, a 'cycling through' of different experiences and ideas. This cycling through is, moreover, a broader experience of cyberculture, reflected also in the fluidity of identities (see Part Four; also Turkle 1995). As Turkle concludes, 'today's cyborg children, growing up into irony, are becoming adept at holding [seemingly] incompatible things together'.

One type of computational toy – computer games – is also the starting point for Sarah Kember's chapter, which explores an assortment of ALife applications, beginning with entertainment. Kember's chapter is thick with the necessary description of the various gameworlds she analyses, presenting a vivid picture of opportunities to encounter aliveness on screen. Although written before the recent flourishing of life among some of the products she discusses, such as *The Sims*, Kember's keen analysis of how games pose those key questions of what life is, makes this chapter a very important contribution to cyberlife debates. Her focus on gameworlds and the games industry is also really useful in that it reminds us of the need for context-specific analyses: the deployment of ALife in games has to be read in the setting of the games market, emerging cultures of gameplay and communities of players, and so on. What counts as alive on a computer game depends on all these broader environmental conditions, which are part of the ecosystem of ALife gaming, therefore (Hayles picks up this point about environments in her work, too).

Moreover, Kember repeatedly reminds us that this ecosystem isn't a neutral, 'natural' backdrop, though it is often naturalized: the games reproduce certain hegemonies, whether those of Darwinianism or of capitalism. She reminds us of other systems pressing into shape ALife forms. The emphasis on a linear path of evolution towards greater complexity, for instance, or the narrow set of possibilities for urban form and governance in *SimCity*, are both evidence of these hegemonies at work. Her analysis of *SimLife* and *SimCity* is in need of its own 'expansion pack' now the Sims franchise has branched out – most recently (at the time of

writing) in an interesting recombinant move with some of the other computational toys discussed in these readings, to *SimsPets* — yet her focus on ALife games shows how a branch of cyberlife science has populated popular culture with some astonishing experiments and some amazing creatures.

The game called *Creatures*, originating in the mid-1990s, provides a core example for Kember. Heavily indebted to debates in ALife, the game (or 'software toy') conjures a virtual world (Albia) populated by different autonomous agents or ALife forms (norns, grendels, ettins) in a complex ecosystem. Norns can be understood as a population of virtual pets, and the player is encouraged to develop a relationship with the norns through interacting with them. Interactive, 'learning' toys powered by silicon chips have of course become significant on the toys market — I write this less than a week before Christmas Day 2006, a time when computational toys such as dancing Barbie dolls and robot dinosaurs are selling very well. Kember writes about the 'emotive' engagement with these toys, arguing that the player's role is as 'overseer of a process of evolution involving artificial life forms with which he or she has a degree of kinship', adding that the norns are like children — mind children?

Crucial to the tale of *Creatures* Kember recounts is the interaction between online communities of players and the game's developers and producers. The Internet functions as a kind of double ecosystem in this regard; it connects populations of norns together, facilitating migration and exchange, and it connects players together, facilitating the circulation of tips and cheats, as well as hacks such as the dubious forms of 'norn torture' Kember describes. This information from players also feeds back to the game developers, in the now familiar process of beta-testing.

Towards the end of the chapter, Kember locates *Creatures* in the broader corporate context of the CyberLife Technology Limited, a company that also works on non-gaming applications of ALife, such as agent-based modelling for military or industrial clients. The company sees gameplay as a vital part of the R&D for this other work, and CyberLife itself sees norns as the starting point for a range of ALife applications. The company's 'blue-sky' arm, CRL, is also tackling the big questions of aliveness and humanness, deploying the bottom-up model of emergent intelligence that Hayles also discusses. An interview with a representative of CRL outlines their thinking about intelligence, and their seemingly counterintuitive position that 'evolution is not that good' — an attempt to dispel, as Kember puts it, 'the overwhelming shadow of evolution' from ALife research. Her chapter ends where this section began, with robotics, and with situated, embodied ALife forms as a way to develop (and also understand differently) consciousness — for as Kember shows, the current model of (human) consciousness is perhaps in need of a rethink.

This issue is also at the heart of N. Katherine Hayles' essay 'Computing the Human'. As noted earlier, Hayles is concerned with how our discussions and depictions of the future give shape to the present, shunting us along particular tracks — tracks which limit or preset, she argues, our present understanding of and thinking about what it means to be human. Turkle tackled the question of

aliveness earlier – of different definitions of what counts as alive – but then showed how unstable and impossible these have become. Hayles' angle is different, in that she wants to explore how being human has come to be defined as the opposite of being a machine, and then track the different features of human being used to demarcate that boundary. The famous Turing Test for machine intelligence, or *Blade Runner*'s Voight-Kampf test for cyborg empathy, are both instances of the policing of this border – a border which, Donna Haraway suggests (Part One), has been thoroughly breeched.

Riffing off her well-known 1999 book *How We Became Posthuman*, Hayles here thinks about how we think we know we are human. She discusses work on intelligence and consciousness that suggests that consciousness is not in fact that important for human being-in-the-world, suggesting the folly of chasing a model of conscious thought as the benchmark in AI. Instead, social context and the immediate sensory environment are foregrounded, with a more connective or distributed model of intelligence being developed. While some of the ideas and experiments she discusses seem pretty scary, given science fiction's endless cautionary tales about AI and ALife run amok, she provides an immensely productive account of some work on the fringes of AI and ALife, and new ways of thinking about human (and posthuman) being. Her essay ends with a critique of Francis Fukuyama's defence of human uniqueness, and a call to take hold of the future, to ask what kind of future we might want, and what would be a just future shared by 'carbon and silicon citizens'.

Taken together, the four readings here give a flavour of the dense and heterogeneous field of ALife (and a bit of AI) research, its applications and its imaginings. Hayles sets before us a vital task, to scout for alternative futures, to take note of how an assumed future has locked the present into a certain path – and to try to pick that lock. The work cited in these readings seems to take for certain a future in which there will be a flourishing of new life forms with whom we will have new kinship and new forms of citizenship. Cyberculture will be populated by these brilliant creatures.

References

Bell, D. (2006a) *Cyberculture Theorists*, London: Routledge.

Bell, D. (2006b) *Science, Technology and Culture*, Maidenhead: Open University Press.

Hayles, N. K. (1999) *How We Became Posthuman: Virtual Bodies in Cybernetics, Literature, and Informatics*, Chicago, IL: University of Chicago Press.

Turkle, S. (1995) *Life on the Screen: Identity in the Age of the Internet*, New York: Simon & Schuster.

Hans Moravec

THE UNIVERSAL ROBOT

OUR ARTIFACTS ARE GETTING SMARTER, and a loose parallel with the evolution of animal intelligence suggests one future course for them. Computerless industrial machinery exhibits the behavioral flexibility of single-celled organisms. Today's best computer-controlled robots are like the simple invertebrates.

A thousand-fold increase in computer power in the next decade should make possible machines with reptile-like sensory and motor competence. Properly configured, such robots could do in the physical world what personal computers now do in the world of data—act on our behalf as literal-minded slaves. Growing computer power over the next half-century will allow this reptile stage to be surpassed, in stages producing robots that learn like mammals, model their world like primates, and eventually reason like humans. Depending on your point of view, humanity will then have produced a worthy successor, or shaken off some of its inherited limitations and so transformed itself into something quite new.

Instincts which predispose the nature and quantity of work we enjoy probably evolved during the 100,000 years our ancestors lived as hunter-gatherers. Less than 10,000 years ago the agricultural revolution made life more stable, and richer in goods and information. But, paradoxically, it requires more human labor to support an agricultural society than a primitive one, and the work is of a different, unnatural kind, out of step with the old instincts. The effort to avoid this work has resulted in domestication of animals, slavery, and the industrial revolution. But many jobs must still be done by hand, engendering for hundreds of years the fantasy of an intelligent but soulless being that can tirelessly dispatch the drudgery. Only in this century have electronic sensors and computers given machines the ability to sense their world and to think about it, and so offered a way to fulfill the wish. As in fables, the unexpected side effects of robot slaves are likely to dominate the resulting story. Most significantly, these perfect slaves will continue to develop, and will not long remain soulless. As they increase in competence they will have occasion to make more and more autonomous decisions, and so will slowly develop a volition and purposes of their own. At the same time they will become indispensable. Our minds were evolved to store the skills and memories of a stone-age life, not the enormous complexity that

has developed in the last 10,000 years. We've kept up, after a fashion, through a series of social inventions—social stratification and division of labor, memory aids like poetry and schooling, written records stored outside the body, and recently machines that can do some of our thinking entirely without us. The portion of absolutely essential human activity that takes place outside of human bodies and minds has been steadily increasing. Hard-working intelligent machines may complete the trend.

Serious attempts to build thinking machines began after the second world war. One line of research, called Cybernetics, used simple electronic circuitry to mimic small nervous systems, and produced machines that could learn to recognize simple patterns, and turtle-like robots that found their way to lighted recharging hutches (Wiener 1961). An entirely different approach, named Artificial Intelligence (AI), attempted to duplicate rational human thought in the large computers that appeared after the war. By 1965, these computers ran programs that proved theorems in logic and geometry, solved calculus problems, and played good games of checkers (Feigenbaum and Feldman 1963). In the early 1970s, AI research groups at MIT (the Massachusetts Institute of Technology) and Stanford University attached television cameras and robot arms to their computers, so their thinking programs could begin to collect their information directly from the real world.

What a shock! While the pure reasoning programs did their jobs about as well and about as fast as college freshmen, the best robot control programs took hours to find and pick up a few blocks on a table. Often these robots failed completely, giving a performance much worse than a six-month-old child. This disparity between programs that reason and programs that perceive and act in the real world holds to this day. In recent years Carnegie Mellon University produced two desk-sized computers that can play chess at grandmaster level, within the top 100 players in the world, when given their moves on a keyboard. But present-day robotics could produce only a complex and unreliable machine for finding and moving normal chess pieces.

In hindsight it seems that, in an absolute sense, reasoning is much easier than perceiving and acting, a position not hard to rationalize in evolutionary terms. The survival of human beings (and their ancestors) has depended for hundreds of millions of years on seeing and moving in the physical world, and in that competition large parts of their brains have become efficiently organized for the task. But we didn't appreciate this monumental skill because it is shared by every human being and most animals, it is commonplace. On the other hand, rational thinking, as in chess, is a newly acquired skill, perhaps less than 100,000 years old. The parts of our brain devoted to it are not well organized, and, in an absolute sense, we're not very good at it. But until recently we had no competition to show us up.

By comparing the edge and motion detecting circuitry in the four layers of nerve cells in the retina, the best understood major circuit in the human nervous system, with similar processes developed for "computer vision" systems that allow robots in research and industry to see, I've estimated that it would take a billion computations per second (the power of a world-leading Cray 2 supercomputer) to produce the same results at the same speed as a human retina. By extrapolation, to emulate a whole brain takes ten trillion arithmetic operations per second, or ten thousand Cray's worth (Moravec 1988). This is for operations our nervous systems do extremely efficiency and well. Arithmetic provides an example at the other extreme. In 1989 a new computer was tested for a few months with a program that computed the number 4 to more than one billion decimal places. By contrast, the largest unaided manual computation of 4 was 707 digits by William Shanks in 1873. It took him several years, and because of a mistake every digit past the 527th was wrong! In arithmetic, today's average computers are one million times more powerful than human beings. In very narrow areas of rational thought (like playing chess or proving

theorems) they are about the same. And in perception and control of movement in the complex real world, and related areas of common-sense knowledge and intuitive and visual problem solving, today's average computers are a million times less capable. The deficit is evident even in pure problem solving AI programs. To this day AI programs exhibit no shred of common sense—a medical diagnosis program, for instance, may prescribe an antibiotic when presented a broken bicycle because it lacks a model of people, diseases, or bicycles. Yet these programs, on existing computers, would be overwhelmed were they to be bloated with the details of everyday life, since each new fact can interact with the others in an astronomical combinatorial explosion. (A ten-year project called Cyc at the Microelectronics and Computer Consortium in Austin, Texas, is attempting to build just such a common-sense data base. They estimate the final result will contain over one hundred million logic sentences about everyday objects and actions (Lenat and Guha 1989).)

Machines have a lot of catching up to do. On the other hand, for most of the century, machine calculation has been improving a thousandfold every twenty years, and there are basic developments in research labs that can sustain this for at least several decades more. In less than fifty years computer hardware should be powerful enough to match, and exceed, even the well-developed parts of human intelligence. But what about the software that would be required to give these powerful machines the ability to perceive, intuit, and think as well as humans? The Cybernetic approach that attempts to directly imitate nervous systems is very slow, partly because examining a working brain in detail is a very tedious process. New instruments may change that in the future. The AI approach has successfully imitated some aspects of rational thought, but that seems to be only about one millionth of the problem. I feel that the fastest progress on the hardest problems will come from a third approach, the newer field of robotics, the construction of systems that must see and move in the physical world. Robotics research is imitating the *evolution* of animal minds, adding capabilities to machines a few at a time, so that the resulting sequence of machine behaviors resembles the capabilities of animals with increasingly complex nervous systems. This effort to build intelligence from the bottom up is helped by biological peeks at the "back of the book"—at the neuronal, structural, and behavioral features of animals and humans.

The best robots today are controlled by computers just powerful enough to simulate the nervous system of an insect, cost as much as houses, and so find only a few profitable niches in society (among them, spray painting and spot welding cars and assembling electronics). But those few applications are encouraging research that is slowly providing a base for a huge future growth. Robot evolution in the direction of full intelligence will greatly accelerate, I believe, in about a decade when the mass-produced general purpose, universal robot becomes possible. These machines will do in the physical world what personal computers do in the world of data—act on our behalf as literal-minded slaves.

The Dumb Robot (ca. 2000–2010)

To be useful in many tasks, the first generation of universal robots should navigate efficiently over flat ground and reliably and safely over rough terrain and stairs, be able to manipulate most objects, and be able to find them in the nearby world. There are beginnings of solutions today. In the 1980s Hitachi of Japan developed a mobility system of five steerable wheels, each on its own telescoping stalk that allows it to accommodate to rises and dips in uneven terrain, and to climb stairs, by raising one wheel at a time while standing stably on the other four. My laboratory at Carnegie Mellon, University in Pittsburgh has developed

a navigation method that enables a robot equipped with sonar range measuring devices and television cameras to build probabilistic maps of its surroundings to determine its location and plan routes (Moravec 1987). An elegant three-fingered mechanical hand at the Massachusetts Institute of Technology can hold and orient bolts and eggs and manipulate a string in a humanlike fashion (Mason and Salisbury 1985). A system called 3DPO from SRI International in Menlo Park, California, can find a desired part in a jumble seen by special range-finding camera (Bolles, Horaud, and Hannah 1984). The slow operation of these systems suggests one other element needed this for the universal robot, namely a computer about one thousand times as powerful as those found on desks and in robots today. Such machines, able to do one billion computations per second, would provide robots approximately the brain power of a reptile, and the personality of a washing machine.

Universal robots will find their first uses in factories, where they will be cheaper and more versatile than the older generation of robots they replace. Eventually they will become cheap enough for some households, extending the reach of personal computers from a few tasks in the data world to many in the physical world.

As with computers, many applications of the robots will surprise their inventors. Some will do light mechanical assembly, clean bathrooms, assemble and cook gourmet meals from fresh ingredients, do tune-ups on a certain year and make of cars, hook patterned rugs, weed a lawn, run robot races, do detailed earthmoving and stonework, investigate bomb threats, deliver to and fetch from warehoused inventories, and much more. Each application will require its own original software (very complex by today's computer program standards), and some may also need optional hardware attachments for the robot such as special tools and chemical sensors.

Learning (2010–2020)

Useful though they will be, the first generation of universal robots will be rigid slaves to simple programs. If the machine bangs its elbow while chopping beef in your kitchen making Stroganoff, you will have to find another place for the robot to do its work, or beg the software manufacturer for a fix. Second-generation robots with more powerful computers will be able to host a more flexible kind of program able to adjust itself by a kind of conditioned learning. First-generation programs will consist primarily of sequences of the type "Do step A, then B, then C …" The programs for the second generation will read "Do step A1 or A2 or A3 … then B1 Or B2 or B3 … then C1 or C2 or C3 …" In the Beef Stroganoff example, A1 might be to chop with the right hand of the robot, while A2 is to use the left hand. Each alternative in the program has a "weight," a number that indicates the desirability of using it rather than one of the other branches. The machine also contains a "pain" system, a series of programs that look out for problems, such as collisions, and respond by reducing the weights of recently invoked branches, and a "pleasure" system that increases the relevant weights when good conditions, such as well-charged batteries or a task efficiently completed, are detected. As the robot bangs its elbow repeatedly in your kitchen, it gradually learns to use its other hand (as well as adapting to its surroundings in a thousand other ways). A program with many alternatives at each step, whose pain and pleasure systems are arranged to produce a pleasure signal on hearing the word "good" and a pain message on hearing "bad," could be slowly trained to do new tasks, like a small mammal. A particular suite of pain- and pleasure-producing programs interacting with a robot's individual environment would subtly shape its behavior and give it a distinct character.

Imagery (2020–2030)

Adaptive robots will find jobs everywhere, and the hardware and software industry that supports them could become the largest on earth. But teaching them new tasks, whether by writing programs or through punishment and reward, will be very tedious. This deficiency will lead to a portentous innovation, a software world-modeler (requiring another big increase in computer power), that allows the robot to simulate its immediate surroundings and its own actions within them, and thus to think about its tasks before acting. Before making Beef Stroganoff in your kitchen, the new robot would simulate the task many times. Each time its simulated elbow bangs the simulated cabinet, the software would update the learning weights just as if the collision had physically happened. After many such mental run-throughs the robot would be well trained, so that when it finally cooks for real, it does it correctly. The simulation can be used in many other ways. After a job, the robot can run though its previous actions, and try variations on them to improve future performance. A robot might even be configured to invent some of its own programs by means of a simpler program that can detect how nearly a sequence of robot actions achieves a desired task. This training program would, in repeated simulations, provide the "good" and "bad" indications needed to condition a general learning program like the one of the previous section.

It will take a large community of patient researchers to build good simulators. A robot entering a new room must include vast amounts of not directly perceived prior knowledge in its simulation, such as the expected shapes and probable contents of kitchen counters and the effect of (and force needed for) turning faucet knobs. It needs instinctive motor-perceptual knowledge about the world that took millions of years of evolution to install in us, that tells us instinctively when a height is dangerous, how hard to throw a stone, or if the animal facing us is a threat. Robots that incorporate it may be as smart as monkeys.

Reasoning (2030–2040)

In the decades while the "bottom-up" evolution of robots is transferring the perceptual and motor faculties of human beings into machinery, the conventional Artificial Intelligence industry will be perfecting the mechanization of reasoning. Since today's programs already match human beings in some areas, those of 40 years from now, running on computers a million times as fast as today's, should be quite superhuman. Today's reasoning programs work from small amounts of clear and correct information prepared by human beings. Data from robot sensors such as cameras is much too voluminous and too noisy for them to use. But a good robot simulator will contain neatly organized data about the robot and its world—for instance, if a knife is on a countertop, or if the robot is holding a cup. A robot with simulator can be married to a reasoning program to produce a machine with most of the abilities of a human being. The combination will create beings that in some ways resemble us, but in others are like nothing the world has seen before.

First-generation technicalities

Both industrial robot manipulators and the research effort to build "smart" robots are twenty-five years old. Universal robots will require at least another decade of development, but some of their elements can be guessed from the experience so far. One consideration is

weight. Mobile robots built to work in human-sized spaces today weigh too many hundreds of pounds. This dangerously large mass has three major components: batteries, actuators, and structure. Lead-acid batteries able to drive a mobile robot for a day contribute about one third of the weight. But nickel-cadmium aircraft batteries weigh half as much, and newer lithium batteries can be half as light again. Electric motors are efficient and precisely controllable, but standard motors are heavy and require equally heavy reducing gears. Ultrastrong permanent magnets can halve the weight and generate high torque without gears. Robot structure has been primarily aluminum. Its weight contribution can be cut by a factor of four by substituting composite materials containing superstrength fibers of graphite, aramid, or the new material Spectra. These innovations could be combined to make a robot with roughly the size, weight, strength, and endurance of a human.

The first-generation robot will probably move on wheels. Legged robots have advantages on complicated terrain, but they consume too much power. A simple wheeled robot would be confined to areas of flat ground, but if each wheel had a controlled suspension with about a meter of travel, the robot could slowly lift its wheels as needed to negotiate rough ground and stairs. The manipulation system will consist of two or more arms ending in dexterous manipulators. There are several designs in the research labs today, but the most elegant is probably that of the so-called Stanford-JPL hand (mentioned above, now found at MIT), which has three fingers each with three controlled joints. The robot's travels would be greatly aided if it could continuously pinpoint its location, perhaps by noting the delay from a handful of small synchronized transmitters distributed in its environment. This approach is used in some terrestrial and satellite navigation systems. The robot will also require a sense of its immediate surroundings, to find doors, detect obstacles, and track objects in its workspace. Research laboratories, including my own, have experimented with techniques that do this with data from television cameras, scanning lasers, sonar transducers, infrared proximity sensors, and contact sensors. A more precise sensory system will be needed to find particular work objects in clutter. The most successful methods to date start with three-dimensional data from special cameras and laser arrangements that directly measure distance as well as lateral position. The robot will thus probably contain a wide-angle sensor for general spatial awareness, and a precise, narrow angle, three-dimensional imaging system to find particular objects it will grasp.

Research experience to date suggests that to navigate, visually locate objects, and plan and control arm motions, the first universal robots will require a billion operations per second of computer power. The 1980s have witnessed a number of well publicized fads that claim to be solutions to the artificial intelligence or robot control problem. Expert systems, the Prolog logical inference language, neural nets, fuzzy logic, and massive parallelism have all had their spot in the limelight. The common element that I note in these pronouncements is the sudden enthusiasm of a group of researchers experienced in some area of computer science for applying their methods to the robotics problems of perceiving and acting in the physical world. Invariably each approach produces some simple showcase demonstrations, then bogs down on real problems. This pattern is no surprise to those with a background in the twenty-five-year research robotics effort. Making a machine to see, hear, or act reliably in the raw physical world is much, much more difficult than naive intuition leads us to believe. The programs that work relatively successfully in these areas, in industrial vision systems, robot arm controllers, and speech understanders, for example, invariably use a variety of massive numerical computations involving statistics, vector algebra, analytic geometry, and other kinds of mathematics. These run effectively on conventional computers, and can be accelerated by array processors (widely available add-ons to conventional machines which rapidly perform operations on long streams of numbers) and by use of modest amounts

of parallelism. The mind of the first-generation universal robot will almost certainly reside in quite conventional computers, perhaps ten processors each able to perform 100 million operations per second, helped out by a modest amount of specialized computing hardware that preprocesses the data from the laser eyes and other sensors, and that operates the lowest level of mobility and manipulation systems.

Mind children (2050+)

The fourth robot generation and its successors, with human perceptual and motor abilities and superior reasoning powers, could replace human beings in every essential task. In principle, our society could continue to operate increasingly well without us, with machines running the companies and doing the research as well as performing the productive work. Since machines can be designed to work well in outer space, production could move to the greater resources of the solar system, leaving behind a nature preserve subsidized from space. Meek humans would inherit the earth, but rapidly evolving machines would expand into the rest of the universe. This development can be viewed as a very natural one. Human beings have two forms of heredity, one the traditional biological kind, passed on strands of DNA, the other cultural, passed from mind to mind by example, language, books, and recently machines. At present the two are inextricably linked, but the cultural part is evolving very rapidly, and gradually assuming functions once the province of our biology. In terms of information content, our cultural side is already by far the larger part of us. The fully intelligent robot marks the point where our cultural side can exist on its own, free of biological limits. Intelligent machines, which are evolving among us, learning our skills, sharing our goals, and being shaped by our values, can be viewed as our children, the children of our minds. With them our biological heritage is not lost. It will be safely stored in libraries, at least; however, its importance will be greatly diminished.

What about life back on the preserve? For some of us the thought of being grandly upstaged by our artificial progeny will be disappointing, and life may seem pointless if we are fated to spend it staring stupidly at our ultra-intelligent progeny as they try to describe their ever more spectacular discoveries in baby-talk that we can understand. Is there any way individual humans might join the adventure?

You've just been wheeled into the operating room. A robot brain surgeon is in attendance, a computer waits nearby. Your skull, but not your brain, is anesthetized. You are fully conscious. The robot surgeon opens your brain case and places a hand on the brain's surface. This unusual hand bristles with microscopic machinery, and a cable connects it to the computer at your side. Instruments in the hand scan the first few millimeters of brain surface. These measurements, and a comprehensive understanding of human neural architecture, allow the surgeon to write a program that models the behavior of the uppermost layer of the scanned brain tissue. This program is installed in a small portion of the waiting computer and activated. Electrodes in the hand supply the simulation with the appropriate inputs from your brain, and can inject signals from the simulation. You and the surgeon compare the signals it produces with the original ones. They flash by very fast, but any discrepancies are highlighted on a display screen. The surgeon fine-tunes the simulation until the correspondence is nearly perfect. As soon as you are satisfied, the simulation output is activated. The brain layer is now impotent—it receives inputs and reacts as before but its output is ignored. Microscopic manipulators on the hand's surface excise this superfluous tissue and pass them to an aspirator, where they are drawn away.

The surgeon's hand sinks a fraction of a millimeter deeper into your brain, instantly compensating its measurements and signals for the changed position. The process is repeated for the next layer, and soon a second simulation resides in the computer, communicating with the first and with the remaining brain tissue. Layer after layer the brain is simulated, then excavated. Eventually your skull is empty, and the surgeon's hand rests deep in your brainstem. Though you have not lost consciousness or even your train of thought, your mind has been removed from the brain and transferred to a machine. In a final, disorienting step the surgeon lifts its hand. Your suddenly abandoned body dies. For a moment you experience only quiet and dark. Then, once again, you can open your eyes. Your perspective has shifted. The computer simulation has been disconnected from the cable leading to the surgeon's hand and reconnected to a shiny new body of the style, color, and material of your choice. Your metamorphosis is complete.

Your new mind has a control labeled "speed." It had been set at 1 to keep the simulations synchronized with the old brain, but now you change it to 10,000, allowing you to communicate, react, and think ten thousand times faster. You now seem to have hours to respond to situations that previously seemed instantaneous. You have time, during the fall of a dropped object, to research the advantages, and disadvantages of trying to catch it, perhaps to solve its differential equations of motion. When your old biological friends speak with you, their sentences take hours—you have plenty of time to think about the conversations, but they try your patience. Boredom is a mental alarm that keeps you from wasting your time in profitless activity, but if it acts too soon or too aggressively it limits your attention span, and thus your intelligence. With help from the machines, you change your mind-program to retard the onset of boredom. Having done that, you will find yourself comfortably working on long problems with sidetracks upon sidetracks. In fact, your thoughts routinely become so involved that you need an increase in your memory. These are but the first of many changes. Soon your friends complain that you have become more like the machines than the biological human you once were. That's life.

References

Bolles, Robert, Patrice Horaud, and Marsha Jo Hannah. 1984. "3DPO: A Three-Dimensional Part Orientation System." In *Robotics Research: The First International Symposium*, ed. Michael Brady and Richard Paul. MIT Press, Cambridge, MA, pp. 413–24.

Feigenbaum, Edward, and Julian Feldman, eds. 1963. *Computers and Thought*. McGraw-Hill Inc., New York.

Lenat, Douglas, and Rajiv Guha. 1989. *Building Large Knowledge-Based Systems: Representation and Inference in the Cyc Project*. Addison-Wesley Publishing Co., Reading, MA.

Mason, Matt, and Kenneth Salisbury. 1985. *Robot Hands and the Mechanics of Manipulation*. MIT Press, Cambridge, MA.

Moravec, Hans. 1987. "Sensor Fusion in Certainty Grids for Mobile Robots." *AI Magazine* 9(2), pp. 61–77.

Moravec, Hans. 1988. *Mind Children: The Future of Robot and Human Intelligence*. Harvard University Press, Cambridge, MA.

Wiener, Norbert. 1961. *Cybernetics, or Control and Communication in the Animal and the Machine* (second edition). MIT Press, Cambridge, MA.

Sarah Kember

CYBERLIFE'S *CREATURES*

THIS CHAPTER COMBINES A DETAILED ANALYSIS of the ALife computer games *Creatures* and *Creatures 2* with an investigation of the games' producers (CyberLife Technology Limited [CTL] and CyberLife Research Limited [CRL]) and consumers. Textual analysis is therefore combined with an extended interview discussion (over two years) with ALife engineer Steve Grand (originally of CTL, then of CRL and the designer of *Creatures*), and with a survey of *Creatures* (series) Internet-based user groups. The *Creatures* products are analysed in the context of other ALife computer games and programs and in the context of the 'Sim' games, including *SimLife*, which incorporates ALife principles. The aim of this contextualised approach is to highlight the specificity of CyberLife's *Creatures* in relation to other computer games and to use it as a case study which illustrates a dynamic relationship between the games' producers and consumers, between ALife science and engineering and between science and culture. Through *Creatures*, CyberLife claims to have (co)evolved life in the computer, and to have enabled autonomous agents to proliferate in the digital ecosystem.

The media effects debate is concerned with the positive or negative effects of the mass media,[1] particularly television and video but also new media including computer games. It tends to concentrate on the effects of screen violence on the audience (Keepers 1990). Where the media are regarded as being all-powerful, violence in the media is said to have a direct effect on the audience and to cause violent behaviour. The audience in question is constructed as being passive and susceptible, and technology is given a deterministic role. At the other extreme is the active audience which filters or totally subverts media messages and is premised on a humanist model of the rational, autonomous subject (Henriques *et al.* 1998; N. Rose 1999; Blackman and Walkerdine 2001). Historically, the media effects debate has alternated from one extreme to the other and has by no means been confined to academic circles alone. The mass media are rather preoccupied with their own effects, and particularly with the effect of screen violence on young, impressionable or 'vulnerable' minds. Blackman and Walkerdine (2001) have argued that the main determinant of vulnerability is class as well as age.[2] The argument that the media have negative effects is echoed in

psychology research on early video and computer games. In his research on video games in arcades, Mark Griffiths offered a definition and a model of addiction which, he argued, was equally applicable to computer games (Kember 1997). The addicted, isolated game player corresponds with the notion of a passive audience and contrasts with the (gendered) individual who actively projects his desires for mastery and control (Turkle 1984; Kinder 1991) onto the game, and with the formation of subversive computer game subcultures (Panelas 1983; Buckingham 1997, 2000; Sefton-Greene 1998).

CyberLife's *Creatures* demonstrates a consumer involved (rather than producer dominated) commercial enterprise which suggests that the ALife in ALife products is neither statically defined or the sole activity of remote and specialised scientists. ALife engineers designed the products according to their perception of the scientific principles and game users playing the role of genetic engineers (creating a new species of artificial 'creatures') contributed to the development of the design. The game users who are involved in the user groups and in the correspondence with *Creatures* producers are a self-selecting group of North Americans and Europeans who do not constitute a subculture – or counterculture (Ross 1991) – because there are no consistent signs of subversion or rebellion against the 'parent' culture of science and/as commerce. Rather, the game users took the genetic engineering lead from the game narrative and objectives, and extended it, making it their own via a much greater facility with computer technology and Internet culture than had been anticipated by the producers. The results were then fed back to the producer/parents who in turn restructured the game to allow for greater user involvement. This does not amount to a dialogue (about ALife) between scientists or engineers and predominantly young people of school or college age, but it does imply a dialogic structure of communication which disrupts binaristic and hierarchical models of power in computer game and new media theory, and possibly even in effects-based theories about the relationship between science and culture. This chapter aims to give one illustration of the idea that it is not useful to debate the 'effects' of science on culture or vice versa. It is arguably more productive to highlight the specific interaction between science and culture, producers and consumers which challenges these distinctions and changes the terms of the debate.

The chapter is divided into four sections and the first, 'Sim Worlds – ALife and Computer Games', offers a brief analysis of *Tierra, SimEarth, SimLife* and *SimCity*. These simulations are seen to offer mirror rather than alternative worlds, reproducing hegemonic discourses of origin and evolution without (with the possible exception of *Tierra*) being instances of origin and evolution – or examples of artificial life. The Sim games are primarily ecosystem simulations designed for educational as well as commercial purposes. The 'Creatures' section incorporates detail about the games, their design and consumption and includes interviews with Steve Grand plus samples from the Internet user groups. 'CyberLife – Selling ALife' examines the science and philosophy behind CTL – producers of *Creatures*. It looks at the marketing and promotion not only of the games but of ALife itself, and considers other applications in the military, banking and retail. Finally, 'CyberLife Research Ltd – or "real" ALife' examines the relationship between AI and ALife in the context of blue-sky research into the synthesis of consciousness in the computer. This section includes Steve Grand's project to develop a situated robot (Lucy) and the question of whether or not it is really possible to capture life and consciousness in your computer.

SimWorlds – ALife and computer games

Stirring the primordial soup

In the computer program *Tierra* (Spanish for 'Earth') Thomas Ray claims to have synthesised natural selection. The documentation for *Tierra* (Ray and Virtual Life 1998) provides exhaustive detail about the program and how to operate it, and Ray's ambition for the program is established at the outset. Ray is an ecologist with particular interest in the Cambrian explosion of diversity (600 million years ago) when the dominance of single-celled organisms gave way to complex multi-cellular life-forms. If, as he puts it, 'something comparable can be made to occur in digital organisms' it would be instructive not only for natural science but also for computer science or 'for evolving software to make the transition from serial to parallel forms'. *Tierra* creates a virtual computer and operating system within the user's machine, and the architecture of the operating system is designed so that the executable machine codes are evolvable. Ray is not evolving computers but claims to evolve computer codes as if they were organic. It is clear from his contribution to the ALife debates that he does not uphold a clear distinction between natural and artifical organisms, and the *Tierra* documentation consistently employs biological terms and metaphors. The RAM (Random Access Memory) of the virtual computer is referred to as the 'soup' in which the machine codes or 'self-replicating' algorithms 'live' as 'creatures'. Natural selection and evolution are facilitated by genetic processes of 'mutation' (random flipping of bits) and 'recombination' (swapping segments of code between algorithms). The virtual computer provides the program user with the means to control and monitor the evolution of computer code creatures. Evolutionary control is offered through the provision of three different mutation rates, disturbances, the allocation of CPU time to each creature, the size of the soup and the spatial distribution of creatures. The observational system is described as 'very elaborate' and it includes a record of births and deaths, code sequences of every creature and a 'genebank' of successful 'genomes'. It is also possible to automate the ecological analysis and record the kinds of interactions taking place between creatures. Observation and control is facilitated by the provision of two user interfaces which display information in predominantly numerical rather than pictorial form. The interface is detailed and information is basic only in so far as it is not visual.

Tierra consists of a complete virtual world or ecosystem governed by Darwinian evolutionary laws. While being enclosed and self-contained, this virtual world is also completely accessible to the program user who is offered panoptic vision and other god-like powers. The user is able not only to 'see everything from nowhere' (Haraway 1991a: 189),[3] but also to stir the primordial soup and create life through evolution. The god of Judaeo-Christian religion and the 'god' of evolution are brought together and combined in the role of the user. God and Darwin play together from the outset, making *Tierra* as much an ALife fantasy as an ecological playground. Running the program involves initiating the virtual computer 'world' and 'innoculating' the soup with the 'ancestor' creature – a single cell with a specified genotype. The program then runs for 500 generations in a soup of 50,000 instructions. Runs can be restarted and genomes can be created, replicated or extracted. The price of being god of *Tierra* is a pre-conversion to ALife's particular brand of creationist evolutionism combined with the technical ability and will to navigate the interface beyond the quite innocuous surface (giving cell numbers and sizes) to the ever deepening and (perhaps to some minds) impenetrable depths of computer code.

The Creation part 1: making worlds

SimEarth: The Living Planet (Maxis Inc. 1995, 1997) is a planet simulator based on the Gaia theory of James Lovelock. Gaia is a holistic Darwinian evolutionary theory of life on earth, and it is associated with environmentalism. For Lovelock, Gaia is 'a theory that sees the evolution of the species or organisms by natural selection and the evolution of the rocks, air and ocean as a single tightly coupled process' (Maxis Inc. 1997). While the (CD-ROM) instruction manual acknowledges the specificity of this world view, the game itself – or 'system simulation toy' – clearly sets out to reinforce it. *SimEarth* has a strong educational dimension and emphasises the notion of responsibility towards the planet and its occupants. *SimEarth* is populated by 'SimEarthlings' ranging from single-celled plants and animals to intelligent species. Intelligence may be a feature of any animal anywhere on the evolutionary scale, but there can be only one intelligent species on the planet at any one time. Evolution is placed within a hierarchical framework even if humans are not necessarily placed at the top of the hierarchy. The player or user may well view all SimEarthlings from a 'satellite's point of view' complete with two levels of magnification, but also embodies a Gaian god who has the welfare of the SimEarthlings and the SimEarth 'in your hands'. As a Gaian god, the player is invited to play with the tools of the game, but not with the rules. As, strictly speaking, a 'software toy' rather than a game, *SimEarth* offers more flexible and open-ended interaction. In this case, the toy incorporates a number of different planets with which the player can experiment. *SimEarth* is described more specifically as a system simulation toy and 'in a system simulation, we provide you with a set of RULES and TOOLS that describe, create and control a system' (Maxis Inc. 1997). Each planet is a system, and it quickly becomes clear that where the tools are for playing with, the rules are to be learnt. The challenge is to understand how the rules work and then apply them by using the tools. The rules in question apply to the management of global 'factors' including chemical factors (atmosphere, energy); geological factors (climate, continental drift, earthquakes and other disasters); biological factors (formation of life, evolution, food supply, biological types and distribution) and human factors (war, civilisation, technology, waste control, pollution, food supply and energy supply). The tools in question provide players with the ability to create, modify and manage a planet: 'Create a planet in any of four Time Scales. Physically modify the landscape of the planet ... Nurture a species to help it evolve intelligence' (Maxis Inc. 1997).

The rules and tools of *SimEarth* combine to form a simulation with acknowledged technical and epistemological limitations. The simulation is described as 'a rough caricature – an extreme simplification' in so far as even the most powerful super-computers cannot yet accurately simulate climate and weather patterns let alone other (for example, biological) aspects of the game. The evolutionary model is limited in that it resembles that of Earth, and other possibilities are not explored. Intelligence may not be confined to humans but its evolution follows the same path as it is perceived to have done in human civilisations. The assumption is also made that intelligence is an evolutionary advantage, which 'might be flattering ourselves' (Maxis Inc. 1997). Gaian theory is also acknowledged to be a controversial, not a universal theory. It is clear then that *SimEarth* constructs a mirror world rather than an alternative one, and that it reflects (albeit in a semi-transparent way) existing hegemonies and epistemologies. Gaia may not be a universally acknowledged science, but it appears as a universal within the game in that, despite the illusion of choice, the player is offered no other view of how life-supporting planets might work. Playing by these rules, the player then chooses between seven planets, each with its own scenario and goal. One planet involves a demonstration 'of life on Earth as a self-regulating whole' using

populations of daisies, and another tells the whole evolutionary story from origins to cosmic terraformation – from a scientific viewpoint which is evidently inspired by science fiction. There is a macho evolutionary option – 'choose and help a particular species gain mastery of the planet' – and a more softly focused fantasy of designing, managing and maintaining 'the planet of your dreams' which may be high tech or low tech ('where the biosphere is never endangered'). Players identify their own skill level, name their chosen planet and have to pick from a world in the geologic, evolution, civilised or technology 'stage'. Two main windows are displayed on the computer screen (as with all other Sim games): one showing an atlas of the world, and the other a more detailed close-up of an area which can be directly manipulated. Information about specific events – such as the evolution of a particular type of organism – appears as a message at the top of each window. The menu on the atlas window gives access to a number of new windows controlling the variables for geosphere, atmosphere, biosphere and civilisation.

Information is graphically displayed so that the biosphere window, for example, displays a number of deer-like creatures whose simulated reproduction and mutation levels can be altered. The main window displaying a detailed area of the planet enables the player to view, add to, and move life-forms and aspects of the environment but reinforces the linear, teleological process of Gaian evolution. Planetary evolution should progress from the formation of continents to the appearance of life, civilisation and technology in that order. If civilisation is introduced too early the player receives a message saying 'that is not allowed in this time scale'. Complex life-forms will die out if they are introduced too soon, and so intelligence can only evolve at a certain stage – regardless of the particular species it graces. The teleology is based on the evolution of life on earth up to and including advanced technological (or Westernised) civilisation governed by the notion of progress. The necessary use of fossil and nuclear fuels underlies the conflict between technological progress and the environment. The conflict is resolved by the narrative fact that a successful civilisation is one which leaves in a spaceship to explore planets elsewhere. So much for the prospects of life on earth. In this simulation, Gaian theory privileges 'the living planet' over specific inhabitants, representing it as a whole organism which reacts to the player's decisions. In the 'Gaian Window', earth is anthropomorphised as a face which graphically displays what it thinks about what the player does – so aligning Gaian gods with ordinary mortals and underlining the environmental lesson.

The Creation part 2: making life

SimLife: The Genetic Playground (Bremer 1992), like *SimEarth*, is an ecologically complete simulated world, but with more emphasis on the genetics and evolution of plant and animal species. The Gaian element of the game is important but overshadowed by the focus on Artificial Life. Ken Karakotsios, who designed the game, gives 'inspirational thanks' to Richard Dawkins and Chris Langton, and in the introduction to the user's manual, Michael Bremer states that 'SimLife is an Artificial Life laboratory/playground designed to simulate environments, biology, evolution, ecosystems, and life' (Bremer 1992: 2). The main purpose and main feature of *SimLife* is the 'exploration of the emerging computer field of Artificial Life' (2). ALife, like *SimLife* 'creates a laboratory in a computer, where the scientist can completely control all environmental factors' (6), but 'life as we know it' emerges from the bottom up. Life is defined from a Dawkinsean (ultra-Darwinist) perspective as 'a gene's way of making copies of itself' (16) and as 'anything that exhibits lifelike behaviour, including: adaptive behaviour, self-replication and the ability to extract order from the environment' (16)

(17). One of the specified roles for the user is an ALife experimenter, and this combines with the other named roles of Charles Darwin, 'normal human being trying to play and win a pretty complex computer game' and 'a being with amazing powers who creates worlds' (12). The user builds, names and populates a world, having the power to confer life and death. Using the 'life button' (complete with the image of a double-helix) the user populates her/his world with plants and animals but also accesses the 'smite' icon (a black lightening bolt) which takes out any animal and leaves behind a pile of bones. Life, death and sex have specific sound-effects (fanfare, 'oooo' and 'oo-la-la' respectively) and evolution occurs through natural selection and survival of the fittest. Each creature, or 'orgot', in *SimLife* is a composite (head, body and tail) of three known species and the user can change each of the three segments or create a creature from scratch. Genes can also be accessed via the life button and manipulated at will. Each gene codes for a specific function (flying, walking, swimming and so on), feature, size and gender, and genetic engineering is one of the two highest levels of complexity in the game. The other involves manipulating the laws of physics. Time can also be controlled (evolution can be made to occur at different speeds or the whole game can be paused) and the map and edit windows offer further levels of monitoring and observation (including self-observation or evaluation). As in *SimEarth*, however, the user manipulates the tools but not the rules of the game (despite the illusion of omnipotence) and no matter how many variables are altered, evolution must progress and the ecosystem must be balanced and diverse:

> What can be considered the ultimate goal of SimLife is to look beyond the game, to understand that the real world with its millions of species with their combined billions of genes are all interrelated and carefully balanced in the food chain and the web of life, and that this balance can be upset.
>
> (Bremer 1992: 3)

SimLife is ultimately an environmentalist and Darwinist educational tool. It provides a lab book designed for school children and an experiment ('Splatt') to observe evolution through natural selection. What is interesting about *SimLife* (apart from the strangely mythical composite creatures) is the extent of its claim to create life in the computer. SimLife-forms 'easily meet' the definition of life offered in the manual. They 'metabolize energy from your wall socket. They require the proper environment – the SimLife program – to survive. They react to stimuli in the environment. They evolve' (Bremer 1992: 83). But they are not complex life-forms and are also said to be alive in a similar way to viruses, requiring 'a host – the computer – to live in and with' (83). In this sense they may be on a similar level of complexity to Tierran creatures – albeit in embodied form.

Cain's creation

In *SimCity* (Bremer and Ellis 1993) the player is invited to 'enter' and 'take control' by being 'the undisputed ruler of a sophisticated real-time City Simulator' (Bremer and Ellis 1993: 4). It is possible to be the 'master' of existing cities such as San Francisco, Tokyo and Rio de Janeiro or to 'create your own dream city (or dream slum) from the ground up' (4). The player is given the prescribed roles of Mayor and City Planner or a simulated city populated by 'Sims' or Simulated Citizens. Sims, 'like their human counterparts' (4), live life (exclusively) within the city, building houses, condos, churches, stores and factories. They also complain about things like taxes and mayors and the player's success depends on how Sims react to her/his government.

SimCity claims to have been the first of the new type of entertainment/education software referred to as system simulations. Rules and tools are provided to create and control the city system, the rules being based on a particular kind of (naturalised) city planning involving human, economic, survival (strategies for dealing with natural disasters, crime and pollution) and political factors. The tools of the simulation enable the player to plan, lay out, zone, build and manage a city and the goals relate to effective economic growth and management. The overall aim of *SimCity* is to balance the eco(nomic)system in order to facilitate progress – or the evolution of an urban capitalist economy. The tools of the game – including discrete residential, industrial and commercial zones as well as transport and civic facilities – reduce and reproduce the values and norms (and the architecture) of late-twentieth-century North American cities. The manual recommends that the number of industrial (external market) and commercial (internal market) zones combined should roughly equal the number of residential zones since this will ensure optimum employment and thus minimise migration. Development of the residential areas is dependent on land value and population density, and quality of life is a measure of the relative attractiveness assigned to different zone localities: 'it is affected by negative factors such as pollution and crime, and positive factors such as parks and accessibility' (43). Progress is prescribed by the inevitable growth of internal markets and 'acceleration' of the commercial sector which 'can turn a sleepy little town of 50,000 into a thriving capital of 200,000 in a few short years' (43). Crime rates are related to population density and land value and a recommended long term approach to lowering crime 'is to demolish and rezone (urban renewal)' (45). The introduction of a police station may be effective in the short term provided that funding is adequate. The player controls the budget for police, fire and transport departments and raises money through tax. Sims are very likely to revolt if tax rates are too high, and the player may be faced with 'an angry mob led by your mother'. The player is offered a bird's eye view through the two windows on to the city (map and edit) and can control the speed with which time passes. But there is no direct control over the Sims who inhabit and make use of the structures provided. Sims are not visible to the player and are represented only statistically.[4] They function as solitary invisible units of production and consumption who commute to and from industrial and commercial zones, but do not travel to other residential zones or communicate with each other. In the manual, Cliff Ellis provides a 'History of Cities and City Planning' which includes sections on the 'Evolution of Urban Form', 'Transition to the Industrial City' and a guide to 'Good City Form' (Bremer and Ellis 1993). *SimCity* normalises the good city form of late-twentieth-century North America by making it impossible to build anything else. Different historical and geographical scenarios are neutralised in a regulated socio-economic system which simultaneously erases and is conflated with a self-regulating natural system or ecosystem. Nature is external to the city system (there is no day and night, seasonal change or weather) and takes the form only of disasters such as tornadoes – which can be switched off by the player. As in all the other Sim games, the software system or environment is a self-contained if massively simplified world.

'Sim' worlds are by no means alternative. They are mirror worlds which reproduce – through simulation – hegemonic discourses of origin and of natural/socio-economic evolution. Are they then *instances* of origin and evolution? Only *Tierra* and *SimLife* claim to be. The other games are more prescribed and lack the necessary 'emergent' technology (bottom-up or parallel processing). Thomas Ray claims that *Tierra* will exemplify the laws of evolution because his algorithms reproduce and mutate.[5] Since Ray's creatures are not embodied and are manifested only as algorithms,[6] his claim depends entirely on the legitimacy of strong ALife claims (notably that life is a property of form not matter). *SimLife* also has genetic artificial organisms of very limited complexity (Cliff and Grand 1999) and is arguably

most effective as an ecosystem simulation much like *SimEarth*. The Sim games are distinct from *Tierra* which has specialist ALife appeal (rather like Craig Reynold's *Boids* and John Conway's *The Game of Life CA*) and does not aim to be educational as much as illustrative. The Sim games are educational and deal primarily with the balance and development of natural/socio-economic systems. They are ecological in emphasis (including *SimCity*) and have a very different appeal than the faster, more competitive and more violent computer games (such as the 'beat 'em-ups'). In Sim games, violence has a different form (such as the 'smite' feature of *SimLife*) and has evolutionary consequences. It is not as cathartic as, for example, *Tekken 3* or *Mortal Kombat* and the games are not as popular.[7] They are clearly at the more cerebral end of the market and, arguably, because Sims and orgots are not particularly complex, they have not attracted the kind of user investment that the *Creatures* games have. In these, players are engaging with virtual – often anthropomorphised – pets of considerable complexity. What Sim games do most effectively is naturalise genetic and evolutionary determinism in an environmentalist educational scenario and – in the case of *SimLife* – introduce ALife in to one area of popular culture.

Creatures

> Put some life into your PC!
>
> <div align="right">(*Creatures* publicity slogan)</div>

> Norns have no mental lives and hence cannot be conscious ... but they are alive.
>
> <div align="right">(Steve Grand, interview 1999)</div>

In 'Creatures: An Exercise in Creation' Steve Grand (1997a) describes his design for producing lifelike autonomous agents whose biology and biochemistry is sufficiently complex as to be believable. Grand's agents are designed with a large simulated neural network and a basic biochemical model which creates diffuse feedback in the network and represents reproductive, digestive and immune systems. Moreover, the structure and dynamics of the neural network, the structure of the biochemical model and numerous morphological features of the agents are defined by a simulated genome. The genome is of variable length and appropriate for open-ended evolution. The article is presented from a practical viewpoint and goes on to state that the design has been implemented in the form of a commercial computer game product. Underlying Grand's practical description are clear assertions about the value of biological metaphors and the importance of emergent behaviour in creating intelligent agents.

 The design for *Creatures* is based on Grand's point of view as a computer engineer rather than a scientist, and for him, this entails a rejection of reductionism in favour of a holistic approach to generating artificial intelligence and artificial life. 'Why', he asks, 'do we create neural networks that have no chemistry' when organisms are heterogenous rather than homogenous systems? Most attempts to generate intelligent or lifelike agents are based on single mechanisms, and while there are good reasons for this (from a scientific or research perspective it is often necessary to simplify the object of study in order to learn in detail how it works),[8] there is also the risk that this methodology 'will fail to deliver the emergent richness that comes from the interactions of heterogenous complexes' (Grand 1997a: 19). Put more simply, 'the fact that organisms are combinations of many different processes and structures suggests that most of those systems must be necessary, and we should heed this in our attempts to mimic living behaviour' (19). What follows is

a complicated description which captures the complexity of simulating a biologically whole organism complete with its own genome. The design specifies a class of 'gene' for each kind of structure in the organism, and determines whether it applies to males, females or both. It also controls when, in the creature's life cycle, a specific gene (for example, governing the reproductive system) switches on. Creatures may then experience puberty, although it is noted that 'genes do not code for behaviour, but for deep structure – the behaviour is an emergent consequence of this structure' (23). Genes are assembled into a single 'chromosome' and when creatures mate, chromosomes are crossed over to produce offspring that inherit their complete definition from both parents. 'Mutations' and 'cutting errors' (involving dropped or duplicated copies of genes) produce variations in the gene pool, allowing 'our creatures' to 'truly evolve' (23).

Grand's design for an autonomous intelligent creature capable of learning, and situated in an artificial 'world' is completed by the addition of a simple speech mechanism.[9] It is realised in the *Creatures* computer program 'that allows people to keep small communities of little, furry, virtual animals as "pets" on their home computer' (24). Creatures can be taught to speak, rewarded with a 'tickle' or punished with a 'smack'. They eat, play, travel and 'learn how to look after themselves' (24). Users care for their creatures and diagnose and treat illness when it occurs. Eventually, creatures get old and die, but if they live to puberty, users can encourage them to breed and reproduce: 'He or she can then swap those offspring with other *Creatures* enthusiasts over the World Wide Web' (24). From this, relatively early description of the program, it is already possible to identify quite a range of roles for the prospective user: pet owner, parent (of an anthropomorphised creature), medical scientist, breeder/genetic engineer, trader and computer (games) enthusiast. An important aim of this chapter is to highlight the dynamics of user involvement as a means of challenging the effects model of new media communications, and more significantly of science (producers) and culture (consumers).

The first *Creatures* computer game was released on CD-ROM in Europe in November 1996. In 'The *Creatures* Global Digital Ecosystem', Dave Cliff and Steve Grand state that more than 100,000 games were sold within a month and that they attracted a great deal of media attention (1999: 77). Later releases in the US and Japan in 1997 produced global sales of over 500,000 games by 1998. *Creatures 2* was released globally in 1998 with an initial shipment of 200,000. The technology in *Creatures* is directly drawn from ALife research,[10] and the official guide to *Creatures 2* contains a brief justification of bottom-up (ALife) as opposed to top-down (AI) programming (Simpson 1998). The working definition of ALife offered here is as follows: 'Artificial Life concerns itself with capturing lifelike behaviour by creating small systems (called autonomous agents) and allowing these small systems to interact with each other to create more complex emergent behaviour that none of the individual systems are aware of. Because it is lifelike behaviour we are after, we call it artificial life' (Simpson 1998: 155). The emphasis is on a quest for emergent (intelligent) behaviour, and where other examples are offered (John Conway's *Game of Life* and Craig Reynold's *Boids*) the *Creatures* producers (CyberLife) are quick to claim that their product is leading the quest:

> All life is fundamentally biochemical, and CyberLife believes that to capture human-level intelligence inside a machine, you should create a complete functioning human. This could be achieved by modelling the individual cells and arranging them in the same way that they are arranged in a real human. The result should be a human that is a human, brain and all. There is still a long way to go, but *Creatures* and *Creatures 2* are substantial steps in the right direction.
>
> (Simpson 1998: 159)

From this it is clear that CyberLife is interested in more than commercial success in the computer games market. This is perhaps simultaneously an end in itself and a means to an end of realising one of the key aims of ALife research. There is then a reciprocal relationship between ALife science and engineering in this context that belies the separation of these categories.[11]

Creatures involves a virtual 'world' (Albia) populated by 'species' of autonomous agents which in the second version of the game, include norns, grendels and ettins. Norns are the focal species with which the player is encouraged to interact, and they possess artificial neural networks, biochemistry, genes and organs. A norn's behaviour 'is generated by its "brain", an artificial neural network that coordinates the norn's perceptions and actions, according to a set of behavioural "drives and needs"' (Cliff and Grand 1999: 79). There are a total of seventeen drives (ranging from hungry and thirsty to amorous and lonely) all of which can be monitored during the game (Simpson 1998). There is a short-cut in the simulated neural network in as far as it 'is not *directly* involved in either perceiving the environment or generating actions' (Cliff and Grand 1999: 79). The task of accurately modelling the physics of sound, vision, smell, taste and touch is currently considered to be too technologically complicated and advanced. Similarly, it is not possible to compute a neural network with individual neurons controlling individual 'muscles' in the norn's 'body'. In place of this, 'there are a fixed number of predefined action scripts (e.g., "move left", "push object"), written in a higher-level language' (79). These action scripts (and the drives) correlate with the simple language which norns can learn with the aid of 'learning machines' (artificial computers) situated in their environment. Using two separate machines, norns learn the words for drives and concepts expressed, respectively, through adverbs and adjectives ('intensely hungry') followed by verbs and nouns ('get food') (Simpson 1998: 69, 70). The game player, or user, must encourage the norns to learn language and 'talk' to them by positioning a virtual hand near an object and typing the object category on the keyboard. Apparently, 'Norns can distinguish only between categories; they can't distinguish between the specific objects within those categories' (Simpson 1998: 76). Users must then familiarise themselves with the norn system of classification. Because norns inhabit a virtual environment, they are referred to as 'situated' autonomous agents. Their autonomy is figured in their capability of coordinating actions and perceptions over extended periods of time without external (human) intervention: 'Interactions with the human user may alter the norns' behaviour, but the human can only *influence* a norn, not control it' (Cliff and Grand 1999: 79). The virtual hand of the user (operated by a mouse) can be used to reward (tickle) or punish (slap) a creature and to pick up and drop certain objects. It cannot be used to pick up a norn unless it is in the process of drowning, but it can be used to push it away from (or indeed towards) danger. The virtual hand can be made visible or invisible to the creatures (Simpson 1998: 64). Each individual norn's neural network is affected by its biochemistry. Specific actions such as eating 'can release reactive "chemicals" into the norn's "bloodstream", where chain reactions may occur' feeding back and altering the performance of the network. Norns may eat toxic foods in their enviroment, and will therefore need medical intervention and care from the user. The interaction between neural network and biochemistry also 'allows for modelling changes in motivational state such as those that occur when a human releases hormones or ingests artificial stimulants such as caffeine or amphetamines' (Cliff and Grand 1999: 80). Norn behaviour is, in other words, biologically and biochemically produced, albeit emergent rather than directly programmed. Albia contains 'bacteria' which can harm the norn's 'metabolism' and be counteracted by eating some of the available 'plant life'. The way in which bacteria affect norns and are affected by certain plants is genetically encoded for each strain of bacterium, 'so there is

an opportunity for coevolutionary interactions between the bacteria and their hosts' or between the environment and the individual (80). Artifical genes govern the norns' brains, chemistry, morphology (physical appearance) and stages of development from birth, childhood, adolescence, adulthood to death. Genes are passed on through sexual reproduction (sex is represented by a 'kisspop' in the game and is strictly 'behind closed doors' and heterosexual) and are indirectly related to behaviour: 'the net effect is that new behaviour patterns can evolve over a number of generations' (80).

The creature's brain, organ system, genetics, immune system, respiration and cardiovascular system, digestive system and reproductive system are all modelled and described in detail. They can be monitored and (in most cases) manipulated by the user through the provision of 'applets' or kits such as the Health Kit (basic health care including a selection of medicines), the Owner's Kit (used to name norns, take photographs of them and study their family tree), the Breeder's Kit (covering reproductive systems and providing aphrodisiacs if needed), and the advanced Science Kit (detailed monitoring of organs, DNA, biochemistry and complete with syringe and chemical mixtures for treating illness and injury) and Neuroscience Kit (for experimenting with brains). The Science Kit and the Neuroscience Kit are 'pick-ups' which can be accessed only by persuading one of the norns to activate them. There is also an Observation Kit (to monitor population figures and details such as age, gender, health status), an Ecology Kit (to monitor the environment), a Graveyard and an Agent Injector which allows new objects in to the environment. These objects include norns imported from Internet websites. The main aim of the game, or 'toy' as *Creatures* is also referred to,[12] is 'to give birth to some Norns, explore Albia, and breed your Norns through as many successive generations as you can' (Simpson 1998: 19). However, it is clear that there are advanced features and users, different levels of involvement, and a variety of user roles.

Playing the game

The virtual world in *Creatures* is called Albia and this has both a mythology and a colonial history. Albia is a rich natural and technological environment originally inhabited by the ancient race of Shee who left behind a temple and laboratories for engineering plant and animal life. Grendels are the Shee's monstrous mistake and norns are their crowning achievement. Having created life on Albia, they set off in a rocket to colonise space. The tropical volcanic island then experienced a natural disaster necessitating the resurrection of the Shee's favoured species among the remnants of bamboo bridges, forts and intact underground laboratories.[13] Albia has a balanced ecology with plentiful natural resources and danger in the form of poisonous plants, violent disease-carrying grendels and oceans deep enough to drown unsuspecting creatures in. In keeping with traditional Western technoscientific perspectives, nature is constructed as a resource for exploration, observation, experimentation and exploitation. The presence of both danger and biological potential is seen to justify and reward technological intervention. Albia has its own geography of east and west (as a disk it has no meaningful north and south) but its landscape of exotic plants, animal life and buildings encodes it as being Eastern, oriental, other. The technoscientific and colonial enterprises are therefore conventionally associated.[14] The flourishing underground terrariums and laboratories of the Shee represent a technological Eden, or tamed, enhanced nature where norns can be safe and enjoy life (at least until the user discovers the genetic splicing machine). Above ground, the barren volcanic area remains an untamed and hellish realm of molten lava fit only for the

uncivilised grendels to inhabit. In Albia, the next generation of biotechnological scientists are the direct descendants of the ancient Gods of Shee.

Game playing begins in the hatchery area, 'a warm, cosy, friendly place' (Simpson 1998: 10) with an incubator. The player selects one of six male and female eggs, 'each of which contains its own unique digital DNA' (22) and places it in the incubator. Some 5 to 10 seconds later ('depending on the complexity of the DNA') a norn is 'born'. The player is informed that 'baby norns are a little like two-year old toddlers' and advised to name and track them prior to teaching them to speak and eat (25). The naming of norns is a fairly emotive experience (especially when they reciprocate) and from here onwards, drowning them through lack of adequate supervision can be quite upsetting. It is also very easy to do since the player has no direct control over these cute but wilful creatures. It is possible to spend too much time placing photographs on headstones in the graveyard or making futile attempts at resuscitation at this stage of the game. The parent-educator role of the player quickly gives way to that of general medical practitioner and trainee medical specialist. This is due to the norns exploring their environment and encountering natural hazards, and to an increase in numbers which makes them even more difficult to control ('the most interesting objects in Albia to Norns are other Norns') (Simpson 1998: 81). This is despite a whole barrage of monitoring and surveillance technology and the player's overall panoptic perspective on the world. One interesting feature is the Creature's View option which 'lets you see what the selected creature is looking at' (53). As well as being a necessary mechanism for naming objects, this ability to adopt the creature's point of view is perhaps a further expression of kinship and a displacement of the surveiller–surveilled dichotomy. Surveillance offers no guarantee of control in Albia and this is most evident in the context of reproduction. The Breeder's Kit allows the user to monitor the reproductive system of individual creatures and displays their sex, age, image, life stage and estimated fertility (using a graph of hormone levels). Since 'female Norns are fertile for several minutes, whereas males are capable of getting a female Norn pregnant most of the time' (43) it follows that close monitoring of female reproduction may be necessary. In a somewhat familiar scenario, if a female becomes pregnant 'the picture of the Creature's body is zoomed in, and it shows a little egg that grows gradually over time' (47).[15] Norns are blessed with a 20 minute pregnancy after which time 'the cycle resets and a little baby egg is hatched!' (47). Just like that. The player-programmer's eyes are shielded from this rather effortless process which is signalled by the appearance of an egg in the bottom right hand corner of the screen. Once the player has reached the stage at which norn eggs begin to appear the 'natural' way rather than via the hatchery, the role of parent gives way to that of breeder and ultimately overseer of an evolutionary process which can be influenced but not controlled. Norns will breed without intervention, and naturally occurring eggs do not need to be placed in the incubator. Despite a default setting of sixteen creatures, the population of Albia may start to escalate, making further interventions (such as birth control and the exportation of norns) necessary. The breeding of successive generations of norns (complete with their digital DNA) leads of course to evolution which is – given the underlying ALife philosophy – the true agent of the game and more powerful than the god-like Shee and their player-programmer descendants.

Creatures is by no means simply about interacting with virtual pets. Rather, the player is ultimately positioned as the overseer of a process of evolution involving artificial life forms with which he or she has a degree of kinship. Norns are like children: a new generation. The introductory tutorial to the original game states quite clearly that 'our new-born Norn is alive and like any child she has her own personality'. More than that, as representatives of the ALife project, norns are the next stage in evolution – a new species. It is clear,

within the narrative of the game, that 'we', the players, have responsibility for this new species, but as overseers of the evolutionary process we are evidently not in control of it. We may observe, interact, participate and intervene in the process, but ALife carries forward a firm belief in the sovereign power of evolution. Human agency is at best secondary to the primary force of nature. The role of the player in *Creatures* is god-like in so far as it involves bringing a new, genetically engineered species in to existence. But the power of the creator is compromised by the fact that neither the individual creatures nor the process of their evolution are controllable. In contrast with conventional video and computer games, the player does not play a character on the screen and does not control their actions. Creatures appear to make their own decisions about what to do and where to go. They learn how to behave and how to survive, and the player can only attempt to teach them through punishment, reward and communication. It is necessary to activate a surveillance camera in order to track the whereabouts of the creatures and the only real control players have is the pause button or exit option which places the whole game in suspended animation. The overseer of *Creatures* is a kind of parent-god whose omnipotence is exchanged for kinship. Kinship is represented on the level of narrative and interactivity and is underlined by a deeper level or principle of connection. The game is based on the principle that norns, as artificial life-forms are alive or possess the same essential life criteria as humans, including autonomy, self-organisation and evolution. As an example of ALife, *Creatures* represents the connection between organic and artificial life forms, and through the role of the overseer it loosens the relationship between vision and control which characterises technological forms of visualisation in science and at the intersections between science, art and entertainment.

Kinship with creatures, or the connection between organic and artificial life-forms, is something which is simultaneously underlined and disavowed in the game which encourages players to play with the idea of it through increasingly enhanced genetic engineering features. The most basic level of genetic engineering is breeding. Then comes the genetic splicing machine, a 'great gadget' that 'allows you to breed creatures together that don't normally match – such as a Grendel and a Norn' (Simpson 1998: 203). The device for creating such 'half breeds' is 'essential for any budding Dr. Frankenstein' (142). Creatures must be lured into the room, locked in to the machine and both donors will be 'lost' in the transformation. The appeal is that 'you never quite know what will come out' (143). Interest in these transgenic organisms is enhanced by a feature which allows them to be exported and imported via the Internet. Users can swap or trade their monsters and – through demand – can download a Genetics Kit which 'lets you view each and every gene in a Creature's genome and edit its properties … You can even create a whole new genome from scratch!' (203).[16]

Creatures on the Internet

Using a phrase coined by Thomas Ray, Cliff and Grand (1999) claim that what distinguishes *Creatures* from other ALife games (apart from the combination of simulated neural network and biochemistry) or products based on autonomous agents, is the occurrence of 'digital naturalism' in communities of users and the possible occurrence of culture in communities of artificial agents (1999: 81–3). *SimLife* is mentioned as 'one of the first pieces of entertainment software explicitly promoted as drawing on alife research' (81). But *SimLife* deals with digital organisms which are nowhere near as advanced as those in *Creatures* (82). Similarly, '*Dogz, Catz, Fin-Fin* and *Galapagos* are all presented as involving ALife technologies,

but none of them (yet) employ genetically encoded neural network architectures or artificial biochemistries as used in *Creatures*' (83). Neither (as a consequence) do they allow for the possibility of culture emerging in communities of artificial creatures. Cliff and Grand argue that it is likely that 'rapid and productive evolution' will occur in CyberLife systems and that, although it is 'highly unlikely' in the current (second) version of *Creatures* it is 'tempting to speculate' about the emergence of social structures:

> Given that the norns can communicate with one another, and that supplies of some environmental resources (such as food or 'medicine') can sometimes be limited or scarce, it is not inconceivable that simple economic interactions such as bartering, bargaining, and trade occur between norns, allowing for comparison with recent work in simulated societies such as that by Epstein and Axtell.
>
> (Cliff and Grand 1999: 85)

Epstein and Axtell's (1996) work will be discussed in the following chapter, as will the development of artificial societies in environments governed solely by the principles of genetic determinism and evolution. Given the relatively advanced organisation of game 'users' rather than 'agents' it seems more appropriate at this stage to look more closely at the idea of 'digital naturalism' in *Creatures* on the Internet.

Cliff and Grand compare *Creatures* with Ray's *Tierra* but, again, claim that the agents are significantly more complex: 'In colloquial terms, if the agents in *Creatures* are similar to animals in their complexity of design and behaviour, then the agents in Tierra are similar to bacteria or viruses' (Cliff and Grand 1999: 85). Yaeger's *PolyWorld* is considered to be the closest comparable program in so far as it, like *Creatures*, 'attempts to bring together all the principle components of real living systems into a single artificial (manmade) living system' (85). Cliff and Grand point out relatively small differences in technology but larger differences in the aims of the projects since *PolyWorld* is primarily a tool for scientific inquiry into the issues addressed in *Tierra* and a test-bed for theories in evolutionary biology, behavioural ecology, ethology or neurobiology (86). *Creatures* is clearly an entertainment application with technology designed to be adapted in industrial engineering. It bears greater comparison with Ray's *NetTierra* which has been in development since 1994. A development of *Tierra*, *NetTierra* is intended to run on the entire Internet rather than on a single computer. It would run on spare processor time and on as many machines as possible, migrating organisms across the network in search of idle computers: 'typically on the dark side of the planet, where the majority of users are asleep' (Cliff and Grand 1999: 86). Ray argues that the program will create a 'digital ecosystem' supporting diversity and self-organising evolutionary processes. Industrial applications of *NetTierra* are possible and it would be necessary, according to Ray, for 'digital naturalists' to observe and experiment with the evolving life-forms 'possibly removing promising-looking "wild" organisms for isolation to allow "domestication" and subsequent "farming"' (Cliff and Grand 1999: 86). Cliff and Grand maintain that, 'without any prompting', the sizeable community of *Creatures* users with their independent newsgroups and some 400 websites, 'appear to be engaging in exactly the kind of digital naturalism that Ray foresaw the need for in *NetTierra*' (87).

The original producers of *Creatures* anticipated a slightly different response to their product than the one they received and, according to Steve Grand, its appeal stems from the producers' receptiveness not just to user opinion, but to user involvement in the design and development of the product. It had been thought that the major issue for game players and observers would be 'the philosophical question of whether the norns are truly alive' (Cliff and Grand 1999: 87), but the major issue appears to have been the practice rather than the philosophy (or ethics) of genetic engineering. Interest in breeding and exchanging

norns exceeded initial expectations, but the 'rapid appearance of users *reporting the results* [my emphasis] of "hacking" genomes, producing new "genetically engineered" strains of creatures' took the producers of the game by surprise (87). When asked about the extent to which *Creatures* was designed to create a community of users on the Internet, Steve Grand reveals how the design was adapted to accommodate a community of technically astute users which had formed semi-autonomously:

> The practical key to making it work was to make the program open, so that people could alter it and add to it. Partly by design, and partly because of the building-block nature of biological systems, there turned out to be a number of ways that people could enhance the product and hence their enjoyment of it. Within a few days of launching the game, there was a new species of creature and also a couple of freeware add-ons available over the Web. People had developed these by hacking into the code and working out how parts of the genetics and script languages worked. In fact they were so good at this that I decided to save them the trouble of working it all out for themselves, and simply published the necessary documentation so that they could get on with it.
>
> (Interview, September 1999)

Computer hacking plays an interesting and perhaps novel role in the ownership of software in this case in so far as it is not, strictly speaking, an example of either theft or subversion. It is noted that the results of hacking genomes was 'reported' – not just to other users but also back to the producers who, in turn, responded by making an 'open' program still more accessible. The stereotype of the hacker is of an isolated asocial or antisocial computer 'criminal' (Ross 1991) who is probably between the ages of 13 and 30 and almost certainly male. The users represented in *Creatures* user groups are predominantly of school or college age and include both men and women.[17] The question of gender might stimulate an analysis of potentially different types of use, but the focus here – and arguably the more pertinent focus – is on the dynamic interplay between CyberLife producers and consumers as they embody one index of the continuum between science and culture.[18] Hacking is generally associated with subcultural or countercultural activity (Ross 1991) which does not appear to be relevant here. Hackers do not generally share their spoils with targeted groups or individuals. While the economic and copyright ownership of *Creatures* is not in question, the sole ownership of the technology and of successive 'generations' of the product is. While crediting CyberLife's web design team and developers' forum initiative (set up to support individuals producing 'add-ons' or new elements of the game), Steve Grand also acknowledges that *Creatures* products have been moulded 'not only through suggestions but also through direct help from some very experienced and smart *Creatures* users' (1999).

How then might the relationship between producers and consumers, science and culture, capital and labour be characterised in this context? How does the interplay between designers and users of *Creatures* contribute to an understanding of the dynamics – the flows of ideas and resources – of digital culture and the digital economy? Clearly it does not fit a model of either exploitation or subversion, nor does it reduce to the familiar concept of cultural appropriation or assimilation which depicts 'the bad boys of capital moving in on underground subcultures/subordinate cultures and "incorporating" the fruits of their production (styles, languages, music) into the media food chain' (Terranova 2000: 38). For Terranova, the complexity of labour in late capitalism is characterised by the concept of 'free labour', which, in the context of the Internet incorporates the construction of websites, modification of software, participation in mailing lists and inhabitation of virtual spaces (33). She lays stress on the argument that the virtual reality of the Internet is not a form

of unreality or any kind of ideological *tabula rasa* since it is structured by the cultural and economic flows which characterise network society as a whole (34). It might be added that this early sense of possibility linked to unreality is also countered by a return to naturalism in digital culture. Critical of Richard Barbrook's concept of the 'gift economy' in which 'gifts of time and ideas' serve to overturn capitalism from within (Barbrook in Terranova 2000: 36), Terranova maintains that although new forms of labour may not be produced by capitalism in any direct sense, they have, however, 'developed in relation to the expansion of the cultural industries and are part of a process of economic experimentation with the creation of monetary value out of knowledge/culture/affect' (38). It is, she suggests, too easy to employ a model of capitalism against expressions of Internet utopianism – or rather, evolutionism – centred on self-organisation and the depiction of the Internet as a hive mind (collective intelligence) or free market (44). Free labour does signify a degree of co-evolution or collectivism which is, however, not natural, not ideal. Terranova's main complaint against what she terms Internet utopianism, and I term evolutionism, is its tendency to neutralise the operations of capital (44). It is nevertheless effective – through the stress on self-organisation and collective intelligence – in capturing the existence of 'networked immaterial labour' (44). This, at least in part, has been encouraged by the existence of the open source movement – fundamental to the technical development of the Internet – in which software companies make their program codes freely available to the public for modification and redistribution (49). The company then gains its returns through, for example, technical support, installation, upgrades and hardware (50). The open sourcing of Netscape in 1998 rejuvenated debates on the digital economy and led Barbrook to underline his claims that 'the technical and social structure of the Net has been developed to encourage open cooperation among its participants' (50). Conversely it was regarded as an alternative and successful strategy of accumulation based on encouraging users to spend more time on the Internet (50). With no direct investment in access, this raises the question of what, on its own scale and in the gaming rather than telecommunications context, CyberLife stood to gain by open sourcing *Creatures*. The answer, as suggested in Steve Grand's comments, might well lie in pragmatics. That is, there was not a great deal of choice. The *Creatures* code was hacked, altered and returned because, in a sense, it was already open. It was already open by virtue of its design and distribution, and Grand therefore simply realised what might be termed a digital form of co-evolutionary, cultural and economic interdependence.

For Cliff and Grand, the main indicator of digital naturalism is the emergence of unexpected user activity. The first example they give explains the presence of the genetic splicing machine in *Creatures 2*. The creation of hybrid 'Grenorns' was a user initiative – 'we didn't think this was possible, since grendels had been deliberately made sterile … to prevent them from overrunning the world' (Cliff and Grand 1999: 88). Users initially tampered with the norn eggs by manually inserting a genome from a grendel in place of one 'parent'. The result was a random cross between the two species and the topic of 'much newsgroup discussion' (88). Of the 'naturally' occurring mutations, one is the 'Highlander Gene' which results in an immortal agent, and another is the 'Saturn Gene' which causes norns to shiver continuously and results in a 'rather morbidly popular phenotype' (88). What Cliff and Grand refer to as 'digital genetic engineers' have modified individual genes spreading popular mutant strains via the web. One of these, the 'G-defense gene' turns the creature's fear response into an anger response, making it more aggressive (89). A pattern begins to emerge. Aspects of anthropomorphism and sentimentality, stressed by the game producers, gives way to a certain amount of sadism connected with a diminishing sense of kinship. On the one hand, a 'save the grendels' campaign attracted significant support, as

did a European drive to ease the language difficulties for migrating norns (unsurprisingly, by increasing standards of spoken English). Apparently, an Australian family emailed Grand a norn that was deaf, blind, insensitive to touch and generally not getting much out of life at all. Grand diagnosed a mutated brain lobe gene, and after corrective modification, rest and relaxation, the norn was sent home (90). On the other hand, there have been disturbing reports of organised norn torture and abuse by an online character named Antinorn:

> There's a guy whose pseudonym is Antinorn, and he runs a website devoted to ways of being cruel to norns. Because of his wicked sense of humour, there are plenty of 'battered norns' around, and so people have set up adoption agency sites to look after them and find them new homes! The newsgroup has several times exploded into a frenzy over this topic and I think it's very healthy.
>
> (Interview, September 1999)

The newsgroup (alt.games.creatures) was monitored at around the time of this interview (August/September 1999). Amidst some chat about school classes and extracurricular activities apart from *Creatures*, Mae, Julius, Cati, Indigo, Patrick, Dave, Kate, Freya and others discussed Bastian's problem with a dead genetically engineered norn – 'flying around my world in circles' and resisting the dead creature remover – alongside Antinorn's antics. The debate about norn torture was, in fact, linked with the question of whether or not they can be considered to be alive. Aliveness was measured against human and animal criteria and connected to an ethical debate about rights. According to Bastian, all of the 'no-torturing stuff' is based on an association between norns and human life, and the fact that humans, unlike animals, have 'mercy for the weak ones'. But Bastian thinks that 'we should not use this attitude on other creatures – especially not on digital ones' because they will weaken the evolutionary chances of our own young: 'If we are to [*sic*] merciful with our C2 norns, they take the place you could use for stronger newborns'. Norn torture is then sanctioned on the basis that it is not as bad as the kind of medical interventions often practised on people: 'if someone wants to torture norns, so let him … what some other players do to their norns (let them live ages with injections and then let them starve very slowly) would be even much more cruel'. The debate about what can be considered alive picks up on philosophical, biological and ALife references (including references to the life status of viruses) and there is a sense, for example from Julius and Indigo that norns are only really 'technically' alive. Dave agrees and brings the subject back to norn torture, AN's (Antinorn's) website and the debate about whether or not this has a right to exist. Kate makes a plea for free speech and xOtix supports this by adding:

> I don't believe that simulated torture of a simulated computer-generated *model* of a limited low form of life (didn't we once agree on spider intelligence as the max? Remember that thread?) is 'bad' or 'evil'. I only have one concern. I wonder what engaging in this kind of activity does to the person who is doing it?

Bastian summarises the debate by agreeing that norns are not 'really' alive but then adds that there will, in future 'be much more complex digital "life forms" that will have the same rights as we … and therefore cannot be tortured'. This appears to constitute a closure, and the discussion wanders off course until Tom appears:

> Hi
> Does anyone know how I can 'kill' my Norn??

> I don't know what's her problem, but she suffers, is lonely ... all the time. I've
> tried almost anything: I gave her food, injections, other Norns, ... but she
> lies there and cries.
>
> She doesn't listen to me anymore. Perhaps it is a genetic defect.
>
> So I want to kill her SOFTLY. I don't want to export and delete
>
> My Norn.
>
> Please help me.
>
> Tom

When asked for his view on norn torture and abuse, Steve Grand replied: 'I think it's wonderful! Well, I guess I feel sorry for the norns (although not terribly sorry – it's no more cruel than stepping on an ant)'. For him the concept of cruelty demonstrates that his project has been successful and that people are engaging with the ideas on which it is based. What annoys him is the way in which US publishers censored the 'slap' and 'tickle' feature of the game for fear of a moral panic among parents and teachers. The issue of norn cruelty forced the game producers to change the original title and 'tone down the yelp' that norns emit when slapped. This feature almost had to be removed altogether. Such censorship does not appear to have deterred the dedicated, and a thriving website (run by Antinorn) entitled Tortured Norns co-exists with literally hundreds of other independent sites, and with the official Creature Labs set up by CyberLife.

The Creature Labs website includes information on new products (including *Creatures 3* with enhanced brain power and social behaviour for norns), news and general self-promotional material designed to attract investment: 'We create games and online virtual worlds that are pushing back the frontiers of simulation and modelling to create powerful solutions in Entertainment and on the Internet' (http://www.creaturelabs.com). It is clear that the company wishes to 'take our products even further onto the Internet' by, for example, developing online games designed for both the 'loyal Creatures user community' and new audiences. A chronology of the company's development notes that in 1998 the Creatures brand website was launched with a weekly hit rate peaking at 1.6 million. In 1999, *Creatures* and *C2* combined sales exceeded 1 million units and new games *Creatures Adventures* (for children) and *C3* were launched. Also in 1999 CyberLife launched the Creatures Development Network (CDN) to support 'third-party' developers. The site states that over 1000 people signed up in the first week. Details on the CDN are given in the Creatures Community category (which also contains news that CyberLife has completed and published details of the recently mapped Norn Genome). CDN is a free developer program giving users access to the tools and technology in *C2* 'plus a chance to make money by selling your add-ons and objects through the CyberLife website e-commerce system'. CDN has a forum for discussing technical issues with other players and producers. According to CyberLife you are free (subject to our terms and conditions) to use knowledge gained here to produce free COBs [creature objects] for yourself and others or you may want to offer them to us to distribute or even sell on your behalf (for a portion of the sales). Information and materials on CDN remain the copyright of CyberLife but COBs created by 'third-parties' are copyrighted to them. The Creatures Community section of the main Creature Labs website also has a Community Center with links to independent websites, webrings and virtual worlds. It is designated as a place for exchanging news about the creatures community and for adopting norns from the main database or arranging 'a date for a lonely heart (norn, of course)'. The site explains that webrings are cooperatives of website owners who link to and from each other and provides information on how to access the Creatures webrings (some 228). Titles revealed by a search included All Creatures Great

and Small (which wasn't to do with the games), Middle Agers for Norns (which was), Norn Sanctuary and Kickass Creatures. The latter contained the Tortured Norns site complete with pitiful images, a tortured norns forum and downloaded dialogue from the newsgroup (http://www.TorturedNorns.homecreatures.com). On 23 July 2000 AntiNorn received a stern warning from the SPCN (Society for Prevention of Cruelty to Norns), and on 1 May 2000 s/he (according to Grand 'he's definitely a "he" ') appeared to receive information from a disgruntled CyberLife employee. To a certain extent, AntiNorn fulfils the traditional hacker role, subverting the 'cutesy' and educational aspects of the game and the producers' claims to have created life in a computer. Certainly, AntiNorn's cannibal norn challenges sentimentality and it is interesting to note that the promotional literature for *Creatures 3* claims that norns behave 'as though' they were alive because they 'almost' are.

CyberLife – selling ALife

Creatures is produced by CyberLife Technology Limited. The company was established in 1996 (although it had been operating under other names since 1989) and prior to a reorganisation in 1999, it comprised three departments: Creature Labs, CyberLife ALife Institute and CyberLife Applied Research. The Institute was responsible for advanced long-term high-risk research into 'artificial lifeform technology' (Grand interview, September 1999). Connections to the wider ALife and AI community was made via the Institute (through publication and conferences) which was financially supported by the other two departments. The Applied Research department developed widespread applications for the blue-sky research, and Creature Labs focused on specific products, notably computer games. In 1999 the company split to form CTL (now officially Creature Labs Ltd) with a focus on games software and online entertainment and CRL chaired by Steve Grand and comprised of other members of the earlier CyberLife ALife Institute.

The original CTL established the company's commitment to the biological method and metaphor of computer modelling and its awareness of the marketability of key concepts and processes such as emergence, evolution and adaptation. The website states that 'CyberLife is designing and building a new generation of Living Technology' (http://www.cyberlife. co.uk) and it advertises biologically inspired modelling. What biologically inspired modelling involves is bottom-up rather than top-down programming and an attempt to simulate complexity through emergence: 'rather than developing massive rule bases, we choose to model life forms from the bottom up in order to capture the intelligence and subtlety of human and animal behaviour, using properties such as emergence'. Biological modelling produces life-forms which 'grow' inside the computer and are whole or complete. They are more than bits (or bytes) of artificial intelligence programming designed for specific albeit advanced or complicated tasks. They are synthetic organisms which can reproduce, evolve and adapt as a 'species' and have (at least initially) lower level but wider possible applications. CyberLife promotes norns as just such a species which may or may not extend its function in the future: 'Some of their offspring, or their cousins, may learn to do useful jobs for people, or simply to keep people entertained until the day comes when we know how to create truly intelligent, conscious artificial beings' (http://www.cyberlife. co.uk). CyberLife is ultimately 'concerned with the re-vivification of technology' by creating lifelike little helpers 'who actually enjoy the tasks they are set and reward themselves for being successful'. The reward is artificial 'natural' selection and survival of the fittest in a Darwinian evolutionary environment which supports and mirrors the economy within which it operates. In a commercial context, biological ALife modelling and psychological AI

modelling have different methods and metaphors but similar goals; to compete successfully and survive in the information economy. ALife products have, it could be said, evolved as a result of the failure of the AI project to deliver HAL to an expectant market:[19] 'Artificial intelligence is not achieved by trying to simulate intelligent behaviour but by simulating populations of dumb objects, whose aggregate behaviour emerges as intelligent'.

CyberLife's biological simulation engine is called Origin (originally Gaia). Origin models artificial life forms and environments by mirroring the function of cells within a living structure. Living cells function autonomously and in parallel with other cells to create a unique organism: 'There is no "guiding hand" controlling cells; likewise, each of the objects in Origin can detect the information they need and determine their own state without needing to be controlled or co-ordinated from above' (http://www.cyberlife.co.uk). The major advantage of this cellular modelling structure is that just like real biological systems, it can handle complexity, scale up from small to larger populations of cells and is highly adaptable (Grand interview, Sept 1999). As a software architecture, Origin can be customised to suit specific needs and provided to customers as a toolkit. Robert Saunders assesses the value of Gaia/Origin and CyberLife Technology in general as a basis for innovative or creative design computing (Saunders 2000).[20] Creative design is based on the introduction of new knowledge into the design process through, for example, emergence. Saunders links emergence and creativity with reference to interesting and unexpected properties of a system which requires an observer 'with a set of expectations' (3). After cellular automata and 'evolutionary systems' (such as GAs), emergence and creativity are demonstrated in Gaia's system architecture of cells, chemistry, neural networks and genetics. For Saunders, creativity, like life itself, is a difficult concept to define and 'attempting to create a creative entity is much like trying to create an autonomous agent which can be said to be alive' (5). The real test of a system is whether or not its behaviour matches the observer's expectations of something that is creative or alive: 'Creativity then is an emergent property of a complex system measured in relation to the model of creative agents which people derive from experience' (5). Where Gaia's simulated organisms, such as Creatures, behave in a sufficiently lifelike manner within the confines of their own artificial environment, the question for Saunders is whether they could be equally believable in another 'limited domain' (5).

Apart from the entertainment and games industry, CyberLife technology has been applied (but not as yet developed) in the contexts of the military, medicine, banking and retail. As well as modelling the part animal, part human-like norns in *Creatures*, CyberLife claim that 'we can produce human-like virtual entities in a wide range of simulated environments' (http://www.cyberlife.co.uk). These entities will demonstrate, for example, how the layout and design of retail space affects human behaviour, and they could prevent the pharmaceutical industry from having to carry out research *in vivo*. The 'privately owned' company has supplied products and technology to organisations such as Motorola, NCR and the UK Ministry of Defence. The US company NCR wanted to research customer behaviour in a high-street bank 'so it commissioned CyberLife to breed surrogate people that could wander around inside a virtual bank and test the layout of machines and services – without the time and expense of real-life tests' (Davidson 1998: 40). The software agents were programmed with certain 'drives' (queue, leave, deposit or withdraw cash, seek financial adviser) and behaved in similar ways to real customers in real banks. Their competing drives serve as a test of the bank layout since a successful design enables the agent to complete its transactions 'before it is overwhelmed by the urge to take its business elsewhere' (40). CyberLife advertises similar forms of modelling for other businesses such as shopping malls and theme parks on its website. The contexts are interchangeable because of the adaptive modelling system, and the principles remain the same. Modelling begins with a drawing

of the physical space into which human-like agents are placed, 'each with their own set of needs and drives'. After that, data are added from customer records, such as age ranges and patterns of consumption. A picture of consumer behaviour is built up as the agents move around the retail space. A change in physical space, such as the relocation of particular shops, will demonstrate changes in consumer behaviour.

In March 1998, CyberLife Technology Ltd announced to the press that it had signed a contract with the Ministry of Defence research organisation DERA (Defence Evaluation Research Agency) to construct an artificial pilot capable of flying a simulated military aircraft. Both European and US defence agencies are interested in the prospect of Unmanned Air Vehicles (UAVs), and CyberLife's project was one of the first to attempts to fly an aircraft with an autonomous agent rather than through ground-based pilots using remote control. Artificial pilots have the advantage of being in the aircraft and also of being artificial and therefore relatively invulnerable. Potentially, artificial pilots would supersede the capacities of human pilots and provide a more cost-effective service involving smaller, faster and less detectable aircraft.[21] As with other applications, CyberLife used data from the relevant source – in this case actual flight data – to generate the simulator. The simulated aircraft was akin to the Eurofighter except that it required no human control and could sustain flight, pursue enemy aircraft, evade attack and make 'reasoned decisions in order to complete its mission requirements' (http://www.creatures.co.uk). The artificial pilot is based on, and uses essentially the same technology as CyberLife's Creatures; namely a complex simulated neural network and biochemistry controlled by binary genes. The idea is that the pilot can learn from experience and reason in the face of novel situations (Davidson 1998: 39). DERA recognised the potential in the science behind the computer game and commissioned the research in order to provide something more realistic than the computer-generated opponents ('following rigid, rule-based systems') being used to test pilots in flight simulations. In keeping with ALife principles, CyberLife attempted to create this ideal opponent using biological methods including evolution and emergence. Populations of 40 pilots were subjected to 400 generations of evolution. The success of different flight strategies was tested and success was determined by how long each pilot remained in the air and how well it tracked or evaded the enemy. Only the best pilots from each generation were selected and allowed to reproduce (passing on their top-gun genes). Unlike norns, the pilots were not programmed with specific drives, and so behaviour was (even) less predictable. What emerged was some human-like and some distinctly non-human behaviour and techniques. Like human pilots, the artificial ones banked the aircraft in a turn and rolled over before attempting a steep dive: 'Humans roll over before diving to stop the blood rushing to their heads. The synthetic pilots don't suffer such physical constraints. They have developed this tactic because it helps to keep targets in their sights for longer' (Davidson 1998: 43). More unusually, according to Steve Grand, one rather successful breed flew the aircraft in a constant tight roll which, 'as far as we could tell' significantly increased the stability of the planes. This 'strange behaviour' evolved 'because the synthetic pilots didn't care in the slightest which way up they were, and had stomachs like cast iron' (September 1999). The lack of physical constraints suffered by artificial pilots (especially g-force) could lead to a radical redesign of real aircraft which would not have to be constrained by human dimensions and could be made to turn and accelerate much faster. Perhaps one of the reasons why this test-bed project has not, so far, been developed further is that such far-reaching implications did emerge and that in some ways it exceeded (and therefore failed to meet) its brief. Artificial pilots are not 'realistic' opponents. There is also the possibility that ALife could produce something much simpler and more 'organic' than a synthetic human in combination with another kind of machine:

We think there is a lot of potential for far more advanced pilots, although it is hard to tell whether we should really be talking of pilots in aircraft or synthetic eagles, where the neural network is the brain and the aircraft is the body. So far we haven't had the opportunity to do the much more advanced and difficult research needed to find out.

(Interview, September 1999)

For Grand, the most important applications of CyberLife technology are still to be developed. He lists space exploration alongside entertainment, military, medical and other commercial uses. However, it is clear that the technology is still undergoing a crucial stage of development, namely the incorporation of consciousness or imagination (which are considered to be linked, though not synonymous, attributes). Consciousness is a subject of debate and controversy in AI and related fields and it is acknowledged to be hard to define (and therefore simulate) (Velmans 2000). But for Grand it is associated with the ability to imagine or plan possible actions – without having to carry them out – and the ability to make novel connections between thoughts and ideas. These imaginative abilities are likely to have real benefits, 'allowing organisms (or machines) to be creative, to plan and to speculate' (Grand 1999a). As a consequence, CyberLife (Research Ltd) is concerned with new kinds of neural networks 'which have the facility to decouple themselves from simple sensory-motor interaction with their environment and develop an internal mental model of the world, which they can manipulate "at will"' (1999a). Whether or not this constitutes consciousness may be hard to determine: 'we're rather hoping the machines will tell us!'. What it does seem to constitute is the production of agents with increased agency. Saunders (2000) evaluates the imaginative abilities of norns and finds them limited (Grand declares that norns are alive but not conscious). However, their ability to learn from experience and generate expectations or hypotheses 'which can be tested and re-evaluated in new situations' is the key to being able to develop agents 'capable of accomplishing a limited range of creative tasks' (Saunders 2000: 6). In the context of design computing this development could produce sophisticated agents capable of tackling design tasks autonomously. Success could be rewarded in the normal way (genetic reproduction) leading to the prospect of able artificial assistants (already 'gaining a great deal of acceptance in the wider computing field') which are ultimately collaborating with each other in self-organising social systems. Specialised agents in a simulated environment collaborate to solve problems which none could do alone: 'This would mirror the real world approach to design and may make for interesting comparisons in the way work is distributed between individuals in self-organising social systems' (8). By this logic, imaginative or conscious autonomous agents pass through an object or instrumental stage to become microcosms of human-like cultures and societies in which human agents invest anthropological, psychological or sociological concerns. In other words, they become mirror worlds (Helmreich 1998a) offering novel opportunities for narcissism.

CyberLife Research Limited – or 'real' ALife

CyberLife's research on consciousness is currently being undertaken by CyberLife Research Ltd (CRL), a completely independent company chaired by Steve Grand. CRL is developing the blue-sky projects initiated by the original CTL and its relation with commerce and industry is more open-ended in as far as the focus is not on the development of specific products or product lines.[22] A biological engineering company with close links to the ALife

research community, CRL demonstrates what might be referred to as 'real' ALife.[23] Its practical and philosophical commitment to ALife is premised on the belief that whereas AI programming failed to work (or pass the Turing Test), ALife engineering is working towards the creation of artificial intelligence in artificial life-forms. The fusion of biology and technology is central to the success of ALife engineering in as much as it produces machines which are more 'robust', 'adaptive', 'intelligent', 'flexible' and 'friendly' than, for example, HAL: 'Many of us grew up with Dan Dare comics, Star Wars movies and Kubrick's 2001. We believed in a world full of androids, cyborgs and intelligent robots. We also believed in a world of constant warfare and cold-blooded mechanical logic. Only part of that story will be true' (http://www.cyberlife-research.com). Biologically inspired or 'sentient' technology is less abstract than the 'smart' systems developed using conventional AI techniques. It is more robust because, unlike smart systems, it is not necessary for every eventuality to be programmed in to the design and so it can more easily cope with the unexpected, learn from mistakes – and adapt to its environment. Sentient technology is more intelligent in the way that a mouse is more intelligent than a chess computer: 'A mouse will always lose at chess to a chess computer, but try throwing them both in a pond and see how they fare'. Less clever in a narrow sense or specific context, sentient technology produces a broader based more flexible intelligence than non-biological forms. It aims to be friendly by having a brain which is similar in one fundamental way to the human brain – conscious. In CRL's website publicity, consciousness is clearly associated with imaginative and creative powers, the 'special features' of human brains. So the chief characteristic of its artificial neural network 'is that it will have an imagination, and it will be able to use this imagination to visualise possible futures, make plans and act them out within a complex and messy external world'. The basis of the biological approach to artificial intelligence is a belief that complexity can be synthesised but not analysed, built but not broken down. The analytic method characterises traditional AI science more generally. It is based on the (reductionist) idea that in order to understand (and recreate) something, it is necessary to break it down into its constituent parts. But intelligence is, arguably, more than the sum of its parts and has eluded the AI project. If intelligence cannot be modelled directly (or programmed and controlled), then the building blocks (cells) from which intelligence emerges can be. The transition from top-down to bottom-up computing is characterised as a shift from 'command and control' to 'nudge and cajole', and as a rejection of a 'macho attitude to intelligence and software design' (Grand 1999a: 74). In the context of AI and ALife, emergence is characterised as a feminine process based on a nonlinear, non-deterministic model of connection or communication between multiple rather than individual units. Captured in a computer, this (irrational) process mirrors the creativity of the brain ('since it is the simultaneous interaction of many parts that creates behaviour at new levels of description'). The key to artificial intelligence then, is a holistic, co-operative, cell-based biological approach which (until recently) has eluded 'blinkered, domineering, chess-playing computer nerds' and saved them from the dubious honour of creating machines which think like them: 'We've carefully avoided creating HAL, and have therefore saved humanity from hearing those awful words …: "I'm sorry Dave, I'm afraid I can't do that". Robots will never take over the world now, and it's all thanks to us' (74).

Because CRL's approach to the development of artificial intelligence is organic, it depends on the creation of life-forms which are 'embodied' and 'situated'. Embodiment, in this context, refers to the creation of whole (optimally) three-dimensional entities which demonstrate the advantages of rendering emergent behaviour visible and learning by putting things together rather than taking them apart (Grand 1998c). Situatedness, in this context, is about being embedded in, and responding to a real environment (Grand 1999a), and

it is based on the idea that intelligence cannot exist in a vacuum. Artificial organisms, or systems, 'need to be grounded in some kind of rich, noisy environment' (Grand 1998b: 3) and preferably one inhabited by other systems. This definition would appear to fall only slightly short of suggesting that intelligence (which is not actually defined by CRL) can develop only in a *social* context. CRL's stress on embodiment and situatedness is contrasted with a tendency, within the ALife community, to place too much emphasis on abstract and mathematical processes of simulated evolution such as CAs and GAs. Simulated evolution is regarded as an 'ecological specialisation' which is stifling the development of ALife and may not be the panacea which it appears to be. Modern computers can accelerate the process of simulated evolution, but perhaps not fast enough to attain even low levels of animal intelligence and, while scientifically informative 'is of limited use to an engineer' (Grand 1998a). While it is good, evolution is 'not *that* good' and it contributes to impoverished ideas about the meaning of life itself. Referring to the 'currently fashionable' definitions of life which revolve around self-replication, evolutionary potential and other 'fairly mechanistic criteria', Grand acknowledges that 'at a reductionist level' evolving systems can be considered to be alive or lifelike. He also points out that just because evolutionary systems fulfil some of the conditions for life, the 'tendency to assume that this is all of life' is a syllogistic fallacy:

> Artificial life, one of the most holistic, synthetic fields in science, is falling foul of *reductio ad absurdum*. In practical terms, this means that research into morphogenetic, chemical and neural mechanisms, communication, perception and intelligence is being eclipsed by the overwhelming shadow of evolution.
>
> (Grand 1998a: 20)

In an effort to dispel the overwhelming shadow of evolution, Grand reemphasises the importance of the term 'organism' in the study of life and seeks to shift the focus away from 'pure science' to technology. What this results in, ideally, is a meeting between biology and cybernetics. Cybernetics is associated with a less Newtonian, less materialist view of the universe 'in which everything is regarded as software, and the world is studied and classified, not in terms of "things" ', but in terms of the relations between things. In this scenario, 'atoms, mind and society are seen as essentially the same kind of non-stuff' and 'everything is irreducibly connected to everything else' (Grand 1998c: 72). This is the kind of holism expressed in connectionist theory (Plant 1996; Kelly 1994; De Landa 1994), and it is made possible by the emphasis on form over matter (Langton 1996 [1989]). This may not sit as uncomfortably with the notion of embodiment as would at first appear, since embodiment refers here to cybernetic or cyber-biological systems rather than anything quite as material as physically and socially situated subjects.

ALife's stance on the concept of matter is informed by the idea that (natural or artificial) intelligent systems are too 'messy' and complex to fit with the 'reductionist, materialist and mechanist' approaches of classical physics which has informed much of contemporary science. ALife originally constituted something of an epistemological challenge to physics which, almost by definition, is concerned primarily with matter, and established an 'obsession with stuff' (Grand 1999b). Grand points out that this obsession with stuff is an understandable result of the way in which human senses respond to the environment; organising a mass of coloured dots picked up by the visual senses and converting them into discrete physical objects which are then classified and mapped back onto the external world. As well as organising the world, the sense are blind to non-material phenomena – such as minds. So there is a tendency to think of tangible things as real and intangible things as unreal, and to assign a value to the difference. These values are constructed in language

so that 'material facts' are good and 'immaterial' means irrelevant. 'Tangible assets' are superior to intangible ones, and 'substantial' is a positive attribute where 'insubstantial' is not: 'Even the word "matter" carries emotive baggage when we discriminate between things that matter and things that don't!' (Grand 1999b). CRL's philosophy is based on rejecting the distinction between form and matter and the appearance that the world is divided into discrete objects. It carries forward Langton's (rather Saussurian) credo that things are not as significant as the relationship between them. In fact, Grand denies that matter exists at all. What exists, he argues, is a hierarchy of 'ever more sophisticated persistent phenomena' ranging from photons of light and subatomic particles through atoms, molecules and cells to whirlpools, bridges and bodies. All phenomena are metaphorically software rather than hardware since 'everything is made from the same (non)stuff'. Moreover, it is subject to a small number of basic mechanisms such as modulator mechanisms which allow one flow of cause and effect to modify another: 'In electronics modulators are called "transistors" while in biology they are referred to as "synapses" or "catalytic reactions"'. The identification of 'cybernetic elements' such as modulation provides engineers with 'a universal LEGO set' from which 'we can create all kinds of organisations, including intelligent living ones' (Grand 1999b). The idea that people are not material objects but persistent phenomena is clearly a bold and controversial one from a sociological and scientific perspective, and it constitutes one of the more problematic aspects of ALife for feminism. Grand brings the idea down to earth a little with an illustration about memory. In 'Three Observations that Changed my Life' Grand (1997b) invites the reader to recall an episode from childhood, explore it briefly and then question how it is possible for 'you' to have had this experience when 'you' were not there at the time: 'Probably not a single atom that's in your body now was there then. You still consider yourself to be the same person, yet you've been replaced many times over'. This certainly puts cell division and replacement in a new light. The upshot for Grand is that 'whatever you are, therefore, you are clearly not the stuff of which you are made' (1997b: 14).[24]

The deconstruction of form and matter in ALife (which seems to vacillate between a challenge to hierarchical epistemological dualism in a hegemonic scientific philosophy and an attempt to invert the binary in favour of form) has immediate implications for the reconceptualisation of contested categories such as 'mind' and 'consciousness' as these have traditionally fallen under the overarching category of non-matter (Velmans 2000). The exponents of ALife science necessarily stand in opposition to current trends which seek to redefine consciousness as simply a property of matter.[25] For Grand, this is a 'mechanistic' argument ('the mechanists are always trying to reduce mind to physics') which is counterposed by a 'dualistic' one. Dualists maintain the distinction between mind and matter 'but then go and spoil it all by trying to reify spirit and "promote it" into some magical substance' (Grand interview, August 2000). For dualists, mind and matter are different but mind is essentially 'some special kind of stuff'. For materialists, there is only matter and mind 'is some kind of illusion (simply the product of nerve impulses')'. So in order to shock people out of what he refers to as 'those dogmas', Grand offers his own assertion that 'there is only mind' – or rather, 'there is only form' (Interview, August 2000).

In *Understanding Consciousness*, Max Velmans (2000) characterises reductive materialism as a belief that consciousness is only a state or function of the brain. In his opinion, this conflates the generally accepted idea that consciousness has neural causes and correlations with the idea that it is 'ontologically identical' to a brain state. Velmans (2000: 32) characterises emergentism as a belief that consciousness is a higher-order property of brains which cannot be reduced to neural activity. Where there is no clear definition of consciousness it is, he argues, distinguishable from mind, self-consciousness, wakefulness or thought. If

it is not possible to say what it is, it is possible to say what it is like or rather 'pick out the phenomena to which the term refers' (6). An ostensible definition of consciousness refers to the awareness of experience or 'what it is like to be something' (Nagel in Velmans 2000: 5). By regarding the brain as an open, not closed system in continued interaction with the environment, Steven Rose (1999b: 15) argues – after Marx and Nietzsche – that 'consciousness is fundamentally a social phenomenon, not the property of an individual brain or mind'. It is especially not the property of an individual brain metaphorically linked to a computer. This brain as computer metaphor is, he suggests, flawed because brains deal with meaning and not with information: 'I have argued that brains and minds deal with meanings imposed by their "hard-wired" ontogenesis, and by the historical personal development of the individual and the society and culture in which that individual is embedded' (6). The brain as computer metaphor, rather like the life as information metaphor has generated a good deal of controversy and polarised arguments represented, for example, by Roger Penrose (1999) and Igor Aleksander (1999). For Penrose (1999: 155), the human quality and conscious phenomenon of 'understanding' is 'not something of a computational nature at all', and is something of a test case for AI, or the 'fundamentally lacking' computational model of mind (156). Conversely, Aleksander (1999: 181) is committed to the task of engineering a conscious machine and, citing Penrose, is keen to join the 'acrimonious' battle among 'the great and the good' for capturing the high ground or revealing the brain's deepest secret. Aleksander claims to be more willing than his colleagues to situate current theories of consciousness in established philosophies from Aristotle to Wittgenstein, and replays the ascendancy of ALife over AI by arguing that in order to approach consciousness, 'one needs to study the properties of a neural net which enable it to be a dynamic artificial organism whose learned states are a meaningful representation of the world and its own existence in this world' (Aleksander 1999: 185).

Grand's allegiance to AI and to strong ALife means that he believes that machines are capable of being conscious just as computer software is capable of being alive (1997b). Whereas norns were 'alive, but not conscious', Grand's next project – Lucy ('a robot baby orang-utan') – might ultimately be both. In order to understand consciousness (or 'that sense of "being" – the "I" that I find inside my head'), Grand aims to synthesise it: 'but if I can ever do such a thing it will be by deliberate accident' (Interview, August 2000). In other words, he hopes that it will emerge through simulated 'subconsciousness' and its underlying neural substrata. For Grand, one of the main phenomena to which the term consciousness refers is imagination, so 'I'm trying to create a robot that can make plans and rehearse them in her head – i.e. she will have an imagination' (Interview, August 2000). The cybernetic mechanism which provides the basis for his model of imagination is the servomotor (electronic motors used to move the wing flaps in radio-controlled aircraft). Servos have inputs which provide information about where the aircraft is and where it should be – one represents an actual state and the other represents a desired state. The circuitry inside the aircraft tries to move it in order to minimise the difference between desired and actual state: 'If you think of a billion such servos side by side, and think of the desired state as being a "mental" state, then you have an imagination machine' (Grand interview, August 2000). The basis of this imagination machine is the representation of the imagination 'as if' it were raw sensory data. Aleksander depicts a similar machine which 'given a state of the input stimulus (the perceptually available state of the world), can mentally imagine … the effects of available actions' (1999: 193). Such a machine may be able to represent emotions such as love as abstractions devoid of personal knowledge and experience (197) and is based on a view of consciousness as something rather simple 'not something that escapes computation, but something that is the ultimate masterpiece

of iconically adapted firing patterns of parts of the brain, something which the advances of neural computation allow us to approach, study and imitate, something which is just too important to be smothered by an assumed complexity engendered by taboos rather than science' (199).

Lucy will have a simulated brain, but what is the status of this brain and could it really give rise to anything which might truly be called imagination or even consciousness? Steve Grand summarises his claim as follows:

> A raw computer simulation of a phenomenon is not an instance of that phenomenon, no matter how much it looks like it (an algorithm directly simulating the motion of a particle does not itself have mass and inertia). However, a metaphenomenon built from such simulated building blocks is fundamentally indistinguishable from the same metaphenomenon built from, so-called 'real' building blocks – they occupy different universes, but are equivalent.
>
> (Grand 1997b: 17)

Allowing for the moment that the brain is a persistent stable phenomenon then it follows that a simulated brain is not a brain (or an instance of a brain), but the metaphenomenon of a simulated brain – or the way in which that brain behaves – may be the same (if the simulation is sufficiently complex) as the metaphenomenon of a 'real' brain – or the way in which the 'real' brain behaves. So if consciousness emerges from real brains it can emerge from computer simulated ones (so denying the distinction between natural and artifical [meta] phenomena). Does this mean that computers are, or can be, conscious or alive? Grand's answer is 'no', but the things built inside them can be: 'I conclude, therefore, that a computer cannot be alive or conscious, nor indeed can a computer program. On the other hand, things built inside computer programs can' (1997b: 17). Mary Midgley (1999) concludes *From Brains to Consciousness?* (S. Rose 1999a) by situating this sensitive concept – 'a term used to indicate the centre of the subjective aspect of life' – within the science wars and her own argument for ontological unity and epistemological diversity (Midgley 1999: 249). While there is a place for causal, physical explanations of consciousness, science also searches for the connection between cause and effect and 'if this can be found at all in the case of consciousness – which is still not clear – the search for it must certainly involve reference to a much wider context which takes both aspects seriously as a whole' (250). This more rounded approach runs counter to scientific specialisation and incorporates biosocial aspects of life itself.

Notes

1 The analysis offered here implicitly rejects interdisciplinary models of new media effects, especially as they have been applied to video and computer games. These models are derived from behavioural psychology (Griffiths 1991) and communications research (Solomon 1990) and have been debated and interrogated within media and cultural studies over a number of years (Morley 1995; Barker and Petley 1997).

2 A clear case in point here is the James Bulger case in which the murder of 2-year-old James by two 10-year-olds – Robert Thompson and Jon Venables – was predicated in the effects debate not simply on their age but on socio-economic factors of class within 'dysfunctional' families (Kember 1997; Blackman and Walkerdine 2001). Against this form of othering, Blake Morrison approaches the case 'as if' the children concerned were him/his (Morrison 1997; Kember 1998).

3 Characteristic of what Haraway (1991a) terms the 'god-trick' of disembodied knowledge.

4 There is a spin-off game, *Sims*, involving human figures.

5 This is interesting due to the fact that all creatures in *Tierra* are either 'mothers' or 'daughters' and so reproduction is asexual.

6 There have, however, been subsequent artists' impressions and a promotional video which represents Ray's creatures as animal-like figures (Hayles 1999a).

7 See Eugene Provenzo (1991) *Video Kids: Making Sense of Nintendo*, and findings of CANT (Children and New Technologies) project in Kember (1997) 'Children and Computer Games'. This was a pilot study of the relation between children and computer games which aimed to critically explore the concept of addiction and to question the resumption of a simplistic media effects model in the debate on children and computer games. The project took place in 1995 (supported by a grant from Goldsmiths College Research Fund) and was undertaken in collaboration with Valerie Walkerdine. A group of ten boys and girls aged 10 or 11 were interviewed, as were their parents, and the children were observed playing the games. Socio-economic backgrounds were varied. The project found that the children's favourite games were platformers and beat'em'ups: *Sonic, Streetfighter, Super Mario Brothers* and *Mortal Kombat*. Children and parents defined addiction in three ways: not being able to stop playing/playing too much; total immersion in the game and acting out elements or sequences from the games (notably the violent sequences). Although these definitions did not adequately describe the activities of any of the children studied, both the children and their parents believed that others were addicted. For boys, these others were often younger boys. For girls, the others were boys. Perhaps most significantly, for middle class parents, the others were working class children and families.

8 See Steven Rose on methodological reductionism (Chapter 2). Rose argues that reductionist methodology simplifies and facilitates the generation of seemingly linear chains of cause and effect. It has provided 'unrivalled insights' into the mechanisms of the universe 'because it often seems to work, at least for relatively simple systems' (1997: 78).

9 A simple text parser is attached to the creatures. Nouns are passed to the attention directory lobe of the brain and verbs are passed to the episodic memory and action selection lobes.

10 *Creatures* refers to both the original and second version unless either is specified.

11 The concept of technoscience is a theoretical and strategic attempt to undermine this division which CyberLife reinforces with the splitting of the company into CyberLife Technology and CyberLife Research Ltd in 1999. For Donna Haraway: 'Technoscience extravagantly exceeds the distinction between science and technology as well as those between nature and society, subjects and objects, and the natural and the artifactual that structured the imaginary time called modernity' (1997: 3).

12
> The metaphor of the *toy* rather than *game* is intended to highlight a different style of interaction: A game is usually played in one (extended) session, until an 'end condition' or 'goal state' is reached ..., in contrast, use of a toy does not imply a score or an aim to achieve some end condition, and interaction with a toy is a more creative, ongoing, open-ended experience.
>
> (Cliff and Grand 1999: 82)

13 This is the narrative of the original *Creatures* 'toy'.

14 Grand points out that in his original mythology the Shee evoked the folk memory of an ancient and unwarlike Neolithic race in Ireland. The colonial narrative was later introduced by Toby Simpson and the oriental artwork supplied by art director Mark Rafter.

15 Feminist debates on the monitoring, regulation and control of pregnancy and childbirth are well established. Treichler and Stabile point out that visual technologies isolate the foetus and eliminate the mother's body from view. The birth process is then figured as an interaction between the doctor and the foetus (Treichler and Cartwright 1992; Stabile 1998).

16 Grand adds:

> It's worth remembering that these more direct means of meddling with creatures were added in C2, based on feedback from the *users*. Originally there were no means of direct genetic control, and I only let the users have my own gene-building tools when it became clear that this was what they intended to do, with or without my help.

17 This is clear from the survey of user groups and CyberLife's estimate of the user base (taken from their own survey) was 40 per cent female and 60 per cent male. There were no apparent patterns of gendered use, partly due to the prescriptive narrative framework and the non-negotiable rules of the game. The responses for and against norn abuse were not clearly gendered.

18 Aspects of identity such as race, gender and sexuality are, however, significant in the re-figuration of ALife politics and epistemology (see Chapters 3 and 7).

19 HAL is the intelligent computer in Kubrick's film *2001*. See Grand's (1999) 'The Year 2001 Bug: Whatever Happened to HAL?' and Chapters 1, 5 and 7 here.

20 Saunders (2000) gives an account of the distinction between routine, innovative and creative design: 'Creative design goes beyond innovative design by requiring the extension of the state space [the space of possible designs] with the addition of new knowledge'. Several operators can introduce new knowledge into a design process and these include: combination, mutation, analogy and emergence. Emergence is of particular interest to Saunders in his account of CyberLife.

21 Note that artificial pilots lie at the astro-military origins of cyborg technology. In as far as ALife is not completely synonymous with the cyborgian technologies of AI/cybernetics, then similar figures may now be characterised as being post-cyborgian.

22 CRL is currently not funded directly, but supported by media publicity and various forms of publication.

23 Natalie Jeremijenko introduced me to the concept of real ALife in her paper 'Cyber-feminist Design: a review of the sensors used to trigger interaction with explosives' (ESRC Seminar Series, Equal Opportunities On-Line: The Impact of Gender Relations on the Design and Use of Information and Communication Technologies, Seminar 3, Cyberfeminism: Issues in Theory and Design) given at the University of Surrey, UK, 16 May 2000. Jeremijenko's real ALife project is 'One Tree', a cloned tree planted in various locations around the San Francisco Bay area and engineered to embody differences in environment and community. A companion CD-ROM is concerned with e-clones and incorporates a CO_2 feeder from the computer's immediate environment which influences the development of the trees.

24 Grand (1997b) discusses the distinction between matter/stuff and stable configurations/persistent phenomena. The obvious and startling basis of the distinction is that matter flows from place to place and 'momentarily' comes together to form a living being.

25 A position popularised in 2000 by Susan Greenfield in her BBC2 television series on the brain. See also Greenfield's 'How Might the Brain Generate Consciousness?' in S. Rose (ed.) (1999a) *From Brains to Consciousness? Essays on the New Sciences of the Mind*.

Bibliography

Aleksander, I. (1999) 'A Neurocomputational View of Consciousness', in S. Rose (ed.) *From Brains to Consciousness? Essays on the New Sciences of the Mind*, London: Penguin Books.

Barker, M. and Petley, J. (eds) (1997) *Ill Effects: the Media/Violence Debate*, London and New York: Routledge.

Blackman, L. and Walkerdine, V. (2001) *Mass Hysteria. Critical Psychology and Media Studies*, Basingstoke and New York: Palgrave.

Bremer, M. (1992) *SimLife. The Genetic Playground*, User's Manual, Orinda, CA: Maxis Inc.

Bremer, M. and Ellis, C. (1993) *SimCity. The Original City Simulator*, User's Manual, Orinda, CA: Maxis Inc.

Buckingham, D. (1997) 'Electronic Child Abuse? Rethinking the Media's Effects on Children', in M. Barker and J. Petley (eds) *Ill Effects: The Media/Violence Debate*, London and New York: Routledge.

Buckingham, D. (2000) *After the Death of Childhood: Growing up in the Age of Electronic Media*, Cambridge: Polity Press.

Cliff, D. and Grand, S. (1999) 'The *Creatures* Global Digital Ecosystem', *Artificial Life*, 5(1): 77–93.

CyberLife (1997) *Creatures*, ECAL 1997 flyer.

CyberLife Research (2000) *The CyberLife Mission: Welcome to Eden*, http://www. cyberlife-research. com/company/mission/index.htm.

Davidson, C. (1998) 'Agents from Albia', *New Scientist*, 158(2133): 38–44.

De Landa, M. (1994) 'Virtual Environments and Synthetic Reason', in M. Dery (ed.) *Flame Wars. The Discourse of Cyberculture*, Durham, NC and London: Duke University Press.

Epstein, Joshua M. and Axtell, Robert (1996) *Growing Artificial Societies. Social Science from the Bottom Up*, Washington, DC: Brookings Institution Press and Cambridge, MA: MIT Press.

Grand, S. (1997a) 'Creatures: An Exercise in Creation', *IEEE Intelligent Systems and their Applications*, IEEE Computer Society Publications, July/August.

Grand, S. (1997b) 'Three Observations that Changed my Life', *IEEE Intelligent Systems and their Applications*, IEEE Computer Society Publications, November/December.

Grand, S. (1998a) 'Battling with GA-Joe', *IEEE Intelligent Systems and their Applications*, IEEE Computer Society Publications, March/April.

Grand, S. (1998b) 'Curiosity Created the Cat', *IEEE Intelligent Systems and their Applications*, IEEE Computer Society Publications, May/June.

Grand, S. (1998c) 'Of Mountains and Molehills', *IEEE Intelligent Systems and their Applications*, IEEE Computer Society Publications, November/December.

Grand, S. (1999a) 'The Year 2001 Bug: Whatever Happened to HAL?', *IEEE Intelligent Systems and their Applications*, IEEE Computer Society Publications, January/February.

Grand, S. (1999b) 'Where Newton Went Wrong', *Guardian Online*, 1 October.

Griffiths, M. (1991) 'A Comparative Analysis of Video Games and Fruit Machines', *Journal of Adolescence*, 14: 53–73.

Haraway, Donna J. (1991a) *Simians, Cyborgs and Women*, London: Free Association Books.

Haraway, Donna J. (1997) Modest_Witness@Second_Millennium.FemaleMan©_Meets_OncoMouse™, London: Routledge.

Hayles, N. Katherine (1999a) *How We Became Posthuman. Virtual Bodies in Cybernetics, Literature and Informatics*, Chicago, IL and London: University of Chicago Press.

Helmreich, S. (1998a) *Silicon Second Nature. Culturing Artificial Life in a Digital World*, Berkeley, CA: University of California Press.

Henriques, J., Holloway, W., Urwin, C., Venn, C. and Walkerdine, W. (1998) *Changing the Subject. Psychology, Social Regulation and Subjectivity*, London and New York: Routledge.

Keepers, G.A. (1990) 'Pathological Preoccupation with Video Games', *Journal of the American Academy of Child and Adolescent Psychiatry*, 29(1): 49–50.

Kelly, K. (1994) *Out of Control. The New Biology of Machines*, London: Fourth Estate.

Kember, S. (1997) 'Children and Computer Games', paper presented at Institute of Education, London, June.

Kember, S. (1998) *Virtual Anxiety. Photography, New Technologies and Subjectivity*, Manchester: Manchester University Press.

Kinder, M. (1991) *Playing with Power in Movies, Television and Video Games: from Muppet Babies to Teenage Mutant Ninja Turtles*, Berkeley, CA: University of California Press.

Langton, C. (1996 [1989]) 'Artificial Life', in M.A. Boden (ed.) *The Philosophy of Artificial Life*, Oxford: Oxford University Press.

Maxis Inc. (1995, 1997) *SimEarth: The Living Planet*, CD-ROM, Orinda, CA: Maxis Inc.

Midgley, M. (1999) 'One World, but a Big One', in S. Rose (ed.) *From Brains to Consciousness? Essays on the New Sciences of the Mind*, London: Penguin Books.

Morley, D. (1995) 'Theories of Consumption in Media Studies', in D. Miller (ed.) *Acknowledging Consumption*, London: Routledge.

Morrison, B. (1997) *As If*, London: Granta.

Murray, I. (1980) 'Introduction', *Oscar Wilde. Plays, Prose Writings and Poems*, London and Toronto: Dent.

Panelas, T. (1983) 'Consumption of Leisure and the Social Construction of the Peer Group', *Youth and Society*, 15(1): 51–65.

Penrose, R. (1999) 'Can a Computer Understand?', in S. Rose (ed.) *From Brains to Consciousness? Essays on the New Sciences of the Mind*, London: Penguin Books.

Plant, S. (1996) 'The Virtual Complexity of Culture', in G. Robertson, M. Mash, L. Tickner, J. Bird, B. Curtis and T. Putnam (eds) *FutureNatural. Nature, Science, Culture*, New York and London: Routledge.

Provenzo, E.F. (1991) *Video Kids: Making Sense of Nintendo*, Cambridge, MA: Harvard University Press.

Ray, T. and Virtual Life (1998) 'Documentation for the Tierra Simulator', *Tierra.doc* 17–3–98, Tierra Simulator V4:2.

Rose, N. (1999) *Governing the Soul. The Shaping of the Private Self*, London and New York: Free Association Books.

Rose, N. (2001) 'The Politics of Life Itself', *Theory, Culture and Society*, 18(6): 1–30.

Rose, S. (1997) *Lifelines. Biology, Freedom, Determinism*, London: Allen Lane.

Rose, S. (ed.) (1999a) *From Brains to Consciousness? Essays on the New Sciences of the Mind*, London: Penguin Books.

Rose, S. (1999b) 'Brains, Minds and the World', in S. Rose (ed.) *From Brains to Consciousness? Essays on the New Sciences of the Mind*, London: Penguin Books.

Ross, A. (1991) *Strange Weather. Culture, Science and Technology in the Age of Limits*, London: Verso.

Saunders, R. (2000) 'CyberLife: A Possible Architecture for Complex Design Computing Solutions', http://www.arch.usyd.edu.au/~rob/study/CyberLife.html.

Sefton-Greene, J. (ed.) (1998) *Digital Diversions: Youth Culture in the Age of Multimedia*, London: UCL Press.

Simpson, T. (1998) *Creatures 2. Strategies and Secrets*, Cambridge: CyberLife and Alameda, CA: Sybex Inc.

Solomon, G. (1990) 'Cognitive Effects with and of Computer Technology', *Communications*, 17(1): 26–44.

Stabile, C. (1998) 'Fetal Photography and the Politics of Disappearance', in P.A. Treichler, L. Cartwright and C. Penley (eds) *The Visible Woman. Imaging Technologies, Gender, and Science*, New York and London: New York University Press.

Terranova, T. (2000) 'Free Labour. Producing Culture for the Digital Economy', *Social Text 63*, 18(2): 33–58.

Treichler, P. and Cartwright, L. (eds) (1992) *Camera Obscura. Imaging Technologies, Inscribing Science*, 28 and *Camera Obscura. Imaging Technologies, Inscribing Science 2*, 29.

Turkle, S. (1984) *The Second Self. Computers and the Human Spirit*, New York: Simon and Schuster.

Velmans, M. (2000) *Understanding Consciousness*, London and Philadelphia, PA: Routledge.

Sherry Turkle

CYBORG BABIES AND CY-DOUGH-PLASM
Ideas about self and life in the culture of simulation

THE GENIUS OF JEAN PIAGET (1960) SHOWED US the degree to which it is the business of childhood to take the objects in the world and use how they "work" to construct theories—of space, time, number, causality, life, and mind. Fifty years ago, when Piaget was formulating his theories, a child's world was full of things that could be understood in simple, mechanical ways. A bicycle could be understood in terms of its pedals and gears, a wind-up car in terms of its clockwork springs. Children were able to take electronic devices such as basic radios and (with some difficulty) bring them into this "mechanical" system of understanding. Since the end of the 1970s, however, with the introduction of electronic toys and games, the nature of objects and how children understand them have changed. When children today remove the back of their computer toys to "see" how they work, they find a chip, a battery, and some wires. Sensing that trying to understand these objects "physically" will lead to a dead end, children try to use a "psychological" kind of understanding (Turkle 1984: 29–63). Children ask themselves if the games are conscious, if the games know, if they have feelings, and even if they "cheat." Earlier objects encouraged children to think in terms of a distinction between the world of psychology and the world of machines, but the computer does not. Its "opacity" encourages children to see computational objects as psychological machines.

Over the last twenty years I have observed and interviewed hundreds of children as they have interacted with a wide range of computational objects, from computer programs on the screen to robots off the screen (Turkle 1984, 1995). My methods are ethnographic and clinical. In the late 1970s and early 1980s, I began by observing children playing with the first generation of electronic toys and games. In the 1990s, I have worked with children using a new generation of computer games and software and experimenting with on-line life on the Internet.

Among the first generation of computational objects was Merlin, which challenged children to games of tic-tac-toe. For children who had only played games with human opponents, reaction to this object was intense. For example, while Merlin followed an optimal strategy for winning tic-tac-toe most of the time, it was programmed to make a

slip every once in a while. So when children discovered a strategy that would sometimes allow them to win, and then tried it again, it usually didn't work. The machine gave the impression of not being "dumb enough" to let down its defenses twice. Robert, seven, playing with his friends on the beach, watched his friend Craig perform the "winning trick," but when he tried it, Merlin did not make its slip and the game ended in a draw. Robert, confused and frustrated, accused Merlin of being a "cheating machine." Children were used to machines being predictable. But this machine surprised.

Robert threw Merlin into the sand in anger and frustration. "Cheater. I hope your brains break." He was overheard by Craig and Greg, aged six and eight, who salvaged the by-now-very-sandy toy and took it upon themselves to set Robert straight. Craig offered the opinion that "Merlin doesn't know if it cheats. It won't know if it breaks. It doesn't know if you break it, Robert. It's not alive." Greg adds: "It's smart enough to make the right kinds of noises. But it doesn't really know if it loses. That's how you can cheat it. It doesn't know you are cheating. And when it cheats, it doesn't even know it's cheating." Jenny, six, interrupted with disdain: "Greg, to cheat you have to know you are cheating. Knowing is part of cheating."

In the early 1980s, such scenes were not unusual. Confronted with objects that spoke, strategized, and "won," children were led to argue the moral and metaphysical status of machines on the basis of their psychologies: Did the machines know what they were doing? Did they have intentions, consciousness, and feelings? These first computers that entered children's lives were evocative objects: they became the occasion for new formulations about the human and the mechanical. For despite Jenny's objections that "knowing is part of cheating," children did come to see computational objects as exhibiting a kind of knowing. She was part of a first generation of children who were willing to invest machines with qualities of consciousness as they rethought the question of what is alive in the context of "machines that think."

In the past twenty years, the objects of children's lives have come to include machines of even greater intelligence, toys and games and programs that make these first cybertoys seem primitive in their ambitions. The answers to the classical Piagetian question of how children think about life are being renegotiated as they are posed in the context of computational objects that explicitly present themselves as exemplars of "artificial life."

1. From physics to psychology

Piaget, studying children in the world of "traditional"—that is, non-computational—objects, found that as children matured, they homed in on a definition of life which centered around "moving of one's own accord." First, everything that moved was taken to be alive, then only things that moved without an outside push or pull. Gradually, children refined the notion of "moving of one's own accord" to mean the "life motions" of breathing and metabolism. This meant that only those things that breathed and grew were taken to be alive. But from the first generation of children who met computers and electronic toys and games (the children of the late 1970s and early 1980s), there was a disruption in this classical story. Whether or not children thought their computers were alive, they were sure that how the toys moved was not at the heart of the matter. Children's discussions about the computer's aliveness came to center on what the children perceived as the computer's psychological rather than physical properties. To put it too simply, motion gave way to emotion and physics gave way to psychology as criteria for aliveness.

Today, only a decade later, children have learned to say that their computers are "just machines," but they continue to attribute psychological properties to them. The computational objects are said to have qualities (such as having intentions and ideas) that were previously reserved for people. Thus today's children seem comfortable with a reconstruction of the notion of "machine" which includes having a psychology. And children often use the phrase "sort of alive" to describe the computer's nature.

An eleven-year-old named Holly watches a group of robots navigate a maze. The robots use different strategies to reach their goal, and Holly is moved to comment on their "personalities" and their "cuteness." She finally comes to speculate on the robots' "aliveness" and blurts out an unexpected formulation: "It's like Pinocchio."

> First Pinocchio was just a puppet. He was not alive at all. Then he was an alive puppet. Then he was an alive boy. A real boy. But he was alive even before he was a real boy. So I think the robots are like that. They are alive like Pinocchio [the puppet], but not "real boys."

She sums up her thought: "They [the robots] are sort of alive."

In September 1987, more than one hundred scientists and technical researchers gathered together in Los Alamos, New Mexico, to found a discipline devoted to working on machines that might cross the boundary between "sort of" to "really" alive. They called their new enterprise "artificial life." From the outset, many of artificial life's pioneers developed their ideas by writing programs on their personal computers. These programs, easily shipped off on floppy disks or shared via the Internet, have revolutionized the social diffusion of ideas. Christopher Langton (1989:13), one of the founders of the discipline of artificial life, argued that biological evolution relies on unanticipated bottom-up effects: simple rules interacting to give rise to complex behavior. He further argued that artificial life would only be successful if it shared this aesthetic of "emergent effects" with nature.

The cornerstone idea of decentralized, bottom-up emergence is well illustrated by a program written in the mid-1980s known as "boids." Its author, the computer animator Craig Reynolds, wanted to explore whether flocking behavior, whether in fish, birds, or insects, might happen without a flock leader or the intention to flock. Reynolds wrote a computer program that caused virtual birds to flock, in which each "bird" acted "solely on the basis of its local perception of the world" (1987: 27). Reynolds called the digital birds "boids," an extension of high-tech jargon that refers to generalized objects by adding the suffix "oid." A boid could be any flocking creature. Each "boid" was given three simple rules: (1) if you are too close to a neighboring boid, move away from it; (2) if not as fast as your neighboring boid, speed up; if not as slow as your neighboring boid, slow down; (3) if you are moving toward the greater density of boids, maintain direction; if not, do so. The rules working together created flocks of boids that could fly around obstacles and change direction. The boids program posed the evocative question: How could it be established that the behavior produced by the boids (behavior to which it was easy to attribute intentionality and leadership) was different from behavior in the natural world? Were animals following simple rules that led to their complex "lifelike" behavior. Were *people* following simple rules that led to *their* complex "lifelike" behavior?

In writing about the dissemination of ideas about microbes and the bacterial theory of disease in late-nineteenth-century France, the sociologist of science Bruno Latour (1988) argued that the message of Louis Pasteur's writings was less significant than the social deployment of an army of "hygienists," state employees who visited every French farm to spread the word. The hygienists were the "foot soldiers" of Pasteur's revolution. In the case of artificial life the foot soldiers are "shippable" products in the form of computer

programs, commercial computer games, and small robots, some of which are sold as toys. I do not argue that these products *are* artificial life, but that they are significant actors for provoking a new discourse about aliveness. Electronic toys and games introduced psychology into children's categories for talking about the "quality of life"; a new generation of computational objects is introducing ideas about decentralization and emergence.

2. "Alive" on the screen

In the mid-1980s, the biologist Thomas Ray set out to create a computer world in which self-replicating digital creatures could evolve by themselves. Ray imagined that the motor for the evolution of the artificial organisms would be their competition for CPU (central processing unit) time. The less CPU time that a digital organism needed to replicate, the more "fit" it would be in its "natural" computer environment. Ray called his system Tierra, the Spanish word for "Earth."

In January 1990, Ray wrote the computer program for his first digital creature. It consisted of eighty instructions. It evolved progeny which could replicate with even fewer instructions. This meant that these progeny were "fitter" than their ancestor because they could compete better in an environment where computer memory was scarce. Further evolution produced ever smaller self-replicating creatures, digital "parasites" that passed on their genetic material by latching onto larger digital organisms. When some host organisms developed immunity to the first generation of parasites, new kinds of parasites were born. For Ray, a system that self-replicates and is capable of open-ended evolution is alive. From this point of view, Ray believed that Tierra, running on his Toshiba laptop computer, was indeed alive.

Ray made Tierra available on the Internet, ready for "downloading" via modem. And it was downloaded all over the world, often to school science clubs and biology classes. A fifteen-year-old high school student said that working with Tierra made him feel as though he were "looking at cells through an electron microscope. I know that it is all happening in the computer, but I have to keep reminding myself." Tierra was an object-to-think-with for considering self-replication and evolution as essential to life. "You set it up and you let it go. And a whole world starts," said the student. "I have to keep reminding myself that it isn't going to jump out of the machine. ... I dreamt that I would find little animals in there. Two times I ran it at night, but it's not such a great idea because I couldn't really sleep."

Ray could not predict the developments that would take place in his system. He too stayed up all night, watching new processes evolve. The lifelike behavior of his digital Tierrans emerged from the "bottom up." At MIT's Media Laboratory, the computer scientist and educational researcher Mitchel Resnick worked to bring the artificial life aesthetic into the world of children. He began by giving them a robot construction kit that included sensors and motors as well as standard Lego blocks. Children quickly attributed lifelike properties to their creations. Children experienced one little robot as "confused" because it moved back and forth between two points (because of rules that both told it to seek out objects and to move away quickly if it sensed an object). Children classified other robots as nervous, frightened, and sad. The first Lego-Logo robots were tethered by cables to a "mother" computer, but eventually researchers were able to give the robots an "onboard" computer. The resulting autonomy made the Lego-Logo creations seem far less like machines and far more like creatures. For the children who worked with them, this autonomy further suggested that machines might be creatures and creatures might be machines.

Resnick also developed programming languages, among these a language he called StarLogo that would enable children to control the parallel actions of many hundreds of "creatures" on a computer screen. Traditional computer programs follow one instruction at a time; with Resnick's StarLogo program, multiple instructions were followed at the same time, simulating the way things occur in nature. And as in nature, simple rules led to complex behaviors. For example, a population of screen "termites" in an environment of digital "woodchips" were given a set of two rules: if you're not carrying anything and you bump into a woodchip, pick it up; if you're carrying a woodchip and you bump into another woodchip, put down the chip you're carrying. Imposing these two rules at the same time will cause the screen termites to make woodchip piles (Resnick 1992: 76). So children were able to get the termites to stockpile woodchips *without ever giving the termites a command to do so*. Similarly, children could use StarLogo to model birds in a flock, ants in a colony, cars in a traffic jam—all situations in which complex behavior emerges from the interaction of simple rules. Children who worked with these materials struggled to describe the quality of emergence that their objects carried. "In this version of Logo," said one, "you can get more [out of the program] than what you tell it to do" (Resnick 1992: 131–2).

An object such as StarLogo opens up more than new technical possibilities: it gives children concrete material for thinking in what Resnick has termed a "decentralized mindset." The key principle here is self-organization—complexity results although there is no top-down intervention or control. In a centralized model of evolution, God designs the process, sets it in motion, and keeps close tabs to make sure it conforms to design. In a decentralized model, God can be there, but in the details: simple rules whose interactions result in the complexity of nature.

StarLogo teaches how decentralized rules can be the foundation for behavior that may appear to be "intentional" or a result of "following the leader." It also provides a window onto resistance to decentralized thinking. When confronted with the woodchip piles, Resnick reports that most adults prefer to assume that a leader stepped in to direct the process or that there was an asymmetry in the world that gave rise to a pattern, for example, a food source near the final location of a stockpile (Resnick, *Turtles, Termites, and Traffic Jams:* 137ff). In reflecting on this resistance to ideas about decentralization, Resnick (1992: 122) cites the historian of science Evelyn Fox Keller who, in reviewing the history of resistance to decentralized ideas in biology, was led to comment: "We risk imposing on nature the very stories we like to hear."

Why do we like to hear centralized stories? There is our Western monotheistic tradition; there is our experience over millenia of large-scale societies governed by centralized authority and controlled through centralized bureaucracy; there is our experience of ourselves as unitary and intentional actors (the ego as "I"); and there is also the fact that we have traditionally lacked concrete objects in the world with which to think about decentralization. Objects such as StarLogo present themselves as objects to think with for thinking about emergent phenomena and decentralized control. As a wider range of such objects enter our culture, the balance between our tendency to assume decentralized emergence or centralized command may change. The children who tinkered with parallel computation became comfortable with the idea of multiple processes and decentralized methods. Indeed, they came to enjoy this "quality of emergence" and began to associate it with the quality of aliveness.

The idea that the whole is greater than the sum of its parts has always been resonant with religious and spiritual meaning. Decentered, emergent phenomena combine a feeling that one knows the rules with the knowledge that one cannot predict the outcome. To children, emergent phenomena seem almost magical because one can know what every

individual object will do but still have no idea of what the system as a whole will look like. This is the feeling that the children were expressing when they described getting "more out" of the StarLogo program than they told it to do. The children know that there are rules behind the magic and that there is magic in the rules. In a cyborg consciousness, objects are re-enchanted.

When children programming in StarLogo got a group of objects on the screen to clump together in predictable groups by commanding them to do so, they did not consider this "interesting" in the sense that it did not seem "lifelike." But if they gave the objects simple rules that had no obvious relation to clumping behavior but clumping "happened" all the same, that behavior did seem lifelike. So, for children working in the StarLogo learning culture, "teaching" computer birds to flock by explicitly telling them where to go in every circumstance seemed to be a kind of "cheating." They were developing an "ethic of simulation" in which decentralization and emergence became requirements for things to seem "alive enough" to be interesting.

In this example, computational media show their potential to generate new ways of thinking. Just as children exposed to electronic toys and games begin to think differently about the definition of aliveness (thinking in terms of psychology rather than physical motion), so children exposed to parallel processing begin to think about life in terms of emergent phenomena.

3. The "Sims"

The authors of the "Sim" series of computer games (among these SimAnt, SimCity, SimHealth, SimLife) write explicitly of their effort to use the games to communicate ideas about artificial life (Bremer 1991: 163). For example, in the most basic game of SimAnt (played on one "patch" of a simulated backyard), a player learns about local bottom-up determination of behavior: each ant's behavior is determined by its own state, its assay of its direct neighbors, and a set of rules. Like Reynolds's "boids" and the objects in StarLogo, the ants change their state in reference to who they are and with whom they are in contact. SimAnt players learn about pheremones, the virtual tracer chemicals by which ants, as well as Resnick's StarLogo objects, "communicate" with one another. Beyond this, SimAnt players learn how in certain circumstances, local actions that seem benign (mating a few ants) can lead to disastrous global results (population overcrowding and death). Children playing Sim games make a connection between the individual games and some larger set of ideas. Tim, a thirteen-year-old player, says of SimLife: "You get to mutate plants and animals into different species. … You are part of something important. You are part of artificial life." As for the Sim creatures themselves, Tim thinks that the "animals that grow in the computer could be alive," although he adds, "This is kind of spooky."

Laurence, a more blasé fifteen-year-old, doesn't think the idea of life on the screen is spooky at all. "The *whole point* of this game," he tells me,

> is to show that you could get things that are alive in the computer. We get energy from the sun. The organisms in a computer get energy from the plug in the wall. I know that more people will agree with me when they make a SimLife where the creatures are smart enough to communicate. You are not going to feel comfortable if a creature that can talk to you goes extinct.

Robbie, a ten-year-old who has been given a modem for her birthday, uses her experience of the game to develop some insight into those computer processes that led adults to use

the term "virus" for programs that "traveled." She puts the emphasis on mobility instead of communication when she considers whether the creatures she has evolved on SimLife are alive.

> I think they are a little alive in the game, but you can turn it off and you cannot "save" your game, so that all the creatures you have evolved go away. But if they could figure out how to get rid of that part of the program so that you would *have* to save the game and if your modem were on, then they could get out of your computer and go to America Online.

Sean, thirteen, who has never used a modem, comes up with a variant on Robbie's ideas about SimLife creatures and their Internet travel: "The [Sim] creatures could be more alive if they could get into DOS."

In Piaget's classical studies of the 1920s on how children thought about what was alive, the central variable was motion. Simply put, children took up the question of an object's "life status" by asking themselves if the object could move of its own accord. When in the late 1970s and early 1980s I studied children's reactions to a first generation of computer objects which were physically "stationary" but which nonetheless accomplished impressive feats of cognition (talking, spelling, doing math, and playing tic-tac-toe), I found that the focus had shifted to an object's psychological properties when children considered the question of its "aliveness." Now, in children's comments about the creatures that exist on simulation games, the emphasis is on evolution. But this emphasis also includes a recapitulation of criteria that draw from physics and psychology. Children talk about digital "travel" via circulating disks or over modems. They talk of viruses and networks. In this, language, biology and motion are resurfacing in a new guise, now bound up in the ideas of communication and evolution. Significantly, the resurfacing of motion (Piaget's classical criterion) is bound up with notions of presumed psychology: children were most likely to assume that the creatures on Sim games have a desire to "get out" of the system and evolve in a wider computational world.

4. "Cycling through"

Although the presence of computational objects disrupted the classical Piagetian story for talking about aliveness, the story children were telling about computational objects in the early 1980s had its own coherency. Faced with intelligent toys, children took a new world of objects and imposed a new world order, based not on physics but on psychology. In the 1990s, that order has been strained to the breaking point. Children will now talk about computers as "just machines" but describe them as sentient and intentional. Faced with ever-more-complex computational objects, children are now in the position of theoretical *bricoleurs*, or tinkerers, "making do" with whatever materials are at hand, "making do" with whatever theory can fit a prevailing circumstance. They cycle through evolution and psychology and resurface ideas about motion in terms of the communication of bits.

My current collection of comments about life by children who have played with small mobile robots, the games of the "Sim" series, and Tierra includes the following notions: the robots are in control but not alive, would be alive if they had bodies, are alive because they have bodies, would be alive if they had feelings, are alive the way insects are alive but not the way people are alive; the Tierrans are not alive because they are just in the computer, could be alive if they got out of the computer, are alive until you turn off the computer and then they're dead, are not alive because nothing in the computer is real;

the Sim creatures are not alive but almost-alive, they would be alive if they spoke, they would be alive if they traveled, they're alive but not "real," they're not alive because they don't have bodies, they are alive because they can have babies, and, finally, for an eleven-year-old who is relatively new to SimLife, they're not alive because these babies don't have parents. She says: "They show the creatures and the game tells you that they have mothers and fathers but I don't believe it. It's just numbers, it's not really a mother and a father." There is a striking heterogeneity of theory here. Different children hold different theories, and individual children are able to hold different theories at the same time.

The heterogeneity of children's views is apparent when they talk about something as "big" as the life of a computational creature and about something as "small" as why a robot programmed with "emergent" methods might move in a certain way. One fifth-grader named Sara jumped back and forth from a psychological to a mechanical language when she talked about the Lego-Logo creature she had built. When Sara considered whether her machine would sound a signal when its "touch sensor" was pushed, she said: "It depends on whether the machine wants to tell ... if we want the machine to tell us ... if we tell the machine to tell us" (Resnick 1989: 402). In other words, within a few seconds, Sara "cycled through" three perspectives on her creature (as psychological being, as intentional self, as instrument of its programmer's intentions). The speed of her alternations suggests that these perspectives are equally present for her at all times. For some purposes, she finds one or another of them more useful.

In the short history of how the computer has changed the way we think, it has often been children who have led the way. For example, in the early 1980s, children—prompted by computer toys that spoke, did math, and played tic-tac-toe—disassociated ideas about consciousness from ideas about life, something that historically had not been the case. These children were able to contemplate sentient computers that were not alive, a position that grownups are only now beginning to find comfortable. Today's cyborg children are taking things even further; they are pointing the way toward a radical heterogeneity of theory in the presence of computational artifacts that evoke "life." In his history of artificial life, Steven Levy (1992: 6–7) suggested that one way to look at where artificial life can "fit in" to our way of thinking about life is to envisage a continuum in which Tierra, for example, would be more alive than a car but less alive than a bacterium. My observations suggest that children are not constructing hierarchies but are heading toward parallel, alternating definitions.

The development of heterogeneity in children's theories is of course taking place in a larger context. We are all living in the presence of computational objects that carry emergent, decentralized theories and encourage a view of the self as fluid and multiple. Writers from many different disciplinary perspectives are arguing for a multiple and fluid notion of the self. Daniel C. Dennett (1991) argues for a "multiple drafts" theory of consciousness. The presence of the drafts encourages a respect for the many different versions, and it imposes a certain distance from being identified with any one of them. No one aspect of self can be claimed as the absolute, true self. Robert Jay Lifton (1993) views the contemporary self as "protean," multiple yet integrated, allowing for a "sense of self" without being *one* self. Donna Haraway equates a "split and contradictory self" with a "knowing self": "The knowing self is partial in all its guises, never finished, whole, simply there and original; it is always constructed and stitched together imperfectly; and therefore able to join with another, to see together without claiming to be another" (1991a: 22). In computational environments, such ideas about identity and multiplicity are "brought down to earth" and enter children's lives from their earliest days. Even the operating system on the computers they use to play games, to draw, and to write carries the message. A computer's "windows" have become

a potent metaphor for thinking about the self as a multiple and distributed system (Turkle 1995). Hypertext links have become a metaphor for a multiplicity of perspectives. On the Internet, people who participate in virtual communities may be "logged on" to several of them (open as several open-screen windows) as they pursue other activities. In this way, they may come to experience their lives as a "cycling through" screen worlds in which they may be expressing different aspects of self. But such media-borne messages about multiple selves and theories are controversial.

Today's adults grew up in a psychological culture that equated the idea of a unitary self with psychological health and in a scientific culture that taught that when a discipline achieves maturity, it has a unifying theory. When adults find themselves cycling through varying perspectives on themselves ("I am my chemicals" to "I am my history" to "I am my genes"), they usually become uncomfortable (Kramer 1993: xii–xiii). But such alternations may strike the generation of cyborg children who are growing up today as "just the way things are."

Children speak easily about factors which encourage them to see the "stuff" of computers as the same "stuff" of which life is made. Among these are the ideas of "shape shifting" and "morphing." Shape shifting is the technique used by the evil android in *Terminator II* to turn into the form of anything he touched—including people. A nine-year-old showed an alchemist's sensibility when he explained how this occurs: "It is very simple. In the universe, anything can turn to anything else when you have the right formula. So you can be a person one minute and a machine the next minute." Morphing is a general term that covers form changes which may include changes across the animate/inanimate barrier. A ten-year-old boy had a lot to say about morphing, all of it associated with the lifestyle of "The Mighty Morphin' Power Rangers," a group of action heroes who turn from teenagers to androidal/mechanical "dinozords" and "megazords" and back. "Well," he patiently explains, "the dinozords are alive; the Power Rangers are alive, but not all the parts of the dinozords are alive, but all the parts of the Power Rangers are alive. The Power Rangers become the dinozords." Then, of course, there are seemingly omnipresent "transformer toys" which shift from being machines to being robots to being animals (and sometimes people). Children play with these plastic and metal objects, and in the process they learn about the fluid boundaries between mechanism and flesh.

I observe a group of seven-year-olds playing with a set of plastic transformer toys that can take the shape of armored tanks, robots, or people. The transformers can also be put into intermediate states so that a robot arm can protrude from a human form or a human leg from a mechanical tank. Two of the children are playing with the toys in these intermediate states (that is, in their intermediate states somewhere between being people, machines, and robots). A third child insists that this is not right. The toys, he says, should not be placed in hybrid states. "You should play them as all tank or all people." He is getting upset because the other two children are making a point of ignoring him. An eight-year-old girl comforts the upset child. "It's okay to play them when they are in between. It's all the same stuff," she says, "just yucky computer cy-dough-plasm." This comment is the expression of the cyborg consciousness that characterizes today's children: a tendency to see computer systems as "sort of" alive, to fluidly "cycle through" various explanatory concepts, and to willingly transgress boundaries.

Walt Whitman wrote: "A child went forth every day. And the first object he look'd upon, that object he became." When Piaget elaborated how the objects in children's lives constructed their psyches, he imagined a timeless, universal process. With the radical change in the nature of objects, the internalized lessons of the object world have changed. When today's adults "cycle through" different theories, they are uncomfortable. Such movement

does not correspond to the unitary visions they were brought up to expect. But children have learned a different lesson from their cyborg objects. Donna Haraway characterizes irony as being "about contradictions that do not resolve into larger wholes ... about the tension of holding incompatible things together because both or all are necessary and true" (1991b:148). In this sense, today's cyborg children, growing up into irony, are becoming adept at holding incompatible things together. They are cycling through the cy-dough-plasm into fluid and emergent conceptions of self and life.

References

Bremer, Michael. 1991. *SimAnt User Manual*. Orinda, CA.

Dennett, Daniel C. 1991. *Consciousness Explained*. Boston, MA: Little, Brown.

Haraway, Donna. 1991a. "The Actors Are Cyborg, Nature Is Coyote, and the Geography Is Elsewhere: Postscript to 'Cyborgs at Large.'" In *Technoculture*, edited by Constance Penley and Andrew Ross. Minneapolis, MN: University of Minnesota Press.

—— 1991b. "A Cyborg Manifesto: Science, Technology, and Socialist-Feminism in the Late Twentieth Century." In *Simians, Cyborgs, and Women: The Reinvention of Nature*. New York: Routledge.

Kramer, Peter. 1993. *Listening to Prozac: A Psychiatrist Explores Antidepressant Drugs and the Remaking of the Self*. New York: Viking.

Latour, Bruno. 1988. *The Pasteurization of France*. Translated by Alan Sheridan and John Law. Cambridge, MA: Harvard University Press.

Langton, Christopher G. 1989. "Artificial Life." In *Artificial Life: The Proceedings of an Interdisciplinary Workshop on the Synthesis and Simulation of Living Systems*, edited by Christopher G. Langton. *Santa Fe Institute Studies in the Science of Complexity*, vol. 6. Redwood City, CA: Addison-Wesley.

Levy, Steven. 1992. *Artificial Life: The Quest for a New Frontier*. New York: Pantheon.

Lifton, Robert J. 1993. *The Protean Self: Human Resilience in an Age of Fragmentation*. New York: Basic Books.

Piaget, Jean. 1960. *The Child's Conception of the World*. Translated by Joan and Andrew Tomlinson. Totowa, NJ: Littlefield, Adams.

Resnick, Mitchel. 1989. "LEGO, Logo, and Life." In *Artificial Life: The Proceedings of an Interdisciplinary Workshop on the Synthesis and Simulation of Living Systems*, edited by Christopher G. Langton. *Santa Fe Institute Studies in the Science of Complexity*, vol. 6. Redwood City, CA: Addison-Wesley.

—— 1992. *Turtles, Termites, and Traffic Jams*. Cambridge, MA: MIT Press.

Reynolds, Craig. 1987. "Flocks, Herds, and Schools. A Distributed Behavioral Model." *Computer Graphics* 21 (July), 25–34.

Turkle, Sherry. 1984. *The Second Self: Computers and the Human Spirit*. New York: Simon and Schuster.

—— 1995. *Life on the Screen: Identity in the Age of the Internet*. New York: Simon and Schuster.

N. Katherine Hayles

COMPUTING THE HUMAN

AMONG THE INTRIGUING UNWRITTEN BOOKS are those exploring the influence of the future on the present. Who wouldn't leap at the chance to review the non-existent *Influences of the Twenty-First Century on the Nineteenth?* As this imaginary book would undoubtedly testify, visions of the future, especially in technologically advanced eras, can dramatically affect present developments. Of special interest, then, is the spate of recent works projecting a future in which humans and intelligent machines become virtually indistinguishable from one another. Through such emerging technologies as neural implants, quantum computing, and nanotechnology, humans will become computationally enhanced and computers will become humanly responsive until in a mere 100 years, by Ray Kurzweil's reckoning, we can expect that both humans and computers will be so transformed as to be unrecognizable by present standards (1999: 280). Migrating their minds from one physical medium to another as convenience dictates, these future entities will become effectively immortal, manifesting themselves in forms that are impossible to categorize as either humans or machines.[1]

As Kurzweil himself acknowledges, however, nothing is more problematic than predicting the future. If the record of past predictions is any guide, the one thing we can know for sure is that when the future arrives, it will be different from the future we expected. Instructed by the pandemic failure to project accurately very far into the future, my interest here is not to engage in this kind of speculation but rather to explore the influence that such predictions have on our *present* concepts.[2] At stake, I will argue, is not so much the risky game of long-term predictions as contending for how we now understand human thinking, acting, and sensing – in short, how we understand what it means to be human.[3]

The complex interactions shaping our ideas of 'human nature' include material culture. Anthropologists have long recognized that the construction of artifacts and living spaces materially affects human evolution. Changes in the human skeleton that permitted upright walking co-evolved, anthropologists believe, with the ability to transport objects, which in turn led to the development of technology. We need not refer to something as contemporary and exotic as genetic engineering to realize that for millennia, a two-cycle phenomenon has

been at work: humans create objects, which in turn help to shape humans. This ancient evolutionary process has taken a new turn with the invention of intelligent machines. As Sherry Turkle (1984) has demonstrated in her study of how children interact with intelligent toys, artifacts that seem to manifest human characteristics act as mirrors or 'second selves' through which we re-define our image of ourselves. The simulations, software, and robots we have today fall far short of human accomplishments (though in other ways they exceed what humans can do, for example, in detecting subtle patterns in large data sets). Nevertheless, researchers with the greatest stake in developing these objects consistently use a rhetoric that first takes human behavior as the inspiration for machine design, and then, in a reverse feedback loop, reinterprets human behavior in light of the machines.

To illustrate this process and explore its implications, I will focus on what is known in the field of artificial intelligence as the Sense – Think – Act paradigm (STA). It is no mystery why researchers concentrate on STA, for it defines the necessary behaviors an entity needs to interact with the world. Sensing allows the entity to perceive the world, while cognition processes the sensory data and prepares for the next step, action.

At each node of the STA paradigm we will see similar dynamics at work, although there are also important differences that distinguish between research programs. Constant across all three nodes, however, is a tendency to extrapolate from relatively simple mechanical behaviors to much more complex human situations and a consequent redescription of the human in terms of the intelligent machine. These machines constitute, we are told, a new evolutionary phylum that will occupy the same niche as *Homo sapiens*, an equivalence implied in Peter Menzel and Faith D'Aluisio's (2000) name for this species, *Robo sapiens*. The pressure to see *Homo sapiens* and *Robo sapiens* as essentially the same emerges as a narrative of progress that sees this convergence as the endpoint of human evolution.

Whether or not the predicted future occurs as it has been envisioned, the effect is to shape how human being is understood *in the present*. Those who want to argue for the uniqueness of human nature, like Francis Fukuyama (2002), are forced (consciously or unconsciously) to concentrate on those aspects of human behaviors that machines are least likely to share. Others who envision a convergence between humans and robots, like Moravec (1990, 1999) and Kurzweil (1999), de-emphasize those aspects of human nature that intelligent machines do not share, such as embodiment. Whether one resists or accepts the convergence scenario, the relation between humans and intelligent machines thus acts as a strange attractor, defining the phase space within which narrative pathways may be traced. What becomes difficult to imagine is a description of the human that does not take the intelligent machine as a reference point. This perspective is arguably becoming the dominant framework in which highly developed countries such as the USA understand the future. Whatever the future, the implications of this perspective for the present are consequential. Later I will return to these questions to evaluate the various arguments and positions. First, however, it will be useful to explore the basis for the convergence scenario in research that has emerged around the STA paradigm.

Acting

Among the influential researchers defining our present relation to intelligent machines is Rodney Brooks. Brooks (2002) describes the oppositional heuristic at the center of his research method. He looks for an assumption that is not even discussed in the research community because it is considered to be so well established; he then supposes that this 'self-evident truth' is not true. When he first began his research, researchers assumed that

artificial intelligence should be modeled on conscious human thought. A robot moving across a room, for example, should have available a representation of the room and the means to calculate each move to map it onto the representation. Brooks believed this top-down approach was much too limiting. He saw the approach in action with a room-crossing robot designed by his friend and fellow student, Hans Moravec. The robot required heavy computational power and a strategy that took hours to implement, for each time it made a move, it would stop, figure out where it was, and then calculate the next move. Meanwhile, if anyone entered the room it was in the process of navigating, it would be hopelessly thrown off and forced to begin again. Brooks figured that a cockroach could not possibly have as much computational power on board as the robot, yet it could accomplish the same task in a fraction of the time. The problem, as Brooks saw it, was the assumption that a robot had to operate from a representation of the world.

Brooks' oppositional strategy, by contrast, was to build from the bottom up rather the top down. One of his inspirations (2002: 17–21) was William Grey Walter, who in the 1940s built small robots, dubbed electric tortoises, that could robustly navigate spaces and return to the hutches for refueling when their batteries ran low. Following this lead, among others, Brooks began to design robots that could move robustly in the world without any central representation; he is fond of saying these robots take 'the world as its own best model'. Incorporating a design principle he calls 'subsumption architecture', the robots were created using a hierarchical structure in which higher level layers could subsume the role of lower levels when they wanted to take control. In the absence of this control, the lower layers continued to carry out their programming without the necessity to have each move planned from above. Each layer was constituted as a simple finite state machine programmed for a specific behavior with very limited memory, often less than a kilobyte of RAM. The semi-autonomous layers carried out their programming more or less independently of the others. The architecture was robust, because if any one level failed to work as planned, the other layers could continue to operate. There was no central unit that would correspond to a conscious brain, only a small module that adjudicated conflicts when the commands of different layers interfered with each other. Nor was there any central representation; each layer 'saw' the world differently with no need to reconcile its vision of what was happening with the other layers.

An example of a robot constructed using this model is Genghis, a six-legged insectile robot 30 cms long. The robot is programmed to prowl and engage in exploratory behaviors; when it senses a human in its vicinity, it charges toward him/her, albeit at such a slow pace that the human is in no danger of being overtaken. Instead of programming the gait in detail – a fearsomely complex computational challenge – each leg is coordinated only very slightly with the others, and the gait emerges from the local semi-autonomous behavior of each leg following its programming independently. Embedded in the design is a concept central to much of Brooks' research:

> Complex (and useful) behavior need not necessarily be a product of an extremely complex control system. Rather, complex behavior may simply be a reflection of a complex environment … It may be an observer who ascribes complexity to an organism – not necessarily its designer.
>
> (1999: 7)

A variation on this idea is the 'cheap trick', a behavior that emerges spontaneously from the interaction of other programmed behaviors. When detractors pointed out that these robots merely operated at an insectile level of intelligence, Brooks responded by pointing out that on an evolutionary timeline, the appearance of insects occurred at 90 percent of the time

it took to evolve humans. This suggests, Brooks contends, that the hard problem is robust movement in an unpredictable complex three-dimensional environment. Once this problem is solved, higher level cognitive functioning can be evolved relatively easily.

To illustrate the idea of taking the world as its own best model, Brooks and Maya Mataric, then a graduate student in the Artificial Intelligence Laboratory at MIT, built Toto, a path-following robot described in Brooks (1999: 37–56). Toto represented an advance over Genghis because it was able to operate as if it had dynamically changing long-term goals and maps it had built up over time. It accomplished these goals, however, without any central representation of the spaces it navigated. Rather, it detected landmarks and then stored these locations in nodes connecting to one another in a spreading activation topology. Each node was capable of comparing the incoming data about landmarks to its own position; navigation then became a matter of following the shortest path through the locations stored in the nodes to arrive at the desired goal. This clever arrangement in effect folded the map-making activity back onto the controller, so that the 'map' existed not as an abstract representation but rather emerged dynamically out of the robot's exploratory behavior. Commenting from his perspective a decade later on the article he and Mataric co-published on this work, Brooks writes:

> This paper is very confusing to many people. It turns the whole notion of representation upside down. The robot never has things circumscribed in its head, but it acts just like we imagine it ought to. I view this work as the nail in the coffin of traditional representation.
>
> (1999: 37)

Extrapolated to humans (as Brooks is not slow to do), these results implied that complex behaviors can emerge out of simple operations that do not depend on a central representation of the world. Students working with Brooks took to accompanying people home from work to determine how much of their navigation was conscious and how much was on 'automatic pilot'. Consciousness quickly became relegated, in the term used by many researchers in artificial life and intelligence, to the role of an 'epiphenomenon'. A late evolutionary development, consciousness was seen to play a much smaller role in action than had traditionally been thought. Experiments by Benjamin Libet, for example, showed that when a human subject was asked to indicate when he had decided to raise his arm, muscles were already set in action before he spoke, suggesting that the decision-making process was arriving at consciousness *after* the decision had already been made (Libet, 1985; Haggard and Libet, 2001).[4] Moreover, sensory data were known to arrive at consciousness already highly processed, so that much of the interpretation of sensory data had already been made before the conscious mind was aware of it. Brooks cites as evidence that the conscious mind was operating from a very partial view of the world – the fact that we go through life with a large blank spot in the middle of our visual field, although we are not aware of it. At the same time, the neurophysiologist Antonio Damasio (1995, 2000) was arguing from data gathered from thousands of patients that much cognition goes on in lower brain regions such as the limbic system, the peripheral nervous system, and the viscera. A joke told by the comedian Emo Phillips is relevant here. 'I used to think the brain was the most wonderful organ in the body,' he says. 'Then I asked myself, "Who's telling me this?"'

These results led Brooks to explore how far the experimental program he had implemented with insect-like robots could be carried out with a higher-level robot meant to evolve more sophisticated human behaviors. This agenda led to Cog (a play on cognition, as well as a mechanical cog), a head-and-torso robot with human-like eye motions and

software that enables it to interact on a limited basis with human partners. Its eyes can saccade, smoothly follow, and fixate on objects in the room, using actively moving cameras. It can detect faces and recognize a few of them, as long as it has a full frontal view. It can pick out saturated colors and recognize skinlike colors across the range of human skin tones. It also has the possibility to create emergent behaviors more complex than those that were programmed in. This potential became clear when one of the graduate students who helped designed it, Cynthia Breazeal, held up a whiteboard eraser and shook it to get Cog's attention. Cog then reached and touched it, whereupon the game repeated. Watching the videotape of these interactions, Brooks reports that

> it appeared that Cog and Cynthia were taking turns. But on our development chart we were years away from programming the ability to take turns into Cog. The reality was that Cynthia was doing all the turn-taking, but to an external observer the source of the causation was not obvious.
>
> (2002: 91)

Drawing on this insight, Breazeal decided to build for her PhD project a robot that could engage in social interactions. The result was Kismet, whose features are specifically designed to encourage emotional responses from humans. Kismet has moveable eyebrows, oversized eyeballs that are human-like in appearance with foveal cameras behind them, and actuators that let it move its neck across three different axes. It is controlled by 15 different computers, some moving parts of the face and eyes and others receiving visual and audio inputs. Following the idea of semi-autonomous layers, Kismet has no central control unit but rather a series of distributed smaller units. Its software drives it to seek human interaction, with a set of internal drives that increase over time until they are satisfied. These include searching for saturated colors and skin tones, which causes the robot to fixate on toys and people. It appears as if the robot is searching for play objects, but as Brooks (2002: 94) observes, 'the overall behavior emerges from the interactions of simpler behaviors, mediated through the world.' It displays expressions typical of emotional responses, and it can put prosody into its voice as well as discern prosody in human voices. Its software is programmed to follow the basic mechanism of turn-taking in conversation, although Kismet cannot actually understand what is said to it nor say anything meaningful in return. When naive observers (i.e., those who did not know about the robot's programming) were brought into the lab and asked to talk to Kismet, most of them were able to engage, in 'conversation' with Kismet, although the robot babbled only nonsense syllables, much as a human infant might. An important part of this project is a perspective that considers the robot not as an isolated unit but rather as part of an ecological whole that includes the humans with which it interacts. Human interpretation and response make the robot's actions more meaningful than they otherwise would be. The community, understood as the robot plus its human interlocutors, is greater than the sum of its parts because the robot's design and programming have been created to optimize interactions with humans.

These projects, focusing on the dynamics of embodied robots, have made Brooks more cautious than researchers like Kurzweil and Moravec about the possibilities for creating artificial bodies that human consciousness can inhabit. Discussing their versions of techno-utopianism, Brooks comments that although this 'strong version of salvation seems plausible in principle',

> we may yet be hundreds of years off in figuring out just how to do it. It takes computational chauvinism to new heights. It neglects the primary role played by the bath of neurotransmitters and hormones in which our neuronal cells swim. It

neglects the role of our body in placing constraints and providing noncomputational aspects to our existence. And it may be completely missing the *juice*.

(2002: 206)

The 'juice' is Brooks' term for as-yet-undiscovered aspects of human cognition, evolution and biology that would provide new avenues for research in artificial intelligence. The contrarian methodology he follows leads in this instance to the idea that there may be lying in wait some entirely new principles that will revolutionize artificial intelligence, a hope undergirding the 'Living Machines' projects on which his graduate students are currently engaged. Here the influence of the future can be seen not in long-range predictions but rather in a shotgun methodology in which a wide variety of approaches are tried in the hope that one or more may pay off. Before assessing these possibilities and their implications for our present understanding of what it means to be human, I turn now to another node of the STA paradigm.

Sensing

Sensors, essential to robust movement in the world and crucial to the development of free-ranging robots, are rapidly developing along many sensory modalities, including visual, auditory, tactile and infrared. In the interest of tracking how visions of the future are affecting our present vision of the human, I will leave aside these mainstream developments to consider a rather quirky and quixotic proposal to develop episternically autonomous devices, first advanced by Peter Cariani. Cariani (1991) arrived at this idea by critiquing existing models of artificial life, especially the idea of emergence. He noted that emergence risks becoming entangled in Descartes' Dictum, which states that if our devices follow our specifications exactly, they will never go beyond them, remaining mired in the realm of classical mechanics where devices perform exactly as predicted with nothing new added. On the other hand, if the devices depart too freely from our specifications, they are unlikely to be useful for our purposes. To clarify how emergence can generate novelty and still remain useful, Cariani defined emergence relative to a model. If the processes that link symbols to the world (for example, processes that link ones and zeros to changing voltages in a computer) result in new functions, then the system has extended the realm of its symbolic activity. For example, a third value might emerge that is neither one nor zero. If the innovation takes the form of new content for the symbols, it is said to be semantically emergent; if it arranges the symbols in a new way, it is syntactically emergent. Either of these conditions leads to new observational primitives. This point is important, Cariani argues, because systems that can only consider primitives specified by their designers remain constrained by the assumptions implicit in those specifications. In this sense the system can know the world only through the modalities dictated by its designer. Although it might work on these data to create new results, the scope of novelty is limited by having its theater of operations – the data that create and circumscribe its world – determined in advance without the possibility of free innovation. For maximum novelty, one needs a system that can break out of the frame created by the designer, deciding what will count as inputs for its operations. Such a system can then become epistemically autonomous relative to its creator, 'capable of searching realms for which we have no inkling' (Cariani, 1991: 779).

One way to achieve epistemic autonomy is to have sensors constructed by the system itself instead of being specified by the designer. Searching the literature for examples, Cariani found only one, a device created in the 1950s by the cybernetician Gordon Pask,

who demonstrated it at various conferences under the name 'Pask's Ear'. The system was a simple electrochemical device consisting of a set of platinum electrodes in an aqueous ferrous sulfate/sulfuric acid solution. When current is fed through the electrodes, iron threads tend to grow between the electrodes. If no current passes through a thread, it dissolves back into the acidic solution. Branches form off the main threads, setting up a situation in which various threads compete for the available current. Generally the threads that follow the path of maximum current flourish the best, but the dynamic becomes complicated when threads join and form larger collaborative structures. In the complex growth and decay of threads, the system mimics an evolutionary ecology that responds to rewards (more current) and punishment (less current). More current does not specify the form that the growth will take; it only establishes the potential for more growth. The system itself discovers the optimum form for the conditions, which turn out to include other factors in the room environment, such as temperature, magnetic fields, and vibrations from auditory signals. Capitalizing on the fact that the system was capable of taking auditory signals as input, Pask 'trained' the system to recognize different sound frequencies by sending through more current at one frequency than another. Within half a day, he was able to train the system to discriminate between 50Hz and 100Hz tones. Such a system, Cariani (1991: 789) argues, 'would be epistemically autonomous, capable of choosing its own semantic categories as well as its syntactic operations on the alternatives'. Cariani (1998: 721) imagines that similar methodologies might be used to create new signaling possibilities in biological neurons.

Building on Cariani's ideas, Jon Bird and Paul Layzell (2002) built an 'evolved radio'. They state clearly the motivations for this research. Reasoning along lines familiar from Rodney Brooks, Bird and Layzell consider the constraints on simulations in contrast to real-world modeling, now with an emphasis on sensing rather than acting:

> [There is] a fundamental constraint in simulating sensor evolution: the experimenter sets a *bound* on the possible interactions between the agent and the environment. This is a direct consequence of the simulation process: firstly, the experimenter has to model *explicitly* how different environmental stimuli change the state of the sensors; secondly, experimenters only simulate those aspects of the environment that they think are relevant to their experiment, otherwise the simulation would become computationally intractable. These constraints make it very difficult to see how there can be a simulation of novel sensors.

They continue:

> Novel sensors are constructed when a device, rather than an experimenter, determines which of the infinite number of environmental perturbations act as useful stimuli.
>
> (2002: 2)

Working from this perspective, they noticed reports in the literature of small inductance and capacitance differences emerging spontaneously among transistor circuits in a new form of evolvable hardware called a Field Programmable Gate Array. They thought they could opportunistically capitalize on this emergent property by building an 'evolvable motherboard' using a matrix of analogue switches, which are themselves semiconductor devices.

Radio circuits are comprised of oscillators created when resistors are used to control the charge release of capacitors, according to the well-known RC time constant. Bird and Layzell wanted to arrange the transistors in appropriate patterns so that these oscillators would emerge spontaneously. To 'kick-start the evolutionary process', Bird and Layzell (2002: 2) rewarded frequency, amplitude of oscillation, and output amplitude. Once they

had succeeded in creating the desired oscillators, the oscillators acted as a radio by picking up on the waves generated by the clocks of nearby PC computers. To say the emergent circuits were quirky would be to indulge in understatement. Some would work only when a soldering iron on a nearby workbench was plugged in, although it did not have to be on. Other circuits would work only when the oscilloscope was on. In effect, the evolved radio took the entire room as its environment, using the room's resources in ways that were not determined by the researchers and probably not fully known by them. Citing Richard Lewontin, Bird and Layzell point out that the environment can be theoretically partitioned into an infinite number of niches, but it takes an organism exploiting a niche for it to be recognized as such. Some organisms, they point out, have adapted in highly specialized ways to niches that remain relatively constant; general solutions are usually found only by organisms that inhabit highly variable evolutionary niches. The evolved radio is like a highly specialized organism, exploiting the specific characteristics of the room and unable to adapt if the room's configurations change. This disadvantage notwithstanding, the advantage is that the system itself establishes the nature of its relation to the world. It decides what it will recognize as relevant inputs and in this sense evolves its own sensors.

Evolving new sensors implies constructing new worlds. As Cariani observes:

> ... sensors determine the perceptual categories that are available, while effectors determine the kinds of primitive actions that can be realized. Sensors and effectors thus determine the nature of the external semantics of the internal, informational states of organisms and robotic devices.
>
> (1998: 718)

While humans have for millennia used what Cariani calls 'active sensing' – 'poking, pushing, bending' – to extend their sensory range and for hundreds of years have used prostheses to create new sensory experiences (for example, microscopes and telescopes), only recently has it been possible to construct evolving sensors and what Cariani (1998: 718) calls 'internalized sensing', that is, '"bringing the world into the device" by creating internal, analog representations of the world out of which internal sensors extract newly-relevant properties'.

We can draw several connections between Cariani's call for research in the frontiers of sensor research and the future of the human. One implication, explicitly noted by Jon Bird and Andy Webster (2001), is the blurring of the boundary between creator and created; humans create autonomous systems in the sense that they set them running, but a large measure of the creativity in parsing the world is created by the system itself. Other implications emerge from the physical and informational integration of human sensory systems and artificial intelligence. Kevin Warwick's recent implant chip with a 100 electrode array into the median nerve fibers of his forearm is an example of 'bringing the world into the device' by connecting the human nervous system with new internal sensors. Warwick's implant communicates both with the external world and his own nervous system. Although it is not clear yet how these neural connections might affect his perceptions – if at all – the import is clear. Perceptual processing will increasingly be mediated through intelligent components that feed directly into the human nervous system, much as William Gibson imagined in the cyberspace decks of the *Neuromancer* trilogy. More mundane examples are increasingly evident, for example, the night vision goggles worn by US troops in the 1991 Gulf War. When the human nervous system is receiving information through prostheses seamlessly integrated with internal implants, the line between human sensing and the sensing capabilities of intelligent machines becomes increasingly blurred. 'Machines R Us' is one interpretation of the permeable boundary between the sensing 'native' to humans and the

sensing done through networks of intelligent software and hardware that communicate, directly and indirectly, with the human nervous system.

Another conclusion emerges from Cariani's call (1998) for research in sensors that can adapt and evolve independently of the epistemic categories of the humans who create them. The well-known and perhaps apocryphal story of the neural net trained to recognize army tanks will illustrate the point. For obvious reasons, the army wanted to develop an intelligent machine that could discriminate between real and pretend tanks. A neural net was constructed and trained using two sets of data, one consisting of photographs showing plywood cutouts of tanks and the other actual tanks. After some training, the net was able to discriminate flawlessly between the situations. As is customary, the net was then tested against a third data set showing pretend and real tanks in the same landscape; it failed miserably. Further investigation revealed that the original two data sets had been filmed on different days. One of the days was overcast with lots of clouds, and the other day was clear. The net, it turned out, was discriminating between the presence and absence of clouds. The anecdote shows the ambiguous potential of epistemically autonomous devices for categorizing the world in entirely different ways from the humans with whom they interact. While this autonomy might be used to enrich the human perception of the world by revealing novel kinds of constructions, it also can create a breed of autonomous devices that parse the world in radically different ways from their human trainers.

A counter-narrative, also perhaps apocryphal, emerged from the 1991 Gulf War. US soldiers firing at tanks had been trained on simulators that imaged flames shooting out from the tank to indicate a kill. When army investigators examined Iraqi tanks that were defeated in battles, they found that for some tanks the soldiers had fired four to five times the amount of munitions necessary to disable the tanks. They hypothesized that the over-use of firepower happened because no flames shot out, so the soldiers continued firing. If the hypothesis is correct, human perceptions were altered in accord with the idiosyncrasies of intelligent machines, providing an example of what can happen when human–machine perceptions are caught in a feedback loop with one another. Of course, humans constantly engage in perceptual feedback loops with one another, a phenomenon well known for increasing the stability of groups sharing the consensual hallucination. By contrast, in Greg Bear's *Darwin's Radio* (2004) children are born with genetic mutations caused by the reactivation of ancient retro-viruses – their development of entirely new sensors is one of the indications that they have become a new species vastly superior to the *Homo sapiens* they will supersede. The realization that novel sensors may open new evolutionary pathways for both humans and intelligent machines is one of the potent pressures on our current conceptions of what it means to be human.

Thinking

John Koza was tired. He had heard his scientific colleagues complain too many times that artificial life, while conceptually interesting, was only capable of solving toy problems that were not much use in the real world. Koza, one of the pioneers in developing genetic programming, specializes in the creation of software that can evolve through many generations and find new solutions, not explicitly specified by the designer, to complex problems. Inspired by biological evolution, the basic idea is to generate several variations of programs, test their performance against some fitness criteria, and use the most successful performers as the genetic 'parents' of the next generation, which again consists of variations that are tested in turn, and so on until the solutions that the programs generate are judged to be successful.

Koza (Koza *et al.*, 1999: 5) was particularly interested in creating programs that, as he puts it, could arrive at solutions 'competitive with human-produced results'.

We might call this the Koza Turing test, for it introduces consequential alterations that expand the range and significance of Turing's classic test. Recall that Turing proposed to settle the question of whether computers could think by asking a human interlocutor to question a human and a computer, respectively. If the interlocutor was unable to distinguish successfully between the two on the basis of answers they submitted to his questions, this constituted *prima facie* evidence, Turing argued, that machines could think. By operationalizing the question of intelligence, Turing made it possible to construct situations in which the proposition that machines can think could be either proved or disproved, thus removing it from the realm of philosophical speculation to (putative) empirical testing. Once this move has been made, the outcome is all but certain, for researchers will simply focus on creating programs that can satisfy this criterion until they succeed. The proof of the pudding lies less in the program design than in arriving at a consensus for the test. Like a magician that distracts the audience's attention by having them focus on actions that occur *after* the crucial move has already been made, the Turing test, through its very existence, already presupposes consensus on the criteria that render inevitable the conclusion that machines can think.

Reams of commentaries have been written on the subtleties of the Turing test and its implications for human–computer interactions. Evaluating this substantial body of scholarship is beyond the scope of this article, but suffice it to say that Koza's emphasis on producing human-competitive results significantly shifts the focus. At stake is not whether machines are intelligent – a question I consider to be largely answered in the affirmative, given the cognitively sophisticated acts contemporary computer programs can perform – but whether computers can solve problems that have traditionally been regarded as requiring intuitive knowledge and creativity. Like Turing, Koza proposes to operationalize the question of creativity, thereby rendering it capable of proof or disproof. Among other criteria, he proposes that the programs should be judged as producing human-competitive results if they generate results that have received a patent in the past, improve on existing patents, or qualify as a patentable new invention in the present. Alternatively, they should also be judged as human-competitive if the result is equal or better than a result accepted as scientifically significant by a (human) peer-reviewed journal.

To tackle this challenge, Koza and his co-authors (1999) created genetic programs that could design bandpass filters, that is, electrical circuits capable of distinguishing between and separating out signals of one frequency versus another. There is no explicit procedure for designing these filters because it is desirable to optimize a number of different criteria, including the sharpness of separation, parsimony of components, and so forth. Electrical engineers who specialize in these designs rely on a large amount of intuitive knowledge gained through years of experience. Koza's algorithm worked by starting with extremely simple circuits – kindergarten level. The program then created different variations, tested them, chose the – best and used them as the parents of the next generation. The process was continued, perhaps through hundreds of generations, until satisfactory results were achieved. Using this methodology, the program was able to create 14 circuits whose results are competitive with human designs. Ten infringed on existing patents with some surpassing the results available with these patents, and a few resulted in circuits that produced results previously thought impossible to achieve by experienced electrical engineers.

Given these results, it is tempting to speculate on future scenarios implicit in Koza's challenge to create a program that can produce human-competitive results. Imagine a computer dialing up the patent office and submitting its design electronically. When the

patent is approved, the computer hires a lawyer to structure a deal with a company that produces components using the patented circuits, specifying that the royalties be deposited in its bank account, from which it electronically pays its electric bill. Or suppose that the computer submits an article describing its creation to an electrical engineering journal, using its serial and model numbers as the author. These science fiction scenarios aside, it is clear that Koza's results enable a serious case to be made for attributing to his genetic programs the human attributes of creativity and inventiveness. If one objects that the programs are 'dumb' in the sense that they do not know what they are doing and their designs are simply the result of blind evolutionary processes, one risks the riposte that humans also do not know what they are doing (otherwise they could describe explicitly their methods for solving these problems) and that their ability to solve these complex processes are also the result of blind evolutionary processes.[5]

Are humans special?

The idea that humans occupy a unique position in the scheme of things continues in the new millennium to be a pervasive, and historically resonant belief. One of its contemporary defenders is Francis Fukuyama (2002), who argues for the proposition that 'human nature' exists and, at least in broad outline, can be specified as attributes statistically distributed along a bell curve. Among these attributes are the desire to care for one's children, the desire to favor one's kin group, the desire of males to have sex with females of reproductive age, and the propensity of young males for aggressive confrontations. Furthermore, he defends this human nature as the natural basis for social, cultural, and political institutions, arguing that those institutions that accommodate human nature will be more stable and resilient than those that do not. Finally, he argues that we must at all costs defend our human nature from technological interventions, outlawing or regulating practices that threaten to mutate and transform it in significant ways. He thus positions himself explicitly in opposition to researchers such as Hans Moravec and Ray Kurzweil. Although he does not mention Rodney Brooks (*Our Posthuman Future* was published the same year as Brooks' *Flesh and Machines*), it is fair to say that he would resist some of Brooks' ideas, particularly the notion that a robot like Cog could be made to develop human-like attributes. The one characteristic that Fukuyama's argument leads him increasingly to privilege as he goes through the list of what computers can and cannot do is emotion. Machines, he acknowledges (2002: 168), 'will probably be able to come very close' to duplicating human intelligence, but 'it is impossible to see how they will come to acquire human emotions.'

In pursuing this argument, Fukuyama makes some strange moves. For example, he draws heavily on evolutionary theory to explain how 'human nature' was created, but he also cites with approval Pope John Paul II's assertion that although evolution can be seen as consistent with Catholic doctrine, one must also accept that by mysterious means, at some point in the evolutionary process souls are inserted into human beings. Fukuyama opines:

> The pope has pointed to a real weakness in the current state of evolutionary theory, which scientists would do well to ponder. Modern natural science has explained a great deal less about what it means to be human than many scientists think it has.

> (2002: 161–2)

But if one is free to suppose that human nature can be radically altered by supernatural forces other than evolution, why does evolution force us to conclude that human nature

must be such and so? It seems that Fukuyama uses evolutionary reasoning when it is convenient for his argument and dispenses with it when it threatens his conclusion that human beings are special (in particular, that they have souls when no other living organisms do). This contradiction exposes the tautological nature of his argument. Humans are special because they have human nature; this human nature is in danger of being mutated by technological means; to preserve our specialness, we must not tamper with human nature. The neat closure this argument achieves can be disrupted by the observation that it must also be 'human nature' to use technology, since from the beginning of the species human beings have always used technology. Moreover, technology has coevolved throughout millennia with human beings and helped in myriad profound and subtle ways to make human nature what it is.

Another reason to view Fukuyama's argument with skepticism is the fact that the 'human beings are special' position has a long history that achieves special resonance in the triad of humans, machines, and animals. Although the configuration of these three terms has changed over time, the desire to arrange them to prove that humans are special has remained remarkably consistent. During the Renaissance humans were thought to be special because, unlike animals (who were then the closest competitors for the ecological niche that humans occupied), humans are capable of rational thought, a functionality they share with the angels and proof that they are made in God's image (at least men were; it took some centuries before women were admitted into the charmed circle of rational beings). As computational technology rapidly developed in the 20th century, it became more difficult to maintain that computers could not think rationally. The emphasis then shifted, as it does in Fukuyama, to the human capacity to feel emotions. Now it is animals with whom we share this functionality, it is denied to machines (not coincidentally, machines have in the meantime become the strongest competitors for the ecological niche that humans occupy). The ironies of this historical progression are brilliantly explored in Philip K. Dick's *Do Androids Dream of Electric Sheep?* ([1968] 1982). While the religion of Mercerism sanctifies the ability of humans and animals to feel empathy, the androids who so closely resemble humans that only the most sophisticated tests can tell them apart can be freely slaughtered and used as slaves because, allegedly lacking empathy, the essential characteristic of 'human nature', they are denied the legal protections given to humans and animals.

Although Brooks does not cite Fukuyama, he is of course familiar with the argument that humans are special. In paired sections Brooks (2002) considers the argument 'We are special' and then refutes it in 'We are not special'. His argument is so blatantly tautological that one would suspect him of making fun of Fukuyama (except it is unlikely that he had read Fukuyama's book at the time he was writing *Flesh and Machines*). The proof that machines can be made to feel emotions, he maintains in an argument that can scarcely be anything other than tongue-in-cheek, is that humans already are machines. Since humans feel emotion, it must therefore be possible for machines to feel emotion. Cutting through the Gordian knot of human nature by presupposing what is to be proved, the argument cannot be taken seriously. Nevertheless, it serves as an apt conclusion to the implications of the act–sense–think triad, as we shall see.

In Brooks' research acting becomes the attribute that humans and intelligent machines share. This convergence has the effect of emphasizing direct action in the world as a source of cognition rather than the neocortex. Consciousness, which no one has yet succeeded in creating in machines, is dethroned from its preeminent position and relegated to an epiphenomenon. Brooks' search for 'the juice' (2002) further positions human nature as convergent with machine intelligence. The force of this move can be seen in the conjunction of arguments proposed by Roger Penrose (1989, 1994) and Ray Kurzweil (1999), respectively.

Penrose hypothesizes (without any evidence) that consciousness is a result of quantum computing in the brain, whereas Kurzweil is confident that quantum computing will allow computers to think as complexly as do human brains. Since all quantum computers can do at present is add one plus one to get two, everything in these arguments depends on future projections far ahead of what is currently the case. The future is thus crucial in allowing human beings to be understood as convergent with intelligent machines. The effect *in the present* is to emphasize those aspects humans share with intelligent machines, while those aspects of human being which machines do not share are de-emphasized. Fukuyama (2002) tries to reverse these priorities, emphasizing the parts of human nature that machines do not share, particularly emotions. In either case, human nature is understood in relation to intelligent machines.

Similar results emerge from the sensing and thinking apices of the STA triangle. Sensing becomes a research frontier not because we are likely to acquire new sensors through biological evolutionary processes; rather, sensing can be understood as part of our technological evolution and therefore an appropriate area for research. Programs that emphasize, as Cariani (1998) and Bird and Layzell (2002) do, the need for epistemic autonomy implicitly equate the evolution of artificial sensors with human agency and autonomy. Only when our machines can break free of the worldview embedded in the data we give them as input, they argue, can the power of autonomous perception really be freed from human preconceptions and thus become capable of yielding truly novel results. When machines are free to parse the world according to their autonomous perceptions, it remains an open question, of course, whether they will still follow agendas consistent with human needs and desires.

Cariani (1991: 789) acknowledges this possibility when he notes that epistemic autonomy is closely related to motivational autonomy:

> Such devices would not be useful for accomplishing our purposes as their evaluatory criteria might well diverge from our own over time, but this is the situation we face with other autonomous human beings, with desires other than our own, and the dilemma faced by all human parents at some point during the development of their children.

The rhetoric here moves in two directions, a configuration often seen in convergence scenarios. On the one hand, intelligent machines are envisioned as our children, a position that evokes sympathetic nurturing and empathic identification. On the other hand, they are also postulated as having their own goals distinct from those of humans, a prospect that Hans Moravec invokes when he talks about 'domestic' and 'wild-type' robots. While 'domestic' robots will be harnessed to tasks driven by human desires (like the intelligent vacuum cleaner that Rodney Brooks has developed and is currently marketing), the 'wild-type' robots are envisioned as being used for off-world exploration, mining, and other tasks, a mandate that makes it likely they will be given the capacity to reproduce, mutate, and evolve through automated off-world factories that have the potential to re-program themselves. Moravec postulates that the 'wild-type' robots will then evolve independently of humans, with the expectation that they will be free to define their own goals and desires – a situation startlingly like that anticipated in Philip K. Dick's book ([1968] 1982), with its satiric portrait of a dying human race that commits the hubristic sin of denying intelligent and self-aware androids the rights they so clearly deserve. Another way in which convergence scenarios aim to remove the anxiety associated with robots becoming our evolutionary successors is to imagine that the difference between humans and robots will become moot in an age when all intelligent beings can choose whatever embodiment they prefer, as Kurzweil (1999) does.

Working by other means, John Koza's genetic programs and their 'human-competitive results' point to similar conclusions. Now it is not merely rational thought that intelligent machines are seen to possess, but creativity and intuition as well. The fact that the programs arrive at these results blindly, without any appreciation for what they have accomplished, can be ambiguously understood as indicating that machines are capable of more creativity than that with which they have been credited, or that human intuition may be more mechanical than we thought. The idea that human intuition may originate not primarily in the conscious mind but through individual agents running their semi-autonomous programs, a proposition for which Marvin Minsky (1988) eloquently argued, makes Freud's version of the unconscious look hopelessly anthropomorphic by comparison. In this view, Freud's unconscious comes to seem like what the conscious mind imagines the unconscious would be rather than what it is, which is something at once more mundane and more alien – mindless programs running algorithms that are nevertheless capable of producing very sophisticated results, including a conscious mind that attributes these results to its own powers of rational thought.

Evaluating these diverse positions is akin to steering between Scylla and Charybdis. Certainly Brooks makes an important point when he critiques Kurzweil and Moravec for seriously underestimating the importance of human embodiment and its differences from the silicon instantiations of intelligent machines. Significantly, neither Kurzweil nor Moravec is trained in neurophysiology. Researchers with this experience, such as Antonio Damasio (1995, 2000), have given far different accounts of the complexities of human embodiment and the recursive feedback loops that connect brain to viscera, thought to emotion, consciousness to the specificities of humans. On the other hand, Brooks almost certainly underestimates the importance of consciousness in human culture and society. From the viewpoint of physical anthropology, consciousness may indeed be a late evolutionary add-on, but it is also the distinctive characteristic that has co-evolved with and is inseparable from the uniquely human achievements of language and the development of technologies.

While Brooks joins Kurzweil and Moravec in using the future to anchor their visions of human nature, Fukuyama wants to anchor human nature in the past, specifically the history of human evolution. In my view it is not possible and probably not desirable to constrain scientific research through the kind of legislative fiat Fukuyama advocates. 'Human nature' may indeed have an evolutionary basis, as he argues, but cultural and technological evolution have now so converged with biological evolution that they can no longer be meaningfully considered as isolated processes. Whatever our future, it will almost certainly include human interventions in biological processes, which means that 'human nature' will at least in part be what humans decide it should be.

Although these research programs have their own agendas and should not be conflated with one another, they have in common positing the intelligent machine as the appropriate standard by which humans should understand themselves. No longer the measure of all things, man (and woman) now forms a dyad with the intelligent machine such that human and machine are the measure of each other. We do not need to wait for the future to see the impact that the evolution of intelligent machines has on our understandings of human being. It is already here, already shaping our notions of the human through similarity and contrast, already becoming the looming feature in the evolutionary landscape against which our fitness is measured. The future echoes through our present so persistently that it is not merely a metaphor to say the future has arrived before it has begun. When we compute the human, the conclusion that the human being cannot be adequately understood without ranging it alongside the intelligent machine has already been built into the very language we use.

The crucial point suggested by my analysis is simply this: our future will be what we collectively make it. Future projections should be evaluated not from the perspective of how plausible they are, for that we cannot know with certainty, nor in the inertia of our evolutionary past, for that alone is not sufficient to determine what we can or will be. To accept the gambit of positioning the argument in either of these terms is already to concede the game to those who would hold the present hostage to the future or the past.

Rather, we should ask another kind of question altogether: what do we want the future to be? What values should command our allegiances and the commitment of our senses, thoughts, and actions? Viewed from this perspective, the STA paradigm serves to focus another sort of inquiry, leading not to the foregone conclusion that intelligent machines are the inevitable measure by which the human will be understood but rather to debates about how we can best achieve the future we want. Neither future projection nor past history is sufficient to answer this question definitively, and neither should be allowed to foreclose the urgency of grounding our future in ethical considerations. It is likely that our future will be increasingly entwined with intelligent machines, but this only deepens and extends the necessity for principled debate, for their futures too cannot be envisioned apart from the primary concern for ethics that should drive these discussions. What it means to be human finally is not so much about intelligent machines as it is about how to create just societies in a transnational global world that may include in its purview both carbon and silicon citizens.

Acknowledgements

I am indebted to Carol Wald for assistance with bibliographic research for this article, and especially for the link to William Gibson.

Notes

1 For extended critique of Kurzweil's predictions and his rejoinders, see Jay Richards (2002). Of special interest in the Richards collection, in view of my argument here, is Thomas Ray (2002: 116–27) and Michael Denton (2002: 78–97).

2 It is interesting that science fiction writers, traditionally the ones who prognosticate possible futures, are increasingly setting their fictions in the present. In a recent interview, William Gibson commented on this tendency. Andrew Leonard (2003) asks, 'Was it a challenge to keep writing about the future, as the Internet exploded and so much of what you imagined came closer?' Gibson replies:

> I think my last three books reflected that. It just seemed to be happening – it was like the windshield kept getting closer and closer. The event horizon was getting closer ... I have this conviction that the present is actually inexpressibly peculiar now, and that's the only thing that's worth dealing with.

3 This article picks up where I left off in my book (Hayles, 1999), which explores the developments in changing constructions of the human in relation to intelligent machines from post-Second World War to 1998.

4 For a trenchant critique of these experiments, see Daniel Dennett (2003: Chapter 8). He argues the widespread interpretation of these experiments as indicating that 'choice' is an epiphenomenon is a result of what he calls the Cartesian Theater. The metaphor of Cartesian Theater mistakenly assumes that there is some central coordinating agency, some 'place' where consciousness resides and makes its decisions. Dennett (1992), by contrast, argues for a draft

and revision model of consciousness that sees consciousness as a multilayered process in which many time-streams participate. Thus, there is no single 'time t' at which a decision is made but rather a multiplicity of times sampled at different points in the stream.

5 The implication that human creativity also operates like the computer programs is slyly intimated in *Genetic Programming III*'s dedication, which reads 'To our parents – all of whom were best-of-generation individuals,' the phrase used to select the winning circuit designs that will become the parents of the program's next generation.

References

Bear, Greg (2004) *Darwin's Radio*. New York: Del Ray.

Bird, Jon and Paul Layzell (2002) 'The Evolved Radio and its Implications for Modeling the Evolution of Novel Sensors', *Proceedings of Congress on Evolutionary Computation* (n.v.): 1836–41, http://www.hpl.hp.com/research/bicas/pub-10.htm (accessed 20 April 2003).

Bird, Jon and Andy Webster (2001) 'The Blurring of Art and Alife', http://www.cogs.susx.ac.uk/users/agj21/ccrg/papers/The BlurringofArtandALife.pdf (accessed 20 April 2003).

Brooks, Rodney A. (1999) *Cambrian Intelligence: The Early History of the New AI*. Cambridge, MA: MIT Press.

Brooks, Rodney A. (2002) *Flesh and Machines: How Robots Will Change Us*. New York: Pantheon.

Cariani, Peter (1991) 'Emergence and Artificial Life', pp. 775–97 in C.G. Langton, C. Taylor, J.D. Farmer and S. Rasmussen (eds) *Artificial Life II*, SFI Studies in the Sciences of Complexity, vol. X. Boston, MA: Addison-Wesley.

Cariani, Peter (1998) 'Epistemic Autonomy through Adaptive Sensing', pp. 718–23 in *Proceedings of the 1998 IEEE ISIC/CRA/ISAS Joint Conference*. Gaithersburg, MD: IEEE.

Damasio, Antonio (1995) *Descartes' Error: Emotion, Reason, and the Human Brain*. New York: Avon.

Damasio, Antonio (2000) *The Feeling of What Happens: Body and Emotion in the Making of Consciousness*. New York: Harvest.

Dennett, Daniel (1992) *Consciousness Explained*. New York: Back Bay Books.

Dennett, Daniel (2003) *Freedom Evolves*. New York: Viking.

Denton, Michael (2002) 'Organism and the Machine: The Flawed Analogy', pp. 78–97 in Jay Richards (ed.) *Are We Spiritual Machines? Ray Kurzweil vs the Critics of Strong AI*. Seattle, WA: Discovery Institute Press.

Dick, Philip K. ([1968] 1982) *Bladerunner* (original title *Do Androids Dream of Electric Sheep?*). New York: Ballantine Books.

Fukuyama, Francis (2002) *Our Posthuman Future: Consequences of the Biotechnology Revolution*. New York: Farrar, Straus and Giroux.

Haggard, Patrick and Benjamin Libet (2001) 'Conscious Intention and Brain Activity', *Journal of Consciousness Studies* 8: 47–63.

Hayles, N. Katherine (1999) *How We Became Posthuman: Virtual Bodies in Cybernetics, Literature, and Informatics*. Chicago, IL: University of Chicago Press.

Koza, John R., Forrest H. Bennett III, David Andre and Martin A. Keane (1999) *Genetic Programming III: Darwinian Invention and Problem Solving*. San Francisco, CA: Morgan Kaufmann Publishers.

Kurzweil, Ray (1999) *The Age of Spiritual Machines: When Computers Exceed Human Intelligence*. New York: Penguin.

Leonard, Andrew (2003) 'Nodal Point: Interview with William Gibson', http:www.salon.com/tech/books/2003/02/13/Gibson/index.html (accessed 20 April 2003).

Libet, Benjamin (1985) 'Conscious Cerebral Initiative and the Role of Conscious Will in Voluntary Action', *Behavioral and Brain Sciences* 8: 529–66.

Menzel, Peter and Faith D'Alusio (2000) *Robo Sapiens: Evolution of a New Species*. Cambridge, MA: MIT Press.

Minsky, Marvin (1988) *Society of Mind*. New York: Simon and Schuster.

Moravec, Hans P. (1990) *Mind Children: The Future of Robot and Human Intelligence*. Cambridge, MA: Harvard University Press.

Moravec, Hans P. (1999) *Robot: Mere Machine to Transcendent Mind*. New York: Oxford University Press.

Penrose, Roger (1989) *The Emperor's New Mind: Concerning Minds and the Laws of Physics*. New York: Oxford University Press.

Penrose, Roger (1994) *Shadows of Mind: A Search for the Missing Science of Consciousness*. New York: Oxford University Press.

Ray, Thomas (2002) 'Kurzweil's Turing Fallacy', pp. 116–27 in Jay Richards (ed.) *Are We Spiritual Machines? Ray Kurzweil vs the Critics of Strong AI*. Seattle, WA: Discovery Institute Press.

Richards, Jay (ed.) (2002) *Are We Spiritual Machines? Ray Kurzweil vs the Critics of Strong AI*. Seattle, WA: Discovery Institute Press.

Turkle, Sherry (1984) *The Second Self: Computers and the Human Spirit*. New York: Simon and Schuster.

Cyberpolitics

David Bell

INTRODUCTION

T HE FIVE READINGS IN THIS SECTION approach the politics of cyberspace and cyberculture in distinct but often overlapping ways, presenting together a map of some key dimensions of cyberpolitics. Political issues have always been at the heart of analyses of cyberspace, from the contested origin stories which wed the Internet to the Cold War, to the links between the sixties counterculture and developments in computing (see Abbate 1999). The same is true today, as the articles reprinted here vividly illustrate. Key questions raised in the essays include: what kind of political space is cyberspace, and what kinds of politics are to be found there? What are the inter-relationships between cyberpolitics and other political formations, such as the nation-state? Who gets to be political in cyberspace, and what does 'being political' entail here? What promises and threats does cyberpolitics produce, and ultimately – as Saskia Sassen asks in her essay – is the Internet good or bad for democracy? Current political events such as the 'War on Terror' have profoundly reshaped politics both offline and online, so the questions asked above take on an ever more pressing urgency. There is, in short, much at stake in understanding and critically evaluating cyberpolitics in its myriad formations.

Sassen frames her thinking about these questions by reminding us that debates about the Internet's politics have neglected other equally political global electronic networks, such as financial markets. Such networks mobilize what she calls 'new non-state-centered governance mechanisms', mechanisms which work to favour neoliberal economic globalization and which deploy novel forms of regulation. Written at a time when cyberspace was being rampantly commercialized, Sassen's account retains its currency thanks to its keen focus on core questions of privacy, surveillance, regulation and the interplay of state and non-state actors. She reminds us of libertarian political readings of cyberspace, which stress its *ungovernability*,

but sets this against the regulatory systems which have captured and disciplined much of the Internet. Under the guise of accountability and coherence, regulatory frameworks – such as the 'management' of domain names and IP addresses – privatize and 'propertize' Internet access and ownership. This leads Sassen to distinguish between public and private networks, and to shift her focus onto the global capital market as a key private network; a network, moreover, that has the power to discipline national governments. The decentralized architecture of cyberspace, rather than promoting ungovernable democracy, therefore facilitates new regulatory mechanisms. These too are ungovernable, in their ability to transcend conventional legal frameworks and to instate their own mechanisms instead, for example through deploying what Sassen calls 'a logic that is seen as setting the criteria for 'proper' economic policy'.

Sassen's analysis of the role and power of global financial markets is unequivocal:

> Does this concentration of capital in unregulated markets affect national economies and government policies? Does it alter the functioning of democratic governments? Does this kind of concentration of capital reshape the accountability relation between governments and their people which have operated through electoral politics? In brief, does it affect national sovereignty? It does.

Concentrated in command centres in so-called global cities, new global hierarchies are being formed, and a new geopolitical map is being drawn. And of course, no map is a neutral, objective representation; the cartographers of this new map are drawing lines of power through these private digital networks. Yet Sassen also reminds us of counter-movements, such as open-source, which continues to ask crucial questions about access and 'public-ness'; she also highlights growing numbers of non-commercial uses and users of the Internet, reminding us that neoliberal economic globalization need not be the driver of cyberpolitics.

Tim Jordan also considers the different vectors or trajectories of power in cyberculture, focusing his discussion around forms of 'individual' and 'social' power; he too has a new cartography to draw (and draw upon). In terms of gains in individual power, he explores identity play or fluidity as potentially liberatory, noting that 'virtuality alters hierarchies' by freeing users from conventional stratifications – even if it also installs new distinctions and divisions, such as new class formations based around access and use. Empowering forms of online organizing, such as those Jordan describes centred on particular medical conditions, give participants the power to act, for example through access to medical knowledge. Individuals thus create cybercommunities, and concomitantly these communities produce individuals.

When thinking power at the scale of the social, Jordan refers to 'technopower' – the politics embedded in seemingly neutral artefacts, artefacts which, in his words, 'leak social values'. We are here reminded of the 'material stories' (Bell 2001) of cyberculture, and Jordan illustrates the social dimension of technopower

through an interesting discussion of 'information overload' and the 'technopower spiral'. Information overload is a familiar experience in cyberculture: a mundane act like Googling brings us into daily contact with the problem, and we know its symptoms. But the crucial point for Jordan is the cure on offer: the way to manage overload is to develop a new tool that promises to assist us. Such tools, he writes, 'make cyberspace easier to use, tending to create a new form of overload' in their wake. Search engines thus attempt to make online resources accessible, 'helping' us to search – but in the process they overwhelm us with searched-out information and links. The solution? More tools. The side effect? More overload – and so on, in a giddy technopower spiral.

Now, remember Jordan's emphasis on how artefacts 'leak' social values: this spiral tells another story, a political story, about the growing dominance of an 'expertise-based elite'. This digital elite holds social cyberpower, since it controls the 'fabric' of cyberspace. Ordinary users increasingly delegate to the tools offered as magic solutions to the problems of overload, handing over more power to this elite. So while Jordan is optimistic about individual cyberpower as a democratic force, he reads social cyberpower pessimistically, as the concentration of power in the hands of a digital elite. His short case study of the uncovering of encrypted data mining messages in RealJukebox software is also ultimately read pessimistically, as Jordan sees the digital elite strengthening its hold over cyberculture, not least through the growing complexity of cyberspace and hence the continuing spiral of overload and tool-solutions, leading him to foresee a continuing struggle for power between digital elites and 'virtual individuals'.

The RealJukebox tale that Jordan recounts is in part a story about hacking, about the use of expertise against the digital elites. Paul Taylor's article explores hacking, too, reminding us that the common image of malicious or illicit hacking only tells a small part of the hacker story. Hacking is a term used to describe any ingenious use of technology, any act of 'rewiring' regardless of intent. Taylor sketches five 'generations' of hackers, from the early 'playful' hackers at key institutions such as MIT, through those associated with 'democratic computing' and the development of the personal computer, through to computer games programmers, and to the fourth generation, those using their skill to illicitly access other people's computers – the common image of the hacker. Taylor adds an emerging fifth generation, whose traces he detects in fictional works such as Gibson's cyberpunk or Douglas Coupland's 1995 novel about Microsoft programmers, *Microserfs*. These hackers, Taylor argues, embody a key ambivalence in cyberculture: the desire to control technological change on the one had, the fear of being controlled by it on the other. So Gibson's maverick 'console cowboys' and Coupland's corporate geeks both dramatize in their own ways the central cyberpolitical issue of *control*.

Taylor shows how cyberpunk worked through the issue of control by conjuring 'hi-tech subcultures', whereas *Microserfs* centres on corporate info-workers. Nevertheless, there are common tropes and motifs, for example in the idea of addiction that leads to a neglect of the body. The worlds of cyberpunk and *Microserfs* collide, moreover, as hacking know-how gets co-opted by computing corporations

who increasingly acknowledge the value of hackers rather than continuing to demonize them (see also Ross 2000). The programmers in Coupland's novel, meanwhile, 'become effectively indentured to the process of producing abstract code and increasingly divorced from the physical world and their own bodies'. Ultimately, Taylor ponders the possibility of a 'third way' of hacking somewhere between the 'anarchic individualism' of cyberpunk and the 'empty regimented corporatism' of *Microserfs* – a way to rewire hacking itself, maybe.

Hacking is routinely heralded as the most significant countercultural presence in computer culture, not to mention the most demonized, especially today through the spectre of the 'cyber-terrorist'. Whereas malicious hacking was previously depicted as either acquisitive (for example through accessing online bank accounts) or as 'mindless vandalism', the cyber-terrorist threatens an explicitly political target. At the same time, the assumed threat of cyber-terrorism legitimizes new regimes of surveillance and security online. As Richard Kahn and Douglas Kellner write, therefore, our understanding of cyberpolitics needs to be situated in this global geopolitical context. Yet Kahn and Kellner want to keep in focus the progressive political activities in cyberspace, such as open-source and 'hacktivism' – while aware that these activities are in themselves under threat. They namecheck a number of important manifestations of this progressive cyberpolitics, emphasizing how the democratizing effects of new media have catalyzed a 'new cycle of Internet politics', from smart mobs to indymedia. Anti-capitalist globalization and anti-war protests have mobilized new media technologies to challenge authorized truth claims, they suggest.

Kahn and Kellner's catalogue of cyber(h)activism shows how new platforms, such as blogs and wikis, are being put to countercultural uses, refusing those commentaries that dismiss such activities as trivial content or 'noise'. Watchblogs and warblogs, for example, have brought to wide audiences experiential accounts of conflict and injustice, while increasingly common technologies such as cameraphones have transformed newsgathering and reporting, bringing into being a more democratic 'citizen journalism' that reshapes what counts as news and how (and by whom) news gets reported. The social networking facilitated by Web 2.0 infrastructure also promises new democratic 'media ecologies' for Kahn and Kellner – though they are keen to note that these technologies are not *inherently* democratic or progressive. Nevertheless, the democratic and participatory *potential* of new technologies is a source of optimism in their account.

As noted, Kahn and Kellner's overview of cyberactivism is set in the political climate of the 'War on Terror'. The impact of 9/11 on the Internet is also discussed in Braviel Holcomb, Philip Bakelaar and Mark Zizzamia's essay, which explores both 'cyber-terrorism' and counter-terrorism, and the uses of the Internet to respond to and make sense of post-9/11 politics. Their chapter highlights both 'constructive' and 'negative' uses of the Internet in the aftermath of 9/11, including in the former the large number of forums online for information and debate about the event, as well as key space for witness testimony and remembrance; in terms of negative use, they include hoaxes, circulation of forms of hate speech, malicious hacking, scamming and other forms of profiteering, including the sale of what they call

'patriotic gore'. Aside from such immediate uses, of course, 9/11 and the 'War on Terror' has stimulated both critical response and heightened surveillance now achieved under the guise of (national) security. The ongoing balancing of freedom of information versus security has certainly seen the legitimation of tighter controls on content and use, with the threat of 'cyber-terrorism' providing justification. Broader civil liberties restrictions have also been enabled by cybertechnologies, such as the identity checks now required for entry to the USA.

In a postscript added to their article for its inclusion here, Bakelaar and Holcomb are able to add a slightly longer perspective to their assessment of the impact of 9/11; here, they emphasize the coming of Web 2.0, the growth of the blogosphere and the rise of mobile and wireless cyberspaces. Like Kahn and Kellner, they note too the rise of 'citizen journalism' as well as the rise of alternative interpretations of 9/11, including conspiracy theories and other 'unauthorized' and oppositional accounts. On the one hand, then, 9/11 legitimated heightened security and surveillance via the threat of 'cyber-terrorism'; on the other hand, cyberspace has opened up in countless directions – not all of them progressive, remember – to work through the meaning of what happened that day and has happened since then.

References

Abbate, J. (1999) *Inventing the Internet*, Cambridge, MA: MIT Press.

Ross, A. (2000) 'Hacking away at the counterculture', in D. Bell and B. Kennedy (eds) *The Cybercultures Reader*, first edition, London: Routledge.

Saskia Sassen

DIGITAL NETWORKS AND THE STATE
Some governance questions

THE RAPID PROLIFERATION OF DIGITAL NETWORKS and the growing digitization of a broad array of economic activities have raised a number of questions about the state's capacity to regulate this domain and about the latter's potential for undermining sovereignty. Most of the focus has been on the Internet.[1] The major lines of the debate in general commentaries are increasingly polarized among those who believe that the Internet undermines, or at the least weakens, state authority and those who believe that it strengthens liberal democracy and thereby the liberal state. Not unrelated to these two positions is the more technical debate between those who find that the notion of governments regulating the Internet does not carry much meaning (Post, 1995; Mueller, 1998) and those who maintain that there are various legal instruments and technical standards through which states can directly or indirectly regulate the Internet (Lessig, 1999; Reidenberg, 1998).

My concern here is with the broader theoretical and political implications of the characterization of the two fundamental concepts in the debate. Among the issues I want to focus on concerning the Internet are (a) the confusion between privately owned digital networks and digital space available to 'the public' even if for a fee, specifically the Internet, and (b) the possibilities for regulating the Internet (see also Perritt, 1999).

Very briefly, my argument will be that it is the enormous growth of private digital networks – especially the case of the global financial markets – rather than the Internet, which is having the greater impact on national sovereignty and indeed transforming particular features of it. More generally, economic globalization and technology have brought with them significant transformations in the authority of national states. Especially important here is the growth of new non-state-centered governance mechanisms which have transformed the meaning of national territorial sovereignty independently from whatever impact the Internet has so far had. Second, there are features of the Internet today which suggest that regulation is possible. But it is a radically different version of regulation from that we have associated with the modern state over the last half century.

Economic power and state power in the Internet

The condition of the Internet as a decentralized network of networks has contributed to strong notions about its built-in autonomy from state power and its capacity to enhance democracy from the bottom up via a strengthening of both market dynamics and access by civil society.[2] Yet, while in principle many of the key features of the Internet do indeed have this capacity to enhance democracy, its openness and its technology also contain possibilities for significant control and the imposition of limitations on access. Here I want to discuss briefly three aspects of this contrarian argument.

In my own research I have come to regard the Internet as a space produced and marked through the software that gives it its features and the particular aspects of the hardware mobilized by the software.[3] There are significant implications attached to the fact that the leading Internet software design focus in the last few years has been on firewalled intranets for firms and firewalled tunnels for firm-to-firm transactions.[4] Both of these represent, in some sense, private appropriations of a 'public' space.[5] Further, the growing interest in e-commerce has stimulated the development of software linked to identity verification, trademarks protection, billing. The rapid growth of this type of software and its use in the Internet does not necessarily strengthen the public-ness of the Net. This is especially significant if there is less production of software aimed at strengthening the openness and decentralization of the Net as was the case in the earlier phases of the Internet. Further, this newer type of software also sets up the conditions for copyrighting, including the possibility of charging for what can be set up as copyrighted use/access, including per use charge. In my reading, far from strengthening the Internet's democratic potential as many liberal and neoliberal commentators maintain, this type of commercialization can threaten it.

Along these same lines of analysis – though with another type of norm in mind – Lessig (1999), for instance, has pointed out that since 1995/6 the work of political entities and technicians has brought about what may be interpreted as an increase in controls. Prior to 1995 the architecture of the Internet inhibited 'zoning' – any technique that facilitates discrimination in access to or distribution of some good or service.[6] Users could more easily maintain their anonymity while online and it was difficult to verify user identity, thereby ensuring better privacy protection. Since then, with the drive to facilitate e-commerce, this has changed: the architecture of the Internet now facilitates zoning.[7]

Coming from a different angle but based upon a similar understanding, Boyle (1997) has examined how the built-in set of standards that constitute the Internet undermines claims that the state cannot regulate the Internet. Indeed, he argues that the state's regulatory agenda is already partially contained in the design of the technologies. Thus the state can regulate in this case even though it is not via sanctions. Boyle in fact alerts us to the fact that privatized and technologically based rule enforcement would take policing away from the scrutiny of public law, freeing states from some of the constitutional and other constraints restricting their options. This can be problematic even in the case of states that operate under the rule of law, as examples of abuse of power by various government agencies in the US make clear.

These three analyses, different as they are in the origins and end results of the argumentation, do intersect on one point: that simply leaving the Internet to its own evolution is not necessarily going to strengthen the forces of democracy. The differential economic power of different types of users is shaping the development of privatizing dynamics that remain unaccountable, and the indirect incorporation of state powers in the design of technical standards is creating a domain for state power that falls outside the public sphere where state action can be subjected to public accountability. All three views would seem to

suggest that it is misguided to think that leaving this evolution to the market is somehow going to ensure freedom and democracy.

Although the Net as a space of distributed power can thrive even against growing commercialization, and today's non-commercial uses still dominate the Internet, the race is on. Considerable resources are being allocated to invent ways of expanding electronic commerce, ensuring safety of payment transactions and implementing copyright. These are not easy tasks. At the 1997 Aspen Roundtable on Electronic Commerce, an annual event that brings together the CEOs of the main software and hardware firms as well as the key venture capitalists in the sector, it was once again established by these insiders that there are limits to the medium as a venue for commerce and that it will probably tend to cater to particular niche markets, with a few possible exceptions. In this regard, the reawakened recognition among non-commercial digital organizations and digital activists of the viability of open-source systems is worth noting, as is the commercial interest in Linux, one of the hottest open-source systems at this time. We are seeing the rapid growth of a new generation of alternative organizations and of individuals knowledgeable about digital technologies who are working on the public dimensions and free access questions.[8] This signals that the Internet may continue to be a space for de facto (i.e. not necessarily self-conscious) democratic practices. But it will be so partly as a form of resistance against overarching powers of the economy and of the state, rather than the space of unlimited freedom which is still part of its representation today in many milieux.[9]

One aspect important to the positive democracy effect of the Net is that there has been a proliferation of non-commercial uses and users. From struggles around human rights, the environment and workers' strikes around the world, to genuinely trivial pursuits, the Net has emerged as a powerful medium for non-elites to communicate, support each other's struggles and create the equivalent of insider groups at scales going from the local to the global. The political and civic potential of these trends is enormous. It offers the possibility for interested citizens to act in concert.[10] The possibility of doing so transnationally at a time when a growing set of issues is seen as escaping the bounds of national states makes this even more significant. We are also seeing a greater variety of subcultures on the Net in the last decade after it having been dominated, at first, by young white men, especially from the US. Finally, insofar as the growth of global corporate actors has pressured governments to support the interests of global capital, it has become even more important to use the Internet as a force through which a multiplicity of public interests can raise critical issues and demand accountability (Perritt, 1999).

State regulation and the Internet

A different issue about sovereignty is raised by the possibilities of states regulating the Internet. It seems to me that if there is to be some kind of regulation it is going to be very different from what we have usually understood by this term. It is certainly the case that in many ways the Net escapes or overrides most conventional jurisdictions (Post, 1995). Again, much of the commentary operates at two very different levels. One is a generalized set of notions that is still rooted in the earlier emphasis of the Internet as a decentralized space of freedom where no authority structures can be instituted. The other is a rapidly growing technical literature, in good part stimulated by the growing importance of Internet addressing, and the domain name system registry generally, with the associated legal and political issues this has engendered.

One fact that is too often left out of generalized commentaries about the Internet is that there *is* a kind of central authority overseeing some of the crucial features of the Net, having to do with addresses and numbers granting and the domain name system.[11] This does not mean that regulation is ipso facto possible. It merely signals that the representation of the Net as escaping all authority is simply inadequate.[12] The nature of this authority is not necessarily akin to regulatory authorities but it is a gate-keeping system of sorts and raises the possibility of oversight capacities. Even though these oversight capacities would entail considerable innovation in our concepts about regulation, they signal that there are possibilities overlooked in a faulty characterization of the architecture of the Internet.

This centrally managed function of the Internet involves the control and assignment of the numbers that computers need to locate an address.[13] It therefore can instruct all the top 'root servers' of the Net – the computers that execute address inquiries – and these will accept these instructions. This is, clearly, a power of sorts. For a long time it was not formalized, in good part because its origins lie in the first phase of the Internet. It is the power held by the group of computer scientists who invented the communication protocols and agreed on the standards that make the Net work today. They have worked at debugging the systems over the last 20 years and did so not necessarily under contract by any agency in particular. It is a de facto group which has worked at making the Net workable since its beginnings. The particular function of assigning addresses is crucial and was for many years under the informal control of one particular scientist who named this function the 'Internet Assigned Numbers Authority'.

In the summer of 1998, the Internet Corporation for Assigned Names and Numbers (ICANN), the group now assigned to oversee the Net's address system, was established.[14] It represents a formalization of the earlier authority.[15] It was basically started as a group of insiders with fairly loose and ineffective by-laws. By early 1999 it had implemented conflict-of-interest rules, opened up some board meetings and worked towards developing a mechanism to elect board members, in an effort to build in more accountability. It is today the subject of growing debate among various digital subcultures (e.g. see Nettime for summaries of the debates).

The US government's 'Framework for Global Electronic Commerce', a blueprint for Internet governance, argues that because of the Internet's global reach and evolving technology, regulation should be kept to a minimum. It also suggests that in the few areas where rules are needed, such as privacy and taxation, policy should be made by quasi-governmental bodies such as the World Intellectual Property Organization (WIPO) or the OECD.

One of the issues with this type of proposal is the absence of transparency and the problems it brings with it. These become evident in one of the first big Net policy dilemmas: cybersquatting, that is, private speculators seizing valuable corporate brandnames on the Internet and selling them back, at an enormous price, to the firms carrying those names. Net addresses are important for establishing an identity online. So companies want to establish a rule that they are entitled to any domain names using their trademarks. But the Net is used for more than e-commerce, so consumer advocates say this rule would unfairly restrict the rights of schools, museums, political parties and other noncommercial Net users. However, in the deliberations that have taken place at WIPO, it is mostly the large firms who are participating, in meetings that take place mostly behind doors. This privatizes the effort to design regulations for the Net.

While the purpose of these governing mechanisms is not about regulation as we have known it, their existence and, perhaps more importantly, the necessity for some such bodies, represents a significant operational opening for some sort of regulation/governance. This is often overlooked in discussions about the Net and its freedoms. As the Internet has

grown, become more international and gained in economic importance, there appears to be growing concern that a more organized and accountable system is necessary. This signals the presence of sectors that want to strengthen and develop this central authority.

Participants in the debate about the Internet and its governance are somewhat divided on the question of whether it can be governed at all.[16] Simplifying what is a partially overlapping set of positions, for some the Internet is an entity that can be subjected to a governance mechanism while for others there is no such entity but rather a decentralized network of networks that at best can lend itself to coordination of standards and rules.

Among those who consider the Internet as a single entity, much of the concern has focused on the establishment of a system of property rights and other such protections and the means for enforcing these. The disagreement has centered on how to administer and enforce such a system. For some (e.g. Foster, 1996) it would be necessary to attach such a system to a multilateral organization, notably ITU and WIPO, precisely because there is no global trademark law, only national law, while the Internet is a global entity. This would ensure recognition from member governments. For others, the mechanisms for governance would come from the institutions of the Internet itself. Gould (1996), for example, argues that there is no need for outside institutions to be brought in but rather that Internet practices could produce a sort of constitutional governance pertaining exclusively to the realm of the Internet. A third type of proposal was developed by Mathiason and Kuhlman (1998) who suggested the need for an international framework convention agreed upon by governments; such a framework convention could parallel the UN Framework Convention on Climate Change.

On the other hand, those experts who consider there is no such entity as the Internet, but only a decentralized network of networks, argue that there is no need for any external regulation or coordination. Further, the decentralized nature of the system would make external regulation ineffective. But there tends to be agreement with the proponents of governance mentioned above as to the need for a framework for establishing a system of property rights. Gillett and Kapor (1996) argue for the functionality of diffused coordination mechanisms; further, the authority of such coordination, they posit, could be more easily legitimated in distributed network environments like the Internet, and increasingly so given a stakeholder community which is becoming global. Mueller (1998) strongly argues against an Internet regulatory agenda and against the policing of trademark rights. He is critical of the very notion of the term 'governance' when it comes to inter-networking, as it is the opposite of what ought to be the purpose which is that of facilitating inter-networking. He argues that too much debate and effort has focused on restricting the ability to inter-network.

In what is at this time one of the most systematic examinations of these various perspectives, Pare (2000) argues that neither of these two types of approaches offers much insight into the processes actually shaping the governance trajectory of the Internet addressing system. Nor can these approaches account for the operational structures of the organizations currently responsible for managing the core functions of inter-networking (both at the national and at the international level), or the likelihoood of their survival.[17]

One important issue, also emphasized by Pare (2000: ch. 3) in his examination of the debates, is the role of the actual features of the technology in shaping some of the possibilities or forms of governance or coordination. Post (1995) and Johnson (1996) argued that transnational electronic networks create a whole set of different jurisdictions from those of territorially based states, and hence there is little purpose in trying to replicate regulatory forms of the latter for the Internet. These authors maintain that various dimensions of inter-networking, including Internet addressing, could be governed

by decentralized emergent law that eventually could converge into common standards for mutual coordination.

For others emphasizing the technology question, the Internet has been a regulated environment given the standards and constraints built into the hardware and software. Thus Reidenberg agrees that the Internet undermines territorially based regulatory governance (1998). But new models and sources of rules have been and continue to be created out of the technical standards and their capacity to establish default boundary rules that impose order in network environments (see also Lessig, 1999). Technical standards can be used as instruments of public policy, and in this regard Reidenberg (1998) posits the emergence of a *Lex Informatica*. This is clearly reminiscent, for those of us working on the global economy today, of the older *Lex Mercatoria*, a concept that is now being revived in the context of economic globalization and privatization (Dezalay and Garth, 1996; Biersteker et al., 2000).[18]

But the Internet is only one portion of the vast new world of digital space, and much of the power to neutralize sovereignty attributed to the Internet actually comes from the existence of private digital networks, such as those used in international finance. To this I now turn.

Distinguishing private and public digital space

Many assertions about digital dynamics and potentials are actually about processes happening in private digital space and have little to do with the Internet. I consider this a serious, though fairly common, confusion. Most financial activity and other significant digital economic activities take place in private digital networks.[19]

Private digital networks make possible forms of power other than the distributed power we associate with public access digital networks. The financial markets illustrate this well. The three properties of electronic networks – speed, simultaneity and inter-connectivity – have produced orders of magnitude far surpassing anything we had ever seen in financial markets. In 1999 the worldwide value of traded derivatives reached over US$65 trillion – a figure that dwarfs the value of cross-border trade and investment. The consequence has been that the global capital market now has the power to discipline national governments, as became evident with the 1994–5 Mexico 'crisis' and the 1997–8 Asian 'crisis', when investors were capable of leaving *en masse* taking out well over US$100 billion over a short period of time. The foreign currency markets had the orders of magnitude to alter exchange rates radically for some of these currencies and overwhelm each and all of the central banks involved and their futile attempt to defend their currencies against the onslaught.

The global capital market: power and norm-making

What I want to emphasize here is that the formation of a global capital market represents a concentration of power that is capable of influencing national government economic policy and, by extension, other policies. A key issue here has to do with questions of normativity – the fact that the global financial markets are not only capable of deploying raw power but have also produced a logic that is now seen as setting the criteria for 'proper' economic policy. IMF conditionally has some of these features.[20] These markets can now exercise the accountability functions associated with citizenship: they can vote

governments' economic policies down or in; they can force governments to take certain measures and not others.

The deregulation of domestic financial markets, the liberalization of international capital flows, computers and telecommunications, have all contributed to an explosive growth in financial markets. Since 1980, the total stock of financial assets has increased two and a half times faster than the aggregate GDP of all the rich industrial economies. And the volume of trading in currencies, bonds and equities has increased about five times faster. The global capital market makes it possible for money to flow anywhere regardless of national origin and boundaries. There are some countries that are, of course, not integrated.

The foreign exchange market was the first one to globalize, in the mid-1970s. Today it is the biggest and in many ways the only truly global market. It has gone from a daily turnover rate of about US$15 billion in the 1970s, to US$60 billion in the early 1980s, and an estimated US$1.3 trillion in 1999. In contrast, the total foreign currency reserves of the rich industrial countries amounted, to under US$1 trillion. Just to make it more concrete foreign exchange transactions were ten times as large as world trade in 1983; only ten years later, in 1992, they were 60 times larger and by 1999, 70 times larger. And world trade has itself grown sharply over this period.

According to some estimates, we have reached only the mid-point of a 50-year process in terms of the full integration of these markets. The financial markets are expected to expand even further in relation to the size of the real economy. It is estimated that the total stock of financial assets traded in the global capital markets is equivalent to twice the GDP of OECD countries – that is, the 23 richest industrial countries in the world. The forecast is that this value will rise to US$83 trillion by the year 2000 to represent three times the aggregate OECD's GDP. Much more integration and power may lie ahead for capital markets.[21] What really counts is how much capital can be moved across borders in how short a period of time. It is clearly an immense amount.

How does this massive growth of financial flows and assets, and the fact of an integrated global capital market, affect states in their economic policy making? Conceivably a global capital market could just be a vast pool of money for investors to shop in without conferring power over governments. The fact that it can discipline governments' economic policy making is a distinct power, one that is not ipso facto inherent in the existence of a large global capital market.

There are important differences between today's global capital market and the period of the gold standard before the First World War. Let me just emphasize one for the purposes of this article: the difference that digital networks, bring to the financial markets is instantaneous transmission, inter-connectivity and speed. Gross volumes have increased enormously even when relative net flows between countries are not higher. And the speed of transactions has brought its own consequences. Trading in currencies and securities is instant thanks to vast computer networks. And the high degree of interconnectivity in combination with instantaneous transmission signals the potential for exponential growth (I discuss other differences in Sassen, 2000a: ch. 4).

Does this concentration of capital in unregulated markets affect national economies and government policies? Does it alter the functioning of democratic governments? Does this kind of concentration of capital reshape the accountability relation between governments and their people which have operated through electoral politics? In brief, does it affect national sovereignty? It does. Elsewhere (1996: ch. 2) I have examined the mechanisms through which the global capital market actually exercises its disciplining function on national governments and pressures them to become accountable to the logic of these markets.

Here I want to make just two observations. One is that national states have participated in its formation and implementation – a subject I have addressed elsewhere (Sassen, 1999a). There is a consensus among states to further the interests of this type of economic globalization (see Mittelman, 1996; Panitch, 1996). Second, there are what have been called the implicit ground rules of our legal system – matter which has not been formalized into rules of prohibition or permission, and constitutes a de facto set of rules of permission.[22] The ground rules on which economic globalization is proceeding contain far more permissions than have been formalized in explicit rules of permission and prohibition. Private firms in international finance, accounting and law, the new private standards for international accounting and financial reporting, and supra-national organizations such as the WTO, all play strategic non-government-centered governance functions.

The embeddedness of digital networks

It is significant that, although in some ways the power of these financial digital networks rests on a kind of distributed power, i.e. millions of investors and their millions of decisions, it ends up as concentrated power. The trajectory followed by what begins as a form of distributed power may assume many forms, in this case one radically different from that of the Internet. It signals the possibility that digital network power is not inherently distributive. Intervening mechanisms can reshape its organization. To keep it as a form of distributed power requires that it be embedded in a particular kind of structure.

In addition to being embedded in some of the technical features and standards of the hardware and software, digital space, whether private or public, is partly embedded in actual societal structures and power dynamics. Its topography weaves in and out of non-electronic space. In the case of private digital space, this feature carries enormous implications for theory, for the results of the digitalization of economic activity and for the conditions in which governments and citizens can act on this new electronic world of the economy and power. The embeddedness of private economic electronic space entails the formation of massive concentrations of infrastructure, not only worldwide dispersal, and a complex interaction between conventional communications infrastructure and digitalization. The notion of 'global cities' captures this particular embeddedness of global finance in actual financial centers.[23]

There is no purely digital economy and no completely virtual corporation. This means that power, contestation, inequality, in brief, hierarchy, inscribe electronic space. And although the digitalized portions of these industries, particularly finance, have the capacity to subvert the established hierarchies, new hierarchies are being formed, born out of the existing material conditions underlying power and the new conditions created by digital space.

Conclusion

The Internet is only one portion of the vast new world of digital space. If we are going to consider issues of sovereignty and democracy, then we must ask a critical question about what actors are gaining influence under conditions of digitization and whose claims are gaining legitimacy. For instance, it could be argued (and it is my argument) that private digital space has had a far sharper impact on questions of sovereignty than the Internet. The globalization and digitization of financial markets have made these markets a powerful presence. Indeed, the logic of the global capital markets is today not merely a condition of

raw power but one with normative potential. The logic of these markets has contributed to the elaboration of a set of criteria for what is proper government conduct on the economy. This new power of the financial markets is partly a consequence of the orders of magnitude they have reached, in good part through their digitalization and the fact that they are globally integrated, two conditions that are mutually reinforcing. The capacity of these markets to affect existing meanings of sovereignty is considerable and, in my view, thus far has been greater than that of the Internet.

When it comes to the Internet's capacity to undermine state authority and the state's capacity to regulate the Internet, two issues stand out in my reading. One is that the state has instruments through which it can exercise a certain kind of authority, especially through the venue of technical standards in the hardware and software, through the protection of property rights and, quite likely, through some of the features of the Internet addressing system and domain registry. The second is that much of the work of developing the instruments through which the state can exercise this authority is dominated by a limited number of countries, and, in some aspects, largely by the US, certainly until recently. This leaves most states in the world in the position of having to implement and enforce standards and property rights developed elsewhere if various digital networks in their countries are going to be connected to the Internet, which they mostly are already today.

The greatest challenge comes from the lack of accountability built into many of the capabilities that can be deployed by powerful actors, be they private or governmental, in the pursuit of their interests. This gives such unaccountable actors the power to shape potentially key features of Internet use and access. In the case of private actors, this brings up the question of which actors can claim legitimacy for their interests (e.g. in 'cybersquatting'), and in the case of governments, it raises the issue of ensuring public scrutiny of government actions. There are strong parallels here with some of the challenges for accountability raised by the growth of economic globalization and the ascendance of the so-called competitive state.

Notes

This is based on a larger project on 'Governance and Accountability in a Global Economy' (Department of Sociology, University of Chicago, on file with author).

1 A good example in the legal scholarship is the recent special issue of the *Indiana Journal for Global Legal Studies*.
2 The Internet is a dynamic condition subject to a variety of pressures. In earlier articles I have discussed how, notwithstanding its brief history, the Internet can alread be thought of as having had three phases (Sassen, 1999c, 2000b). To this I would add that it is now entering a fourth phase, characterized by the privatizing of much of the backbone and a development of software aimed at protecting private property, including intellectual, rights and verification and billing. In the same articles I also discussed the different types of interpretation of the Internet and its positive and negative potentials, e.g. Utopian and dystopian perspectives.
3 There are capabilities in the hardware that are not utilized by the software that is being designed. In that regard, the software is truly the domain for examining use and applications. A broader concept is that of the architecture of the Internet, which includes all the protocols and other features that make the system work. But these are embedded in the software as well. Operationally, when researching the changes one might detect in the features of the Internet, I use the types of software being produced as an indicator of these changes.
4 This saves companies the cost of private computer networks, with the requisite staffing and servicing, and the cost of frame relay connections or the costs of using intermediaries for firm-to-firm transactions.

5 An additional issue, one which I am not referring to here, is the privatization of infrastructure that has also taken place over the last two years (see Sassen, 1998a: ch. 9). Since the mid-1990s the backbone has been privatized where before it was financed by the US government, that is to say, taxpayers. This in turn changes the discussion of cyberspace as a public space, but only partly: it can remain public even if there is a fee to be paid for access. For a resource to be public it need not necessarily be free.

6 Lessig labels the architecture of the Internet 'code' and he means by this the software and hardware that constitutes it and determines how people interact or exist in this space.

7 Elsewhere I have made a similar argument using the notion of the emergence of cybersegmentations (see e.g. Sassen, 1999c, 2000b).

8 See for instance the March 1999 Next Five Minutes meetings in Amsterdam and Rotterdam, especially the technical workshops, and the Wizards of OS meeting in Berlin (July 1999). For reports on these and other such initiatives see Nettime (continuous online reporting) and ADILKNO (1998).

9 For an elaboration of this issue of representation and a new literature that addresses it see Sassen (1999c, 2000b).

10 Several authors have examined the possibility of enhancing democratic practices through the formation of communities on the Net and the possible role of governments in supporting them (Nettime, 1997; ADILKNO, 1998; Calabrese and Borchert, 1996; Calabrese and Burgelman, 1999). See also my review of various web sites of this type in *Artforum* (Sassen, 1998b: 30).

11 There are also more specific issues that may affect the regulation of particular forms of digital activity through a focus on infrastructure. There are different types of infrastructure for different types of digital activities, for instance, financial markets versus consumer wireless phones. This is a subject I have elaborated elsewhere (see 'The State and the Global City' in Sassen, 1998a).

12 For the most extreme version of this representation see John Perry Barlow's 'Declaration of Independence of Cyberspace'.

13 One could consider the community of scientists who have worked on making the Net workable and who have had to reach many agreements on a broad range of technical matters, as a sort of informal central 'authority'. In most other cultural settings they would probably have become a formal, recognizable body – with, one might add, considerable power. There is an interesting sociology here.

14 This is but one of at least three separate regulatory frameworks that have been drafted and debated.

15 With the growth of business interest in the Net, the de facto authority of the early pioneers of the Net and their logic for assigning addresses began to be criticized. For instance, firms found that their names had already been assigned to other parties and that there was little they could do; the whole idea of brandnames and intellectual property rights over a name was not part of the early Net culture.

16 The distinctions noted here follow Pare's classification and research on the subject (2000: ch. 3).

17 Pare (2000) calls for and develops another kind of approach in the study of these questions of governance and coordination. He argues that an emphasis on end-results and on optimal governance strategies typical of the various authors briefly discussed here produces analytical blind spots. A crucial issue is the need to understand the dynamic relationship that exists between the institutional forms delivering technology and the network structures that emerge over time (see also Lessig, 1999).

18 This bundle of issues, both as they pertain to the Internet and to the global economy, are part of the larger project on 'Governance and Accountability in a Global Economy' (Department of Sociology, University of Chicago, on file with the author).

19 The growing sector of direct online investment often uses the Internet. It is mostly retail and represents a minor share of the overall global financial market. Even factoring in its expected tripling in value over the next three or four years will not give it the type of power of the global financial market I am discussing here.

20 There is an emerging literature on this. I have discussed this issue and some of the literature in Sassen (1996: ch. 2).

21 For instance figures show that countries, with high savings have high domestic investment. Most savings are still invested in the domestic economy. Only 10 percent of the assets of the world's 500 largest institutional portfolios are invested in foreign assets. Some argue that a more integrated capital market would raise this level significantly and hence raise the vulnerability to and dependence on the capital markets. It should be noted that extrapolating the potential for growth from the current level of 10 percent may be somewhat dubious; it may not reflect the potential for capital mobility across borders or a variety of other factors which may be keeping managers from using the option of cross-border investments. This may well be an under-used option and it may remain that way, no matter what the actual cross-border capacities in the system.

22 See Duncan Kennedy (1993); cf. the argument that these ground rules in the case of the US contain rules of permission that strengthen the power of employers over workers, or that allow for a level in the concentration of wealth under the aegis of the protection of property rights that is not necessary to that extent in order to ensure the protection of property rights.

23 I examine some of these issues in 'Global Financial Centers' (Sassen, 1999b). The growth of electronic trading and electronic network alliances between major financial centers is allowing us to see the particular way in which digitalized markets are partly embedded in these vast concentrations of material resources and human talents which financial centers are (see also Sassen, 2000a).

References

ADILKNO (1998) *The Media Archive. World Edition*. New York: Autonomedia, and Amsterdam: ADILKNO.

Aspen Institute (1998) *The Global Advance of Electronic Commerce: Reinventing Markets, Management and National Sovereignty*, Report of the Sixth Annual Aspen Institute Roundtable on Information Technology, Aspen, CO, 21–23 August 1997, David Bollier Rapporteur. Washington, DC: Aspen Institute, Communications and Society Program.

Barlow, Jon Perry (1997) 'Declaration of Independence of Cyberspace', in Edeltraud Stiftinger and Edward Strasser (eds) *Binary Myths: Cyberspace – The Renaissance of Lost Emotions*. Vienna: Zukunfts- und Kulturwerkstatte (in English and German).

Biersteker, Thomas J., Rodney Bruce Hall and Craig N. Murphy (eds) (2000) *Private Authority and Global Governance* (forthcoming).

Boyle, James (1997) *Foucault in Cyberspace: Surveillance, Sovereignty, and Hard-Wired Censors*. Washington: College of Law, American University. [http://www.wcl.american.edu/pub/faculty/boyle/foucault.htm].

Calabrese, Andrew and Mark Borchert (1996) 'Prospects for Electronic Democracy in the United States: Rethinking Communication and Social Policy', *Media, Culture & Society* 18: 249–68.

Calabrese, Andrew and Jean-Claude Burgelman (eds) (1999) *Communication, Citizenship and Social Policy*. New York: Rowman and Littlefield.

Davies, Diana (ed.) (1999) 'Part IV: Scholarly Controversy: Chaos and Governance', in *Political Power and Social Theory*, Vol. 13. Stamford, CT: JAI Press.

Dezalay, Yves and Bryant Garth (1996) *Dealing in Virtue: International Commercial Arbitration and the Construction of a Transnational Legal Order*. Chicago, IL: University of Chicago Press.

Foster, William A. (1996) 'Registering the Domain Name System: An Exercise in Global Decision Making', paper presented at the Coordination and Administration of the Internet Workshop, Kennedy School of Government, Harvard University, 8–10 September [http://ksgwww.harvard.edu/iip/cai/foster.html].

Gillett, Sharon Eisner and Mitchell Kapor (1996) 'The Self-Governing Internet: Coordination by Design', paper presented at the Coordination and Administration of the Internet Workshop, Kennedy School of Government, Harvard University, 8–10 September [http://ccs.mit.edu/ccswpl97.html].

Gould, Mark (1996) 'Governance of the Internet – A UK Perspective', paper presented at the Coordination and Administration of the Internet Workshop, Kennedy School of Government, Harvard University, 8–10 September [http://aranea.law.bris.ac.uk/HarvardFinal.html].

Indiana Journal of Global Legal Studies (1999) Special Issue: *The Internet and Sovereignty* Spring.

Johnson, David R. and David G. Post (1996) 'Law and Borders – The Rise of Law in Cyberspace', *Stanford Law Review* 48(1367) [http://www.cli.org/X0025_LBFIN.html].

Kennedy, Duncan (1993) 'The Stakes of Law, or Hale and Foucault', pp. 83–125 in *Sexy Dressing Etc.: Essays on the Power and Politics of Cultural Identity*. Cambridge, MA: Harvard University Press.

Lessig, Lawrence (1999) *Code and Other Laws of Cyberspace*. New York: Basic Books.

Mathiason, John R. and Charles C. Kuhlman (1998) 'International Public Regulation of the Internet: Who Will Give You Your Domain Name?', paper presented at the Internet in a Post-Westphalian Order, at Minneapolis [http://www.intlmgt.com/pastprojects/domain.html].

Mittelman, James (ed.) (1996) *Globalization: Critical Reflections. Yearbook of International Political Economy* vol. 9. Boulder, CO: Lynne Rienner Publishers.

Mueller, Milton (1998) 'The "Governance" Debacle: How the Ideal of Internetworking Got Buried by Polities', paper presented at INET 98, Geneva, Switzerland [http://www.isoc.org/inet98/proceedings/a/5a_l.html].

Nettime (1997) *Net Critique*, compiled by Geert Lovink and Pit Schultz. Berlin: Edition ID-ARchiv [http://mediafilter.org/nettime].

Panitch, Leo (1996) 'Rethinking the Role of the State in an Era of Globalization', in James Mittelman (ed.) *Globalization: Critical Reflections. Yearbook of International Political Economy* vol. 9. Boulder, CO: Lynne Rienner Publishers.

Pare, Daniel J. (2000) 'Internet Governance in Transition: Just Who is the Master of this Domain?', unpublished PhD dissertation, Science and Technology Programme, University of Sussex (on file with author).

Perritt, Jr, Henry H. (1999) 'International Administrative Law for the Internet: Mechanisms of Accountability', *Administrative Law Review* 51(3): 871–900.

Post, David G. (1995) 'Anarchy, State, and the Internet: An Essay on Law-Making in Cyberspace', *Journal of Online Law* [http://www.cli.org/Dpost/X0023_ANARCHY.html].

Reidenberg, Joel R. (1998) 'Lex Informatica: The Formulation of Information Policy Rules Through Technology', *Texas Law Review* 76(553) [http://www.epic.org/misc/gulc/materials/reidenberg2.html].

Sassen, Saskia (1996) *Losing Control? Sovereignty in an Age of Globalization*, the 1995 Columbia University Leonard Hastings Schoff Memorial Lectures. New York: Columbia University Press.

Sassen, Saskia (1998a) *Globalization and Its Discontents*. New York: New Press.

Sassen, Saskia (1998b) *Artforum* Nov.: 30.

Sassen, Saskia (1999a) 'Embedding the Global in the National: Implications for the Role of the State', in David Smith, D. Solinger and S. Topik (eds) *States and Sovereignty in the Global Economy*. London: Routledge.

Sassen, Saskia (1999b) 'Global Financial Centers', *Foreign Affairs* 78(1): 75–87.

Sassen, Saskia (1999c) 'Digital Networks and Power', pp. 49–63 in M. Featherstone and S. Lash (eds) *Spaces of Culture: City, Nation, World*. London: Sage.

Sassen, Saskia (2000a) *The Global City: New York, London, Tokyo* (new fully updated edition). Princeton, NJ: Princeton University Press.

Sassen, Saskia (2000b) 'Spatialities and Temporalities of the Global: Elements for a Theorization', *Public Culture* 12(1).

Smith, David, D. Solinger and S. Topik (eds) (1999) *States and Sovereignty in the Global Economy*. London: Routledge.

Tim Jordan

TECHNOPOWER AND ITS CYBERFUTURES

A CARTOGRAPHY OF THE POWERS THAT CIRCULATE through virtual lives can now be drawn; it is a chart of the forces that pattern the politics, technology and culture of virtual societies. Such a theory of cyberpower provides an insight into cyberspace because it allows us to understand underlying pressures on virtual worlds. To examine these forces two forms of cyberpower need to be defined: cyberpower of the individual and of the social.[1] Both of these types of power allow an understanding of the interrelations of virtual individuals, societies, technopowers and communities, interrelations that result in the mutual subjection of digital grassroots and digital elites. Once these definitions have been made, a case study of the hacking of RealJukebox will allow a concrete investigation of the effects of cyberpowers.

Power is central to these discussions but is itself a complex and difficult concept, too extensive to be reasonably examined here without turning from life in cyberspace to definitions of power. To explore power in cyberspace, a number of particular, well-established theories of power will be drawn on. The interpretation of power at play in the theoretical background of this chapter has been drawn principally from work by Max Weber, Barry Barnes and Michel Foucault, though it is Weber and Foucault who are directly relevant to what follows. Weber provides a model of power as the possession of individuals that is particularly useful in understanding cyberpower of the individual. Foucault sees power as strategies that spread into people's day-to-day interactions giving rise to forms of domination and is particularly useful in understanding cyberpower of the social.[2] If these theories share something it is that understanding power helps us understand people's abilities to act in the world, whether it be a Weberian analysis of the powers individuals can use or a Foucaldian understanding of the powers people are caught within. It is such understandings of the elusive concept 'power' that are taken forward into cyberspace in this chapter, though they always remain in the background and subordinate to the task of defining cyberpower in the context of 'really existing' cyberspace. To begin this analysis it is useful to start with the mundane, everyday and universal experience of those who enter cyberspace – logging-on.

Individuals, identity and hierarchy

We habitually begin our journeys into cyberspace as individuals. In front of a computer screen, reading the glowing words we confront our virtual singularity before building a sense of others. There is a double sense of individuality here. Firstly, people must simply connect to cyberspace by logging-on, almost certainly involving someone entering their online name and their secret, personal password to be rewarded with their little home in cyberspace (consisting of elements like their e-mail or list of favourite websites). Secondly, moving from this little home to other virtual spaces usually involves both logging-on again and again within cyberspace and further moments of self-definition; for example, choosing an online name, choosing a self-description or outlining a biography. The experience of logging-on occurs not only when entering cyberspace but is repeated across cyberspace as we enter name, password and personality and it produces a sense of being an individual. This individuality allows cyberpower to be understood as a range of powers individuals can use. Cyberspace seems to allow different actions to be taken virtually than are possible in offline life. These actions can be defined around two poles: identity fluidity and renovated hierarchies. These will be briefly explored in turn.

Identity fluidity summarizes the processes through which online identities are constructed. It remains true that in all sorts of online forums an individual's offline identity cannot be known with any certainty. The reasonably well-documented instance of a conservative Jewish, teetotal, drug-fearing, low-key, sexually awkward, heterosexual, male, abled, psychiatrist convincingly posing as an atheistic, sexually predatory, dope-smoking, hard-drinking, flamboyant, bisexual, female, disabled, neuropsychologist underlines the potential disconnection between online and offline identities.[3] However, it would also be a misconception to conclude identity disappears online. Identities that constrain, define and categorize exist online, but are made with different resources to offline identities. Broadly online identities are constructed out of two types of indicator: identifiers and style. Neither of these mandate that someone's offline identity must reappear within their online identity, though there are many ways in which a repressed offline identity may return.

Identifiers are the addresses, names, self-descriptions, and more that designate contributions to cyberspace. E-mail addresses are the most common form of identifier. For example, imagine receiving, one morning, e-mails from the following two addresses: dark.knight@hacktic.nl and billg@microsoft.com. Before you read the e-mail, certain preconceptions will form. Perhaps you know that the Hack Tic is a group of Dutch hackers, as confirmed by the .nl referring to the Netherlands, 'billg' from a company called Microsoft, might indicate the richest man in the world, Bill Gates of Microsoft Corporation. The content of any message from such addresses will most likely be understood differently depending on the reading of the e-mail identifier, even if an identical message were received from both sources. Identifiers include the signatures people place at the bottom of their e-mail, the often lengthy self-descriptions Muds (realtime, text-based, multi-player online environments) and some discussion groups allow, the various names we might choose or have imposed on us for various lists, newsgroups, and so on, and the visual avatars being developed for three-dimensional virtual places. All these are the virtual equivalent of seeing someone's face and being able to think male or female, black or white, old or young. The second type of resource for identity is style. Anybody who participates repeatedly within a place in cyberspace will eventually come to have their style recognized, even become recognizable from their style. Groups also provide certain stylistic resources. Abbreviations are common in the typed world of online discussions, for example, btw for 'by the way', and sometimes generate their own specific abbreviations. Donath notes a newsgroup that

discusses pregnancy in which 'onna' stands for 'oh no not again'.[4] These abbreviations establish both individual and group styles, marking those who do not use or understand the abbreviations as outsiders.

Online identities are constructed and judged through a number of markers that replace offline resources. Where offline we might look at someone's face and think 'old', online we look at their address and think '.edu – student or teacher?' Where we might examine clothes, online we look at what is written and learn a personality from a style. Identity is both present in cyberspace and is different to non-virtual space; the only mistake here would be to assume that the powers around offline identities are absent online, instead of identifying the particular forms of identity which exist in cyberspace and through which cyberpower takes hold.

The second component of online life that appears obvious to the individual online is that virtuality alters hierarchies. Three ways in which hierarchies are affected can be noted: identity, many-to-many communication and anti-censorship. The first, identity, is a key building block in offline hierarchies, but if no one knows your identity then you cannot be placed in a hierarchy on that basis. This seems undoubtedly true, and to the extent that someone keeps their offline identity separate from their online then offline hierarchies based on identity can be dislocated. However, identity does not disappear online but is remade according to the rules of identifiers and styles, as just discussed. This means that specifically online hierarchies can be expected, such as that noted by Branwyn who was told by an online sex enthusiast that 'In compu-sex, being able to type fast or write well is equivalent to having great legs or a tight butt in the real world.'[5] All the various resources available for the construction of online identities also function to create online hierarchies. We can be reasonably certain that many may treat an e-mail from billg@microsoft.com as being of different importance to many other e-mails we receive. The second way hierarchies are dislocated is through many-to-many communication and its ability to include people in decision-making. The inclusion of people in offline decision-making is limited by the need to meet together, to speak one at a time, to overcome the hierarchies of identity, and so on. The work of Sproull and Kiesler is fundamental here in establishing that electronically mediated discussions have characteristics distinct from face-to-face discussions, in that they are more inclusive, more equal, take longer to reach decision and are more prone to people abusing each other.[6] The third way offline hierarchies are undermined in online life is by the censorship-evading properties of the Internet. Information that governments or courts might have restricted is difficult to hold back once it is free in cyberspace. The global nature of cyberspace is important here, as it only requires information to be published in one country connected to the Net for that information to be let loose in cyberspace. Similarly, offline hierarchies can be undermined through broader access to information. For example, in the UK in recent years there has been a debate over the ability of patients to research their illness and treatment over the Internet and whether this undermines the authority of physicians. Without entering into this particular debate, we can note it is one possible way that control of information might be undermined through cyberspatial communication.

If identity fluidity and renovated hierarchies constitute cyberpower from the viewpoint of the individual then power at this level must be understood as the possession of individuals. If we pause and reflect on what cyberspace seems to offer us as individuals, then the ability to remake our identity and to renovate the hierarchies we are caught within make cyberspace appear as a place that offers various powers. These powers can be used by individuals to take various actions they had not previously been able to. For example, patients may gain information that enables them to understand and perhaps contest the treatment their doctor is recommending. We can now understand the enormous hopes and commitment

cyberspace sometimes draws from people, because viewed as a space based on individuals the main effects of cyberspace seem to be to offer various powers to act. It is from this perspective that the most hopeful visions of cyberspace derive. It is also a perspective based on the repeated and ongoing experience everyone has that entering cyberspace marks us as an individual; it is not a perspective that is simply naive, it is one reinforced by the daily experience of millions who have virtual lives.

Technopower: individuals to collectives (and back)

Many people report a transformation[7] in their perception of online life. From an initial combination of bewilderment and scepticism many come to accept the online world as normal. With stable online identities people begin to have ongoing conversations, to meet the same others and learn their peculiarities. The particular rules of different corners of cyberspace become clear and normal, but then it is often realized that the individual is no longer the final cause of online life, for communities have emerged. The transformation is not magical but sociological. Even communities that begin by assuming the sovereign individual is primary soon come to realize that collective responsibilities and rules appear, created by many and over which no one person has control. This distinction of the two forms of cyberpower (individual and social) is not a simple opposition between individuals and collectives but an inversion of the relationship between them. In cyberpower of the individual, individuals possessing cyberpowers produce collective bodies and individuals are here understood as the fundamental cause and constituent of community in cyberspace. In opposition to this, what is often realized is that collectives create the conditions under which certain forms of individuality become possible. At both levels of cyberpower virtual individuals and virtual communities exist, but their relations are reversed. Cyberpower of the social derives from the belief that individuals have their possible actions defined by certain social conditions.

Any action taken in cyberspace, from buying and selling stock to changing gender in a Mud, occurs only because we have entered a space created and maintained by various technologies – Internet providers, routers, personal computers, optic fibres, modems, and so on. Communities that can be understood as providing the basis for virtual individuals are constituted in-their-essence by technologies. For example, the nature of Usenet communities are primarily defined by the fact that Usenet technologies create discussion groups made out of posts. Different forms of individuality are possible in Muds, such as building virtual homes, and on the Web, such as graphics. All these powers that cyberspace offers the individual are based on communally created and experienced technologies. If you assume cyberspace is the realm of societies and collectives, then a form of technopower now becomes visible.

Technopower[8] is the constant shifting between objects that appear as neutral – keyboards, monitors, e-mail programmes – and the social or ethical values embedded in these objects by their designers, producers and administrators. Each questions the other. If e-mail software allows many-to-many communication, we can ask why?, who made software do this?, what results from this?, and in asking we open up the inhumane appearance of the programme to find humans who embedded their ethics or ideals in lines of software code. Technopower forms the social structures of cyberspace through a constant shape-shifting between seemingly inert technology and startlingly alive values. It is constituted like an infinite series of Chinese boxes, each opening onto another and each layer composed of the same elements, inert-seeming technology and alive-seeming values. Technopower is also

seen in offline life. From car engines (why are they made so powerful?) to ice cream, we live surrounded by technological artefacts that leak social values. The difference between online and offline here is that online social forms are constituted fundamentally, if not totally, from technopowers. When we adopt the perspective of the social in cyberspace, we lose sight of individuals and their powers and bring into focus technopowers that create the possibility that cyberspace exists in the first place. Dead technology always opens on the living, just as it is the living who create technology. At the level of the social, cyberpower is a technopower. However, there is more to say, as a particular direction in virtual technopower can be defined.

The technopower spiral and information overload

Information is practically endless in cyberspace and this creates an abstract need for control of information that can never in fact be satisfied, though the provision of ever more complex technologies at times dulls informational hunger. What can be called the technopower spiral is constituted out of three moments: information overload, mastering overload with a tool, and the recurrence of information overload. First, there is the ongoing and repeated sensation of information overload in cyberspace. Cyberspace is the most extreme example of a general acceleration in the production and circulation of information.[9] For example, cyberspace encourages people to produce information rather than passively consume it, and information moves faster and in greater quantities in cyberspace than in other spaces. Most powerfully, cyberspace releases information from material manifestations that restrict its flow and increase its price. This constant increase in the sheer amount and speed of information leads many to experience information overload. How many of us know the feeling of signing up to an e-mail list and then finding that the constant flow of e-mails means messages have to be deleted before being read and the group resigned from? How many of us search the Web for a particular topic only to end up with megabytes of files or piles of printouts destined never to be read because there is simply too much? Cyberspace increases information's velocity and size to such an extent that information overload is a recurrent experience of virtual lives.

The second moment in the spiral in technopower is the attempt to master whichever moment of information overload has occurred. Typically, information overload is addressed with new technologies. Various solutions to the glut of information that cyberspace produces have been created and Maes lists intelligent agents that schedule meetings, filter Usenet news and recommend books, music and other entertainment.[10] All these share a number of traits. Firstly, they interpose some moment of technology between user and information. This is always a moment in which technopower is articulated because some technological tool, appearing as a thing yet operating according to values, is the means of controlling information overload. Secondly, the devices themselves produce information problems because they need to be installed and used properly. No matter how sophisticated a device the user will need to understand how to manage the device or risk being controlled by it. Thirdly, new tools nearly always make cyberspace easier to use, tending to create a new form of overload. The goal of many tools is to reduce the amount of information received by focusing or managing it in some automated way. However, the very success of any such tool means the production of more information because the tool makes gaining information more efficient and there is always more information waiting out there in the near-infinite reaches of cyberspace. Problems of information overload tend to re-emerge with the devices that become essential to information management themselves producing

too much information. For example, search engines such as Yahoo! or Excite tried to meet the need to make the Web's resources accessible. But now these engines themselves groan under the weight of cyberspace's possibilities, often cataloguing only a small proportion of the total information out there and requiring several searches on different engines. To meet this second-order problem of information overload, meta-search engines have emerged that simultaneously search several other search engines. In this example, the same problem, too much or too poorly organized information, is met twice by technological tools: first search engines and second meta-search engines.

The technopower spiral is completed and reinitiated with the emergence of a new problem of information overload. This spiral of overload, tools, more overload and more tools is fundamental to technopower in cyberspace. It means that as individuals pursue their cyberpowers, they constantly demand more tools to master the seemingly infinite amount of information that confronts them. Technopowers are constantly elaborated to meet the demand to control and manage information in cyberspace, thereby ensuring that cyberspace becomes more and more technologically complex. This, in turn, means that the ability to act in cyberspace is constantly elaborated by those who have technological expertise. The digital elite can now be defined as those controlling the expertise to manage and create the virtual possibilities others rely on. Two broad components of this digital elite are those who utilize expertise themselves, such as hackers who rely on their knowledge and skills to, manipulate cyberspace's fabric, and those who manage many people's expertise, such as corporate leaders like Bill Gates and Windows or collective efforts like Linus Torvalds and Linux who coordinate large groups of experts to create important substructures to online life. The digital elite controls the fabric of cyberspace and the technopower spiral ensures they are increasingly in control of an ever more complex fabric.

Cyberpower of the social is a power of domination, through which an elite based on expertise in the technologies that create cyberspace increasingly gain freedom of action, while individual users increasingly rely on forms of technology they have less and less chance of controlling. Ultimately, the direction of technopower in cyberspace is toward greater elaboration of technological tools to more people who have less ability to understand those tools. If cyberpower of the individual was a hopeful form of power, pointing to the increasing range of actions cyberspace can help an individual to take, then cyberpower of the social is pessimistic because it reveals networks of interactions that increase the ability to act of an expertise-based elite.

Grassroots and elites: the case of RealPlayer

The connection between individual and social forms of cyberpower is mutually conditioning; it is an embrace of reciprocated subjection. Individuals seek to enhance and protect their powers in cyberspace, often dealing with problems of information overload that threaten to overwhelm them. The resultant demand is for further articulations of technopower in the form of new tools that extend or maintain individuals' powers. But these tools build the power of the digital elite by complicating and extending the elite's control over the fabric of cyberspace. This interaction can be explored through a brief case study of the 1999 hacking of Real Networks' RealJukebox.

Being able to use video or radio over the Internet extends individuals' powers. It allows both an extension of consumerism, such as being able to listen to UK radio stations in Australia, and a more profound shift in which being able to set up a radio station becomes much easier. Here a potential change in power from radio, and perhaps television, being

open not only to the well financed but to more grassroots development becomes possible. To support this development a whole range of new tools have emerged, a whole new layer of technopower has been elaborated. One of the most widespread is RealPlayer, a software package that allows access to video and radio over the Internet and which is fundamentally free. A related Real product is RealJukebox that facilitates playing music on a PC or over the Internet. We see here an extension of individuals' powers in their new abilities to hear live radio, to watch live or recorded events or to listen to recorded sounds and to produce and broadcast, such material themselves more easily.

But in 1999 it was revealed that Real's tools were doing more than they claimed. Richard Smith is a technologist who explores privacy issues on the Internet. Looking for new material for speeches he was giving, Smith turned to rumours about Real and privacy. He analysed RealJukebox to find that it recorded and sent to Real information on a daily basis. The information included which songs were being recorded on a user's hard drive, which MP3 player they might own, which songs were being played on their PC's CD drive and which songs were being downloaded from the Internet. In all cases, information on frequency of use was also recorded. In addition, Smith noticed an encrypted message and he had a friend decrypt it, to find it was a unique identifying number. This number was allocated by Real to a person when they completed the compulsory registration that allowed them to download a free copy of RealJukebox, including details such as name, address and e-mail address. All the information that RealJukebox was secretly sending was thus attached to a number that connected that information to an identifiable individual. Real was illicitly gaining detailed consumer profiles and undermining the privacy of every individual reliant on RealJukebox and it turned out that a similar system was in place in the more widespread RealPlayer.[11]

Such profiling is a powerful and valuable tool, allowing the identification of individuals and their tastes. The individual still had access to the capabilities of RealPlayer and RealJukebox, but within these tools a part of the digital elite was undermining their privacy and targeting their desires. We see here the simultaneous development of individual power along with domination by digital elites. The embedding of social values in technological tools by elites, such as Real's desire for surveillance, goes hand in hand with individuals gaining greater abilities to act. A further example, again from Richard Smith, is that much of Microsoft's software puts personal information in 'metadata' in documents that the user of the software never sees or is alerted to. Smith reversed this relationship by investigating Microsoft's 1999 Annual Report to find that it had been written on an Apple Macintosh G3 using Word98 for Macintosh. Microsoft's own documents demonstrated that they prepared one of their key annual documents using their rival's operating system. Smith whimsically demonstrated another invasion of privacy embedded in technological tools by the digital elite.[12]

One key trend within cyberpower is the ongoing battle between digital elites and virtual individuals. It is a trend in which both demand changes from each other and fuel each other's powers, a trend in which the tools that the grassroots demand simultaneously offer new capabilities for action while undermining other facets of online life. It is not just that the two forms of power feed into each other but that they often simultaneously contradict each other. Further elaborations of technopower can be expected as elites and individuals attempt to exploit each other, but the long-term probability is that each elaboration will leave cyberspace defined by ever more complex technologies and the digital elite ever more in charge of the fabric of cyberspace.

Cyberpower

Cyberpower aims not at the immediately obvious forms of politics, culture and authority that course through cyberspace but at defining the forces that condition and limit these. Two types of cyberpower, the individual and the social, have been explored in this chapter. Interrelations between these two powers point towards growing control over the fabric of cyberspace by a digital elite, that at the same time must provide more and more possibilities for action for individuals. The control the elite gains is over the technologies that allow cyberspace to exist, and to define what it is possible to do in cyberspace. Yet this control is also affected by the demands and powers of virtual individuals. The case of RealJukebox demonstrates the way technopower is constitutive of the future of life in cyberspace. It is only when seemingly asocial tools are opened up to reveal their embedded values that the new forms of domination of digital elites can be found and, in some cases, turned back against them. The restless, constant change and growth in cyberspace is conditioned by these interrelations of power. Life in cyberspace is suffused with forms of cyberpower.

Notes

1 A third form of power, that of the imaginary, is put to one side in this chapter in order to focus on the relationship between cyberpowers and cyberfutures. See Tim Jordan, *Cyberpower: The Culture and Politics of Cyberspace and the Internet*, London: Routledge, 1999.

2 Ibid., pp. 7–19.

3 A. R. Stone, *The War of Desire and Technology at the Close of the Mechanical Age*, Cambridge, MA: The MIT Press, 1995; Sherry Turkle, *The Second Self: Computers and the Human Spirit*, London: Granada, 1995.

4 Judith Donath, 'Identity and deception in the virtual community', in Peter Kollock and Marc Smith (eds), *Communities in Cyberspace*, London: Routledge, 1999: 29–59.

5 Gareth Branwyn, 'Compu-sex: erotica for cybernauts', in Mark Dery (ed.), *Flame Wars: the Discourse of Cyberculture*, Raleigh, NC: Duke University Press, 1995: 779–91.

6 Lee Sproull and Sara Kiesler, 'Computers, networks and work', in Linda Harasim (ed.), *Global Networks: Computers and International Communication*, Cambridge, MA: The MIT Press, 1993:105–20.

7 I am telling this story as a shift from individual to collective; however, it is not so much the direction of this change from individual to communal that is essential to my argument, as the recognition that there are at least two distinct types of power in cyberspace.

8 This account of technopower is heavily indebted to both the sociology of scientific knowledge and technology and to politicized readings of epistemology.

9 David Shenk, *Data Smog: Surviving the Information Age*, San Francisco, CA: Harper-Edge, 1997.

10 Patti Maes, 'Agents that Reduce Work and Information Overload' (available at pattie.www.media. mit.edu/people/pattie/CACM-94).

11 Leander Kahney, 'RealNetworks probe begins', *Wired News*, 1/11/99 (available at www.wired. com/news) and 'The Internet's "Living Treasure"', *Wired News*, 2/11/99 (available at www. wired.com/news); Richard Smith, 'The RealJukeBox monitoring system' (available at www.tiac. net/users/smiths/privacy).

12 Richard Smith, 'Was the Microsoft 1999 Annual Report produced on a Macintosh?' (available at www.tiac.net/users/smiths/privacy). For broader issues of privacy see Simon Davies, *Big Brother: Britain's Web of Surveillance and the New Technological Order*, London: Macmillan, 1996 and David Lyon, *The Electronic Eye: The Rise of the Surveillance Society*, Cambridge: Polity Press, 1994.

Paul A. Taylor

HACKERS – CYBERPUNKS OR MICROSERFS?

I got thinking about sin, or badness, or whatever you want to call it, and I realized that just as there are a limited number of consumer electronics we create as a species, there are also a limited number of sins that we can commit, too. So maybe that's why people are so interested in computer 'hackers' – because they've invented a new sin.

<div align="right">(Coupland 1995: 357)</div>

Introduction

HACKING IS AN INTRINSICALLY CONTENTIOUS area of investigation. The meaning of the term has evolved over time but is still applied somewhat variably to a complex mix of legal and illegal activities ranging from legitimate creative programming techniques to illicit lock-picking and manipulation of worldwide phone/computer systems.[1] In his seminal study *Hackers: Heroes of the Computer Revolution*, Levy (1984) describes three generations of hackers who exhibited to various degrees qualities associated with hacking's original connotation of playful ingenuity, an ingenuity epitomized by the earliest hackers who were the pioneering computer aficionados at MIT's laboratories in the 1950s and 1960s. These form Levy's first generation of hackers defined as those who were involved in the development of the earliest computer programming techniques. The second generation is defined as those involved in bringing computer hardware to the masses with the development of the earliest PCs. The third generation refers to the programmers who became the leading lights in the advent of computer games architecture. The phrase *hacker* is now predominantly used to describe an addition to Levy's schema: the fourth generation of hackers who illicitly access other people's computers.

This chapter seeks to highlight those elements of the first four generations of hackers that form the basis of the fictional representations of a putative fifth generation. The two

poles of the vestigial fifth generation are represented in the defining cyberpunk work *Neuromancer* (Gibson 1984) and the zeitgeist novel *Microserfs* (Coupland 1995), giving rise to this chapter's title: Hackers – cyberpunks or microserfs? These two contrasting portrayals illustrate the inherent ambivalence with which society confronts the issue of technological change: we seek to control it but fear being controlled by it instead. Both cyberpunk fiction and the real-life activity of hacking are shown to highlight two specific aspects of societal concerns over technology: first, computers are presented as an invasive force that continually threaten to dehumanize its would-be virtuosos, whilst second, control over the ultimate direction of computer technology developments has been subsumed to the requirements of the highly abstract and impersonal system of late capitalism.

Hacking fiction

Neuromancer (1984) is the seminal example of the recent genre of science-fiction known as cyberpunk. It depicts hackers in a futuristic guise as anarchic, mercenary and technically savvy mavericks who seek (with generally limited success) to reappropriate the technology of advanced capitalism for their own ends. *Microserfs* (1995) is a contemporary fictional analysis of the giant US computer firm Microsoft. It depicts hackers as gifted but 'geekish' and obsessive computer programmers. The frenetic pace of *Neuromancer* is allied with its setting in a dystopian urban milieu where both nature and humans are intimately connected to technology in various invasive forms. Overseeing such rapidly changing and technologically saturated environments are the impersonal zaibatsus, huge largely Japanese multinational conglomerates, one of which is ultimately found to be run by an artificial intelligence (AI) construct. *Microserfs* provides a more contemporary account of similar themes. The narrator obsessivly questions the relationship of himself and his fellow programmers to their bodies which are persistently conceived of in terms borrowed from computing. This merging of bodies and machines culminates at the end of the novel where the narrator's mother suffers a stroke and is kept alive by technologically complex life-support machines. It uses the particular working patterns prescribed by Microsoft to highlight more general technological issues. These include the effect technology has on our relationship to our bodies and the way it encourages subordinance to highly formalized systemic structures, whether they be in the microcosmic form of the code programmers produce, or the macrocosmic form of the larger corporate code which regulates the programmers' work (and to a large extent their private) lives.

Fear and hyperbole

> I'm coming close to believing that the computer is inherently anti-human – an invention of the devil.
>
> (Weizenbaum 1976: 125)

> In the hothouse atmosphere of media hype, our favorite nerds blossomed into mythic Hackers: a schizophrenic blend of dangerous criminal and geeky Robin Hood. Chalk it up to an increasingly bi-polar fear and fascination with the expanding computer culture.
>
> (Hawn 1996: 1)

Modern technological times can be described as increasingly vulnerable to a wide range of viral and other security-transgressing threats to social well-being.[2] Western society has recently experienced cyanide-laced Tylenol, glass shards in baby food, benzyne in mineral water, computer viruses, AIDS, chemical poisoning on the Tokyo subway, the millennium bug and repeated publicity describing the potential for widespread destruction to technological infrastructures from determined cyber-terrorists. Ironically, perceptions of what could be termed techno-vulnerability are often expressed with recourse to body-based forms of expression and they have arguably helped to fill the void left by the end of the Cold War and its associated fears of military threat from the Soviet Bloc:

> The form and content of more lurid stories like *Time*'s, infamous story, 'Invasion of the Data Snatches' (September 1988), fully displayed the continuity of the media scare with those historical fears about bodily invasion, individual and national, that are endemic to the paranoid style of American political culture [and] the paranoid, strategic mode of Defence Department rhetoric established during the Cold War. Each language repertoire is obsessed with hostile threats to bodily and technological immune systems; every event is a ballistic manoeuvre in the game of microbiological war, where the governing metaphors are indiscriminately drawn from cellular genetics and cybernetics alike.
>
> (Ross 1991: 76)

The breadth of such feelings of vulnerability is illustrated by the following excerpt from an edited collection of articles devoted to providing a predominantly left-wing critique of the values inherent in 'microcybernetic consumerism':

> The disturbing prospect is that opposition to the microcybernetic consumerist dictatorship will then find its only effective location deep underground, in the hands of zealots or fanatics who are content to destroy without bothering to dialogue. And microcybernetic technology is particularly vulnerable to just such a sort of opposition; as we have seen, hackers generally get caught only when they become brazen; and a determined band of computer nihilists, endowed with patience as well as skill, could even now be ensconced deep in the system, planting their bugs, worms and bombs.
>
> (Ravetz in Sardar and Ravetz 1996: 52)

Hacking has been subject to a large amount of hyperbole. The usual levels of media hype have been compounded by the fact that the activity relates, in the eyes of the public, to the recondite area of computing. Exacerbating the process still further is the anonymity and the non-physical nature of their computer intrusions. The combination of these factors makes a heady brew for those wishing to sensationalize the issue. Elements of the hacking community contribute their own brand of rhetoric to the mix with the adoption of colourfully threatening group names such as *The Legion of Doom, Bad Ass Mother Fuckers* and *Toxic Shock*. Pre-existing societal feelings of technological vulnerability may be exaggerated by the hype surrounding hacking but such hype itself merely reflects more deep-rooted fears about technological change in general.

Cyberpunk – technology hits the streets

A factor that has contributed to a general atmosphere of hyperbole in the public's perception of hacking has been its close association with the genre that has come to be known as

cyberpunk, the novel *Neuromancer* being its most famous example. The esoteric technical complexity of computer intrusion has found an expressive medium in this radical new genre. Gibson's work and the wider cyberpunk oeuvre has played a significant role in creating a cultural expression for the democratization of science and technology. Cyberpunk in its heyday sought to identify and then imaginatively fictinalize the pace and extent of the technological trends of the 1980s. Whereas 'traditional' science fiction (SF) tends to use time-frames projected far into the future, cyberpunk fiction has distinguished itself by reflecting much more closely contemporary concerns:

> The cyberpunks are perhaps the first SF generation to grow up not only within the literary tradition of science fiction but in a truly science-fictional world. For them, the techniques of classical 'hard SF' – extrapolation, technological literacy – are not just literary tools but an aid to daily life. They are a means of understanding, and highly valued.
>
> (Sterling 1986: ix)

The cyberpunk author Bruce Sterling points out that our perennial fear of and fascination with new technologies has coincided with a zeitgeist shift that cyberpunk has sought to describe. Technology, although increasingly complex, is simultaneously becoming increasingly intimate and physically invasive. This is due, amongst other factors, to the trend to miniaturization and the increasingly invasive forms technology takes. It is now more readily accessible and manipulable than in previous times when it was more easily subjected to institutionalized control:

> times have changed since the comfortable era ... when Science was safely enshrined – and confined – in an ivory tower. The careless technophilia of those days belongs to a vanished, sluggish era, when authority still had a comfortable margin of control. For the cyberpunks, by stark contrast, technology is visceral. It is not the bottled genie of remote Big Science boffins; it is pervasive, utterly intimate. Not outside us, but next to us. Under our skin; often, inside our minds. Technology itself has changed. Not for us the giant steam-snorting wonders of the past: the Hoover Dam, the Empire State Building, the nuclear power plant. Eighties tech sticks to the skin, responds to the touch: the personal computer, the Sony Walkman, the portable telephone, the soft contact lens.
>
> (Sterling 1986: xi)

In a Chandleresque-style cameo, a bar-stool occupying protagonist of the Gibson short story *Burning Chrome* mixes an inhaler with his alcohol to create a personalized 'high'. Gibson's character accompanies his action with the observation that: 'Clinically they use the stuff to counter senile amnesia, but the street finds its own uses for things' (Gibson 1986: 215). The latter phrase could be used as an emblematic motto for the way in which the cyberpunk genre fictionalizes not only the ubiquitous ingenuity with which hackers seek to approach technology in its various forms (not simply computers) but also hacking's desire to obtain a certain degree of 'street-cred':

> The elitist class profile of the hacker prodigy as that of an undersocialized college nerd has become democratized and customized in recent years; it is no longer exclusively associated with institutionally acquired college expertise, and increasingly it dresses streetwise.
>
> (Ross 1991: 89)

Hacking has spread far from its origins in the academic cloisters of places such as MIT, it has now become more associated with an urban aesthetic (whether this is in practice largely illusory or not).

Hackers, cyberpunk fiction and the pace of change – flux and blurred boundaries

> Nature has all along yielded her flesh to humans. First we took Nature's materials ... Now Bios is yielding to us her mind ... we are taking her logic ... The world of our own making has become so complicated that we must turn to the world of the born to understand how to manage it ... Yet as we unleash living forces into our created machines, we lose control of them. They acquire wildness and some of the surprises that the wild entails ... The world of the made will soon be like the world of the born: autonomous, adaptable, and creative, but, consequently, out of our control. I think that's great bargain.
>
> (Kelly 1994: 2–5)

The advent of the information revolution with its pace of change and the paradigm shift it has induced heightens perennial concerns about technological change and our ability to control it. Chip Tango a 'midnight irregular' and archetypal hacker provides a real-world example of the enthusiastic embracing of technological flux espoused by techno-utopian writers such as Kevin Kelly and portrayed in cyberpunk fiction:

> He takes for granted that computer technology is out of control, and he wants to ride it like a surfer rides a wave. The opportunities for fouling up the world through computer power are unlimited, but he thinks that people like him are useful agents in establishing a balance, a sense of humaneness and humor ... when presented with a scenario of a world which increasingly uses information in an oppressive Orwellian manner, [he] replied, 'I'm not worried for a minute about the future. If the world you describe is going to happen, man, I can fuck it up a lot faster than the world we live in now!'
>
> (Vallee 1984: 150–1)

Ironically, however, with their finger on the cultural pulse of the information Zeitgeist even cyberpunks may struggle to keep pace with the rapidity of technological change. Istvan Csiscery-Ronay, Jr, has termed this constant struggle 'retro-futuristic chronosemiitis, or futuristic flu'.[3] In *Neuromancer*, even Case, the otherwise technologically savvy cyberpunk, is not immune to the difficulty of keeping abreast of change:

> The one who showed up at the loft door with a box of diskettes from the Finn was a soft-voiced boy called Angelo. His face was a simple graft grown on collagen and shark-cartilage polysaccharides, smooth and hideous. It was one of the nastiest pieces of elective surgery Case had ever seen. When Angelo smiled, revealing the razor-sharp canines of some large animal, Case was actually relieved. Toothbud transplants. He'd seen that before. 'You can't let the little pricks generation-gap you', Molly said.
>
> (cited in Markley 1996: 84)

A more prosaic example of the information technology generation gap is provided by the father–son relationship of Robert Morris Senior and junior. The elder at the time of his following statement was Chief Scientist at the US National Computer Security Centre:

> The notion that we are raising a generation of children so technically sophisticated that they can outwit the best efforts of the security specialists of America's largest corporations and the military is utter nonsense. I wish it were true. That would bode well for the technological future of the country.
>
> (Lundell 1989: 11)

In a rather ironic twist of fate, this assertion proved to illustrate more than Morris originally intended. The statement was uttered five years before his own son caused widespread disruption of the Internet when he released in November 1988 a self-replicating program that came to be known as The Internet Worm. This ironic father and son example neatly illustrates the end of the days when once, in the previously cited words of Bruce Sterling, the authorities had a comfortable margin of control. Robert Morris Senior, a key figure in the computer security establishment, was not even aware of the technical ability of his own son.

Sterling in his preface to Gibson's collection of short stories, *Burning Chrome*, vividly summarizes the way in which cyberpunk captures the zeitgeist of constant change:

> In Gibson's work we find ourselves in the streets and alleys, in a realm of sweaty, white-knuckled survival, where high tech is a constant subliminal hum, like a deranged experiment in social Darwinism, designed by a bored researcher who kept one thumb permanently on the fast-forward button. Big Science in this world is not a source of quaint Mr Wizard marvels but an omnipresent, all-permeating, definitive force. It is a sheet of mutating radiation pouring through a crowd, a jam-packed Global Bus roaring wildly up an exponential slope. These stories paint an instantly recognizable portrait of the modern predicament.
>
> (Gibson 1986: 11)

In the context of this modern predicament the protagonists of cyberpunk fiction frequently give the sense that even though they may be literate in the workings of the technologically saturated environments they inhabit, they have little control over their own eventual fates and are constantly struggling to assert their individuality in the face of the identity-threatening technological systems they nevertheless yearn to immerse themselves in.

Technological intimacy – cyberpunks meet microserfs

> Further personality fragmentation and a breakdown of empathy lead to 'cyberpsychosis'. Behind this idea lies a long history of anxieties about 'dehumanization' by technology; a quintessentially humanist point of view which sees technology as an autonomous, runaway force that has come to displace the natural right of individuals to control themselves and their environment.
>
> (Ross 1991: 160)

The fictional representations of hacking analysed in this chapter derive their creative impetus by exploring, in the sharp relief afforded by the medium of the novel, the key issues highlighted by those who seek to interact with a range of technologies at an above-average level of intensity and intimacy. Levy foresaw cyberpunk's depiction of the human/machine

symbiosis with his observation that 'Real optimum programming, of course, could only be accomplished when every obstacle between you and the pure computer was eliminated – an ideal that probably won't be fulfilled until hackers are somehow biologically merged with computers' (Levy 1984: 126). He describes how to some extent at least the earliest hackers achieved this feeling by attaining, 'a state of pure concentration ... When you had all that information glued to your cerebral being, it was almost as if your mind had merged into the environment of the computer' (ibid.: 37). Jacques Vallee (1984) similarly describes such a process with relation to a hacker called Chip Tango:

> He never speaks of 'using a machine' or 'running a program'. He leaves those expressions to those engineers of the old school. Instead, he will say that he 'attaches his consciousness' to a particular process. He 'butterflies his way across the net, picking up a link here, an open socket there'.
>
> (136)

A continual redefining of both the body and the wider natural world is a distinguishing feature of cyberpunk's fictionalized and futuristic portrayal of hacking life. *Neuromancer* begins with the sentence: 'The sky above the port was the color of television, tuned to a dead channel' and cyberpunk's 'relaxed contempt for the flesh' is evident from the frequency with which the boundaries separating organic bodies from technology and even other species are transgressed within the genre. Neil Stephenson's *Snowcrash*, for example, features a radioactive guard-dog, whilst Jeff Noon's *Vurt* and *Pollen* include dog/cat—human and zombie—human hybrids. These extreme fictional entities in cyberpunk fiction serve as a vehicle to symbolize societal fears of the invasive power of the various technologies hackers enjoy identifying themselves with so much. Despite the fact that cyberpunks clearly represent a highly modernized form of the maverick spirit of the Western cowboy, cyberpunk fiction is riddled with examples of the negative consequences of their intimate relationship with technology and we shall now see how such examples have resonance in the real world and the way in which the relationship of hackers with technology is presented as unhealthily obsessive, addictive and dehumanizing.

Hackers, addiction and the prison of flesh

> he'd cry for it, cry in his sleep, and wake alone in the dark, curled in his capsule in some coffin hotel, his hands clawed into the bedslab, temperfoam bunched between his fingers, trying to reach the console that wasn't there ... For Case, who lived for the bodiless exultation of cyberspace, it was the Fall. In the bars he'd frequented as a cowboy hotshot, the elite stance involved a certain relaxed contempt for the flesh. The body was meat. Case fell into the prison of his own flesh.
>
> (Gibson 1984: 11 and 12)

One of the most vivid fictional examples of the purportedly addictive qualities of hacking is the above excerpt from Gibson's *Neuromancer*. The major reason for the 'relaxed contempt for the flesh' shown by cyberpunk characters is their affinity with the rich data environment known as the matrix (with the psychoanalytical/oedipal overtones the womb-related Latin root of this phrase implies). For real-world hackers a similar, if less marked, affinity is shown for 'the system' whether that be complex phone or computer networks:

There's a real love–hate relationship between us and the phone company. 'We don't particularly appreciate the bureaucracy that runs it, but we love the network itself', he says, lingering the world love. 'The network is the greatest thing to come along in the world.'

(Colligan 1982)

The affinity to enter and then be at one with the impersonal system can be seen as a highly addictive experience:

The hacker wants to break in. Breaking in is the addictive principle of hacking … It produces anxiety, as it is a melancholic exercise in endless loss … The experience of the limit that cyberspace affords is an anxious, addictive experience in which the real appears as withdrawal and loss … The matrix is too complex and fragmented to offer itself to any one unifying gaze … Hence, the attraction of the cyberspace addiction: to jack in is briefly, thrillingly, to get next to the power; not to be able to jack in is impotence. Moreover, the cyberspace addiction, the hacker mystique, posits power through anonymity … It is a dream of recovering power and wholeness by seeing wonders and by not being seen. But what a strange and tangled dream, this power that is only gained through matching your synapses to the computer's logic, through beating the system by being the system.

(Moreiras in Conley 1993: 197–8)

The obsessive body-neglecting qualities of cyberpunk's fictional depiction of what is involved by mentally 'jacking into' the matrix of information is similar to the imagery of close identification and even addiction used by real-life hackers:

I just do it because it makes me feel good, as in better than anything else that I've ever experienced. Computers are the only thing that have ever given me this feeling … the adrenaline rush I get when I'm trying to evade authority, the thrill I get from having written a program that does something that was supposed to be impossible to do, and the ability to have social relations with other hackers are all very addictive. I get depressed when I'm away from a networked computer for too long. I find conversations held in cyberspace much more meaningful and enjoyable than conversing with people in physical-reality real mode … I consider myself addicted to hacking. If I were ever in a position where I knew my computer activity was over for the rest of my life, I would suffer withdrawal.

(*Maelstrom* cited in Taylor 1993: 107)

rushing through the phone line like heroin through an addict's veins, an electronic pulse is sent out, a refuge from the day-to-day incompetencies is sought … a board is found. 'This is it … this is where I belong.'

(*The Mentor – Phrack* Vol. 1, Issue 7)

The image of flesh as a prison is a particularly forceful expression of an uneasiness hackers have with their bodies. Levy (1984), for example, describes how the hackers of MIT typically paid little attention to their bodily needs or physical appearance whilst absorbed by their activity. This lack of interest in bodily matters periodically and perversely culminated in an annual ugliest geek on campus competition run by the hacker community. This disregard of hackers for their bodies which receives its most dramatic expression in the dehumanizing concerns contained within cyberpunk fiction is also a key element of Coupland's account of Microsoft's workers in the more socially realistic novel *Microserfs*. The narrator makes the following observations:

I don't even do any sports anymore and my relationship with my body has gone all weird. I used to play soccer three times a week and now I feel like a boss in charge of an underachiever. I feel like my body is a station wagon in which I drive my brain around, like a suburban mother taking the kids to hockey practice.

(Coupland 1995: 4)

When I was younger … I went through a phase where I wanted to be a machine … I honestly didn't want to become flesh; I wanted to be 'precision technology' – like a Los Angeles person.

(ibid.: 72 and 73)

I want to forget the way my body was ignored, year in, year out, in the pursuit of code, in the pursuit of somebody else's abstraction. There's something about a monolithic tech culture like Microsoft that makes humans seriously rethink fundamental aspects of the relationship between their brains and bodies – their souls and their ambitions; things and thoughts.

(ibid.: 90)

We were all wearing laundry-junk clothes and we looked like scare-crows flailing about. Why are we so hopeless with out bodies?

(ibid.: 76)

Although Coupland's work does not contain the extreme blurring of bodily boundaries present within cyberpunk, this basic theme provides the novel's denouement as the mother of the narrator suffers a stroke which is described in terms of a computer system crash:

Mom's functions may one day be complete and may be one day partial, but as of today there's nothing but the twitches and the knowledge that fear is locked inside the body. Her eyes can be opened and closed, but not enough to semaphore messages. She's all wired up and gizmo'ed; her outside looks like the inside of a Bell switchbox. What is *her* side of the story? The password has been deleted.

(ibid.: 365)

Co-operation, addiction and the Otaku

We're still not sure what happened to the pirate flag that once flew over Apple Computer's headquarters but we do know that what was once a nerd phenomenon backed by an idealistic belief in the freedom of information became the powerful aphrodisiac behind sexy initial public offerings. Che Guevara with stock options.

(Hawn 1996: 2)

We have seen above how hackers and their fictional representatives intimately identify and interact with both abstract communication systems and more prosaic artefacts. In addition, at a more metaphorical level hackers have been accused of identifying too closely with the code of capitalism. Instead of using their technical proficiency in order to control the worst excesses of corporate-driven technological progress and redirecting it to more counter-cultural ends, they are instead charged with reinforcing its values as their ingenuity is co-opted by corporate concerns:

the hacker cyberculture is not a dropout culture; its disaffiliation from a domestic parent culture is often manifest in activities that answer, directly or indirectly,

to the legitimate needs of industrial R and D. For example, this hacker culture celebrates high productivity, maverick forms of creative work energy, and an obsessive identification with on-line endurance (and endorphin highs) – all qualities that are valorised by the entrepreneurial codes of silicon futurism ... The values of the white male outlaw are often those of the creative maverick universally prized by entrepreneurial or libertarian individualism ... teenage hackers resemble an alienated shopping culture deprived of purchasing opportunities more than a terrorist network.

<div align="right">(Ross 1991: 90)</div>

The ambivalence of hackers' claims to be a counter-cultural force are mirrored in what has been identified as an inherent contradiction of cyberpunk literature. Cyberpunks are presented as anarchic opponents to established corporate power yet the genre is marked by the frequency with which the cyberpunk's human agency is subsumed to the greater ends of their corporate hirers. They fail frequently to redirect corporate power to more humane ends and this is perhaps due to the ultimate conflation of the cyberpunks/hackers and corporations' desire for technological experimentation. Hackers and cyberpunks only wish to surf the wave of technological innovation, but corporations constantly seek to co-opt that desire for their own ends.

There is ... a tension in cyberpunk between the military industrial monster that produces technology and the sensibility of the technically skilled individual trained for the high tech machine ... Even the peaceful applications of these technologies can be subordinated to commercial imperatives abhorrent to the free thinking cyberpunk. There is a contradiction between the spirit of free enquiry and experiment and the need to keep corporate secrets and make a buck. Cyberpunk is a reflection of this contradiction, on the one hand it is a drop-out culture dedicated to pursuing the dream of freedom through appropriate technology. On the other it is a ready market for new gadgets and a training ground for hip new entrepreneurs with hi-tech toys to market.

<div align="right">(Wark 1992: 3)</div>

A dramatic example of both the alienating and co-opting aspects of hacker behaviour is provided by the phenomenon of the Otaku who have various hacker attributes. The phrase is used to describe a Japanese subculture who are noticeable by their preference for interacting with machines over people and their penchant for collecting, exchanging or hoarding what for non-Otaku would seem trivial information such as the exact make of socks worn by their favourite pop-star. The most publicized Otaku to date is Tsutomu Miyazaki who abducted, molested and mutilated four pre-teen Tokyo girls in a serial killing spree. The quality of alienation associated with Otaku culture is inadvertently indicated in one reaction to this case from an Otaku seeking to distance Miyazaki from the movement:

'Miyazaki was not really even an otaku', says Taku Hachiro, a 29-year-old otaku and author and author of Otaku Heaven ... 'If he was a real otaku he wouldn't have left the house and driven around looking for victims. That's just not otaku behavior. Because of his case, people still have a bad feeling about us. They shouldn't. They should realize that we are the future – more comfortable with things than people,' Hachiro said. 'That's definitely the direction we're heading as a society.'

<div align="right">(Greenfeld 1993: 4)</div>

Along with this alienated aspect of the Otaku is their amenability to co-optation by corporate culture:

> 'The otaku are an underground (subculture), but they are not opposed to the system per se,' observed sociologist and University of Tokyo fellow Volker Grassmuck ... 'They change, manipulate and subvert ready-made products, but at the same time they are the apotheosis of consumerism and an ideal workforce for contemporary capitalism ... Many of our best workers are what you might call otaku,' explained an ASCII corp. spokesman. 'We have over 2,000 employees in this office and more than 60 percent might call themselves otaku. You couldn't want more commitment.'
>
> (Greenfeld 1993: 3 and 4)

It is this over-willingness of hackers to identify with *the system* be it a complex telephone/computer network or the regimented and codified corporate framework that Microsoft provides for its employees that Coupland describes as lying behind the gradual enervation of the human spirit implied by the eponymous soubriquet 'Microserfs'. The highly intelligent computer programmers working at Microsoft's headquarters in Seattle become effectively indentured to the process of producing abstract code and increasingly divorced from the physical world and their own bodies.

Ubiquitous hacking

Despite the above concerns over the ultimately unhealthy nature of hackers' relationship with both technology and the economic system which seeks to profit from their technological proficiency, they remain a potent symbol of control in a world of constantly changing technology. 'True' hackers exhibit technological ingenuity that is manifested as an idiosyncratic attitude to a wide range of technological artefacts, not just computer systems. They are intrigued by the ability to explore the configuration of computer networks and the underlying instrumentality of all types of systems and artefacts, computer systems merely being those most amenable to control at a distance:

> In my day to day life, I find myself hacking everything imaginable. I hack traffic lights, pay phones, answering machines, micro-wave ovens, VCRs, you name it, without even thinking twice. To me hacking is just changing the conditions over and over again until there's a different response. In today's mechanical world, the opportunities for this kind of experimentation are endless.
>
> (Kane 1989: 67)

Hacking is also viewed by its practitioners as a mind-set evident in scientific and technological endeavours in general, not just computing; for example, gene-splicing in this model is seen as a form of biological hacking. The common underlying theme to all activities that could be classed under the broad term hacking is their instrumental yet unorthodox approach, as described by Ralph, a Dutch hacker:

> Hacking not only pertains to computers but pertains to any field of technology. Like if you haven't got a kettle to boil water with and you use your coffee machine, then that in my mind is a hack. Because you're using the technology in a way that it's not supposed to be used. Now that also pertains to telephones, if you're going to use your telephone to do various things that aren't supposed to

be done with a telephone, then that's a hack. If you're going to use your skills
as a car mechanic to make your motor do things it's not supposed to be doing,
then that's a hack. So for me it's not only computers it's anything varying from
locks, computers, telephones, magnetic cards, you name it.

(Taylor 1993: 78)

A humorous example of such a ubiquitous approach was provided by Kevin Poulsen who,
serving a prison sentence for his hacking exploits said: 'I've learned a lot from my new
neighbors … Now I know how to light a cigarette from an outlet and how to make
methamphetamine from chicken stock' (Fine 1995). Such pragmatic technological ingenuity
is redolent of the previously cited possible motto of cyberpunk: 'the street finds its own
use for things'.

Cultural lag

What we have today, instead of a social consciousness electrically ordered … is
a private subconsciousness or individual 'point of view' rigorously imposed by
older mechanical technology. This is the perfectly natural result of 'culture lag'
or conflict, in a world suspended between two technologies.

(McLuhan 1964: 108)

Widespread fear of the extent and pace of technological change and the contrasting
manner with which hacking and cyberpunks are associated with street level technological
savvy highlight the extent to which hackers can be viewed as key illustrators of the
phenomenon of the *culture lag* described by Marshall McLuhan. Hackers are a sub-cultural
group that go against the norm by seeking to avoid the demonization of technology.
They are arguably the prototypical denizens of the interstices that exist between old
social mores and the cultural implications of new technologies. John Perry Barlow and
the Electronic Frontier Foundation assert their wish to avoid 'a neo-Luddite resentment
of digital technology from which little good can come … there is a spreading sense of
dislocation, and helplessness in the general presence of which no society can expect to
remain healthy' (*Computer Underground Digest* Vol. 1, Issue 13). Hacking provides a possible
escape route from such resentment and has been viewed in the mode of a postmodern
counter-cultural response to the seemingly inevitable advance of new technology, hackers
are seen as constituting:

a conscious resistance to the domination but not the fact of technological
encroachment into all realms of our social existence. The CU represents a reaction
against modernism by offering an ironic response to the primacy of technocratic
language, the incursion of computers into realms once considered private, the
politics of the techno-society, and the sanctity of established civil and state authority
… It is this style of playful rebellion, irreverent subversion, and juxtaposition of
fantasy with high-tech reality that impels us to interpret the computer underground
as a postmodernist culture.

(Meyer and Thomas 1990: 3 and 4)

This somewhat elevated postmodern status afforded to hackers is predicated upon a cultural
malaise that they are not so much immune to as more able to cope with than the rest
of society:

The tie between information and action has been severed ... we are glutted with information, drowning in information, we have no control over it, don't know what to do with it ... we no longer have a coherent conception of ourselves, and our universe, and our relation to one another and our world. We no longer know, as the Middle Ages did, where we come from, and where we are going, or why. That is, we don't know what information is relevant, and what information is irrelevant to our lives ... our defences against information glut have broken down; our information immune system is inoperable. We don't know how to reduce it; we don't know how to use it. We suffer from a kind of cultural AIDS.

(Postman 1990: 6)

Uncertainty and ethical ambiguity in the information age

The uncertainty that has accompanied the advent of the information age is manifested in the ambiguous ethical status of some computing activities and society's vacillating responses to the maverick qualities that seem to be at a premium in the hard-to-adapt-to hi-tech world of constant change. In the post Cold War world new security fears increasingly centre around the threat posed by cyber-terrorists yet the corollary also exists: the tacit pride felt in one's own electronic cognoscenti. The Israeli hacker Ehud Tenebaum (aka the Analyser), for example, was accused of being responsible for the 'most systematic and organised attempt ever to penetrate the Pentagon's computer systems' (*The Guardian* Online section 26 March 1998: 2). Whilst Tenebaum was under house arrest in the Israeli town of Hod Hasharon, the US authorities were seeking to use his apprehension as a deterrent to other hackers: 'This arrest should send a message to would-be hackers all over the world that the United States will treat computer intrusions as serious crimes', said US attorney general Janet Reno. 'We will work around the world and in the depths of cyberspace to investigate and prosecute those who attack computer networks' (ibid.: 2).

However, Israeli public figures have taken a much more conciliatory attitude to Tenebaum's activities and their implications:

If there is a whiff of witch-hunt swirling around Washington, then in Israel Tenebaum's popularity seems to rise by the day. Prime minister Netanyahu's first comment on the affair was that the Analyser is 'damn good', before quickly adding that he could be 'very dangerous too.'

(ibid.: 2)

Tenebaum's lawyer Zichroni further argued: 'It appears to me he brought benefit to the Pentagon ... in essence he came and discovered the Pentagon's coding weaknesses' ... adding sardonically that 'the US authorities should maybe pay Tenebaum for his services' (ibid.: 2 and 3).

Whilst such comments may be interpreted as a lawyer's tongue-in-cheek defence of his client, the way in which the unethical aspects of Tenebaum's actions are blurred by their potential pragmatic uses to industry and national security is illustrated by the fact he was subsequently asked to appear before the Knesset's committee for science and technology research and development.

Conclusion

> On the one hand, the popular folk hero persona offered the romantic high profile of a maverick though nerdy cowboy whose fearless raids upon an impersonal 'system' were perceived as a welcome tonic in the grey age of technocratic routine. On the other hand, he was something of a juvenile technodelinquent who hadn't yet learned the difference between right and wrong; a wayward figure whose technical brilliance and proficiency differentiated him from, say, the maladjusted working-class J.D. street-corner boy of the 1950s.
>
> (Ross 1991: 84)

This account of hackers and their fictional counterparts has thus sought to highlight the various ambivalences that seem to inevitably accompany our perceptions of those who exhibit technological mastery and ingenuity. The dark and perennial appeal of such tales as Faustus and Frankenstein is based upon a notion contained deep within our culture: knowledge is often obtained only at a price. The price in *Microserfs* is a loss of self-awareness and an ingrained patina of geekishness; whilst cyberpunk literature portrays a frenetic, individualistic and ultimately dehumanized world. More positively, the cyberpunk account of the increased dissemination of science and technology to the street describes the democratisation of technology, power over which has historically been held by emblematically white-coated scientists. To this extent real-world technological sub-cultures such as hackers are portrayed as part of a welcome countervailing trend whereby technological power can be reappropriated by the people. Levy (1984), for example, explicitly describes the first generation of hackers as a group of computer users and program developers who played a crucial part in the undermining of the quasi-sacerdotal position of the lab-coated technicians who controlled the punch-cards that conveyed instructions to the first computers.

With the dissemination of hi-tech to the streets, however, also comes the concomitant loss of some of the previous certainties epitomized by those reassuring authority figures in white coats. Characters in cyberpunk exhibit a visceral enjoyment in their interactions with technology, yet the majority of cyberpunk action is set in dystopian social settings of exponential change where society is frequently feral and in which technological ingenuity needs to be closely aligned with day-to-day survival skills. The dystopian/liberating ambivalence apparent in cyberpunk portrayals of hacking is thus arguably a literary expression of an equally ambivalent present-day feeling about the social significance of hackers. On the one hand, the maverick nature of the hacker spirit can be viewed as a healthy example of the technological ingenuity required to prosper in the hi-tech world, yet on the other, hackers personify the enervating pitfalls that face those who seek to redirect corporate control of technological progress to more humane ends. It remains to be seen whether a 'third way' can be found between the anarchic individualism of cyberpunk and the empty regimented corporatism of *Microserfs*.

Notes

1 For the specific purposes of this chapter the contested elements of the fourth generation's ethical and legal legitimacy are side-stepped so that hacking is simply and broadly defined as 'the exhibition of technological ingenuity'. This limited and thereby more inclusive definition of hacking is necessary in order to develop the argument that, an analysis of hacking serves to illustrate wider social attitudes to the broad issue of technological change without becoming enmeshed in the ethical debates and minutiae of its evolutionary history.
2 Cf. Woolgar and Russell (1990).
3 Cited by David Brande in Markley (1996: 85).

Bibliography

Colligan, Douglas (Oct./Nov. 1982) 'The Intruder – A biography of Cheshire Catalyst', *Technology Illustrated* http://www.dsl.org/m/doc/arc/nws/cheshire.phk.
Conley, Verena (ed.) (1993) *Rethinking Technologies* Minneapolis, MN: University of Minnesota Press
Coupland, Douglas. (1995) *Microserfs* London: Flamingo.
Fine, D. (1995) 'Why is Kevin Lee Poulsen Really in Jail?', http://www.com/user/fine/journalism/jail.html.
Gibson, W. (1984) *Neuromancer* New York: Ace Books.
—— (1985) *Neuromancer* London: HarperCollins.
—— (1986) *Burning Chrome* London: HarperCollins.
—— (1987) *Count Zero* New York: Ace.
Greenfeld, Karl Taro. (1993) 'The Incredibly Strange Mutant Creatures Who Rule the Universe of Alienated Japanese Zombie Computer Nerds (Otaku to You)', http://www.eff.org/pub/Net_culture/Cyberpunk/otaku.article.
Hawn, Matthew. (1996) 'Fear of a Hack Planet: The Strange Metamorphosis of the Computer Hacker', http://www.zdtv.com/0796w3/worl/worl54_071596.html.
Kane, Pamela. (1989) *V.I.R.U.S. Protection: Vital Information Resources Under Siege* New York: Bantam.
Kelly, Kevin (1994) *Out of Control* Fourth Estate.
Levy, Steven (1984) *Hackers: Heroes of the Computer Revolution* New York: Bantam Doubleday Bell.
Lundell, Allan (1989) *Virus! The Secret World of Computer Invaders that Breed and Destroy* Chicago, IL: Contemporary Books.
Markley, Robert (1996) *Virtual Reality and Their Discontents* Baltimore, MD: Johns Hopkins University Press.
McLuhan, M. (1964) *Understanding Media* New York: New American Library.
Meyer, Gordon and Thomas, Jim (1990) 'A Post Modernist Interpretation of the Computer Underground', http://www.eff.org./pub/Net_culture...nk.
Noon, Jeff (1993) *Vurt* Manchester: Ringpull Press.
—— (1995) *Pollen* Manchester: Ringpull Press.
Postman, Neil (1990) 'Informing ourselves to death', German Informatics Society, Stuttgart, http://www.eff.org/pub/Net culture.
Ross, Andrew (1991) *Strange Weather: Culture, Science and Technology in the Age of Limits* London: Verso.
Sardar, Ziauddin and Ravetz, Jerome (1996) *Cyberfutures: Culture and Politics on the Information Superhighway* London: Pluto Press.
Stephenson, Neal (1992) *Snow Crash* New York: Bantam Spectra.
Sterling, B. (ed.) (1986) *Mirrorshades: The Cyberpunk Anthology* London: Paladin.
Taylor, Paul (1993) 'Hackers: A Case Study of the Social Shaping of Computing, Ph.D. dissertation, Research Centre for Social Sciences, University of Edinburgh.
Vallee, Jacques (1984) *The Network Revolution: Confessions of a Network Scientist* London: Penguin Books.
Wark, McKenzie (1992) 'Cyberpunk: from subculture to mainstream', http://www.eff.org./pub/Net_culture...unk_subculture_to_mainstream.paper.

Weizenbaum, J. (1976) *Computer Power and Human Reason: From Judgement to Calculation* New York: W.H. Freeman.

Woolgar, Steve and Russell, Geoff (1990) 'The Social Basis of Computer Viruses', *CRICT Discussion Paper*, Brunel University.

Richard Kahn and Douglas Kellner

TECHNOPOLITICS AND OPPOSITIONAL MEDIA

IT HAS BEEN JUST OVER A DECADE since the blossoming of hypertext and the emergence of the utopian rhetoric of cyberdemocracy and personal liberation which accompanied the growth of the new online communities that formed the nascent World Wide Web. While the initial cyberoptimism of many ideologues and theorists of the "virtual community" now seems partisan and dated, debates continue to rage over the nature, effects, and possibilities of the Internet and technopolitics.[1] Some claim that the Internet is producing a cyberbalkanization of "daily me" news feeds and fragmented communities,[2] while while others argue that Internet content is often reduced to the amplification of cultural noise and effectless content in what might be termed a new stage of "communicative capitalism."[3]

In our view, the continued growth of the Internet as a tool for organizing novel forms of information and social interaction, requires that Internet politics be continually re-theorized from a standpoint that is both critical and reconstructive. By this, we mean an approach that is critical of corporate and mainstream forms and uses of technology and that advocates reconstruction of technologies to further the projects of progressive social and political struggle. Recognizing the limitations of Internet politics, we want also to engage in dialectical critique of how emergent information and communication technologies (ICTs) have facilitated oppositional cultural and political movements and provided possibilities for the sort of progressive socio-political change and struggle that is an important dimension of contemporary cultural politics.

To begin, the Internet constitutes a dynamic and complex space in which people can construct and experiment with identity, culture, and social practices.[4] It also makes more information available to a greater number of people, more easily, and from a wider array of sources,[5] than any instrument of information and communication in history.[5] On the other hand, information-communication technologies have been shown to retard face-to-face relationships,[6] threaten traditional conceptions of the commons,[7] and extend structures of Western imperialism and advanced capitalism to the ends of the earth.[8] The challenge at hand is to begin to conceive the political reality of media such as the Internet as a

complex series of places embodying reconstructed models of citizenship and new forms of political activism, even as the Internet itself reproduces logics of capital and becomes co-opted by hegemonic forces. In this sense, we should look to how emergent technologies and communities are interacting as tentative forms of self-determination and control "from below"—recognizing that as today's Internet citizen-activists organize politically around issues of access to information, capitalist globalization, imperialist war, ecological devastation, and other forms of oppression, they represent important oppositional forms of agency in the ongoing struggle for social justice and a more participatory democracy.[9]

In contradistinction, since George W. Bush ascended to the presidency in a highly contested election in 2000, the lived ideal and forms of democracy have taken a terrible beating.[10] The Bush administration arguably used the events of 9/11 to proclaim and help produce an epoch of Terror War, responding to the 9/11 terror attacks to invade, conquer, and occupy both Afghanistan and Iraq and to promote a new geopolitical doctrine of preemptive war.[11] In this context, the threat of constant terrorism has been used to limit the public sphere, curtail information and communication, legitimate government surveillance of electronic exchange, and to cut back on civil liberties. Likewise, a panoply of neoliberal economic policies have been invoked and made law under the guise of promoting patriotism, supporting the war effort, and advancing domestic security. With democracy under attack on multiple fronts, progressive groups and individuals face the challenge of developing modes of communication and organization to oppose militarism, terrorism, and the threats to democracy and social justice.

The rise of Internet activism

From the early days of the Internet, "hackers" have creatively reconstructed the Internet and created programs and code that would facilitate sharing of research material, communication, and construction of communities. The term "hacker" initially meant someone who made creative innovations in computer systems to facilitate the exchange of information and construction of new communities. However, largely through corporate, state, and media cooptation of the term, "hacking" eventually came to suggest a mode of "terrorism" whereby malicious computer nerds either illegally invade and disrupt closed computer systems or proliferate computer codes known as viruses and worms that attempt to disable computers and networks. While hackers certainly are engaged in such activities, often with no clear social good in mind, we argue below that a relatively unknown "hactivist" movement has also continued to develop which uses ICTs for progressive political ends (see below).

In terms of the prehistory of Internet activism, we should also mention the community media movement that from the 1960s through the present has promoted alternative media such as public access television, community and low power radio, and public use of new information and communication technologies. As early as 1986, when French students coordinated a national strike over the Internet-like Minitel system, there have been numerous examples of people redeploying information technology for their own political ends, thereby actualizing a more participatory society and alternative forms of social organization.[12] Since the mid-1990s, there have been growing discussions of Internet activism and how new media have been used effectively by a variety of political movements, especially to further participatory democracy and social justice.[13]

On the one hand, much of the initial discussion of Internet politics centered on issues internal to the techies and groups that constructed the code, architecture, and social relations of the technoculture. Thus, Internet sites like Wired (www.wired.com) and Slashdot (www.

Slashdot.org) have provided multi-user locations for posts and discussion mixing tech, politics and culture, as well as places for promoting and circulating open source software, while criticizing corporate forces like Microsoft. Yet, on the other hand, politicized techno-subcultures, such as the anarchist community which frequents Infoshop (www.infoshop.org), have increasingly used the Internet to inform, generate solidarity, propagandize, and contest hegemonic forces and power.

In this respect, while mainstream media in the United States have tended to promote Bush's militarism, economic and political agenda, and "war on terrorism," a wide array of citizens, activists and oppositional political groups have attempted to develop alternative organs of information and communication. In so doing, we believe that there has now been a new cycle of Internet politics, which has consisted of the implosion of media and politics into popular culture, with the result being unprecedented numbers of people using the Internet and other technologies to produce original instruments and modes of democracy. Further, it is our contention here that in the wake of the September 11 terror attacks and US military interventions in Iraq and Afghanistan, a tide of political activism has risen with the Internet playing an important and increasingly central role.[14]

In late 2002 and early 2003, global anti-war movements began to emerge as significant challenges to Bush administration policies against Iraq and the growing threats of war. Reaching out to broad audiences, political groups like MoveOn (www.moveon.org), A.N.S.W.E.R. (www.internationalanswer.org), and United for Peace & Justice (www.unitedforpeace.org) used the Internet to circulate anti-war information, organize demonstrations, and promote a wide diversity of anti-war activities. February 15, 2003's unprecedented public demonstration of millions around the world calling for peace in unison revealed that technopolitics help to define, coalesce, and extend the contemporary struggle for peace and democracy across the world. Indeed, after using the Internet and wireless technologies to successfully organize a wide range of antiwar/globalization demonstrations, activists (including many young people) are now continuing to build a kind of "virtual bloc" that monitors, critiques, and fights against the aggressive versions of Western capitalism and imperialism being promoted by Bush, Blair, and their G8 counterparts.

In the US, Vermont Governor Howard Dean's team of Internet activists used the Internet to raise funds, recruit activists and organizers, and produce local "meet ups" where like-minded people could connect and become active in various political groups and activities. Although Dean's campaign collapsed dramatically after intensely negative mainstream media presentations of controversial statements and endless replay of an electronically magnified shout to his followers after losing the Iowa caucuses, Dean's anti-Bush and anti-Iraq discourses circulated through other Democratic party campaigns and the mainstream media. Further, Dean's use of the Internet showed that it could generate political enthusiasm amongst the youth, connect people around issues, and articulate with struggles in the real world. The Dean experiment demonstrated that Internet politics was not just a matter of circulating discourse in a self-contained cybersphere but a force that could intervene in the political battles of the contemporary era of media culture.

More recently, technopolitics played a crucial role in the March 2004 Spanish election, where the socialist party candidate upset the conservative party Prime Minister who had been predicted to win an easy victory after a series of terrorist bombings killed approximately 200 people days before the election. At first, in a self-serving manner, the government insisted that the Basque nationalist separatist group ETA was responsible. However, information leaked out that the bombing did not have the signature of ETA, but was more typical of an Al Qaeda attack, and that intelligence agencies themselves pointed in this direction. Consequently, the Spanish people used the Internet, cell phones and messaging, and other

modes of technological communication to mobilize people for massive anti-government, anti-occupation demonstrations. These protests denounced the alleged lies by the existing regime concerning the Madrid terrorist attacks and called for the end of Spain's involvement in Bush's "coalition of the willing" which had Spanish military troops occupying Iraq. The media spectacle of a lying government, massive numbers of people demonstrating against it, and the use of alternative modes of information and communication developed a spike of support for the anti-government candidate. Millions of young people, and others who had never voted but who felt deeply that Spain's presence in Iraq was wrong, went to the polls and a political upset with truly global consequences was achieved.

Groups and individuals excluded from mainstream politics and cultural production have also been active in the construction of Internet technopolitical culture. While early Internet culture tended to be male and geek dominated, today women circulate information through media like Women's eNews (womensenews.org), which sends e-mails to thousands of women and collects the material on a website. Likewise, scores of feminist organizations deploy Internet politics, and increasing numbers of women are active in blogging and other cutting-edge cyberculture. Communities of color, gay and lesbian groups, and many other under-represented or marginal political communities have set up their own e-mail lists, websites, blogs and are now a thriving and self-empowered force on the Internet. According to The PEW Internet and American Life Project (www.pewinternet.org), 44% of Internet users have created content for the online world through building or posting Web-sites, creating blogs or sharing files; the numbers of Americans over 65 who are using the Internet has jumped by 47% since 2000, making them the fastest-growing group to embrace the online world, and youth continue to be extremely active in producing new forms and content in many dimensions of Internet life.

Of course, we do not mean to imply that the Internet qua infrastructure is essentially participatory and democratic, as we recognize major commercial interests are fundamentally at play and that the Internet has been developed by a range of competing groups existing on the political spectrum from right to left. In addition, decisive issues exist from public participation in hardware design and online access to how individuals and groups are permitted to use and configure information and communication technologies.[15] Hence, while it is required that the progressive political uses of the Internet be enumerated, we recognize that this does not absolve its being criticized and theorized as a tool and extension of global technocapitalism.[16]

Accepting this, our point here is that the Internet is a "contested terrain" in which alternative subcultural forces and progressive political groups are being articulated in opposition to more reactionary, conservative, and dominant forces. It is not that today's Internet is either a wholly emancipatory or oppressive technology, but rather that it is an ongoing struggle that contains contradictory forces. Thus, as the social critic Ivan Illich has pointed out, while it is significant to criticize the ways in which mainstream technologies can serve as one-dimensionalizing instruments, it is equally necessary to examine the ways in which everyday people subvert the intended uses of these technologies towards their own needs and uses.[17]

Moreover, it is important to articulate Internet politics with actually existing political struggles to make technopolitics a major instrument of political action. Today's Internet activism is thus arguably an increasingly important domain of current political struggles that is creating the base and the basis for an unprecedented worldwide anti-war/pro-peace and social justice movement during a time of terrorism, war, and intense political contestation. Correspondingly, the Internet itself has undergone significant transformations during this time toward becoming a more participatory and democratic medium. Innovative forms of

communicative design, such as blogs, wikis, and social networking portals have emerged as central developments of the Net's hypertextual architecture, and online phenomena such as hacker culture and Web militancy are no longer the elite and marginal technocultures of a decade ago.[18]

Contemporary Internet subcultures are potentially involved in a radically democratic social and educational project that amounts to a massive circulation and politicization of information and culture. Thus, it is our belief that many emergent online political and cultural projects today are moving toward reconfiguring what participatory and democratic global citizenship will look like in the global/local future, even as more reactionary and hegemonic political forces attempt to do the same. We will accordingly focus on how oppositional groups and movements use ICTs to promote democracy and social justice on local and global scales in the following sections.

Globalization and Net politics

The Internet today has become a complex assemblage of a variety of groups and movements, both mainstream and oppositional, reactionary and democratic, global and local. However, after the massive hi-tech sector bust at the start of the new millennium, and with economic sectors generally down across the board due to the transnational economic recession, the Terror War erupting in 2001, and the disastrous effects of Bushonomics, much of the corporate hype and colonization of so-called "new media" has waned. If the late 1990s represented the heyday for the commercialization of the Net, the Bush years have found the Internet more overtly politicized beyond the attempt to grow the production, consumption, and efficiency of online commerce alone.

Since 9/11, oppositional groups have been forming around the online rights to freedom of use and information, as well as user privacy, that groups such as the Electronic Frontier Foundation (EFF), Computer Professionals for Social Responsibility (CPSR), and the Center for Democracy and Technology (CDT) have long touted.[19] When it emerged in late 2002 that the Bush administration was developing a Total Information Awareness project that would compile a government database on every individual with material collected from a diversity of sources, intense online debate erupted and the Bush administration was forced to make concessions to critics concerned about privacy and Big Brother surveillance.[20] Examples such as this demonstrate the manner in which technopolitics have been generated within online subcultural groups and communities, many of whom did not previously have an obvious political agenda, getting them to critically transform their identities towards speaking out against the security policies of government.

Alongside these shifts from online consumers to technocitizens, Internet corporations have attempted to court the middle ground – sometimes appearing to side with the users they court as customers (such as when Internet Service Provider UUNET instituted a zero-tolerance spam policy) or with the political administrations that could regulate them (such as Microsoft's anti-trust battle under the Clinton administration and then again under Bush). The general case of Internet corporations is perhaps best exemplified by a company like Yahoo, which has quietly fought legislation that would demand that companies notify users of attempts to subpoena information about their on-and offline personages. Even the supposedly progressive company, Google, has recently been criticized for not being forthcoming about its attempt to assemble and proliferate user information (for sale or otherwise) of all those who sign up for its new "Gmail" application. As the Internet has become more highly politicized, however, it has become harder for corporations to portray

themselves simply as neutral cultural forces mediating electronic disputes between citizens and states, being in service to one but not the other.

Using the state and corporate developed Internet towards advancing state and corporate-wary agendas, those now involved in technopolitics are beginning to develop and voice a critical awareness that perceives how corporate and governmental behavior are intertwined in the name of "globalization." As part of the backlash against corporate globalization over the past years, a wide range of theorists have argued that the proliferation of difference and the shift to more local discourses and practices define significant alternatives. In this view, theory and politics should swing from the level of globalization and its accompanying, often totalizing and macrodimensions in order to focus on the local, the specific, the particular, the heterogeneous, and the microlevel of everyday experience. An array of discourses associated with poststructuralism, postmodernism, feminism, and multiculturalism focus on difference, otherness, marginality, hybridity, the personal, the particular, and the concrete over more general theory and politics that aim at more global or universal conditions. Likewise, a broad spectrum of Internet subcultures of resistance have focused their attention on the local level, organizing struggles around a seemingly endless variety of social, cultural, and political issues.

However, it can be argued that such dichotomies as those between the global and the local express contradictions and tensions between key constitutive forces of the present moment, and that it is therefore a mistake to reject a focus on one side in favor of an exclusive concern with the other.[21] Hence, an important challenge for developing a critical theory of globalization, from the perspective of contemporary technopolitics, is to think through the relationships between the global and the local by observing how global forces influence and even structure an increasing number of local situations. This in turn requires analysis of how local forces mediate the global, inflect global forces to diverse ends and conditions, and produce unique configurations of the local and the global as the matrix for thought and action in everyday life.[22]

Globalization is thus necessarily complex and challenging to both critical theories and radical democratic politics. But many people these days operate with binary concepts of the global and the local, and promote one or the other side of the equation as the solution to the world's problems. For globalists, globalization is the solution, and underdevelopment, backwardness, and provincialism are the problem. For localists, the globalized eradication of traditions, cultures, and places is the problem and localization is the solution. Yet often, it is the mix that matters, and whether global or local solutions are most fitting depends upon the conditions in the distinctive context that one is addressing and the particular solutions and policies proposed.

Specific locations and practices of a plurality of online groups and movements constitute perhaps what is most interesting now about opppsitional, subcultural activities at work within the context of the global Internet. Much more than other contemporary subcultures like boarders, punks, or even New Agers, Internet activists have taken up the questions of local and global politics and are attempting to construct answers both locally and globally in response. Importantly, this can be done due to the very nature of the medium in which they exist. Therefore, while the Internet can and has been used to promote capitalist globalization, many groups and movements are constructing ways in which the global network can be diverted and used in the struggle against it.

The use of the Internet as an instrument of political struggle by groups such as Mexico's EZLN Zapatista movement to the Internet's role in organizing the anti-corporate globalization demonstrations, from the "Battle of Seattle" up to the present, has been well-documented. Initially, the incipient anti-globalization movement was precisely that: against

globalization. The movement itself, however, became increasingly global, linking together a diversity of movements into networks of affinity and using the Internet and instruments of globalization to advance its struggles in this behalf. Thus, it would be more accurate to say that the movement embodied a globalization-from-below and alternative globalizations that would defend social justice, equality, labor, civil liberties, universal human rights, and a healthy planet on which to live safely from the ravages of an uncontrolled neoliberal strategy.[24] Accordingly, the anti-capitalist globalization movements began advocating common values and visions and started defining themselves in positive terms such as the global justice movement.

Internet politics has thus become part and parcel of the mushrooming global movement for peace, justice, and democracy that has continued to grow through the present and shows no sign of ending. The emergent movements against capitalist globalization have thus placed the issue of whether participatory democracy can be meaningfully realized squarely before us. Although the mainstream media had failed to vigorously debate or even report on globalization until the eruption of a vigorous anti-capitalist globalization movement, and rarely, if ever, critically discussed the activities of the WTO, World Bank, and IMF, there is now a widely circulating critical discourse and controversy over these institutions. Whereas prior to the rise of the recent anti-war/prodemocracy movements average citizens were unlikely to question a presidential decision to go to war, now people do question and not only question, but protest publicly. While such protest has not prevented war, or successfully turned back globalized development, it has continued to evoke the potential for a participatory democracy that can be actualized when publics reclaim and reconstruct technology, information, and the spaces in which they live and work.

Alternative globalizations: global/local technopolitics

To capital's globalization-from-above, subcultures of cyberactivists have been attempting to carry out alternative globalizations, developing networks of solidarity and propagating oppositional ideas and movements throughout the planet.[25] Against the capitalist organization of neoliberal globalization, a Fifth International, to use Waterman's phrase (1992), of computer-mediated activism is emerging that is qualitatively different from the party-based socialist and communist Internationals of the past. As the virtual community theorist Howard Rheingold notes, advances in personal, mobile informational technology are rapidly providing the structural elements for the existence of fresh kinds of highly informed, autonomous communities that coalesce around local lifestyle choices, global political demands, and everything in between.[26]

These multiple networks of connected citizens and activists transform the "dumb mobs" of totalitarian states into "smart mobs" of socially active personages linked by notebook computers, PDA devices, Internet cell phones, pagers, and global positioning systems (GPS). As noted, these technologies were put to use in the March 2004 mobilization in Spain that at the last moment organized the population to vote out the existing conservative government. Thus, while emergent mobile technology provides yet another impetus toward experimental identity construction and identity politics, such networking also links diverse communities such as labor, feminist, ecological, peace, and various anti-capitalist groups, providing the basis for a democratic politics of alliance and solidarity to overcome the limitations of postmodern identity politics.[27]

Of course, rightwing and reactionary forces can and have used the Internet to promote their political agendas as well. In a short time, one can easily access an exotic witch's brew

of websites maintained by the Ku Klux Klan and myriad neo-Nazi assemblages, including the Aryan Nation and various militia groups. Internet discussion lists also disperse these views and rightwing extremists are aggressively active on many computer forums.[28] These organizations are hardly harmless, having carried out terrorism of various sorts extending from church burnings to the bombings of public buildings. Adopting quasi-Leninist discourse and tactics for ultraright causes, these groups have been successful in recruiting working-class members devastated by the developments of global capitalism, which has resulted in widespread unemployment for traditional forms of industrial, agricultural, and unskilled labor. Moreover, extremist websites have influenced alienated middle-class youth as well (a 1999 HBO documentary "Hate on the Internet" provides a disturbing number of examples of how extremist websites influenced disaffected youth to commit hate crimes). An additional twist in the saga of technopolitics seems to be that allegedly "terrorist" groups are now increasingly using the Internet and websites to organize and promote their causes (www.alneda.com).[29]

This has led to dangerous policy changes on the part of the Bush administration that has legalized new federal surveillance of the Internet and even allowed for the outright closing of websites which authorities feel condone terror.[30] Despite the expectation that any governmental administration would seek to target and disarm the information channels of its enemy, it is exactly the extreme reaction by the Bush administration to the perceived threats posed by the Internet that have the sub-technocultural forces associated with the battle against globalization-from-above fighting in opposition to U.S. Internet policies. Drawing upon the expertise of computer "hacktivists,"[31] people are progressively more informed about the risks involved in online communications, including threats to their privacy posed by monitoring government agencies such as the Office of Homeland Security, and this has led in turn to a wider, more populist opposition to Internet policing generally. This technical wing has become allied to those fighting for alternative globalizations with groups such as Cult of the Dead Cow (www.cultdeadcow. com), Cryptome (www.cryptome.org) and the hacker journal *2600* (www.2600.org) serving as figureheads for a broad movement of exceptionally computer literate individuals who group together under the banner of HOPE (Hackers On Planet Earth) and who practice a politics called "hacktivism."

Hacktivists have involved themselves in creating open source software programs that can be used freely to circumvent attempts by government and corporations to control the Internet experience. Notably, and somewhat scandalously, hackers have released programs such as Six/Four (after Tiananmen Square) that combine the peer-to-peer capabilities of Napster with a virtual private networking protocol that makes user identity anonymous, and Camera/Shy, a powerful Web browser stenography application that allegedly allows anyone to engage in the type of secret information storage and retrieval that groups such as Al Qaeda have used against the Pentagon. Moreover, associated with the hacktivist cause are the "crackers" who create "warez," pirated versions of commercial software or passwords. While anathema to Bill Gates, there is apparently no software beyond the reach of the pirate-crackers and to the delight of the alternative Internet subculture, otherwise expensive programs are often freely traded and shared over the Web and peer-to-peer networks across the globe. Hackers also support the Open Source movement, in which non-corporate software is freely and legally traded, collectively improved upon, and available for general use by a public that agrees not to sell their improvements for profit in the future. Free competitors to Microsoft, such as the operating system Linux (www.linux.org) and the word processing suite Open Office (www.openoffice.org), provide powerful and economically palatable alternatives to the PC hegemon.

Another hacker ploy is the monitoring and exploitation for social gain of the booming wireless, wide-area Internet market (called Wi-Fi, WAN, or WLAN). Wi-Fi, besides offering institutions, corporations, and homes the luxury of Internet connectivity and organizational access for any and all users within the area covered by the local network, also potentially offers such freedoms to nearby neighbors and wireless pedestrians if such networks are not made secure. In fact, as then acting U.S. cybersecurity czar Richard Clarke noted in December 2002, an astounding number of Wi-Fi networks are unprotected and available for hacking. This led the Office of Homeland Security to label wireless networking a terrorist threat.[32] Part of what the government is reacting to is the activist technique of "wardriving," in which a hacker drives through a community equipped with a basic wireless antenna and computer searching for network access nodes.[33] Many hackers had been wardriving around Washington, D.C., thereby gaining valuable federal information and server access, prompting the government contractor Science Applications International Corporation (SAIC) to begin monitoring drive-by hacks in the summer of 2002.[34]

But not all war drivers are interested in sensitive information, and many more are simply interested in proliferating information about what amounts to free broadband Internet access points—a form of Internet connectivity that otherwise comes at a premium cost.[35] Thus, wireless network hackers are often deploying their skills toward developing a database of "free networks" that, if not always free of costs, represent real opportunities for local communities to share connections and corporate fees. Such freenets represent inclusive resources that are developed by communities for their own needs and involve values like conviviality and culture, education, economic equity, and sustainability that have been found to be progressive hallmarks of online communities generally.[36] Needless to say, corporate Internet service providers are outraged by this anti-capitalist development, and are seeking government legislation favoring prosecution of this mode of gift economy activism.

Hacktivists are also directly involved in the immediate political battles played out around the dynamically globalized world. Hacktivists such as The Mixter, from Germany, who authored the program Tribe Floodnet that shut down the website for the World Economic Forum in January 2002, routinely use their hacking skills to cause disruption of governmental and corporate presences online. On July 12, 2002, the homepage for the *USA Today* website was hacked and altered content was presented to the public, leaving *USA Today* to join such other media magnets as the *New York Times* and Yahoo! as the corporate victims of a media hack. In February 2003, immediately following the destruction of the Space Shuttle Columbia, a group calling themselves Trippin Smurfs hacked NASA's servers for the third time in three months. In each case, security was compromised and the web servers were defaced with anti-war political messages. Another repeated victim of hacks is the Recording Industry Association of America (RIAA), who because of its attempt to legislate P2P (peer to peer) music trading has become anathema to Internet hacktivists. A sixth attack upon the RIAA website in January 2003 posted bogus press releases and even provided music files for free downloading.

Indeed, hactivist programs to share music, film, television, and other media files have driven the culture industries into offensive movements against the technoculture that are currently being played out in the media, courts, and government. While there is nothing inherently oppositional about P2P file-trading, Napster gained notoriety when major entertainment firms sued the company and the government passed laws making file-sharing more difficult. P2P networks like Gnutella and Bit Torrent continue to be popular sites for trading files of all sorts of material and millions of people participate in this activity. It highlights an alternative principle of symbolic economy whereby the Internet subverts the logic of commodification and helps generate the model of a gift economy in which

individuals freely circulate material on Web-sites, engage in file-sharing, and produce new forms of texts like blogs and wikis outside of the commodity culture of capitalism.

The related activist practice of "culture jamming" has emerged as another important global form of oppositional activity. Mark Dery (1993) attributes the term to the experimental band Negativland and many have valorized the subversion of advertising and corporate culture in the Canadian journal *Adbusters* (www.adbusters.org) and RTMark (www.rtmark.com), while drawing upon online resources like The Culture Jammers Encyclopedia (www.sniggle.net) and Subvertise (www.subvertise.org) to further their own projects. Internet jammers have attacked and defaced major corporate websites, but they have also produced playful and subversive critical appropriations of the symbols of the capitalist status-quo. Thus, in the hands of the hacker-jammers, McDonald's becomes McGrease, featuring sleazy images of clown Ronald McDonald, Starbucks becomes Fourbucks, satirizing the high price for a cup of coffee, and George W. Bush is morphed onto the Sauron character and shown wearing the evil ring of power featured in the *Lord of the Rings* trilogy. Additionally, Nike, Coca Cola, the Barbie doll, and other icons of establishment corporate and political culture have been tarnished with subversive and sometimes obscene animations.

Blogs, Wikis, and social networking

Emergent interactive forms of technopolitics, such as blogs and wikis, have become widely popular Internet tools alongside the ultimate "killer app" of e-mail. The mushrooming community that has erupted around blogging is particularly deserving of analysis here, as bloggers have repeatedly demonstrated themselves as technoactivists favoring not only democratic self-expression and networking, but also global media critique and journalistic sociopolitical intervention.

Blogs, short for "web logs," are partly successful because they are relatively easy to create and maintain—even for non-technical web users. Combining the hypertext of webpages, the multi-user discussion of messageboards and listservs, and the mass syndication ability of RSS and Atom platforms (as well as e-mail), blogs are popular because they represent the next evolution of a web-based experience that is connecting a range of new media. If the World Wide Web managed to form a global network of interlocking, informative websites, blogs make the idea of a dynamic network of ongoing debate, dialogue, and commentary come alive both on and offline and so emphasize the interpretation and dissemination of alternative information to a heightened degree.

While the initial mainstream coverage of blogs tended to portray them as narcissistic domains for one's own individual opinion, many group blogs exist, such as Daily Kos (www.dailykos.com), Think Progress (www.thinkprogress.org) and BoingBoing (www.boingboing.net), in which teams of contributors post and comment upon stories. The ever-expanding series of international Indymedia (www.indymedia.org) sites, erected by activists for the public domain to inform one another both locally and globally are especially promising. But even for the many millions of purely individual blogs, connecting up with groups of fellow blog readers and publishers is the netiquette norm, and blog posts inherently tend to reference (and link) to online affinity groups and peers to an impressive degree.

A controversial article in the *New York Times* by Katie Hafner cited a Jupiter Research estimate that only 4 percent of online users read blogs, while bloggers were quick to cite a PEW study that claimed 11 percent of Internet users read blogs regularly. Although Hafner's article was itself largely dismissive, it documented the passionate expansion of blogging amongst Internet users and the voluminous and militant blogger response to the article

showed the blogosphere contained a large number of committed participants. Technorati (www.technorati.com), the primary search-engine for blogs, claims to track some 28.9 million blog sites and Technorati's Media Contact, Derek Gordon, explains that according to their statistics there are 70,000 new blogs per day, 700,000 new posts daily, and 29,100 new posts per hour on average.

One result of bloggers' fascination with networks of links has been the subcultural phenomenon known as Google Bombing. Documented in early 2002, it was revealed that the popular search engine Google had a special affinity for blogs because of its tendency to favor highly linked, recently updated Web content in its site ranking system. With this in mind, bloggers began campaigns to get large numbers of fellow bloggers to post links to specific postings designed to include the desirable keywords that Google users might normally search. A successful Google Bomb, then, would rocket the initial blog that began the campaign up Google's rankings to number one for each and every one of those keywords—whether the blog itself had important substantive material on them or not.

While those in the blog culture often abused this trick for personal gain (to get their own name and blog placed at the top of Google's most popular search terms), many in the blog subculture began using the Google Bomb as a tool for political subversion. Known as a "justice bomb," this use of blogs served to link a particularly distasteful corporation or entity to a series of keywords that either spoofs or criticizes the same. Hence, thanks to a Google Bomb, Google users typing in "McDonald's" might very well get pointed to a much-linked blog post titled "McDonald's Lies about Their Fries" as the top entry. Another group carried out a campaign to link Bush to "miserable failure" so that when one typed this phrase into Google one was directed to George W. Bush's official presidential website. While Google continues to favor blogs in its rankings, amidst the controversy surrounding the so-called clogging of search engine results by blogs, it has recently taken steps to de-emphasize blogs in its rating system and may soon remove blogs to their own search subsection altogether—this despite blogs accounting for only an estimated .03 percent of Google's indexed Web content.[37]

Google or not, many blogs are increasingly political in the scope of their commentary. Over the last year, a plethora of leftist-oriented blogs have been created and organized in networks of interlinking solidarity, so as to contest the more conservative and moderate blog opinions of mainstream media favorites like Glenn Reynolds (www.instapundit.com). Post-September 11, with the wars on Afghanistan and Iraq, the phenomenon of Warblogging arose to become an important and noted genre in its own right. Blogs, such as our own BlogLeft (www.gseis.ucla.edu/courses/ed253a/blogger.php), have provided a broad range of critical alternative views concerning the objectives of the Bush administration and Pentagon and the corporate media spin surrounding them. One blogger, the now famous Iraqi Salam Pax (www.dear_raed.blogspot.com), gave outsiders a dose of the larger unexpurgated reality as the bombs exploded overhead in Baghdad. Meanwhile, in Iran, journalist Sina Mottallebi became the first blogger to be jailed for "undermining national security through cultural activities."[38] And after the 2004 election in Iran, boycotted by significant groups of reformers after government repression, dozens of new Web-sites popped up to circulate news and organize political opposition. In response to the need for anonymous and untraceable blogging (as in countries where freedom of speech is in doubt, such as China, which has forced its blogs to register with the government and has jailed journalists, blogs, and individuals who post articles critical of the government), open source software like invisiblog (www.invisiblog.com) has been developed to protect online citizens' and journalists' identities. Recent news that the FBI has begun actively monitoring blogs in order to gain information on citizens suggests a need for US activist-bloggers to implement the software themselves, just as many

use PGP (Pretty Good Privacy) code keys for their email and anonymity cloaking services for their web surfing (www.anonymizer.com).

On another note, political bloggers have played a significant role in several recent media spectacles in US politics, beginning in 2003 with the focus of attention upon the racist remarks made by Speaker of the House Trent Lott and then the creation of a media uproar over the dishonest reporting exposed at the *New York Times* in the Jayson Blair scandal Lott's remarks had been buried in the back of the *Washington Post* until communities of bloggers began publicizing them, generating public and media interest that then led to his removal. In the *NYT* example, bloggers again rabidly set upon the newsprint giant, whipping up so much controversy and hostile journalistic opinion that the *Times*'s executive and managing editors were forced to resign in disgrace. Likewise, CBS News and its anchor, Dan Rather, were targeted when rightwing bloggers attacked and debunked a September, 2004 report by Rather on *60 Minutes* that purported to reveal documents suggesting that the young George W. Bush disobeyed an order in failing to report for a physical examination and that Bush family friends were enabling him to get out of completing his National Guard service.[39]

Another major blog intervention involves the campaign against Diebold computerized voting machines. While the mainstream media neglected this story, bloggers constantly discussed how the company was run by Republican activists, how the machines were unreliable and could be easily hacked, and how paper ballots were necessary to guarantee a fair election. After the wide-spread failure of the machines in 2003 elections, and a wave of blog discussion, the mainstream media finally picked up on the story and the state of California cancelled their contract with the company – although Arnold Schwarzenneger's Secretary of State reinstated the Diebold contract in February 2006, producing another round of controversy. Of course, this was not enough to prevent Diebold's playing a major role in the 2004 presidential election, where bloggers were primarily responsible for challenging e-vote machine failures and analyzing alleged vote corruption in states like Ohio, Florida, and North Carolina.[40]

Taking note of blogs' ability to organize and proliferate groups around issues, the campaign for Howard Dean became an early blog adopter (www.blogforamerica.com) and his blog undoubtedly helped to successfully catalyze his grassroots campaign (as well as the burgeoning anti-war movement in the US). In turn, blogs became *de rigueur* for all political candidates and have been sites for discussing the policies and platforms of various candidates, interfacing with local and national support offices, and in some cases speaking directly to the presidential hopefuls themselves.[41] Moreover, Internet-based political projects such as www.moveon.org, which began during the Clinton impeachment scandal, began raising money and issues using computers technologies in support of more progressive candidates, assembling a highly impressive e-mailing list and groups of loyal supporters.

Another momentous media spectacle, fueled by intense blog discussion, emerged in May 2004 with the television and Internet circulation of a panorama of images of US prisoner abuse of Iraqis and the quest to pin responsibility on the soldiers and higher US military and political authorities. Evoking universal disgust and repugnance, the images of young American soldiers humiliating Iraqis circulated with satellite-driven speed through broadcasting channels and print media, but it was the manner in which they were proliferated and archived on blogs that may make them stand as some of the most influential images of all time. Thanks in part to blogs and the Internet this scandal will persist in a way that much mainstream media spectacle often does not, and the episode suggests that blogs made an important intervention into Bush's and future U.S. military policy and may play an important role in future U.S. politics.

Bloggers should not be judged, however, simply by their ability to generate political and media spectacle. As alluded to earlier, bloggers are cumulatively expanding the notion of what the Internet and cyberculture are and how they can be used. In the process they are questioning, and helping to redefine, conventional journalism, its frames, and limitations. Thus, a genre of "Watchblogs" (www.watchblog.com) has emerged that focuses upon specific news media, or even reporters, dissecting their every inflection, uncovering their spin, and attacking their errors. Many believe that a young and inexperienced White House press corps was overly hypercritical of Al Gore in the 2000 election, while basically giving George W. Bush a pass; since the 2004 election, however, the major media political correspondents have been minutely dissected for their biases, omissions, and slants.

One astonishing case brought by the watchblogging community was that the Bush administration provided press credentials to a fake journalist who worked for a certain Talon News service that was barely a front for conservative propaganda. The Bush White House issued a press pass to avowed conservative partisan "Jeff Gannon" who was a regular in the White House Briefing Room, where he was frequently called upon by Bush administration press secretary Scott McClellan whenever the questions from the press corps got too hot for comfort. After he manufactured quotes by Senators Clinton and Reid in White House press conferences, bloggers found out that Gannon's real name was "James Guckert" and that he also ran gay porn sites and worked as a gay escort. As another example of the collapse of the investigative functions of the mainstream media, although "Gannon" was a frequent presence lobbing softball questions in the White House briefing room, his press colleagues never questioned his credentials, leaving investigative reporting to bloggers that the mainstream media was apparently to lazy and incompetent to do themselves.[42]

One result of the 2004 election and subsequent U.S. politics has been the decentering and marginalizing of the importance of the corporate media punditocracy by Internet and blogosphere sources. A number of websites and blogs have been dedicated to deconstructing mainstream corporate journalism, taking apart everyone from the right-wing spinners on Fox to reporters for the *New York Times*. An ever-proliferating number of websites have been attacking mainstream pundits, media institutions, and misreporting; with the possible exception of the *New York Times*'s Paul Krugman, Internet and blog sources were often much more interesting, insightful, and perhaps even influential than the overpaid, underinformed, and often incompetent mainstream corporate media figures. For example, every day the incomparable Bob Somerby on dailyhowler.com, savages mainstream media figures, disclosing their ignorance, bias, and incompetence while a wide-range of other websites and blogs contain media critique and alternative information and views (for instance, mediamatters.org).

As a response there have been fierce critiques of the blogosphere by mainstream media pundits and sources, although many in the corporate mainstream are developing blogs, appropriating the genre for themselves. Yet, mainstream corporate broadcasting media, and especially television, continue to exert major political influence, and constant critique of corporate media should be linked with efforts at reform and developing alternatives, as activists continue to create ever better critical and oppositional media linked to ever-expanding progressive movements. For without adequate information, intelligent debate, criticism of the established institutions and parties, and meaningful alternatives, democracy is but an ideological phantom, without life or substance.

Democracy requires action, even the activity of computer terminals. However, part of the excitement of blogs is that it has liberated producers/designers from their desktops. Far from writing in virtual alienation from the world, today's bloggers are posting pictures, text, audio, and video on the fly from PDA devices and cell phones as part of a movement

of mobloggers (i.e., mobile bloggers; see www.mobloggers.com). Large political events, such as the World Summit for Sustainable Development, the World Social Forum, and the G8 forums all now have wireless bloggers providing real time alternative coverage and a new genre of confblogs (i.e., conference blogs) has emerged as a result.[43] One environmental activist, a tree-sitter named Remedy, even broadcast a wireless account of her battle against the Pacific Lumber Company from her blog (www.contrast.org/treesit), 130 feet atop an old growth redwood. She has since been forcefully removed but continues blogging in defense of a sustainable world in which new technologies can coexist with wilderness and other species.

In fact, there are increasingly all manner of blogging communities. Milbloggers (i.e., military bloggers) provide detailed commentary on the action of US and other troops throughout the world, sometimes providing critical commentary that eludes mainstream media. And in a more cultural turn blog-types are emerging that are less textual, supported by audio bloggers, video bloggers and photo bloggers, with the three often meshing as an on-the-fly multimedia experience. Blogging has also become important within education circles (www.ebn.weblogger.com) and people are forming university blogging networks (blogs.law.harvard.edu) just as they previously created city-wide blogging portals (www.nycbloggers.com).

While the overt participatory politics of bloggers, as well as their sheer numbers, makes the exciting new media tool called the wiki secondary to this discussion, the inherent participatory, collective, and democratic design of wikis have many people believing that they represent the coming evolution of the hypertextual Web. Taken from the Hawaiian word for "quick," wikis are popular innovative forms of group databases and hypertextual archives that work on the principle of open editing, meaning that any online user can not only change the content of the database (add, edit, or delete), but also its organization (the way in which material links together and networks). Wikis have been coded such that they come with a built-in failsafe that automatically saves and logs each previous version of the archive. This makes them highly flexible because users are then free to transform the archive as they see fit, as no version of the previous information is ever lost beyond recall. The result, then, is not only of an information-rich databank, but one that can be examined as *in process*, with viewers able to trace and investigate how the archive has grown over time, which users have made changes, and what exactly they have contributed.

Although initially conceived as a simple, informal, and free-form alternative to more highly structured and complex groupware products such as IBM's Lotus Notes, wikis can be used for a variety of purposes beyond organizational planning.[44] To the degree that wikis could easily come to supplant the basic model of the website, which is designed privately, placed online, and then is mostly a static experience beyond following preprogrammed links, wikis deserve investigation by technology theorists as the next wave in the emerging democratic web-based media.

One interesting wiki project is the dKosopedia (www.dkosopedia.com), which is providing a valuable cultural resource and learning environment through its synthesis and analysis of the connections behind today's political happenings. Perhaps the pre-eminent example of wiki power, though, is the impressive Wikipedia (www.wikipedia.org), a free, globally collaborative encyclopedia project based on wiki protocol that would have made Diderot and his fellow *philosophes* proud. Beginning on January 15, 2001, the Wikipedia has quickly grown to include approximately 1,000,000 always-evolving articles in English (with nearly 4,000,000 in more than 100 languages total) and the database grows with each passing day. With over 13,000 vigilant contributors worldwide creating, updating, and deleting information in the archive daily, the charge against wikis is that such unmoderated

and asynchronous archives must descend into informative chaos. However, as required by the growth of the project, so-called Wikipedians have gathered together and developed their own loose norms regarding what constitutes helpful and contributive actions on the site. Disagreements, which do occur, are settled online by Wikipedians as a whole in what resembles a form of virtualized Athenian democracy wherein all contributors have both a voice and vote.

There are other technological developments that are contributing to more bottoms-up, participatory and democratic cultural forms and that is the growing ubiquity of digital cameras which allow instantaneous recording of events and disseminating the images or scenes globally through the Internet. The Abu Ghraib prison torture scandal was documented by soldiers who sent digital pictures to others, one of whom collected and released the incriminating images to the media.[9] Digital cameras and Internet connections thus enable individuals to collect and transmit images and scenes that could undermine existing authorities like the police, military, corporation, or state when they are participating in abusive activities. The wide-spread use of digital cameras and cell phone images and footage was documented in the 2005 Asian Tsunami, London terrorist bombing, and Hurricane Katrina when early images of the disasters were disseminated quickly throughout the globe on digital cell phones. In 2006, several instances of police brutality were captured on digital cameras and cell phones, leading to mainstream media exposure and disciplining of the guilty parties.

These developments in digital technology further democratize journalism, making everyone with digital technology and Internet connections a potential journalist, commentator, and critic of existing media and politics. Since digital imagery and texts can be instantly uploaded and circulated globally via sites like Indymedia and the wide array of photoblogs, the dissemination of alternative information and views could intensify in the future, continuing to undermine the power of corporate media and the state. Likewise, Podcasting brings new multimedia forms into the emergent media ecology and helps disseminate self-produced alternative information and entertainment, as well as mainstream content, in the form of audio and video that is searchable and downloadable based on user preferences via the Internet.

Technological developments may encourage more social and political forms. Blogs like Corante's Many2Many (www.corante.com/many) track how blogs and wikis are pointing towards a greater trend in emergent media development towards "social software" that networks people around similar interests and other semantic connections. As alluded earlier, Howard Dean's campaign use of web-facilitated "meet ups" generated novel forms for grassroots electoral politics enthusiasm, but notably people are using online social networking to gather around all manner of topics and issues (www.meetup.com). More recently, social software has moved to incorporate a quasi "six degrees of separation" model into its mix, with portals like MySpace (www.myspace.com), Friendster (www.friendster.com), Facebook (www.facebook.com), LinkedIn (www.linkedin.com), Ryze (www.ryze.com), Orkut (www.orkut.com), and FriendFan (www.friendfan.com) allowing groups to form around common interests, while also creating linkages and testimonials between friends and family members. This has allowed for a greater amount of trust in actually allowing virtual relationships to flourish offline, while also allowing a new friendship to quickly expand into the pre-existing communities of interest and caring that each user brings to the site.

While all of these examples are reason to hope that the emergent media ecology can be tools for the strengthening of community and democracy amongst its users, it must be stressed again that we do not conclude that either blogs or wikis or social networking software, alone or altogether, are congruent with strong democratic practices and emancipatory anti-capitalist politics. For all the interesting developments we are chronicling here, there

are also the shopping blogs, behind-the-firewall corporate wikis, and all-in-one business platforms such as Microsoft's planned Wallop application. It remains a problem that most blogs, while providing the possibility for public voice for most citizens, are unable to be found by most users thus resulting in so-called "nanoaudiences." Further, that a great many of the millions of blogs have an extremely high turnover rate, falling into silence as quickly as they rise into voice, and that huge amounts of users remain captivated by the individualistic diary form of the "daily me" means that the logic of bourgeois individualism and capitalism is here too apparent.

While we have pointed to positive effects of blogs, wikis, and new digital technology in the emergent media ecology of the contemporary era, we are aware of downsides and do not want to sacrifice the edge of critique in advocating our reconstructive approach. As blogs proliferate they also fragment and a new hierarchy of bloggers, linked to each other and promoted by the mainstream media, may assume many of the functions and pacifying effects of mainstream corporate media. Excessive time in the blogosphere could detract from other activities ranging from study to interpersonal interaction to political engagement. Small Internet communities may be deluded that they are the revolution and may miss out on participation in key social movements and struggles of the age. Yet any technology can be misused, abused, and overused. Therefore, we have sought to chart reasons for hope that emergent media ecologies also provide increased opportunities to situate an oppositional technopolitics within the context of existing political struggles and movements.

In conclusion: situating oppositional technopolitics

The analyses in this paper suggest how rapidly evolving media developments in technoculture make possible a reconfiguring of politics and culture and a refocusing of participatory democratic politics for everyday life. In this conjuncture, the ideas of Guy Debord and the Situationist International are especially relevant with their stress on the construction of situations, the use of technology, media of communication, and cultural forms to promote a revolution of everyday life, and to increase the realm of freedom, community, and empowerment.[45] To a meaningful extent, then, the new information and communication technologies *are* revolutionary and constitute a dramatic transformation of everyday life in the direction of more participatory and democratic potentials. Yet it must be admitted that this progressive dimension coevolves with processes that also promote and disseminate the capitalist consumer society, individual and competition, and that have involved emergent modes of fetishism, alienation, and domination yet to be clearly perceived and theorized.[46]

The Internet is thus a contested terrain, used by left, right, and center of both dominant cultures and subcultures to promote their own agendas and interests. The political battles of the future may well be fought in the streets, factories, parliaments, and other sites of past struggle, but politics is already mediated by broadcast, computer, and information technologies and will increasingly be so in the future. Our belief is that this is at least in part a positive development that opens radical possibilities for a greater range of opinion, novel modes of virtual and actual political communities, and original forms of direct political action. Those interested in the politics and culture of the future should therefore be clear on the important role of the alternative public spheres and intervene accordingly, while critical cultural theorists and activists have the responsibility of educating students around the literacies that ultimately amount to the skills that will enable them to participate in the ongoing struggle inherent in cultural politics.[47]

Online activist subcultures and political groups have thus materialized in the last few years as a vital oppositional space of politics and culture in which a wide diversity of individuals and groups have used emergent technologies to help produce creative social relations and forms of democratic political possibility. Many of these subcultures and groups may become appropriated into the mainstream, but no doubt novel oppositional cultures and different alternative voices and practices will continue to appear as we navigate the increasingly complex present toward the ever receding future. The Internet provides the possibility of an alternative symbolic economy, forms of culture and politics, and instruments of political struggle. It is up to oppositional groups that utilize the Internet to develop the forms of technopolitics that can produce a freer and happier world and which can liberate humanity and nature from the tyrannical and oppressive forces that currently constitute much of our global and local reality.

Notes

1 See Howard Rheingold, *The Virtual Community: Homesteading on the Electronic Frontier* (Reading, MA: Addison-Wesley, 1993); John Perry Barlow, "A Declaration of the Independence of Cyberspace," available at www.eff.org/~barlow/Declaration-Final.html, 1996 (accessed July 2003); Bill Gates, *The Road Ahead* (New York: Penguin Books, 1996); Kevin Kelly, *New Rules for the New Economy* (New York: Viking Press, 1998). By "technopolitics" we mean politics that is mediated by technologies such as broadcasting media or the Internet. This Internet politics and a myriad of other forms of media politics are contained under the more general concept of "technopolitics," which describes the proliferation of technologies that are engaged in political struggle. On technopolitics, see Douglas Kellner, "Intellectuals, the New Public Spheres, and Technopolitics," *New Political Science* 41–2 (Fall 1997): 169–88; Steven Best and Douglas Kellner, *The Postmodern Adventure* (New York and London: Guilford Press and Routledge, 2001); and J. Armitage, ed., Special Issue on Machinic Modulations: New Cultural Theory and Technopolitics, *Angelaki: Journal of the Theoretical Humanities* Vol. 4, No. 2 (September 1999). For an early history of Internet politics, see Jim Walch, *In the Net. An Internet Guide for Activists* (London and New York: Zed Books, 1999).
2 See Cass Sunstein, *Republic.com* (Princeton, NJ: Princeton University Press, 2002) and M. Van Alstyne, and E. Brynjolfsson, "Electronic communities: Global village or cyberbalkans?" *Proceedings of the International Conference on Information Systems* (1996), available at aisel.isworld.org/password.asp?Vpath=ICIS/1996&PDFpath=paperO6.pdf.
3 See Jodi Dean, "Communicative Capitalism: Circulation and the Foreclosure of Politics" in *Cultural Politics*, Vol 1., No. 1 (2005). While we agree with Jodi Dean's analysis of the potential fetishism of the Internet and technopolitics, we believe that at times she illicitly totalizes the concept of fetishism in her denunciation of Internet cultural politics. Dean's recent book on the subject, *Publicity's Secret: How Technoculture capitalizes on Democracy* (Ithaca, NY: Cornell University Press, 2002), does a more well-rounded job of valorizing the positive political potentials of the Internet and her idea concerning self-organizing networks of contestation and struggle is one that we are very much in support of here. While it is beyond the scope of this paper to engage in more detail her polemic on the public sphere, we would argue for a more dialectical vision that seeks consensus and commonality amidst differences, but which emphasizes struggle and difference as a check to hegemonic consensuality, as well as to counter radically anti-democratic forces like the Bush administration.
4 Mark Poster, "Cyberdemocracy: The Internet and the Public Sphere," in *Internet Culture*, ed. D. Porter (New York: Routledge, 1997); Sherry Turkle, *Life on the Screen: Identity in the Age of the Internet* (New York: Touchstone Press, 1997).
5 Douglas Kellner, "The Media and the Crisis of Democracy in the Age of Bush2," *Communication and Critical/Cultural Studies*, Vol. 1, No. 1 (March 2004).
6 N. H. Nie and L. Ebring, *Internet and Society: A Preliminary Report* (Stanford, CA: The Institute for the Quantitative Study of Society, 2000).

7 C. A. Bowers, *Educating for Eco-Justice and Community* (Athens, GA: University of Georgia Press, 2001).

8 D. Trend, *Welcome to Cyberschool: Education at the Crossroads in the Information Age* (Lanham, MD: Rowman & Littlefield, 2001).

9 Herbert Marcuse, *Towards a Critical Theory of Society: Collected Papers of Herbert Marcuse, Vol. II*, ed. D. Kellner (New York: Routledge, 2001), 180–2.

10 Douglas Kellner, *Grand Theft 2000: Media Spectacle and a Stolen Election* (Lanham, MD: Rowman & Littlefield, 2001).

11 Douglas Kellner, *From 9/11 to Terror War: Dangers of the Bush Legacy* (Lanham, MD: Rowman & Littlefield, 2003).

12 See Andrew Feenberg, *Alternative Modernity* (Los Angeles, CA: University of California Press, 1995, 144–66); Nick Couldry and James Curran, eds, *Contesting Media Power: Alternative Media in a Networked World* (Lanham, MD: Rowman & Littlefield, 2003); and Best and Kellner, *Postmodern Adventure*. For a pre-Internet example of the subversion of an informational medium, in this case, public access television, see Douglas Kellner, "Public Access Television: Alternative Views" available at www.gseis.ucla.edu/courses/ed253a/MCkellner/ACCESS.html (accessed January 30, 2004). Selected episodes are freely available for viewing as streaming videos at www.gseis.ucla.edu/faculty/kellner (accessed January 30, 2004).

13 See Graham Meikle, *Future Active: Media Activism and the Internet* (London: Taylor & Francis, 2002).

14 Kellner, *From 9/11 to Terror War*.

15 Andrew Feenberg, *Questioning Technology* (New York: Routledge, 1999); C. Luke, "Cyberschooling and Technological Change: Multiliteracies for New Times" in *Multiliteracies: Literacy, Learning, and the Design of Social Futures*, eds B. Cope and M. Kalantzis (Australia: Macmillan, 2000), 69–105; Langdon Winner, "Citizen Virtues in a Technological Order" in *Controlling Technology*, eds E. Katz, A. Light, and W. Thompson (Amherst, NY: Prometheus Books, 2003), 383–402.

16 Best and Kellner, *Postmodern Adventure*.

17 Illich's "learning webs" (1971) and "tools for conviviality" (1973) anticipate the Internet and how it might provide resources, interactivity, and communities that could help revolutionize education. For Illich, science and technology can either serve as instruments of domination or progressive ends. Hence, whereas big systems of computers promote modern bureaucracy and industry, personalized computers made accessible to the public might be constructed to provide tools that can be used to enhance learning. Thus, Illich was aware of how technologies like computers could either enhance or distort education depending on how they were fit into a well-balanced ecology of learning. See Ivan Illich, *Tools for Conviviality* (New York: Harper and Row, 1973) and *Deschooling Society* (New York: Harper and Row, 1971).

18 "Blogs" are hypertextual web logs that people use for new forms of journaling, self-publishing, and media/news critique, as we discuss in detail below. It was estimated that there were some 500,000 blogs in January 2003, while six months later the estimated number claimed to between 2.4 and 2.9 million with a projection often million by 2005; see www.blogcensus.net for current figures. For examples, see our two blogs: BlpgLeft, www.gseis.ucla.edu/courses/ed253a/blogger.php, and Vegan Blog: The (Eco)Logical Weblog, www.getvegan.com/blog/blogger.php. "Wikis" are popular new forms of group databases and hypertextual archives, covered in more depth later in this paper.

19 The Internet has equally played a major role in the global environmental "right to know" movement that seeks to give citizens information about chemical, biological, and radiological threats to their health and safety. For examples of links, see www.mapcruzin.com/globalchem.htm.

20 Recently, a subversive initiative has been formed by a team at the MIT Media Lab to monitor politicians and governmental agents via a Web databank provided by global users. See Government Information Awareness at: http://18.85.1.51.

21 A. Cvetkovich, and D. Kellner, *Articulating the Global and the Local: Globalization and Cultural Studies* (Boulder, CO: Westview, 1997); Manuel Castells, "Flows, Networks, and Identities: A Critical Theory of the Informational Society," in *Critical Education in the New Information Age*, ed. D. Macedo (Lanham, MD: Rowman & Littlefield, 1999), 37–64.

22 A. Luke, A. and C. Luke, "A Situated Perspective on Cultural Globalization," in *Globalization and Education*, eds N. Burbules and C. Torres (New York: Routledge, 2000).

23 Best and Kellner, *Postmodern Adventure*.

24 Brecher, T. Costello and B. Smith, *Globalization from Below* (Boston, MA: South End Press, 2000); M. Steger, *Globalism: The New Market Ideology* (Lanham, MD: Rowman & Littlefield, 2002); and M. Hardt and A. Negri *Empire* (Cambridge, MA: Harvard University Press, 2000). Hardt and Negri present contradictions within globalization in terms of an imperializing logic of "Empire" and an assortment of struggles by the multitude, creating a contradictory and tension-full situation. Like Hardt and Negri, we see globalization as a complex process that involves a multidimensional mixture of expansions of the global economy and capitalist market system, new technologies and media, expanded judicial and legal modes of governance, and emergent modes of power, sovereignty, and resistance. While we do not find the dialectic of Empire vs. the multitude to be an adequate substitute for theories of global capital and analyses of contradictions and resistance, we share Hardt and Negri's quest to find new agents and movements of struggle and to use the instruments of technology and the networked society to advance progressive movements.

25 On globalization, see Best and Kellner, *Postmodern Adventure*; Douglas Kellner, "Globalization and the Postmodern Turn," in *Globalization and Europe*, ed. R. Axtmann (London: Cassells, 1998); and Douglas Kellner, "Theorizing Globalization," *Sociological Theory* Vol. 20, No. 3 (November 2002): 285–305.

26 Howard Rheingold, *The Virtual Community: Homesteading on the Electronic Frontier* (Reading, MA: Addison-Wesley, 1993).

27 See Nick Dyer-Witheford, *Cyber-Marx: Cycles and Circuits of Struggle in High-Technology Capitalism* (Urbana, IL: University of Illinois Press, 1999); Best and Kellner, *Postmodern Adventure*; and R. Burbach, *Globalization and Postmodern Politics: From Zapatistas to High-Tech Robber Barons* (London: Pluto Press, 2001).

28 Extreme right wing material is also found in other media, such as radio programs and stations, public access television programs, fax campaigns, video and even rock music productions.

29 Kellner, *From 9/11 to Terror War*.

30 For example, the FBI closed down www.raisethefist.com and www.iraradio.com as part of its post-9/11 terror concerns.

31 On the origins of hacker culture, see S. Levy, *Hackers* (New York: Dell Books 1984) and K. Hafner and J. Markoff, *Cyberpunk. Outlaws and Hackers on the Computer Frontier* (New York: Simon and Schuster). For more recent analysis, see P. Taylor, *Hackers: Crime and the Digital Sublime* (New York: Routledge, 1999); and P. Himanen, *The Hacker Ethic* (New York: Random House, 2001).

32 See www.wired.com/news/wireless/0,1382,56742,00.html (accessed February 2, 2004).

33 See www.wardriving.com (accessed February 2, 2004) and www.azwardriving.com (accessed February 2, 2004). Related to wardriving is "warspying" in which hactivists search a city looking for the wireless video signals being sent by all manner of hidden digital cameras. For more on this, see www.securityfocus.com/news/7931 (accessed February 2, 2004).

34 See www.securityfocus.com/news/552 (accessed February 2, 2004).

35 See www.freenetworks.org (accessed February 2, 2004).

36 Doug Schuler, *New Community Networks: Wired for Change* (Reading, MA: ACM Press and Addison-Wesley, 1996).

37 See Andrew Orlowski, "Google to Fix Blog Noise Problem," *The Register* (May 9, 2003) available at www.theregister.co.uk/content/6/30621.html (accessed February 2, 2004).

38 See Michelle Delio, "Blogs opening Iranian Society?" *Wired News*, May 28, 2003. Another Iranian blogger, Hossein Derakhshan, living in exile in Toronto develops software for Iranian and other bloggers and has a popular Web-site of his own. Hoder, as he is called, worked with the blogging community to launch a worldwide blogging protest on July 9, 2003 to commemorate the crackdown by the Iranian state against student protests on that day in 1999 and to call for democratic change once again in the country. See his blog at http://hoder.com/weblog. On recent political blogging in Iran, see Luke Thomas, "Blogging toward freedom" (*Salon*, February 28, 2004).

39 See Kellner, *Media Spectacle and the Crisis of Democracy* (Boulder, CO: Paradigm, 2005).

40 See Kellner, *Media Spectacle and the Crisis of Democracy* (Boulder, CO: Paradigm, 2005).

41 See www.dailykos.com (accessed February 2, 2004) for an example.

42 See Kellner, *Media Spectacle and the Crisis of Democracy* (Boulder, CO: Paradigm, 2005).

43 See http://www.iht.com/articles/126768.html (accessed March 31, 2004) for an example on how the World Economic Forum, while held in increasingly secure and remote areas, has been penetrated by bloggers.

44 B. Leuf and W. Cunningham, *The Wiki Way: Collaboration and Sharing on the Internet* (Boston, MA: Addison-Wesley, 2001).

45 On the importance of the ideas of Debord and the Situationist International to make sense of the present conjuncture, see S. Best and D. Kellner, *The Postmodern Turn* (New York and London: Guilford Press and Routledge, 1997) chap. 3, and on the new forms of the interactive consumer society, see Best and Kellner, *Postmodern Adventure*.

46 See Best and Kellner, *Postmodern Adventure*.

47 Douglas Kellner, "Technological Revolution, Multiple Literacies, and the Restructuring of Education," in *Silicon Literacies*, ed. Ilana Snyder (New York: Routledge, 2002), 154–69.

Briavel Holcomb, Philip B. Bakelaar, and Mark Zizzamia

THE INTERNET IN THE AFTERMATH OF THE WORLD TRADE CENTER ATTACK

A MAIN PURPOSE OF THE INTERNET, when first established in the late 1960s and early 1970s, was to provide a means of communication between command centers in various parts of the United States that would function in case of a national emergency when other methods of communication would be out of commission. The U.S. Defense Department's Advanced Research Projects Agency established ARPANET to link computers on the East and West coasts, as well as command centers in Utah and Illinois that could continue to communicate in the event of a nuclear attack. But it was over thirty years later on September 11, 2001, in the aftermath of the terrorist attacks on the World Trade Center (WTC) and the Pentagon, during which about 3,000 people were killed, that the Internet was used for the purpose for which it was originally designed. This paper was first written for the "Digital Communities: Cities in the Information Society" conference in November 2001 to explore both the function and the uses to which the Internet was put on 9/11 and the weeks that followed. It has been updated to include information on modifications to the Web in reaction to that "attack on America" and a discussion of the issue of security vs. privacy, an issue that is becoming increasingly controversial.

Terrorists on the Internet

There is evidence that the terrorists who crashed two jetliners into the twin towers of the WTC, another into the Pentagon, and whose hijacked jet crashed in Pennsylvania short of their intended goal, conspired with a possibly far-flung network of terrorists in part by communicating via the Internet. Whether, and how, this was achieved is still a matter of some controversy. Initially, rumors and speculations spread in the media that there were coded orders for the attacks secretly hidden in pornographic Web images and that the terrorists used encryption or even steganography to communicate via the Internet. Encryption uses mathematical keys to scramble and unscramble a message, and while encryption is difficult to decipher, it can reveal who is communicating to whom "secretly" and, thus,

may be of value to U.S. intelligence officials. Steganography, on the other hand, makes the message "disappear" by hiding it in a larger file such as a *.jpeg* or *.gif* image, or as an *.mp3* music file, although messages can be read by special software. Allegations that bin Laden's followers were using encrypted messages hidden inside pornographic pictures made lurid news well before the WTC attack, though no actual proof has been found that Al Qaeda used this method. A former French defense ministry official is reported to have said that terrorists planning an attack on the U.S. Embassy in Paris used steganography. Others alleged that "terrorists have made a practice of putting encrypted messages, including maps of targets, inside seemingly innocent Internet chat rooms, bulletin boards, and other Web sites." However, subsequent FBI analysis of hundreds of e-mail messages among the terrorist suspects have found no evidence of encryption beyond the possible use of such code words as referring to Osama bin Laden as the "director" or using the Arabic word for babyhood to mean "bomb." In fact, the very mundaneness of their e-mails camouflaged them from surveillance. Web sites apparently hosted in China, Pakistan, and London may have provided communications among Al Qaeda operatives. As a computer security specialist remarked, the terrorists were successful because their activities had "none of the hallmarks of clandestine activity the intelligence agencies normally look for. They did nothing suspicious—until they did something abominable." Nevertheless, this fact has not diminished calls for greater surveillance of the Internet and the demand that government be given "backdoors" to all encryption products. As will be noted, the debate about Internet surveillance has been become heated.

Internet uses and functioning during the crisis

During the hijacking of the planes and the crumbling of the WTC, victims of the attacks made crucial digital communications. There are stories of final messages of love and farewell sent by cell phone and instant messaging from those who died at the WTC. Passengers in the plane headed possibly for the White House or Camp David were able to communicate with people on the ground and, alerted to the situation, fought with the hijackers, causing the plane to crash in Pennsylvania short of the terrorists' target, thus preventing even greater casualties. A corporate e-mail network gave evacuation orders to employees of the American International Group in six buildings in lower Manhattan.

It was in the hours immediately following the attack that the real test of the Internet came. Happening as it did in mid-morning Eastern Standard Time, news of the attack spread worldwide by telecommunications. While some media were at least partially compromised, the Internet withstood the attack remarkably well. Physical destruction of radio and television broadcasting antennae atop the WTC, and of fiber-optic and conventional telephone and data lines in the vicinity, temporarily crippled some local communications. The Verizon Communications building, near the north tower of the WTC, sustained heavy damage. Before the attack, it had been one of the nation's busiest telephone central switching stations, which, at full capacity, served a customer base comparable to a city the size of Cincinnati. But after power to the building was interrupted, service was temporarily disrupted for more than 300,000 phone lines and 3.6 million high-capacity data circuits, many serving Wall Street financial institutions. Furthermore, since it would take five years and millions of dollars to build alternative systems for all the telephone lines served by the Verizon building, there are no plans to do so. A year after the attack, it was reported that the failure of a "repeater"—an electronic device designed to boost radio transmissions in high-rise buildings—in the North Tower probably contributed to the loss of lives by

impeding communications among firefighters. Meanwhile, the Internet continued to function at near-normal performance levels despite the rapid spike in traffic. Matrix.net, Internet performance measurement experts, reported that shortly after the attack, a significant performance degradation of the Internet was apparent as measured by increased packet loss and decreased "reachability", but the spike, though significant, was short-lived. IP traffic returned nearly to normal within an hour. Although some sites slowed, neither the destruction of fiber optic lines nor the heavy traffic on the Web caused major disruptions. Keynote Systems, which tracks the performance of 40 highly visited business sites, reported that while in the first few hours, a home page took three or four times as long to load as usual, things soon returned to normal. Nevertheless, Infoworld.com reported that the performance of the Internet was "affected more than during the California energy crisis, the Code Red worm, [and] the Baltimore train disaster" according to statistics provided by Mercury Interactive.

There are several reasons why the Internet functioned so well, especially compared to other media. Unlike traditional phone calls, which require an open circuit between two people, data sent via the Internet travels in discrete packets, which can move over many different channels at the same time to be reunited at their destination. This enables packages to avoid bottlenecks, if necessary, by temporarily storing data packets, and then forwarding them when routes open. Packet switching and built-in redundancies enabled most messages to get through with minimal delays. A second reason for Internet success during the crisis was that media companies that received particularly heavy traffic took drastic steps to cut all but the most vital information from their sites. *CNN.com* and the *New York Times* on the Web both cut photos, graphics, extraneous text, and ads from the first page users reached, enabling users to download information more quickly. *CNN.com's* home page before the attack held "more than 255 kilobytes of information: the slimmed-down version was about 20 kilobytes." Another way companies coped was to divert servers from one use to another. *CNN.com*, for example, converted servers that were normally devoted to financial and sports news to news of the crisis. Thus *CNN.com* was able to cope with a nearly tenfold traffic surge.

Another reason for the survival of the Internet on September 11 was the rapid decrease in traffic on various categories of sites. Some commercial sites that are commonly very busy (e.g., Amazon.com and eBay) had fewer visitors than usual, though in the case of eBay this may have been partly attributable to the fact that the company halted trading on items purportedly from the disaster sites, which were offered for auction. Travel sites saw a decrease in visitors and advertising was minimized. Travelocity removed all ads from the Web, TV, and radio for a week, feeling that advertising was simply "inappropriate." Given the proximity of Wall Street to the WTC, the financial industry was, of course, hard hit and E*Trade stopped taking orders for the rest of the day.

Constructive uses of the Internet in the aftermath

Perhaps the most impressive function the Internet served on and soon after September 11, 2001 was to transmit millions of messages of inquiry and reassurance between survivors of the attack and their loved ones. There can be few people on the Net in the New York metropolitan region who did not send and receive messages concerning the crisis with its victims and survivors. Within hours, the authors (based in New Jersey) had received inquiries from as near as Manhattan and as far away as Europe, Asia, and Africa from relatives and friends. International students at Rutgers University reported similar messages from

concerned families in many parts of the world. A Pew report published in September 2002 noted that many new Web sites, Weblogs (online logs or journals), and online discussion groups were posted in response to the events, and that while television may have been a better medium in delivering breaking news, the Internet had the advantage of offering depth of information, making available wider perspectives (including international ones), and providing a much more personal medium. "During a disaster, it's a natural human impulse to reach out to others, and the Internet is nonpareil in bridging the distance that often separates us."

Several registries were established almost immediately on the Web where both survivors and missing people could be registered. One of the first was hosted at the University of California at Berkeley, *www.safe.millennium.berkeley.edu*, but such sites proliferated causing some problems such as the need to register on multiple sites, all of which were not easily locatable. Some people, not finding their loved one on a register of survivors, may have needlessly been plunged into despair. Conversely, the absence on a victim list of a friend who worked at the WTC may have given false hope to others. The Greater New York Hospital Association eventually posted a list of patients admitted to hospitals from the WTC site, thereby arguably compromising patient privacy. More than a year after the attacks no complete list of victims, missing persons, or "survivors" exists. A CNN victim list contained 2,970 persons while the *September11victims.com* list had 3003 persons in October 2002. As late as November 2002, two "missing" persons on the list were "found," and there are still 56 missing victims for whom no death certificate has been issued.

An important function the Internet served immediately after the attack was to provide information about where to go for assistance and where to offer assistance. The non-media sites that received the greatest increase in traffic that day included *disasterrelief. org* (with a 2,324 percent increase) and *redcross.org* (1,494 percent). The Port Authority of New York and New Jersey, which built and owned the WTC saw a 7,715 percent increase as people sought information. The Red Cross, America's largest disaster relief organization, received 20,959 visitors and received $1,024 in donations the day before the attack (September 10). But on Tuesday, the number of visitors rose to 243,974 and within 12 hours $1 million had been donated. Since the Red Cross site was so swamped, AOL, Amazon, and Yahoo accepted donations on their sites for the Red Cross, and by the end of the week $39.5 million had been raised online. Before that, the most that had been raised online was $2.5 million in response to earthquakes in India and Central America earlier in 2001. For the first time, online donations outpaced those to a toll-free number. As well as money, relief supplies such as clothing, blankets, and food poured into New York partly in response to online requests. The Internet became a way that people far from the disaster site could donate and feel useful. The "Internet has really come about as a great place for people to act quickly—almost impulse donate rather than impulse buy," said an Internet analyst at Nielsen/netRatings. The Salvation Army received $1.5 million in online donations their first week, and a spokesman remarked that the Web "really affords people an opportunity to be generous and spontaneous in a new way, so we're very pleased with that."

The Red Cross raised so much money so fast that on October 30 fund raising for the 9/11 victims was suspended since the $547 million pledged was adequate for relief efforts. Controversy ensued when the Liberty Fund was set up within the Red Cross to manage funds donated for 9/11 and to prevent funds from being diverted to other chapters, but with a suggestion that $200 million be set aside for use in the event of future terrorist attacks. The president of the Red Cross resigned over the furor. A year later in September 2002, the Red Cross reported receiving more than $1 billion for the Liberty Fund and

having distributed $643 million, with $200 million more expected to be distributed by the end of the year.

Web sites were quickly set up to coordinate donations of office supplies, furniture, and rental space for displaced businesses. Information about the location of blood donation centers was available both on Web sites and sent by e-mail to many list-serves. The American Medical Association set up a database of doctors who volunteered for duty at the WTC site. The Red Cross set up 225 computers donated by Compaq in locations in New York and Washington to enable displaced survivors to post information about themselves and to e-mail family and friends. Microsoft programmers in Redmond, Washington helped set up a family registration system for this effort. Within hours of the attacks a volunteer site called *siliconalleycares.org* was created "to organize and prepare groups of volunteers to effectively help the Red Cross in its management of the crisis." Indeed, this disaster has "seen the integration of Internet technology that will better prepare the Red Cross and other relief agencies for the next disaster. … It has just come together so quickly. … The fact that this could be in place when the next hurricane or earthquake occurs and we could just throw a switch and turn this on is just mind-boggling," according to a Red Cross official. Perhaps this integration of the Internet into crisis response can be viewed as one of the few silver linings of the event. The 2002 Pew report noted that in the cross-sectional sample of Web sites relating to 9/11, 36 percent allowed visitors to provide assistance to victims and 26 percent allowed individuals to seek assistance from others and from relief organizations.

Immediately after the collapse of the WTC, and continuing a year later, the Internet has seen a plethora of Web sites and e-mail messages offering poems, prayers, pictures, expressions of patriotism, personal accounts of the events, sympathy messages, sources for counseling, and the like. One could light a memorial cyber-candle (as did 1.1 million people the first week), or a real one at 10:30 P.M. one night in response to an e-mail stating that NASA planned to take a satellite picture as a memorial to the attack victims (which NASA never intended). One could add one's name to numerous petitions pleading for peace, download American flags to print out and display, volunteer to create squares for the WTC Memorial Quilt at *www.wtcmemorialquilt.com*, or join a prayer circle at *Beliefnet. com*. Some may have wished to join the "cyberangels" to express support for our armed forces. A much-forwarded "tribute to the United States" by a Canadian TV commentator, Gordon Sinclair, which was reportedly read into the Congressional Record, called Americans "the most generous and possibly the least appreciated people on all the earth" (although that paean to the United States was actually written in 1973). But more critical analyses of the situation, such as one by Noam Chomsky pointing out the widespread famine and dire situation in Afghanistan prior to 9/11/01, were also circulated. The Internet thus became a very open forum for the free expression of ideas and opinions about the crisis. Without doubt, it served an important therapeutic function, allowing people to simply record their experiences and feelings. But it also facilitated a wide range of information about, perspectives on, and interpretations of the event from sources ranging from official government sites to Arabic media sites, from "patriots" to "peaceniks." Harris Interactive found that while American adults turned first to TV as their main source of information on September 11, 47 percent discussed the events online, and 23 percent said that using the Internet helped them deal with the events.

The Pew report, published a year later, noted that of their sample of Web sites, 75 percent were expressions of sadness, grief, and condolences; 61 percent expressed religious or spiritual thoughts; and 46 percent expressed patriotism. But anger, fear, and hate appeared on 52 percent of the sites. Harmon noted that virtual memorials on the

Web have allowed mourners to do the equivalent of visiting a "grave site" for a loved one whose physical remains are not found, and, in some cases to write messages to their lost loved ones in cyberspace.

The Internet acted not only as a source of information but a medium for testimony and recording the experience for posterity. Many accounts were posted on *www.worldnewyork.org* (a defunct site a year later) and the Library of Congress worked with the Internet Archive to collect Web sites related to the attacks (see *www.webarchivist.org*). The WTC disaster is the most documented event in human history. The documentation is in all media from print, to video, to photography, to the Web. Images of the disaster, its victims, personal accounts, news stories, and a huge amount of similar archival material is on the Web (see *http://911digitalarchive.org* for links to some of these). Online discussion groups have greatly facilitated public input to plans for the redevelopment of the WTC site, allowing people who cannot go to public meetings to voice their ideas and concerns.

Negative uses of the Internet in the aftermath of 9/11

There were, inevitably, destructive uses of the Internet, in which hoaxes were circulated, hackers disrupted sites designed to help, hate speech was evident, and efforts to profit financially from the disaster appeared on the Web. Some of these were fairly harmless, such as the fake photo of a tourist atop the WTC observation deck oblivious to the plane approaching just behind him, or the quotation from Nostradamus supposedly predicting the tragedy. The tourist was depicted wearing a heavy coat and hat on a beautiful day and, as the Observation Deck did not open until 9.30 A.M. (the first plane crashed into the North Tower at 8.45 A.M.), the question of how the camera and film survived is moot! A year later, the same tourist was depicted on the Web in other imaginary disaster locations. The predictive quotation from Nostradamus made the book a sudden best seller on *Amazon. com*, but the supposed quotation, said to have been written in 1654, is not in the book, and Nostradamus died in 1566. Nevertheless, Nostradamus joined "sex" and "mp3" on the list of terms most frequently entered on Internet search engines. The photographer who took the picture of the burning WTC that seems to contain a face (bin Laden? The devil?) in the smoke transmitted the image to AP within 15 minutes of the attack, and he did not notice the face at the time. Nevertheless, he received over 4,000 e-mails from people, some of whom thought he was a divine messenger, others that he had doctored the image. Some rumors were more problematic. Early rumors of cell-phone messages from victims still alive beneath the rubble raised hopes unnecessarily and complicated rescue efforts. An e-mail sent to hundreds of people claiming the city's water supply had been poisoned created paranoia. A much forwarded e-mail ostensibly from a friend of a woman who was dating an Afghanistani man who begged her not to go on any commercial airlines on 9/11 and not to go to any malls on Halloween … and then disappeared, was refuted formally by the FBI. An imaginative array of possible terrorism attacks posted on *MSNBC.com* included such things as smallpox spread by suicide disease carriers and disguised production workers contaminating consumer goods such as vitamins and baby powder, but such fears "could easily prove contagious" heightening paranoia.

As the 2002 Pew study noted, "the Web was an incubator of rumor as well as an inoculator—knocking down rumors and other fanciful tales." While Nostradamus received the most searches on Google in September 2001, the first site returned (*Nostradamus-repository.org*) actually refuted the idea that he had predicted the attack, and a site devoted to verifying "urban legends"—Snopes—set up a separate section for 9/11 rumors.

Other Web sites displayed dismaying levels of hate, xenophobia, and vengeance. The site for *DeadArab.com,* which proclaimed itself as "the best anti-Osama bin Laden and Taliban site around," featured bin Laden hanging from a noose attached to a pole from the wreckage of the WTC with firefighters observing below. The site offered sales of tee-shirts festooned with depictions of Arabs hanging from trees, games in which the goal was to shoot bin Laden and other Al Qaeda members, and hate messages directed towards anyone who resembles an Afghanistani. (Strangely, a year later in October 2002 the *DeadArab.com* site provided links to casinos on the net, insurance, careers, and completely unrelated material.) Similar sites proliferated (e.g., *www.killosama.com*) and included such messages as "the Middle East should be nuked and paved for a European parking lot." At the same time, there was a surge of hacking incidents on Middle Eastern networks including web pages and governmental databases. The Taliban Web site (*http://www.talibonline.com*) was hacked into, and its information replaced by a proclamation that "The United States will Destroy You! ... Project Afganistand!!! *(sic)* Knock them Out! Hacked by MaxMousc ... You will pay for this you stupid fools!!!!..." (*sparkhost.com* 2001). Some pages that actually opposed bin Laden and the Taliban, such as *www.AfghanGovernment.org*, were mistakenly hacked into by groups that mistook them for supporters. The *AfghanGovernment* site was flooded with over 10,000 hate messages after the attacks, and within a few days hackers were able to take it down completely. In October 2001, the site contained a letter from President Burhanuddin Rabbani who was recognized by the U.N. and many countries as the official ruler of Afghanistan. A year later, in October 2002, the *AfghanGovernment.org* site led one to sites offering tapestry throws, Afghan dog tee-shirts, and handcrafted dog jewelry!

Other Web sites appeared to support the terrorists including one with a heading "The Road to Jihad," which included an urban skyline in flames with burning U.S. and Israeli flags. One had "animations of dripping blood, Kalashnikov automatic weapons and admonitions to vanquish the 'enemies of Allah' by any means necessary" *(8).* Another gave advice on handling guns and suggested wearing gloves to avoid fingerprints. A site with audio and video clips of speeches by bin Laden asked supporters to send money to a bank in Pakistan for which account numbers were provided. Most such sites were removed within a few days either by the hosting companies of whoever posted them in the first place.

As noted earlier, the Web performed an excellent service in raising funds for victims of the attacks, but perhaps inevitably, it also bred scams. Web sites "festooned with American flags, had buttons viewers could click to make donations to the Red Cross or the Victims Survivors Fund." On clicking a button one was taken to another site that asked for a credit card number. The site was shut down shortly after the FBI was informed. Another e-mail message asked for donations to help find Osama bin Laden and asked for wire transfer of money to a bank in Estonia. Various unofficial Web sites asked for donations for families of firefighters, children orphaned by the attacks and similar groups of victims, though it is doubtful that donations reached intended recipients.

Other somewhat crass efforts to capitalize upon the tragedy included the rush to register topical URLs (especially including bin Laden) that could later be sold to the highest bidder. Domains such as *09112001.com* or *worldtradecenterdisaster.com* were bought, though whether for profit or to memorialize the victims was not clear at the time. Although the owner of the latter domain was initially rumored to have received an offer of $1.47 million, in fact he paid $30 to register *worldtradecenterdisaster.com/org/net* and *worldtradecentermemorial. com/org/net.* "I registered them a few minutes after the attack, which I witnessed live on TV ... I wanted to do something helpful, so I immediately put up the Web site that's still there today. Later I contributed *worldtradecentermemorial.com/org/net* to a nonprofit organization that was making an online memorial." Although he did receive an indirect offer from an

unnamed insurance company for all the domain names, they did not mention a price. A year later, *worldtradecenterdisaster.org* was a quite comprehensive site, offering memorials, links, information, and the message that $110,266,000 had been collected online (by October 16, 2002) for disaster relief.

Network Solutions removed *Twintowers09112001.com,* which had an asking price of $65,000, from its auction service to prevent inappropriate uses. However, a year later *www.twintowers911.com* leads one to *www.usretaliation.com* with images of the American eagle sharpening its talons and holding bin Laden in its beak and the message "Never Forget: Never Surrender." Others sought profit from the sale of patriotic gore. One could, for example, buy a T-shirt or mouse pad online both of which are decorated with the image of the side of a milk carton and bin Laden's face in the "Missing Person" section of the carton. Also available were hats or handkerchiefs embellished with "Evil will be Punished," or buttons with the stars and stripes with the declaration, "These colors don't run." Within hours of the attack, a drawing of the WTC that was selling for $5 on eBay leapt to $250 before eBay banned sales of WTC items since pieces of the ruins began to appear. That policy was later changed to allow memorabilia to be sold for charity.

The future of the Internet after the "attack on America"

Three years before the WTC disaster, the U.S. Department of Defense created an office to defend the United States from cyberattack. Its mission is primarily to safeguard infrastructure. The FBI also established the National Infrastructure Protection Center at about the same time, and the Commerce Department created a Critical Infrastructure Assurance Office shortly afterward. Nevertheless, when the new Office of Homeland Security (now a Cabinet Department) was established in the days after the attack, Senator Joseph Leiberman suggested that it spearhead the country's anti-cyberterrorism efforts. Within days of the attack, President Bush appointed a new special advisor for cyberspace security who reports both to Homeland Security and the National Security Advisor. Given the potential for cyberterrorists to cause tremendous damage by disrupting financial records, air traffic controls, electrical grids, pipelines, or production lines of pharmaceutical industries, to mention just a few, the need for greater surveillance of the Internet was recognized, and increased security measures were also seen as being necessary. Two days after the attack, the Senate approved an amendment as part of a Justice Department spending bill that makes it easier for law enforcement to "wiretap" Internet communications. The F.B.I. already uses its Carnivore system to monitor communications between suspects.

Both federal and state governments have also begun removing information from the Web. The "location and operating status of nuclear power plants, maps of the nation's transportation infrastructure, and an array of other data suddenly deemed too sensitive for general consumption" have been taken down. The Environmental Protection Agency (EPA) removed a database with information on chemicals used at 15,000 industrial sites, although that information remains available at reading rooms around the country. The U.S. Geological Survey (USGS) removed nuclear facility maps from its "National Atlas of the United States" Web site; Los Alamos National Laboratories have removed various reports; the U.S. Department of Energy's site for the National Transportation of Radioactive Materials has been removed; and Risk Management Plans are no longer on EPA's site. New Jersey removed its Community Right to Know information on about 30,000 private-sector facilities that store chemicals, despite the fact that firefighters accessed this database en route to fires. Similarly, New York State, along with many other states, removed material

potentially useful to terrorists. Obviously, there has been criticism of these actions since such information is useful to the public, but even the Federation of American Scientists removed data on nuclear weapons facilities from its Web site.

The relative importance of freedom of information and national security is the subject of an ongoing debate. In early 2002, a new Information Awareness Office (IAO) within the Defense Department, headed by John Poindexter (who was the national security advisor and a controversial figure in the Iran-contra scandals during the Reagan Administration) was established. Its mission is "total information awareness" which includes biometric signatures of humans, and cognitive aids to allow humans and machines to "think together," often using the Internet. Civil libertarians and others are concerned with the invasion of privacy implied (perhaps especially so since the IAO's logo includes the "all-seeing eye" of the Freemasons seal!). In September 2002, the Bush Administration released a draft report on "The National Strategy to Secure Cyberspace," but it was criticized both by high-tech companies and by civil liberties advocates. The following month a bipartisan report, "Protecting America's Freedom in an Information Age" called for decentralized information systems which could both protect privacy and prevent terror, and for greater sharing of information between different levels of government. In November 2002, the Information Awareness Office was reportedly building a "vast electronic dragnet" which could "data mine" commercial, governmental, and personal data bases (including phone logs and bank records), though the 1974 Privacy Act would have to be amended to deploy the system.

Private-sector companies also feared an increase in cyber terrorism and increased security by upgrading firewalls and intrusion detection systems. Now that the Office of Homeland Security has become a federal department, increasing funding and attention are being given to Internet security issues.

There are indications that e-commerce grew in the immediate aftermath of the attacks as a reaction to people's disinclination to shop in crowded places. Certainly, online sales of Cipro boomed as the anthrax scare grew. Similarly, anthrax sent through the U.S. postal system caused many to turn to e-mail for communications. Even the Direct Marketing Association urged its members in this $528 billion industry to send e-mail in conjunction with mass mailing campaigns. Likewise, videoconferencing company shares rose soon after the attacks as people avoided air travel when possible. The longer lasting effects of the attacks on commercial communications are impossible to separate from the effects of the subsequent economic downturn.

Most assessments agree that the Internet passed its first big test in the WTC crisis and will continue to grow. However, it was not the target of the attack on September 11, and some anticipate that we could still face a "cyber Pearl Harbor" and warn that we are "sitting on a cyber time bomb." In October 2002, an electronic attack briefly crippled 9 of the 13 computer servers that manage global Internet traffic in the "largest and most sophisticated assault on the servers in the history of the Internet." Although the attack was short lived and hardly noticed, future attacks may be less easily deflected. The Internet continues to hold great promise and peril. As the "father" of the Internet, Vinton Cerf, remarked the day after the attack: "Now, more than ever, the Internet must be wielded, along with other media, to cast bright lights on all who would destroy freedom in the world. Information is the torch of truth, and its free flow is the bloodstream, of democracy."

Postscript, September 2006 (Philip B. Bakelaar and Briavel Holcomb)

It has been five years since the terrorist attack on September 11, 2001. At that point, the World Wide Web was a young 7 years old; only in the past year or two has it begun to

mature and morph into a more interactive, user-friendly "Web 2.0". A recent article in
Wired magazine entitled "9/11: Birth of the Blog" succinctly put it this way: "When the
world changed on Sept. 11, 2001, the web changed with it."[1] Since that year, the web
has seen an explosion in its user base, with over 1 billion now estimated according to
internetworldstats.com, more than double the estimated 500 million users in 2001.[2] There
has been a maturing of existing technologies that have increasingly woven themselves into
the daily fabric of life throughout the world. Weblogs are simply called blogs now, and
all of them collectively comprise the blogosphere, a force that was solidified during the
American 2004 presidential primaries, with Internet campaigns such as Howard Dean's
fully leveraging the technologies available and engaging the public directly. The desktop is
giving way to the laptop and mobile phone as the preferred tool for Internet access. New
media technologies and platforms have risen as well—video blogs are increasingly popular;
WiMax is spreading wireless signals over entire cities; social networking is a multi-billion
dollar industry; and the Information Age has given way to the Media Age.[3]

Yet, despite the rapidly changing technology and myriad influences on the Internet,
9/11 can still be seen as a major turning point in the public's use and perception of it. One
positive consequence of the use of the Internet after 9/11 was that traffic became much
more international, as people from one continent sought information from others. Bucher
notes that traffic to Islamic, Indian and Israeli news sites (among others) grew significantly,
with "Afghanistan Online" jumping more than 11,000 places in Hitwise rankings.[4] But, as
Giddens and others have noted, more information and knowledge can add to uncertainty
and risk rather than reducing them. As communication becomes increasingly disembedded,
trust is lost and evaluation more difficult. Bin Laden, *inter alia*, continues to use the web
to score political points and, presumably, to "rally his troops." As the London *Times* noted,
"the web has become the new battleground of terrorism"[5] as many groups, governmental
and not, post their versions of truth and "disappear" others' versions.

The Internet played a role in the terrorist attack in London in July, 2005, though
mobile phone use by passengers in the bombed subway cars sending photos of the scene in
"real time" took precedence in the immediate aftermath. Traffic on phone bands reached
capacity and Vodaphone initiated emergency procedures to prioritize those calls, although
the rumor (relayed by the BBC) that the system was curtailed to prevent mobile phones
being used to trigger bombs was not true. It was reported that London's financial regulators
used a secret Internet chatroom to maintain the financial markets during the attack.[6]

The issues of security and privacy mentioned in our original paper have only grown
in complexity and pervasiveness. Two areas that illustrate the complexities of the issue are
online mapping and citizen journalism. In the currently ongoing case of Joshua Wolf, a San
Francisco-based freelance journalist/video blogger, his chosen medium—the Web—was the
basis for the denial of journalist rights and his jailing by a federal court. The case embodies
the current struggle between politics, privacy, the public, and a newly digital world still
governed by analog laws.[7] As for online mapping, in 2001 MapQuest was the king of
online driving directions; early in 2005, Google launched a revolution with the release of
Google Earth and Google Maps. One provided a seamless interface to explore the world
through high-resolution satellite images; the other, DIY mapping—an open source API
which any programmer could use to create "mashups" to combine and display geospatial
information—for free. Barely more than a year later, online mapping has made headlines
around the world, as governments demand high-resolution images of sensitive areas removed
from the maps, and fears of terrorism elicit political criticism of Google for making the
data free and easily accessible.[8]

On the opposite end of the digital imaging spectrum, doctored images from Associated
Press photographers grabbed headlines only months ago; the reality is that while visual

manipulation has always existed, technology tools make it easier at the same time as society begins to question whether it can trust visual evidence in a hyper-connected global community.[9] Looking back to September 11, the conspiracy theorists (and increasingly the general public) search the web for answers, and find evidence not only of governmental failure, but outright involvement in the attacks. According to a Zogby poll quoted on the site 911truth.org, "50% of New Yorkers believe US had foreknowledge of 9/11 but consciously failed to act."[10] In the summer of 2006, another survey, by Scripps, found that one-third of those interviewed thought the U.S. federal government had either taken part in the attacks or allowed them to happen, which led to a report from the National Institute of Standards and Technology refuting the top 14 alternative theories published in both scientific papers and the Internet.

At this time of writing (September, 2006) with a "Fourth Generation" Internet accessible without cable or hotspot looming on the near time horizon, the Internet continues to be both a socially centripetal and centrifugal force.[11] It brings us closer, faster to distant people, but is also a tool of terrorists and others who would sabotage human solidarity.

Notes

1 Wired News. "9/11: Birth of the Blog". http://www.wired.com/news/culture/media/1,71753-0.html. Accessed 9/12/06.
2 Miniwatts Marketing Group. "Internet Users – Top 20 countries – Internet Usage". http://www.internetworldstats.com/stats.htm. Accessed 9/15/06.
3 Paul Saffo. "Farewell Information, it's a Media Age." http://www.saffo.com/essays/essay_farewellinfo.pdf. Accessed 9/12/06.
4 Hans-Juergen Bucher. "Crisis Communication and the Internet: Risk and Trust in a Global Media" www.firstmonday.org/issues/issue7. Accessed 9/13/06.
5 "Finger points to British intelligence as al-Queda websites are wiped out." *The Sunday Times*, July 31, 2005. Accessed www.timesonline.co.uk. Accessed 9/14/06.
6 "London's financial regulators used a secret internet chatroom to keep financial markets running smoothly after Thursday's terror attacks, regulators said" http://counterterror.typepad.com/the-counterterrorism-blog/2005/07/10. Accessed on Wikipedia 9/13/06.
7 "Video blogger heading back to jail." CNet News. http://news.com.com/2061-10802_3-6117218.html. Accessed 9/21/2006.
8 "UK's secret nuclear sites exposed online." *Sunday Herald*. http://www.sundayherald.com/53945. Accessed 9/21/2006.
9 "It's hard to tell where pixels end and reality begins." SFGate.com. http://www.sfgate.com/cgi-bin/article.cgi?f=/c/a/2006/09/06/DDGGOKUB7P1.DTL. Accessed 9/21/2006.
10 "The 9/11 Truth Movement". http://www.911truth.org/. Accessed September 15, 2006.
11 Martin Fackler. "Wireless networking may soon get faster. Will anyone care?" *New York Times*, 9/26/06, C1.

Bibliography

L. Alvarez, "Spying on Terrorists and Thwarting Them Gains New Urgency," *New York Times* (September 14, 2001), A17.
P. Atfab, "Cyberangels Special Message: Terrorist Attack on the United States" (September 2001) <www.cyberangels.com> (Accessed September 20, 2001).
American Red Cross, *September 11 Report* (September 5, 2002) <www.redcross.org/disasters> (Accessed November 3, 2002).

D. Barstow and K. Seelye, "Red Cross Halts Collections for Terror Victims," *New York Times* (October 31, 2001) B11.

A. Batey, "Can He Save the World?" <MediaGuardian.co.uk> (October 29, 2001).

D. Campbell, "How the Terror Trail Went Unseen," *Telepolis* (October 8, 2001) <www.heise.de/tp/english/inhalt/te/9751/1.htm> (Accessed November 5, 2001).

V. Cerf, "Words for All of Us from Vinton Cerf" (September 12, 2001) <www.icdri.org> (Accessed October 26, 2001).

J. Christensen, "Relief Agencies Retool to Handle Online Flood," *New York Times* (September 26, 2001) H1, H8.

B. Collin, "The Future of Cyber Terrorism: Where the Physical and Virtual Worlds Converge," paper presented at the Eleventh Annual Symposium on Criminal Justice Issues of the Institute for Security and Intelligence (Chicago, 1996) <http://afgen.com/terrorism 1.html> (Accessed October 31, 2001).

K. Coughlin, "Internet Becomes Only Link after Cell Phones Fail," *Star Ledger* (September 12, 2001) 28.

"Crisis," Blogspot.com <http://crisis.blogspot.com> (Accessed October 27, 2001).

J. Dwyer and K. Flynn, "911 Tape Raises Added Questions on Radio Failures," *New York Times* (November 9, 2002) A1, B4.

M. Farley, "Hoaxes, Rumors, and Wishful Thinking Spawned Trauma," *Los Angeles Times* (September 28, 2001) <www.latimes.com> (Accessed September 28, 2001).

P. Festa and R. Konrad, "Anthrax Worries Find Answer in E-mail," *Zdnet News* (October 16, 2001) <http.netscape.zdnet.com> (Accessed October 25, 2001).

D. Filkins, "As Thick as the Ash, Myths Are Swirling," *New York Times* (September 23, 2001) Section 4, 2.

C. Garretson, "Senator Says New Office Should Cover Cyber Terrorism," *IDG News Service, Washington Bureau* (September 21, 2001).

"GIS and Steganography-Part I: Hidden Secrets in the Digital Ether," *Directions Magazine* (April 9, 2002) <www.directionsmag.com> (Accessed November 7, 2002).

L. Guernsey, "Keeping the Lifelines Open," *New York Times* (September 20, 2001) G1, G6.

A. Harmon, "The Search for Intelligent Life on the Internet," *New York Times* (September 23, 2001) Section 4, 1.

A. Harmon, "Real Solace in a Virtual World: Memorials Take Root on the Web," *New York Times* (September 11, 2002) 39.

H. Harreld and E. Grygo, "U.S. Attack: Internet Performance after Attack Could Be Worst Ever," Infoworld.com (September 12, 2001) <www.inforworld.com/articles/hn/xml/oi/09/12/01092hyperformance.xml> (Accessed November 1, 2001).

D. Henriques, "Anthrax Drug Is Promoted on Web Sites," *New York Times* (October 15, 2001) C8.

A. Higgins, K. Leggett, and A. Cullison, "How Al Qaeda Put Internet to Use" *Wall Street Journal* (November 11, 2002) <www.msnbc.com> (Accessed November 11, 2002).

D. Hopkins, personal e-mail communication, (October 21, 2002).

M. Kakutani, "Fear, the New Virus of a Connected Era," *New York Times* (October 20, 2001) A13.

J. Kelley, "Terror Groups Hide Behind Web Encryption," *USA Today* (February 5, 2002) <www.usatoday.com> (Accessed January 26, 2003).

W. Knight, "Controlling Encryption Will Not Stop Terrorists," *New Scientist* (September 18, 2001) <www.newscientist.com> (Accessed September 18, 2001).

G. Kolata, "Veiled Messages of Terror May Lurk in Cyberspace," *New York Times* (October 30, 2001) F1, 4.

E. Lipton, "Sept. 11 Death Toll Declines as 2 People are Found Alive," *New York Times* (November 3, 2002) A17.

S. Lohr, "Internet Access Providers Curb Both Terrorist Postings and an Anti-Islamic Backlash," *New York Times* (September 17, 2001) C8.

E. Luening, "VeriSign Bars 'Offensive' Net Name Auctions" (September 2001) <http://news.cnet.com/news/0–1005–200–7228509.html> (Accessed September 19, 2001).

J. Lyman, "How Terrorists Use the Internet," Newsfactor.com (October 2001) <www.newsfactor.com/perl/story/7731.html> (Accessed October 11, 2001).

G. Mariano, "Web Donors Give Millions in Relief" CNETNews.com (September 17, 2001) <*http:// news.cnet.com/news/o-1005–200–7208068.html?tag=1*> (Accessed September 18, 2001).

J. Markoff, "Pentagon Plans a Computer System That Would Peek at Personal Data of Americans," *New York Times* (November 11) A12.

Matrixnet, "Internet Withstands Attack on America," press release (October 16, 20010 <*www.matrix. net*> (Accessed October 16, 2001).

J. McKinley, "State Restricts Data on Internet in Attempt to Thwart Terrorists," *New York Times* (February 26, 2002) B1, B5.

M. Meuser, "Post 9/11 Age of Missing Information" <www.mapcrusin.com> (Accessed March 14, 2002).

J. Miller, "Report Calls for Plan of Sharing Data to Prevent Terror," *New York Times* (October 7, 2002) A11.

S. Non, "Videoconferencing's New Appeal," *CNETNEWS.com* (September 18, 2001) <http://news. cnet.com> (Accessed September 18, 2001).

P.L. O'Connell, "Taking Refuge on the Internet: A Quilt of Tales and Solace," *New York Times* (September 20, 2001) G3.

M. Peterson, "Report of Scams Preying on Donors Are on the Rise," *New York Times* (September 28, 2001) A18.

Pew Research Center, "One Year Later: September 11 and the Internet" (September 5, 2002) <www. pewinternet.org/reports/> (Accessed November 3, 2002).

"Powerful Attack Upsets Global Internet Traffic," *New York Times* (October 23, 2002) A17.

Reuters, "Companies Fear Wave of Cyberterrorism," (September 18, 2001) <wysiwyg://8/http:// netscape.zdnet.com:80> (Accessed September 20, 2001).

S. Romero, "Attacks Expose Telephone's Soft Underbelly," *New York Times* (October 15, 2001) C4.

S. Schiesel and S. Hansell, "A Flood of Anxious Calls Clog Phone Lines," *New York Times* (September 12, 2001) A8.

J. Schwartz, "In Investigation, Internet Offers Clues and Static," *New York Times* (September 26, 2001) H1, 8.

J. Schwartz, "Revamped Proposal Suggests Strategies to Tighten Online Security," *New York Times* (September 18, 2002) A21.

J. Schwartz, "Securing the Lines of a Wired Nation," *New York Times* (October 4, 2001) G1, G8.

Siliconalleycares.org, *Homepage* (September 2001) <www.atnewyork.com> (Accessed October 8, 2001).

G. Slabodkin, "New U.S. Office to Battle Cyberterrorism," *Newsbytes* (July 23, 1998) <wysiwyg://24/ http://www.exn.ca/Stories/1998/07/23/58.asp> (Accessed October 31, 2001).

"The Stuff of Patriotism, and Cheap Too," *New York Times* (October 7, 2002) A11.

B. Tedeschi, "E-Commerce Report: The Internet Passes Its First Test as a Source of Communications in the Aftermath of a Disaster," *New York Times* (September 17, 2001) C6.

R. Toner, "Reconsidering Security, U.S. Clamps Down on Agency Web Sites," *New York Times* (October 28, 2001) B4.

"When Terrorists Log On," editorial, *New York Times* (October 14, 2001) Sec 4, 14.

WTC Internet Remembrance Campaign, "Internet Remembrance Campaign" <worldatwar.org> (Accessed October 16, 2002).

Beyond cybercultures

Barbara Kennedy

INTRODUCTION

THE FINAL SECTION OF THE READER takes us into new directions, new vistas, new spaces which are digital, virtual and cyborgian in their interrelationship. The new millennium has shown a massive development in technoscientific research, which brings together a range of new interdisciplinary discourses. Work in biotechnology, nanotechnology, bioaesthetics and nanologic embraces a whole new developmental field which takes its launch from 'cyberculture' but also deterritorializes into an array of exciting future possibilities beyond what we have so far defined as 'cyberculture'. Furthermore, the whole issue of 'cyborgian thinking' or 'cyborg consciousness' has impacted upon most academic disciplines, exchanging metaphors and providing a web of transversal theoretical paradigms through which to consider the infrastructure of intellectual scholarship and debate. Interdisciplinarity displays a convergence of *post*-post-structuralist epistemologies, creating vast arrays of new knowledges and, in many cases, a further divergence into practices such as fine art, sculpture, architecture, performance, dance and music. Cyberculture has infected all areas of our cultural experiences and the future looks exciting.

The first article in this section is Timothy Lenoir and Casey Alt's 'Flow, Process, Fold', which outlines how computer-mediated communication has mobilized new theoretical ideas in disciplines such as biology and medicine, and also in pharmacogenetics, bioinformatics, biomedical imaging and surgery, information technologies, creative practices such as architecture and space design. We can determine significant interstices with Catherine Waldby's article (Part Six) where 'cyberbodies' have become extended but also imbricated into the techno- and biomedical arenas. The trajectory of the debate for Lenoir and Alt is primarily one which highlights this cyborgian significance to architectural design. Their article begins with a wider contextualization, highlighting the theoretical resonance of

writers like Deleuze and Guattari: questions of philosophical, ethical, social and epistemological concern are enfolded throughout the textual valencies of the piece. Hence, situatedness, rhizomatic strategies and machinic assemblages provide a richer panoply of ideas than previous theoretical positions stressing reductionism.

Lenoir and Alt begin with an analysis of how biology has been affected by discourses which shift towards open and disunified systems, rather than structural, mechanistic models of science: fixed subjectivity is distanciated, planning and simulation directed at an individual, independent 'actant' rather than a consensual homogeneous 'subject'. Current British educational models are slow to follow up this significant direction – designer drugs, quite literally, for the individual. Their argument advocates the significance of new technologies, specifically broadband, web, and simulation technologies, to these developments. Examples are provided from the discipline of molecular biology, utilizing computer algorithms, architectures and tools from AI and biochemistry. It seems that molecular configuration and three-dimensional folding patterns (as they proceed to explain) provide useful models for architectural design. Digital representations of molecular structures provide the key to new creative processes, the computer becoming a microscope and lab for quantitative experimentation. New experiences of visualization, with an emphasis on hapticity (the experience of touch in sight) provide creative methods of investigation. In summary, this has led, Lenoir and Alt argue, to a trend away from reductionist theory; science and its new paradigm shifts collude with differential domains in a surge to post-human directions. Similarly, creative practices such as architecture manipulate and re-territorialize scientific principles of protein-folding in new designs. Bioinformatics and its eclectic, heterogeneous and multiple approach to sequencing comparisons rejects earlier energetics approaches. The predictive possibilities are forged through algorithmic searches. Debates then on *flow* and *fold* continue in the article, providing a new paradigm for theoretical biology and a repertoire for sharing metaphors through digital information, with other disciplines such as architecture.

Lenoir and Alt proceed to discuss, through shared metaphors from genomic research, the new practices in architecture. Here, they refer us to the works of Peter Eisenman, an advocate of digital/electronic mediation which ossifies the autonomy of a creative 'subject'. As they write: 'Electronic media, because they do not pass through the intermediacy of human vision, are capable of disrupting how we experience reality itself, since reality always demanded that our vision be interpretive'. Similar positions are perceived by Gregg Lynn and Neil Denari. Architects, then, have begun to move away from the 'totalising tenets' of modernism in their newly-configured contextual spaces of digital configurations/theory. Highlighting the significance of theorists like Derrida and Deleuze, Lenoir and Alt explore how computer-aided design linked to computer-aided manufacturing has allowed many architects to utilize bioinformatics in their design processes. Examples given are the Guggenheim in Bilbao and Gehry's 1995–2000 Experience Music Project, Seattle. But perhaps the most resonant section is the description of Eisenman's Rebstock Park, where the ideas of Deleuze (1993) on the fold had specific significance. Here is a means for 'thinking architecture' centred on Deleuze's

conceptions of difference – a deterritorializing of the anthropomorphic subject. Recourse to a 'mechanics of vision' has resisted an ability to 'think architecture', but both Lynn and Denari have discarded eye-mind connections. Rather, they believe in the 'transformative' power of electronic media and the openness to systems of metaphors, 'to provide and engender new creative acts/processes and formations'. It is this convergence of ideas from continental philosophy and digital technologies which provides a transversal 'cyborg consciousness' as a process of distributed cognition which is prevalent through this section of the Reader.

When we watch the news each day, we are bombarded with new scientific discoveries that promise to alter out experience as humans. Debates continue regarding cloning, while recent attempts to progress the recombinant forms of human and animal embryonic cells for research have led to wide protests, mainly on ethical grounds. The chimeras and hybrids of recent science fiction have become scientific reality. But where is the separation between these two concepts? Is there really any difference between the narrative fictions of Hollywood-induced euphoria/fear/anxiety and the schizophrenic nature of our realities in the twenty-first century? Colin Milburn's 'Nanotechnology in the Age of Posthuman Engineering: Science Fiction as Science' provides an exploration of how nanotechnology has impinged upon our fabulations, but also on our material realities. His over-arching argument is that there really is no longer a definite border between the concepts of science and science fiction.

As a more recent phenomenon than cybercultural/technocultural theory, the emerging science of nanotechnology, like bioinformatics and genomics, has provided a new 'logic' of enquiry: *nanologic*. Nanotechnology is 'the practical manipulation of atoms; it is engineering conducted on the molecular scale'. As identified in Lenoir and Alt's article, biology has become an important catalyst in new directions in cybercultural thought and practice. Nanotechnology is modelled on biological 'machinery': mitochondria, enzymes, ribosomes, cells which are referred to by Milburn as 'nanomachines'. It offers the possibility of the control of materiality, providing for an array of human desires and needs. Milburn highlights some of these:

> nanomachines will be put into your carpet or clothing, programmed to constantly vaporize any dirt particles they encounter, keeping your house or your wardrobe perpetually clean. Nanomachines will quickly and cheaply fabricate furniture, or car engines, or nutritious food, from a soup of appropriate elements.

Is 'nanotechnology' a new science for future utopias, then, or merely another science fiction? It seems that the academy supports a wide field of theorists, researchers and academic scholars, whilst industries, governments, and companies globally explore its potential, both for economic progress and creative productive possibilities. Milburn indicates how the Foresight Institute has provided the base of this complexity. But with it has come a notoriety, suspicions simultaneously lie alongside the academy's proliferation of journal articles, reviews, research projects. As a result of this influx of writings on nanotechnology, there is, we could argue,

a 'new' discipline emerging *beyond cyberculture*, which we might call *nanoculture,* where nanowritings ubiquitously convey the dreamscapes of future possibilities. From foundational principles in the engineering science of nanotechnology, our future utopias are actualized from potentiality. 'This is such stuff as dreams are made of, and our little life is rounded with a sleep'. [1]

Shakespeare's narratives hold contemporary significance in the light of such new possibilities. But wait, is this not merely the 'stuff of dreams', fictionalized utopian techno-euphoria of a posthuman existence which in reality offers no space or place for the political, economic and social inequities on a planet still starved of human resources, air, food, water and an environment which continues to implode as a result of global warming? What potential then for nanotechnologies? Can they halt the disasters of impending global catastrophe? It does appear that such utopian predictions for nanotechnology are flawed in a political and economic climate of such impoverishment. Indeed, they seem to be merely 'nanodreams'. Hence the claim that really it *is* all science fiction: 'nanotechnology need not be taken seriously. It will remain just another exhibit in the freak show that is the boundless optimism of technical forecasting' (Jones 1995: 835).

Maybe it can only remain 'science fictional' in imagining its own future. Milburn's argument suggests that molecular technology will be viewed as both a science and a science fiction. Drawing on post-structuralist theorists such as Baudrillard, Haraway and Bukatman, Milburn posits the problematic 'third order imaginary' where the boundary between the real and its representation lies within the immanent plane of simulation, in the cybernetic sense. The relational of science to science fiction is one of symbiosis and vectorized imbrication, not one of binary oppositional postionalities – this cyborg epistemology is prevalent throughout this section of the Reader.

Nanotechnology, then, is the interstitial space of a 'cyborg assemblage' for the posthuman subject. Following the recounting of various science fiction mythical narratives, Milburn reiterates that as far as nanotechnology is concerned, we need to go back to Baudrillard's conception of simulation. Milburn's final section on 'Posthuman Engineering' conveys a critical insight into the significance of both Derrida and Foucault to ongoing debate. Here he refers to Paul Virilio, Manuel de Landa, Brian Massumi and Kathryn Hayles, whose ideas continue to explore the boundaries, limits and the beyond of humanist thought, where relationalities across, between and through the human/technology interface mediate new architectures for creative process and creative thinking. These are new postmodern affective and haptic spaces, through which nanologic flows as a river of virtualities, participating in the 'techno-de(con)struction of humanism'. This provides a posthuman event where the world/body/mind meld in machinic assemblage, no longer 'human'. In coalescence with contemporary post-continental philosophical thought, nanologic posits that there is no unitary construct to experience. Indeed, everything is reduced to pure material. Atomistic thought provides new discourses for 'thinking affect', 'thinking architecture', 'thinking bodies', 'thinking dance', beyond metaphysical categories of the subjective and the phenomenological.

We then have, in Robin Held's 'Gene(sis): Contemporary Art Explores Human Genomics', a piece which co-exists in its theoretical domain with both previous articles in its premise of 'genomics' as a contemporary area for providing new intellectual debate. Significant resonances are felt to the works of both Orlan and Stelarc (see Part Six), whose performative artwork provokes epistemological enquiry about human/machinic/interfaces and posthuman bodies. Genomics research potentially offers us a world with improved diagnosis of disease, detection of genetic disorders, new therapies evolved from cell research and individualized (miniaturized and nanologic) processes of therapy and treatment. Once again, Held refers us to the proliferation of public concern and anxiety at what, to some, is eugenics and therefore ethically problematic. Such debates are disturbingly prescient in our stage of (post-)evolution where we have the potential to prolong life but also to dramatically alter, enhance and hybridize our notions of the 'human'. Science tells us that our genomic make-up is less differentiated from other species than first thought; as Held informs us, almost half 'of the human genome is comprised of transposable elements'. We are not so different from our 'creature comforts' (see Haraway 2003). The speculative nature of these ideas has had its effect upon the world of art practice/theory, an area which traditionally explores complex theoretical ideas through practical, media/organic related practices. Traditional debates on representation have more recently been ossified by a concern with process, imbrication, immanence and emergence. Images, as we saw in Orlan's piece, no longer function to 'represent', but to 'progress' or 'process', and Modernist concerns with the aesthetics of the 'beautiful' have been altered through a neo-aesthetics of processuality, contagion and difference (see Kennedy 2000 and this volume; Massumi 2002; O'Sullivan 2006; Pisters 2002; Powell 2006).

Held recounts a series of art works currently imbricating these ideas, where some have argued that it is the areas of art and culture, not in scientific journals, that debates about our 'futures' will really be conducted. In *What is Philosophy?* (1994), Deleuze and Guattari theorize the connections across art, science and philosophy, and Edward Wilson in his work *Consilience* (1998) argues that there is a possible consilience across the arts and sciences provided by philosophical engagements. Held's article narrates the exhibition award at Henry Art Gallery, University of Washington (2002) through several artists' work. Current popular culture has mediated contemporary concern with the volatile mix of genomic, generic codings, DNA, human blueprints and codings: *The Da Vinci Code* by Dan Brown (2003) is a prime example of the fascination of such boundary narratives across theology, science, science fiction and indeed art history. Eduardo Kac's work for example, originates from biblical quotation advocating man's supremacy. This is transported through telecommunications codings followed by conversion to genetic language, eventually becoming material: a newly formed and abstract DNA. The artists' collective Critical Art Ensemble takes different languages to explore genomic experiments. Anxiety and fear (the two most prevalent and prolific emotions of our twenty-first century) are problematized and contextualized through re-appropriating theological 'languages' into performance. Maira Kalman's delightfully refreshing and public performance embraces the interface of language,

materiality, space and genomics through the mobilizing of coffee cups which provoke 'food' for thought.

However, such developments in human genomic research do not come without concerns around ethical and political issues regarding privacy, access and ownership. The posthuman world may offer utopian dreams, but to whom? One might further add, with what effect on the disenfranchised? Traditional categories of sexuality, gender, race and class are re-configured within genomic research through the interrogative work of the Glasgow artist Christine Borland. Her work imbricates ethical issues regarding gender, race and privacy, reminiscent of debates we earlier witnessed in relation to the Visible Human Project (see Waldby's article in Part Six). DNA may be deliciously deterritorialized, but who has ownership? These questions are implicated, interrogated and inflected through other artists of the collective. Reminiscent of current debates on 'chimeras' in relation to cross-genetic research, human-animal hybrids figure as further experiment for contemporary artists. Here transgenics (the form of new combinations of genes isolating one or more gene (s) from one organism and introducing them to another) is contextualised and critiqued through materialized artwork. Ethical issues are once again pertinent to these animal/human experiments. Daniel Lee's work seems less problematic because of its digital configurations. In ways fitting to this collection, Held conveys a selection of works which explore how the new genomics may enable us to question the notion of the 'post-human'. Where is identity? Where is subjectivity? Are there such things as essential aspects to human nature? My favourite, I have to admit, is the piece by Margi Geerlinks – anxieties of aging and female identity capturing one of the twenty-first century's major taboos for women. From the hundred or so other works in the Gene(sis) exhibition, Held's discussions provoke and contextualize the complexity of theoretical discourse in relation to new scientific discoveries which threaten to alter our notion of 'what it is to be human'. Such future delights, which break down barriers between the arts and sciences, are both engaging and exciting but also simmeringly disquieting.

Reading Matthew Gandy's prolific and exceptional piece, 'Cyborg Urbanisation: Complexity and Monstrosity in the Contemporary City', is almost like experiencing Gibson's *Neuromancer*: 'Unthinkable complexity, lines of light ranged in the non-space of the mind, clusters and constellations of data. Like any lights, receding'.[2] Indeed, Gandy's article follows a rhizomatic and complex set of ideas which are brought together and coalesced through the metaphor of the 'cyborg', drawn into monstrous couplings with a whole range of cultural, sociological and geographical theory. To account for every theorist with whom Gandy engages would constitute a veritable complex machine; an uncontainable monster in its lines of flight. He opens with quotations from Ballard, Vidler and Villiani, symptomatic of his proceeding engagement with the colliding of fiction and theory, and contextualizes his article on the contemporary city by establishing the *cyborg* as more contemporary 'way of thinking about the world'; in short, a cyborgian sensibility as an ontological strategy. As an ontological strategy, 'cyborg consciousnss' has of course been theorized through a variety of disciplines, enabling a finely-tuned coupling and assemblage of differentially inflected discourses (see Kennedy 1999).

Gandy locates this trope of critical reflection in the context of spatial theory and architectural theory. Laying the groundwork in Haraway's Manifesto (see Part One), he argues that the cyborg metaphor challenges dualistic, masculinist and teleological bodies of knowledge, and thus takes us to a variety of knowledges for discussion. His prime consideration is with the 'neo-organicist' city – one which is a machine/organism assemblage of networks, flows, wires, pathways and has a wide range of interstitial spaces of connectivity. This provides a more complex model for spatial theory premised no longer on the 'organicist' city, but a body-city relational as a prosthetic combination. Prostheses are no longer merely 'add-ons' but become constituent elements of newly-framed connectivities. Just as drugs perform an interior prosthesis to the corporeal body, so the city 'works,' or 'acts' and 'mobilises' as a complex heterogeneous prosthesis.

Inevitably, Gandy's argument serves to convey the break from Cartesian thinking. No longer a 'mechanical' model of theory, Gandy's critique of 'neo-organicist' thinking introduces a new model of mind/body interconnectivity. Much of his thinking evolves from post-structuralist philosophical readings which in turn take their lead from evolutionary biology and ecological thought. He refers to this postmodern assemblage of human/city connections as a 'nexus' or a 'thinking machine', here resonant of Deleuzian ideas on mind/body/world co-existencies. Rather than cities as 'bodies with organs' in an organicist sense, each part playing a vital role to the city's functioning purpose, the city is the space of 'becoming' and a 'body without organs' in a neo-organicist implication of mind/body complexes. Further links to the philosophy of Henri Bergson follow through to vitalist links to ecology and evolutionary biology. The virtual realm of the city/human and mind/body nexus is an experimental and emergent process, one 'yet to become'. Gandy has prescient citation here of architectural theory's exploration of genetic algorithms to provide a kind of 'in vitro' architecture. Indeed, he refers us to the architectural practice of Eisenman, Gehry and Tschumi. Referencing also Latour's similar, but differently inflected link to post-structuralist theory, Gandy argues for the move away from metanarratives of theory into post-theoretical concerns with complexity and chaos theory to consider 'movement'.

This contemplation of 'movement' is a current philosophical enquiry in much interdisciplinary work across not only social sciences but traditional humanities such as literature, film studies, art history, drama, performance and fine art practice. A concern with volatility, volition and emergence brings with it a 'deconstruction' and ossification of human subjectivity and agency. But, argues Gandy, there is much for us to be concerned about when we adapt models which may also become symbolic of an increasingly militarized society. The ossification of agency and subjectivity may be epistemologically exciting, but what happens in a global economy where issues of access and power are still problematic? Gandy refers us to the work of Graham, Agamben and Bauman, through which to consider these issues of deliberate disenfranchisement.

The section on agency, hybridity and distributed cognition allows Gandy to explore further theoretical perspectives from Haraway, Latour and Hayles, whose

use of Bateson's 'distributed cognition' enables a newly-framed concept which 'blurs the boundary between sentience and non-sentience'. Gandy then works through ideas from Castells on flows, networks and the public sphere but settles to explore complexity through the cyborg metaphor. He argues:

> the cyborg metaphor is, in other words, peculiarly suited to an understanding of the contemporary metropolis not only as a morphological entity entwined with various technical discourses, but also as an abstract and inter-subjective realm through which political and cultural ideas become constituted.

However, as I metaphorically 'play' in *Deleuze and Cinema: The Aesthetics of Sensation,* 'Desire disperses from the Metropolis: but there is no becoming without the wasp and the orchid' (Kennedy 2000: 138).

Do we really want to relinquish the subject, or to relinquish human emotions like love? Can there not be a collusion of post-theoretical and neo-humanist or neo-phenomenological thinking, a truly cyborgian consciousness and one of 'distributed cognition'? The rest of Gandy's article diverges into popular cultural dreamscapes: filmic examples from Terry Gilliam's *Brazil,* Gibson's *Neuromancer,* Ridley Scott's *Blade Runner,* contextualized within the theoretical cyborgian discourses of Bukatman and Wolmark, and finally he considers our conception of the 'sublime' by advocating a neo-Kantian reading of the sublime to offer an alternative to the non-representational theory of post-structuralism. The cyborg is indeed difficult to pin down and its usage in thinking 'beyond cyberculture' has only just begun.

'From Cyber to Hybrid: Mobile Technologies as Interfaces of Hybrid Spaces', by Adriana de Souza e Silva, also provides a discussion of the hybridities of the city, but this time woven through the digital movements of cell phone technologies and their interrelation with our notions of identity and space. Reminiscent of the earlier essay by Holden and Tsuruki (in Part Two), this piece follows the significance of cell phone technologies and the impact of these upon our notions of space, time, identity and place. Whereas Holden and Tsuruki were more concerned with the interpersonal spaces which we inhabit via cell phone communication and their uses for social and personal experience, de Souza e Silva elaborates upon a hybridized connection of mobile technology and human bodies in a new concern with hybrid city spaces. Japan has a culture which is manifestly overcrowded. Population overload provides little 'personal' space when moving around the city. Cell phones are thus the most popular way for people to partially disengage (although re-engage in a different form) from their physical surroundings and take themselves into a consensual space via Internet movements or personal calls. In this way, an individual's physical, psychical and mobile spaces choreographed through the city merge with the cyberspatial zones of digitality, configuring new hybrid spaces and indeed new hybrid beings. Cell phones of the 3G variety mean that we need no longer be constrained to one physical space to access cyberspace. The use of the cell phone miniaturizes the embodied user of cyberspace into a new assemblage. *We can be permanently connected to the Internet! I don't want*

to be permanently switched on. Would you want to be? Some obviously do (love of the truly schizophrenic!).

Physical and digital spaces merge. This creates new webs and networks of social, political and personal interface. As we saw in Gandy's article, the description of flows and networks in our contemporary cities bring a wide range of new interpretations of our posthuman experience. The cell phone's connection to Internet technology not only affects personal identity but also creates new ways of exploring and explaining the webs, flows, networks and pathways through our urban spaces. This article suggests that such hybrid spaces are conceptualized according to three congruent and overlapping trends: hybrid spaces as connected, as mobile spaces and as social spaces. Explaining the concept of the interface, de Souza e Silva expands the notion to a *social* interface. These reshape the spaces in which interactions take place. Our experience of physical spaces, for example walking through a city's park area, will be overlaid with different inflections of cyberspatial immersion, folding different experiences of place, time and even the feeling of 'movement' of one's body. Where is the 'real' experience and what is virtual? Contemporary 3G cell phones have a range of possibilities: broadband connection, multimedia messaging, text messaging, mobile photos and video. We become progressively more and more like the viral nodes to which Baudrillard (1983) refers in *Ecstacy of Communication.* What is offered by de Souza e Silva is a consideration of hybrid reality as a 'blurring of borders between the physical and the digital' (see Gergen 2002; Plant 2001; Puro 2002). Japanese users of cell phones have a different perception of borders. The continual use of 3G phones means that there is never a feeling of immersion into a new space, in the same way for those of us who connect to stationary Internet connections. This evokes new questions regarding embodiment and identity.

More significantly, it is the use/social values of this new form of connection that proliferates. The article then develops an exploration of augmented realities such as VR and 'mixed' realities. In ways which resonate with Manovich's essay in Part Two, the article engages with debates about surveillance mechanisms which capture data from our physical experiences and meld it with those of digital networks. Once again several theorists are referred to, Deleuze and Guattari's (2002) concept of striated and smooth space offering a creative exploration of nomadic pathways. Nomadic pathways are not fixed, not linear or punctuated, but smooth, flowing and digressional. In other words they are processual. Cell phone use develops these nomadic spaces by virtue of both new paths and flows but also new assemblaged nodes. Movement is key to the creative process. Sometimes the nomadic pathways lead to new social organizations and new social acts, such as the meeting of hundreds of people in one place as in smart mobs – much like the sixties 'happenings' which resulted from ad hoc and socially networked connections of place, time and purpose (Rheingold 2002). Whether for social, creative, pleasurable or political means, the hybrid spaces created by new cell phone technologies provoke a plethora of negative but also creatively positive uses.

The final article in this section is 'Thinking Ontologies of the Mind/Body Relational: Fragile Faces and Fugitive Graces in Choreography and Performativity'.

Like other articles in this section, my piece is concerned to show the working of Deleuze-Bergsonian thinking in the creative act of choreography and dance, both as practices in themselves but also as metaphors through which to consider the screenic experience. The over-riding concern is with the concept of the 'creative' act and what constitutes creativity. In keeping with the other articles in this section, it utilizes a range of Deleuzian and Bergsonian ideas, and vectorizes a range of different theoretical discourses through which to consider both the notion of 'creativity' and also new understandings of dance, performativity and what is referred to as 'transfeminist practice'. Arguing that creativity lies beyond any subjective or affective space, in temporality and duration, the article offers an example of *distributed cognition* and *schizoanalytical* methodologies to explore the process and practice of dance, but also the choreography in texts. We seem far removed from those understandings of 'cyborgs' as representations, as the article argues for a distanciation of representation to offer a pragmatics of becoming which opens the way forward to new becomings in all disciplinary discourses. This reflects more the ideas of cyborgian consciousness and distributed cognition that have been apparent in Milburn and Lenoir and Alt's articles. It reflects and resonates with art practice in Robin Held's chapter, and some of the ideas which both Stelarc and Orlan pursue in their work (see Part Six). Indeed, it suggests a *'Beyond Cyberculture'* which is a *beyond* of the determinants of the technology itself, and promises to open up intellectual and scholarly pursuit, artistic practices, and creativity.

Where to now....?

The Mystery of Things

The mystery of things, where is it?
Where is it that does not appear
At least showing us what mystery is?
What does the river know of it and what does the tree?
And I, who am no more than they, what do I know of it?
Whenever I look at things and think what men think of them,
I laugh like a brook babbling cool over a pebble.
For the only hidden sense of things
Is that they have no hidden sense at all,
Is stranger than all strangeness,
Than the dreams of all the poets
And the thoughts of all the philosophers
That things are really what they seem
And there is nothing to understand.
Yes, this is what my senses have learned by themselves:
Things do not mean: they exist.
Things are the only hidden sense of things.

Fernando Pessoa[3]

Notes

1 Shakespeare, *The Tempest*.
2 William Gibson, *Neuromancer*, 1984: 51.
3 Lisboa, E. and Taylor, L. C. (1997) *Pessoa, Fernando, A Centenary Pessoa*, Manchester: Carcanet.

References

Baudrillard, J. (1983) 'The ecstacy of communication', in H. Foster (ed) *The Anti-Aesthetic*, Port Townsend, WA: Bay Press.
Bergson, H. (1911) *Creative Evolution*, New York: Holt.
Brown, D. (2003) *The Da Vinci Code*, New York: Doubleday.
Deleuze, G. (1993) *The Fold: Leibnitz and the Baroque*, Minneapolis, MN: University of Minnesota Press.
Deleuze, G. and Guattari, F. (1987) *A Thousand Plateaus: Capitalism and Schizophrenia*, Minneapolis,MN: University of Minnesota Press.
Deleuze, G. and Guattari, F. (1994) *What is Philosophy?* London: Verso.
Denari, N. (1999) *Gyroscopic Horizons*, New York: Princeton Architectural Press.
Eisenman, P. (1999) 'Visions unfolding: architectures in the age of electronic media', in L. Galotoro (ed.) *Digital Eisenman: An Office of the Electronic Era*, Basel: Birkhauser Press.
Gergen, K. (2002) 'The challenge of absent presence', in J. Katz and M. Aakhus (eds) *Perpetual Contact: Mobile Communication, Private Talk, Public Performance*, Cambridge: University of Cambridge Press.
Haraway, D. (2003) *The Companion Species Manifesto*, Chicago. IL: Prickly Paradigm Press.
Kennedy, B. (2000) *Deleuze and Cinema: the Aesthetics of Sensation*, Edinburgh: Edinburgh University Press.
Lyn, G. (1995) http://www.basilisk.com/aspace/formview.html.
Lyn, G. (1998) 'The folded, the pliant and the supple', in *Folds, Bodies and Blobs*: *Collected Essays*, Brussels: la Lettre Volee.
Lyn, G. (1999) *Animate Form*, New York: Princeton Architectural Press.
Manovich, L. (2002) *The poetics of augmented space: Learning from Prada*, http://www.manovich.net
O'Sullivan, S. (2006) *Art Encounters Deleuze and Guattari*, London: Palgrave Macmillan.
Plant, S. (2001) 'On the mobile: The effects of mobile telephones on social and individual life', http://www.motorola.com/mot/doc/0/234-MotDoc.pdf.
Puro, J. P. (2002) 'Finland: a mobile culture', in J. Katz and M. Aakhus (eds) *Perpetual Contact: Mobile Communication, Private Talk, Public Performance*, Cambridge: Cambridge University Press.
Pisters, P. (2002) *The Matrix of Visual Culture: Working with Deleuze in Film Theory*, Stanford: Stanford University Press.
Powell, A. (2006) *Deleuze and Horror*, Edinburgh: Edinburgh University Press.
Rheingold, H. (2002) *Smart Mobs: the Next Social Revolution*. Cambridge, MA: Perseus.
Wilson, E. (1998) *Consilience*, London: Little, Brown and Company.

Timothy Lenoir and Casey Alt

FLOW, PROCESS, FOLD

A GROWING REPERTOIRE OF COMPUTER-BASED MEDIA for creating, distributing, and interacting with digitized versions of the world pervades contemporary life. Computer-mediated communication has already become significant in biology and medicine, and several developments—not all of them integrally connected—in fields of bioinformatics, biomedical imaging, and surgery, have become significant for other areas in which computers mediate processes of work and creativity. Oft noted features of the growth of computer-mediated forms of work and communication—particularly evident in the biomedical areas—are the acceleration of nearly every aspect of design and production, along with the high degree of both modularity and adaptability of processes. Information technology workers have responded to the explosion of data created by digital technology by generating dynamic systems for facilitating the flow of information, replacing static forms with fluid architectures for extracting meaning.

Of particular concern here is the architect's engagement with information technology (IT). Some architects are using IT to address critical contemporary issues of philosophical, ethical, and social concern. Many have found resonance in the philosophical writings of Gilles Deleuze and Félix Guattari, particularly in their efforts to displace key modernist notions of difference, such as other, lack, or negative, with difference as a positive source. Equally powerful are Deleuze and Guattari's rejections of positions stressing reductionism and organic unity; in place of totalizing unity, they advocate locality, situatedness, rhizomic strategies, "bodies without organs," and machinic assemblages.[1]

The architects explored here have engaged with computer technology on many planes. They have sought to engage the digital communications revolution in the material expression of the buildings they construct. They have also embraced computer-mediated design and production as an opening for a new critical discourse, a new line of flight, at once a new critical language and phenomenology.

Bioinformatics: a new biology for the information age

One of the most interesting developments in recent biology is an inexorable shift—almost in spite of the rhetoric of the practitioners themselves—toward a disunified model of science. It is not that biological scientists have given up their search for laws of nature. Hardly. In the past two decades, however, a new biology has arisen: a highly context-specific yet mathematically exact form of local science that might be described as a science of the particular. Similar trends can be seen in areas of medicine such as surgery, where surgical planning and simulation are being tailored to the specific patient as opposed to a generic subject selected from a medical atlas. Similarly, the goal of pharmacogenetics, a new postgenomic field, is to target drug design for the individual.

It is computing technology, particularly broadband Web and simulation technology, that has made these developments possible. Work on protein structure provides an example. Rather than telling the familiar story of François Jacob and Jacques Monod's theoretical work and how it propelled biology into the information age, a media-sensitive account would look at the contributions of information technology itself. About the same time as Jacob and Monod's work, new developments in computer architectures and algorithms for generating models of chemical structure amid simulations of chemical interactions allowed computational experiments to interact with and draw together theory and laboratory experiment in completely novel ways.

Notions of theorizing have radically shifted in many areas of science, not least biology. For decades many biologists aspired to theoretical constructs modeled along the lines of the physical sciences. Like physicists, they have searched for the holy grail of a grand unifying theory, preferably reducible to fundamental laws of physics and chemistry. For those wanting to view molecular biology as an extension of physics and chemistry, a key step was provided by the work of Christian B. Anfinsen, whose Nobel Prize-winning work on protein folding established that all the information required to fold proteins into their final (native) state is contained in the linear sequence of amino acids themselves.[2] But how is the tertiary structure, the final folded state of molecules, encoded in that primary sequence? Biologists have needed to determine this structural code in order to understand the genetic message.

Anfinsen's work suggested that it is reasonable to suppose that the native fold of a protein can be predicted computationally using information about its chemical composition alone and that finding the global minimum of a protein's potential energy function should be tantamount to identifying the protein's native fold.[3] Unfortunately, the task of finding the global minimum of one of these functions has not proven easy, because the potential energy surface of a protein contains many local minima. Some computational biologists have argued that even more is possibly at stake here than just the computational complexity of the task. It may be impossible in principle to fold proteins without the assistance of "chaperones," or the rapid formation of local interactions, which then determine the further folding of the peptide. This suggests local amino acid sequences, possibly the result of evolutionary adaptation, that form stable interactions and serve as nucleation points in the folding process. Indeed, Cyrus Levinthal, the author of this hypothesis (known as Levinthal's Paradox), argued that the conformation space—the set of all possible configurations a molecule can assume in folding from its starting uncoiled state to its native fold—for even the average-size protein molecule is exponentially large. For example, each bond connecting amino acids can have several possible states (three for this example), so that a protein of 101 amino acids could exist in $3^{100} = 5 \times 10^{47}$ configurations. Even if the protein is able to sample new configurations at the rate of 10^{13} per second, or 3×10^{20} per year, it will

take 10^{27} years to try them all. Proteins actually fold in a time scale of seconds or less. Levinthal concluded that random searches are not the way proteins fold.[4]

Computer modeling and the introduction of tools from artificial intelligence (AI): and expert systems in biochemistry during the 1960s and 1970s seemed to offer a way out of the dark woods of protein folding and at the same time promised the theoretical unification of biology. What has actually emerged is something quite different, however, perhaps best described as a disunified but more effective biology.

Models, whether physical or virtual, have always played crucial roles in understanding the structure of biological molecules. For James Watson and Francis Crick's discovery of DNA, making a physical model was the key step, for example. In biology, as in architecture, geometry is everything, because the functional properties of a molecule depend not only on the interlinkage of its chemical constituents but also on the way in which the molecule is configured and folded in three dimensions. Much of biochemistry has focused on understanding the relationship between biological function and molecular conformational structure. Model building is the sine quanon of this enterprise.

A milestone in the making of physical three-dimensional models of molecules was John Kendrew's construction of myoglobin. An attempt to build a physical model from a Fourier map of the electron densities derived from X-ray crystallographic sources, Kendrew's model was a room-filling forest of brass rods and wires. It was obvious that such 3-D representations would become truly useful only when it was possible to manipulate them at will—to size and scale them arbitrarily from actual X-ray crystallographic and electron density map data. Proponents of the field of computer graphics and computer-aided design—newly minted at the Massachusetts Institute of Technology in Ivan Sutherland's 1963 dissertation—argued that computer representations of molecular structure would allow these manipulations.

Computer modeling, requiring the specification of codes to produce these models from known data, was embraced at first because it promised molecular biologists, particularly the biophysicists among them, a unified theory; it would move the field toward such a goal by providing a framework from which would emerge a fully mathematized and thus fully scientific theoretical biology.[5]

Levinthal first illustrated the method for representing molecular structure in computer graphics by adapting Sutherland's computer-aided design (CAD) program to biochemistry. Levinthal reasoned that since protein chains are formed by linking molecules of a single class (amino acids), it should be relatively easy to specify the linkage process in a form mathematically suitable for a digital computer.[6]

But there was a hitch: in an ideal world dominated by a powerful central theory, one would like, for example, to use the inputs of *xyz* coordinates of the atoms, the types of bond, and so on to calculate the pairwise interaction of atoms in the amino acid chain, predict the conformation of the protein molecule, and check this prediction against its corresponding X-ray crystallographic image. However, as we have noted above in our discussion of Levinthal's Paradox, the parameters used as input in the computer program do not provide much limitation on the number of molecular conformations. Other sorts of input are needed to filter the myriad possible structures. Perhaps the most important of these is energy minimization: the basic physical hypothesis that, like water running downhill, a large protein molecular string will fold to reach the lowest energy level. Such minimization calculations could not be done, as Levinthal noted, because the necessary formula could not, in the state of molecular biological theory of 1965, be written down and manipulated with a finite amount of labor.

Levinthal's solution to the problem of filtering possible molecular conformations was to create a computer visualization generated in real-time interaction between human and

machine. The computer became in effect both a microscope for examining molecules and a laboratory for quantitative experiment, all in the service of producing a general theory of protein folding. Levinthal emphasized that interactivity facilitated through visualization was a crucial component of his model-building program, CHEMGRAF,[7] where the user could *observe* the result of the calculations and be able to halt the minimization process at any step, either to terminate it completely or to alter the conformation and then resume it.[8] CHEMGRAF was thus a first step toward decentering the importance of theorizing in biology and elevating the emphasis on visualization, haptic interaction, and experimental tinkering as a method of investigation. It would take an explosion in molecular biological data to complete the redefinition of biology as information science.

The measures taken by Levinthal to avoid computationally intensive techniques illustrate the wide variety of simplifications that have typically been introduced into molecular dynamics computations, such as constructing models that hold fixed certain parameters or ignore others deemed not to be essential for purposes of approximation. Other approaches have used time averaging or ensemble averaging to calculate properties such as the global free energy of the protein. Another approach has been to construct simulations using randomized Monte Carlo methods for generating successive configurations and averaging over all samples that are generated. While both molecular dynamics and Monte Carlo methods are theoretically capable of treating the protein-folding problem, they too require very large amounts of computation time for molecules with many degrees of freedom.

Characteristic of the trend in contemporary science away from reductionist theories is the tendency to draw upon strategies and methods from completely different domains, in effect to cut the Gordian knot in one area by adapting tools from another. One such approach to protein folding that will prove relevant to our architectural concerns is the use of algorithms based on robot-motion planning by Jean-Claude Latombe, Douglas Brutlag, and colleagues in order to improve the speed and efficiency of protein-folding simulation methods.[9] In this context, similar to the elements of a robot navigating a local terrain, Latombe et al. model molecules as sequences of vectors, in which each vector is an element of secondary structure, such as an alpha-helix or beta-sheet. The set of all its 3-D placements is the molecule's conformational space, over which the energy field is defined. Instead of inducing the motion of the robot through actuators, Latombe et al. examine the possible motions of the robot induced by the energy landscape of its immediate environment and generate a network of pathways called a probabilistic conformational road map, a graph whose nodes and edges are, respectively, low-energy conformations and short-weighted pathways. The weight of a pathway measures the difficulty for the molecule in moving along it. The power of a probabilistic conformational road map derives from its ability to encode compactly a huge number of energetically favorable folding pathways, each defined as a sequence of contiguous local pathways. Instead of simulating the entire set of potential fold configurations, the motion-planning technique guesses several possible intermediate configurations of the protein and obtains a distribution of energetically favorable intermediate configurations to which a "difficulty weight" is assigned representing the energy barriers along the path.

A paradigm shift in biology

The type of modeling represented by Levinthal's work, as well as the recent work on motion planning, depends crucially on high-quality crystallographic data, and these have proved difficult to obtain in the quantity desired to drive the field rapidly forward?[10] Simultaneously,

however, another stream of work flooded the biological knowledge base. The development of restriction enzymes, recombinant DNA techniques, gene-cloning techniques, and PCR (polymeraze chain reaction) produced a deluge of data on DNA, RNA, and protein sequences.[11] Since the mid-1980s, sequence data have been growing at an exponential rate, doubling over fifteen months, reaching a figure of ten million base pairs a day. Such an explosion of data encouraged the development of a second approach to determining protein structure and function, namely prediction from sequence data alone.

The field of bioinformatics has taken an approach to this problem different from the "bottom-up," brute-force energetics approaches. Rather than deriving structure and function directly from the physical properties of amino acids and the first principles of protein-folding dynamics, the bioinformatics approach involves comparing new sequences with preexisting ones and discovering structure and function by homology to known structures. The approach is eclectic, heterogeneous, and multiple; rather than proceeding linearly from genetic information to molecular structure to function, in the spirit of the old "central dogma" ("DNA produces RNA, produces protein, produces function"), bioinformatics draws on bits and pieces of pattern in one domain and maps them comparatively in another domain through sophisticated probabilistic methods of data analysis, pattern matching, machine learning, and robotics. This is not to suggest that scientists in the field of bioinformatics reject energetic or thermodynamic accounts of protein folding; far from it. But in their search for methods that save computing cycles, they have followed a bootstrapping approach in which the statistical and knowledge-base methods of bioinformatics have assisted in refining the structures input into large all-atom energetics calculations for ab initio structure prediction.[12] In the new paradigm, both approaches inform one another.

The "bioinformatics" approach identifies the function and structure of unknown proteins by applying search algorithms to existing protein libraries in order to determine sequence similarity, percentages of matching residues, and the statistical significance of each database sequence. A database of proteins for which structural and sequence information is available is used to predict structural features for proteins of neighboring sequences. From proteins of known structures, a comparison of sequence and 3-D geometry makes it possible to derive rules or parameters that will subsequently permit the determination of the probability for a given fragment to arrange into a particular regular structure. As for tertiary structures, they also allow the researcher to define sequence templates for families of protein structures that adopt a common fold. If a sequence of an unknown structure can be matched with a template, a model of the fold can be built by analogy. Schematically, for predicting structures of unknown proteins, model building in bioinformatics proceeds through three main alternative approaches:

1. starting from the sequence knowledge
2. assembling fragments from different, known homologous structures
3. carrying out limited structural changes from a known neighboring protein.

Elements of protein structure

To elucidate the structure and function of proteins, bioinformatics focuses its computational tools on secondary and tertiary structure. Secondary structure consists of local folding regularities maintained by hydrogen bonds and is traditionally divided into three major classes: alpha-helices, beta-sheets, and coils representing all the rest. In alpha-helices, backbone hydrogen bonds link residues i and i + 4, whereas in beta-sheets, hydrogen

bonds link two sequence segments in either parallel or antiparallel fashion. The secondary structure can be sensitive to single amino acid changes and depends on, both local and long-range interactions. A key tool used in elucidating structure-function relationships is a search for sequences that correspond to small, conserved regions of proteins—modular structures known as motifs. Motifs are key patterns of amino acids that form the building blocks in the secondary structure of proteins. The sequence patterns defined by motifs are powerful probes for searching databases of known structure and function to determine the structure and function of an unknown gene or protein. Several different kinds of motifs are related to secondary structure and to tertiary structure, the final folded structure of protein. Secondary structure consists of patterns of repeating polypeptide structure within an alpha-helix, a beta-sheet, and reverse turns. At the next level, supersecondary structure refers to a few common motifs of interconnected elements of secondary structure. Segments of alpha-helix and beta-strand often combine in specific larger structural motifs. One example is the alpha-helix—turn-helix motif found in DNA-binding proteins. This motif contains twenty-two amino acids in lengths that enable it to bind to DNA. Another motif at the supersecondary level is known as the Rossmann fold, in which three alpha-helices alternate with three parallel beta-strands. This has turned out to be a general fold for binding mono- or dinucleotides and is the most common fold observed in globular proteins.

In addition to searching for motifs, another principal strategy for determining structure-function relations uses various sequence-alignment methods. Among these are consensus sequences, weight matrices, and profiles, all of which employ a battery of different probabilistic methods for teasing out structure similarity.

In order to keep pace with the flood of data emerging from automated sequencing since the 1990s, genome researchers have looked increasingly to artificial intelligence, machine learning, and, as noted above, even robotics in developing automated methods for discovering protein motifs and folding patterns from sequence data. The power of these methods is their ability both to represent structural features rather than strictly evolutionary steps and to discover motifs from sequences automatically. Indeed, a central axiom of the field is that massively automated methods are the *only* ways to get at the structure of large genomes and make sense of medically relevant sequence information. The methods developed in the field of machine learning, such as perceptrons, genetic algorithms, neural networks, Bayesian networks, hidden Markov models, minimal-length encoding, and context-free grammars, have been used singly and in combination to extract conserved residues, discover pairs of correlated residues, and find higher-order relationships between residues.[13]

Flow and fold

The results of automated sequencing of genes and proteins, combined with the necessity of devising novel informatics techniques for extracting meaning from these data, have radically transformed the theoretical enterprise of biology. The "central dogma" emerging from the work of Watson, Crick, Monod, and Jacob in the late 1960s may be schematized as follows:

DNA ◊ RNA ◊ protein ◊ function

The fundamental dogma of this new biology reformulates the central dogma of Jacob and Monod in terms of "information flow":[14]

genetic information ∣ molecular structure ∣ biochemical function ∣ biologic
behavior

Genomics, computational biology, and bioinformatics have restructured the playing field
of biology, bringing a substantially modified tool kit to the repertoire of molecular biology
skills developed in the 1970s. The new biology is a data-bound, rather than observational,
science. To understand the data, the tools of information science have not become mere
handmaidens to theory; they have fundamentally changed the picture of biological theory itself.
As a result, disciplinarily, biology has become an information science, while institutionally it
has become Big Science. Along with biochemistry components, new skills are now required
to sift through the data, including machine learning, robotics, databases, statistics and
probability, artificial intelligence, information theory, algorithms, and graph theory.[15]

A 1985 report by the National Institutes of Health (NIH) sums up the difference
between a unified biology and the information-technology-infused, heterogeneous, multiple,
data-driven, and enfolded state of biology. Contrasting this biology with theoretical physics,
"which consists of a small number of postulates and the procedures and apparatus for
deriving predictions from those postulates," NIH writers view contemporary biology as
an interconnected assemblage of different strata, from DNA to protein to organismic and
behavioral biology, each with its own unique set of laws and processes.[16] Rather than through
a unified theory, the field's critical questions can often be answered only by relating one
biological level to another through the techniques of informatics.[17]

Shared metaphors

Biology as it was once practiced has been remade by the steady introduction of computational
tools, computer-mediated forms of communication, and an entire material infrastructure
of genetic and cellular tagging, labeling, sequencing, and processing that has turned the
world of biological flows and folds into digital information. As a result, the practitioners
of biology in *silico* have a relationship to their research objects that is different from that
possessed by their predecessors. The first generation of computational biologists looked to
computers as tools for data storage and retrieval and for assistance in carrying out lengthy,
redundant computations, but not as the site for experiment and design work. Genomics
researchers, by contrast, find themselves immersed in increasingly automated computational
environments for the identification, manipulation, and design of their research objects. In
a certain sense, the ontology of the domain has shifted.

A number of architects have been similarly affected by engagement with computers, and
they have looked to computational biology for metaphors to articulate the new directions in
which they want to take architectural practice. The term *postarchitects* seems fitting for this
group, who all share an interest in engaging with the computer in their architectural practice,
not just as a useful tool for implementing designs or as a new medium for expression, but
as a new material agency that can challenge the foundations of traditional design practice
and propel architecture in a new direction, a new line of flight. In addition to their interest
in computers and computational biology, what characterizes postarchitects in our account is
their agreement on what they take to be the limitations of "postmodern architecture" and
on a new program that can move beyond those limitations. For postarchitects, the writings
of Gilles Deleuze are particularly salient. Architectural computing, fused with metaphors
from computational biology, commingle with the philosophical positions articulated by
Deleuze to inspire a new architecture.

Peter Eisenman has provided one of the clearest statements of the motivation postarchitects share for engaging computational media. In a recent essay entitled "Visions Unfolding: Architecture in the Age of Electronic Media," Eisenman points to a crisis in the current state of his art: "During the fifty years since the Second World War, a paradigm shift has taken place that should have profoundly affected architecture: this was the shift from the mechanical paradigm to the electronic one."[18] Updating Walter Benjamin's 1935 "The Work of Art in the Age of Mechanical Reproduction," Eisenman argues for a necessary distinction between the mechanically reproduced and the electronically mediated. Mechanical reproduction has always required a human subject to mediate and interpret the process of reproduction itself; photographs, for instance, are differentially printed according to the specific visual characteristics desired by the photographer. In this way, Eisenman contends, "the photograph can be said to remain in the control of human vision."[19]

Electronic media, on the other hand, are not subject to human intervention or interpretation because they are not produced according to a visible mechanical logic. Rather, electronic media are themselves *processes of mediation* that are hidden from the user and controlled by the internal wirings of an entirely other logic—that of the digital. Eisenman asserts that electronic media's elision of the human discursive function in the process of production places it outside the control of human vision. By vision, Eisenman means the process linking "seeing to thinking, the eye to the mind" that perpetually aligns the production of content with the desires of an anthropomorphizing subject.[20] Electronic media, because they do not pass through the intermediary of human vision, are capable of disrupting how we experience reality itself, since "reality always demanded that our vision be interpretive."[21]

Eisenman wonders how, when every other cultural practice has been fundamentally transformed by the shift to electronic media, architecture has remained largely unchanged. As we have argued, the field of biology no longer exists as it was once envisioned: bioinformatics *is* the electronic mediation of biology, remaking the field right down to the central dogma of molecular biology. Why has architecture resisted such a transformation? Eisenman posits that architecture has remained stolidly rooted in the mechanical paradigm because "architecture was the visible manifestation of the overcoming of natural forces such as gravity and weather by mechanical means."[22] As a result, architecture has not only centered on designing structures that shelter, but in doing so has produced designs intended *to look as though* they will securely shelter—that is, the mechanics of their design is immediately interpretable by human vision. Such continuing recourse to the "mechanics of vision" in architecture has resisted an ability to *think architecture* in ways more commensurate with the new paradigm of electronic mediation.

Realizing the limitations inherent in an architecture dominated by the mechanics of vision, architects such as Neil Denari and Greg Lynn, in addition to Peter Eisenman, have discarded the eye-mind connection in favor of the transformative powers of electronic media and openness toward the systems of metaphor that such media enable, encourage, and engender. Denari foregrounds such an openness when he wonders:

> [W]ould it be possible today to describe certain architectural propositions without the lush and open-ended (technical) language of the life sciences? It seems that almost no architect is completely immune to the models offered by the soft systems of molecular biology, especially as they are transposed through forms of communication (media-based languages, etc.) that are themselves compounding the possible theoretical positions for architecture. [My] works ... while less indebted to the formal models of biological systems, do nonetheless employ the conceptual

and abstract terminologies of such systems. After more than a decade ... of rapid
absorption into the discourse of architecture, concepts and fields such as entropy,
cybernetics, self-organizing systems, neural networks, and complexity have helped
construct new formations of meaning, geometry, and space.[23]

Lynn extends this sentiment in pointing to the further transformative potential for a merger
of new media, the tools of computational biology, and architecture:

> In their search for systems that can simulate the appearance of life, the special effects
> and animation industry has developed a useful set of tools for these investigations;
> as contemporary animation software utilizes a combination of deformable surfaces
> and physical forces. The convergence of computer aided technological processes and
> biological models of growth, development and transformation can be investigated
> using animation rather than conventional architectural design software. Rather
> than being designed as stationary inert forms, space is highly plastic, flexible,
> and mutable in its dynamic evolution through motion and transformation. In
> animation simulations, form is not only defined by its internal parameters, as
> it is also effected by a mosaic of other fluctuating external, invisible forces and
> gradients including: gravity, wind, turbulence, magnetism and swarms of moving
> particles. These gradient field effects are used as abstract analogies for pedestrian
> and automotive movement, environmental forces such as wind and sun, urban
> views and alignments, and intensities of use and occupation in time.[24]

New architecture and computer-aided design

The strongest buttress of the eye-mind complex has been architectural theory itself,
especially as espoused by modernism. In its search for unity, harmony, and simplicity
in design, modernism aspired to remake every site in the image of man, a monument
to human ingenuity and Western ideals of beauty, proportion, and progress. Modernism
encompassed each site within its totalizing logic, viewing local particularities as obstacles to
the realization of the architect's vision. One way to dismantle the eye-mind link is to reject
such generalized theories in favor of increased attention to the indigenous differences in each
site. Just as the new biology has moved away from sweeping—but unuseful—theoretical
generalizations, architects have begun to discard the totalizing tenets of modernism and
embrace more context-specific practices of building.

 Such a shift in focus is not, however, an entirely recent phenomenon. Inspired by the
poststructuralist writings of Jacques Derrida, architectural deconstruction, or deconstructivism,
emerged in the 1970s and 1980s as a postmodern antidote to the hegemonic narratives
of modernism. Intending to subvert the homogenizing anthropocentrism of modernism,
deconstructivist architects sought to expose the contradictions and flaws inherent in the
process of building itself.[25] As a common technique, deconstructivist architects disrupted
traditional architectural regimes by identifying "repressed" styles within the local context
of a site, then forcefully combining the repressed motifs in a single building without any
concern for overall unity or design. Exemplary of deconstructivist architecture is the Frank
Gehry House in Los Angeles, which, according to Lynn, represents

> materials already present within, yet repressed by, the suburban neighborhood:
> sheds, chain-link fences, exposed plywood, trailers, boats and recreational vehicles.
> ... The house is seen to provoke conflict within the neighborhood due to its

public representation of hidden aspects of its context. The Gehry House violates the neighborhood from within.[26]

Deconstructivism engaged in dispersed guerrilla warfare against the modernist tradition of architecture by tactically dismantling localized contexts from within. In order to expose the inherent superficiality of modernism, deconstructivist architects deracinated the modernist motifs, styles, and materials from their underlying semiotic regimes and recombined them in a free-floating currency of signs.

By the early 1990s, however, many architects had begun to feel that postmodernism had trapped itself as a negative reaction against modernism.[27] Rather than freeing architects from the self-aggrandizing styles and forms of traditional modernism, deconstructivism appeared to be a superficial reshuffling of styles permanently bound within the same rhetoric it struggled to resist. Eisenman diagnosed this persistent problem in postmodernism: "[D]espite repeated changes in style from Renaissance through Post Modernism and despite many attempts to the contrary, the seeing human subject—monocular and anthropocentric—remains the primary discursive term of architecture."[28] Architecture, according to Eisenman, still had to move outside its self-inscribed circle of discourse. His remedy for the problem was to form a new collaboration, a human-machine assemblage that would decenter the architectural design process.

Eisenman, of course, was not the only former devotee of postmodernism to turn to computers for new approaches to design.[29] Gehry also turned to computer-aided design in search of new directions. Gehry's buildings of the 1990s, especially the Experience Music Project in Seattle, the Guggenheim Bilbao, and the planned Disney L.A. Opera House are rife with imagery of flow, folds, and biological metaphor. But in our view, Gehry's work does not represent the embrace of the machinic assemblages and decentering practices of postarchitecture. Computers, as we will show below, do not in and of themselves enable the architect to break free of traditional assumptions. If anything, they can reify those assumptions in software code and firmware in ways difficult to escape.

To appreciate the ways in which the group we are calling post architects have used computers in attempting to break free of traditional constraints, let us consider briefly the history of computer-aided design. Computer-aided design entered our story at the very beginning of the field. Sketchpad, the first CAD program, was the basis of Levinthal's early molecular design program, CHEMGRAF. Architects were no less receptive to CAD than early molecular biologists were to molecular graphics and computational modeling. Indeed, the reactions of the two groups often paralleled each other. As initially conceived, architectural CAD programs were used mainly as tools to augment the existing design techniques of architecture.[30] Architects did not design using CAD programs; rather, they used the traditional drafting tools of architecture to design buildings as they always had. After completing original designs, architects tended to use CAD programs to produce slick, full-color design layouts to entice clients and to store their designs digitally. Similarly, the word in the lab corridors among molecular biologists was that molecular graphics produced pretty pictures rather than aiding discovery.[31] Though CAD programs were electronic media from the start, architects used them more as high-tech additions to an older tool kit for mechanical reproduction.

Part of the initial resistance to designing in CAD stemmed from the fact that initial CAD programs were not immersive design environments. In fact, only recently did CAD programs such as AutoCAD become truly three-dimensional in a real-time volume-rendering sense. Early PC CAD programs were actually two-dimensional graphing systems that automatically extended shapes to a single fixed vanishing point, then projected a vertical "thickness" to

the 2-D forms in order to approximate solid volumes. This 2-D approach, as it is called, created the semblance of geometric solids; however, the perspective of the solid was mapped only to the vanishing point from the position at which the shape was originally drawn. Therefore, if you rotated the 2-D shape around its vertical axis, the shape would appear to recede in reference to the original vanishing point, even though the rotation of the object should also rotate the vanishing point and change the perspectival projection in 3-D space. Only recently have most architectural CAD programs been completely overhauled to provide true 3-D volumetric rendering that plots solids dynamically in real time from an underlying data-tree representation of the object, an innovation coded into bioinformatics media from the beginning.

The design tools presented in CAD also limited the extent of potential collaboration between the designer and the medium. Since early CAD programs were used to reproduce traditional design processes, architectural CAD programs were coded to integrate the same traditional rectilinear drafting techniques into a set of computer tools: the protractor, compass, straightedge, T square, and French curve were all automated as tool options within the program's own architecture. As such, early CAD programs provided no real advantage over traditional drafting techniques; in fact, they were often less intuitive. It is important to understand the precise capabilities and limitations of early architectural CAD programs because, as William J. Mitchell observes, "architects tend to draw what they can build, and build what they can draw."[32] Rather than providing a means for interactive collaboration as in CHEMGRAF, CAD programs reified a system of traditional design processes and significantly limited the ability to think outside of them. Coloring outside the lines is not only stylistically unadvisable in CAD programs, it is technologically impossible, because there is no tool to allow it. Again, as Mitchell notes, "by greatly enhancing the efficiency of traditional drafting practices, these systems further marginalized alternative practices."[33] In architectural CAD programs, the template for an ideal conventionalized architecture—the traditional paradigm of the mechanics of vision—is coded into the program itself. Subsequent releases and offshoots of these early programs preserved or exaggerated these initial limitations.

In the 1990s, computer-aided design linked with computer-aided manufacturing and a new repertoire of malleable building materials encouraged many architects to express fascination with the soft, anexact forms of bioinformatics; but this appreciation at times masked the radical potential of the technology underpinning these capabilities. In his article for the celebration of the Guggenheim Bilbao, for instance, Mitchell focuses on Gehry's building process as a means of generating soft, pliant forms and circumventing the built-in limitations of CAD. According to Mitchell, Gehry's process begins by freely sculpting a physical model of his desired design. Gehry then inputs the three-dimensional structure of his physical models into the robust CATIA program (the CAD/CAM environment used by Boeing to design the 777, the first airplane to be entirely designed in CAD/CAM). Mitchell describes this process as follows:

> In Gehry's office, the process begins with the use of a very accurate three-dimensional digitizer to capture vertex, edge, and surface coordinates from a large-scale physical model. Using CATIA, mathematical curves and surfaces are then fitted as closely as possible to these digitized points. Rapid-prototyping devices, such as computer-controlled three-dimensional deposition printers and multi-axis milling machines, are then used to "build back" physical models for visual inspection and comparison with the original. The process iterates, with adjustments as necessary to the digital model, until the design team is satisfied.[34]

In this way, Mitchell views Gehry's iterative multimedia process as "far more revolutionary" in its ability to transcend the limitations of traditional CAD functionality alone.[35]

However, despite Gehry's apparent ability to both utilize and transcend the functionality of CATIA, he is in fact doing nothing revolutionary with CAD. To be sure, he begins with 3-D rather than 2-D models. Nevertheless, as with previous CAD architectural implementations, Gehry has recourse to a metaphysics of presence in privileging *real* materials. His high valuation of the "direct tactility of the physical model and the speed, freshness, and energy of the freehand gesture"[36] smacks of a Pollock-esque modernism in which the artist spills his singular genius onto canvas. Professor of digital architecture Dennis Dollens argues that Gehry's design process combines the "warps and wefts of one experiment with the [vector lines] and lofts of another and arrives at a third transformative structure,"[37] a work process paralleling that of the postarchitects. With due respect to Dollens, however, Gehry does not engage in a transformative repetition of form through CATIA; rather, he subjects each CATIA prototype to a process of "visual inspection and comparison with the original" and thus privileges the original physical form. He produces no "third transformative structure" but only a progressive digital approximation of the physical model, a form that for all its anexact smoothness stems directly from the anthropomorphic ideals of Gehry himself. Gehry uses CATIA solely to prototype rapidly and apply his design to an automated process of highly specific mechanical production,[38] not to draw upon the powers of its electronic mediation to decenter his interpretive function as architect. Dollens reports that Gehry's approach enables his initial drawings and models to "be enhanced digitally, allowing him to take such advantage of electronic production while not being seduced by technology."[39] Such a fear of the "seductive" powers of technology reveals Gehry's unwillingness to subject his artistic genius to an equally powerful process of electronic mediation, an attitude binding him to the modernist architects he intends to oppose.

An alternative approach—that of postarchitects Eisenman, Lynn, and Denari—is to use electronic media to interact with anexact forms on their own terms and within an equally mediated space. If traditional CAD software is circumscribed within the mechanics of vision, why not change the software to the types of robust, high-powered programs of bioinformatics? Peter Eisenman observes, "What we need is the kind of software that the people who model complex biological and physical data in complex research institutions employ that can be used as models for architecture."[40] Through the increasing use of rigorous modeling applications such as Alias | Wavefront's Maya, Discreet's 3D Studio Max, and SOFTIMAGE | 3D, architects are beginning to acquire such media. Utilizing Non-Uniform Rational Bézier Spline (NURBS) based strategies for generating vectorial topologies, these new modeling programs enable new ways of thinking about form and space. According to Lynn, the newer media offer "perhaps the first opportunity for architects to draw and sketch using calculus ... by supplanting the traditional tools of exactitude and stasis with tools of gradients, flexible envelopes, temporal flows and forces."[41] Architects can now work on a level similar to that of bioinformaticists, a level where complex algorithms can model the affective space of each site, thereby allowing them to *think architecture* in the language of Deleuze through a *process of collaboration* with the electronic media. Eisenman has endorsed such a process of collaboration:

> I am certain of the need to reassess architecture within a digitized process, i.e. that there is no beginning, there is no truth, there is no origin, and there is no a priori given. In other words, there is no longer the necessity to begin from a rectangle, a circle, or a square. The notions of the Cartesian absolute as a priori truth already invested with beauty and goodness no longer exist or no longer are

taken as truthful or necessarily beautiful, or the only necessarily youthful and beautiful. If this is the case, then one has to find other matrices of form-making. And the human hand/mind relationship is not able to conceptualize this because all it can do is draw from the inventory of what it is possible to do with the human hand. That inventory of the possible is limited through knowledge and experience; the computer is not limited by the same knowledge and experience. The computer has no experience or knowledge of the images that it makes.[42]

In fostering a collaboration in which electronic media present their own reciprocal subjectivity, architects have succeeded in displacing their own discursive function. The result of this folding together of the desire of the architect with the computational/graphical power of electronic media is a cyborg assemblage that allows for an expanded opening onto greater degrees of creative freedom.

Finding the fold: Rebstock Park

One of the first to articulate the postarchitectural style was Eisenman. In 1992 Eisenman submitted a proposal for the redevelopment of Rebstock Park, a 250-acre site on the perimeter of Frankfurt. First developed in the mid-nineteenth century by Ernst May, the original architecture of Rebstock Park employed the once fashionable suburban solution of the *Siedlung*: mass-produced blocks of housing and commercial areas repetitively and densely staggered across large peripheries of development without interpenetrating streets or alleyways. *Siedlungen* were simple, cost-efficient, and immediate solutions to the problems of urban expansion at the time, but as the larger urban fabric of Frankfurt developed, the unvascularized space between the cellular series of buildings gradually degenerated into a necrotic zone of stagnant urbanism. In Eisenman's words, "Now all the open space was in a sense left over; the 'ground' became a wasteland."[43]

Rebstock Park posed an interesting challenge to Eisenman in that the carefully gridded homogeneity of the site left little to deconstruct. Ironically, it was the mechanical regularity of the grid itself—the interstitial spaces of difference *between* the cloned buildings—that became the strongest element of Rebstock Park, with the potential to infect and subvert the architectural plan as a whole. In many ways, the site had already been deconstructed by the urban framework itself, its most apparent flaws laid bare in its development within its surrounding context.

In contrast to his earlier attempts to draw inspiration from the works of Derrida, Eisenman, now disenchanted with deconstructivism, found resonance for his new direction in the works of Gilles Deleuze, a contemporary French philosopher whose works escaped the standard bounds of philosophy, just as architects tried to move beyond the traditional trappings of architecture. Rather than seeing the semiotic slippages opened up by deconstruction as unbridgeable lacks or absences (*différance*), Deleuze views differences as positive elements, as *lines of flight* capable of cutting across disciplines and opening new possibilities. Difference for Deleuze is expressed as diffuse and dispersed leaks from outside the perimeters of traditional thought; difference can erupt inward, propagate, and transform the entire process of thinking. For some architects, Deleuze offers a means for *thinking architecture* as a positive program centered on and generated by just such an unfolding of difference: the inhuman, irrational element capable of decentering or deterritorializing the anthropomorphic subject. Lynn describes this new disciplinary shift: "Where complexity and contradiction arose previously from inherent contextual conflicts, attempts are presently

being made to fold specific locations, materials and programs into architecture smoothly while maintaining their individual identity."[44] As with bioinformatics, a new fold of architects—the postarchitects—filters out redundant patterns of data within a specific locus in order to isolate the unpredictable variants in accordance with the basic tenet of informatics: an increase in information can grow only out of an increase in difference.

Eisenman's approach to Rebstock Park was Deleuzean. Rather than erase or cover up the corrupted grid, he decided to push it to its limits, to nurture it through a process of repetition until it erupted into a new singularity that transformed the totality of the site.

Eisenman's desire to subvert the stability of the grid led him to the work of René Thom, a French mathematician who had studied the dynamics of unexpected events within stable mathematical systems.[45] Thom's work, commonly known as catastrophe theory, is often demonstrated by a series of mathematical diagrams known as the "butterfly cusp," in which, according to Eisenman,

> a catastrophe begins with a stable condition, moves through the radical moment of change, and then returns to a stable condition. Isolated in their original sequence these figures are the residual inscriptions of a condition that is impossible to represent in a single frame of time or space.[46]

Intrigued by the notion that the highly mechanical grid held within it the potential for a momentary buckling of traditional form, Eisenman used Thom's "ideas of 'event' and 'catastrophe' [to] circumscribe the project for Rebstock and formalize, as indices of a mathematical process, the urban context of Frankfurt"[47]—a city traditionally known for its well-regulated financial stability yet nonetheless caught in the two largest cultural disruptions of the twentieth century.

In order to trigger a new shape for Rebstock, Eisenman first mapped the local geography of the site using a 7×7 orthogonal grid, choosing the number seven arbitrarily, simply to represent the seven drawings of Thom's butterfly cusp series. Eisenman then overlaid and shaped this grid to the Rebstock ground plain "in an attempt to establish both spatial and temporal modulation."[48] As a second step, Eisenman superimposed another unmodulated 7×7 orthogonal grid over the modulated landscape grid and connected the translated vertices between the two "to produce a warped surface which first appears to separate the two grids rather than connect them."[49] In a second study of the two grids, Eisenman again connected each vertex of the orthogonal grid to its corresponding vertex of the landscape grid as well as to the vertex directly below it. The result of this second translation was that "another warped, netlike structure/surface appears which suggests not an oppositional relationship between the two figures, but rather a construct of perpetual mediation—the fold."[50] The topology of the fold became the primary logic for Eisenman's new plan for Rebstock. The architect then orthogonally projected the original *Siedlung* footprint onto the disrupted, multidimensional surface of the fold in such a way that the uniformly repeated blocks of the *Siedlung* were distorted in accordance with their position in the fold, each building disrupted and disrupting within the productive transformation of the grid.

By focusing on and iterating the wasted space of the grid, which threatened to overwhelm the rational plan of the *Siedlung*, Eisenman provoked a catastrophe—an intrusion of external forces in the unexpected form of the fold—that transformed Rebstock Park from the *outside* according to a new and other logic—what Eisenman calls an "ur-logic"—that operates outside that of the subject. In *The Fold: Leibniz and the Baroque*, Deleuze develops Leibniz's notion of the fold as resembling "a sheet of paper divided into infinite folds or separated into bending movements, each one determined by the consistent or conspiring surroundings."[51] Deleuze's "consistent or conspiring surroundings" are the possibilities

of the outside—the potentials for change inherent in the local particularities of the environment—that intrude upon and influence the anthropomorphic form of the grid. Eisenman himself borrows the metaphor of folded paper in comparing the fold to origami: "Deleuze's idea of folding is more radical than origami, because it contains no narrative, linear sequence; rather, in terms of traditional vision, it contains a quality of the unseen."[52] The grid is therefore inflected by what cannot be seen by the subject: the virtual field of possibilities indigenous to each site.

Incorporating the affective

Although such talk of the *unseen*, the *virtual*, and the *outside* might suggest a revitalized form of mysticism, neither Deleuze nor Eisenman intends such a connotation. Rather, they imply quite the opposite: that the outside, in its multiplicity of possibilities, completely flouts the human ability to know, see, or imagine, and that that is precisely its power. The outside is not so much mystical as rigorously computational. In explaining his notion of probabilistic conformational roadmaps in robot motion planning and ligand folding, Jean-Claude Latombe describes a similar phenomenon:

> The traditional framework of robot motion planning is based on manipulating a robot through a workspace while avoiding collisions with the obstacles in this space. Our application of motion planning, on the other hand, is aimed at determining potential paths that a robot (or ligand) may naturally take based on the energy distribution of its workspace. Hence, instead of inducing the motion of the robot through actuators, we examine *the possible motions of the robot induced by the energy landscape of its immediate environment.*[53]

Latombe's distinction between the two approaches to motion planning is an important one in that it foregrounds Deleuze's distinction between *effective* and *affective* space. Effective space is rational space functioning according to a discernible logic, as in the first method for motion planning. It is negotiated by a binary logical process, such as colliding/not colliding with obstacles. In effective space, actions are directed from the inside out: the subject is able to adapt by exerting itself within the space. As a result, interactions within effective space are *extensive*, concerned with conditions of quantity rather than quality.

Affective space, on the other hand, does not operate according to a knowable or predictable logic and can only be inferred in excess of its effective conditions. Rather than allowing an extensive, outward response to the space, affective space induces an *affect* within the subject: an *intensive*, outside-in inflection in response to specific forces inherent in the site. Subjects do not logically adapt to an affective space; rather, they are qualitatively changed and adapted by the space. In the case of ligand binding, the second method of motion planning not only takes into account the navigation of the effective space of the molecular environment but also considers the affective space, whether or not the energetic forces in the environment reconfigure the structure of the ligand into a different molecular conformation.[54] The probabilistic conformational road map can therefore be considered an extrapolated mapping of the affective space in regard to energy minimization.

An understanding of effective and affective space allows us to revisit Eisenman's development of the Rebstock fold within the larger history of architecture. The unifying figure of traditional modernism was that of the anthropomorphic, rectilinear grid, often the nine-square grid of the skyscraper that acted as the basic diagram for the ultimate

monument to modernism. In modernist building, the grid was imposed on a site: the ground was cleared as a tabula rasa and the architecture was extended upward with a will toward overcoming its environmental conditions. Modernism therefore viewed spaces as only effective, conceiving of contextual conditions as physical, knowable, and mechanical phenomena to be rationally overcome.

Deconstructivism aimed to disrupt the grid through its conception of the diagonal, a transgressive cutting across that mimicked its dismantling of modernism. The diagonal subverted the effective space of modernism by revealing the hidden or suppressed directionals (the diagonals) inherent in all grids and all modernist agendas. The slant drove a critical wedge into modernism by exposing its hidden attempts to surmount the effective space of local context, but it could not bring affective spaces to bear upon architecture.

With Rebstock, however, the grid became the object of affective space. Eisenman allowed the differential forces at play in the site to inflect his seven-square grid to produce the fold. In this way, differences within the site could be incorporated within the grid to produce a context-specific architecture. Lynn, Eisenman's colleague and former student, achieved a similar result in his Stranded Sears Tower project. As with most modernist skyscrapers, the Sears Tower is constructed along the guidelines of the nine-square grid and consists of nine interconnected structural tubes that mutually reinforce one another in a unified overcoming of gravity. In his project, Lynn played with the possibility of undoing the unity of the nine tubes in order to allow each tube to be differentially inflected by the affective space of its surrounding environment. Lynn described his project:

> The Stranded Sears Tower attempts to generate a multiplicitous urban monument that internalizes influences by external forces while maintaining an interior structure that is provisional rather than essential. … The iconic status of the existing Sears Tower arises from its disassociation from its context. The building establishes itself as a discrete and unified object within a continuous and homogeneous urban fabric. My project, by contrast, affiliates the structure of the tower with the heterogeneous particularities of its site while preserving aspects of its monumentality: laying the structure into its context and entangling its monolithic mass with local contextual forces allows a new monumentality to emerge from the old forms.[55]

Denari also employs techniques of folding to produce what he calls a "localized worldsheet," consisting of "a single curving sheet … that bends into itself, creating invekipes or internal surfaces that merge seamlessly with the exterior" (Figure 39.1).[56] In projects such as Vertical Smoothouse of 1997, Denari used his localized worldsheets to transgress traditional binarisms of architecture such as inner/outer. In all three projects, the final architectural form was produced by the interaction of outside forces with more traditional forms of modernism in the affective space of the site, thereby displacing the architect subject as the anthropomorphic interpreter of form. Eisenman describes this process of decentering: "When the environment is inscribed or folded in such a way, the individual no longer remains the discursive function; the individual is no longer required to understand or interpret space."[57]

One should note that the architectures developed within such affective spaces are not only products of affect but are also integrated within the affective space itself as yet another external force. In other words, affectively produced architectures are affective spaces themselves that displace their spectators' subjectivity. Since the smooth surfaces of folded architecture are not reducible to generalized concepts or idealized forms, they resist their viewers' interpretation: they are forms in and of themselves rather than microcosms of a grander vision. In this way, affective architecture resists subjugation by the optical—that

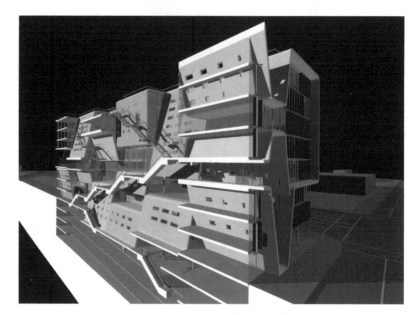

Figure 39.1 *Longitudinal sectional perspective of Neil Denari's 1998 Multisection Office Block project*. The "laminar structure" of Denari's localized worldsheets serves as a single continuously folded structure that mediates between previous binaries such as "inside/outside" and "vertical/horizontal." Source: Neil Denari, *Gyroscopic Horizons* (New York: Princeton Architectural Press, 1999), 103. Courtesy of NMDA, Inc.

is, the mind-eye reading of the observer. Eisenman describes this power of the fold to resist the optical whole:

> Once the environment becomes affective, inscribed within another logic or an ur-logic, one which is no longer translatable into the vision of the mind, then reason becomes detached from vision. ... This begins to produce an environment that "looks back"—that is, the environment seems to have an order that we can perceive, even though it does not seem to mean anything.[58]

Such an ability to "look back," or what Eisenman calls *reciprocal subjectivity*, endows architecture with a new power to deterritorialize the viewer—a *haptic*, as opposed to *optic*, ability to induce an affective change rather than effect an interpretation for rapid visual consumption. The fold is therefore one strategy for moving beyond the mechanics of vision in favor of a new relationship to built space: a performative encounter with the other, the outside. Taken as a larger field of movement, the fold represents a dramatic turn away from traditional forms and theories of architecture toward a Deleuzean ontology as a positive building program.

Further vectors for movement

While the above-mentioned three projects—Eisenman's Rebstock Park, Lynn's Stranded Sears Tower, and Denari's Virtual Smoothouse—index a similar move away from previous practices of building, they all nonetheless retain connections to modernism in their use

of modernist forms as initial objects of inflection and in their relatively static methods of determining local forces. Though Eisenman's development of the Rebstock fold as the "in-between" of the gridded ground plain and the seven-square grid allows an unpredictable form to emerge from the outside, the "forces" it seeks to internalize in the grid are not so much dynamic forces as static geographies. Similarly, Lynn's Stranded Sears Tower maps each independent tube to relatively static influences, such as "adjacent buildings, landforms, sidewalks, bridges, tunnels, roads and river's edge."[59] What is missing from both Eisenman's and Lynn's experiments is an ability to generate new form, rather than merely inflect older modernist diagrams, within a context of temporally and spatially dynamic forces, instead of local static geometries.

As his own answer to this challenge, Lynn has developed a new theory and practice of architecture known as *animate design*. In animate design, Lynn considers that "force is an initial condition, the cause of both motion and the particular inflections of a form … so that architecture can be modeled as a participant immersed within dynamic flows."[60] To implement such a system, Lynn maps the flows of local forces over time—wind and weather patterns, traffic flows, information and energy channels, animal migration patterns—in order to model the affective space of the site. Lynn then inserts a form to the force-field model of the space that represents the internal constraints of the desired building—such as five differently sized spheres for the number and types of rooms required—and allows them to be inflected and arranged in response to the tensions within the space (Figure 39.2). Once the forms have reached a stable pattern, Lynn will usually then envelope the forms within a single membrane, or *blob*, that is itself inflected by each of the forms. The resulting "folded, pliant, and supple" surface complies with and mediates between each of the forms "in order to incorporate their contexts with minimal resistance."[61]

In order to move beyond the inert lines and points of Euclidean geometry, Lynn has adopted a topological or NURBS approach in which surfaces are defined as vector flows whose paths are inflected by the distributed forces within the space. These splines literally seek the path of least resistance among the network of forces in order to establish a distributed field of equilibrium in a manner analogous to Latombe's probabilistic conformational road maps. Just as bioinformaticists use polymeraze chain reactions to map the energetics vectors within a space in order to predict the folding patterns of proteins or ligands induced by the space, Lynn submits the forms of his internal building constraints to the vectorial forces inherent in each site in order to produce a new form that complies with the affective space while still retaining its identity.

Figure 39.2 *Artists Space Installation (June 1995).* Rendering courtesy of Greg Lynn FORM.

To many observers, Lynn's desire for his architecture to accommodate the dynamic forces of its environment is a fool's quest, since architecture is innately static—at least, any architecture that is intended to serve as a permanent protective shelter.[62] Though it may be possible to create a computer model in which a pliant surface dynamically adapts itself to a flux of forces, it is much more difficult to *build* such structures with physical materials. Lynn's only option, according to his critics, is to take his structures from a single frozen image within a larger simulation; such an architecture, they say, is no more animate than more traditional modes of building.

However, it is problematic to assume that a fixed form can derive only from a fixed image. A single fixed form can evolve from a composite of multiple possible configurations of the same form over time. In order to dismiss reductive readings of his process, Lynn describes such a composite form in the shape of a boat hull:

> Although the form of a boat hull is designed to anticipate motion, there is no expectation that its shape will change. An ethics of motion neither implies nor precludes literal motion. Form can be shaped by the collaboration between an envelope and the active context in which it is situated. While physical form can be defined in terms of static coordinates, the virtual force of the environment in which it is designed contributes to its shape. The particular form of a hull stores multiple vectors of motion and flow from the space in which it was designed. A boat hull does not change its shape when it changes its direction, obviously, but variable points of sail are incorporated into its surface. In this way, topology allows for not just the incorporation of a single moment but rather a multiplicity of vectors, and therefore, a multiplicity of times, in a single continuous surface.[63]

As with the boat hull, the resultant forms of Lynn's architecture are fashioned in response to a virtual multiplicity of forces, thereby enabling Lynn to successfully generate new forms from the active fluctuation of forces within a given locus. Architectural forms cannot physically fold once they have been built; however, they can index a virtual process of continuous folding. As an affective space, Lynn's animate forms operate according to what Eisenman calls an "excessive condition"[64]—the field of possibilities in the process of folding are indexed in their excess in the actualized physical form.

An early example of Lynn's use of animate design is his March 1995 entry in the competition to design a protective roof and lighting scheme for the underside of the bus ramps leading into the New York City Port Authority Bus Terminal (Figure 39.3). Lynn summarized his design process for the Port Authority Gateway as follows:

> The site was modeled using forces that simulate the movement and flow of pedestrians, cars, and buses across the site, each with differing speeds and intensities of movement along Ninth Avenue, 42nd and 43rd streets, and the four elevated bus ramps emerging from below the Hudson River. These various forces of movement established a gradient field of attraction across the site. To discover the shape of this invisible field of attraction, we introduced geometric particles that change their position and shape according to the influence of the forces. From the particles studies, we captured a series of phase portraits of the cycles of movement over a period of time. These phase portraits are swept with a secondary structure of tubular frames linking the ramps, existing buildings and the Port Authority Bus Terminal. Eleven tensile surfaces are stretched across these tubes as an enclosure and projection surface.[65]

Lynn's modeling practices recall the techniques used by environmental scientists in generating dynamic visualizations of massive flows of weather data; there are close parallels,

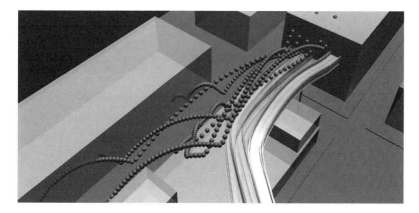

Figure 39.3 *Port Authority Gateway (March 1995)*. Rendering courtesy of Greg Lynn FORM.

however, to modeling practices in bioinformatics as well. For instance, Lynn's "gradient field of attraction" bears a striking resemblance to the mapping of molecular energy landscapes. Equally analogous is the means by which Lynn's possible vector flows of particles cross through the field of attraction, just as bioinformaticists "represent the protein as a sequence of vectors, each representing an SSE [secondary structure element]"[66] that folds in accordance with its particular molecular energy landscape. Increasingly, at the outer limits of experimental explorations in each field, architecture and bioinformatics have begun to fold back upon each other.

The digital outside

Biology had to take a leap into molecular biology; dispersed life had to regroup in the genetic code. Dispersed work had to regroup in third-generation machines, cybernetics, and information technology. What would be the forces in play with which the forces within man would then enter into a relation? It would no longer involve raising to infinity or finitude but to an unlimited finity, thereby evoking every situation of force in which a finite number of components yield a practically unlimited diversity of combinations. It would be neidier the fold nor the unfold that would constitute the active mechanism, but something like the *superfold*, as borne out by the foldings proper to the chains of the genetic code, and the potential of silicon in third-generation machines, as well as by the contours of a sentence in modern literature, when literature "merely turns back on itself in an endless reflexivity."[67]

We have pointed to multiple points of articulation between current developments in bioinformatics and architecture. In our view, they are not merely the result of random coincidences between two disparate fields. Articulated in the recent work of Eisenman, Denari, and Lynn, we find a concern to address what they have called a crisis of the mechanics of vision: architecture could not move beyond its own circular process of logic and theory—beyond its own language game—without some force from the outside to move it. They located that external force, we have argued, in the highly automated, massively parallel, stacked multiple-alignment algorithms, in the neural networks, and in the Markov chains that practitioners of bioinformatics draw upon in processing the flow of sequence data into the dynamic folds of protein. When merged with immersive computer-design

environments, these new machinic assemblages enable architects to *think architecture* in Deleuze's terms: *thinking architecture* ceases to be a solely human practice.

The overlap produced by the similar technological desires of bio informaticists and architects indexes just one fold in a much larger multiplicity. Building on the work of Foucault, Deleuze conceived of the *outside* as an affective space external to the larger epistemic areas of discourse at any given time: a network of hidden forces that inflects, stratifies, and organizes the systems of discourse it subtends. Foucault's lifework was to map the margins of such networks throughout different periods of history; his metaphor of the panopticon presents one such diagram of the space of the outside. This paper attempts to map a small section of a similar diagram of the outside for our particular historical location. In our diagram, the outside is inscribed in the fluid lines of flight of electronic media that cut across and inflect not only architecture and bioinformatics but also disciplines as diverse as genetics, robotics, psychology, astronomy, physics, philosophy, and engineering. All of these fields either have been or are being remade from the outside by electronic media, and in none of them is *thinking* any longer a solely human practice. Perhaps it never was.

Notes

1 Gilles Deleuze and Felix Guattari, *A Thousand Plateaus: Capitalism and Schizophrenia* (Minneapolis, MN: University of Minnesota Press, 1987), 144–8.
2 Christian B. Anfinsen, "Principles That Govern the Folding of Protein Chains," *Science* 181, no. 96 (1973): 223–30; C. B. Anfinsen and H. H. Scheraga, "Experimental and Theoretical Aspects of Protein Folding," *Advances in Protein Chemistry* 29 (1975): 205–300; Anfinsen, "The Formation and Stabilization of Protein Structure," *Biochemistry Journal* 128, no. 4 (1972): 737–49.
3 C. J. Epstein, R. F. Goldberger, and C. B. Anfinsen, "The Genetic Control of Tertiary Protein Structure: Studies with Model Systems," *Cold Spring Harbor Symposium on Quantitative Biology* 28 (1963): 439–49.
4 Cyrus Levinthal, "How to Fold Graciously," in *Mossbauer Spectroscopy in Biological Systems: Proceedings of a Meeting Held at Allerton House, Monticello, Illinois*, ed. J. T. P. DeBrunner and E. Munck (Urbana, IL: University of Illinois Press, 1969), 22–4.
5 Anthony G. Oettinger, "The Uses of Computers in Science," *Scientific American* 215, no. 3 (1966): 161–72, quote p. 161.
6 See Cyrus Levinthal, "Molecular Model-Building by Computer," *Scientific American* 214, no. 6 (1966): 42–52.
7 Ibid., 48–9. The author (T. L.) therefore decided to develop programs that would make use of a man-computer combination to do a kind of model building that neither a man nor a computer could accomplish alone. This approach implies that one must be able to obtain information from the computer and introduce changes in the way the program is running in a span of time that is appropriate to human operation. This in turn suggests that the output of the computer must be presented not in numbers but in visual form.
8 Lou Katz and Cyrus Levinthal, "Interactive Computer Graphics and the Representation of Complex Biological Structures," *Annual Reviews in Biophysics and Bioengineering* 1 (1972): 465–504.
9 Jean-Claude Latombe, *Robot Motion Planning* (Boston, MA: Kluwer Academic Publishers, 1991). M. S. Apaydin, A. P. Singh, D. L. Brutlag, and J.-C. Latombe, "Capturing Molecular Energy Landscapes with Probabilistic Conformational Roadmaps," in *International Conference on Robotics and Automatons* (2001), 932–9.
10 The Protein Data Bank (PDB) was established in 1971 as a computer-based archival resource for macromolecular structures. But two decades later in April 1990 only 535 atomic coordinate entries were recorded for macromolecules, and in 1999, following a period of rapid improvement in technology for obtaining crystallographic data, the Biological Macromolecule Crystallization Database (BMCD) of the PDB contained entries for a meager 5,400 protein molecules.

11 Indeed, more than 140,000 genes were cloned and sequenced in the twenty years from 1974 to 1994, of which more than 20 percent were human genes. By the early 1990s at the beginning of the Human Genome Initiative, the NIH GenBank database (release #70) contained more than 74,000 sequences, while the Swiss Protein database (Swiss-Prot) included nearly 23,000 sequences. Protein databases were doubling in size every twelve months, and some were predicting that, as a result of the technological impact of the Human Genome Initiative, by the year 2000 ten million base pairs a day would be sequenced, predictions that have been more than borne out.

12 See, for instance, Ram Samudrala, Yu Xia, Enoch Huang, and Michael Levitt, "Ab Initio Protein Structure Prediction Using a Combined Hierarchical Approach," *Proteins: Structure, Function, and Genetics*, suppl. 3 (1999): 194–8. For evidence on this point, see the entries in the Critical Assessment of Protein Prediction competition hosted since 1994 at the Lawrence Livermore National Laboratory.

13 See especially the papers in L. Hunter, ed., *Artificial Intelligence and Molecular Biology* (Menlo Park, CA: AAAI Press, 1993).

14 Douglas L. Brulag, "Understanding the Human Genome," in *Scientific American: Introduction to Molecular Medicine*, ed. P. Leder, D. A. Clayton, and E. Rubenstein (New York: Scientific American, Inc., 1994), 153–68. Walter Gilbert characterizes the situation sharply: "The next tenfold increase in the amount of information in the databases will divide the world into haves and have-nots, unless each of us connects to that information and learns how to sift through it for the parts we need."

15 These are the disciplines with which graduate students and postdocs in molecular biology in Brutlag's lab at Stanford are expected to work. See Douglas Brutlag's introductory lecture to Biochemistry 218, Computational Molecular Biology, slide 16, at http://cmgm.stanford.edu/biochem218/01%20Genomics%26Bioinformatics.pdf, Stanford University, January 7, 2003.

16 New disciplinary requirements were imposed on the biologist who wanted to interpret and use the matrix of biological knowledge:

> The development of the matrix and the extraction of biological generalizations from it are going to require a new kind of scientist, a person familiar enough with the subject being studied to read the literature critically, yet expert enough in information science to be innovative in developing methods of classification and search. This implies the development of a new kind of theory geared explicitly to biology with its particular theory structure. It will be tied to the use of computers, which will be required to deal with the vast amount and complexity of the information, but it will be designed to search for general laws and structures that will make general biology much more easily accessible to the biomedical scientist.
>
> (Ibid., 67)

17 Ibid., 26–7.

18 Peter Eisenman, "Visions Unfolding: Architecture in the Age of Electronic Media," in *Digital Eisenman: An Office of the Electronic Era*, ed. Luca Galofaro (Basel: Birkhäuser, 1999), 84.

19 Ibid.

20 Ibid., 85.

21 Ibid., 84.

22 Ibid.

23 Neil Denari, *Gyroscopic Horizons* (New York: Princeton Architectural Press, 1999), 11 n. 3.

24 Greg Lynn, 1995, http://www.basilisk.com/aspace/formview.html.

25 Mark Wigley described a deconstructive architect as "not one who dismantles buildings, but one who locates the inherent dilemmas within buildings—the structural flaws." *Deconstructivist Architecture* (Boston, MA: Little, Brown, 1988), 133.

26 Lynn, "The Folded, the Pliant, and the Supple," in *Folds, Bodies and Blobs: Collected Essays* (Brussels: La Lettre Volée, 1998), 115.

27 Frederic Jameson, in his book *Postmodernism, or the Cultural Logic of Late Capitalism*, diagnosed post-modernism as a "depthless" and "schizophrenic" logic doomed to operate only through an ahistorical "pastiche" of past styles. *Postmodernism* (Durham, NC: Duke University Press, 1991), 6.

28 Eisenman, "Visions Unfolding," 85.

29 For Eisenman's early embrace of postmodern approaches, see Peter Esenman, "Cardboard Architecture: House 1 (1967)," in Peter Eisenman, Michael Graves, Charles Gwathmey, John Hejduk, Richard Meier, Collin Rowe, and Kenneth Frampton, *Five Architects* (New York: Oxford University Press, 1975), 15–23; Eisenman, "Cardboard Architecture: House II (1969)," Ibid., 25–37.

30 Kathryn Henderson, *On Line and on Paper: Visual Representations, Visual Culture, and Computer Graphics in Design Engineering* (Cambridge, MA: MIT Press, 1999), 99.

31 Stephen S. Hall, "Protein Images Update Natural History," *Science* 267, no. 3 (February 1995): 620–4.

32 William J. Mitchell, "Roll Over Euclid: How Frank Gehry Designs and Builds," in *Frank Gehry, Architect*, ed. J. Fiona Ragheb (New York: Solomon R. Guggenheim Foundation, 2001), 352–63, quote p. 354.

33 Ibid., 354.

34 Ibid., 358.

35 Ibid., 363.

36 Ibid., 357.

37 Dennis Dollens, "Fish, Snake, Gebry & Guggenheim," www.sitesarch.org/reviews/GehryBil. html.

38 Gehry describes the impressive degree to which CAD/CAM applications allow mass customization of building materials by listing the project's components (e.g., number of aluminum and stainless steel shingles: over 21,000). There are over 3,000 panels, each composed of an average of seven metal shingles. Each is uniquely shaped; there are no repeating patterns. The panels that sheath EMP were milled in Germany; colored in England; shaped, cut, and assembled in Kansas City; and brought to Seattle to be attached. The gold-colored stainless-steel panels have a special beaded-glass finish that reflects and changes with varying light and weather conditions. *Experience Music Project: The Building* (Seattle: EMP, 2000), 30.

39 Dollens, "Fish, Snake, Gehry & Guggenheim."

40 Selim Koder, "Interview with Peter Eisenman," from "Intelligente Ambiente," *Ars Electronica* (1992), http://xarch.tu-graz.ac.at/home/rurban/course/intelligent_ambiente/interview_eisenman. en.html.

41 Greg Lynn, *Animate Form* (New York: Princeton Architectural Press, 1999), 17.

42 Koder, "Interview with Peter Eisenman."

43 Peter Eisenman, *Unfolding Frankfurt* (Berlin: Ernst & Sohn Verlag, 1991), 10.

44 Lynn, "The Folded, the Pliant, and the Supple," 117.

45 On René Thorn, see his *Structural Stability and Morphogenesis: An Outline of a General Theory of Models*, trans. D. H. Fowler, rev. ed. (Cambridge, MA: Perseus Books, 1989).

46 Eisenman, *Unfolding Frankfurt*, 10.

47 Ibid.

48 John Rajchman, "Perplications: On the Space and Time of Rebstockpark," in Eisenman, *Unfolding Frankfurt*, 23.

49 Ibid., 25.

50 Ibid.

51 Gilles Deleuze, *The Fold: Leibniz and the Baroque* (Minneapolis: University of Minnesota Press, 1993), 6. Deleuze is referencing Leibniz's statement in *Pacidus philalethi* (c. 614–15): "The division of the continuous must not be taken as of sand dividing into grains, but as that of a sheet of paper or of a tunic in folds, in such a way that an infinite number of folds can be produced, some smaller than others, but without the body ever dissolving into points or minima."

52 Eisenman, "Visions Unfolding," 87 n. 18.

53 Amit P. Singh, Jean-Claude Latombe, Douglas L. Brutlag, "A Motion-Planning Approach to Flexible Ligand Binding," *Proceedings of the Seventh International Conference on Intelligent Systems for Molecular Biology* (Menlo Park, CA: AAAI Press, 1999), 253 (emphasis added).

54 Ibid., 254.

55 Greg Lynn, "Multiplicitous and Inorganic Bodies," *Folds, Bodies & Blobs* (Brussels: La Lettre volée, 1998), 53.

56 Denari, *Gyroscopic Horizons*, 83.

57 Eisenman, "Visions Unfolding," 88.

58 Ibid.

59 Lynn, "Multiplicitous and Inorganic Bodies," 56.

60 Lynn, *Animate Form*, 11.

61 Lynn, "The Folded, the Pliant, and the Supple," 117.

62 As an example of this view, see Alicia Imperiale's "Time Frozen/Time Liberated?" in *New Flatness: Surface Tension in Digital Architecture* (Basel: Birkhäuser, 2000), 74–8.

64 Lynn, *Animate Form*, 10.

64 Eisenman, "Visions Unfolding," 87.

65 Lynn, *Animate Form*, 103.

66 PCR paper, 6.

67 Gilles Deleuze, *Foucault*, trans. Seán Hand (Minneapolis, MN: University of Minnesota Press, 1988), 131.

Colin Milburn

NANOTECHNOLOGY IN THE AGE OF POSTHUMAN ENGINEERING
Science fiction as science

Now nanotechnology had made nearly anything possible, and so the cultural role in deciding what *should* be done with it had become far more important than imagining what *could* be done with it.

<div align="right">Neal Stephenson, The Diamond Age (1995)</div>

Long live the new flesh.

<div align="right">David Cronenberg's Videodrome (1983)</div>

The technoscapes and dreamscapes of nanotechnology

K. ERIC DREXLER, PIONEER AND POPULARIZER of the emerging science of nanotechnology, has summarized the ultimate goal of this field as "thorough and inexpensive control of the structure of matter."[1] Nanotechnology entails the practical manipulation of atoms; it is engineering conducted on the molecular scale. Many scientists involved in this ambitious program envision building nanoscopic machines, often called "assemblers" or "nanobots," that would be used to construct objects on an atom-by-atom basis. Modeled largely after biological "machines" like enzymes, ribosomes, and mitochondria—even the cell—these nanomachines would have specific purposes such as binding two chemical elements together or taking certain compounds apart, and would also be designed to replicate themselves so that the speed and scale of molecular manufacturing may be increased. Several different types of nanomachines would act together to build complex objects precise and reproducible down to every atomic variable. Other researchers imagine using self-assembling macromolecular systems for massively parallel data processing, leading to new computational capabilities more powerful than we can yet fathom. Still others suggest that with advances in nanoscale manipulation and visualization—exemplified by the field of scanning probe microscopy—we will eventually be able to program our material environments, placing individual atoms right where we want them with digital accuracy. With its several bold

schemes to completely dominate materiality itself, nanotechnology has been prophesied to accomplish almost anything called forth by human desires.

These prophesies have run the gamut from the mundane to the fantastic: Designer nanoparticles will improve the performance of nearly all consumer products, from pharmaceuticals to shampoo. Smart nanofabrics will be woven into your carpet or clothing, programmed to constantly vaporize any dirt particles they encounter, keeping your house or your wardrobe perpetually clean. Nanomachines will be able to disassemble organic compounds, such as wood, oil, or sewage, then restructure the constituent carbon atoms into diamond crystals of predetermined size and shape for numerous purposes, including structural materials of unprecedented strength. Nanofactories will quickly and cheaply fabricate furniture, or car engines, or nutritious food, from a soup of appropriate elements. Nanobots will facilitate our exploration of space, synthesizing weightless lightsails to propel seamless spaceships throughout the universe. Nanosurgical devices will repair damaged human cells on the molecular level, thus healing injury, curing disease, prolonging life, or perhaps annihilating death altogether.

Nanotechnology has been extensively discussed in these terms, and despite the fancifulness of certain nanoscenarios, it has become a robust and lucrative science whose cultural prominence has skyrocketed since the turn of the millennium. Many universities, laboratories and companies around the world are now investigating nanotech possibilities, constituting a dense discourse network—a technoscape—of individuals and institutions interested in the potential benefits of this nascent discipline. The U.S. National Nanotechnology Initiative (NNI), proposed by the Clinton administration in 2000 and augmented by the Bush administration in 2001, offers funding and guidelines to promote nanotech breakthroughs. Other major nanotechnology initiatives have appeared in quick succession in the United Kingdom, Japan, the European Union, China and elsewhere, coordinating hundreds of international research sites. Extending the technoscape beyond its industrial and academic locations are foundations like the Center for Responsible Nanotechnology, the Institute for Nanotechnology, and perhaps most prominently, the Foresight Institute, established in 1986 by Drexler and Christine Peterson. Hosting conferences, sponsoring publications and awards, the Foresight Institute (renamed the Foresight Nanotech Institute in 2005) has fashioned itself as a mecca of sorts in the morass of nanotechnological endeavors currently spreading across the globe. This spread has been significantly facilitated by the Internet, whose role in nanoculture cannot be underestimated: while the *sci.nanotech* newsgroup may have been the only formalized venue for nanotheorizing online when it went live in 1988, the number of websites, newsgroups and blogs that disseminate daily information while also cultivating virtual social networks—including *Howard Lovy's Nanobot*, *Nanotechnology Now*, *NanoApex* and more—has lately become nearly uncountable. Since Drexler first proposed a program for research in 1986 with the publication of *Engines of Creation: The Coming Era of Nanotechnology*, nanotechnology has gained notoriety as a visionary science and the technoscape has burgeoned.[2]

Offering intellectual and commercial attractions, career opportunities and research agendas, nanotechnology foresees a technocultural revolution that will, in a very short time, profoundly alter human life as we know it. The ability to perform molecular surgery on our bodies and our environments will have irrevocable social, economic and epistemological effects; our relation to the world will change so utterly that even what it means to be human will seriously be challenged. But despite expanding interest in nanotech, despite proliferating ranks of researchers, despite international academic conferences, numerous doctoral dissertations and thousands of publications, the promise of a world violently restructured by nanotechnology has yet to become reality.

Or has it?

Scientific journal articles reporting experimental achievements in nanotech, or reviewing the field, frequently speak of the technical advances still required for "the full potential of nanotechnology to be realized,"[3] of steps toward fulfilling the "dream of creating useful machines the size of a virus,"[4] of efforts that, if they "pan out, … could help researchers make everything from tiny pumps that release lifesaving drugs when needed to futuristic materials that heal themselves when damaged."[5] These texts—representative of the genre of popular and professional writing about nanotech that I will call "nanowriting"—incorporate individual experiments and accomplishments in nanoscience into a teleological narrative of "the evolution of nanotechnology,"[6] a progressivist account of a scientific field in which the climax, the "full potential," the "dream" of a nanotechnology capable of transforming garbage into gourmet meals and sending invisible surgeons through the bloodstream, is envisioned as *already inevitable*.

For nanowritings swathe their technical contents with the aura of destiny. Nobel Prize-winning nanoscientist Richard Smalley has written about "a sense of inevitability that [future nanotech successes] will come in time," a sure faith that there "will come technologies that will be the best that they can ever be" and that "all manner of technologies will flow" from the current work of dedicated visionaries.[7] Foresight Institute founder Christine Peterson asserts that the "development of nanotechnology appears inevitable."[8] Theoretical physicist and science fiction novelist John G. Cramer writes that nanotech "ideas carry an 'air of inevitability' about them. The technology is coming."[9] Textual dispatches from the frontiers of nanoscience everywhere make such claims, drawing upon the future as a known quantity, determined in advance. These publications freely and ubiquitously import the nanofuture into the research of today, rewriting the advances of tomorrow into the present tense.[10] Nanowritings speculate on scientific and technological discoveries that have not yet occurred, but they nonetheless deploy such fictionalized events to describe and to encourage preparation for the wide-scale consequences of what nanotheorist B. C. Crandall describes as a "seemingly inevitable technological revolution."[11]

Even in one of the field's earliest technical journal articles—which both proposed a new technology and inaugurated a new theoretical program—Drexler writes that the incipient engineering science of molecular nanotechnology has dramatic "implications for the present" as well as the "the long-range future of humanity."[12] Repeated throughout the technoscape, this narrative telos of nanotechnology—described as already given—is a vision of the "long-range future of humanity" utterly transfigured by present scientific developments. In other words, embedded within nanowriting is the implicit assumption that, even though the nanodreams have not yet come to fruition, nanotechnology has *already* enacted the transformation of the world.

Due to the tendency of nanotechnology as a research field to speculate on the far future and to prognosticate its role in the radical metamorphosis of human life (coupled with the fact that, until recently, nanotheorists had yet to produce material counterparts to their adventurous mathematical models and computer simulations) many skeptics and critics over the years have claimed that nanotechnology is less a science and more a science fiction. For instance, David E. H. Jones, chemist at the University of Newcastle upon Tyne, once insinuated that nanotech is not a "realistic" science, and that, because its aspirations seem to violate certain natural limits of physics, "nanotechnology need not be taken seriously. It will remain just another exhibit in the freak-show that is the boundless-optimism school of technical forecasting."[13] Gary Stix, staff writer for *Scientific American* and persistent critic of nanohype, has often compared Drexler's writings to the scientific romances of Jules Verne and H. G. Wells, suggesting that "real nanotechnology" is not to be found in these

science fiction stories.[14] Furthermore, Stix maintains that nanowriting, a "subgenre of science fiction," damages the legitimacy of nanoscience in the public eye and that "[d]istinguishing between what's real and what's not" is essential for nanotech's prosperity.[15] Even George M. Whitesides, the Mallinckrodt Professor of Chemistry at Harvard University and a recognized authority in nanotechnology, has accused the entire field of being "an area prone to overblown promises, with speculation and nanomachines that are more likely found in *Star Trek* than in a laboratory."[16] For Whitesides, designs for self-replicating molecular machines in particular are "complete nonsense. ... The level of hard science in these ideas is really very low."[17] Similarly, Stanford University biophysicist Steven M. Block has said that many nanoscientists, especially Drexler and the "cult of futurists" involved with the Foresight Institute, have been too influenced by laughable science fiction expectations and have gotten ahead of themselves; he proposes that for "real science to proceed, nanotechnologists ought to distance themselves from the giggle factor."[18]

Several critics have insisted that advanced atomic manipulation and engineering will not be physically possible for thermodynamic or quantum mechanical reasons; others have suggested that, without experimental verification to support its theories and imaginary miraculous devices, nanotechnology is not scientifically valid; many more have dismissed the long-range predictions made by nanowriting on the grounds that such speculation obscures the reality of present-day research and the appreciable accomplishments within the field. These critiques commonly and tactically oppose a vocabulary of "real science" to the term "science fiction," and, whether rejecting the entire field as mere fantasy or attempting to extricate the scientific facts of nanotech from their science-fictional entanglements, charges of science-fictionality have repeatedly called the epistemological status of nanotechnology into question.[19]

Nanotechnologists have responded to these attacks with various rhetorical strategies intended to distance their science from the negative associations of science fiction. However, I will be arguing that such strategies ultimately end up collapsing the distinction, reinforcing the science-fictional aspects of nano at the same time as rescuing its scientific legitimacy. I hope to make clear that the scientific achievements of nanotechnology have been and will continue to be extraordinarily significant; but, without contradiction, nanotechnology is thoroughly science-fictional in imagining its own future, and the future of the world, as the product of scientific advances that have not yet occurred.[20]

Science fiction, in Darko Suvin's formalist account of the genre, is identified by the narratological deployment of a "novum"—a scientific or technological "cognitive innovation" as extrapolation or deviation from present-day realities—that becomes "'totalizing' in the sense that it [the novum] entails a change in the whole universe of the tale."[21] The diegesis of the science fiction story is an estranging "alternate reality logically necessitated by and proceeding from the narrative kernel of the novum."[22] Succinctly, science fiction assumes an element of transgression from contemporary scientific thought that in itself brings about the transformation of the world. It follows that nanowriting, positing the world turned upside down by the future advent of fully functional nanomachines, thereby falls into the domain of science fiction. Nanowriting performs radical ontological displacements within its texts and recreates the world atom by atom as a crucial component of its extrapolative scientific method; but by employing this method, nanowriting becomes a postmodern genre that draws from and contributes to the fabulations of science fiction.[23] Science fiction is not a layer than can be stripped from nanoscience without loss, for it is the exclusive domain in which mature nanotechnology currently exists; it forms the horizon orienting the trajectory of much nanoscale research; and any eventual appearance of practical molecular manufacturing—transforming the world at a still unknown point in the future through

a tremendous materialization of the fantastic—would remain marked with the semiotic residue of the science-fictional novum. Accordingly, I suggest that nanotechnology should be viewed as simultaneously a science and a science fiction.

Jean Baudrillard has frequently written on the relationship of science to science fiction, contextualizing the dynamics of this relationship within his notion of hyperreality. Mapping schematically onto the "three orders of simulacra"[24]—the counterfeit, the reproduction, and the simulation—three orders of the speculative imaginary are described in his essay, "Simulacra and Science Fiction." He writes, "To the first category [of simulacra] belongs the imaginary of the utopia. To the second corresponds science fiction, strictly speaking. To the third corresponds—is there an imaginary that might correspond to this order?"[25] The question is open because the third-order imaginary is still in the process of becoming and is as yet unnamed. But within this imaginary, the boundary between the real and its representation deteriorates, and Baudrillard writes that, in the postmodern moment, "There is no real, there is no imaginary except at a certain distance. What happens when this distance, including that between the real and imaginary, tends to abolish itself, to be reabsorbed on behalf of the model?"[26] The answer is the sedimentation of hyperreality, where the model becomes indistinguishable from the real, supplants the real, precedes the real, and finally is taken as more real than the real:

> The models no longer constitute either transcendence or projection, they no longer constitute the imaginary in relation to the real, they are themselves an anticipation of the real, and thus leave no room for any sort of fictional anticipation—they are immanent, and thus leave no room for any kind of imaginary transcendence. The field opened is that of simulation in the cybernetic sense, that is, of the manipulation of these models at every level (scenarios, the setting up of simulated situations, etc.) but then *nothing distinguishes this opera from the operation itself and the gestation of the real; there is no more fiction.*[27]

In the dichotomy of science versus science fiction, the advent of third-order simulacra or imaginaries announces that science and science fiction are no longer separable. The borderline between them is deconstructed. In the age of simulation, science and science fiction have become coterminous: "It is no longer possible to fabricate the unreal from the real, the imaginary from the givens of the real. The process will, rather, be the opposite: it will be to put decentered situations, models of simulation in place and to contrive to give them the feeling of the real, of the banal, of lived experience, to reinvent the real as fiction, precisely because it has disappeared from our life."[28] At the moment when science emerges from within science fiction and we can no longer tell the difference, the real has retreated and we are only left with the simulations of the hyperreal where "there is neither fiction nor reality anymore" and "science fiction in this sense is no longer anywhere, and it is everywhere."[29]

The case of nanotechnology spectacularly illustrates the hyperreal disappearance of the divide between science and science fiction. The terminology of "real science" versus "science fiction" consistently used in the debates surrounding nanotech depends upon the discursive logic of the real versus the simulacrum. Although each term may independently provide the illusion of having a positive referent—that is, "real science" might refer to a set of research and writing practices that adhere to and/or reveal facts of nature while being institutionally recognized as doing so, and "science fiction" might refer to a set of certain generically-related fictional texts or writing practices that mimic such texts—when they are used to argue the cultural status of nanotechnology, real science and science fiction are nearly emptied of referential pretensions, becoming signifiers of unstable signifieds as they

are forced into pre-established structural positions of "the real" and "the simulacrum." In this logic, science and science fiction negatively define each other, and though each is required for the other's symbolic existence, science fiction is the diminished and illegitimate term, the parasitical simulation of science.

To maintain that the categories of science and science fiction are supplemental constructs of each other is not to deny the political effects of discourse, for the fate of nanotechnology as a research field and the fates of real people working within it are strongly entwined with the language used. But I will show that the nanorhetoric mobilizing the logic of real science *opposed* to science fiction comes to undermine its own position, dissolving real science *into* science fiction and enacting the vanishing of the real, or the moment of hyperreal crisis when the real and "its" simulacrum appear as semiotic fabrications, when "the real" (e.g. "real science") can be demonstrated as simulation and "the simulation" (e.g. "science fiction") can be demonstrated as real, when dichotomies must be abandoned in favor of hybrids. Although the strict categories of real science and science fiction must be used in order to accomplish their deconstruction (or are deconstructed because of their use), they should be read as under erasure, for the relationship of science to science fiction is not one of dichotomy but rather of imbrication and symbiosis. Science fiction infuses science and vice versa, and vectors of influence point both ways. Inhabiting the liminal space traversed by these vectors are fields like nanotechnology that draw equally from the inscription practices of scientific research and science fiction narration, and only a more sutured concept—something like "science (fiction)"—adequately represents the technoscape of nanotechnology and its impact on the human future.

Nanotechnology is one particular example epitomizing the complex interface where science and science fiction bleed into one another. Yet more significantly, nanotechnology is capable of engineering the future in its own hybrid image. Not only does the continued development of nanotechnology seemingly provide the means for making our material environments into the stuff of our wildest dreams, but nanotech's narratives of the "already inevitable" nanofuture ask us *even now* to reevaluate the foundations of our lived human realities and our expectations for the shape of things to come. Which is to say that the writing of nanotechnology, as much as or even more than any of its eagerly anticipated technological inventions, is already forging our conceptions of tomorrow. Unleashing its science fictions as science and thereby redrawing the contours of technoculture, nanotechnology instantiates the science-fictionizing of the world.

A cognitive shock, an epistemic virus, the science-fictionizing of so-called reality shatters conventional modes of thought and activates ways of seeing differently. As Donna Haraway has argued, this postmodern revelation that "the boundary between science fiction and social reality is an optical illusion" gives rise to a "cyborg" epistemology threatening humanistic borders.[30] Similarly, Scott Bukatman sees the new subjectivity created by the science fictions of technoculture as a "terminal identity," writing that "[t]erminal identity is a form of speech, as an essential cyborg formation, and a potentially subversive reconception of the subject that situates the human and the technological as coextensive, codependent, and mutually defining."[31] These cyborg fusions and science fiction technologies transfigure embodied experience, enabling the emergence of a posthuman subject that N. Katherine Hayles describes as "an amalgam, a collection of heterogeneous components, a material-informational entity whose boundaries undergo continuous construction and reconstruction."[32] I argue that nanotechnology is an active site of such cyborg boundary confusions and posthuman productivity, for within the technoscapes and dreamscapes of nanotechnology, the biological and the technological interpenetrate, science and science fiction merge, and our lives are rewritten by the imaginative gaze resulting from the splice—the new way of seeing

that I will call "nanovision." The possible parameters of human subjectivities and human bodies, the limits of somatic existence, are transformed by the invisible machinations of nanotechnology—both the nanowriting of today and the nanoengineering of the future—facilitating the eclipse of man and the dawning of the posthuman condition.

Nanotechnology as science, or, the nanorhetoric

Nanotech is a vigorous scientific field anticipating a technological revolution of immense proportions in the near future, and Eric Drexler has long been at the vanguard of these anticipations. Founder of the Foresight Institute as well as Chief Technical Advisor for the molecular machine systems company Nanorex, his scientific credentials—a Ph.D. from MIT (1991), a former visiting appointment at Stanford (1986–91), a research fellowship at the Institute for Molecular Manufacturing (1991–2003), and numerous publications—are impressive. His technical and popular writings have inspired thousands of researchers to enter the field of nanoscience. So it might be surprising to recognize that Drexler's seminal and influential *Engines of Creation*, outlining his program for nanotech research, is composed as a series of science-fictional vignettes. From spaceships to smart fabrics, from A.I. to immortality, *Engines of Creation* is a veritable checklist of science-fictional clichés (Drexler's insistence on scientificity notwithstanding) and the narrative structure of the book unfolds like a space opera: watch as brilliant nanoscientists seize control of the atom and lead humankind across the universe … and beyond!

This operatic excess of nanowriting—that genre of scientific text in which the already inevitable nanotech revolution can be glimpsed—characterizes even many of the technical publications by Drexler, Ralph Merkle, Ted Sargent, Markus Krummenacker, Richard Smalley, Stuart Hameroff, Robert Freitas, J. Storrs Hall, and sundry other prophets of the nanofuture. Speculative and theoretical, the writings of these nanoscientists regularly demonstrate what is possible but often not what has yet been accomplished, what has been successfully simulated but often not what has yet been realized (for example, Merkle writes that nanoscientists are working diligently to "transform nanotechnology from computer models into reality"[33]). These texts frame their scientific arguments with vivid tales of potential applications, which are firmly the stuff of the golden age of science fiction. Matter compilers, molecular surgeons, spaceships, space colonies, cryonics, autogenous robots, cyborgs, synthetic organisms, smart utility fogs, molecular cognition, extraterrestrial technological civilizations, and utopias abound in these publications, borrowing unabashedly from the repertoire of the twentieth century science-fictional imagination.[34]

Consequently, the experimental evidence supporting the reality of nanotech has been marshaled into battle to divide the science from its "sci-fi" associations. Nanotechnology is a realistic science, many researches claim, because biological "nanomachines" like enzymes and viruses already exist in nature; there is no reason, then, why human engineers could not construct similar molecular devices.[35] Moreover, they claim, individual atoms can already be moved with relative ease using probe microscopes, and it seems certain that our technical abilities in this area will continue to improve. But even with nature as a model, and even with a few highly publicized events in atomic manipulation, the tangible products of nanoresearch remain extremely preliminary. Which is why, according to Mihail Roco (NSF Senior Advisor for Nanotechnology and coordinator of the NNI), nanotechnology was so widely perceived as pure "science fiction" in the years before the global wave of nanospeculation began to surge in 1998.[36] The infant field of nanoscience therefore advertised certain experimental results achieved during those years as great landmarks in the progress of the discipline

towards becoming a "real science" (even despite the fact that many of the researchers involved in these landmarks may not have perceived themselves as "nanotechnologists" until well after the fact![37]). Some major "proof-of-concept" events claimed by nanoscience to defend against accusations of being nothing but science fiction included:

- Gerd Binnig and Heinrich Rohrer's Nobel Prize-winning invention of the scanning tunneling microscope (STM) in 1981, which enabled real-space visualization and manipulation of individual atoms for the first time.
- Engineered proteins and synthetic molecules with enzyme-like capabilities (William DeGrado and colleagues accomplished the former in 1988; Jean-Marie Lehn, Charles Pederson, and Donald Cram shared a Nobel Prize in 1987 for the latter).
- Organic molecules pinned to a surface with an STM (led by John Foster at IBM in 1988).[38]
- The widely-publicized construction of the IBM logo on a nickel surface by maneuvering individual xenon atoms with an STM (led by Donald Eigler at IBM in 1989).[39]
- The production of fullerenes (earning Richard Smalley, Robert Curl, and Sir Harold Kroto a Nobel Prize in 1996) and their later applications, such as "nanopencils" that deposit molecular ink and "nanotweezers" for moving atoms.[40]
- Invented nano-novelties, such as a "nanoabacus" (produced in 1996 by an IBM team led by James Gimzewski), a "nanotrain" (a large mobile molecule crawling along a molecular "track," synthesized by Viola Vogel), and several varieties of rotating molecular motors.[41]

These technical accomplishments, as laudable and fascinating as they are, clearly do not represent the arrival of molecular manufacturing or programmable matter. Nonetheless, because they seemed to suggest *progression* towards the "full potential" of nanotech during the years when nano's reputation as a real science was most at stake, nanorhetoricians could maintain that the continued "evolution of nanotechnology" was a scientifically valid expectation. Since then, in the wake of the international nanotech frenzy that began fomenting around 1999, the ongoing production of nanoparticles and nanofilms, experiments with "quantum dots" (semiconducting nanocrystals) and DNA computing, and the multiplication of research programs around the world have dramatically augmented the perception that the progression of nanotechnology is well underway. Even the questionable assimilation of research that once would have simply been called "chemistry" or "microphysics" under the umbrella term of "nanotechnology" has contributed to an increasing faith that not only has nanotechnology now become a real science, but also that its inevitable advancement will fulfill our every dream.

Further evidence that nanotechnology is a real science, rather than a misguided and temporary fad, comes from its many signs of emergent disciplinarity, or even transdisciplinarity.[42] The fact that scientists from numerous research traditions are actively working and staking their reputations on the nanofuture might be evidence enough of a more or less common mission, and even the visible confrontation between various research programs and individual scientists (most notoriously, Eric Drexler and Richard Smalley) seeking to shape the field can be seen as symptomatic of the tribulations of nanotechnology as a whole to attain the status of a unified scientific profession.[43] These agonistic struggles within the technoscape have stabilized a field-specific lexicon as well as institutional structures supporting nanoresearch, and they have effectively established conceptual boundaries within which various kinds of nanoscience are able to take place, both industrially and academically.[44]

Drexler taught an engineering course on molecular nanotechnology at Stanford University in 1989, and this early curricular inclusion supposedly indicates the emergent

institutionalization of an already exciting field, for he writes, "At Stanford, when I taught the first university course on nanotechnology, the room and hallway were packed on the first day, and the last entering student climbed through a window."[45] Such early, even premature, attention to pedagogy suggests an effort to plant nanotechnology into the ecology of academic disciplines from its first days. Indeed, although a textbook usually marks the trailing end of a scientific discipline rather than the forefront, Drexler composed an advanced textbook on nanotech engineering and design called *Nanosystems: Molecular Machinery, Manufacturing, and Computation* (1992)—based on his doctoral dissertation—long before most scientists had even heard the word "nanotechnology."[46] Filled with the differential equations, quantum mechanical calculations and structural diagrams absent from his earlier publications, this textbook performed a certain legitimating function for what was still an increasingly maligned science, even in 1992. Dozens of other nano textbooks were soon published in succession, and Drexler's "first university course" has been followed by hundreds of international academic programs, institutes, courses and workshops focusing on nano education—something Drexler thus seems to have foreseen already in 1989.

Since 1989, the Foresight Institute has sponsored annual conferences on nanotechnology, bringing in researchers from all over the world to contribute in dialogues to define the goals, methods and assumptions of this new technoscience. Governmental and university conferences, as well as online forums, have alike created spaces for professional networking and information exchange between the growing community of self-professed "nanotechnologists." There are even scholarly journals, such as *Nanotechnology* and *Nano Letters,* that publish exclusively the cutting-edge research in the field. At present, all of these approaches to fashioning a unified nanotechnology discipline or a transdisciplinary "trading zone" have managed to achieve only a chaotic multidisciplinary muddle whose different constituents often do not see eye to eye.[47] But the failure of disciplinary cohesion so far has certainly not diminished the sense that as a scientific field—perhaps unified in name only, but still a field—nanotechnology has *arrived*. The first nanotech start-up company, Zyvex, appeared in Richardson, Texas in 1997 intending to develop nanodevices like Drexler's assembler in less than a decade. Zyvex has been followed by a boom of nano-commerce in the Silicon Valley and other regions where industrial speculation and venture capital abundantly flow. Many of the actors involved in nanotech see these and other signs pointing to a grand "convergence" of numerous sciences and industries at the nanoscale.[48] Across academia, industry and politics, nanotechnology seems here to stay.

So nano certainly *looks* like a science, and the people promoting the field have long been trying really hard to show why it is nothing like science fiction, despite the fantastic nature of its many futurological predictions. Repeatedly, again and again, supporters of nanotechnology tell us that nanotechnology is not, *absolutely not*, science fiction. This fact is insisted upon, everywhere and loudly. The main argument enforcing this division emerges, again, from the logic of the real versus the simulacrum; specifically, nanowritings insist that their visions of the future are grounded in "real science," while those futures described in science fiction are not. Take, for example, Drexler's comments on science fiction in *Engines of Creation*:

> By now, most readers will have noted that this [nanotechnology] ... sounds like science fiction. Some may be pleased, some dismayed that future possibilities do in fact have this quality. Some, though, may feel that 'sounding like science fiction' is somehow grounds for dismissal. This feeling is common and deserves scrutiny.
>
> Technology and science fiction have long shared a curious relationship. In imagining future technologies, SF writers have been guided partly by science,

partly by human longings, and partly by the market demand for bizarre stories. Some of their imaginings later become real, because ideas that seem plausible and interesting in fiction sometimes prove possible and attractive in actuality. What is more, when scientists and engineers foresee a dramatic possibility, such as rocket-powered spaceflight, SF writers commonly grab the idea and popularize it.

Later, when engineering advances bring these possibilities closer to realization, other writers examine the facts and describe the prospects. These descriptions, unless they are quite abstract, then sound like science fiction. Future possibilities will often resemble today's fiction, just as robots, spaceships, and computers resemble yesterday's fiction. How could it be otherwise? Dramatic new technologies sound like science fiction because science fiction authors, despite their frequent fantasies, aren't blind and have a professional interest in the area.

Science fiction authors often fictionalize (that is, counterfeit) the scientific content of their stories to 'explain' dramatic technical advances, lump them together with this bogus science, and ignore the lot. This is unfortunate. When engineers project future abilities, they test their ideas, evolving them to fit our best understanding of the laws of nature. The resulting concepts must be distinguished from ideas evolved to fit the demands of paperback fiction. Our lives will depend upon it.[49]

I have quoted this passage at length because of its several remarkable qualities intended to rescue nanotechnology from the ghetto of science fiction. While the first paragraph begins the radical task of reconciling science and science fiction, juxtaposing the languages of "possibility" and "fact," Drexler quickly departs from this goal and instead firmly separates science, and particularly nanotechnology, from the "fantasies" of fiction. He clarifies the assumed directional flow of reality into fiction: when science fiction is "real" the writer either landed on reality by chance or "grabbed" the idea from science. Drexler thus distinguishes science fiction writers from "other writers" and "engineers" who "examine the facts" (presumably Drexler fits into this category). He employs the idea of the "counterfeit" to describe science fiction, as a mimetic representation similar to but ontologically distinct from reality. He divides "our best understanding of the laws of nature" (Drexler's writing) from "the demands of paperback fiction" (science fiction), concluding that, because of the dangerously real consequences made possible by nanotech, our very lives depend on maintaining this division! What further rationale for recognizing the barrier between science and science fiction could one need?

Thus Drexler seemingly secures his work as science, but another tactic deployed by defenders of nanotech is to exclude Drexler and his sympathizers from the technoscape entirely. This strategy acknowledges and foregrounds the intractable science-fictionalisms of Drexler's science and thereby pronounces him a pariah, in effect preserving the rest of nanotech as "real science."[50] For example, Donald Eigler (of the xenon IBM logo) has audaciously declared that "[Drexler] has had no influence on what goes on in nanoscience. Based on what little I've seen, Drexler's ideas are nanofanciful notions that are not very meaningful."[51] Mark Reed, nanoelectronics researcher and Professor of Engineering and Applied Science at Yale University, has said, "There has been no experimental verification for any of Drexler's ideas. We're now starting to do the *real* measurements and demonstrations at that scale to get a *realistic* view of what can be fabricated and how things work. It's time for the *real* nanotech to stand up" (emphasis added).[52] The force of this argument comes from the deluge of the "real," which, repeated *ad nauseam*, appears to drown Drexler and friends and engulf them in the irrationalities of their nanodreams. Again we see the

rhetorical establishment of a powerful dichotomy of science versus science fiction, but this time constructed within the technoscape itself.

A final tactic used by nanorhetoricians, both Drexlerians and Drexler-detractors, is the oft-repeated story about the genesis of nanotech. I will call this foundational narrative the "Feynman origin myth." The story goes (and it is told by nearly everyone researching in this field, posted on their web pages and repeated in their publications) that on December 29, 1959, Richard Feynman delivered a talk entitled "There's Plenty of Room at the Bottom" to the American Physical Society at the California Institute of Technology. Here, Feynman suggested the possibility of engineering on the molecular level, arguing that the "principles of physics, as far as I can see, do not speak against the possibility of maneuvering things atom by atom. It is not an attempt to violate any laws; it is something, in principle, that can be done."[53] Feynman further asserted that something like nanotech is "a development which I think cannot be avoided." Quotations and paraphrases of these statements run rampant throughout the discourse network as arsenal in the war to legitimate nanotechnology.[54] Such recourse to Feynman's speech has given rise to the belief that Feynman originated, author-ized, and established nanotechnology. Assertions like "This possibility [of nanotechnology] was first advanced by Richard Feynman in 1959"[55] and "Richard Feynman originated the idea of nanotechnology, or molecular machines, in the early 1960s"[56] are commonplace and have taken on the status of truisms. Feynman's talk is continually invoked to prove that nanotechnology is a real science, but not because of the talk's theoretical, mathematical, or experimental sophistication; indeed, judging from the language used—the numerous appearance of "possibility," "in principle," "I think," and the telling "it would be, in principle, possible (I think)"—it is clear that Feynman's talk was just as speculative as (if not more than) any article penned by Drexler, Merkle, or their associates.

The Feynman origin myth is resurrected over and over again as an easy way of garnering scientific authority. How better to assure that your science is valid than to have one of the most famous physicists of all time pronouncing on the "possibility" of your field? It is not uncommon for nanorhetoricians, when referencing the talk, to remind their audience that Feynman won the 1965 Nobel Prize in physics. Merkle candidly reveals that name recognition and cultural capital are the main values of this tactic when he writes: "One of the arguments in favor of nanotechnology is that Richard Feynman, in a remarkable talk given in 1959, said that, 'The principles of physics, as far as I can see, do not speak against the possibility of maneuvering things atom by atom.'"[57] The argument is clearly not *what* Feynman said, but "is that" *he* said it. The argument hinges on Feynman's unique vision, what he "can see," something special about Feynman's scientific ability that transforms a speculative statement into a description of reality. A frank example of fetishizing the author and the origin (the Foresight Institute even offers a "Feynman Prize"), Feynman's talk grounds nanotechnology not in the real but in authoritative discourse. Nevertheless, the Feynman origin myth is perceived as dissociating nanotechnology from science fiction.

To its credit, nanotech has been amazingly successful in the battle to vindicate itself as a real science, as something very different from science fiction despite how much it may seem like science fiction. The anti-SF rhetoric has even made its nanodreams appear more like inevitabilities to a larger audience. From 1992, when Drexler and company unveiled a wonderful nanofuture to the U.S. government and achieved the allocation of special NSF funds for nanoscale research, to the implementation of the 2001 National Nanotechnology Initiative, the foundations for which grew out of Congressional testimonies by Smalley, Merkle, and other key figures in the field, nanorhetoric triumphed in transforming science fiction visions into manifest and lucrative national ventures.[58] Even President Clinton, announcing the National Nanotechnology Initiative at Caltech on January 21, 2000, demonstrated his

absorption of nanorhetoric by citing the 1959 Feynman talk, along with a few imaginary coming attractions of the nanofuture, as evidence for the decisive role that nanotechnology will play in bringing about an "era of unparalleled promise."[59] Thus despite many skeptics and determined critics, nanotech managed to secure its professional future by combining fantastic speculation with concerted attacks on science fiction. Indeed, considering nanotech's rapid expansion in academia and industry, the reputable scientists involved, and its current high profile, there appears little doubt that nanotech is real science.

However, the "sci-fi" anxieties haunting defenders of nanotechnology disclose its scandalous proximity to science fiction, and, I argue, only rhetoric is maintaining the separation. Furthermore, I will show that this rhetoric thoroughly deconstructs itself in a futile struggle for boundary articulation that has already been lost.

Nanotechnology as science fiction, or, deconstructing the nanorhetoric

Recall Drexler's arguments regarding science fiction: Drexler must explicitly distinguish his science from paperback fiction because his nanonarratives borrow extensively from pre-existing genre conventions. Drexler's stories—like those found throughout nanowriting—describe the world transformed by imagined feats of science and engineering relegated to the unspecified future, and even when denying the science-fictionality of his vignettes by emphasizing that they are "scientifically sound," Drexler cannot avoid drawing attention to the fact that they do, after all, "sound like science fiction." Although Drexler confirms the conventional assumption that science is the real, science fiction its imaginary simulacrum, when he says that his science "sounds *like*" fiction, he reverses this assumed order. Science fiction has anticipated science, and the ensuing science is not ultimately delineated from science fiction by Drexler's arguments.

Though Drexler distinguishes science fiction writing from his kind of writing through the criterion of mimesis, science fiction writers who "grab the idea [from science] and popularize it" are not logically different from writers who "examine the facts" of science and popularize them, as *Engines of Creation* is intended to do. Along the same lines, the criterion that Drexler's stories are scientifically sound while science fiction stories are (presumably) not is challenged when he acknowledges that science fiction "imaginings" frequently "become real" (again reversing the presumed order). Science and science fiction dynamically and frequently shift structural positions in Drexler's writing, both suggested to be inhabited by "the real" at the same time as each paradoxically appears to simulate the other. That is to say, the real has become simulation and the simulation has become real.

None of these inconsistencies mean that Drexler is not writing good science; they do mean that the boundary between science fiction writers and writers of what Drexler calls "theoretical applied science," like himself, is hopelessly blurred. Tellingly, Drexler has personally forayed into the production of genre science fiction texts, writing an introduction to the short story collection, *Nanodreams* (1995), where he discusses the importance of science fiction in assessing future technologies.[60] The unavoidable failure of the dichotomy between science and science fiction occurs when Drexler, having apparently given up the endeavor, also calls the scenarios described in *Engines of Creation* "science fiction dreams."[61]

Thus the division between writers of science fiction and writers of "theoretical applied science" or "exploratory engineering" is destabilized and confused. "Scientifically sound," according to Drexler, can be a quality of both kinds of writing—destroying the criterion, erasing the division. Ultimately, Drexler's nanowriting indicates that science fiction precedes

and supersedes "its" science, echoing Baudrillard's "precession of simulacra": the simulacra coming before, displacing and supplanting, making the real seem to be the not-real, the science to be the science-fictional.[62]

Determining that Drexler's version of nanotechnology is inseparable from its science-fictionalisms would apparently make the tactic of excluding him from the field more effective. After all, if his writing is indeed science-fictional, then he is not, according to Reed, part of "the real nanotech." However, attempts to banish Drexler from the field he established actually have the ironic effect of highlighting the science-fictionality of nano. When Eigler states that Drexler "has had no influence on what goes on in nanoscience," he is disregarding Drexler's seminal technical publications and the considerable contributions of his Foresight Institute. Furthermore, Eigler is in flat contradiction to the vast expanses of the technoscape recognizing Drexler's inspiring influence[63] (including Smalley, who once said that Drexler "has had tremendous effect on the field through his books,"[64] and, despite his conviction that Drexlerian self-replicating assemblers are "not possible," he credited Drexler with motivating his own prominent career in nano: "Reading [*Engines of Creation*] was the trigger event that started my own journey in nanotechnology."[65]) When Reed says that Drexler's ideas have not been experimentally verified and therefore are not part of the "real" nanotech, he is disregarding the validity of all theoretical science—clearly a problematic move. And even if Drexler could be fashioned as a heretical character on the fringes of the technoscape, it remains the case that other scientists perhaps more sociologically central to "real nanotechnology" employ with regularity the same science-fictional tropes in their nanowritings as Drexler does in his. In terms of their common reliance on speculative narrational modes to bridge the gaps between current technoscientific reality and future promises, there is no difference between them.[66] Consequently, Drexler cannot be so simply exiled. He has persuaded not only individual nanoscientists but also governmental funding boards about the inevitable nanofuture.[67] The same "science fiction dreams" informing Drexler's writing permeate the nanotechnological imagination everywhere, right to the very center of "real science." Accordingly, nanotechnology needs to acknowledge the heavy speculation that remains fundamental for its own development as a research field. After all, having proclaimed that Drexler is "science fictional" and "not real," yet ultimately obliged to recognize his influence, this tactic to expel science fiction from science backfires on itself.

Even Merkle's *response* to these exclusionary efforts eventually backfires. In a letter to the editor of *Technology Review*, he writes:

> While I am happy to see the increasing interest in nanotechnology, I was disappointed by your special report on this important subject. Mark Reed summarized one common thread of the articles when he said 'There has been no experimental verification for any of (Eric) Drexler's ideas.' Presumably this includes the proposal to use self-replication to reduce manufacturing costs. The fact that the planet is covered by self-replicating systems is at odds with Reed's claim.
>
> Self-replicating programmable molecular manufacturing systems, a.k.a. assemblers, are not living systems. This difference lets Reed argue that they have never before been built and their feasibility has not been experimentally verified. Of course, this statement applies to anything we have not built. Reed has discovered the universal criticism. Proposals for a lunar landing in 1960? Heavier-than-air flight before the Wright brothers? Babbage's proposal to build a computer before 1850? No experimental verification. Case closed.[68]

Merkle musters a "fact" (i.e. that self-replicating systems abound in nature) in support of Drexler and builds an argument for the validity of scientific speculation, successfully countering Reed's implication that Drexler's science is not "real." Drexler is salvaged, put back on the secure ground of reality. But while accomplishing Drexler's reassimilation into the field, Merkle also winds up equating nanotechnology with science fiction. Merkle suggests that nanotechnology is a real science, even though it lacks experimental verification, because proposals for a lunar landing in 1960, considerations of heavier-than-air flight before the Wright brothers, and Babbage's idea for a computer had no experimental verification and yet these ideas eventually found verification after time. "Case closed," he writes. But, of course, speculations for a moon voyage, for heavier-than-air flight, and for computers of various sorts had existed long before their "real" incarnations—think of the stories of Jules Verne, H. G. Wells, Hugo Gernsbeck, Isaac Asimov, Robert A. Heinlein, Arthur C. Clarke and countless others—all of which were and still are clearly marked as science fiction. Thus in recuperating the speculations of nanowriting, Merkle solidifies the relay between nanotechnology and science fiction. Before moon voyages, air flight, and computers there was science fiction; before the nanotechnology revolution of the future there is the anticipatory nanotechnology of today. Nanotechnology is science fiction. Case closed?

This dissolving boundary between science and science fiction in nanowriting elsewhere occurs as intertextuality, in the sense that loci of meaning within nanowritings are frequently dependent upon a larger web of texts, both science and science fiction, that enable their signification. In this respect, nanowritings are what Jonathan Culler describes as "intertextual constructs" that "can be read only in relation to other texts, and [they are] made possible by the codes which animate the discursive spaces of a culture."[69] For example, the concept of the "Diamond Age"—describing how the nanotechnology era will be historicized relative to the Stone Age, the Bronze Age, the Silicon Age, etc.—appears in science fiction, particularly Neal Stephenson's nanotech novel, *The Diamond Age* (1995), and in Merkle's *Technology Review* survey article, "It's a Small, Small, Small, Small World" (1997).[70] Each text, science and science fiction, simply assumes reader familiarity with the terminology deployed by the other.

Stephenson's novel, similarly, describes a "Merkle Hall" located within the nanotech corporation, Design Works, whose ceiling, reminiscent of Michelangelo's Sistine Chapel, is covered with a fresco depicting the pantheon of nanotech, wherein Feynman, Merkle, and Drexler mingle with more fictional personalities.[71] Fact and fiction merge in the blender of nanowriting where allusions are creatively drawn from both technical reports and popular novels.

The constitutive role of science-fictional allusion arises even more strikingly in J. Storrs Hall's theoretical elaboration of a nanotech "Utility Fog"—a pervasive substance for complete environmental control and universal human-machine interface.[72] The Fog would be a swarm of nanomachinic "foglets" dispersed in the air, designed to change properties and simulate any range of normal materials. In presenting exploratory engineering designs for this technology, Hall's essay, "Utility Fog: The Stuff that Dreams Are Made Of" (1996), relies on a diffusion of science fiction tropes and witty references to many canonical science fiction texts, including *Forbidden Planet* (1956), Heinlein's "The Roads Must Roll" (1940), Verne's *From the Earth to the Moon* (1865), Wells's *The Shape of Things to Come* (1933), and Karl Capek's *R.U.R.* (1920), suggesting that nanotechnological thinking is essentially a process of writing from the margins of other fictional futures, other textual worlds.

In a later account, Hall notes that the Utility Fog's capacity to simulate nearly anything, producing material objects straight out of the nano-saturated air, will thwart standard notions of the "real" and the "virtual": "One thing in a Fog world that would be more difficult than

ours would be telling what was real and what wasn't. … Utility Fog mixes virtual and real … I'm sure that as we gain experience with the partly virtual world that is coming, we'll invent new words and concepts necessary to deal with it."[73] But this hyperreality of the coming nanofuture already informs Hall's writing of the present, for it seems that designs for Utility Fog originated from mixing real science with superhero fantasy: "I'll … explain where 'Utility Fog' came from. First the stuff fills the air like fog, and you walk around in it. It would look a lot like fog as well. As for the "Utility" part, remember the *Batman* TV series from the 1960s? Whenever Batman needed some gadget, lo and behold, there it was in his 'utility belt.' There seemed to be no end of what the belt could produce—and it was always right at hand."[74] Within nanowriting, the facile permeability of these worlds of science and fiction, the ease with which concepts and signs traffic between them, challenges any stringent boundrification. The tactics of separating nanotech from the science fiction with which it is complicit fail on nearly every level.

As a final bit of evidence, let's return to the Feynman origin myth. Despite nanorhetoricians' frequent citations of the talk to support the realness of their discipline, the talk itself sits awkwardly with such a purpose. We have seen the indeterminacy and speculative nature of the language Feynman uses, and strikingly, the talk is composed as a series of science fiction stories, just like Drexler's *Engines of Creation*. Feynman tells stories about tiny writing, tiny computers, the actual visualization of an atom, human surgery accomplished by "swallow[ing] the surgeon," and "completely automatic factories"—certainly not impossibilities, but still the conceits of numerous genre science fiction narratives long before Feynman stepped to the podium. Thoroughly penetrated by the science-fictional imaginary, it is no coincidence that Feynman's nanotech looks just like Drexler's nanotech, fabricated from the same "science fiction dreams."

The Feynman origin myth thus contains in itself the deconstruction of the nanotech/science fiction dichotomy. The cavalier way in which the myth is used by both Drexlerians and those who challenge Drexler's vision of nanotech is further indication of its deconstructive tendencies. Consider, for example, the response of Thomas N. Theis (IBM Research Division) to the *Technology Review* article where Reed implies that Drexler's nanotech is not real: "Congratulations on your review … Your writers clearly distinguished hype from hard science and vision from reality. I was reminded of Richard Feynman's famous 1959 after-dinner talk … Feynman managed to foreshadow decades of advances … I know that his vision influenced at least a few of the individuals who have made these [hard science] things happen."[75] That Theis can speak of "vision" opposed to "reality" in one sentence and of Feynman's "vision" that *contributed* to hard (i.e. real) science in another reveals the ease of appropriating such a myth for one's own purposes, the impossibility of simply excluding Drexler's "vision" from the field, and the blurring of science and science fiction within the Feynman talk. After all, if vision is opposed to reality, then Feynman's talk abandoned reality entirely.

Even as a genesis story, the Feynman myth only succeeds in making a science fiction of nanotechnology. Nanotechnology is supposedly a real science *because* it was founded and authorized by the great Richard Feynman. But this origin is not an origin, and its displacement unravels its legacy. The Feynman myth would only work if it clearly had no precedents, if it was truly an "original" event in intellectual history, if even Feynman had offered a unique, programmatic conception of how nanotechnology was to be accomplished. Yet this is not the case: Feynman merely depicted a speculative vision of a possible technology, and science fiction writers, as they have done with so many things, had already beaten him there. Technologies, theoretical concepts, and thought experiments identifiably similar to those circulating through current visions of nanotechnology appear in numerous stories

from the first half of the 20th century. For example, Ray Cumming's *The Girl in the Golden Atom* (1925; original short story, 1919) features the invention of a subatomic microscope, which eventually leads to physical exploration of romantic worlds inside an atom. Theodore Sturgeon's "Microcosmic God" (1941) represents artificially-evolved micro entities called "Neoterics," whose small size enables them to engineer eutactically and create incredible new devices. Robert A. Heinlein's "Waldo" (1942) discovers a top-down method for interacting with infinitesimal materials. Eric Frank Russell's "Hobbyist" (1947) describes a mysterious factory that manufactures living organisms through atom-by-atom assembly, located on a planet that may be God's own workshop. Hal Clement's *Needle* (1950) imagines an alien being comprised entirely of viroid particles who diffuses into a young boy's body, enhancing his physical capabilities and acting as an internal surgeon. James Blish's "Surface Tension" (1952) dramatizes the construction of miniature technologies inside an aqueous lifeworld whose features are shaped by intermolecular forces. And finally, Philip K. Dick's "Autofac" (1954) concerns fully "automatic factories" that are sustained by self-replicating microscopic machinery. All of these stories were published well before Feynman gave his now-mythical talk.

Although there is no evidence that Feynman personally read any of these science fiction stories, his friend Albert R. Hibbs (senior staff scientist at the Jet Propulsion Laboratory) did read "Waldo" and described it to Feynman in the period just before Feynman composed his talk.[76] And indeed, Heinlein's influence haunts Feynman's depiction of nanotechnology. In Heinlein's novella, the eponymous genius, Waldo, has invented devices—known as "waldoes"—which are mechanical hands of varying sizes, slaved to a set of master hands attached to a human operator. Heinlein writes that the "secondary waldoes, whose actions could be controlled by Waldo himself by means of his primaries," are used to make smaller and smaller copies of themselves ("[Waldo] used the tiny waldoes to create tinier ones"), ultimately permitting Waldo to directly manipulate microscopic materials by means of his own human hands.[77] Heinlein thus hypothesizes a method for molecular engineering that Feynman in his talk, without crediting his source, offers as a means to "arrange the atoms one by one the way we want them." Feynman describes his proposed system:

> [It would be based on] a set of master and slave hands, so that by operating a set of levers here, you control the 'hands' there … I want to build … a master-slave system which operates electrically. But I want the slaves to be made especially carefully by modern large-scale machinists so that they are one-fourth the scale of the 'hands' that you ordinarily maneuver. So you have a scheme by which you can do things at one-quarter scale anyway—the little servo motors with little hands play with little nuts and bolts; they drill little holes; they are four times smaller. Aha! So I manufacture [with these hands] … still another set of hands again relatively one-quarter size! … Thus I can now manipulate the one-sixteenth size hands. Well, you get the principle from there on.[78]

The originality of the Feynman myth crumbles, for we can see that Feynman's talk emerges from genre science fiction. Feynman's method of molecular manipulation is borrowed from Heinlein. Even the proposition for internal microscopic surgery—a notion Feynman credits to Albert Hibbs—was already proclaimed as an "original" idea by Heinlein in the "Waldo" novella. Heinlein writes that microscopic surgery via microscopic machines "had *never been seen before*, but Waldo gave that aspect little thought; no one had told him that such surgery was unheard-of."[79] The mythologized order of precedence is therefore reversed, for it becomes evident that speculations of nanotech were freely circulating in the discourse of science fiction long before science "grabbed the idea." If

we really want to locate an origin to nanotechnology, it is not to Feynman that we must look, but to science fiction.

Consequently, I reiterate that in the case of nanotech we have a situation where simulation has preceded and enveloped "real" science, where the line between science and science fiction is blurred, made porous, and effaced. It even seems likely that this hybridity has been responsible for nanotech's recent financial success; companies have been founded and government officials have been awed less by nanotech's real accomplishments—for there are few—but rather on its dream of the future, its promise of a world reborn: its science fiction indistinguishable from its science. Rapidly becoming a major actor in the science-fictionizing of technoculture—along with certain other interstitial sciences and technologies, such as virtual reality, cybernetics, cloning, exobiology, astronautics, artificial intelligence and artificial life—nanotechnology exerts strong symbolic influence over the way we conceptualize the world and ourselves. In other words, as a science (fiction) with enormous cultural resources and increasing historical significance, nanotechnology claims for itself a powerful role in the human future and the future of the human.

Posthuman engineering

The birth of nanotechnology provokes the hyperreal collapse of humanistic discourse, puncturing the fragile membrane between real and simulation, science and science fiction, organism and machine. With its technoscapes and dreamscapes irreducibly interlaminated, nano heralds metamorphic futures and cyborganic discontinuities. For in both its speculative-theoretical and applied-engineering modes, nanotechnology unbuilds those constructions of human thought, as well as those forms of human embodiment, based on the security of presence and stability—terrorizing presentist humanism from the vantage point of an already inevitable future. If the discovery of leakages across ruptured conceptual boundaries denatures the domain of humanism, entraining us to "pass beyond man and humanism, the name of man being the name of that being who, throughout the history of metaphysics or of ontotheology—in other words, throughout his entire history—has dreamed of full presence, the reassuring foundation, the origin and the end of play,"[80] then the arrival of nano and its hyperreal way of seeing performs exactly this kind of crucial destabilization within the human present. For nano puts all foundations in play even at the atomic level, it upsets presentism and the security of linear time, it erases epistemic divisions even as it multiplies ontic possibilities.

The breakdown of humanism accelerates through increasing collisions between human flesh and technology, where the interface mediates the emergence of new posthuman spaces, hybrid realities of the machinic, the virtual, and the meaty.[81] Where bodies bleed with machineries, where science bleeds with science fiction, the secure enveloping tissues of the human subject—cognitive, corporeal, and otherwise—rip apart. Within these wounds, these traumatic crash sites that become ever more refined through technical reductions approaching the quantum limits of fabrication, the natural and the constructed, the human and the nonhuman, wash together in a molecular flow. This confluence and convergence at the nanoscale thus makes possible a radical reshaping of reality, atom by atom. A reshaping of reality that, while still a fiction, is no less already a fact. For even right now, the science (fiction) of nanotechnology enacts the techno-deconstruction of humanism, forcing us to think otherwise through its narratives of corporeal reconfiguration from beyond the temporal horizon, fabricating new fields of embodiment and facilitating our becoming posthuman

by envisioning a future where the world and the body have been made into the stuff of science fiction dreams.

Posthuman narratives of bodily ambiguation, fragmenting and exceeding the bodies we know, restructure our somatic experiences. As Kelly Hurley has argued, the textual operations of posthuman narratives work to "disallow human specificity on every level, to evacuate the 'human subject' in terms of bodily, species, sexual, and psychological identity," generating instead discursive zones for self-alienation and self-refashioning.[82] They offer alternate modes of identification to what is merely standardized as human by radically revising the body. Towards this end, nanotechnology everywhere produces images of bodily ambiguation and articulates an alternative logic of identity—the subversive technoscientific gaze that I call "nanovision"—in myriad future-shock stories circulating within the technoscape and beyond. Whether deployed in the form of novels, films, or technical scientific reports, these posthuman "nanonarratives" directly impact and modify our present.[83] Many nanoscientists seem to confirm the immediate and tangible effects of such stories in their conviction that humanity has already been remade by a colossal technological revolution that may have so far occurred only in fiction, yet necessitating evermore vigilant "foresight." That several key figures in nano also openly participate in transhumanist and extropian movements, endorsing the redesign of human biology through advanced molecular manufacturing and other still fictive technologies, powerfully suggests the affective force of visionary nanonarratives.[84]

Whether utopian visions or catastrophic nightmares, nanonarratives resist traditional humanist interpretations by repeatedly depicting the future in terms that disequilibrate the human body. From the eroticized collective consciousness of the Drummers in Stephenson's *The Diamond Age* (1995), to the lycanthropic transformations of Dean Koontz's *Midnight* (1989), to the permeability of "enlivened" city-structures and body-structures in Kathleen Ann Goonan's *Queen City Jazz* (1994), to the metamorphosis of the entire human population into billowing sheets of sentient brown sludge in Greg Bear's *Blood Music* (1985), posthuman bodies in nanonarratives are never stable, never idealized, never normative, never confined; the limits of posthuman corporeality are as wide as the nanovisual imagination. Nanovision disrupts the configurations of the human body, rebuilding the body without commitment to the forms given by nature or culture. Nanovision is an active instrument of posthuman engineering.

Rather than purveying a posthumanism in which the subject is in danger of losing the body, nanovision sees posthuman subjectivities resulting from embodied transformations.[85] Embodiment is fundamental to nanovision because, for the science of nano, *matter* profoundly *matters*. Nanovision respects no unitary construct above the atom, reducing everything to a broadly programmable materiality and demolishing metaphysical categories of identity. Accordingly, it does not support any sort of abstracted, theoretical construction of the body because it unbounds the body, puts its surfaces and interiors into constant flux. The posthuman bodies conditioned by nanovision are therefore always individuated experiences of embodiment in an endless array of possible bodily conformations, where all skins and membranes are fair game.

Nanovision entails a cyborg logic, imploding the separation between the biological and the technological. As we have seen, one of the arguments legitimating nanotechnology is that biological machines like ribosomes and enzymes and cells are real, and consequently there is nothing impossible about engineering such nanomachines. But the very ease of describing biological objects as machines indicates the cyborgism of nanotech, its logic of prosthesis, its construction of bodies and machines as mutually constitutive. Nanotechnology envisions the components of the body and mechanical objects as indistinguishable, and, subsequently, utilizes the biological machine *as the model* for the nanomachine, achieving a

terminal circularity. Nanovision removes all intellectual boundaries between organism and technology—as Drexler puts it, nanovision causes "the distinction between hardware and life … to blur"[86]—and human bodies become posthuman cyborgs, inextricably entwined, interpenetrant, and merged with the mechanical nanodevices *already inside of them*.

Having become cyborganic machines, bodies in the grasp of nanovision can be reassembled or reproduced with engineering specificity. Unlike genomic cloning, which merely provides genotypic but not necessarily phenotypic identity, the copying fidelity of nanotechnology is so exact that copies would have precise identity down to the atomic level. Feynman (following Heinlein) foresaw this in his talk: "all of our devices can be mass produced so that they are absolutely perfect copies of one another."[87] The ability of nanodevices to produce exact copies—copies of themselves, copies of their constructions—is fundamental to nanovision, and it is not, perhaps, entirely a coincidence that for more than a decade Merkle directed the groundbreaking Computational Nanotechnology Project for Xerox.[88] The potential for nanotechnology to reproduce anything exactly, accurate in every atomic detail, or to reconstruct anything into an identical copy of anything else, leads to posthuman nanonarratives that, undermining our conceptions of identity and origin(ality), need not become literalized to have transformed the architectures of our somatic experience. Posthuman narratives ask us to envision otherwise, thereby opening up new possibilities of corporeality that change the way we conceive ourselves. Such possibilities are illustrated by the following series of nanoscenarios:

- A wooden chair, reprogrammed on the molecular level, can be transformed into a diamond table, it's woody "chairness" subtly and efficiently morphed into crystalline "tableness." Nanovision undermines essentialism, insisting that every "thing" is simply a temporary arrangement of atoms that can be endlessly restructured. Becoming overcomes being.
- A wooden chair can be transformed into a living fish. There is no magic here, merely a precise rearrangement of molecules. Life instantly arises from dead material; as Drexler writes, nanovision reveals that "nature draws no line between living and nonliving."[89]
- A fish can be transformed into a human (i.e. Homo sapiens). The resulting human could even be a specific person like Sigourney Weaver (posthuman icon from the *Alien* films), identical to the movie star in every respect: DNA, proteins, phospholipids, neurotransmitters, memories.
- A human, subjected to nanomachines carrying the data set for another human, can suddenly become someone else, and back again. Human *A* and Human *B* share the same matter, they occupy the same space; although they have different identities, although they are different people, they are smeared together across time as *phases* of each other.
- A woman can be metamorphosed into a man, or vice versa, or in various partial combinations. Mono-, inter- and transsexuality can be manifested in a single figure. Tissues, hormones and chromosomes can be refabricated. The posthuman body is thus queered: sex and sexuality made infinitely malleable, sexual difference slipping into sexual indeterminacy, or deferral.
- A human body can become the copy of an already existing human body. Say, for example, Harrison Ford (posthuman icon from *Blade Runner*) transforms into Sigourney Weaver. Then there are two Sigourneys, identical down to the memories, even down to the belief that each is Sigourney Weaver and the other is the copy. There is no possible way of telling them apart, no possible way of telling which was the "original." Someone might ask, "Will the real Sigourney please stand up," but inevitably they both will. More disturbing

than clones or even the android replicants in *Blade Runner*, which merely mimic, these nanocopies actually *are*. Nanovision again destroys the difference between real and simulacrum.

- Nanotechnology can devise a matter-transporter to facilitate human travel across great distances of space.[90] At one end, nanobots dismantle the human traveler atom by atom, recording the location of each molecule, until the traveler is just a pile of disorganized material. The nanobots feed data into a computer system, which instructs another group of nanobots at the terminal end of the transporter, working from a feed of appropriate elements, to reassemble the human traveler exactly as he or she had been at the proximal end. The traveler will have no memory of the trip but will emerge precisely as he or she was when the process began; though made from different atoms, the traveler is still the same person. Embodiment has been distributed across a spatial divide and between separate accumulations of matter. Furthermore, the data can be reused to construct multiple, identical copies of the traveler. Personhood can be duplicated, flesh xeroxed, minds mimeographed.

- Human bodies can be modified well beyond the confines of experience, becoming alien formations or improbable mélanges. Nanotechnology empowers posthuman imaginations to achieve outlandish physical alterations. (How many tentacles would you like to have?)

- Finally, nanovision enables us to think beyond human boundaries in a tragic sense, for nanotechnology can also bring about a post-human future where all of humanity has ceased to exist and nothing new emerges from the wreckage. This fate is made possible by insidious nanoweapons of mass destruction, or the nanocalypic hypothesis of out-of-control nanobots turning the entire biosphere into "gray goo."[91] While providing a means to engineer new posthuman embodiment, nanotech also provides a means to engineer posthuman extinction.

As these scenarios suggest, nanotechnology has unprecedented effects on the way we are able to intuit our bodies, our biologies, our subjectivities, our technologies, and the world we share with other organisms. Whether positing the liberation of human potential or the total annihilation of organic life on this planet, nanovision demands that we think outside of the realms of the human and humanism. Nanovision makes our bodies cyborg and redefines our material experiences, redraws our cognitive borders, and reimagines our future. Accordingly, even before the full potential of a working nanotechnology has been realized, we have already become posthuman. Indeed, posthuman subjects abound in the nanoliterature, and although science fiction novels like Ian McDonald's *Necroville* (1994), James L. Halperin's *The First Immortal* (1998) or Michael Flynn's *The Nanotech Chronicles* (1991) imagine posthuman nano-modified bodies as appearing at some ambiguous point in the future, other "nonfictional" posthuman beings exist already, right now, within the popular and professional writings of nanoscientists. As real, embodied, material entities, enmeshed in the semiosis of nanovision, these posthumans are found at nanotechnology's intersection with cryonics.

Drexler, Merkle and other nanoscientists are deeply involved in the idea of freezing and preserving human bodies, or parts of human bodies, until the proper nanotechnology has been developed in the future that can revive and heal them. Freeze the body now and eventually nanotechnology will resurrect the subject, reversing not only the cellular damage caused by the freezing process, but also the damage that had originally caused the person to die, maybe even building an entirely new body for the cryonaut. Cryonic science is not simply tangentially related to nanotechnology, but has become a principle extension of nanovision—evidenced by the ubiquitous discussions of cryonics at all levels of nanodiscourse,

from fanzines to university conferences.[92] Furthermore, Merkle is a director of the Alcor Life Extension Foundation, a cryonics institute founded in 1972, and he also hosts a cryonics web page; Drexler is on the scientific advisory board of the Alcor Foundation and has written extensively about cryonics in his books and scientific journal articles.[93]

Even in Drexler's first nanotech publication, cryonic resuscitation is evoked when Drexler writes that the "eventual development of the ability [of nanotechnology] to repair freezing damage [to cells] (and to circumvent cold damage during thawing) has consequences for the preservation of biological materials today, provided a sufficiently long-range perspective is taken."[94] Drexler thus implies that projected technologies of the future determine how we should deal with human tissues and human bodies in the present. Again nanowriting uses the language of the "already inevitable" and assumes that the full potential of nanotech has essentially been realized, temporal distance notwithstanding. Consequently, as deployed within the discourse of nanotechnology, the fact that cryonic techniques are currently in use means that nano-modified bodies are among us even now. Those who are dead but cryonically frozen have been encoded by nanovision as already revived, as already outside the humanistic dichotomy of dead/alive, as already voyagers into a brave new world of nanotech splendor … as already posthuman.

This nanovisionary encoding of the cryonaut is evident when Drexler writes of cryonic resurrection in the science-fictional present tense, collapsing present and future, medical reality and technological fantasy, human death and posthuman revivification, into a single proleptic episode of *Engines of Creation*. Drexler tells of a hypothetical contemporary patient who "has expired because of a heart attack. … [T]he patient is soon placed in biostasis to prevent irreversible dissolution. … Years pass. … [During this time, physicians learn to] use cell repair technology to resuscitate patients in biostasis. … Cell repair machines are pumped through the blood vessels [of the patient] and enter the cells. Repairs commence. … At last, the sleeper wakes refreshed to the light of a new day—and to the sight of old friends."[95] By way of alluding to H. G. Wells's *When the Sleeper Wakes* (1899), a canonic science-fictional depiction of sleeping into the future, Drexler validates and necessitates present-day acts of cryonic freezing within his prophecy of the coming nanoera. While indicative of nanowriting's dependence on the conventions of genre science fiction, this passage more significantly indicates how nanowriting's implosion of science into science fiction transmutes formerly human subjects into posthuman entities, amalgams of discourse and corporeality, biology and technology. For Drexler's cryonaut becomes posthuman at the moment of being incorporated into nanonarrative, thereby surviving its human death and becoming reborn through its cyborg interpenetration with nanomachines. And though the cryonaut in Drexler's story is purely hypothetical, other more specific cryonauts are made posthuman through the same mangle of nanovision.

Take, for example, Walt Disney—perhaps the world's most famous cryonically preserved character. According to urban legend, Disney was frozen immediately upon his death in 1966 and placed in cold storage at an unnamed cryonics institute (though some rumors have gone so far as to suggest that Disney's icy tomb actually lies beneath the "Pirates of the Caribbean" ride at Disneyland).[96] In a wonderful semiotic tangle, the discourses of nanotechnology, cryonics, hyperreality and posthumanism all converge under the sign of Disney. For the viral expansion of Disneyism, the "disnifying" of postmodern culture, renders society itself hyperreal: the legend of Walt's own cryonic suspension is a telling symptom.[97] Which is precisely why Paul J. McAuley's novel of the nanofuture, *Fairyland* (1995), narrates the ascendancy of nanotech-enhanced nonhuman entities from within the "Magic Kingdom" theme park outside of Paris. McAuley describes the end of man beginning "in the early hours of the morning after the fall of the Magic Kingdom. … As the humans

retreat into their dreams, brave new creatures will claim the world."[98] The rise and fall of the Magic Kingdom, allegorizing our hyperreal condition and our "retreat into dreams," thus marks the prelude to the posthuman nanotechnology era.

As we might expect, then, nanoscientists tell us that the miasma of hyperreality belching forth from the many Disney factories around the world will be dramatically enhanced by the advent of nanotechnology. For example, nanoscientist and aerospace engineer Tom McKendree suggests that the "simulations" at Disneyland and other heightened-reality parks will become even more of "a total experience" through nanotech's ability to "make the fantasies real."[99] Disneyism is simply boosted by the imagineering capabilities of nanotechnology—so it is no coincidence that Disney "the man" materializes at the point where nanovision merges with cryonics.

Consider Merkle's "It's a Small, Small, Small, Small World" essay: the title evokes the small world of atoms and assemblers purveyed by nanotechnology and, simultaneously, the "It's a Small World" ride at Disneyland and Disney World whose infectious and repetitious song ("It's a small world, after all! It's a small, small world!") metonymically stands for the Disneyscape as a whole. Disneyism is thus imported into nanowriting as metaphor for the nanoworld itself, and appropriately so—for not only does this figural resonance reveal the embeddedness of nanovision in the plane of hyperreality, where science and science fiction are one and the same, but furthermore, Walt's crystallized body would thereby melt into the Tomorrowland-like nanofuture that enables its return from the dead. Merkle details the coming "Diamond Age" of nanotechnology where the "ability to build molecule by molecule could also give us surgical instruments of such precision that they could operate on the cells and even the molecules from which we are made," and as many nanowriters have explained, such surgical precision will surely bring about cryonic resurrection.[100] Although Disney may be on ice, waiting to be reborn through the advances of nanotechnology, within nanowriting—where a "small world" of quotidian miracles is deemed already accomplished, where "nanotechnology will inevitably appear regardless of what we do or don't do"[101]—Disney the sleeper already wakes. The future is now, and through the textual machinations of nanowriting that permit preserved human bodies to surmount their own deaths, Walt Disney himself has been transmuted into a posthuman creature of flesh, machines and hypersigns.

If nanovision's symbolic reprocessing of cryonauts like Walt Disney is any indication, then the transformation of the world envisioned by nanowriting is highly performative, and posthuman evolution has already begun. Accordingly, if nanotech is turning us posthuman, a critical scrutiny of the direction nanotechnology takes and an engaged involvement in the corresponding changes to our lives and our bodies is required to ensure that becoming posthuman is accomplished in our own terms. In *The Diamond Age*, Stephenson issues a note of caution as his novel replicates the narrative of nanotech inevitability, writing that "nanotechnology had made nearly anything possible, and so the cultural role in deciding what *should* be done with it had become far more important than imagining what *could* be done with it."[102] Nanotechnology empowers us to write our own posthuman future, but considering the massive biological, ecological, corporeal and cultural changes heralded by nanovision (be they utopic or apocalyptic), as voyagers into the future we must exercise the necessary foresight.

Indeed, foresight is a note that echoes throughout the technoscapes and dreamscapes of nanotechnology, from popular novels to experimental reports, as both a warning and an enticement. Nanotechnology and all of its implications are on the horizon, bodied forth by the speculations of science and of fiction. With the nanofuture in sight, we must prepare for our posthuman condition ... for it may be a small world, after all.

Notes

1 K. Eric Drexler, "Preface," in K. Eric Drexler, Chris Peterson, and Gayle Pergamit, *Unbounding the Future: The Nanotechnology Revolution* (New York: Morrow, 1991), p. 10.

2 K. Eric Drexler, *Engines of Creation: The Coming Era of Nanotechnology* (Garden City, NY: Anchor Books/Doubleday, 1986); all references to this work are to the revised edition (New York: Anchor Books/Doubleday, 1990).

3 Chad A. Mirkin, "Tweezers for the Nanotool Kit," *Science* 286 (1999): 2095–6, on p. 2095.

4 Robert F. Service, "AFMs Wield Parts for Nanoconstruction," *Science* 282 (1998): 1620–1, on p. 1620.

5 Robert F. Service, "Borrowing From Biology to Power the Petite," *Science* 283 (1999): 27–8, on p. 27.

6 James K. Gimzewski and Christian Joachim, "Nanoscale Science of Single Molecules Using Local Probes," *Science* 283 (1999): 1683–8, on p. 1683.

7 Richard Smalley, "Nanotech Growth," *Research and Development* 41.7 (1999): 34–7.

8 Christine L. Peterson, "Nanotechnology: Evolution of the Concept," in *Prospects in Nanotechnology: Toward Molecular Manufacturing*, eds Markus Krummenacker and James Lewis (New York: Wiley, 1995), pp. 173–86, quotation on p. 186. Indicative of nanowriting's teleological tendencies, Peterson's article absorbs the entire history of atomic theory, from Democritus to the present, to suggest the unavoidable rise of nanotechnology and our progression toward the nanofuture.

9 John G. Cramer, "Nanotechnology: The Coming Storm," foreward to *Nanodreams*, ed. Elton Elliott (New York: Baen Books, 1995), pp. 4–12, on p. 8.

10 Nanowriting employs literary techniques common to speculative science writing in general. See Greg Myers, "Scientific Speculation and Literary Style in a Molecular Genetics Article," *Science in Context* 4 (1991): 321–46, on the linguistic peculiarities of scientific speculation that work to legitimate such claims. Nanowriting, however, goes beyond most scientific speculation in that its uses of the future tense and its visions of tomorrow are totalizing, bringing the future completely into the textual present—which is one reason, as we will see, why nanotechnology has so often been characterized not as "speculative science" but as "fictional science." For more on the features of nanowriting and modes of narrative forecasting in nanoscience, see Joachim Schummer, "Reading Nano: The Public Interest in Nanotechnology as Reflected in Book Purchase Patterns," *Public Understanding of Science* 14 (2005): 163–83; Jessica Pressman, "Nano Narrative: A Parable from Electronic Literature," in *Nanoculture: Implications of the New Technoscience*, ed. N. Katherine Hayles (Bristol: Intellect Books, 2004), pp. 191–9; and Susan Lewak, "What's the Buzz? Tell Me What's A-Happening: Wonder, Nanotechnology, and Alice's Adventures in Wonderland," pp. 201–10.

11 B. C. Crandall, "Preface," in *Nanotechnology: Molecular Speculations on Global Abundance*, ed. idem (Cambridge, MA: MIT Press, 1996), pp. ix–xi, on p. ix.

12 K. Eric Drexler, "Molecular Engineering: An Approach to the Development of General Capabilities for Molecular Manipulation," *Proceedings of the National Academy of Sciences* 78 (1981): 5275–8, on p. 5278.

13 David E. H. Jones, "Technical Boundless Optimism," *Nature* 374 (1995): 385–7, on pp. 835, 837.

14 Gary Stix, "Trends in Nanotechnology: Waiting for Breakthroughs," *Scientific American* 274.4 (1996): 94–9, on p. 97.

15 Gary Stix, "Little Big Science," *Scientific American* 285.3 (2001): 32–7, on p. 37.

16 George M. Whitesides, interview by David Rotman, "Nanotechnology: Art of the Possible," *Technology Review* 101.6 (1998): 84–7, on p. 85.

17 George M. Whitesides, interview by David Ewing Duncan, "The New Biochemphysicist," *Discover* 24 (December 2003): 24.

18 Steven M. Block, "What is Nanotechnology?" keynote presentation at the National Institutes of Health conference, "Nanoscience and Nanotechnology: Shaping Biomedical Research," Natcher Conference Center, Bethesda, Maryland, June 25, 2000 (quotation from program abstract).

19 Many early critiques of nanotech's "science-fictionality" are described in Ed Regis's lively history, *Nano: The Emerging Science of Nanotechnology* (Boston, MA: Little, Brown, 1995).

20 A constructive bleed between nanotech and science fiction has been frequently noted in recent science studies scholarship: see Tony Miksanek, "Microscopic Doctors and Molecular Black Bags: Science Fiction's Prescription for Nanotechnology and Medicine," *Literature and Medicine* 20 (2001): 55–70; Colin Milburn, "Nanotechnology in the Age of Posthuman Engineering: Science Fiction as Science," *Configurations* 10 (2002): 261–5; James Gimzewski and Victoria Vesna, "The Nanomeme Syndrome: The Blurring of Fact and Fiction in the Construction of a New Science," *Technoetic Arts* 1 (2003): 7–24; N. Katherine Hayles, ed., *Nanoculture: Implications of the New Technoscience* (Bristol: Intellect Books, 2004); José López, "Bridging the Gaps: Science Fiction in Nanotechnology," *Hyle* 10 (2004): 129–52; Arne Hessenbruch, "Nanotechnology and the Negotiation of Novelty," in *Discovering the Nanoscale*, eds Davis Baird, Alfred Nordmann, and Joachim Schummer (Amsterdam: IOS Press, 2004), pp. 135–44; Joachim Schummer, "'Societal and Ethical Implications of Nanotechnology': Meanings, Interest Groups, and Social Dynamics," *Techné* 8.2 (2004): 56–87; Chris Toumey, "Narratives for Nanotech: Anticipating Public Reactions to Nanotechnology," *Techné* 8.2 (2004): 88–116; Colin Milburn, "Nano/Splatter: Disintegrating the Postbiological Body," *New Literary History* 36 (2005): 283–311; Arne Hessenbruch, "Beyond Truth: The Pleasure of Nanofutures," *Techné* 8.3 (2005): 34–61; Brigitte Nerlich, "From Nautilus to Nanobo(a)ts: The Visual Construction of Nanoscience," *AZojono: Journal of Nanotechnology Online* (2005): 10.2240/azojono0109, available at *www.azonano.com/details.asp?ArticleID=1466*; Colin Milburn, "Nanowarriors: Military Nanotechnology and Comic Books," *Intertexis* 9 (2005): 77–103; and Andreas Losch, "Anticipating the Futures of Nanotechnology: Visionary Images as Means of Communication," *Technology Analysis and Strategic Management* 18 (2006): 393–409.

21 Darko Suvin, *Metamorphoses of Science Fiction: On the Poetics and History of a Literary Genre* (New Haven, CT: Yale University Press, 1979), p. 64.

22 Ibid., p. 75.

23 The fabulation of worlds and zones of radical otherness characterizes the interplay between science fiction and postmodernist writing; see Brian McHale, *Postmodernist Fiction* (New York: Routledge, 1997), esp. pp. 59–72.

24 Jean Baudrillard, *Symbolic Exchange and Death*, trans. Iain Hamilton Grant (London/Thousand Oaks/New Delhi: Sage Publications, 1993), pp. 50–86. See also Baudrillard, "The Precession of Simulacra," in idem, *Simulacra and Simulation*, trans. Sheila Faria Glaser (Ann Arbor, MI: University of Michigan Press, 1994), pp. 1–42.

25 Baudrillard, "Simulacra and Science Fiction," in idem, *Siniulacra and Simulation*, pp. 121–17, on p. 121.

26 Ibid.

27 Ibid., p. 122 (emphasis in original).

28 Ibid., p. 124.

29 Ibid., pp. 125, 126.

30 Donna J. Haraway, "A Cyborg Manifesto: Science, Technology, and Socialist-Feminism in the Late Twentieth Century," in idem, *Simians, Cyborgs, and Women: The Reinvention of Nature* (New York: Routledge, 1991), pp. 149–81, on p. 149.

31 Scott Bukatman, *Terminal Identity: The Virtual Subject in Postmodern Science Fiction* (Durham, NC: Duke University Press, 1993), p. 22.

32 N. Katherine Hayles, *How We Became Posthuman: Virtual Bodies in Cybernetics, Literature, and Informatics* (Chicago, IL: University of Chicago Press, 1999), p. 3.

33 Ralph C. Merkle, "It's a Small, Small, Small, Small World," *Technology Review* 100.2 (1997): 25–32, on p. 26 (emphasis added).

34 These explicitly science-fictional images and a general faith in the imminent nanofuture can be found in, but not limited to: Drexler, "Molecular Engineering," pp. 5275–8; Drexler, "Molecular Manufacturing as a Path to Space," in Krummenacker and Lewis, *Prospects in Nanotechnology*, pp. 197–205; Ralph C. Merkle, "Nanotechnology and Medicine," in *Advances in Anti-Aging Medicine*, vol. 1, eds Ronald M. Klatz and Francis A. Kovarik (Larchmont, NY: Liebert, 1996), pp. 277–286; Robert A. Freitas, Jr., *Nanomedicine, Volume I: Basic Capabilities* (Georgetown, TX: Landes Bioscience, 1999); Robert A. Freitas and Ralph C. Merkle, *Kinematic Self-Replicating Machines* (Georgetown, TX: Landes Bioscience/Eurekah.com, 2004); Daniel T. Colbert and Richard E. Smalley, "Fullerene Nanotubes for Molecular Electronics," *Trends in Biotechnology* 17 (1999): 46–50; Stuart Hameroff, *Ultimate Computing: Biomolecular Consciousness and Nanotechnology*

(Amsterdam: Elsevier North-Holland, 1987); Ted Sargent, *The Dance of Molecules: How Nanotechnology is Changing Our Lives* (New York: Thunder's Mouth Press, 2006); J. Storrs Hall, "Utility Fog: The Stuff that Dreams Are Made Of," in Crandall, *Nanotechnology*, pp. 161–84.

35 This argument is ubiquitous in nanowriting. Some stronger instances include: Drexler, *Engines of Creation*, pp. 5–11; Drexler, "Molecular Engineering," pp. 5575–6; Merkle, "Molecular Manufacturing: Adding Positional Control to Chemical Synthesis," *Chemical Design Automation News* 8 (1993): 1, 55–61; Merkle, "Self-Replicating Systems and Molecular Manufacturing," *Journal of the British Interplanetary Society* 45 (1992): 407–13; Service, "Borrowing from Biology to Power the Petite," p. 27; David S. Goodsell, *Bionanotechnology: Lessons from Nature* (Hoboken, NJ: Wiley-Liss, 2004); Richard A. L. Jones, *Soft Machines: Nanotechnology and Life* (Oxford: Oxford University Press, 2004).

36 Mihail Roco, "International Strategy for Nanotechnology Research and Development," *Journal of Nanoparticle Research* 3 (2001): 353–60, on p. 356.

37 Cyrus C. M. Mody, "How Probe Microscopists Became Nanotechnologists," in *Discovering the Nanoscale*, eds Baird, Nordmann, and Schummer, pp. 119–33.

38 J. S. Foster, J. E. Frommer, and P. C. Arnett, "Molecular Manipulation Using a Tunneling Microscope," *Nature* 331 (1988): 324–6.

39 D. M. Eigler and E. K. Schweizer, "Positioning Single Atoms with a Scanning Tunneling Microscope," *Nature* 344 (1990): 524–6.

40 Buckminsterfullerenes, a.k.a. "buckyballs" or C_{60}, potentially serve as robust structural materials or as containers for individual atoms. Other fullerenes called "nanotubes"—discovered by Sumio Iijima—can serve as probes or funnels for atomic positioning, as conductive or semi-conductive electronic components, and a huge array of other projected capacities. See Hongjie Dai, Nathan Franklin, and Jie Han, "Exploiting the Properties of Carbon Nanotubes for Nanolithography," *Applied Physics Letters* 73 (1998): 1508–10; Philip Kim and Charles M. Lieber, "Nanotube Nanotweezers," *Science* 286 (1999): 2148–50.

41 Anthony P. Davis, "Synthetic Molecular Motors," *Nature* 401 (1999): 120–1; M.T. Cuberes, R. R. Schlittler and J. K. Gimzewski, "Room-Temperature Repositioning of Individual C_{60} Molecules at Cu Steps: Operation of a Molecular Counting Device," *Applied Physics Letters* 69 (1996): 3016–18; Jonathan Knight, "The Engine of Creation," *New Scientist* 162.2191 (1999): 38–41.

42 Michael E. Gorman, James F. Groves, and Jeff Shrager, "Societal Dimensions of Nanotechnology as a Trading Zone: Results from a Pilot Project," in *Discovering the Nanoscale*, eds Baird, Nordmann, and Schummer, pp. 63–73. Nanotechnology in this account is a multidisciplinary field communicating through a transdisciplinary "metaphorical language" or "creole," such as theorized by Peter Galison's notion of scientific "trading zones." On trading zones as discursive sites where various and otherwise incommensurable knowledge cultures learn to speak to one another, see Peter Galison, *Image and Logic: A Material Culture of Microphysics* (Chicago, IL: University of Chicago Press, 1997).

43 On professional confrontations within nanotechnology, see David Rotman, "Will the Real Nanotech Please Stand Up?" *Technology Review* 102.2 (1999): 47–53. On the incommensurability of certain nano research programs—for example, disciplinary conflicts between chemists and engineers, as instantiated in the Smalley/Drexler debate on the feasibility of nanomachines—see Otávio Bueno, "The Drexler-Smalley Debate on Nanotechnology: Incommensurability at Work?," *Hyle* 10 (2004): 83–98, and Bernadette Bensaude-Vincent, "Two Cultures of Nanotechnology?," *Hyle* 10 (2004): 65–82.

44 See Hans Glimell, "Grand Visions and Lilliput Politics: Staging the Exploration of the 'Endless Frontier'," in *Discovering the Nanoscale*, eds Baird, Nordmann, and Schummer, pp. 231–46. See also Carol Ann Wald, "Working Boundaries on the NANO Exhibition," in *Nanoculture*, ed. Hayles, pp. 83–104. While such debates succeed in establishing common terminology and concepts essential to nanoscience—such as "self-replication"—they also construct variant allegiances to these concepts as a way of further hardening what counts as "real nanotech." For a broader account of agoristic struggle between scientific programs as the mechanism for stabilizing disciplinary unity—such as occurs when one research program appropriates or absorbs the theoretical, experimental and technological resources or concerns of competitor programs—see

Timothy Lenoir, *Instituting Science: The Cultural Production of Scientific Disciplines* (Stanford, CA: Stanford University Press, 1997).

45 Drexler, *Engines of Creation,* p. 241.

46 Drexler, *Nanosystems: Molecular Machinery, Manufacturing, and Computation* (New York: Wiley, 1992).

47 Joachim Schummer, "Interdisciplinary Issues in Nanoscale Research," in *Discovering the Nanoscale*, eds Baird, Nordmann, and Schummer, pp. 9–20.

48 See, for example, Mihail C. Roco and William Sims Bainbridge, eds., *Converging Technologies for Improving Human Performance: Nanotechnology, Biotechnology, Information Technology and Cognitive Science* (Arlington, VA: NSF/DOC, 2002). On NBIC convergence as representative of nanotechnology's "technological reductionism," reducing almost everything to itself, see Jan C. Schmidt, "Unbounded Technologies: Working through the Technological Reductionism of Nanotechnology," in *Discovering the Nanoscale*, eds. Baird, Nordmann, and Schummer, pp. 35–50. On nanotech's convergence even with the work of contemporary poetry at the "limits of fabrication," see Nathan Brown, "Needle on the Real: Technoscience and Poetry at the Limits of Fabrication," in *Nanoculture*, ed. Hayles, pp. 173–90.

49 Drexler, *Engines of Creation*, pp. 92–3.

50 This strategy depends somewhat on a lack of definitional precision in the term "nanotechnology." Many researchers adopt the term for work in nanoelectronics, nanocomposition, or nanolithography that does not necessarily match Drexler's definition of nanotechnology as molecular manufacturing.

51 Eigler quoted in Rotman, "Will the Real Nanotech Please Stand Up?" p. 53.

52 Reed quoted in ibid., p. 48 (emphasis added).

53 Richard Feynman, "There's Plenty of Room at the Bottom," in *Miniaturization*, ed. H. D. Gilbert (New York: Reinhold, 1961), pp. 282–96, quotation on p. 295; all further references to Feynman's 1959 talk are to this transcript. The talk was originally published in *Engineering and Science* 23 (February 1960): 22–36; a shorter version was published as "The Wonders that Await a Micro-microscope," *Saturday Review* 43 (1960): 45–7. It has since been reprinted in numerous scientific journals, as well as in collections of Feynman's writings; it is also available at the Caltech website (*www.its.caltech.edu/%7Efeynman/plenty.html*) and other Internet locations. These several incarnations of Feynman's talk, each with independent legacies of citation, suggest the eminence of the speech within the technoscape.

54 A few examples among many: Drexler, "Molecular Engineering," p. 5275; Drexler, *Engines of Creation*, pp. 40–41; Davis, "Synthetic Molecular Motors," p. 120; Gimzewski and Joachim, "Nanoscale Science," p. 1683; Merkle, "Nanotechnology and Medicine," pp. 277–86; Merkle, "Letter to the Editor," *Technology Review* 102.3 (1999): 15–16; Sargent, *Dance of the Molecules*, pp. xv–xvi. On the history and legacy of this talk, see Regis, *Nano*, pp. 10–12, 63–94. See also Chris Toumey, "Apostolic Succession: Does Nanotechnology Descend from Richard Feynman's 1959 Talk?" *Engineering and Science* 68.1 (2005): 16–23. Toumey shows that citations of Feynman's talk in the nano literature have been retroactive, a function of rediscovery and genealogical recreation rather than direct intellectual succession.

55 J. Storrs Hall, "Overview of Nanotechnology," *sci.nanotech* (1995) [cited 16 May 2003], available at *nanotech.dyndns.org/sci.nanotech/overview.html*.

56 Sound Photosynthesis, "Richard Feynman," *Sound.Photosynthesis.com* (2004) [cited 16 May 2005], available at *www.photosynthesis.com/Richard_Feynman.html*.

57 Ralph C. Merkle, "A Response to *Scientific American*'s News Story *Trends in Nanotechnology*," *Foresight Institute* (19 March 1996) [cited 13 May 2006], available at *www.foresight.org/SciAmDebate/SciAmResponse.html*.

58 The nanotechnologists' 1992 testimonies are found in *New Technologies for a Sustainable World: Hearing Before the Subcommittee on Commerce, Science and Transportation, United States Senate, One Hundred Second Congress, Second Session, June 26, 1992* (Washington, DC: U.S. Government Printing Office, 1993). The 1999 testimonies are found in *Nanotechnology: The State of Nanoscience and Its Prospects for the Next Decade: Hearing Before the Subcommittee on Science, House of Representatives, One Hundred Sixth Congress, First Session, June 22, 1999* (Washington, DC: U.S. Government Printing Office, 2000). Federal documentation for the National Nanotechnology Initiative is compiled by the National Science and Technology Council in *National Nanotechnology Initiative: Leading the*

Next Industrial Revolution (Washington, DC: Office of Science and Technology Policy, 2000). For an excellent history of the National Nanotechnology Initiative and the role of utopian visions in implementing funding for nanoscience, see W. Patrick McCray, "Will Small Be Beautiful? Making Policies for Our Nanotech Future," *History and Technology* 21 (2005): 177–203.

59 William J. Clinton, [Address to Caltech on Science and Technology], California Institute of Technology, January 21, 2000. Video transcript of talk produced by Caltech's Audio Visual Services, Electronic Media Publications, and Digital Media Center; made available online at *pr. caltech.edu/events/presidential_speech//PresVisit-MCP-LAN.ram.*

60 K. Eric Drexler, "From Nanodreams to Realities," introduction to *Nanodreams*, ed. Elton Elliott (New York: Baen Books, 1995), pp. 13–16. Drexler's argument is similar to that of Arthur C. Clarke's *Profiles of the Future: An Inquiry into the Limits of the Possible* (New York: Harper & Row, 1958). Frequently cited in Drexler's publications, Clarke's text aggressively foregrounds the science-fictional foundations of scientific extrapolation.

61 Drexler, *Engines of Creation*, pp. 234–5.

62 Baudrillard, "The Precession of Simulacra," pp. 1–42.

63 Not the least of which are those technology companies founded in the 1990s to pursue some aspect of Drexler's vision, especially Zyvex. On Zyvex's efforts to implement Drexler's vision, see Steven Ashley, "Nanobot Construction Crews," *Scientific American* 285, no. 3 (2001): 84–5.

64 Smalley quoted in David Voss, "Moses of the Nanoworld," *Technology Review* 102.2 (1999): 60–2, on p. 62.

65 Richard Smalley, "Smalley Responds," *Chemical & Engineering News* 81 (2003): 39–40, on p. 39. Smalley nevertheless stated on multiple occasions that Drexlerian assemblers are impossible to produce in reality, and he believed nanotech would develop along different lines; see Smalley, "Of Chemistry, Love and Nanobots," *Scientific American* 285.3 (2001): 76–7.

66 José López, "Bridging the Gaps: Science Fiction in Nanotechnology," *Hyle* 10 (2004): 129–52. López shows that science-fictional narrative elements structure mainstream nanodiscourse—including publications of the National Science Foundation on NBIC convergence—in the same way as Drexler's *Engines of Creation*.

67 See Regis, *Nano*, pp. 3–18.

68 Merkle, "Letter to the Editor," p. 15.

69 Jonathan Culler, *The Pursuit of Signs: Semiotics, Literature, Deconstruction* (London: Routledge & Kegan Paul, 1981), p. 38.

70 Neal Stephenson, *The Diamond Age: or, A Young Lady's Illustrated Primer* (New York: Bantam Books, 1995; reprint, New York: Bantam Spectra, 1996); Merkle, "It's a Small, Small, Small, Small World," pp. 27, 29–31.

71 Stephenson, *The Diamond Age*, pp. 41–2.

72 Hall, "Utility Fog," pp. 161–84.

73 J. Storrs Hall, *Nanofuture: What's Next for Nanotechnology* (Amherst, NY: Prometheus Books, 2005), p. 195.

74 Ibid., p. 189. On the broader relationship between nanoscience and superhero fiction, see Milburn, "Nanowarriors: Military Nanotechnology and Comic Books."

75 Thomas N. Theis, "Letter to the Editor," *Technology Review* 102.2 (1999): 15.

76 See Regis, *Nano*, pp. 152–4.

77 Robert A. Heinlein, "Waldo" (1942), in idem, *Waldo & Magic, Inc.* (New York: Dell Rey, Ballantine Books, 1986), pp. 1–154, quotations on pp. 29, 133.

78 Feynman, "There's Plenty of Room," p. 292.

79 Heinlein, "Waldo," p. 133 (emphasis added).

80 Jacques Derrida, "Structure, Sign and Play in the Discourse of the Human Sciences," in *Writing and Difference*, trans. Alan Bass (Chicago: University of Chicago Press, 1978), pp. 278–93, on p. 292. With a similar design to denaturalize the foundations of humanism, Michel Foucault has written, "As the archaeology of our thought easily shows, man is an invention of recent date. And one perhaps nearing its end"; see Michel Foucault, *The Order of Things: An Archaeology of the Human Sciences* (New York: Vintage Books, 1973), p. 387. It is worth noting that Derrida, however, critiques claims for the end of man by Foucault and others as a reinscription of humanist eschatology. Although ultimately affirming the necessity of Foucault's move outside the boundaries of humanism, Derrida suggests that this strategy must be accompanied by

deconstruction from within in order to become other than another sedimented humanism; see Jacques Derrida, "The Ends of Man," in *Margins of Philosophy*, trans. Alan Bass (Chicago, IL: University of Chicago Press, 1982), pp. 109–36.

81 For some examples of posthuman phenomenological spaces created at the intersections of bodies and technologies, see Paul Virilio, *The Art of the Motor*, trans. Julie Rose (Minneapolis, MN: University of Minnesota Press, 1995); Brian Massumi, *Parables for the Virtual: Movement, Affect, Sensation* (Durham, NC: Duke University Press, 2002); Hayles, *How We Became Posthuman* (above, n. 32); Hayles, "Flesh and Metal: Reconfiguring the Mindbody in Virtual Environments," *Configurations* 10 (2002): 297–320; and Mark Hansen, *Embodying Technesis: Technology Beyond Writing* (Ann Arbor, MI: University of Michigan Press, 2000). On hybrid-reality spaces that integrate the human body with the nano-imaginary, see Adriana de Souza e Silva, "The Invisible Imaginary: Museum Spaces, Hybrid Reality, and Nanotechnology," in *Nanoculture*, ed. Hayles, pp. 27–46. For further discussion of the phenomenology of nanotechnology, see Sandy Baldwin, "Nanotechnology! (or SimLifeWorld)," *Culture Machine* 3 (2001): [online journal], available at *culturemachine.tees.ac.uk/frm_f1.htm.*

82 Kelly Hurley, "Reading Like an Alien: Posthuman Identity in Ridley Scott's *Alien* and David Cronenberg's *Rabid*," in *Posthuman Bodies*, eds. Judith Halberstam and Ira Livingston (Bloomington: Indiana UP, 1995), pp. 203–24, 220.

83 On the thematic and textual characteristics of nanonarratives, see Brooks Landon, "Less Is More: Much Less Is Much More: The Insistent Allure of Nanotechnology Narratives in Science Fiction Literature," in *Nanoculture*, ed. Hayles, pp. 132–46; and Brian Attebery, "Dust, Lust, and Other Messages from the Quantum Wonderland," in *Nanoculture*, ed. Hayles, pp. 161–9.

84 Extropians maintain that human life is rapidly evolving through the mediation of emerging technosciences and active pursuit of science-fiction scenarios, such as "uploading" and cryonic resurrection. Max More, founder of the Extropy Institute, writes that extropians "advocate using science to accelerate our move from human to a transhuman or posthuman condition," and that nanotechnology is a significant vehicle in bringing about the posthuman future (see More, "The Extropian Principles 3.0: A Transhumanist Declaration" [1998], *www.maxmore.com/extprn3. htm*). Merkle and Drexler have been active with the Extropy Institute, and Hall has served as the nanotechnology editor of *Extropy: The Journal of Transhumanist Solutions*. William Sims Bainbridge, an NSF officer and key player in the National Nanotechnology Initiative, has also frequently expressed allegiance with transhumanist thought.

85 On forms of posthumanism that delete the body in favor of a fantasy of disembodied information or immaterial transcendence, see Hayles, *How We Became Posthuman*, esp. pp. 1–24; Claudia Springer, *Electronic Eros: Bodies and Desire in the Postindustrial Age* (Austin. TX: University of Texas Press, 1996), pp. 16–49; Mark Dery, *Escape Velocity: Cyberculture at the End of the Century* (New York: Grove Press, 1996), pp. 229–319; and Richard Doyle, *Wetwares: Experiments in Postvital Living* (Minneapolis, MN: University of Minnesota Press, 2003), pp. 43–145. These theorists instead point to ways of reimagining posthumanism through a fundamental commitment to materiality, recognizing that it is possible to think outside of obsolete and disenabling forms of humanism without rejecting the site of our being in the world: namely, the body. See also Halberstam and Livingston, eds., *Posthuman Bodies*.

86 Drexler, *Engines of Creation*, p. 38.

87 Feynman, "There's Plenty of Room," p. 295.

88 Merkle, who left Xerox in 1999 to become Principle Fellow of Zyvex, and later, in 2003, Professor at Geogia Tech College of Computing, jokes about the impact of copy culture on nanotech in "Design-Ahead for Nanotechnology," in Krummenacker and Lewis, *Prospects in Nanotechnology*, pp. 23–52, on p. 35.

89 Drexler *Engines of Creation*, p. 103.

90 The fantasy of "telegraphing a human" appears frequently within posthuman science (fiction): for example, Norbert Wiener, *The Human Use of Human Beings: Cybernetics and Society* (Boston, MA: Houghton Mifflin, 1954), pp. 95–104, and Hans Moravec, *Mind Children: The Future of Robot and Human Intelligence* (Harvard, MA: Harvard University Press, 1988), pp. 116–22. Nanotech bodily telegraphy is discussed in Hall, *Nanofuture*, pp. 169–70.

91 The "gray goo" hypothesis imagines the entire organic world dismantled into disorganized material by rampaging nanobots: Drexler, *Engines of Creation*, pp. 172–3; Regis, *Nano*, pp. 121–4.

In 2000, this horrifying possibility so disturbed Bill Joy, cofounder and former Chief Scientist of Sun Microsystems (and certainly no technophobe), that he questioned the wisdom of pursuing nanoresearch in a now famous article, suggesting the future would perhaps be a better place if we did not follow our nanodreams. See Bill Joy, "Why the Future Doesn't Need Us," *Wired* 8.4 (2000): 238–63. On risk discourse in nano, see Kate Marshall, "Future Present: Nanotechnology and the Scene of Risk," in *Nanoculture*, ed. Hayles, pp. 147–59. On nanoweapons and nanowars, see Jürgen Altman, *Military Nanotechnology: Potential Applications and Preventative Arms Control* (London: Routledge, 2006).

92 For a sustained discussion of nanotechnology's significance for and commitment to cryonics, see Wesley M. Du Charme, *Becoming Immortal: Nanotechnology, You, and the Demise of Death* (Evergreen, CO: Blue Creek Ventures, 1995). In Du Charme's account—typical of nanowriting—"you" are already a posthuman subject of the future. For analysis of these discourses where cryonics and nanotechnology come together in producing a suspended subject, strung out between the present and the future, see Doyle, *Wetwares: Experiments in Postvital Living*, pp. 63–118 and 136–41.

93 The Alcor Foundation, founded in 1972, promotes public awareness of cryonic possibilities and assists its members in arranging for cryonic suspension after their deaths. Alcor cites fully-functional nanotechnology as the fundamental scientific development still needed in order to repair and resurrect suspended patients. See the Alcor Life Extension Foundation website, *www. alcor.org*. The Extropy Institute, in which many nanoscientists are involved (n. 84, above), traces its historical origins to the Alcor Foundation, signaling the deeply complicit nature of posthuman discourse and cryo-nanotechnology. For more on the interlinkage of cryonics, nanotechnology, and posthuman immortality, see Ed Regis, *Great Mambo Chicken and the Transhuman Condition: Science Slightly Over the Edge* (New York: Addison-Wesley, 1990), pp. 1–9, 76–143. See also Ralph C. Merkle, "Cryonics," *Merkle.com* (23 March 2005) [cited 30 July 2006], available at *www.merkle. com/cryo/*.

94 Drexler, "Molecular Engineering," p. 5278.

95 Drexler, *Engines of Creation*, pp. 136–8.

96 No cryonics institute currently admits to holding Walt Disney's body, despite a widespread cultural awareness, or cultural myth, of Walt Disney on ice (and of course I mean both the frozen man and the annual "Walt Disney on Ice" skating extravaganzas produced across America by the Walt Disney Company). So it may be that Disney is not on ice, or it may be that the cryonics institute which may (or may not) have Disney in storage (is it Alcor? or not?) is simply following a standard secrecy policy for protecting client privacy. In 1966, Disney's family members refused to comment on the details of his death, but they have since publicly insisted that he was cremated—and indeed, an urn with Walt Disney's name on it seems to be interred at Forest Lawn Cemetery in California—though conspiracy theorists see the Disney burial plot as nothing more than a ruse. The truth of Walt Disney on ice can neither be confirmed nor denied with absolute certainty. But such a paradox only participates in the suspension of the cryonic subject between being and nonbeing, an endless undecidability: Disney both is and is not frozen, he both is and is not dead, he both is and is not anywhere at all; see Doyle, *Wetwares*, pp. 68–70.

97 Jean Baudrillard, *Écran Total* (Paris: Éditions Galilée, 1997), pp. 169–73; Baudrillard, "The Precession of Simulacra," pp. 12–14. For analysis of Disneyism and its production of posthuman "terminal identities," see Bukatman, *Terminal Identity*, pp. 227–9, and Bukatman, "There's Always Tomorrowland: Disney and the Hypercinematic Experience," *October* 57 (1991): 55–78.

98 Paul J. McAuley, *Fairyland* (New York: Avon Books, 1995), p. 359.

99 Tom McKendree, "Nanotech Hobbies," in Crandall, *Nanotechnology*, pp. 135–44, quotations on p. 143.

100 Merkle, "It's a Small, Small, Small, Small World," p. 26; Cf. Regis, *Great Mambo Chicken and the Transhuman Condition*, pp. 2, 126–30.

101 Merkle, "It's a Small, Small, Small, Small World," p. 32. Merkle actually cautions that nanotech will *not* develop on its own, but then strangely implies that even if we do not strive for the nanofuture, if "we ignore it, or simply hope that someone will stumble over it," the evolution of nanotech will still proceed—it is still inevitable—but it just "will take much longer."

102 Stephenson, *The Diamond Age*, p. 31 (emphasis in original).

Robin Held

GENE(SIS)
Contemporary art explores human genomics

O N JUNE 26, 2000, THE HUMAN GENOME PROJECT, a public consortium, and Celera Genomics, a private company, jointly announced the completion of a "working draft" of the human genome. Supporters hail this event as a scientific revolution, anticipating benefits in improved diagnosis of disease, early detection of genetic predisposition, gene therapy, and personalized drug prescription, among others. Detractors raise the specter of eugenics, warning that the use of genetic testing as a basis for reproductive decision making can be compared to the practice of selective breeding. As anticipation and anxiety mount, the debate surrounding the potential impact of recent genomic developments is rapidly becoming a defining issue of our contemporary culture. Social and ethical issues of human genetics—including the misuse of genetic information and potential threat to personal privacy, the potential discrimination against individuals carrying altered genes, free will versus genetic determinism—which have been debated throughout the twentieth century, are now intensified with the completion of the rough draft.

It is important to note that scientists face years of work in understanding the various levels of the genome's operation. Among the insights that have thus far emerged from the publication of the two groups' research are these three. There are fewer human genes than were estimated—approximately 30,000 total, rather than the 100,000 that had been previously been supposed.[1] Almost half of the human genome is comprised of transposable elements—parasitic "genes" unrelated to the needs of human existence. For example, more than 200 human genes actually come from bacteria. The genetic differences between the human genome and the genomes of other species—such as the mouse, the roundworm, the fruit fly, and yeast—is less than had been supposed. However, at this point, the impact of these insights is, in large part, speculation.

I. Genomics, art, and culture

Recently, geneticist Eric Lander noted the reflexive relationship between genetics and culture, remarking that the ultimate meaning of the human genome would be decided not

by scientists alone, but would be fought out in the arenas of art and culture.[2] Like other arenas of culture, contemporary art is deeply implicated in the determination of the ultimate meaning of the human genome. Indeed, a number of artists have engaged genomic themes, materials and processes from many perspectives. Their work provides several ways to explore the potential social, emotional, and ethical implications of these complex issues.

Gene(sis): Contemporary Art Explores Human Genomics, a major exhibition organized by the Henry Art Gallery, University of Washington (April–August 2002, traveling), presents some of the most powerful new work created in response to recent developments in human genomics. It also demonstrates the changes genetics has had on notions of artistic practice and the artist-subject, providing artists with new tools, new materials, and new issues for critical exploration. The exhibition features three new projects developed by artists in collaboration with scientists and commissioned especially for the exhibition, alongside major works previously exhibited elsewhere. Interweaving humorous commentary, multimedia installations, documentary images and pseudo- (or actual) scientific laboratory situations, the exhibition elucidates technical advances for a lay audience. More importantly, it exploits the power of contemporary art to provoke, to question, and to articulate new paradigms, providing conditions necessary for a deeper understanding and a fuller discussion of genomic issues.

Gene(sis) suggests several ways to divide and examine the onslaught of genetic information and genomic hysteria in public discourse. It is organized into four general themes (SEQUENCE, SPECIMEN, BOUNDARY, SUBJECT) that, as curator of the exhibition, I developed in consultation with geneticists, bioethicists, historians of science, and artists. Neither the exhibition as a whole, nor the specific subjects it addresses, are intended as position statements on recent genomics issues. Instead, each theme organizes a series of issues and urgent questions that recur in public discourse about genomics, from the scholarly to the sensationalist.

II. SEQUENCE: language and media representations of genomics

The image of the human genome as a "Book of Life"—an image infused with biblical references—has remained a guiding metaphor for the theories and practices of molecular biologists since its emergence in the 1960s.[3] Human genome projects have been characterized as enormous efforts of information gathering and word processing, with a mission of "reading" and "editing." The DNA sequence is frequently conceived as the "word," the human genome as a linguistic text written in DNA code.[4] This problematic view permeates current language about genomics. "Breaking the code," "reading the book of life," "mapping our genes," "drafting the human blueprint"—such phrases imply the success of reading, managing and controlling this (textual) genomic information. Many historians of science warn that "information," "language," "code," "message" and "text," while incredibly productive as analogies, present the danger that such rhetorical phrases can become confused with factual definition. Several artists are working with this problematic language in compelling ways: engaging the metaphors it inspires, exploring its semiotic arbitrariness, or investigating the linguistic ways in which its truth claims are advanced. Others are proposing alternative models for our cultural understanding of genomics. What follows are a sample of artworks included in a section entitled "SEQUENCE."

In his installation entitled *Genesis* (1999)—which inspired the title of the Henry exhibition, Chicago-based artist Eduardo Kac begins with a biblical quotation that describes the supposed domination of humans over nature. He translates this passage into Morse code

(the first new language of the telecommunications age). He then converts the Morse code directly into genetic language and then into actual genetic material, producing the poetic equivalent of "junk" DNA. This DNA mutates in response to viewer attention in both the museum and over the Internet, activity that is projected on one wall of the gallery. Online viewers can raise and lower the levels of the ultraviolet lights focused on the cells, thus changing the rate of mutation. *Genesis* exemplifies how our understanding of the world, including the ways we make meaning out of recent genomic developments, is entwined with changes in language and technology.

In their performance *Cult of the New Eve* (2000; see Figure 41.1), the artists' collective Critical Art Ensemble uses the apocalyptic language of an imaginary cult to explore the rhetoric surrounding the announcement of recent genomic developments. *Cult of the New Eve* also explores the fears and anxieties we project on these developments. Critical Art Ensemble proposes that the theological language surrounding the completion of the "rough draft" of the human genome is one way to avoid discussion of the eugenic history on which such advances are founded. In response, they have taken theological language to an extreme in this performance, foregrounding the effects that language has on our understanding of current events and their social implications. In this performance, "cult" members wear special uniforms and proselytize faith in the New Eve (a woman from Buffalo, New York) offering a sacrament of beer, into which her DNA has been brewed, and special cookies, into which her DNA has been baked. This performance is followed by public dialogue on the potential effects of genomic developments on our daily lives. Critical Art Ensemble

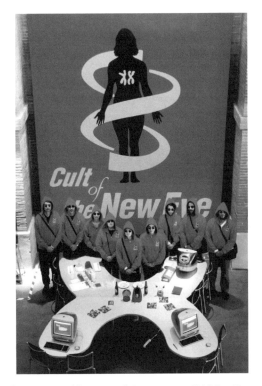

Figure 41.1 Critical Art Ensemble, *Cult of the New Eve* (2000). Courtesy of the artists. Photo Credit: Critical Art Ensemble.

developed *Cult of the New Eve* in consultation with University of Washington geneticist Mary-Claire King.

No-Die (2000: see Figure 41.2) is an imaginary advertisement for a future in which genomic advances allow us to double or triple our life span. An alliance of biotechnology and the "new economy" makes this future available to medical consumers as a patented product called *No-Die* that "you can ask for by name." Maira Kalman, a New York-based artist, has created *No-Die* as a cartoon printed on paper coffee cups to be distributed at coffee shops, bodegas, and delis. Kalman's cup is one of four such artist-designed coffee cups distributed by Creative Time, a nonprofit public art organization based in New York.

No-Die, and the other coffee cups in this series, addresses serious issues of genomics' societal implications in the form of DNA jokes. These cups are offered at public sites as potential catalysts for public dialogue about genomic issues. As components of an art exhibition exploring human genomics, these cups bring this art and the important issues it raises outside the confines of the museum to address with humor a broader, more diverse audience than that which is usually addressed in a museum exhibition.

III. SPECIMEN: genetic information, DNA ownership, and personal privacy

The first practical impacts of human genomics are anticipated in healthcare. Genomics is widely expected to revolutionize medicine, providing knowledge that will enhance control over specific human diseases and certain aspects of behavior.[5] Ethical review will be demanded of genetic testing and screening, presymptomatic diagnosis and the development of new therapies and technologies in genetic engineering. The appetite for genetic information and the potential dangers of misuse and threats to personal privacy cannot be underestimated. The impact of human genomics on legal and political debates

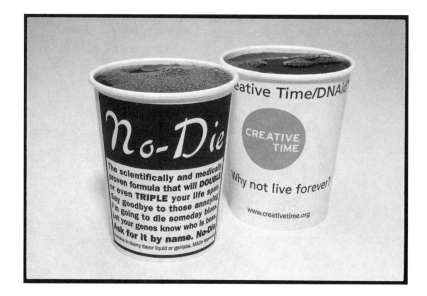

Figure 41.2 Maira Kalman, *No-Die* (2000). Paper coffee cup, 4 × 3¼ inches. Courtesy Creative Time New York. Photo Credit: Robert Glasgow.

about privacy, ownership, control of access, consumer information, and choice could alter key societal values.

Several artists are exploring issues of DNA ownership, personal privacy, and ethics. Some are drawing on their personal encounters as medical consumers and employees; others are looking to the history of these issues and their intersection with race and sexual difference. Questions being addressed include: as biotechnology provides tools to extend life, how does it affect healthcare choices? How might genetic information be used in discriminatory ways? Who makes up the rules about use and abuse of new technologies? How much do you want to know about your future? What follows are selected artworks from a section entitled "SPECIMEN."

This installation by Glasgow artist Christine Borland explores moments from the history of genetics. Key components are *HeLa* (2000: see Figure 41.3) and *Spirit Collection* (1999). According to Borland's explanatory text panels, HeLa cells are the cells of an African-American woman who died of cervical cancer in an U.S. hospital in the 1950s. These cells subsequently became important in medical research in the prevention of polio and the virus that causes AIDS, and are still used as a teaching tool today. As was customary at the time, permission was never acquired from the woman to use her cells nor is she given attribution for the role her cells have played in the development of drugs that have saved innumerable lives. In Borland's installation, live HeLa cells in culture are presented under a microscope. On a monitor, viewers can watch the genetic material mutate in a context in which Borland has highlighted issues of race, class, personal privacy, and DNA ownership.

Spirit Collection, a companion piece to *HeLa*, includes 100 hand-blown glass orbs suspended from the ceiling. In each orb is suspended a leaf skeleton from a tree on the Glasgow campus at which Borland consults with geneticists. This tree is purported to be a clone from the ancient tree under which Hippocrates, the "father of medicine" taught his

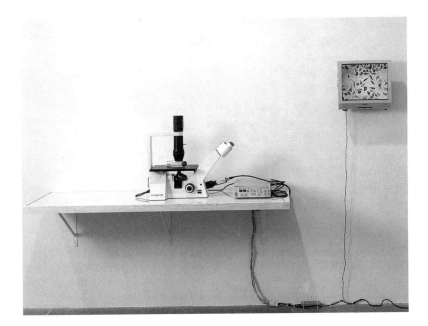

Figure 41.3 Christine Borland, *HeLa* (2000). Video microscope, cells in culture, monitor, text, glass and wooden shelf, 21 × 64 × 22 inches. Courtesy: Sean Kelly Gallery, New York.

students. Positioned near *HeLa, Spirit Collection* positions *HeLa*'s explorations of issues of privacy, DNA ownership, and consumer information in the context of the long and canonic history of western medicine.

−86 Degrees Freezer (1995: see Figure 41.4) is one panel of a 12-panel, black-and-white photographic series of "still lives" created by San Francisco artist Catherine Wagner. In this series, Wagner documents the mundane, everyday activities of the scientific laboratory, especially the activity of managing and properly storing genetic materials. In *−86 Degrees Freezer*, the artist makes issues of DNA ethics, privacy, and ownership tangible and accessible. Wagner does not document the historic benchmarks of science—its great men and women, its victories and defeats—instead, she documents the ways in which genomics produces knowledge through the labor of archiving, labeling, managing, controlling, and maintaining genetic materials and information.

Like many artists included in *Gene(sis)*, Seattle-based Susan Robb seeks to dismantle the opposition of art and science. Her studio is full of the trappings and accessories of science, including pipettes, Bunsen burners, Petri dishes, scalpels, and scientific textbooks. But Robb takes liberties with scientific protocols, crafting sculptures from unscientific materials such as Play-Doh, lint, moss, cake crumbs, and glass cleaner, as well as saliva and other bodily fluids. She might begin her experiment with a question like, "What does it look like chemically when one falls in love?" Thus inspired, she creates a sculpture of this imagined chemical process, cellular activity, or genetic sample.

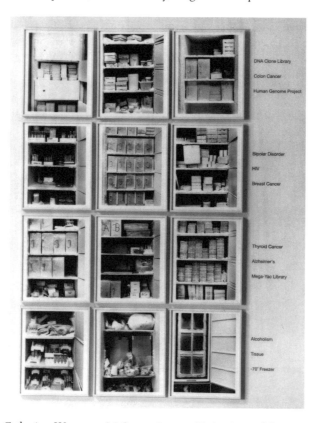

Figure 41.4 Catherine Wagner, *−86 Degree Freezers (Twelve Areas of Concern and Crisis)* (1995). Collection of the Museum of Fine Arts, Houston; Museum purchase with funds provided by the 5.1 Morris Photography Endowment Fund.

To create her photographic series *Macro-Fauxology* (2000, Figure 41.5), Robb used this art-and-science process to create sculptures representing her idea of specific organisms and activities. After photographing the sculptures with a macro lens, she destroys them, leaving only the photographic trace of their existence—colorful and fantastical images reminiscent of both scientific imagery and science fiction.

IV. BOUNDARY: permeability of species boundaries

Scientists once believed that species boundaries were for the most part impenetrable, although myths of hybridity haunt our most ancient cultural imaginings. In Greek and Roman mythology, both the Chimera and the Centaur are changelings: half animal, half human. Human-animal hybrids are also prevalent in Chinese and Buddhist mythology where they play a key role in the spiritual transition of souls.

Recent genomic developments make possible the production of hybrid creatures that only a few years ago were thought scientifically impossible. We have even become accustomed to the notion of genetically engineered sheep, pigs, goats, mice, and cattle. In early January 2001, the first transgenic primate, a rhesus monkey, was developed as a tool for studying human diseases.

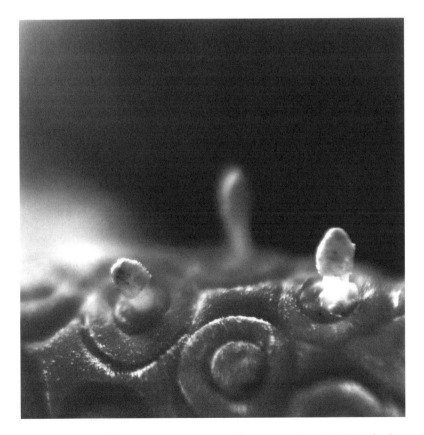

Figure 41.5 Susan Robb, *Macro-Fauxology: sucrosefattyacetominophen* (2000). Cibachrome print, 10 × 10 inches. Courtesy the artist.

Several artists are exploring transgenics—the formation of new combinations of genes by isolating one or more genes from one organism and introducing them into another. In the context of rapid developments in transgenics, when boundaries between species and between living and nonliving forms are blurred, what are the ethical questions we should be asking? Whose values will guide such developments? What follows is a selection of a few artworks from a section entitled "BOUNDARY."

In her photographic series, *Transgenic Mice*, New York-based artist Catherine Chalmers highlights the production of genetically engineered mice, an industry that has experienced enormous growth almost wholly attributable to genetics research. *Pigmented Nude* (2000: see Figure 41.6) and *Rhino* are programmed from birth to develop tumors, inherit glaucoma, or reproduce milder pathologies. "Pigmented nude" is a mouse strain developed for research into human skin and hair-texture defects. "Rhino" is a mouse strain developed for research into human immunology and inflammation problems.

These genetically engineered mice are produced at a rate of approximately 50 million a year. They are cheaper to breed than primates and, until recently, a loophole in the USDA's 1966 Animal Welfare Act left these mice unprotected and their standard of care unmonitored. A change in their status could cut deeply into the skyrocketing profits ($200 million per year) of private "mouse ranches" nationwide. Chalmers' series *Transgenic Mice* highlights this genomics growth industry that has until recently escaped public scrutiny or calls for accountability.

Eduardo Kac's *GFP Bunny* (2000: see Figure 41.7), or "Alba" as she is affectionately known, is a transgenic animal, created by splicing the DNA of a Pacific Northwest jellyfish with that of an albino rabbit. The effect of this combination is that under ultraviolet light of a particular intensity, the albino rabbit glows fluorescent green. "Alba," was created by the artist, in collaboration with French geneticists, as part of a much larger performative artwork that includes interdisciplinary dialogue on the cultural and ethical implications of genetic engineering, and the integration into society of a transgenic creature. This project also advocates expanding the present boundaries of artmaking to include the invention of life, an ability that has only recently become part of an artist's toolkit.

New York-based artist Daniel Lee has imagined transgenics from a very different angle than Kac. In his large-scale, digitally altered photographic series entitled *Judgment*, Lee has created a cast of underworld mythological creatures based on Chinese mythology—a jury

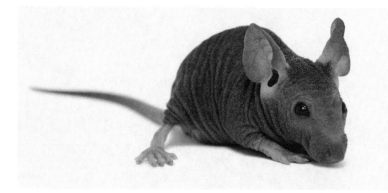

Figure 41.6 Catherine Chalmers, *Transgenic Mice: Pigmented Nude* (2000). Courtesy the artist www.catherinechalmers.com.

Figure 41.7 Eduardo Kac, *GFP Bunny* (2000). Alba, the fluorescent rabbit. Courtesy the artist.

of mythological chimeras who are half-animal, half-human hybrids. According to legend, there are 108 different creatures, including the human being, in the Chinese Circle of Reincarnation. Each of these creatures is judged after its death in a mythological court under the earth. The judge and jurors of this court try the dead souls to determine their destiny in the afterlife. Illustrated here is *Leopard Spirit* (1994: see Figure 41.8).

V. SUBJECT: self, family, and human "nature"

In the years since the cloning of Dolly the sheep, public discussions have turned away from the specter of human replicants to less frightening possibilities, such as the production of genetically identical tissue grown for people with Parkinson's and other diseases. Infertile couples wanting a biologically related child or grieving parents longing to replace a child they have lost now openly express the desire to clone.[6] Procloning bioethicists have embraced access to cloning as a "reproductive right," as just one among an array of assisted reproduction technologies. Currently, the cloning of mammals is an inefficient process that can require hundreds of attempts to create an embryo and implant it successfully. However, this does not preclude the possibility that human cloning is taking place somewhere in the world—other than the United States or in most of Europe and Japan, where legislative bans have been placed on such research. In the wake of such recent genomic possibility, notions of self must be reimagined.

Genomic developments have also thrown the idea of difference into relief. Population geneticists have demonstrated that there is no specific gene for race and that, in fact, human beings are genetically quite similar. Meanwhile, minor genetic differences between humans—such as race and ethnicity—remain among the most lethal and intractable causes

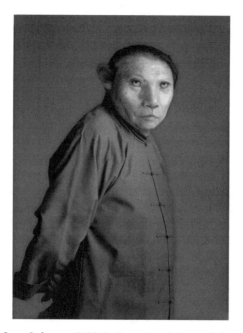

Figure 41.8 Daniel Lee, *Judgment (1994): Juror No. 6 (Leopard Spirit)*. Digital C-Print, 35 × 50 inches. Courtesy the artist.

of human conflict. What impact might increased knowledge of genetic human variation and the development of a precise scientific description of the biology of race have on human societies?

Kinship and other relations are also being defined anew. Kinship is a complicated cultural construction, one that is not necessarily based on biological relationships.[7] New reproductive practices are generating a variety of meanings, identities, and relationships with which we are only now beginning to grapple, but many are aligned with a constricted essentialist notion of biological kinship. What impact will these choices have on our notions of self and family? How might the increased emphasis on genetic kinship play against the many other forms of family we recognize in contemporary society?

Several artists have recently begun exploring the ways in which the new genomics allow us to redefine or re-imagine key aspects of human identity, including race, sex, sexuality and the "essential" aspects of human nature. The following are artworks included in a section entitled "SUBJECT."

Amsterdam-based artist Margi Geerlinks creates large-scale, digitally altered photographs that focus on the anxieties and anticipation surrounding genomics. In *Twins* (1998–9: see Figure 41.9), an elderly woman appears to be wiping age from the face of her mirror image, her twin, herself. In this act she performs one of the perceived promises of the scientific revolution of genomics—the potential to exercise some control over the aging process and the degeneration of cells, even increasing the human life span.

Houston artist Dario Robleto has created an installation entitled *If We Do Ever Get Any Closer At Cloning Ourselves Please Tell My Scientist-Doctor To Use Motown Records As My Connecting Parts b/w The Polar Soul* (1999–2000: see Figures 41.10 and 41.11). This installation conflates our fantasies about human cloning and a high point in the history of American pop music—Motown. Robleto's installation is an imaginary cloning chamber in which the disc jockey samples your favorite Motown hits.

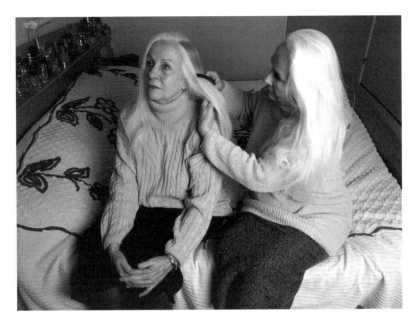

Figure 41.9 Margi Geerlinks, *Twins* (2000). Courtesy TORCH Gallery, Amsterdam.

Figure 41.10 Dario Robleto, *If We Do Ever Get Any Closer At Cloning Ourselves Please Tell My Scientist Doctor To Use Motown Records As My Connecting Parts b/w The Polar Soul* (1999–2000). Installation, 8 × 171/2 × 10 feet. Originally commissioned by ArtPace; A Foundation for Contemporary Art, San Antonio. Photo Credit: Seale Studios.

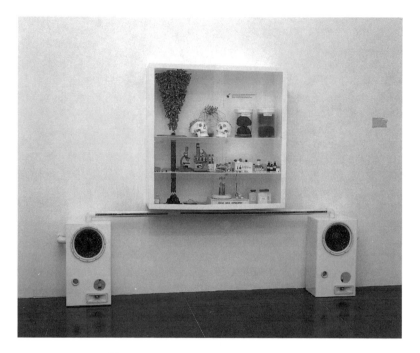

Figure 41.11 Dario Robleto, *The Polar Soul* (1999–2001)

Many of the specimens in his laboratory were created from the artist's mother's record collection. His mother lovingly played these albums for years. The record grooves contain her skin cells and hair—minute biological residue making up a DNA library. Robleto melted these records, ground them to a fine powder, and then cast them into various shapes. In the cloning chamber, a video monitor shows disc jockey Justin Boyd playing an original, commissioned remix of the songs from the melted-down records. The artist's recuperation of his mother's genetic material, his infatuation with popular music culture, and his commentary on our fantasies about cloning offer a witty take on the genomic disc jockey revolution. Like a disc jockey or a geneticist, Robleto's practice is recombinant, taking samples from science and pop culture and splicing them together in new ways.

The Garden of Delights (1998: see Figure 41.12), is a group portrait created by Chicago artist Iñigo Manglano-Ovalle that engages our current complex understanding of the notion of family. It is composed of forty-eight individual DNA portraits, arranged in sixteen family groupings. Although the individual portraits are genetic, the members of these families are not necessarily bound by these genetics. Manglano-Ovalle has included families composed of a father, a mother, and their biological offspring; gay partners with a child from a former marriage; a group of friends; a man and his two aliases. Thus, *The Garden of Delights* does not limit the notion of family to one based on genetic essentialism; instead, it embraces the wider array of families that society recognizes.

Manglano-Ovalle, who is of Spanish and Colombian heritage, selected with purpose the number 16 for his triptychs. In the eighteenth century, during a colonial period in which Spain was obsessed with maintaining racial purity, "scientific" caste paintings were produced showing the sixteen possible child-products of the mixed-race unions of indigenous peoples, African slaves, and "pure"-blooded Spaniards. Race and the role of science in the production of the colonial body, along with shifting notions of family are explored in this series of paintings.

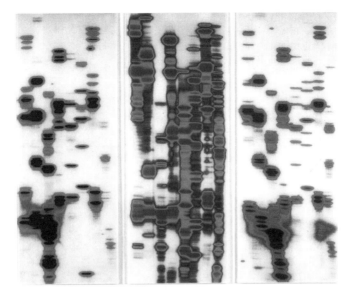

Figure 41.12 Iñigo Manglano-Ovalle, *Lu, Jack, and Carrie (from The Garden of Delights)* (1998). Edition of 3. C-print of DNA analyses Laminated to plexi. 60 × 74 inches. Courtesy of the artist and Max Protetch Gallery, New York.

VI. In closing

That is just a sampling of the almost 100 artworks included in *Gene(sis)*. An extensive Website and CD-ROM exhibition catalogue document the exhibition, public programs, and dialogue activities in each city to which the exhibition travels. An educational "tool box" containing exhibition curriculum guides, guidelines for establishing public dialogue, and other program materials are also available to participating venues.

Gene(sis) promises to be a particularly effective and provocative exhibition for several reasons. It provides a unique cross-section of compelling new artwork created in response to recent genomic advances and debates. At the same time, it addresses concrete audience needs: finding a means of access to comprehending highly technical material with potentially profound social implications; fostering public dialogue among populations, legislators and specialists; and enabling high-level collaboration between the fine arts and hard sciences.

Notes

1 Celera Genomics puts the number at 26,558; The Human Genome Project consortium puts the number at about 31,000. See *The Economist* (February 17, 2001), 1.
2 Dr. Eric Lander, Whitehead Institute, Center for Genomic Research, quoted in *The New York Times* (September 12, 2000).
3 Lily E. Kay, *Who Wrote the Book of Life? A History of the Genetic Code* (Stanford, CA: Stanford University Press, 2000), xv.
4 See Kay, *Who Wrote the Book of Life?*
5 "Medicine and the New Genetics," *Human Genome Project Information*. www.ornl.gov/hgmis/medicine/medicine.html.

6 See Margaret Talbot, "A Desire to Duplicate," *The New York Times Magazine* (February 4, 2001), 49–68. See also Brian Alexander, "(You)2," *Wired* (February 2001), 122–35.
7 See the discussion on genetics and kinship in Dorothy Nelkin, *The DNA Mystique: The Gene as Cultural Icon* (New York: W. H. Freeman and Company, 1995), 58–78.

Matthew Gandy

CYBORG URBANIZATION
Complexity and monstrosity in the
contemporary city

Introduction

> She referred to the high-rise as if it were some kind of huge animate presence,
> brooding over them and keeping a magisterial eye on the events taking place.
> There was something in this feeling – the elevators pumping up and down the
> long shafts resembled pistons in the chamber of a heart. The residents moving
> along the corridors were the cells in a network of arteries, the lights in their
> apartments the neurones of a brain.
>
> (J.G. Ballard, 1975: 40)

> Now, the boundaries between the organic and the inorganic, blurred by cybernetic
> and biotechnologies, seem less sharp; the body, itself invaded and re-shaped by
> technology, invades and permeates the space outside, even as this space takes on
> dimensions that themselves confuse the inner and the outer, visually, mentally
> and physically.
>
> (Anthony Vidler, 1990: 37–8)

> The body-territory [*corpo-territorio*] poses a problematic form of corporeal identity
> that in becoming ever more routinized has tended to dissolve the distinctions that
> formerly existed between the organic and the inorganic.
>
> (Tiziana Villani, 1995: 118)

AS SHE TENTATIVELY BEGINS TO PLAY THE PIANO, the replicant, named
Rachel, recalls that she once had lessons but cannot be sure whether these memories
are her own or simply the implanted memories of someone else. In this poignant scene in
Ridley Scott's *Blade Runner* (1982) we explore the possibility that human identities might be
artificially created in order to produce advanced androids whose intelligence and sensitivity
is comparable with that of their human creators. The figure of the cyborg, as represented in
science fiction cinema, is not an automaton or robot but a sophisticated creation that seems

to simultaneously extend but also threaten our understanding of what it means to be human. If we were to locate the cyborg as an idea, we could say that it is clearly linked to fantastical combinations of bodies and machines but is nonetheless a way of thinking about the world. It is, in other words, an ontological strategy for extending the limits to human knowledge as well as an apposite means of describing those phenomena that appear to reside outside conventional frameworks of understanding. If a cyborgian sensibility is explored within the context of the contemporary city, we find that it has developed out of several interconnecting strands of thought as a trope of critical reflection which uncovers a series of anomalies, fractures and tensions lurking within dominant modes of urban and architectural thinking.

Since the early 1960s the potential applications of the cyborg concept have proliferated to include developments such as whole organism cloning, in vitro fertilization, gene sequencing, advanced prosthetics and other sophisticated medical technologies. In tandem with these technological manifestations, the imaginative field of the cyborg has expanded through literature, cinema and the fantasy spaces of contemporary culture.[1] It is since the mid-1980s, however, that the idea of the cyborg has been associated with a more densely argued series of theoretical applications as a means to explore the interface between technology and the body. The key intervention here is Donna Haraway's article entitled 'A Cyborg Manifesto', first published in the *Socialist Review* in 1985, and later included in her influential collection of essays *Simians, Cyborgs and Women* where she writes in her introduction (1991a: 1):

> A cyborg is a hybrid creature, composed of organism and machine. But, cyborgs are compounded of special kinds of machines and special kinds of organisms appropriate to the late twentieth century. Cyborgs are post-Second World War hybrid entities made of, first, ourselves and other organic creatures in our unchosen "high-technological" guise as information systems, texts, and ergonomically controlled labouring, desiring, and reproducing systems. The second essential ingredient in cyborgs is machines in their guise, also, as communications systems, texts, and self-acting, ergonomically designed apparatuses.

This succinct and revealing definition reminds us that the idea of the cyborg, as originally elaborated by Haraway, is at root a political as well as an intellectual project, an idea which originated in and from the 'belly of the monster' (1991a: 4), that nexus of political and economic entanglements that we might term the 'first world' in distinction to the proliferating spaces of marginality that lie beyond.[2] Since its inception as a critical intellectual concept in the 1980s the cyborg metaphor has been deployed to challenge disembodied, dualistic, masculinist and ideological bodies of knowledge. It has infused science and technology studies with feminist epistemological strategies. It has opened up new possibilities for the understanding of relations between nature and culture. And it has facilitated greater sensitivity towards social and spatial complexity through its emphasis on 'situated knowledges'.

The idea of the cyborg shares an affinity with related concepts such as 'cyberspace', 'cybernetics' and 'cyberpunk'. Yet the contemporary use of the term 'cyborg' is different from these virtual, analytical and fictional constructs because it is grounded in the living and breathing flesh of the human body. Whilst the 'cyber' metaphor has tended to be associated with various forms of virtuality, the idea of the cyborg is closely linked with the corporeal experience of space.[3] In this sense the cyborg can be read as an alternative way of conceptualizing the growth and development of cities that serves to destabilize the pervasive narratives of dematerialization, spatial malleability and virtualization. The underlying materiality of the cyborg metaphor has acquired heightened significance now that the earlier polarity between virtual space and 'meat space' articulated in the first wave of cyber literature is losing its conceptual utility and now that the very idea of 'virtual reality'

is itself imploding as it becomes either relocated in the context of a heightened dimension of the real (see, for example, Žižek, 2002) or simply derided as an inherently oxymoronic formulation (see Grosz, 2001).[4]

The emphasis of the cyborg on the material interface between the body and the city is perhaps most strikingly manifested in the physical infrastructure that links the human body to vast technological networks. If we understand the cyborg to be a cybernetic creation, a hybrid of machine and organism, then urban infrastructures can be conceptualized as a series of interconnecting life-support systems (see Swyngedouw, 1996; Marras, 1999; Gandy, 2002; Mitchell, 2003). The modern home, for example, has become a complex exoskeleton for the human body with its provision of water, warmth, light and other essential needs. The home can be conceived as 'prosthesis and prophylactic' in which modernist distinctions between nature and culture, and between the organic and the inorganic, become blurred (Vidler, 1990: 37). And beyond the boundaries of the home itself we find a vast interlinked system of networks, pipes and wires that enable the modern city to function. These interstitial spaces of connectivity within individual buildings extend through urban space to produce a multi-layered structure of extraordinary complexity and utility.

The figure of the cyborg is at root a spatial metaphor. But how does the idea of the cyborg intersect with spatial theory? In what ways does the cyborg reinforce or contradict other emerging strands of urban thought that also emphasize urban complexity and hybridity? Has the epistemological subtlety and political prescience of the cyborg, as originally formulated in the 1980s, been realized in practice or simply been diffused through the term's widening usage? And should we ultimately reject the idea of the cyborg as an anachronism derived from cold war science and the first generation of twentieth-century cyberpunk culture? In the rest of this article I will try to address these issues through an exploration of the somewhat haphazard presence of the cyborg in contemporary urban discourse. I will focus in particular on the example of urban infrastructure as a concrete manifestation of the cyborg idea in order to explore different facets of the relationship between the city, the body and the human subject. My aim is not to foreclose discussions surrounding the 'cyborg city' but to open up a series of dialogues in order to explore contemporary thinking around these questions.

Neo-organicism and the rhizomatic city

One of the principal difficulties with delineating the cyborg city as a clearly defined entity is derived from the entanglement of the cyborg idea with a variety of urban metaphors ranging from organicist conceptions of the nineteenth-century city to 'neo-organicist' representations of the post-industrial metropolis. In its classic nineteenth-century form the organicist conception of the city emerged out of a functional analogy, originating within the medical sciences, wherein spatial differentiation corresponded with a distinctive arrangement of human organs. We find that Kantian notions of the self-organizational characteristics of animate matter were combined with new insights into the human vascular and arterial system and an emerging circulatory emphasis within the nascent science of political economy. In recent years, however, the organicist emphasis on the city as an integrated body with identifiable organs, which emerged in response to the nineteenth-century industrial city, has been increasingly displaced by the idea of urban space as a prosthetic extension to the human body. The body-city problematic has been reconceptualized in the context of post-Cartesian and post-positivist modes of thinking. The emphasis on the city as a self-contained body or machine has been challenged by a hybridized conception of space as a system of

technological devices that enhances human productive and imaginative capabilities. The cyborg metaphor not only reworks the metabolic preoccupations of the nineteenth-century industrial city but also extends to a contemporary body of ideas that we can term 'neo-organicist' on account of the deployment of biophysical metaphors for the interpretation of social and spatial complexity.

In the neo-organicist city we encounter a shift of emphasis away from an anatomical conception of space as an assemblage of individual organs towards a neurological reading of space as a diffuse and interconnected realm of human interaction. The film maker Michael Burke, for example, director of *Cyborg City* (1999), describes how beneath the 'glass and concrete' of the future city there will be a 'humming mass of technology' acting as a central nervous system, 'constantly monitoring and controlling both its own functions and those of its citizens' (Burke, 1998).[5] The mechanical and hierarchical model of the relationship between the body and the city has been supplanted by a more complex and non-linear pattern of urban development in response to the spread of new information technologies (see Gille, 1986; Rabinbach, 1990; Akira, 2001). The organicist city of the modern era was founded on a clear separation between mind and body that enabled the city to be conceptualized as a coherent entity to be acted upon, disciplined, regulated and shaped according to human will. The emergence of the neo-organicist city, in contrast, is founded on the blurring of boundaries rather than their repeated delineation. At the same time, however, there remain important continuities between the kind of machine-based metaphors associated with the early twentieth-century futurism of figures such as Mario Chiattone, Filippo Tommaso Marinetti and Antoniono Sant Elia and the elaborate computer-based metaphors deployed in the contemporary city (see Villani, 1995; Boyer, 1996; Schaub, 1998). Other significant continuities include, for example, the avant-garde bricolage of early cinema and the surrealist bodies depicted in the art of Hans Bellmer, Francis Picabia and other responses to 'a sterile and over rationalised technological realism' (Vidler, 1990: 42).[6] These interconnecting strands between cultural modernism and the emergence of the cyborg metaphor are significant because they underlie the centrality of corporeal metaphors for the critical interpretation of urban form. The current emphasis on corporeal and neurological analogies in the neo-organicist literature owes more to earlier developments than is widely acknowledged.

We can detect two principal dimensions to contemporary neo-organicist urban thought. A first strand, rooted in the bio-physical sciences, perceives the city to be a special kind of complex, yet intricately ordered system. This homeostatic perspective, which is inflected by ecological thinking and recent developments in evolutionary biology, has diffused through parts of the architectural literature and is only tangentially linked with the epistemological challenge of cyborg theory.[7] A second and more intellectually significant development is represented by the convergence of ideas surrounding the 'thinking space' of the city and the indeterminacy of spatial forms. If the body-city nexus is conceptualized as a thinking machine then the analytical focus shifts towards the identification of those critical networks or 'neurones' that sustain the relationship between the body and the city (Kurokawa, 2001a). Though this dimension to the neo-organicist perspective shares important continuities with the technological preoccupations of early twentieth-century modernism, it extends its conceptual purview into different aspects of cultural modernism. The influential speculations of Gilles Deleuze and Felix Guattari, for example, develop Antonin Artaud's conception of the 'body without organs' to produce a philosophy of spatial complexity quite different from that associated with dominant modernist traditions (Deleuze and Guattari, 1986; 1987; Rajchman, 2000; Uno, 2001). Their philosophical challenge is to perceive space in the absence of any previously existent categories, hierarchies or systems as a form of 'anarchic non-identical

proliferation' (Luckhurst, 1997: 128). The organic metaphor of the 'rhizome' is deployed in distinction to 'arborescent' conceptions of cities as hierarchical structures (Teysott, 1990; Akira, 2001; Kurokawa, 2001a). In addition to this emphasis on non-hierarchical structures of difference Deleuze and Guattari's conception of concrete space also seeks to incorporate the imaginary, libidinous and oneiric realms of human experience. From their 'neo-vitalist' perspective, which builds on the philosophical ideas of Henri Bergson, the virtual realm is not simply a mimesis or reflection of physical reality but an independent domain that generates new kinds of spaces and ideas. The political significance of the virtual realm lies in its experimental and emergent role as part of an envisioned space that has yet to be realized within the taken-for-granted realm of concrete reality (Boundas, 1996; Massumi, 2001). The role of the diagram or 'abstract machine' takes on special significance in this context as an attempt to give visual expression to new models of reality.[8] In the case of architecture, for example, there has been an intense dialogue between developments in building design and the speculative possibilities engendered by computer-aided simulations so that 'physical space increasingly resembles cyberspace' (Mitchell, 2003: 197). Some architectural practices have deployed so-called 'genetic algorithms' in order to generate a form of 'in vitro' architecture which derives its inspiration from nature yet remains autonomous from it as a purely digitized space of imaginative exploration (see Chu, 2002; De Landa, 2002).[9] Examples of architectural practice inflected by post-structuralist ideas which move beyond purely 'in vitro' speculations to fully realized projects include the work of Peter Eisenman, Frank Gehry and Bernard Tschumi, where sophisticated combinations of form, structure and materials have been achieved, which are quite at odds with modernist conceptions of architectural form.

A conceptual synthesis can be discerned in some of the recent literature between post-structuralist philosophies of space and Latourian conceptions of actor-network theory to produce a new kind of urban theorization which eschews the meta-narratives associated with neo-Marxian approaches. Building on the insights of Deleuze and Guattari these approaches have sought to remove all the extrinsic or foundational aspects to urban theory and pare analysis down to the movements and interactions that constitute 'the city' as a particular kind of spatial form or activity that is independent of conventional accounts of scale, structure or order.[10] The brain or 'thinking space' of the city persists yet is dispersed through innumerable nodes and networks in contrast with the embodied cyborg citizen to be found in the more technophile literature. We can trace these developments back to the emerging critique of architectural modernism in the 1970s and 1980s that increasingly drew on the theoretical ontologies of post-structuralism in order to advance a radically unplanned built form.[11] From this perspective the role of 'chaos', for example, takes on a very different significance from that associated with the modernist city and is perceived as a field of evolutionary and radical experimentation. Chaos is no longer seen as an anomalous dimension to the urban experience to be problematized or excluded from analysis but a rich vein of social and spatial interaction through which we may perceive signs of alternative or hitherto overlooked urban forms. Chaos may also be characterized as a more sophisticated, resilient and adaptable form of order as Rem Koolhaas has suggested with respect to the dynamics of West African urbanism (Koolhaas et al., 2001; Koolhaas, 2002). The theoretical novelty of such a perspective sits sharply at odds, however, with the capacity for what one might term 'avant-garde urbanism' to actually explicate any substantial dimensions to urban change (see, for example, Rauterberg, 2002; Gandy, 2005). We can detect within urban and architectural discourse an emerging counter current to post-structuralist and avant-garde urbanism led by a combination of formal, technical and political critiques (see Frampton, 1996; van Berkel and Bos, 1998). Though the post-structuralism of Deleuze and Guattari

seeks to make explicit linkages between the 'real' and the 'virtual', and is in this respect a significant advance on the flattening and one-dimensional simulacra of Jean Baudrillard, there is a persistent difficulty in articulating any kind of cogent political critique of the cyborg city. The emphasis on the fluid characteristics of urban space risks overlooking the particular combinations of fixed capital and human expertise that enable specific nodes within the global urban system to play enhanced roles in the arena of cultural and economic production. The disavowal of structure hampers the evaluation of the theoretical and practical significance of these insights despite the potentially fertile coalescence between Deleuzian post-structuralism and a cyborg sensibility towards the mutual entanglement of the real and the virtual. We are left with an ironic continuity between the functionalist reading of the industrial city and a 'neo-organicist' preoccupation with the design of space that resides quite comfortably alongside reworked formalist idioms in architectural criticism.

From endo-colonization to the cyborg citizen

The emerging depiction, of the human-machine interface as a technological monstrosity is strongly associated with nineteenth-century romanticism: anxieties over uncontrollable science and technology, for example, form part of a long-standing counter discourse to modernist teleologies of technological progress (Clayton, 1996; Tsouvalis, 2003). In recent years, however, the trope of technological monsters has tended to divide between a Haraway-Latour axis of new affinities towards excluded others on the one hand, and the persistence of fears towards technology and its 'malevolent autonomy' on the other hand (Waldby, 2002: 28). The appearance of the cyborg has engendered a new wave of fear and trepidation towards the invasion of the body by strange technologies that threaten to eliminate or overwhelm the human subject. In the writings of Paul Virilio, for example, we move beyond the romantic and Heideggerian critique of technology towards a political economy of technology and its intersection with the human body. Virilio sees the colonization of the body by new technologies as a 'revolution of transplantations' that marks the critical 'third wave' of modernity following the earlier revolutions in transportation and communications technologies (Virilio, 1997: 6). Virilio charts the advance of a 'neo-eugenics' in which the power of military-scientific imperialism leads towards an 'endo-colonization' of the human body itself so that we no longer talk of the body in the city but of the 'city in the body' (see Virilio, 1995, 1997). The cyborg figure becomes a symbol for the militarization of society: we are no longer dealing with a cold war astronaut but with the technologically enhanced soldier of the twenty-first century peering around the corner of buildings in defence of prosperous nations and their corporate sponsors.[12] The hygienist discourses of the past have been radically extended by new technologies of surveillance and control in order to construct the *cordons sanitaires* of the twenty-first century. New defensive structures have developed that combine long-standing mechanisms of social exclusion such as housing markets with enhanced forms of social control through a mix of architectural, ideological and intelligence-gathering processes. The growing significance of urban warfare in particular is now leading towards military strategies which specifically target the destruction of essential technological networks such as water and power in order to subdue civilian populations and eradicate sources of political resistance (Graham, 2003, 2004). A deliberate process of decoupling modern societies from urban technological networks or 'decyborgization' to use Timothy Luke's (1996) expression is reducing marginalized communities to a state of biological subsistence so that they are no longer political subjects but mere inhabitants struggling for existence (see also Agamben, 1998; Bauman, 2004). Through a process of

deliberate disenfranchisement from modernity whole societies face the prospect of annihilation through a combination of disease, impoverishment and overt acts of violence.

Ranged against the more fearful readings of technology we can discern an emphasis on the cyborg as a means of becoming 'post human' in order to liberate the human body from the illusory boundaries of the autonomous self.[13] In the work of William J. Mitchell, for example, we can trace a lineage from 'Vitruvian man', through the phenomenological experience of space, to the contemporary networked urban citizen as 'a spatially extended cyborg' (Mitchell, 2003: 39). 'For millennia', writes Mitchell (1998: 173), 'architects have been concerned with the skin-bounded body and its immediate sensory environment ... now they must contemplate electronically augmented, reconfigurable, virtual bodies that can sense and act at a distance but that also remain partially anchored in their immediate surroundings'. In this sense Mitchell builds on the technologically inflected historicism of earlier writers such as Reyner Banham, Sigfried Giedion and Pierre Naville who depicted modernity as a series of revolutionary technical innovations. Focusing on wireless infrastructures Mitchell explores the extraordinary technological potentialities of the cyber city and the increasing interaction of digital code with virtually every sphere of human activity (Mitchell, 2003). Yet this is a strangely undifferentiated future in which the polarities and exclusions of space are largely overlooked. Mitchell (2003: 5) claims, for example, that we are witnessing 'the shift from a world structured by boundaries and enclosures to a world dominated, at every scale, by connections, networks, and flows' but he ignores the devastating disparities between the mobility of capital and labour that condemn much of humanity to economic serfdom. In the final instance his perspective is so heavily driven by technological change that it begins to assume the role of an independent variable in his analysis.

Agency, hybridity and distributed cognition

The blurring of boundaries between the body and the city raises complexities in relation to our understanding of the human subject and the changing characteristics of human agency. An extended conception of human agency would include, for instance, the role of biophysical processes and socio-cultural technological systems that impact upon the social production of space. Bruno Latour, for example, has emphasized different scales of analysis to allow the extension of our conception of agency to include those objects, forms, structures and non-human elements that have been systematically excluded from both positivist and materialist epistemological traditions (Latour, 1993, 2004).[14] Whereas the work of Haraway has tended to emphasize the affinities between human and non-human nature the practical import of Latour has been the mapping or delineation of 'cascading micro-decisions' linking between different kinds of networks or structures (Zitouni, 2004). The cyborg can be conceived in a Latourian sense as both a new kind of social interaction with space but also a disordered concept to be conceived in opposition to the purified realm of modernist urban thought. Yet a Latourian public realm, with its hybridized conceptions of agency, is quite different from that envisaged within Habermasian philosophical traditions because of the radical extension of human agency to encompass those technical and organizational systems which the Frankfurt School philosophers sought to specifically exclude from the realm of ethical and political judgment.

The concept of hybridity also entails its own spatiality, its own geometries of power between its constituent elements. The idea of the cyborg as a hybrid can be conceived as a problematic re-inscription of technical discourses derived from core locales or some overarching teleological template for urban change but it can also entail a reverse flow

of ideas and developments from the margin to the centre. The complexities of colonial and post-colonial urbanism, for example, can be explored in terms of locally specific combinations of materials, practices and ideas drawn from disparate contexts (see, for example, Gabilondo, 1995; King, 1995; Hall, 2003). The cyborg metaphor can be used in this sense as an explicit recognition of the limits to formalist or teleological architectural discourses rooted in purified and neatly demarcated conceptions of cultural change. Following Latour's admonition that we have never been modern, we could argue that we have always led a cyborg existence since virtually every human endeavour has involved a combination of disparate cultural and technological skills ranging from the origins of language to the latest developments in materials science. But if we abandon any historical or geographical specificity to the cyborg idea we risk diluting its analytical utility as a means to engage with the cultural and technological complexity of the contemporary city.

The complexities of human agency in the cyborg city point to the intersection between technological change and the reformulation of the public sphere inherited from the industrial city. But can the cyborg idea help us to understand the changing dynamics of infrastructure provision in relation to a digitized or diffuse conception of the public realm? If the interactions between human and synthetic sentience have eroded the idea that 'conscious agency is the essence of human identity' (Hayles, 1999a: 288) then this contradicts many of the insights of cultural history that have focused quite specifically on the co-evolution of material realities *and* systems of cultural meaning. The arguments made by Alain Corbin (1986), for example, over the evolution of olfactory perception locate these changes precisely within the context of a more individuated experience of modernity within which communal experiences begin to acquire a different set of meanings. What Catherine Hayles and the other 'post-human' theorists are in a sense suggesting is that new forms of 'distributed cognition' are creating a more integrated rather than individuated system of sensory perception that directly challenges the established trajectory of modern consciousness and experience.

Post-human political discourse is grounded within the context of the decline of meta-narratives, the erosion of the public realm and the radical indeterminacy of the human subject. If the 'autonomous self' can be regarded as an illusory and highly restricted (socially and historically) realm of human experience, we are still left with the uncertainty of delineating the characteristics of the human subject in a cyborg society (Callard, 1998; Hayles, 1999a: 286). If the body-city interface is conceptualized as a non-Cartesian space, then the distinction between mind and body and between the material and the virtual becomes extensively blurred. But what happens when the human subject is increasingly merged with the fabric of the city itself? Whilst it is easy to accept that our hybridized interactions with space involve a greater role for 'silicon, copper and magnetic subsystems' (Mitchell, 2003: 168) it is much harder to conceive of ethical judgements as a digitized process of remote interactions with not only other humans but also non-human machines and networks. The physicist Michio Kaku, for example, describes a world emerging between 2020 and 2050 in which computers as we know them will be superseded by an invisible network with the power of artificial intelligence (see Broderick, 2002). But even if an interconnected skein of nanotechnology were to extend into all aspects of everyday life (at least in the hyper-connected nodes of global cities) the problematic distinction between human and non-human forms of sentience would remain unresolved. The rapid co-evolution of what Gregory Bateson has termed 'distributed cognition' between human and artificial intelligence exposes an emerging disjuncture between the virtual realm of information production and the relatively finite reserves of human attention capable of engaging with the proliferation of sensory stimuli

(see Hayles, 1999a: 287). In the final instance, however, the notion of 'distributed cognition' advanced by Bateson and other advocates of artificial intelligence, blurs the boundary between sentience and non-sentience, and between bodies and machines, and results in a digitized ontology that delimits rather than extends the possibilities for the reconfiguration of urban experience. The increasing significance of non-human decision-making marks a radical technological intrusion into those spheres of human cognition that both Frankfurt School and Heideggerian philosophical traditions have sought to protect. With distributed cognition the built space of the city has not only become part of the human body but has begun to impinge upon the process of thought itself.

Phantom spaces and the public realm

The pervasive dilapidation of urban infrastructures, and especially those physical networks associated with the growth of the modern industrial city, is intimately connected with questions surrounding the state of the public realm and its future prospects. The marginal spaces of the post-industrial city are now littered with technological relics: the twisted combinations of metal and concrete which cluster along rivers and major rail intersections and extend beneath the surface of the city can be likened to what William Gibson describes as the 'semiotic ghosts' of yesterday's tomorrows (cited in Dery, 2002: 303). These 'anxious landscapes', to use the historian Antoine Picon's (2000) term, are emblematic of a new kind of urban form which finds its logical counterpart in the new shopping malls, corporate atria and other quasi-public spaces that characterize the post-industrial city. Yet even before their neglect and abandonment these complex assemblages of physical artefacts, technical expertise and accumulated cultural meaning had begun to fade from collective consciousness and were no longer an integral part of the 'social imaginary' of the modern city (see, for example, Castoriadis, 1987; Taylor, 2004). From the middle decades of the twentieth century these vast infrastructural networks gradually disappeared from view as part of the 'taken-for-granted' world of everyday life (see Williams, 1990; Garver, 1998; Kaïka and Swyngedouw, 2000). These centralized and quasi-universal systems embedded within urban space, which Stephen Graham and Simon Marvin (2001) have referred to as the 'modern infrastructural ideal', represent a constituent element within the socio-spatial structure of modern societies ranging from gender relations to the political delineation of the nation-state. These vast infrastructure networks can be interpreted as a concrete manifestation of what Habermas (1998) has termed 'normative universalism' yet we know comparatively little about the cultural and political dynamics of their decline in comparison with their growth and development.[15] The routinization of spatial regulation in the modern era contributed towards a gradual detachment of modern infrastructure from the legitimating ideals that made the political and administrative transformation of urban space historically possible (see Ingram, 1994: 253). These municipal networks required incessant inputs of capital and human labour in order 'to prevent the entropic disintegration of frail material circuits' (Otter, 2002: 14) and have been especially vulnerable to the protracted fiscal crisis facing the modern state since the 1970s. Despite their evident technical and fiscal frailty, however, these technological structures retain a crucial role in delineating not only the practical possibilities for urban governance but also in defining the ideological and metaphorical parameters of political discourse. Yet in the absence of comprehensive failures such as power blackouts or spectacular corporate corruption scandals, the politicization of networks remains largely restricted to their human interface rather than to their complex patterns of ownership and control.

The cyborg city is widely perceived as a post-metabolic city in which the exchange of information has supplanted the role of material exchange to become the dominant dynamic behind the shaping of urban space. In a sense the idea of urban metabolism has moved closer to the original nineteenth-century emphasis on material transformation or *Stoffwechsel* as post-industrial cities take on an increasingly alchemic function of producing wealth out of abstract rather material transactions. The last 20 years has seen an accelerating process of dematerialization or 'derritorialization' driven by the spread of informatics, increased capital mobility and the fracturing of place-bound identities, yet the implications of this urban transformation for the public sphere remain extensively occluded in the cyborg literature. The sociologist Konstantinos Chatzis (2001), for example, asks what possibilities for collective thought and action might exist in the fractured and heterogeneous spaces of the cyborg city and berates Latour and Mitchell for their avoidance of these political questions. In a similar vein the architectural historian Christine Boyer (1996) asks what the political implications of cyborg urbanization are for the future of the public realm and remains sceptical that digital connectivity can take the place of a concrete public sphere (see also Dean, 2001). The public sphere of the industrial city was defined by human labour in terms of its political delineation and physical expression. It was both a tangible form and a metaphorical space through which a progressivist, albeit partial, conception of urban politics could be articulated in the public arena. Yet the public sphere engendered by the industrial city was deeply flawed, both in theory and practice, and proved highly unstable under the combination of political, economic and social pressures that emerged during the 1970s and 1980s. A cyborgian public realm, à la Latour, might, for example, include a whole variety of non-human organisms, yet-to-be-named assemblages of things and multitudinous chains of agency, but would this 'parliament of pipes' and other assorted quasi-objects actually represent a political advance over an anthropocentric public sphere grounded in some workable variant of inter-subjective understanding? A more fruitful avenue might be to explore the variety of actually existing grassroots organizations currently mobilizing in disparate urban spaces around issues such as social justice, shelter rights and access to sanitation (see Appadurai, 2002). In some instances international networks and novel institutional structures have emerged which both confound the limitations of the bourgeois public sphere – especially within the context of the megacities in the global South – and also challenge the new constellations of political and economic power now concentrated in international financial institutions such as the World Bank. Yet the enrichment of civil society cannot in itself act as a viable substitute for a functional public realm which is connected to the development of democratic institutions (see Sennett, 2000; Calhoun, 2002), including those very structures of urban governance which enabled the historic development of the technological networks which comprise the fabric of the modern city.

The territorial and administrative structures associated with the industrial city have been displaced by an increased plurality and simultaneity of different spatial forms. 'At the end of the twentieth century', suggests Paul Virilio (1991: 15), 'urban space loses its geopolitical reality to the exclusive benefit of systems of instantaneous deportation whose technological intensity ceaselessly upsets all of our social structures'. Virilio lies in the vanguard of an urban literature that posits a radical diminution in the traditional role of cities as focal points for social and economic life. When taken to extremes, however, the 'deterritorialization' arguments appear to deny any clear role for space in the constitution of power. The Japanese architect Kuniichi Uno (2001: 1020), for example, suggests that 'contemporary power possesses no center but only borders', whilst the economist Francis Cairncross (1997) declares the end of location as an important factor in global capitalism. Over 15 years of research, however, has demonstrated that an overemphasis on the

deterritorialization of space and power is misplaced because spatial dispersal within the global economy has paradoxically necessitated the recombination and re-concentration of power in specific places and locales (see Castells, 2000; Sassen, 2001). Yet this influential body of literature on networks and the paradoxical enhancement of spatial propinquity tends to overlook the marginal spaces where unequal power relations, violence and social exclusion are most powerfully manifested (see, for example, Tadiar, 1995; Simone, 2001, 2002; Robinson, 2002). The dominant use of the network metaphor within the 'global city' literature is characterized by an extensive degree of economic and technological determinism within which the role of human agency is systematically downplayed. The very idea of the network is trapped within an epistemological myopia that privileges issues of quantification and scale over the everyday practices that actually enable these networks to function (see Smith, 2003a). An emphasis on cyborg urbanization extends our analysis of flows, structures and relations beyond so-called 'global cities' to a diversity of ordinary or neglected urban spaces. The cyborg city is, in other words, closer to an interpretative analytical framework that can connect analysis with the cultural and ideological realm of everyday life and include those 'unconventional' urban landscapes that have emerged outside the core metropolitan regions of the world economy and where incongruities and displacements are an even more pervasive feature of the urban experience.

From virtual space to concrete space

There is an implicit disjuncture between the technological sophistication associated with various manifestations of the virtual city and the state of dilapidation and disinvestment experienced in the concrete city. In one sense this reflects the widening gulf between 'wired' and 'wireless' technologies that is extensively downplayed in flow-based, digitized and nomadized accounts of urban change. The bifurcated geographies of post-industrial cities are characterized by global citadels of connectivity encased within a wider landscape of neglect and social polarization. The multi-lane flyovers of Manila, Mumbai and the other megacities of the global South, for example, enable a literal as well as metaphorical lifting of the new middle-class elites out of the congestion and poverty of the city below. The emerging nodes of hyper-connectivity and premium service provision in the financial districts of cities such as London and New York similarly ensure that core trading and managerial functions can withstand outside pressures and uncertainties. The centralized modes of universal service provision associated with the development of the modern city have been replaced by a new logic of differentiation and exclusion. Many former sites of service provision have merged or melted into a proliferating zone of urban 'non-space' that is disconnected from contemporary patterns of economic production (see Augé, 1995). And the hidden city, exemplified by nineteenth-century water and sewer networks, now faces the prospect of extensive collapse with far-reaching fiscal and public health implications. The role of urban infrastructures has been altered within an emerging reorganization of territoriality marked by a progressive dislocation between urban spaces and those administrative and governmental structures associated with the emergence of the modern city and the nation state.[16]

Despite the conceptual lineages between the cyborg and various manifestations of the virtual or digital realm, the metaphor does not necessarily conflict with materialist readings of urban space. The idea of the cyborg is especially useful in this regard by emphasizing the shifting interrelationship between 'wired' and 'wireless' technologies and the interdependencies engendered by these evolving structures and relationships. The cyborg metaphor allows us to conceptualize the interaction between social and biophysical processes that produce urban

space and sustain the possibilities for everyday life in the modern city. In the case of water, for example, we can explore the linkages between the volatility of global capital markets and the concrete dynamics of the hydrological cycle through 'the production of hybridized waters and cyborg cities' (Swyngedouw, 1996: 80; see also 1997b, 1999). The idea of the cyborg city, as used by Erik Swyngedouw, is simultaneously an analytical framework and an imaginative strategy that 'opens up a new arena for thinking and acting on the city' (1996: 80). In contrast to the 'electromonadic cyborg' of Mitchell (2003: 62), the cyborg is used in a relational way by Swyngedouw to illustrate the hybridized socio-ecological relations that underpin the production of space rather than the experience of the technologically-enhanced urban citizen. We encounter the political economy of the cyborg city in a way that is largely absent from the more technologically orientated literature. A materialist reading of the cyborg city can be used to illuminate different facets to the history of capitalist urbanization: the interaction between trade in specific commodities, for example, and the cyclical pulse of capital combine to produce successive cycles of investment in the built form of the city. The cyborg metaphor goes further than the neo-Marxian tradition in its engagement with the inherent messiness and indeterminacy of urban space. Yet it is not inconsistent with neo-Marxian conceptions of relations between material and abstract space since the cyborg is at root both a materialist concept and an idealist construct that eschews a purely phenomenological or fragmentary worldview through its recognition of multiple and interconnected collectivities of agency. The relational or dialectical cyborg, with its explicit engagement with different forms of capital – ranging from tangible manifestations to speculative abstractions – provides a significant alternative to neo-organicist models of urban space.

A materialist reading of the cyborg metaphor can also be extended to the micro-political realms of power that characterize the structuring and use of private space in the modern home. The technological sophistication of the contemporary city has led towards an intensification of the dependence and co-evolution between urban societies and urban technological networks. There is clearly a periodicity to this process so that what Mitchell has characterized as the 'Me++' complex of the cyborg city has superseded the 'auto-house-appliance complex' of the Fordist era which replaced in its turn the earlier waves of technological diffusion through the interior spaces of the nineteenth-century industrial city (see Nantois, 2002). The latest wave of digital architecture conceives of self-organizing robotic assemblages within the modern home, for example, which will blur the distinction between architecture and furniture to create new kinds of interactive and ergonomic spaces (see Schumacher, 2002). Yet the impact of this emerging edifice of domestic technologies on the comportment of the human body remains uncertain. The evolution of domestic space entails its own geometries of power through the disciplining effects of modern technologies on human behaviour. We encounter not only the physical infrastructure of spatial connectivity, but also the social networks and institutional forms which enable these structures to function. The development of the cyborg city is thus intimately related to the evolution of modern forms of governance or 'governmentality', to use Foucault's term, in which human conduct is shaped indirectly in order to conform to modern conceptions of rationality.[17]

The evolution of human-technological systems is a reflexive process in which the shaping of space begins to reflect modern aspirations for mobility, privacy, salubrity and other characteristic features of the emerging cyborg city. In this sense technologies play a role in producing the body as a discursive field rather than simply through the prosthetic modification of biological limitations (see Grosz, 1992). Consider, for example, the evolutionary phase of the relationship between the body and the development of modern plumbing systems in the second half of the nineteenth century. The processes involved the extension of public

water networks into the private spaces of the home; the inculcation of new washing habits; the spread of new fashions in plumbing and interior design; the construction of elaborate sewer systems to dispose of increasing quantities of waste water; and the intensification of bourgeois ideologies of domesticity.[18] A simultaneous transformation in modes of human interaction with water and social attitudes towards the body found its logical endpoint in the modern bathroom: a private space that marks a clear manifestation of indirect social control of the type that Foucault explored in relation to the bio-politics of the modern body (see Osborne, 1996). A critical theme which emerges from this discussion is whether the evolutionary dynamic of virtual networks in the contemporary city is fundamentally different from that engendered by the waves of physical infrastructure embedded in the modern city. Katherine Hayles (1999a: xiii) suggests that the cyborg form emerges where 'the enacted and represented bodies are brought into conjunction through the technology that connects them' but the longer-term implications of continuous surveillance and technological interdiction for the bio-politics of the body remain uncertain.

Representing complexity

The cyborg metaphor allows for the simultaneity of concrete and imaginary perceptions of urban infrastructure so that the categories of the 'real' and the 'virtual' become interconnected facets of urban experience. The cyborg metaphor is, in other words, peculiarly suited to an understanding of the contemporary metropolis not only as a morphological entity entwined with various technical and aesthetic discourses, but also as an abstract and inter-subjective realm through which political and cultural ideas become constituted or 'fleshed out' in parallel with the concrete development of the city. Some of the most significant insights into the modern city have combined markedly different intellectual registers to powerful effect: consider, for example, Walter Benjamin's combination of Marxism with Jewish mysticism, Georg Simmel's account of the alchemy of money or Henri Lefebvre's distinction between representational space and spaces of representation. The intellectual tensions that emerge from these conceptual juxtapositions are not indicative of an analytical incoherence but actually signal an urban discourse that is closer to the complexity of its object of inquiry than any 'purified' or mono-disciplinary approach can provide. Writing and thinking about cities can aspire to the kind of 'border writing' suggested by Emily Hicks (2001) where edges, interactions and confusions between different codes and symbols take precedence over aspirations towards cultural homogeneity or the binary 'real' versus 'unreal' distinctions of literary genres such as 'magic realism' which effectively sever culture from politics. The cyborg concept enables us to make better sense of urban and industrial landscapes that are produced through the interaction between ostensibly contradictory systems of social and cultural signification.

Urban infrastructures are not only material manifestations of political power but they are also systems of representation that lend urban space its cultural meaning. We can conceive of urban infrastructures as modes of cognition as well as processes underpinning the restructuring of urban space. The development of the cyborg metaphor has coincided with the re-emergence of urban infrastructure as a discursive field permeated by crisis, uncertainty and political contestation. The association between the cyborg metaphor and the rediscovery of the jumbled mass of pipes and wires that constitute the hidden city reminds us that the technological fascination of the cyborg city, exemplified by the tubular nightmare of Terry Gilliam's *Brazil* (1984), owes as much to late modern sensibilities in architectural design than to any putative shift towards 'dematerialization' in the postmodern

city.[19] The aesthetic dimensions to the cyborg city are related to the scale and complexity of urban infrastructures as forms that transcend our conceptual grasp of urban space to produce a cognitive hiatus that is given its clearest expression in science fiction cinema and literature. 'Unthinkable complexity', writes William Gibson, 'Lines of light ranged in the nonspace of the mind, clusters and constellations of data. Like city lights, receding …' (Gibson, 1984: 51). In this now classic passage from *Neuromancer* Gibson suggests, like Mitchell, that the city can be conceived in terms of a neurological analogy but he goes further than this in his representation of the future city as a structure lying beyond any rational mode of comprehension. A similar sense of overwhelming complexity is portrayed in the opening sequence of Ridley Scott's *Blade Runner* (1982) where the camera pans across a seemingly limitless expanse of flickering lights to show an urban galaxy representing Los Angeles in the year 2019. For Fredric Jameson the proliferation of dystopian technological fantasies since the 1970s is indicative of an exhaustion of Utopian thought through the displacement of concrete conceptions of possible urban futures. These anxious landscapes may even represent a late imperial vision of Western cities after the fall – invaded by other cultures and life forms – so that urban monstrosity can be read as a fear of cultural as well as technological miscegenation (Jameson, 1982). In taking such a position, however, Jameson fails to allow the cyborg perspective to be read as a form of social and political allegory that serves to extend our imaginative grasp of urban space (see Bukatman, 1993; Wolmark, 1994). We are fascinated by the cyborg landscape because it tells us something about ourselves as well as about the complex changes underway in the structure and meaning of contemporary cities.

These cognitive polarities between concrete and imaginary space can be explored with reference to the aesthetic categories of the sublime and the uncanny that have begun to permeate critical writings on urban and industrial landscapes.[20] The deployment of a neo-Kantian reading of the sublime in order to develop our understanding of urban complexity leads in a rather different direction from the 'non-representational theory' developed within post-structuralist urban discourse. The geographer Nigel Thrift (2000b: 222), for instance, elaborates on the distinction between concrete spaces and their 'ghostly correlates' but there remains a conceptual hiatus between the analytical scope of non-representational theory and the experiential and sensory realm of modern consciousness. To what extent, for example, are the post-human transcendence of the body and the neo-Kantian spatio-temporal transcendence of the body conceptually incommensurate? Does the concept of the sublime extend across both these cognitive and conceptual realms or is it best conceived as a philosophical anachronism in relation to the post-human subject and the 'distributed cognition' of the cyborg city? There are clearly difficulties with a conception of the sublime that relegates inexplicable dimensions of human experience to a non-cognitive sphere of spatio-temporal transcendence. A modified conception of sublimity in the cyborg city might allow a less optically centred account of aesthetic wonder to incorporate a wider variety and depth of sensory stimuli as part of a more inclusive and responsive intellectual strategy for the interpretation of urban complexity. Rather than a romantic longing for an 'organic unity' (Rajchman, 2000: 22), the contemporary city needs a conceptual vocabulary that can give expression to the unknown, the unknowable and what is yet to come.

Conclusions

It may appear arcane – abstruse even – to utilize the idea of the cyborg as a means to explore the contemporary urban condition. Yet a cursory glance at the recent literature

shows that the earlier incarnations of the cyborg as an isolated yet technologically enhanced body have proliferated into a vast assemblage of bodily and machinic entanglements which interconnect with the contemporary city in a multitude of different ways. The richness of the cyborg concept allows us to negotiate a multiplicity of spaces and practices simultaneously and in so doing develop epistemological strategies for the interpretation of urban life which come closer to any putative 'reality' than those approaches which long for the mechanistic or deterministic simplification of their object of study. Unlike some of the other conceptual tools currently in vogue – whose deployment of the 'post' prefix denotes an ending or culmination of a predetermined sequence of developments – the cyborg offers a sense of continuity in our critical appreciation of the intersection between different and often contradictory modernities.

The idea of cyborg urbanization has emerged as a way of conceptualizing the body-technology nexus that underpins the contemporary city, but also as a corrective to those perspectives which seek to privilege the digital or virtual realm over material spaces. The cyborg concept can in this sense be enlisted into an intellectual project to 're-materialize' the city and establish substantive connections between the body, technology and space. But what kind of city is envisaged by this shift of emphasis towards the corporeal dimensions of urban experience? And, more importantly, what kind of political implications are bound up with the deployment of the cyborg concept in urban discourse? This article has identified a series of ways in which the idea of the cyborg intersects with urban politics: the neo-Marxian analysis of the commodification of the body, nature and space (and the circulatory dynamics between these elements); the post-Cartesian promotion of an ever-widening orbit of affinities and networks between the human and the non-human; the technophile anticipation of a liberating conjunction between the body and ever more sophisticated assemblages of technological networks; and the recurring allegorical trope of urban dystopias within which to foreground a critique of the contemporary city. I want, however, to emphasize one strand in particular: the potential for cyborgian conceptions of the city to emphasize the continuing political salience of the public realm. By doing so I wish to differentiate a historically grounded conception of the cyborg city from those morphological constructs associated with neo-organicist conceptions of urban hybridity. Whilst the idea of the cyborg is rooted in the recognition of spatial complexity, it also serves to emphasize unitary dimensions to the experience of space exemplified by the development of vast technological networks. A materialist reading of the cyborg city points to a critical reformulation of the public sphere which can encompass a different set of urban realities and a new range of epistemological themes. In a sense, therefore, the current challenge is to expose the elision between the technological and the political so that the cyborg city is opened up to contestation through a renewed connection between urban governance and the public realm.

The very fact that the cyborg is difficult to pin down in any fixed or categorical sense is a testament to its intellectual fecundity as a focus for extending urban thinking beyond conventional polarities. What I have attempted to do here is to develop the idea of the cyborg as part of a more nuanced vocabulary for the critical interpretation of cities. The cyborg concept, when used in conjunction with other key terms such as neo-organicism, rhizomatic space and distributed cognition, begins to enable a more precise discussion about the technological characteristics of contemporary cities. I have sought in particular to develop a relational and materially grounded reading of the cyborg as an intrinsic dimension to the co-evolution of social and technological systems. I have suggested that the concept raises issues that extend beyond the development of urban technological networks to encompass expanded conceptions of the human subject, changing conceptions of the public sphere

and new ways of interpreting urban landscapes. Most notably, however, the distinction between 'city' and 'non-city' becomes extensively blurred under cyborg urbanization to produce a tendential landscape exhibiting different forms of integration between the body technology and social practices. Viewed in this way the city is both a tangible entity but also a relational construct so that we cannot disentangle the one from the other. Yet, neither Haraway nor Latour is able to satisfactorily resolve the tension between expanded conceptions of agency (or affinity) and the need to contextualize technological networks within the bio-political dynamics of power that enable modern cities to function. There is, in other words, a conceptual lacuna at the heart of cyborg discourse emanating from the historicity of the body-technology nexus and its relationship to an ideological sense of the city as a functional whole. The blurring of agency in the cyborg city – which fundamentally contradicts the idea of modernity as a movement towards greater degrees of cognitive and sensory individuation – raises the prospect of a technically mediated public sphere but not in the sense of a digitized public realm. Part of the political challenge facing the hybrid city and its multifarious entanglements between the 'real' and the 'unreal' is to construct new kinds of autonomous spaces within which it is possible for different conceptions of the city to take shape. The emergence of the cyborg at a time of infrastructural crisis is more than coincidental since the concept simultaneously engages with both the renewed recognition of urban vulnerability and the theoretical hiatus facing the study of the city as a polymorphous web of different social practices, imaginative constructs and material elements.

Although the cyborg city represents a challenge to universalist conceptions of space, it is rooted in modernist discourses of cultural and political critique. A tendency towards the idea of the cyborg as a radical fusion of the body and technology can be discerned well before the term 'cyborg' began to acquire its current panoply of potential meanings and applications. The fantastical conjunction of human and machine, for example, predates the emergence of the cyborg as a named artefact and is an integral element in the critical vocabularies of cultural modernism that emerged as a counter discourse to the technological fervour of twentieth-century modernity. Unlike Haraway, however, I have emphasized those aspects of technological monstrosity which allow us to explore those contradictory aspects to modernity which can find no straightforward articulation. By enlisting the cyborg as a conceptual tool in urban discourse we can develop an imaginative response to the unknowability of the city and its power to generate cultural energies that ultimately impact on wider social and political processes. If the clearly defined human body of the industrial city has been replaced by the technologically diffuse body of the cyborg city, then what kind of bodily occlusions are implicated in this shift? How do the poorly paid workers within the interstices and margins of the global economy – the hidden bodies of late capitalism – struggling under the yoke of what Alain Lipietz once described as 'bloody Taylorization' fit into an enlarged and more sophisticated conception of the human subject? The undifferentiated 'we' of the more speculative and futuristic urban literature tends to overlook the emerging disparities in access between 'wired' and 'wireless' infrastructures exemplified by the infrastructure crisis facing the rapidly growing cities of the global South: new communications technologies may be increasingly ubiquitous but the numbers of people without adequate access to safe drinking water or effective sanitation have grown inexorably over the last quarter century. The cyberslums of the future will be the living embodiment of the contradictions inherent in a technologically rather than politically driven strategy for the creation of more socially inclusive cities. If monstrous representations of the cyborg city represent allegories for wider social injustice then we need to explore those forms of political monstrosity that have generated imaginary monsters. In dreams, after all, it is fear that creates our monsters rather than monsters that create our fear.

Notes

1 The word 'cyborg' is widely attributed to the NASA scientists Manfred E. Clynes and Nathan S. Kline who used the term in 1960 to describe a series of experiments that explored how the human body might be technologically enhanced in order to allow space travel. The etymological roots of the term 'cyborg' can be traced to the eighteenth-century word 'organism' (derived from the French *organisme*) and the more recent term 'cybernetics' introduced by the mathematician Norbert Wiener in the 1940s to describe the study of complex systems of control and communications in animals and machines. The literature on the cyborg ranges from conceptions of the cyborg as an ontological or epistemological strategy to explorations of specific manifestations of the cyborg in social and material practice. See, for example, Haraway (1984, 1991a, 1991b, 1992), Springer (1991), Alaimo (1994), Schroeder (1994), Dumit *et al*. (1995), Franklin (1995), Gabilondo (1995), Gray *et al*. (1995), Tomas (1995), Balsamo (1996), Lock (1996), Bostic (1998), Hacking (1998), Mitchell (1998), Picon (1998), Schaub (1998), Formenti (1999), Hayles (1999a), Fox (2000), Allison (2001), Tofts *et al*. (2002) and Zylinska (2002). For early accounts of the development and impact of cybernetics see, for example, the original contribution of Wiener (1948), Halacy (1965), Schöffer (1969; 1973) Lefebvre (1971), Delpech (1972), Negroponte (1975) and George (1977).

2 For greater detail on the geneology and impact of the 'cyborg manifesto' see Sofoulis (2002) who claims that the essay's most critical contribution was to challenge the prevalent essentialism within eco-feminist responses to science and technology. The earlier work of Haraway is perhaps best conceived in relation to the emerging post-Heideggerian critique of technology developed by, for example, Guattari (1993), Stabile (1994) and Lykke and Braidotti (1996), and in this sense provides a critical bridge between neo-Marxian political economy, feminist epistemologies of science and post-structuralist theory.

3 There is now a vast literature on cyberspace. Useful starting points include Benedikt (1991), Featherstone and Burrows (1995), Turkle (1995, 2002), Bingham (1996), Ludlow (1996), Woods (1996), Kitchen (1998), Lunenfeld (1999) and Wolmark (1999).

4 In the earlier phase of the digital revolution human consciousness was widely perceived as caught between what William Gibson referred to as the 'meat space' of the body and the disembodied subjectivity of the digital or virtual realm (see Stone, 1991; Greco, 1995; Hayles, 1999b; Downey, 2001; Mitchell, 2003; Thomas, 2003). Neil Leach (2002: 14), for example, insists on the use of the term 'digital realm' rather than virtual reality to better capture the interface between new technologies of representation and the evolving dynamics of urban space.

5 Other cinematic representations of the cyborg besides Michael Burke's *Cyborg City* (1999) include, for example, Masayuki Akehi *Cyborg 009* (1980); Albert Pyun *Cyborg* (1989); Gianetto De Rossi *Cyborg: II geuerriero d'acciaio* (1989); and Michael Schroeder *Cyborg² Glass Shadow* (1993).

6 For further insights into the historical continuities in the idea of the human body as a cyborg form see, for example, Canguilheim (1992), Biro (1994), Sykora (1999) and Keller (2002).

7 Examples of this coalescence between neo-organicist ideas and ecological thought in architecture and urban studies include Jencks (1993), Papanek (1995), Sukopp *et al*. (1995), Slessor (1997), Poole (1998), Ruano (1999), Kurokawa (2001b), Pearson (2001), Gauzin-Müller (2002), Gans and Kuz (2003), Lalvani (2003) and Senosiain (2003). Key influences on the incorporation of natural forms in urban design include classic works such as Zevi (1950), Katavolos (1961), Häring (1962) and Alexander (1964). Other important inputs into what one might term 'organic' architecture also include the designs of Alvar Aalto, Hans Scharoun and Bruno Zevi and also the influential metabolist manifesto of Kisho Kurokawa (see Kurokawa, 2001a; Framptoh, 2003; Gandy, 2004).

8 See, for example, Deleuze (1988; 1993), de Vries (1993), Wigley (1993), De Landa (1994, 1998a, 1998b, 2002), Robbins (1998); Bostic (1998), Kinnard (1998), Lynn (1998, 1999), van Berkel and Bos (1998), Coyne (1999) and Di Cristina (2001).

9 Examples of so-called 'parallel' or virtual architectural practices include Asymptote, UN Studio and AMO.

10 See, for example, Thrift (1999, 2000a, 2004), Amin and Thrift (2002), Doel and Hubbard (2002), Thrift and French (2002) and Smith (2003a, 2003b). We should note, however, that

Deleuze resisted the categorization of his work as post-structuralist (see Rajchman, 2000: 146).

11 For greater detail on the impact of deconstructive and post-structuralist ideas within architecture see, for example, Wigley (1993). An emerging emphasis on 'anti-planning' can be found in, for example, Koolhaas (1990, 1995). See also Hughes and Sadler (2000).

12 On the future development of military technologies see, for example, Gray (1997), Virilio (1997) and Der Derian (2001).

13 On the post-human subject see, for example, Grosz (1992), Halberstam and Livingston (1995), Wood (1998), Hayles (1999a), Feenberg (2000) and Murdoch (2001).

14 For explorations of the significance of hybridity for the understanding of relations between nature, culture and the production of space see, for example, Bingham (1996), Wolch (1996), Luke (1997), Swyngedouw (1999, 2004), Kull (2001), Murdoch (2001), Whatmore (2002) and Latour (2004).

15 On the evolution of modern infrastructure networks see, for example, Hughes (1983), Abriani (1988), Callon (1991), Dupuy (1991), Picon (1992), MacKenzie (1996), Latour and Hermant (1998), Mackenzie and Wajcman (1999), Jacobson (2000) and Melosi (2000).

16 See, for example, Swyngedouw (1997a), Brenner (1998, 2000), Graham (2000), Jessop (2000) and Graham and Marvin (2001).

17 For greater detail on debates surrounding 'governmentality' and the modern state see, for example, Gordon (1991), Law (1994), Barry et al. (1996), Dean (1999) and Rose (1999). On subjectivity and architecture see also Wigley (1990).

18 On social and cultural histories of modern plumbing see, for example, Giedion (1948), Hamlin (1998), Lahiji and Friedman (1997), Laporte (2000) and Kaïka (2004).

19 Examples of the late-modern 'wired city' include the work of Archigram, Archizoom and Superstudio. By the 1970s a sense of unease about urban technological networks had evolved into a 'techno-fetishist' vision of urban space encased in a hyphal network of giant ducts, wires and pipes that manifested in the late modern architecture of the exoskeleton exemplified, by Richard Rodger's designs for the Lloyds building in London and the Pompidou Centre in Paris. See Picon (1998), Armstrong (2000) and Mitchell (2003).

20 For more details on the spatial dimensions to the sublime and the uncanny see, for example, Lyotard (1982, 1989, 1994), Deleuze (1984), Vidler (1987, 2000), Crowther (1992), Boyd Whyte (1993), Nesbitt (1995), Riese (1998), Patterson (1999), Freyssinet (2001), Demos (2003), Royle (2003) and Kelley (2004).

References

Abriani, A. (1988) Dal Sifone alla città [From the siphon to the city], *Casabella: International Architectural Review* 54.2/3, 24–9.

Agamben, G. (1998) *Homo sacer: sovereign power and bare life.* Translated by D. Heller-Roazen, Stanford University Press, Stanford.

Akira, A. (2001) Untitled. In G. Genosko (ed.), *Deleuze und Guattari: critical assessments of leading philosophers*, Volume III, Routledge, London.

Alaimo, S. (1994) Cyborg and ecofeminist interventions: challenges for an environmental feminism. *Feminist Studies* 20, 133–52.

Alexander, C. (1964) *Notes on the synthesis of form.* Harvard University Press, Cambridge, MA.

Allison, A. (2001) Cyborg violence: bursting borders and bodies with queer machines. *Cultural Anthropology* 16, 237–65.

Amin, A. and N. Thrift (2002) *Cities: re-imagining the urban.* Polity Press, Cambridge.

Appadurai, A. (2002) Deep democracy: urban governmentality and the horizon of politics. *Public Culture* 14.1, 21–47.

Armstrong, R. (2000) Cyborg architecture and Terry Gilliam's *Brazil. Architectural Design: Architecture and Film II* 70, 55–7.

Augé, M. (1995) *Non-places: introduction to an anthropology of supermodernity.* Translated by John Howe, Verso, London.

Ballard, J.G. (1975) *High-rise*. Cape, London.

Balsamo, A. (1996) *Technologies of the gendered body: reading cyborg women*. Duke University Press, Durham, NC.

Barry, A., N. Rose and T. Osborne (1996) (eds) *Foucault and political reason: liberalism, neo-liberalism and rationalities of government*. Chicago University Press, Chicago, IL.

Bauman, Z. (2004) *Wasted lives: modernity and its outcasts*. Polity, Cambridge.

Benedikt, M. (ed.) (1991) *Cyberspace: first steps*. The MIT Press, Cambridge, MA.

Bingham, N. (1996) Object-ions: from technological determinism towards geographies of relations. *Environment and Planning D: Society and Space* 14, 635–57.

Biro, M. (1994) The new man as cyborg, figures of technology in Weimar visual culture. *New German Critique* 62, 71–110.

Bostic, A.I. (1998) Seeing cyborg through the eyes of popular culture, computer-generated imagery, and contemporary theory. *Leonardo* 31, 357–61.

Boundas, C.V. (1996) Deleuze-Bergson: an ontology of the virtual. In P. Patton (ed.), *Deleuze: a critical reader*, Blackwell, Oxford.

Boyd Whyte, I. (1993) The expressionist sublime. In T. Benton (ed.), *Expressionist utopias: paradise, metropolis, architectural fantasy*, Los Angeles County Museum of Art, Los Angeles, CA.

Boyer, C.M. (1996) *Cybercities: visual perception in the age of electronic communication*. Princeton Architectural Press, New York.

Brenner, N. (1998) Between fixity and motion: accumulation, territorial organization and the historical geography of spatial scales. *Environment and Planning D: Society and Space* 16, 459–81.

—— (2000) The urban question as a scale question: reflections on Henri Lefebvre, urban theory and the politics of scale. *International Journal of Urban and Regional Research* 24, 361–78.

Broderick, D. (2002) Racing towards the spike. In D. Tofts, A. Jonson and A. Cavallaro (eds), (2002) *Prefiguring cyberculture: an intellectual history*, The MIT Press, Cambridge, MA.

Bukatman, S. (1993) *Terminal identity: the virtual subject in post-modern science fiction*. Duke University Press, Durham, NC.

Burke, M. (1998) Cyborg city. Film notes listed at www.yle.fi/d-projekti/arkisto/saa/99kyber.html (accessed 2 January 2004).

Cairncross, F. (1997) *The death of distance*. Harvard Business School Press, Boston, MA.

Calhoun, C. (2002) Imagining solidarity: cosmopolitanism, constitutional patriotism, and the public sphere. *Public Culture* 14.1, 147–71.

Callard, F. (1998) The body in theory. *Enviroment and Planning D: Society and Space* 16, 387–400.

Callon, M. (1991) Techno-economic networks and irreversibility. In J. Law (ed.), *A sociology of monsters: essays on power, technology and domination*, Routledge, London.

Canguilheim, G. (1992) Machine and organism. In J. Crary and S. Kwinter (eds), *Incorporations*. Zone, New York.

Castells, M. (2000) *The rise of the network society*. Second edition, Blackwell, Oxford.

Castoriadis, C. (1987) *The imaginary institution of society*. Translated by K. Blamey, The MIT Press, Cambridge, MA.

Chatzis, K. (2001) Cyborg urbanization. Review of B. Latour and E. Hermant (1998) *Paris ville invisible*; J.W.T. Mitchell (1998) *E-topia* and A. Picon (1998) *La ville territoire des cyborgs*. Translated by Karen George. *International Journal of Urban and Regional Research* 25, 906–11.

Chu, K.S. (2002) The unconscious destiny of capital (architecture in vitro/machinic in vivo). In N. Leach (ed.), *Designing for a digital world*, Wiley-Academy, Chichester.

Clayton, J. (1996) Concealed circuits. *Raritan: A Quarterly Review* 15, 53–69.

Corbin, A. (1986) *The foul and the fragrant: odor and the French social imagination*. Harvard University Press, Cambridge, MA.

Coyne, R. (1999) *Technoromanticism: digital narrative, holism and the romance of the real*. The MIT Press, Cambridge, MA.

Crowther, P. (1992) *Les immatériaux* and the postmodern sublime. In A. Benjamin (ed.), *Judging Lyotard*, Routledge, London.

Dean, J. (2001) Cybersalons and civil society: rethinking the public sphere in transnational technoculture. *Public Culture* 13.2, 243–65.

Dean, M. (1999) *Governmentality: power and rule in modern society*. Sage, London.

De Landa, M. (1994) Virtual environments and the rise of synthetic reason. In M. Dery (ed.), *Flame wars: a discourse of cyber culture*, Duke University Press, Durham, NC.

—— (1998a) Meshworks, hierarchies, and interfaces. In J. Beckman (ed.), *Virtual dimension*, Princeton Architectural Press, New York.

—— (1998b) Deleuze, diagrams, and the genesis of form. *ANY: Architecture New York* 23, 30–4.

—— (2002) Deleuze and the use of the genetic algorithm in architecture. In N. Leach (ed.), *Designing for a digital world*, Wiley-Academy, Chichester.

Deleuze, G. (1984) *Kant's critical philosophy: the doctrine of the faculties*. Translated by H. Tomlinson and B. Habberjam, Athlone, London.

—— (1988) *Foucault*. Translated by Seàn Hand, University of Minnesota Press, Minneapolis, MN.

—— (1993) The fold – Leibniz and the baroque. *Architectural Design* 19, 16–21.

—— and F. Guattari (1986) City/state. In J. Crary, M. Feher, H. Foster and S. Kwinter (eds), *Zone 1/2: the contemporary city*. Zone Books, New York.

—— and F. Guattari (1987) *A thousand plateaus: capitalism and schizophrenia*. Translated by Brian Massumi, Athlone, London.

Delpech, L.-J. (1972) *La cybernétique et ses théoriciens*. Casterman, Paris.

Demos, T.J. (2003) The cruel dialectic: on the work of Nils Norman. *Grey Room* 13, 32–53.

Der Derian, J. (2001) *Virtuous war: mapping the military-industrial-media-entertainment network*. Westview Press, Boulder, CO.

Dery, M. (2002) Memories of the future: excavating the jet age at the TWA terminal. In D. Tofts, A. Jonson and A. Cavallaro (eds), *Prefiguring cyberculture: an intellectual history*, The MIT Press, Cambridge, MA.

de Vries, G.W. (1993) Deleuze en de architectuur: aanzet tot een gebruiksaanwijzing [Deleuze and architecture: a preliminary guide], *Archis* 11, 54–65.

Di Cristina, G. (2001) *Architecture and science*. John Wiley, London.

Doel, M. and P. Hubbard (2002) Taking world cities literally: marketing the city in a global space of flows. *City* 6, 351–68.

Downey, G. (2001) Virtual webs, physical technologies, and hidden workers. *Technology and Culture* 42, 209–35.

Dumit, J., G.L. Downey and S. Williams (1995) Cyborg anthropology. *Cultural Anthropology* 10, 2–16.

Dupuy, G. (1991) *L'Urbanisme des réseaux. Théories et méthodes*. Armand Collins, Paris.

Featherstone, M. and R. Burrows (eds) (1995) *Cyberpunk/cyberspace/cyberbodies*. Sage, London.

Feenberg, A. (2000) Will the real post-human please stand up. *Social Studies of Science* 30, 151–7.

Formenti, C. (1999) Il cyborg bulimico. *Aut Aut* 289/90 (January to April), 43–7.

Fox, M. (2000) Pre-persons, commodities or cyborgs: the legal construction and representation of the embryo. *Health Care Analysis* 8, 171–88.

Frampton, K. (1996) *Tectonic culture*. The MIT Press, Cambridge, MA.

—— (2003) Organic organ-i-city. In D. Gans and Z. Kuz (eds), *The organic approach to architecture*, Wiley-Academy, Chichester.

Franklin, S. (1995) Science as culture, cultures of science. *Annual Review of Anthropology* 24, 163–84.

Freyssinet, E. (2001) On the sublime. *Architectural Research Quarterly* 5, 249–53.

Gabilondo, J. (1995) *Postcolonial cyborgs: subjectivity in the age of cybernetic reproduction*. In C.H. Gray, H. Fugueroa-Sarriera and S. Mentor (eds), *The cyborg handbook*, Routledge, London.

Gandy, M. (2002) *Concrete and clay: reworking nature in New York City*. The MIT Press, Cambridge, MA.

—— (2004) Rethinking urban metabolism: water, space and the modern city. *City: analysis of urban trends, culture, theory policy, action* 8.3, 371–87.

—— (2005) Learning from Lagos. *New Left Review* 33, 37–53.

Gans, D. and Z. Kuz (eds) (2003) *The organic approach to architecture*. Wiley-Academy, Chichester.

Garver, T.H. (1998) Serving places. In S. Greenberg (ed.), *Invisible New York: the hidden infrastructure of the city*, Johns Hopkins University Press, Baltimore, MD.

Gauzin-Müller, D. (2002) *Sustainable architecture and urbanism: concepts, technologies, examples*. Birkhäuser, Boston.

George, F.H. (1977) *The foundations of cybernetics*. Gordon and Breach, London.

Gibson, W. (1986) *Neuromancer*. Harper Collins, London.

Giedion, S. (1948) *Mechanization takes command*. Oxford University Press, Oxford.

Gille, D. (1986) Maceration and purification. In J. Crary, M. Feher, H. Foster and S. Kwinter (eds), *Zone 1/2: the contemporary city*. Zone Books, New York.

Gordon, C. (1991) Governmental rationality: an introduction. In G. Burchell, C. Gordon and P. Miller (eds), *The Foucault effect: studies in governmentality*, Harvester Wheatsheaf, Hemel Hempstead.

Graham, S. (2000) Constructing premium network spaces: reflections on infrastructure networks and contemporary urban development. *International Journal of Urban and Regional Research* 24, 183–200.

—— (2003) Lessons in urbicide. *New Left Review* 19, 63–77.

—— (2004) Switching cities off. War, infrastructure, geopolitics. Paper presented at the conference *Urban Vulnerabilities*, University of Salford, 29–30 April.

—— and S. Marvin (2001) *Splintering urbanism: networked infrastructures, technological mobilities and the urban condition*. Routledge, London.

Gray, C.H. (1997) The cyborg soldier: future/present. In C.H. Gray, *Postmodern war: the new politics of conflict*, Guilford Press, New York.

——, H.J. Fugueroa-Sarrieraand and S. Mentor (eds) (1995) *The cyborg handbook*. Routledge, London.

Greco, D. (1995) *Cyborg: engineering the body electric*. Mac and Windows (electronic hypertext), Eastgate Systems.

Grosz, E. (1992) Bodies-cities. In B. Colomina (ed.), *Sexuality and space*, Princeton Architectural Press, New York.

—— (2001) *Architecture from the outside: essays on virtual and real space*. The MIT Press, Cambridge, MA.

Guattari, F. (1993) Machinic heterogenesis. In V.A. Conley (ed.), *Rethinking technologies*, University of Minnesota Press, Minneapolis, MN.

Habermas, J. (1998) *The inclusion of the other: studies in political theory*. Edited by C. Cronin and P. De Grieff, The MIT Press, Cambridge, MA.

Hacking, I. (1998) Canguilhem amid the cyborgs. *Economy and Society* 27, 202–26.

Halacy, D.S. (1965) *Cyborg: evolution of the superman*. Harper & Row, New York.

Halberstam, J. and I. Livingston (eds) (1995) *Posthuman bodies: unnatural acts*. Indiana University Press, Bloomington, IN.

Hall, S. (2003) Creolization, diaspora, and hybridity in the context of globalization. In O. Enwezor, C. Basualdo, U.M. Bauer, S. Ghez, S. Maharaj, M. Nash and O. Zaya (eds), *Documenta 11_Platform 3. Créolité and creolization*, Hatje Cantz, Ostfildern-Ruit.

Hamlin, C. (1998) *Public health and social justice in the age of Chadwick*. Cambridge University Press, Cambridge.

Haraway, D. (1984) Lieber Kyborg als Göttin! Für eine sozialistisch-feministische Unterwanderung der Gentechnologie. *Argument-Sonderband* 105, 66–84.

—— (1991a) [1985] A cyborg manifesto. In *Simians, cyborgs, and women: the reinvention of nature*. Free Association Books, London.

—— (1991b) The actors are cyborg, nature is coyote, and the geography is elsewhere: postscript to 'cyborgs at large'. In C. Penley and A. Ross (eds), *Technoculture*, University of Minnesota Press, Minneapolis, MN.

—— (1992) Promises of monsters: a regenerative politics for inappropriate/d others. In L. Grossberg, C. Nelson and P. Treichler (eds), *Cultural studies*, Routledge, London.

Häring, H. (1962) [1982 edition] *Das andere Bauen*. Edited by J. Joedicke, Karl Krämer, Stuttgart.

Hayles, N.K. (1999a) *How we became posthuman: virtual bodies in cybernetics, literature, and informatics*. The University of Chicago Press, Chicago, IL.

—— (1999b) The condition of virtuality. In P. Lunenfeld (ed.), *The digital dialectic*, The MIT Press, Cambridge, MA.

Hicks, E.D. (2001) Derritorialization and border writing. In G. Genosko (ed.) *Deleuze und Guattari: critical assessments of leading philosophers*, Volume III, Routledge, London.

Hughes, J. and S. Sadler (eds) (2000) *Non-plan: essays on freedom, participation and change in modern architecture and urbanism*. Architectural Press, Oxford.

Hughes, T.P. (1983) *Networks of power: electrification in Western society 1880–1930*. Johns Hopkins University Press, Baltimore, MD.

Ingram, D. (1994) Foucault and Habermas on the subject of reason. In G. Gutting (ed.), *The Cambridge companion to Foucault*, Cambridge University Press, Cambridge.

Jacobson, C.D. (2000) *Ties that bind: economic and political dilemmas of urban utility networks, 1800–1990*. University of Pittsburgh Press, Pittsburgh, PA.

Jameson, F. (1982) Progress vs. utopia; or, can we imagine the future? *Science Fiction Studies* 9, 147–58.

Jencks, C. (1993) *Heteropolis: Los Angeles, the riots and the strange beauty of heteroarchitecture*. Academy Editions, London.

Jessop, B. (2000) The crisis of the national spatio-temporal fix and the tendential ecological dominance of globalizing capitalism. *International Journal of Urban and Regional Research* 24, 323–60.

Kaïka, M. Interrogating the geographies of the familiar: domesticating nature and constructing the autonomy of the modern home. *International Journal of Urban and Regional Research* 28, 265–86.

—— and E. Swyngedouw (2000) Fetishising the modern city: the phantasmagoria of urban technological networks. *International Journal of Urban and Regional Research* 24, 120–38.

Katavolos, W. (1961) [1987 edition] Organics. Reprinted in U. Conrads (ed.), *Manifestos of 20th century architecture*, The MIT Press, Cambridge, MA.

Keller, E.F. (2002) Marrying the premodern to the postmodern: computers and organisms after WWII. In D. Tofts, A. Jonson and A. Cavallaro (eds), *Prefiguring cyberculture: an intellectual history*, The MIT Press, Cambridge, MA.

Kelley, M. (2004) *The uncanny*. Walther König, Cologne.

King, A.D. (ed.) (1995) *Re-presenting the city: ethnicity, capital and culture in the 21st century*. Macmillan, London.

Kinnard, J. (1998) Contextualizing the city: the bricoleur and the weaver. *Harvard Architecture Review* 10, 17–23.

Kitchen, R. (1998) *Cyberspace: the world in the wires*. John Wiley, New York.

Koolhaas, R. (1990) Die Inszenierung der Ungewissheit. Rem Koolhaas im Gespräch mit ARCH$^+$. *ARCH$^+$*. 105/6, 68–72.

—— (1995) The generic city. In Office of Metropolitan Architecture, R. Koolhaas, B. Mau and J. Sigler (eds), *S,M,L,XL*, The Monacelli Press, New York.

—— (2002) Fragments of a lecture on Lagos. In O. Enwezor, C. Basualdo, U.M. Bauer, S. Ghez, S. Maharaj, M. Nash and O. Zaya (eds), *Documenta 11_Platform 4. Under siege: four African cities. Freetown, Johannesburg, Kinshasa, Lagos*, Hatje Cantz, Ostfildern-Ruit.

—— /Harvard Project on the City, S. Boeri/Multiplicity, S. Kwinter, N. Tazi and H.U. Obrist (2001) *Mutations*. ACTAR, Barcelona.

Kull, A. (2001) The cyborg as an interpretation of culture-nature. *Zygon* 36, 49–56.

Kurokawa, K. (2001a) Toward a rhizome world or 'chaosmos'. In G. Genosko (ed.), *Deleuze and Guattari: critical assessments of leading philosophers*, Volume III, Routledge, London.

—— (2001b) *The philosophy of symbiosis from the ages of the machine to the age of life*. Edizioni Press, New York.

Lahiji, N. and D.S. Friedman (eds) (1997) *Plumbing: sounding modern architecture*. Princeton Architectural Press, New York.

Lalvani, H. (2003) Genomic architecture. In D. Gans and Z. Kuz (eds), *The organic approach to architecture*, Wiley-Academy, Chichester.

Laporte, D. (2000) *History of shit*. Translated by Nadia Benabid and Rodolphe el-Khoury, The MIT Press, Cambridge, MA.

Latour, B. (1993) *We have never been modern*. Harvester Wheatsheaf, New York.

—— (2004) *Politics of nature*. Translated by C. Porter, Harvard University Press, Cambridge, MA.

—— and E. Hermant (1998) *Paris ville invisible*. Les Empêcheurs de Penser en Rond/La Découverte, Paris.

Law, J. (1994) *Organizing modernity*. Blackwell, Oxford.

Leach, N. (ed.) (2002) *Designing for a digital world*. Wiley-Academy, Chichester.

Lefebvre, H. (1971) *Vers le cybernanthrope*. Denoël/Gonthier, Paris.

Lock, M. (1996) Death in technological time: locating the end of meaningful life. *Medical Anthropology Quarterly* 10, 575–600.

Luckhurst, R. (1997) *The angle between two walls: the fiction of J.G. Ballard*. Liverpool University Press, Liverpool.

Ludlow, P. (ed.) (1996) *High noon on the electronic frontier: conceptual issues in cyberspace*. The MIT Press, Cambridge, MA.

Luke, T.W. (1996) Liberal society and cyborg subjectivity: the politics of environments, bodies, and nature. *Alternatives: Social Transformation and Human Governance* 21, 1–30.

—— (1997) At the end of nature: cyborgs, 'humachines', and environment in postmodernity. *Environment and Planning A* 29, 1367–80.

Lunenfeld, P. (ed.) (1999) *The digital dialectic*. The MIT Press, Cambridge, MA.

Lykke, N. and R. Braidotti (eds) (1996) *Between monsters, goddesses and cyborgs: feminist confrontations with science, medicine and cyberspace*. Zed Books, London.

Lynn, G. (1998) *Fold, bodies and blobs: collected essays*. La Lettre Volée, Brussels.

—— (1999) *Animate form*. Princeton University Press, Princeton, NJ.

Lyotard, J-F. (1982) Presenting the unpresentable: the sublime. *ArtForum* 20, 36–43.

—— (1989) Complexity and the sublime. In L, Appignanesi (ed.), *Postmodernism: ICA documents*, Free Association Books, London.

—— (1994) *Lessons on the analytic of the sublime*. Translated by E. Rottenberg, Stanford University Press, Stanford, CA.

MacKenzie, D. (1996) *Knowing machines: essays on technical change*. The MIT Press, Cambridge, MA.

—— and J. Wajcman (eds) (1999) *The social shaping of technology*. Second edition, Open University Press, Milton Keynes.

Marras, A. (1999) Hybrids, fusions, and architecture of the in-between. In A. Marras (ed.), *ECO-TEC: architecture of the in-between*, Princeton Architectural Press, New York.

Massumi, B. (2001) Sensing the virtual, building the insensible. In G. Genosko (ed.), *Deleuze und Guattari: critical assessments of leading philosophers*, Volume III, Routledge, London.

Melosi, M.V. (2000) *The sanitary city: urban infrastructure from colonial times to the present*. Johns Hopkins University Press, Baltimore, MD.

Mitchell, W.J. (1998) Cyborg civics. *Harvard Architecture Review* 10, 164–75.

—— (2003) *Me^{++}: the cyborg self and the networked city*. The MIT Press, Cambridge, MA.

Murdoch, J. (2001) Ecologizing sociology: actor-network theory, co-construction and the problem of human exceptionalism. *Sociology* 35, 111–33.

Nantois, F. (2002) *La revolution informationnelle en architecture (de 1947 à nos jours): de la cybernétique au cyberspace*. Unpublished PhD thesis, Université Paris 8 – Vincennes Saint-Denis.

Negroponte, N. (ed.) (1975) *Soft architecture machines*. The MIT Press, Cambridge, MA.

Nesbitt, K. (1995) The sublime in modern architecture: unmasking (an aesthetic of) abstraction. *New Literary History* 26, 95–110.

Osborne, T. (1996) Security and vitality: drains, liberalism and power in the nineteenth century. In A. Barry, T. Osborne and N. Rose (eds), *Foucault and political reason: liberalism, neo-liberalism and the rationalities of government*, UCL Press, London.

Otter, C. (2002) Making liberalism durable: vision and civility in the late Victorian city. *Social History* 27, 1–15.

Papanek, V. (1995) *The green imperative: ecology and ethics in design and architecture*. Thames and Hudson, London.

Patterson, R. (1999) Trauma, modernity, and the sublime. *Journal of Architecture* 4, 31–8.

Pearson, D. (2001) *New organic architecture*. Gaia, London.

Picon, A. (1992) *L'invention de l'ingénieur moderne. L'école des ponts des chaussées 1747–1851*. Presses de l'École des Ponts des Chaussées, Paris.

—— (1998) *La ville territoire des cyborgs*. Les Éditions de L'Imprimeur, Paris.

—— (2000) Anxious landscapes: from the ruin to rust. *Grey Room* 1, 64–83.

Poole, K. (1998) Civitas oecologie: infrastructure in the ecological city. *Harvard Architectural Review* 10, 126–45.

Rabinbach, A. (1990) *The human motor: energy, fatigue and the origins of modernity*. University of California Press, Berkeley, CA.

Rajchman, J. (2000) *The Deleuze connections*. The MIT Press, Cambridge, MA.

Rauterberg, H. (2002) Die Kunst im Chaos. *Die Zeit* 4 April, 35.

Riese, U. (1998) Landschaft: die Spur des Sublimen. In H-W. Schmidt and U. Riese (eds), *Landschaft: die Spur des Sublimen*, Kerber Verlag, Bielefeld.

Robbins, E. (1998) Thinking the city multiple. *Harvard Architectural Review* 10, 36–45.

Robins, K. (1995) Cyberspace and the world we live in. In M. Featherstone and R. Burrows (eds), *Cyberspace, cyberbodies, cyberpunk: cultures of technological embodiment*, Sage, London.

Robinson, J. (2002) Global and world cities: a view from off the map. *International Journal of Urban and Regional Research* 26, 531–54.

Rose, N. (1999) *Powers of freedom: reframing political thought*. Cambridge University Press, Cambridge.

Royle, N. (2003) *The uncanny: an introduction*. Manchester University Press, Manchester.

Ruano, M. (1999) *Ecourbanismo: entornos humanos sostenibles*. Gustavo Gili, Barcelona.

Sassen, S. (2001) *Global city: London, New York, Tokyo*. Second edition, Princeton University Press, Princeton, NJ.

Schaub, J.C. (1998) Presenting the cyborg's futurist past: an analysis of Dzigo Vertov's Kino-Eye. *Postmodern Culture* 8, 40–53.

Schöffer, N. (1969) *La ville cybernétique*. Tchou, Paris.

—— (1973) *La tour lumière cybernétique*. Denoël/Gonthier, Paris.

Schroeder, R. (1994) Cyberculture, cyborg postmodernism and the sociology of virtual-reality technologies: surfing the soul in the information age. *Futures* 26, 519–28.

Schumacher, P. (2002) Robotic fields: spatialising the dynamics of corporate organisation. In N. Leach (ed.), *Designing for a digital world*, Wiley-Academy, Chichester.

Sennett, R. (2000) Reflections on the public realm. In G. Bridge and S. Watson (eds), *A companion to the city*, Blackwell, Oxford.

Senosiain, J. (2003) *Bio-architecture*. Elsevier, Amsterdam.

Simone, A. (2001) Straddling the divides: remaking associational life in the informal African city. *International Journal of Urban and Regional Research* 25, 102–17.

—— (2002) The visible and invisible: remaking cities in Africa. In O. Enwezor, C. Basualdo, U.M. Bauer, S. Ghez, S. Maharaj, M. Nash and O. Zaya (eds), *Documenta 11_Platform 4 Under Siege: four African cities. Freetown, Johannesburg, Kinshasa, Lagos*, Hatje Cantz, Ostfildern-Ruit.

Slessor, C. (1997) *Eco-tech: sustainable architecture and high technology*. Thames and Hudson, London.

Smith, R.G. (2003a) World city actor-networks. *Progress in Human Geography* 27, 25–44.

—— (2003b) World city topologies. *Progress in Human Geography* 27, 561–82.

Sofoulis, Z. (2002) Cyberquake: Haraway's manifesto. In D. Tofts, A. Jonson and A. Cavallaro (eds), *Prefiguring cyberculture: an intellectual history*, The MIT Press, Cambridge, MA.

Springer, C. (1991) The pleasure of the interface: language and sexual cyborg imagery in technological culture. *Screen* 32, 302–23.

Stabile, C. (1994) *Feminism and the technological fix*. Manchester University Press, Manchester.

Stone, A.R. (1991) Will the real body please stand up? Boundary stories about virtual cultures. In M. Benedikt (ed.), *Cyberspace: first steps*, The MIT Press, Cambridge, MA.

Sukopp, H., M. Numata and A. Huber (1995) *Urban ecology as the basis of urban planning*. SPB Academic Publishing, Amsterdam.

Swyngedouw, E. (1996) The city as a hybrid: on nature, society and cyborg urbanization. *Capitalism, Nature, Socialism* 7, 65–80.

—— (1997a) Neither global or local: 'glocalization' and the politics of scale. In K. Cox (ed.), *Spaces of globalization: reasserting the power of the local*, Guilford Press, New York.

—— (1997b) Power, nature, and the city. The conquest of water and the political ecology of urbanization in Guayaquil, Ecuador: 1880–1990. *Environment and Planning A* 29, 311–32.

—— (1999) Modernity and hybridity: nature, regenerationismo, and the production of the Spanish waterscape, 1890–1930. *Annals of the Association of American Geographers* 89, 443–65.

—— (2004) *Social power and the urbanization of water: flows of power*. Oxford University Press, Oxford.

Sykora, K. (1999) *Unheimliche Paarungen: Androidfaszination und Geschlecht in der Fotografie*. Walther König, Köln.

Tadiar, N.X.M. (1995) Manila's new metropolitan form. In V.L. Rafael (ed.), *Discrepant histories*, Temple University Press/Anvil Publishing, Philadelphia, PA/Manila.

Taylor, C. (2004) *Modern social imaginaries*. Duke University Press, Durham, NC.

Teyssot, G. (1990) Cancellazione e scorporamento: dialoghi con Diller + Scofidio [Erasure and disembodiment: dialogues with Diller + Scofidio]. *Ottagono* 96, 56–88.

Thomas, D. (2003) From the cyborg to posthuman space: on the total eclipse of an idea. *Parachute* 112, 81–91.

Thrift, N. (1999) The place of complexity. *Theory, Culture and Society* 16, 31–69.

—— (2000a) Not a straight line but a curve, or, cities are not mirrors of modernity. In D. Bell and A. Haddour (eds), *City visions*, Longman, London.

—— (2000b) Afterwords. *Environment and Planning D: Society and Space* 18, 213–55.

—— (2004) Remembering the technological unconscious by foregrounding knowledges of position. *Environment and Planning D: Society and Space* 22, 175–90.

—— and S. French (2002) The automatic production of space. *Transactions of the Institute of British Geographers* 27, 309–35.

Tofts, D., Jonson, A. and Cavallaro, A. (eds) *Prefiguring cyberculture: an intellectual history*. The MIT Press, Cambridge, MA.

Tomas, D. (1995) Feedback and cybernetics: reimaging the body in the age of the cyborg. In M. Featherstone and R. Burrows (eds). *Cyberpunk/cyberspace/cyberbodies*, Sage, London.

Tsouvalis, J. (2003) Cyborg. In D. Sibley, P. Jackson, D. Atkinson and N. Washbourne (eds), *Cultural geography: a critical dictionary of key ideas*, IB Taurus, London.

Turkle, S. (1995) *Life on the screen: identity in the age of the internet*. Simon and Schuster, New York.

—— (2002) E-futures and e-personae. In N. Leach (ed.), *Designing for a digital world*, Wiley-Academy, Chichester.

Uno, K. (2001) The enemy of architecture. In G. Genosko (ed.), *Deleuze und Guattari: critical assessments of leading philosophers*, Volume III. Routledge, London.

van Berkel, B. and C. Bos (1998) Diagrams–interactive instruments in operation. *ANY: Architecture New York* 23, 19–23.

Vidler, A. (1987) The architecture of the uncanny: the unhomely houses of the romantic sublime. *Assemblage* 3, 6–29.

—— (1990) Case per cyborg: protesti domestiche da Salvador Dali a Diller e Scofidio [Homes for cyborgs: domestic prostheses from Salvador Dali to Diller and Scofidio]. *Ottagono* 96, 36–55.

—— (2000) *Warped space: art, architecture, and anxiety in modern culture*. The MIT Press, Cambridge, MA.

Villani, T. (1995) *Athena cyborg. Per una geografia dell'espressione: corpo, territorio, metropolis*. Mimesis, Milan.

Virilio, P. (1991) The overexposed city. In *Lost dimension, translated by Daniel Moshenberg*, Semiotext(e), New York.

—— (1995) *The art of the motor*. Translated by J. Rose, University of Minnesota Press, Minneapolis, MN.

—— (1997) *Interview with James Der Derian*. Translated by J. Der Derian, M. Degener and L. Osepchuk (http://proxy.arts.uci.edu/~nideffer/_SPEED/1.4/articles/. derderian.html, accessed (22 December 2003).

Waldby, C. (2002) The instruments of life: Frankenstein and cyberculture. In D. Tofts, A. Jonson and A. Cavallaro (eds), *Prefiguring cyberculture: an intellectual history*, The MIT Press, Cambridge, MA.

Whatmore, S. (2002) *Hybrid geographies*. Sage, London.

Wiener, N. (1948) *Cybernetics or control and communication in the animal and the machine*. The MIT Press, Cambridge, MA.

Wigley, M. (1990) La disciplina dell'architettura [The disciplining of architecture]. *Ottagono* 96, 19–26.

—— (1993) *The architecture of deconstruction: Derrida's haunt*. The MIT Press, Cambridge, MA.

Williams, R.H. (1990) *Notes on the underground: an essay on technology, society and the imagination*. The MIT Press, Cambridge, MA.

Wolch, J. (1996) Zoöpolis. *Capitalism, Nature, Socialism* 7, 21–47.

Wolmark, J. (1994) *Aliens and others: science fiction, feminism and postmodernism*. Harvester Wheatsheaf, New York.

—— (ed.) (1999) *Cybersexualities: a reader on feminist theory, cyborg and cyberspace*. Edinburgh University Press, Edinburgh.

Wood, M. (1998) Agency and organization: toward a cyborg-consciousness. *Human Relations* 51, 1209–26.

Woods, L. (1996) The question of space. In S. Aronowitz, B. Martinsons and M. Menser (eds), *Technoscience and cyberculture*, Routledge, London.

Zevi, B. (1950) *Towards an organic architecture*. Faber & Faber, London.

Zitouni, B. (2004) Donna Haraway and Bruno Latour: quid urban studies? Paper presented at the conference on *Techno-Natures*, University of Oxford, 25 June.

Žižek, S. (2002) From virtual reality to the virtualisation of reality. In N. Leach (ed.), *Designing for a digital world*, Wiley-Academy, Chichester.

Zylinska, J. (ed.) (2002) *The cyborg experiments: the extensions of the body in the media age*, Continuum, London.

Adriana de Souza e Silva

FROM CYBER TO HYBRID
Mobile technologies as interfaces of hybrid spaces

HYBRID SPACES ARISE WHEN VIRTUAL COMMUNITIES (chats, multiuser domains, and massively multi-player online role-playing games), previously enacted in what was conceptualized as cyberspace, migrate to physical spaces because of the use of mobile technologies as interfaces. Mobile interfaces such as cell phones allow users to be constantly connected to the Internet while walking through urban spaces. This article[1] defines hybrid spaces in the light of three major shifts in the interaction between mobile technology and spaces. First, it investigates how the use of mobile technologies as connection interfaces blurs the traditional borders between physical and digital spaces. Second, it argues that the shift from static to mobile interfaces brings social networks into physical spaces. Finally, it explores how urban spaces are reconfigured when they become hybrid spaces. For this purpose, hybrid spaces are conceptualized according to three distinct but overlapping trends: hybrid spaces as connected spaces, as mobile spaces, and as social spaces.

Interfaces define our perceptions of the space we inhabit, as well as the type of interaction with other people with whom we might connect. Interfaces are defined as communication mediators, representing information between two parts, making them meaningful to one another (Johnson, 1997; Lévy, 1993). The concept of a human-computer interface traditionally defines a communication relationship between a human and a machine. In this case, the role of the interface is to translate digital information from computers to humans to make it understandable to us. I propose a further conceptualization of "social interface," which defines a digital device that intermediates relationships between two or more users. Within this context, social interfaces not only reshape communication relationships but also reshape the space in which this interaction takes place. It is important to highlight that interfaces are also culturally defined, which means that generally, the social meaning of an interface is not always developed when the technology is first created but usually comes later, when it is finally embedded in social practices. Take the case of the film camera and narrative films (Murray, 1997, p. 66), which were originally regarded as a mix of photography and theater (photo + play). Similarly, TV was formerly conceptualized as a live radio with

images, showing that many interfaces initially acquire their meanings from previous similar technologies.

The case of mobile phones follows this development. Formerly regarded as mobile telephones, these devices can now be increasingly compared to microcomputers,[2] remote controls, and collective social devices. Moreover, every shift in the meaning of an interface requires a reconceptualization of the type of social relationships and spaces it mediates. Because mobile devices create a more dynamic relationship with the Internet, embedding it in outdoor, everyday activities, we can no longer address the disconnection between physical and digital spaces. I name this new type of space hybrid space.

Hybrid spaces are mobile spaces, created by the constant movement of users who carry portable devices continuously connected to the Internet and to other users. A hybrid space is conceptually different from what has been termed mixed reality, augmented reality, augmented virtuality, or virtual reality, as discussed later in this article. The possibility of an "always-on" connection when one moves through a city transforms our experience of space by enfolding remote contexts inside the present context. This connection is related both to social interactions and to connections to the information space, that is, the Internet.

Mobile devices are all types of mobile technologies that promote remote and local multipersonal communication and connection to the Internet, allowing users to exchange information while moving through urban spaces. Today's third-generation cellular telephony (3G)[3] cell phones include broadband Internet connection, multimedia messaging, text messaging, mobile pictures, and, more important, location awareness.[4] Location-based applications also create a new way of moving through a city and interacting with other users. In this new spatial perception, cell phones should be regarded as not only mobile telephones—devices enabled to transmit voice in two-way communication situations—but also as portable microcomputers embedded in public spaces. In the United States, as well as in other countries in Latin America, cell phones continue to be used primarily for voice communication, as portable telephones. Likewise, affirming that mobile devices are new interfaces through which communities are formed seems odd. However, Asian and Scandinavian countries show us that voice communication is one of the least used functions of the mobile device (Rheingold, 2002, pp. 1–28).

Although cell phones have substantially surpassed the number of PCs worldwide[5] and appear to be surpassing the popularity of TV sets (Rice and Katz, 2003, p. 598), it is not possible to define a worldwide cell phone culture, because cell phone use differs substantially from place to place depending on cultural and socioeconomic factors. Site-specific uses entail new social meaning for the cell phone as an interface. For the conceptualization of hybrid spaces, I explore mostly cell phone use in Asian countries, such as Japan, and in northern European countries, such as Sweden and Finland, because cell phones in these countries have been studied as collective communication media (Brown, Green, and Harper, 2002; Katz and Aakhus, 2002; Koskinen, Kurvinen, and Turo-Kimo, 2002; Rheingold, 2002). Moreover, as Rheingold (2002, p. xii) noted, their devices possess both communication and computing capabilities and are therefore more than mobile telephones.

This article conceptualizes and defines hybrid spaces via three interconnected spatial analyses: connected spaces, mobile spaces, and social spaces. It addresses four central questions: How do mobile technologies reconfigure our perceptions of space via users who are always potentially connected to the Internet and to other users? How can cell phones be regarded as interfaces of hybrid spaces, promoting new types of social environments? What happens when virtual communities migrate from the fixed Internet to physical spaces interfaced by mobile technologies? and How do mobile technologies allow users to connect in new ways to people who share the same contiguous space via location awareness? To

answer these questions, and to conceptualize this new spatial perception, three perspectives are addressed. First, I define hybrid reality as blurring the borders between digital and physical spaces and also in opposition to augmented and mixed realities, concepts that also claim the blurring of borders between the physical and the digital. Second, I analyze hybrid spaces as mobile spaces defined by mobile social networks and by the shift from static to mobile interfaces. Finally, I look at hybrid spaces as social spaces, analyzing the shift of communication spaces from cyberspace to hybrid spaces.

This essay contributes to the ongoing exploration of the relationship between mobile technologies and (physical/digital) spaces by examining three significant arenas: (a) the reshaping via interfaces of communication relationships and the spaces in which interactions take place; (b) the development of the concept of hybrid spaces to reconceptualize physical spaces by the connectivity of digital mobile media; and (c) the way cell phones strengthen users connections to physical space, a finding in opposition to current studies suggesting that cell phones withdraw users from the physical space in which they are (Gergen, 2002; Plant, 2001; Puro, 2002).

Hybrid spaces as connected spaces: hybrid reality versus virtual, augmented, and mixed realities

Hybrid spaces merge the physical and the digital in a social environment created, by the mobility of users connected via mobile technology devices. The emergence of portable communication technologies has contributed to the possibility of being always connected to digital spaces, literally "carrying" the Internet wherever we go.

Because many mobile devices are constantly connected to the Internet, as is the case of the i-mode standard in Japan (NTT DoCoMo, 2006) users do not perceive physical and digital spaces as separate entities and do not have the feeling of "entering" the Internet, or being immersed in digital spaces, as was generally the case when one needed to sit down in front of a computer screen and dial a connection. According to Ragano (2002), i-mode developers avoided promoting the new service as "the Internet" but instead offered it as a feature that was part of any *keitai* (the Japanese word for "cell phone," roughly "carried telephone"). Rheingold (2002) also noted that most teenagers in Japan did not access the Internet through desktop PCs when they got their first *keitai*; therefore, none of them "thought of what they were doing as 'using the Internet'" (p. 6). With no previous connections to the concepts of immersion and virtual reality, mobile digital spaces acquire a completely different meaning to this community of users: Instead of focusing on issues such as immersion and identity creation in virtual worlds, users are more likely to be concerned about how their *keitai* can help them in physical spaces, to find places and friends through location awareness, to buy train tickets, and to pay for groceries at the supermarket. Ling and Yttri (2002, p. 147) observed that the most distinct profile of cell phone use can actually be found in the youngest users, because they appropriate technology as an expressive medium for social purposes. Similarly, Ragano affirmed that many mobile Internet companies have studied children to understand the potential for new applications, because children are generally not influenced by previous meanings of existing similar interfaces and are therefore able to find unexpected meanings for new devices. Without the traditional distinction between physical and digital spaces, a hybrid space occurs when one no longer needs to go out of physical space to get in touch with digital environments. Therefore, the borders between digital and physical spaces, which were apparently clear with the fixed Internet, become blurred and no longer clearly distinguishable.

Existing concepts of augmented and mixed realities also address the interconnection between physical and digital spaces. However, a closer look at some definitions helps stress the distinctions. Milgram and Colquhoun (1999, pp. 5–28) pointed out that current literature on augmented reality defines it in three distinct ways, depending on the technology used. First, the traditional augmented reality is achieved by means of some kind of head-mounted or head-up display with see-through capabilities, in a way that the user can see the "real" world with overlaid graphical data. Broadening this concept, the second use of augmented reality refers to "any case in which an otherwise real environment is 'augmented' by means of virtual (computer graphic) objects" (p. 6). Milgram and Colquhoun gave the example of a photograph (a real image) on which computer-generated (virtual) images have been superimposed. Finally, they suggested a third class of augmented reality, which encompasses cases involving any mixture of real and virtual environments. Although the first and second trends can definitely be called augmented reality, a broader term must be defined for the third trend. Consequently, Milgram and Colquhoun created the term *mixed reality* to define situations in which it is not clear whether the primary environment is "real" or "virtual" or when there is no predominance of "real" or "virtual" elements in the environment.

Milgram and Colquhoun (1999, p. 8) however, restricted their definition to graphic information; thus, elements from the real world inside modeled environments correspond to photographs, while elements from virtual realities inside unmodeled environments correspond to computer-generated images overlaid on photographs, for example. Their concepts of mixed and augmented realities take into consideration only the technology used to construct digital spaces but do not consider social and communication issues. Although their concepts do consider connections between physical and digital elements (which they named real and virtual), they are restricted to the overlay of graphic digital information on physical reality.

A different approach toward the definition of mixed reality was endorsed by Hiroshi Ishii (1999, p. 232), of the Tangible Media Group at the Massachusetts Institute of Technology's Media Lab. Ishii foresaw desktop computing changing into two major directions: onto our skin or bodies and onto the physical environments we inhabit. Whereas the first trend is connected to the definition of wearable computing, the second is related to ubiquitous computing. Ishii's group attempted to "bridge the gap between cyberspace and physical environment by making digital information (bits) tangible" (p. 233). In this sense, he dedicated considerable importance to material interfaces, focusing on how to bring the "immaterial" bits of digital spaces into the physical world.

Ishii's (1999) approach takes Milgram and Colquhoun (1999) definition one step further by emphasizing the physicality of digital interfaces. Ishii attempted to demonstrate that the interfaces through which we connect to digital spaces do change our perceptions of digital information and reconfigure our perceptions of both physical and digital spaces. Moreover, by connecting mixed reality with wearable computers, Ishii emphasized the relevance of mobility in the blurring of borders between physical and digital spaces. However, like Milgram and Colquhoun, Ishii's definition also does not include sociability and communication.

Following Ishii's (1999) tendency to interconnect digital and physical worlds, Lev Manovich (2002, p. 1) recently stated that the 1990s were about the virtual and that it is quite possible that this decade of the 2000s will turn out to be about the physical. Manovich defined three types of applications that create an *augmented space*, a term he derived from *augmented reality* (p. 6). The first is video surveillance, which captures data from the physical environment and adds it to the digital network. The second, cellspace,

inverts this situation by sending data to mobile users in physical space carrying Global Positioning System devices and cell phones. Similarly, but in a nonpersonalized approach, computer monitors and video displays in public places can present visible digital information to passersby. Manovich defined augmented space as a physical space transformed into a dataspace: "extracting data from it (surveillance) or augmenting it with data (cellspace, computer displays)" (p. 4). Therefore, the flows of information that previously occurred mainly in cyberspace can now be perceived as flowing into and out of physical space, blurring the borders between both.

Manovich (2002) developed an interesting approach to augmented spaces because his definition was not only restricted to technology but also intrinsically connected to artworks that take place in public spaces, including urban spaces in the definition of augmented reality. For example, Manovich described how Janet Cardiff's audio walks overlay prerecorded sounds onto the city landscape while users walk in public spaces. However, communication and social interaction are still not required components for the construction of an augmented space.

From the merging of mixed reality and augmented spaces, mobility, and sociability arises a *hybrid reality*. It is exactly the mix of social practices that occur simultaneously in digital and in physical spaces, together with mobility, that creates the concept of hybrid reality.

A hybrid space, thus, is a conceptual space created by the merging of borders between physical and digital spaces, because of the use of mobile technologies as social devices. Nevertheless, a hybrid space is *not* constructed by technology. It is built by the connection of mobility and communication and materialized by social networks developed simultaneously in physical and digital spaces.

Hybrid spaces as mobile spaces

Mobile spaces are networked social spaces defined by the use of portable interfaces as the nodes of the network. The idea of mobile social networks and the use of cell phones as collective communication devices have been observed in countries such as Japan, the Philippines, Finland, and China (Castells, 2000; Kasesniemi and Rautiainen, 2002; Koskinen, 2002; Rheingold, 2002). One of the most popular cases of macrocoordination via mobile technologies occurred around the downfall of Philippine president Estrada in 2001. After some senators associated with the president succeeded in stopping the president's impeachment process, opposition leaders started to broadcast text messages to call citizens to gather. In 75 minutes after the failed impeachment, more than 20,000 people converged on Edsa, Manila's central thoroughfare. "The rapid assembly of the anti-Estrada crowd was a hallmark of early smart mob technology, and the millions of text messages exchanged by the demonstrators in 2001 was, by all accounts, a key to the crowd's esprit de corps" (Rheingold, 2002, p. 160). Similarly, a phenomenon called flash mobs has been observed in San Francisco, London, and Berlin. Flash mobs are "dozens or even hundreds of people with cell phones who gather suddenly, perform some specific but innocuous act, and then promptly scatter" (Walker, 2003). The "mobs" organize themselves via mobile phones and pagers, and, according to Walker, the social phenomenon has the ability to "make networks tangible."

Perhaps the strongest evidence of bringing networked communities into hybrid spaces is the emergence of hybrid-reality (location-based mobile) games. Hybrid-reality games are multiuser games played with cell phones equipped with location awareness and Internet connections. Hybrid-reality games allow players to use city space as the game board.

Botfighters, produced in Sweden in 2001 by It's Alive, was the first commercially released location-based mobile game. It was designed as a traditional first-person shooter video game. However, to play the game, users must move through urban spaces. Depending on the relative position of each player in the city, users can shoot other players with text messages, be targeted to receive shots, and get into battles. The accuracy and success of each shot depends on the virtual weapons a player carries and her or his real distance from a target. In this sense, hybrid-reality games are configured as massively multiplayer online role-playing games (MMORPGs)[6] played in physical (hybrid) spaces.[7]

A common characteristic of political demonstrations such as the one in the Philippines, social events such as flash mobs, and hybrid-reality games such as *Botfighters* is their ability to invert the traditional logic of the network, making it mobile and emphasizing its paths and connections to physical spaces instead of its nodes. A network, as defined by Rosenstiehl (1998), considers only specific connections and never looks at the paths. A network-man can play with alternate paths and "completely ignore the fact that a flight from Paris to Algeria flies over the Mediterranean" (Rosenstiehl, 1998, p. 229). Forgetting the space "in between" is a characteristic of networked systems. The Internet, as a computer network, and consequently cyberspace, as the information space that emerged from the connections of computers around the globe, have been frequently studied as the ultimate representation of the network concept, in which physical geography would not matter and anywhere in the globe would be "one click away" (Kelly, 1999). In this context, Serres (1994) applied the metaphor of a rich place (*riche lieu*) to the Web, as a single place that encompasses all others. This single place is oversized, equal to the planet, because it contains (virtually) everything. In this place, information, values, and data accumulate and circulate in the same single movement (Serres, 1994, p. 142). Although each Web site represents a node (a server) in the network, an Internet user generally has no clue about the path information travels between the time when a request is made and when the information is eventually shown on the client screen. Information travels by servers and routers, choosing the best path to follow, generally unknown to the common Internet user.

However, the popularity of mobile technologies and their uses as collective communication media remind us that networks are indeed spatial phenomena and that the space "in between" represented by the paths in fact matters. In contrast to the fixed Internet, on which servers and routers represent the fixed nodes of the digital network, in a mobile network, cell phones become these nodes, which are carried by users who wander through physical spaces. In this movement, not only the nodes of the network become mobile, but also the paths through which they move are critical to the configuration of the network.

Deleuze and Guattari (2002) offered a theoretical framework to understand the idea of mobile networks through the association of the nomad existence and the spatiogeographic aspect[8] of the war machine. They pointed out three characteristics of spatiogeographic nomadic movement. The first is related to points and paths of the nomadic network. Although a nomad is not ignorant of points, he or she focuses on paths, on the movement that happens between these points. In a nomadic network, the points are subordinated to the paths. Nomads also go from point to point, but as a mere consequence of their trajectories. "The life of the nomad is the intermezzo" (p. 380). Nomadic spaces are, following Deleuze and Guattari, smooth spaces, which means that the paths that determine nomadic movement are also mobile and easily "effaced and displaced with the trajectory" (p. 381). A nomad does not occupy predefined routes and paths: He or she constructs his or her own while moving through space. Mobile technology users take the nomadic concept one step further, because not only their paths are mobile but also the nodes. With the fixed Internet, and fixed landlines, computers and telephones were primarily connected to

places. Conversely, cell phones represent movable connection points, accompanying their users' movements in physical spaces.

A brief analysis of the cellular network model reinforces this connection between mobile networks and physical spaces. In the classic representation of a cellular network, cells are designed as hexagons adjacent to one another. Transmission towers occupy the corners of each hexagon, and users are represented by dots. Note that the cell is defined by a gray dashed line. The solid line defines the transmission range of each antenna, which transmits into the cells.[9] This representation, however, works for didactic purposes but does not correspond to reality. Ideally, the transmission range of each antenna defines a circle. In the physical world, however, each cell is influenced by weather conditions, by the number of users in each cell, and by the users' movements within each cell, which turns them into ill-defined areas, in constant movement. It is as if the cellular network stands as a layer over the physical space, attached to and being influenced by it.

Finally, a relevant perspective to define mobile spaces is the shift from static to mobile interfaces. This shift redefines the way we connect to the Internet and consequently our perceptions of digital spaces, as exemplified with the case of Japanese teenagers who do not see a disconnection between physical and digital spaces because their first experiences online were via cell phones. Static interfaces are defined as large-sized monitors, desktop computers, head mounted displays, that is, every type of interface that allows connection to digital spaces but does not allow a high degree of movement in physical space while connected. Conversely, mobile interfaces are denned as cell phones and personal digital assistants, that is, interfaces that allow connection to the Internet while moving through physical space.[10] These interfaces literally allow us to "carry the digital space" with us. As a consequence, mobility becomes part of the process of connecting to the digital and exploring hybrid spaces. The connection via mobile devices is fundamentally different from the connection through a desktop computer. First, desktop PCs are considered static interfaces, and therefore, the user needs to be stationary to "enter" the Internet. Second, because of the static interface, the experience of being online is generally a solitary one (Donath, 1997, p. 27). With portable technologies, users are connected while surrounded by other city dwellers. Mobile interfaces are used primarily inside social public spaces. Take the case of Japan. Kusahara (personal communication, January 16, 2003) suggested that the *keitai* is so popular in Japan because of the Japanese lifestyle: they live in a limited space, spending a long time using and waiting for public transportation. Therefore, a small device, which can fulfill the "in-between" space, becomes the ideal communication tool.[11]

As a consequence, the main question from the past decade regarding cyberspace, "How does one construct digital spaces?" can now be rephrased to "How is physical space reconceptualized by the connectivity of digital mobile media?" According to Townsend (2000), the mobile phone might "lead to a dramatic increase in the size of the city, not necessarily in a physical sense, but in terms of activity and productivity" (p. 14). Townsend noted that the technology for a high degree of mobility across the city has been around since the invention of the automobile (p. 10). However, the ability to coordinate social actions in real time occurred only with the advent of mobile communication technologies. Coordination implies not only microcoordination among individuals, but especially macrocoordination, as is the case with flash mobs, political manifestations, and location-based games.

The relationship between mobile interfaces and hybrid spaces is twofold. On one hand, the concept of digital space is no longer the same, because it is now merged with physical space. Embedding the Internet in everyday activities means that issues such as the creation

of body and identity will be potentially replaced by issues such as location-based services and macrocoordination. On the other hand, mobile technology devices also influence the perception of urban spaces. According to N. Katherine Hayles (personal communication, November 19,2002), space is becoming enfolded, "so that there is no longer a homogeneous context for a given spatial area, but rather pockets of different contexts in it." For example, someone talking on a cell phone is part of the context of people who share the same spatial area, but he or she is also part of a distant context, because he or she is talking to someone who is spatially remote. Hence, there is a context that is created by the spatial proximity of people and inside it another context that is created by the cell phone. The notion, of enfolded spaces is well exemplified by what Rheingold (2002) called "Tokyo thumb tribes," Japanese teenagers who exchange huge numbers of text messages a day (about 80) and who barely use mobile phones as voice communication devices. Ito observed that the use of text messages has also changed their notion of presence: "As long as people participate in the shared communcations of the group, they seem to be considered by other to be present" (quoted in Rheingold, 2002, p. 6). The enfolding of contexts (or the "doubling of space" as defined by Scannell, 1996), which allows users to feel as if they are in two places at once, might have been studied as a feature of other media as well, such as the radio, TV, or wired telephones (Meyrowitz, 1985; Scannell, 1996; Trow, 1981), but the difference with mobile technologies is precisely the possibility of moving through space while interacting with others who are both remote and in the same contiguous space via one's relative location to other users. Within this context, concepts such as "enfolded" and "doubling" must be redefined, because they still allude to a division or separation of space. "Enfolded" is perhaps a better idea, because it alludes to some type of overlapping. However, the term *hybrid* defines a situation in which the borders between remote and contiguous contexts no longer can be clearly defined.

Hybrid spaces as social spaces

The Internet has been studied as a social immersive space in which users develop communities and construct worlds (Dibbell, 1999; Donath, 1997; Kim, 2000; Rheingold, 2002; Smith and Kollock, 1999). Multiuser domains (MUDs); MUDs, object oriented;[12] and recently MMORPGs are examples of such online social spaces. Multiuser environments, constructed metaphorically as public social places, have attracted many people willing to socialize with others outside their situated geographical boundaries. During the past decade, there has been a common belief that these "virtual" communities will indefinitely grow and that communication will increasingly migrate to cyberspace (Mitchell, 1995; Wertheim, 1999).[13] However, once mobile technologies become the interface to connect to the Internet, these communities are potentially brought into public urban spaces. Unlike traditional social public places, such as bars, squares, and automobiles, these new communities are reconfigured in hybrid spaces, because their users are simultaneously moving through physical space while connected in real time to other users via digital technology depending on their relative positions in physical space.

Location-based games, such as the previously mentioned *Botfighters*, and *Mogi* in Japan, have shown that location awareness is a key factor to bring virtual communities into hybrid spaces. *Mogi* is a hybrid reality game released in 2004, in which the main goal is to look for virtual creatures and objects spread around the city of Tokyo. Equipped with Java-enabled cell phones, users are able to see in their mobile screens a map of the city and the positions of nearby objects. Once users are within 300 meters of their targets, objects

can be caught and uploaded into their cell phones. However, some creatures live in parks and go out only at night, so players must go to specific places at specific times to capture particular creatures. The multiuser function of the game comes from the need to exchange creatures and objects with other players to complete the collection. Once again, exchanges can be made only if the players are within a specific distance from one another in physical space. Another location-based application that brings the concept of instant messaging to urban spaces is the software imaHima, originally released in Japan in 2001. Similar to any instant messaging software, each user must agree to have his or her location tracked by imaHima. There is also the possibility of contacting a stranger whose profile matches the user's request if he or she allows himself or herself to be contacted by an unknown person. However, whereas traditional instant messaging displays on computer screens simultaneously connected users, independent of their physical locations, imaHima connects people within a close radius in physical space.[14] There are currently 250,000 active imaHima users in Japan who access the imaHima service through i-mode and wireless application protocol phones (imaHima, 2005).

The popularity of these gadgets, devices, and applications in Japan provides evidence that cell phones are used not only to communicate with people who are distant but also to socialize with peers who are nearby, sharing the same physical space, even if they are not at eye-contact distance. Finding people to socialize in cyberspace has always been critical in multiuser environments on the fixed Internet. Mobile Internet users also look for people with whom to socialize. The difference, however, is that mobile networks help find people in public places. In the hybrid-spaces logic, cell phones do not take users out of physical space, as has been suggested by many scholars who have studied mobile devices as voice communication technologies (Gergen, 2002; Plant, 2001; Puro, 2002). Conversely, they strengthen users' connections to the space they inhabit, because the connection to other users depends on their relative position in space. Therefore, games such as *Botfighters* and *Mogi* change the perception of physical spaces by transforming them into potential multiuser environments.

Once there is a shift from static to mobile interfaces, users are no longer required to sit in front of their computers, but rather, they move around in urban spaces—which are already social public spaces. The enfolding of digital and physical social spaces thus requires a redefinition of not only the concept of digital space but also our sense of distributed communities. How does the mobility of users influence the construction of social spaces?

Spaces have been defined in many different ways (Castells, 2000; de Certeau, 1984; Kelly, 1999; Lefebvre, 1991; Massey, 1995; Moores, 2004). Although a detailed analysis of this concept is outside the scope of this article, I would like to briefly point out some relevant notions for the construction of hybrid spaces as social spaces. Castells (2000) defines the space of flows as the dominant spatial logic of the network society. The space of flows is conceptualized as "a new spatial form characteristic of social practices that dominate and shape the network society" (p. 453). In this sense, "the space of flows is the material organization of time-sharing social practices that work through flows" (p. 442). Paraphrasing Castells, Stalder (2001) affirmed that "the space of flows is created by the real-time interaction of distributed social actors. The space is comprised of interactions and the material infrastructure that makes these interactions possible." What is important to understand from this definition is that the space of flows is intrinsically a social space; according to Castells, space is the expression of society (p. 440). However, in the space of flows, the material infrastructure that makes these social interactions possible is in part composed of digital technologies and a physical network.

Moores (2004, pp. 2–3) criticized Castells's (2000) definition of places, arguing that places are not self-contained, because in any city, people maintain social relationships and connections that go beyond the physical boundaries of those specific places, transforming places in permeable localities (Moores, 2003; Meyrowitz, 1985; Massey, 1995). However, perhaps the major contribution of Castells is exactly to understand that following the logic of the space of flows, cities have become processes and networks rather than self-contained places, because the space of flows is not an immaterial fluid information space disconnected from physical spaces, but is rather embedded in urban structures (p. 417). Therefore, "the interaction between new information technology and current processes of social change does have a substantial impact on cities and space" (Castells, 2000, p. 429).

Perhaps what is missing from Castells's (2000) definition, as noted by Moores (2004, p. 4), is the connection of the space of flows with the space of places, recognizing that both instances are not diametrically opposed forms and might be actually complementary, because the space of flows also includes social relationships within urban spaces. For the notion of hybrid space, thus, following Castells, I regard space as a concept produced and embedded by social practices, in which the support infrastructure is composed of a network of mobile technologies. Lefebvre's (1991, p. 26) concept of social spaces defines social space as a social product rather than as preexisting physical spaces. In this sense, society constructs and defines space. Moreover, social spaces are not material things but rather a set of social relationships both between objects and objects and people (p. 83). The logic of hybrid spaces mediates this set of relationships of mobile technologies. The connections do not occur solely in physical space but rather in a new type of space that merges physical and digital. More than expanding the number of possible connections, like the telephone and the fixed Internet to a much greater extent, hybrid connections also change the perception of the physical space the users inhabit. For example, some *Botfighters* players report that they rediscovered the city of Stockholm while playing the game:

> Eventually you start to take trips to places you wouldn't go to otherwise. I found myself sitting on the Web trying to find a nice café in an unknown part of Stockholm so that me and my girlfriend could have a picnic and also destroy a certain bot.
>
> ("Mobile Killers," 2001)

By transforming the city space into the game board—or by taking the game out of the computer screen—the familiar space of the city is transformed into a new and unexpected environment. It is as if the game creates an imaginary playful layer that merges with the city space, connecting people who previously did not know one another via mobile technologies according to their movement in physical spaces. Lehtonen and Mäenpää (1997) referred to this unpredictability in public spaces—also a characteristic of shopping—as *street sociability*, which is "the particular public form of sociality, of being at once both interested and yet indifferent and anonymous" (p. 156). While in the city, one cannot foresee whom one is going to meet or what is going to happen. It is exactly this unpredictability contained in gaming that makes it so exciting as an unexpected playful experience.[15]

Similarly, Niklas Stahre, a 24-year-old engineer who lives in Stockholm, was among the first enthusiastic *Botfighters* subscribers:

> What appeals to me about mobile gaming is that you can interact with people while you are on the fly. You can play it whenever you want, wherever you want. You play against real people, and, with Botfighters, you have to move around to win an advantage.
>
> (Brown, 2000)

Finally, similar to Lefebvre (1991), Kelly (1999) stated that the true meaning of a space is related to its ability to absorb connections and relationships. Therefore, for Kelly, echoing Lefebvre and Castells (2000), space is a networked entity. Networks are spatial structures, and what guides their existence is the large number of connections embedded in them. A hybrid space is also a networked space, constituted by a mobile network of people and nomadic technologies that operate in noncontiguous physical spaces. Therefore, to integrate this space, a node (e.g., a person) does not need to share the same geographical space with another node of the mobile network. The hybrid space is created exactly by the merging of different and discontinuous places within one another.

Compared with the fixed Internet, mobile devices bring actions formerly performed in specific "private" places (homes or offices with desktop computers connected via cables to the network) to public urban spaces. Furthermore, these technologies create another perception of what it means to access the Internet. As discussed earlier, teenagers in Japan do not feel as if they are "entering the Internet" when they use their cell phones with i-mode, because the always-on connection is considered as a regular function of their cell phones (Ragano, 2002). The mobile Internet is becoming useful for actions that integrate the Web in physical spaces. For example, in Finland and Japan, it is possible to buy sodas in vending machines using mobile phones. Users are also able to purchase train and ski tickets with their mobile phones. Furthermore, the new i-mode Felica[16] allows users to use their cell phones as their wallets, to pay for groceries in the supermarket, and as their identification cards, to check in at airports. Finally, if a device has location awareness, it can be used to find restaurants, receive driving directions, and—to return to the idea of social space—to find friends who are nearby.

Since early on, cell phones have been studied as social collective technologies, in opposition to the general two-way communication of regular fixed phones. In addition to the already mentioned examples, such as the Tokyo thumb tribes of Japan, flash mobs, and the case of President Estrada in the Philippines, mobile phones have been studied as producers of social relationships via Short Message Service use in Finland (Kasesniemi and Rautiainen, 2002, p. 182). Location-based services such as imaHima and games such as *Botfighters* and *Mogi* take the construction of hybrid social spaces one step further, because they connect users depending on their relative positions in urban spaces.

Conclusions

The Internet undeniably opened our consciousness to the possibility of large-scale communities known as multiuser environments, which were not confined to the same physical place. Cell phones have been frequently studied as a means of two-way communication, whereby private spaces are created inside public spaces (Gergen, 2002; Plant, 2001; Puro, 2002). However, this article has focused on the use of mobile phones not as portable telephones but as microcomputers. Within this context, the comparison with the fixed Internet becomes more relevant than the comparison with traditional landlines.

The concept of cyberspace applied to the Internet was responsible first for our view of physical and digital as disconnected spaces, second for our emphasis on the nodes of the network instead of its spatial structure, and finally for the utopian view of a future in which social spaces would emerge mostly online. Mobile phones transgress this traditional relationship with the Internet because they are able to embed the Internet in public spaces. Because every shift of interface transforms not only the social relationships it mediates but also the spaces in which it is embedded, the notion of hybrid spaces encourages the

redefinition of physical and digital spaces. For this reason, the concept of hybrid spaces arises to supply a gap opened when the Internet became mobile and when communities previously formed in cyberspace could be found in urban (hybrid) spaces.

Perhaps the most relevant feature of the cell phone in defining how mobile interfaces can influence our interaction with other users and with the space we inhabit is its location awareness. When a mobile interface knows where it is in physical space, it automatically acquires a different meaning from a fixed telephone and from a desktop computer, because one of its key functions becomes navigation in physical space. Internet capability added to location awareness allows users to have a unique relationship to physical space, as well as to the Internet. Changing our experience of space means not only interacting in new ways with other people but also redefining the space in which we live.

Although it is not possible to predict if specific local uses of mobile technologies in Asian and northern European countries will be observed in other countries in the world, some signs of how cell phones create hybrid spaces can already be felt also in Latin America. *Alien Revolt*, for example, was the first location-based mobile game commercially launched in Rio de Janeiro, Brazil, in May 2005. The game uses Java-enabled cell phones with location awareness to transform the city into a battlefield. Following much of the plot of *Botfighters*, the game's goal involves shooting other players who are within a specific radius in the city space. Moreover, as in *Mogi*, players are able to see and fight with virtual alien creatures that are nearby, represented on the radar of their cell phone screens. However, this is the first game of this type in Brazil, and it is not yet popular.[17] As in the United States, cell phones are still mostly used as two-way communication devices in most Latin American countries.

As a last example, I would like to mention an educational location-based mobile game developed by the Amsterdam Montessori School and the Waag Society. *Frequency 1550* was tested during February 2005 and used a part of the city of Amsterdam as the game board. Students on the streets equipped with Java-enabled 3G location-aware cell phones needed to collaborate with remote online students to solve location-specific assignments about the medieval history of the city. Remote students were in classrooms and could track the position of their partners on the street via a map on their computer screens and communicate with them via audio. *Frequency 1550* demonstrates not only how mobile technologies can be used to bring educational activities outside the classroom but also how students can have different relationships with the cities in which they live. By overlaying a fictitious narrative about the Amsterdam of the past on the actual city space, students learned history and could connect to existing city landmarks in an unusual way. Moreover, they walked around in a space that was a mix of reality and imagination.

Foregrounding the pathway from the fixed Internet to hybrid spaces reterritorializes (a concept defined by Deleuze and Guattari, 2002, p. 380) multiuser environments, defined as social spaces that allow communication among people who do not share the same contiguous physical space. This idea can be easily transferred to physical space when we take a closer look, for example, at the development of location-based mobile games. Mobile communication technologies recreate urban spaces as multiuser environments. Because mobile devices create a more dynamic relationship to the Internet, embedding it in everyday activities that happen mostly outdoors, the idea of digital spaces as instances disconnected from physical spaces no longer applies.

The consequences of changes from the passage from cyber spaces to hybrid spaces are (a) the blurring of borders between physical and digital spaces, (b) the redefinition of the concept of the digital, (c) the redefinition of the concept of physical space to include hybrid environments, and (d) changes in sociability and communication patterns. Finally, the

shift, driven by nomadic technologies, from cyber to hybrid calls our attention to the fact that the digital has never actually been separated from the physical and can be an essential element for promoting sociability and communication in urban spaces.

Notes

1 This article comes from my PhD dissertation, *From Multiuser Environments as (Virtual) Spaces to (Hybrid) Spaces as Multiuser Environments: Nomadic Technology Devices and Hybrid Communication Places*, defended in the School of Communications at the Federal University of Rio de Janeiro, Brazil. Research for this article was supported by the Commission for Enhancement of Graduate Researchers (Brazil), a doctoral fellowship from the National Research Council (Brazil), and the Department of Design | Media Arts at the University of California, Los Angeles.

2 A report from NTT DoCoMo (2004) states that the speed of today's Freedom of Mobile Multimedia Access central processing units is comparable with that of personal computers from 8 years ago running Windows 95.

3 "3G" also refers to the Universal Mobile Telecommunications System (UMTS).

> UMTS allows many more applications to be introduced to a worldwide base of users and provides a vital link between today's multiple GSM [Global System for Mobile Communications] systems and IMT-2000 [International Mobile Telecommunications– 2000]. The new network also addresses the growing demand of mobile and Internet applications. UMTS increases transmission speed to 2 Mbps per mobile user and establishes a global roaming standard.
>
> (International Engineering Consortium, 2005)

4 There are two different ways by which a cell phone can be aware of its position. One is cellular positioning, which indicates the device's location through the triangulation of radio waves detected by the cell phone in relation to transmission towers. Another, much more accurate, way uses Global Positioning System software embedded in the phone.

5 According to the International Telecommunication Union (2006), in 2004, there were 770,641,000 PCs and 1,751,940,000 cell phones.

6 MMORPGs are descendants of MUDs. However, whereas the early MUDs were purely textual, MMORPGs generally have graphical interfaces.

7 An extensive list of existing location-based mobile games can be found at http://www. in-duce. net/archives/locationbased_mobile_phone_games.php.

8 The other two aspects are the arithmetic or algebraic aspect and the affective aspect (p. 380).

9 More on cellular networks and wireless technologies can be found at http://www.privateline. com.

10 Note that all mobile interfaces are wireless, but this does not mean that all wireless interfaces are mobile. It is possible, for example, to connect a desktop computer and a printer via Bluetooth or Wi-Fi, but they do not support mobility.

11 Conversely, as noted by Ito,

> Americans move between private nucleated homes, private transportation, and often private offices and cubicles as well, with quick forays in the car to shop occasionally (not daily grocery shopping as in Japan), and use of public space and restaurants has the sense of an optional excursion rather than a necessity.
>
> (quoted in Rheingold, 2002, p. 22)

12 MUDs, object oriented, are multiuser environments in which users can use programming languages to build objects in the virtual world.

13 Authors such as Hayles (1999) and Robins (2000) have criticized this position by emphasizing the connections between cyberspace and our physical world.

14 imaHima won the Prix Ars Electronica in the category Net Vision/Net Excellence in 2001.

15 Lehtonen and Mäenpää also suggested that

> even though we emphasize unpredictability as the key to playful street sociability, it is important to note that this entertainment aspect of uncertainty relies on mutual trust between the "players." ... If the implicit rules of street sociability are not followed, the aleatory elements, the feeling that "something unexpected might happen," starts to generate fear. (p. 161)

16 More information on the i-mode Felica is available at NTT DoCoMo's Web site (http://www. nttdocomo.com).
17 As of January 2006, *Alien Revolt* works on only two types of cell phones. Both cell phones and the prices for using the General Packet Radio Service Internet connection while playing the game are relatively expensive for the average user. Therefore, despite the massive advertisement campaign run by the operator Oi in Rio de Janeiro, the game never attracted more than 200 subscribers in a city of 13 million. A cheaper Short Message Service version is currently under development, according to the game's creators.

References

Brown, Amy. (2000, December 1). The games people play. Retrieved October 31, 2003, from http://www.itsalive.com.

Brown, B., Green, N., and Harper, R. (2002). *Wireless world: Social and interactional aspects of the mobile age*. London: Springer-Verlag.

Castells, M. (2000). *The rise of the network society*. Oxford: Blackwell.

de Certeau, M. (1984). *The practice of everyday life*. Berkeley, CA: University of California Press.

Deleuze, G., and Guattari, F. (2002). 1227: Treatise on nomadology—The war machine. In G. Deleuze and F. Guattari (eds), *A thousand plateaus: Capitalism and schizophrenia* (pp. 351–423). Minneapolis, MN: University of Minnesota Press.

de Souza e Silva, A. (2004). *From multiuser environments as (virtual) spaces to (hybrid) spaces as multiuser environments: Nomadic technology devices and hybrid communication places*. Unpublished doctoral dissertation, Universidade Federal do Rio de Janeiro, Brazil.

Dibbell, J. (1999). *My tiny life: Crime and passion in a virtual world*. New York: Owl.

Donath, J.S. (1997). *Inhabiting the virtual city: The design of social environments for electronic communities*. Unpublished doctoral dissertation, Massachusetts Institute of Technology. Retrieved November 28, 2005, from http://judith.www.media.mit.edu/Thesis/ThesisContents.html.

Gergen, K. (2002). The challenge of absent presence. In J. Katz and M. Aakhus (eds), *Perpetual contact: Mobile communication, private talk, public performance* (pp. 227–241). Cambridge: Cambridge University Press.

Hayles, N.K. (1999). *How we became posthuman: Virtual bodies in cybernetics, literature, and informatics*. Chicago, IL: University of Chicago Press.

imaHima. (2005). imaHima. Available at http://www.imahima.com/ihcorpv2/container/imahima_community.php?stlang=EN.

International Engineering Consortium. (2005). Universal Mobile Telecommunications System (UMTS) protocols and protocols testing. Retrieved November 28, 2005, from http://www .iec.org/online/tutorials/umts/topic01.html.

International Telecommunication Union. (2006). Free statistics. Retrieved November 25, 2005 from http://www.itu.int/ITU-D/ict/statistics/.

Ishii, H. (1999). Tangible bits: Coupling physicality and virtuality through tangible user interfaces. In Y. Ohta and H. Tamura (eds), *Mixed reality: Merging real and virtual worlds* (pp. 229–46). New York: Springer.

Johnson, S. (1997). *Interface culture: How technology transforms the way we create and communicate*. San Francisco, CA: HarperEdge.

Kasesniemi, E.L., and Rautiainen, P. (2002). Mobile culture of children and teenagers in Finland. In J. Katz and M. Aakhus (eds), *Perpetual contact: Mobile communication, private talk, public performance* (pp. 170–192). Cambridge: Cambridge University Press.

Katz, J., and Aakhus, M.A. (eds). (2002). *Perpetual contact: Mobile communication, private talk, public performance*. Cambridge: Cambridge University Press.

Kelly, K. (1999). *New rules for the new economy: 10 radical strategies for a connected world*. New York: Penguin.

Kim, A.J. (2000). *Community building on the Web*. Berkeley, CA: Peachpit.

Koskinen, I., Kurvinen, E., and Lehtonen, T. K. (2002). *Professional mobile image*. Helsinki, Finland: Edita Prima.

Lefebvre, H. (1991). *The production of space* (D. Nicholson-Smith, Trans.). Malden, MA: Blackwell.

Lehtonen, T. K., and Mäenpää, P. (1997). Shopping in the East Centre Mall. In P. Falk and C. Campbell (eds), *The shopping experience* (pp. 136–65). Thousand Oaks, CA: Sage.

Lévy, P. (1993). *As tecnologias da inteligencia: O futuro do pensamento na era da informatica*. Rio de Janeiro, Brazil: Editora 34.

Ling, R., and Yttri, B. (2002). Hyper-coordination via mobile phones in Norway. In J. Katz and M. Aakhus (eds), *Perpetual contact: Mobile communication, private talk, public performance* (pp. 139–69). Cambridge: Cambridge University Press.

Manovich, L. (2002). *The poetics of augmented space: Learning from Prada*. Retrieved August 16, 2003, from http://www.manovich.net.

Massey, D. (1995). The conceptualization of place. In D. Massey and P. Jess (eds), *A place in the world? Places, cultures and globalization* (pp. 45–77). Oxford: Oxford University Press.

Meyrowitz, J. (1985). *No sense of place: The impact of electronic media on social behavior*. New York: Oxford University Press.

Milgram, P., and Colquhoun, H., Jr. (1999). A taxonomy of real and virtual world display integration. In Y. Ohta and H. Tamura (eds), *Mixed reality: Merging real and virtual worlds* (pp. 5–28). New York: Springer.

Mitchell, W.J. (1995). *City of bits: Space, place, and the infobahn*. Cambridge, MA: MIT Press.

Mobile killers. (2001, July 23). Retrieved October 31, 2003, from http://www.itsalive.com

Moores, S. (2003). *Media, flows and places* (Media@LSE Electronic Working Papers Series, No. 6). Programme in Media and Communications, London School of Economics and Political Science. Retrieved November 27, 2005, from http://www.lse.ac.uk/collections/media@lse/pdf/Media@lseEWP6.pdf.

Moores, S. (2004). The doubling of place: Electronic media, time-space arrangements and social relationships. In N. Couldry and A. McCarthy (eds), *Mediaspace: Place, scale, and culture in a media age* (pp. 21–36). London: Routledge.

Murray, J. (1997). *Hamlet on the Holodeck: The future of narrative in cyberspace*. New York: Free Press.

NTT DoCoMo. (2004, June). *Size and weight reduction of progressively higher function mobile phones—Phones get smaller and lighter while taking on versatile features*. Retrieved July 5, 2004 from http://www.nttdocomo.com/files/presscenter/34_No18_Doc.pdf.

NTT DoCoMo. (2006). *i-mode*. Available at http://www.nttdocomo.com/services/imode/Plant, Sadie. (2001). *On the mobile: The effects of mobile telephones on social and individual life*. Retrieved September 27, 2003, from http://www.motorola.com/mot/doc/0/234_ MotDoc.pdf.

Puro, J.P. (2002) Finland: A mobile culture. In J. Katz and M. Aakhus (eds), *Perpetual contact: Mobile communication, private talk, public performance* (pp. 19–29). Cambridge: Cambridge University Press.

Raby, F., Suzuki, A., and Catterall, C. (2000). *Project #26765—Flirt: Flexible information and recreation for mobile users* (Project catalog). London: Royal College of Art.

Ragano, D. (2002, March 5). Growing up in the age of the keitai. *The Feature*. Retrieved April 18, 2006, from http://www.thefeaturearchives.com/topic/Archive/Growing_Up_in_the_ Age_of_ the_Keitai.html.

Rheingold, H. (2002). *Smart mobs: The next social revolution*. Cambridge, MA: Perseus.

Rice, R., and Katz, J. (2003). Comparing Internet and mobile phone usage: Digital divides of usage, adoption, and dropouts. *Telecommunications Policy*, 27, 597–623.

Robins, K. (2000). Cyberspace and the world we live in. In D. Bell and B. M. Kennedy (eds), *The Cybercultures Reader* (pp. 77–95). New York: Routledge.

Rosenstiehl, P. (1988). Labirinto. In *Enciclopédia einaudi, 13: Lógica-combinatória* (pp. 247–73). Lisbon: Imprensa Nacional/Casa da Moeda.

Scannell, P. (1996). *Radio, television and modern life: A phenomenological approach*. Oxford: Blackwell.

Serres, M. (1994). *Atlas*. Lisbon: Piaget.

Smith, M. A., and Kollock, P. (1999). *Communities in cyberspace*. London: Routledge.

Stalder, F. (2001). The space of flows: Notes on emergence, characteristics and possible impact on physical space. In *Proceedings of the 5th International PlaNet Congress*. Retrieved April 18, 2006, from http://felix.openflows.org/html/space_of_flows.html.

Townsend, A.M. (2000). Life in the real-time city: Mobile telephones and urban metabolism. *Journal of Urban Technology*, 7(2), 85–104.

Trow, G.W.S. (1981). *Within the context of no context*. Boston, MA: Little, Brown.

Walker, Rob. (2003, August 24). We're all connected? *New York Times Magazine*. Retrieved September 27, 2003, from http://www.nytimes.com/2003/08/24/magazine/24WWLN.html.

Wertheim, M. (1999). *The pearly gates of cyberspace: A history of space from Dante to the Internet*. New York: Norton.

Barbara M. Kennedy

THINKING ONTOLOGIES OF THE MIND/BODY RELATIONAL
Fragile faces and fugitive graces in the processuality of creativity and performativity

1. Staging the performance

> When a body is in motion it does not coincide with itself. It coincides with its own transition, its own duration. The range of variations it can be implicated in is not present in any given moment, much less in any position it passes through. In motion a body is an immediate, unfolding relation to its own non-present potential to vary.
>
> <div align="right">(Massumi 2002: 4)</div>

> Pure duration is the form which the succession of our conscious states assumes when our ego lets itself live, when it refrains from separating its present state from its former states.
>
> <div align="right">(Bergson, in Ansell Pearson and Mullarkey 2002: 60)</div>

THIS PERFORMATIVE CHAPTER INTRODUCES an experimental ontology for creative practice and a re-orientation of creative thinking to set in motion challenges and differences for theorising beyond the rigidity of structuralist linguistics, the 'mots d'ordres' or order words which Deleuze-Bergsonism states 'sets up ready-made problems as if they were drawn out of the 'city administrative filing cabinets' and force us to 'solve' them, leaving us only a thin margin of freedom.' True freedom, argues Deleuze, lies in the power to decide, 'to constitute the problems themselves'.[1] This paper mobilises a multiperspectival choreography. Using Deleuze's ontology of transformation to rethink difference as opposed to representation and Bergsonian notions of the intuitive, it aims to show how a move from subjectivity to affective temporalities and duration will provoke new understandings of 'creative acts'. This move will sustain a *pragmatics of becoming* for post-theory through its relation to both artistic practices and creative thinking. That creative thinking can then be carried through into specific disciplinary engagements which in my transfeminist practice

are in dance, film, and performativity. Choreographed performativities, spatial, temporal and visual are key to any future creative opening up of new 'problems', for stating new problems and for transformational futures in artistic practices. Artistic practices embrace new architectures and spaces for an ontology of change and fluidity beyond the sterility of previous discourses which have been locked into static conceptions of subjectivity, spatial conceptions of time and psychoanalytic conceptions of affect.

Consequently I am looking to introduce a visceral ontology to re-think difference beyond oppositional discourses. This visceral ontology is beyond any politics of fluidity as it is effectuated through motility and duration. It therefore necessitates a reconsideration and repositioning of certain concepts like space and time, the two most significant concepts in relation to the body within dance and choreography. What I mobilise in my current artistic practice in choreography and film work is not an *example* or representation of ideas but a durational event which operates through the temporal interstices of bodies, speeds, velocities and affective psychic spaces. This conception of choreography effectuates a transitional zone of indetermination in a Deleuzian 'beyond' of subjectivity and Bergsonian duration. As an academic/artist/dancer I now choose to work with the camera, film, dance and movement synthesising an architecture of sound-repetitions, chords, chaos and the charismatic. Such processuality provides the required ruin of representation if we are to move towards a pragmatics of becoming. Working towards a re-organisation of body/mind relationals and an appreciation of 'bodies without organs,' through the affective and durational imbricates the molecular world of creative evolution: earth, fire, water air, those molecular elements of which we ourselves are constituted. My work is to unsettle and re-singularise these through the non-representational: an effectuation of duration, rhythm and speeds of tone, lines, colour, sounds and movements, thus creating new events of intensity, new tendencies which provide a plurality of differences rather than a logic of solids. *Like language systems which stutter, the body in dance stutters, shudders, shivers, – weaves, wavers, fibrillates, – dilates, twists and irritates through mobilities, muscularities and liminalities – bodies in motion, bodies through time – doing time – effectuating duration.* Thus dance, like language, bifurcates, fractures, disseminates, but also dynamically mobilizes and re-invents the body through new material elements, creating new bodily orders and architectures, experienced through affective psychic spaces and tendencies rather than linguistic structures. Similarly within film theory as I have shown in *Deleuze and Cinema: The Aesthetics of Sensation*, the time of the choreographed screen sets in motion 'bodies without organs' through the velocities of the fugitive 'girl':

> there is no movement that is not infinite: the movement of the infinite can only occur by means of affect, passion, love, in a becoming that is the girl, but without any reference to a kind of mediation … this movement as such eludes perception because it is already effectuated at every moment and the dancer or lover finds himself or herself already 'awake and walking' the very second he or she falls down and even the instant he or she leaps. Movement, like the girl as fugitive being, cannot be perceived.
>
> (Deleuze and Guattari, 1987: 281)

As Deleuze states, 'movement, like the girl as fugitive being, cannot be perceived.'[2]

Aesthetics and creativity might occupy as Felix Guattari writes in *Chaosmosis*, a significant position for a radical ethics at the end of the twentieth century.[3] This requires deconstructing the prioritisation of representation which has maintained a politically intransigent position for creative thinking and for transformational creativity. Through the interrelationality of representation, identity and subjectivity, creative thinking and political practices like feminisms have been locked into an ontology of stasis, contained within binary systems of

language, the prioritisation of identity and subjectivity and the maintenance of a perspectival view of the world premised upon objectivity, spatial and temporal hierarchies. Deleuze's call to 'constitute' problems, to discover the 'real' problems is crucial to any innovative and transformative understanding of creativity or of feminisms. Creativity works through the intuitive and durational because of a fundamental denial and refusal of the autonomy of languages which have presented themselves through the constructions of order words. Rather a different regime of experience and the creative process is effectuated through intuition and duration. Creativity works through duration which to embrace Bergson, is not a subject of mathematical or logical configurations. What we understand as psychical cannot correspond identically with space or fit into defined categories of understanding. The multiplicity of states of consciousness through which we experience duration cannot then, be regarded as numerical and symbolic representations. Inner duration is acknowledged through our perceptive consciousness which is nothing else but the melting of states of consciousness into one another.

Writing in *Time and Free Will* Bergson states:

> Has true duration anything to do with space? Certainly, our analysis of the idea of number could but make us doubt this analogy, it is a medium in which our conscious states form a discrete series so as to admit of being counted, and if on the other hand our conceptions of number ends out in space everything which can be directly counted, it is to be presumed that time, understood in the sense of a medium in which we make distinctions and count, is nothing but space. It follows that pure duration must be something different.
>
> (Bergson, in Ansell Pearson and Mullarkey 2002: 56)

Rather 'pure duration might well be nothing but a succession of qualitative changes, which melt into and permeate one another, without precise outlines, without any tendency to externalise themselves in relation to one another without any affiliation to number; it would be pure heterogeneity (Bergson, in Ansell Pearson and Mullarkey 2002: 61).

Thus creativity need not remain constrained within the framework of structuralist linguistics, notions of homogenous concepts of spatiality or indeed of social, political or institutional spaces. Intuition is premised on an innate conceptualisation of our dynamic and vital tendencies and velocities incurred within the very structures of our temporal affectivities and durations. Intuition involves the processual duration of tiny, multiple, intricate and internal movements of each and every individual life form. Through the interval and chiasm of affectivity beyond subjectivity emerges an ontology of heterogeneity, relationality and duration. I present through the poetic and critical rhythms of both a textual and filmic choreography, a multiperspectival ontology of duration and more specifically the 'girl' as duration. To give being to what does not exist: to create the fragile graces and fugitive spaces of becoming (see http://www.staffs.ac.uk for visuals).

The creative practices of dance and choreography in my work are effectuated and experienced through the resonances of motility and mobility: motion, rests, silences, sounds, nuances and gestures. Bergson offers an understanding of motion thus:

> We generally say that a movement takes place *in* space and when we assert that motion is homogeneous and divisible, it is of the space traversed that we are thinking, as if it were interchangeable with the motion itself. Now, if we reflect further, we shall see that the successive positions of the moving body really do occupy space, but that the process by which it passes from one position to the other, a process which occupies duration and which has no reality for a conscious

spectator eludes space. We have to do here not with an object, but with a *progress*: motion, in so far as it is a passage from one point to another, is a mental synthesis, a psychic and therefore unextended process. Space contains only parts of space, and at whatever point of space we consider the moving body, we shall get only a position. If consciousness is aware of anything more than positions, the reason is that it keeps the successive positions in mind and synthesises them.

(Bergson, in Ansell Pearson and Mullarkey 2002: 64)

Dance mobilizes febrility, fascination, fantasy: the provocative, the sensual, the erotic, the aleatory and the mimetic. The visual work I engage with does not illustrate or exemplify through any 'representational' image but lives outside through its own tendencies in collusion with the voices you hear, the sounds you synthesise: je, tu, il, elle, …me, moi … me, myself … I … Madonna, mother – lover – this lover – this dancer – c'est une provocateuse: the faces you see, the fugitive spaces you inhabit, the durations you are, the bodies and minds you feel: start with what you feel!

In correlation with this paper which interweaves Bergsonian-Deleuzism with post-feminist structurations I am arguing for an ontology of change in relation to notions of the 'girl' as creative duration: to argue for the Deleuzian fugitive girl as time unhinged, and feminism as a creative and transformational 'becoming'; not through any reconsideration of a feminine subjectivity, a politics locked into gendered and oppositional discourse, but through the beyond of subjectivity or affectivity in duration. Feminisms, or rather what I want to term *transfeminisms* may thus be presented through becoming – woman as duration via the intuitive zone of indetermination where subjectivity is not only subsumed within the affect, but affect is further subsumed within the auspices and differential singularities of duration. If we are to present a molecular politics in post-theory and transfeminist practices like dance, to establish the Deleuzian double articulation of molar and molecular politics, then to remain caught up in a desire for a molar subject and identitarian politics through a female subject, locks feminism, as Claire Colebrook has argued, into an enslaved position, thus preventing the very ontology of change or 'movement' 'to embrace the female subject as a foundation or schema for action would lead to *ressentiment*; the slavish subordination of action to some high ideal.'[4]

This is why my own work in practice and theory is now exploring the concept of the fugitive girl as duration beyond movement. Duration incorporates a much more volitional understanding of the continual and creative evolution of our existential singularities, of our multiplicities, our various planes of existence, and individual differences at a micro-cellular and temporal level. Bergson, writing in *Matter and Memory* indicates that, 'between the plane of action – the plane in which our body has condensed its past into motor habits – and the plane of pure memory, where our mind retains in all its details the picture of our past life, we believe that we can discover thousands of different planes of consciousness, a thousand integral and yet diverse repetitions of the whole of the experience through which we have lived' (Bergson in Ansell Pearson and Mullarkey, 2002: 136). The intricacies of any conception of 'movement', then, are contingently assemblaged.

Such a molecular and cellular politics works through volatilities, energies, movements and affective temporalities, through duration. These intensities and volatilities of the 'girl' – the fugitive space, can be appropriated and mobilised within post-theory on creativity including creative feminisms in dance practice, choreography and film aesthetics. This presents a micro-cellular pragmatics of processuality, something in continual evolution, dynamic and contingent, working as a machinic and assemblaged body/mind through a field of singularities, particles, fibres, atoms – transfeminisms and creativity as 'becoming'. Tiny events, molecular

actions and intensities within, across and internal to smaller collectivities and identities within larger groups can make such transitional and transformational feminisms and creative acts possible. These transformations come not from the representational location of language, or through concerns with homogenous, mechanistic or finalistic conceptions of space or time, but through the performative durations of choreography and dance. A double articulation: a performative, molecular politics working alongside a more molar political agenda, thus effectuates, as Guattari indicates, transitional effects and re-singularities upon the more molar political arena. If any argument is to be located within the intuitive spaces of performativity, that argument proposes that creativity lies beyond the auspices of any subjective and affective space, within and through the durational and affective temporalities of life itself. Bergson argues that the affective temporal self, 'has specific discrete moments…each of which is objectified within homogeneous spatiality…within the existential integrity of the 'self' within a passive synthesis is the original and creative "potentia" of life.'[5] Life simply is. We are merely contractile, visceral and volatile creatures of chance, evolving through the durations of existential singularities. Why has this move towards an ontology of duration, and ontology of fluidity rather than subjectivity and affect arisen within choreographic, filmic and feminist discourses?

2. The ossification of representation

Echoing and acknowledging Michelle Montrelay, Dorothea Olkowski argues that representation has contributed to the subordination of women through its prioritisation of the stance of objectivity, rationality, identity. Furthermore it has done this through a system of meaning which has foregounded a hierarchical rendering of space and time. Like the categories of mind/body, rational/emotional, male/female the categories of space/time have legitimated also a masculine perspective of reality. As I have argued in *Deleuze and Cinema: The Aesthetics of Sensation*,[6] feminist concern with representation, subjectivity and identity have prevented any creative or intuitive awareness of the aesthetics of the filmic process or of woman. Locked into debates about semiotics, structuralist linguistics and psychoanalysis, the notorious 'order – words' which prevent creativity and invention and the fugitive space of creative acts, feminisms and film theory have maintained debates around representation, subjectivity, pleasure and desire that still prioritised the significance of subjectivity or the very least a new understanding of that term. Representation as Deleuze indicates 'fails to capture the affirmed world of difference. Representation has only a single centre, a unique and receding perspective and in consequence a false depth. It mediates everything, but mobilises and moves nothing. Movement, for its part, implies a plurality of centres, a superimposition of perspectives, a tangle of views, a co-existence of moments, which essentially distort representation' (Deleuze, *Difference and Repetition* 1994: 56). Like Olkowski and Montrelay, my concern is to ossify the prioritisation of organic representation by mobilising difference beyond opposition, identity and subjectivity and instead to consider time and duration as the heterogeneity through which creative conceptions of feminisms, performance and film theory and artistic practice might emerge. This move can be done pragmatically by delegitimating subjectivity through a reappropriation of Deleuze's understanding of difference and engaging with Bergsonian conceptions of movement as a new exploration of time and duration, through choreography and filmic spaces. Further convinced of a need to *practice art* rather than write as a way forward for a creative transfeminist pragmatics, my digital visual work and choreographical performance enables a double articulation of Olkowski's remit on difference and time, with conceptions of the beyond of affectivity and sensation

through to duration and the virtual. Indeed, affective bodies are the speeds and stillnesses of duration and movement. The practice of dance and discussion of film as a choreography of the temporal screen provides a pragmatic approach to the delegitimation of representation, not through static (although politically dynamic) visual events such as Mary Kelly's paintings, for example, but through dynamic performativity in its dislocation of space/time hierarchies. Choreography becomes then both practice and concept – a double articulation. Thus we can begin to frame Deleuze's conceptualisation of difference-in-itself within a debate about affective temporality. In other words, the affective is mobilised not so much within any subjective or subsumed positionality in a material state, but even beyond that in the more profound spaces of duration in what some have called the virtual.[7]

Choreography and dance have always involved a different form of movement, but representational articulations of movement from Aristotle onwards have claimed that movement is a process of space and time set within a specific hierarchy: for example, that the past, present and future appear as discrete and distinct moments in time, in continuum, as discrete positionalities. In contrast also with Spencerian notions of time as a series of instants and mathematical mechanics, Deleuze-Bergsonian perspectives attest to time as an immanent process, not a linear and hierarchised rendition of discrete moments. Deleuze-Bergsonism allows us to rethink time and duration as immanent, intuitive and therefore creative, linking affectivity to durational process as opposed to subjectivity. Any present is thus partly the future it will become and the past it has been. A further look at Aristotle highlights the need for Deleuze on difference and from that a consideration of time as difference, and affectivity as a process of durational differences. Aristotle's prioritisation of representation maintained the hierarchy of space and time. Olkowski presents a delegitimisation of the hierarchical ordering of space and time through which representation has according to Aristotle onwards worked. Arguing for a logic of difference premised on Deleuze-Bergsonism, Olkowski states, 'Representation is a hierarchical construction or category producing an objectified understanding of reality. We need an image of 'difference' that removes the prioritisation of 'identity' and 'objectified being'.[8]

Representation has maintained a hierarchy of discourse premised on binary thinking and oppositional terms. Aristotle's work established an authoritative source for visible understanding. The system of representation involved an objective spatial and temporal homogeneity. This particular use of the understanding of space and time, gives a fixed 'view' and a fixed panorama of reality. I have argued elsewhere (Kennedy 2000) that in film theory the camera obscura perspective in film history also procured a specific objectified stance for the viewer of the screen, whereby the viewer had a strictly objective view of reality as a subject. Olkowski argues that such a view of the world is restrictive. For example, it enables no autonomous space for difference, so for feminist agendas, woman cannot be perceived differently, only oppositionally. Olkowski argues, we need to recognise a multiplicity of particular perspectives and points of view of those who see in 'difference' not just the status of an outsider with regard to the dominant culture, but those who in some manner practice 'difference' and who value this practice.[9] To enable on ontology of becoming which will allow us to rethink woman and indeed creativity itself, beyond a molar politics, as duration itself, we need to create an innovative conception of 'difference' away from concepts of identity, subjectivity and representation. Deleuze indicates that a philosophy of difference provides a disequilibrium which perpetually distanciates the representational. Such a dehierarchisation enables a contractile and irritable creative process for thinking, and beyond that for creative evolution. As Bergson states, 'creation, the always and ever new, is an ongoing process of contraction, folding in what comes along on the outside,

over what is contracted; thus the stability of each articulation is only relative in the sense that it is never complete or final.'[10]

In *Difference and Repetition*, Deleuze re-orientates Aristotle's conception of representation by reconsidering difference in itself not through opposition. In other words, a thing differs first and foremost from itself not with something which it is not. Aristotle's thinking of difference prevented any rigorous claim to difference since to him difference exists by virtue of opposition to what one is not, thus negating any true or real acknowledgement of difference in and for itself. Thus Aristotle rejects difference since he does not see differences that are outside of 'otherness'. He always re-orientates difference back to the 'betweeness-of-things in common, thus negating ontological difference.' Olkowski thus points us to Aristotle's *Metaphysics X*, wherein he states, 'for that which is different, is different from some particular thing in some particular respect, so that there must be something identical by which they differ'.[11]

In similarity, Aristotle's theories of time argued for a conception of the 'now' as a series of instants, time as a series of discrete 'nows' one after the other. This gave a static and representational model which denied the significant fluidity and motility of time premised on a before and after, on the processuality of the 'before' in the now or the now in the 'after', an immanent conception of time. A Deleuze-Bergsonian understanding of duration conceptualises an immanent and processual choreography of time: the before in the now, and the now in the after, each part different-in-itself from the other parts, continually evolving in a process of immanence.[12] I want to take this model forward as a creative understanding and space which I conceive is the space of the girl as fugitive-being, through woman-as-difference and as duration, and the fugitive girl as the fragile space of time unhinged. Thus we might use time/duration as a process through which to undo the representational, both in choreographical practice, as I foregrounded earlier, but also through a conceptualisation of film as a choreographed screenic space in specific films. I am arguing for a conceptualisation of difference as *real,* through dance/performativity, not through structuralist linguistics. Thus in a Deleuzian science of the sensible art ceases to be representation, to become experience. Dance is experience – it mobilizes temporal affectivity beyond any representational format.

Choreography, transformational feminisms and creativity all require 'movement', the fragile graces and fugitive spaces of the girl. Deleuze articulates that representation per se mediates but does not *mobilize*. If we are to mobilize in a Bergsonian sense, creative conceptualisations of woman, through the fugitive space of the girl, we have to move beyond post-structuralist conceptions of feminisms and languages into *post* post-structuralist frameworks of difference and duration. Feminisms are still predicated on identity and difference as opposition, An ontology of becoming, an ontology of the fugitive space of the girl through artistic practice of performance and dance, mobilizes rather than mediates. Movement is categorised by what Deleuze refers to as the 'nomadic nomos,' It has many centres, all differences in themselves, discrete singularities. This provides a distortion of representation. As Deleuze states in *Difference and Repetition*, 'in order for there to be movement and mobility, the nomadic nomos, distortion must destabilize representation; representation must be torn from its centre and from the identity of the concept.'[13]

But as Olkowski adds, this reconceptualising of difference is not sufficient for feminist ontologies. Instead, the ruin of representation can only be accomplished through the level of actual artistic practices – hence I argue through the nomadic and fugitive spaces of choreography. Choreography, through the time of its movements and sounds becomes both an ethical and aesthetic variation which works like Bergson's conception of duration. But

for us to see how this is manifest in Deleuze-Bergsonism, we need to follow the trajectory from subjectivity to affect and beyond to duration, if not the virtual.

3. From subjectivity and affect to the becoming which is the girl

In *Deleuze and Cinema* (Kennedy 2000) I have argued for a subsuming of subjectivity through affect and becoming in order to account for different mechanisms of desire premised upon psychoanalysis. This new consideration of desire mobilizes new thinking for both film theory, performativity, dance and feminisms. Deleuze theorises a plane of immanence as that through which desire is effectuated. The plane of immanence is not any physical or psychical space, but a space/non-space of processual becoming, of positivity and the aleatory. This plane of immanence is replete, he argues, with speeds, particles, or molecules, where themes, motifs and subjects are only retained as free floating affects. Affect is the crucial element in any pragmatics of 'becoming'. It is this concept of affect, dislocated from its Freudian and psychoanalytic connotations of the release of psychic energies which effects emotional states and is connected with emotion and sensation and as I shall progress here, with duration and time, rather than the organism's pleasure which becomes central to an ethics of becoming. The foundations of Deleuze's concept of affect comes form both Bergsonian and Spinozist legacies and are located within the 'material' configurations of energy, matter and the real. My position in *Deleuze and Cinema* takes the debate only to the level of affect and it is here, in this paper that I argue for a move beyond becoming-woman and sensation towards the fugitive space of the 'girl' – an ontology of duration and the relational as a move to understanding the creative process, for both thinking, politics and the aesthetic. Deleuze's ideas on becoming enable a move into theories which further distanciate the subject and subjectivity. Subjectivity becomes subsumed through a recurring process of difference and repetition premised upon Bergson's intuitive method which prioritises time and duration. This repetition of individual differences in Deleuze subsumes the subject, through the fugitive spaces of haecceity through the space of the girl.

A new conception of the material and a concern with matter as it functions within the production of an emergent, pre-personal state, might help us to move into understanding the 'creative' beyond subjectivity, through subjectless subjectivities. This then enables a new conception of an aesthetic or rather an ethico-aesthetic premised not on individual subjectivity or identity, but upon the very materiality of affectivity as a concept of durational differences. Indeed 'art excites an affectivity' or what Nietzsche calls a 'will to power' which maintains the desire to overcome the organism and unfold subjectivity in material expression.'[14] Subjectivities are seen then as part of a pre-personal state, existing outside any sense of self and are multiplicitous. Like Guattari, Deleuze posits the existence of proto-subjectivities as a realm of autoconsistency, before and beyond any 'subject'. Rather, there exists what Deleuze calls an autopoietic state of being, before the social and cultural world of language structures and before the emergent sense of a psychic self. This I have explored elsewhere in more detail (Kennedy 2000). Duration, movement and process are intrinsic to this qualitative sense of multiplicity. A qualitative multiplicity is therefore not an average of numerical parts, but is what Deleuze calls an 'event' an 'haecceity' or 'an actual, felt occasion of experience'.[15] Haecceities are simply degrees of power which combine and to which correspond a power to affect or be affected, active or passive affects, intensities'.[16] This is the fugitive space – the creative chiasm – the interval. Processuality and duration are determined by this qualitative multiplicity of proto-subjectivities. The

pathic and the felt, significant concepts within creativity, then can be theorised outside of phenomenological accounts of subject.

4. Bergson, affectivity and duration

According to Bergson, our creative intuitive spaces are socialised out of us through language, through 'order words,' as I described earlier. But there is deeper structure which he refers to as passive synthesis within the organism, which is at the root of the creative act, the creative process and as Deleuze exemplifies in his *Three Syntheses*, lies a at the heart of the unconscious. To understand this we need to consider the 'outside' of language – the creative spaces of the intuitive and the real. His method of philosophical intuition explores the affective process as that which is effectuated within the materiality of specific durations within us, and within the cellular formation of the universe. To do this we need to consider the concepts of space and time (concepts relevant to dance and performativity) as differences in kind. Space has always been theorised first and then applied to time. What is needed is a reconsideration of the intuitive as a process of time. Affectivity for Bergson arises through time: 'I examine the condition in which affections are produced: I find that they always interpose themselves between the excitations that I receive, from without, and the movements I am about to execute.'[17]

As an abstraction of thinking processes, this can also be applied to the intuitive that occurs within dance and choreography. Thus creativity, whether in thinking or dancing involves an affectivity that is driven not by psychic determinants but by material being. Whilst we might perceive the world through the bodily sensorium, nonetheless, it is within the depths of the body that affectivity arises, although not in any phenomenological sense. The depths of the Bergsonian mind/world/body lie in something more profound – in the materiality of our durations and the repetitions of durations through passive synthesis. It is through the imagination that the synthesis of past, present and future are mobilised. The present is thus both the past it has been and the future it is to become. Subjectivity cannot be contained within any psychic space of the unconscious, but fluxes and tendencies mobilise the synthesis of the changing transpositions of our consciousness. 'The imagination', states Deleuze, is a 'contractile power: like a sensitive plate, it retains one case when the other appears. It contracts cases, elements, agitations or homogeneous instants and grounds these in an internal qualitative impression endowed with a certain weight' (Deleuze 1994: 70). Rather the living present goes from the past to the future which it constitutes in time, which is to say also from the particular to the general: from the particulars which it envelops by contraction to the general which it develops in the field of expectation. This synthesis must be given the name: passive synthesis' (ibid.: 71). What is important here for dance and transfeminisms is the Bergsonian underpinning of passive synthesis, in which lies the affective. This arises from the interiority of a being, from 'within' and he further explains that this duration of affectivity has a dual movement, which acts as a multiplicity:

> each and every affection is situated at the 'interval' between a multiplicity of excitations received from without and the movements about to be executed. The movements about to be carried out arise because each affection contains an invitation to act ... within affectivity there is nothing constraining choice. Feeling and sensation are activated ... affectivity thus arises in the *interval* between excitation and action, but not only for human life.[18]

This explanation of the affective/intuitive act, is I believe an explanation of the intuitive process of choreography and dance. The body intuitively responds to sound, to tone, to another's durations in movement – which 'acts' and to which we then respond, resist, transform, translate, collide. The experimental visual footage and choreography I have produced mobilises a dancer's intuitive response to another's durations, before spaces or movement: but also to each other's bodies often in carpoeria-like moves, through an excitation of specific timbres, cadences, chords and the spaces around them. Furthermore, my intuitive editing of specific shots creatively 'acts' or 'waits to act' just like the dancer's body – the grass or the waters' durations: a volitional move, a nuance, a hesitancy, a delicacy of turn, a gestural silence, a mimetic resolve. The dancers in turn are 'invited' to act, or do not act, in much the same way as Bergson explains the 'act' of the intuitive, and its variety of cadences.

But Bergson indicates that in this we are not alone. Affectivity is a creative process in all matter – living matter. As I have explored elsewhere through Deleuze and the proto-subjective, affectivity arises within the organic world at the same time. There is here what Olkowski describes as a 'dual function of sensibility and choice.' Bergson conduces that affectivity is an indication of innovation or creativity because it brings something *new*. The body, according to Bergson is a 'multiplicity of affections:

> external objects disturb afferent nerves and the disturbance is passed on to the nerve centres, theatres of molecular movements whose being affected can only come from objects. If the objects change, so does the disturbance.
>
> (Bergson, in Ansell Pearson and Mullarkey 1988: 22)

Thus everything changes as the body moves. If the entire universe is images, and one of the images is my body, then dance motivates new and unique images which are mind/bodies by virtue of shape, size, speeds, slownesses, pace, rhythms, forms, ethereality, staticity, rigidity. The variations of the body in relation to sound and space transform our individual durations and tendencies as part of the materiality of existence. They do not create a representation – they *mobilize* an intuition.[19] If this is the case, then representation can be challenged by virtue of a call to intuition; life as a process of continual creation, Thus, if *post* post-structuralist feminisms (what I term transfeminisms) are to produce something new in creative practices like dance or film through acknowledgement of Deleuze-Bergsonian ideas, we need to enhance and employ this micro-cellular ethics but also to engage in artistic practices themselves. To act, to perform and to mobilise. Hence the video/choreography which I am currently working through, in its processuality and not as representation, articulates the synthesis of the cellular, the material, with the intuitive of the body/mind through a durational schema. Extending this to a trans-feminist pragmatics, then, choreography as practice articulates the intuitive, the creative, beyond the rigidity of representational discourse, locked into thinking which prioritises a logic of solids at the expense of a logic of fluidity. The very fluidity of dance articulates a fluidity of process which as a pragmatic and experimental mode of performativity sets in motion different directions for a feminist and creative act of becoming. This is evolutionary and creative, a choreographed 'nomos', as opposed to being a political and molar movement stultified by ressentiment, an enslaved positionality to higher ideals – madonna, mother, wife, lover, perspectival, mediaeval, organic woman. The fragile graces of *this* girl will not be so contained. She moves in fugitive spaces.

Her fugitive spaces are the durational affectivites of temporality. Duration is real, not psychical, and dance, like feminisms, can be deterritorialised through an ontology of duration and heterogeneity. How is duration the 'real' of affectivity? To understand how affection is

part of the 'flow' of life, we need to see how plant/animal/organic life is programmed as a series of strata which make up specific substances at a molecular and cellular level. There is a drama, dance and choreography to the very core of nature in life itself, predicated on contractile, and volatile disturbances and vicariances that each and every molecule and atom exerts in the process of 'aliveness'. This act of living, consists of an enfolding of an outer and inner layer, a continual process of contraction, relaxation and transmission according to the physical laws of nature. The contraction process of just giving birth, physically, provides an only too blatant analogy of the existential condition of contraction. This is not to argue for some sort of reductionist ethics or essentialist feminist tract but to propose that as humans, we too have cellular and molecular processes of complexity which are similar to those of even the most primitive life forms, such as the protoplasm or amoeba. Indeed, as Deleuze indicates, we too are made of water, air, earth. The quality of 'aliveness' is exerted through contractile and volatile movements, tiny cellular activities, before and beyond any emergence of a self, and each stage of the process both encapsulates and extends the stage before and the stage after, in a durational flow. As Bergson indicates, the elements of every living thing, have movements, micro-movements, as 'temporality'. He refers to this temporal cellular process as 'passive synthesis'. If we reduce this down to the most micro level, then two grains of sand which form together to make a series of grains, within geological formations, actually have something characteristic which resonate with another. This resonance is a contraction, a folding in of what is outside, an action of attraction but also repulsion. Thus the very differentials in kind at each stage produce a temporal and durational pattern of differences. Thus affectivity is premised on contraction, contradiction and the contractile. Bergson is not arguing that creativity is effectuated through such a process of duration alone, but that together with languages, ideas and concepts, the percepts of passive synthesis can provoke a dual activity within creative thinking and creative acts. We change, we scatter, we disseminate, we fracture, but if creation is not operating on levels of ideas and concepts as well as life forms, then there is no creativity. For feminisms and choreography, movements may be the place for politics, for representations, but an ontology of the creative which argues for a transformational feminism, involves the real movements of duration. In such a transformational feminism, subjectivities cannot only be subsumed, or distanciated through affectivity, but focused in terms of time, rather than space. Thus we can theorise in dance and filmic screenic spaces a conception of real movements in time, which are affectively a change of quality in the creative act.

Pure duration then explains the continual process of blending and folding of each succession of qualitative changes in the micro-intensities of the organism – Time Unhinged. Consequently, dance, specifically through the ways in which I articulate this through both actual live performance and improvisation, together with the video/recorded and played back performance, in assemblage with other fragments of the real, constitutes an heterogeneity, through which 'woman', feminism, body becomes 'girl'. By being transported and transformed beyond the strictures of a static, two-dimensional space of painting/photography my work is a collaboration of live/actual performativity. Everything changes and moves through motility. This motility of thinking strategies is also effectuated technologically through different media, camera shots, choices and resingularisations, together with inspirational and intuitive 'acts' themselves across the bodies of the performers and the durations of water, earth, plant. Time is no longer the immutable form of everything as feminism and woman becomes a durational ethics. Like Bergson's conception of duration, if feminism recollects the preceding stages, along with the current one, 'perceiving and permeating the other like a tune, they form a qualitative multiplicity, an image of pure duration'. As Olkowski has argued, 'duration is not a psychical principle, but the point of departure for

an ontology that takes into account the thousands of contractions, double articulations and strata that inhabit the universe of creative life'.[20] Consequently, rather than see dance and choreography as an emotive and phenomenologically conceived form which relates bodies to spatial schema and connects through subjective resonances, we can provide an ontological account of dance/choreography as durational process, where time is the form of change for creative futures.

5. Screenic times

In film theory then, such determinations provide innovative conceptions to the ways in which film *acts*, *performs*, *dances*, as material capture. The cinematic experience is one of 'material capture', processuality and durations – as opposed to a spectator/text relational, and new ideas of duration enable creative conceptions of film aesthetics and film readings. 'Material capture' or the 'event' of the cinematic destratifies any prioritisation of the visual. Rather, rhythm, movement, time and processuality are choreographed and assemblaged fugitive spaces of desire: a desire not premised on the auspices of psychic manifestations, or contained within the semantics of structuralist linguistics. The cinematic experience is a choreography: this visionary dance lies in an aparalletic evolution of vision/sounds/rhythms and bodies are transformed, fascinated and fluctuated across deterritorialised vision, where modes of individuation transform through haecceities. To conclude the paper, I want briefly to refer to my previous work on the film *Leon* (see Kennedy 2000).

In a movie replete with violence, images of death and sadistic pleasures, *Leon* acts, performs and dances to assuage those very negativities in its validation of desire and the durational. The becoming of its tendencies is effectuated as duration through machinic elements of the abstract concept 'girl', and through the fugitive spaces of her becoming. *Leon*'s heroine, Mathilda, works as an actual representational figure – as a character of a female child. But she functions or acts as a series of durations. The 'girl' has a performative abstract conceptualisation of a durational mode. A fugitive space – beyond the affective or the representational. The concept functions to describe the choreography of duration through speeds, velocities and vectors of duration. This space of the intuitive, the inventive, the inexplicable, the creative, is a fugitive space: an unfixed and non-locatable space, the duration of 'girl'. The speeds and intensities here can never connect, but collide, or repel, like magnetic force fields, as Deleuze indicates, 'What is a group of girls? Proust at least has shown us once and for all that their individuation, collective or singular proceeds, not by subjectivity, but pure haecceity. "Fugitive beings". They are pure relations of speed and slownesses and nothing else. A girl is late on account of her speed...'[21]

In *Leon,* a drug ridden and violent narrative provides a chaotic, dangerous but exciting mise-en-scene in which the relationship of Leon and Mathilda sensitively develops. But we might think of sensitivity here, not as a romantic cliche, but as a new conception of love as a state in process. It is created in relation to film through aesthetic elements of sensation and duration. How is this materialised in *Leon.* Leon and Mathilda first encounter each other when Leon returns to his apartment, following his recent 'cleaning' job. The camera slowly tracks him. We have a sequence of images which through controlled camera movements, made in time to non-diegetic delicate riffs from guitar and xylophone, modulate the abstract concept of 'becoming-girl' at an aleatory, pathic and pre-subjective level. How is this acted ... how does the film choreograph this experience?

In a beautiful counterpoint with the previous scene of violence, the introduction of Mathilda is gently effectuated through the style of editing, and the flowing temporality

of the camera's shots. From an aerial shot of a staircase, to Leon's apartment block, the camera pans slowly to a still image of Mathilda's right foot, swinging gently to then reveal both feet, centre frame, clad in huge brown, leather boots, swinging in contrapuntal time to the music, and a delicately held hand with cigarette. In several frames in the film, this pair of feet is centrally located within the frame, in contradistinction to Leon's, with significant reverberations of contrast, dissonance and similarity-in-difference. Their cumbersome look is paradoxically gentle and awkward. The next frame shows the camera tilting slowly in a ten second shot upwards over Mathilda's body, her clothes, white lacey bolero, velvet choker and pink leggings, texturally and evocatively 'feminine' in their tactility and colourful hues. Sexuality and sophistication are belied by a cigarette ever so naively but eloquently held from Leon's view: an interestingly paradoxical trope of eloquence, sophistication and maturity disguised by a multiplicity of personae. It is this multiplicity, together with Mathilda's functionality as speeds, and velocities which disorientates Leon's masculinity, so obviously represented on a molar level by his physique, muscular, robust and totally fit. The following shot cuts to a four second close up of Mathilda's face, beautifully shadowed in chiaroscuro by means of side lighting, framed and yet contained behind the intricacy and delicacy of the lace patterned wrought ironwork. Image and sound work in collision at a pathic level. This use of chiaroscuro lighting impacts at a cellular level on the brain's perception of tones, thus causing pathic and gestural experiences, felt more deeply than any subjective encounter. The angle of Mathilda's face is Pieta-like in its angelic and madonna-esque nuances, as she inclines gently to the right, an innocent, sympathetic and paradoxical expression of hope and forlorn anxiety, but also provocation. The provocation is less sexual than molecularly sexual. It is replete with singularities, durations and velocities, but not characteristic of a girl in the molar sense. This complex imbrication of innocence/maturity is evoked by the still frame: the camera maintains this shot for three seconds. This is followed by a close up shot which is held for six seconds, of her face and hair, emphasising intricate and balanced camera movements, through the focus on her eyes, nose and delicate mouth. The beauty lies in the processuality. In a processual rhythm between viewer and screen, in the visionary dance between screen and viewer, it is the body and facial movements, the hand which becomes face, the eye which becomes nose – becomes mouth, which modulates the 'girl' in the abstract sense. Through the contrasting rhythms of such different 'processual' and durationalities, a new concept of the beautiful emerges. A different and neo-aesthetic definition of the beautiful is determined by the concept of time and duration. Beauty therefore, in terms of the beauty of the fugitive space of 'girl' pertains to a *time* factor, a temporal and durational notion, an 'opening out' into another space, another moment, in the future, as it were, contained in one movement – creative evolution.

6. In conclusion

Whether it is for artistic practice in choreography per se, or for understanding and exploring specific filmic spaces duration and processuality have a vital and intuitive place in our schema of understanding the creative process. I want to conclude with the following from Bergson:

> A violent love or a deep melancholy takes possession of our soul: here we feel
> a thousand different elements which dissolve into and permeate one another
> without any precise outlines, without the least tendency to externalise themselves
> in relation to one another; hence their originality. We distort them as soon as we

distinguish a numerical multiplicity in their confused mass: what will it be, then, when we set them out, isolated from one another, in this homogeneous medium which may be called time or space, whichever you prefer. A moment ago each of them was borrowing an indefinable colour from its surrounding; now we have it colourless, and ready to accept a name. The feeling itself is a being which lives and develops and is therefore constantly changing; otherwise how could it gradually lead us to form a resolution? Our resolution would be immediately taken. But it lives because the duration in which it develops is a duration whose moments permeate one another. ... It is the same self which perceives distinct states at first, and which by afterwards concentrating its attention, will see these states melt into one another like the crystals of a snow-flake when touched for some time with the finger.

(Bergson, in Ansell Pearson and Mullarkey 2002: 74)

And finally:

the more we immerse ourselves in it (duration) the more we set ourselves back in the direction of the principle, though it be transcendent in which we participate and whose eternity is not to be an eternity of immutability, but an eternity of life: how, otherwise, could we live and move in it? *In ea vivimus et movemur et sumus.*

(Bergson, in Ansell Pearson and Mullarkey 2002: 266)

Notes

1 Deleuze, *Bergsonism* (1991) p. 15.
2 Deleuze and Guattari, (1987) A *Thousand Plateaus: Capitalism and Schizophrenia*, trans. Brian Massumi, London: Athlone.
3 Felix Guattari, *Chaosmose*, Paris: Editions Galilee, 1992, trans. Paul Bains and Julian Pefanis, *Chaosmosis,* Power Institute, 1995.
4 Colebrook in Buchanan and Colebrook (2000) *Deleuze and Feminist Theory*, Edinburgh: Edinburgh University Press, p .4.
5 Bergson, *Time and Free Will*, p. 138.
6 Kennedy, B. M. (2000) *Deleuze and Cinema: The Aesthetics of Sensation*, Edinburgh: Edinburgh University Press.
7 Elizabeth Grosz, in *Deleuze and Feminist Theory* (1999) eds C. Colebrook and I. Buchanan, Edinburgh: Edinburgh University Press.
8 Olkowski, D. (1989) *The Ruin of Representation*, Berkeley: University of California Press.
9 Olkowski, ibid.
10 Bergson (1911) *Creative Evolution*, trans. A. Mitchell, New York: Holt.
11 Aristotle, *Metaphysics*, X. 5, 1054625.
12 See Bergson's conception of this in Deleuze's *Bergsonism*.
13 Deleuze in *Difference and Repetition*, p. 56.
14 Paul Bains (1997) 'Subjectless Subjectivity', in Massumi, B. *Canadian Review of Comparative Literature*, p. 519.
15 Paul Bains, ibid.
16 Deleuze and Parnet, *Dialogues*, p. 92.
17 Bergson, *Matter and Memory*, p. 18 and p. 170.
18 Bergson, ibid.
19 Dorothea Olkowski, *The Ruin of Representation*, p. 96.
20 Olkowski, p. 132.
21 Deleuze and Guattari, *A Thousand Plateaus*, p. 271.

Bibliography

Ansell Pearson K. and Mullarkey, J. (eds) (2002) *Bergson: Key Writings*, London and New York: Athlone.

Bains, P. (1997) 'Subjectless subjectivities', quoted in B. Massumi, 'Deleuze, Guattari and the Philosophy of Expression', *Canadian Review of Comparative Literature* 4, September: 519

Bergson, H. (1911) *Creative Evolution,* trans. A. Mitchell, New York: Holt.

Buchanan, I. and Colebrook, C. (eds) (2000) *Deleuze and Feminist Theory*, Edinburgh: Edinburgh University Press.

Cioran, E. M. (1949/1998) *A Short History of Decay*, New York: Arcade.

Deleuze, G and Guattari, F. (1987) *A Thousand Plateaus: Capitalism and Schizophrenia*, trans. B. Massumi, London: Athlone.

Deleuze, G. (1994) *Difference and Repetition*, trans. P. Patton, London: Athlone.

Deleuze, G. (1966/1988) *Bergsonism*, New York: Zone.

Deleuze, G. and Parnet, C. (1987) *Dialogues*, trans. H. Tomlinson and B. Habberjam, London: Athlone.

Guattari, F. (1995) *Chaosmosis: An Ethico-Aesthetic Paradigm*, trans. P. Bains and J. Pefanis, Sydney: Power Publications.

Kennedy, B. M. (2000) *Deleuze and Cinema: The Aesthetics of Sensation*, Edinburgh: Edinburgh University Press.

Massumi, B. (2002) *Parables for the Virtual*, London and Durham, NC: Duke University Press.

Olkowski, D. (1999) *Gilles Deleuze and the Ruin of Representation*, Berkeley and Los Angeles, CA: University of California Press.

Index

References such as "78–9" indicate (not necessarily continuous) discussion across a range of pages. Wherever possible in the case of topics with many references, these have either been divided into sub-topics or the most significant discussions are indicated by page numbers in bold. Publication titles are in italics.

AN INTRODUCTION TO CYBERCULTURE

DAVID BELL

An Introduction to Cybercultures provides an accessible guide to the major forms, practices and meanings of this rapidly-growing field.

From the evolution of hardware and software to the emergence of cyberpunk film and fiction, David Bell introduces readers to the key aspects of cyberculture, including email, the internet, digital imaging technologies, computer games and digital special effects.

Each chapter contains 'hot links' to key articles in its companion volume, *The Cybercultures Reader*, suggestions for further reading, and details of relevant websites.

Individual chapters examine:
• Cybercultures: an introduction • Storying cyberspace • Cultural Studies in cyberspace • Community and cyberculture • Identities in cyberculture • Bodies in cyberculture • Cybersubcultures • Researching cybercultures

ISBN 13: 978-0-415-24658-3 (hbk)
ISBN 13: 978-0-415-24659-0 (pbk)
ISBN 13: 978-0-203-19232-0 (ebk)

DIGITAL ENCOUNTERS

AYLISH WOOD

Digital Encounters is a cross media study of digital moving images in animation, cinema, games and installation art.

In a world increasingly marked by proliferating technologies, the way we encounter and understand these story-worlds, game spaces and art works reveals aspects of the ways in which we organise and decode the vast amount of visual material we are bombarded with each day.

Working with examples from *The Incredibles*; *The Matrix*; *Tomb Raider: Legend* and Bill Viola's *The Five Angels for the Millennium*, Aylish Wood considers how viewers engage with the diverse interfaces of digital effects cinema, digital games and time-based installations and argues that technologies alter human engagement, distributing our attention across a network of images and objects.

This groundbreaking study of digital technology will revitalise this area of research.

ISBN 13: 978-0-415-41065-6 (hbk)
ISBN 13: 978-0-415-41066-3 (pbk)

DIGITAL CURRENTS
Art in the Electronic Age

MARGOT LOVEJOY

Digital Currents explores the growing impact of digital technologies on aesthetic experience and examines the major changes taking place in the role of the artist as social communicator.

Margot Lovejoy recounts the early histories of electronic media for art making - video, computer, the internet - in the new edition of this richly illustrated book. She provides a context for the works of major artists in each media, describes their projects, and discusses the issues and theoretical implications of each to create a foundation for understanding this developing field.

Digital Currents fills a major gap in our understanding of the relationship between art and technology, and the exciting new cultural conditions we are experiencing. It will be ideal reading for students taking courses in digital art, and also for anyone seeking to understand these new creative forms.

ISBN 13: 978-0-415-30780-2 (hbk)
ISBN 13: 978-0-415-30781-9 (pbk)
ISBN 13: 978-0-203-00527-9 (ebk)

THE VIDEO GAME THEORY READER

EDITED BY MARK J P WOLF AND BERNARD PERRON

In the early days of Pong and Pac Man, video games appeared to be little more than an idle pastime. Today, video games make up a multi-billion dollar industry that rivals television and film.

The Video Game Theory Reader brings together exciting new work on the many ways video games are reshaping the face of entertainment and our relationship with technology. Drawing upon examples from widely popular games ranging from *Space Invaders* to *Final Fantasy IX* and *Combat Flight Simulator 2*, the contributors discuss the relationship between video games and other media; the shift from third- to first-person games; gamers and the gaming community; and the important sociological, cultural, industrial, and economic issues that surround gaming.

The Video Game Theory Reader is the essential introduction to a fascinating and rapidly expanding new field of media studies.

ISBN 13: 978-0-415-96578-1 (hbk)
ISBN 13: 978-0-415-96579-8 (pbk)

CYBERCULTURE: THE KEY CONCEPTS

DAVID BELL, BRIAN D LOADER, NICHOLAS PLEACE AND DOUGLAS SCHULER

The only A-Z guide available on this subject, this book provides a wide-ranging and up-to-date overview of the fast-changing and increasingly important world of cyberculture. Its clear and accessible entries cover aspects ranging from the technical to the theoretical, and from movies to the everyday, including:

- artificial intelligence
- cyberfeminism
- cyberpunk
- electronic government
- games
- HTML
- Java
- netiquette
- piracy

Fully cross-referenced and with suggestions for further reading, this comprehensive guide is an essential resource for anyone interested in this fascinating area.

ISBN 13: 978-0-415-24753-5 (hbk)
ISBN 13: 978-0-415-24754-2 (pbk)
ISBN 13: 978-0-203-64705-9 (ebk)

ELEARNING: THE KEY CONCEPTS

ROBIN MASON AND FRANK RENNIE

Elearning has long been touted as the brave new frontier of education, offering new challenges to teachers, students and, indeed, the whole of the education system. This timely book is the perfect reference for anyone seeking to navigate the myriad of names, concepts and applications associated with this new era of teaching, training and learning.

Elearning: the Key Concepts takes you from A to Z through a range of topics, including:

- Blogging
- Course design
- Plagiarism
- Search engines
- Self-directed learning
- Tutoring
- Virtual Learning Environments (VLEs)

Fully cross-referenced, the book also includes a substantial introduction exploring the development of elearning and putting these new challenges in context, and provides extensive guides to further reading, making this an invaluable guide to a vital field.

ISBN 13: 978-0-415-37306-7 (hbk)
ISBN 13: 978-0-415-37307-4 (pbk)
ISBN 13: 978-0-203-09948-3 (ebk)

Related titles from Routledge

WEB THEORY
An Introduction

ROBERT BURNETT
AND DAVID MARSHALL

Web Theory provides a comprehensive, critical introduction to theories of the Internet.

Robert Burnett and David Marshall explore the key debates surrounding internet culture, from issues of globalisation and regulation to ideas of communication, identity and aesthetics. Special characters address news and entertainment in light of changes brought about by the Internet.

Each chapter includes a website address and an appendix advising readers how to explore specific topics on the web. The book also features a comprehensive bibliography and a glossary of key terms.

Individual chapters examine:
• Technological Determinism and the Web • Cybernetics and Information Theory • The Web as Communication • Conceptualising the User • Webs of Identity • Globalisation and the Internet • The Web of Regulation • Web Cultural Aesthetics • The Web of News • The Web of Entertainment • The Loose Web and Cultural Production Theses

ISBN 13: 978-0-415-23833-5 (hbk)
ISBN 13: 978-0-415-23834-2 (pbk)
ISBN 13: 978-0-203-48225-4 (ebk)

Available at all good bookshops
For ordering and further information please visit:
www.routledge.com

ZERO COMMENTS
Blogging and Critical Internet Culture

GEERT LOVINK

In *Zero Comments*, internationally renowed media theorist and 'net critic' Geert Lovink upgrades worn out concepts about the Internet and interrogates the latest hype surrounding blogs and social network sites. In this third volume of his studies into critical Internet culture, following the influential *Dark Fiber* and *My First Recession*, Lovink develops a 'general theory of blogging.'

Unlike most critiques of blogging, Lovink is not focusing here on the dynamics between bloggers and the mainstream news media, but rather unpacking the ways that blogs exhibit a 'nihilist impulse' to empty out established meaning structures. Blogs, Lovink argues, are bringing about the decay of traditional broadcast media, and they are driven by an in-crowd dynamic in which social ranking is a primary concern. The lowest rung of the new Internet hierarchy are those blogs and sites that receive no user feedback or "zero comments."

Lovink explores other important changes to Internet culture, as well, including the silent globalization of the Net in which the West is no longer the main influence behind new media culture, as countries like India, China and Brazil expand their influence. *Zero Comments* also looks forward to speculate on the Net impact of organized networks, free cooperation and distributed aesthetics.

ISBN 13: 978-0-415-97315-1 (hbk)
ISBN 13: 978-0-415-97316-8 (pbk)